PHL

KU-295-716

54060000202472

£45
19×70

The Albert Memorial

THE
PAUL HAMLYN
LIBRARY

TRANSFERRED FROM

THE
CENTRAL LIBRARY
OF THE
BRITISH MUSEUM

2009

WITHDRAWN

The Albert Memorial

*The Prince Consort National Memorial:
its History, Contexts, and Conservation*

Edited by Chris Brooks

Published for the Paul Mellon Centre for Studies in British Art
by Yale University Press, New Haven and London

*The editor gratefully acknowledges the generous support he has received from
The Leverhulme Trust and The Paul Mellon Centre for Studies in British Art*

*English Heritage and Yale University Press
gratefully acknowledge the role of the Albert Memorial Trust
in commissioning the publication of this book*

All rights reserved. This book may not be reproduced in whole or in part, in any form (beyond that permitted by sections 107 and 108 of the US Copyright Law and except by reviewers for the public press), without written permission from the publishers.

© 2000 Copyright by The Albert Memorial Trust

Designed by Derek Birdsall RDI
Typeset by Shirley Thompson / Omnific
Printed in Italy by Conti Tipocolor

Library of Congress Catalog Number 00-105539
ISBN 0 300 07311 9

WITHDRAWN

T7. 6 (ALB)

942.1 ALB

Illustration on page 12: detail of plate 7.

Contents

Foreword by Sir Jocelyn Stevens

Preface by Chris Brooks

Life and Image

1: 'The Late Illustrious Prince' *12*
Hermione Hobhouse

2: Representing Albert *44*
Chris Brooks

Making the Memorial

3: George Gilbert Scott, the Memorial Competition, and the Critics *98*
Gavin Stamp

4: Building the Memorial: the Engineering and Construction History *134*
Robert Thorne

5: The Sculpture *160*
Benedict Read

6: Iconography and Victorian Values *206*
Colin Cunningham

7: Francis Skidmore and the Metalwork *252*
Peter Howell

8: The Mosaics *286*
Teresa Sladen

9: Albertopolis: The Estate of the 1851 Commissioners *308*
John Physick

Saving the Memorial

10: 'It is so much less ugly dull' *340*
Maintenance, Repairs, and Alterations 1872–1983
Michael Turner

11: Repair and Conservation 1983–1998 *364*
Alasdair Glass

12: The Conservation Programme *394*
Mike Corfield

Epilogue *420*
Chris Brooks

Project Credits *428*

Notes *430*

Index *447*

Picture Acknowledgements *454*

8706

Foreword

The life of Albert, Prince Consort of England, was an extraordinary one. In a little over two decades, between his marriage to Queen Victoria in 1840 and his premature death in 1861, he influenced the whole society and culture of his adopted country. A patron of the arts and sciences, an advocate of social improvement, a reformer of education and the army, a keen supporter of innovation in agriculture and industry, a skilled political adviser to the Queen and to government, Prince Albert was involved in everything. His comprehensive interests were most fully expressed through the Great Exhibition of 1851. His death shocked the country and left Queen Victoria heart-broken, and her own commemoration of him – principally in the Royal Mausoleum at Frogmore and the Albert Memorial Chapel at Windsor – was soon paralleled by commemorative projects throughout Britain. The greatest of these was the Prince Consort National Memorial in London, the spectacular gothic shrine designed by George Gilbert Scott in 1862, eventually completed in 1876 with the unveiling of John Foley's great gilded statue of the Prince.

For more than a century the Albert Memorial braved urban pollution and the British weather without the thorough and regular maintenance so complex a structure needed. Years of neglect took their toll, but the monument's gradual decay went largely unnoticed until, one morning in 1983, a large piece of the lead cornice was found lying on the steps. The problem could no longer be ignored. As the Memorial disappeared behind scaffolding and corrugated iron, a 'Save Albert' campaign, spearheaded by the Victorian Society and vigorously supported by the *Evening Standard*, was launched. Despite the Government's announcement in 1987 that the Memorial would be fully repaired, rumours of plans to demolish it persisted. In early 1994, supported by Westminster City Council, I persuaded Peter Brooke, then Secretary of State for the Department of National Heritage, to allow English Heritage to restore the Memorial, and to contribute £8 million towards the cost – budgeted by the Department at £14 million.

H. R. H. The Prince of Wales agreed to be the Patron of the Albert Memorial Trust, which I formed to find some of the money needed. In the event, the Trust raised £1.25 million and English Heritage contributed a further £2 million, to meet the actual cost of £11.25 million, a saving of nearly £3 million. The 1995 handbook to the Memorial by Chris Brooks, Chair of the Victorian Society and one of the Trustees, has a foreword by the Prince of Wales, who writes of his great great great grandfather:

> *Prince Albert was a remarkable man in a remarkable age. Above all he believed that the Arts, the Sciences and Commerce could be brought together for the benefit of all British people. The Albert Memorial is as remarkable as the man it commemorates. George Gilbert Scott designed it not only to celebrate the Prince Consort's life, but also to explain the ideals and aspirations of the whole Victorian age. The Memorial's unique combination of architecture, sculpture and craftsmanship makes it one of the masterpieces of the Gothic Revival, and one of Europe's greatest public monuments.*
>
> *After more than a century of decay, English Heritage is, thankfully, restoring the Monument to its original grandeur. It is enormously heartening to see the conservation and craft skills of the late twentieth century matching those of our Victorian predecessors, and it is a pleasure to support a conservation project of such national and international significance.*

English Heritage began work on the Albert Memorial in the autumn of 1994: the programme of conservation, repair and restoration, described in detail in the later chapters of this book, took four years to complete.

For Gilbert Scott the building of the Memorial was 'a great collaborative project'. For English Heritage, saving the Memorial was an immense privilege as well as a most challenging and satisfying job, not only because of the unique and complicated nature of the work needed, but also because of our admiration for the very special qualities of the man it commemorates, and our gratitude for the legacy he left to this nation. Scott wrote that he designed the Memorial '*con amore*'. I do not exaggerate when I say that all those engaged on its restoration also worked *con amore*. With nineteen contractors on site not an hour was lost and the whole programme, which required innumerable skills, was finished to the highest standards a year earlier than expected.

Her Majesty the Queen, speaking at the re-opening of the Memorial, referred to the people who had worked incessantly on its construction, day and night, often in freezing conditions, so many years ago. 'The craftsmen and women of today', the Queen said, 'have suffered, I hope, rather less, but their achievement has not fallen short of their forerunners. This is no mausoleum, but a celebration of a great and good life. The words on it read, "Queen Victoria and Her People to the Memory of Albert Prince Consort as a tribute of their gratitude for a life devoted to the public good". I am delighted that Albert's Memorial has been so lovingly and generously saved, and that all who now pass by will see him again, as those who knew and loved him best wished him to be remembered. This restoration is a triumph, and I congratulate English Heritage and all those others who have achieved it.'

In thanking those I begin with Peter Brooke for allowing English Heritage to get on with the job, and for his Department's contribution of £8 million; Chris Smith, the Secretary of State for Culture, Media and Sport, for enabling us to finish it; Ken Minton, Chairman of John Mowlem and Co. plc., the main contractors, not only for the success of his management but also for his generous gift towards the cost of the reopening night's event; Brian Bowen, the site manager, and his excellent staff; the Trustees of the Albert Memorial Trust; the Commissioners of English Heritage; and Westminster City Council. Special thanks are due to Dame Vivien Duffield for her munificent donation to the Albert Memorial Trust; Alasdair Glass, English Heritage's Project Director, for his exceptional management of the programme; Duncan Wilson, the site architect; Peter Inskip and Peter Jenkins, the architects; the English Heritage staff who were involved, and everyone who contributed so brilliantly to the conservation of Britain's most glorious monument either through their patience and skill, or through their financial support. And finally, for this book, I thank Chris Brooks and the contributors, the Paul Mellon Centre for Studies in British Art, and Yale University Press.

The *Son et Lumiere* presentation of the restored Memorial reached its climax as the Queen revealed Prince Albert's glittering statue and, following a fanfare by the State Trumpeters and preceding Beethoven's Ninth Symphony, Queen Victoria's poignant words, spoken by Dame Judi Dench, soared above the huge crowd: 'One day, dearest Albert, everyone will see you as I do'.

I like to think that Queen Victoria's wishes were fulfilled that night.

Sir Jocelyn Stevens CVO
Chairman of English Heritage 1992–2000

Preface

Chris Brooks

Shortly before eleven o'clock on the evening of Saturday 14 December 1861, in the Blue Room of Windsor Castle, Prince Albert, the adored Consort of Queen Victoria, died of what was diagnosed at the time as typhoid fever. He was forty-two years old, three months younger than Victoria, to whom he had been married since 1840. Albert's health had been uncertain for several years, and he was exhausted by the bureaucratic drudgery he imposed on himself, describing it to his eldest daughter in 1860 as 'the treadmill of never-ending business'.[1] His final illness lasted a bare fortnight. The country was almost wholly unprepared for the news of Albert's death. 'Short of my own nearest and dearest,' wrote Lord Shaftesbury in his diary, 'the shock could not have been greater! The desolation of the Queen's heart and life! The deathblow to her happiness on earth!'[2] Victoria went into permanent mourning. Writing in her journal nearly forty years later, on 26 August 1900, she still recorded the date as Albert's birthday: 'How I remember the happy day it used to be, and preparing presents for him, which he would like'.[3] Albert's early death and the Queen's sudden bereavement shocked and moved people throughout Britain. In the days before Albert's funeral, at Windsor on 23 December, even working-class families, with little enough money to spare, bought black ribbons to wear as a mark of sympathy and respect. 'Every shop in London', wrote the diarist Sir William Hardman, 'has kept up mourning shutters, and nothing is seen in all drapers', milliners', tailors' and haberdashers' shops but black. Everybody is in mourning'.[4] The sorrow was sincere, but tinged with self-reproach, for the sympathy that seemed to unite the country at Albert's death had often been withheld in his lifetime. 'For the truth is, and I think all true Britons feel it this day,' said Charles Kingsley in one of the many memorial sermons preached on the Sunday before Albert's funeral, 'that we were not altogether fair to the Prince'.[5]

Kingsley was right. Except for the years around the 1851 Great Exhibition, that he had largely inspired, the Prince had never enjoyed consistent popularity. In the 1840s he was simultaneously glamourised as Victoria's handsome young husband, patronised as an exotic novelty, and satirised as an interloper on the make. Although, as his and Victoria's family grew, he was represented as an exemplar of very British and very bourgeois domestic values, a nationalistic press could never forget for long that Albert was a foreigner. His accent, his attitude to field-sports, the way he sat his horse, all marked him as unBritish. This was a constant stimulus to suspicion, particularly of his increasing influence on the formulation of foreign policy. At the time of the Crimean War in the mid-1850s, distrust turned into more or less open accusations of disloyalty, fuelling an extraordinary rumour that Albert – and even Victoria – had been arrested on charges of treason. Ridiculous as this was, parliamentary leaders found it necessary publicly to exonerate the Prince, and testify to his sterling service in the national interest. Underlying many of the problems Albert encountered in his relationship with his adopted country was the ambiguity of his constitutional position: there were no adequate precedents for the role of the husband of a queen regnant. The situation was not regularised until 1857, when Victoria issued Royal Letters Patent creating him Prince Consort of England, with a rank second only to her own. Even then, Albert could derive little satisfaction from his elevation, for it had come as the personal gift of his wife, not as a public acknowledgement from parliament or people.

Prince Albert's answer to the fickleness of opinion was work. His mentor, Baron Stockmar, had imbued him with a sense both of the high destiny peculiar to princes, and of the responsibilities such a destiny entailed. In the year Albert came courting Victoria, Thomas Carlyle was roundly blaming the parlous Condition of England on the 'self-cancelling Donothingism' of the ruling elite.[6] A few years later it was Carlyle again who famously announced 'All work, even cotton-spinning, is noble; work is alone noble'.[7] Albert worked nobly: to encourage the arts both privately and publicly; to promote the cause of art manufactures; to support progress in science and technology; to urge the remedy of social abuses. He reformed the royal finances and the Royal Household; helped initiate the modernisation of university education; allied himself with the campaign to secure decent artisan housing; tried to tackle the gross inefficiencies of the army; and laid the foundation stones of public building projects by the score. Above all he was the prime mover of the Great Exhibition: 'my beloved Husband', wrote Victoria rapturously, 'the creator of this great "Peace festival", uniting the industry and art of all nations of the earth... Dearest Albert's name is for ever immortalised'.[8] Away from the public show, he laboured incessantly on the voluminous letters, memoranda, reports and despatches that made up the business of state. Through it all one sees a man constructing his own place and role, identifying the making of the self with the making of the nation. In 1836 Stockmar had written that Albert would need not only 'energy and inclination', but also 'that earnest frame of mind which is ready of its own accord to sacrifice mere pleasure to real usefulness'.[9] A quarter of a century later, Albert's life had indeed been one of 'real usefulness'; but still, as he was painfully aware, his historical place in the making of Britain had not won him a place in the nation's affections.

Something of this, as Kingsley suggested, seems to have been in people's minds as they donned their mourning for the dead Prince during the last bleak days of December 1861. In the weeks and months that followed, civic authorities, town councils, learned institutions, and charitable bodies throughout Britain determined to give material expression to their sense of his worth and their loss – and perhaps to make posthumous amends for previous ingratitudes. By the middle of 1862, the commemoration of Prince Albert had taken on all the character of a national movement. Its greatest product was the Prince Consort National Memorial, erected in London on the edge of what is now Kensington Gardens. Always known simply as the Albert Memorial, it was designed by George Gilbert Scott in 1862, took a decade to build, and was not completed until 1876, when John Foley's mighty gilded statue of the Consort was at last unveiled.

The Memorial's aesthetic history has been, if anything, even more chequered by disapproval and lack of sympathy than the career of the man it commemorates. For while it has become one of Britain's best known monuments, it has also been one of the least understood or appreciated. By the time it was finally completed, artistic and architectural taste was turning sharply away from the manner of the High Victorian period. Within a short while the character of the Memorial's ornament was deplored by supporters of the Arts and Crafts Movement, its statuary denigrated by supporters of the New Sculpture, its moral earnestness derided by the aesthetes who embraced Art for Art's Sake. As cultural fashions in the first half of the twentieth century set against all things Victorian, Modernists and their allies found the Memorial at best absurd, at worst offensive. To Kenneth Clark in 1928, it was 'the expression of pure philistinism';[10] Dudley Harbron, a couple of years later, smugly dismissed it as 'a pastry-cook's pagoda';[11] in 1950, Reginald Turnor noted that it was 'treated as London's chief architectural joke ... apparently fail[ing] to appeal even to those critics who are trying to rehabilitate Victorianism'.[12] Such critical dislike certainly influenced the way the Memorial was treated: having already lost much of its colour to London's polluting grime, it was steadily stripped

of its gilding in the early twentieth century, most notably on the figure of Albert himself; repairs in the 1950s, following war damage, were crude; little was ever done in the way of maintenance. Even with the re-evaluation of Victorian architecture that set in around 1960, the Memorial languished in critical estimation. As late as the 1980s, when the fall of leadwork from the flèche made the need for major work obvious, there were proposals to dismantle it. Then, following much debate, came the decision to save the Memorial, and English Heritage's great programme of conservation, repair and restoration, begun in earnest – after further official prevarication – in 1994. Light, glittering, entrancing, the Albert Memorial that was unveiled in October 1998 was a revelation.

This book tells the story of the Memorial and its cultural contexts, from the Prince it commemorates, through the long and intricate process of its creation, to its restoration by English Heritage. The generosity of the Leverhulme Trust, the Paul Mellon Centre for Studies in British Art, and the Albert Memorial Trust have made the book possible. All material from the Royal Archive is quoted by gracious permission of H.M. the Queen. Many people and organisations have helped: individual contributors to the book have included personal acknowledgements with the notes to their chapters. For the book overall I would particularly like to thank the staffs of the Royal Archive, the National Portrait Gallery Archive, and the Devon and Exeter Institution. Special debts of gratitude are owed to Carolyn Starren, Local Studies Librarian of Kensington Central Library, Cathy Houghton of the English Heritage Picture Library, Hugh Alexander of the Image Library at the Public Records Office, Graham Newton, churchwarden of St Alkmund's, Driffield, and Dr Geoffrey Tyack. For many different sorts of help and support I am also most grateful to friends in the Victorian Society and in Exeter University's School of English, particularly Grace Moore, whose help with the final text has been invaluable; also to Steven Parissien, and to my picture researcher Julia Brown, to whose generous labours the whole book owes a great deal.

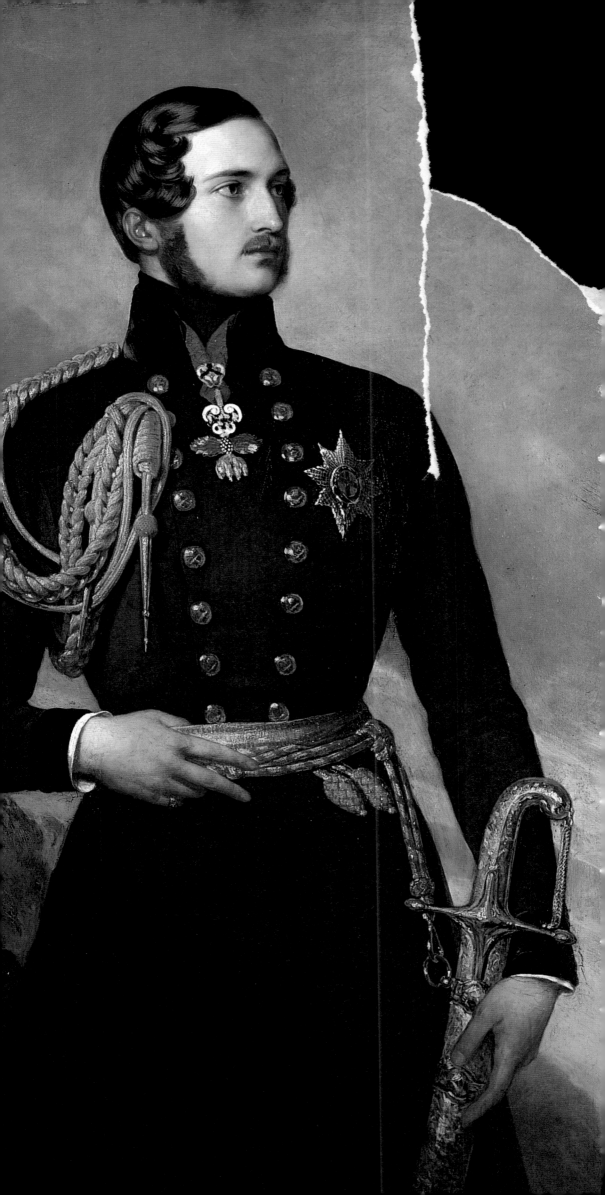

PART ONE: LIFE AND IMAGE

Chapter 1

'The Late Illustrious Prince'

Hermione Hobhouse

'With Prince Albert we have buried our sovereign,' wrote Benjamin Disraeli. 'This German Prince', he continued, 'has governed England for twenty-one years with a wisdom and energy such as none of our kings has ever shown.'[1] Lord Granville, one of Albert's most loyal allies among the Whig grandees, not a constituency that found a lot of common ground or sympathy with the Prince, wrote to his friend Lord Canning, Governor-General of India. 'The most valuable life in this country has been taken, and the public are awakening to the value of the good and wise man who has gone. The loss to the country is great: to the Queen it is irreparable'.[2]

The monument which is the subject of this book was compared by its creator to those other great architectural symbols of devotion to a royal spouse in Britain, the Eleanor Crosses. The Albert Memorial is, as much as the Taj Mahal, a symbol of human love and personal devotion, but the prominence of its position, and the support of large sections of the public, attest that it was not only a tribute from a widowed queen, but also from her people. It testifies to the reputation and achievements of Prince Albert in his relatively short life.

The Prince is often seen, unfairly, as stuffy, pompous, and rather a spoilsport, an impression enhanced by the overwhelming royal mourning which swamped the court after his death. Certainly he reformed the management of the Royal Household, and replaced his young wife's preference for late night balls and London life with a greater emphasis on country pursuits at Windsor and Osborne. However, as a student, he had a reputation for witty caricature, and Lady Lyttelton, governess to the royal children, records many occasions on which his informal and entertaining comments on palace life were far from stuffy. In the heyday of the movement for Sunday observance led by Evangelicals like Lord Shaftesbury, he deplored what was known as a 'Sunday face'. Moreover, he understood that the efforts to restrict Sunday openings of places like the British Museum and the Crystal Palace, and even the performance of military bands in the Royal Parks on the Sabbath, removed colour and recreation from the lives of the working classes for whom Sunday was the only day off. He also admitted the need for moderate drinking, instancing the failure of the 'Ghillies Ball' at Balmoral when beer and not whisky was served. The great Whig families, at whose houses he and the Queen stayed, may have seen him as a pedantic, over-precise, provincial foreigner. But his feeling for the needs of ordinary people endeared him to them, and helps explain how widely he was commemorated after his death. Although London's Albert Memorial was the 'National Memorial', it was paralleled by monuments and by institutions founded in his memory throughout the country.[3]

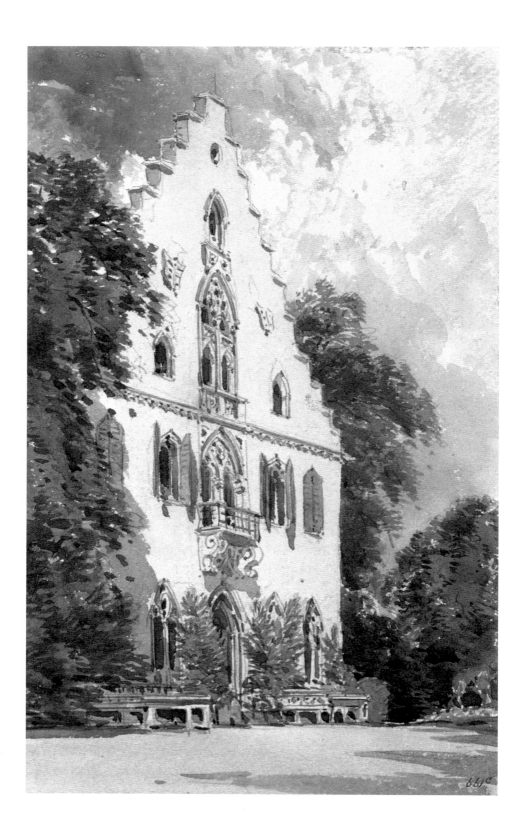

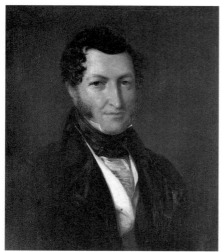

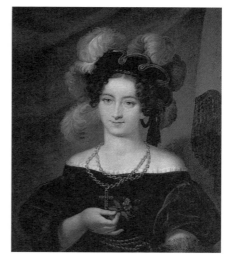

The 'Albertine' period, from 1840 to the early 1860s, was arguably a greater period of interest in the arts, of innovation in manufacturing, and of reform in government than the 'Victorian' period that followed from the 1860s to the end of the century. It takes its intellectual flavour from its eponymous hero, whose carefully engineered upbringing created him, almost deliberately, for the role.

Albert Francis Charles Augustus Emmanuel, Prince of Saxe-Coburg-Gotha, was born in the Schloss Rosenau (1), just outside the Thuringian town of Coburg, on 26 August 1819. His father was Duke Ernst I of Saxe-Coburg-Saalfeld (1784–1844; 2), and his mother the Duchess Luise of Saxe-Gotha (1800–1831; 3), their marriage uniting the two Saxon duchies. Coburg was small, non-royal, and Protestant, looking to Leipzig for its political allegiances, but also influenced by its larger Catholic neighbour, Bavaria, raised to the status of a kingdom during the Napoleonic Wars. Prince Albert's grandparents, Duke Franz-Anton (1750–1806; 4) and his wife Duchess Augusta of Reuss-Ebersdorf (1757–1831), were a formidable couple who gave the little duchy an importance far greater than its size warranted. Duchess Augusta produced a large family, and one daughter was selected by Catherine the Great as a bride for one of her sons. This created a Russian connection which, in the dynastic politics of Europe, benefited all the handsome Coburg sons when it came to marriage. One of the boys, Ferdinand (1785–1851), married into the important Hungarian Kohari family, producing a son who secured the hand of Donna Anna Maria, the Queen of Portugal. Another Coburg son, Leopold (1790–1865), visited London in the train of the Allied sovereigns, the Tsar of Russia and the King of Prussia, in 1814, resulting in his courtship and marriage, two years later, to Princess Charlotte, only child of the Prince Regent and heir to the British crown.

In 1817 Princess Charlotte's death in childbirth left the royal succession unprovided for, and precipitated an indelicate rush to matrimony amongst her uncles, the sons of George III, most of whom had settled into late middle age with their mistresses. The Duke of Clarence (1765–1837) abandoned Mrs Jordan and a brood of Fitzclarences for Adelaide of Saxe-Meiningen, while the Duke of Kent (1767–1820) said farewell to twenty-seven years with Madame Saint Laurent, and entered into marriage with Leopold's sister, the widowed Duchess Victoire of Leiningen (1786–1861). In 1819 at Kensington Palace, the Duchess of Kent gave birth to the Princess Victoria, delivered by the same midwife who was to attend Albert's birth at the Rosenau three months later.

1. Schloss Rosenau, near Coburg, birthplace of Prince Albert; William Callow, *Souvenirs of Rosenau* (Victoria and Albert Museum).

2. Prince Albert's father, Ernst, Duke of Saxe-Coburg and Gotha (1784–1844); portrait by Sir George Hayter, 1840 (Royal Collection).

3. Prince Albert's mother, Luise, Duchess of Saxe-Coburg and Gotha (1800–1831); portrait by Louise Leopoldine de Meyern, after an original by Ludwig Doll, *c.* 1820 (Royal Collection).

4. Franz-Anton, Duke of Saxe-Coburg Saalfeld (1750–1806), grandfather of Prince Albert and Queen Victoria; portrait by Herbert L. Smith (Royal Collection).

The Coburg Connection – as the family's dynastic network was known – thus gave Albert both his place in European politics and his future wife. It also brought him a great deal of hostility from the British court, which saw the Coburgs as scheming and over-ambitious foreigners.

Albert's father, Duke Ernst, had served in the army during the Napoleonic Wars, had given his people a constitution, and reorganised the finances of the duchy. He was a connoisseur, who employed the great Karl Friedrich Schinkel to rebuild the Ehrenburg Palace in the centre of Coburg, and had a fine collection of Viennese and French furniture. However, his marriage to the Duchess Luise – wedded when little more than a child – was unsuccessful, and Albert's parents separated when he was only five. It was a traumatic parting for the children, who never saw their mother again.

Albert and his elder brother Ernst (1818–1893) – later Duke Ernst II – were brought up together (5), becoming very close and remaining devoted to each other despite their different destinies and contrasting characters. A degree of stability was provided by Christoph Florschütz, a tutor who remained

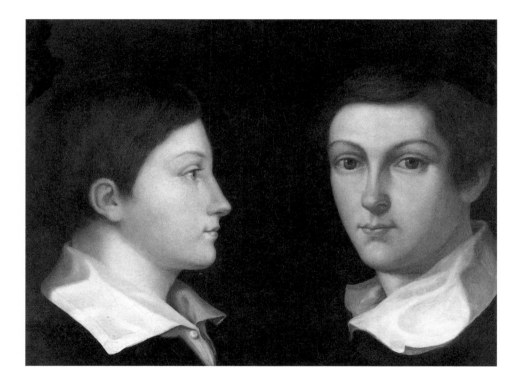

with them from 1823 till 1838. They had a good education and benefited from playing with other children, in marked contrast to the lonely childhood of the little Princess Victoria. Coburg had its own cultural tradition, a fine theatre, and a proud place in German Protestant history, since at a critical moment in the Reformation Martin Luther had found refuge in the Veste Coburg, the medieval castle high above the town. The boys had access to the countryside and rural sports, for which Albert developed a lifelong passion – to the later amusement, and sometimes indignation, of the British press. He and his brother had their own small gardens, and subsequently contrived a *naturmuseum* for which they collected plants and specimens. In due course, Albert was sent to Belgium, to the court of his uncle Leopold, to tour in Italy under the guidance of Baron von Stockmar (1787–1863), and to study at the University of Bonn, more suitable for a Protestant prince than the University of Munich, which was closer but Catholic.

The boys' two grandmothers were very important in their lives, partly because they were the children of a broken home. The Duchess Augusta kept in close touch with her daughter, Victoire, and seems to have been the architect of Albert's marriage. 'The little fellow is the pendant to the pretty cousin', she wrote to the Duchess of York in 1821, 'very handsome, but too slight for a boy; lively, very funny, all good nature and full of mischief.'[4] Augusta had two important coadjutors in Leopold, largely resident as a royal widower in England until he was elected King of the Belgians in 1831, and Stockmar, who had been part of his household and who subsequently moved into that of the young Queen Victoria. Leopold was particularly significant as he provided for his widowed sister and her children, badly off after the Duke of Kent's death in 1820 and refused financial support by George IV. Stockmar and Leopold were to advise the two young Coburg cousins, usually wisely, but often too well for English public opinion. The Clerk to the Privy Council, Charles Greville (1794–1865), who loved a good gossip, observed that being the 'lucky Coburgs' (6) did not make the family popular.[5] This prejudice was mitigated by the approval later given to Albert himself by a substantial part of the British public, but it made things difficult for him in his early married life.

Queen Victoria succeeded to great popular acclaim in 1837, but by 1839 her advisers were anxious to see her settled. She had already demonstrated her view of the royal prerogative through the Bedchamber affair, and despite Lord Melbourne's liking for the role, the management of a headstrong queen scarcely out of her teens was a considerable problem for her ministers. They were inclined to agree with Lord Grey (1764–1845): 'The best thing that could be for the Princess would be to marry soon, and to marry a Prince of ability. *He, as her bosom friend, would then be her most natural and safest private secretary.*'[6]

5. Prince Albert and his brother Prince Ernst (1818–1893); double portrait by Louise Leopoldine de Meyern, 1829 (Royal Collection).

6. Charles Hunt, *The Wonder of Windsor*, *c.* 1841 (British Library); coloured lithograph showing the 'lucky Coburgs'.

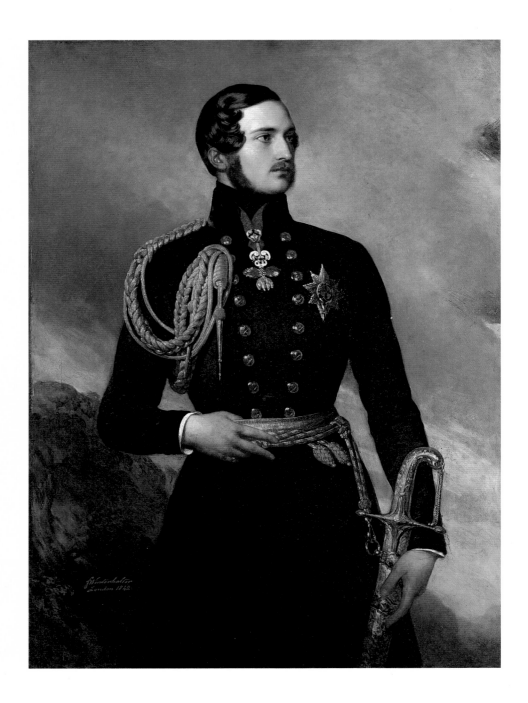

7. Franz Xaver Winterhalter, *Prince Albert*, 1842
(Royal Collection); Albert wears a field-marshal's
undress uniform, with the star of the Garter and the
badge of the Golden Fleece.

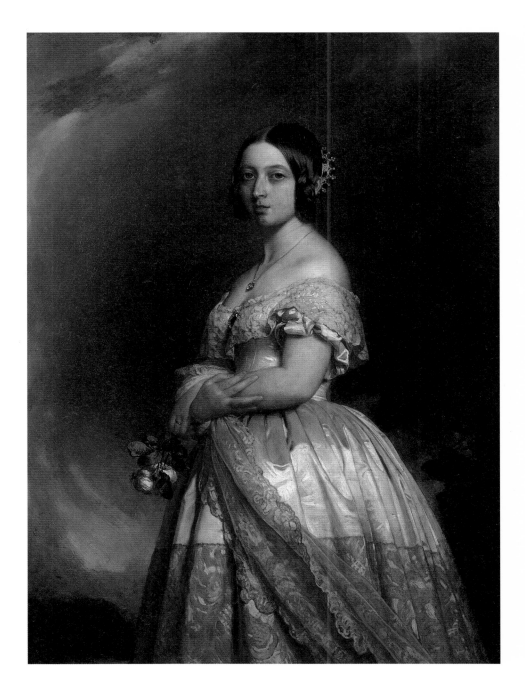

8. Franz Xaver Winterhalter, *Queen Victoria*, 1842
(Royal Collection).

Albert made two visits to England as a young man, the first in 1836, and the second in November 1839, when the Queen proposed and he accepted. It was not unexpected, as he had been trained in many ways as Victoria's spouse, but he had become apprehensive that if he did not marry her, he might be too old to embark on a fresh career. Happily the Queen fell in love with her cousin, and they were married on 10 February 1840, the beginning of one of the happiest of royal marriages. However, Albert's reception by the political establishment did not make him feel very welcome, as he later wrote to Stockmar.

> *A very considerable section of the nation had never given itself the trouble*
> *to consider what really is the position of the husband of a Queen Regnant.*
> *When I first came over here, I was met by this want of knowledge ... Peel cut*
> *down my income, Wellington refused me my rank, the Royal Family cried*
> *out against the Foreign interloper, the Whigs in office were only inclined to*
> *concede to me just as much space as I could stand upon. The Constitution*
> *is silent as to the Consort of the Queen.*[7]

The success of the marriage was very largely due to Prince Albert's self-denying and skilled support of his wife. Though originally banned from anything to do with her business as monarch, the almost continuous pregnancies in their early married life meant that his help was soon very welcome. He so grew into the post of indispensable private secretary, that on his death it was asked 'where can she look for that support and assistance upon which she has leaned in the greatest and least questions of her life ?'[8] Albert's description of his role, in a letter to Wellington written ten years after the marriage, is well-known, but cannot be bettered:

> *[This position] requires that the husband should entirely sink his* own
> individual *existence in that of his wife – that he should aim at no power by*
> *himself or for himself – should shun all contention – assume no separate*
> *responsibility before the public, but make his position entirely a part of*
> *hers ... As the natural head of her family, superintendent of her household,*
> *manager of her private affairs, sole* confidential *adviser in politics, and*
> *only assistant in her communications with the officers of the Government,*
> *he is, besides, the husband of the Queen, the tutor of the royal children,*
> *the private secretary of the sovereign, and her permanent minister.*[9]

Though the pressure of business became more and more relentless, until Albert saw himself as the donkey confined in the Carisbrooke Castle treadmill,[10] in the earlier part of his married life there was time for family pursuits. He and the Queen had sketching and engraving lessons, there were visits to country houses, and evenings spent putting albums of watercolours and engravings together. Court life was inevitably formal, and Victoria dined regularly with her ministers, as well as with members of the court. Court balls often had a historical theme, and in addition to outings to the opera and theatre in London, plays were put on at Windsor. The Prince's contribution as 'superintendent of her household' was significant, and established sound finances for the royal family. With the assistance of Stockmar, he investigated the way in which the Royal Household was run, discovering all kinds of sinecures and lucrative patronage exercised by the traditional Great Officers of State like the Lord Chamberlain, the Lord Steward, and the Master of the Horse. Different areas of the household staff were technically under the management of different Great Officers, leading to confusion and

mismanagement. By returning this patronage to the sovereign Albert not only made a great many savings, but also reorganised the Household, making royal home life more comfortable as well as more economical. With the savings Victoria and Albert were able to build Osborne House on the Isle of Wight, and in due course to embark on the purchase of Balmoral Castle, in Aberdeenshire. This contrasted with the reliance on parliamentary grants which had been such a marked – and resented – feature of George IV's building enterprises, and gave the royal finances a degree of independence.

In his management of the Queen's business, Albert's most significant political contribution was to lift the crown above party loyalties. Victoria began her reign as a Whig monarch, fiercely partisan, defeating Sir Robert Peel (1788–1850) in his attempt to form a Tory administration and engineering the return of her beloved Lord Melbourne (1779–1848). When Melbourne offered his secretary George Anson as private secretary to the young prince, Albert was doubtful about taking into his household someone he feared might be politically biased: 'the selection should be made without regard to politics: for if I am really to keep myself free from parties, my people must not belong exclusively to one side. Above all, the appointments should not be mere "party rewards", but they should possess other recommendations'.[11]

In the event, he accepted Anson, and the two men became great friends. Albert's initial objection had been founded on principle not on personality, as he later explained.

> I do not think it is necessary to belong to any Party. Composed as Party
> is here of two extremes, both must be wrong. The exercise of an unbiased
> judgement may form a better and wiser creed by extracting the good
> from each ... My endeavour will be to form my opinions quite apart from
> politics and party, and I believe such an attempt may succeed.[12]

The British parliamentary classes stuck to their fierce party allegiances, shifting though they often were in early Victorian times. Albert, however, gradually distanced the crown from issues of party, despite occasional feuds like that between the royal couple and the dreaded Lord Palmerston (1784–1865) – 'Pilgerstein', as they nicknamed him.[13] Thus when Peel returned as leader of another Tory government in 1841, Albert managed the change-over with diplomacy, and quickly established a rapport and friendship with Peel which endured until the latter's untimely death. Indeed, this loyalty led him to commit his most serious political solecism, when he appeared in the House of Commons gallery to hear Peel speak on the controversial repeal of the Corn Laws in January 1846. According to the German editor of the Prince's letters, Kurt Jagow, writing in the aftermath of the abdication of Edward VIII in 1936, 'the political ideal' of the sovereign's independence from party, which derived from Leopold and Stockmar, 'in the person of Albert was destined to influence the course of British history'.

> Albert's historical task was to win by systematic labour for the Crown
> the position it should properly occupy ... When all is considered, it is in
> essence due to the merits of the German Prince, who for less than two
> decades sat upon, or rather stood by, the throne of England as the faithful
> guardian of the Crown, that today the British monarchy is able to
> command the power, prestige and internal strength, required by the
> British Empire to hold together its self-governing members, and to take
> rank as a World Power.[14]

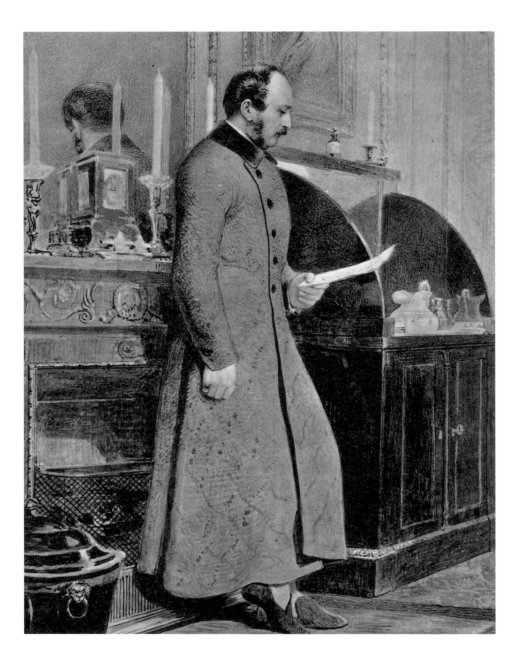

9. Robert Thorburn, *Prince Albert reading
the Trent Despatch*, 1862 (Royal Archives).

The standing of the crown was enhanced by independence from political squabbles, as too by the changed character of royal life. In common with much of the country, Victoria was horrified by her scandalous Hanoverian uncles, and there was genuine apprehension in the first years of the reign that she should die without issue and be replaced by one of them. By the mid-1840s, however, Victoria's court was settled: free from overt political bias, respectable, well-managed, with no royal paramours in sight, and no worry about the succession – possibly even too full of royal children.

The sovereign was still very involved in the day-to-day management of government, particularly of foreign affairs, where the royal family had a number of correspondents not available to the Foreign Secretary. Gradually Prince Albert's involvement in such matters was accepted and even praised. Lord Clarendon could complain to Greville in 1847 that the royal couple 'interfere and meddle in a very inconvenient manner with everything they can'; ten years later, however, his views had changed:

> [Albert's] knowledge and information are astonishing and there is not a department of the Government regarding all details and management of which he is not much better informed and more capable than the Minister at the head of it; in Foreign Affairs particularly he has prevented a great deal of mischief, and kept the Government out of innumerable scrapes ... Prince Albert ... is to all intents and purposes King, only acting entirely in her name. All his views and notions are those of a Constitutional Sovereign, and he fulfils the duties of one.[15]

The last despatch amended by Prince Albert did indeed get the government out of just such a 'scrape'. Late in 1861, the United States, immersed in the Civil War, interfered with a British steamship. The Federal navy had stopped the *Trent*, flying a British flag, but carrying two envoys from the dissident southern states to England to rally support. These Confederate emissaries were taken off the ship, causing fury in Britain at the supposed insult to the flag. The navy was made ready for war in the Atlantic, and an aggressive despatch was prepared by Lord John Russell, then Foreign Secretary. The Prince, already mortally ill, re-wrote it to allow both British and American governments to step back from a potentially disastrous conflict. War was avoided without either side losing face (9).

Prince Albert also had a talent for selecting advisers from many walks of life. When he came to open the Albert Dock in Liverpool in 1846, the engineer Robert Rawlinson (1810–1898) was impressed by his familiarity with a wide range of skills and their practitioners. 'The Prince was at home with such men amidst such works. To an architect he could talk as an architect; to an engineer, as an engineer; to a painter, as a painter; to a sculptor, as to a sculptor; to a chemist, as to a chemist; and so through all the branches of Engineering, Architecture, Art, and Science'.[16]

This talent equipped him to pick a 'kitchen cabinet' of men who enabled him to carry out his various enterprises, and who, after Albert's death, carried on those ventures, bringing many of them to fruition. He had, of course, his official secretaries: first George Anson, who died suddenly in 1849; then Colonel Charles Grey (1804–1870), son of the former Prime Minister and one of the Prince's biographers (10). Colonel Charles Phipps (1801–1866), another member of the Household, was brother to Lord Normanby, British ambassador

in Paris. Albert found his most aristocratic ally in the second Earl Granville (1815–1891; 11), who worked with him as vice-president of the Royal Commission for the Exhibition of 1851. He also forged relationships with leading politicians, notably Peel, whose death in 1850 after a riding accident came as a great blow. Benjamin Disraeli (1804–1881) was always anxious to assist in the Prince's projects, and even Palmerston came to appreciate his capacity for hard work – and for managing the Queen. Some of Albert's advisers were German: his 'adviser in art' Ludwig Grüner (1801–1882; 12), who had accompanied him on his Italian tour and followed him to England; Ernst Becker, his librarian; and Carl Rulandt, who researched and wrote up Albert's projected study of Raphael. Others of the Prince's inner circle included Henry Cole (1802–1882), civil servant and eventual overlord of the South Kensington Museum,[17] the Scottish chemist Lyon Playfair (1818–1890), and Charles Eastlake (1793–1865), President of the Royal Academy.

It was Sir Robert Peel who found Prince Albert his first independent job, as Chairman of the Royal Commission for the decoration of the New Palace of Westminster – the Houses of Parliament. The building of the New Palace had not been without problems, and the Commission was appointed in the autumn of 1841 to oversee the decoration, paintings and sculpture to adorn the new building.[18] One of the proposals was the use of 'true fresco', recently revived by the Nazarenes in Munich: Albert, together with Peel and the painter William Dyce (1806–1864), was one of the few men in England who had some understanding of what it involved. His reaction was characteristic. First of all he advocated and organised a competition for cartoons, depicting great moments from British history, suitable for wall-paintings. The result of this was a very popular exhibition, which filled Westminster Hall in the summer of 1843. Secondly, he embarked on a small-scale experiment to give prominent artists of the day an opportunity to use the technique. Among others, Dyce, Eastlake, Edwin Landseer (1802–1873), and Daniel Maclise (1806–1870) were invited to decorate a garden pavilion on the island in the lake at Buckingham Palace. Thomas Uwins (1782–1857), who also worked on the building, described the interest taken by the royal couple:

Coming to us twice a day unannounced and without attendants, entirely
stript of all state and ceremony, courting conversation, and desiring
reason rather than obedience, they have gained our admiration and love ...

In many things they are an example to the age. They have breakfasted,
heard morning prayers with the household in the private Chapel, and are
out some distance from the Palace talking to us in the summer-house,
before half-past nine o'clock – sometimes earlier. After the public duties of
the day, and before their dinner, they come out again, evidently delighted to
get away from the bustle of the world to enjoy each other's society in the
solitude of the garden.[19]

In the event, 'true fresco' proved too problematic, particularly in the English climate, and many of the pictures in the Palace of Westminster were carried out in oil, a medium more familiar to British artists. Where large murals were concerned, a German technique was adopted on Albert's advocacy by which waterglass was used to stabilise the paintings, a method which has proved more resistant to the London atmosphere. It was the Prince who persuaded Maclise to paint the two famous waterglass murals for the New Palace's Royal Gallery, *The Death of Nelson* and *The Meeting of Wellington and Blücher after Waterloo*.

Prince Albert's well-established relationship with Peel also smoothed out the royal family's housing problems, though these were hardly significant when compared to those of many British people, as *Punch* – discussed in the following chapter – pointed out. But Victoria wanted somewhere to get away to the seaside, Brighton Pavilion being unsuitable for a family with four children under four years old, and Peel found Osborne House in the Isle of Wight for her. This was sufficiently remote to give some privacy, but close enough to Portsmouth to make visits to the navy convenient. It was bought in 1845 out of the savings on the Household, and Victoria could write with delight to Uncle Leopold of 'purchasing... a place of *one's own*, quiet and retired, and free from all Woods and Forests, and other charming Departments who really are the plague of one's life.'[20] The intention had been merely to make a few alterations,

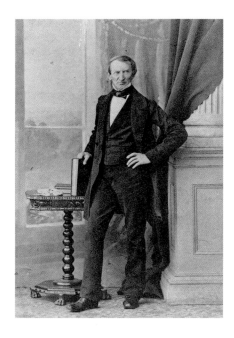

10. General Charles Grey (1804–1870),
Albert's secretary after 1849; photograph
of 1859 (Royal Archives).

11. Granville George Leveson-Gower, Second
Earl Granville (1815–1891); photograph by
John and Charles Watkin, c. 1860
(Royal Archives).

12. Ludwig Grüner (1801–1882), Albert's
principal artistic adviser; photograph of 1860
(Royal Archives).

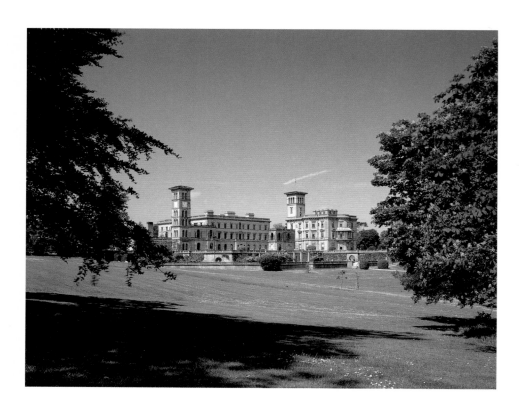

13. Osborne House, designed by Prince Albert and Thomas Cubitt, 1845–51.

14. Thomas Cubitt (1788–1855); anonymous portrait of *c.* 1850 (National Portrait Gallery).

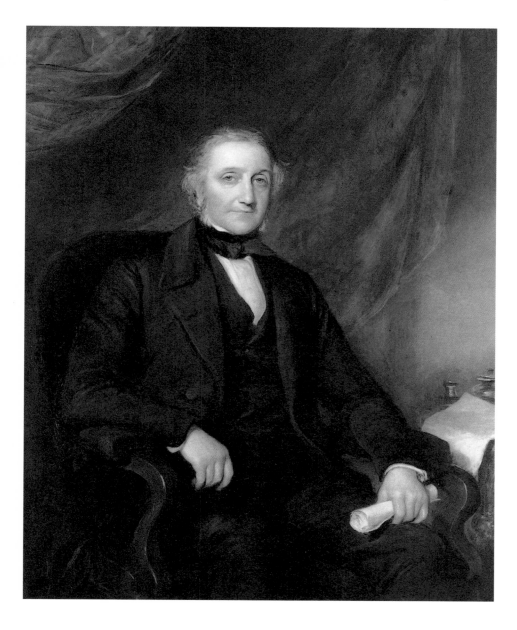

but the great metropolitan builder Thomas Cubitt (1788–1855; 14),[21] employed in preference to any well-known architect, persuaded Prince Albert that it would be cheaper and more satisfactory to build a new house. Working with Cubitt and Grüner, Albert was able to create a house that accommodated family, court, and the numerous royal visitors throughout the Queen's long life. Completed in 1851, Osborne (13) reflects Albert's preference for the classical style, appropriate to a setting that reminded him of the Bay of Naples, his interest in gardening, and his desire to provide his children with an informal and healthy upbringing, reminiscent of his in Coburg. Dyce's great wall-painting on the stairs, *Neptune Entrusting the Command of the Sea to Britannia*, was carried out in true fresco, and the house provided a fine background to the Prince's other works of art.

Windsor Castle had been extensively remodelled for George IV by Sir Jeffry Wyatville, and was relatively convenient, comfortable and in good order structurally. Little needed doing to it, and Albert found his chief occupation at Windsor as Ranger of the Great Park, where he could indulge his liking for country life, and develop the various farms within the Home and Great Parks. He was a serious and successful farmer, keen to promote scientific agriculture (15). Bluntly, he told the assembled nobility and gentry of England at the 1848 meeting of the Royal Agricultural Society, 'Science and mechanical improvements have in these days changed the mere practice of cultivating the

15. John Leech, 'Prince Albert the British Farmer', *Punch*, 25 November 1843.

soil into an industrial pursuit, requiring capital, machinery, industry and skill'.[22] The outlying farms in the Great Park were planned more modestly as they were intended as exemplars for working farmers, each one carrying a different breed of cattle and worked on a slightly different system, but the Home Farm, built in the late 1840s, was designed by the leading agricultural engineer and architect George Dean, with fine hygienic buildings. The Royal Dairy of 1858–9 (16), described by one of the Prince's most enthusiastic biographers as a 'work of most wonderful complexity as well as admirable engineering',[23] was scientifically planned to keep milk fresh before the advent of refrigeration. However, as designed by the sculptor and architect John Thomas (1813–1862) for the Prince, the decoration is equally important: the heat-defying roof is painted in Chinese colours, and the hygienic tiles are exquisitely decorated with symbols of the seasons, portraits of the royal family, and rural motifs.

Buckingham Palace had had an unhappy history since George IV, with the assistance of John Nash, had embarked on up-grading Buckingham House in the 1820s. Ambitious, always over-spent, and almost unaccountable financially, the project had angered parliament and had resulted in the disgrace of the elderly Nash. It was incomplete at George IV's death, and his brother, William IV, had refused to move in, enthusiastically offering it to the House of Commons in 1834 after fire had destroyed the old Palace of Westminster. The Queen and the Prince had occupied it, but found it lacking in accommodation for both children and staff (17), and inadequate for large parties, which had to be held at St James's Palace. Lyon Playfair investigated the kitchen and drains, and found them in worse condition than some of those in the large urban areas investigated by the Parliamentary Commission on the Health of Towns. Again Peel smoothed the way, and Prince Albert was able to insist on the employment of Cubitt as contractor, though he had to accept the official architects, initially Edward Blore (1787–1879), from 1845 to 1850, and then James Pennethorne (1801–1871) in 1852–6.

Even hampered by a committee of cabinet ministers and the presence of the dreaded Department of Works, Woods and Forests, Albert had considerable influence on the alterations to the Palace. It was his insistence on the reuse of fireplaces and other decorative elements from the dismantled interiors of the Brighton Pavilion that created the splendid ensemble of the Queen's Luncheon Room, and the central room on the east front with its famous balcony. The suite of entertainment rooms in the South Wing were even more his creation: the Ballroom, first used in 1856, was decorated with a series of panels after Raphael, and both it and the Ball Supper-Room were designed with the assistance of Ludwig Grüner. Unfortunately all this magnificent decoration was destroyed when the Ballroom suite was redecorated for Edward VII in 1902. The Blore façade, compared unflatteringly to Caserta by contemporaries, was re-fronted to the design of Aston Webb for George V, though little was changed structurally, even the Victorian windows remaining *in situ*.

Prince Albert is well remembered as a patron of the arts, but there were other areas in which he had a considerable influence. The first of these was the army. In the usual manner he was asked to become colonel of various regiments, and this gave him the opportunity to suggest some sensible reforms. First of all, he very effectively lent his weight to the campaign to abolish duelling, which was still regarded as the only honourable way for an officer to deal with insults or criticism, though a successful duel might lead to prosecution. He also busied himself with military uniforms, most famously in 1843 with the ludicrous affair

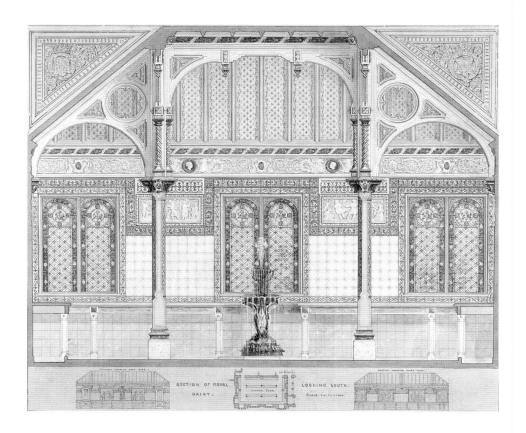

16. John Thomas, design for the interior of the Royal Dairy, Windsor, 1858–9 (Royal Collection).

17. John Leech, 'A Case of Real Distress', *Punch*, 29 August 1845; Albert, with Victoria and the royal children, beg to be relieved from the inconveniences of Buckingham Palace.

of the so-called 'Albert Hat' which he designed for the general use of the infantry. The hat was detested by the army and largely unadopted, but, as Chris Brooks describes in chapter two, it was a godsend to *Punch*, which guyed it on every possible occasion. More successfully, Albert assisted in the design of a more weather-proof coat for the soldiers. He was also concerned over military training and education, arguing successfully that the army should have a proper training ground where cavalry and infantry could practise manoeuvres together, before being despatched to war in foreign parts. There was a summer camp at Chobham in 1853, attended by both the Queen and the Prince (18), and subsequently land at Aldershot was bought, close to the railways to the Channel ports, then seen as menaced by the French. This provided both 'field day country' and room for the 'military town', where Albert built and endowed an Officers' Library.

Prince Albert was recruited to the cause of housing for the working classes soon after his arrival in England, becoming in 1844 the President of the Society for Improving the Conditions of the Labouring Classes, which planned and commissioned hostels and family dwellings designed by the Society's architect, Henry Roberts (1803–1876).[24] The Prince was much involved, using his role as landlord and employer at Windsor to provide decent housing for his labourers, and taking advantage of the Great Exhibition in 1851 to erect and publicise a pair of model cottages, built at the adjacent Knightsbridge Barracks. After the Exhibition was over they were dismantled and moved to Kennington Park in south London, where they stand today.

Education was always an interest, and Albert was at his best perhaps in dealing with the problems of the educational establishment. In 1847 he was invited to stand as Chancellor of Cambridge, possibly in the mistaken view that he would protect the universities from the winds of change. In an unusual disputed election, he won by a narrow margin, recruited allies within Cambridge, and was involved in the changes to curriculum and regulations which modernised the older universities in the 1850s. He was also concerned with the problems of Irish education, particularly the difficulty of setting up the three colleges of the newly established Irish university – in Cork, Galway, and Belfast – without those in the south turning 'into Roman Catholic seminaries and in the north into a Presbyterian school'. He proposed adding civil engineering and agriculture to the syllabus, together with the Irish language, then largely seen as a matter for the 'peasantry on the one hand and the Antiquaries'. [25]

The greatest opportunity for Albert to put his ideas into practice came through the Society of Arts, which he joined in 1843, becoming President in succession to the Queen's uncle, the Duke of Sussex (1773–1843), at the end of the year. The Society had been founded for the 'Encouragement of Arts, Commerce and Manufactures' in 1754, with the intention of promoting mechanical inventions and other innovations of use to farmers, seafarers and those engaged in manufacturing industry. By the mid-nineteenth century it was losing momentum, partly because commercial rewards made its premiums seem small, partly because other, more specialised bodies had been set up in the various fields of its activities.[26] New initiatives were clearly needed, and some members of the Society, led by the indefatigable Henry Cole, had been pursuing the idea of promoting a national exhibition of manufactures. Such exhibitions had been held regularly in France since the Napoleonic wars, and had been organised in parts of Germany by the Zollverein – the Customs Union of north

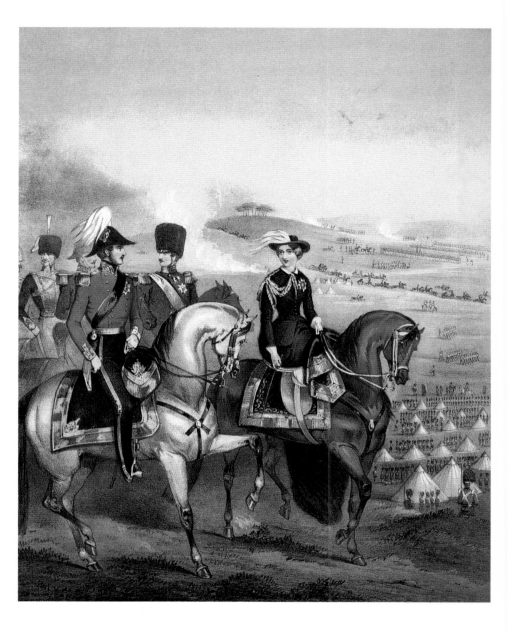

18. *The Camp Polka*, music cover of 1853
by J. Brandard, showing the summer camp
at Chobham (O'Rorke Collection).

German states. Although the Society's early attempts to emulate the Paris exhibition of 1844 were initially unsuccessful, the appointment as Secretary of John Scott Russell (1808–1882), a naval engineer, gave fresh impetus to the scheme, and led to a national exhibition in Birmingham in 1849. That same year Cole and two other members of the Society, Francis Fuller (1807–1887) and Matthew Digby Wyatt (1820–1877), visited the quinquennial French Exhibition in Paris. On the way back to London, Fuller travelled with Thomas Cubitt from Portsmouth and discussed the idea of an exhibition in the capital. Approaches were made to Prince Albert, and on 30 June 1849 he saw Cole, Scott Russell and Fuller, together with Cubitt in his role of royal builder. At this meeting, the critical decisions were taken: Albert declared for an international exhibition; on Cubitt's advice the idea of using Leicester Square was abandoned in favour of Hyde Park; and the members of the Society accepted the Prince's opinion that central government must be involved.

A further meeting at Osborne, attended by the President of the Board of Trade, resulted in an instruction from the Prince, as President of the Society of Arts, to Scott Russell, Cole, Fuller, and Digby Wyatt to sound out the manufacturing districts for support. This was sought in two forms: a

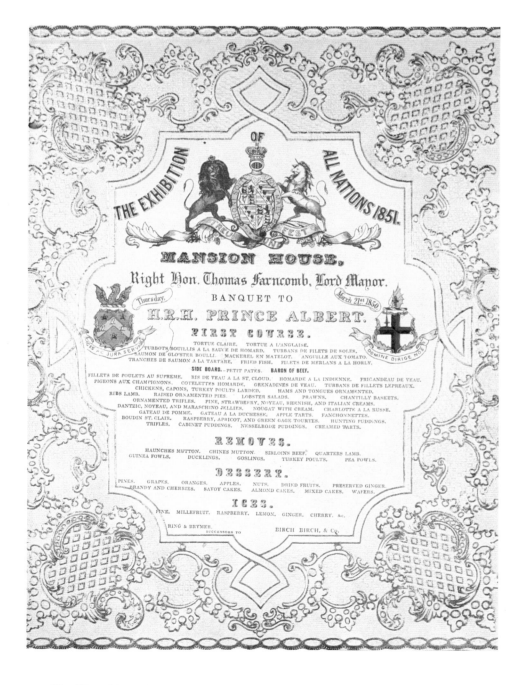

'subscription list' of those who would be willing to provide funding, and local committees who would identify exhibitors from their areas and select the articles for display. Reaction was tested through a number of public meetings, including one in Dublin and a very successful one at the Mansion House in London in October. These overtures allowed the level of support from merchants and manufacturers to be gauged: the results were almost universally encouraging. Though the idea of a Royal Commission headed by the Prince had been mooted early on, it was skilfully kept in the background until there was a clear public demand for government involvement. Meanwhile, Albert diplomatically remained as simply the president of a learned and proselytising society. Though initially timid at the prospect of a new and untried national adventure, the ministry was eventually won over. When the Royal Commission was published in January 1850, Prince Albert was appointed President, and Earl Granville his equally hard-working Vice-President. Its membership brought together the leaders of political opinion, including the then prime minister Lord John Russell (1792–1878), Sir Robert Peel, the future prime ministers William Gladstone (1809–1898) and Lord Derby (1799–1869), and one of the parliamentary champions of free trade, Richard Cobden (1804–1865). There were *ex officio* members, like the presidents of the Geological Society, the Institution of Civil Engineers, and the East India Company, who alone could tap the products of the subcontinent. One of these, the Civil Engineers' president Sir William Cubitt (1807–1861), proved so useful as chairman of the Building Committee that he was re-appointed in his own right in 1851.[27] The City of London was represented by the bankers Thomas Baring (1799–1873) and Lord Overstone (1796–1883), the aristocracy by the Duke of Buccleuch (1806–1884), and private collectors by the Earl of Ellesmere (1800–1857). The secretaries to the Commission were Stafford Northcote (1818–1887), formerly Gladstone's private secretary, and Scott Russell, while members of the former Executive Committee under the Society of Arts continued to serve; these included Cole and Digby Wyatt, with a Colonel Reid as Secretary.

The first requirement was for a building, and the story is well-known. The Building Committee, full of architects and engineers, was keen to provide a design themselves, which turned out to be uninspiring, expensive and impractical. Happily for the Exhibition's success, Joseph Paxton (1801–1865) came up with his famous design for a mighty glass-house, which was championed by the *Illustrated London News*. The Commission seized the opportunity and accepted the scheme in July 1850. In the event, Paxton's Crystal Palace (20) became the icon of the Exhibition.

19. Menu of a banquet for Prince Albert at
the Mansion House, London, 21 March 1850,
to raise funds for the Great Exhibition
(Private Collection).

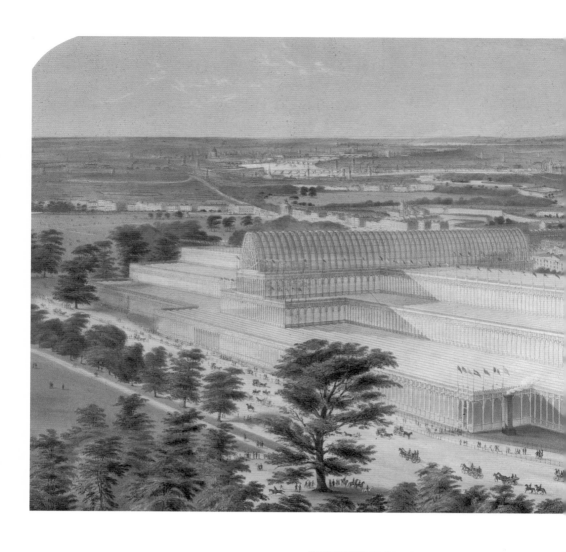

20. Charles Burton, *Aeronautic View of the Palace of Industry*, lithograph of 1851 (Guildhall Library).

21. David Roberts, *The Opening of the Crystal Palace for the Great Exhibition*, 1851 (Agnew).

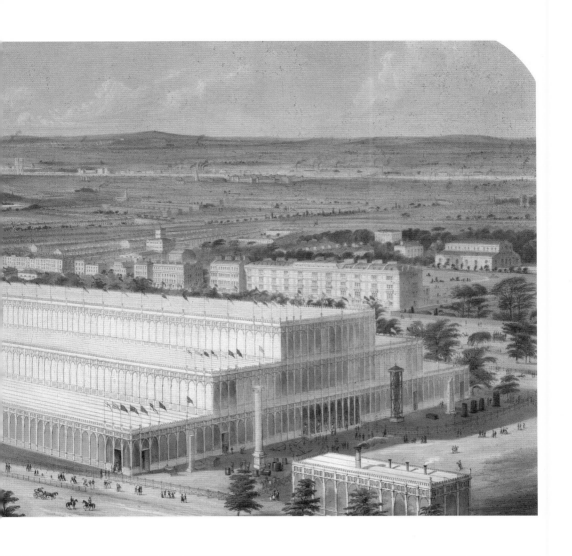

Throughout, the Prince was an assiduous and hard-working President, chairing most of the meetings himself, and largely responsible for ensuring international participation on the juries and working committees, a matter initially canvassed through the Foreign Office and British representatives overseas. Albert's insistence on the international character of the Exhibition ensured that it would have an unprecedented impact. The organisation required was daunting: high quality exhibits had to be found; local committees had to assemble products from all over Britain; exhibitors and jurors from abroad had to be secured; exhibits had to be transported to London from around the world; adequate display space had to be ensured; and the eventual distribution of prize medals had to be seen to be even-handed and non-contentious – not the least important consideration in an international context. No country had ever attempted anything so ambitious. Over thirty states or groupings of countries agreed to exhibit and they filled one end of the Crystal Palace. The other was taken up by the United Kingdom and six groups of British colonies and dependencies.

Some of the groupings may sound strange to modern ears: Italy was represented through Austria and Sardinia, the Kingdom of Naples refusing to participate; Algerian produce was exhibited by the French Ministry of War, that of India by the Honourable East India Company; and though the German states were listed separately, most exhibited under the banner of the Zollverein. It was predominantly a European affair, though the United States was an important exhibitor. Some exhibits were received from the 'States of South America', comprising 'Brazil, Chili, Mexico, New Granada and the Society Islands'. In addition, goods for exhibition were sent by the governments of China, Persia, and Egypt. All these participants were represented *pro rata* on the juries which gave the prizes in each of the thirty classes into which the exhibits were classified, ranging from Raw Materials to Machinery and Fine Arts.

Prince Albert devised the scheme for classifying the exhibits, as he devised so much that was crucial to the whole enterprise. There is not space here to describe in detail the progress and enormous success of the Exhibition of the Works of Industry of All Nations, to quote the official title of what became known, quite simply, as the Great Exhibition. The mere statistics are extraordinary, and the very fact that they were so well collected and presented was a reflection of the Prince's long-standing interest in the discipline. Nearly 14,000 exhibitors were involved, of whom 7,300 were from the United Kingdom and Dependencies. The largest single foreign participant was France, whose 1700 exhibitors filled a larger space with goods than any other, followed at a distance by Austria, Belgium and the United States. However, the German states grouped together led the world in numbers of exhibitors. The Exhibition was opened by the Queen on the prescribed day, 1 May 1851 (21); the cost was roughly as forecast and the guarantors were not called upon. There were no riots or civil disturbance as its detractors had foretold; there was only one small fire; and the temperature of the largest glass building in the world was maintained at a tolerable level throughout the summer. A mere three years after 1848, the European Year of Revolutions, 'the least-defended and wealthiest capital in the world' had invited in its foreign and provincial neighbours and had found few problems. Over six million people had visited the Exhibition (22, 23) by the time it closed in October, and a substantial profit had been made.

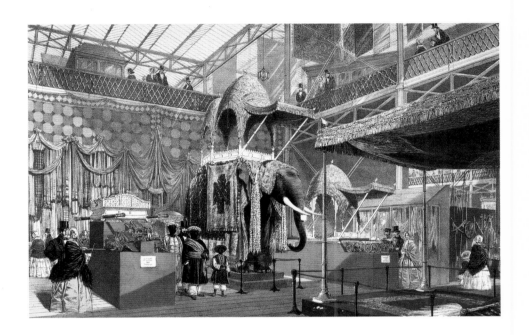

22. Joseph Nash, *The India Court of the Great Exhibition*, chromolithograph
from Dickinson's *Views of the Great Exhibition*, 1851 (Guildhall Library).

23. Louis Haghe, *The Medieval Court of the Great Exhibition*, chromolithograph
from Dickinson's *Views of the Great Exhibition*, 1851 (Christopher Wood Gallery).

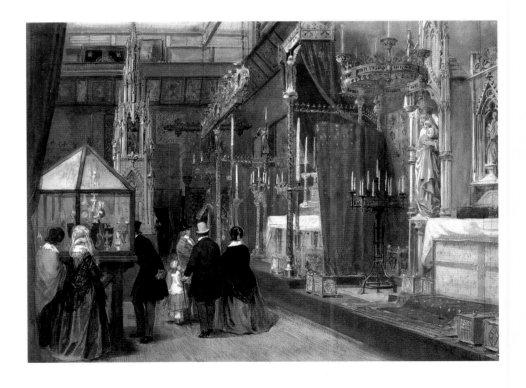

There were some problems in arranging the removal of the Exhibition building, complicated by Paxton's attempts to have it retained in Hyde Park. In the end, however, it was dismantled by the contractors who built it, Fox Henderson, and re-erected on an even larger scale at Sydenham, in south London, where it remained the home of numerous popular attractions until destroyed by fire in 1936. A week after the Exhibition closed, Lord John Russell wrote to the Queen:

> The grandeur of the conception, the zeal, invention, and talent displayed in the execution, and the perfect order maintained from the first day to the last, have contributed together to give imperishable fame to Prince Albert. If to others much praise is due ... it is to his energy and judgement that the world owes both the original design and the harmonious and rapid execution ... no one can deprive the Prince of the glory of being the first to conceive ... this beneficent design, nor will the Monarchy fail to participate in the advantage ... No Republic of the Old or New World has done anything so splendid or so useful.[28]

The Great Exhibition had been such a success that the Lord Mayor of London proposed a monument on the Hyde Park site, to include a statue of the Prince. Albert was appalled.

> I can say, with perfect absence of humbug, that I would rather not be made the prominent feature of such a monument, as it would both disturb my quiet rides in Rotten Row to see my own face staring at me, and if (as is very likely) it became an artistic monstrosity, like most of our monuments, it would upset my equanimity to be permanently ridiculed and laughed at in effigy.[29]

After some negotiation, it was agreed that a statue of Britannia rather than the Prince would be suitable, and Albert interested himself in the outcome. There were further delays but eventually, in 1858, a competition for the design was won by the sculptor Joseph Durham (1814–1877). A place for the memorial was found, not in Hyde Park but on the opposite side of Kensington Gore in the newly laid out gardens of the Royal Horticultural Society. While it was being erected in the summer of 1861, a statue of the Queen was substituted for that of Britannia, but Albert's sudden death resulted in her statue being replaced by one of him – at Victoria's own request. The Memorial to the Exhibition of 1851 was finally unveiled on 10 June 1863 (25). When the Society's gardens were built over in the 1890s, it was removed to the terrace immediately south of the Albert Hall, where it stands today.[30]

24. Silk mourning ribbon, monochrome, 1861, commemorating Albert as the 'projector' of the Great Exhibition (National Portrait Gallery); the picture is taken from a portrait of 1840–1 by William Charles Ross.

25. Joseph Durham, *Memorial to the Exhibition of 1851*, South Kensington, London, 1861–3 (Kensington Central Library).

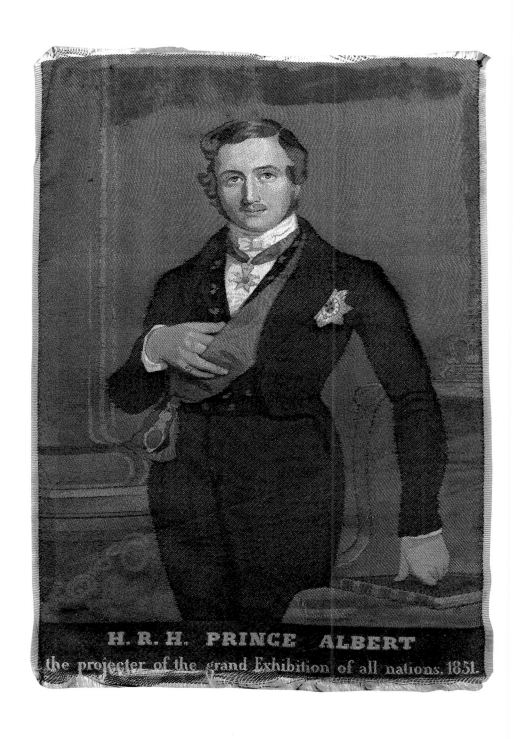

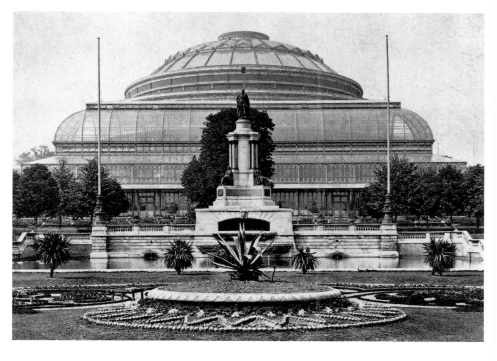

A more lasting and significant memorial to the Great Exhibition was devised by the Prince himself. Even before it closed he was busy with a scheme for putting the profit that had been made to good use.[31] His first thought was an international institution of learning, that would match the scope of the Exhibition itself. This was amended after discussion with his chosen advisers – William Cubitt, along with Reid, Lyon Playfair and Cole from the Executive Committee – to a scheme for a national educational institution, more in keeping with the funds available. He was also aware of concern about the contents of the National Gallery in their cramped quarters in Trafalgar Square, subject to the smoke and atmospheric pollution of central London. Pursuing the possibilities of a new site, the government had already made overtures to owners of land in Brompton and Kensington Gore, to the south of where the Great Exhibition building had stood. This fitted with Albert's growing ideas for the area. Additional government funds were made available, and the Commissioners for the 1851 Exhibition were able to purchase a substantial parcel of land in what was later christened South Kensington.

Prince Albert's original sketch plan suggested a layout for the estate with the National Gallery where the Albert Hall now stands, flanked by colleges and museums of art and science, with a concert hall and garden to the south. His death came too early for him to see more than the start of his great scheme. Though the South Kensington Museum was established under Cole's direction in the grounds of the old Brompton Park House to the south-east of the site, the only element of Albert's dream that he saw realised was the magnificent formal gardens of the Royal Horticultural Society. These were laid out in 1860–1, in the centre of the estate between Cromwell Road and Kensington Gore, largely under the inspiration of the Prince himself, acting in a dual capacity as President both of the Society and of the 1851 Commissioners. But his vision survived him: the eventual creation of what became known as Albertopolis is described by John Physick in chapter nine.[32] Even so, the driving energy of the man himself was missed. Almost certainly, South Kensington would look very different today had Prince Albert lived.

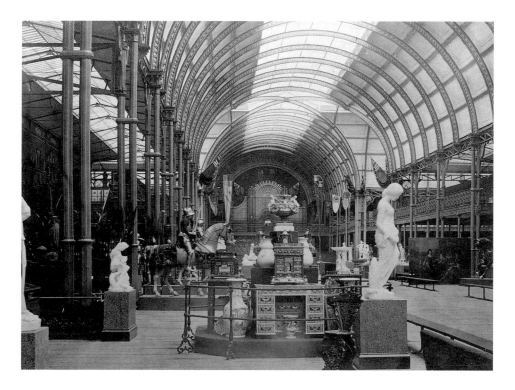

26. Interior of the Manchester Art Treasures Exhibition, 1857 (Manchester Central Library).

The triumph of the 1851 Exhibition encouraged the promotion of others, both in the United Kingdom and abroad, though few, it has to be said, achieved the same success. Prince Albert was concerned with three more. The Dublin Exhibition of 1853 was very much in the 1851 mode, as was the decennial exhibition planned for 1861, but postponed for a year because of war in Italy. The Manchester Art Treasures Exhibition (26) of 1857[33] was a different matter however, proposed by an influential group of Mancunian businessmen and supported by the Prince as a way of providing for the works of art excluded from the 1851 Exhibition because of lack of space. With some 17,000 items on show it was, in the words of Winslow Ames, 'the first really great general exhibition of works of art',[34] attracting treasures from great private collectors like Lord Hertford, as well as many royal loans sent to encourage aristocrats and industrialists to follow suit. As well as Old Masters, it contained modern works, including sculptures, paintings, prints and photographs. There was even a preview of a National Portrait Gallery. Prince Albert did not live to see the international exhibition of 1862, mounted in a substantial building on the Cromwell Road, designed by Captain Fowke and the team from the South Kensington Museum, and built by the contractor John Kelk (1818–1886), already working on the Museum and in due course to become contractor for both the Albert Memorial and the Albert Hall.

Albert's death on 14 December 1861 from what was diagnosed as typhoid fever, plunged Victoria into a lifetime of mourning. Throughout the country there was genuine shock, and a generosity towards the Prince's career not always evident in his lifetime. Characteristic was the *Times*, often one of his sharpest critics, particularly in matters of foreign policy:

> *the nation has just sustained the greatest loss that could possibly have fallen upon it ... this man, the very centre of our social system, the pillar of our state, is suddenly snatched from us ... It is not merely a prominent figure that will be missed on public occasions ... it is the loss of a public man whose services to this country, though rendered neither in the field of battle nor in the arena of crowded assemblies have been of inestimable value to this nation.* [35]

The public estimation of Prince Albert's contribution to British history has come full circle in the century and a half since his death. The two works commissioned by the Queen, Colonel Charles Grey's *Early Years of the Prince Consort*, published in 1867, and Theodore Martin's massive five-volume, *Life of the Prince Consort*, published in 1875–1880 and issued in sixpenny parts as the *People's Edition* in 1882, were important accounts containing much original source material, but were, understandably, uncritical. During Victoria's lengthy widowhood Albert's role became forgotten, the enterprises he had initiated were compromised, and carrying them out as he had proposed became less important – as can be seen in the gradual attrition of the South Kensington scheme. As attitudes shifted in the late nineteenth and early twentieth centuries, Albert, together with the Queen herself, became the butt of jokes by writers of a younger generation, like Lytton Strachey and Laurence Housman. Official postures tended to be rather stuffily defensive. Housman recorded that of the fifty short – and, by modern standards, innocuous – plays about Queen Victoria and Prince Albert, *Happy and Glorious*, which he wrote between 1920 and 1941, only twenty passed the Lord Chancellor as fit for production on the English stage.[36]

Hector Bolitho was the English writer who started the re-evaluation of Prince Albert, a difficult task after the Great War had destroyed the traditional British alliance with the German states, and the respect for German values and achievements. Moved by the wealth of material in the Coburg archives, and the simple background of the Schloss Rosenau and Coburg city, Bolitho's purpose was to 'help this generation to understand the devout, unselfish and cultivated man who contributed, more perhaps than the Queen herself, to the growth of this country during the forties and fifties of the last century.'[37] In the 1960s, the New England author Winslow Ames brought out a very important assessment of the Prince's role as a patron of design and the arts. This was a product of an increasingly serious interest in Victorian culture, which brought Victorian Societies into being on both sides of the Atlantic. Over the last thirty years, scholarly and academic engagement with the Victorian period has expanded prodigiously. So too has popular interest, from books and magazines, to television and cinema. Albert himself has been the subject of a number of important biographies: by Daphne Bennett in 1977; by Robert Rhodes-James in 1983, written with full access to the Royal Archives; and most recently, in 1997, by Stanley Weintraub.[38] In 1983 the Royal College of Art, with considerable courage and prescience, mounted an exhibition on the Consort, *Prince Albert: His life and work*, also commissioning a book of the same name. This was the first time the creator of South Kensington was acknowledged by an exhibition on his own territory, bringing his importance into focus for the British public for the first time.[39] Without the whole process whereby our understanding, both of Prince Albert and of the culture of which he was a part, has been broadened and deepened, the Albert Memorial itself might not have survived. As it is, however, English Heritage's great programme of repair and restoration can be seen as a culmination of that process.

Albert's work for education and the arts was of outstanding importance. His crucial political achievement was to modernise the role of monarchy within parliamentary government. At his death, the Queen was left not only without a husband and a confidant, but also without a private secretary, the significance of which was far greater in the days when the monarch was more involved in day-to-day decisions of government. Writing to the young Duke of Albany in 1876, Disraeli, the then prime minister, put it as follows:

> *The business transacted by the Sovereign ... is very considerable; far beyond what the world imagines ... Not a despatch arrives in this country, or leaves it, which is not entrusted to Her Majesty ... In addition to which, the private correspondence of Her ambassadors and ministers with the Secretary of State also reaches the Queen ... Your Royal Father's criticisms on the draft despatches, submitted to the Queen, I know, were of much moment, and frequently adopted by the Ministers.*

Here, in effect, is a posthumous tribute to the Prince Consort's influence, and to his accomplishment in establishing an acceptable way for the sovereign to work with the other estates of the realm in a parliamentary system. This was, perhaps, Albert's greatest legacy to his adopted country. It was at the heart of an extraordinary record of public service and stands as a constitutional achievement alongside the social and cultural triumph of the Great Exhibition, and its outcome in South Kensington's complex of museums and colleges.

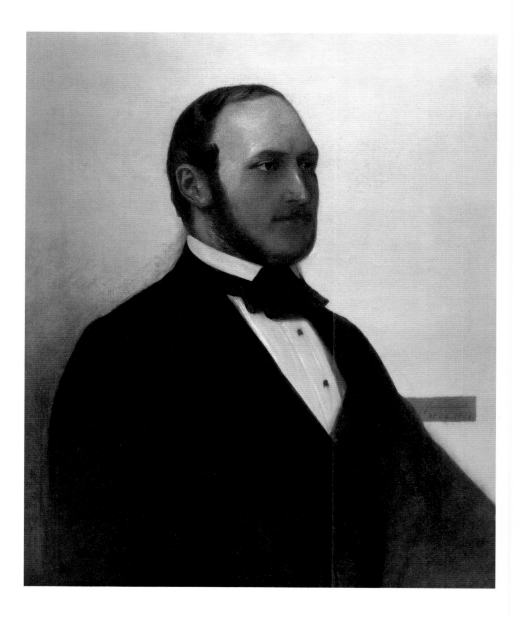

27. Franz Xaver Winterhalter, *Prince Albert*, 1861 (Rafael Valls); the last portrait of Albert during his lifetime, completed posthumously.

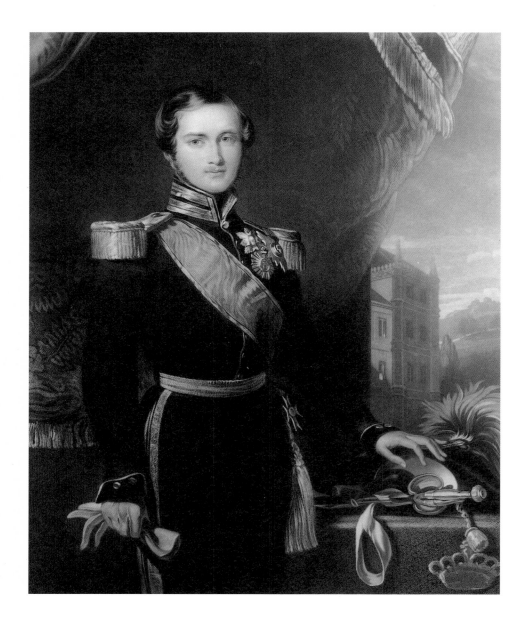

28. Charles Edward Wagstaff, *Prince Albert*,
mezzotint after a portrait of 1839–40
by George Patten, published by Hodgson
& Graves, 1840 (National Portrait Gallery).

Chapter 2

Representing Albert

Chris Brooks

In the last weeks of 1839, the *Spectator* sardonically anticipated the reaction of printsellers and publishers to the marriage of Queen Victoria and Prince Albert that had been announced for the following February:

> *We shall then have in the newspapers a daily average of three-and-thirty entirely exclusive memoirs of the Prince ... and a proportionate number of superb, and the only genuine portraits, given 'gratis with our week's number' ... Even the masses will not be forgotten, whom to satisfy the yearnings of natural loyalty, revived in hearts not yet dead to every nobler emotion, hearts still English – and other things too tedious to enumerate – fine cuts at a penny each, with a limited number of proofs on India paper at two-pence farthing, will be issued by various other spirited 'friends of the people'.*[1]

By the time of the wedding the *Athenaeum*, wearying rapidly, refused even to speculate 'How many brushes and burins will be engaged, before the end of the year, in multiplying "counterfeit presentations" of Prince Albert', though the *Art Union* – reviewing the George Patten painting then being exhibited in London – was optimistic that a portrait of the Prince, 'at the present moment, the most interesting gentleman in her Majesty's dominions ... cannot fail to be agreeable to all classes of the British people'.[2] Doubtless closer to the actual experience of many among the piously evoked 'British people' was the facetiousness of *The Royal Wedding Jester*, even if its publication was every jot as opportunistic as the jumble of commemorative products it laughed at:

> *As the time approached for the celebration of the Royal nuptials, our ears were stunned in walking the streets by jangling ballad-mongers, chaunting the praises of the royal couple, likenesses of whom stared us in the face at every corner ... you were accosted by a man with shaggy hair, who bawled loud enough to be heard over half the metropolis, 'Vill you buy the poortreat of the wonderful furriner vot's to have our beautiful Queen for his loving and confectionary wife' ... You peevishly pursue your way, and in your haste narrowly escape upsetting an image-board and its bearer. You must look up ... [and see that] ... a host of Albert and Victoria's occupy the whole board, of all sizes and dimensions – some of them, in truth, of such babyish proportions ... you might imagine that the royal pair had already multiplied sweet images to an alarming extent.*[3]

The proliferation of images of Prince Albert around the time of the marriage was a rerun of the frenetic production of pictures of Victoria that had accompanied her accession and coronation some three years earlier. Both were

the result, to quote Peter Funnell's admirable account of Albert's portraiture, 'of the burgeoning art trade and print culture of the early Victorian period … the highly active and efficient world of dealers and printsellers both at the top and bottom ends of the market.'[4] For the more affluent there were the officially sanctioned engravings put out by the London dealers Hodgson & Graves and Colnaghi & Puckle, taken from Patten's portrait – showing Albert in military uniform standing before Schloss Ehrenburg (28) – and from the miniature by William Charles Ross, a head and shoulders of the Prince with fetching curls and liquid eyes which was a particular favourite of Victoria's.[5] Others followed after the marriage, notably a further Ross miniature of 1840–1, which has Albert elegantly posed in formal dress wearing the sash and star of the Garter.[6] Among the cheap cuts, a steel engraving by E. W. Topham, with Albert at half-length in uniform, was probably the most widely disseminated (29): constantly reissued, later versions give the Prince progressively longer side-whiskers and a bushier moustache (30).[7]

Vigorously productive though the print market was, however, it was soon to be outdone in its ability to generate images of royalty, and – in the present context – of Albert in particular, by the emergence and rapid expansion of an illustrated periodical press with a mass audience. Two journals are of particular importance here, and will be the joint focus for much of this chapter: *Punch*, which began publication in July 1841, and the *Illustrated London News*, which first appeared in May 1842. As publishing ventures they were not wholly unprecedented; *Punch*, in particular, had numerous forerunners and rivals that offered similar miscellanies of humour and satire. But in the quality and quantity of images they contained, both were strikingly innovatory, and the *ILN* highly ambitious in seeking to provide comprehensive visual coverage of major national and international events. Published weekly, both were aimed at an educated, predominantly middle-class readership, and achieved a large circulation,[8] initially in London, later – thanks to the rapid spread of the railways – throughout the country. Both became what were, in effect, cultural institutions, and continued successful publication well into the twentieth century.

The mass manufacturing of representations of Prince Albert was only possible because economic and material developments created and sustained an

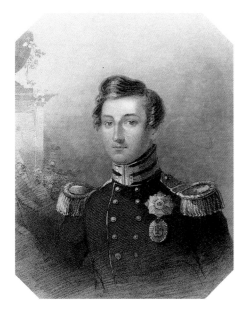
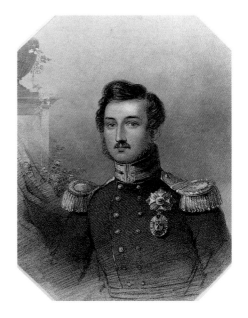

expanding cultural market in visual images, firstly through the print trade, secondly through illustrated periodicals. But though these developments multiplied Albert's image, the diversity of the representations that resulted answered to conflicting anxieties and expectations that were social, political, ultimately ideological in their nature. The official approval extended to engravings based on the Patten and Ross portraits, mentioned earlier, indicates how keen the court and political élite were to establish an 'authentic' image of Albert. And authenticity was a matter discussed, with varying degrees of seriousness, by contemporary sources from the high-minded *Art Union* to the irreverent *Royal Wedding Jester*. Questions about verisimilitude were generated by concerns about how pictures of the Prince shaped perceptions of his role. Implicitly, Albert depicted was Albert defined. And that definition, as Hermione Hobhouse has discussed in chapter one, was a ticklish business. To the English, Albert was a foreigner, even if a 'wonderful furriner', the offspring of minor European royalty, which, despite relative poverty, had acquired a not-unjustified reputation for dynastic scheming. Dominant definitions of gender roles meant that he was expected to become the head of his and Victoria's family, but he also had to remain her subject.[9] Crucially, there were no adequate precedents for the constitutional position of the husband of a queen regnant. Though ministers were anxious for a marriage that would secure the succession and, patriarchally enough, exercise a steadying influence on the Queen, they were equally worried that Albert's ambitions would chafe against the restrictions with which a long and troubled history of constitutional development had hedged the power of the throne.[10] Finally, behind it all, were hopes and fears about the emergence of a democratic, or at least populist monarchy in a Britain edging towards representative government.[11]

Early portraits of Prince Albert, from Patten's painting of 1839–40, depict him most frequently in military uniform. In the 1840–1 portrait by John Partridge he is arrayed in the exotic splendour of a colonel of hussars (31); in 1842 Franz Xaver Winterhalter portrayed him three-quarter-length in the undress uniform of a field-marshal; he is in full field-marshal's uniform, complete with baton and feathered hat, for a full-length set piece by John Lucas, also painted in 1842 (47); as too in a contemporary miniature by Robert Thorburn, and a huge oil of 1846 by Sir Francis Grant; there are others.[12] Sculptural representations of Albert show more variety in dress, but they were far less amenable to the mass distribution that characterised engravings of paintings, and almost all of them are busts: hardly any full-length statues of the Prince were executed during his lifetime.[13] Edward Hodges Baily's bust of 1841 swathes the Prince in his Garter robes, but classicising drapery was the favourite, as in the bust of 1844 by John Francis, and another of 1848 by Baron Carlo Marochetti[14] – greatly admired by Victoria and Albert, and later to be

29. E. W. Topham, *Prince Albert*, engraving after an unknown original, published by Joseph Rogerson, 1 February 1840 (National Portrait Gallery).

30. E. W. Topham, *His Royal Highness Prince Consort*, engraving after an unknown original, published by Joseph Rogerson, ?late 1840 (National Portrait Gallery).

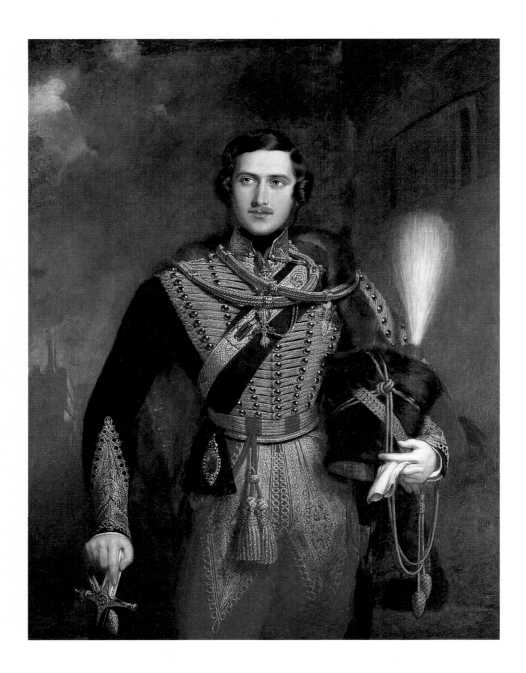

31. John Partridge, *H.R.H. The Prince Consort*,
1840–1 (Royal Collection); he is portrayed as
colonel of the 11th Hussars (Prince Albert's
Own), in the uniform he largely designed.

centrally, and controversially, involved in the National Memorial. Even so, military dress was used for busts of Albert through the 1840s and 1850s, and it is significant that an early example by Henry Weekes (32), portraying a youthful Prince in field-marshal's uniform with prominent epaulettes, was reproduced in biscuit ware, presumably for the commercial market.[15] Peter Funnell has argued convincingly that representing Albert in military uniform was a way of negotiating his problematic constitutional position: uniform conferred authority, but only as an epitome of service to the sovereign.[16] Albert may have been a field-marshal, but he held that rank within the British armed forces of which Victoria was the head.

Formal portraits, such as those considered here, are iconic. They confront the viewer with semantic closure, meanings that are consistent, self-sustaining, fixed – and this seems true even of the relatively clumsy portraits that circulated at the popular end of the print market. Their ideological purpose, after all, was to establish an image of Prince Albert that resolved the ambiguities of his role, both political and personal. Once illustrated journalism arrived, however, representing Albert took on a new and necessarily far more diverse range of significances. For the programme set out by the *Illustrated London News*, iconic reiteration was insufficient – indeed, for the most part, inappropriate. So saturated are we now with instant news and the moving image, that it is easy to underrate the innovativeness and impact of the *ILN*: dozens of pictures every week, ranging from vignettes to panoramic fold-outs,[17] showing landscapes, townscapes, buildings, inventions, personalities, and above all, events – the contemporary world in the process of becoming. As a figure in such a world so imaged, the *ILN*'s Albert had to be active. More precisely, he had to be depicted not simply as an icon, but as a dynamic agent acting in and upon his own times.

Initially he appears in the setting of the court, and as a participant in state occasions: playing Edward III to Victoria's Isabella in the medieval *bal masqué* of May 1842, arriving at St James's Palace for a royal levee, attending a reception in the Queen's drawing room, sitting beside her at the prorogation of parliament.[18] Much of this is heavily glamourised, indeed sycophantic: 'such a scene may never occur again till doomsday' fawned the hack who covered the *bal masqué*.[19] But the periodical's representational repertoire quickly diversified and broadened out. Graph 1 (see p. 432) charts the changing pattern and composition of the *ILN*'s depiction of Prince Albert until his death in 1861.

32. Henry Weekes, *Prince Albert*, biscuit ware bust, *c.* 1841 (Private Collection).

There are nearly 600 images in all, and they have been sorted into six subject categories. In descending order of frequency they are: royal tours and state visits from foreign dignitaries (39%); images in which Albert is associated with the arts or sciences, or with instances of progress, including laying foundation stones and opening institutions and exhibitions (26%); state pageantry and the court (12%); scenes of the royal family and domestic life (10%); military occasions (9%); engravings of portraits or statues of the Prince, effectively representations of representations (4%).[20] The first two categories, Victoria and Albert visiting or being visited, and Albert – with or without Victoria – engaged in the stuff of social or cultural progress, account, strikingly enough, for two-thirds of all the images.

The *ILN* was quick to recognise the pictorial potential of the tours, producing commemorative issues and supplements to mark them. As early as September 1842, issues of the periodical are taken up with the royal visit to Scotland: embarkation at Woolwich, reception at Holyrood, views of Scone and Dalkeith, arrivals at Edinburgh and Perth (33), with cheering crowds and triumphal arches all the way.[21] The resultant medley of scenery and architecture was firmly in the tradition of the volumes of picturesque and antiquarian views that had been marketed successfully to middle-class readers since the beginning of the century. But depicting the tour also allowed the *ILN* to establish a characteristic, and ideologically charged, image of the royal couple: they sit in an open carriage escorted by cavalry, and are driven through Britain's towns and cities, past grand buildings and along famous streets, often fitted with grandstands dense with spectators, always thronged with people enthusiastically demonstrating their support and affection. The formula was readily adjusted for tours by train (34), when the royal carriage was conveniently distinguished by a large crown sprouting from the roof (35),[22] or for marine tours, where the royal yacht steams into ports and harbours packed

33. Entry of Victoria and Albert into Perth, *Illustrated London News*, 17 September 1842.

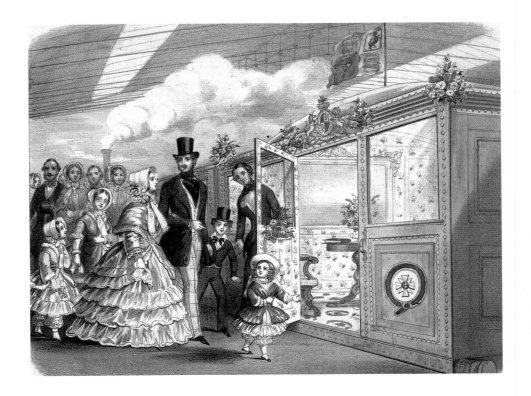

34. The royal family boarding the royal train for Scotland, chromolithograph, *c.* 1845 (Museum of British Transport).

35. Victoria and Albert, returning from the 1849 Scottish tour, change railway gauges at Gloucester, *Illustrated London News*, 6 October 1849.

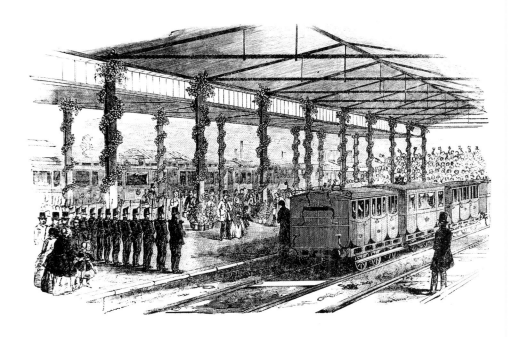

round by welcoming masses, or past vessels crowded with huzzaing tars.[23] Constantly repeated in the pages of the *ILN* throughout Albert's life, these are images of popular monarchy. Indeed, they imply a 'democratic' basis for the throne, for though depictions of the court emphasise glamour and exclusivity, illustrations of the tours suggest that royal authority depends upon the approbation of the people. That approbation is attested through spectacle, the very scale of which often reduces the royal couple, ironically, to tiny, distant figures. To render them distinct, the pictures in the *ILN* simplify and summarise their appearance: Albert, usually holding his topper or doffing it to the crowd, becomes a hawkish profile, with pronounced side-whiskers and moustache; Victoria becomes a bonnet and shawl, sometimes accompanied by a parasol.

The *ILN* pictures of Albert on the autumn tour of 1842 are far more numerous than those that place him in the court, and include the periodical's first image of him without Victoria – a cut entitled 'Buck Shooting' which has him in tartan trews and a feathered bonnet, leaning on his rifle beside a dead deer.[24] There are more images of Albert the courtier, resplendent in field-marshal's uniform, in 1843, the peak year for such representations: doing the honours at a royal levee during the Queen's pregnancy, then, with Victoria, at the christening of Princess Alice, at Drury Lane Theatre, at the Mecklenburg marriage, and – looking especially ornamental – at a 'drawing room' and a state ball in Buckingham Palace.[25] And the *ILN* had lost none of its capacity for obsequiousness: the 'drawing room' exemplifies 'that stately intercourse of ceremony which is so aristocratic', 'it stirs the whole spirit of *ton*'.[26] Nonetheless, these images are outnumbered not only by those showing Albert accompanying Victoria on the tours and state visits of that year,[27] but also – though only just – by illustrations that identify him with notions of progress. In two engravings, he inspects a collection of scientific instruments at King's College, London, then watches a demonstration of the electro-magnetic telegraph (36); in another set of cuts he is at Bristol to launch Brunel's *SS Great Britain*, the first iron-hulled steamship with screw propulsion; in three more he is on a trip to Birmingham, being conducted through the cavernous interiors of a sword-grinding factory, a rolling mill, and a glass works; for the *ILN*'s Christmas number, appropriately, he is pictured with Victoria in the poultry house at Windsor, one of the products of his enthusiasm for scientific agriculture.[28]

In the majority of these images, importantly, Victoria is not present; though Albert's position derived from his marriage, his public association with progressive developments shows him – literally so in the illustrations – assuming an independent role. This construction of Albert diversified, but also complemented, the associations attaching to the military figure of formal portraiture. That the *ILN* was pursuing something like a deliberate policy in its representations of the Prince is strongly suggested by the periodical's first issue of 1844. This contains a three-quarter-length portrait of him dressed in a general officer's frock coat, his left hand grasping his sword scabbard, Windsor Castle in the distance. Revealingly, the argument of the accompanying poem by 'W' consciously – and clumsily – manoeuvres the military signification of the image into line with a role conceived primarily in terms of civilian and cultural leadership.

All hail ! young Albert ! – princely – great –
We never can another meet,
Who'll give the jointure of his dow'r,
The deed of influence and pow'r,
So readily to Science – Art …
The rich man's fav'rite – poor man's friend;
The peaceful, yet if wish'd the bold,
As any warrior sire of old.[29]

The *ILN*'s topicality meant that it could reinforce or reinvent its image – or images – of Albert on a weekly basis. And as the Prince Consort was pictorially recruited into the periodical's developing ideology of optimism and social progress, all the images are consistently positive. This is certainly not the case with *Punch*, obviously different in conception, though every bit as topical, sharing much of the ideology, and equally innovative in its use of illustration. Its humorous take on contemporary events involved more than irreverent banter and cracking jokes, for *Punch* took seriously the politically radical inheritance of English satire, which had always had royalty and the aristocracy as central targets. 'We are advocates for the *correction* of offenders', stated the first issue in 1841, and headed a list of 'visual and oral cheats by which mankind is cajoled' with the 'noble in his robes and coronet'.[30] A year later, as we have seen, the *ILN* would launch its first issue fawning on the world of the court. To *Punch*, by contrast, the court was deeply suspect, its glittering surface always likely to prove an illusion – and a cruel one in a Britain where the misery of the 'hungry forties' was visited upon the already stark lives of many thousands of working people. Thomas Carlyle derided an 'idle, game-preserving and … corn-lawing Aristocracy', with its 'Donothingism in Practice and Saynothingism in Speech', and asked 'has the world … ever seen such a phenomenon till very lately ? Can it long continue to see such ?'[31] *Punch*, albeit with less of a snarl, asked similar questions. What purpose did Britain's aristocratic élite really serve ? How far was all the pageantry mere 'quackery', to use a favourite term of Carlyle's ? And, crucially, what did that prime ornament of the court, Prince Albert, actually *do* ?

36. Albert attends a demonstration of the electro-magnetic telegraph at Somerset House,
Illustrated London News, 1 July 1843.

Much of *Punch*'s coverage of the Prince's career engaged these questions, with results that were frequently hostile. All the *ILN*'s images of him were, in one way or another, supportive. Through *Punch*, however, we can track a history of fluctuating responses to, and representations of, Albert's activities. Graph 2 (see p. 432) charts every appearance of the Prince in the periodical during his lifetime, both in the textual matter and in the illustrations, from passing jokes and puns to full-page cartoons. Each occurrence has been categorised as positive, negative, or neutral in its attitude, and an approximate weighting to each item has been given in an attempt to reflect its relative prominence.[32]

Punch's first visual representation of Albert came a few weeks after the birth of the Prince of Wales – John Leech's full-page cartoon, 'Cupid Out of Place'.[33] Wearing a pantomime tunic and wings over a footman's breeches and stockings, a raffishly bewhiskered Albert sprawls in a chair before the fireplace, idly picking his teeth with one of Cupid's darts; on the floor lies his empty quiver, labelled 'Protocols'. It is an insulting image: a lackey dressed up to look like the god of love, he has done the job he was hired for by fathering a male heir to the throne, and is now 'out of place', an unwanted servant who will have to find work. Implicit in this image of redundancy was the question of what – beyond carrying out his dynastic duty – Albert was good for. What role was he expected, or indeed equipped, to fulfil in return for the wages he drew from the public purse? *Punch* had already gibed at the hangers-on in his household, the 'Tooth-brush in Ordinary, and Shaving-pot in Waiting'; a week after the 'Cupid' cartoon it printed a description of the wretched lying-in ward at Sevenoaks Workhouse

37. John Leech, 'Cupid Out of Place', *Punch*, 4 December 1841.

beside an account of the kennel arrangements for 'Prince Albert's Hounds'; in 1842, Leech's second cartoon of the Prince, 'The Queen's "Sevenpence"', shows Victoria dutifully shelling out to Peel for the newly-levied income tax, while a dandified Albert looks on aghast, hands stuffed into pockets from one of which bulges a money-bag labelled £38,000.[34] From *Punch*'s viewpoint, Albert was expensive, and what he was doing in return largely unimpressive.

Two silhouettes of him in 1842 – carrying a huge trowel for laying the foundation stone of the Royal Exchange, and dandling the royal babies on his knee[35] – are genially ironic, each guying the accoutrements of his military uniform, so important in the iconography of the official portraits. In *Punch*'s facetious account of the Scottish tour he is invented as an amiable travelling-companion, tolerant of the endless municipal receptions, though there is none of the *ILN*'s sense of him and Victoria as the focus for popular support of the monarchy.[36] By contrast, items on Albert's hunting are clearly hostile,[37] and *Punch* sustained a consistent attack on the servility that surrounded the royal couple, and the Prince in particular. Targets included the Court Circular, its banalities regularly parodied,[38] and, importantly in the present context, the commercial appropriation of Albert as a fashion icon – from the craze for 'Albert ties'[39] to 'the Albert Saloon' advertised by a Ramsgate hairdresser.[40] Although these are slight pieces, they cumulatively construct a definite and derogatory image of the Consort: good-hearted enough, but pampered, indulged at the taxpayers' expense in his love of field sports, dandified whether in uniform or civilian dress, and the occasion of foolish freaks of fashion among an obsequious

38. John Leech, 'Royal Nursery Rhymes', *Punch*, vol. 4 (1843).

British public. In effect he is Victoria's pet, which is just how a Leech cartoon of early 1843, 'Royal Nursery Rhymes' depicts him (38): with tax revenues falling, Victoria as Mother Hubbard finds the national cupboard bare, while Albert, her long-tailed pet bird, peeks down at her through the bars of a cage hanging from the kitchen ceiling.[41] Although there is positive coverage as 1843 continued, several events sharpened *Punch*'s criticism of the court, and of Albert in particular: the Mecklenburg marriage, involving the grant of a state annuity to the niece of the loathed King of Hanover; the establishment of a charitable institution for Germans in England – 'we have been accustomed to look upon the entire kingdom as one vast asylum for these gentry'; an announcement of the gross income of the Duchy of Cornwall, managed by Albert – 'The grossness of these revenues cannot for one moment be questioned'; even the apparently increased size of the Consort's chair at the prorogation of parliament – 'What has Prince Albert lately done to entitle him to a larger share of elbow-room than was formerly allowed him ?'[42]

Then, in the autumn of 1843, Albert designed a new cap for the infantry (39): as Hermione Hobhouse explained in the previous chapter, it came from his interest in providing more rational uniform for the common soldier, and was based on German models. Nobody liked it. The *ILN* gave it a small illustration and a short paragraph that tactfully avoided any mention of the Prince.[43] *Punch* went for the 'Albert Hat', as it was quickly christened, with gusto. In 'Prince Albert's Studio' (40), Leech depicts him surrounded by sketches and items of military dress, proudly finishing off one of the hats with a napping-iron, while Victoria and two of the children gaze sceptically at a lay-figure stuffed awkwardly into uniform with an Albert Hat crammed onto its head.[44] The Hat was indeed a perfect satirical vehicle. Since Albert's 'accession … to the Royal Husbandship of these realms' – and, the accompanying text implies, because of that position – he had 'devoted the energies of his mind and the ingenuity of his hands' to military millinery, and the Hat was the result. Something that should at least have been useful had been turned, by his notions, into an absurdity, 'a decided cross between a muff, a coal-scuttle, and a slop-pail': so much for Albert as an arbiter of sartorial elegance. Its design, moreover, epitomised his foreignness, confirming the way that, according to *Punch*, all things German – including the Queen's husband – were being foisted on the country.[45] Alien, futile, and ridiculous, the Hat was the return on a gullible nation's investment, ideological as well as financial, in the Prince. The poem alongside the cartoon, advertising the wares of 'Albert & Company, late of Gotha House', drives the point home: 'His prices, he trusts, none will fancy are dear, / By contract he takes thirty thousand a-year !'

But the satirical impact went even further, I think. Firstly, the Hat's absurdity subverted the whole status of military uniform, semantically so critical, as *Punch* knew full well, to Albert's representation in formal portraiture. And, with delicious irony, he was responsible for the subversion himself: in modern parlance, he had unwittingly deconstructed his own image. Secondly, earlier in 1843, Thomas Carlyle – whose influence on *Punch* I have already suggested – published *Past and Present*, in which he memorably analyses a giant hat, then being paraded around London as an advertising gimmick, as one of the vacuous 'phenomena' produced by modern malaise. The paradoxically substantial emblem of nullity, Carlyle's hat is the diagnostic product of a society in which 'the Quack has become God',[46] a counterfeit world of simulacra where appearances mimic and replace realities. The Albert Hat

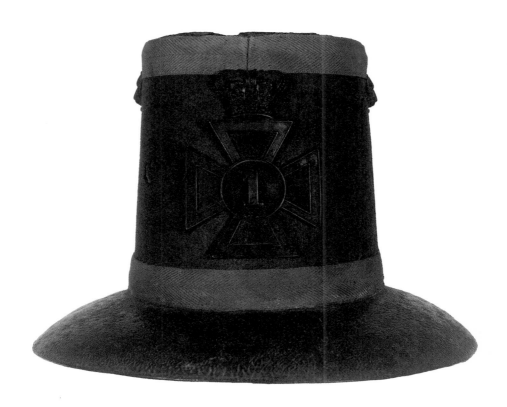

39. A prototype of the 'Albert Hat', 1843 (National Army Museum).

40. John Leech, 'Prince Albert's Studio', *Punch*, 28 October 1843.

The Ballad of Windsor Chase.

[From the back of a piece of Tapestry.]

41. Illustration to 'The Ballad of Windsor Chase', *Punch*, 16 March 1844.

42. John Leech, 'Just Kilted – A Scene at Blair Atholl', *Punch*, 5 October 1844.

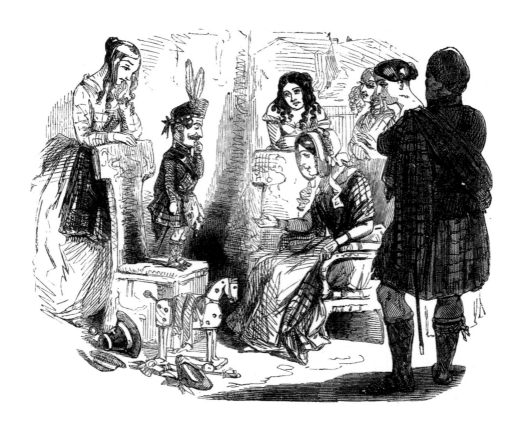

arrived a couple of months after the publication of *Past and Present*, and *Punch*, I believe, seized on the parallel with the giant hat. Here, in a precisely similar object, was a precisely similar emblem that could be used to indict Albert – however unfairly – as a sham, both the creator and creation of unrealities. What followed over the next couple of years, the peak period for *Punch*'s coverage of Albert, was a remarkable series of cartoons and textual items which represented him as engaged in a continuous and delusive masquerade. There is only room here for a selection of some of the contributory images.

In November 1843, *Punch*'s long account of the royal visit to Cambridge includes a text illustration of Albert preening in his new D.C.L. robes before a delighted Victoria.[47] Leech's comparatively positive cartoon 'Prince Albert the British Farmer' (15) – occasioned by one of Peel's speeches – nevertheless stresses an element of dressing-up, of make-believe, with Albert, leaning on a pitch-fork, in a costume that incongruously combines top hat, high stock, and elegantly slender shoes, with a yokel's smock embroidered with the royal arms, and rustic gaiters.[48] In the spring of 1844, a report that Albert was hunting hares specially brought to Windsor for the purpose suggested that he was not even a proper sportsman: a wonderful illustration to the spoof-antique 'Ballad of Windsor Chase' (41) shows him in huntsman's gear, but wearing an Albert Hat, leaping fences while podgy hounds and hares puff across country.[49] Later in the year a report from the royals in Scotland that the Consort had taken to tartan prompted Leech's 'Just Kilted – A Scene at Blair Atholl' (42): an infant-sized Albert in bonnet, plaid, and kilt, stands coyly on a chair for the admiration of Victoria and the court ladies.[50] During Louis-Philippe's state visit Leech went in for more infantalising in 'The Head Pacificator of Europe', which has Mr Punch reconciling the French king, who has been playing at soldiers, with his 'Little Sister' Victoria, who clutches her Albert dolly, complete with Hat.[51]

In 1845 *Punch*'s mockery of Albert's hunting and doubts about his sportsmanship were sharpened, firstly by his unEnglish enthusiasm for *battue* shooting,[52] then by the tally of slaughtered game during the royal tour of Coburg. Three particularly sharp cartoons resulted, each ringing the changes on the Prince's costumes. In 'Sport ! or, A Battue Made Easy' he wears a white topper with a check jacket and trousers – an outfit shown in several *ILN* cuts – and blasts away at pheasants and hares in the convenient confines of a sitting room.[53] Among '*Punch*'s Valentines for 1845' he appears astride a rocking horse as 'The Prince of Sportsmen' (43), accompanied by little wooden hounds and wearing a boy's jacket and feathered hat, with a toy sword at his side. The verse below reads, 'My sportsman bold, oh, is it true, / Hundreds you kill'd at one *battue* ? / Had Fortune cast your lot in trade, / Zounds, what a poult'rer you'd have made !' – where 'poult'rer' puns incisively with 'palterer', a trifler with serious matter.[54] In 'An Historical Parallel; or, Court Pastimes', he is in the check jacket again, this time with an Albert Hat, complacently presenting a pile of dead and dying deer to a simpering Victoria.[55] Meanwhile, the *bal costumé* that year had had an eighteenth-century theme: in Leech's 'Children at Play' (44) Victoria shows the Countess of Nemours her dolls, who are notables of the day costumed for the ball, but cradles in her arms her favourite, Albert as a dolly with powdered wig and tricorn hat, while a portrait of the Prince in field-marshal's uniform looks down from the wall.[56]

When, in the autumn, the royal couple left to tour Coburg, Leech's 'Les Adieux de Buckingham Palace' (45) self-reflexively assembled elements from

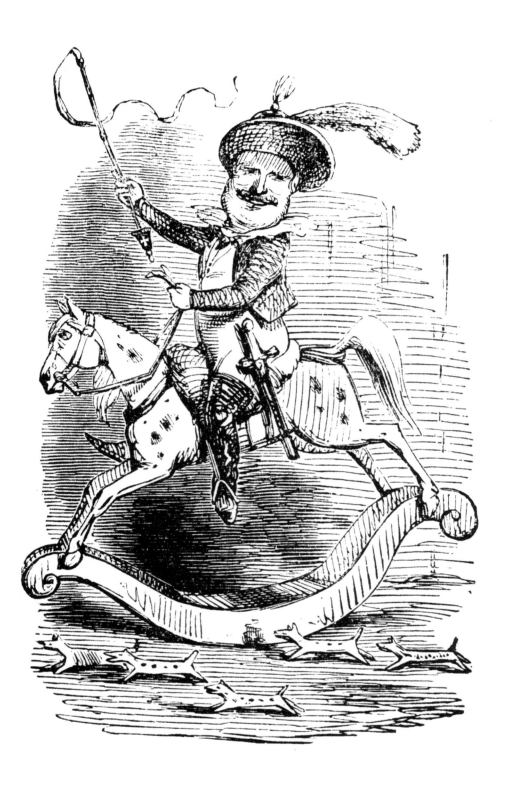

43. 'The Prince of Sportsmen', from 'Punch's Valentines for 1845', *Punch*, 22 February 1845.

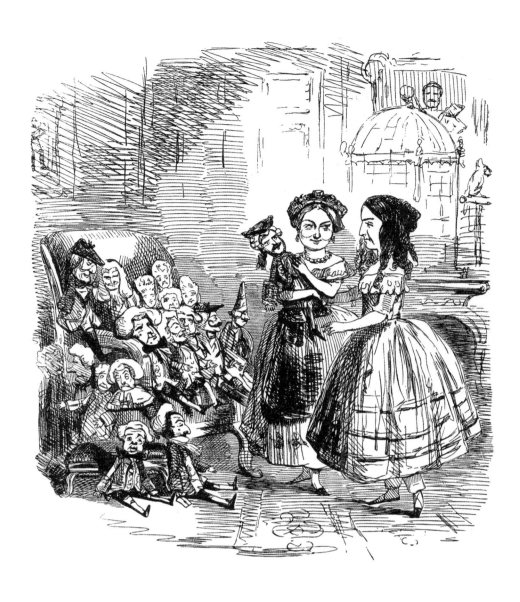

44. John Leech, 'Children at Play', *Punch*, 21 June 1845.

45. John Leech, 'Les Adieux de Buckingham Palace', *Punch*, 23 August 1845.

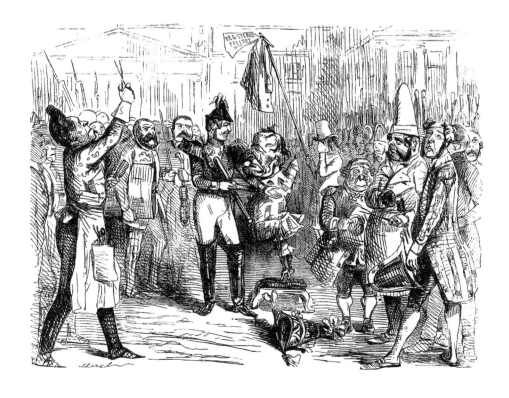

the representational schema through which he and *Punch* had constructed Albert. In the centre, Field-Marshal Prince Albert, carrying an outsize baton and wearing an absurdly small feathered hat and absurdly large epaulettes, is embraced by Mr Punch, tearfully bidding farewell to one of his favourite butts – who grins good-naturedly. The grieving crowd that surrounds them comprises a group of woebegone flunkies in livery, a hairdresser flourishing his scissors, an importunate German portraitist and musician, a weeping tailor who holds a paletot aloft, and a phalanx of beadles, whose vanity about their uniforms associated them with the Prince in *Punch*'s mind.[57] There is a similar self-awareness and reflexivity in what is effectively the climactic image in this whole series of representations, though it did not appear until some eighteen months after 'Les Adieux'. In March 1847 Albert was inaugurated as Chancellor of Cambridge University: *Punch* thought – probably rightly – that his election was an attempt by the University authorities to curry royal favour, and – quite wrongly – that he would be a mere cipher. Leech produced one of his greatest cartoons, 'Prince Albert "At Home"' (46).[58] The title refers to the

famous one-man stage-show of Charles Mathews, whose quick-change abilities enabled him to perform a bewildering sequence of different characters in the course of an evening. Part of the joke being that the Mathews who was supposedly 'At Home' was always being somebody else. In the cartoon the Prince stands centre stage, posed proudly in his Chancellor's robes. Around him is a posse of other Alberts – in the uniforms of a field-marshal and a colonel of hussars, in his D.C.L. robes and wearing a judge's wig, dressed for a day's shooting, in eighteenth-century costume and medieval garb, and in dishabille, in a dressing gown, lovingly caressing an inevitable Albert Hat. Here is the ironic antithesis of formal portraiture's attempt to fix an authentic image of the Consort: instead of defining identity, Leech dissipates it. Albert is all the figures in the cartoon, and he is none of them: they are 'favourite impersonations', as the accompanying text says in mock admiration, and the way 'he "makes up" for all the different parts, however opposite they may be, is truly astonishing.'[59]

46. John Leech, 'Prince Albert "At Home"', *Punch*, 20 March 1847.

Complementing its cumulative construction of Albert as masquerader, *Punch* sustained a running critique of the official images put out by the portrait painters. A few examples will have to suffice. Reviewing the 1844 Royal Academy, *Punch* earnestly drew attention to the fine detail in 'Portrait of the Hat of His Royal Highness Prince Albert; with His Royal Highness's favourite boot-jack', by 'Sandseer'; in the following year, an item headed 'Delightful Novelty' is 'charmed to see in the shops a new portrait of Prince Albert … [which] … was very much wanted; and makes, we think, the forty-fifth this year', then turns to the Academy and 'Thorburn's new picture of Field Marshal His Royal Highness Prince Albert … the forty-sixth'; in the same issue, an injured beadle – actually 'A Hinjerd Biddle' – writes proudly to claim that John Lucas's portrait of Albert (47) shows him holding a beadle's staff, and includes a little sketch of the painting (48) to which has been added a match-stick Victoria waving from the battlements of Windsor Castle; three weeks later a line illustration, 'The Only Way Left to Paint F.M. Prince Albert', presents an equestrian portrait from the rear, the huge, absurdly tilted epaulettes and prodigiously feathered hat perched above the horse's backside.[60]

Through all this, the Albert Hat was pervasive. Its function was at once mnemonic and synecdochic: just mentioned in the text or included in an illustration, it reminded readers of the fiasco of Albert's original efforts at design, and stood for the whole masquerade which *Punch* represented – both alleged and imaged – as constituting his identity, or lack of it, at this period. Among the cartoons described earlier, as well as the occurences already noted, the Albert Hat appears among a litter of discarded playthings in 'Just Kilted', forms the pommel of Albert's toy whip in the 1845 Valentine, and is displayed under a glass dome at the back of the room in 'Sport !' In the text – to take a few examples – *Punch* reported that the Peace Convention Society had given Albert a gold medal for services rendered to peace by 'the ridicule his new regulation hat has thrown upon the army'; claimed he had presented several of the hats to a celebrated troupe of Ojibbeway Indians visiting Windsor, who later thanked 'the Great Warrior Albert' for the spittoons; suggested that 'His Royal Highness of Gotha' was about to design a new police hat to match the infantry one; and sympathised with French complaints about English arms being sent to Morocco if the Albert Hat was among the exports.[61] Among the Hat's numerous other cartoon appearances, three are particularly striking. In Kenny Meadows' double-page 'Mirror of Parliament for 1844', a giant Albert Hat replaces the crown on top of the state coach.[62] In Leech's ' Mars Attired by Prince Albert', one of *Punch*'s 'Designs for National Statues', a uniformed Albert drops the Hat over the head of a curmudgeonly God of War.[63] And in the acerbic 'A Case of Real Distress' (17), occasioned by royal complaints about the inconveniences of Buckingham Palace, a lugubrious Consort leads out his importunate family, his field-marshal's uniform more ridiculous than usual and his notorious Hat proffered to the public with both hands.[64] The Hat indeed took on a life of its own, especially once it was actually issued to a few militia regiments: it features most prominently in the score or so of Leech cartoons depicting the military ineptitudes of the 'Brooke Green Volunteer'.[65]

47. John Lucas, *H.R.H. Prince Albert*, 1842 (Institute of Directors);
Albert wears the full dress uniform of a field-marshal.

48. Illustration to 'New Portrait of H.R.H. Prince Albert' by 'A Hinjerd Biddle',
parodying the Lucas portrait, *Punch*, 10 May 1845.

As *Punch* was constructing its unflattering version of Albert, the *ILN* was responding to many of the same episodes in his career. Needless to say, the resultant images, individually and cumulatively, are wholly positive. Coverage of the 1844 Scottish tour sets the royal couple alternately amidst rapturous crowds and glorious crags.[66] Louis-Philippe's visit is a dignified state occasion in which Albert is a central figure.[67] The trip to Coburg is depicted in ingratiating detail,[68] with due weight on the reverence with which the Prince shows Victoria Luther's sanctuary in the Citadel of Coburg,[69] and with a number of views engraved by the *ILN* from Albert's own sketch-book – a publishing coup that enhances both the periodical's standing and the Prince's cultural credentials. Even the notorious *battue* at Gotha becomes a decorous affair, with Albert and his fellow marksmen taking aim from a little pavilion while the deer trot along in the foreground.[70] The semantic differences between the images in *Punch* and those in the *ILN* are patent. But in one area of representation there is considerable congruence – depictions of Victoria and Albert, and of the two of them with their children, which emphasise domesticity. In the *ILN* in the mid-1840s there is a marked increase in the number of such images, usually presented as vignettes. To take just a few examples from the second half of 1844: the royal couple sit comfortably on a sofa with one of the infants in the Yellow Drawing Room at Buckingham Palace; Victoria plays the piano on the royal yacht while Albert turns the pages of the score for her; the children are introduced to a fat and affable Louis-Philippe (49), the Princess Royal hanging shyly onto her father's hand while the other two hesitate and Victoria smiles encouragingly.[71] These representations have a teasing duality: they are at once exclusive, glimpses into a privileged world, and inclusive, for the royals at home turn out to be just like any other family.

This development in the depiction of British royalty also happened in official portraiture – notably Landseer's *Windsor Castle in Modern Times* (50), finished in 1845, and Winterhalter's *The Royal Family* of 1846 (51) – and has been well-discussed.[72] The process of 'domestification', to use Schama's term, negotiated between the dynastic and the private, sustaining the special status of the monarchy but also celebrating family values readily identifiable with the middle-class ideology of hearth and home. The *ILN*'s vignettes of royal

49. Victoria and Albert introduce the royal children to Louis-Philippe,
Illustrated London News, 12 October 1844.

50. Edwin Landseer, *Windsor Castle in Modern Times*, 1841–5 (Royal Collection).

51. Franz Xaver Winterhalter, *The Royal Family*, 1846 (Royal Collection).

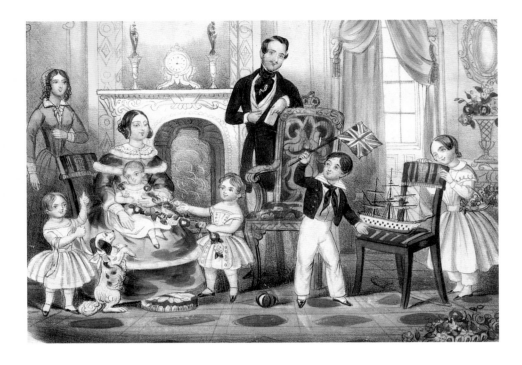

52. The royal children in the nursery, chromolithograph, *c.* 1844 (Stapleton Collection).

53. W. Clark, 'Welcome ! Royal Stranger', engraving published by F. Glover, 1841 (National Portrait Gallery).

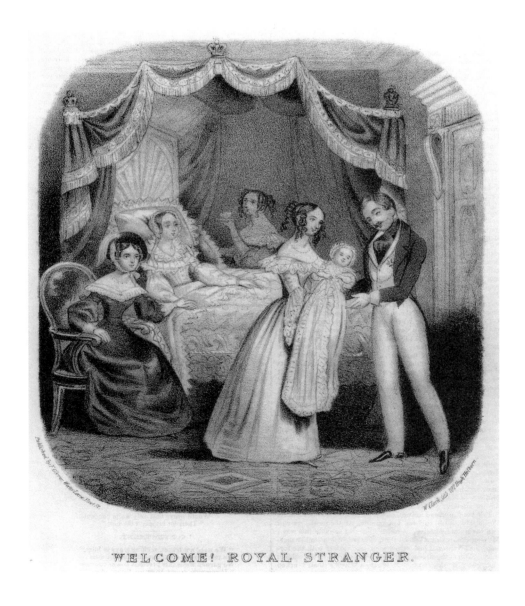

WELCOME! ROYAL STRANGER.

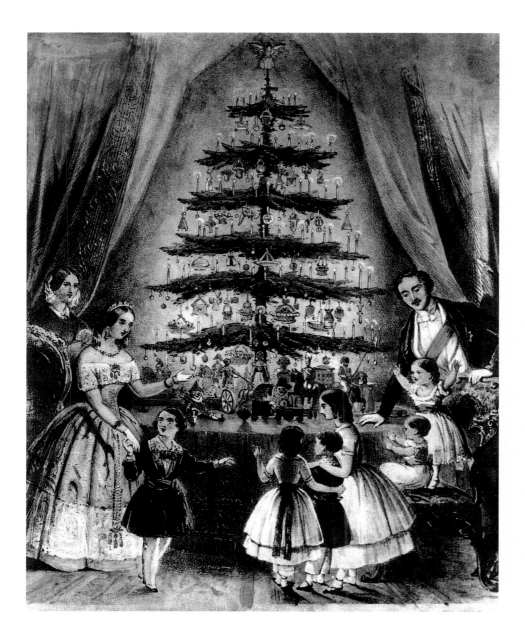

54. 'The Royal Christmas Tree',
Illustrated London News Christmas Supplement,
23 December 1848.

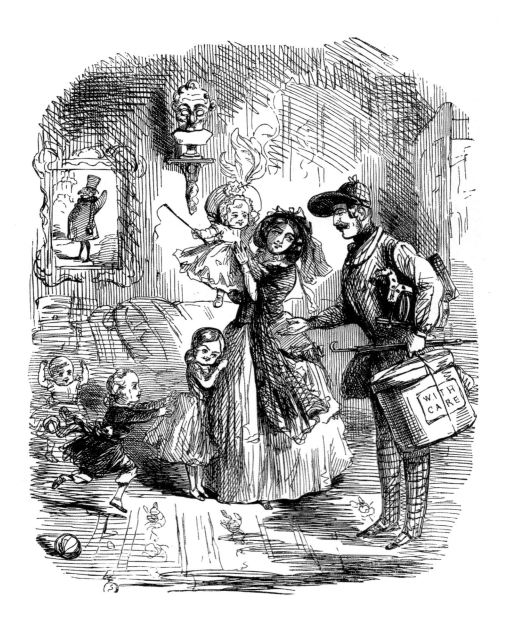

55. John Leech, 'No Place Like Home !',
Punch, 6 September 1845.

domesticity were part of a broader cultural dissemination of such imagery. The print market brought out family groups and imaginary domestic scenes (52): two of the earliest, *Welcome ! Royal Stranger* (53) and *As Well as Can be Expected*, both engraved by W. Clark and published by F. Glover of Water Lane, show Albert receiving the brand-new Princess Royal, and the proud couple nursing the baby;[73] a coloured lithograph of *c.*1843 by Dean & Co., *The Queen and Prince Albert at Home*, has Albert romping on all fours with the Princess Royal and the Prince of Wales while Victoria sits the latest infant on his back.[74] Even a radical sheet like *Reynolds's Miscellany* was not immune, giving its readers a thoroughly respectful wood engraving of the royals in 1846.[75] And the *ILN*'s rivals joined in too: the *Pictorial Times* scored a notable success in its Christmas number for 1846 with 'Christmas at Windsor Castle', a whole-page engraving of the royal family handing out presents around the tree that Albert had introduced into the festivities;[76] it was not until the Christmas of 1848 that the *ILN* brought out a similar, though more up-market, version of the scene (54).[77]

Though initially more sceptical, inclined to be acid about the sentiment lavished on 'the dear little baby royalties'[78] and how much they would cost the public purse, *Punch* also warmed to the domestic image of Victoria and Albert. Early on, *Punch* tended to use domesticity to soften the satire: in 'Prince Albert the British Farmer' (15), for example, the Queen as a milkmaid and the children playing in the farmyard turn the scene into a family idyll that, for all it is spoofed, is nevertheless charming. A couple of years later, the image is unambiguously positive. In Leech's 'No Place Like Home !' (55), marking the return from the Coburg trip, Victoria and Albert, laden down with luggage and presents, have just stepped through the front door of their middle-class house, to be greeted by the excited children; a bust of Mr Punch beams down on the happy group.[79] The middle-class character of the scene is important, for the domesticity with which *Punch* endowed the couple is, by definition, bourgeois. Knocking the royals down a class or two was a standard satirical ploy that *Punch*, to an extent, inherited: issues of the *Penny Satirist*, for example, regularly opened in 1840–1 with a lower-middle-class Victoria and Albert gossiping over breakfast.[80] By the mid-1840s, however, *Punch*'s use of the trope had changed its whole emphasis: as well as the 'No Place Like Home !' cartoon, Victoria and Albert – now almost invariably depicted together – are shown interviewing Russell for the job of butler, in their breakfast room discussing Russell's incongruous appearance in Peel's clothes, strolling arm in arm through Hyde Park while Mr Punch tells them what he thinks of the Wellington statue.[81] They are a bourgeois couple, England is their 'establishment', and they are anxious for the proper running of the house and grounds. Ideologically charged, such representations bid to detach the monarchy from the court and aristocracy, appropriating it instead to the bourgeoisie, thus aligning Victoria and Albert with the structural shift that transferred major elements of economic and political power from the upper to the middle class in the course of the nineteenth century. With that shift, according to *Punch* and, indeed, the *ILN*, came higher standards of public and private morality, intellectual and cultural advance, social improvement, reform – all the constituents of progress. Finally, it is only when *Punch* represents Albert in this way, as a bourgeois, that there is no suggestion of masquerade. To the Albert *Punch* wanted, and therefore sought to construct, being a progressive middle-class gentleman was a reality not merely another role.

Although *Punch* and the *ILN* often differed widely in how they responded to, and thus represented, Prince Albert, there was a marked similarity in the level of coverage that both afforded to his activities in the early and mid-1840s. Graph 3 (see p. 432) plots comparative coverage in the two periodicals, simply assigning one unit on the left axis to each occurrence, regardless of relative importance. Because the data for *Punch* include textual as well as pictorial items, a third graph line has been introduced to register visual representations only. Thus, while overall coverage in *Punch* appears consistently somewhat higher than in the *ILN* between 1842 and 1848, the total of actual images is – as one might expect – substantially lower. Even so, the close correlation between the profiles of the graph lines for these years suggests some kind of reciprocal relationship. As we have seen, *Punch* was very conscious of current representations of Prince Albert, and its own images of him were very often reactions to them. Though it is less overtly signalled, the people producing the *ILN* are likely to have shared that consciousness – particularly as there were personal links between the staff of the two journals, which also had a number of contributors in common.[82] Certainly, there is a strong sense that the two periodicals, both fully aware of their innovatory impact, were playing off one another, and where *Punch*'s depictions of Albert are predominantly – though not exclusively – critical, the *ILN*'s are unflaggingly positive. Thus, an early Victorian household subscribing to both periodicals would have been treated to scores of varying and often conflicting representations of the Consort: adding both together gives totals of between fifty and seventy separate images annually for each of the peak years, 1843, 1844, and 1845. And, of course, there were all the other pictures of him as well – from the rest of the illustrated press, in portraits and prints, on sheet music covers (56). Never before had royalty been subject to this level of pictorial exposure. Moreover, though most of this mass of representation shows Queen and Consort together, a substantial number are of Albert alone: in the *ILN* there are far more images of Albert without Victoria than of her without him.

Peaking in 1843–5, coverage of Prince Albert in both *Punch* and the *ILN* fell in 1846, rose again in 1847 – the year of the Cambridge Chancellorship – then tumbled in 1848, continuing to do so in *Punch* through 1849. The catalyst was 1848 itself, the 'Year of Revolutions' that burst across Continental Europe. The *ILN* came into its own, for here was mightier matter than the doings of the British royals: with history making itself in the most tumultuous and visually dramatic manner, the *ILN* filled its pages with images of insurrection and strife from France, Germany, Austria, and Italy. *Punch*, also engaged with what was happening across the English Channel, was rather differently affected. The periodical's radicalism, much of which had come from the acerbic pen of Douglas Jerrold, was already weakening by 1846; the events of 1848 enfeebled it further. Satirising the *status quo* and tilting at the institutions of state took on a very different complexion when the very order of things was being turned upside down. Though sympathetic to the aspirations and struggles of European liberals, as soon as Chartist militancy appeared at home Mr Punch, in common with most of the English bourgeoisie, found himself on the side of the establishment. This was no time to attack the Consort: ubiquitous in one guise or another only a couple of years before, Albert makes only a dozen appearances in *Punch* in 1849. The *ILN* presents a complete contrast. Its coverage of the royal tour of Ireland – where revolution had spluttered briefly – and its continuation to Scotland[83] is so intensive as to bear the stamp of conscious policy,

La Valse à deux temps.

56. *La Valse à deux temps*, music cover of
c. 1841 (O'Rorke Collection).

an ideological strategy to promote British constitutional monarchy, exemplified by images of Victoria and Albert peacefully engulfed by a loyal and affectionate people. It is the antithesis to the previous year's pictures of popular insurrection throughout Europe. As well as making Albert a focal figure in the royal tour, the *ILN* also showed him with the Queen for the opening of parliament in the spectacular setting of Pugin's newly finished House of Lords (57) – profoundly resonant after the Year of Revolutions; laying the foundation stones of Great Grimsby Docks and of a reformatory in Reigate; escorting Victoria round the Royal Academy; and, Victoria being indisposed, opening the London Coal Exchange with the Princess Royal held tight by one hand and the Prince of Wales by the other.[84] Probably uncalculated, it was a touch of informality, an affirmation of domestic values amidst official pomp, that perfectly complemented the image of the royals that the *ILN* had constructed during the year: 'perhaps the most remarkable feature of the whole ceremony', the paper enthused.[85]

 Punch approved of the Coal Exchange opening as well[86] – but by this time its whole attitude to Prince Albert had veered round. Shifting attention away from Albert, for the reasons suggested above, *Punch* not only dropped him as a satirical target – there are no hostile items about him in the whole of 1849 – but also reconstructed him along positive lines. Or, as *Punch* claimed, he reconstructed himself. The change was signalled in the early summer of 1848, after Albert had addressed the Association for the Improvement of the Working Classes, in an article entitled 'Prince Hal and Prince Al. – A Parallel'. Just as Shakespeare's Hal abandoned a riotous youth to emerge as a great national leader, so Albert, at a moment of national crisis, has thrown off 'another kind of dissipation – the waste of time'. His speech, 'judicious and apposite', offers remedies for the 'wide-spread feeling of discontent among the labouring population' that *Punch* sees as the cause of the 'movement directed against monarchical institutions … throughout Europe'. 'The whole British public cheers him, and cries "Bravo !" and asks "Who would have thought it ?"'[87] Later in the year, with the news that Albert was promoting major reforms at Cambridge, Leech deftly reworked his images of the Prince in masquerade to show him in a combination of field-marshal's uniform and Chancellor's robes storming the citadel of academic reaction (58).[88] By 1849 *Punch*'s tone had become positively smug: 'When so many other Princes are going down, it is gratifying to see our own Prince going up … in our estimation'.[89] Albert, it seems, was not a sham, a Carlylean 'quack', after all.

 Jolted into changing its construction of Albert by the spectre of revolution, *Punch* found its revised opinion amply confirmed by the Great Exhibition. For the *ILN*, the Exhibition was a vindication of all its promotion of the Prince and his activities – and the occasion for some of the most spectacular images it was ever to publish. Despite some initial hesitancy, particularly over the Hyde Park site,[90] *Punch* soon decided that the idea of the Exhibition conformed with its own belief in social progress – more broadly, with the mild reforming liberalism that had largely replaced its earlier radicalism. Something rather more urgent, perhaps, is implied by Leech's 'Specimens from Mr Punch's Industrial Exhibition of 1850', where Punch shows Albert specimens of exploited and destitute workers, hopefully – as the sub-title says – 'To Be Improved in 1851'.[91] But the ambiguity of tone does not recur, and, in any case, the representation of the Consort is wholly sympathetic: grave, mature, and concerned, he is clearly an ally in the cause of amelioration. Whether or not the conditions highlighted

57. Albert attends the robing of Victoria for the 1849 opening of parliament, *Illustrated London News*, 3 February 1849.

58. John Leech, 'H.R.H. Field-Marshal Chancellor Prince Albert taking the Pons Asinorum', *Punch*, 25 November 1848.

by the cartoon were 'improved' by 1851, as the Exhibition neared and opened it dominated everything else in *Punch* and the *ILN*. Both periodicals, indeed, could claim to have made a major contribution to its success: the *ILN* by enthusiastically publishing Paxton's design for the Exhibition building,[92] *Punch* by christening it the Crystal Palace.[93] Unsurprisingly, the number of representations of Albert and items about him increased significantly in both, as in the rest of the press. There were official portraits and views of proceedings as well, among them Henry Phillips's large ensemble painting of the 1851 Commissioners (59),[94] Winterhalter's arresting group portrait *The First of May*,[95] and Henry Selous's picture of the opening ceremony in the Crystal Palace.[96] The *ILN* pictured Albert's involvement from beginning to end: presiding over fund-raising banquets at the Mansion House and in York Guildhall; visiting the workmen building the Crystal Palace (60); with the Queen and the children for the grand opening; reading the Commissioners' final address at the closing ceremony.[97] With thousands of images of the Crystal Palace and its astonishing contents, the *ILN*'s whole coverage celebrated spectacle, abundance, productive power, material progress. And Albert as the prime mover, for he was 'the projector and ruling genius of the whole scheme'.[98] For the *ILN*, the requirement – discussed earlier – that Prince Albert should be represented as a dynamic agent acting upon history was never more completely fulfilled.

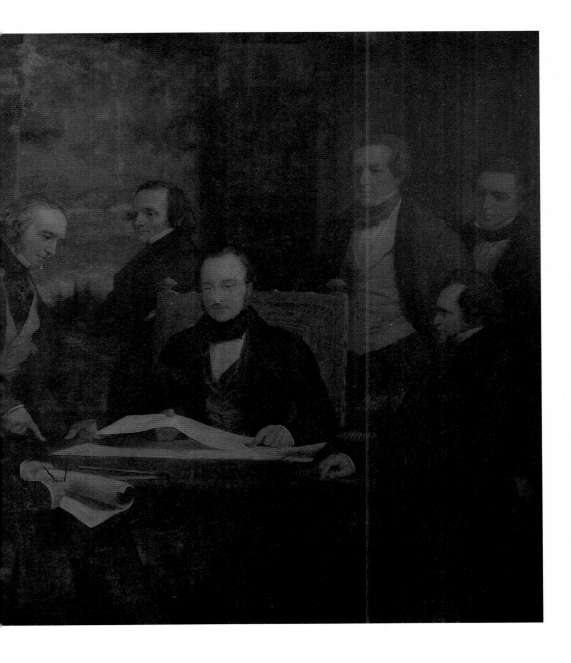

59. Henry Windham Phillips, *The Royal Commissioners for the Great Exhibition, 1851*, 1850–1 (Victoria and Albert Museum).

60. Albert visits the workmen building the Crystal Palace, *Illustrated London News*, 11 December 1850.

In *Punch*, both textually and pictorially, the years of the Great Exhibition are by far the most positive period for representations of Albert: between 1849 and 1852 there are only a couple of satirical digs at his expense. Two cartoons seem to me particularly important in the way they extend the semantic range of *Punch*'s images of him, and for both there are analogies in the *ILN*. 'Her Majesty, as She Appeared on the First of May, Surrounded by "Horrible Conspirators and Assassins"' (61) – probably by Leech – shows Mr Punch ushering Victoria and Albert, with the Princess Royal and the Prince of Wales, down the nave of the Crystal Palace, which is packed with smiling women and cheering men.[99] While it gives primacy to the Queen, it constructs her and Albert, together with the children, as the focus for a popular, even 'democratic' monarchism – a representational strategy we saw earlier in the *ILN*'s cuts of the royal tours. At the same time, the quotation in the cartoon's title – taken from warnings about the threat posed by the crowds assembled for the Exhibition – recalls the revolutionary scares of 1848 and the extent to which *Punch*'s remaking of Albert, here fully vindicated, was a response to those anxieties. The second cartoon is John Tenniel's 'The Happy Family in Hyde Park' (62): the Crystal Palace is a kind of peep-show filled with the peoples of the world in various national costumes all dancing together, and Albert is the

61. John Leech, 'Her Majesty, as She Appeared on the First of May, Surrounded by "Horrible Conspirators and Assassins"', *Punch*, vol. 20 (1850).

proprietor, pointing out the contents to spectators who are also in national dress; in the foreground Mr Punch grins invitingly at the reader, who becomes one of the onlookers.[100] This is, I think, the single most positive image of Prince Albert in the whole of *Punch*. It has parallels scattered through the *ILN* which show the Consort enthusiastically pointing things out, explicating them, to those around him, particularly Victoria – details of the model of the Mansion House, the features of an ancient stairway at Burghley, folk dances in Coburg, a picture in the Royal Academy Annual Exhibition (63).[101] Complementing this type of image are others in which Albert is singled out from a group by his studious attention to what is happening – listening to Mendelssohn's *Oedipus*, watching a theatrical performance at Windsor, following a game of cricket at Castle Howard, examining the Britannia Bridge with Robert Stephenson, visiting the Holyhead slate quarries.[102] 'The Happy Family in Hyde Park' has him as both instructor and entertainer, at once earnestly attentive and engaging. Tenniel's cartoon transmutes – who knows how consciously ? – the 1840s images of the Prince as masquerader. Rather than making a show of himself, Albert harnesses showmanship to national goals of peace and prosperity, becoming the country's – indeed the human family's – principal educative entertainer, its explicator-in-chief.

62. John Tenniel, 'The Happy Family in Hyde Park', *Punch*, vol. 21 (1850).

63. Victoria and Albert visit the Royal
Academy Annual Exhibition, detail,
Illustrated London News, 26 May 1849.

Albert's popularity did not last, either with *Punch* or the public. In the long run-up to the Crimean War, he was widely believed to be meddling in foreign affairs. In particular, to be prompting vacillation in Lord Aberdeen's government because conflict with Russia, supposedly a strategic necessity for Britain, was not in the interest of the smaller German states. Residual distrust of Albert as a foreigner stoked his unpopularity: according to one journalist he was the principal agent of 'the Austro-Belgian-Coburg-Orleans clique, the avowed enemies of England, and the subservient tools of Russian ambition'.[103] In January 1854, in a spasm of national hysteria, a rumour that Albert had been arrested for treason ran round the country, and a crowd gathered at the Tower of London in hopes of seeing the Consort banged up. When parliament assembled at the end of the month the situation was sufficiently grave for political leaders to mount a concerted defence of the Prince's role: Victoria, at least, was relieved by 'the triumphant refutation of all the calumnies'.[104] *Punch* regarded the treason rumour as ludicrous enough,[105] but several items in 1853 present Albert – for the first time – as a conspiratorial figure whose intrigues with European royalty are unknown to Victoria.[106] In the poem 'Hints and Hypothesis', from the first issue of 1854, he is a 'young foreigner' who has married 'a true English maiden' and become a favourite 'with the high and the low', but has started to interfere with matters 'Over which she should have unrestricted dominion';[107] a cartoon in the same number depicts Albert as a shifty cove skating on thin ice labelled 'Foreign Affairs Very Dangerous'.[108]

Clearly re-emerging were the old doubts about the Consort's constitutional position, entwined as before with prejudice about his not being English. *Punch* could never quite forget this, and, once the conflict began, one consequence was Albert's exclusion from the periodical's images of patriotism and national solidarity. Particularly barbed is Leech's 'Throwing the Old Shoe' (64), in which Victoria hurls a shoe for luck after the Brigade of Guards, marching past her balcony on their way to war; she is surrounded by the royal children, but there is no Prince Albert.[109] A few weeks later, substituting for the absent Consort and reanimating all the issues of the mid-1840s, came a new hat for *Punch* to lampoon – protective headgear Albert designed for the Guards. One illustration shows a cap 'that would *completely* spoil the appearance of our picked men, humbly suggested to H.R.H. F.M. P.A., while he is about it'; another, as if in some absurd instruction manual, shows four views of the 'New Albert Bonnet'; a third gives the Grenadiers a complete new uniform, 'as improved by H.R.H. F.M. P.A.' (65) – stilt shoes, flared skirt, fur shoulder pads, an enormous brolly, and the bonnet.[110] Military millinery in peacetime was a different matter from toying with uniforms when men were about to fight, and the feminisation of the Grenadiers' outfit makes a waspish point. Surely, sneers the accompanying text, Albert could not have been responsible. After all, 'precluded as he is by his position from sharing in the dangers of active service', he 'must of course be content with gracefully wearing his own uniform as Field-Marshal, and could never think of interfering with that of the army, of which he is not permitted to be more than an ornament.'[111] This goes further than the deconstruction of the Prince's image I remarked earlier when discussing the Albert Hat episode. By an intense irony, the very costume chosen for the early portraits as a means of validating his role, at once conferring dignity and indicating his service to the Queen, became for *Punch* during the Crimean War the defining sham, worn by a Consort who had abused his constitutional position, and confirming him as a mere ornament when real

64. John Leech, 'Throwing the Old Shoe', *Punch*, vol. 26 (1854).

65. 'The British Grenadier as improved by H.R.H. F.M. P.A., decidedly calculated to Frighten the Russians', *Punch*, vol. 26 (1854).

soldiers were fighting and dying. Once news began to emerge of the gross mismanagement of the Crimea campaign, *Punch* went for Albert – quite unfairly – as typifying the incompetence and sinecurism of the army high command. In 'Military Reform – A Noble Beginning', a fat and balding Prince, wrapped in a dressing-gown, lays his field-marshal's uniform, and the sack of money that went with it, on 'the altar of his country'.[112] Leech's 'Grand Military Spectacle' (66), the bitterest of these images, shows the wounded and disabled heroes of the Crimea gazing incredulously at an array of high-ranking dotards, most prominent among them Prince Albert, smug and paunchy in full uniform.[113] In 'More Noble Conduct of H.R.H. F.M. P.A.' – a pendant to 'Military Reform' – he kneels in his dressing-gown before Victoria, petitioning 'to be Placed on the same Footing as his more Fortunate Brethren in the Line'; on the wall a bleak canvas entitled 'Before Sebastopol' hangs beside a portrait of him in Chancellor's robes.[114] In the same issue 'An Invocation from the Army', addressed 'To an Illustrious Field-Marshal', summarises *Punch*'s attitude:

> *Rest thee, Albert, rest thee now,*
> *With thy laurels on thy brow;*
> *Rest thee, warrior, let the fame*
> *Thou hast earn'd suffice thy name;*
> *Rest, and as a man of peace,*
> *Meddling with our Army cease;*
> *Martial business leave alone,*
> *Be content to mind thine own.*[115]

66. John Leech, 'Grand Military Spectacle. The Heroes of the Crimea Inspecting the Field-Marshals', *Punch*, 3 November 1855.

67. The royal family bids farewell to the First Battalion of the Scots Fusilier Guards, departing for the Crimea, detail, *Illustrated London News*, 11 March 1854.

If *Punch*, and a large part of the population, lost faith in Albert over the period of the Crimean War, the *ILN* did not. Indeed, it confronted directly the interrelated problems of his constitutional position and his standing in the army. Between 1853 and 1856, with the exception of royal tours – about which more shortly – there are more pictures of Albert in a military role than in any other, and he is almost always with Victoria. The innovatory army exercises at Chobham in 1853, which were largely Albert's idea and about which *Punch* was inclined to be dismissive, are given extensive coverage in the *ILN*.[116] A curtly dismissive paragraph in January 1854, 'The Slanders against Prince Albert', is the only notice given to the rumours that got everybody else so excited.[117] With war decided, Albert as colonel-in-chief gravely inspects the Grenadiers prior to embarkation.[118] Where Leech excludes him in 'Throwing the Old Shoe', the *ILN*'s impressive image of the Guards' farewell (67) shows the balcony of Buckingham Palace crowded, with Victoria leaning forwards and Albert doffing his hat in salute to the soldiers below.[119] And so on throughout the war, the

Consort constantly accompanying and supporting the Queen: with the princes Edward and Alfred they visit the wounded at Chatham, an occasion that became an important element in the whole iconography of the Crimean War;[120] together they distribute campaign medals;[121] tiny figures in an open carriage, they review the Guards in Hyde Park on their return.[122] Pictorially and ideologically, Albert is indivisible from Victoria as a representational focus for patriotic feeling and, indeed, as an emblem of national unity. In this context, one *ILN* image seems to me particularly remarkable. In May 1854 Victoria launched the battleship *Royal Albert*: among several pictures of the occasion, one, full-page, shows the prow of the vessel filling the whole frame, its figurehead of the Prince in Garter robes reared gigantically over the minute

figures of the Queen and the royal family, including Albert himself (68).[123] As the weight given to the image suggests, the moment, the act of launching Albert's ship, takes on a peculiar significance. What is being sent forth here is a representation, a vast Albert icon: representation was the *ILN*'s distinctive business, it had disseminated hundreds of images of Albert over the years, and was doing so now at a moment of crisis both for the country and for the Prince. Although – as *Punch* constantly reminded its readers – the man himself could not go to war, his image could, in the symbolically appropriate form of a vast figurehead. Effectively – and I think consciously – the *ILN* pictures the moment at which the representation becomes more important than, even subsumes and replaces, the reality.

68. The launch of *The Royal Albert*,
Illustrated London News, 20 May 1854.

In 1855, when the muddle of the Crimea somehow turned into victory, the *ILN* vindicated Albert, and its own version of him, by simple force of pictorial reiteration. Even more than the parades and reviews in which he figured, the *ILN* was able to exploit the visit of Napoleon III and the Empress Eugénie, Victoria and Albert's return tour to France, and, at the end of the year, Victor Emmanuel's visit to England. There are medallion portraits of Queen and Consort as pendants to those of their royal guests;[124] there are imposing architectural vistas and lively street scenes, especially in Paris;[125] and a few engravings that are impressive just as technical achievements –in particular, one enormous fold-out showing the Prince with Napoleon and Eugénie driving below the ramparts of Windsor on their way to meet the Queen.[126] Numerous as they are, however, these images as a whole do not substantially extend the *ILN*'s existing repertoire for representing Albert. Nor indeed do those published between 1856 and the Prince Consort's death, though one full-page cut of the Manchester Art Treasures Exhibition with Victoria and Albert arm-in-arm, eagerly touring the showcases (69), is one of the most fetching representations of him in his role of explicator.[127] There is also an overall reduction in quantity, and by 1860, with the Prince of Wales on an official visit to North America and Prince Alfred in South Africa, the *ILN*'s focus is beginning to shift towards the pictorial possibilities offered by the younger royals. In *Punch* too there is a steady decline, textually and graphically, in the amount of coverage given to Albert. There is the occasional squib, such as the Leech cartoon attacking his attempt to shift the National Gallery to South Kensington,[128] and a few jokey cartoons of him as an ageing pater familias.[129] By the last years there is little or no animosity; but one feels that that is because Mr Punch has rather lost interest in the Prince.

Formal portraits of Prince Albert continued to be painted in the 1850s, and easel pictures of royal events. But portraits in particular are few, especially compared to the numbers that had poured out in the early 1840s. Winterhalter's full length of the Consort in the uniform of a colonel of the Rifle Brigade, finished in 1859, is perhaps the most imposing, but it is also entirely conservative in the conventions it observes.[130] By this time, as Peter Funnell has pointed out, 'the oil portrait and the engraving had been joined by another medium in which Albert's likeness could be propagated: the photograph'.[131] Photography offered a challenge to portraiture as a vehicle of authenticity – and fixing an authentic image of the Prince was, it will be remembered, a central concern in the first years of his marriage. As well as people, of course, photography was also able to capture, with what seemed unprecedented accuracy, landscapes, townscapes, buildings, even – though motion was a problem – contemporary events. That is, it also presented a challenge, potentially at least, to the kinds of authority and immediacy with which the engravings that filled the *ILN* were invested. It would be many years before a means of cheaply combining photographs with letterpress arrived, but the *ILN* quickly recognised the need to lay claim to the peculiar authenticity of the new medium. During the 1850s the periodical started to publish engravings based on photographs: among the first, significantly, were images of wounded Crimean soldiers taken from photographs commissioned by the Queen.[132]

69. Victoria and Albert visit the
Manchester Art Treasures Exhibition,
Illustrated London News, 11 July 1857.

Victoria and Albert were enthusiastic about the possibilities of the medium from its early days, but their interest intensified after 1853 when they became Patrons of the Photographic Society of London. They acquired a 'double body folding camera', installed darkrooms at Buckingham Palace and Windsor, commissioned work from leading photographers, bought prints, and began to assemble photographic albums, taking particular pleasure in collecting views of places visited on their tours – thus doing for themselves what the *ILN* was doing for its readers. Albert conceived the idea of using photography in cataloguing Raphael's drawings, and it was at his suggestion that the Manchester Art Treasures Exhibition included photographs, many from the royal collection.[133] A large part of that collection was made up of pictures of the royals themselves – of Victoria and Albert as a couple, of Albert alone, of the children, and of the family as a group. Evident in these images, as Funnell has said, is 'the tendency of the medium to render informal the subjects whom it captures and the apparent willingness of Albert and Victoria to submit themselves to this'.[134] In the context, informality and domesticity went together: the photographs thus consolidated and amplified elements within the representation of Albert that, as

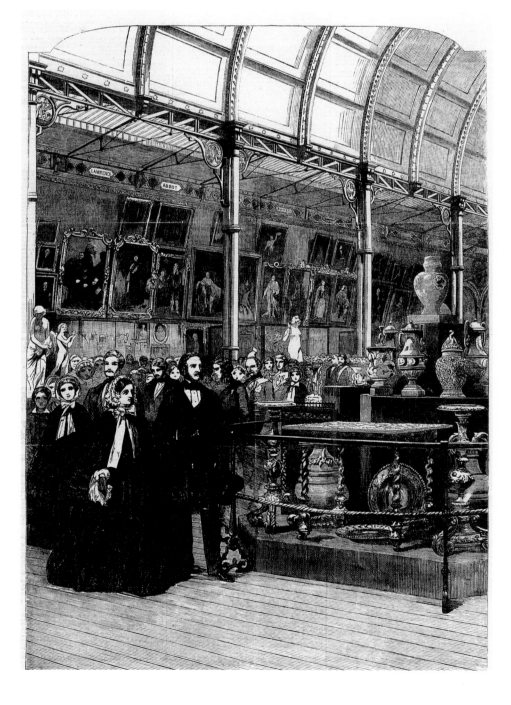

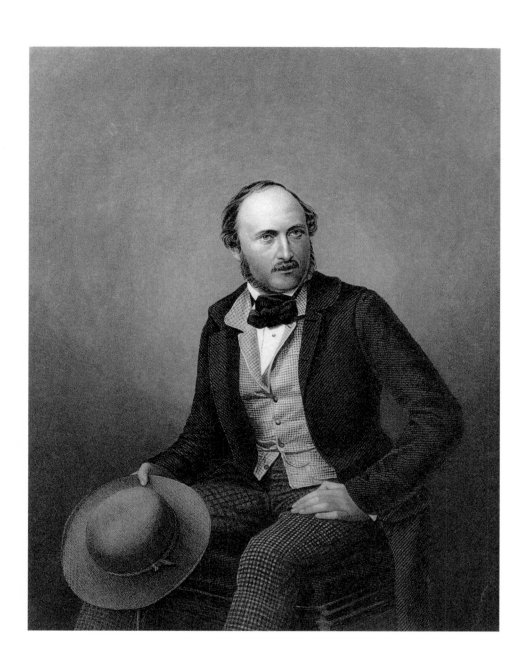

we have seen, entered state portraiture in the mid-1840s and were central to his depiction in both the *ILN* and *Punch*. With a handful of exceptions, they show Albert in civilian dress, sometimes quite casual. None more so than one taken at Osborne in August 1855 by John Edwin Mayall, which, in 1862, became the basis of an engraving by Daniel John Pound (70), reputed to have sold over 60,000 copies: the Prince is seated, a broad-brimmed hat held negligently in one hand, and he leans forward, head part-turned to gaze intently at the camera and the spectator.[135]

It was through engraving that photographic images of the royal family initially got into public circulation, either as individual prints or, increasingly, in the illustrated press. The first such in the *ILN* appeared in May 1856, a picture of the Princess Royal from a Mayall photograph, to mark her forthcoming wedding to the Crown Prince of Prussia.[136] At the end of 1858 came a rather conservative portrait of the Prince of Wales in military uniform, again after Mayall.[137] The next, six months later, is a family group, Victoria and Albert with all the children on the terrace at Osborne, from a photograph by Caldesi and Montecchi (71).[138] The *ILN*'s competitors were also stirring: the *Illustrated News of the World*, for example, opened 1859 with a picture of Prince Albert, based on a photograph, as one of its 'Portraits of Eminent People'. This somewhat piecemeal dissemination changed in 1860 when Victoria and Albert sanctioned the publication of Mayall's *Royal Album*, the first publicly available collection of photographs of the Queen and Consort. For the *Athenaeum*, 'the lineaments of the royal race' were here reproduced 'with a homely truth, far more precious to the historian than any effort of a flattering court artist'.[139] The *Album* was a major catalyst in the explosive popularisation of photography that came with the *carte de visite*, introduced into England in 1857 and sufficiently cheap for working people to be able to afford photographs of themselves – thus sharing a medium of representation with royalty. This democratisation through the image was dramatically and ironically confirmed by the loss of that most pictured and represented of men, Prince Albert himself. Such was the national shock and sympathy following his death that, within a week, 'no less than 70,000 of his cartes-de-visite were ordered' from the London firm of Marion & Co.[140] The demand for the Pound engraving after Mayall, noted earlier, had the same cause.

The extraordinary mass desire to own an image of the late Consort (72) was, of course, the first manifestation of the commemorative impulse that was soon to be felt at every level of British culture.[141] Its greatest expression was the National Memorial that is the subject of this book. As will be clear from Hermione Hobhouse's chapter, the Memorial sought to commemorate a life of astonishing activity, of great and diverse public service. As should be clear from the present chapter, the man who led that relatively short life was subject throughout it to a pressure of representation, a sheer volume of visual construction, a burden of being depicted, that was unprecedented.

70. Daniel John Pound, *The Late Prince Consort*, engraving of 1862 after a photograph of August 1855 by John Edwin Mayall (National Portrait Gallery).

71. Caldesi and Montecchi, *The Royal Family on the Terrace at Osborne*, photograph taken on 26 May 1857 (Victoria and Albert Museum).

Punch's jibes about all the portraits contain an important historical truth: because of the revolution in visual culture brought about by technological innovations, by the marketing of engraved and later photographic prints, and by the dynamic emergence of illustrated periodicals, more images of Albert were produced than of anybody apart from Victoria herself. The people who made the Prince Consort National Memorial, from Scott who designed it to Kelk's workmen who built it, must all have been among the consumers of those images. In chapter five Benedict Read discusses the sculptural genesis of the Memorial, and in chapter six Colin Cunningham analyses its iconography. In the context of the present chapter, it is worth speculating on how the accumulated history of Albert's representation during his lifetime may have affected the Memorial's conception.

72. Camille Silvey, *The Prince Consort*, photograph for a *carte de visite*, July 1861, issued as a commemorative image (National Portrait Gallery).

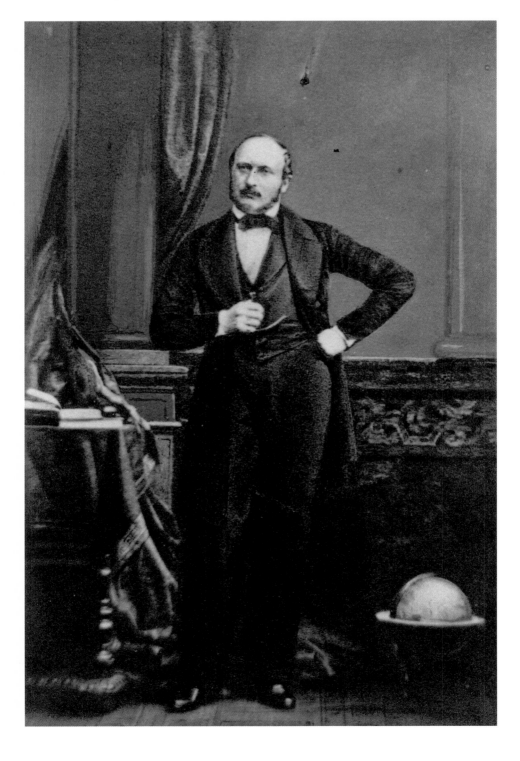

Most obviously, the Memorial's iconographical emphasis on the Prince's role in the Great Exhibition – in part a response to its site – fixes Albert to the period in which representations of him were consistently at their most positive. This is reinforced by the way the national costumes that appear variously in the Memorial's sculpture, and the extraordinary diversity of artefacts – from a steam-hammer to an Indian shawl – replicated in marble, recreate the visual imagery through which the Exhibition itself was represented. The Memorial thus permanently identifies Albert, as the co-ordinating figure, with the abundance, productive power, and material progress that were celebrated in press coverage of the Exhibition – notably, in the present context, by the *ILN*. This identification supersedes or precludes others. Tellingly, the Memorial makes no reference to the Prince's military role; there are no uniforms, so long the focus of *Punch*'s satire, and nothing connects the monument's image of Albert with the controversies surrounding his position during the Crimean War. Nor is he associated with the family life, the domesticity, that had become such a significant element in the paintings, engravings, and photographs; the very piety with which that role was invested and which gave it such ideological potency, made its representation on a highly public monument inappropriate. Such considerations affected not only the iconography of the Memorial as a whole, but also – crucially – the central statue of the Consort himself. Avoiding the different problems presented by military uniform and domestic dress, the sculptor John Foley represented Albert in Garter robes. They establish rank and dignity, and carry chivalric connotations; moreover, as the Garter was in the personal gift of the sovereign, the robes affirm allegiance. Yet they also belonged to the privileged world of the court, something the *ILN*'s snobbery traded on in early days, but a potentially uncomfortable association given that the Memorial was supposed to be an expression of popular feeling, and that the whole tendency of royal representation was moving towards greater informality.

The problem is countered by how the figure is posed, and how it relates – visually and iconographically – to the whole Memorial. It has little in common with other statues of the Prince, neither the one or two executed during his life, nor the many created to commemorate him. Instead, Foley represented Albert seated and relaxed, but looking out attentively, the overall posture close to that in one of the Consort's least formal images – the 1855 Mayall photograph that had been so widely distributed, as I noted earlier, in the form of the 1862 engraving by Pound. The set of the torso and turn of the head are precisely similar, while the right hand casually holds not a hat but a catalogue of the Great Exhibition. Representation builds on representation: the catalogue contained images of the exhibits, which now reappear – are re-presented indeed – as significant details in the Memorial's sculptural programme. That semantic link reinforces a spatial one. Because of the way the Memorial is disposed, Albert seems to be a participant in the multitude of figures and objects assembled to commemorate him. The effect was conscious, and Albert's pose is integral to it: he appears, in Foley's words, 'as if taking an earnest and active interest in that which might be supposed to be passing around him'.[142] This attentiveness is key to the Memorial's inclusiveness, its peculiar brand of populism. As noted earlier, attentiveness characterises Albert in a number of *ILN* cuts where he is a listener or observer, and relates to the body of images in which he is shown as an explicator, the role most fully realised through the Great Exhibition. Both types of representation inform *Punch*'s most positive depiction of him, as the

73. 'Fashion in Hyde Park',
a scene set on the steps of the Albert Memorial,
Illustrated London News, July 1873.

showman-educator in Tenniel's 'The Happy Family in Hyde Park'. In the cartoon Mr Punch invites us to join the show, both to watch and to become part of it, for the human family is at once Prince Albert's audience and his exhibit. The Memorial too is both an entertainment, a marvellously diverting display, and a vehicle of instruction, a didactic compendium of representations. And, as its audience, we indeed join the show (73), for the Memorial was designed to have visitors entering its space, walking round the sculptural groups, climbing the steps, studying the details of the podium frieze – finding access. In this sense, as we visit and look, we too form part of the Memorial's complement of figures, part of its assembly of people: we become members of the Family in the Park (74). Amidst it all, attentive, participatory, 'taking an earnest and active interest', sits Prince Albert, who organised the Great Exhibition and for whom the great exhibition that is the National Memorial was organised, the showman who has become the centrepiece of the show, the exhibitor exhibited.

74. Members of the Federation of Women's Institutes break for lunch during their Annual General Meeting, May 1960; photograph by William Vanderson.

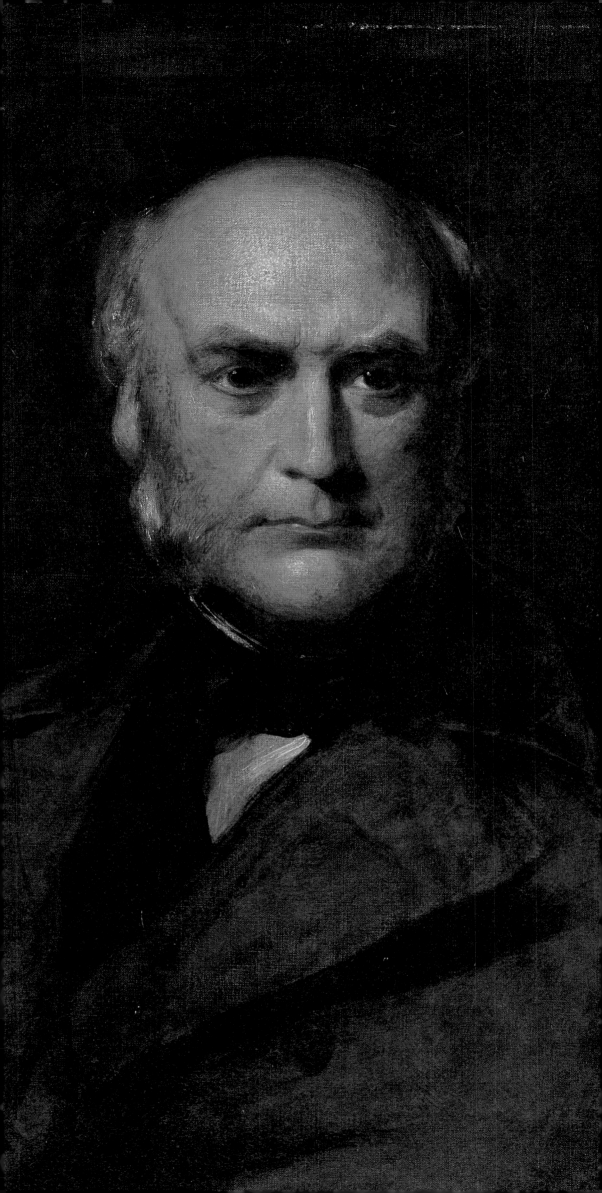

George Gilbert Scott, the Memorial Competition, and the Critics

Gavin Stamp

'I have been this day to Osborne to be knighted. I have had a very agreeable day', recorded George Gilbert Scott (75) on 9 August 1872. The architect went on to describe all the details of his journey from London to the Isle of Wight by special train and boat in his *Personal and Professional Recollections*, and how 'at length I was summoned. Having made my bows, the sword was handed to the Queen. She touched both my shoulders with it, and said in a familiar gentle way, "Sir Gilbert". Then she held out her hand, I kneeled again and kissed it, and backed out, the whole taking something less than half a minute … I thank God for the honour.'[1]

Such was his reward for having designed the national memorial to Queen Victoria's late husband, which had been unveiled to public gaze the previous month. It was a major monument of the Gothic Revival, which, more than any other structure in Britain, has come to represent the values and aspirations of its time.

The Albert Memorial was a triumph for its architect, although the criticism and abuse to which it has always been subjected began to needle Scott long before it was finished. 'This being my most prominent work', he wrote in July 1872, 'those who wish to traduce me will naturally select it for their attacks. I can only say that if this work is worthy of their contempt, I am myself equally deserving of it, for it is the result of my highest and most enthusiastic efforts.'[2] The Memorial was also a triumph for what Scott called 'the Gothic Renaissance'. It was the first significant example of official or royal patronage for the muscular, polychromatic, sculptural gothic, based on thirteenth-century precedents, which was so energetically promoted in the 1850s by Scott and others. It was not the first Gothic Revival public building in London, of course, for there was the spiky late gothic palace for democracy by the Thames created by Barry and Pugin two decades earlier. But taste, or fashion, had shifted since then; as Charles Eastlake's *History of The Gothic Revival* – published in the year of Scott's knighthood – rather smugly put it, 'in an artistic point of view, the selection of the style adopted for the Houses of Parliament has long been pronounced a mistake'.[3]

When Scott was chosen as the designer of the Albert Memorial in 1863, he was still smarting from his recent defeat by Lord Palmerston in that most ferocious engagement in the 'Battle of the Styles' in which he had been forced to

75. Sir George Gilbert Scott (1811–1878),
portrait by George Richmond, 1876–7 (detail)
(Royal Academy).

design the new Foreign Office in an Italianate classical manner rather than in gothic. He had yet to receive the commission for the new buildings for Glasgow University or that for the Midland Grand Hotel at St Pancras Station, where he succeeded in putting up the sort of thing he had had in mind for Whitehall. Only a few gothic public buildings had appeared by this date: the Oxford Museum had lately been completed in Italian gothic by Deane and Woodward, and in 1861 Edward William Godwin (1833–1886) had won the competition for Northampton Town Hall with an Italian gothic design; while Scott himself had just begun building his gothic town hall in Preston. But such secular gothic monuments as Manchester Town Hall, by Alfred Waterhouse (1830–1905), still lay in the future, as did the important competition for the new Royal Courts of Justice in the Strand which would confirm the (short-lived) ascendancy of Victorian gothic.

In fact, given the traditional British reluctance to spend public money on public art, the architectural prejudices of those in government at Westminster, and especially of those who ran things in South Kensington, it seems extraordinary that an elaborate and expensive gothic design was ever chosen to honour the Prince Consort, let alone realised. Scott was the only architect invited to submit a design who was committed to the Gothic Revival. His victory was therefore a famous one, and the resulting Albert Memorial a tribute to his prestige, influence and pertinacity as well as to his resourceful talent as a designer. Drawings and a splendid model of his design were among the architectural exhibits selected to represent Britain at the Universal Exhibition in Paris in 1867. Here, the *Building News* noted, Scott had 'a stall all to himself, but he is a favoured individual, and a sort of royal personage, being the immortaliser of Prince Albert, and South Kensington dare not quite extinguish him'.[4]

A month after the death of Prince Albert, on 14 January 1862, a public meeting was held at the Mansion House to consider raising money to create a 'lasting Memorial to His Late Royal Highness'. It was convened by the Lord Mayor, William Cubitt, the brother of the builder of Osborne House. A committee was appointed to solicit donations, but the moving spirits of the project were Charles Grey, Albert's former secretary and now secretary to the Queen, and Sir Charles Phipps, Keeper of the Privy Purse.[5] It was agreed that any funds raised should be placed at the Queen's disposal. In February, to find a suitable design for a memorial, she appointed a four-man committee of which the most important and influential member was Sir Charles Eastlake. Associated with Prince Albert since the 1841 Commission on the decoration of the New Palace of Westminster, Eastlake was the first director of the National Gallery and President of the Royal Academy, as well as the uncle of the historian of the Gothic Revival, and he took a leading role in the artistic side of the Memorial until his death in 1865 – as Benedict Read's chapter traces.

The first proposal was for an obelisk combined with an equestrian statue of the Prince, to be raised in Hyde Park on the site of the 1851 Great Exhibition. It was resolved that such an obelisk must be taller than any surviving from antiquity, but the results of a search for a quarry to yield the required 150 foot granite monolith were not encouraging. The idea was then abandoned, to the apparent relief of Queen Victoria. The site for the proposed memorial was now moved westward to the edge of Kensington Gardens,[6] where it was to stand on the axis of the estate purchased by the 1851 Exhibition Commissioners. In May 1862, seven notable architects were asked to advise on the project: Thomas

Leverton Donaldson (1795–1885), William Tite (1798–1873), Sydney Smirke (1798–1877), James Pennethorne (1801–1871), Matthew Digby Wyatt (1820–1877), Philip Charles Hardwick (1820–1890), and George Gilbert Scott. All were established, academic architects, and a classical bias in their selection was clear. Other than Scott, no Gothic Revivalist who had already made a name for himself, such as William Butterfield (1814–1900) or George Edmund Street (1824–1881), had been approached. And Scott himself did not hesitate to point out that three of his fellow consultees had opposed his original gothic design for the Foreign Office. The group of seven reported in June and recommended that the Kensington Road be straightened, and – if funds permitted – that a public hall should be erected to the south of it in connection with the Memorial. As for the Memorial itself, 'if it cannot be a Monolith Obelisk; the forms which suggest themselves are, 1st, an Obelisk in several stones; 2ndly, a Column; 3rdly, a Gothic Cross; 4thly, a large group or groups of Sculpture; and 5thly, a Building: a Statue of the Prince Consort being in any of these cases the most prominent object'.[7] Having listed the options, the group rejected both the obelisk and the column, and, with Scott dissenting, were ambivalent about the notion of the 'Gothic Cross'.

In the following month, the seven architects were invited to submit proposals for the Memorial and its surroundings, together with a hall. The brief they were given was far from straightforward:

> *The design for the architectural portion of the Memorial should be regarded chiefly as a means of ensuring the most effective arrangement of the sculpture which is to complete it. The position, dimensions and material of the statues may be indicated without anticipating or interfering with the conceptions of the sculptors. It is conceived that this system of combined invention, so common among the architects and sculptors of antiquity when employed on temples and mausoleums, is no less desirable and practicable when the object is to provide an architectural base for groups of sculpture surmounted by the [Prince's] statue, which is required to be conspicuous.*[8]

In the event, Smirke and Tite declined to participate and were replaced by the two architect sons of Sir Charles Barry, Charles Barry jnr (1823–1900) and Edward Middleton Barry (1830–1880). The designs were ready early the following year and, in February 1863, were viewed by the Queen at Windsor Castle. She considered that 'there were only 2 that would at all do, and only *one* that is really applicable' – which was Hardwick's.[9] But the other was Scott's, which Victoria thought 'very handsome, but too much an imitation of W[alter]. Scott's' – of which more shortly – 'and too like a market cross'.[10] As the only gothicist selected, Gilbert Scott evidently felt isolated and insecure, but he had influential supporters, notably Victoria, Crown Princess of Prussia, the Queen's eldest and favourite daughter, whom she consulted. Nor was he reticent about pressing his own claims. After all, he was known to the Queen, who had already asked him to convert the Wolsey Chapel, in St George's at Windsor Castle, into an Albert Memorial Chapel.

Scott was concerned to emphasise the Christian character of gothic and to point out that the obelisk was very difficult to 'Christianize'.[11] Indeed, after the obelisk idea had been abandoned, he showed the Queen the drawing he had made 'for my own personal satisfaction and pleasure' to show how 'to render that idea consistent with that of a christian monument.

*This I effected by adding to its apex, as is believed to have been done by the
Egyptians, a capping of metal, that capping assuming the form of a large
and magnificent cross. The (so-called) 'Iona' cross is, in fact, the christian
version of the obelisk, and though the idea of a cross of metal on a colossal
obelisk is different from this in type, it is not so in idea. The faces of the
obelisk I proposed to cover with incised subjects illustrative of the life,
pursuits &c. of the Prince Consort. The obelisk was to have had a bold and
massive base, at the angles of which were to be placed four granite lions,
couchant, after the noble Egyptian model. The whole was to be raised on an
elevated platform, approached by steps from all sides.*[12]

The final design Scott submitted was very different from an obelisk,
however Christian. An entry in his notebook for 10 March 1864 describes it:

*My idea in designing it was, to erect a kind of ciborium to protect a statue
of the Prince; and its special characteristic was that the ciborium was
designed in some degree on the principles of the ancient shrines. These
shrines were models of imaginary buildings, such as had never in reality
been erected; and my idea was to realise one of these imaginary structures
with its precious metals, its inlaying, its enamels, etc., etc. This was an
idea so new, as to provoke much opposition.*[13]

It was also completely different from the schemes submitted by the other
competitors – although the courtiers and organisers were loath to admit they
were holding anything so vulgar as an architectural *competition*. Most were
designs inspired by Renaissance precedents, influenced by modern French and
German models and dominated by sculpture. And, in truth – at least to judge by
what drawings survive today – most of them were not very impressive.

The drawings submitted by Edward Middleton Barry, architect of the
Royal Opera House (1857–8) and later of the Charing Cross Station Hotel
(1864), are lost, and his design is now the most obscure.[14] However, the drawings
illustrating the designs offered by his elder brother, Charles Barry jnr, who
subsequently designed the new buildings for Dulwich College (1866–70) in
south London, survive. One was for an equestrian statue (76); the other
proposed a statue of the Prince placed within an open arched temple, or shrine,
surmounted by a cupola, north Italian Renaissance in style, richly decorated,
and embellished with sculpture (77). In the document submitted with his
drawings, he acknowledged the Certosa of Pavia as a model. The *Builder* was
very impressed, finding the style and character of the building to be 'unique in
this country; which he considers a point of great importance, in that it shall not
be liable to be mistaken for, or confounded with, any building in common use'.[15]

76. Charles Barry jnr,
Competition Design for the Albert Memorial, 1862
(British Architectural Library, R.I.B.A.).

77. Charles Barry jnr,
Competition Design for the Albert Memorial, 1862
(British Architectural Library, R.I.B.A.).

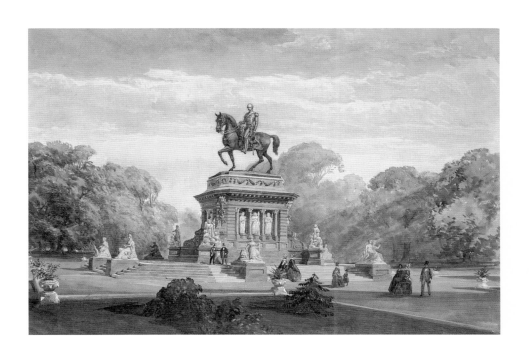

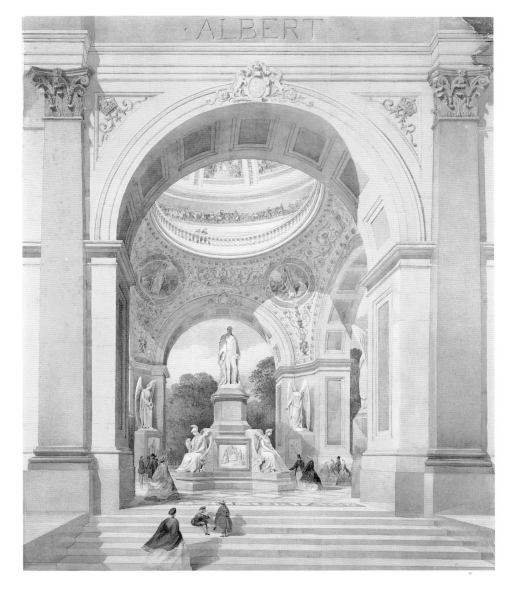

Donaldson, who – like Charles Barry – had been one of Scott's principal opponents over the Foreign Office, was Professor of Construction and Architecture at University College, London. Born in the previous century, he had been the first honorary secretary of the Institute of British Architects, and was rather more distinguished as a teacher than as a designer. Like Barry, he proposed to house a statue of the Prince in an open Corinthian temple, but one with a stepped roof inspired by reconstructions of the Tomb of Mausolus – the Mausoleum – at Halicarnassus. Flanking this shrine were to be pools and fountains while in front was a rather commonplace Corinthian hall with an octastyle portico (78).[16]

Rather more sophisticated was the scheme submitted by Hardwick, the son of the Philip Hardwick who had designed the famous Euston Arch back in 1835. Competent in both classic and gothic, he chose to use the Renaissance manner for a statue of the Prince raised high on a sculptured base, reached by a curved double staircase rising in front of a semi-circular screen wall, the whole attended by pools, fountains and elaborate landscaping contained by retaining walls (79). Queen Victoria may have been impressed, but the *Builder*, obviously finding the design insufficiently architectural, merely noted that 'Mr Hardwick contents himself with a design for a group of sculpture and a Pedestal'.[17]

Much better – in fact, the best of the (surviving) classical designs – was the one offered by that most competent government architect, James Pennethorne. Although he had used gothic at the Public Record Office (1850–1), he had no doubt that classical architecture was 'more suitable than the Mediaeval or Romanesque, to commemorate the pure and Classic tastes of the Prince Consort'.[18] His temple design was in an austere Greek style, with a close order of square columns reminiscent of the work of Schinkel and it was surmounted by a stepped pyramidal roof on the Halicarnassus model (80). This would have been combined with pools and fountains and a 'Central Hall of Science and Art'.

78. Thomas Leverton Donaldson, Competition Design for the Albert Memorial, 1862 (British Architectural Library, R.I.B.A.).

79. Philip Hardwick, Competition Design for the Albert Memorial, 1862 (British Architectural Library, R.I.B.A.).

80. James Pennethorne, Competition Design for the Albert Memorial, 1862 (Private Collection).

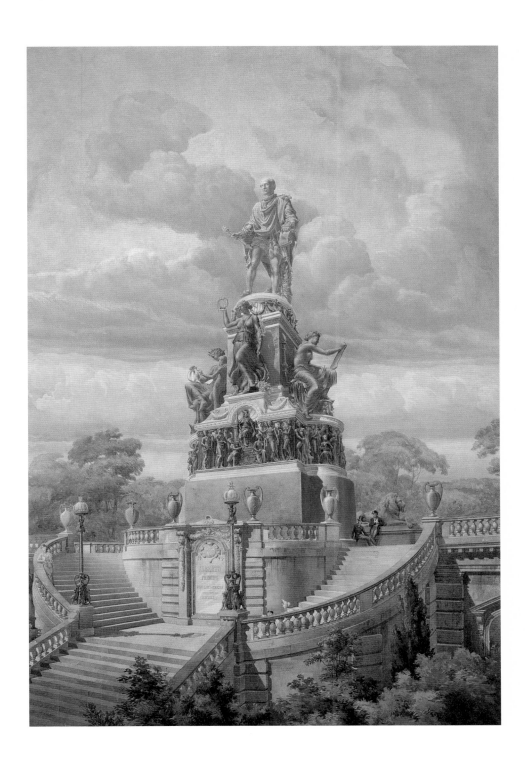

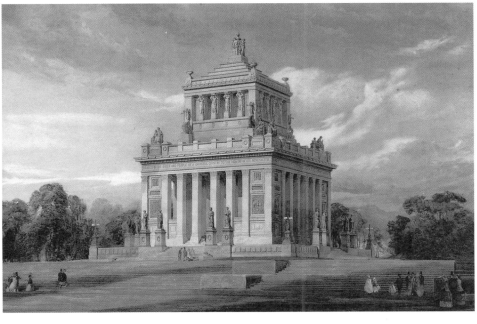

The drawings showing the proposals by Matthew Digby Wyatt, the first Slade Professor of Fine Arts at Cambridge, who had worked with Brunel at Paddington Station (1852–4) and was to collaborate with Scott in designing the India Office (1867), have also disappeared. This is particularly unfortunate as, to be on the safe side, Wyatt had submitted three schemes: one purely sculptural; one an open temple with four porticoes; and one a '"cross", so to speak, Italian Gothic in style, highly decorated',[19] which might well have been comparable with Scott's project.

Such were the design solutions from the architects invited by the Memorial Committee to consider the problem. But there are also some surviving unsolicited schemes for the Albert Memorial, which are particularly intriguing. One was made by the historian, orientalist and author of the *Illustrated Handbook of Architecture*, James Fergusson (1808–1886). His

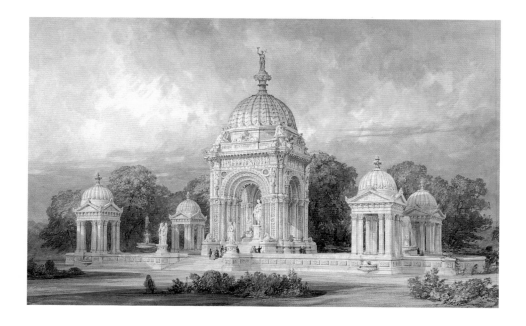

81. James Fergusson,
Design for the Albert Memorial, 1862
(Victoria and Albert Museum).

82. Alexander Thomson,
Design for the Albert Memorial, 1862
(original drawing at the Glasgow School of Art
as reproduced in the *Architectural Review*
in May 1904).

design (81), which was exhibited at the Royal Academy in 1864, proposed a domed central canopy flanked by domed pavilions, all in a Renaissance classical style, which verged towards the Romanesque.[20] Joseph Durham, the sculptor of the Memorial to the Exhibition of 1851, also made a design, as did at least one foreign architect. This was Jacob Ignaz Hittorff (1792–1867), the architect of the Gare du Nord in Paris (1861–5), who proposed a species of large *cinquecento* garden pavilion with an open apsidal niche containing a statue; his design dates from 1862 and was dedicated to Professor Donaldson, his 'ancien et devoué ami'.[21]

By far the most interesting as well as the most mysterious alternative design for the Albert Memorial was made by the Glasgow architect Alexander 'Greek' Thomson (1817–75), who later made a particularly incisive public attack on Scott's gothic designs for Glasgow University. Thomson's proposal (82), which is recorded only in one large and badly damaged perspective drawing, would seem to have been a development of the idea of an obelisk, a pure form which he considered 'an imperishable thought, a symbol of truth and justice'.[22] In Hyde Park, however, the obelisk was to be surmounted by an attenuated dome, and to rise from a cruciform podium on which continuous friezes of sculpture were broken by Thomson's favourite pylons, the whole raised up on a massive base of steps and guardian lions. 'For unspeakable, Semitic majesty', Alexander Stoddart has written, 'this design has no equal; in its ideal shadow, the executed design by Sir George Gilbert Scott appears a cuckoo clock'.[23]

Scott's design was certainly very different in conception (83). In his accompanying *Explanatory Remarks on the Designs Submitted for The Memorial to His Royal Highness the Prince Consort and the Proposed Hall of Science*, Scott satisfied himself that Albert had not been hostile to gothic, then set out his rationale:

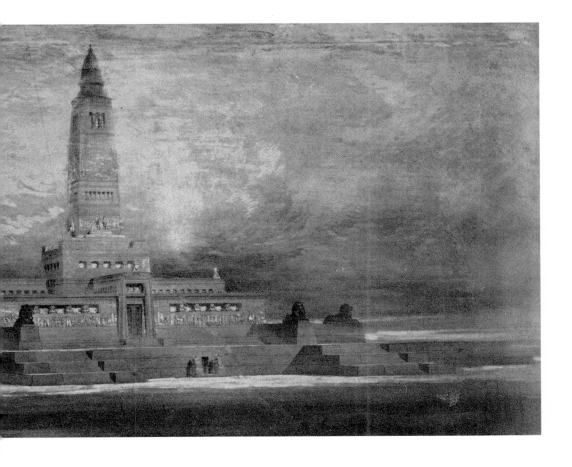

I have not hesitated to adopt in my design the style at once most congenial with my own feelings, and that of the most touching monuments ever erected in this country to a Royal Consort – the exquisite 'Eleanor Crosses'. I would further suggest that this style has a peculiar appropriateness in the present instance, from the circumstance that its perfect revival has been, up to the present time, the one great characteristic of the history of architecture during the reign of Queen Victoria.

The Eleanor Crosses (84) were only a starting point, however. Scott's design, as he explained, departed significantly from their basic form:

[T]he great purpose of an architectural structure, as part of the Memorial, is to protect and overshadow the Statue of the Prince. This idea is the key-note of my design; and my next leading idea has been to give to this over-shadowing structure the character of a vast shrine, *enriching it with all the arts by which the character of* preciousness *can be imparted to an architectural design, and by which it can be made to express the value attached to the object which it protects.*[24]

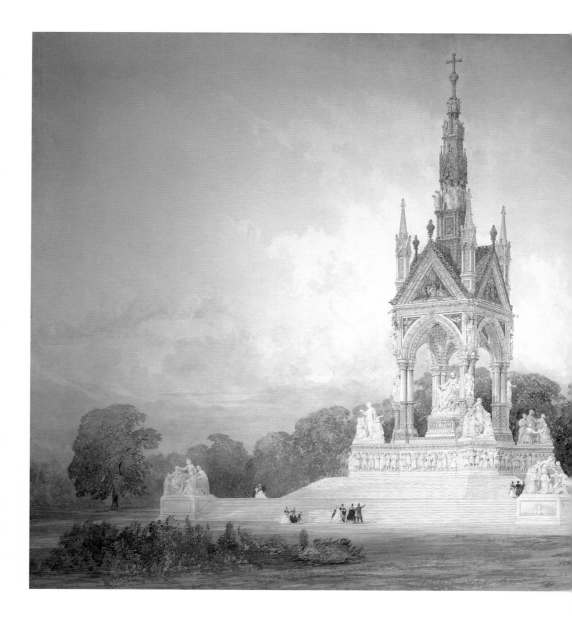

In May 1863 it was announced that the Queen had approved the recommendation of the Memorial Committee and selected 'a magnificent design by Mr Scott, for a Gothic cross', to which, apparently, 'her Majesty had already given the preference among the many beautiful designs submitted for her judgement'.[25] In its Report, dated 25 March, the Committee praised Hardwick's design for its 'general conception' and treatment of sculpture, and for being 'the only design according to which the Memorial itself, irrespective of the Hall, could be executed at a cost within the amount subscribed' – which by then was about £60,000. Nevertheless, Scott's design was preferred, if with some reservations:

> *while admitting the somewhat sepulchral character of what are called Gothic crosses ... we ... do not dwell on the objection, likely to be urged, of a certain want of originality in a monument of this kind, because we believe that the beauty of this example, if it could be carried into execution without sacrificing the richness and completeness of its effect, would abundantly compensate for any actual or imagined resemblance to other structures coming under the denomination of a Gothic Cross.*[26]

83. George Gilbert Scott,
Competition Design for the Albert Memorial,
1862 (Royal Collection).

84. Eleanor Cross, Geddington,
Northamptonshire, 1294.

Scott had also prepared several designs for the 'hall of science' associated with the Memorial. His favourite scheme was in a 'round-arch byzantine' style with a domed hall inspired by the church of Hagia Sophia which, he thought, if carried out, 'would … be scarcely excelled in beauty of form by any single and unbroken interior in existence'.[27] Scott also offered this in his 'pointed-arch style' as well as submitting designs for a smaller and cheaper rectangular hall in both Byzantine and gothic, but all remained on paper. There was now insufficient money available to proceed with the 'hall of science'. As John Physick describes in chapter nine, Henry Cole thought the idea too good to drop, and began promoting a joint-stock scheme to realise it. But Scott, not one of the circle of designers Cole favoured, was edged out of the project: while the architect was preoccupied with the Memorial on one side of the Kensington Road, Cole proceeded with his own plans on the other. In 1870 the Prince of Wales opened the great red-brick and terracotta gasometer of the Royal Albert Hall (249, 250), designed for Cole by those two compliant Royal Engineers, Francis Fowke (1823–1865) and Henry Scott (1822–1883).

Although, among the competitors, Gilbert Scott was in a minority of one in his fervent commitment to gothic, there would seem to have been a certain inevitability about his appointment to design the Memorial. On 28 March, to the annoyance of the Committee, the *Times* had leaked the news that 'a single monument is to be erected … It is to be what is called an Eleanor Cross, something similar to the Martyrs' Memorial in Oxford, or the monument erected to Sir Walter Scott, at Edinburgh … The whole structure is to be intrusted to Mr Gilbert Scott, so that we doubt not that full justice will be done to the utmost demands of Gothic architecture'.[28] In reviewing the designs the following week, the *Builder* discussed Scott's design first, commenting that his 'series of drawings … are magnificent in execution; and, as pictures, far surpass all the rest'. Then came a demurring note, 'We cannot, however, resist asking whether it is exactly what all wish who are striving for the honour of nineteenth-century advance, that wanting an Albert Memorial we should be forced to take an "Eleanor Cross". There is surely something humiliating in the admission.'[29] This doubtless provoked Scott into firing off one of his usual self-justifying letters, because, two weeks later, the journal printed the text of his *Explanatory Remarks* – a privilege granted to no other competitor.[30]

There was only one important dissenting voice to Scott's appointment: that of his 'arch-opponent' in the Foreign Office affair, the prime minister Lord Palmerston, who told the Queen that he did not like any of the designs and would much prefer 'an open Grecian temple' containing a statue of Albert.[31] But Palmerston, in many ways a man of the Regency, no longer reflected either popular or educated taste. Moreover, Victoria did not forget how often he had clashed with Albert over foreign affairs, and her indignation had been refuelled in 1862 when Palmerston had tried to reduce the Treasury's contribution to the Memorial project. This time Palmerston's architectural preferences were ignored, doubtless to Scott's gratification. The project was beyond the control of the government which, thought the *Builder*, should now take no further part. The 'Committee of Advice', having done its work, should be dissolved as 'the Memorial originated with the popular voice, and we would retain for it the popular character … The English People began the good work: let the English people finish it'.[32] This must have been music to the ears of Scott, who always knew his audience. After all, in explaining his own role in the Gothic Revival, Scott had remarked that, 'amongst Anglican architects, Carpenter and

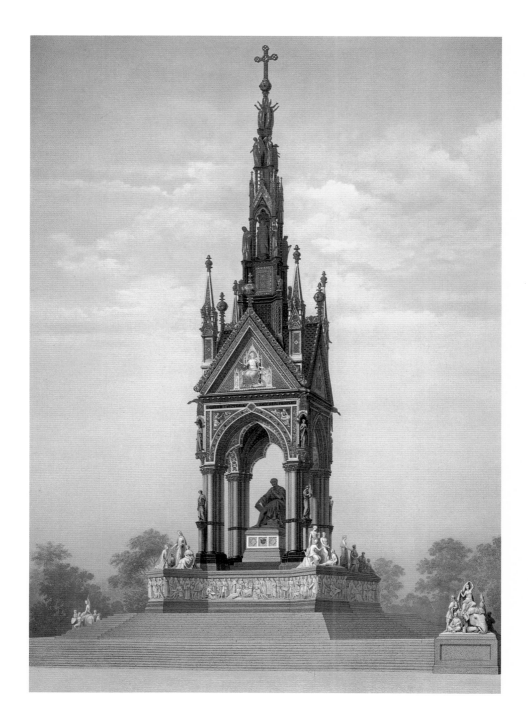

85. The Albert Memorial, London,
chromolithograph from *The National
Memorial to his Royal Highness
The Prince Consort*, 1873
(Kensington Central Library).

Butterfield were the apostles of the high church school – I, of the multitude'.[33]

When he received the commission to proceed with his design for the Albert Memorial, George Gilbert Scott was fifty-one years old and at the summit of an astonishingly successful career that would earn him burial in Westminster Abbey in 1878. One of his obituarists, the architect Edward William Godwin, hesitated 'to nominate Scott's works as those of a genius', but found Scott's strengths – albeit ambivalently – elsewhere:

If he had not the great gift he however possessed others which in these days are perhaps even more conducive to success. He was indefatigable in business and a fervent worker. No chance was ever missed, no opportunity neglected, and thus he obtained a somewhat unenviable notoriety among less energetic or less industrious architects, of being over anxious to obtain commissions.[34]

Even so, Godwin paid tribute to the sweetness of Scott's character, noting that 'he was one of those who spoke well of you behind your back, and, above all, one who, though he desired to be just in his estimate of men, could look kindly upon their shortcomings'. Others agreed. A. J. B. Beresford-Hope, champion of ecclesiological gothic and leader of the High Church party in the Commons, recalled 'how truly modest he was. If anything, he carried that out to a fault. He was anxious; he was often hurt in his feelings by things which he could afford to laugh at … with all his zeal, all his earnestness, and all his conviction, he never bore malice'.[35]

Scott had been born in 1811 at Gawcott in rural Buckinghamshire, the son and grandson of Anglican clergymen. He had been an articled pupil of James Edmeston (1791–1867), a dim London architect who was rather more successful as a hymn-writer and was the author of *Lead us, Heavenly Father, lead us*. Scott had then worked for the contractors Grissell and Peto on the Hungerford Market (1833) and assisted Henry Roberts – later associated with Prince Albert's artisan housing interests – on the Fishmongers' Hall (1831–4) before setting up in practice in 1835. He first achieved success in partnership with William Bonython Moffatt (1812–1887) in the ruthless business of securing commissions for the new Union workhouses being built under the Poor Law Amendment Act of 1834. Most of these were severely utilitarian in character. But Scott had not forgotten his childhood enthusiasm for sketching old churches and now began to design new ones. Indeed, he rose to fame and fortune on the back of the wave of church building resulting from the great revival of the Church of England initiated by the Oxford Movement. But of these first crude essays he was later ashamed, having been 'awakened to a truer sense of the dignity of the subject'.[36]

This 'awakening', Scott recalled, came from his acquaintance with the polemics of the Cambridge Camden Society, whose founders he contrived to meet, and with the writings of Pugin. He was thereby introduced both to ecclesiological gothic, with its emphasis on liturgical correctness, and to the 'True Principles' of Pointed or Christian Architecture. In his *Recollections*, Scott presented this as a dramatic Damascene conversion. 'Pugin's articles excited me almost to fury', he remembered, 'and I suddenly found myself like a person awakened from a long feverish dream, which had rendered him unconscious of what was going on about him'. Later, he recalled, 'I was awakened from my slumbers by the thunder of Pugin's writings … I was from that moment a new man. Old things (in my practice) had passed away, and,

behold, all things had become new, or rather modernism had passed away from me and every aspiration of my heart had become mediaeval … I cared for nothing as regarded my art but the revival of gothic architecture.'[37] Scott would give Pugin a prominent place on John Birnie Philip's podium frieze of architects on the Memorial (155), and when Queen Victoria insisted that he too should appear there, he placed himself with characteristic modesty, as he explained to General Grey:

> *I have … chosen an unobtrusive position behind the figure of Pugin to whom I desired to do all honour as the head of the revival of mediaeval architecture and in many respects the greatest genius in architectural art which our age has produced … He was our leader and our most able pioneer in every branch of architectural work and decorative art and had it not been for his labour it would have been impossible to have produced such a work as this memorial: not to mention that his writings have been the one great guide to the return to truthful, generous and real principles in our art, which up to his time had been almost forgotten. My ambition, then, would be to appear as his disciple, and to do him all the honour he deserves and which there is a strong tendency to deny him.*[38]

The practical consequences of Scott's awakening were soon evident. In 1840, he had demonstrated his skill in using a scholarly gothic with the winning design for that 'Gothic Cross' in Oxford, the *Martyrs' Memorial* (86). Two years later he secured the approval of the Cambridge Camden Society with his design for rebuilding the church of St Giles, Camberwell, London. In 1845 Scott won the international competition for rebuilding the Nikolaikirche in Hamburg, his design carried to completion (87) after he managed to defeat the German architect Gottfried Semper (1803–1873) with the assistance of a local faction intent on reviving gothic within Germany.[39] At the time, there was probably no other architect in Europe – not even Pugin – who could have produced so competent and convincing an essay in the medieval style. From this triumph, Scott went on to build up a large ecclesiastical practice back home, and was

86. George Gilbert Scott, *The Martyrs' Memorial*, Oxford, 1841–3; lithograph by Louis Haghe, 1840.

87. George Gilbert Scott, Nikolaikirche, Hamburg, 1845–63.

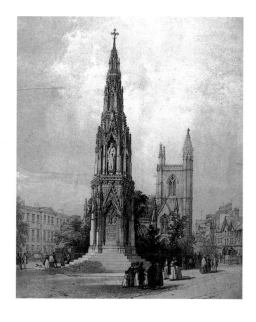

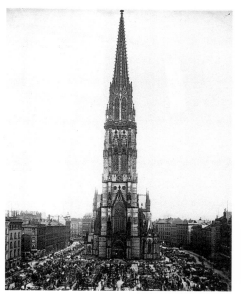

responsible for such grand churches as St George's, Doncaster (from 1854); All Saints', Sherbourne, Warwickshire (1862–4); St Mary Abbots in Kensington (1869–72); and St Mary's Episcopal Cathedral in Edinburgh (1874–9).

All Souls', Haley Hill, Halifax (1856–9) was, Scott thought, 'on the whole, my best church' (88).[40] It is certainly representative, with its asymmetrically placed tower and spire, rich Decorated gothic, sumptuously carved detail, and figure sculpture inside and out, together with fine stained glass by the firm of Clayton and Bell, whose formation Scott was instrumental in encouraging. But his church work was never as innovative as Butterfield's or as strongly influenced by Continental gothic as Street's. Later Scott would complain of 'Ruskinism, such as would make Ruskin's very hair stand upon end; Butterfieldism gone mad with its endless stripings of red and black bricks'.[41] He was content to accept the orthodoxy of an English Geometrical Decorated gothic, or 'Middle Pointed', as 'our agreed *point de départ*' or 'nucleus of development', although by the later 1850s he was introducing French details into his work.[42] After his death, one obituarist observed that Scott's architecture had 'the merit of being a thoroughly national revival of the Gothic style. In sentiment and in detail it neither offended by its violence nor sacrificed English to modern sympathies. If not remarkable for its originality, or its energy, it was always pleasing, moderate, and sensible. Indeed it had, in common with its author, a geniality that was eminently impressed upon everything he did'.[43]

Scott appreciated the importance of writing to keep his name before the public, and in 1857 published *Remarks on Secular and Domestic Architecture, Present and Future*. He followed Pugin in maintaining that gothic was a universal style, and showed more readiness for innovation in his secular work than in his churches. Scott argued that 'our Gothic Renaissance' need not be constrained by the use of the pointed arch and that it could encompass modern improvements like plate-glass and cast-iron; indeed, he insisted, 'these iron constructions are, if anything, more suited to Gothic than classic architecture'.[44] And, in considering the architecture of the future, Scott addressed that dilemma of his age, acute historical consciousness, which meant that, in contrast to all former periods, 'we are acquainted with the history of art … This is amazingly interesting to us as a matter of amusement and erudition, but I fear is a hindrance rather than a help to us as artists'.[45] Perhaps his Albert Memorial design would demonstrate this.

The writing of *Remarks on Secular and Domestic Architecture* coincided with the competition for new government offices in Whitehall, which enabled Scott to demonstrate the utility of his theories in the designs he submitted (89). But although he managed deviously to secure the commission, the story ended in defeat, compromise and the undermining of his status as a leader in the gothic crusade. Scott presented his own side of this absurd saga in his *Recollections*. He had not won any of the three original competitions but had managed, during the short-lived Conservative government under Lord Derby, to get the job for the Foreign Office. But when, in 1859, 'my arch-opponent became once more autocrat of England', Palmerston insisted that Scott produced a classical design. He tried a compromise design in a sort of Byzantine style, but this was dismissed by the prime minister as 'neither one thing nor t'other — a regular mongrel affair', so that there was nothing for it but resignation or to do as he was told.[46] Which he did: Scott's Italianate design for the Foreign Office was accepted by parliament in 1861.

88. George Gilbert Scott, All Souls', Haley Hill, Halifax, Yorkshire, 1856–9.

89. George Gilbert Scott, final gothic design for the Foreign Office, London, perspective view, 1859 (British Architectural Library, R.I.B.A.).

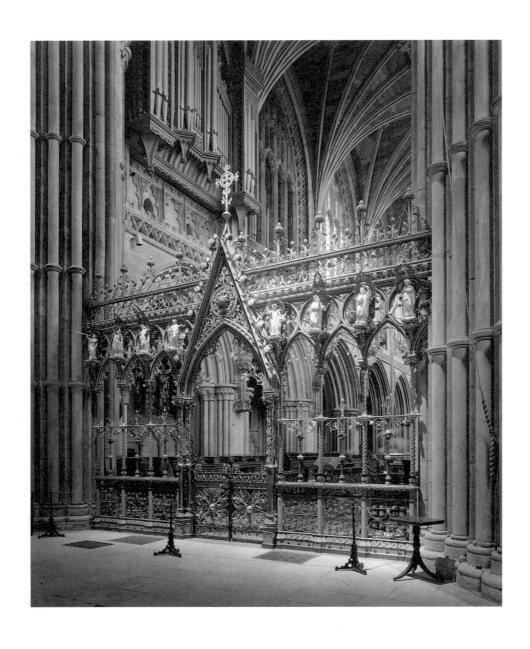

90. George Gilbert Scott, Francis Skidmore
and John Birnie Philip, Choir Screen,
Lichfield Cathedral, 1859–63.

At this time, Scott was running what must have been the largest architectural office in Britain, if not in Europe. When Thomas Graham Jackson (1835–1924) was a pupil in 1858–61, there was a staff of twenty-seven, including pupils, salaried assistants and clerks, in the Georgian house in Spring Gardens, Charing Cross. 'Of Scott we saw but little', Jackson recalled,

> *He was up to the eyes in engagements and it was hard to get him to look at our work. I have seen three or four men with drawings awaiting correction or approval grouped around his door. The door flew open and out he came: 'No time today!'; the cab was at the door and he was whirled away to some cathedral where he would spend a couple of hours and then fly off to some other great work at the other end of the kingdom.*[47]

This incessant activity accounts for such apocryphal stories as Scott telegraphing Spring Gardens from a provincial railway station to ask, 'I am in Coventry. Why?'

Cathedrals were an important part of Scott's practice. Like other church architects, Scott was inevitably drawn in to the restoration – often the rebuilding – of old churches, both to deal with the consequences of neglect and to reorganise them to meet contemporary liturgical requirements. His first important restoration was that of St Mary's, Stafford, begun in 1842, and eventually he built up a huge practice in this field, becoming the best known of restoration architects. Scott's first cathedral, Ely, was acquired in 1847, and eventually he became involved with almost every large mediaeval church in England and Wales. In 1849 he became surveyor to Westminster Abbey, 'a great and lasting source of delight',[48] where his principal achievement was the rescuing of the Chapter House (1864–5) from degradation and ruin. Scott had a profound knowledge of medieval architecture, for which he developed an intuitive understanding and, in 1861, published his *Gleanings from Westminster Abbey*.[49]

Scott's metalwork and furniture were conspicuously good, and much of his cathedral work consisted of designing new furnishings in response to the demands of modern Anglican choral worship. Often he designed openwork screens as a compromise between the need for a liturgical division and the fashion for an uninterrupted vista to the altar. Sometimes these were of timber, but at Lichfield (1859–63; 90), Hereford (1862–3; 204), Worcester (1864–5), and Salisbury (1869–70) Scott designed screens of metal combined with other materials which were made by Francis Skidmore, the art-metalworker based in Coventry whose career is discussed by Peter Howell in chapter seven. These screens were among Scott's finest and most inventive creations. However, Scott was sometimes anxious about the final result. At Hereford, for example, he complained that Skidmore had 'followed my design, but somewhat aberrantly. It is a fine work, but too loud and self-asserting for an English church'.[50] But when this composition of wrought and cast iron, copper and brass, mosaic, semi-precious stones and timber, all coloured and gilded, was exhibited at the 1862 International Exhibition in London, the *Illustrated London News* pronounced it 'the most noble work of modern times', claiming it 'stands forth to the world as a monument to the surpassing skill of our land and our age'.[51] This imaginative use of metalwork and other techniques would seem to have given Scott the cue for his proposal that the Albert Memorial should be 'the realisation in an actual edifice, of the architectural designs furnished by the metalwork shrines of the middle ages'.[52]

Scott described his intentions in designing the Memorial both in his *Explanatory Remarks* and subsequently in the *Recollections*:

> *Those exquisite productions of the goldsmith and the jeweller profess in nearly every instance to be models of architectural structures, yet no such structures exist, nor, so far as we know, ever did exist ... They are architecture as elaborated by the mind and the hand of the jeweller; an exquisite phantasy realized only to the small scale of a model. My notion, whether good or bad, was for once to realize this jeweller's architecture in a structure of full size, and this has furnished the key-note of my design and of its execution.*[53]

As examples of the ancient metalwork shrines, which inspired the treatment of the gabled roof and the flèche on the Memorial, 'having the same beaten metal-work, the same filigree, the same plaques of enamel, the same jewelling, the same figure-work in metal', Scott cited those of 'the Three Kings at Cologne (91), of our Lady at Aix-la-Chapelle, of St Elizabeth at Marburg (206), of St Taurin at Evreux', and 'many other well-known specimens of the ancient jeweller's craft'.[54] Elsewhere he referred to the 'extremely rich tabernacles'[55] on the retabulum in Westminster Abbey. And he recognised that, 'for the perfect carrying out of this idea I am indebted to the skill of Mr Skidmore, the only man living, as I believe, who was capable of effecting it'.[56]

As for the open canopied form of his Gothic Cross, Scott acknowledged that it 'may be more fitly compared to the magnificent "Ciboria" which overshadow the Altars of the ancient Basilicas ... I had not at first aimed at imitating them, but in thinking out my design, it naturally grew into a close resemblance of them from the similarity of the conditions, and the propriety of adopting the same type of monumental structure is sufficiently proved, by its use in the great Scaliger Monument in Verona'[57] (92).

91. Nikolaus of Verdun, Shrine of the Three Kings, Cologne Cathedral, *c.* 1185–1200.

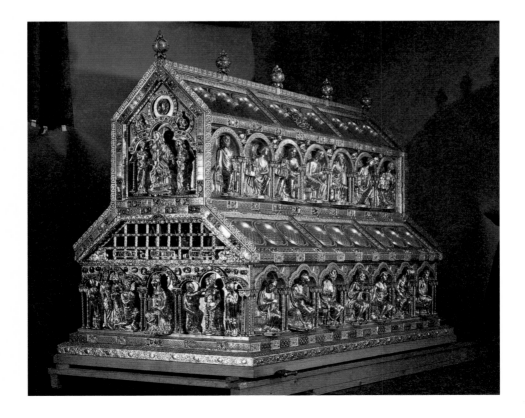

92. John Ruskin, *Study of the North Gable
of the Tomb of Can Mastino II, Verona*, 1852
(Ashmolean Museum).

There were many examples that Scott might have studied. In May 1863, the artist Richard Redgrave (1804–1888) showed General Grey a drawing in the South Kensington Museum of a shrine in a Florentine church which Grey thought so similar to the approved design, apart from the flèche, that 'it certainly deprives Scott of all claim to originality'.[58] This was probably Pieraccini's drawing of the shrine of the Madonna by Andrea Orcagna (*c.*1308–68) in Or San Michele (93); Francis Fowke, the future designer of the Albert Hall, also noted the similarity when he visited Italy later in 1863.[59] More recently, Elisabeth Darby and Nicola Smith have found a much closer precedent in the thirteenth-century ciborium by Arnolfo di Cambio (1232–1301) in San Paolo fuori le Mura, Rome (94), which not only has pointed rather than round arches supporting triangular pediments but also has corner pinnacles and statues in niches at the angles.[60] 'The truth is that the Cross is an Italian design, imported whole into Hyde Park', complained Francis Turner Palgrave (1824–1897), the compiler of the *Golden Treasury*. That may be true, but it is not necessary to concur with his further criticism, that 'it wants that first and last thing in architecture, appropriateness. It fails, not because so much is copied from older sources – for in all architecture copying holds a great place – but because it is *unimaginative* copying, and hence neither fused into harmony with itself, nor appropriate to its situation.'[61]

It is possible, as Nicola Smith has suggested, that Scott wished to underplay these Italian precedents because a ciborium over an altar was associated with Roman Catholicism and had therefore provoked controversy when introduced into Anglo-Catholic churches.[62] But while Scott's idea of realising a metalwork shrine full-size may have been 'so new, as to provoke much opposition', there was certainly nothing novel about his revival of the gothic canopy form. This type of structure had been adopted for the well-publicised memorials to Lord George Bentinck (1849) in Mansfield (95), by Thomas Chambers Hine (1813–1899), and to Henry Handley M.P. (1850), in Sleaford, Lincolnshire, designed by William Boyle. Both men were Protectionist politicians, and the association may have caused the form to fall out of favour following the Repeal of the Corn Laws.[63] Some decades earlier, Karl Friedrich Schinkel had portrayed canopied Gothic monuments in his stage sets; these Scott surely cannot have known, although he might possibly have seen the published design for Schinkel's Monument to the Liberation (1818–21) on the Kreuzberg in Berlin (96), which is a sort of Eleanor Cross in cast-iron.[64]

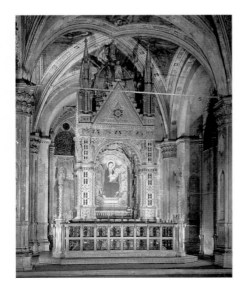
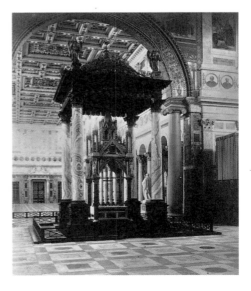

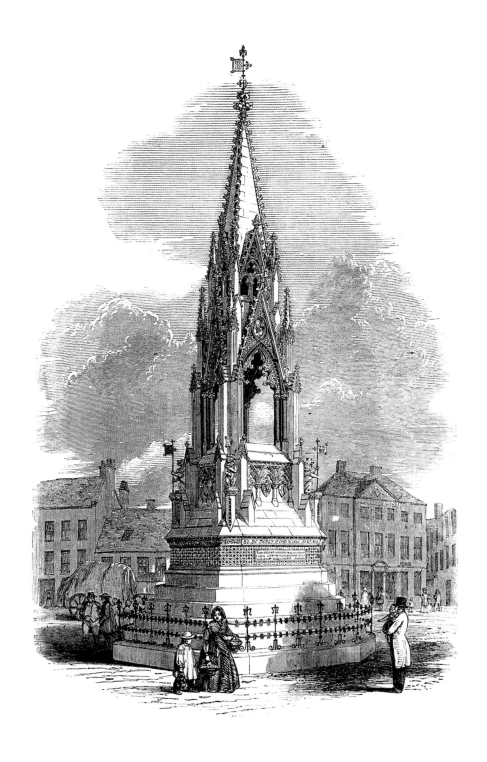

95. Thomas Chambers Hine,
Memorial to Lord George Bentinck,
Mansfield, Nottinghamshire, 1850,
Illustrated London News, 19 January 1850.

93. Andrea Orcagna, Shrine of the Madonna,
Or San Michele, Florence, *c.* 1340.

94. Arnolfo di Cambio, Ciborium,
San Paolo fuori le Mura, Rome, 1285.

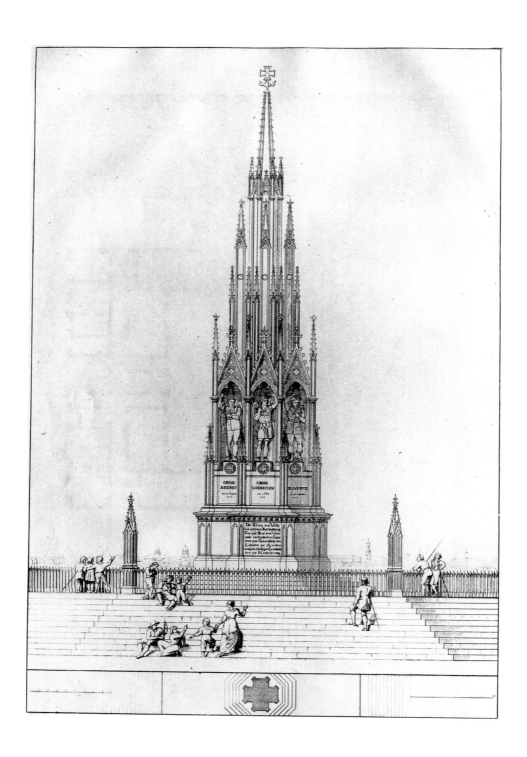

96. Karl Friedrich Schinkel, *Monument to the Liberation*,
Berlin-Kreuzberg (1818–21); engraving by J. M. Mauch after Schinkel,
published in the *Sammlung architektonischer Entwürfe*, 1823.

97. George Meikle Kemp, *Sir Walter Scott Monument*, Edinburgh, 1840–6;
the statue of Scott by John Steell.

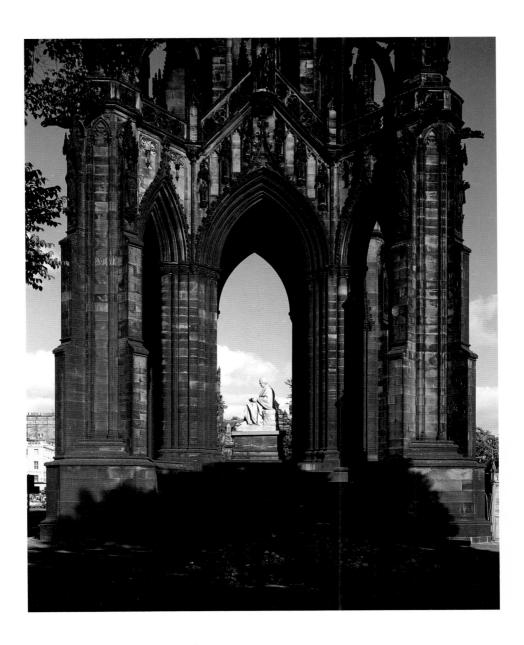

Above all, however, there was the prominent monument to Sir Walter Scott in Edinburgh, completed in 1844 (97). As noted earlier, even Queen Victoria had immediately spotted the resemblance between Scott's design and the tall, crocketed and pinnacled stone flèche designed by George Meikle Kemp (1795–1844) to shelter the marble statue of the novelist by John Steell (1804–1891). As the proposal to raise a gothic monument in the Athens of the North provoked controversy, the leading antiquary, John Britton (1771–1857), had sent a somewhat pompous 'Address' to the building committee in 1833 which anticipated some of Gilbert Scott's later arguments:

> *in recommending a cenotaph for Sir Walter Scott at Edinburgh in the form*
> *and general character of a Christian cross, I am influenced by the*
> *conviction that a design of this kind is more analogous to the present age –*
> *to the partialities of the deceased, to the pervading character of his writings*
> *– than any other species of architectural composition. Neither Egyptian,*
> *Grecian, nor Roman could be made to impart that locality and nationality*
> *of sentiment which belongs to the architecture of the middle ages. This*
> *brings with it and belongs to the chivalric and romantic annals of Great*
> *Britain. It blends the military and monastic; it unites the civil and*
> *ecclesiastical emblems of bygone days.*[65]

In his *Recollections*, Scott claimed that he made his design for the Albert Memorial '*con amore*, and before I was invited to compete for it. Though I say *con amore*, in one sense it was the reverse, for I well remember how long and painful was the effort before I struck out an idea which satisfied my mind ... I remember vividly ... the sudden relief when, after a long series of failures, I hit upon what I thought the right idea'.[66] It has often been suggested that this relief actually came from opening the issue of the *Builder* for 8 November 1862 and seeing the plate of the Albert Memorial that Thomas Worthington (1826–1909) had designed for Manchester. The monument, unveiled in 1867, consists of a gothic canopy enclosing a statue of the Prince Consort by Matthew Noble (1817–1876), surmounted by a spire flanked by four pinnacles (98). In his study of Worthington, Anthony J. Pass quotes the architect's recollection that the Bishop of Manchester advised him to have an engraving of his design published 'as the competition for the Great National Memorial to be erected in Hyde Park was coming on, and it was not impossible that some similar treatment might be adopted by some competitors, though this would, of course, be on a greatly larger scale. The Memorial in Hyde Park by Gilbert Scott afterwards was really a similar treatment. So his Lordship's surmises were justified'.[67]

Whether Scott was influenced by Worthington's project in particular cannot, of course, be proved, and the chronology suggested in his own recollections of the process rules out any connection. Besides, Scott's design for an Albert Memorial differs from Worthington's in several important respects. The conception of the carved frieze on the podium is quite different; Worthington's canopy is carried on massive corner piers, not clustered columns; the canopy arches are not cusped; and they are contained within steeply pointed gables taken from those at the church of Santa Maria della Spina at Pisa. Scott's arches, in contrast, support discrete triangular gables, a feature that makes his source of inspiration more likely to have been in Rome than Manchester. Furthermore, Worthington's shrine has none of the jewel-like character that was achieved by Scott, and that makes the Hyde Park Memorial so unusual and distinctive.

The Albert Memorial is the most conspicuous product of the mid-Victorian enthusiasm for sculptural richness and polychromy achieved by the use of differently coloured and textured materials. In it, granites, marbles, and other stones were combined with bronze, copper, and iron, whether coloured, electro-plated or gilded, along with vitreous enamel, glass mosaic and much more. Scott's *Explanatory Remarks* set out his intentions:

> *It is my object to unite in the Memorial all, or as many as possible, of those decorative arts which the Prince Consort so anxiously fostered. Thus, besides sculpture, which is the primary form in which monumental art must express itself, and in addition to actual architecture and architectural carving, which must ever be its closest ally, I have largely availed myself of repoussé work in metal; of enamel; of inlaying in rich polished stones, such as crystals, cornelians, granite, porphyry, &c.; of pictures and other decorations in mosaic-work, &c.; so as to render the Memorial rich with all the arts which can be united with architecture.*

98. Thomas Worthington,
The Albert Memorial, Manchester, 1862–7;
the statue of Albert by Matthew Noble.

'By thus introducing all the arts subsidiary to architecture', Scott continued, 'we should not only be rendering the Memorial replete with beauty, and giving it that air of preciousness so essential to its object, but should be at once displaying and calling into exercise arts which the Prince Consort so earnestly desired to encourage'.[68]

Whether all the different aspects of the Memorial as realised are united in harmony is, perhaps, debatable. While the character of the shrine-form and the detail of the upper parts is certainly gothic, the same cannot really be said of the mosaic panels by John Clayton, the character of which is discussed by Teresa Sladen in chapter eight. And the principal sculptures are certainly not gothic – not the marble groups, nor Foley's figure of the Prince, nor the magnificent podium friezes by Scott's sculptors, Henry Hugh Armstead and John Birnie Philip (Benedict Read debates the consequences of this stylistic mixing in chapter five). Scott later confessed that 'I think I ought to have exercised a stronger influence on the sculptors than I have done'.[69] But his understanding of collaboration was different from the kind of integrated design and production later associated with William Morris and the Arts and Crafts Movement. Even so, in 1891 the architect and writer, Robert Kerr (1823–1904), could claim that the Memorial's 'peculiarities of execution serve in a certain measure to emphasise the idea of strait-laced academicalism being undermined by the more popular principle of the day....

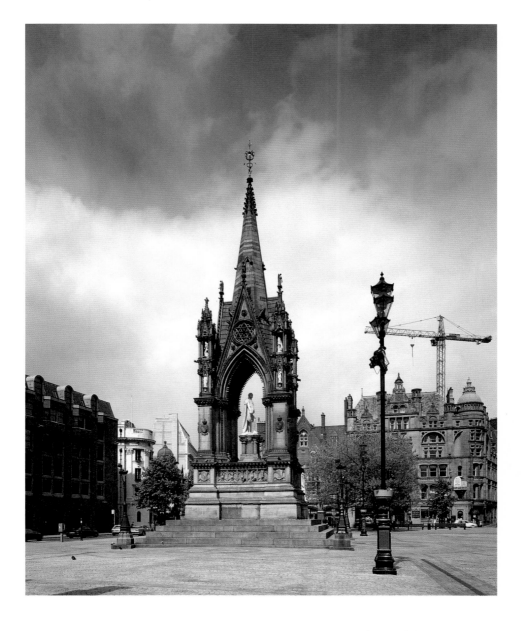

Scott's aim was to utilise the architect as a reality to the utmost, in the capacity of a trained general officer of artizans, the chief of all the workmen. His continual cry, it is true, was for better artizans, not for better architects; but these ideal workers were always to work under an ideal architect as chief-worker – one who should direct them, not as a mere commercial agent, but as an expert universal artist rejoicing alike in all their work. [70]

This seems true. As subsequent chapters demonstrate, it is clear that Scott was not only responsible for the overall conception of the Memorial, both architecturally and iconographically, but that he also managed to retain a remarkable degree of control over the detailed execution of his designs. As a result, we can see the Albert Memorial as surely the greatest example of that Romantic ideal, the *gesammtkunstwerk* – total art work – of the Victorian age in Britain. It realised the highest aspirations of the Gothic Revival by uniting the talents of the architect, the sculptor, the stone-carver, the mosaicist and the metalworker. Full of symbolism and allegory, and rooted in a particular understanding of history, it was also designed to be read in detail for its significance fully to be comprehended.

Work began on realising Scott's conception on 6 May 1864, and the Memorial which was unveiled – without Foley's figure – in 1872 differed only in one significant respect from the design selected nine years earlier. This was the height of the metal flèche: in June 1863, worn down by constant sniping and cajoling from his principal enemy in South Kensington, Henry Cole, Scott agreed to increase the elevation of the monument. Later, he regretted this, writing in 1872 that 'the greatest fault in the design, in my own opinion, is that

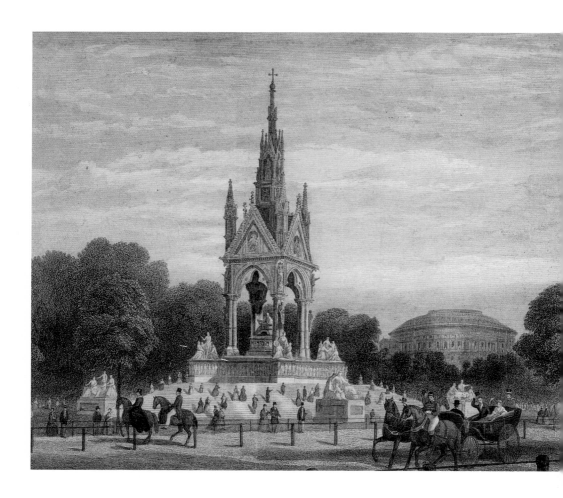

the flèche is too high'.[71] He made this admission in a detailed defence of certain aspects of the design which had already caused comment. There had been complaints that the supports of the flèche were invisible; that the clustered columns holding the canopy did not look strong enough to do their work, although Scott had beefed them up at an early stage; that much of the height of the flèche was lost, and its outline broken; that the podium, being of white marble, weakened the visual effect; and that the great mass of steps diminished the scale of the superstructure.

Unfortunately, like successful architects before him and more especially since, Scott was morbidly sensitive to the slightest hint of disapproval in the press. He was certain that he would have 'to bear the brunt of criticisms upon this work of a character peculiar, as I fancy, to this country. I mean criticism premeditated and predetermined wholly irrespective of the merits of the case'. In the original manuscript of his *Recollections*, in a passage written on 11 July 1872, Scott went further:

> *I have some years since had one great attack made on me of this kind. I believe that Mr Beresford Hope though nominally friendly, is only too glad to promote these attacks and it was, I dare say, he who set upon me one of the most vindictive and unscrupulous writers of the age. I believe I had offended that man a few years before – by perfect accident and that he has always remembered it against me. I have last week been the subject of an equally vicious attack in another print and I am told that I have to expect another probably this week in the* Saturday Review.
> *[in the margin: 'It did not appear']* I must trust in God and take Courage.[72]

99. Thomas Abiel Prior,
The Albert Memorial and Hyde Park,
engraving of 1869
after a drawing by G. H. Andrews
(Kensington Central Library).

Scott then reproduced in full a letter from Austen Layard, who had taken Eastlake's place on the Advisory Committee. Layard assured him that 'those who have had anything to do with the Press know from whence these criticisms come, and can trace the motives for them. In this case they appear to represent the opinions of one prejudiced and unfriendly man, opposed to the judgement and taste of the million'.

Just who he supposed this vindictive and powerful manipulator of opinion might have been Layard did not reveal, but what seems to have caused offence was an anonymous article, 'The State of English Architecture', published in the *Quarterly Review* for April 1872. Scott might have suspected this had been written by his earlier critic, F. T. Palgrave, or by the anonymous author of the 'equally vicious attack' on the Albert Memorial published in the *Pall Mall Gazette* for 5 July 1872. This was Sidney Colvin (1845–1927), who became Slade Professor of Fine Art at Cambridge the following year, whose article described the Memorial as 'organic nullity disguised beneath superficial exuberance'.[73] But Scott clearly did not know who his enemy was: his former pupil, T. G. Jackson, later recalled that 'for some reason or other I fancied he had taken a dislike to me; why I could not imagine, till I was told he was under the impression that I was the author of a very slashing article in the *Quarterly Review* which made havoc of him and the school to which he belonged'.[74] In fact, the culprit was the architect-turned-critic, John T. Emmett, who, while ridiculing the 'eminent architect', did not once mention Scott's name or attempt to analyse what he dismissed as 'the Hyde Park trophy'. But there could have been no doubt of the identity of his target when he complained that 'architects are so little like "chief builders", that they almost cease to be builders at all; and there are ludicrous but authenticated tales of their ignorance of their own nominal works'.[75]

The design of so important and so public a monument had naturally attracted comment both favourable and hostile from the beginning. Of particular concern to Scott had been the criticisms – both direct and indirect – made by the egregious but influential Henry Cole, who, in 1863, published and privately circulated his *Memorandum on Crosses and Shrines in England* – described by Stephen Bayley as a 'calculated exercise in pedantry' intended to demonstrate that Scott's design had no respectable precedent.[76] But the first adverse criticisms of the gothic shrine idea in the press seem to have been the essays by Palgrave published in 1863, 'The Albert Cross and English Monumental Sculpture'. Palgrave sharpened his attack when the essays were republished three years later:

> *Without entering here on the larger question of Mr Gilbert Scott's rank among our Gothic architects, beyond expressing the opinion (resting upon examination of his works) that his style wants originality and imagination, it is indisputable that he has but little practice in that species of ornamental designing of which the Cross will be one of the most elaborate examples ever yet attempted.*[77]

Worse was to come, and not just from Colvin and Emmett. There were criticisms in the *Building News* and the *Athenaeum*, and in 1872 it was reported that the great French writer and architect, Eugène-Emmanuel Viollet-le-Duc (1814–1879) was unhappy about what he saw as a lack of unity in the Memorial's conception:

This monument, which has the form of an immense baldaquin, recalls the Italian Gothic style. It is surmounted by a sharp spire, and four decorated gables ornamented with mosaics. In a word, everything so far recalls the Middle Ages. But on the four angles of the steps forming the basement of the monument are placed groups in white marble, conceived in the antique style, that is to say, composed of allegorical and nude figures. I say nothing of the proportion of the figures, which is in complete discord with the rest of the monument, but I must insist on the deplorable effects caused by these discrepancies. In all modern English architecture it is the same: there is a want of unity, and ... of harmony. [79]

Of course, Viollet's criticisms reflect the perspective from the other side of the English Channel, where attitudes to architecture and design were very different, but they also indicate a larger shift in opinion, evident in the *Athenaeum*'s view in 1873 that 'the thing, as a memorial of the Prince is at once preposterous and false.

The disgust of educated men has long ago given place to a feeling of cold contempt. The monument, as it is, represents, not unfairly, the hopes and aspirations excited by the Exhibition of 1851. Call the structure the Cross of Lost Hopes, or the Optimist's Memorial, and we shall in some degree comprehend the intentions of the sculptors. [79]

As this assault suggests, the real trouble was that times had changed, both for architecture and for the Memorial's architect. When the Albert Memorial was first unveiled and Scott was knighted, he was sixty-three. He had been seriously ill and, earlier that year, his 'dearest Carry', the long-suffering wife who had supported her workaholic husband so uncomplainingly, had died, leaving Scott bereft and consumed with guilt. In declining health and spirits, he began to let his practice contract and he was increasingly out of touch with architectural and cultural developments, which were leaving the Albert Memorial behind as an expression of the ideals of the previous decade. Such is always the fate of the architectural work that takes time to realise, but by 1872 the broader certainties and claims to universality of the Gothic Revival were under attack. Scott's design had caught the crest of a wave that was now breaking. A great change in direction was taking place, with Scott's own architect sons experimenting with alternatives to gothic – with the new 'Queen Anne' manner promoted, in particular, by Richard Norman Shaw (1831–1912), which goths of Scott's generation regarded as a snare and a delusion. Meanwhile, opposition to the kinds of restoration practice with which Scott was associated grew, culminating in 1877 with the foundation of the Society for the Protection of Ancient Buildings by William Morris, who would later refer to Scott as 'the (happily) dead dog'. [80]

The 1870s was a decade of doubt and disillusionment, and the Albert Memorial – along with Scott's Midland Grand Hotel at St Pancras (1868–74), the slowly rising Law Courts (1868–82) by Street, and Butterfield's Keble College in Oxford (1867–83) – became representative of a previous generation, whose ideas seemed old-fashioned and were increasingly ridiculed. The critics were usually either artists and writers, or younger architects with new and different sensibilities and aspirations, for whom Scott and the gothic shrine he created in Hyde Park were easy and obvious targets. But there is no reason to suppose that, in its time, the Albert Memorial was anything but a popular success. As

Layard of Nineveh had insisted so reassuringly to Scott at the time of the Memorial's unveiling, hostile criticism was 'opposed to the judgement and taste of the million'. He was convinced, perceptively enough, 'that if so grand and splendid a monument had been erected in Italy or in Germany, our countrymen would have gone many hundreds of miles to see it, and would have pronounced it an example of the vast superiority of foreign over English taste'. Though he was 'equally convinced', with insular arrogance, 'that such a monument could not have been erected out of England'.[81]

In 1882, despite being an admirer of Norman Shaw's 'Queen Anne' houses in London's Bedford Park, the American critic Moncure Daniel Conway could still sympathise with the gothic of the Albert Memorial and describe it as 'the noblest monument in Europe'.[82] And in his revised edition of James Fergusson's *History of the Modern Styles of Architecture*, published as late as 1891, Robert Kerr – whose tastes, admittedly, had been formed in the mid-Victorian decades – could praise 'the universally known and admired monument erected in London to the memory of the late Prince Consort, in a certain sense the *chef-d'œuvre* of Sir Gilbert Scott'. In Kerr's view, the 'simple magnificence of its design, and the extraordinary splendour of its adornment, confer upon the Albert Memorial the very highest distinction amongst modern works of art'[83] – although the last word that springs to mind when contemplating the Memorial is 'simple'.

Kerr's encomium was to be the last for a long time. The Edwardian revivers of the Grand Manner had no time for Victorian gothic. After the Great War, as the world turned in violent if necessary reaction against the values of the previous century, so the Albert Memorial, in its inescapable prominence, came to symbolise all that seemed most ludicrous and reprehensible about the Victorian Age. It became at once a joke and an outrage. Of the many disparaging judgements of Scott's masterpiece, that by Kenneth Clark in his pioneering study, *The Gothic Revival*, published in 1928 is perhaps the most thoughtful as well as representative:

> *It was intended to have, and certainly achieved, a popular success, whereas the true Revival appealed to men with ideals, either esthetic or religious … Of course the philistine is always compelled to borrow a pinch of ideals in order to make his lump rise … but for the most part the Albert Memorial is the expression of pure philistinism, and as such is not a document of much value to the student of taste … [it] has always appealed in the same degree to the same class of people – the people who like a monument to be large and expensive-looking, and to show much easily understood sculpture, preferably of animals.* [84]

Some twenty years later, however, Clark had revised his opinion. 'Untrue', he wrote in a 1949 footnote to this passage, 'and the arguments which follow unconvincing. But arguable that the Albert Memorial is a document for the study of mid-Victorian taste rather than of the Gothic Revival'.

So famous and so familiar is the Albert Memorial, and so much taken for granted as one of the sights of London – at least until official neglect threatened its survival – that, even now, it is difficult to put Scott's achievement in its context, or even to *see* the thing objectively. The hostile and dismissive opinion of Victorian architecture in general, and Victorian Gothic in particular, reflected by Clark in 1928, may have slowly given way to sympathetic understanding, with educated opinion beginning to see the value of the austere, mannered work

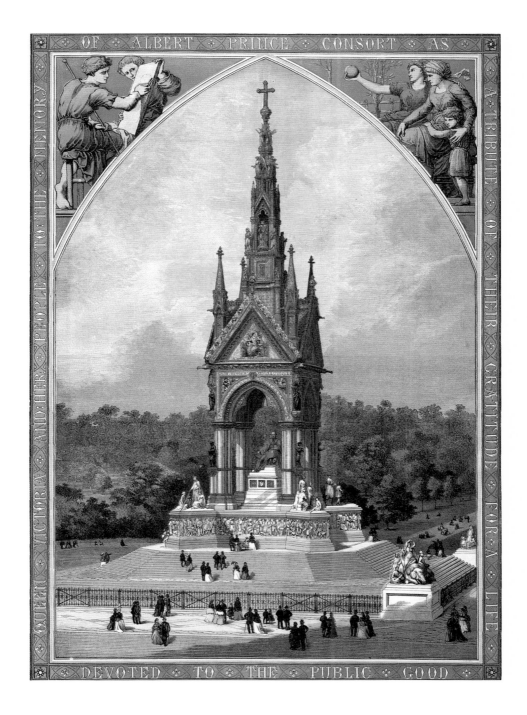

The border text reads: OF · ALBERT · PRINCE · CONSORT · AS · A · TRIBUTE · OF · THEIR · GRATITUDE · FOR · A · LIFE · DEVOTED · TO · THE · PUBLIC · GOOD · QUEEN · VICTORIA · AND · HER · PEOPLE · TO · THE · MEMORY

100. The Albert Memorial, London, chromolithograph of *c.* 1876 (Kensington Central Library).

of Butterfield and Street by the 1940s. But the Albert Memorial did not benefit directly from this revisionism, while Scott and his architecture continue to present a problem for the historian: he was just too prolific and unashamedly middle-brow – 'of the multitude', as he himself put it. In 1962, four years after the foundation of the Victorian Society, Keble College was no longer laughed at as it had been in Clark's day, but the Albert Memorial was an easy enough target for it to appear on the first pictorial cover of the satirical magazine *Private Eye* (101) with the caption, 'Britain's First Man into Space. Albert Gristle Awaits Blast-Off'.[85] Even the authors of the first authoritative account of its creation, published by the *Survey of London* in 1975, considered that 'the aesthetic condemnation of the memorial may be accepted' while respecting it as 'an ambitious essay in the ancient tradition of the mother of the arts'.[86]

Today, following its magnificent restoration, we can see the Albert Memorial in all its intended amazing, glittering, even vulgar glory, and so understand the popular enthusiasm it engendered in the 1870s. Something that

101. *Private Eye*, first pictorial cover, 7 February 1962; photograph by Lucinda Lambton.

has survived so triumphantly cannot simply be dismissed as a failure. But it is still difficult to place in its artistic context, particularly in its relationship to the mainstream of the Gothic Revival. Scott always preferred the sculptural to the abstracted; he was not so resourceful a designer as Street, not as inventive as Butterfield, not as refined as Bodley, while the problem remains that he did far too much, so that his work can often seem repetitive, mechanical. But it is also clear that when Scott really bothered, he could be very good indeed – and, as he said, the Albert Memorial was 'the result of my highest and most enthusiastic efforts'. If the form of the gothic cross was old-established and familiar, he nevertheless managed to do something quite new with it, making it a feast of different materials and constructional techniques, and the product of many different but complementary skills. All that was possible because of Scott's unusual idea of making a full-sized structure which was, as he put it, 'the realization in an actual edifice, of the architectural designs furnished by the metal-work shrines of the middle ages'. This really was original and novel. It was Scott's vision to build in Kensington 'an exquisite phantasy' which the Middle Ages had realised only on the small scale of a model. The result may not be exquisite, but it is extravagant and extraordinary. Despite inconsistencies and infelicities, the Albert Memorial is a unique creation, to be judged on its own terms as well as by the standards of its time, the 1860s – that strangely vigorous and fruitful decade in British cultural history.

Lord Salisbury once said that when he wanted to know what the middle classes were thinking, he spoke to the Queen.[87] As Scott's design for the Albert Memorial had to appeal to the Prince Consort's grieving widow as well as to the widest public – for its purpose as a national symbol was clear and unambiguous – it may well represent contemporary bourgeois taste and, in its sentimentality and exotic incongruity, might seem to teeter on the edge of the ridiculous. But it is not ridiculous: it is rather wonderful. There is nothing like the Albert Memorial anywhere abroad; there is nothing else quite like it anywhere in Britain. George Gilbert Scott's unlikely shrine expresses the mid-Victorian love of colour, of richness and exuberance, of figurative sculpture. It is also a supremely confident manifestation of that remarkable love-affair with the medieval which dominated the nineteenth century – and in England that passion for gothic went so deep that it had more creative, and more curious, consequences than in any other country.

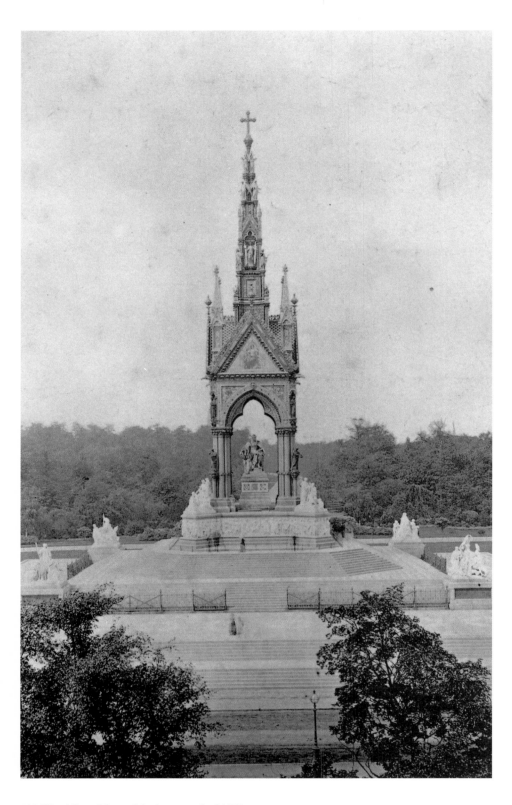

102. The Albert Memorial, photograph of 1876,
taken soon after the unveiling of the statue of Prince Albert.

Building the Memorial: the Engineering and Construction History

Robert Thorne

High on the list of the most notable buildings of the mid-Victorian age are those that express the progressive technical developments of the time. In many cases the demand for new types of building, or buildings on an unprecedented scale, could never have been met had it not been for the developments of new materials and construction techniques. Station trainsheds, market halls and exchanges, industrial buildings, even the New Palace of Westminster, exploited the latest innovative possibilities, especially in the use of cast and wrought iron. Most of all the Crystal Palace, though it did not produce the progeny that some had expected, gave a foretaste of how the assembly of industrialised materials could create a new architectural vocabulary. Where these types of building have survived they are particularly admired, above all because their innovative qualities are clear for all to see. The construction of, for instance, Paddington Station or the great slip roofs at Chatham Dockyard, is exposed and intelligible for anyone who cares to look.

The Albert Memorial was never such a structure, nor was it meant to be. If built in another era, a monument of such symbolic importance might have been conceived of as a feat of pure construction, but this was precluded by the associational aesthetics that dominated the Victorian idea of commemoration. The early proposal for an obelisk to commemorate Prince Albert would have produced one of the most straightforward forms of Memorial, yet even then it was intended to surround the monument with statuary. When – as Gavin Stamp has explained – the idea of an obelisk was set aside, a more complex combination of architecture and sculpture was favoured as an appropriate way to symbolise the Prince's interests and deeds. The design came to be looked upon as a 'trophy of the associated arts',[1] intended to maximise the iconographic role of the Memorial. Construction was subordinate to that role.

It is hardly surprising therefore, that discussion of the different schemes that were originally submitted for the Memorial paid little attention to how they would be built; nor that Scott's scheme, once chosen, was analysed in terms of its appropriateness and its historical precedents rather than its structural logic. It is true that a few commentators, applying Puginian precepts to Scott's design, at least raised a query about its construction. For instance James Thorne, compiling his annual review of architecture in the *Companion to the British Almanac*, commented on the incongruity of having a 'vast tabernacle' carried on four supporting columns.[2] He was writing in 1863, when not much was known about what the process of construction would be. Subsequently, when similar qualms were raised there still was very little analysis of the construction. The treatment of each part of the Memorial was frequently

described, down to the minutest detail, but without an overview of how it was put together. It appears that there was so much to say about the meaning of each part, and the role of those responsible for the embellishment, that anything hidden from view was soon forgotten.

A major benefit of the English Heritage conservation and repair programme has been to redress that balance. The dissection of the Memorial has provided an unprecedented opportunity to learn how it was put together in the first place, and how it has performed since it was completed. That in turn has raised questions about the roles of those involved in its construction; how they were chosen, the terms under which they worked, and how they related to each other. What emerges is a different way of looking at the Memorial, which treats it as a landmark in mid-Victorian building history, in the same way as others have described it as the epitome of High Victorian art. Understanding the anatomy of the structure adds a dimension to the story which has previously been omitted, even by those who witnessed its original construction taking place.

From the outset, the fact that Scott was chosen meant that the Memorial was in the hands of an architect who knew more than many of his contemporaries about the arts of construction, and was actively interested in the technical developments of the time. He was unusual in having obtained some of his training with the contractors Grissell and Peto, at the time when they were building the technically complex Hungerford Market, designed by Charles Fowler (1792–1867).[3] Subsequently he worked with Henry Roberts, an architect well-versed in the practicalities of building. But these experiences were secondary once he had been awakened to the significance of gothic architecture. Here was a form of architecture that was not just of antiquarian interest, but had an enduring validity because of its basis in principles of sound construction. Like other gothicists, Scott paid tribute to the medieval world order, but what mattered most of all to him were the lessons medieval architecture could teach in how to build. The primacy of gothic, as proclaimed by him throughout his writings, lay in the truthfulness of all the architectural elements that it included.

Since he regarded gothic as a robust, universally applicable system of architecture, Scott was more broad-minded than many where the question of new materials was concerned. Its inherent flexibility meant that gothic could absorb innovation without losing its authority. In particular Scott was interested in the use of cast and wrought iron, and introduced it where appropriate in his own designs. In his *Remarks on Secular and Domestic Architecture* he acknowledged the architectural qualities of iron construction, especially for roofs: 'a really good iron roof is, perhaps, as easily made pleasing as ugly'. Also cast iron bridges could be beautiful and it would, he thought, take 'the most ingenious bungler' to ruin the natural lines of a suspension bridge.[4] Such structures were anathema to many gothicists, as were many of the buildings produced by the new railway age. By contrast Scott was prepared to admit that he admired the great Fox Henderson trainshed at New Street Station, Birmingham (1852) and the arched roof of the Gare de L'Est in Paris (1847–52) which would, he thought, 'be perfectly suitable for a Gothic hall'.[5] In the same context, he claimed the Roundhouse, Camden Town (1847), a major railway structure, as an exemplary gothic design.

These opinions explain why Scott was willing to use iron, especially in secular commissions such as Kelham Hall, Nottinghamshire (1858–61); and also

why he took such an interest in patent systems of fireproof floor construction, all of which relied on iron beams or joists. They also help confirm why the Midland Railway was so right to choose him as the architect for their hotel at St Pancras, on which work was started the year after the Albert Memorial. He had the right sympathies to create a building which integrated superbly with the trainshed designed by the engineer William Henry Barlow (1812–1902), and which incorporated iron where there were structural advantages in doing so. Yet the Midland Grand Hotel also revealed paradoxes in Scott's treatment of iron, which are echoed in his design for the Albert Memorial. In some of the principal rooms the ironwork is flaunted for all to see, elsewhere it is hidden by plaster, and in a few locations the plasterwork deceives the eye about the exact role that iron is playing.[6] Such visual gymnastics are not what Scott the gothic theorist was advocating. But he was not the first architect, nor the last, to say one thing yet do another.

Underlying the objections of Scott's contemporaries to the use of iron in architecture was a nervousness about their professional status. As long as iron was used as a decorative element it was an accepted part of their repertoire, but when its structural role came to the fore they were compelled to rely either on the advice of their ironwork supplier or, increasingly, on the expertise of a consulting engineer. It was galling to have to admit that part of their work was not fully at their command. Scott was sufficiently self-assured to be untroubled by such anxieties: as well as accepting the legitimacy of iron construction he willingly acknowledged engineering advice. Where the Albert Memorial was concerned he credited the structural engineering thus: 'For the arrangement and construction of the iron work forming the interior of the flèche, as well as of the great girders by which it is supported, I am indebted to my friend Mr F. W. Shields, the eminent engineer'.[7]

103. Philip Delamotte, the open colonnade of the Crystal Palace during re-erection, from *Photographic Views of the Progress of the Crystal Palace at Sydenham*, 1855 (London Metropolitan Archives).

Francis Webb Sheilds (1820–1906), as his surname was usually spelt, had trained with the engineer Charles Vignoles (1793–1875) and spent his first years of professional practice in Australia. Returning to Britain in 1851, he obtained one of the most demanding jobs of the time, that of resident engineer for the re-erection of the Crystal Palace at Sydenham (103). In its rebuilt form that structure was made much larger than its Hyde Park version, with iron replacing many of the original wood components. The multitude of detailed calculations required convinced Sheilds of the need for an engineering textbook, which he produced under the title *The Strains on Structures of Ironwork* (1861). In 1860 he set up as a consultant and over the subsequent decades was in demand not just in Britain but throughout the world, for instance in Portugal, Iceland and back in Australia where his career had begun. In London he was responsible for the conceptual design on the basis of which the Victoria Embankment was built.[8]

It is not known how Scott and Sheilds first met but they worked together on restoration projects, notably at Salisbury Cathedral (from *c.* 1861) where Sheilds designed the diagonal ties to stabilise the tower.[9] As well as helping Scott with the ironwork, which is fundamental to the structure of the Albert Memorial, Sheilds advised him on the foundations. Though his role on the Memorial was unpublicised and ill-defined – for instance we do not know what he was paid – Sheilds was crucial to the project's successful execution.

Sheilds merits his due because where the ironwork of the Memorial is concerned it is Skidmore's name that has primacy. It is his dazzling metalwork on the flèche that the eye can see, not the structure that supports it. Scott was a loyal admirer of Skidmore's work, and the two men shared a similar outlook on the use of iron in construction. But he knew at first hand of Skidmore's tendency to run away with a project and add ideas of his own – as Peter Howell discusses in chapter seven. Scott regarded the metalwork as 'the soul of the Memorial, and its most marked characteristic',[10] which meant inevitably that he turned to Skidmore for its execution. However, he must have known about the fiasco of the roof of the Oxford Museum (1855–60), where Skidmore's structurally inept design led to a partial collapse and necessitated the help of William Fairbairn (1789–1874) to sort out the mistakes.[11] And Scott, like everyone else, referred to the great screen in Hereford Cathedral which Skidmore executed for him as being of iron construction, yet he must have been aware that the main beam and arches of the screen are in fact wood embellished with metal, and are far less stable than the eye imagines. Skidmore was his art metalworker, and there was none better, but he was not to be trusted with the overall concept of how the Memorial would be built.

The fourth individual whose contribution was crucial to the success of the Memorial was the contractor John Kelk. In many respects he was a natural choice. Having served his apprenticeship with Thomas Cubitt he worked in conjunction with Thomas Brassey (1805–1870) and Peto and Betts on major railway and public projects, and developed a name for himself in building the Carlton Club (1854), the west wing of Somerset House (1856), and the complex of Victoria Station and the Grosvenor Hotel (1860–2) – all high profile London commissions. He had made his fortune before he was forty, and true to type had set himself up with a country estate at Bentley Priory, at Stanmore in Middlesex. Indeed such was his success that in 1862, aged forty-six, he announced his intention of retiring and handed over his building business to Messrs Smith and Taylor. But in fact retirement was simply a readjustment of

his resources, and he continued to be active in railway, dock and building works well into the 1870s.[12] Apart from his eminence, Kelk had also been closely associated with the South Kensington projects linked with the Prince Consort's name. He acted as the intermediary in enabling the Commissioners of the 1851 Exhibition to purchase the estate on which the cluster of institutions and museums in the area now stands, and he erected many of the early buildings of the Victoria and Albert Museum. Together with Lucas Brothers he was the contractor for the Exhibition Building of 1862 (104) and he helped clear the debts of that exhibition, which was far less successful than its predecessor.[13]

Thanks to his reputation and his South Kensington links – especially via the linchpin of the South Kensington interest, Henry Cole – Kelk was bound to feature on any shortlist of contractors for the Memorial. In fact, however, there was no shortlist or tendering process because Kelk got in first and offered to do the work at cost, and to bear any additional expenditure himself. He was

104. John Kelk , with the other main contractors for the 1862 International Exhibition building, *Illustrated London News*, 10 May 1862.

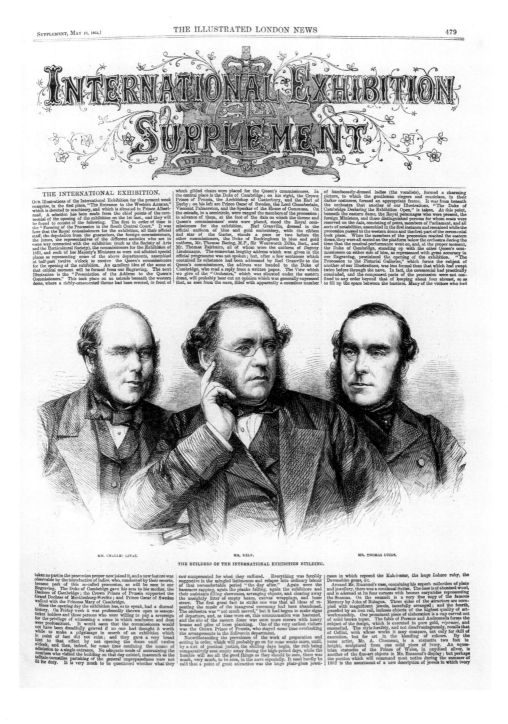

someone who could afford to be magnanimous and also, as he frankly admitted to Cole at the time of the 1862 Exhibition, he hoped for social preferment. Having been disappointed on that occasion, when he complained of being 'always treated as a Tradesman', surely this time he would be adequately honoured.[14] The image of his returning from retirement to undertake this public obligation added to the dignity of his appointment.[15]

Kelk offered to build the Memorial in April 1863 but it was not until exactly a year later that the terms of his contract were agreed. Given the complexity of the project, especially the number of craftsmen and artists involved, this is hardly surprising, but there was also the question of who would have responsibility for marshalling these forces. Kelk and Scott started out with an initial suspicion of each other: Scott looked upon Kelk as too closely linked to Cole, with his interfering instincts, whilst Kelk was nervous of Scott's 'running wild' with the project.[16] It boiled down to a question of who would authorise changes that would affect the contract price. Ultimately it was agreed that Kelk would contract to build the whole monument, except the eight statue groups around the podium and the statue of the Prince, and the various craftsmen and sculptors were sub-contracted to him. These included Skidmore, Armstead and Philip, and Salviati, who made the mosaics and whose role is described in Teresa Sladen's chapter. Kelk's price was £85,508, which was based on an estimate that included £17,313 for Skidmore's work, £4,300 for the mosaics, and £19,531 for Philip's and Armstead's sculptures. Scott's fee was £5,000, plus £600 for his Clerk of Works.[17] The overall contractual arrangements ran smoothly, and only caused Kelk anxieties when it came to Skidmore's claims for additional works.[18]

Before discussing the supply of materials and the overall progress of the works it will be useful to say what kind of structure it was that Kelk was asked to build (105). Scott's description of the Memorial as 'a vast and magnificent shrine or tabernacle' gives a visual clue but leaves unanswered the question of how it was put together.[19] First, the foundations and substructure: because of the discovery of sand and water just below the surface of the site, the main part of the Memorial is founded on a 17 feet thick concrete raft built off the underlying gravel. On top of this rises a massive brick vaulted undercroft of 868 arches supporting the steps and podium (106): within this a great central brick pier carries the statue of Albert. At the time it was constructed this undercroft was celebrated as being almost a building in itself (107), but it is now known only to those who venture beneath the Memorial via a furtive entrance at the edge of the steps.

Above the substructure stands the podium, enwrapped by Armstead's and Philip's sculptural reliefs, and the structure of the shrine itself begins. The four columns which support the canopy, each consists of eight granite shafts around a central core. These are not granite monoliths, but are divided at a third of their height with the joint concealed behind an embellished bronze band: the core also is jointed, but at a different point (108). Because of the way the shafts are assembled, plus the use of copper cramps and the filling of grooved connections with Portland cement, each column acts as one structural unit.[20]

105. Section through the Albert Memorial, looking west, from *The National Memorial to his Royal Highness The Prince Consort*, 1873 (Kensington Central Library).

106. The brick undercroft during construction, *Illustrated London News*, vol. 46, 21 January 1865.

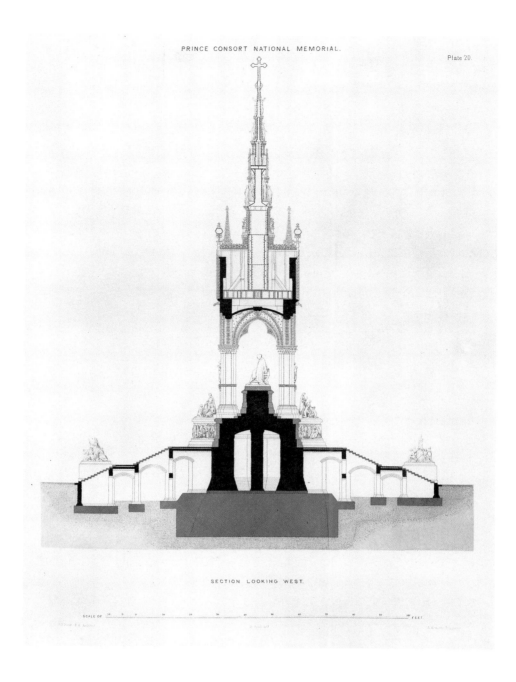

PRINCE CONSORT NATIONAL MEMORIAL.

Plate 20.

SECTION LOOKING WEST.

SCALE OF FEET

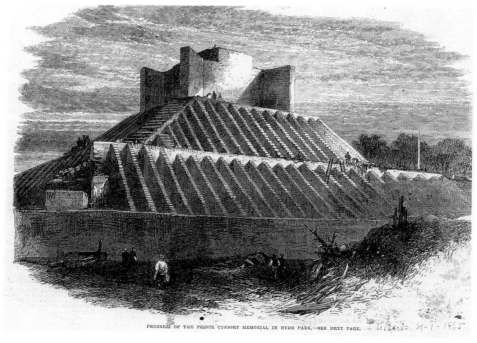

PROGRESS OF THE PRINCE CONSORT MEMORIAL IN HYDE PARK.—SEE NEXT PAGE.

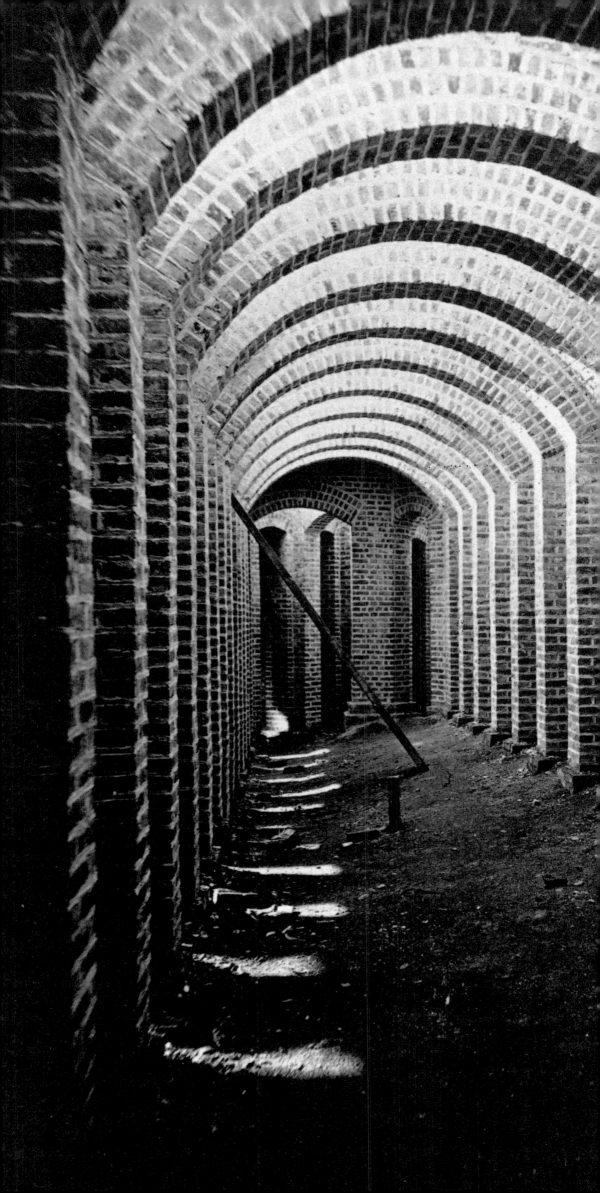

107. The brick undercroft near completion, photograph of 1865 (Kensington Central Library).

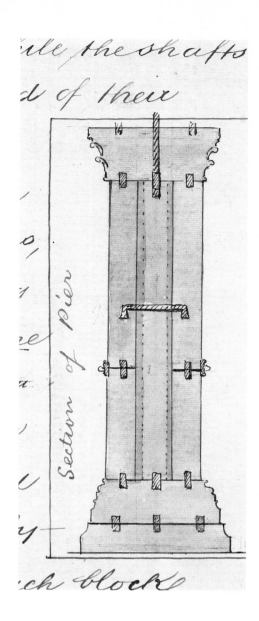

108. Sketch section through one of the columns supporting the canopy, from Scott's 'Prince Consort Memorial, Report to January 1869' (Royal Archives).

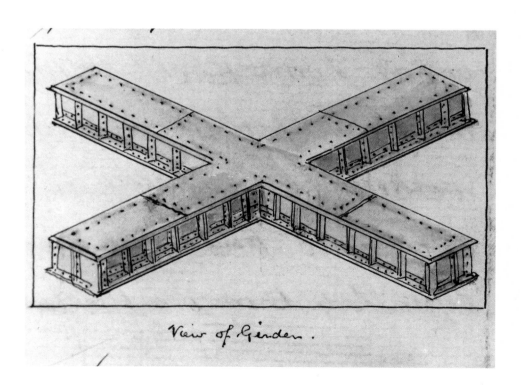

View of Girder.

109. Sketch of the cruciform box girder supporting the flèche, from Scott's 'Prince Consort Memorial, Report to January 1869' (Royal Archives).

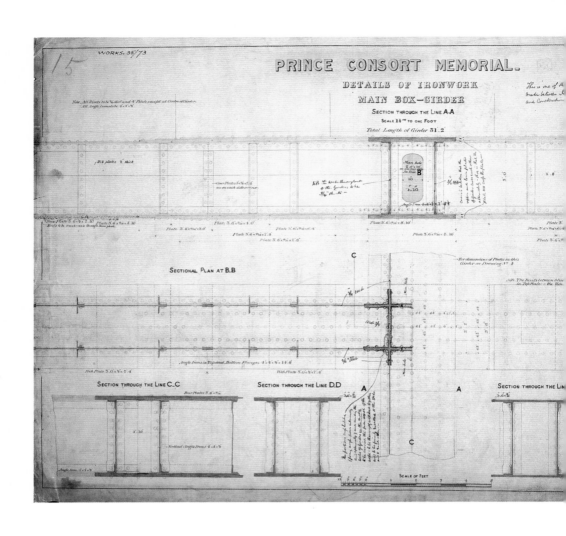

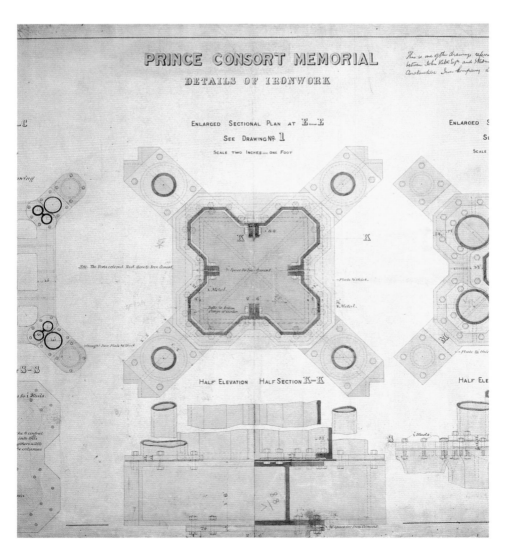

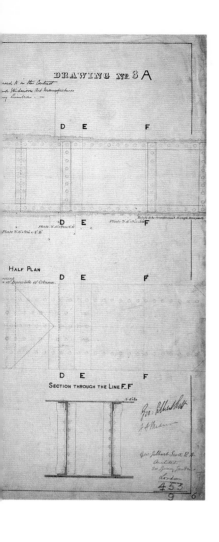

110. Details of ironwork, box girders, and masonry, from Scott's construction drawings (Public Record Office).

111. Enlarged sectional plan of ironwork at E-E, from Scott's construction drawings (Public Record Office).

112. Sectional plan of the Memorial, from *The National Memorial to his Royal Highness The Prince Consort*, 1873 (Kensington Central Library).

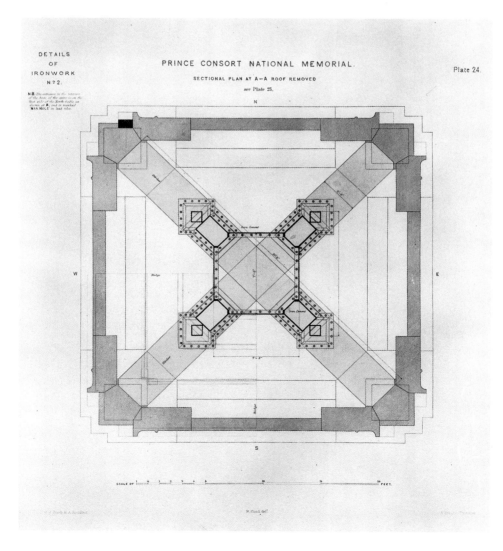

The four columns, thus strengthened, are able to carry the canopy and flèche, but they do so by means that deceive the eye. Hidden within the canopy, a cruciform wrought iron structure (109) transmits the weight of the flèche (some 190 tons) to granite blocks above the columns. The ironwork is in the form of riveted plate box girders, 3 ft. 6 in. wide and 3 ft. 4½ in. deep, of two plate thickness in the webs and four plates in the top and bottom flanges (110). Although they form a cross, and distribute the load evenly, these girders were assembled as a single beam with two arms attached to it: there really is no other way that they could have been constructed and hoisted into place. They are an essential part of the structure, but they are neither visible nor architecturally expressed (111, 112). They were designed – presumably by Sheilds – to perform their function without disturbing Scott's preconceived architectural concept.

By squeezing into the space within the canopy it is possible to see how the load from the flèche is transmitted to the cruciform girders. What is essentially a vertical box girder rises in three stages to the upper roof level, with a lattice beam dividing the first two levels from the third. This central core, of bolted cast iron, supports the iron frame to the canopy roofs, plus the sculptured and decorative embellishment of the lower parts of the flèche, including the lions and the eight statues of the Christian and moral virtues. At a yet higher level, as the flèche tapers, the core becomes a cluster of columns and finally a single shaft supporting the orb and cross (113). This vertical iron armature is the fundamental part of Skidmore's metalwork.

Implicit in Scott's idea of the Memorial as a shrine was the use of a wide and exotic range of materials, to express the quality of preciousness in the object and the person it commemorated. The more decorative of these materials – the metals, enamels and mosaics – are discussed elsewhere in this volume. But even confining attention to the structural materials the range is still unusually wide, especially the different kinds of stone employed. Scott was not alone in being fascinated by the contrasting colours and textures of different materials. His contemporaries revelled in the resources put at their disposal by improved transport links and better production methods, with results that are to be seen in almost every mid-Victorian building. And like anyone enjoying a new freedom they sometimes overreached themselves by trying to do too much at once. Scott was not immune from that fault, and certainly his ambitions for the Memorial stretched the supply of some materials to the limits.

113. Section of flèche, from *The National Memorial to his Royal Highness The Prince Consort*, 1873 (Kensington Central Library).

PRINCE CONSORT NATIONAL MEMORIAL.

DETAILS
OF
IRONWORK
Nᵒ 1.

Plate 23.

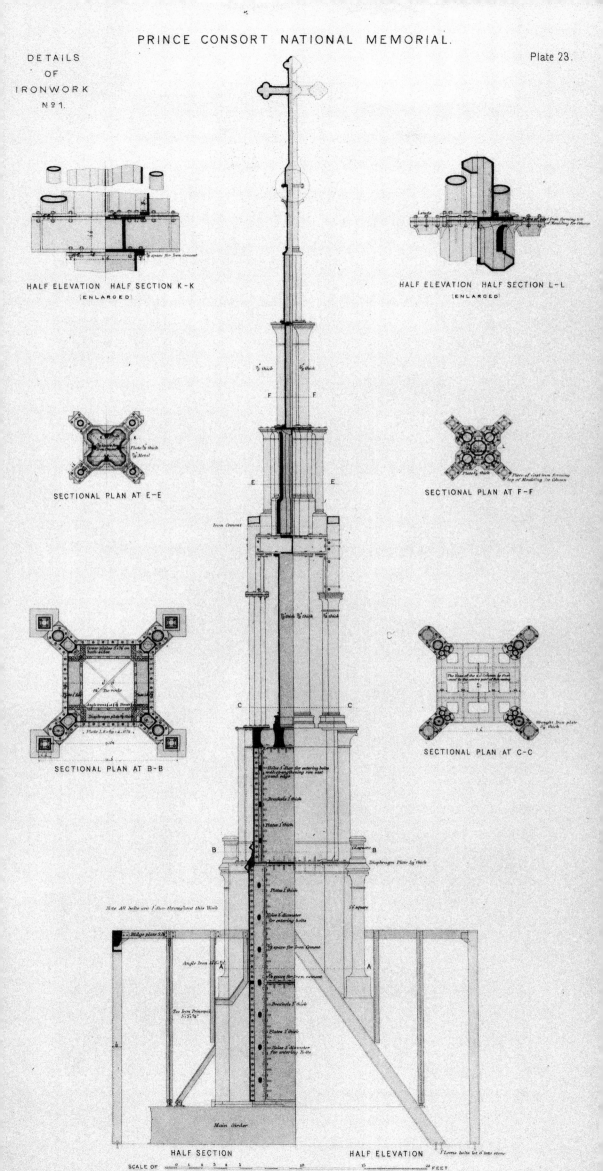

HALF ELEVATION HALF SECTION K-K
(ENLARGED)

HALF ELEVATION HALF SECTION L-L
(ENLARGED)

SECTIONAL PLAN AT E-E

SECTIONAL PLAN AT F-F

SECTIONAL PLAN AT B-B

SECTIONAL PLAN AT C-C

HALF SECTION HALF ELEVATION

SCALE OF

SECTION OF SPIRE
Showing Construction

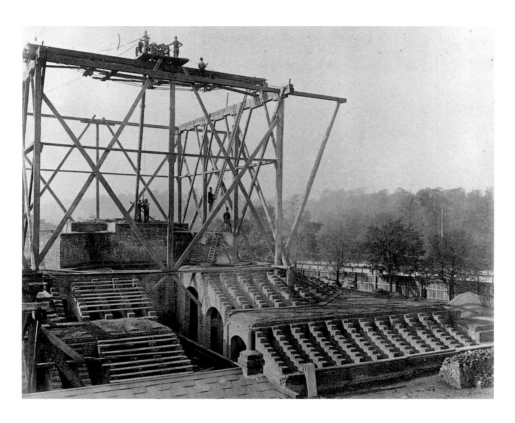

114. The brick undercroft during construction,
photograph of *c.* 1865 (Kensington Central Library).

115. Quarrying at Castlewellan, photograph of *c.* 1865 (Royal Archives).

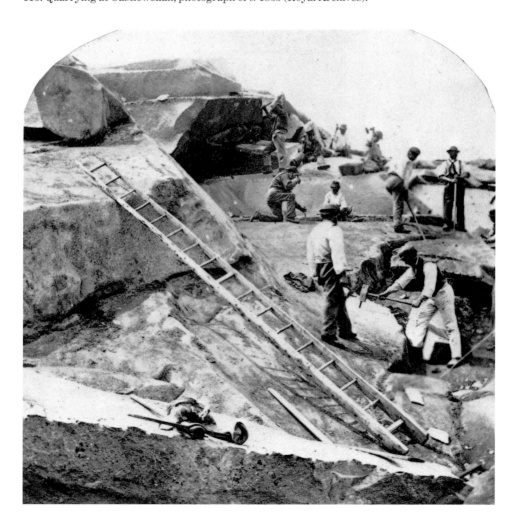

The brickwork of the substructure (114) was not a problem. The bricks were supplied by Messrs Richardson whose works at Acton, then on the western edge of London, were within easy distance of the site. The foreman bricklayer, William Jacobs, had already worked on major projects such as the Palace of Westminster, the *Nelson Memorial* in Trafalgar Square, and the Crystal Palace.[21] The structural ironwork, which was Skidmore's responsibility, was manufactured apparently without difficulty. He may not have made every component himself, for he is likely to have farmed out casting to other Midlands ironmasters. Even so, the essential parts were supplied to him at Coventry for a trial assembly of the flèche in 1866. Scott attributed this superstructure to Skidmore and no-one else.[22]

The story of how the stonework was supplied was less happy and straightforward: occasionally it degenerated into outright farce. The problem was not the building-stones from conventional sources – Portland stone for the canopy, and Darley Dale sandstone for the column capitals – but the search for high quality granite from the further reaches of the British Isles. Large quantities of granite were required, for the steps to the Memorial, the podium and four main columns. In 1864 orders were placed with suppliers on the Ross of Mull in Scotland and at Castlewellan in Co. Down, Ireland (115). The delivery of the Scottish granite was delayed, first by a strike amongst the quarrymen and then by the difficulty of finding a steamer to carry it; but that was nothing compared with what happened in Ireland. The quarry at Castlewellan was opened specially for the purpose, but the supplier, Thomas Scott, was totally ill-prepared for the problem of conveying the granite to the nearest harbour at Newcastle and lifting it onto a ship for the journey to London. The mishaps that ensued became a long-running saga involving William Cross, Kelk's foreman, who had to make seven visits to the quarry, and even Scott himself, who turned up in Ireland and joined in the search to find a wagon capable of carrying the granite.[23] Once the first batch of stone had reached Newcastle there was no crane to lift it, and once a crane had arrived and been put to work the ship to carry the consignment settled on the bottom of the silted harbour. After such a chain of events it is hardly surprising that the first Irish granite did not arrive in London till Autumn 1866, and even that was not the end of the story: the ship carrying a subsequent load was dismasted in a gale and driven into a Scottish port, from which there was no means of carrying the granite onward overland.[24] Even the Queen was drawn into commenting on the absurd unreliability of the Irish supply. Ultimately, in 1867, Kelk decided to do what perhaps he had longed to do earlier, and finished the granite work by switching his allegiance to Scottish and Cornish suppliers. The saga ended in an aptly melodramatic way when poor Thomas Scott, his business in ruins, committed suicide in a Dublin hotel.[25]

As others have pointed out, Scott's wide palette of materials did not extend to the use of terracotta, which by the time of the competition in 1863 had begun to establish itself in the vocabulary of at least some architects.[26] But the arguments used by the advocates of terracotta hardly seemed relevant to Scott, especially for this project. A utilitarian, reformist aesthetic was not part of the ideal which the Memorial was meant to convey. Ironically, however, it did become part of the ideal embodied in the Royal Albert Hall and the exhibition buildings of South Kensington, many of which were finished while the Memorial was under construction. Because they incorporate so much terracotta they appear to leave the Memorial isolated, as if it represents another age and spirit.

On the other hand, the contrast also serves to emphasise the peculiar quality of 'preciousness' that, as Gavin Stamp has shown, was so central to Scott's conception of the Memorial.

The Victorian construction industry could put up buildings and structures extremely fast when called on to do so. The engineering contractors Fox Henderson had the skills and resources to construct the Crystal Palace in eleven months from the time when Charles Fox (1810–1874) first saw Paxton's sketches, and Lucas Brothers – who worked with Kelk on the 1862 exhibition building – rebuilt the Royal Opera House in less than eight months in 1857–8.[27] Commercial buildings, theatres and civil engineering works were completed at a speed which outpaced anything that can be achieved today. But for the Memorial speed was not the first priority, and even if it had been its peculiarities made it extremely difficult to programme the work with any certainty; not just the range of materials used but also the role of sculpture in the design. Even in the most elaborate mid-Victorian churches there was less sculpture, and certainly less *in situ* carving to allow for.

Yet even if speed was not essential, Kelk was never intentionally dilatory. He took possession of the site in May 1864 and that month began work on the foundations. By the end of the year the brickwork substructure had been completed and was being generally admired. The pace then slackened, mainly because the supply of granite, ordered in September, was behind schedule. The first blocks of Ross of Mull granite for the lower part of the podium were not fixed till November 1865.[28] The rest of the podium, including the marble friezes that were to be carved by Armstead and Philip, was built over the next six months (116, 117), and the two sculptors erected the temporary wooden screens behind which they were to carry out their arduous task.

With the podium in place, there was a pause followed by a burst of activity to construct the main columns and the canopy (118, 119). Scott said that this part of the work took just thirteen weeks, an astonishing pace given the complexity of the structure, and the primitive character of the site equipment. There were no steam-powered hoists, and instead Kelk relied on three hand-driven hoists to lift blocks of ten tons or more (121–124). Four blocks weighing a total of forty tons – presumably the granite blocks on which the box girders rest – were raised in eleven hours.[29] While the arches of the canopy were being turned tie-rods were fixed to restrain any outward thrust during construction. They were left in place till 1871, and when they were removed their looseness showed that the structure was performing extremely well. As Scott proudly reported to Henry Cole, 'not the smallest sign of weakness has ever shown itself'.[30]

The completion of the canopy early in 1867 marked the point where Skidmore's contribution began (120). The fact that he had already carried out a trial assembly of the flèche suggests that most of the metalwork components were prefabricated and had their decoration added before they left his works in Coventry. Scott saw at least some of the parts when he visited the works in May 1866.[31] It made good sense to do as much preparatory work as possible, especially when dealing with enamels and decorative metals, but ultimately the true test was whether everything fitted together on site. The advocates of prefabrication always set out with the best of intentions, but end up having to adapt and adjust the components when it comes to the final assembly. Skidmore was no exception: one of the discoveries of the recent conservation project has been how much adaptation was needed in putting every detail of the flèche together.

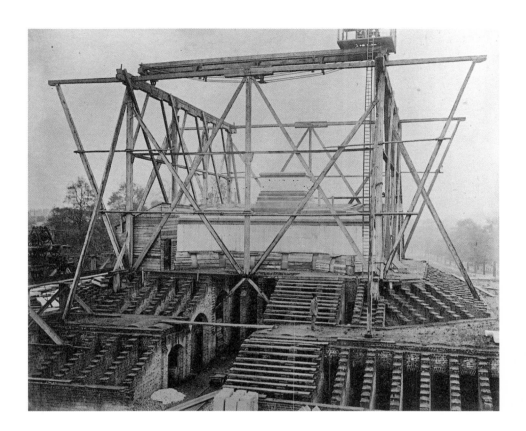

116. The podium and pedestal under construction,
photograph of *c.* 1866 (Kensington Central Library).

117. The pedestal nearing completion,
photograph of 1866 (Kensington Central Library).

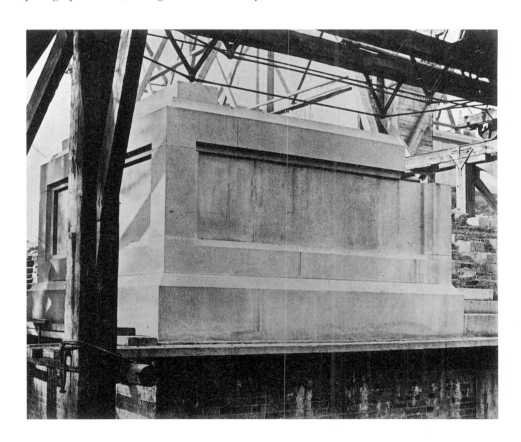

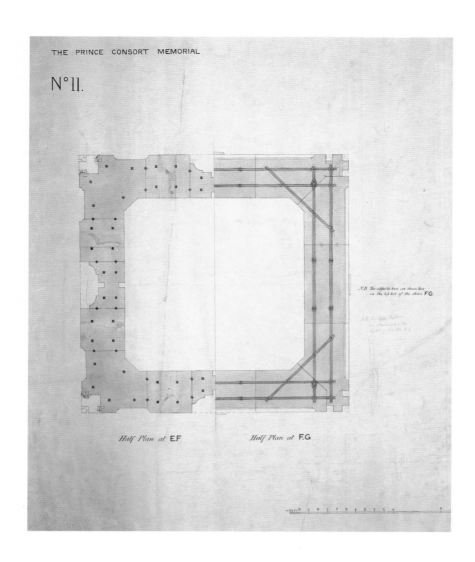

N.B. The supports here are shown here on the left half of the chives **F.G.**

Half Plan at **E.F** Half Plan at **F.G**

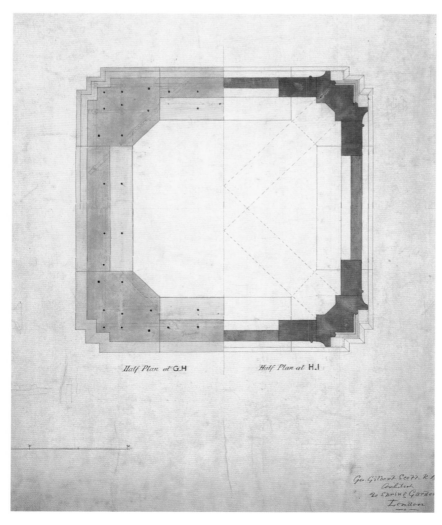

Half Plan at **G.H** Half Plan at **H.I**

Geo. Gilbert Scott. R.A.
Architect
31 Spring Gardens
London

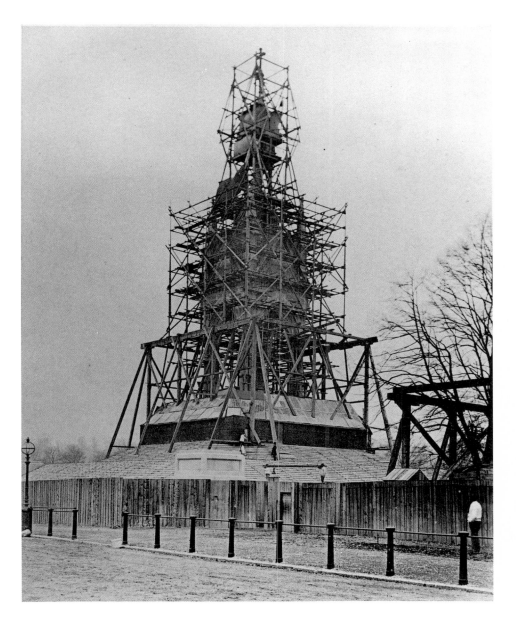

120. The Memorial under its construction
scaffolding, photograph of *c.* 1870
(Kensington Central Library).

118. Half plan of masonry and ironwork
in the canopy, from Scott's construction drawings
(Public Record Office).

119. Half plan of masonry and ironwork
in the canopy, from Scott's construction drawings
(Public Record Office).

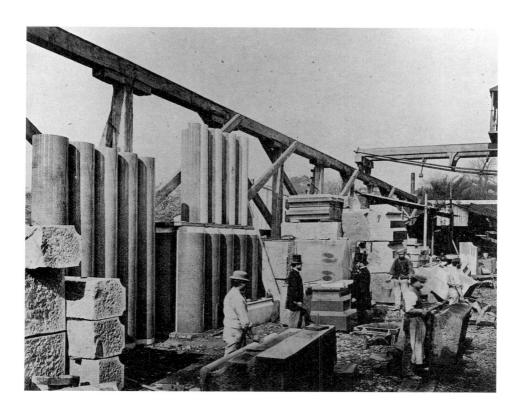

121. Polished granite columns and the podium plinth ready to be set in place,
photograph of 1867 (Kensington Central Library).

122. Stonework for the canopy under shelter on the edge of the construction site,
photograph of *c.* 1867 (Kensington Central Library).

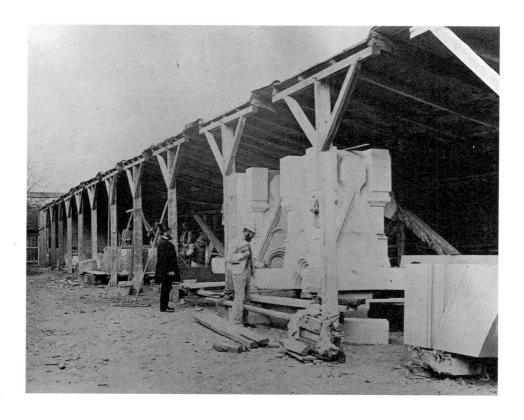

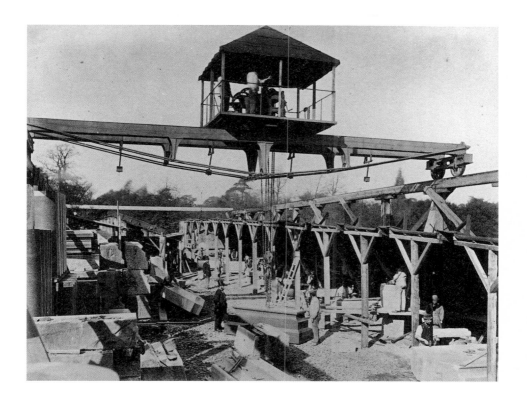

123. Overhead travelling crane at work on the site, photograph of *c.* 1867
(Kensington Central Library).

124. Storage sheds and overhead crane on the site, photograph of *c.* 1867
(Kensington Central Library).

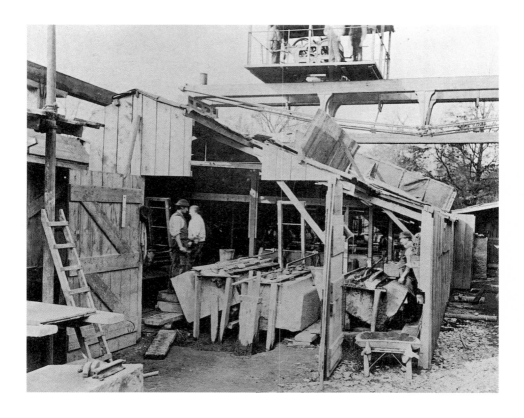

The problem for Skidmore was not the structural ironwork (125), which seems to have come together fairly smoothly. The basic structure of the flèche was put up in just over a year, from the start of work on the box girders in May 1867 to the fixing of the cross in June 1868.[32] Where the system of prefabrication ran into difficulties was with the more decorative elements, such as the colonettes and the leadwork panels. Sorting out these elements appears to have delayed work on the figures around the flèche, in particular the upper and lower angels, to Kelk's intense irritation.[33] And then there was the gilding to be completed. The scaffolding around the flèche was not taken down till 1871 (126), at which stage the main tasks which remained to be done were at a lower level: the completion of the podium sculptures and, finally, the addition of the statue of Prince Albert.

In essence work on the structural aspects of the Memorial took four years, followed by a further four years for the completion of the sculptures and embellishment. The Memorial was revealed to the public – minus the statue of Prince Albert – in 1872 (127, 128), and in the same year it was handed over to the safekeeping of the Office of Works. The statue was not put in place until November 1875, and then it was gilded *in situ*. The uncovering of the fully gilded statue in March 1876 (102) marked the end of the whole project, twelve years after work on site had started.

Kelk drew up his final accounts in 1872. He had managed to make a saving of £4,462 on his original estimate of £85,508. During the course of the works there had been a fair number of extras, however, including the making of an additional flight of steps on the south side and railings provided by Skidmore. Kelk's final net costs amounted to £91,770.[34] Taking the project as a whole, it is interesting to see what proportion of the overall costs are attributable to sculpture and what to the rest of the construction (including fees). Within a total expenditure of £143,645 sculpture accounted for around 46 per cent and the rest of the works 54 per cent.[35] On those terms alone sculpture really was a major element, deserving all the attention it received.

The final accounts for the Memorial provide one way of reviewing it in the broad context of the Victorian building world. The 1860s was a period of intense building activity, especially in London. The first part of the main drainage system was completed (1858–65),[36] the first underground railway was opened (1863), and five main line stations were built by fiercely competing railway companies.[37] At the same time as these engineering enterprises every part of the metropolis, especially the City, acquired new buildings often of a scale that quite eclipsed their predecessors. The decade set the seal on the transformation of London to a world city. For the building industry, which has always liked to rank projects in purely monetary terms, the Memorial was not the most significant project of the time. Looked at in crude cost terms it was overshadowed by projects such as the building of St Pancras Station (at least £435,000), and the Midland Grand Hotel (£438,000),[38] not to mention the Royal Albert Hall (£214,000), which reached completion as the scaffolding was being removed from the Memorial.[39] Setting aside what was spent on the sculptural element, the cost of the Memorial was roughly equivalent to that of one of the major City office blocks built to service London's financial community.

Since the Memorial was such a highly unusual project cost comparisons provide only a limited perspective on its constructional significance. Of greater interest is the question of whether it was unusual or innovative in the way it was built. Generally Kelk stuck to conventional building methods, relying on

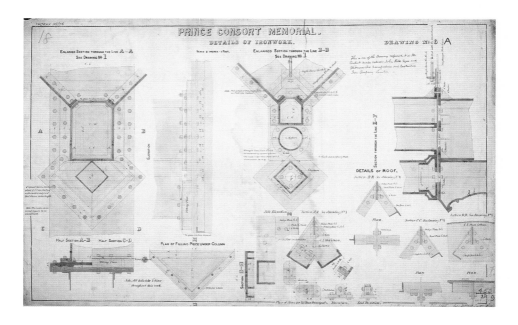

125. Details of structural ironwork, from Scott's construction drawings (Public Record Office).

126. The Memorial's construction scaffolding half-struck , photograph of *c.* 1871
(National Monuments Record).

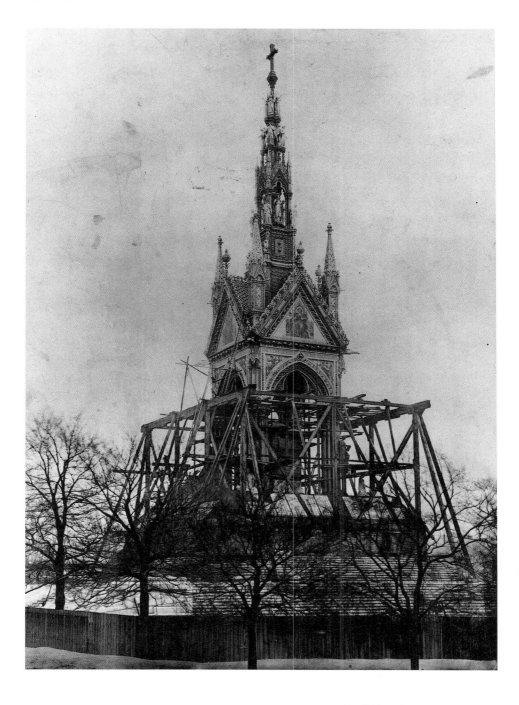

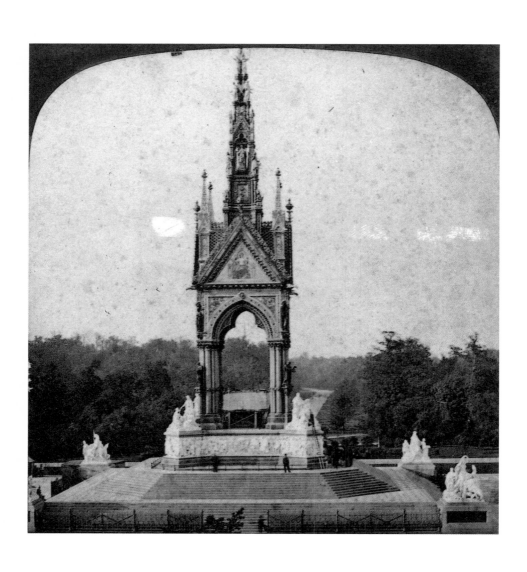

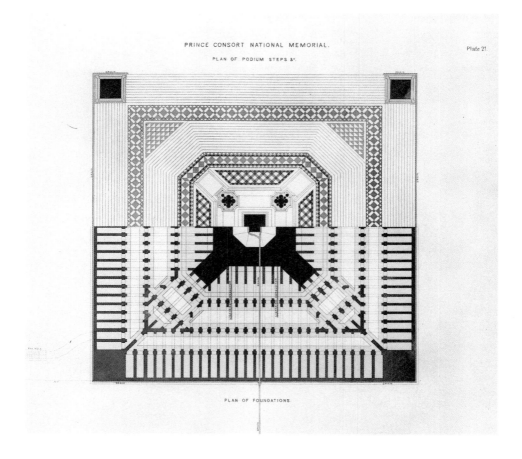

PRINCE CONSORT NATIONAL MEMORIAL.

PLAN OF PODIUM STEPS &c.

Plate 21.

PLAN OF FOUNDATIONS.

muscle-power rather than machines, including stone worked by hand and lifted by hand-driven hoists. However, the *Builder* did remark upon the use of special site equipment for the polishing of the granite columns, the first time this had been done in London.[40] And we know from photographs that a travelling crane was used to move blocks of stone around the mason's yard on site (123, 124). What was less remarked upon, though in many ways more significant, was the amount of pre-assembly involved in putting together the flèche. Trial erections were common in the engineering world: the roof of the Royal Albert Hall, for example, was given a trial assembly in the works of the firm that made it. But to treat a building as a prefabricated kit of parts was still unusual, particularly when traditional masonry construction was being used. What Scott required of Skidmore was a compromise: to produce something traditional in appearance and character, but using at least some prefabricated construction. And Scott was prepared to accept that some of the crafting of the Memorial took place many miles from London, rather than during the process of construction, which was the medievalist ideal.

Inside Skidmore's glittering flèche, the wrought iron box girders which support the superstructure were not in themselves a technical innovation. The idea of the riveted box girder had been developed in the 1840s, most notably by Robert Stephenson (1803–1859) and William Fairbairn in the design of the Britannia Bridge (1845–50), across the Menai Straits, where the girders were used as stiffened tubes through which trains could pass. The research and testing associated with that project considerably enhanced the status of wrought iron as a structural material.[41] Although box girders never became as common as riveted I-section beams, or rolled I-sections, they gained a secure place in engineering knowledge. So when Sheilds designed the girders for the Memorial he was not developing a new concept: instead he was applying the existing concept to a highly unusual problem. The structural genesis of Sheilds' solution is acknowledged on the Memorial itself by a relief carving of the Britannia Bridge included in the statuary group representing Engineering.

Whether it be in matters of cost, or the methods and materials used, it would be wrong to expect the constructional aspects of the Albert Memorial to be startlingly new. Because of the architectural ideal that Scott aspired to, construction was bound to play a secondary, deferential role, even a role that is deceitful in some respects. It was not the first time that has happened, nor the last. From the point of view of construction what is most remarkable about the Memorial is not its innovative aspects but simply that Sheilds, Kelk and even the wayward Skidmore did what was expected of them so extremely well. That itself was a testimony to the maturity of the mid-Victorian building industry, without which Scott and his contemporaries would never have achieved as much as they did.

127. The Memorial soon after opening,
still without the statue of Albert, photograph
of 1872 (The Howarth-Loomes Collection).

128. Ground plan of the Memorial and its
paving, from *The National Memorial to his
Royal Highness The Prince Consort*, 1873
(Kensington Central Library).

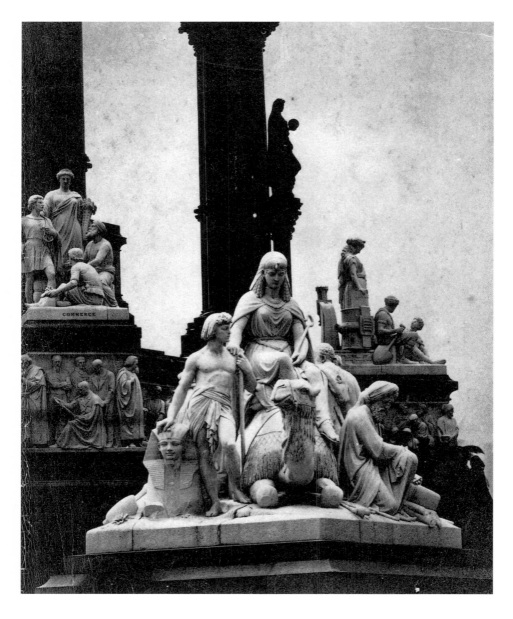

129. William Theed's *Africa*, 1865–71,
with surrounding sculpture;
photograph of *c.* 1875
(National Monuments Record).

Chapter 5

The Sculpture

Benedict Read

Considering the sheer quantity of sculpture present on the Albert Memorial (129), and the fact that at least twelve artists, many of them leading sculptors of the day, were involved in its execution, it might seem puzzling that in the literature on the Memorial of the last forty years so little consideration has been given to the sculpture in its own right. There may be reasons of cultural history behind this – of all the arts of the Victorian era, sculpture has been the least featured in the general Victorian revival of recent times. And while there have been two accounts of the sculpture in this period that have shown some sympathy and understanding of the art,[1] the major accounts of the Memorial have largely been written by architectural or design historians. Thus, the *Survey of London*'s account, though it attempts to place the sculpture in relation to contemporary coverage, reveals a misunderstanding of the range of critical views then current, so the dismissiveness of the *Athenaeum* and the *Times* is taken as evidence of 'a lack of faith in the nation's sculptural talent'.[2] But the *Athenaeum*'s principal art critic, Frederick George Stephens (1828–1907), a founding Pre-Raphaelite, did not reflect mainstream attitudes, and the *Times* was so persistently and unreasonably antagonistic to British public sculpture as to provoke a counter-attack from the *Art Journal*,[3] far more representative of informed critical opinion. For the *Art Journal*, the Memorial was 'the most glorious opportunity for British sculptors to show what they can really do',[4] requiring 'the grandest effort that our school of sculpture has ever been called upon to put forth';[5] and, as the statuary was completed, the journal found its different elements, 'spirited', 'appropriate', 'vigorous yet refined',[6] 'very graceful',[7] 'elegant',[8] 'fine, approaching to grandeur'.[9] Even so, as we shall see, the nineteenth century, as well as the twentieth, was persistently to underestimate sculpture's role in the Memorial.

From the first, moves to erect a National Memorial to the Prince Consort involved senior figures from the Royal Academy. The Mansion House meeting of 14 January 1862 was attended by the sculptor Richard Westmacott (1799–1872),[10] Professor of Sculpture at the Academy between 1857 and 1869; and the painter William Dyce (1806–1864), Royal Academician since 1848, former Director of the Government Schools of Design and Professor of the Theory of Fine Art at King's College, London, attended the follow-up meeting on 21 February.[11] By then, most importantly, the President of the Royal Academy himself, Charles Eastlake (130), had become a member of the general committee convened after the Mansion House gathering.[12] The February meeting received a letter from Charles Grey, the Queen's Secretary, proposing that the Memorial should be an obelisk. Significantly, this was to include

statuary groups at the base, each of which might be entrusted to a different sculptor. Anxious for the best advice about the design, the details, and the choice of artists, Victoria wanted to call together a small committee and – Grey continued – he had already written to the individuals concerned. The Royal Household was clearly worried about the looming artistic decisions, and though the Memorial was deeply important to Victoria, she distrusted her own aesthetic judgement, as she later confided to her *Journal*: 'it is terrible for me, who do not thoroughly understand severe & correct art, as my beloved one did, in such a wonderful degree, to have to decide on what is best'.[13]

Guidance had already been sought from William Theed (1804–1891) and John Henry Foley (1818–1874),[14] sculptors whose work Victoria and Albert had commissioned, and on 10 February Charles Phipps contacted Eastlake 'to ask privately' for his 'assistance and advice' on the details of the obelisk proposal:

> *We hear now that a monolith can be attained 150 feet in height – this would require a base of proportionate dimensions, and at the projecting corners of this base, it is proposed to place Groups of Statuary, either allegorical or illustrative of the leading points of the Prince's character. In the front of the Obelisk it is also contemplated to place an Equestrian statue of Him in whose honour the Monument is raised. It is supposed that all this Statuary work would give an opportunity of employing several eminent Artists in that branch, each Group, though forming part of one provisionally approved design, being executed by a different Sculptor.*

From the very beginning, then, sculpture was crucial to the Memorial, but Phipps was highly conscious of the problems involved. Not only – he confessed to Eastlake – was he ignorant of the '*Rules* of Art, which can no more be invaded with impunity than the rules of spelling', but he was getting contradictory advice: 'One tells me that it is wrong to place an Equestrian Statue in front of the base of An Obelisk – another says that groups of Statues by different Artists must be inharmonious'. Eastlake's expertise was needed, and Phipps, writing on 10 February 1862, was confident that he would be anxious to help the Queen 'in Her present desolate state when She can see nobody'.[15] Eastlake must have replied immediately, for on 12 February Phipps wrote again thanking him for his 'opinions with regard to the combination of an Obelisk, and Groups of Statuary' and, significantly, 'the employment of an Architect'.[16] By the end of the month the Queen's advisory committee had been set up: the Earl of Derby, the Earl of Clarendon, the Lord Mayor, and Eastlake as Secretary. Grey told Clarendon that Eastlake's appointment was the Queen's own suggestion, so that she 'might make to him, for the information of the Committee any communications She might wish to make', while he would be 'charged with the duty of keeping Her constantly informed of all that is done'.[17]

The significance of Eastlake's role in the creation of the Albert Memorial cannot be overestimated. His dominance of the mid-Victorian art world is, perhaps, difficult to grasp today,[18] for he was at the same time both President of the Royal Academy and Director of the National Gallery. In the one role he governed the principal national association of painters, sculptors and architects, his presidency described by the architect Charles Robert Cockerell (1788–1863) as 'earnest, steady, most judicious, business-like, kind, full of tact, consideration, and even policy'.[19] In the other he was the country's chief curator of historic art, scrupulous, energetic and discriminating in building up the collection.

There was though a third position he occupied which made him particularly appropriate as adviser for the Memorial: since 1841 he had been Secretary of the Royal Fine Arts Commission established – as Hermione Hobhouse described earlier – under Albert's chairmanship to supervise the decoration of the New Palace of Westminster. Eastlake was very active in pursuing the Commission's aims, organising competitive exhibitions and negotiating with artists. His work here was particularly praised by his successor as adviser on the Memorial, Austen Henry Layard, who paid tribute to his 'business habits and ... power of dealing with details', the 'conscientious accuracy' of his records, and the 'delicate consideration' that characterised 'his relations with the various artists, painters, sculptors and others ... connected with this great undertaking'.[20] And of course, the very fact that the 'great undertaking' had been one of Albert's Grand Projects commended Eastlake to the bereft Queen.

The first difficulties confronting Eastlake and the Memorial Advisory Committee were the practical and financial problems of the obelisk scheme. As Grey explained to Eastlake in April 1862, a 'mere Obelisk', without sculptural groups and a statue of Albert, would hardly do. Rather than risk this, the Queen would prefer 'some Architectural design ... which might admit of the Sculptural combination to which she had looked to form one of the principal features of the Monument'. Indeed, Grey thought that Victoria would not be sorry to hear that ideas of an obelisk had been dropped.[21] The Committee duly recommended abandoning the obelisk, and – as Gavin Stamp's chapter describes – architects were invited[22] to advise on what form the monument should take, and whether it should be combined with some kind of commemorative public institution.[23] Meanwhile the protracted debate on whether the specified statuary should be in bronze or marble began, as too the argument about whether it needed protection from London's polluted atmosphere. 'Why not have the personal Monument in a Hall ?', asked Henry Cole in a letter of 21 April to Grey, 'A gilt bronze statue sitting on a pedestal surrounded by & decorated with sculptures & bas reliefs emblematic of Arts & Sciences & Industry ... The Hall itself might always be open to the Public and the Statue &c would be infinitely better preserved within doors than without, in such a climate as ours.'[24]

130. Sir Charles Lock Eastlake (1793–1865),
photograph by Caldesi,
c. 1862 (National Portrait Gallery).

Although Grey had earlier confided to Eastlake his concerns about there being 'so much jealousy of the Kensington people, & so much dislike of Cole in particular',[25] he thought the hall a good idea.[26] Judiciously, Eastlake conceded that the statue could be inside, in which case it could be in marble, and said there were good arguments for marble indoors and bronze out. But he was also firm that the Committee should 'be allowed to consider themselves free with regard to this question.'[27]

When the architects reported back, the Committee duly noted their scepticism about combining the monument with a building:

> *The Memorial, if erected in conjunction with any large building or institution, would lose in individual grandeur and importance; it would be difficult to treat it otherwise than as a subordinate object even outside the building; and if placed within, it would be seldom seen, and would not be the national monument immediately under the public eye, which most people are expecting.*

As for the options for the Memorial itself, a giant obelisk in different stones would overpower the essential statue of the Prince, while a statue on top of a column would be invisible. If the monument was to be sculptural and in the open air, it would need to be big to be effective, and would have to be of bronze – even though the metal's rapid darkening in the British climate was 'injurious to the effect of a work of art'; perhaps a different mixture of metals could be found. Rauch's memorial to Frederick the Great in Berlin (1851; 130) and Fernkorn's to the Archduke Charles in Vienna (1860), 'among the finest monuments of modern times', had managed to retain their lustrous colour, as too the classic examples of the Greek horses in Venice and Marcus Aurelius in Rome. Gilding 'in particular parts' and under certain conditions might be resorted to.[28]

In July 1862 architects were invited to submit designs. Eastlake's specification makes clear the extent to which the Memorial's architecture was envisaged – in line with Victoria's wishes – as a setting for sculpture:

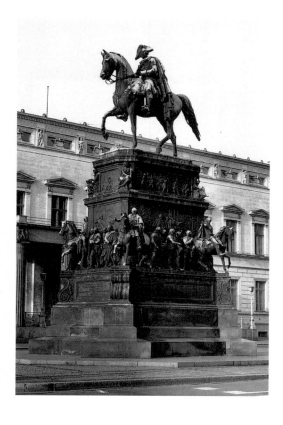

131. Christian Daniel Rauch,
Monument to Frederick the Great,
Berlin, 1836–51.

The design for the architectural portion of the Memorial should be regarded chiefly as a means of ensuring the most effective arrangement of the sculpture which is to complete it. The position, dimensions, and materials of the statues may be indicated without anticipating or interfering with the conceptions of the sculptors. It is conceived that this system of combined invention, so common among the architects and sculptors of antiquity when employed on temples and mausoleums, is no less desirable and practicable when the object is to provide an architectural base for groups of sculpture surmounted by the statue, which is required to be conspicuous ... Should a design be approved by Her Majesty, the Architect offering it will be commissioned to execute the work in conjunction with the Sculptor or Sculptors who may be selected.[29]

Eastlake's carefully explicit directions show how wrong the *Survey of London*'s account of the Memorial is in claiming that 'Architects rather than sculptors were now clearly in control of the design'.[30] Thus, when the various designs were assessed their ranking depended not on the architecture *per se*, but on the way it set off, displayed the sculpture.

In a memorandum to the Queen, early in 1863, Grey rated the designs by Scott, Charles Barry jnr, and Hardwick as the best: Barry's pedestal was good though the statue on top was 'commonplace'; Hardwick's impressive gilt bronze statue, twenty-five feet high, lacked connection with its surrounding terraces; Scott offered eight statuary groups, and used all the available money on the Memorial rather than on its setting, but the marble he proposed for the sculpture 'would not stand in this climate', and the Prince's statue seemed subordinate to the Gothic cross.[31] In a letter to Eastlake of 27 February, Grey said Victoria wanted to reiterate 'what you have already heard personally from Herself', and was anxious lest the Committee's recommendation 'should turn out to be at variance with the Queen's ultimate decision'. In summary, most of the designs looked too much like mausoleums; Hardwick's was ingenious, but 'the Statue would seem to be rather an ornament to the Garden than the Garden a fitting accompaniment and subordinate to the Statue'; Victoria had concluded 'that it will be better on the whole to adopt Mr. Scott's design for a Gothic Cross'.[32]

In March 1863, the Advisory Committee's report to the Queen praised the 'ability, ingenuity, and taste' of the designs, and 'the wisdom of the course suggested by Your Majesty'.[33] Referring to the general question of the durability of open-air statuary, the report noted that though schemes proposing marble sculptures had placed them within a building, the Committee thought that bronze, with or without gilding, and in some cases Sicilian marble, were suitably durable materials for statuary outdoors.[34] It was recognised that the designs could only 'indicate the position and dimensions' of any statues, 'leaving the Sculptors themselves uncontrolled in all other respects', and that 'judgement ought not to be influenced by any defects of detail in such necessarily vague representations of sculptured forms.' For the future, the specifics of the sculpture should be worked out in consultation with 'those whose studies and practice lead them to regard monumental works with reference to the site they are to occupy, and in relation to surrounding objects.'[35] Regarding the proposals, the Committee had been guided by the idea, 'prominent at all times among civilized nations, of a statue in a conspicuous situation, sufficiently large to form ... a commanding point of attraction', with 'accompaniments at

different heights to enrich the mass and sustain the impression intended'. Though Hardwick's design was thought good in this respect, it was too dependent on the accompanying hall. Scott's design was preferred because – quoting his own carefully worked-up explanatory text – it adopted 'the style of the most touching monuments ever erected in this country to a Royal Consort', the Eleanor Crosses, and had ' the character of a vast shrine expressive of the value attached to the statue it protects'.[36] Happily, and of course, the Committee's decision coincided with the Queen's wishes. It is also clear that the report's expert discussion of sculpture, its materials, and its position within the overall concept of a monument, can only have come from Eastlake.

When the Executive Committee was set up to oversee the building of the Memorial, both Phipps and Grey – discussing the possible membership – agreed at once on Eastlake: 'a good referee for the Queen', Grey wrote, 'on all subjects of Art or the Employment of Artists'.[37] Before any artists were employed, however, there were managerial and financial issues to settle. On 29 April 1863, Grey told Scott to separate 'the Architectural and Sculptural portions of the Work' and determine the cost of each:

> *Till this is decided the Queen is not in a position to communicate with the Sculptors whom Her Majesty may wish to employ and with whom when the proper time comes, Her Majesty will be anxious to communicate personally. It will be for you to point out, as part of the general design, what the size of the various figures forming the groups of statuary and the height of the Bas Reliefs should be. But ... each individual sculptor should not only know that he is selected directly by Her Majesty but that he receives his commission in fact exclusively from Herself.*[38]

Scott replied with his own worries about the cost of the sculpture, especially if the executants were appointed unconditionally – 'in such cases there is really *no limit* to the value which sculptors might have about their works.' At Eastlake's direction, Scott had already approached Theed for an '*opinion* on the probable cost', and been given a hasty estimate. Unbeknown to Scott, Theed had then sent a revised estimate to the Executive Committee, '*greatly* in excess of the first' and '3 times as much' for the podium frieze. Scott responded by getting far more reasonable costings from Henry Hugh Armstead (1828–1905) and John Birnie Philip (1824–1875), 'very talented' younger sculptors, one of whom had received 'very marked praise' from Albert himself. In addition, Scott secured Theed's agreement that the frieze should be done by a younger man.[39] Clearly, Scott was already intent on retaining control of the podium sculpture, which he regarded as part of the structure, 'being in fact wrought in the substance of the monument itself'.[40] In his report to the Executive Committee of 7 March 1864, he seemed to believe this control had been 'graciously conceded', subject to Victoria and her advisers approving preliminary models.[41] His cost estimates in the report, and others supplied the following month, include the figures in the flèche with the ornamental work, the architectural carving with the mosaics and gilding of the stonework, and the podium sculpture with the eight niche figures on the columns.[42] Ultimately, as Robert Thorne indicated in the previous chapter, sculpture would account for just under half of the total cost of the Memorial.

Although it was made clear to Scott by Doyne Bell that the contracts for such work must be made through Kelk, he was assured he would still retain control.[43] In fact Scott had begun assembling a team of carvers and sculptors in

July 1863, when making the model of the Memorial (134). For this Scott employed William Brindley, of the architectural sculptors Farmer and Brindley, with Armstead doing the statuary. Brindley, described by Scott as 'a man whose whole soul is absorbed in and devoted to his art', was to carry out all the Memorial's decorative sculpture.[44] The contract – a rare survival for work of this type – is signed by Brindley for the firm and Kelk as contractor. *Inter alia*, it provides for 'four large capitals to large piers in Darley Dale stone ... 140 feet material to be carved into crockets in hollow of arch ... Niches and Canopy. four Corbels to base of ditto – eight bases to columns carved mouldings – eight Capitals to columns – eight carved abaci to ditto. Canopy to ditto ... Sixteen lions at angles of Pinnacles ... 112 feet main cornice, five gurgoyles [sic]'.[45] Brindley worked under the 'very careful and anxious guidance' of Scott, who 'most carefully studied and revised' his models before 'allowing them to be commenced in stone'.[46]

The figure sculpture executed under Scott's immediate supervision consisted of the podium frieze by Armstead and Philip, eight statues against the columns of the canopy, eight statues half way up the spire by James Redfern, and eight more clustered round the base of the cross by Birnie Philip. These sculptors, as well as Farmer and Brindley, all worked closely with Scott at various points in their careers. Philip had produced figures for Scott at Jesus College Chapel, Oxford (1854–60) and All Souls', Haley Hill, Halifax (1856–9), the reredos at Ely Cathedral (*c.* 1857), and the screen at Lichfield (1859–63). Farmer and Brindley worked on Scott churches at Wooland and Cattistock in Dorset (1856, 1858),[47] and did the choir stall carving at Westminster Abbey (1859) and choir statuary at Lichfield (1860). According to Scott, Armstead came to his attention 'during the great Exhibition of 1862 through his beautiful figure-groups on the Outram shield'[48] and through his designs for the narrative relief sculpture (1861–3) on Prichard and Seddon's Ettington Park, Warwickshire.[49] Scott's connections with Redfern, though plentiful after the mid-1860s, are hard to establish initially.[50] Redfern had been taken up by the ecclesiologist A. J. B. Beresford Hope and placed for training with John Richard Clayton, and this may have been how he came to Scott's attention – indeed, Armstead had also been, since his student days, an 'intimate friend' of Clayton's, who was 'more than a brother' to him for over sixty years.[51] Clayton, in turn, designed the group of St George and the Dragon atop Scott's Westminster Scholars' Memorial in Broad Sanctuary, Westminster (1861), which was executed by Philip.[52] And Clayton, of course, designed the Albert Memorial's mosaics – as described in Teresa Sladen's chapter. Variously linked, these craftsmen-artists were essential to Scott's vision of a total gothic aesthetic uniting sculpture, ornament, mosaic, tilework and stained glass – an idea that had its English origins with Pugin and would shape much of Morris's Arts and Crafts. For Scott it emphatically included sculpture, and his team worked extensively with him till the end of his career, particularly in the restorations at Salisbury, Worcester, Westminster Abbey, Gloucester, Ely and Lichfield.

On 15 March 1864 Grey wrote to Eastlake with the Queen's choice of fine art sculptors for the Memorial: Baron Carlo Marochetti (1805–1867) for Albert; for the four outer groups, Theed, Foley, John Gibson (1790–1866) and John Bell (1812–1895); for the four smaller groups a choice from Matthew Noble (1817–1876), Lawrence Macdonald (1799–1878), Thomas Thornycroft (1815–1885), Patrick MacDowell (1799–1870), Joseph Durham and John Lawlor (1820–1901). Eastlake was asked to consider how commissioning should

be handled: designs followed by models might be produced, with the Queen retaining the final say on how the statues should be executed. Among the sculptors, Grey's letter concludes, Victoria was 'rather anxious' that Thornycroft should be picked. 'He is very poor, & the Prince had a high opinion of his ability. H. M. has *not* a very high opinion either of Noble or Durham – Yet they have executed the most popular statues of the Prince'.[53] Victoria's selection of sculptors is perhaps unsurprising. Theed, Foley, Marochetti, Noble, and Durham had done or were doing portrait busts or statues of Albert, who had also bought works from some of them, as also from Gibson, Bell, Macdonald, and Lawlor.[54] In the event, Gibson said he was too old, and was replaced for a larger group by MacDowell; Macdonald was dropped, possibly because he lived permanently in Rome, so too – unsurprisingly – were Noble and Durham, who were substituted by Henry Weekes (1807–1877) and William Calder Marshall (1813–1894). All those chosen, except Marochetti, had been involved in the programme of sculpture commissioned for the Palace of Westminster by the Royal Fine Arts Commission (132)[55] – chaired by Albert, with Eastlake as Secretary. It is reasonable to see Eastlake's hand in the choice made by the Queen – dismayed, as we have seen, by the 'difficulty' of choosing sculpture with Albert gone. In this sense, the final selection of artists for the Memorial was not just a tribute to the Commission's work, but its triumphant conclusion, as the careers of seven of the nine sculptors chosen had developed out of their involvement with the Westminster scheme. Only Marochetti, whose selection was strictly personal to the Queen, was wholly outside this; for Lawlor, though he did nothing at Westminster for the Commission, had worked on the architectural sculpture, before coming to Prince Albert's attention at the Great Exhibition.[56]

While the sculptors were being chosen, the terms of their contracts had to be drawn up. This was a tricky and potentially litigious issue,[57] made more sensitive by the very nature of the Memorial. The reputation of the crown was involved; there was a large voluntary subscription; and parliament was providing public money, jealously guarded by a dubious Gladstone, then Chancellor of the Exchequer. Two earlier public monuments gave ample cause for disquiet: work on the *Wellington Memorial* in St Paul's Cathedral, begun in 1855, was constantly delayed and was to remain unfinished until 1912;[58] and the *Nelson Memorial* in Trafalgar Square, for which the first competition had been held in 1837, was not completed until 1867 when Landseer's lions were unveiled (133).[59] In 1863, indeed, Gladstone had expostulated about the cost of the lions and what he saw as a parallel with the cupidity of Marochetti:

> *Does Sir E Landseer mean to give us four designs of Lions or only one ? ...*
> *You may think it strange that I should suggest anything so flat and poor*
> *as the repetition of the same design on the four pedestals or bases. And*
> *I should have thought so too, had I not learned that Baron Marochetti had*
> *repeated the same Angel !! on the four tablets of the monument at Scutari*
> *for which I am told he received above £17,000.*[60]

Eastlake's reply to Grey's letter of 15 March marked the start of a meticulous process of consultation. He proposed to begin by telling each sculptor what was actually required of his group – subject matter, scale, number of figures and so forth. If bronze was used, sculptors needed to retain a measure of control: 'in the event of the casting being undertaken independently of the artist, he would be at liberty, ultimately, to retouch the cast'. The sculptors

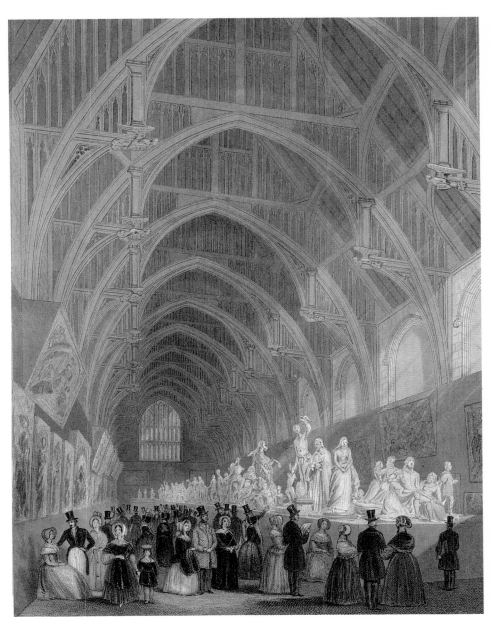

132. The exhibition in Westminster Hall of models of statuary for the New Palace of Westminster, 1844; hand-tinted engraving by William Radclyffe, after a drawing by B. Sly (Benedict Read).

133. John Ballantyne, *Sir Edwin Landseer Sculpting his Lions*, c. 1865 (National Portrait Gallery).

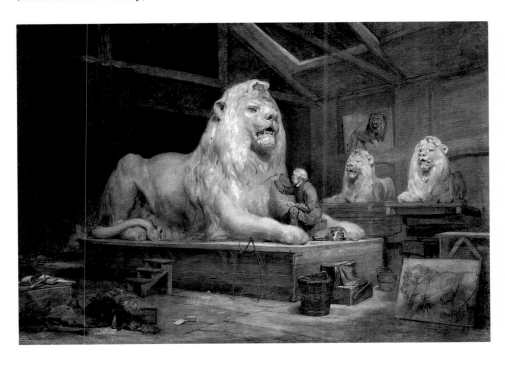

should consult each other, as well as Scott, to ensure proportions agreed and designs were varied.[61] A fortnight later, on 1 April, Henry Cole weighed in with a memorandum to Grey, its fifteen bullet points – the phrase is wholly appropriate to his manner of communication – amounting to an assertion that the major part of making sculpture came down to artisan manufacture. Though an artist drew up or modelled the original design, he need not be involved in enlarging it to a working model, or in its final execution – and the contracts for the Memorial should reflect this.[62] One wonders what experience Cole had of working with Fine Art sculptors: his close association with the madly obsessive John Bell could never have borne out his opinions, and the great names he cites in support of his argument – Flaxman, Chantrey, Rauch, Thorwaldsen – were all safely dead. Cole's views were rightly ignored while Eastlake, far more experienced and knowledgeable, was guiding the project, but they may well have influenced attitudes to the Memorial's sculptors after Eastlake's death. Meanwhile, Eastlake worked assiduously on the contracts. At his suggestion, Grey called on Foley to get his opinion of the proposed terms, and Phipps also wrote to Gibson about them.[63] Eastlake agreed with Foley that the final execution of the sculptures from the large model stage should not be treated as a separate process, especially if the groups were to be carried out in stone. In addition, if the first model were objected to, the sculptor should have a chance to amend it before it was absolutely rejected.[64]

The final terms to be offered for the eight statuary groups came in a letter of 14 May 1864 signed by Grey. After a preamble explaining that 'H.M. has determined to entrust the execution of each group to a separate sculptor', the letter offered the recipient either one of the large groups comprising 'five human figures and an animal or such other emblems as you should think most appropriate to represent' or one of the smaller groups containing four figures, specifying the size in both cases. The sculptor would be invited 'to furnish a design, consisting of a small model in clay', from which, if approved by the Queen, he would be 'asked to execute a full sized or working model'. Victoria was to purchase 'both the design and the working model', which would be 'her absolute property, until the completion of the work' when they would revert to the sculptor. If the Queen did not approve the design, the sculptor could be asked 'to modify it, or to furnish an entirely new one'. If the groups were to be in marble, the execution would be left entirely to the sculptor, to be completed within an agreed time. However, the Queen reserved the right 'to select someone else' if, through 'illness or any other cause', the completion date was not met. This provision, and that whereby Victoria owned the design and full-sized model, were necessary, the letter continued, 'in order to prevent the completion of this great work being indefinitely postponed by the death or illness of those engaged in its execution'. If the groups were bronze then the Queen would be 'at liberty to have the casting executed where, and in the manner She may think best'. As funds were limited, 'and no addition to them of any importance can be looked for', the commission was offered 'at the rate of £800 a figure' and, in the larger groups, '£400 for the animal', giving totals of £4,400 each for the groups representing 'the four quarters of the globe' and £3,200 each for those of the industrial arts. The sculptor was then asked whether, for the sum offered, he was able to undertake the design, 'the full-sized working model', and 'the complete execution of the work in marble or bronze', and the time needed for completion. An answer was required as soon as possible, though the letter acknowledged that estimates for 'the complete

execution' of a marble group would depend 'on the description of marble to be employed'.[65]

The complexity of the contract was unusual, but for good reason. The control exercised by the Queen through the Executive Committee was crucial to ensure the Memorial's overall design was not prejudiced, and to insure against death or incapacity – admirably farsighted as it happened. The sculptors were given some rights over the process of final execution, as well as being able to change the initial design if it was unsatisfactory – again a useful safeguard as things turned out.

As yet, of course, the choice of material for the groups had not been determined. One of the major foundries of the time, Elkington's of Birmingham, had submitted a list of sample costs in March 1863 for bronze-casting or zinc/copper deposit.[66] Interestingly these were for works by royal favourites – *Boadicea* by John Thomas (1813–1862), *Viscount Hardinge* by Foley or – from a scheme sponsored by royalty – the *Magna Carta Barons* commissioned for the House of Lords by the Royal Fine Arts Commission. In March 1864 Scott expressed regret at the apparent preference for bronze 'as the dark colour of bronze is not so agreeable as the light colour of marble', though he was prepared to accept that 'durability is the first consideration'.[67] Eastlake reported that there had been 'strong representations' from the sculptors as to the unsuitability of bronze 'from its rapid tendency to become black'. It had therefore been decided 'that the groups should be executed in what is called Sicilian marble, which though less brilliantly white than the ordinary statuary marble, is calculated to last well, even in this climate in the open air'.[68] Maybe this was not surprising. From the beginning Scott was determined to maintain 'rigorous control' over the sculptors, for they had the power 'to shipwreck the whole project'. In particular, he wanted to ensure the 'style of treatment etc. which would best harmonize with the character and intent of the design'.[69] Eastlake supported this, and also encouraged the artists to consult with one another.[70] The sculptors of the four large groups met with Scott by July 1864, and said that they shared his preference for marble over bronze; further meetings, some including Eastlake, took place later in the year.[71]

Significantly, the sculptors of the *Continents* – Bell, Foley, MacDowell and Theed – not only consulted together but also negotiated as a body. The royal favour enjoyed by Foley and Theed may well have been crucial when they began quibbling over the financial terms laid down in Grey's letter of 14 May. In June 1864, in a joint letter, they accepted the commissions, but pointed out the extraordinary difficulty of combining five figures and an animal. This was not unreasonable, for in practice such multi-figure compositions were virtually unknown. The sculptors wrote again on 5 July, and on 9 July Foley and Theed met the Executive Committee who agreed to increase payment to £5,000 per group. The four sculptors tried again on 22 March 1865, when they wrote claiming that the £5,000 was insufficient, as the marble was much harder than any they were used to and thus took far longer to work. In a letter of 17 April to all eight group sculptors, the Committee detailed how payment would be made: first instalment when the sketch model was approved, second when the quarter-sized model was finished, third when carving started, fourth when the group was complete, and final payment when it was fixed in position. An appended letter to the *Continents'* sculptors summarised negotiations to date, pointing out that they had known about the marble for some months when they accepted

the commissions: as funds were now 'fixed with great exactitude and nicety', and all the contracts agreed, the Committee could not reconsider the payment for the groups. However, they thought it 'so extremely desirable that all the artists engaged in the various branches of the Memorial should work heartily and feel their exertions are remunerated on a scale satisfactory to themselves', they undertook to review the matter in the event of there being any surplus money available.[72]

With the contract letters sent out and accepted, the sculptors began work on their initial models. Scott, who had ensured the sculptors would consult with him, had already formulated an overall narrative structure for the monument, which he laid out in a letter to Grey on 25 April 1864. 'My idea in designing the Memorial was that the upper and smaller tier of groups should illustrate allegorically or otherwise, the principal industrial arts and occupations; and that the lower and larger groups should relate to the four quarters of the Globe in reference to their appearing as contributions to the two International exhibitions.'

The descriptions Scott then gives of the groups are broadly similar to what was finally produced: their iconography is discussed by Colin Cunningham in the following chapter. Armstead's renderings of them on the model (134) are commended by Scott 'as regards their outline and dimensions as portions of the general design'.[73] Having met the sculptors, Scott wrote in July 1864 to Doyne Bell saying that they all wanted to borrow 'the groups belonging to the model … as their General guides'. Although Bell refused permission, he suggested that copies could be made from Armstead's moulds.[74] There is no record of this being done, but it demonstrates how determined Scott and the sculptors were to follow the original design and conception of the Memorial.

The sculptors submitted their models in November 1864, the figures measuring about one foot in height. Though the models do not survive, contemporary photographs allow us to assess their relationship to Armstead's versions, and to trace the process of adjustment and amendment all the way through to the groups on the Memorial itself. The Queen's views were of first importance, but also crucial was their mediation through Eastlake, who was asked – in a letter from Grey of 6 December – to deal with Scott and the sculptors on her behalf. She was generally pleased with the models, though she thought considerable changes would be required in some. In representing her views, Grey told Eastlake, 'HM relies implicitly on your tact and discretion to prevent the proverbial sensitiveness of artists being offended on either side'.[75]

Eastlake had already arrived at his own views, formulated in a letter of 21 November. Of the models for the *Continents*, Foley's *Asia* (135) was 'a work of real excellence', while Bell's *America* (136) and MacDowell's *Europe* (137) were 'quite safe in their general arrangement'. However, 'some of the details' of MacDowell's design needed correction:

> *The festoon (or what has the effect of one) held by France and England is not, I think, a fortunate idea – nor can detached olive branches be executed well in sculpture. It appears to me also that the figure of Britannia is not characteristically conceived – Germany and Italy are better, though in the latter the bust, considered as an allusion to former empire is hardly intelligible and moreover looks like a buried statue.*

Theed's *Africa* (138) was less satisfactory: 'it has no principal view – or, which comes to the same thing, the principal view wants breadth and simplicity'.

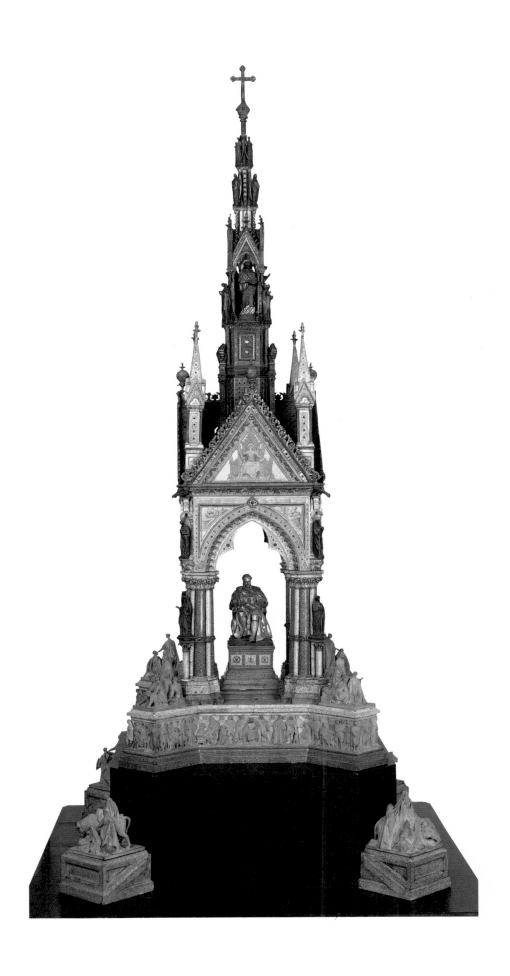

134. Model of the Albert Memorial made
by William Brindley, with sculpture groups by
Henry Hugh Armstead, 1863
(Victoria and Albert Museum).

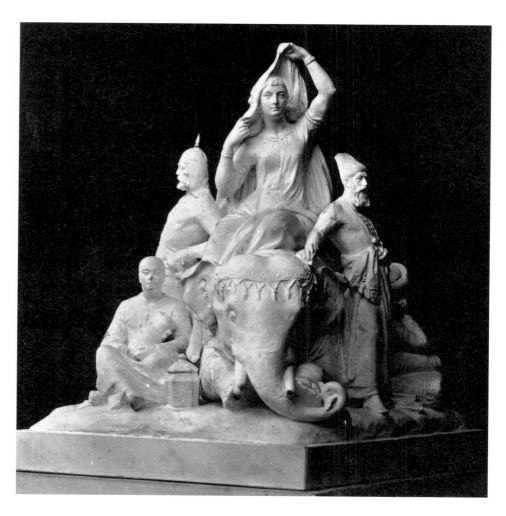

135. John Henry Foley, Model of *Asia*, 1864 (Royal Archives).

136. John Bell, Model of *America*, 1864 (Royal Archives).

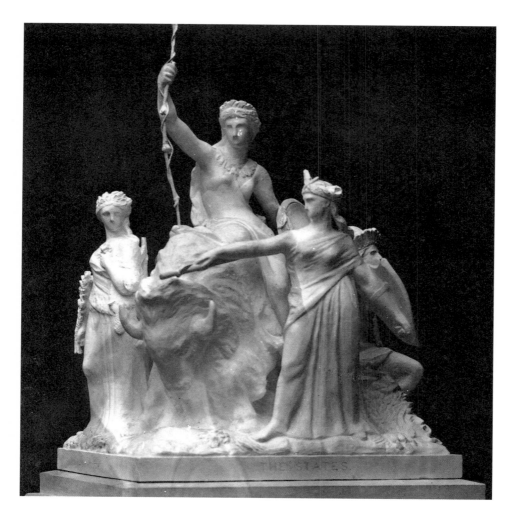

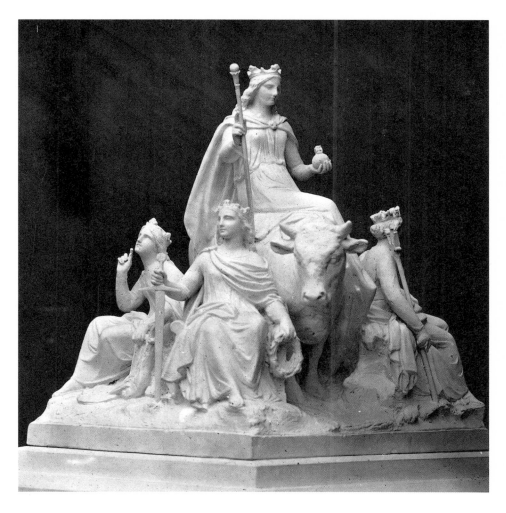

137. Patrick MacDowell, Model of *Europe*, 1864 (Royal Archives).

138. William Theed, Model of *Africa*, 1864 (Royal Archives).

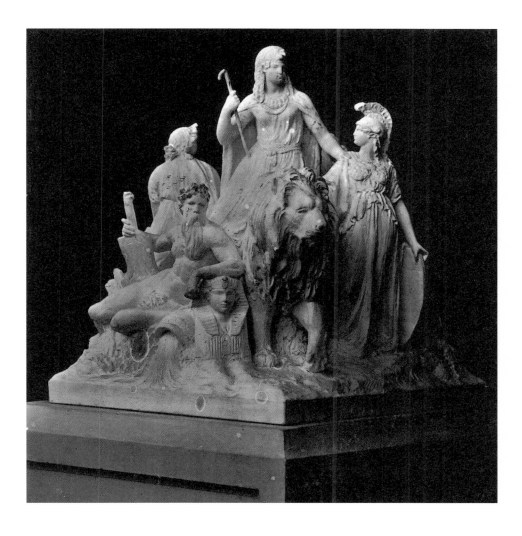

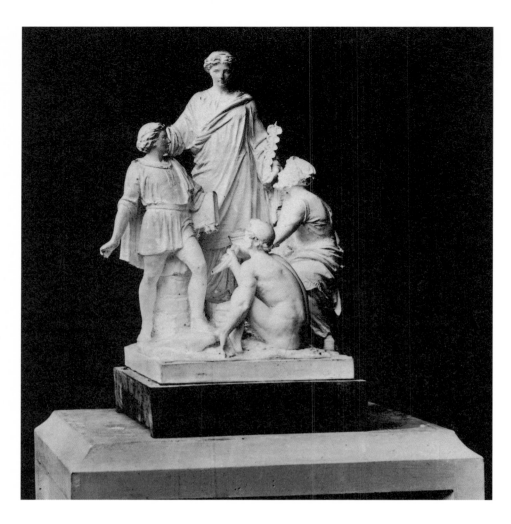

139. Thomas Thornycroft, Model of *Commerce*, 1864 (Royal Archives).

140. William Calder Marshall, Model of *Agriculture*, 1864 (Royal Archives).

But as Theed 'is always ready to hear criticism and never tired of making alterations', Eastlake was sure the composition could be improved, and the 'details are sure to be well studied'. Of the *Industrial Arts*, Thornycroft's *Commerce* (139) and Calder Marshall's *Agriculture* (140) needed 'only minor alterations', but Weekes' *Manufactures* (141, 142) and Lawlor's *Engineering* (143) were 'more open to criticism'. Indeed Eastlake thought Lawlor's work 'hardly seems to be that of a practised artist'. Nevertheless, provided Scott was satisfied with the masses and their shapes, then Eastlake was confident it would all turn out well. 'Foley's work is glorious' he reiterated, 'all the more welcome and important as it will constitute a point of excellence which the other sculptors will doubtless do their utmost to rival'.[76]

In his role as Victoria's representative, Eastlake sent more detailed critiques to the sculptors. His letter of 2 January 1865 to John Bell, apparently part of an ongoing discussion, is characteristic, both in its steady grasp of the Memorial's overall conception and its scrupulous attention to detail. The figure personifying Canada, Eastlake wrote, would be 'intelligible', and posed so as to appear 'collected, peaceful, and, as regards the other states, independent'. But rather than carrying a palm branch, 'chiefly the emblem of Victory', he suggested she should have 'a sceptre, not grasped by, but within her folded hands'. It could 'terminate in a crown as its finishing ornament, which … might just clear her shoulders', as having 'too many detached, liney forms' was undesirable, particularly because 'the architect wishes to avoid the partial introduction of bronze'. The sceptre 'would indicate attachment to a monarchical government'. Eastlake doubted whether 'a crown of oak leaves would connect her more with England', proposing instead 'a crown of ears of corn, indicating part at least of the produce of the colony'. Turning to the figure representing the United States, he congratulated Bell on overcoming earlier difficulties 'by making her guide, rather than restrain, the eager progress of America': the 'baton … in her right hand connects her with the animal and indicates control over his movements'. The shield on her arm was more problematic, for it could appear defensive, and 'the action of the figure is such that, while so armed, she seems marching to battle'. Such a representation might be thought to refer to 'passing political interests' – Eastlake meant events connected to the American Civil War – which was 'not desirable' in 'a permanent monument', especially as the Memorial was so intimately connected with the Great Exhibition, when 'the meeting of different nations … was altogether peaceful'. Regarding the other figures, which Eastlake praised as 'unmistakable', 'Mexico might perhaps be represented in the act of rising from a recumbent posture', but Bell was right to show him 'in the costume of the Aborigines', 'for the Indian subjects even of the modern Mexican Governments have been numerous'. With the 'representative of South America', the only problem was 'the musket he holds': apart from 'the difficulty of executing it in marble', Eastlake feared it was 'somewhat below the general dignity of your general style of representation'. Finally, Eastlake urged Bell, 'keep your altered model in the clay for some time, and when you have pleased yourself with the composition … carry through the work to a greater degree of finish than that of the first model'.[77]

When Eastlake reported on the sculptors' amended models on 2 March 1865, he noted that 'alterations more or less important were suggested for each': perhaps the most substantial was changing the animal in Theed's *Africa* from a lion to a dromedary (144).[78] On 13 March Doyne Bell told Foley,

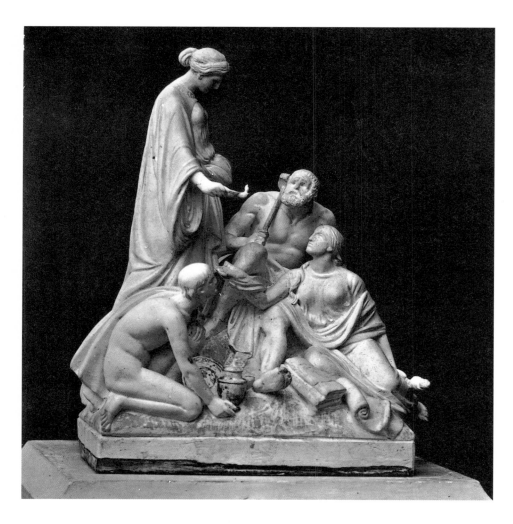

141. Henry Weekes, Model of *Manufactures*, 1864 (Royal Archives).

142. Henry Weekes, *Manufactures*, 1865–71; photograph of *c.* 1875 (National Monuments Record).

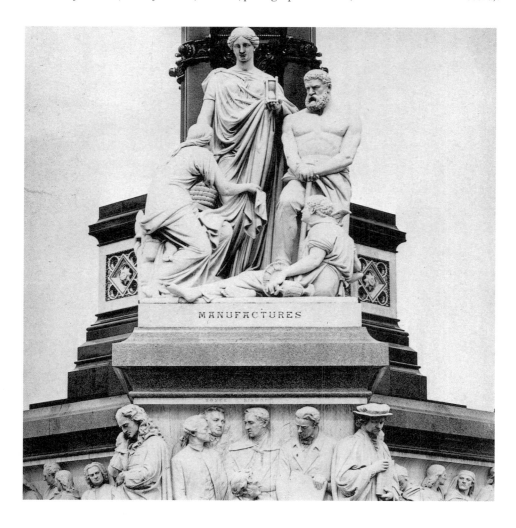

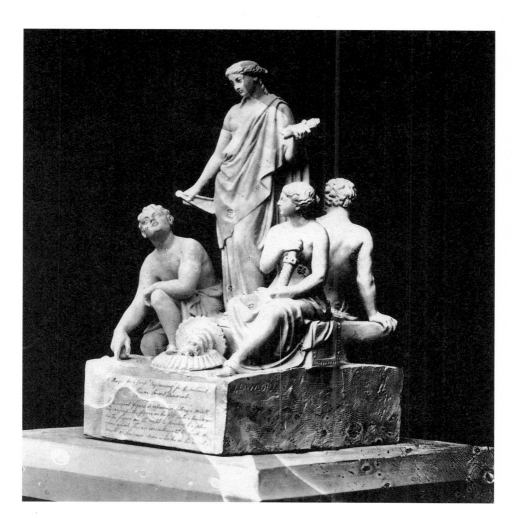

143. John Lawlor, Model of *Engineering*, 1864 (Royal Archives).

144. William Theed, Second Model of *Africa*, 1865 (Royal Archives).

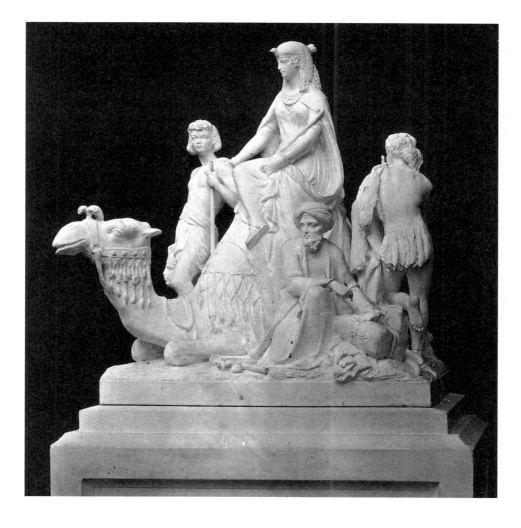

MacDowell, Theed, Bell, Calder Marshall, Weekes and Thornycroft that the Queen had approved their models: subject to some slight modifications to be pointed out by Eastlake, they could at once proceed to the next stage.[79] The one sculptor not included was Lawlor, who was having difficulties producing an adequate model, and continued trying for the rest of the year. A Doyne Bell memorandum of 2 December noted that Lawlor had by then submitted five models, the latest being much larger than those of the other artists. Lawlor had complained of his inability to model on a small scale, and at Scott's suggestion he had been allowed to carry out his ideas on a scale selected by himself. It proved successful (145): with certain conditions, Doyne Bell proposed that the sculptor should proceed to the full-sized working model.[80]

Eastlake did not participate in the later stages of the negotiations with Lawlor. In August 1865 he had left England for Italy, 'exceedingly unwell'; he died at Pisa on Christmas Eve.[81] Earlier in the year, writing to the Crown Princess of Prussia, Grey had paid tribute to him: 'we owe much to Sir Charles Eastlake's tact and conciliatory manner in dealing with the different artists'.[82] The Executive Committee lost little time in finding a successor. On 15 January 1866 Grey wrote to Austen Henry Layard, inviting him 'to act upon the Committee … in the place of the late Sir Charles Eastlake'. The Queen felt, Grey continued, 'that your knowledge of Art will be of great use to her in any future discussions that may arise as to the groups of Sculpture of which the working models are now being prepared'. Generally though, with the possible exception of the expected government grant of gun-metal for the bronzes, Grey did not think 'this charge will entail any great amount of trouble upon you'. It was a wildly inaccurate forecast.[83]

Layard is now best remembered as the excavator of Nineveh and Babylon, the author of *Nineveh and its Remains* (1848–9), and the man who brought the British Museum its great collection of Assyrian antiquities. He was, however, many things in his life – traveller, adventurer, diplomat, possibly a spy, archaeologist, author, politician, Member of Parliament, Government Minister and art expert.[84] As Teresa Sladen outlines in chapter eight, Layard had an intense and highly knowledgeable enthusiasm for the art of the Italian Renaissance, particularly painting. From 1855 he corresponded with Eastlake on art historical matters, and one of Eastlake's last acts, on his deathbed in Pisa, was the acquisition of a painting for the National Gallery through Layard's advice. Had Layard not been a serving minister in the Foreign Office, it seems likely he would have succeeded Eastlake as the Gallery's Director – but regulations made this impossible. Instead, he became a Trustee, which he remained until his death in 1894, when he bequeathed some of his own collection to the Gallery. Though he could not aspire to Eastlake's position at the Royal Academy, Layard was also involved with contemporary art, and was friendly with both Frederic Leighton and John Millais.

Layard immediately set about his duties with characteristic vigour and thoroughness. In early February he visited MacDowell's studio: his criticism was limited to 'the right leg of the French figure – which either from the disposition of the drapery, or the position of the left leg, had the appearance of having been amputated at the knee'. MacDowell promised to amend the drapery.[85] Drapery also worried Layard on Weekes's figure of Industry, and he suggested consultation with Scott.[86] Visits to Calder Marshall and Lawlor followed – the latter after advice from Grey that 'he is one of the artists who will *require watching*'.[87] Thornycroft's *Commerce* Layard found 'altogether

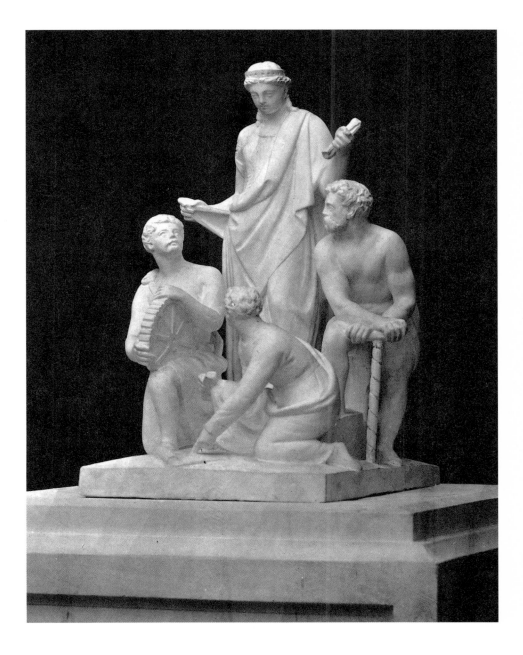

145. John Lawlor,
Final Model of *Engineering*, 1865
(Royal Archives).

satisfactory', and he was 'much pleased with the model' of Bell's *America*, the sculptor having removed many of the details which previously impaired the group's general effect.[88] On visiting Foley's studio in July, Layard – informed by his Middle Eastern travels – suggested that *Asia* should include not a Turk as first intended but an Arab, to represent 'the great typical race, which has given a religion and laws to so large a portion of the East'. As Foley was enthusiastic Layard further proposed that the Arab 'recline on the saddle used for riding the Dromedary, and … either hold, or have near him, a MS of the Koran'. He promised to send the sculptor 'some Eastern objects' so Foley could 'introduce appropriate details':[89] Persian writing implements[90] and a camel saddle[91] arrived in due course.

Layard also took a close interest in the work of Armstead and Birnie Philip on the sculpture for the podium frieze. Having seen their models, he was concerned about an apparent difference in depth of relief: while Armstead confined himself to two levels of relief, some of Philip's figures were so detached as to be almost in the round, which he offset by introducing a further level, in very low register.[92] Revisiting Armstead's studio with Scott, and inspecting part of the full sized model, Layard was somewhat reassured, and despite 'a certain meanness and "stringyness" in the limbs' thought Armstead's work promised 'to be very creditable to him'.[93] With Philip he was less happy, the use of an extra relief plane increasing the inevitable complications inherent in combining figures in the round and in relief. Treating 'one part … truthfully and literally and the other conventionally' had, Layard thought, no precedent 'in the works of the great Greek sculptors', and 'Mr Scott quite agreed'. Layard's anxieties about the possible disharmony between the two contributions were scarcely allayed by hearing that there was 'some little professional jealousy between Mr Armstead and Mr Philip, which makes them unwilling to consult one another, and to work together … [as] … they ought to do'.[94]

In a magisterial letter to Philip of 3 March 1866, Layard spelt out his criticisms and his remedies. The 'heads of your figures', he told Philip, 'wanted variety and character and were modelled too much on one type'. Although the Greeks represented gods and heroes by means of 'a general and to a certain extent, single type as in the reliefs of the Parthenon … in representing individuals they would scarcely have done so'. Though 'portrait busts or statues of pure Greek workmanship of the best time' were rare, Philip was directed to the 'undoubted copies of early works … in the British Museum', such as the 'fine portrait statue of Mausolus, from the ruins of Halicarnassus'. Having examined the statues in the Museum specifically 'with a view to seeing whether they could afford … any hints for treatment', Layard thought Philip might study them 'with advantage'. 'Mr Newton, the keeper of the classic antiquities' was willing to help, and Philip should also consult 'Visconti's great work, the *Iconographie Grecque et Romaine*' for authoritative details and portraits. Anxious for authenticity, Layard asked whether Philip was aware 'that according to a tradition preserved by Greek writers, Phidias was bald ?' (146) Turning to the treatment of the relief, Layard said he had 'carefully studied the main reliefs "alto", "mezzo" and "basso"' in the Museum, 'with reference to the … employment of the three together in the same work', and urged Philip to read 'Sir Charles Eastlake's excellent paper on bas reliefs':

> *You will find by reference to the monuments preserved in the British*
> *Museum that even the Romans generally avoided the use of three in the*

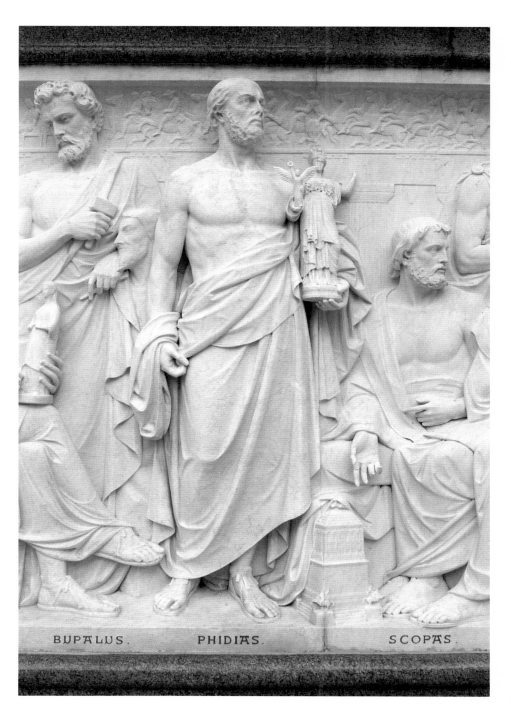

146. John Birnie Philip,
'Phidias' from the *Sculptors* frieze,
1866–72.

The inline text in the image reads: BUPALUS. PHIDIAS. SCOPAS.

same work ... [and when] ... perspective and conventional treatment
was adopted by the Greeks it was in reliefs placed considerably above the
spectator, as in the friezes of the Parthenon and on the Mausoleum ...
[where] ... effects which we cannot now perhaps understand, were
obtained by the use of colour.

Philip's difficulty was 'to reconcile the true with the conventional in reliefs which are lifesize and may be examined by the spectator almost on his own level'.[95] A couple of months later, on 17 May, Layard was able to write of major improvements. His and Scott's suggestions had been taken up diligently by Philip: the heads in the frieze had more character, the draperies were better, the details that had been introduced added a good deal to the general effect. Philip's work, Layard felt, now promised to be highly satisfactory.[96]

One aspect of the Memorial, however, proved the rashness of Grey's prediction that Layard's responsibilities would be relatively trouble-free: the statue of the Prince Consort himself. Its commission from Marochetti was by its nature problematic, for it came directly and personally from the Queen, who was paying for the statue herself. Her choice of Marochetti resulted from the high regard she and Albert had for his work, and is unlikely to have involved consulting Eastlake. Technically, the statue was not part of the Executive Committee's remit, which was mainly concerned with overseeing the effective handling of public money and completion of the project. Indeed, the agreement with Marochetti was possibly only a verbal one, and Grey at one point expressed doubts whether the Baron was even bound by the same conditions as the other sculptors.[97] Marochetti turned sixty in 1865, and there is no doubt he was under pressure from his success in obtaining commissions for public statues both in Britain and abroad. With varying degrees of enthusiasm, he was working on a seated figure of Albert for Aberdeen (147) and an equestrian statue of the Consort for Glasgow (148), as well as on the twin effigies of Albert and Victoria for the Royal Mausoleum at Frogmore. According to one anecdote, Victoria sent a lady-in-waiting to view the model of a statue of Albert that Marochetti had not even started. Having escorted her to the studio door, behind which his faithful chief modeller was making noises intended to convey hard work, Marochetti warned her that his initial models were always nude: 'draperies and uniforms I leave, in great measure, to my assistants. At this moment the statue is still undraped'. The lady-in-waiting decided to come back another day.[98]

On Layard's first visit to Marochetti's studio in February 1866 the large model of his statue for the Memorial was still incomplete, and the sculptor had made changes from the small model previously submitted to the Queen.[99] The question of the amount of bronze needed to cast the statue arose in April[100] – a sensitive issue, for the government was providing the metal, and Marochetti had been implicated in instances of questionable practice involving bronze-casting. Gladstone's indignant comments on the Baron's charges for the *Angel of Scutari* have already been quoted; earlier, Marochetti had appeared as a neutral witness in a lawsuit brought against Louis Soyer, accused of 'diverting' bronze cannons supplied by the French Government for statues of the Duc d'Orleans in Paris and Algiers.[101] The Memorial's Executive Committee also worried whether Marochetti had adopted certain suggestions the Queen had made about the statue's proportions: he replied claiming ignorance of any such proposals, though he had taken up other suggestions about likeness and costume.[102]

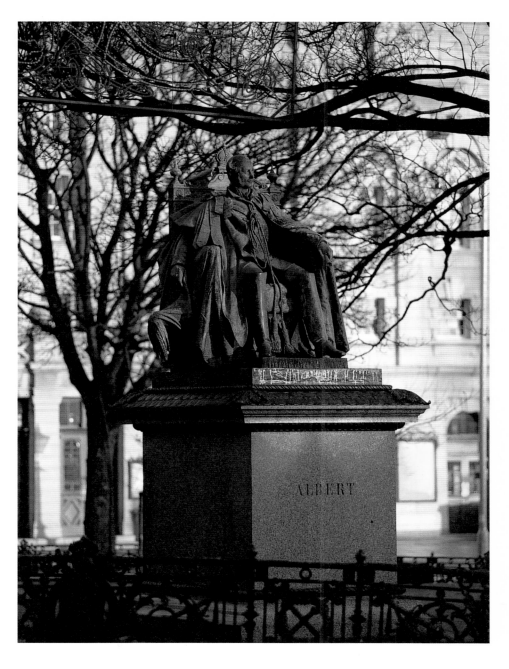

147. Carlo Marochetti, *Prince Albert*, Aberdeen, 1862–3.

148. Carlo Marochetti, *Prince Albert*, Glasgow, 1864–6.

Not until early January 1867 was Layard able to report he had seen the 'almost completed' full-size plaster – but in so small a room he could not form any opinion about its merits or the effect so large a mass might produce.[103] The Queen would have to see it, Grey wrote, but in the meantime she wanted Layard's and Scott's opinion: 'there are so many considerations as to size, etc. in connection with the Architectural design' that she had to know whether Scott was satisfied.[104] On 7 March Layard replied that he and Scott had visited Marochetti's studio, where the statue was 'almost finished'. They did not think the Queen should see it yet: 'anything but a favourable impression can be derived from so large a mass in pure white plaster, seen from a very small distance – and without light and shade to give the proper effect to the modelling of the more delicate parts.' Marochetti was suggesting the model should be gilded and even silvered in parts, which could be done in about a month. All three agreed the model should be tried *in situ* on the Memorial. 'It is really impossible to judge of the effect of so large a mass – nearly 14 feet high – when seen from the distance of only a few feet and on a level with the spectator.' It might be altogether different when seen from a distance, at a considerable elevation and in the open air. Every care had to be taken that only Victoria and those immediately concerned with the Memorial should see the model in place, as premature public criticism might be prejudicial to the ultimate success of the monument.[105]

Layard must have known trouble was brewing. No sooner had the Queen intimated that she would wait and see the gilded model in position, than Marochetti visited Layard and complained he felt 'uncomfortable' about the impression it had made on Scott, and was afraid he might be required to make considerable alterations.[106] He was quite right. Shortly afterwards Scott wrote to Layard:

> *I am glad that the cast will be 'tried up' in its place as any figure to be placed at that elevation is difficult to be judged of otherwise than in position, and this seems to me doubly difficult in case of a sitting figure which is so apt to look – to use a familiar term – 'all of a heap' when seen from below. The Baron says that he has no doubt about its effect and his experience must give him every means of judging, but to others it would be satisfactory to see with their own eyes.*[107]

Meanwhile, Marochetti was still working on the statue. On 25 March he invited Layard to see the head, 'before I cast it in plaster';[108] on 5 April he claimed the statue would be finished 'in a few days';[109] on 9 April he said he would be ready for the trial 'within a fortnight'.[110] A fortnight later Scott had decided 'Marochetti does not care to try it up'.[111] But eventually the experiment was made, and on 29 April Victoria viewed the model in position.[112]

As soon as he saw it, Scott wrote to Layard: something had to be done. The figure gave an impression of '*prodigious size*', 'ungainly clumsiness', even 'ugliness'.

> *It strikes me that, when a statue is to be magnified to so Colossal a size, it needs to be* refined, *its proportions a little* lightened, *and the folds of the* drapery *reduced, or it becomes offensive just as a man would if viewed through a gigantic Magnifying glass. I had hoped that the distance and height would have modified this, but they fail to do so.*

Instead, the figure was thrown 'into a heap' by the perspective, 'the body ... *sunk* and *shortened* while the legs look unnaturally developed'. Moreover, in scaling up the drapery from the small model, the folds had become 'so large as to be *impossible*'. Scott urged that the body 'be a little unnaturally *lengthened* to meet the first difficulty and the folds *more subdivided* and *lightened* to meet the second'. And when this was done, the whole figure should be reduced mechanically by at least 5 per cent.[113]

At a meeting with Layard and Scott, Marochetti claimed the best solution was to replace the seated figure with one on horseback, and offered to try this out with the cast of an equestrian Albert that he just happened to have in his studio – probably the Glasgow one. Scott objected: an equestrian figure was inconsistent with the general design and object of the Memorial. Instead, Layard proposed substantial alterations in the drapery, and an overall reduction by about 7½ per cent. Marochetti conceded, but wanted the Queen's sanction for the changes first.[114] On 4 May Grey forwarded Victoria's approval, adding that there was 'no doubt that the front view, especially, was too heavy, and from the Mass of Drapery extending right and left beyond the Pedestal, that it had a somewhat shapeless appearance.'[115] Scott was still convinced Marochetti favoured an equestrian figure, and towards the end of June wrote to Layard repeating in some detail how this was entirely against the design and spirit of the Memorial.[116] Layard sent the letter with one of his own to Grey, who replied promptly. Having read the letters, Victoria had instructed Grey to tell Marochetti that 'in the face of such a strong expression of opinion from Mr Scott, an Equestrian Statue must not be thought of – Surely he ought, as Mr Scott says, to be able to overcome the difficulties in the way of a satisfactory arrangement of a sitting figure'.[117]

In August 1867 matters came to a head. As he related to Layard on 7 August, Scott was invited to Marochetti's studio with assurances that if the model was not right now, 'nothing would make it do', only to find 'a mechanical reproduction, to a scale one tenth smaller, of the former figure (in the nude)'. Scott thought it was 'worse than useless to offer the smallest suggestion'; whatever was proposed, Marochetti pronounced it 'to be wholly inadmissible' and seemed 'determined to do just the reverse'. Scott was close to giving up.

> *My own conclusion is that he has no wish for it to succeed, but by a determined refusal to correct all defects ... to drive us to the adoption of an equestrian figure or to shift the blame of failure from himself to me. I am myself convinced that if he had any real desire to make the figure successful he would have no difficulty in effecting it, but I simply despair of inducing him to make even the smallest effort ... He says that his first model was merely imitated from Armstead's little model which I lent him,* as he thought that was what I wanted. *I can only say that I had no thought of his following it when I shewed it to him and that* he asked me *to leave it with him ... but I suppose ... he had made up his mind that whatever said – be it great or small, must – ipso facto – be wrong – and went so far as to say he wished we would go to another sculptor.*[118]

Layard quickly intervened. After a long session with Marochetti he reported to Grey that the sculptor had promised 'he would do his utmost to execute a seated figure which would satisfy Mr Scott'. The scale of the figure had been reduced, and Marochetti was endeavouring to make it more lively: one of the arms would be extended; the Prince would be given a scroll engraved with

a representation of the Great Exhibition; the 'heaviness' and 'lumpiness' of the Prince's cloak would be eliminated.[119] Grey in response was unimpressed, especially as Marochetti was now demanding payment for work he had not completed. It might be necessary, Grey concluded, to take Marochetti at his word, and find another sculptor.[120] Layard remained confident,[121] but little happened until the turn of the year, when the situation was suddenly and dramatically resolved. On 29 December 1867, at Passy near Paris, Marochetti died of a heart attack brought on by too much high living.[122] In a letter to Layard, then in Venice, Scott wrote of his 'deep concern and surprise' at 'the startling intelligence'.[123] Replying on 8 January, Layard said he had last seen the Baron at Calais the previous month: Marochetti's parting words had been to promise 'that on [Layard's] return to England the model of the Prince Consort Statue would be ready'.[124]

The immediate question, of course, was what should happen next. Should a new artist be engaged, and if so, what exactly would he need to do ? Scott's opinion was decided, as he told Layard: 'I would say that we have *only one* man suited to the work and that that man is *Foley*'. Admittedly, Foley was 'very backward' with the *Asia* group, but it needed only 'a moderate amount of his own time.' As to whether any of Marochetti's work could or should be used, Scott believed 'the new artist ought not to have his ideas cramped by being asked to work with any reference to these merely tentative models, but ... should start afresh on his own thoughts'.[125] Writing back to Scott, Layard largely agreed: 'It is perhaps a proof of Foley's acknowledged superiority in his art that, when I learnt of Baron Marochetti's death, his name occurred to me at once as it has done to you, as that of the sculptor who ought to undertake the statue.'[126]

The situation was delicate , however, and Victoria sufficiently sensitive on the issue to give Grey a difficult time, as he confided to Bell: 'She said Marochetti was the only Sculptor – positively the *only* one in England of really transcendent genius – and I think was not pleased with the utter silence in which I received the expression of this opinion. – I *could* not coincide in it.'

She accused Grey, and the English generally, of disliking Marochetti because he was a foreigner, and she was determined to see whether his work was sufficiently advanced to be finished by his assistants; if not, she would go to Theed.[127] A range of views circulated unofficially. Cole thought Theed would do, otherwise Foley.[128] Arthur Thompson, from Scott's office, feared Layard would favour Henri Triqueti and Susan Durant, both working on the Albert Memorial Chapel at Windsor, while the critic Palgrave would lobby for his friend Thomas Woolner. Thompson concluded that 'Foley seems the only man', though he later noted that Scott jumped at the idea of using Armstead.[129] Meanwhile, John Bell was busily promoting himself, bombarding Layard and others with suggestions, including a figure he had already modelled of Albert kneeling at prayer, sword clasped before him (149).[130]

First, however, the Executive Committee had to decide on the merits of Marochetti's model in its latest state. For this purpose, 'three gentlemen, whose opinions would command respect' were asked to report back to the Queen: Layard, Lord Stanhope – a historian and antiquary who had earlier been a Royal Fine Arts Commissioner – and Charles Newton.[131] Newton was an archaeologist and scholar who had helped excavate the Mausoleum at Halicarnassus in the 1850s, and brought parts of it back to the British Museum, with which he had been associated since 1840, and where he became Keeper of

Greek and Roman Antiquities in 1861. Newton was a close friend of the painter George Frederick Watts, and a correspondent of Layard, who – as we saw earlier – had advised Birnie Philip to consult him over the podium frieze.[132]

On 18 March Layard, Stanhope, and Newton visited Marochetti's studio, where his assistants, 'known not to rank high in their profession', had been working to complete the model, apparently still nude at the sculptor's death, though his son claimed otherwise.[133] Unanimously, the committee of three agreed that the model was not good enough to be accepted, and that it would not be sensible to employ another artist to complete it.[134] When Victoria inspected the statue on 31 March, she found it 'certainly not satisfactory', though she wanted the head kept for another sculptor to use on a new figure. All in all, she thought the turn of events 'most unfortunate & annoying'.[135]

In April Layard was authorised to approach Foley about executing the figure. Initially the intention was only to commission a full-sized plaster model, which would then be cast independently.[136] Evidently this was not made clear to Foley who, when he did understand, argued that such a course would be impracticable. 'My experience has impressed upon me the imperative necessity for the author of the model to direct and have entire control over the bronze founders and all others engaged upon his work.' Without such control results could be poor, and damaging to a sculptor's reputation: indeed, Foley wrote, he often worked on the bronze himself.[137] In the end a compromise was reached: Foley retained control throughout, but strict conditions tied payment to approval at each stage of production – thus insuring against the kind of situation that had arisen with Marochetti.[138] Foley set to, and in August Layard was able to report that his first sketches were 'very great improvements upon Baron Marochetti's design'. One in particular had the Prince seated on a stool, which Layard found preferable, as 'the arms of a chair always produce an unpleasant and confused appearance in the figure'.[139] By November Foley had completed a further sketch model which Layard inspected with Scott: it was better still, and promised 'a really fine work'. Foley had brought animation to the face and figure of the Prince, who now leant forward as if taking 'an earnest and active interest' in what was passing around him (150).[140]

149. John Bell, Model of Prince Albert proposed for the Memorial, 1868 (Royal Archives).

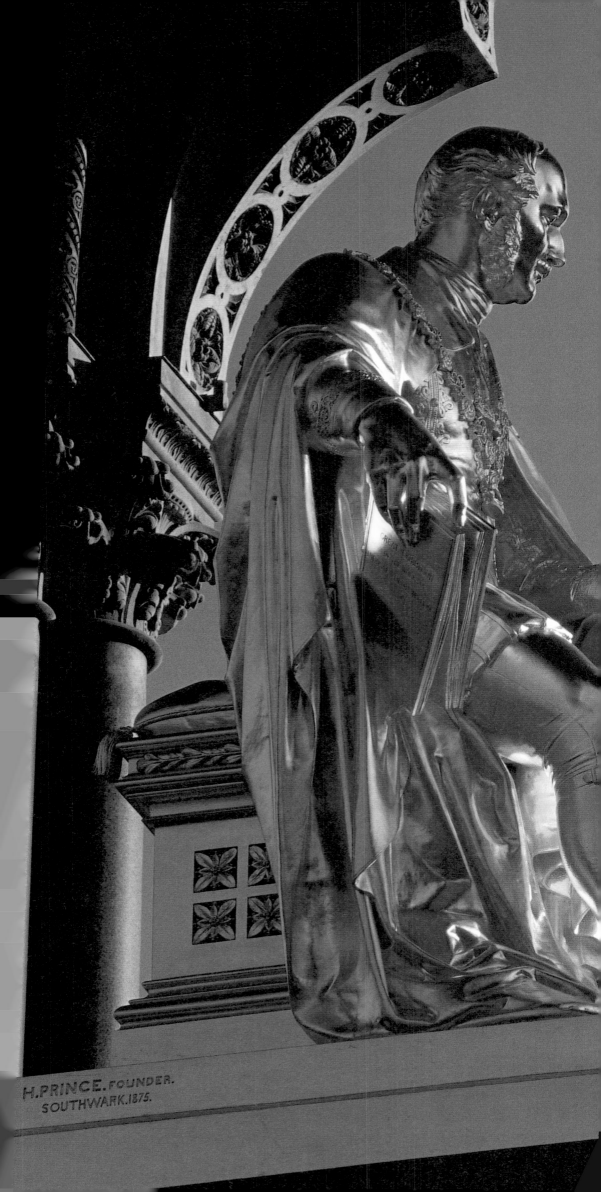

H.PRINCE.FOUNDER.
SOUTHWARK.1875.

150. John Henry Foley, *Prince Albert*, 1868–76.

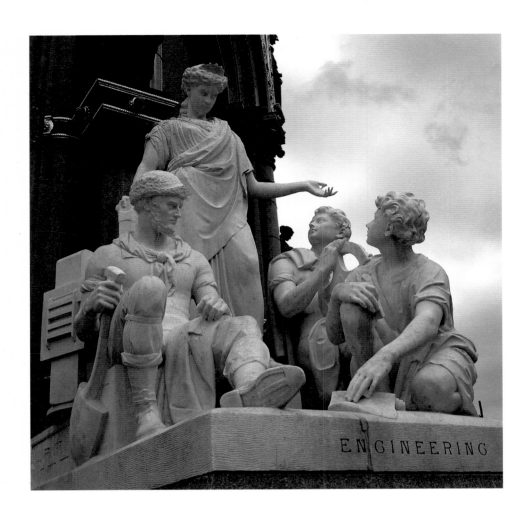

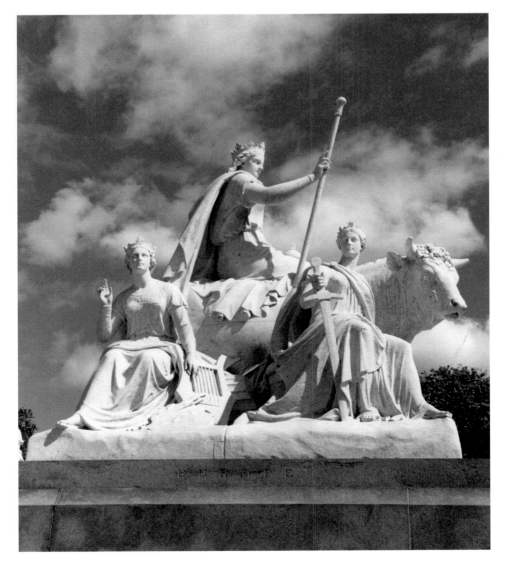

Through all the arguments and anxieties about the figure of the Prince Consort, progress on the rest of the sculptural programme had continued steadily enough. Lawlor completed the model for *Engineering* in January 1867, and was paid £800 in April; he began working in marble in June, and received the third instalment of his payment in September 1868 (151).[141] The full-scale model of MacDowell's *Europe* was completed with the figure of Italy in October 1867. At the same time the composition's centrepiece, Europa seated on a bull, was under way in marble, and MacDowell was reported to be 'expecting a further supply of marble from Italy which will enable him to put the other figures in hand at once' (152).[142] In May 1868 Calder Marshall's *Agriculture* (153) was completed in marble and was ready to be placed on the Memorial.[143] Only the delays to Foley's *Asia* caused some concern.

151. John Lawlor, *Engineering*, 1865–71, during restoration.

152. Patrick MacDowell, *Europe*, 1865–71.

153. William Calder Marshall's *Agriculture*, from *The National Memorial to his Royal Highness The Prince Consort*, 1873 (English Heritage Photographic Library).

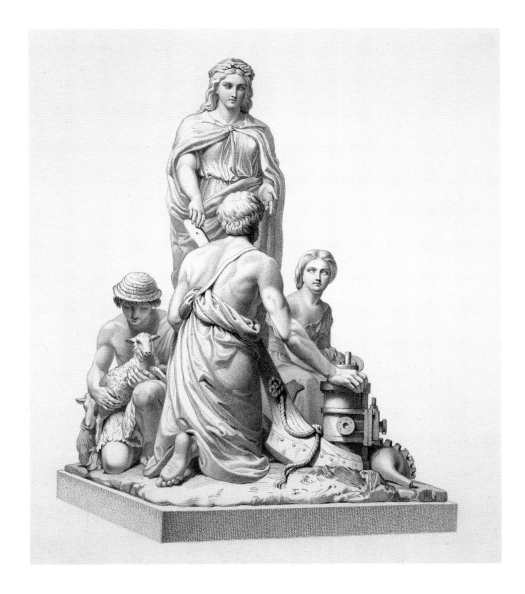

Layard was also keeping watch over the progress of the podium frieze (154), and had his say on the inclusion of Scott among the architects – a proposal of Philip's that Scott himself had vetoed. 'Mr Philip has consequently substituted the late Mr Pugin for Mr Scott', Layard wrote, 'but very unwillingly'. Pugin, in Layard's view, 'was no doubt a very skilful and conscientious designer of Gothic ornaments and architectural details, but he can scarcely be classed among the great architects of the country'. And he cited Raphael's self-portrait in *The School of Athens* as a precedent that would justify the inclusion of Scott.[144] Grey agreed, and had no doubt that 'the Queen will be of the same opinion'.[145] Scott submitted to the royal will, and his portrait medallion duly appeared behind Pugin's shoulder (155). A more serious problem arose in February 1869 when Kelk, concerned that work on the podium was behind schedule and over budget, asked Armstead when he thought it might be finished. Armstead replied 'in about three years', and responded to Kelk's observation that his contract had already overrun by four months with the remark, 'contracts were only made to be broken'. In defending Armstead to Layard, Scott said he had been joking, thinking that Kelk was too. Artists, though, are tremendously sensitive, and Kelk had not only spoken disparagingly of Armstead, but was also affecting his nerves: on one occasion Armstead was so upset by Kelk's arrival on site that his hand shook, causing the drill to slip and stun the marble, so that he had to redo a whole face. Scott was willing to 'pat them both on the back with both hands' if that would help 'expedite matters';[146] Layard too did his best to keep everybody calm.

By this time Layard had become First Commissioner of Works in Gladstone's 1868 government, but it was a position he held only until October 1869, when he resigned to become Ambassador at Madrid. In so doing he helped the government out of a political fix by vacating a ministerial post that could safely be given to the difficult but influential Acton Smee Ayrton (1816–1886).[147] Layard's decision may also have reflected his frustration at the Treasury's blocking his ambition to convert the First Commissionership into a Ministry of Fine Art.[148] On top of which, his marriage in March 1869 may well have modified his enthusiasm for a hectic political career. Transferred to Madrid, Layard could hardly continue on the Executive Committee. Grey's letter on his resignation was genuinely appreciative:

> *You threw yourself into the work with such real interest and hearty good will, that it was a great pleasure to act with you … [The Queen] desires me to say how truly sensible she is of all you have done to promote this work – and of how much the satisfactory progress of the Sculpture is due to your constant attention to it, and to your knowledge of Art.*[149]

For a moment there was some question of Ayrton, Layard's successor at the Office of Works, following him on the Executive Committee as well.[150] Judging by comments made to Layard about the new First Commissioner this could well have been disastrous. 'Ayrton yr successor !' exclaimed Lord Elcho, 'The only fit man in the Government replaced by the most unfit';[151] while Leighton hoped the appointment 'may prove a kind of reductio ad absurdum of the whole system and lead to a better state of things – He will sicken everybody'.[152] Certainly the brusque way Ayrton sorted Alfred Stevens (1817–1875) over the still unfinished *Wellington Memorial* in St Paul's provided a chilling example of how he interpreted government intervention in the arts.[153] The proposal went no further. Somebody was needed, Doyne Bell told Grey,

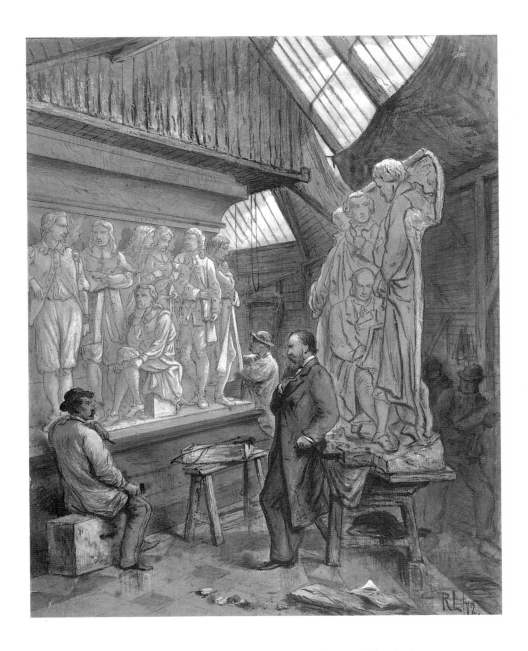

154. R. L., *John Philip Sculpting the Podium Frieze*, 1872 (Museum of London).

155. John Birnie Philip, 'Pugin' with other English architects, including the medallion portrait of Scott, from the *Architects* frieze, 1866–72.

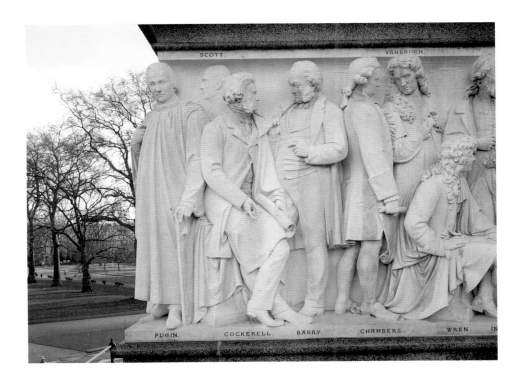

'with good art knowledge – accustomed to intercourse with artists – and whose name would carry weight with the public'. He suggested Charles Newton, a choice fully endorsed by Layard: 'we could think of no other person so entirely well qualified'.[154] As we have seen, Newton had already advised on the tricky issue of Marochetti's model, and helped with Birnie Philip's podium relief. The Queen duly agreed, and Newton was asked to take up his duties alongside Layard until the latter's departure.[155]

Work on the sculptural programme was entering its last stages: Calder Marshall received his final payment in August 1870 with the installation of *Agriculture*,[156] Lawlor's *Engineering* was completed by March 1871.[157] By June 1872 Doyne Bell was able to report that all the sculpture was done except for the central figure, Bell's *America* (156) and Foley's *Asia* (157)[158] – though the final

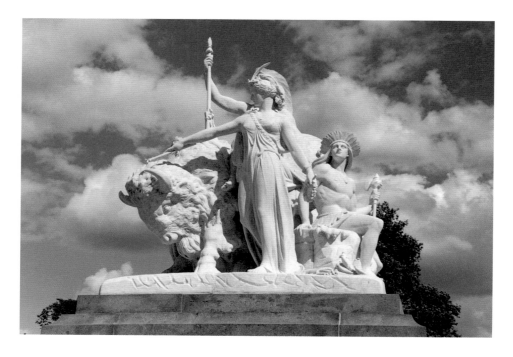

156. John Bell, *America*, 1865–71.

157. John Henry Foley, *Asia*, 1865–71.

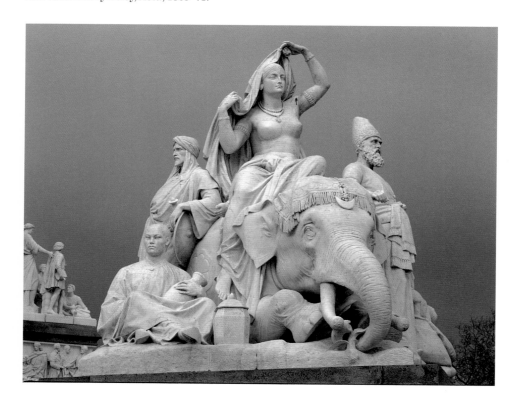

payment for this was made the following month.[159] Deciding how the bronze sculptures should be finished was more problematic, though Newton did not think the artists involved needed to be consulted.[160] When Foley saw the effects of the experimental varnish on the figures of the *Sciences*, he was horrified and told Scott, who agreed. 'We tried each to liken the varnished surface to something it reminded us of; *my* similitude was the sugar "suckers" of which children are so fond; *his* – the glazed Hams one sees in Shop windows !'[161] As Michael Turner describes in chapter ten, the varnish was removed after a few months.

The principal delay though was with the statue of the Prince Consort. Newton reported in January 1873 that, though the main lines of the composition were settled, Foley was still making 'many very important alterations'.[162] In fact, it was not until a year later that the moulding of the final plaster model got under way.[163] Meanwhile, in November 1873, founders asked to estimate for casting the statue 'appear to have been puzzled by the unexampled size of the work'.[164] They had good reason, as Doyne Bell wrote in the following March: 'I think I am correct in saying that no such piece mould has ever been hitherto made – it consisted of nearly 1500 pieces'. The last two pieces probably weighed 2 tons and 3½ tons respectively, and would require a long time and much summer weather to dry.[165] Then, in August 1874, with the casting of the statue under way, Foley died. Various anecdotes related his death to his labours on the Memorial – to the hours spent sitting on the wet clay of the *Asia* group while modelling the central female figure,[166] or to working on the Albert figure *in situ* during the autumn of 1870.[167] Whatever the reasons, he had been unwell for some time, and the course of his final illness was rapid:

> *It appears that Mr Foley went to a wedding party and had intended to return to his studio at 4 o'clock in the afternoon, for it was his practice never to be out at night, but on this occasion his friends persuaded him to remain until the evening, when he caught a chill from remaining near an open window: he complained at once of pain in the side and asked for brandy: he went home but did not seem much worse (though he remained in bed) for three days – the medical men pronounced it at first to be pleurisy and after a fortnight's illness, he gradually sank and died.[168]*

Although much of the statue, being made at the Southwark foundry of Henry Prince & Co., was substantially complete, some of the casting and the finishing off remained to be done – and there were even problems finding the contract between Foley and Prince.[169] Foley had left instructions to his studio assistants, chief among them Thomas Brock, later to be the sculptor of the *Victoria Memorial* in The Mall.[170] While acknowledging that Brock was 'an intelligent young man',[171] Doyne Bell and Newton had anxieties about the final castings, which they sought to allay by appointing supervisory referees. Foley's executor chose Weekes to represent the sculptor's estate, and Armstead represented the interests of the Queen.[172] Henry Prince protested at this apparent slur on his thirty years' experience as a bronze caster, but eventually agreed to the referees' presence in his foundry.[173] On 1 March 1875, Armstead and Weekes were afforded 'much gratification' by being able to report the work 'good in metal, of sound casting, and in every way satisfactory'.[174] Newton then authorised the final chasing and union of the joints, to be carried out, as far as possible, under Brock's supervision.[175] Eventually, at about one o'clock on the afternoon of Thursday 25 November 1875, the figure of Prince Albert was

manoeuvred onto its pedestal, thus completing the Memorial's complement of statues.[176] Even so, the sculptural programme was not quite finished, for the statue was immediately enclosed for the process of gilding. Not until the hoardings came down to reveal the glittering Consort, on 9 March 1876, was the National Memorial finally complete.

There is no doubt that the intellectual conception and basic design of the sculptural programme should be credited to George Gilbert Scott. His earliest idea for a monument in the form of an obelisk featured 'incised subjects illustrative of the life, pursuits, &c, of the Prince Consort', with four sculptures – of lions – at the base. And his first design for the actual Memorial – made before he was invited to compete for it – included the podium frieze illustrating the arts. Indeed, the character of the medieval reliquaries Scott cited as his inspiration meant that figure-work would be an essential element of the Memorial. In the first elevations, the sculpture was drawn out in a general way by John Richard Clayton and Scott's eldest son, and from these ideas the programme was formulated in three dimensions by Armstead for the large model, prepared under Scott's own direction.[177]

We can take it therefore that the model represents Scott's formal ideas for the sculpture, whatever individual modifications may subsequently have taken place. By and large, the general patterning and movement of the frieze are already present and individual figures are identifiable, though their contexts might change. On the *Poets and Musicians* frieze, for example, Dante is already represented reclining; Homer is seated centrally, but looks to the left rather than straight ahead and down; Goethe is recognisable to the right, as also, further on, is Handel, though he has only one companion in his conversazione rather than the two in the final scheme. With the flèche sculpture, the model shows four large aediculed figures on the four axes, with smaller angels at the angles, whereas the *Virtues* Redfern finally produced are of equal size, and though similarly positioned, constitute a more coherent ensemble. And where the pinnacle angels on the model seem lifeless, Birnie Philip's host is animated like a crowd of Happy Clappers (158). We can follow the evolution of the marble groups in detail, from the first model, through the artists' sketch models, to the final versions. Additionally, we know that the starting point for all of them was the very specific programme of symbolism that Scott drew up in April 1864, and that was quoted earlier in this chapter. As well as proposing 'the principal industrial arts and occupations' and 'the four quarters of the Globe', Scott went into considerable detail. Africa, for example, he thought should be 'represented by a female figure (perhaps representing ancient Egypt) on a lion, surrounded by a Nubian a negress and figures intended to idealize the river Niger and the Nile'.[178] Although, as indicated earlier, the idea of 'allegorical or illustrative' statuary had been integral to the conception of the memorial from as early as February 1862, the substantial development and realisation were due to Scott and his office. As Eastlake noted in March 1865, 'The architect, still consulting Her Majesty's pleasure, proposed the subject for both series of groups'.[179]

Through all the interventions and changes in detail described in the course of this chapter, there was no substantial dilution of Scott's core vision. Although the iconographical content, discussed at length by Colin Cunningham, was the result of much collaborative discussion, Scott was always centrally influential. Eastlake and Layard both worked with Scott in their negotiations with individual sculptors. Scott debated issues with the sculptors directly, and seems to have written to them as well. They may have had casts of Armstead's models

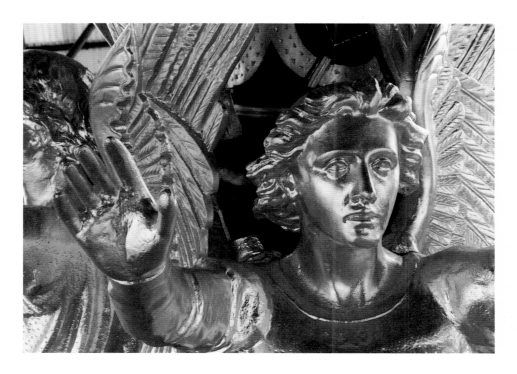

158. Detail of the group of angels on the flèche, by John Birnie Philip, 1868–70.

159. Henry Hugh Armstead, 'Poussin' from the *Painters* frieze, 1866–72.

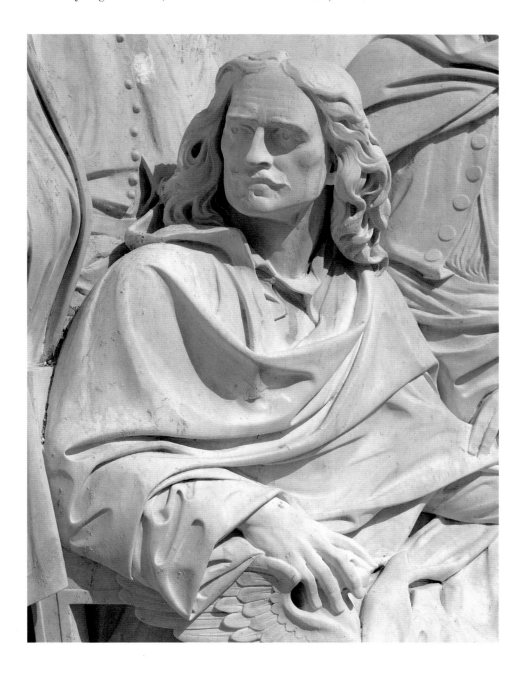

to work from, and Marochetti, as we saw, used the seated figure of the Prince Consort from the model of the Memorial. It is clear the sculptors themselves contributed their ideas – from the correspondence between Eastlake and Bell about the details of *America*, to Birnie Philip's proposal to incorporate Scott's portrait in the podium frieze. Moreover, Philip and Armstead clearly did considerable research into the likenesses of the historical figures they portrayed (159). Though Scott in the end may have regretted that he did not exercise firmer control over the sculptors,[180] given the strong professional and individual artistic personalities involved it is remarkable how much of an integrated vision was achieved. It is symptomatic of this that the descriptions contributed by the executant artists to the Memorial's official *Handbook*, and to the resplendent *National Memorial* volume of 1873, usually retain a core of what Scott had formulated at the start.

The originality of Scott's vision has not been sufficiently recognised. Sources and analogies for his scheme can be cited, and were at the time, but these are only ever partial, and in extending or developing them Scott produced a very different overall effect. The painted *Hemicycle* by Paul Delaroche (1797–1856) at the École des Beaux-Arts in Paris provides a genuine parallel to the assembly of the artistic great and good on the podium, and there are analogous works by Peter Cornelius (1824–1874) in Munich and Johann Friedrich Overbeck (1789–1869) in Frankfurt,[181] as well as sculpted Walhallas at Kelheim and Regensburg. However, far more likely conceptual prototypes for Scott's profuse sculptural programme are the elaborate narrative and allegorical displays familiar to him from the west fronts of medieval cathedrals. Before designing the Memorial, he had already been responsible for restoring or recreating such schemes at Lichfield and Salisbury, and he had an intimate knowledge of many more, both from England and from continental Europe.

Among other works, Edinburgh's *Sir Walter Scott Memorial* has an enshrined, seated central figure, with an elaborate narrative sculpture on the rest of the structure – but the component figures are all relatively small-scale, and wholly subsidiary to the architectural framework. Moreover, while envisaged in the original design, only eight out of sixty-four figures were complete at the time of the Memorial's inauguration in 1844; the others were only executed and installed between 1871 and 1882.[182] The monumental fountain at Nîmes (1851), over thirty feet high, with large scale figures by James Pradier (1790–1852) forming part of an architectural ensemble in a prominent urban site was known to Eastlake and cited by him,[183] but only as an example of how figures at this scale had been successfully integrated with architecture. Also unveiled in 1851 was Berlin's *Monument to Frederick the Great* by Christian Daniel Rauch (1777–1857), mentioned as a parallel by Eastlake and likely to have been well known to the British royals, as well as being widely publicised in Britain.[184] Although wholly different in style and conception, it included corner groups on two levels, narrative friezes in relief, and portrait figures gathered in conversational groups. Layard for his part specifically sent Armstead photographs of Claus Sluter's *Puits de Moise* at Dijon, a genuine late medieval grouping of conversing figures round an architectural structure. It might seem almost perverse to cite Louis Rochet's *Monument to Don Pedro the First*, erected in Rio de Janeiro in April 1862 – except that the work has four groups around the base comprising indigenous peoples, complete with feathery hats, accompanied by local animals, and the model had been shown at the Paris Salon of 1861.[185]

The Memorial itself includes quite specific source references sculpted in shallow relief and forming the background of Philip's friezes of architects and sculptors. There is an Eleanor Cross, mentioned to such poignant effect by Scott himself in the text accompanying his competition design for the Memorial. The Parthenon frieze is shown behind Phidias, and its western pediment behind the sculptors of the figures once there, Ictinus and Callicrates (160); both featured as models in the writings on sculpture of Eastlake and, as we have seen, in the advice of Layard. In front of a silhouetted Gothic arcade stands a group of medieval architects, whose work could be taken to exemplify the perfect fusion of sculpture and architecture in the cause of didactic narrative. One of these architects, Jean de Chelles, holds a model of the central door of the west façade of Notre-Dame in Paris, restored by Viollet-le-Duc as recently as 1848–55, its reinstated gothic sculpture by Geoffroy-Dechaume including groups of figures and even reliefs of the Liberal Arts.[186] Finally, at the feet of the classical sculptors Scopas, Bryaxis, and Leochares, Birnie Philip placed a miniature Mausoleum of Halicarnassus, on which all three sculptors allegedly worked together (160). A monument to a consort, it was one of the Seven Wonders of the Ancient World, its central figure elevated on a plinth rising from a series of steps, with relief sculptures and four corner groups – and it was a constant imaginative presence for those involved in creating the Albert Memorial. As was noted earlier, Layard had directed Birnie Philip to study the Mausoleum's sculpture; the reconstruction of the Mausoleum Philip included in the frieze was that of Eastlake's great friend, Cockerell; and the discovery and acquisition of the Mausoleum's remains had been one of the principal achievements of Charles Newton's professional career.

160. John Birnie Philip, Greek sculptors from the *Sculptors* frieze, 1866–72.

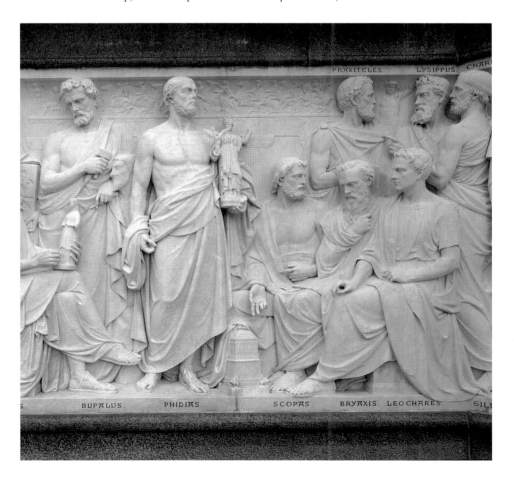

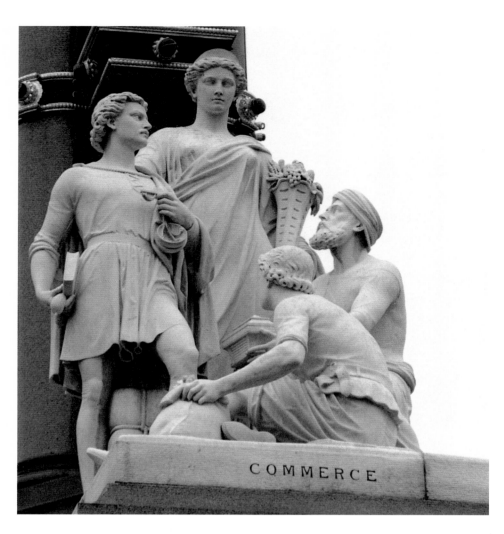

161. Thomas Thornycroft, *Commerce*, 1865–71.

162. John Henry Foley, the Persian poet from *Asia*, 1865–71.

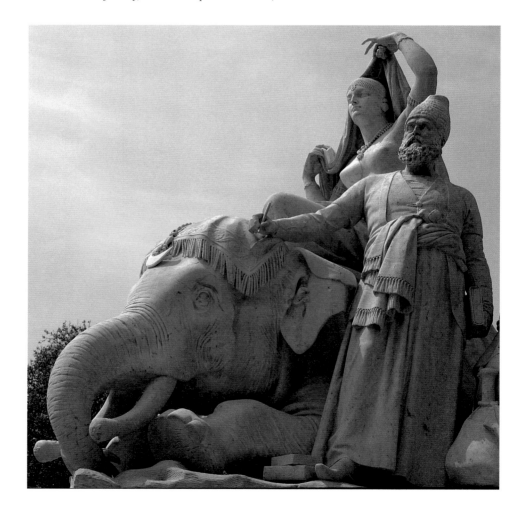

The sheer range of the works that provide analogies for Scott's conception of the Albert Memorial demonstrates that there was no single source for his ideas. What emerged was an exceptional imaginative and expressive fusion. Central to its originality were the narrative demands Scott's conception made upon the sculptural programme, especially the eight marble groups. The lack of prescription in his initial idea that the groups 'should illustrate allegorically or otherwise their message' allowed for a variety of sculptural approaches, as the *Art Journal* recognised. Thus, *Europe* has a 'somewhat mixed character, referring at once to classic Art and modern progress', and MacDowell 'eschewed allegory as much as possible'[187] – though the journal later wondered why he had 'adopted a mythological instead of a historical interpretation of his subject'.[188] *Commerce* (161) is emblematic, while *Agriculture* is illustrative,[189] *Engineering* combines the ideal and the realistic,[190] *Asia* rejects allegory in favour of representative portraiture (162).[191]

This mixing of narrative technique was not in itself problematic, for it was part of the *lingua franca* of European sculpture at the time. For example, the 1854 groups in the Louvre's Cour du Carrousel – *Force, Order, War, Peace* – by Antoine-Louis Barye (1796–1875), each comprises two figures, an adult and a child, and an animal, illustrating between them functions of the State. What made the Albert Memorial groups different were their scale and their attendant narrative complexity. For both there were only limited precedents in British public sculpture – the odd allegorical or narrative figure, sometimes two or four per monument. Matthew Noble's 1856 *Wellington Memorial* in Manchester is exceptional in having four single supporting allegorical figures plus four narrative reliefs, while the elaborate allegorical representations of Alfred Stevens' *Wellington Memorial* in St Paul's flourished still unseen in his studio. By and large, such complexity had only really featured in British sculpture in so-called Ideal Works – those drawn from mythology, literature, or history. And the market for these was very limited, however much they were held to be the acme of the sculptural hierarchy.[192] In effect, the sculptors of the Albert Memorial had little practical experience in the field of large-scale, multi-figure composition, and the demands made upon them were wholly out of the common run. 'With the exception of the Toro Farnese' (163), the *Art Journal* noted perceptively, 'we remember nothing in a spirit similar to that of the four larger

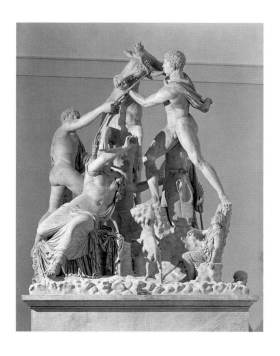

163. Apollonius and Tauriscus of Tralles, *The Farnese Bull*, Roman copy of fourth century BC bronze (Museo Nazionale, Naples).

aggroupments'.[193] Recent precedents in British sculpture were certainly scarce: some multi-figure, narrative-cum-allegorical groups among the Napoleonic War memorials in St Paul's Cathedral, such as Richard Westmacott's *Abercromby Monument* (1809), a few entries, not proceeded with, among submissions for the *Nelson Memorial* at the end of the 1830s. Significantly, however, the one major opportunity for such works had been the competitions for the Palace of Westminster sculptures organised by the Royal Fine Arts Commission under Prince Albert and Eastlake, in which, as we have seen, many of the Albert Memorial sculptors participated. Entry specifications, drawn up by Eastlake, were for ideal or portrait statues or groups, the subjects left to the choice of the artists. As with the paintings that were also being commissioned, most entries combined historical and sentimental themes, usually with one or two portrait figures. But, as contemporary illustrations show, there were a number of more elaborately composed groups, including H. C. Shelton's *The Burial of the Princes in the Tower of London* and J. D. H. Browne's *Caractacus Before Claudius Caesar*. Two groups submitted by the better known John Graham Lough (1798–1876) even included horses, but these were generally judged eccentric.[194] Ideologically pervasive was the synthesis of history and narrative with moral exemplification, for the story of British constitutional development was held to embody the triumph of such abstract virtues as courage and justice. In this sense, the overall sculptural scheme envisaged for the new Palace of Westminster, a total of some 270 exemplary historical statues,[195] offers a prototype for the programme actually carried out on the Albert Memorial.

The need to synthesise allegory and symbolism with more realistic narrative or historical representation was a major factor in determining the Memorial's distinctive stylistic fusion, its combination of gothic framework and architectural forms with the classically influenced naturalism of the sculpture. Scott was explicit about this, and quite clear as to what he wanted. 'I do not in any degree aim at an imitation of Medieval art', he wrote. Painting and sculpture, in his view, did not attain the same level as architecture in the Middle Ages. What Scott sought was a sculptural mode that blended the highest qualities of both medieval and antique work:

> *There is a marvellous consanguinity between the best Medieval sculpture of the 13th century and that of the Greek period, just when it had thrown off Archaicism but not yet begun to lose its pristine purity ... I counsel their united study, with a view – not to the direct imitation of either – but to the production of an art directly emanating from the artist's own mind, and uniting the highest qualities of the two – More Greek than medieval, yet joining to the glorious perfections of the one the warmth of feeling which characterises the other ... In bringing these two in contact lies the hope of future Art – Neither should be copied, neither style should be, strictly speaking, revived. The sentiment of the two must be united and the perfect art of Greece warmed with the deep feeling of the Gothic period.*[196]

With the exception of Armstead's work on the model and on the Memorial itself, Scott felt that, in the end, the sculpture never quite realised his aspirations for it. Nevertheless, what was achieved was remarkable. Schooled as neo-classicists, matured through work for the Royal Fine Arts Commission, galvanised by Scott's vision, the Memorial's sculptors created a style independent both of medieval and antique precedent, a final flowering of mid-

Victorian sculpture that was distinctively modern. In May 1871, the *Art Journal*, not always uncritical, recognised that the Memorial 'augurs ill for those who are pleased habitually to croak about our "utter want of able sculptors"'.[197] 'We have at last something of which we may be justly proud', the journal concluded in August of the following year.[198] Obviously the contemporary 'croakers' could not see it. Nor would it be reasonable to expect such champions of the Aesthetic Movement as Stephens of the *Athenaeum* – whose views were referred to at the start of this chapter – or Sidney Colvin of the *Saturday Review*, to acknowledge what had been achieved. Yet it is their assessment, springing from the partisan viewpoint of 'art for art's sake', that has largely determined the negativity of subsequent critical opinion. A far more balanced judgement from the generation of critics emerging in the 1870s was that of Edmund Gosse, principal champion of the 'New Sculpture' movement. Writing in 1881, Gosse claimed that if the Memorial had been done 'at the present moment' it would have been 'a nobler, a more harmonious composition'. But he also paid tribute to it as 'a very striking monument, full of talent, full of force; it marked a moment of revival, it celebrated the abandonment of all petty jealousy in favour of a great national effort in art'.[199] A 'great national effort' indeed, for the Memorial is by far the largest body of public sculpture in Britain, and it represents a summation of the public statuary movement, the so-called 'statuemania', which began in the early 1850s and in which Britain led Western Europe for some twenty years.[200]

The final judgement may fittingly be left to Layard, for some time so crucially involved in the work. Returning from Madrid in July 1872 and seeing for the first time the almost complete Memorial, he wrote to Scott:

> I must offer you my warmest congratulations upon the great success which has been achieved. It is a magnificent monument, which will be an honour to the country and to you. I had always been of opinion … that when the memorial was completed and fully exposed to view, men of knowledge and of fair and impartial judgement would be astonished at its beauty and originality.[201]

The key terms should be emphasised: 'knowledge', 'fair and impartial judgement', above all 'beauty and originality'. For those who cannot see the truth and justice of Layard's tribute, maybe the fault is their own.

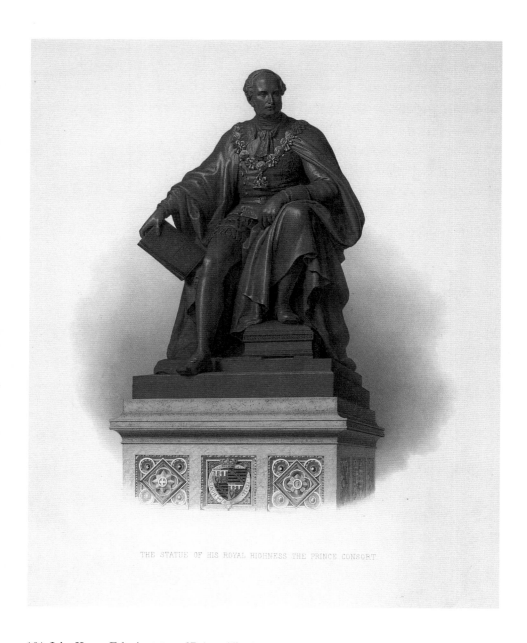

THE STATUE OF HIS ROYAL HIGHNESS THE PRINCE CONSORT

164. John Henry Foley's statue of Prince Albert,
chromolithograph from *The National Memorial
to his Royal Highness The Prince Consort*, 1873
(Kensington Central Library).

Chapter 6

Iconography
and Victorian Values

Colin Cunningham

High in the centre of a vast and gem encrusted reliquary, sit the ten tons of gilded bronze that are the portrait statue of Albert (150, 164). The statue is the core of a richly complex population of symbolic figures with a message that demands careful reading. So much is claimed, so much asserted as attributes of the Prince, that it is worth exploring in some detail how this Memorial exemplifies the values of Victorian Britain. Of course there was no single unified value-system; but the Memorial gives a remarkably detailed picture of the values of those who designed and built it. However, their message needs to be read today, not only for what they chose to include, but also for what they ignored or felt constrained to omit. A remarkably complete analysis of the iconography is given by James Dafforne, who in 1878 published a sumptuous illustrated book, *The Albert Memorial in Hyde Park: Its History and Description*.[1] He drew extensively, though not exclusively, on the official handbook,[2] and his account can usefully be taken as a guide to how a sympathetic Victorian read the Memorial's meanings.

The figure of the Prince himself sets the tone. Dafforne points out that 'the whole Memorial was designed and constructed for the reception, on a lofty pedestal, of an enthroned figure, robed and typical of royal rank.' But, he continues, the aim was 'to embody rank, character, and enlightenment, with the individuality of portraiture, and to convey a sense of that special intelligence which indicates an active, rather than a passive, interest in those pursuits of civilisation illustrated in the accompanying figures, groups, and *relievi*.'[3] Albert is clothed in the voluminous robes of the Garter, the highest honour in the land and in the personal gift of the monarch. This places Albert accurately at the pinnacle of British society and links him firmly to that long line of monarchs and great nobles of which his marriage to Victoria had made him a part. At the same time, as Chris Brooks's chapter points out, the figure's pose relates to one of the most informal images of the Prince, the seated portrait that was engraved by Pound in 1862 after a photograph by Mayall.

The most common pose for a commemorative statue was the standing figure, and this was the version offered by Hardwick in his widely acclaimed design for the National Memorial – discussed by Gavin Stamp in chapter three. Mounted portraits were traditionally reserved for monarchs and great commanders, such as the Duke of Wellington a few hundred yards away atop the Hyde Park arch – until he was removed to Aldershot in 1883. Albert himself was so commemorated in Edinburgh, Glasgow, Liverpool, Wolverhampton and in the City of London (165).[4] But an equestrian statue was firmly ruled out for the National Memorial – as Benedict Read describes in the previous chapter. Instead, Albert is represented seated on a backless stool, not even a throne: attention is deflected to other things than the simple fact of royal status.

The Consort is shown with a catalogue of the Great Exhibition (166) bearing an image of the Crystal Palace. It is a significant detail, part of a web of meanings that repeatedly tie the Memorial to the event widely regarded as Albert's greatest achievement. The Memorial itself was located at the point where a line drawn through the length of the Crystal Palace site intersected the central axis of the 1851 Commissioners' estate: it thus positioned Albert symbolically in relation both to the Exhibition and to the cultural enclave he planned to grow out of it. As chapter one has already described, Joseph Durham's Memorial to the Exhibition, with Albert's statue replacing Victoria's, was being erected in the Royal Horticultural Society's Gardens as Scott was designing his gothic shrine. Scott's Memorial – with its galaxy of angels, virtues, sciences, industrial arts, creative geniuses and continents – would take the Great Exhibition as the catalyst for an expression of the whole range of the Prince's interests and influence. In summing up all that was most admired in Albert's career, it would also be an expression of Victorian values.

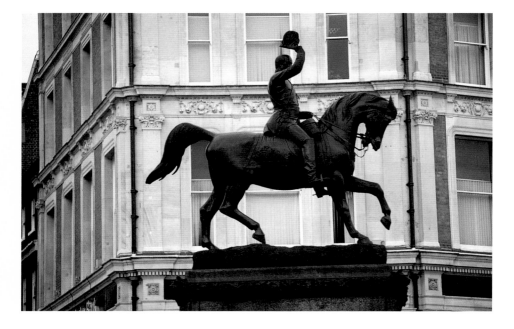

165. Charles Bacon, *Prince Albert*, Holborn Circus, London, 1874.

166. Detail of the Great Exhibition Catalogue from John Henry Foley's statue of Prince Albert.

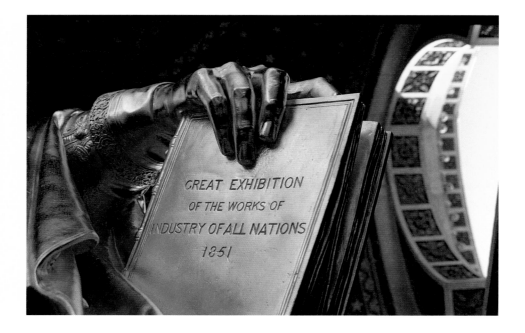

As Benedict Read's chapter makes clear, the memorial's iconographical scheme was devised by George Gilbert Scott, its elaborate web of meanings indivisible from the architectural structure and the sculptural programme. In his letter to Charles Grey of April 1864, Scott not only proposed the statuary groups representing 'the principal industrial arts and occupations' and 'the four quarters of the Globe', but also went into considerable detail about their symbolic content.[5] The subsequent model made under Scott's direction included the Parnassus frieze, and allowed him further to refine his ideas for the sculptural groups. The representational elements in the Memorial's metalwork, including the great flèche, and the subjects of the mosaics, were determined either directly by Scott or by reference to the iconographical structure he had established. At the same time, it is also apparent that many details of the marble and bronze sculptures, and of the mosaics, came from their executants, or from advisers like Eastlake and Layard, in the process of actually making the Memorial.

The central figure of Albert, posed as if 'taking an earnest and active interest in all that might be supposed to be passing around him',[6] directs us to the assembled company of marble and bronze characters who populate the Memorial. Its every part has a message, from the more abstract sense of a Christian tradition and a national style in the choice of gothic, to the specific detail of the Great Exhibition catalogue. In effect, the Memorial articulates a complex and wide ranging discourse that engages history, culture and society, moral values and aspirations. Nobody, of course, supposed that Albert actually embodied all this, but the global reach of the iconography and the centuries of tradition invoked add up to a mighty claim, and while the Memorial's discourse addressed the broadest public, it was also a distillation of the values with which Victoria wished her beloved husband to be associated.

As Mark Girouard has pointed out[7] the Queen and Albert had stood at the peak of the pyramid of earnest Victorians for whom domestic purity, religious seriousness and a sense of duty were paramount. Albert's career, as Hermione Hobhouse has shown, revealed a deep commitment to living out and fostering these values; and it is no surprise that 'Prince Albert's Cottages' – actually designed by Henry Roberts – formed one of the star exhibits of the Great Exhibition. Re-erected in Kennington Park they stand as a witness to his concern for decent housing and social improvement. Other interests embraced science and education, as his service as Chancellor of Cambridge University showed.[8] And he was passionately committed to the Arts, not only collecting and commissioning works, but also encouraging artistic endeavour and broader cultural engagement – as witness his support for the Manchester Art Treasures Exhibition. Various of these concerns are reflected in monuments to the Prince in towns and cities throughout the kingdom – as a brief selection will indicate.[9] Exeter named its new museum and art gallery an Albert memorial. In the small Yorkshire mill town of Queensbury the Foster family provided their people with a much needed Albert memorial drinking fountain. The city of Cambridge hastily dedicated a set of almshouses, built in 1859, as the Royal Albert Almshouses. Framlingham in Suffolk established an Albert Memorial College. While Manchester, first off the ground with a statue beneath a gothic canopy, used the memorial as the focus of city centre renewal, naming Albert Square as the heart of its new civic centre.

The National Memorial, as the inscription states, was a 'tribute', erected by 'Queen Victoria and her people' out of 'gratitude' for 'a life devoted to the

public good'. That 'public good' was a specific version of Albert's achievements, in which the Great Exhibition, or certain aspects of it, ranked high. Albert himself would probably have felt it unfair to personalise the exhibition so. When it had been suggested that the Great Exhibition itself be commemorated with a statue of the Prince, he made it known that he would prefer the memorial fund to be spent on 'the endowment of professorships, or to the institution of periodical exhibitions; to the purchase of fine works of art for the National Museum, or the endowment of prizes for specific objects'.[10] Significantly, as Gavin Stamp has discussed, the Memorial Committee originally intended to provide both a monument and some kind of 'hall of science'. As things turned out, of course, Scott built the Memorial and Henry Cole's Royal Albert Hall stood in for the other half of the scheme. Both relate in complex ways to notions of 'the public good', and the message of the Memorial in particular can only be understood in the context of the society that produced it. The structure effectively speaks three principal languages: the language of piety, the language of progress, and the language of power.

We may begin at the top with piety. The flèche itself is an echo of the heavenward aspiration of gothic churches, and here it is topped by a cross, as a sign that Albert was a Christian Prince in a Christian land. It is certainly true that Victoria was head of the established church and the power of that established church was still considerable. Albert's personal piety is also well established. Yet this has to be seen as to some extent a statement of conventional aspiration when we remember that, a full decade before the Prince's death, the 1851 religious census had embarrassingly shown only 58 per cent of the population of England and Wales worshipping regularly, and of those little more than half attending the established churches.[11] The year 1876, when Albert's statue was eventually unveiled, saw the celebrated trial of the atheist Charles Bradlaugh (1833–1891) and Annie Besant (1847–1933); and by 1880 Bradlaugh had been elected to Parliament. So even as the monument was being built secularism was on the move. Yet the Christian message is firmly underlined by the sculptures of the spire, inhabiting, as it were, the heavenly sphere above the earthly level of Albert himself. Two tiers of angels enlarge the message (167). Unlike the host of mourning angels that peopled the cemeteries of late Victorian Britain, these nameless angels are actively involved in Albert's translation to a better place. The upper tier raise their arms heavenward, while the lower tier reach down towards earth, now deprived of such a worthy Prince. The official handbook described their attitude as 'suggestive of the resignation of worldly honours'.[12]

This message of piety is continued at the base of the flèche where James Redfern's figures, *Faith, Hope, Charity* and *Humility* (168, 171) stand in niches. These, described by Dafforne as the Christian virtues, are distinguished by conventional symbols. It could have been assumed they would be easily recognised: the conventional iconography of medieval and Renaissance

167. John Birnie Philip's two tiers of angels around the point of the flèche, 1868–70.

168. James Redfern, *Virtues*, 1867–70; *Fortitude, Charity, Prudence* and *Temperance* in position on the flèche.

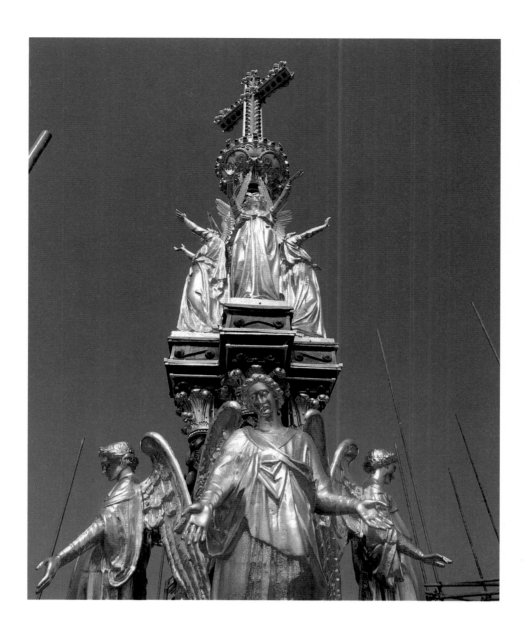

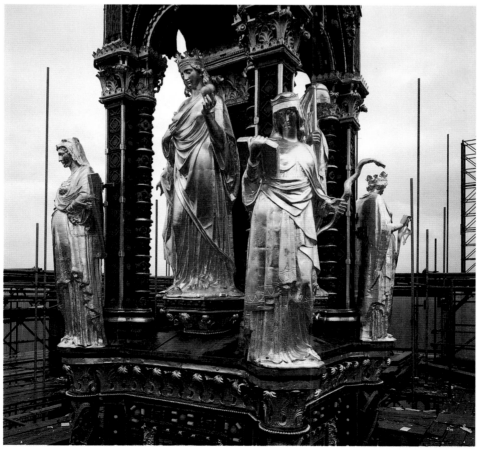

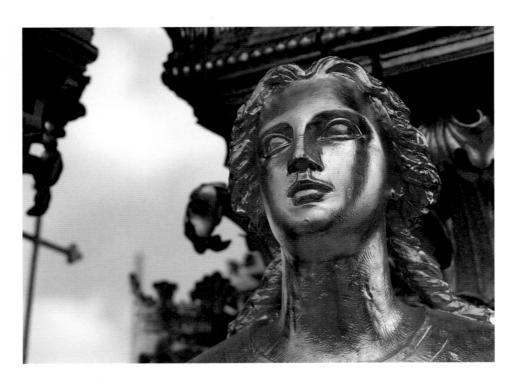

169. James Redfern, *Hope*, 1867–70.

170. James Redfern, *Temperance*, 1867–70.

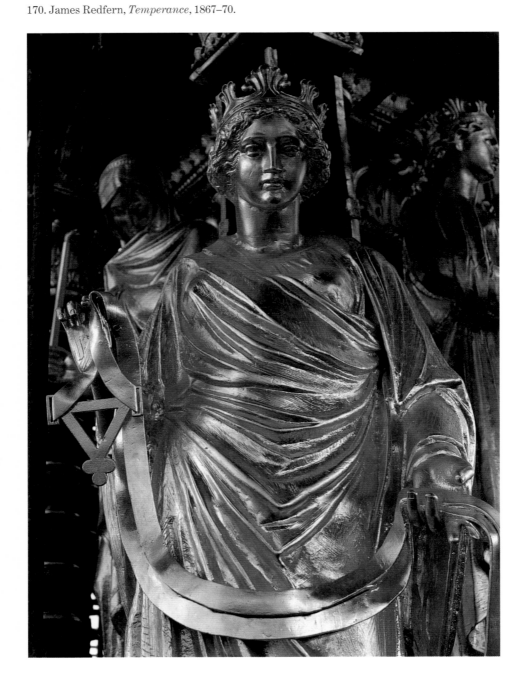

religious art was much studied during the period, and had been collected and described most famously by Anna Jameson in a typically Victorian lexicographic research project published a dozen years before the Prince's death.[13] *Faith* holds her usual cross and chalice, *Hope* (169) gazes upwards and leans on the anchor that St Paul likened her to, while *Charity* carries the flaming heart that was common from the fourteenth century on. However, there was a difficulty. As set out by St Paul [14] there are but three theological virtues. One more was needed for this foursided spire, and the inclusion of *Humility* on a royal memorial is striking – though appropriate to the way Victoria and Albert contributed to the democratisation of royalty. Redfern's *Humility* is a veiled woman, with eyes cast down, carrying a candle – more normally an attribute of Faith or Charity. She is barefoot, as she should be, but there is no sign of the crown that she is usually shown trampling. Perhaps that would have been open to misinterpretation on this particular monument.

171. James Redfern, *Virtues*, 1867–70; *Temperance*, *Faith* and *Justice* in position on the flèche; below them are heraldic lions holding scrolls with Albert's motto, *Treu und Fest*

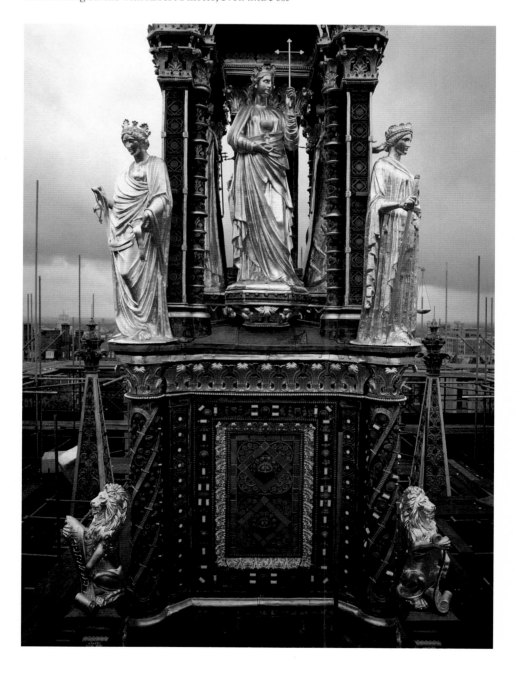

172. James Redfern, *Prudence*, 1867–70.

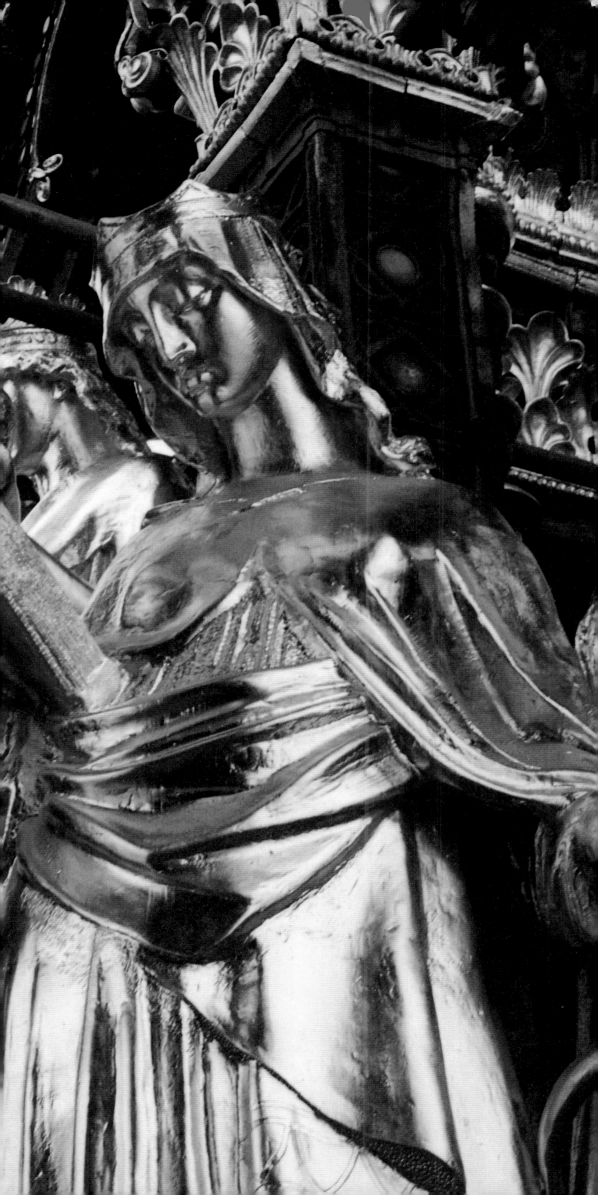

Between the Christian virtues, and standing more prominently at the angles of the spire, are the figures of the four cardinal virtues – *Prudence, Temperance, Fortitude* and *Justice* (168, 171). These, described by Dafforne as the four 'moral' virtues are a traditional quartet expressive of public probity. *Justice* has her usual sword and scales, and *Temperance* (170) her bridle, though not, interestingly, her other medieval attribute, the vessel of liquor. Here at least, the demon drink, subject of such obsessive anxiety among Victorian moralists, is not represented as a particular concern, though the year of the Memorial's completion was that in which per capita beer consumption reached its peak, with wine and spirits peaking at much the same time. [15] Another quirk of the moral iconography is the fact that *Fortitude* has exchanged her common warrior dress for the alternative of Hercules' lion skin and club – though her shield does hang behind her. *Prudence* (172) is shown clutching her snake, encouraging the 'wisdom of serpents'[16], and the back of her head-dress is fashioned into the Janus mask of an old man, symbolising both the wisdom of age and the ability to be circumspect and look both ways at once. This was a characteristic that the Prince had certainly needed as he worked to ensure himself a place in British society. So too, perhaps, self-knowledge: in her other hand *Prudence* holds a rectangular mirror, which in the Renaissance signified that a wise man had the ability to see himself as he really was.

The general message of heavenward aspiration and probity would have been accepted not only as a claim of what Albert had been, but also what a prince should be. Such an assessment of his personal behaviour was bound up with the concept of the English gentleman, something that would have seemed entirely laudable to Albert and his admirers, particularly when the royal family had made themselves a model for decent behaviour in the eyes of so many of their people. These gentlemanly values, though less insistent, are also a part of the Memorial, where they are portrayed by reference to medieval chivalry.[17] The vault of Albert's canopy (173, 174) bears his own and the Queen's coat of arms, symbols that would have been recognised not only as recording Albert's lineage but also as echoing Romantic attitudes to the Middle Ages. Heraldry was a conventional mark of nobility, and medievalism of this sort might have seemed almost old fashioned by the 1860s. It had been adopted by the Young England Tories in the early decades of the Queen's reign, and codified by Kenelm Digby in *The Broad Stone of Honour* as long ago as 1822.[18] But the fact that Digby's book was actually re-issued in an expanded five volume edition in 1877 demonstrates that the concept of chivalry was still very much alive. The smaller details of the monument's decoration make constant reference to Albert, the *parfait gentil knight*, through the conventional language of heraldry. The lead roof of the canopy is moulded with a gothic A for Albert, and the two principal German crests he was entitled to bear; at the corners of the flèche small British lions clutch his motto '*Treu und Fest*' (171); while below, he himself wears the robes of the Garter, the oldest and most prestigious Order of Chivalry. The whole message is of a piece with the choice of the gothic style[19] and its encrustation as one vast reliquary.

173. John Richard Clayton's armorial mosaic on the vault of the canopy, chromolithograph from *The National Memorial to his Royal Highness The Prince Consort*, 1873 (Kensington Central Library).

174. John Richard Clayton's armorial mosaic on the vault of the canopy, 1866–8.

Yet all this alludes only to Albert's personal qualities and values, not to the impact of those values on the land he lived in. The lower parts of the Memorial, where the sculptures are closer to the viewer and thus easier to study in detail, relate to Albert's achievements and aspirations. It is here that a richer and more specific iconography expands into the languages of progress and power. Progress comes first in the form of the eight allegorical figures of *Sciences* by Armstead and Philip (175, 176), and the four groups of *Industrial Arts*. The former identify Albert with scientific advance, a connection epitomised in 1858 when he chaired the annual meeting of the British Association of Science. But the statues are not particularly prominent, perhaps because some aspects of science needed careful handling. Geology, for instance, had disproved the biblical account of creation, the celebrated tussle between Bishop Samuel Wilberforce (1805–1873) and Thomas Huxley (1825–1895) over evolution had taken place only a year before Prince Albert's death,[20] and the controversy between science and religion was at its height around 1864. Circumventing this, the statues offer a broad and inclusive definition of science that allows them to stand for Albert's interest in intellectual pursuits and education generally.

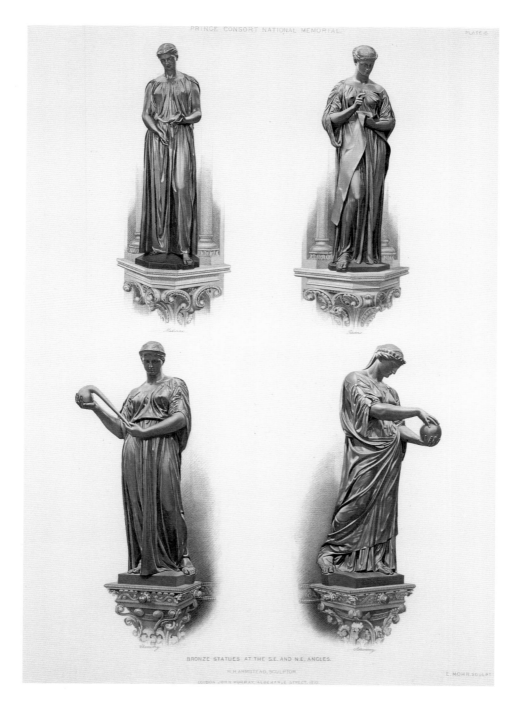

Like all the major sculptures, the figures are carefully labelled in case the iconography should be unreadable – though, high up as they are, the labels are all but indecipherable. The statues stand in niches on the outer angles of the Memorial: *Astronomy*, *Chemistry*, *Geometry* and *Geology* at the lower level; *Rhetoric*, *Medicine*, *Philosophy* and *Physiology* at the upper. Evidently, they form a representation of science or, more precisely, advanced knowledge as then perceived: rhetoric and philosophy would hardly be considered among the sciences today. Although geology, and with it the study of fossils, is shown as a distinct discipline, biology and botany are still subsumed in the broader study of physiology, while physics had yet to become established as a separate science at all. Nevertheless, science in the modern sense was already much in evidence on the South Kensington site, with moves underway to house the natural history collections of the British Museum in a splendid museum of their own less than half a mile from the Memorial.[21]

175, 176. *Sciences*, by Henry Hugh Armstead and John Birnie Philip, from *The National Memorial to his Royal Highness The Prince Consort*, 1873 (English Heritage Photographic Library).

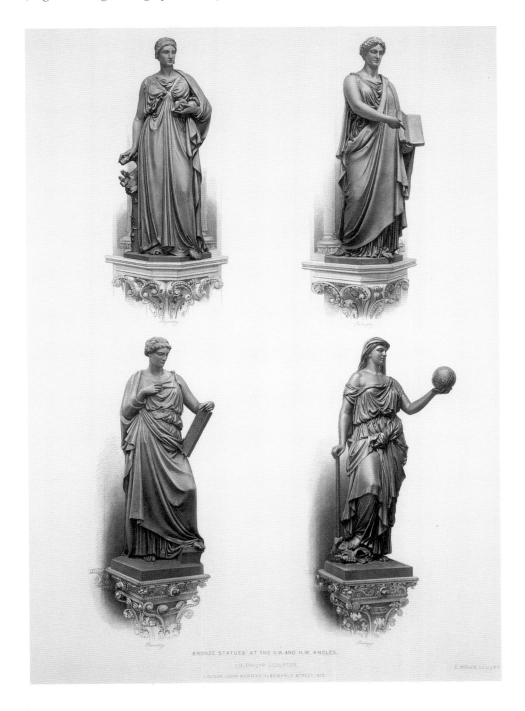

BRONZE STATUES AT THE S.W. AND N.W. ANGLES.

J. B. PHILIP, SCULPTOR.

H. H. ARMSTEAD SCULP.

LONDON JOHN MURRAY, ALBEMARLE STREET, 1873.

Curiously, perhaps, the figures of the Sciences attracted very little comment in any of the principal contemporary descriptions of the Memorial.[22] Evidently they were not controversial symbols; and individually they are of a high standard. One at least was separately exhibited at the Royal Academy.[23] Their attributes are mostly conventional – a retort for *Chemistry* and a pair of compasses for *Geometry*, while *Physiology* (278) clasps a small baby symbolising the most perfect of natural forms, and points to the microscope that was the basis of so much Victorian natural science. *Astronomy* (177) carries a heavenly globe and wears a band of stars, *Medicine* (279) has the classical cup and the serpent of Asklepios, while *Rhetoric* has merely a speech to read and *Philosophy* an open book which she holds towards the spectator. The one remaining science, *Geology*, is portrayed in a slightly more pointed way, however. Looking out from a monument that is itself a geological exhibition, the figure holds a geologist's hammer, with piles of ore and fossil bones scattered at her feet. The reference to fossil animals strikes an intellectually progressive note at a time when the Natural History Museum was still being built, and when the first reconstructions of dinosaurs were fresh in mind.[24] This aspect of the iconography is not prominent, however, and the fossil bones and ores are difficult to distinguish. Similarly, a reference to the dangers of uncontrolled exploitation: *Geology* holds in her hand a partly excavated earthly globe reminding us of the depredations resulting from the search for precious metals. This detail seems to express unease – albeit very muted – about the impact of technology upon the natural world, and casts doubt upon the ultimate perfectibility of scientific progress. Surprising, perhaps, in the 1870s, these are anxieties that would find a ready response today.

There was more scope for a detailed programme, and arguably more need to acknowledge imperfections, in the next series of sculptures. Just below the Consort's statue, at the corners of the podium, four groups represent the *Industrial Arts* that made the bustling world around Albert possible. Each comprises a female figure, symbolising the skill's spirit or genius, who presides encouragingly over three representative figures engaged in its practical applications. The groups are *Agriculture*, *Manufactures*, *Commerce* and *Engineering*. In these groups is found the Memorial's principal acknowledgement of the modern world, the economic reality of mines and foundries, of shipyards, railways and mills – the industrial city that Dickens's *Hard Times* (1853) had portrayed as desolate and dehumanising Coketown. The prosperity that resulted for many from the Victorian economic revolution was something to celebrate; and there were clear signs that the urban squalor that also resulted was being tackled. London, for instance, was just completing Bazalgette's great sewerage system with its miles of tunnels and imposing pump houses. However, although the *Industrial Arts* groups do contain references to specific works, the more mundane business of improving sanitation, health and housing is not commemorated – despite Albert's active interest in these issues. One could hardly memorialise a prince through drains, especially when it was popularly supposed that bad drains were to blame for the typhoid that killed him.

177. Henry Hugh Armstead, *Astronomy*, 1868.

In prime position at the front of the Memorial are *Manufactures* and *Agriculture* (153, 178), representing the new and the older worlds. As a major landlord, Albert had of course been involved in agriculture and had been an enthusiastic supporter of new systems of High Farming. Such an attitude was very much of a piece with his general interest in improvements, and the royal farm at Windsor was run on model lines with new and carefully planned buildings. Year in year out, Prince Albert's pigs had been admired at Smithfield, and *Punch* had caricatured him as 'the British Farmer' back in 1843 – as Chris Brooks discusses in chapter two. But the golden age of Victorian High Farming had been in the 1850s and 1860s. By 1876, when Albert's statue was unveiled, there would have been many visitors to the Memorial to whom *Agriculture*'s message of progress was bitterly ironic. For the early 1870s saw the onset of the Great Agrarian Depression, which would last well into the twentieth century, remorselessly eroding the incomes of farmers and landowners, accelerating rural depopulation, and permanently reducing the importance of agriculture in the national economy. Nonetheless, agriculture provided the staple of life and had to come first, as the skill without which civilisation of any kind would have been impossible. Dafforne, in describing the group, found it easy to cite biblical precedents for the development of the craft right back to Adam and the Book of Genesis. In so doing, he was establishing the farming of the Victorian era, and Albert's contribution to it, as the climax of an immense historical tradition.

In fact, biblical precedent forms a part of the history Dafforne offers of all the *Industrial Arts*, with the exception of engineering. *Agriculture* contains a female figure with ears of corn and a sickle, and a shepherd boy with a lamb and ewe: contemporary viewers would readily have identified their relationship to Christian symbolism – the bread of life, and the Lamb of God. Simultaneously, however, crops and livestock are the principal divisions of agriculture, so the shepherd boy – to quote Dafforne – 'serves as an allusion to the breeding and rearing of cattle'.[25] Livestock was the staple of upland farms, particularly in the Scottish Highlands, where the Prince also had interests. However, with the spread of deer forests and the problems of Scottish crofters very much a current concern, the sculptor, Calder Marshall, may have felt that a direct reference could be misinterpreted. Part of the problem he faced was how to design a group of four figures that could encompass the whole range of British agriculture: if cattle rearing is only referred to obliquely, fishing is omitted altogether. On a general level, however, the pairing of livestock farming and cereal production would have been recognised by an informed viewer of the 1870s as connoting the mixed agriculture that was fundamental to the High Farming that was still prospering – particularly in the richer south and east of Britain – when Calder Marshall sculpted the group.

Semantically sharper, the key to the whole group in fact, is the iconography of the other two figures. At the front stands a husbandman, his back to us almost as though he were in the front row of the attentive crowd. He leans on a hand plough, perhaps the oldest symbol of agriculture, but has his free hand on a piston, and is looking up at the allegorical figure of Agriculture, who is described as 'pointing out the advantages on the side of modern improvements'. The whole ensemble is thus firmly linked to the idea of progress, here particularly relevant to the Memorial's Great Exhibition theme: among much else, the combine harvester, the American MacCormick Reaper, had first been displayed at the Crystal Palace in 1851. It was an invention that would revolutionise agriculture, and – ironically enough – would play a major

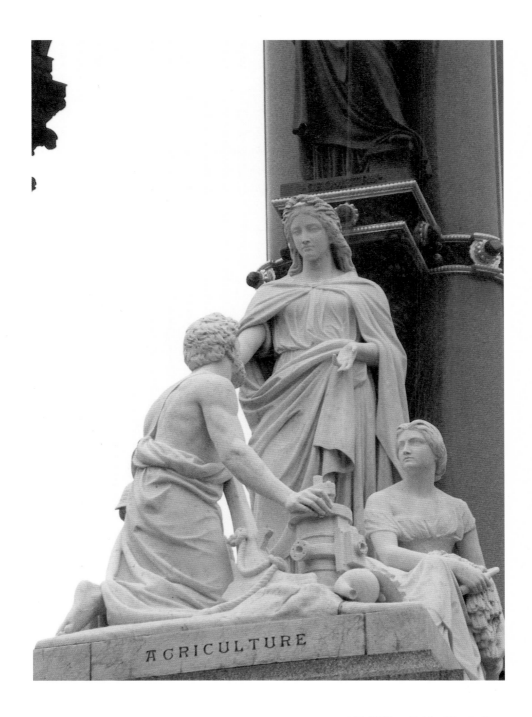

178. William Calder Marshall,
Agriculture, 1865–71.

179. Ford Madox Brown, *Work*, 1852–65 (Manchester City Art Gallery).

180. Henry Weekes, *Manufactures*, 1865–71.

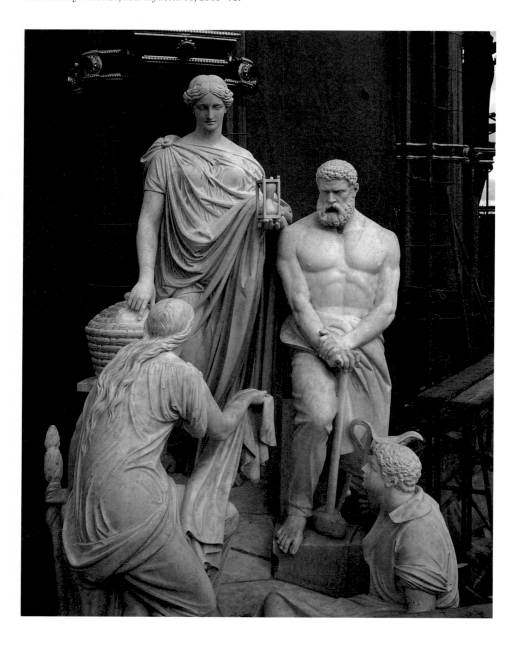

part in the Great Agrarian Depression, for it allowed corn to be produced far more cheaply on the broad prairies of America than in the small fields of England. Here is one of many places where the thoughtful reader may find uncomfortable secondary allusions in the Memorial. Contemporary descriptions, though, seem untroubled. Instead, Dafforne lauds the nobility of agricultural toil, quoting no less a sage than Thomas Carlyle (1795–1881) in his support. ' "Venerable to me is the hard hand, crooked, coarse; wherein notwithstanding, lies a cunning virtue, indefeasibly royal, as of the sceptre of this planet ... Hardly entreated brother ! ... toil on – toil on. Thou art in thy duty, be out of it who may. Thou toilest for the altogether indispensable – for daily bread" '.[26]

Praise of the noble labourer was a regular theme around this time, most notably perhaps, in Ford Madox Brown's painting *Work*, which was first exhibited in 1865 (179). Brown's picture is notable for its sympathy for the conditions of the labouring classes, as too for the candour with which he portrays the disability that often followed from poor working conditions: his central group deliberately opposes the hump-backed pot-boy, debarred now from manly labour and driven to hawking beer and tobacco, to the upstanding young navvy with a flower in his teeth. The idealisation characteristic of the Albert Memorial precludes any such frankness. The second group, *Manufactures* (180), includes a factory girl whom Dafforne actually describes as 'too well favoured in every way, it is to be feared, to have been modelled after nature'. She represents the clothworkers: rightly so, as they were the most numerous single class of industrial workers, and the mills were the most obvious industrial landmarks. But Dafforne goes on to admit that the ' "hives of industry" in our great manufacturing towns, where the noise of the shuttle almost puts to silence the gossip of the busy workers, is not the most genial atmosphere for fostering such healthy-looking and attractive females as the sculptor' – Henry Weekes – 'has here introduced'. It is a surprisingly straightforward admission of the extent to which the Memorial presents a sanitised picture of Victorian life and the march of progress.

Of course the mill-girl is not the whole of the manufacturing message. Dafforne offers the slightly lame explanation that 'so few as four personal types confines the artists to little else than bare allusion.' The obligatory allegorical female is flanked by a beehive, symbolising industriousness, and holds an hourglass. Time was certainly money in an age when 'machinery has to so great an extent superseded hand work of almost every kind',[27] but whether the concentration on time and time-keeping was to be regarded as progress would depend on the status of the viewer. The very dominance of machinery made it difficult to personalise industrial production. Though the representation of heavy industry as a 'broad-shouldered bare-armed worker in iron' is appropriate enough, he is modelled like a Hercules or, indeed, like Vulcan himself: hands resting on a hammer, he stands improbably barefoot in his forge, one foot on an anvil, set about with a smith's vice and pigs of iron.

The other figure in the group is a youthful potter, who stands for art manufactures – which had been an abiding interest of Albert's, and had formed a large part of the 1851 exhibits. Here again Weekes chose a branch of manufacturing in which hand craftsmanship still played a major part. Indeed, the sample of ware shown is heavily modelled, and, if not cast in a mould, would have involved a good deal of handwork – as did the Palissy Ware[28] that was a particularly popular line of Doulton's at the time. On grounds of aesthetic

appeal, the decision to represent such an elaborate piece of pottery is fair enough; much less so the fact that the potter Weekes unworriedly depicts is a child labourer. Although some of the worst industrial exploitation of children had been legislated against by mid-century, the 1850s and 1860s – as Best has pointed out[29] – were still a grim period in the history of child labour: the numerical peak of under-fifteen employment came in 1871, with 619,000 children at work in a variety of industries.[30]

Iconographically, perhaps the most successful and least ambiguous of the *Industrial Arts* is Thomas Thornycroft's *Commerce* (181), one of the two rear groups. It was, as Dafforne stated, 'absolutely essential … that the means by which England has acquired so much of her wealth and her position among the nations of the earth – for there is scarcely a port or a harbour within the five great divisions of the globe where the British flag is not seen – should be … duly recognised in the memorial.'[31] Yet, though commerce is recognised as central to the British nineteenth-century position, it is not nineteenth-century commerce that is depicted. This is perhaps the reason why the message is less open to misinterpretation – or rather one is less ready to measure what is represented against a surrounding reality. Commerce herself bears a cornucopia: by her agency wealth and abundance pour forth – though the disposition of the group is such that she seems less engaged with her companion figures than is the case with the presiding spirits of the other *Industrial Arts*. The 'real' people consist of a young merchant, said to be modelled from the sculptor's more famous son Hamo Thornycroft (1850–1925), an eastern merchant and a rustic. The eastern merchant symbolises trade in luxury items, and is shown proffering a casket of jewels. The rustic represents commerce in the necessities of life, and opens a sack of corn for the young merchant, whose youth suggests the energy needed for commercial success, and who stands beside a bale of cotton – indicative of the textile trade which was at the heart of Victorian prosperity. But the details of his dress, described as Anglo-Saxon, divorce him from contemporary life, stressing instead the long tradition of trading. He carries a ledger and purse, symbolising the capital and credit needed, and a balance and scales, very much the equipment of a medieval merchant, to indicate the importance of barter. The figure is an interesting cross between allegory and personalisation. Though its very distance in time may seem to weaken its impact now, we must recognise the cultural resonance that historicised representation held for the Victorians. Certainly, the trans-historical range of costume on the Memorial as a whole can be understood as a determined attempt to universalise a complex message.

There is no such ambivalence in the case of Lawlor's group, *Engineering* (151). Nor could there be, as this was the one skill for which there was no established allegorical repertoire, and Dafforne could not cite biblical precedent. Nevertheless, he does refer to Archimedes, to Xerxes bridging the Hellespont, and the Egyptians building pyramids. At the back of the group, however, are shown the Britannia and Menai bridges, two monuments of modern British engineering of which the Victorians could rightly be proud. Yet they are difficult to see, represented in low relief as a sort of illustration rather than having any presence in the group. Scale was of course a problem, but it is tempting to suspect a failure of confidence here in the face of the authority the Victorians invested in precedent and tradition. At the same time, the steam cylinder, standing at the rear of the group along with other items of contemporary machinery, embraces modernity, paying tribute to the centrality of steam power. As Dafforne put it, 'the variety of uses to which the steam

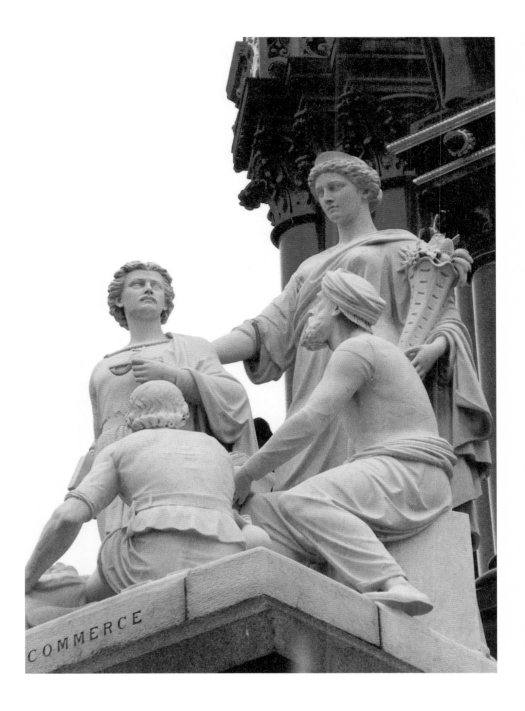

181. Thomas Thornycroft, *Commerce*, 1865–71, the figure of the young merchant modelled after the sculptor's son.

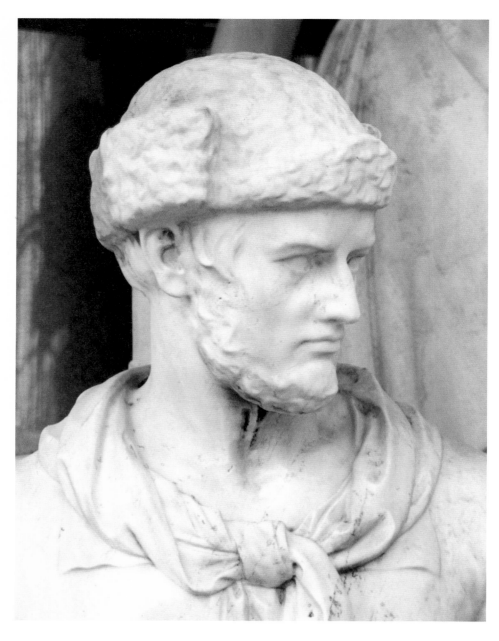

182. The navvy from John Lawlor's *Engineering*, 1865–71.

183. Hubert von Herkomer, *Hard Times*, 1885 (Manchester City Art Gallery).

engine is applied can scarcely be enumerated for it has now become almost a necessity to our very existence, and affects every condition of our life.'[32]

The presiding female genius is depicted directing three workers, who neatly encapsulate the stages of civil or mechanical endeavour, then the only concerns of the engineer. A young man with compasses, the engineer himself, points to a plan as an indication of the design stage. One of the two 'embodiments of the labour grade', clutching a cogwheel, is the mechanical engineer 'who develops the art of the engineer by means of machinery'. The other, shovel to hand and dressed in the furry cap, loose necktie and tied trousers of the navvy 'awaits orders'.[33] A realistic representation of the Victorian labourer (182), his dress particular and easily recognisable, this figure is the Memorial's most explicit depiction of the contemporary working-class. He is as convincing as the sturdy navvy 'on the tramp' in the painting *Hard Times* (1885; 183) by Hubert Herkomer (1849–1914) – though Lawlor, in keeping with the Memorial's idealising intent, shows labour as heroically purposeful rather than downtrodden.

The four groups of *Industrial Arts* are among the most interesting parts of the Memorial iconographically, because they attempt to relate Prince Albert directly to the contemporary world. Such enterprises are always difficult, because an appropriate symbolic language may not be readily available, and because it is so often possible to find alternatives to the particular situations represented. No such difficulties attended the commemoration of his association with the arts. This element occupies the greatest space on the Memorial, for there are the four mosaics as well as the Parnassus frieze that courses round the podium. The whole sequence associates the Prince with the greatest creative artists, not inappropriately given his activities as a patron and his concern for the educative value of the arts. This was why art manufactures featured so largely in the Great Exhibition: beautiful objects, it was supposed, would enhance the lives of those who used them and those who made them. The same educative intention lay behind all the Prince's aspirations for Albertopolis, where architecture, painting, sculpture and music were all to have a place. There too, on the Memorial, is poetry, because of its primary association with music. As Dafforne put it, 'when music is conjoined to poetry it is an art, not of diminished importance, but of independent nature, its office then being to enforce the meaning of the words and add a colouring to them. As an adjunct it is a beautiful illustration of language'.[34]

Throughout his life, Albert was closely and constantly engaged in the visual arts: from sketching and painting with Victoria, to encouraging the Manchester Art Treasures Exhibition; from the design of workers' housing to the planning of Osborne and Balmoral. Albert's deep interest in the Renaissance found one expression in his admiration for Raphael,[35] who sits enthroned in the centre of the Memorial's frieze of painters. But that interest also inspired his encouragement of contemporary art: from supporting the attempt, albeit unsuccessful, to establish a British school of fresco painters, to persuading Victoria to purchase that remarkable recreation of thirteenth-century Italy, *Cimabue's Celebrated Madonna ... Carried in Procession through the Streets of Florence* (1854–5; 184)[36] – the first major work of Frederic Leighton (1830–1896).

The Memorial's mosaics and the Parnassus frieze together exemplify the mid-Victorian canon of great artists, which has fascinated art historians as much for the people omitted as for those included.[37] Placing the mosaics in the

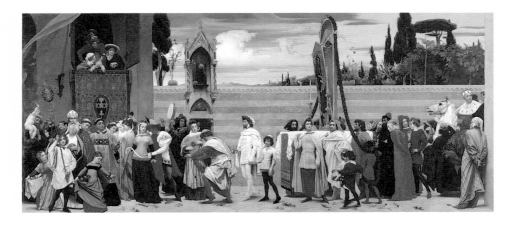

184. Frederic Leighton, *Cimabue's Celebrated Madonna … Carried in Procession through the Streets of Florence*, 1854–5 (Royal Collection, on loan to The National Gallery).

185. South gable of the Memorial, with John Richard Clayton's mosaic representing Poetry, 1866–8.

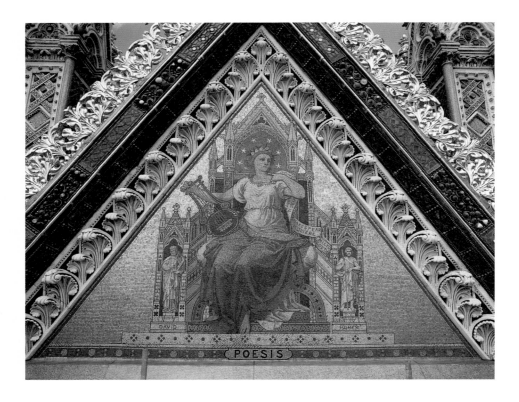

canopy ties the heavenly aspirations of the upper part of the Memorial to Albert's engagement with the arts, establishing a linking theme of divine inspiration. Helping out the iconography, each of Clayton's allegorical figures is carefully labelled – albeit in Latin – and semantically connected to the mosaic figures in the spandrels below, which show representative practitioners of the relevant art. Reflecting Albert's particular enthusiasms, painters, sculptors and architects occupy three sides of the Memorial; but Clayton's *Poesis* sits in the front gable (185, 232), with poets and musicians filling the frieze below, because – as Dafforne says – music was thought to be the oldest of all the arts. The gothic throne *Poesis* occupies has flanking niches containing the figures of Homer and King David – respectively, for the Victorians, the founders of secular and sacred poetry. In one hand she holds a scroll bearing a select list of immortals – Homer, Virgil, Dante, Shakespeare, Molière, Milton, Goethe – while the lyre in her other hand symbolises the age-old union of poetry and music. Echoing the main theme, the spandrels below show a poet (236) and musician, each supplied with a listening acolyte.

In the frieze of musicians and poets on the south front of the podium (186), the significances of Clayton's allegorical and representative figures are made vivid and particular – an effect repeated and renewed on each side of the Memorial. There are 169 figures in all, in deep relief, three-quarters life-size, based wherever possible upon portraits. 'It must', says Dafforne of the south front, 'have cost the sculptor no little research into the early annals of music to trace out the men most worthy of being commemorated in his work'.[38] It must also have been extremely difficult to make the selection since there were so many poets and musicians to chose from – as too, on the other sides of the podium, painters, sculptors and architects. Omissions as well as inclusions reveal the taste of the time. The frieze as a whole covers all periods and all the nations of the western tradition: though Eurocentric by today's criteria, the effort to achieve universality is impressive. It is equally notable that, in this British monument, British writers and artists are not particularly favoured. They feature prominently, as one would expect; but there is a definite attempt to set national artistic achievements in the context of an international tradition.

186. Henry Hugh Armstead's *Poets and Musicians* frieze, from *The National Memorial to his Royal Highness The Prince Consort*, 1873 (Kensington Central Library).

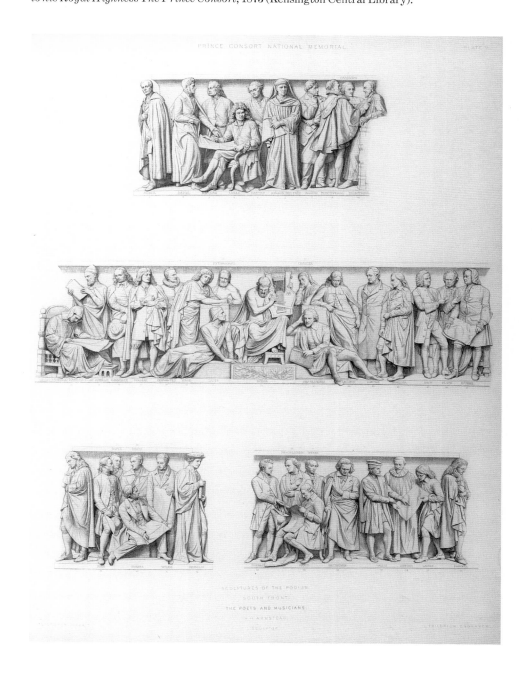

With only one side allotted to poets and musicians, the problem of selection was even more acute, particularly as the sculptor, Armstead, used only thirty-eight figures – the fewest of any of the fronts. The choice reveals a good deal about the Victorian canon. Given the determination to adopt a transnational approach, it is no surprise to find the centre given to Homer, nor that he is flanked by Shakespeare and Dante: all three are named on *Poesis'* scroll. Between him and Shakespeare stands Chaucer whom, on this British monument, one might have expected to find on the scroll as well: even on the frieze he appears only in the background, head and shoulders visible as he leans contemplatively on Homer's throne. His balancing figure, for the friezes are symmetrically composed, is – surprisingly – Pythagoras. His inclusion is justified on the grounds that he established the mathematical theory of notation; but it could equally be that the sculptor was in some perplexity as to who could stand for the earliest of musicians. King David in the mosaic above was a dubious choice after all, for he is recorded as a performer rather than a composer; but at this period he was still popularly believed to be the author of the Psalms, and was thus seen as the founding father of poetry and music in the Judaeo-Christian tradition.

A range of difficulties besets the rest of this collection. There are only three British poets, Chaucer, Shakespeare and Milton. Alfred Tennyson was still alive and so was excluded by the decision to represent only the illustrious dead. Given Albert's and Victoria's enthusiasm for Balmoral and their passion for the Highlands, it seems almost an insult to have left out Robert Burns. Nor does the Memorial give recognition to the anonymous bards who were so important to Welsh cultural history; and there is no Irish harpist. Perhaps more surprising is the absence of Edmund Spenser and William Wordsworth, both read enthusiastically by the Victorians, who came to regard the latter as a spiritual teacher.[39] It could well be argued that this side of the Memorial reveals a definite act of self-denial that resigned places many of its viewers would have expected to be reserved for British poets to creative geniuses from other lands. The omissions from what would be today's canon of British poets are numerous, but they are paralleled by the absences in Francis Turner Palgrave's influential anthology *The Golden Treasury*, first published in 1864.[40] Lord Byron's private life clearly made his inclusion on the Memorial too risky, for all his continuing popularity; William Blake was still virtually unknown; though John Keats was admired by the Pre-Raphaelites, neither he nor the atheistic Percy Shelley were widely read until the later years of the century. Alexander Pope probably missed by only a year or so: interest in eighteenth-century poetry revived in the 1870s alongside the Queen Anne movement in architecture. John Donne and Andrew Marvell are also absent: the Metaphysicals were not re-evaluated until the early twentieth century.

By contrast, musicians from the sixteenth to the eighteenth century are much in evidence: Thomas Tallis, Orlando Gibbons, Henry Lawes, Henry Purcell, Thomas Arne and William Boyce all make an appearance (187). In all there are seven British composers to the three poets, which is an interesting – if somewhat wayward – estimate of the national contribution to the relative spheres. By virtue of *Messiah* and his English career, George Frederick Handel might have been included as an honorary Briton, but Armstead arranged the figures by nationality and Handel stands with his fellow Germans. The seventh is Henry Bishop, a minor composer whose pretty songs delighted the Regency period: hardly an adequate successor to the rest, especially when set against

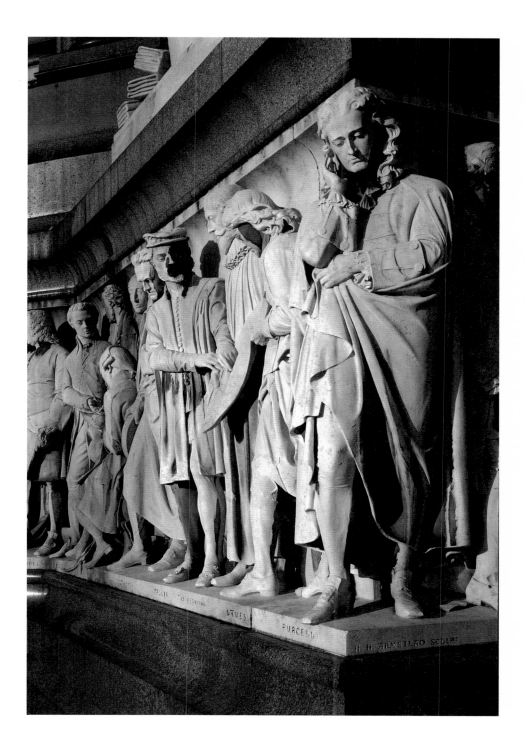

187. Henry Hugh Armstead, English composers
from the *Poets and Musicians* frieze, 1866–72;
before cleaning and repair.

near-contemporaries like Beethoven. But it seems that somebody had to represent nineteenth-century British music, and the choice was undeniably limited. More interesting in terms of musical appreciation as a whole is the weight given to late medieval and Renaissance composers, with Josquin des Prés, Claudio Monteverdi, Giacomo Carissimi, and Giovanni da Palestrina all present. Their inclusion places this aspect of the Memorial within advanced Victorian taste, and parallels similar re-evaluation in the appreciation of painting. [41] It is equally important that so many of the musicians were known as composers of sacred music, a choice which underlines the religious intent of the Memorial as a whole.

Dafforne sets out to explain the combining of poetry and music on one face of the frieze, not on the entirely justifiable grounds that the Prince's interests were principally in the visual arts,[42] but more curiously in the way music and song are linked. 'When the two are combined, as in the patriotic songs of a nation, the effect is often irresistible, and oftentimes men will rush to almost certain death with the music of well-known songs sounding in their ears.'[43] This is an unusual example for Dafforne to cite, especially as it is his only reference to pieces of music rather than musicians, and one wonders whether he had in mind the tales of pipers playing on Havelock's column of highlanders as they swept to the relief of Lucknow during the horrors of 1858. Certainly the sentiment adumbrates the more jingoistic patriotism of the last decades of the century.

In the *Poets and Musicians* frieze, Homer and Virgil have to do duty for all the great writers of the classical world. This short measure was amply compensated in the commemoration of sculpture. In the gable, Clayton's *Sculptura* (233) is flanked by Michelangelo, as might be expected, and by Phidias, guiding genius behind the Parthenon marbles that were the pride of the British Museum.[44] *Sculptura* holds a maquette and a sculptor's maul, indicative of the two approaches to the art, glyptic and plastic. The same distinction is echoed in the spandrel with a modeller and a carver. Below, in John Birnie Philip's frieze (188), these theoretical divisions merge: the background is filled with shallow relief representations of famous works of carving, while some of the figures hold maquettes. Whereas Armstead organised his friezes – Poetry and Painting – by national schools, Philip chose to dispose the representatives of Sculpture and Architecture in a broadly historical sequence. The two approaches complement one another, and both closely reflect contemporary thinking about cultural taxonomy. Accepting Michelangelo as the obvious candidate for the centre of the *Sculptors* frieze (189), Philip arranged his figures chronologically from left to right, beginning with an anonymous Egyptian and ending with the Danish sculptor Bertel Thorvaldsen. Several of the most famous are represented with their most celebrated work in the background: Phidias has his Parthenon, Benvenuto Cellini his Perseus, and the Medici Tomb makes a fine backdrop for Michelangelo.

The inclusion of ten sculptors from the ancient world out of a total of forty-two, is a reflection both of the burgeoning power of archaeology and of the importance of classical learning as a part of the education of a gentleman in the Victorian period. No less than eight of the ancients are Greeks (160), a selection that nonetheless leaves out Polykleitos, the author of the canon.[45] The equally famous Praxiteles, 'the chief representative of the later Greek school',[46] is present but hardly prominent: his celebrated *Hermes carrying the boy Dionysus*, from Olympia, was not excavated until 1877. The progress of archaeological discovery was clearly an important determinant. Thus it is no

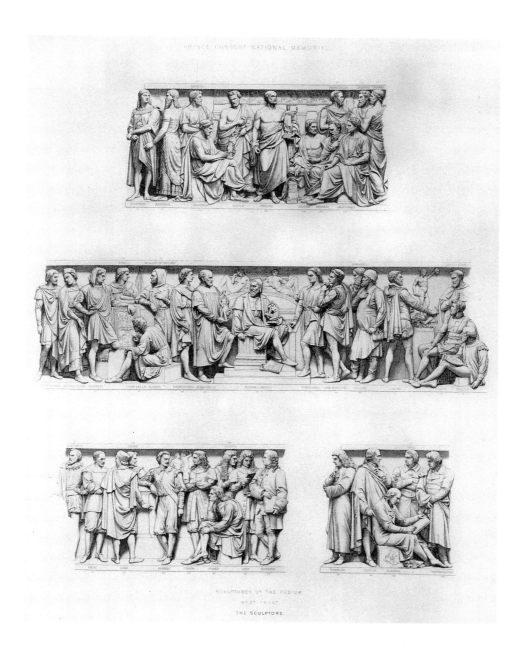

188. John Birnie Philip's *Sculptors* frieze, from *The National Memorial to his Royal Highness The Prince Consort*, 1873 (Kensington Central Library).

189. John Birnie Philip, 'Michelangelo', with 'Donatello', 'Torrigiano' and others, from the *Sculptors* frieze, 1866–72.

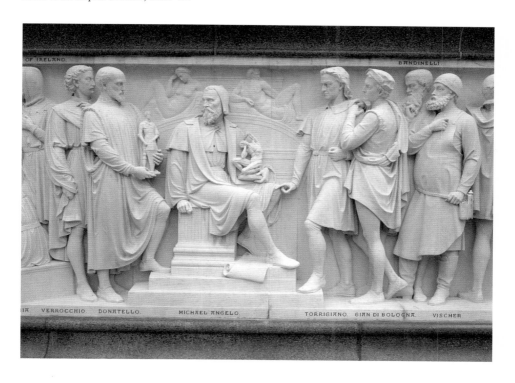

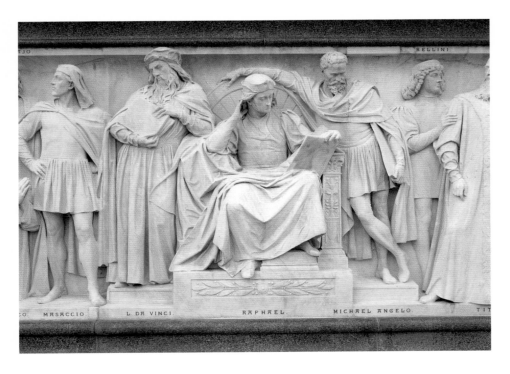

190. Henry Hugh Armstead, 'Raphael', with 'Leonardo da Vinci', 'Michelangelo' and others, from the *Painters* frieze, 1866–72.

191. Henry Hugh Armstead's *Painters* frieze, from *The National Memorial to his Royal Highness The Prince Consort*, 1873 (Kensington Central Library).

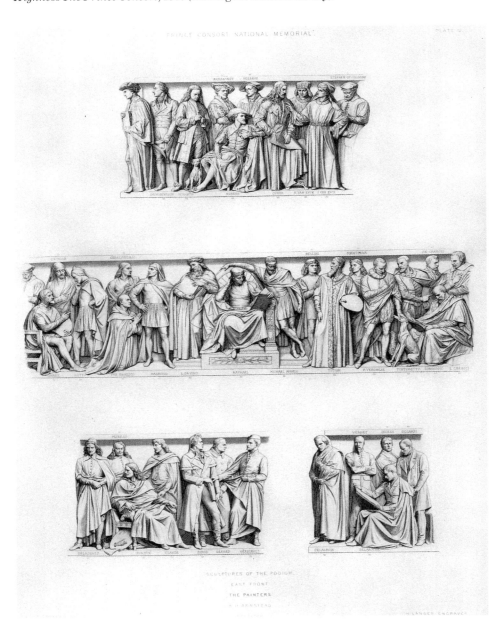

surprise to find that Leochares and Bryaxis, sculptors of the Mausoleum at Halicarnassos, figure in the frieze: fragments of the Mausoleum had reached the British Museum in 1846. Phidias, the designer of the Parthenon sculptures is, of course, featured as 'the greatest sculptor of Greece' though the same source, while mentioning that the Elgin marbles were 'the glory of our National Museum', notes only that they were 'probably executed under his direction'.[47]

Although the inhabitants of the frieze were partly determined by what was then known of ancient art, the largest national group is the Italians – fourteen in all, ten of them from the fifteenth and sixteenth centuries, among them Lorenzo Ghiberti, Donatello, Andrea del Verrocchio, Giovanni di Bologna, and Michaelangelo himself. This is direct testimony to the centrality the Victorians accorded to the southern Renaissance, and it is amplified by the inclusion of four sixteenth-century French sculptors – Jean Goujon, Pierre Bontemps, Germain Pilon, and the potter Palissy, noted earlier. Of medieval carving outside Italy there are just three representatives: the German Peter Vischer; the Englishman William Torel, who made the gilded bronze effigies of Henry III and Eleanor of Castile in Westminster Abbey; and William of Ireland, sculptor of the Eleanor crosses, one of which appears behind him and Torel – a nice compliment to the overall purpose of the Memorial and, as Benedict Read's chapter suggests, one of several references to its sources. Post-medieval British sculpture makes a stronger showing: Nicholas Stone, Grinling Gibbons, Francis Bird, John Bushnell, and John Flaxman – so influential on Clayton – bringing the tradition into the nineteenth century; while the seventeenth-century Dane, Caius Gabriel Cibber, and eighteenth-century Frenchman, Louis-François Roubilliac, both of whom settled in England, also appear. The inclusion of Gibbons, as well as Palissy and Luca della Robbia, all renowned as much for their decorative as their figurative work, suggests the aesthetic importance that ornament had for the High Victorians. Palissy and della Robbia, particularly, were ideal representatives of the union of art and craft that the Great Exhibition had sought to promote, and both were formative influences in the so-called South Kensington style, burgeoning at precisely this moment in the Museum that grew out of the aspirations of 1851.

The distinctive emphases of mid-Victorian high cultural taste are equally evident on the east side of the Memorial, where *Pictura* on her mosaic throne is flanked by the Greek Apelles, none of whose works survive, and by Raphael. In the podium frieze Raphael reappears as 'the artist who is presumed to stand at the head of his professional brethren [and] occupies the point of honour in the centre' (190).[48] As we have seen, this reflects both Albert's personal preference and the contemporary evaluation of art historians. And predictably the frieze (191), grouped by Armstead into national schools, is dominated by Italians. The first chronologically is Cimabue, and the early Renaissance – still, as was noted earlier, a relatively novel taste – is represented by Giotto, Orcagna, Fra Angelico and Masaccio. But it is the High Renaissance that gets pride of place, with the mighty central trio of Leonardo da Vinci, Michaelangelo and the enthroned Raphael. But the absence of so important a figure as Sandro Botticelli is a reminder that appreciation had further to develop: in the 1870s Botticelli's *Birth of Venus* and other great works were still in store in the Uffizi, deemed unworthy of the wall space.

Among the painters representing the modern period, the frieze makes the French pre-eminent, beginning with those firm English favourites Nicolas Poussin and Claude Lorraine, and coming down to such recent figures as

Jean-Auguste-Dominique Ingres, Eugène Delacroix, the now little-known Gabriel Decamps, and the immensely popular history painter Paul Delaroche. Delaroche's great mural, *The Artists of All Ages* (1836–41), in the hemicycle of the École des Beaux-Arts was one of the inspirations for the whole concept of the Parnassus frieze, and the Memorial's Victorian audience was conscious of the parallel. As Dafforne put it, 'to any one of true artistic taste, no individual portion of the Albert Memorial is likely to prove more interesting'. In the British contingent – William Hogarth, Thomas Gainsborough, Joshua Reynolds, David Wilkie and Joseph Mallord William Turner – the omission of John Constable is a surprise from a twentieth-century standpoint, but it accurately reflects contemporary judgements, which promoted Turner, 'the greatest landscape painter the world has ever seen'[49] according to Dafforne, at Constable's expense. Evident here is the influence of John Ruskin's determined advocacy of Turner in *Modern Painters*, the first volume of which had been published twenty years before the Memorial was designed, and which reached its fourth edition in 1873.[50] Ruskin's views, and the way he ranked artists, seems pervasive in the choice of figures for the frieze, in much the same way as his passionate crusade for the values of gothic semantically underpins the whole Memorial – especially, perhaps, the characteristic of 'redundance' which he equated with gothic's spiritual and creative generosity.[51]

The Memorial's whole assemblage of great creative figures is fascinating for us today, and no aspect of it more so than the frieze of architects (192), for here Scott had the opportunity to reflect upon the tradition to which his own work, not least the Albert Memorial itself, belonged. Accordingly, in the gable mosaic, *Architectura* (234) holds an elevation of the Memorial on her lap; and in the throne niches – rather than the cultural heroes of the Italian Renaissance so apparent elsewhere – are Ictinus, architect of the Parthenon and exemplar of the classical tradition, and Solomon, builder of the Temple in Jerusalem. Solomon here stands as the originator of religious architecture, and his presence connects to the religious semantic of the whole Memorial:[52] to the Christian connotations of gothic style, to the angels and virtues of the flèche, to the mosaic of King David as founder of religious poetry, even to the composers of sacred music on the frieze. Philip's chronologically ordered architects' frieze contains more figures than any of the others, so presumably more architects were considered worthy of inclusion. Yet the art occupies the rear face of the Memorial, so there is almost a confusion of status and interest: or perhaps Scott, hyper-sensitive to criticism, was only too aware of how the press would have reacted to anything that looked like a 'puff' for his own profession.

Even though the Italians are not present at *Architectura*'s throne, they have some prominence in the frieze. The seated, central figure is Arnolfo di Lapo, known as Arnolfo di Cambio today: but he is there as a gothic master, the designer of Florence Cathedral. Behind him leans Giotto, and in the background rises the famous campanile he added to Arnolfo's cathedral. This was the structure in which Ruskin had found the perfect union of architectural Power and Beauty, [53] and Scott himself was actually replicating it as the tower of Bombay University during the period of the Memorial's completion;[54] nearer to home, it had even been copied in industrial Leeds. Accompanying the campanile in the frieze is the cathedral's great dome, designed by Filippo Brunelleschi, whose figure completes an Italian trio in the middle of the architects. The prominence thus given to the Duomo is in part a reflection of the Victorians' fascination with Florence and the developing interest in the early Renaissance.

But it is also significant that this one building embodies the shift from medieval gothic to Renaissance classicism, a transference that was crucial to nineteenth-century architectural history – and indeed to Victorian architecture itself.

Eight of the ten Italian architects represented were leaders of Renaissance classicism, and there are no less than twelve architects from classical antiquity, including Callicrates and Ictinus complete with the Parthenon behind them. Rather surprisingly Vitruvius, who has a claim to being the father of classical architectural theory, is not included, though he is referred to by Dafforne in his explanation of the frieze's meaning. The great French heirs to the Renaissance, from the sixteenth to the eighteenth century, are ignored except for Philibert Delorme and François Mansart. This allows space for post-medieval British architects: eight figures in all, from the shadowy Elizabethan John Thorpe to Charles Robert Cockerell, who had died as recently as 1863. Even so, Nicholas Hawksmoor and Robert Adam are both missing: their

192. John Birnie Philip's *Architects* frieze, from
The National Memorial to his Royal Highness
The Prince Consort, 1873 (Kensington Central Library).

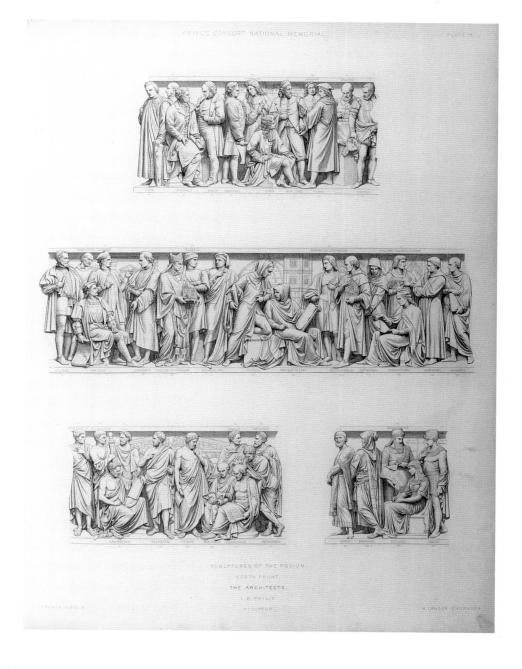

re-establishment in the canon of taste had to wait until the Baroque revival of the 1890s and the emergence of neo-Georgianism around 1900. What is genuinely curious, however, is the dominance of classical architects on this gothic monument. Only nine figures represent the European Middle Ages: Arnolfo and Giotto from Italy; the Frenchmen, Jehan de Chelles and Robert de Coucy, who designed, respectively, the west portico of Notre Dame and the cathedral of Rheims; the Anglo-Normans, William of Sens and William the Englishman, both of whom worked on Canterbury Cathedral; from Germany, Erwin von Steinbach, believed to have designed the west front of Strasbourg Cathedral; and the ecclesiastics, William of Wykeham and Abbé Suger – who were principally patrons. Scott might well have regretted this relative paucity, but too many of the medieval architects, or rather masons, were anonymous – or, at least, unknown to the Victorians.[55] The only anonymous figures admitted to the podium are the representative Egyptian and Assyrian who start the *Sculptors* frieze, their presence explained by the British Museum's collections from Egypt and Nineveh. Nevertheless, it was at least possible for the *Architects* frieze to celebrate the revival of gothic: to Augustus Welby Pugin Scott assigned prime position on the angle of the north-east pedestal (155), a rapt figure looking away from all the rest, who include his collaborator at the Palace of Westminster, Charles Barry. And behind Pugin, as earlier chapters have noted, is a medallion portrait of Scott himself.

One other figure deserves special mention. Nitocris, queen of Egypt, who was said to have commissioned the third pyramid, is there among the representatives of the distant past, which is commemorated by 'those who encouraged the art rather than by architects themselves'.[56] She is the only woman on the podium frieze and is an important reminder of the extent to which 'official' Victorian values were determined by men. In the Memorial's account, the great acts of creative genius and cultural achievement are emphatically a male preserve. Woman's role, Coventry Patmore had famously claimed, was to be 'the Angel in the House', the home maker: for the purposes of the Memorial such a function could be ignored – just as was Albert's own role as a devoted family man. The notion that men and women properly occupied separate spheres was pervasive in Victorian middle-class ideology. Among the labouring classes protection and separation did not extend to women any more than to children, as *Manufactures* makes clear – probably inadvertently. The corollary to middle-class constructions of gender is found in the upper section of the Memorial, populated by women turned into idealised allegorical figures. Even so, it is worth remembering that Barbara Bodichon (1827–1891), early campaigner for female suffrage, had published *Women and Work* in 1857, and *On the Subjection of Women* by John Stuart Mill (1806–1873) appeared in 1869. Women were already in the forefront of literature: Elizabeth Barrett Browning (1806–1861) had been a serious contender for the poet-laureateship in 1850; the novels of Charlotte Brontë (1816–1855) and Marian Evans [George Eliot] (1819–1880), their male pseudonyms a literary open secret, were widely acclaimed, and the £10,000 Eliot was offered for *Romola* (1863) was unprecedented; even more successful, the 'sensation' novels of Mary Braddon (1835–1915) were runaway best-sellers throughout the 1860s. In fact the decade of the building of the Memorial saw the first real successes of emerging feminism in careers such as Florence Nightingale's, in events such as the foundation of Girton College, Cambridge, and in the long campaign that led to the first Married Women's Property Act of 1870.

Iconographically, the Parnassus frieze is particularly important for what it tells us about the configuration of taste and art history in the High Victorian period. To associate Prince Albert with the Memorial's selection of creative geniuses was bold: but he had been a firm believer in the educative value of the arts, following the Ruskinian doctrine that beauty was in itself an improver of humanity. In this sense the frieze and mosaics can be taken as a reiteration of the belief in progress shown by the *Industrial Arts* and the *Sciences*. That is not to suggest, of course, that the Victorians thought the art of each succeeding generation was an improvement on that before. Rather, the Memorial attests to the Victorians' unprecedented cultural historicism, their abiding sense of artistic inheritance and the inspiration to be drawn from the past. It could be a burden as well as a benefit, helping to foster a paradoxical – and characteristically Victorian – lack of confidence in the creative efforts of the present. Albert, by his promotion of the study of art and art history, undoubtedly shared this reverence for earlier ages. Although it embodies such reverence, his Memorial triumphantly uses the past, exploiting the very density of its historical references in an imaginative strategy that exemplifies High Victorian gothic at its most creative.

The Memorial's final language is that of power, announced through the four large groups representing the *Continents* at the corners of the whole structure. Conceived as 'representing allegorically the quarters of the globe', they celebrate firstly Albert's centrality to the 1851 Exhibition, and secondly the subsequent 'Great International Exhibitions which have done so much for art'.[57] The detailed iconography seems to have more to do with politics and the advance of civilisation than with art, and it seems likely that most Victorian spectators would have seen them primarily as connoting the British Empire's global reach and world-wide commerce. As with the rest of the Memorial, meaning is revealed by what is omitted as well as what is included. There is an initial omission in the very arrangement: Europe, Asia, Africa and the Americas are accommodated, but, with only four corners to the Memorial, Australasia was left out. Australia had contributed to the Great Exhibition, though the *Illustrated Exhibitor* felt it necessary to explain that a collection with 'apparently little to attract' nevertheless revealed that the country had 'sources of great wealth … in the number and extent of her mineral productions, the variety and excellence of her cereal produce, and the rich and numerous specimens of timber adapted for ship-building, furniture or cabinet work'.[58] Certainly Australia was becoming increasingly important to imperial trade – not least because of the vast gold deposits discovered in the 1850s. Even so, mid-Victorian Britain knew little about its distant colony, and even less about New Zealand, though the novelist Anthony Trollope (1815–1882) was to publish a major account of Australia the year after the Memorial's official unveiling.[59] But it seems unlikely that many people in the mother country at the time of the Memorial's design would have been able to relate existing notions of civilisation with the emerging societies of Australasia.

The meanings of the *Continents* groups are involved; yet most contemporary commentators seem to have accepted the iconography presented, and reserved their criticism for matters of aesthetics and realism. The very complexity of the iconography, in the *Continents* as elsewhere, effectively allowed the Memorial to be all things to all people – and that fluidity, that semantic diversity, can be counted a part of its achievement. Representational and decorative richness allows a flexibility of interpretation

that seems entirely appropriate to a Memorial that needed to speak to an audience that was not only national but – given Albert's prominence – international. Each of the *Continents* comprises four figures, illustrating aspects of relevant countries or peoples, composed around a representative animal on which is seated a fifth figure – in each case female – intended to typify the spirit of the continent.

In MacDowell's *Europe* (152, 193), the continent is represented by the nymph Europa, seated on the bull that, in Greek myth, carried her to Zeus. Dafforne remarks her queen-like pose, but notes scathingly that the animal 'appears to be … a small breed of oxen' – though he accepts a full-sized bull would have been too large in relation to the rest of the group. He offers no comment, however, about the fact that Europa is crowned and carrying an orb and sceptre, other than recording that this representation symbolises the 'influence which our quarter of the globe has exercised over the others'.[60] The cultural dominance thus assumed would have been taken as natural and right by almost all Victorians.

The allegorical female figures who accompany Europa and her bull represent those nations 'who have played the most important part in the annals of Europe'.[61] These are Britain, France, Germany and Italy – so other countries like Spain, a former great power, or the vast polyglot empire of Austria, are omitted. Aside from such historical selectiveness, the current world of *realpolitik* gave Macdowell problems. Albert was a German prince, Britain's dynastic connections with the German states were deeply rooted, and in 1871, after the group had been designed but before the opening of the Memorial, Germany became a unified state. But the unification had only come after the Franco-Prussian War had humiliated France and brought down Napoleon III's Second Empire. Macdowell already had France positioned at the front of the group, with a sword to symbolise her military prowess and a laurel wreath for her victories in war – bitterly ironic given the outcome of her war with Prussia, and ambiguous even in London, where Wellington's memorial was less than half a mile away. Germany, on the other hand, sits at the rear of the group with an open book and a thoughtful expression to indicate German renown in literature and science. Sharing the rear rank with Germany is Italy (194), whose unification, begun in 1860, had been completed with the incorporation of Rome and the papal territories in 1870. 'Certain critics' says Dafforne, mindful of national political progress, 'consider that the position of the head and the uplifted hand may be taken as showing Italy awakening from a dream'.[62] She is depicted with a lyre and palette, symbols once again of her contribution to the Renaissance, and is seated on a broken column, a reminder of former imperial greatness. In prime position on the inner side of the front rank, sits Britain, gazing towards the gilded statue of Albert. Predictably, she holds a trident emblematic of maritime strength, and the base of the group obediently turns into waves for her. It is striking that the four national figures appear self-absorbed, visually and spatially detached from one another – a more realistic representation of international suspicions than was perhaps intended.

193. Patrick MacDowell's *Europe*, from *The National Memorial to his Royal Highness The Prince Consort*, 1873 (Kensington Central Library).

194. Patrick MacDowell, 'Italy' from *Europe*, 1865–71.

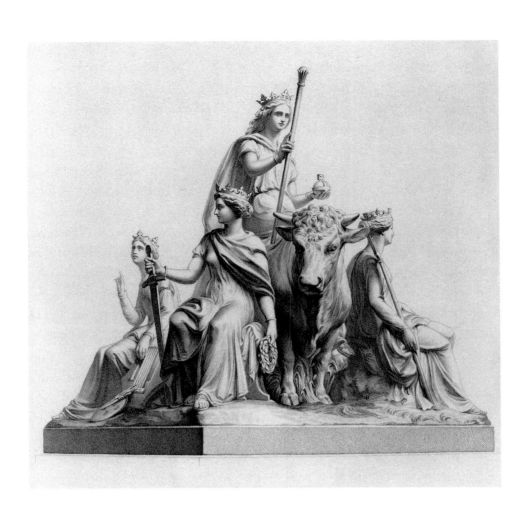

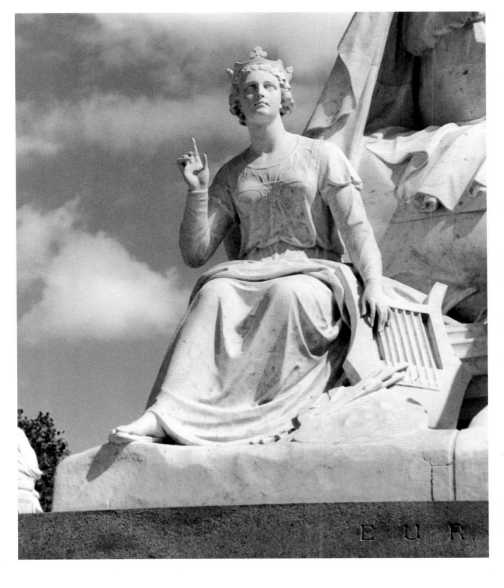

If *Europe* was an unconsciously candid recognition of the realities of the Great Powers, John Henry Foley's *Asia* (157, 195) offered a reflection of imperial values. The central animal of the group, which carries the female figure of Asia, is an Indian elephant, described by Dafforne and the official *Handbook* to the Memorial as typifying 'the subjection of brute force to human intelligence'.[63] The bejewelled Asia unveils herself, an allusion to the revelation of Asian, and particularly Indian, products at the Great Exhibition. Yet the figure is also described as sinking into luxurious ease – a casual assumption of imperial superiority that possibly reflects contemporary feelings about the subcontinent, where Hindu and Mogul civilisations had been subsumed in the Raj. Yet India itself is represented by an armed warrior, a reference to military prowess that may have stirred uncomfortable memories of the Mutiny – to Indians the First War of Independence – but also complimented the numbers of Sikh and other Indian soldiers who were the mainstay of the Raj army. The other three figures are a Persian poet with his pen and books (162), a Chinese potter with a porcelain vase (196), and an Arab merchant for Asiatic Turkey. With the Indian warrior, they jointly represent 'learning, industry, courage, and enterprise – the combined elements of the national greatness of this quarter of the globe'.[64]

195. John Henry Foley's *Asia*, from *The National Memorial to his Royal Highness The Prince Consort*, 1873 (Kensington Central Library).

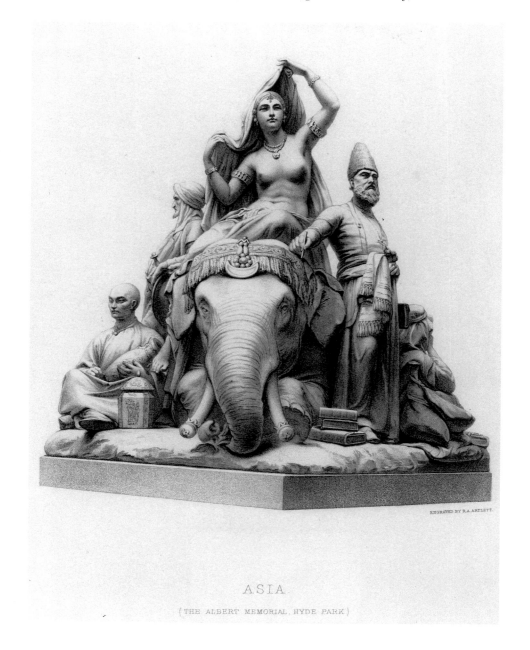

ASIA

(THE ALBERT MEMORIAL, HYDE PARK)

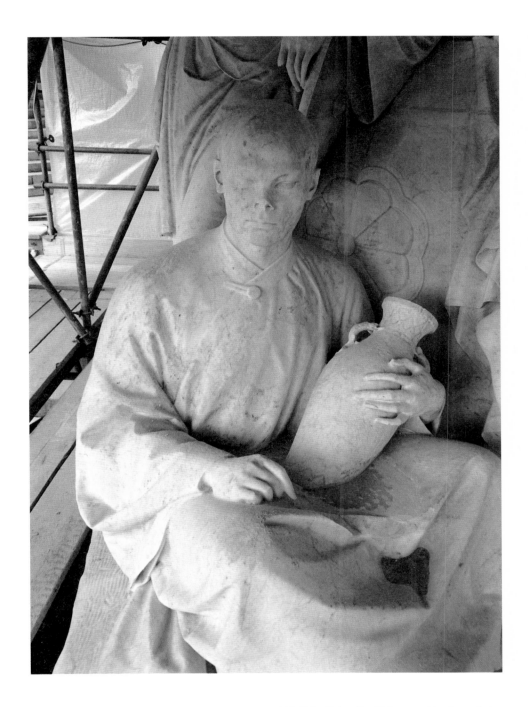

196. John Foley, the Chinese potter from *Asia*, 1865–71.

The semantics of Theed's *Africa* (129, 197) are less straightforward. For Victorians, ancient Egypt was the earliest recorded civilisation, and the figure of Africa is shown in costume based on Egyptian statues and wall paintings. But her beast, the camel, is shown kneeling 'as having completed its journey',[65] the continent's ancient civilisation having come to an end – a message reinforced by the inclusion of a half-buried sphinx. Quite how one should realise the camel is not about to start on its journey is not explained – though, given nineteenth-century European assumptions about Africa, the issue probably did not arise for contemporaries. Kneeling at the front of the group is an Arabian merchant with bales of cotton, minerals, vegetable drugs, elephants' teeth and so on – one of the Memorial's many reminders of the age-old importance of commerce. Balancing him on the other side of the plinth, leaning nonchalantly against the buried sphinx, is a young male, described as 'a troglodyte from the desert between the Nile and the Red Sea'.[66] Dafforne's words suggest a race not touched by the benefits of progress; interestingly, the *Handbook* adopts a more neutral description of him as 'a Nubian, or inhabitant of the eastern limits of this continent'.[67] To the rear of the group, turned away from the spectator and deep in conversation, are a female figure, clearly European, and a black African tribesman (198). Dafforne says she is instructing him in the arts of civilisation.[68] The assumption behind such a representation can today look like arrogance, but we must accept as genuine the belief of the time that European values represented betterment for the continent's peoples: the *Handbook* speaks of 'efforts made by Europe to improve the condition of these races'.[69] And there would have been many in the contemporary audience who remembered Britain's part in ending the slave trade little more than a generation before – alluded to, modestly enough, by the broken chains that lie at the African's feet.

197. William Theed's *Africa*, from *The National Memorial to his Royal Highness The Prince Consort*, 1873 (Kensington Central Library).

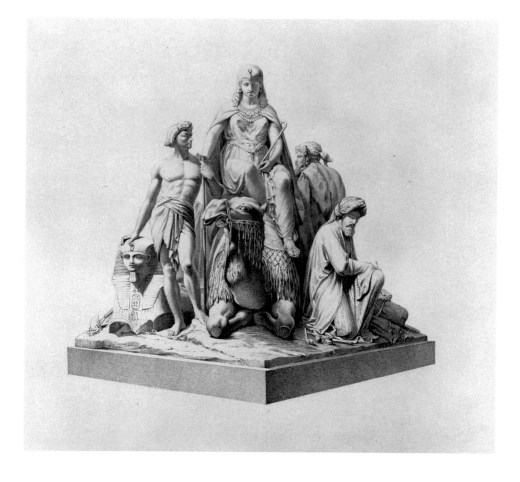

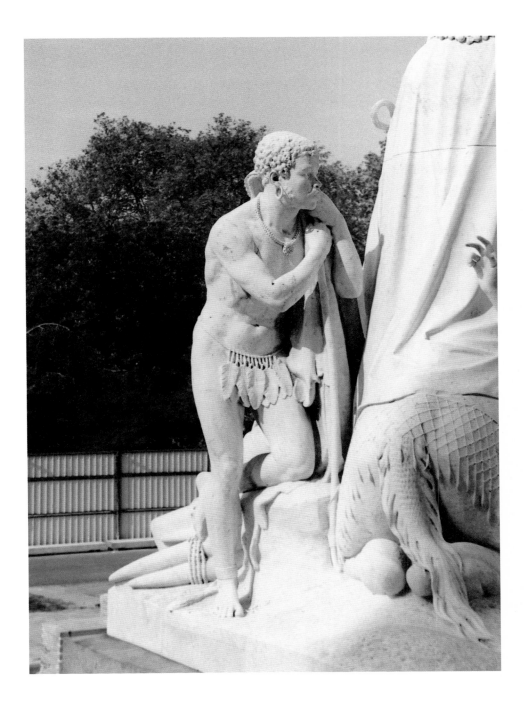

198. William Theed, the African
tribesman from *Africa*, 1865–71.

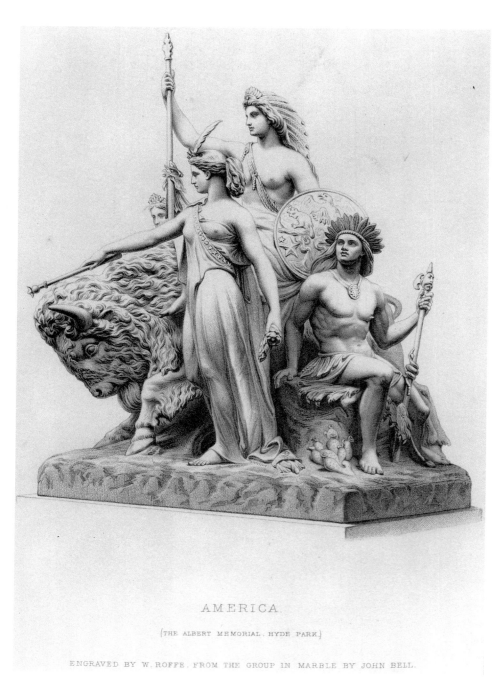

AMERICA.

(THE ALBERT MEMORIAL, HYDE PARK.)

ENGRAVED BY W. ROFFE, FROM THE GROUP IN MARBLE BY JOHN BELL.

199. John Bell's *America*, from *The National Memorial to his Royal Highness The Prince Consort*, 1873 (Kensington Central Library).

Patronising though it seems to us now, the idea that European culture was the highest form of civilisation was sincerely, often earnestly, held by many high-minded Victorians. And for most viewers of the Memorial, Albert's adopted country could be represented as being in the vanguard, not only in the progress of manufactures and commerce but also in civilised values. By the 1870s, however, this comforting assumption was becoming increasingly difficult to sustain in the face of developments across the Atlantic: John Bell's group, *America* (156, 199), is replete with ambiguities. The feather-crowned figure of America rides a bison, a fair choice at the time of the opening of the Western States, and the animal is shown 'bearing her forwards through the long prairie grass; signifying thereby the rapid progress of the country in the march of civilisation'. The specific and narrow nature of the civilisation thus commemorated is revealed in Dafforne's next remarks:

> *It should be remembered that America, so far as her earliest annals are known could scarcely be called a barbarous nation at any time. The comparatively few inhabitants of the vast continent when first discovered were hardly numerous enough to be designated a people, and they, by degrees, have died out. The 'red man' has almost vanished from view.*[70]

Written a mere five years after the United States army actually conceded defeat at the hands of the Santa Sioux,[71] this bland assumption appears biased to say the least. There is much in the group that stresses both the introduction – or imposition – of what were regarded as progressive values, and, by corollary, the primitive nature of native American cultures. Thus the central figure holds a stone pointed lance, her bison is covered with a bear skin, and on the ground is an Indian quiver with but two arrows left. Bell's iconography was probably doing no more than replicating what most citizens of the United States understood by the history of their country and their civilisation. More telling perhaps, particularly on a British monument, is that he chose, uniquely among the four Continents, to portray his group in motion, adopting as his motto for the composition the word 'Advance !'[72] It was an acknowledgement of the industrial and technological progress that was rapidly giving the United States a decisive lead over Britain.

Like Macdowell with Europe, Bell had to deal with serious issues of *realpolitik* – particularly relevant as Albert's last diplomatic act had been to defuse Anglo-American tensions. Britain had taken a thoroughly ambiguous stance towards the secessionist states during the Civil War (1861–5): there had been regular threats from Lincoln's government to invade Canada, relations with the Grant presidency were little better, and, as Bell was working on the group, the United States was vigorously demanding compensation from Britain for the destruction wrought by the Confederate raider *Alabama*.[73] Creditably, Bell rose above such national rivalries – encouraged to do so, as described in the previous chapter, by Eastlake. The shield carried by the central figure of America is carved with the eagle and stars of the States, as well as the Canadian beaver, and the female figure representing the United States, with stars and an eagle's feather in her head-dress, leads the whole group. Most importantly, it is she who with her sceptre directs the forward motion of the bison. On the other side stands Canada, equipped with snowshoes and ears of wheat, with the national maple leaf and the mayflower for Nova Scotia woven in her head-dress, but still clasping the British rose to her bosom. These two females are patently western in appearance, for the nineteenth century saw American civilisation as

the product of European immigration. With the arrival of Europeans, in Dafforne's account of events, the continent 'suddenly sprang forth from a savage state into one that externally, at least, was directly its opposite'.[74]

The group's location of civilisation is confined largely to North America, however, though Central and South America are not quite ignored. A Mexican Indian with a staff and Aztec head-dress sits behind the United States, a sample of the cochineal cactus at his feet – something that his part of the world could supply for the west. Yet he too is stirring, peering forward and rising up as if restless – a reference to the Mexican revolutionary wars of the 1860s which has to be read as sympathetic to national striving for independence. More pathetic is the figure of South America, seated behind Canada and shown as a half-breed Spanish Indian, part naked but with a sombrero and poncho. He holds a carbine and lasso, to signal his part in raising the beef that was already being exported to Britain from places such as Fray Bentos.[75] The high civilisations such as the Incas, though their history was well known, are as completely ignored as the Spanish Empire that conquered them: their omission was presumably justified on the grounds that they were extinct. Certainly the southern American's other attributes reflect primitivism or the natural world. His horn is made from that of a wild cow and one can make out a Brazilian orchid and an Amazonian lily beside him. These natural wonders link the representation back to Albert's world and the nineteenth-century passion for plant-collecting. The Amazonian lily, named *Victoria Regia* in 1837, was even linked to the Great Exhibition, as its structure was one source of inspiration for Paxton's Crystal Palace – a tenuous but typical appropriation.

The richly complex iconography of the whole Memorial is shot through with such detailed references to the Great Exhibition. They provide a constant grounding, a historical point of reference, for the meanings examined in this chapter. For the Memorial's celebration of material progress, of art and industry, of commerce, of Britain's eminence as a world power, of the cultural inheritance the nineteenth century claimed, of what the mid-Victorians understood by civilisation. The limitations and inequities of the assumptions upon which that understanding was based, the selectiveness of the world-view assembled in homage to Albert, are evident from our later perspective. Ideologically, the Memorial's values are Eurocentric, inclined to be patronising and even dismissive towards non-European traditions; they are male-dominated, assigning to women a depleted role in culture and history; and they are class-bound, tending to be smug about prosperity without asking how far down society that prosperity reached. But all understanding, including our own, is based upon assumptions determined by time and place, their inadequacies only too apparent to subsequent generations. And in the larger context of mid-Victorian culture, the very values the Memorial promoted were subject to criticism every bit as public as the Memorial itself. Dickens's novels, the cultural anatomies of Ruskin and Matthew Arnold (1822–1888), the social philosophy of John Stuart Mill (1806–1873), the writings of Bodichon and the early feminists, provided a cumulative critique of contemporary assumptions that was nothing if not vigorous. Moreover, as we have seen, the very elaborateness of the Memorial's iconographic programme, the diversity of its meanings, invite divergent readings. Even Dafforne, who was certainly in tune with dominant values, is aware that such a complex body of representation prompts varied, and sometimes contradictory, interpretation.

Yet, at the same time, the Memorial is proud of the achievements that it brings to the commemoration of Prince Albert. And with reason. Britain in the nineteenth century became the world's first urbanised and industrialised nation. Though the national wealth that resulted was unevenly distributed and there were gross inequalities, many of the worst social and economic abuses that attended the process had been reformed or were being tackled by the 1860s. The shape of a more democratic future emerged in 1867 when the Second Reform Act enfranchised large numbers of working-class men for the first time, and by the time the Memorial was opened a state system of primary education had been instituted, which would soon encompass all children. The whole period was one of unprecedented scientific and technological progress; the country's transport system was revolutionised; major advances were made in medicine, sanitation, and health-care. And, though the Victorians themselves were endlessly self-critical about their own cultural attainments, there were the achievements of the period's literature, art, and – not least – architecture, its creative variety and expressiveness epitomised by the Memorial. To the prosperity, progressiveness, and creativity of his adopted country, Prince Albert, in his short career, had contributed remarkably. The Memorial, 'a tribute of … gratitude for a life devoted to the public good', rightly recognises this; and, whatever the ambiguities or shortcomings we may now detect, it celebrates Albert and the world he helped to make with optimism and self-confidence.

200. Francis Skidmore (1817–1896), portrait
from his obituary in the *Coventry Times*,
18 November 1896.

Francis Skidmore
and the Metalwork

Peter Howell

In his 'Retrospective Report' on the Albert Memorial, of 1869, Scott described the metalwork as 'in many respects the most remarkable part of the whole work, inasmuch as it stands quite alone in character and workmanship among either modern or ancient structures'.[1] He considered that the only man who could possibly have carried it out was Francis Skidmore (200).[2] As very little has been published on this extraordinary man, it will be well to provide a brief account of his career.

Francis Alfred Skidmore was born in Birmingham on 14 February 1817.[3] His father, also Francis, was a jeweller and silversmith, who seems to have come from London, settling by 1822 in Coventry, where he had a shop in Hertford Street. By 1828 he had moved to Cross Cheaping. In 1835 he became a churchwarden of Holy Trinity Church, the second great medieval church of Coventry, whose vicar was Walter Farquhar Hook, later famous as Vicar of Leeds.

The young Skidmore (an only child) was apprenticed to his father, and would have learned such skills as chasing, engraving, casting, soldering, and working with jewels. He developed a strong interest in historic metalwork. One may surmise that this was stimulated both by the passion for medieval antiquities current at the time, and more particularly by the celebrated medieval remains of his home town. One obituary states that he 'entered on the study of ancient metalwork and manufacture at home and abroad', though very little is known of his travels.[4]

The arts of metalworking had flourished in England in an unbroken tradition since the Middle Ages. Silver and gold work had been executed to the highest standards, the craft having been invigorated by considerable numbers of Huguenot refugees. Similarly, wrought ironwork of high quality had been provided for such uses as railings, staircase balustrades, fanlights, gates, and so on. Work in other metals – whether lead, copper, brass or bronze – was equally accomplished. As the gothic style was revived in the eighteenth and early nineteenth centuries, metalwork came to be executed in what was thought to be an appropriate manner, but was essentially classical in form with an overlay of fancy gothic ornament. Examples are the designs made by the fifteen-year-old Pugin for plate for St George's Chapel, Windsor. In his maturity, however, Pugin not only produced authentically medieval designs, but also claimed that his friend John Hardman of Birmingham was reviving ancient techniques of metalworking and enamelling.[5] The claim was exaggerated. For one thing, champlevé enamelling had more recently been used in the jewellery trade, especially for mourning jewellery. For another, Pugin and Hardman made use of 'the most sophisticated modern methods available to a mid-nineteenth century Birmingham metal foundry'.[6]

Skidmore's 'earliest work was in the repair and restoration of church plate, and in the production of elaborate iron and brass hinges, locks &c., for the oaken boxes in which such plate was to be preserved'.[7] In 1845 his mark was entered at the Birmingham Assay Office, under the name of 'Francis Skidmore and Son'. His earliest known works, two silver chalices, were marked in that year. One, for St John the Baptist, Coventry, is decorated with enamel plaques and engraving, and the other, for St Giles, Exhall, near Coventry, is decorated with jewels and engraving.[8] In a letter of about 1845, to John Hardman, Pugin mentioned a priest who had obtained his plate from Coventry, where Father W. B. Ullathorne – then priest in charge of the Coventry mission, later an archbishop – had bought candlesticks at half Hardman's price.[9] It would be interesting to know whether the maker was Skidmore.

Certainly the contemporary interest in building and furnishing churches was responsible for an increasing demand for suitable liturgical vessels, and Maureen Bourne has drawn attention to W. F. Hook's concern with ecclesiastical propriety.[10] Hardman had first begun to manufacture church metalwork to Pugin's designs in 1838, and in 1843 the Cambridge Camden Society appointed William Butterfield as its agent for the commissioning of church furnishings: he worked with the London silversmiths John Keith and Son to produce church plate. It was Keith who supplied plate to Christ Church, Coventry in 1843.[11]

At the Great Exhibition of 1851 Skidmore showed various items of church plate, which were illustrated in colour in Wyatt's *Industrial Arts of the Nineteenth Century* (202).[12] In his text Wyatt stated that Skidmore had only made plate for a few years, but had studied the old forms and processes for many years. The plate shown included a two-handled chalice, intended to revive a tradition of the early church, and items incorporating enamels and niello work. Skidmore was awarded a medal.

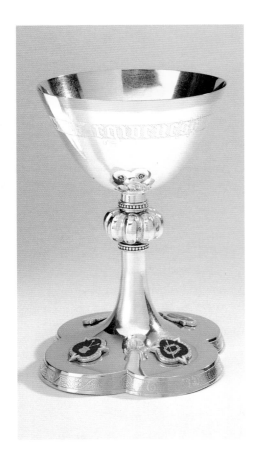

201. Francis Skidmore, Chalice, 1846; silver, parcel-gilt, decorated with enamels; from St Alkmund's Church, Duffield, Derbyshire.

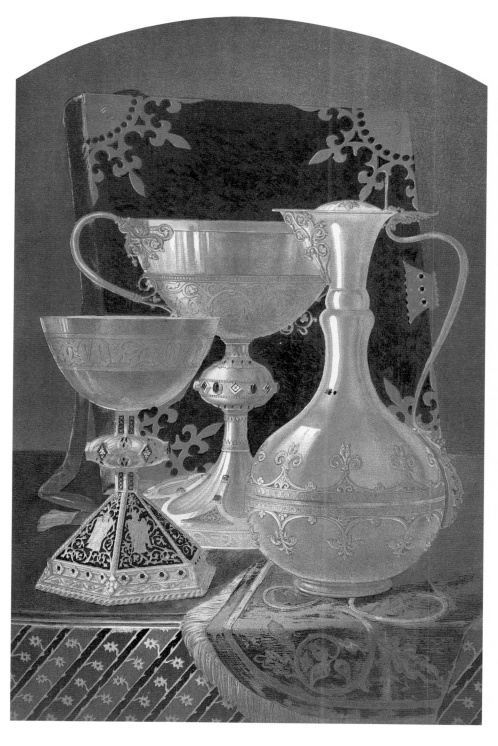

202. 'A Group of Church Plate by Skidmore of Coventry',
chromolithograph from Matthew Digby Wyatt,
Industrial Arts of the Nineteenth Century, 1853
(Victoria and Albert Museum).

In June 1852 he was elected a member of the Oxford Architectural Society (OAS), a connection which would prove very important for him. In the same month he showed members 'a specimen of the revived art of niello'.[13] Two years later he gave two lectures to the Society. The first dealt with ecclesiastical metalwork, including the use of niello and enamel, and predicted that 'England should now achieve pre-eminence as the seat of metal manufactures'.[14] Various works of his were shown, including 'a binding of massive silver', which was perhaps the one now in the Herbert Art Gallery at Coventry. The second paper – perhaps unexpectedly – was on the warming and lighting of churches.[15] He argued that gas stoves and lights provided the opportunity for beautiful effects – 'groups of small scintillations of flame' – with the delicacy of hammered metal. Light standards of wrought iron could have supports like flying buttresses, and the correct foliage should be used to suit the style of the church. He claimed furthermore that warm, bright churches would make evening services more attractive, and that this would encourage the working classes to attend. It is interesting to note that one of the first churches lit with gas had been Holy Trinity, Coventry, in 1830: this resulted from Hook's introduction of evening services.[16]

Skidmore's earliest datable work in non-precious metals is the gas wall-brackets of brass for St Mary's Guildhall, Coventry, for which the designs were approved in May 1850.[17] In the next year he supplied free-standing gas-light fittings for St Michael's Church.[18] These were admired on the OAS visit in 1856 as 'some of Mr Skidmore's most beautiful gas standards'.[19] An earlier Society visit to Coventry, in June 1854, had included Skidmore's 'manufactory', where members saw 'cups, ewers, salvers, and gas fittings'.[20] His church furnishings were not confined to plate and gas fittings. In 1852 he supplied altar rails in wood, iron and brass for Butterfield's restoration of Cubbington Church, Warwickshire,[21] and in 1854 brass altar rails for St Michael's, Oxford.[22] In 1855–6 he made screens for Ilam Church, Staffordshire, as part of the restoration by Scott:[23] they are of extraordinary delicacy, incorporating foliage and flowers. This was not his first job for Scott: he had made a flagon, chalice and paten for St John the Baptist, Eastnor, Herefordshire, which Scott restored in 1852–3.[24] In 1856 he made a font canopy for Holy Trinity, Coventry, again with Scott as architect,[25] as well as doing his first job for Alfred Waterhouse (1830–1905), supplying some of the ironwork for Hinderton Hall, Cheshire.[26] Both Scott and Waterhouse were to be crucial for Skidmore's career.

Meanwhile his ideas were ranging even further. In 1856, at the Architectural Museum in London, he gave a lecture to the Ecclesiological Society – of which he was a member – that suggested that cathedrals could be built of iron, the interstices of their frames filled with ceramics, marble, or stone carvings.[27] This notion was in the air at the time: Richard Cromwell Carpenter had begun a design for an iron church before his death in 1855, and in 1856 his partner William Slater designed one that was published in the Society's *Instrumenta Ecclesiastica*.[28] Slater's church had columns of four separate rods bound together by spiral bands. He obtained estimates for the church from Troughton and Bevan, in cast iron, and from Skidmore, in wrought and cast iron. The latter was higher – £2,500 as opposed to £2,150 – but Skidmore claimed that he could erect a church to hold 800 for a third less than the equivalent cost in stone.[29] Iron was more than a cheap expedient, however: as he argued in his lecture, it should be used for the development of Christian art.

In 1853 Skidmore had sold the jewellery business in Cross Cheaping and

opened 'Skidmore and Son, manufacturers of church plate and metalwork', in a yard off West Orchard Street.[30] It seems that his father – who died in 1860 – was not particularly involved in the new business. Also in 1853 Skidmore married Emma Carless, daughter of a Coventry watch-gilder, 'a lady of very similar tastes to his own'.[31] In the 1851 Census, when already resident in the Skidmore household, she was described as 'assistant to silversmith'.[32]

It was at this time that Skidmore's great opportunity to show how iron could be applied to gothic architecture occurred. In 1854 a competition was held for a new museum for the University of Oxford.[33] This was intended to provide space both for the teaching of scientific subjects and for the display of the scientific collections. The competition rules stipulated that the teaching accommodation should be laid out on three sides of a quadrangle, to be roofed in iron and glass, in which the collections would be shown. The idea for this – said to have been due to Philip Pusey, brother of the Tractarian Pusey – came from contemporary railway stations. The architect whose design won the competition, Benjamin Woodward, proposed that cast iron should be used for the shafts, with wrought iron plate arches above.

It is not known for certain how Skidmore came to be chosen to execute the ironwork. There is no evidence that he had erected any structural ironwork before this date. It seems that the crucial figure – as so often with the Museum – was Dr Henry Acland, who would have known Skidmore through the OAS. In February 1855 Woodward told the Delegates that Skidmore had undertaken to contract for the iron roof, and showed them a sketch of the proposed ironwork, which was 'much admired'. This is presumably the design shown in a lithograph intended to accompany an appeal for donations to a special fund for decoration, and in an engraving reproduced in the *Builder* for 7 July 1855. Frederick O'Dwyer describes these as showing 'impossibly slim columns of clustered tubes braced by tubular arches that can have given little structural support, inset with spandrel decoration consisting of iron foliage and leaves. Above the spandrels are tubular lattice girders which presumably would have supported the valley gutters.'[34]

The foliage spandrels were important features, not just as decoration, but as relating to the teaching programme of the Museum. Skidmore sent Acland a photograph of a design for an elaborate wrought iron 'tomb', in the form of an ogival arch, to give an idea of what he proposed.[35] In his 'Second Letter' about the Museum, addressed to Acland and dated 20 January 1859, John Ruskin illustrated a spandrel representing horse-chestnut leaves, with some perceptive criticism of it. He is known to have himself made either six or eight designs for spandrels, but unfortunately neither the drawings nor photographs of them survive.[36] By March 1856 Skidmore had made an 'improved' design for the roof, and estimates for this were submitted. Skidmore's original estimate had been for £5,216, but he was so excited by the chance of showing the properties of wrought iron, which, he said, 'held out the possibility of uniting artistic ironwork with the present tubular construction and a prospect of a new feature in the application of iron to Gothic architecture', that he offered to execute the entire structure in 'wrought tubular construction' alone for £3,100. The remodelled design was welcomed by Scott as 'a vast improvement'.[37]

Skidmore's offer was accepted. Deane and Woodward wrote in a report, probably of 1860, that 'considerations of economy and confidence in Mr Skidmore's ability, which we were justified by previous enquiry in entertaining (and which we believe has carried him with success through every other

undertaking) induced us to advise the acceptance of his offer'. However, by February 1858 there was trouble: the columns had given way 'in several instances'. At his own cost, Skidmore consulted the distinguished civil engineer William Fairbairn, who in 1854 had published *On the Application of Cast and Wrought Iron to Building Purposes*. In a report dated 7 April 1858, Fairbairn supported Skidmore's proposal to strengthen the columns by an inner shaft of cast iron. In April, Sir Thomas Deane – standing in for Woodward, whose health had caused him to leave Oxford – read a statement to the Delegates. He praised Skidmore: 'he bears a high character as one of the finest metalworkers in England'. He reported that the strengthening work had begun, but had not set all doubts at rest. Fairbairn had recommended the addition of a second core, and the substitution of plate iron ribs for the tubular ones presently used, all the decorative parts to remain the same. Skidmore himself explained the situation 'with great frankness', and promised to guarantee stability.

In May 1858 the Delegates asked Convocation – the university's governing body – for a grant for the work on the roof. It was stated that Skidmore, for the amount of his original estimate, was willing to reconstruct all the ironwork to Fairbairn's specification, using a large portion of cast iron combined with wrought, and including new bases for the columns. He would remove the existing structure at his own cost. This meant that he was bound to make a substantial loss. Fairbairn's report stated in Skidmore's defence that the existing structure had been prepared for a lighter roof than it eventually had to bear because Woodward had introduced modifications, including the use of thicker glass, for strength and waterproofing.[38] The subsequent history of the roof has been one of constant trouble, and it is something of a miracle that it has survived.[39]

Its loss would have been a tragedy. There is really nothing like it anywhere else (203). Despite the heavier rebuilding of 1858, it is of astonishing lightness, and the tall gothic arches harmonise perfectly with the stone and brick structure. The roof still has its original painted decoration, much faded. It should have been painted in much richer colours, but academic bickering led to its 'looking as if it had been drawn through a river of bread sauce' – as the *Building News* put it.[40] Ruskin's attitude to the roof was characteristically ambivalent. In 1859 he wrote to his father: 'All the practical part, excellent. All the decorative in colour, vile.' His good opinion must have been influenced by the fact that the wrought iron was worked by hand: Acland pointed out that one piece of foliage was made of twenty-five pieces of iron, welded in different ways.[41] However, much later, in 1877, Ruskin said that he knew it was all over with the building when Woodward allowed iron[42] – he must have forgotten that Woodward was bound by the competition brief.

It was presumably the Museum commission which led Skidmore, in 1857, to move to new works in Coventry, further from the centre, on a site between Raglan and Alma Streets, where the factory eventually covered three-quarters of an acre.[43] At about this time 'Messrs Skidmore and Company' was formed. By 1861 the business was expanding, and a foundry was set up for large base metal work. In 1865, needing more capital to execute contracts in hand and on offer, Skidmore formed a partnership with five others as 'Skidmore's Art Manufactures and Constructive Iron Company'. The works and business were valued at £30,456, and it was proposed to raise £100,000; Skidmore was to act as Managing Director for seven years.[44]

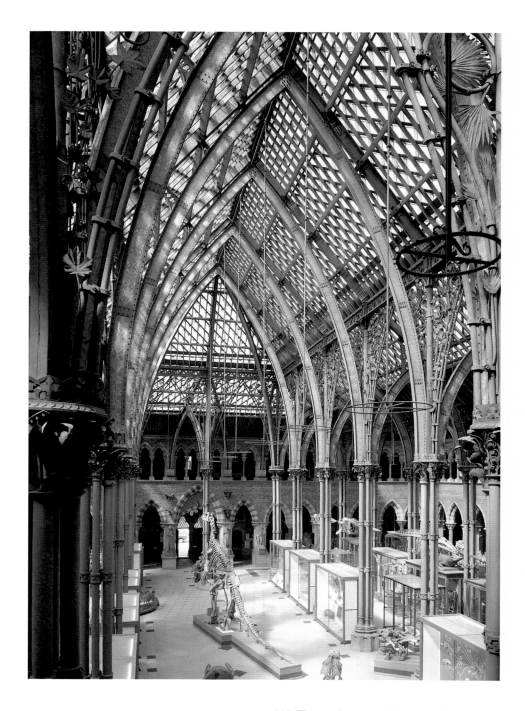

203. Thomas Deane and Benjamin Woodward,
The University Museum, Oxford, 1855–60;
the roof by Francis Skidmore.

Apart from the Albert Memorial, the only other constructional ironwork by Skidmore of which evidence has come to light is the Market in Darlington built in 1861–3 to the design of Alfred Waterhouse.[45] It was a fairly conventional light structure of cast-iron columns supporting an iron roof, all set over a deep basement because of the sloping site, with vaults held on cast-iron brackets. On the opening day part of the floor gave way, and two bulls and one man fell through: the latter died. The cause was traced to a faulty casting. Waterhouse was exonerated, but never used a complete iron structure again. Skidmore's unfortunate experiences at Oxford and Darlington may well explain why he did not do more structural ironwork.

In 1859 Skidmore gave a lecture to the OAS on 'Ancient Metalwork applied to Domestic Purposes, and the Uses of Iron, in Reference to the New Museum',[46] supporting his ideas with iron models. He pointed out the superiority of ancient examples to modern ones, especially in the use of enamels and niello. Plate and ribbed iron were already being used for strength in the fourteenth century, so this was not 'a railway idea'. Iron should be used more in architecture, especially now that it was easily obtainable. He argued that thirteenth-century conventional foliage carving was derived from metalwork: metal craftsmanship was in advance of stone. Tellingly, in the present context, he also suggested that 'not unfrequently shrines were original models of churches, first made in metal, and then serving for the general idea of a church'. In discussion, J. H. Parker found Skidmore's theories about foliage carving 'far from improbable',[47] and Acland, arguing the suitability of glass and iron for gothic, praised his 'manful' handling of the Museum problems.

The International Exhibition of 1862 offered Skidmore an opportunity even more striking than had that of 1851. He had already supplied some magnificent metalwork for Lichfield Cathedral, being restored by Scott. The most remarkable piece is the choir screen (90), a light but elaborate structure of wrought iron, copper and brass, incorporating 'imitations of various fruits in ivory, onyx, and red and white cornelian',[48] with eight angel musicians modelled by John Birnie Philip on each side, and a frieze of open scrollwork above. Skidmore also made the large and lavish pulpit, of wrought iron, brass, copper, enamels and marble, with a bronze group of St Peter preaching, and a double staircase, as well as the gates into the choir aisles, the fronts of the central parts of the choir-stalls, and gas fittings.

Skidmore wanted to show an exhibit of major size and splendour at the 1862 Exhibition, and offered, at a low price, to make a choir-screen similar to Lichfield's for Hereford Cathedral (204).[49] He did not receive Scott's designs until January 1862, but the screen was on show in May – an astonishing achievement, considering its elaboration. Most surprisingly, the upper part of the screen's structural framework is entirely of wood, despite the fact that the *Builder* stated it was of cast iron, and the Jurors reported that 'the whole is formed of wrought iron'. Apparently, for the purposes of the Exhibition, the screen had to be free-standing, and using timber avoided top-heaviness.[50] The decorative elements were in wrought iron, brass and copper, with panels of mosaic, and bosses of marble, feldspar and crystal. The painted colours were taken from the oxidation of the metals used – following Ruskin's dictum that iron looks best when rusting – with some greens added, along with 'a little gilding'. Within the vesica panel over the central arch was a statue of Our Lord, while on each side stood two groups of angels looking adoringly at Christ, with angel musicians at either end: these were electrotyped in copper.

In his *Recollections*, Scott pondered the broader significance of the screen.

Metal-work has, during the period in question, made considerable
progress, though it has suffered its share from the eccentric mania of the
day. Mr Skidmore can claim an eminent place both in skill, progress, and
eccentricity. My own individual share has not been great, excepting that
I have had one or two great works carried out, such as the choir-screens at
Lichfield and Hereford cathedrals. Both of these were designed in full by
myself, and are carried out according to my designs, in general: in both,
however, as in all his works, Mr Skidmore has 'kicked over the traces'
wherever he has had a chance. In some cases the work has gained, and in
some suffered from this. Original ideas have been imported, but a certain
air of eccentricity has come in with them. On the whole the works are
both very fine, and especially the latter.[51]

The Hereford screen was much praised. Christopher Dresser called it
'undoubtedly one of the finest works of modern times';[52] the *Builder* 'offered our
commendation'.[53] The *Illustrated London News* was beside itself.

It is scarcely ten years since many of our most distinguished architects set
themselves to oppose the introduction, or at least the extensive use of, iron
or other metals for architectural purposes, and maintained with the utmost
virulence that it was impossible to invest iron with architectural features
… Mr Skidmore was at this time regarded as a man of more enthusiasm
than judgement – as the keeper of a hobby which might please him, but
which it was hoped he would keep to himself and not trouble any one else to
ride. Indeed, he was regarded by some as almost a monomaniac – nothing
but metal … The battle has been fought; the victory has been won; and …
the Hereford screen stands before us as the grandest and most triumphant
achievement of modern architectural art – a monument which … hushes
to silence all objectors; for by gazing upon it their preconceived notions
become blasted and withered as by the petrifying glance of a Medusa.[54]

204. George Gilbert Scott and Francis Skidmore, Choir Screen, Hereford Cathedral,
chromolithograph of 1862 (Victoria and Albert Museum).

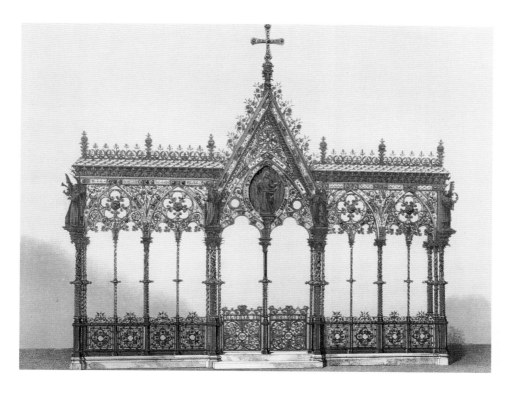

Scott himself – always prone to self-doubt – came to have reservations: 'Skidmore followed my design, but somewhat aberrantly. It is a fine work, but too loud and self-asserting for an English church'.[55] Later, his words were seized upon by those who wanted to remove the screen from the cathedral: they got their way in 1967.[56] The screen was not Skidmore's only exhibit in 1862. In addition, he showed a large gas corona, also for Hereford; a group of 'four gas standards of great size, all of them in brass', intended for the cathedrals of Hereford, Lichfield, Norwich, and Calcutta; and 'screens', presumably subsidiary ones, for Lichfield and Ely. He was awarded a medal, as he was again at the Dublin Exhibition of 1865.[57]

Not surprisingly, Skidmore's public success led to many commissions, and the 1860s were the high point of his activity. It may be wondered who provided the designs, when an architect was not involved. Skidmore was an artist himself, and a member of the Spring Gardens Sketching Club, named after the site of Scott's office, with a membership largely made up of his past and present pupils and assistants.[58] Skidmore's earliest works were based on his own designs, subsequently those by architects, and he later recruited designers to work for him. The name of one is known, and he is notable as one of the finest designers of his time – Bruce J. Talbert (1838–1881), who seems to have worked for Skidmore for a few years after about 1862.[59] His influence has been detected in a silver flagon made in 1863 for All Saints, Bisley, Gloucestershire, and in a clock made in 1863 for Malvern Girls' College.[60] Even when working for an architect Skidmore might propose a design of his own, as he did in 1867 for the pulpit ironwork at Ely Cathedral: here Scott overruled him.[61] In the discussion after a lecture on ironwork, given to the RIBA by William White in 1865, John Pollard Seddon praised Skidmore's design skills:

> In metalwork there was very little indeed that was decent. In the work of Mr Skidmore ... there was great excellence, but that was mainly owing to the fact that Mr Skidmore was himself an artist, and had devoted much study and superintendence to the work, but that gentleman had recently stated that he had completely failed in obtaining or educating a single artist workman.[62]

Skidmore continued to do a great deal of work for Scott: for example, the superb gates for the screen of Exeter College Chapel, Oxford, of about 1859, which are of iron and brass, with mastic decoration.[63] He made two other choir-screens for cathedrals, at Worcester and Salisbury, but the stinginess of the donor at the latter resulted in its being 'sadly stinted', as Scott recorded, though adding that despite 'loss, and infinite trouble, in screwing down its expense ... Mr Skidmore has here done his *very utmost*'.[64] Though the resulting screen was less elaborate than those at Hereford or Lichfield, its removal in 1959 was a substantial loss to the cathedral. His finest work for Chester Cathedral, where he also executed the choir-screen gates and altar rails, was the magnificent hanging cross, removed in 1921 to St Luke's, Dunham-on-the-Hill, Cheshire.[65] For Oxford Cathedral, in the mid-1870s, he made the superb railings around the choir.[66]

A substantial proportion of the firm's work must have consisted of gas-light fittings, and it is a pity that so few survive. Skidmore's enthusiasm for this type of light, as far back as 1854, has already been quoted. Edward Cutts' *Essay on Church Furniture and Decoration* praises his gas standards highly, and illustrates a charming example in brass, with the gas jets emerging from foliage

as if to represent the flowers.[67] Such lighting was not just ecclesiastical: commissions from Scott included Brill's Baths at Brighton in 1862, and the St Pancras Station and Hotel in 1869–72.[68]

By the 1870s, however, Scott was tending to use Thomas Potter and Son, or James Leaver of Maidenhead – who did G. E. Street's ironwork – instead of Skidmore.[69] The reason may well have been Skidmore's dilatoriness, which caused much annoyance to the St Pancras Construction Committee. One of his most faithful clients among architects, until about 1870, was Alfred Waterhouse.[70] Their collaboration over Darlington Market has already been mentioned, along with Waterhouse's first commission, for Hinderton Hall, in 1856–7. There followed many more, mostly for domestic or public buildings, including the Manchester Assize Courts and Town Hall, and Strangeways Gaol. Waterhouse often commissioned ironwork from more than one maker for the same job, his other preferred firms in these years being Robert Jones of Manchester, and Hart and Son – later Hart, Son, Peard and Co. What seems to have been Skidmore's swansong for Waterhouse was a particularly challenging commission. When set up in front of the new Eaton Hall, the splendid eighteenth-century 'Golden Gates' needed to be extended, and in about 1871 Skidmore executed the side-screens to Waterhouse's design.[71] However, Skidmore's deliveries were unreliable, and Waterhouse turned to Jones and to Hart, Son, Peard for the rest of his career.[72]

Part of the trouble was that Skidmore was a perfectionist, to such an extent that, even when work had been loaded on the dray, he would sometimes take it off for inspection, and anything unsatisfactory would be broken up and redone.[73] One of his employees, David Hiorns, who had been apprenticed to him in 1856, said that Skidmore 'worked for a good name, got the name, but lost money. He would break up goods of pounds and pounds in value just because they did not suit him in some trifling particular'.[74] Another workman wrote that the 'hardest master he had to satisfy was himself; he never thought of his own interest for one moment, his only thought being how he could improve the work he had in hand, no matter what the cost might be.'[75] Yet another said that 'he was very strict in the workshop; if any article, be it of base or precious metal, iron, copper, silver, or gold, was not as true as a hair – it did not matter how long it had taken to make, or how much labour had been spent on it, if there was the least flaw or imperfection in it, either in design or make, he would have it either altered or broken up, and another made instead.'[76] As one obituary put it, 'his commercial instincts were overpowered by his artistic sensibilities'.[77]

Naturally Skidmore worked for many other architects, and a few examples will suffice. In 1864 he made a superb canopy for Arthur Blomfield's monument to Bishop Pearson in Chester Cathedral.[78] For Dr Magee, who became Bishop of Peterborough in 1868, he made a pastoral staff, 'designed by a clergyman', which included turned ivory work.[79] One of his works for Waterhouse gives a clue to yet another aspect of Skidmore's production. In 1864–5 Waterhouse designed a dressoir for J. E. Hodgkin: Skidmore supplied the ironwork.[80] At the South Staffordshire Industrial and Fine Art Exhibition, held at Wolverhampton in 1869, Skidmore showed 'works in various metals and wood, distinguished by the characteristics for which they are celebrated; i.e. originality in metalwork; in wood, their chairs and corner cupboard with floriated hinges of metal well indicate the style adopted by them in furniture'.[81] He had already shown furniture at the Coventry Industrial Exhibition of 1867.[82] Skidmore further diversified into church memorials. He made brasses – one, for example,

designed by Scott, in St George's Chapel, Windsor, to the Duchess of Gloucester, who died in 1857.[83] Scotland provided Skidmore with some of his last commissions, including two memorials in Edinburgh,[84] the choir screens in St Mary's Cathedral there,[85] and the *porte cochère* of Glasgow Central Station – both these last dating from 1879.[86]

About 1870 Skidmore's partners pushed him out of the firm: as we will see later, the circumstances related directly to his work on the Albert Memorial. He moved to the eighteenth-century Manor House at Meriden, a village some seven miles north-west of Coventry. Here he faced considerable problems: as there was no gas supply, he had to send his brazing work to Birmingham or Coventry.[87] In 1872 his old firm went into liquidation, the works were sold, and the business taken over by Winfields of Birmingham. Skidmore had for some years had an 'establishment' in Birmingham, and he moved there, to Cape Hill, from Meriden. Soon after 1890, however, he was back in Coventry, living in Eagle Street – an unfashionable street of two-storey brick terraces.[88]

The latter part of his career showed a decline. Part of the problem was that ironwork was going out of fashion, in both ecclesiastical and domestic architecture. When Scott's former pupil, John James Stevenson (1831–1908), launched his attack on 'destructive restoration' in 1877, he singled out among incongruous new furnishings introduced into old churches 'the gimcrack brasswork screens and gas-brackets with their vulgar blue paint, from the eminent firm of Skidmore'.[89] In his 1874 book *Modern Parish Churches*, another Scott pupil, John Thomas Micklethwaite (1843–1906) argued strongly in favour of wooden screens, rather than iron ones. In a lecture of 1907, Temple Moore (1856–1920) said that he did not think 'iron screen work ever looks quite satisfactory with our English work, and certainly the modern examples one sees are rarely successful'.[90] These changes in architectural taste left Skidmore behind, as witness the drawings dated 1890 in a catalogue issued by 'F. A. Skidmore: Coventry and 24 Hunter's Road, Birmingham'.[91] Although Renaissance elements in the domestic metalwork – railings, grates, vanes, finials, hinges – show some consciousness of current taste, the church metalwork – screen, altar rails, lecterns, gas standards – looks extremely old-fashioned (205).

Skidmore's last years were sad. His health was poor, and he was partially blind. Although he had in his prime been 'well formed in body', with 'an extremely intelligent face', by the time he returned to Coventry he was 'a bent and broken old man'.[92] On a visit to London in connection with proposed additions to the Embankment railings, which were his work, his poor sight led to his being run over by a carriage. Thereafter he could not travel, and he lost much business.[93] In 1893 he qualified for the 'Freemen's Seniority', or pension, and in 1894 a subscription was got up to provide for his declining years.[94] A poignant recollection tells how he would visit St Michael's Church to see his pulpit and gas standards, talk to old friends, and pray; at noon he had to be reminded to go and collect his pension.[95] Skidmore died in 1896, at the age of seventy-nine, leaving his widow, Emma, a daughter, and three sons – two of whom were in Australia.[96] He was buried in London Road Cemetery, just beside the Anglican chapel, where a well-designed cross, of stone not iron, had been set up to commemorate his parents.

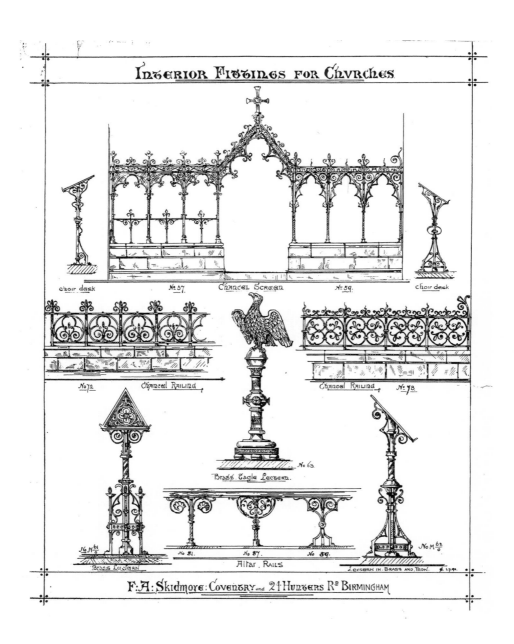

205. 'Interior Fittings for Churches', from
Francis Skidmore's catalogue of 1890
(Peter Howell).

The Memorial

Writing his *Recollections,* in 1864 or soon afterwards, Scott devoted his fifth chapter to 'a few observations upon the progress ... of the [gothic] revival' between 1845 and 1864, including the role of metalwork.

> With gold and silver work and jewellery I have had nothing to do. This is foolish of me, as I delight in nothing more, but my avocations will not permit me. I hope that the Memorial to the Prince Consort will be a success in the way of metal-working, if not invaded by interference on the one side, or by wildness on the other.[97]

The last remark picks up a preceding passage – quoted above – about Skidmore 'kicking over the traces'. That Scott's mind passed straight from 'gold and silver work and jewellery' to the Albert Memorial is, of course, no coincidence. As Gavin Stamp has described in chapter three, Scott intended the Memorial to be a full-size realisation of the 'jeweller's architecture' of the medieval shrine-makers (206, 207).

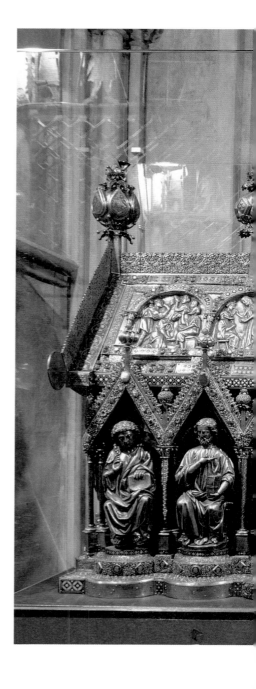

206. Shrine of the Emperor Charlemagne, Aachen Cathedral, 1215; detail of Otto II.

207. Shrine of St Elizabeth, Elisabeth-kirche, Marburg, thirteenth century.

The parts in which I had it in my power most literally to carry out this thought were naturally the roof with its gables, and the flèche. These are almost an absolute translation to the full-size of the jeweller's smallscale model. It is true that the structure of the gables with their flanking pinnacles is of stone, but the filling-in of the former is of enamel mosaic, the real-size counterpart of the cloisonné enamels of the shrines, while all the carved work of both is gilded, and is thus the counterpart of the chased silver-gilt foliage of shrine-work. All above this level being of metal, is literally identical, in all but scale, with its miniature prototypes. It is simply the same thing translated from the model into reality. [98]

Significantly, Scott's ideas recall Skidmore's argument in 1859, cited earlier, that 'not unfrequently shrines were original models of churches'.

In the creation of the Memorial, Skidmore was responsible for manufacturing the structural ironwork, described by Robert Thorne in chapter four; the metallic decoration of the canopy (209, 212); the whole of the flèche (208, 214); the metal statues at the top (210); and the railings around the steps,

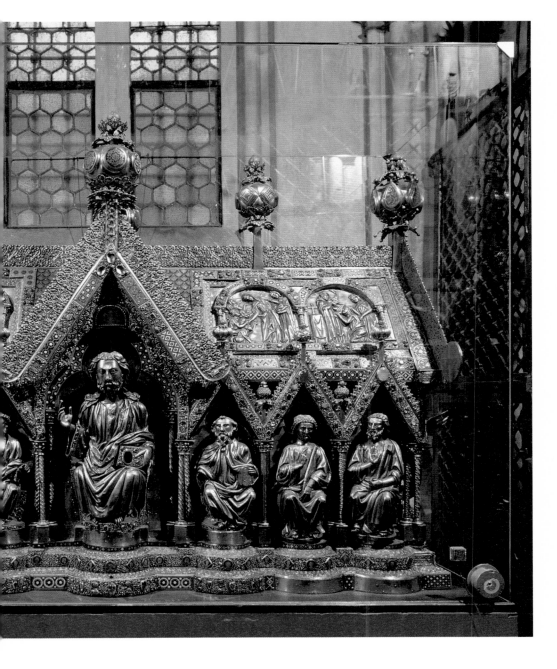

together with the enamel shields on the pedestal, and the inlaying of the decorative metalwork with vitreous enamel, spar, agates, and onyxes.[99] The flèche was clad in lead, at least a quarter of an inch thick, needed to protect the ironwork from 'atmospheric influences', and attached by 'a vast quantity of bronze screws'.[100] The leadwork was prefabricated at Skidmore's works, and soldered together on site – welding *in situ* not being possible at the time. In *Remarks on Secular and Domestic Architecture*, Scott had suggested the use of ornamental leadwork on roofs, recommending a lecture by William Burges published the previous year.[101] Skidmore relished the opportunity of 'elevating a tame and generally cumbrous material into one of adornment and beauty, by the use of geometric patterns and vitrified enamel inlays'.[102]

In a report to the Executive Committee, dated 7 March 1864, Scott wrote: 'I had, while my design was in the course of preparation, consulted as regards the metalwork the most talented artist we have in that material, Mr Skidmore'. He proposed, for both the metalwork and the carving, 'either to reserve in the contract the amounts of the estimates for these portions, or to make them subjects of separate agreements as you may determine'.[103] But the contractor, John Kelk, was not keen on the idea that these parts of the Memorial should be 'kept in Scott's hand', and insisted that they should be under his own control. General Grey told the Queen that he agreed:

> *It is precisely this portion of the work that admits of most changes during its progress, and if Mr Scott has the power, as Mr Kelk expresses it, of 'running riot', it would be impossible to say into what amount of expenditure we might not be led. Skidmore, who will do the ironwork, is, like Mr Scott himself, very clever, but very wild, and what Mr Kelk presses the necessity of is that Mr Scott shall not be able to go to Mr Skidmore, or any of the other contractors for the ornamental work, to make any change, without going through him.*[104]

208. Metalwork of the flèche, photograph from Scott's 'Prince Consort Memorial, Report to January 1869' (Royal Archives).

209. Metalwork on one of the canopy gables, photograph from Scott's 'Prince Consort Memorial, Report to January 1869' (Royal Archives).

The Committee backed this view, and Scott wrote to them on 16 March: 'I have only entered into (hypothetical) arrangements with two parties – Mr Skidmore and Mr Farmer the carver. I have discussed those questions with both of them, and neither of them raise objection, provided that they are *morally* and *bona fide* acting under myself as the architect'. His lavish praise of Kelk fails to conceal his irritation.[105] By May 1866 Skidmore's work was under way, and Scott, after consulting him, reported to Doyne Bell:

> *I have just been to Coventry to see the first stage of the metalwork being executed by Mr Skidmore. This consists of the roof of the monument, the decorative finishings of the Gables and Ridges, and the base of the spire or flèche. The whole of this is carried out in a first-rate manner and forms a very noble work.[106]*

It was at this point that the matter of the grant by the government of some redundant guns captured in the Crimean War and stored at the Woolwich Arsenal, came to a head. This had first been proposed in April 1863, and was foreseen in Scott's approximate estimates of March 1864, which include the item 'Allow for bronze given £6,000'.[107] In May 1866 Bell asked Scott whether such a grant would help, and he replied that it would be 'a very important gain':

> *One part should be used for works already arranged to be executed in copper or bronze, and accounted for by Mr Skidmore as a part of the payment for his work, and the other part to be used in rendering the work more perfect, that is to say by substituting bronze for other metalwork now arranged for, as for example making the cross and lighter portions of the tabernacle work wholly of bronze instead of being of copper and lead overlaying a nucleus of iron. The same would apply to the cresting of gables and ridges which have a framework of iron – to the fastenings of many parts which are of iron covered over with lead or tin, but which would be better of bronze. For these ... purposes I think that from 30 to 50 tons of bronze could be very advantageous indeed.[108]*

On 29 May 1866 Skidmore wrote to Bell that progress on the work had stopped, and his men were left idle, for lack of metal, and asked him to hurry on the grant of the bronze.[109] Scott backed him up urgently: 'In consequence of the rapid manner in which Mr Skidmore is proceeding with the metalwork the certificates are given more rapidly than at an earlier period of the works'.[110]

The grant, which required a vote in parliament, involved a remarkable amount of political manoeuvring. Palmerston, Gladstone, Lord Derby, Lord John Russell and Disraeli were among the cast of participants.[111] On 31 July Bell told Scott that 71 tons of gun-metal had been granted, of which about 50 tons would be made available to Skidmore. The Committee presumed that this would reduce his contract by about £3,500, and stressed 'that *all* the metal allocated ... must be used in the work and that on no account must it be sold or otherwise disposed of'.[112] Further detailed negotiations ensued. The Committee seems to have assumed that Skidmore would only use the gun-metal for parts not yet executed, specified by Scott as 'the statues, certain parts of the cresting, capitals and cornices'.[113] One problem for Skidmore was that he could not say exactly how much gun-metal he would require for each part until he had experience of the quality of the metal, and he also pointed out that he needed to take into account the value of the labour on the ironwork which would now be

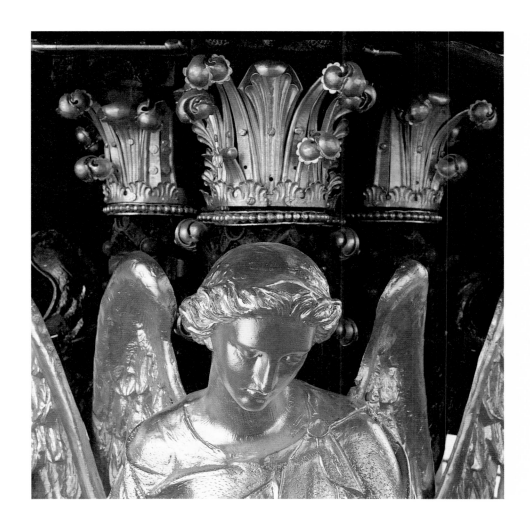

210. One of John Birnie Philip's angels in
position on Skidmore's flèche.

211. Metalwork foliage decoration, photograph from Scott's 'Prince Consort Memorial, Report to January 1869' (Royal Archives).

212. Metalwork on one of the canopy gables, photograph from Scott's 'Prince Consort Memorial, Report to January 1869' (Royal Archives).

rendered useless. Bell assured him that the Committee understood, and Scott approved the issue of the second instalment of 25 tons.[114]

After some doubts, Grey accepted that the Committee would have to bear the extra cost of Skidmore's labour in redoing work, and reckoned that this could come out of the amount saved on his original estimate, 'though this would deprive us of the hoped for means of giving additional remuneration, which they well deserve, to the sculptors'.[115] Skidmore again pressed Bell for the gun-metal: he would have bought copper to keep his men in work had he not been expecting it.[116] Once the guns arrived, he told Bell, he would 'break up all the metal, melt it down, add the requisite mixture to the alloy, and then work it'. Bell told him that the Committee 'would not call on [him] to return to Woolwich one or two tons of metal which might be remaining after the work is completed', but that he must not sell an ounce, or make any public use of it.[117] The guns were finally delivered by Messrs Pickford from Woolwich to Coventry in the middle of September.[118]

In April of the following year – 1867 – the Committee decided that it wanted a report on the progress of Skidmore's work, particularly his use of the gun-metal. It also hoped that the metal statues for which he was responsible would be designed to match the rest of the sculpture on the monument.[119] Scott discussed this with Skidmore, and as a result commissioned James Redfern to make small-scale models of the eight figures representing the Virtues. The angels round the top of the flèche, which would be 'comparatively small, and placed further from the eye', would be modelled, under Scott's direction, by someone selected by Skidmore, then submitted to Austen Layard, artistic adviser to the Committee since Eastlake's death in 1865.[120]

To assess progress Scott's clerk of works, Richard Coad, visited Coventry, reporting on 2 November both on the metalwork under construction and that already delivered to Hyde Park, which consisted chiefly of the supports for the ornamental scrollwork (211) surmounting the gables and ridges, and the bolts, screws and other fastenings. These had been changed, according to Scott's instructions, in a very substantial manner. Coad remarked 'that the ironwork forming the constructive portion of the spire is most substantially executed, securely bolted together, and firmly attached to the wrought iron girders on which it rests.' So that copper could be substituted for iron, 'it has been necessary to take to pieces, in a most careful manner, by unscrewing and unsoldering all such portions, thus involving a considerable amount of extra labour and much expense'. Even so, 'considerable progress has been made in fixing the metalwork of the two lower stages, in height about 33 feet above the girder supporting it'.[121] Coad apparently visited Coventry again in December, and again found that copper had been duly substituted. In his report, Coad registered surprise at 'the amount of labour it entailed, for it involved the almost entire taking to pieces of the work previously executed'. Evidently impressed, he said he was 'quite satisfied with the faithful performance of the work, even to the substitution of small screws.'[122]

213. (overleaf)
The upper canopy of the flèche,
1866–70, as restored.

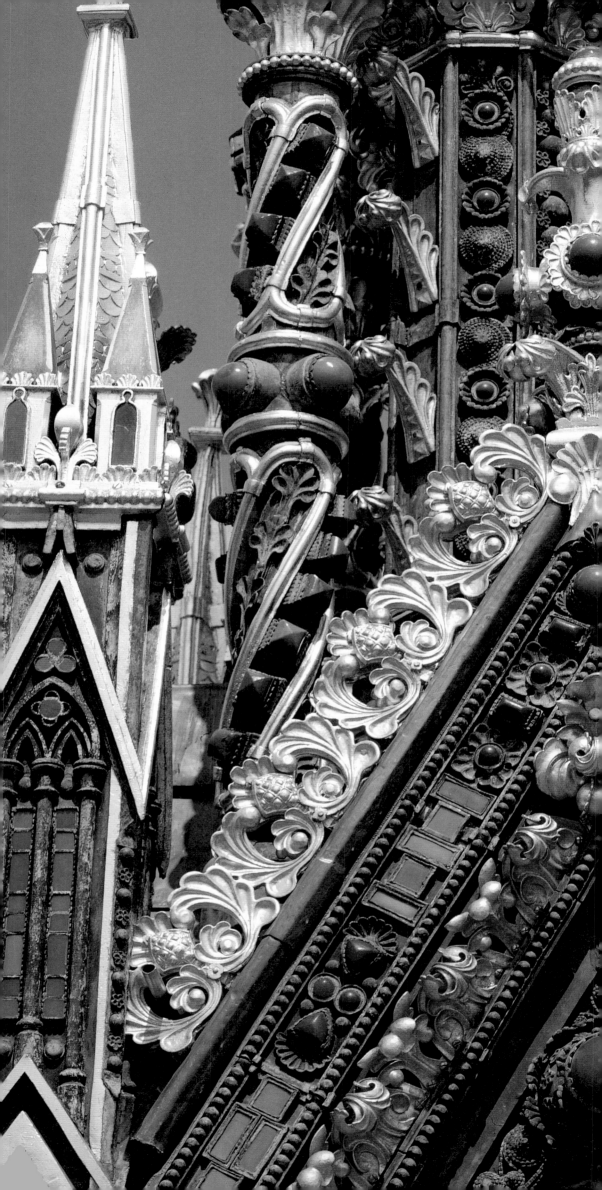

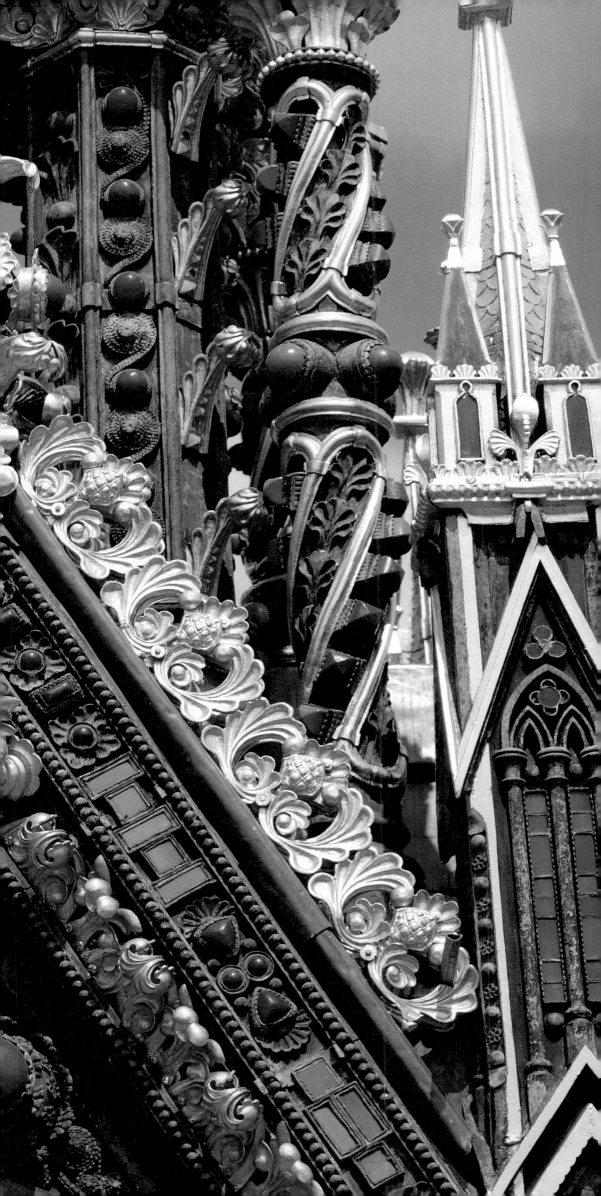

Despite the Committee's insistence that the metal from the cannon must actually be used for the Memorial, evidence that it was not comes from a reminiscence contributed to one of Skidmore's obituaries by an anonymous former workman:

> *Something like thirty heavy cannons ... were sent by the Government to be converted into artistic material, but a very little experience sufficed to convince Mr Skidmore that the task of breaking them up and utilising them again would be anything but remunerative to him. So they were consigned to a Birmingham firm, and metal more suitable procured in their stead.*[123]

Skidmore's problem was apparently that, until the Turkish cannon arrived, he had no idea of their metallic content. They could have been pure bronze – an alloy of about 90 per cent copper and 10 per cent tin – but could also have been of gun-metal, which consists of bronze with an admixture of about 2 per cent zinc to eliminate porosity in casting. Skidmore could have used the cannon metal for cast statues, and to replace the wrought copper-work with bronze castings of the same form.[124] He certainly did the latter. None of the existing metalwork is repoussé copper. The foliage is all of cast bronze – that is, copper alloy – attached by screws. The angels and Virtues are of pure copper, but the lions are bronze, crudely cast. The statues were made in sections, fitted

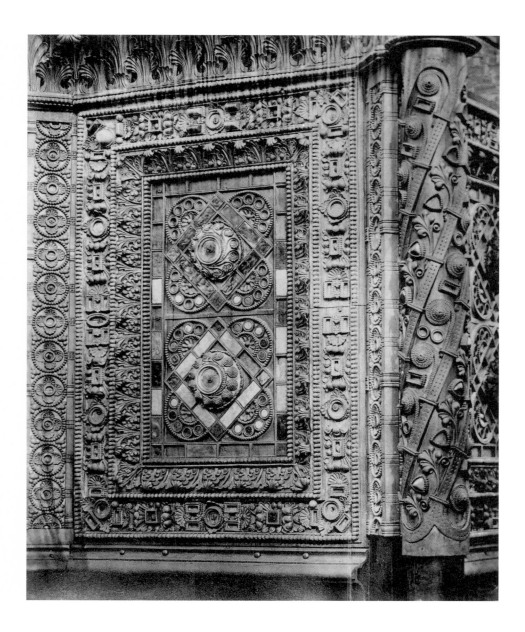

together with brackets. Andy Mitchell, the sculpture conservator employed in the English Heritage restoration, considers it inconceivable that Skidmore could have got the copper for the statues out of cannon, although he could have used them for the lions, the decorative bronze-work, and the railings.[125]

By May 1867 the building of the Memorial had reached the tops of the arches.[126] At his works in Coventry, Skidmore had already completed the whole structure of the flèche. In an adulatory article in the *Art Journal*, Charles Boutell explained Skidmore's astonishing 'rapidity' by the fact that he had 'concentrated upon it both his own devoted attention and the chief resources of the powerful establishment under his direction'.[127] In that year, part of the flèche was shown at the Exposition Universelle in Paris. It is not clear precisely how much, as the catalogue lists, under 'Bronze and other Art Castings and Repoussé-Work', merely 'Portion of Canopy for memorial to the Prince Consort'.[128] Not everyone was impressed. Friedrich Pecht, a painter sent as critic of the *Deutsche Allgemeine Zeitung*, described the 'colossal cast iron gable' as 'ein höchst geschmackloses Ungeheuer von Composition' – 'an extremely tasteless monster of composition'.[129] Scott showed the model of the Memorial.[130]

Meanwhile, construction of the large metal girder to support the spire was begun, and Messrs Skidmore erected a workshop and forges at the site, with gas carried eventually right up to the top of the cross. In August 1867 they began to put up the flèche (213–217), finally fixing the cross to the apex on 12 June 1868. The Committee wanted to know when the gilding and decoration of the spire and roof would be finished, when the statues would be fixed, and when the scaffolding would be removed.[131] Skidmore reported that the figures were 'progressing well': two of the largest were in the vat, and a third nearly ready, while the rest would be put in at the rate of two a week. The 'depositing' would occupy four or five months, and the gilding a further two. The enamels of the upper part should be finished in two months. Skidmore added: 'I am particularly anxious to draw the work to a conclusion, and will use every exertion'.[132]

By October, however, the Committee was getting anxious. Scott had 'several personal interviews' with Skidmore, and again dispatched Coad to Coventry: his detailed report concluded that 'the whole of the figures and the lions can be deposited by the middle of March 1869'. There were twelve vats in operation, four of them 'sufficiently large to receive the large figures completely in order to give them a bath to hide the solder points'. It was further calculated that 'the completion of the soldering of the spire and fixing the remainder of the roof tiles (about eighty) will occupy two months'. Scott's covering letter revealed that Redfern had so far only completed five of the full-size models for his eight figures. There was a problem about the angels too, since the work of the sculptor employed by Skidmore had 'not given satisfaction': Scott was negotiating with John Birnie Philip and Redfern.[133]

214. Metalwork on the base of the flèche, photograph from Scott's 'Prince Consort Memorial, Report to January 1869' (Royal Archives).

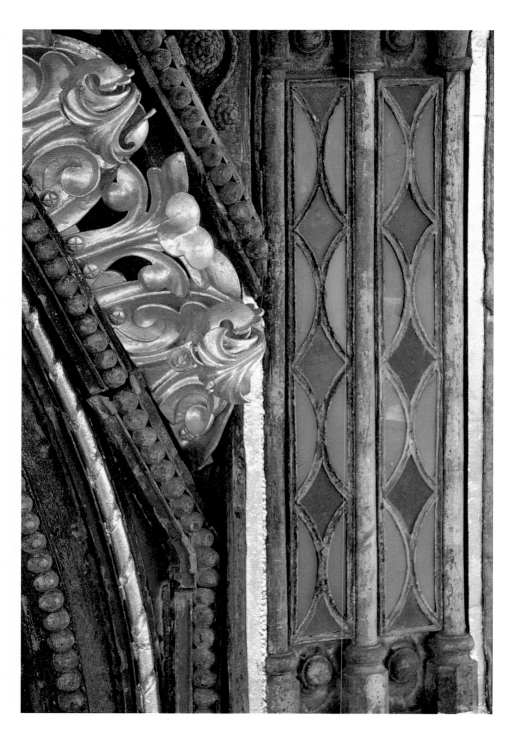

215. Detail of metalwork from
the canopy gables, 1866–70.

After the Committee met in November, Bell wrote to Kelk of 'considerable apprehension' at 'the delays which have already occurred in carrying out this portion of the structure', and which might 'materially impede the completion of the whole work'. He asked Kelk to get Skidmore's promise to complete within a prescribed period, not later than April 1869. The Committee was particularly disappointed that designs were not yet available for the upper figures.[134] Kelk sent Skidmore a stern letter, asking for assurances about dates, and threatening legal action for breach of contract.[135] Skidmore replied two days later, promising that the last six large figures would be fixed in April; the lions could not be fixed until the figures were gilded, as the scaffolding stood on their bases. 'This difficulty and delay', he added, 'has been greatly enhanced by the extra work resulting from increased area and the alteration of various portions from iron to copper, involving twice working the parts.'[136] In reply, Kelk's clerk of works, H. Mason, told Skidmore that Kelk would accept no liability for extra work: he had only given orders for the change from iron to copper, compensated by the grant of gun-metal.[137] This seems to go against what had earlier been agreed, and is clear evidence of Kelk's unfairness to Skidmore. Even so, Kelk did tell Bell that he thought Skidmore would 'act up to his promises and if so it will be soon enough, as it would be impossible to do any gilding to speak of before May'[138] – because dry weather was essential for the process.

In December Scott informed Bell that the problem of the upper figures was resolved: Philip – commissioned to do the angels – had almost finished modelling four, and Redfern was 'getting on' with the four remaining Virtues. 'Thus the twenty figures which appear in Mr Skidmore's work, and for which less provision in point of art was made than for those more within the range of the eye, are now not only in a satisfactory state in point of artistic merit but are in a position of great advancement.'[139] The 'Retrospective Report' Scott produced for the Committee in January 1869 described the Memorial's progress towards completion.

216. Detail of metalwork from the flèche, 1866–70.

217. Detail of enamelling from the flèche, 1868–9.

*It is now in a very advanced state, wanting little more than the figures, the
inlaying with enamel, and the gilding for its completion. Unfortunately it
is at present so surrounded with scaffolding as to be nearly invisible, but,
to those who are able to ascend the scaffolding and make a close inspection,
the work cannot fail to be a source of surprise and admiration.*[140]

It seems that all the statues (218) were fixed at least by the summer.
Meanwhile, experiments to determine the extent of the gilding led Scott to
decide that far more of the Memorial should be gilded than originally planned.
The Committee sanctioned an extra grant.[141] By September, however, Skidmore
had still not started gilding, and Kelk decided to terminate his contract and
finish off the work himself. Bell told Grey on 23 October that, as a result, 'the
Skidmore Company' had made Skidmore resign, and had 'taken up the work
most vigorously'; preparations were in hand and gilding would begin 'next
week'.[142] So long as there were no violent gales, Kelk reckoned that the
subcontractor would finish gilding the flèche by Christmas, and that the rest
could be completed once the scaffolding came down: it was removed from the
spire by March 1870.[143]

In June 1870, Charles Newton – Layard's successor as the Committee's
artistic adviser – drew attention to a problem that was to cause much anxiety
over the next few years. 'The gilt figures in the upper part of the monument
have confused outlines, because they are not relieved against any ground but
gilt ground ... There is so much gold in the upper part of the monument that it
dazzles and confuses the eye instead of enabling it to discriminate more readily
the parts.' Whether or not Newton was right, his suggestion that the upper
statues should be 'relieved or framed in deep blue glass or enamel grounds' can
hardly have seemed a practical proposition.[144]

Skidmore's involvement in the Memorial was not over yet. Although the
spire was complete, there were still items of metalwork to be executed – the
enamel shields on the pedestal of Albert's statue, and the upper and lower
railings around the steps. Kelk's letters of 23 October and 26 December make it
clear that, although Scott wanted Skidmore, he did not, claiming that, if
Skidmore got the commissions, 'the Committee must expect to pay whatever he
likes to charge, and have them finished when he pleases'.[145] Matters were not
helped at this point by the fact that both Scott and Skidmore had severe
problems. In October 1870 Scott had suffered a serious heart attack, and was
more or less out of action until the next spring.[146] Skidmore's business
difficulties had grown even more acute following his forced resignation from his
firm. In December 1870 John Oldrid Scott – who was acting for his father – told
Bell that Skidmore had 'within the last few days severed his connection with his
company'.[147] Back in October Kelk had written to Bell, 'I suppose you know that
Mr Skidmore has left the works in the country and is now I believe acting for
himself'.[148] Kelk must surely have meant that Skidmore had left his Coventry
works for the country, but it is not in any case easy to understand exactly what
had happened. Bell tried to keep things moving, asking J. O. Scott in December
why his father's design for the upper railing had not yet reached Kelk. Scott
assured him that it was being drawn out, but also advised that the matter of the
shields should be left for a while because of Skidmore's difficulties. 'My father',
he added, 'will be most desirous that Mr Skidmore and not the company should
carry out his works which are now in their hands'.[149]

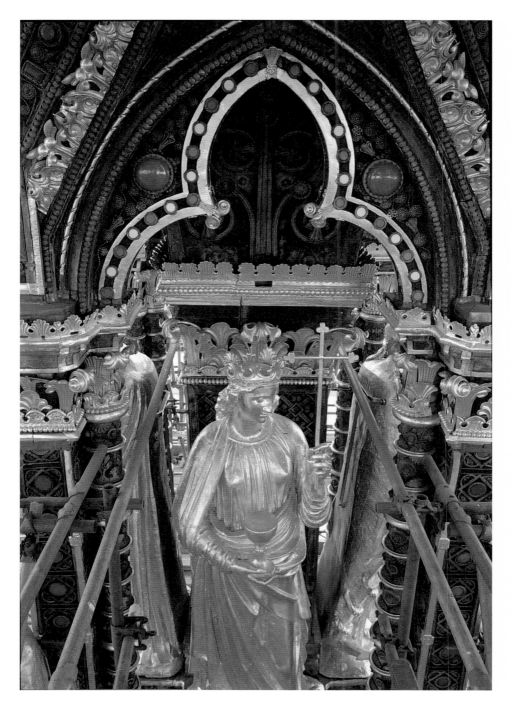

218. One of James Redfern's *Virtues* in position
on Skidmore's flèche during restoration.

Scott senior's own endorsement of Skidmore came the following month:

[Skidmore] assures me that he has full facilities for undertaking large orders. He has all the best men from the Coventry works, and the furnace which will be finished in about ten days will be capable of turning out about ten tons of castings a day. The company have taken pains I know to let people know that he has no plant, but he assures me that such statements are quite unfounded. There can therefore be no reason why he should not give a tender for the bronze railing if the Committee will permit it.[150]

As for the enamelled shields, Scott doubted 'whether anyone in England *can* do them but himself, and he is able to do them *at once*'. 'I am most anxious', Scott went on, 'that all the metalwork should be done by him. His name will in future times stamp it with a value of its own, and it is an unjust slight upon a man to make exceptions of parts unless the reason be sufficient.'[151]

In March J. O. Scott reported that, although Skidmore could execute the upper, bronze railings 'within reasonable time', he could not do the lower, wrought iron ones yet, but insisted that his father wanted Skidmore to have both jobs.[152] The Committee duly approved the designs, and Skidmore duly reassured Bell about completion dates.[153] A great deal of confusion followed. When Kelk saw Skidmore's working drawings for the lower railings he was convinced 'that the gates will not carry their own weight', so they had to be modified.[154] The estimate rose from £2,560 to £2,810.[155] Kelk made difficulties over pencil alterations to the drawings, and there was a muddle about specimen sections. The contract was not signed until September.[156]

Meanwhile, the upper railings – low and comparatively simple – were complete in July.[157] Skidmore seems to have fixed the lower ones (219), which are of extraordinarily rich and elaborate design, by March 1872.[158] He lost about £700 on them because of a sudden rise in the price of iron.[159] Worse was to follow.

219. George Gilbert Scott and Francis Skidmore,
the gates and lower railings to the Memorial, 1870–2.

The Queen was due to inspect the Memorial in July, and Skidmore was forced by Kelk to agree to gild the lower railings – a task for which his estimate of £655 was accepted in April – in what Scott later called 'a wholly unpracticable time'. Unseasonable bad weather meant that two of the three sides gilded by July were a failure. Although Scott urged that Skidmore should receive 'the most liberal treatment', he does not seem to have done so.[160] All four sides were regilded by William Lott.[161]

Skidmore's last work on the Memorial was making the enamelled shields for the pedestal of Prince Albert's statue (220). This turned out to be even more of a nightmare than the railings. Clayton provided the drawings,[162] and in October 1872 Skidmore sent Bell an estimate of £50 per shield, undertaking to complete them by April 1873.[163] By November 1873 the Committee was growing angry, reproaching Skidmore for 'dilatoriness and want of faith'.[164] In December he reported that two shields were done, and the remaining three almost ready.[165] By mid-December the two shields that had been fixed were deteriorating.[166] To an extent, John Oldrid Scott defended Skidmore. 'The scale is larger than there is any experience for', he wrote, and 'these failures are of course a most fair cause of a part of the delay'; but added, 'the rest is doubtless purely Skidmorian'.[167] In January Skidmore explained to Bell that the different colours of enamel required different firing temperatures, and the problems were exacerbated by the exceptional size of the shields. A solution had been devised: the quarterings of each colour would be prepared separately in a separate metal frame, and these would then be fitted together. The gilding would be done by hand, and not by electrogilding – a process which Bell had always considered 'certain to fail in the open air'.[168] The shields were finally fixed by March 1874, and Scott senior pronounced them 'highly satisfactory'.[169] Skidmore received his paltry £250, plus £8 for fixing.[170]

220. Francis Skidmore, enamel shields of arms of Queen Victoria and Prince Albert, 1872–4; as restored.

Conclusion

Scott said that, for the perfect realisation of his concept of the Memorial, he was 'indebted to the skill of Mr Skidmore, the only man living, as I believe, who was capable of effecting it, and who has worked out every species of ornament in the true spirit of the ancient models'.[171] The nineteenth century was the great age of iron, and its heroic figures were many. There were the structural ironworkers who created such masterpieces as Robert Stephenson's tubular Britannia Bridge across the Menai Straits, built 1845–50, and the roof of 1854 to Birmingham New Street Station by Fox, Henderson – which was greatly admired by both Skidmore and Scott. There were also the craftsmen in metal, such as John Hardman of Birmingham, James Leaver of Maidenhead, Hart, Son and Peard, and Thomas Potter. What made Skidmore unique was his ability to manufacture metalwork over the whole range, from large to small. He possessed the boundless enthusiasm and self-confidence necessary to enable him to exploit modern technology to the full, together with a scholarly passion for the revival of gothic. His technical prowess is surprising in a man who started out as a silversmith, but his geographical location in the Midlands was essential to his success, for he could benefit both from the region's small-scale craft traditions as well as from its modern metallurgic industries. For all that his enthusiasm was said to outrun his business sense, he cannot have been 'unbusinesslike': in the company prospectus of 1865 Joseph Phillips praised his book-keeping and his business practice.[172] Until his business problems developed – for reasons that are by no means clear – around 1870, he was renowned for his efficiency and speed of delivery. His subsequent deficiencies in these respects must have been due in large part to the difficulties of his location in a country village. The tributes from his former workmen published after his death show how much they admired him. He never ceased to regard himself as an artist, and, ruinous as this may have been to his commercial success, it is what makes his work so remarkable, and what made him just the man for the Albert Memorial.

There is no other monument of the nineteenth century like it. Numbers of other memorials comprise an elaborate canopy sheltering a statue, for which the most celebrated models were the '*Arche Scaligere*' at Verona – the tombs of Cangrande, Mastino and Cansignorio, erected in the fourteenth century – which Ruskin so much admired. Examples include Kemp's Walter Scott Memorial in Edinburgh of 1840–6, the 1863–6 Albert Memorial in Manchester designed by Thomas Worthington, and Henri Franel's monument to the Duke of Brunswick at Geneva, built 1874–9. In all these, however, the canopy and superstructure are made of stone. The use of metal in Hyde Park was not matched anywhere else. Its origin in the common ambition of Scott and Skidmore to turn the reliquaries of the Middle Ages into a full-scale structure was similarly unique. The lavish decoration was also exceptional. Already in 1855 Scott had praised the 'wonderful ciborium' of Or San Michele in Florence, 'one of the most splendid works of its kind in existence, decorated with sculpture, inlaid marble, coloured glass, and almost every kind of enrichment'.[173] In the Albert Memorial he set out to rival that masterpiece, and Skidmore was the only man who could make it possible.

Charles Boutell, himself an expert on medieval metalwork, described the Memorial as 'in all probability the greatest and most important artistic work in metal in existence in the world'.[174] Even at the time it was built, there were many who thought it too delicate for an outdoor structure in the British climate. Its triumphant restoration has proved that after well over a century, despite war damage and neglect, Scott's soaring masterpiece can, thanks to Skidmore's passionate craftsmanship, still tell its tale with brilliance and delight.

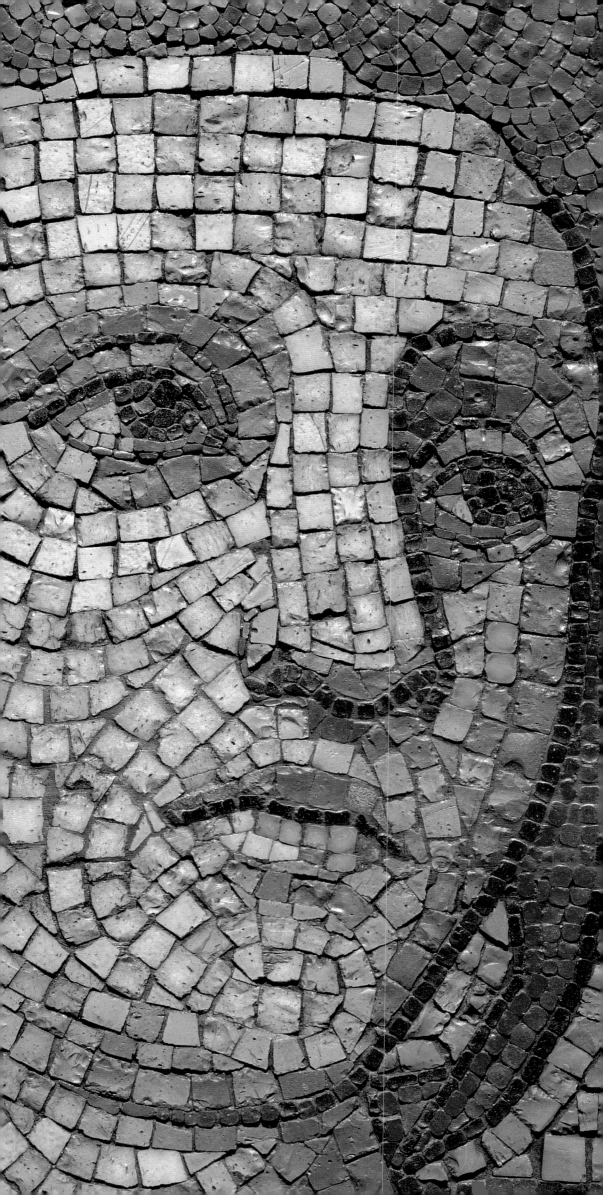

The Mosaics

Teresa Sladen

George Gilbert Scott conceived the Memorial to Prince Albert as a piece of 'jeweller's architecture',[1] a huge shrine in which mosaic would play the part of the cloisonné enamels used to enrich the reliquary caskets of the Middle Ages. As a decorator, he much preferred the glitter of metal and shimmer of glass and mosaic to the softer texture and more varied tones of painted decoration.[2] In his 1869 report to the Prince Consort Memorial Committee, he described mosaic as 'the special handmaid of, or rather the sister art to, architecture', and went on to point out how appropriate it was that this revived art should be dedicated to one 'who delighted so much in inventions tending to enrich and extend the range of Artistic effort'.[3]

By the time of Albert's death in December 1861, architects and their patrons had lost confidence in painted decoration, and were searching for new ways to add polychromy to the walls of their buildings. Largely as a result of the difficulties experienced with the Palace of Westminster murals, it was believed that the combination of pollution and a damp climate made fresco unsuitable for use in Britain, and so the focus of attention had shifted to mosaic, another art associated with Italy, but one which promised to be both more durable and easier to clean.

The first serious suggestion that mosaic should be used for a major scheme of decoration was made in 1859. An article published in The *Builder* urged those responsible for the care of St Paul's Cathedral to follow the original intentions of Sir Christopher Wren and decorate the dome with mosaic. It was pointed out that the material could be obtained from Murano in Venice, 'even if our own manufacturers do not surpass or equal it'.[4] The writer of this piece was certainly up to date, for at this time Dr Antonio Salviati, who did so much in the early 1860s to promote the use of Venetian mosaic, had only just set up his glassworks on the island of Murano,[5] and British glass and ceramic manufacturers were still struggling to produce a similar product or viable alternative.[6]

By 1862, however, much progress had been made. The International Exhibition of that year contained examples of Salviati's glass mosaic in addition to those of the established Roman and Russian manufacturers, and British ceramic mosaic was also on display, though mainly intended for floors and pavements.[7] J. B. Waring's lavishly illustrated catalogue, produced the following year, includes much information on the different firms and the relative

221. John Richard Clayton and Salviati & Company,
Poesis, 1866–8.

costs of their products.[8] The only large scale mural mosaic he illustrated was the one exhibited by the Imperial Glassworks of St Petersburg. It portrayed a figure of St Nicholas in his patriarchal robes, about twenty feet high, and was valued at £4,000. Although Waring described it as magnificent, he pointed out that its cost 'would restrict the use of the art to the narrowest limits', and added in a footnote that the prices quoted for making the mosaics proposed for St Paul's Cathedral, both by this manufacturer, and by the Vatican Glassworks in Rome, had been so high as to be dismissed out of hand.[9]

The other glass mosaic to which Waring drew attention was that of Dr Salviati.[10] His exhibits included some vases made of chalcedony-agate, a revived form of Venetian glass, and a table and stand inlaid with glass and marble mosaic. Waring described how the firm had been set up a few years before, and had already 'brought the manufacture of glass mosaic to great perfection'. He appeared entirely confident that Salviati would, in the near future, be carrying out commissions for large scale mural mosaics both in Britain and the rest of Europe. How was it that Salviati, before establishing any kind of track record, had managed to acquire such a reputation in this country ?

Dr Antonio Salviati (1816–1890) was a lawyer who had abandoned his profession in order to revive the ancient Venetian arts of glass and mosaic. In 1859 he joined forces with Lorenzo Radi, the last surviving member of a family of Murano glass makers, a man who had, by careful experimentation, managed to rediscover some of the more refined techniques of Venetian glass manufacture.[11] Radi, then, supplied the practical expertise required to run the glassworks, while Salviati, though not a wealthy man, put up the capital, and provided the entrepreneurial skills needed to sell such a specialised product. As the success of the enterprise was dependent on their ability to manufacture mosaic at a price people could afford, they developed a method of prefabrication whereby the mosaics could be made in Murano, and then despatched, in sections, to the buildings for which they were designed.[12]

In April 1863, when Scott's design was chosen for the Albert Memorial, two other major projects involving mosaic were about to be put in hand. One of these was the scheme, already mentioned, for St Paul's Cathedral; the other was that for the decoration of the Wolsey Chapel at Windsor, then in the process of being converted by Scott into the Albert Memorial Chapel.[13] In all three cases Salviati was employed to make the mosaics. In addition to being the first commissions for large scale mosaics carried out in England, they were also the most important. No other works as prestigious as these were undertaken in Britain until the very end of the century.[14] The mosaics at St Paul's were made under the direction of the Surveyor of the cathedral, Francis Cranmer Penrose (1817–1903); while those for the Albert Memorial Chapel, as in the case of the Albert Memorial itself, were overseen by Scott.

The choice of Venetian mosaic for the Albert Memorial was not, however, a foregone conclusion. Within days of Scott's scheme being announced the winner, Colin Minton Campbell of Minton Hollins and Company had written to General Grey, the Chairman of the Memorial Committee, offering to carry out one of the designs for the tympana in ceramic mosaic free of charge.[15] Initially, Scott was inclined to favour the proposal, partly for reasons of economy, partly because it would encourage British enterprise, and partly because he thought that ceramic might be more durable than glass mosaic, and therefore better able to withstand the English climate.[16] But as no one in this country had experience of using either material, Scott was faced with a dilemma.

When it came to the decoration of his buildings, Scott generally relied on the assistance of Clayton and Bell, the firm of stained glass painters that he had himself helped to found.[17] It comes as no surprise, therefore, to find that in the summer or early autumn of 1863 John Richard Clayton (1827–1913) went to Venice, where the *Builder* reported he was seen discussing the mosaics in St Mark's with Dr Salviati. The two men were looking at the way the tesserae were handled 'in the centre of the vaulting' and the reporter commented that he hoped the mosaics to be made for the Albert Memorial Chapel would 'be the better for that examination'.[18] It may be inferred that Clayton had gone to Venice at Scott's request to find out more about the design of mosaics generally, and the establishment and working practices of the firm of Salviati in particular.

The contract for the Windsor mosaics was signed in July 1864.[19] Keen to proceed with the National Memorial in London, Scott wrote to the Memorial Committee the following month to suggest that, as all the other 'leading branches of work' had been settled, it was time to put the mosaics in hand. Evidently he was convinced by this time that glass mosaic would be the best material to use, for he added that 'Venice is the very land and home of mosaic-work and it seems hopeless as yet to equal the works of those who have been brought up among the ancient productions of this noble art'.[20]

But now the project was delayed for a different reason; Scott could not decide on the subjects to be represented in the tympana. He made a first, tentative suggestion in August 1864, 'There might be two historical and two more abstract subjects : as, for example, The Installation as Chancellor of the University of Cambridge, and The Inauguration of the Great Exhibition of 1851, as the historical subjects and, for the other class, Representations illustrating the Prince's encouragement and cultivation of Arts and Sciences.'[21] But ten months later, in June 1865, he abandoned the idea of historical subjects altogether because this would necessitate portraying figures in modern dress, and advocated instead 'subjects of a more ideal kind'.[22] He then went on to suggest that each tympanum might contain a princely figure acting as a patron of the particular branch of art represented on the corresponding side of the podium below. This idea was approved by both the Queen and the Committee the following month.[23]

Yet, once again, months were to pass without, apparently, any further action being taken. And then, early in 1866, another problem arose. Immediately after the death of Prince Albert the Queen had initiated the building of the Royal Mausoleum at Frogmore. Work had started in March 1862, and was finished in December the same year.[24] The ceiling of the porch of the mausoleum had been enriched with mosaic made by Salviati's firm, probably the first work of this kind to be carried out in England. But now, only three years later, it appeared to be changing colour. This re-opened the whole question of the durability of mosaic, especially when placed in the open air.

In February 1866, Doyne Bell, the Secretary of the Committee, wrote to Scott asking him to have Salviati explain the matter, and provide some guarantee that if his mosaics were used on the Memorial they would not be affected in the same way.[25] Salviati's explanation, when it came, was not found entirely satisfactory, and the Committee insisted on an assurance that he would replace the mosaic at his own cost in the event of any deterioration.[26] It was not until May 1866 that everyone had been reassured and Scott was finally able to draft the contract for the work. The date specified for completion of the mosaics was 29 September 1868.[27]

John Richard Clayton, the man chosen by Scott to design the mosaics for both the Prince Consort National Memorial and the Prince Albert Memorial Chapel at Windsor, was born in 1827, the grandson of a north country portrait painter, Frederick Hollingsworth. As a seventeen year old, he worked as an apprentice sculptor at the New Palace of Westminster; he then attended Leigh's Art School, going on to study sculpture for six months at the Royal Academy; a few years later he was employed by Anthony Salvin (1799–1881) as clerk of works for the restoration of Wells Cathedral. In the1850s he became a freelance draftsman working as a book illustrator and designer of painted decoration and stained glass.[28] He was trained as a stained glass cartoonist by Richard Cromwell Carpenter (1812–1855), one of the leading architects of the ecclesiological movement.[29] Clayton provided illustrations for Matthew Digby Wyatt's catalogue of the 1851 Exhibition, and went on to make the cartoon for Wyatt's Huskisson Memorial Window, formerly in Chichester Cathedral.[30] He was making glass for Scott from 1854,[31] and in the following year went into partnership with Alfred Bell (1832–1895) (222).

Clayton's most obvious strengths as a designer are his flair for outline, and his mastery of monumental composition. In the first case, he was clearly influenced by John Flaxman (1755–1826), whose works he greatly admired,[32] and in the second, he often took as his models the carefully constructed compositions of the Early Italian Florentine painters and sculptors. In the 1850s Clayton was friendly with the Pre-Raphaelites and, like them and many

222. John Richard Clayton (1827–1913 [left] and Alfred Bell (1832–1895) in their studio, photograph of the 1870s (David Clayton).

others of his generation, shared the enthusiasm of John Ruskin (1819–1900) for the so-called 'Italian Primitives'. He never made direct copies, but many of the designs he carried out for stained glass windows in the 1850s and 1860s are clearly influenced by their works, especially those of Fra Angelico (1387–1455) and Lorenzo Ghiberti (1378–1455). Clayton, however, did not stick rigidly to any one style; as a draftsman he was required to carry out designs for many different purposes, and could adapt himself to whichever manner of drawing he thought appropriate. In the case of stained glass windows, for example, he was able to draw figures in an approximate Early English, Decorated or Perpendicular manner, according to the style of the church. But he could, just as easily, produce a design to a classical formula if that was what the building required. Beneath all these different types of stylistic dress, however, there is always a certain architectural stability in his compositions, which clearly derives from an underlying sympathy for the principles of classical, rather than medieval, design.

As a young man Clayton had wanted to be a sculptor, and it is possible to see the reason for this in all his work. He was really only interested in portraying the human figure, and treated all other subject matter in a very perfunctory manner. But his concentration on the architecture of the body, while a weakness when it came to certain types of design, did give him a sound grasp of the way in which figures could best be linked to the overall form of a building. Scott drew attention to this when he wrote that Clayton 'unites, more

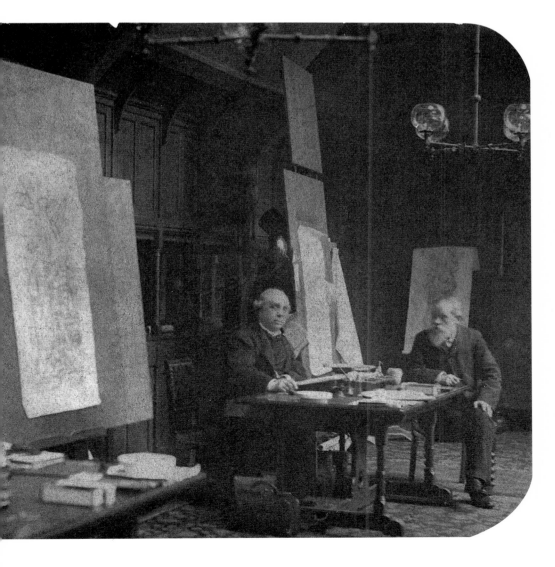

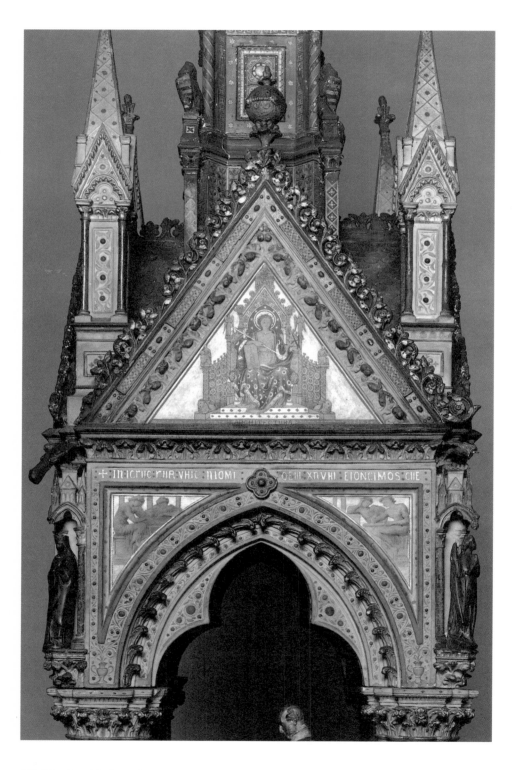

223. Mosaic gable detail from
the 1863 model of the Memorial
(Victoria and Albert Museum).

than any other man I know, great artistic powers with a perfect knowledge of that firm and severe manner of drawing which is so suited to the harmonizing of historical art with architectural composition.'[33]

When Clayton was asked to provide the first sketch for one of the tympana of the Memorial, he quickly realised that the subjects suggested by Scott presented a problem. On 3 July 1866, he wrote to Scott, enclosing a drawing and explaining that, although he had made several attempts to do so, he had found it impossible to produce a satisfactory design depicting 'the princely patronage of the art'. Consequently, he had substituted 'the abstract idea of Poetry represented by its spirit or muse' for the one stipulated, adding that it would be confusing to have idealised figures of princes shown in the mosaics immediately above the realistically conceived statue of Prince Albert himself. He went on to say : 'By representing in the Tympanum as we have done, a figure resolving the idea elaborated in the Podium, we preserve what seems to us an invaluable connexion [sic] and emphasis between the base and pediments.'[34]

Scott agreed to the change of subject matter, and passed the sketch on to Austen Henry Layard who, following the death of Sir Charles Eastlake in 1865, had joined the Committee as chief adviser to the Queen on artistic matters. Layard approved the design in principle, and was later to write that he much preferred the single figures to the groups originally proposed, as they gave 'repose to the upper part of the monument which is already exceedingly rich in details'.[35] Even so, he did not accept Clayton's design without criticism, as Scott seems to have done, and immediately arranged to meet Clayton to discuss the project in more detail. Layard wanted a new sketch prepared in which the figure of Poetry was to be simplified, the architectural details modified and the heraldic emblems omitted.[36] It was agreed that, over the next month or two, Clayton would execute four careful designs to be fixed on a model of the Memorial so that the Committee and Scott should be able to judge the effect (223). Then, if they were thought satisfactory, he was to make a full-sized cartoon to be placed in the tympanum of the Memorial itself for final approval.[37] After the meeting with Clayton, Layard wrote to tell Scott what had been arranged, adding that he himself was going abroad in a few days time, and that Clayton had undertaken to have the four designs ready in the course of the autumn.[38]

Layard's close involvement in the completion of the Memorial's sculptural programme is fully discussed in chapter five. In many ways his role in relation to the mosaics was even more crucial. Having gained considerable celebrity as an archaeologist (224), and as the author of *Nineveh and its Remains* (1848) and *Monuments of Mesopotamia* (1850), Layard had returned from his last expedition in 1851, and became a member of Parliament in 1852. But in 1855, following a spell of ill health, he spent three months in Italy, the country where he had passed the happiest part of his childhood.[39] When he was eight his family had moved to Florence, where they rented one floor of the Palazzo Rucellai. His father was enormously interested in painting, and together he and his son spent much time exploring the galleries and churches of Florence. Layard became so keen on art at this time that he wished to become a painter himself, but this was not encouraged.[40]

During his stay in Tuscany in 1855, he began to immerse himself in art once more, becoming deeply concerned at the deteriorating condition of many of the frescoes in the area.[41] Always a man of action, he began to collect information about, and make tracings of, the ones that interested him most. On his return to

England he presented his material to the Arundel Society with which, for the next five or six years, he was to be closely involved.[42] He continued to visit Italy every autumn between 1856 and 1860, making tracings and writing accounts of the frescoes. These records were later published by the Arundel Society, usually accompanied by chromolithographs made from watercolours of the frescoes commissioned from Italian artists (225, 226).[43]

It is not known when Layard first met Salviati. This may have taken place in the autumn of 1860 when Layard spent two weeks in Venice.[44] But whether or not the two men met on this occasion, they were certainly acquainted by 1862, as a letter addressed by Salviati to Layard makes clear.[45] It was written in London, and concerns the difficulties Salviati was having over a job he had undertaken in Egypt,[46] the commission for which – as the letter reveals – he had originally obtained through Layard. In view of this, it seems possible that Layard was also helping Salviati at this time by giving him introductions to influential people in England.

When Layard left England in July 1866, he made his way to Italy, arriving in Venice in September. Once there, he went to see Salviati. What he found must have come as a shock, for Salviati was on the point of bankruptcy; he had borrowed money to keep the firm afloat, but had now reached the point when he could borrow no more.[47] The situation was so serious that he was unable to complete the commissions in hand, among them the mosaics for Windsor and for the Albert Memorial. Layard was appalled, and decided that he would have to take action. Accordingly, he wrote to some friends in England to ask for help, and they clubbed together to buy Salviati's business, including both the factory in Murano and the palace on the Grand Canal in Venice from which it was run.[48] The new company was registered in England under the title of Salviati and Company (Limited) on 2 January 1867, with an office at 431 Oxford Street, London. The Management Committee initially consisted of Layard himself, Lacklan Mackintosh Rate – with whom Layard had been at school – and William Richard Drake. The Committee agreed to employ both Dr Antonio Salviati and his son Giulio and, as part payment for his business, Salviati received four of the thirty-two shares issued, each valued at £500.[49]

When Layard returned to London at the end of November 1866, he had hoped to find all the sketches for the mosaics fixed on the model as agreed. But

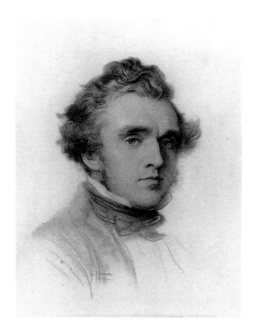

224. Sir Austen Henry Layard (1817–1894) after his return from Mesopotamia; portrait of 1848 by George Frederic Watts (National Portrait Gallery).

225. Lithograph of Perugino's *Martyrdom of St Sebastian* issued by the Arundel Society, 1856 (Victoria and Albert Museum).

226. Tracing by Layard of one of the archers from Perugino's *Martyrdom of St Sebastian*, 1855 (Victoria and Albert Museum).

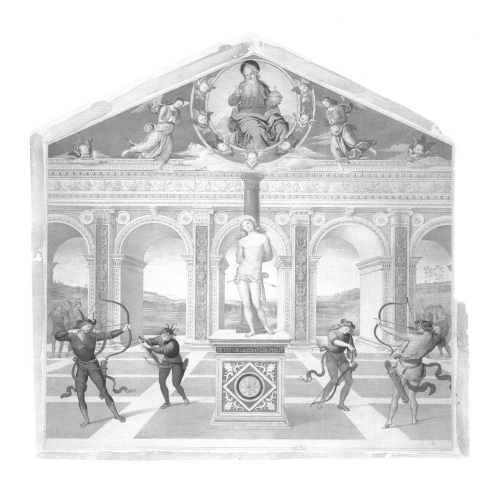

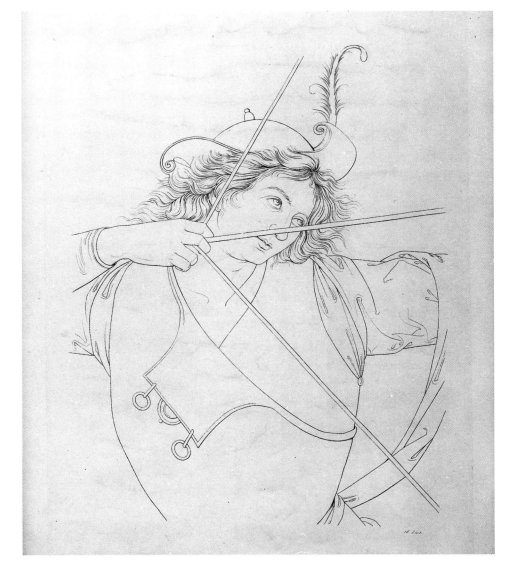

in fact Clayton had only finished one, and was working on the second.[50] Layard was furious. While he was in Venice, Salviati had told him that Clayton had failed to send the cartoons for the Albert Memorial Chapel mosaics on time, and this had caused the financial problems of the Murano glassworks.[51] Layard took this accusation very seriously but it is possible that, had he known Salviati better, he might not have done so. Some ten years later, he was to write to Lady Eastlake, who had met Salviati in Venice, that she should not allow herself 'to be teased by him about his affairs'. He went on to describe Salviati as 'Always conspiring and intriguing – jealous, grasping, unscrupulous, and lying'.[52]

Evidently Layard saw things very differently in 1866; he must have felt that, while he himself was working so hard to keep the mosaic projects in England going, Clayton was making the situation worse. In consequence, December saw a flurry of letters from Doyne Bell and General Grey to Scott, all expressing anxiety over Clayton's behaviour, and asking him to ensure that there was no further delay.[53] In January 1867, Scott forwarded a schedule to Clayton, drawn up by Doyne Bell, proposing a series of dates by which the sketches and full size cartoons for the mosaics were to be completed.[54]

227. John Richard Clayton, Designs for mosaics for the west side of the Memorial, from Scott's 'Prince Consort Memorial, Report to January 1869' (Royal Archives).

Clayton replied that though he could finish the sketches by 20 February as required, there was no possibility of his being able to carry out the full size cartoons, all of which were to be painted with oils in full colour, by 20 May. He explained that each of these colossal figures would take two months at least, and suggested instead a completion date of 20 October 1868, with the smaller figures intended for the spandrels to be finished by 20 August of the same year.[55] Evidently, Scott agreed that this was reasonable, and a new agreement with a revised timetable was drawn up. This was sent to General Grey on 26 January 1867, together with a letter from Scott explaining that the work could not be done adequately in less time.[56]

Neither Layard, who thoroughly distrusted Clayton by this time, nor the members of the Committee were at all pleased by this turn of events and, though they accepted the revised schedule, they did so with great reluctance.[57] Layard wrote to Doyne Bell suggesting that, in order to waste as little time as possible, Clayton's cartoons should be sent to Salviati seriatim. He added, 'I am afraid we shall have a great deal of trouble with Clayton but I will do my best to keep him to his time.'[58] A few days later, Doyne Bell wrote to Scott begging him

228. John Richard Clayton, Designs for mosaics for the east side of the Memorial, from Scott's 'Prince Consort Memorial, Report to January 1869' (Royal Archives).

to urge Clayton to get on with the cartoons as fast as possible. As the letter makes clear, dissatisfaction was mounting:

> At the meeting of the Committee which was held today some very strong remarks were made respecting the time which Mr Clayton requires for the preparation of these cartoons, and his not unfrequent habit of delaying the completion of works of this nature which have been entrusted to him. Indeed it was even suggested that some other artist should be employed.[59]

Scott must have shown this to Clayton, for on 9 February Clayton wrote a highly emotional letter to Layard justifying his behaviour. It begins with a long section on the Albert Memorial Chapel at Windsor, saying that he personally had had to produce cartoons for both the stained glass and the mosaic work, and that he could not give priority to the mosaic. Probably unaware that Salviati's firm was near collapse, he writes dismissively, 'In respect of Dr Salviati's demands, which have been in constant urgency under some great pressure of his private affairs, I have, despite all friendly good will and effort in his favour often found it impossible to keep pace with his convenience.' He went on to point out that although only half of the Chapel's stained glass had been done, three quarters of the mosaic was already in place. Turning to the Albert Memorial he claimed that the only delay up to that time had arisen with regard to the subject matter, and added that 'Since this has been determined in favour of my suggestion submitted about a year ago, I am not aware that there has been one hours waste of time.' He then wondered how it could be supposed that any artist living could produce 'full size cartoons – oil paintings in fact – of twelve figures all larger than life – four of the series being of colossal proportions' and 'deliver them at the astounding rate of three weeks per figure'. He finally asked that the time allowed for the completion of the cartoons should be extended from eight to eighteen months.[60]

Layard was infuriated by this letter,[61] but realising that the Committee had no option but to continue to employ Clayton, he replied in measured tones.[62] He explained that, as Clayton had failed to produce the cartoons for Windsor on time, Salviati had had the extra workmen he had employed standing idle, and that he was having to pay a penalty for every week which had passed since the final day of the contract, 11 July 1864. He also pointed out that if Clayton were allowed to extend the time schedule for the cartoons of the Albert Memorial, Salviati would be subject yet again to considerable loss and great inconvenience. In fact, Layard saw everything from Salviati's point of view – not surprisingly perhaps, as he had just become manager of the Venice glass works, a business teetering on the edge of collapse.

It is easy to understand why Layard, by this date supremely self confident and successful, a man of vast energy, someone who generally dashed off letters by return of post, was irritated by the delay. But he was doing Clayton an injustice. Because so much time had been lost over which kind of mosaic to use, and then over the subject matter of the tympana, this part of the project had started late, and Clayton was being expected to work to an impossible schedule. Designers such as Clayton and Alfred Bell were frequently not accorded the status of artists; they were regarded as decorators, and treated as artisans rather than gentlemen. This was later reflected by the fact that, although Scott thought Clayton and Bell should have a contract with the Committee, as did the sculptors, this was rejected by the Committee, which decided that they should be contracted to the builder instead.[63]

Scott understood the problem well, as is clear from the account of Clayton and Bell in his *Recollections*:

> *They were the first in this country who became glass-painters, because they were artists; but it is a destructive profession, and if the greatest artist that ever lived had become in early life a glass-painter, and had had a great run of business, I do not hesitate to say that his future fame would have been ruined. No real art can stand against a constant high-pressure and working against time.*[64]

It was Scott who smoothed matters over. He talked to Clayton, who agreed to deliver all the remaining cartoons for Windsor within the next three months, and persuaded the Committee to allow Clayton the extra time he wanted for the Albert Memorial cartoons, assuring the members that this would not cause any delay to the completion of the Memorial.[65] In the second half of February 1867, Clayton and Bell set out a schedule proposing a series of dates for the delivery of the cartoons, with a completion date of 30 July 1868.[66] This was accepted and, in May, the Articles of Agreement were drawn up between Clayton and Bell and the contractor, John Kelk. They were to be paid £800 for the cartoons and sketch designs.[67] From this time on, although neither Layard nor the members of the Committee ever seem to have got over their distrust of Clayton,[68] there were no further problems.

When Layard had discussed Clayton's first sketch of the figure of Poesia before leaving for Italy, he had been particularly concerned about the form and detail of the throne, and had referred Clayton to an altar-piece depicting the Coronation of the Virgin by Taddeo Gaddi (*c.* 1300–1366), as illustrated in Rosini's *Storia della Pittura Italiana*.[69] But the throne Clayton developed for all the figures in the tympana of the Memorial has little in common with the one suggested by Layard. Instead he adopted a baldacchino type, found in paintings such as the *Ognissanti Madonna* (229) by Giotto (1267–1337), now in the Uffizi in Florence. This echoed the form of the Memorial itself and fitted neatly into the triangular shape of the gable.

Even so, Layard was right to stress the importance of the design of the throne. He must have perceived that Clayton was far more interested in drawing figures, and that the throne was likely to be treated as an afterthought. Firms that made stained glass windows divided the different components of their designs into separate categories: the most skilled artist would draw the figures, and sometimes only their faces and hands, while others would just do architectural canopy-work, or drapery and decorative details. The mechanical treatment of the thrones, used in all four tympana, recalls the stylised canopy-work employed by firms such as Clayton and Bell to fill out their stained glass windows or schemes of painted decoration. These thrones look flat in comparison to the figures, and were to remain the weakest element of the designs.

The first full-sized cartoon, depicting the figure of *Poesia* destined for the south side of the canopy, was finished in July: Scott wrote to Layard to say it had just been fixed up on the Memorial.

> *It looks very fine so far as general design goes but I differ much from Clayton as to the question of tone. As it stands it is very gay, pronounced and prominent. Whereas I think it should have a quiet, rich and sombre tone rather like an old painting: rather giving the impression as retiring*

as the quietest part of the composition rather than thrusting itself forward and challenging the public gaze.[70]

Clayton, who may not have been greatly interested in colour, was asked to tone it down before showing it to Layard.[71]

Scott also suggested that, to maintain the unity of treatment and tone, Clayton should always keep one completed painting in hand while he was working on the next. With this agreed, the cartoons were sent off to Venice in sequence for Salviati's firm to reproduce the designs in mosaic. In October 1867, Layard was in Venice once more, getting involved with the day to day management of the glassworks and even, it appears, taking part in the actual production of the glass, as he described in a letter to his aunt:

> *I have become immensely interested in the glass manufactory and could remain here for months watching its progress – a lucky idea struck me a few days ago which has led to the most brilliant results, as has enabled us to produce glass which for gorgeous magnificence of colour and fine texture has never been reached by ancients or moderns.*[72]

229. Giotto di Bondone, *Ognissanti Madonna* (Uffizi).

It is hard not to wonder if Layard's close involvement with the glassworks was proving rather irksome for Salviati, as it was soon after this that a change took place in the structure of the company. Or perhaps the offer of a fifteen-year contract to restore the ancient mosaics of St Mark's in Venice, made by the Italian Ministry of Education sometime towards the end of 1867, was conditional on the work being done by an Italian firm.[73] Whichever was the case, relations between the two men soured. Layard considered Salviati financially untrustworthy and, when the Venetian detached himself from the English-owned company and founded a new one under his own name, the two firms became bitter rivals.[74]

230, 231. John Richard Clayton's mosaics for the gables and spandrels of the Memorial, chromolithographs from *The National Memorial to his Royal Highness The Prince Consort*, 1873 (Kensington Central Library).

Early in January1868, the registered office of the English company was changed from 431 Oxford Street – Dr Salviati's address in London – to 30 St James's Street, Piccadilly, and Salviati's shares were transferred to one Matteo Montecchi who resided at the company's new address.[75] On 31 August the name of the organisation was changed from Salviati and Company to the Venice and Murano Glass and Mosaic Company, with registered offices at 30 St James's Street.[76] Dr Salviati's son, Giulio, continued to work for the firm, which remained in business until the First World War.[77]

Clayton worked steadily on the cartoons throughout 1867 and managed to complete the entire series by the end of February 1868, five months ahead of time. Shortly after this, the Committee asked Kelk to obtain the cartoons of the mosaics from Clayton and Bell when they were returned by Salviati. In reply to Kelk's letter, Clayton and Bell said they were prepared to waive their customary rights of ownership since 'the work in question is one in which her majesty's interests are involved', and agreed to send them to Kelk, after having repaired any damage that might have occurred in transit. They merely asked in their letter that the cartoons should 'never be exhibited unless indeed at an altitude corresponding with that for which they were specially painted.' [78]

In view of this reply, it is slightly odd, and perhaps a measure of the Committee's distrust of Clayton, that it felt the need to seek a legal opinion as to the ownership of the cartoons. The reason was that the Committee now wished to publish an illustrated book on the Memorial, though it had not seen fit to mention this to Clayton and Bell. The solicitor, as so often in such cases, was not entirely sure of the answer. On 7 July 1868, Doyne Bell wrote to Clayton to inform him that 'arrangements have been concluded with Mr Murray for the publication of an illustrated work on the Memorial, and that it has been decided to illustrate the mosaic work by means of chromo-lythography [*sic*]' (230, 231). He also asked Clayton to send him a short description of the scheme of mosaic decoration, and arrange for the cartoons to be forwarded to him by 1 October in order that the 'chromolyths' might be prepared from them. Clayton replied that he was happy to place the cartoons at the disposal of the Committee, and would hand over the entire set as soon as they were returned by Salviati. But he followed this up with a detailed objection to the use of chromolithography, which he described as a 'mixed process' that combined metallic engraving with lithography and was, in his view, detrimental to both. 'We are disposed to take it for granted', he continued, 'that no one devoted to art and familiar with its processes supposes that chromo-lithography ever yet did a truly artistic thing or that in the nature of the process it ever can'. Rather, he added, 'By the more abstract treatment of form without colour and little light and shade a magnificent work may be accomplished, satisfying alike the eye of the artist, conniseur [*sic*] and public generally'.[79] Here again can be detected Clayton's overriding interest in sculptural form and outline.

It is no surprise to find that the Committee took little notice of Clayton's views; it had already decided on the use of chromolithography, and Doyne Bell did not bother to answer the letter until November, when he wrote asking Clayton to send him the remaining cartoons.[80] The last mosaics to be carried out were the ones depicting the allegorical figures of *Architectura* and *Pictura*, and these arrived in London towards the end of 1868, in time for the last one to be fixed on the monument the following spring.[81] In December Salviati returned the last cartoons to Clayton and Bell, and they were immediately sent on to be used for the publication,[82] which duly appeared in 1873 as the *Souvenir Album of*

232. John Richard Clayton and Salviati & Company, *Poesis*, 1866–8.

233. John Richard Clayton and Salviati & Company, *Sculptura*, 1866–8.

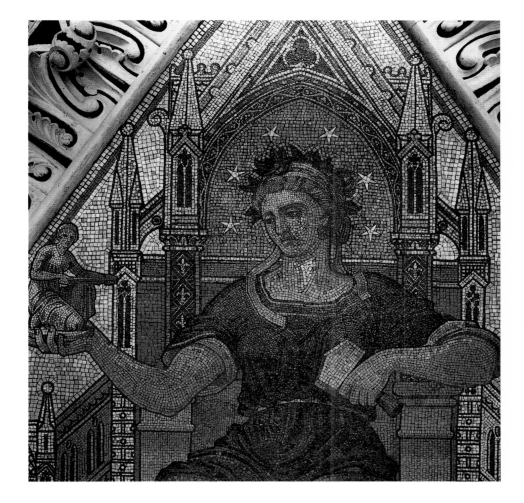

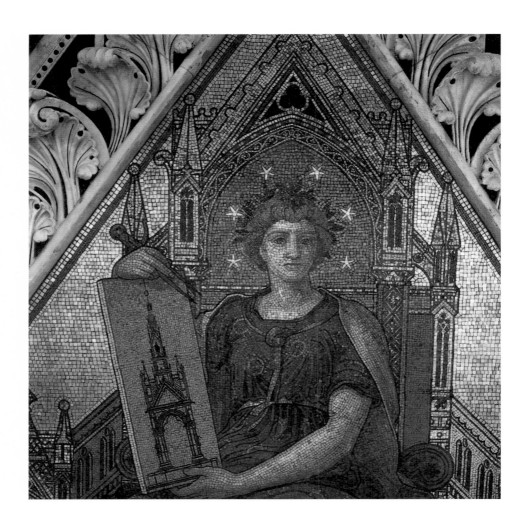

234. John Richard Clayton and Salviati & Company, *Architectura*, 1866–8.

235. John Richard Clayton and Salviati & Company, *Pictura*, 1866–8.

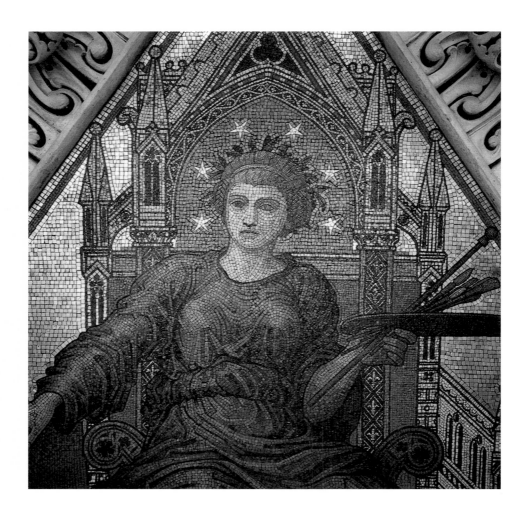

The National Memorial to the Prince Consort. With the exception of the inscription, which was to run round the monument above the figures in the spandrels, the mosaic work was now complete. Even here, though, there was a delay. Scott's original designs had not included a commemorative inscription, and for some time proposals had amounted to little more than a statement of the dates of Albert's birth and death. This was too bald, but more fulsome alternatives were equally unsatisfactory. It was not until the end of July 1869 that the final form of the inscription was decided upon and approved by the Queen. It runs: 'Queen Victoria and Her People / to the Memory of Albert Prince Consort / as a tribute of their gratitude / for a life devoted to the public good'. The last eight words were contributed by Scott himself, who also designed the lettering – gold Lombardic capitals on a blue ground. The inscription was set out by Clayton, using Salviati's mosaics.[83]

The members of the Committee must surely have heaved a sigh of relief once they no longer had to worry about the vagaries of Clayton, whom they probably regarded as an awkward and opinionated man. But in fact, the production of the pictorial cartoons and mosaics had taken an extraordinarily short time – less than two years in all. Furthermore, the enthroned figures of Poetry, Sculpture, Architecture and Painting (232–235), for both the subject matter and the design of which Clayton had been responsible, did provide an extraordinarily satisfactory decorative scheme for the mosaics on the Memorial. They all vary slightly in pose and dress, but the designs are linked overall by the gold mosaic backgrounds, the similar form of the thrones, and the monumental treatment of the figures themselves.

The *Builder* was impressed by Clayton's designs:

> *He has treated his subjects with poetical as well as pictorial feeling. His figures, Greek in their proportions, in their small poised heads, in their regularity and general similarity of feature – low brows, straight noses, full eyes, prominent chins – are Medieval in their handling. He seems to have treated them with the purity and severity of the ancient Greek models, yet clothed them with the warmth and life of Medieval associations.*[84]

Certainly there is a fusion of the two traditions, the form of the thrones and treatment of the looser folds of the garments of the muses are medieval in style, while the figurative drawing and way in which the drapery clings to the upper parts of the bodies are strongly classical in feeling. While the gestures of the four figures vary, their poses echo one another, and each is depicted with items appropriate to the art represented. *Pictura* carries a palette and brushes, with one hand resting on a canvas; *Poesis* bears a lyre and a name scroll of famous poets; *Sculptura* has a maul in one hand and lifts up a maquette in the other; *Architectura*, in a proudly self-referential gesture, displays the design of the Albert Memorial itself.

Even more successful, perhaps, are the groups in the spandrels (236). Clayton was at his best when designing figures within a tight architectural framework. The spandrels to either side of *Pictura*, and those that are linked with the figure of *Sculptura*, make an interesting contrast. In the first, a young painter with his board held up by another, looks across to the opposite spandrel which is occupied by the group he is sketching; while in the second, two young sculptors, facing away from each other, are working on statues. On the left hand side, the boy is carving a figure of a seated woman, while on the right a bearded man, resembling one of the many classical busts of elder statesmen, looks over

the shoulder of the young sculptor who is modelling a figure in a toga. This is the best balanced of the pairs of spandrel designs, and the most Greek in feeling. Is it a coincidence that it portrays sculpture, the profession Clayton had so wished to embrace ?

The mosaics of the Albert Memorial are among the few really important examples of this type of decoration produced in Britain in the nineteenth century. The thing which sets them apart from the vast majority of Victorian mosaics is that, rather than being applied as an afterthought to an earlier building, these murals were conceived as an integral element of the architect's design. The overall form of the Memorial is largely Italian gothic, and Scott believed the images in the gables should be modelled on 'Florentine works of the fourteenth century'.[85] But although his design deploys a historical style that consciously acknowledges its country of origin, it was part of the ethos of the time that art forms should be adopted 'without slavish reference to the past'.[86] Scott's attitude to mosaic was essentially modern and practical; he wanted a material which would look similar to painted or enamelled decoration, but be able to withstand the British climate.

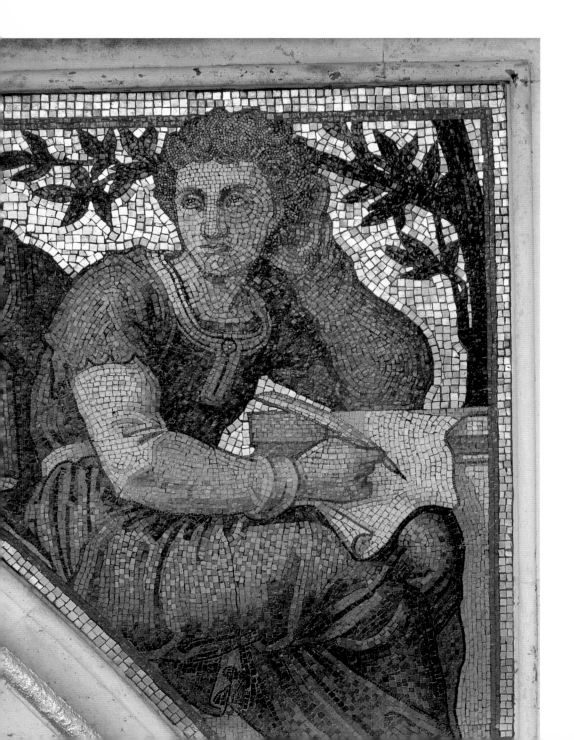

In the 1860s, enthusiasm for structural polychromy was at its height, and had mosaic not been prohibitively expensive, it would surely have taken its place as a major decorative medium. But as it was, although decorators and glass manufacturers turned out small pictorial items, such as reredoses and wall plaques, by the score, few architects had clients wealthy enough to enable them to employ the medium extensively in their buildings. This was unfortunate since mosaic is seen at its best on a grand scale, used as a monumental form of decoration. As William Morris is reputed to have said, 'Mosaic is like beer – a little is no good'.[87]

Only two of Scott's contemporaries, William Burges (1827–1881) and William Butterfield, succeeded in developing the decorative potential of mosaic in ways that were distinctively their own. Both fully understood that mosaic was not just a means of making 'petrified paintings' and used it effectively as a form of architectural decoration. Although Burges failed in his bid to carry out a major scheme of mural decoration in glass mosaic, he was able to realise a number of marvellous designs for marble mosaic floors, including the very elaborate ones at Worcester College Chapel, Oxford (1865–6), and St Finbar's Cathedral (1877) at Cork, in Ireland.[88] Butterfield's most ambitious scheme of mosaic decoration is that of Oxford's Keble College Chapel (1875–6). Here the mosaics, with their white grounds and tesserae set in rows rather than curved to follow the contours of the forms, bear little resemblance to Italian ones, even though made by Venetian workmen.[89]

The mosaics of the 1860s and 1870s are often compared unfavourably with those designed at a later date by members of the Arts and Crafts Movement who, by reverting to the use of traditional techniques, succeeded in making murals with the luminous quality characteristic of ancient mosaics. But what such critics fail to see is that the peculiar vitality of the art of the High Victorian period derives from its self confidence; architects and designers working at that time were not fettered by their knowledge of the past, they adapted the art forms of previous eras to match the spirit of their own age, and at times succeeded in creating works which were daringly new.

The style of the mosaics of the Albert Memorial is as eclectic as that of the monument itself. The gold mosaic background belongs to the Byzantine and Venetian tradition; the throne is gothic, but with a baldacchino looking back to the Early Christian period; and the figures are part Greek, part Italian gothic, but imbued with a feeling, a character, which is unmistakably Victorian. The way the mosaics were made was also partly old and partly new. On the one hand mosaic was an ancient art, based on the rediscovery of forgotten methods of glass manufacture; on the other, its contemporary use was made possible by technical advances which enabled murals to be prefabricated in their country of origin for despatch to buildings in any part of the world. The mosaics of the Albert Memorial are, then, a fine example of the kind of enterprise for which the Prince had campaigned so hard: an exchange of skills between one country and another, and a perfect marriage of Art and Industry.

236. John Richard Clayton and Salviati & Company, spandrel mosaic representing Poetry, 1866–8.

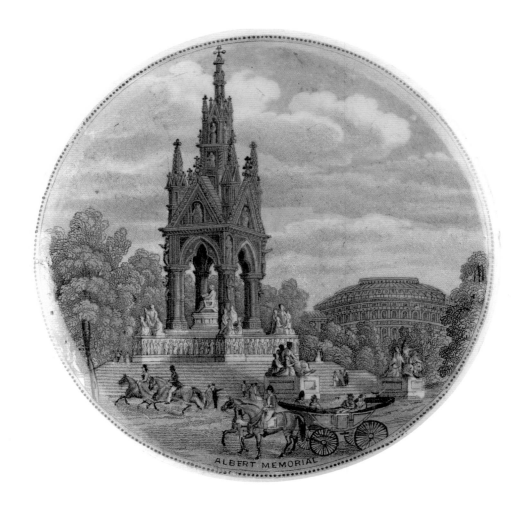

237. The Albert Memorial, with the Albert Hall in the background, pictorial pot lid, late nineteenth century (Royal College of Music).

Chapter 9

Albertopolis:
the Estate of the
1851 Commissioners

John Physick

The Exhibition of the Works of Industry of All Nations was opened by Queen Victoria before a gathering of about thirty thousand spectators on 1 May 1851. The Exhibition had not had a trouble-free history since it had been proposed in 1849 by the Society of Arts, of which Prince Albert had recently become President. From the first, the most important concern was that of finance: the government would not make any public funds available, but hoped that all the money would be forthcoming from the public and the manufacturers of the country. However, the Society entered into a contract with two speculators, George and James Munday, who offered to back the exhibition provided that they received two-thirds of any profits. This arrangement did not meet with the Prince's approval, and he decided that there ought to be a Royal Commission, which would undertake financial and administrative control as well as all the practical arrangements. The Royal Commission was issued on 3 January 1850, and its Commissioners included: Prince Albert as President; the Liberal Prime Minister, Lord John Russell, and his Conservative predecessor, Sir Robert Peel; Lord Stanley – later the Earl of Derby – and W. E. Gladstone, both Prime Ministers of the future; Earl Granville, William Cubitt, Charles Lock Eastlake PRA, Richard Cobden, Jones Loyd – later Lord Overstone – and Thomas Baring; with Sir Stafford Northcote and J. Scott Russell as its secretaries, assisted by Edgar Bowring of the Board of Trade. After a protracted and acrimonious legal argument with the Mundays, it was not until July 1851 that the contract was cancelled, and they grudgingly accepted Robert Stephenson's arbitration that they should be awarded compensation of £5,130.

Special Commissioners, Dr Lyon Playfair and Lt-Col. J. A. Lloyd were sent round the country to whip up enthusiasm both for donations and exhibits, which they found rather hard-going. As late as August 1850 Playfair reported that he was proposing to visit Glasgow, Paisley, Dunfermline and other towns in Scotland in order 'to stir them up again as they were lethargic'.[1] In addition to such problems, the Royal Commission had to cope with arguments about the site of the Exhibition. Earl Spencer offered the use of three hundred acres of waste ground in Battersea, and among other places considered were Regent's Park, Primrose Hill, Victoria Park, Wormwood Scrubs and the Isle of Dogs. There were objections to them all – Wormwood Scrubs was thought to be too far out of London, and who would even consider making a journey out to the damp and unsavoury Isle of Dogs ? Fortunately, the Office of Woods and Forests agreed to an area of Hyde Park, south of the Serpentine, provided that the Royal Commission agreed to the Exhibition building being removed as soon as the Exhibition had closed.

The site secured, the Commissioners had to think about the building. After a public competition, elements of various entries were combined into an enormous brick building, weighed down by an iron dome with a diameter of two hundred feet, designed by Isambard Kingdom Brunel. Public opinion was horrified: fortified by the universal condemnation and led by the *Times*, residents of Kensington petitioned Parliament to withdraw permission for the use of Hyde Park. The government was worried by a building of thirteen million bricks, and the length of time it would take to demolish it – even if enough bricks could be found in only a few months to build it in the first place. A debate was arranged in the Commons. Shortly before this took place, one of the commissioners, Sir Robert Peel, died after a riding accident. Peel had been a staunch supporter of the Prince and the Exhibition, and at his last meeting of the Commission had said of Hyde Park, 'That shall be the site or none'.[2] Fortunately for the Exhibition's future, Peel's death had a sobering effect on the Commons: 'the feeling of the House was completely altered and all parties seemed to agree that Hyde Park was the best site'.[3] After the debate, Henry Cole found Prince Albert very nervous, telling Cole that he had never thought anyone could have objected and that he had been prepared to give up the Exhibition.[4] Brunel's detested building was discarded by the Commissioners as soon as Joseph Paxton showed them his design for a prefabricated iron, glass and wood building, and most of the opposition evaporated when it was engraved in the *Illustrated London News*. Press and public alike were captivated by the Crystal Palace. The Commissioners gave their approval to the building on 16 July 1850,[5] everyone hoping that it really could be erected in time.

By now, finance was no problem, due mainly to the efforts of Playfair and Lloyd; donations, requests for exhibition space and lists of exhibits began to roll in by the end of 1850, guarantees of money were announced, and the Bank of England agreed to lend against these promises. Immense resources of energy and administration were called upon, especially from the Commission's Executive Committee of Colonel W. Reid, who was Chairman, Henry Cole, Matthew Digby Wyatt, C. W. Dilke, Francis Fuller and George Drew – though the last two did little work. Henry Cole became the dominant member; all was achieved in only a few weeks and many hundreds of exhibits from all over the country, from Europe and Asia, the Empire and America, were in place and ready by the end of April 1851.

In spite of forecasts of doom, it soon became apparent to Prince Albert that he would be vindicated and the Great Exhibition in Joseph Paxton's Crystal Palace was about to achieve an overwhelming success. Just before the opening on 1 May 1851, Prince Ernst August of Hanover had told King Friedrich Wilhelm of Prussia that Prince Albert, 'the great originator of this folly', was 'beginning to jibber with anxiety'.[6] Piqued, but perhaps also amused, Albert wrote to the King:

> *The rumour that the court has been forced to make up its mind to dessert London … is one of the many inventions concocted by the enemies of our artistic and cultural venture and of progress in civilisation to frighten the public. From the very start they have shown remarkable persistence and ingenuity. Mathematicians have calculated that the Crystal Palace will blow down in the first strong gale; engineers – that the galleries would crash in and destroy the visitors; political economists have prophesied a scarcity of food in London owing to the vast concourse of visitors; doctors – that*

owing to the many races coming in contact with each other, the Black Death
of the Middle Ages would make its appearance, as it did after the crusades;
moralists – that England would be infected by the scourges of the civilised
and uncivilised world; theologians – that this second Tower of Babel would
draw upon it the vengeance of an offended God.[7]

Happily none of these predictions materialised: millions of visitors arrived in happy and wondering mood, many by innovative excursion trains from all over the country, and as early as August 1851 the Prince was considering what should be done with the profits – subsequently disguised as the 'surplus' – which he then estimated would be over £100,000 (some £5,000,000 today).[8] Another thing on his mind was the fate of the Crystal Palace building afterwards.

The Crystal Palace had rapidly become a favourite with the public and there was a strong campaign to retain it in Hyde Park, largely due to Paxton himself, egged on by the *Times*, which reversed its early criticism of the 'monstrous greenhouse' and was in 1852 against the 'wanton annihilation' of this 'wondrous building'. The Prince was adamant, however, as the Royal Commission had agreed that it was to be removed as soon as the Exhibition closed; but if the government wanted to preserve the Crystal Palace, that was nothing to do with the Commission, nor was any of the surplus to be diverted. The building was, in his view, simply a covering for the exhibits, and at their 47th meeting the Commissioners agreed that their contract with the Office of Woods and Forests to remove the building before 1 June 1852 was binding. Eventually the Crystal Palace was bought by a company, the chairman of which was also the chairman of the Brighton Railway Company, and rebuilt in enlarged form at Sydenham, where Owen Jones and Matthew Digby Wyatt were engaged to superintend the work: it sadly disappeared in a mass of molten metal and glass in the spectacular fire, watched by the present writer, during the evening of 30 November 1936.

In order to deal with the surplus, Prince Albert, the President of the Royal Commission issued to deal with the administration and finances of the Exhibition, convened a meeting at Buckingham Palace on 13 August 1851 with Reid, Cole, Playfair, Northcote, and Dilke – all of them principal organisers of the Exhibition. Cole's diary records that Thomas Cubitt[9] was also present, although he is not mentioned in the minutes. One of the main points put to them was that £50,000 should be spent on buying land on which to establish institutions devoted to Raw Materials, Machinery, Manufactures and the Fine Arts.[10] The Prince wondered whether the learned societies could be brought together and 'united in their institutions, reserving to each its individuality and its self supporting and self managing Character, but bringing them under a general System … in order to secure a certain uniformity among them.' For 'matters of Interest common to them' he suggested 'a Central Committee of their Chairmen', to which 'might be added the Statistical Society.'[11] The Prince's 'advisers' agreed with him in principle but, as Cole recorded in his diary, nobody approved of the details; indeed, he noted later that they 'all concurred strongly against the Prince's plan'.[12] Albert told Stockmar that each had pushed for his own particular interest[13] – but the plan was modified.

A week later, the Prince took William Gladstone and other Commissioners aside and told them of his ideas, although nothing was recorded officially.[14] A snag then occurred: the government's Law Officers, the Commission was told,

would have to be consulted, as the Commissioners' authority ceased with the Exhibition, and a Supplemental Charter would be required for managing the surplus – by now established at £186,000. The Prince, rightly judging this a formality, went ahead with his plan for buying land, although many of the Commissioners were not told at once. It was left to Lord Granville, the Commission's Vice-Chairman, to write to them to explain that the Prince was hoping to acquire land in Brompton, although its eventual use had not been settled. The Commissioners generally agreed, although some thought that the Prince was thinking of commercial development, and Gladstone prudently asked if the investment would be a good one. The area that the Prince had his eye on was south of Hyde Park, largely comprising the remains of market gardens – including Brompton Park House, the home of Henry Wise the eighteenth-century gardener – divided between several landowners, including the Earl of Harrington, the Smith's Charity, Baron de Villars, and at least two speculators, Charles Freake and John Aldridge. In order to keep prices low, negotiations would have to be undertaken with some secrecy and delicacy: if owners knew that the Prince and the 1851 Commissioners were interested, inevitably prices would rise.

As soon as the size of the expected surplus became known, the Royal Commission received many suggestions for its disposal: there were proposals for Mechanics' Institutes, for the establishment of Colleges of Arts and

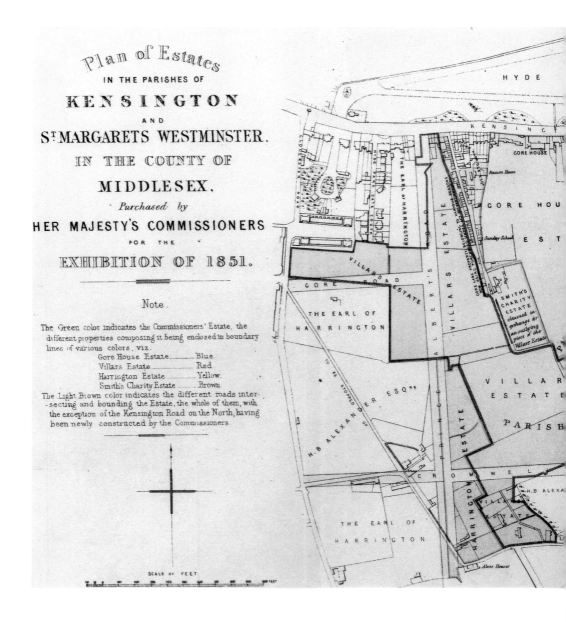

Manufactures in the regions, for a statue of the prince, travelling studentships, gardens, museums, and more.[15] Henry Cole told Colonel Charles Grey – Albert's Secretary – that the Society of Arts looked towards one-third of the surplus, but the Prince, through Grey, let it be known that the Society had 'no claim whatever'.[16] Albert was determined that the surplus would not be frittered away on limited or partial schemes, but should be applied to one institution for Industrial Education which would 'extend the influence of Science and Art upon Productive industry'.

The Royal Commission received its Supplemental Charter on 2 December 1851. This gave very wide powers, 'to dispose of the surplus in the furtherance of any plans that may be devised by us, to invest it in such manner as we may think fit, and generally do whatever we may consider necessary for carrying out such plans and directing any establishment or institution to be funded in pursuance of them'. In addition the Commission would be able to buy land in any part of 'Her Majesty's dominions, and to apply or dispose of them in all respects as we may think fit'.[17]

With this go-ahead for the Prince's plan the Commission asked John Kelk to undertake negotiations with the various landowners. Also involved by now was Gore House, opposite Kensington Gardens, which the government was considering as a possible site for a new National Gallery. In all, land amounting to some 130 acres was available, which Kelk estimated would cost £400,000 to

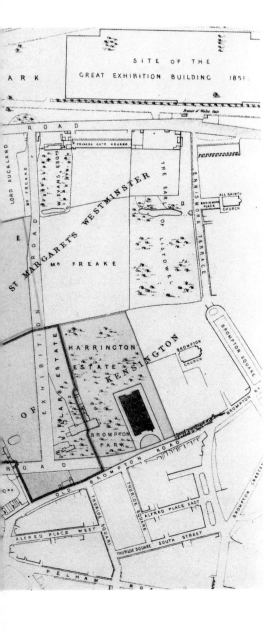

238. Map of the South Kensington estate of the Great Exhibition Commissioners at the time of purchase in 1852 (Trustees of the Commissioners of 1851).

buy. Negotiations were protracted, difficult, and at times unpleasant, but eventually the only plot that eluded the Commission was the Eden Lodge Estate, at the northern end of Exhibition Road – now occupied by the Royal Geographical Society. In total, the Commissioners managed to acquire an estate of about 86 acres (238).

The Commissioners' estate was to develop over the following decades into the district of museums and cultural institutions that the Victorians christened Albertopolis. Its building history is exhaustively detailed in the *Museums Area* volume of the *Survey of London*. The account that follows in this chapter concentrates primarily on the northern part of the estate, which forms the architectural ambience of the Albert Memorial, and where the gardens of the Royal Horticultural Society were laid out and the Albert Hall built.

The cost of all this property was more than the surplus. Benjamin Disraeli, as Chancellor of the Exchequer, had hinted that the government might help, but the administration changed in December 1852, and Gladstone became Chancellor in Lord Aberdeen's Coalition Ministry. At the Prince's request Bowring sent Gladstone a summary of the Commission's activities, and told him that only £28,000 was left on hand.[18] Gladstone replied by way of a Treasury Minute on 15 February 1853, and offered up to £150,000. In return, he asked that the Commissioners should add to their number, *ex officio*, the Lord President of the Council, the First Lord of the Treasury, the Chancellor of the Exchequer, the President of the Board of Trade, and the First Commissioner of Works. The Commissioners were happy to agree, shortly afterwards electing Disraeli as a Commissioner in his own right, as well. A problem soon emerged, for Gladstone took the view that, as the government had put up about half the money, they should have the right to a say in the use of the land.

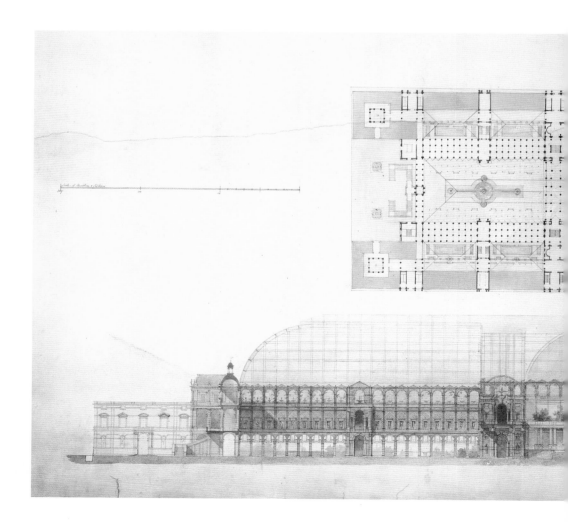

Meanwhile, as Albert pondered the site's possibilities, the Commission made a start by laying out three broad roads on the estate – Cromwell Road, Exhibition Road, Prince Albert Road (now Queen's Gate), and an off-shoot to the west, today's Queens Gate Terrace. The most important institution that the Prince hoped to attract was the National Gallery, for the future location of which a parliamentary select Committee was set up, holding its first meeting on 26 April 1853. The Gallery's building in Trafalgar Square, which it shared with the Royal Academy, was congested and there were fears that pictures were being damaged by the heavily polluted atmosphere of central London. Alternative sites suggested included Kensington Gardens, as well as the estate of the 1851 Commissioners.[19] At first, the Committee was prepared to recommend the Commissioners' estate. An encouraged Prince Albert came up with a sketch plan: two large edifices on Kensington Gore for colleges of art and science, with the National Gallery in the centre, housed in a building of 190,000 square feet, as against the mere 28,000 square feet provided in Trafalgar Square. South of the Gallery two more large buildings were to be used for museums of Industrial Art, Patented Inventions, and Trade, and there was plenty of open space for gardens with fountains and statues. South of Cromwell Road would be land available for 'private houses, or other institutions, or perhaps, the necessary official residence'. The plan also left an area of twelve acres, west of Holy Trinity, Brompton, 'which might be best for the learned Societies as might express a wish to move, being the portion of ground nearest London'. In addition, if land were available, there might be an Academy of Music and a concert hall, but this would require extra government money.[20]

When Gladstone was told of the plan, he was cautious,[21] especially as nobody had previously mentioned a possible need for additional funds. He

239. Gottfried Semper, Design for a museum building for the Commissioners' estate, 1854 (Trustees of the Commissioners of 1851).

thought that Prince Albert should work out his proposals more definitely to establish if the estate really was large enough to accommodate everything proposed, particularly as he considered that too much open space was being planned: 'We ought not in such a neighbourhood ... provide anything in the nature of new Park ground'. As Gladstone wrote to Lord Granville, 'I by no means attempt a *veto* ... but I think we are not ripe for deciding upon it with the information before us'.[22] Almost immediately, Gladstone found himself at odds with his fellow Commissioners. Colonel Grey told Bowring he had heard that the government, ignoring the fact that the Commission's estate had been purchased specifically for purposes of science and art, wanted to build a barracks on the twelve acres to the east of Exhibition Road, and that Gladstone favoured the idea.[23] The Prince – 'it must be steadily resisted' – and others, including house owners in the area, were outraged and protested loudly to Gladstone, who was rather taken aback by the reaction.[24]

Nevertheless, the barracks question rumbled on until 1854: 'is not the consent of the commissioners necessary for such a mis-appropriation of the ground ?' asked Grey. 'If so I think there is little doubt that it will not be given'.[25] In the meantime Prince Albert, in order to stake a claim to the disputed twelve acres, asked the German refugee, Gottfried Semper, then a professor at the Government School of Design, to design a building, somewhat on the lines of Paris's Palais Royal (as he said), with a colonnade, shops, and apartments above, and in the centre a space suitable for concerts and other purposes, including a museum. Unfortunately, Semper's project (239), covered by an enormous iron and glass roof, proved to be uneconomical and was abandoned.[26] Instead, Henry Cole, now charged with revitalising the Government School of Design, was asked if he would be prepared to move it and the Museum of Manufactures from Marlborough House to Brompton. Cole seized the opportunity, and the Commissioners erected a temporary iron structure on the site – quickly christened the Brompton Boilers (240). Cole must have thought the name of the district insufficiently distinctive, for he suggested to Albert – who readily agreed – that the area of the Commissioners' estate should be renamed South Kensington. In 1857 the South Kensington Museum and an art school opened in the Boilers, where they were later joined by a science school.

While these manoeuvres were underway, the question of the National Gallery was still unresolved, and there was no sign of the government coming to any decision. Losing patience, Albert decided that control of the estate needed to be independent of any ministry. In 1858, he asked Disraeli, once again Chancellor of the Exchequer, whether the government would take back the money granted to the Commission five years before: Disraeli thought they would.[27] A parliamentary bill was devised, and passed the Commons on 12 July 1858, despite fears that Gladstone would oppose it in committee.[28] The Commissioners arranged a mortgage with the trustees of Greenwich Hospital, and repaid the grant, less £60,000 for the site occupied by the South Kensington Museum, part of the newly created Department of Science and Art.[29]

The architects Cockerell, Donaldson, and Pennethorne, the painter Richard Redgrave (1804–1888), and Cole himself all provided the Prince with possible layouts for the estate (241), but these could only be ideal projects, for there was still no firm agreement about either use or buildings. It was known by now that none of the learned societies showed any inclination to leave their central London premises, even though Albert was still hoping for the National Gallery, and perhaps the Royal Academy as well. He also seems to have dropped

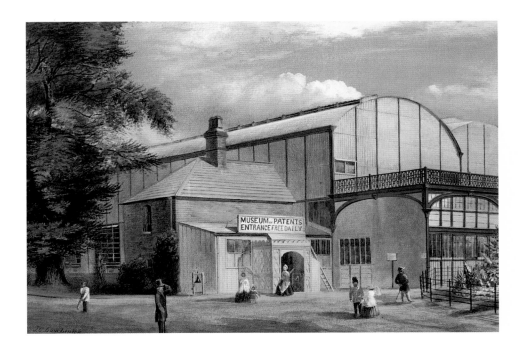

240. J. C. Lanchenick, *The Brompton Boilers and the Entrance to the Patent Museum*, 1863
(Victoria and Albert Museum).

241. Charles Robert Cockerell, Plan for the layout of the Commissioners' estate, *c.* 1853
(Trustees of the Commissioners of 1851).

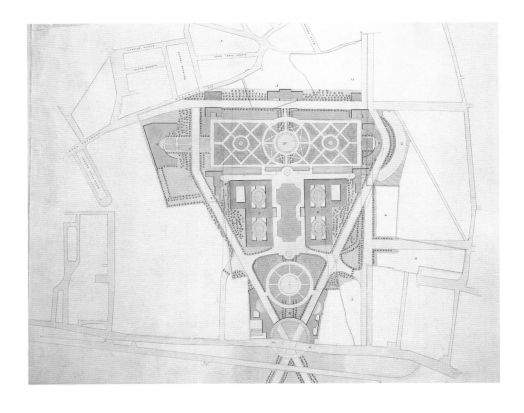

the idea of a concert hall, though it remained at the back of Cole's mind. By the end of 1858, the fight to acquire the National Gallery had been lost. Subsequently, despite being offered land on the Commissioners' estate, the Royal Academy decided Kensington Gore was too distant a location, especially as there was the prospect of moving to Burlington House, in Piccadilly.

Prince Albert was not only President of the Royal Society of Arts and the Royal Commission for the 1851 Exhibition, but also of the Royal Horticultural Society. In 1859, he arranged favourable terms for the Society to take a thirty-one-year lease on twenty acres of the estate in order to lay out an ornamental garden. Unable to keep himself out of anything that was going on in South Kensington, Henry Cole busied himself with the scheme, visiting Italy with Captain Francis Fowke, the Royal Engineer who was architect to the Science and Art Department, to seek architectural inspiration. Cole sent back photographs – now in the Victoria and Albert Museum – of Roman buildings, particularly the cloisters of San Paolo Fuori Le Mura, and San Giovanni in Laterano, and noted the use of terracotta, which he thought might be a suitable and cheap way of reproducing ornament at South Kensington.[30] The Prince commissioned William Andrews Nesfield to lay out the garden, and Sydney Smirke, together with Fowke, to design the surrounding arcades, which culminated at the north in Fowke's impressive iron and glass conservatory (242). Terracotta decoration was carried out by the talented pupil of Alfred Stevens, Godfrey Sykes, assisted by James Gamble and Reuben Townroe. In what turned out to be his last public engagement, Prince Albert opened the garden on 5 June 1861 (243).[31]

One thing that seemed to obsess Henry Cole (244) was somehow to place on the Commissioners' land an exceptionally large public hall. In 1857 he proposed one to Albert, capable of accommodating 30,000 people, incautiously asserting it would 'require no great expense'. The Prince thought the idea of a 'Music Hall larger than a Roman Amphitheatre'[32] was wholly incredible. Cole was undaunted. While abroad in the following year, he drew up a prospectus for a 'Chorus Hall Company' with a capital of at least £150,000, to be raised by

242. Royal Horticultural Society Gardens, South Kensington, photograph of *c.* 1865 (Victoria and Albert Museum.

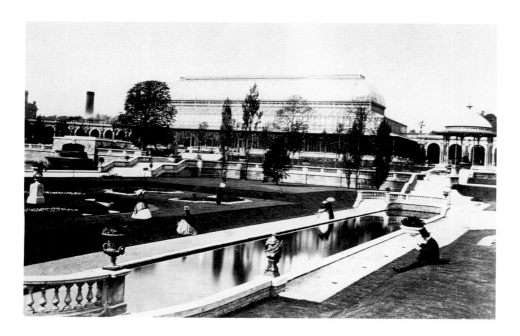

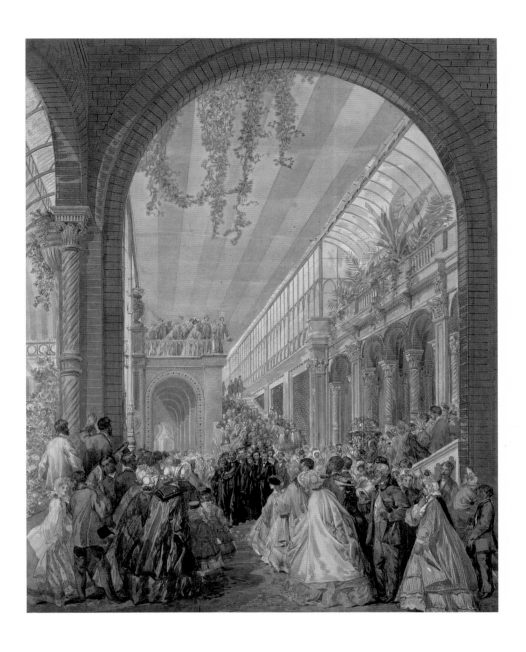

243. Edmund Walker, *Prince Albert and the Royal Children at the Opening of the Royal Horticultural Society's Building at South Kensington 5 June 1861*, 1861 (Victoria and Albert Museum).

244. Sir Henry Cole (1808–1882), *Vanity Fair* cartoon by James Tissot, 1871 (Victoria and Albert Museum).

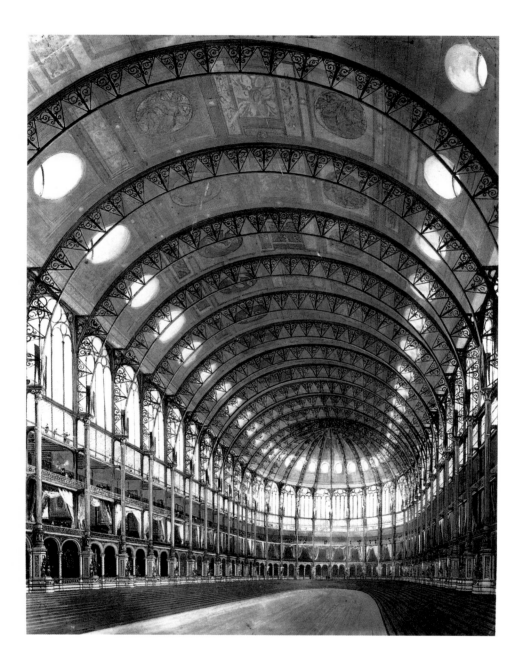

245. Francis Fowke, Proposed ceremonial hall
for the 1862 International Exhibition building,
probably drawn by John Liddell
(Victoria and Albert Museum).

subscriptions and shares of £5 each. The hall it would build would be larger than any then existing in the country, would provide a home for musical concerts including oratorios, exhibitions, organ recitals, public meetings, flower shows, and the like, and, he hoped, would be part of the International Exhibition being planned for 1861.

Early in 1858, Cole had proposed to the Society of Arts that a follow-up exhibition should be held ten years after the Great Exhibition. The Society approved, although the Prince was not enthusiastic. Another Royal Commission – for once, not chaired by Albert – was issued, and the 1851 Commissioners gave permission for the use of their land flanking Cromwell Road. Cole, having no faith in professional architects, arranged for the exhibition building to be designed by Fowke, whose design included a huge ceremonial hall (245). By the end of 1860, it was obvious that it could not be afforded, and the hall was dropped early in the next year. Cole's diary for 21 February records the chain of events:

> *Fowke came and proposed that the hall should be given up to secure all the rest, and I agreed … Ld Gr[anville], said to Mr. [Robert] Lowe we must give up the hall … agreed that a little Hall wouldn't do: a little red lion does not answer for a great one. Kelk came and he [Saxon] Snell, [John] Liddell, Redgrave, Fowke and I coloured a revised ground plan leaving out the Hall.*

Thus hastily scaled-down, the exhibition building went ahead: a couple of weeks later work began on laying out the ground for it.[33]

Prince Albert died on 14 December 1861, by which time the South Kensington estate was beginning to take shape. The Royal Horticultural Society Gardens and the large conservatory had been opened. The museum complex was established on the east side of Exhibition Road, and plans were well advanced for permanent buildings by Fowke; along Cromwell Road his building for the Exhibition was nearing completion. Delayed by war between France and Austria, deflated by Albert's death and a worsening slump in the cotton industry, the Exhibition was eventually opened by the Prince of Wales on 1 May 1862 (246). Unlike its predecessor it only just managed to break even, finishing indeed with a small deficit of about £11,000. Fowke's exhibition building was universally condemned, though Cole did his best to have it retained and incorporated in his museum empire. The House of Commons had other ideas: the government bought the land from the 1851 Commissioners for £120,000, but not the building, which was largely demolished. In January 1864, Cole's empire- building hopes were raised again by the decision to use the site for a museum which would house the natural history holdings of the British Museum, the Patent Museum, and other collections. The subsequent competition for the building was won, to Cole's delight, by Francis Fowke. Fowke, though, died at the end of 1865, and his plans were given to Alfred Waterhouse to carry out. The whole scheme was then stalled by a change of government: when Waterhouse at last received permission to go ahead he was also empowered to revise the original plans. The terracotta Romanesque palace he created for the Natural History Museum (247), first opened in 1881, was radically different from Fowke's conception.

The unexpected death of Prince Albert left the 1851 Commissioners headless, and for a long time they floundered, until, on 16 April 1864, they elected the Earl of Derby, one of their original members and a former Prime

246. Wallpaper commemorating
the 1862 International Exhibition
(Private Collection).

Minister, as president. However, Henry Cole – a great pamphleteer – had already seized every opportunity to proclaim his own views on the future development of the Commissioners' estate, not hesitating, when it was convenient, to claim that he knew what the wishes of the Prince Consort had been, always implying no-one else did. He was quick off the mark after the Prince's death. On 31 December 1861, he proposed an industrial university, The Albert University, to be established in South Kensington, to grant degrees and honours in sciences and arts which directly influenced the works of industry. Unlike London University, he continued, it would not require examination for matriculation, and would offer degrees in mining, chemistry, painting, architecture, and sculpture, when combined with an industrial application. With an eye to future funding, Cole argued that Durham's Memorial to the Exhibition of 1851 – described in Hermione Hobhouse's chapter – should be the Prince's 'first great national monument', but that 'this would not nearly absorb the whole of the large National Subscription which may be expected'.[34]

Despite Cole's efforts to pre-empt the commemoration of Albert, attention from 1862 focused on George Gilbert Scott's Prince Consort National Memorial. As Gavin Stamp describes in chapter three, initial proposals included a 'hall of science' as well as a monument, and Scott provided preliminary designs for one. By 1863, however, it was clear that the money available would pay only for the Memorial, and the idea of a hall was dropped. Here was Cole's chance and he took it. He revised the grandiose proposal of 1857–8, producing a scheme for an oval hall at least 250 by 300 feet, though this time seating only (!) 15,000, enclosed by galleries and shops, with apartments above. At one stage in the development of Cole's idea even Scott was pulled in to design gothic blocks of flats.[35] Bowring told Colonel Grey that the Commissioners would not like the 'chambers to be built facing the park', but added that Cole thought them 'an indispensable part, as by this means much of the sinews of war will be provided'[36] – in other words, the much-needed money. The proposal for 'chambers' was eventually dropped, ironically, in view of the Commissioners' later sale of the land for Norman Shaw's looming Albert Hall Mansions. The Hall itself thus remained to be developed as an isolated, free-standing building.

247. Alfred Waterhouse, *The Natural History Museum*, 1876, showing the final design (Victoria and Albert Museum).

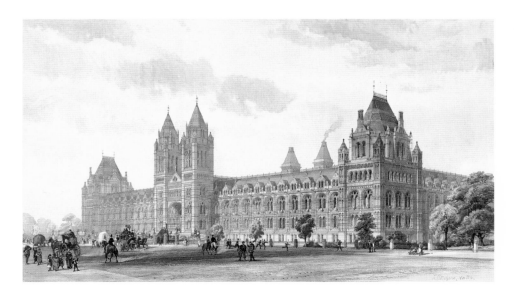

In November 1864 Cole was in Arles and Nîmes looking at Roman amphitheatres with Fowke and Colin Minton Campbell.[37] On their return, Fowke's architectural team made a small model of a hall, which Cole and Redgrave took to Osborne to show the Queen and the Prince of Wales on 29 January 1865. The response, Cole recorded, was positive.[38]

Cole was now faced with the problem of raising at least £200,000, in spite of scepticism and suspicion about the activities of South Kensington in establishment circles. Undaunted, he told Grey 'I have come to the conclusion that the only way to get the Memorial Hall done, is to *do* it', and decided to go it alone as a personal ambition – 'I don't intend to be beaten in this matter'[39] – especially as the 1851 Commissioners were proving reluctant to assist the project. This may have been partly due to the lack of enthusiasm of their newly elected President, who thought Cole's proposal was 'an entirely visionary scheme' for which there was no apparent demand.[40] Later, Derby confided to Grey that, '[f]rom what cause I know not', Cole was 'one of the most generally unpopular men I know', and feared his prominent part could have an adverse effect on public opinion.[41] During the first half of 1865, the Commission's secretary wondered if its members would agree to their estate being offered as security for a loan to build the hall; Cole thought it unlikely,[42] though if it happened 'we are all in clover'.[43] Commissioners were concerned about the future use of the building, particularly whether it would really be confined to occasions of art or science. Even so, Phipps told the Queen that they had 'partially admitted that *something* to carry out the Prince's plan of establishing a … Hall was to be undertaken'.[44] In discussion with one of the hesitant Commissioners, Robert Lowe, Bowring became convinced that his opposition sprang from a deep suspicion of Cole and all his works.[45]

At this point, though Cole was determined to achieve a large memorial hall dedicated to arts and science, he was still undecided about what precisely it might be used for. Even the hall's plan was fluid, at first straight-sided with

248. First model of the Royal Albert Hall, *c.* 1865 (Victoria and Albert Museum).

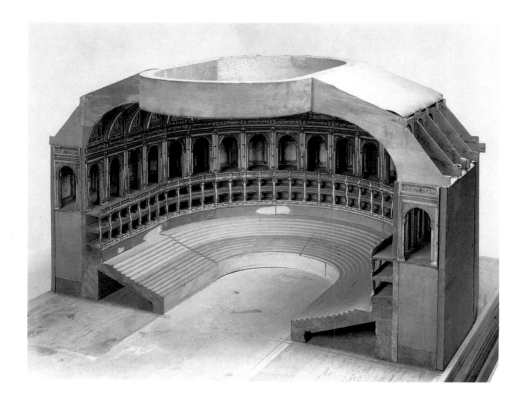

apsidal ends (248), before eventually becoming an ellipse. All the same, he sent out prospectuses offering leases on boxes at £1,000 and £500, and single seats for £100. Slowly money began to come in: the Queen bought two boxes, the Prince of Wales one, and other members of the royal family also subscribed. Some eminent figures declined to take up the offer, including Gladstone; Cole was undismayed – 'the less politicians had to do with the Hall the better'.[46] From the middle of May 1865, the financial situation began to look very much brighter, and Victoria was told that Derby would propose that the Commissioners should guarantee £50,000 towards the cost of the Hall, in addition to giving the site, provided subscriptions from the public totalled £150,000.[47] The 1851 Commission, not involved as a body in the Albert Memorial, decided to offer the site on a lease of one shilling annually for 999 years.[48] The land was immediately to the north of the Royal Horticultural Society's conservatory, on the central axis of the estate. The Albert Memorial was located at the point where this axis intersected with that of the Great Exhibition building. Cole later recalled his own part in this happy geographical symbolism:

> It was said that Lord Palmerston declared that he had heard from the Queen that Her Majesty had sent for me and asked my opinion: that I had pointed out this site as the intersecting point of two straight lines, one drawn through the site of the '51 Exhibition, the other through the Royal Horticultural Gardens; that the Queen instantly accepted the idea and called it a 'revelation from Providence'. If Lord Palmerston told this story, it was more likely his own invention. I am not aware that I even discussed the site with General Grey or any one. Possibly when General Grey talked to me, I concurred in the propriety of the present site, and he may have spoken of my concurrence.[49]

Cole was a considerable thorn in the flesh for Gilbert Scott, constantly carping at the design of the Memorial: Gavin Stamp earlier discusses Cole's hostile *Memorandum on Crosses and Shrines in England*. More fairly, perhaps, he also criticised Scott's extensive use of marble, which would be badly affected by London's atmosphere. This influenced the choice of materials for the Hall, Cole deciding not to look northwards towards the Memorial but, instead, southwards to the Horticultural Gardens and the South Kensington Museum, with their use of red brick and terracotta.

When Fowke died in December 1865, his successor, appointed by Cole, was Colonel Henry Scott, another Royal Engineer, who was then running the Royal Horticultural Society Gardens. Recruited into the South Kensington Museum camp as its architect, he took over the planning of the Hall as well. Initially Cole was worried because Grey had nominated Gottfried Semper, 'of whom the Prince Consort had a very high opinion'.[50] But Derby advised against appointing Semper, as it would be considered a slur on British architects to pass them over for a foreigner 'not known here by any of his work'.[51] Backed by a team of architectural assistants, Henry Scott designed the exterior of the Hall, which Fowke had not had time to develop. After various changes, due largely to economic pressures, it eventually emerged with a two-storied elevation above a basement, surmounted by an open gallery and a stone balustrade. Behind this was another storey with a frieze in ceramic tesserae, within which a further storey supported the glass roof. The whole building is structurally remarkable, a great brick cylinder covered by a glass dome held on wrought-iron trusses, the design of which involved consultation with such leading engineers as John

Fowler (1826–1864), the inventor of the steam plough, and John Hawkshaw (1811–1891), designer of the Severn Tunnel. The Hall originally had three porches, until the demolition of the Royal Horticultural Society's conservatory, when a south porch was added. Three large finely detailed plaster models of alternative treatments of the elevation are in the Victoria and Albert Museum.[52]

The architectural writer James Fergusson tried to have the plan of the Hall changed,[53] but Cole was determined to press on. To hasten the work and reduce costs, he drafted in staff from the South Kensington Museum as well as the Science and Art Department, among them the architect's office, the design team of Reuben Townroe and James Gamble – who soon went off to assist Alfred Stevens with the sculpture of Dorchester House and the Wellington Monument – the photographer, Sergeant Benjamin Spackman, and the Ladies' Mosaic Class. Although Scott took overall responsibility for the frieze, Cole was clearly closely concerned in the development of the scheme.[54] The design was a co-operative effort, with individual artists – many of them involved in the decoration of the Museum – producing different sections of the frieze, or collaborating to settle its general disposition: Edward Armitage (1817–1896), John Callcott Horsley (1817–1903), Stacy Marks (1823–1898), Frederick Richard Pickersgill (1820–1900), Edward Poynter (1836–1919), Frederick Yeames (1835–1918). Among artists who approached Cole about working on the frieze was Daniel Maclise – though he told Cole that 'Leighton was the Man'[55] – and involved, too, was the sculptor Armstead, responsible for so much major work on the Albert Memorial, rising on the opposite side of the road.

The foundation stone of the Hall of Arts and Science was laid on 20 May 1867 by Queen Victoria, 'at first rather Sad, but brightened up afterwards'.[56] A month later, having seen engravings of the proposed building (249), a writer to the *Times*, suggested that the Hall could be compared to nothing but a Strasburg pie, with a glass crust – adding, 'I only hope that the contents will be half as good'.[57]

249. Final design for the Royal Albert Hall, *Illustrated London News*, 1867.

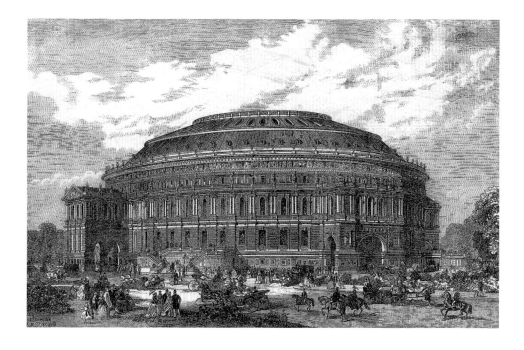

Reuben Townroe designed all the exterior terracotta decoration, with its repeated motifs of British national symbols; but Cole, uniquely, had his own heraldic crest and motto, set within a shield at the east entrance. For making glass mosaic panels in the South Kensington Museum, Cole had employed Salviati, whose role in the Memorial's mosaics is described in Teresa Sladen's chapter. For the Hall's 800-feet long frieze, however, Cole opted for closer personal control, which meant local production – a decision influenced, no doubt, by Minton, Hollins and Co. having recently established a workshop adjacent to the Hall. They indeed manufactured the frieze, which is of buff ceramic, the figures outlined in black on a chocolate background.[58] The design, to illustrate artistic and scientific activity, was divided among the various artists in sections of fifty feet, and was drawn up on a scale of 1 : 6.5, providing cartoons about eight feet in length. These were photographed by Sergeant Spackman, enlarged onto paper, traced, and then passed to the Ladies' Mosaic Class, who, under the supervision of the Minton firm, finished the large tesserae that comprise the frieze.

Over the main entrance, on the north, Edward Poynter's design shows the countries of the world bringing their products to the 1851 Exhibition: Britannia, seated in the centre, is accompanied by Peace, Concord, Plenty and Prosperity. The other sections of the frieze, moving to the right, are: Music, Sculpture and Painting, by Pickersgill; then Princes, Patrons and Artists, by Armitage; Workers in stone, wood and brick, and Architecture, by Yeames; the infancy of Arts and Sciences, by Pickersgill; Agriculture, Horticulture and Land Surveying, Astronomy and Navigation, by Stacy Marks; Philosophers, Sages and Students, by Armitage; Engineering by Horsley; Mechanical Powers, by Armstead; Pottery and Glass-making by Pickersgill.

It is not realistic here to describe in full the busy procession that makes up the eight hundred feet of the frieze, but it is worth giving an indication of its general character and contents. In contrast to the sculptural programme of the Albert Memorial, the frieze, with the exception of Poynter's section, eschews allegory. The principal features are all pictorial scenes of artists, people at work, their products and patrons. That a fairly large proportion of the frieze was devoted to agriculture and gardening was doubtless because, at the time of its execution, the Royal Horticultural Society's Gardens, immediately south of the Hall, was the main feature of the Commissioners' estate. Depicted in this section are ploughing with oxen, sowing, reaping, building stooks, grape-gathering, and workers in a garden.

Pickersgill's Music, Sculpture and Painting illustrates a harpist, the carving of a crucifix and a font, and monks working on a wall-tomb; Niccola Pisano is represented with a drawing of his pulpit at Pisa, and Benvenuto Cellini shows a tazza to Michelangelo; a cardinal examines a triptych, there is an enamellist, and Raphael paints a Madonna and Child. Patrons and Artists, by Armitage, includes a discussion of the Parthenon, painting an Etruscan vase, and a sculptor unveiling a statue of a lion. Yeames's architectural section depicts the building of a Roman temple, a triumphal arch, a mosaicist, brickmaking, and Egyptians hauling a sphinx into position. To go with these are representative buildings of the Christian tradition: Constantine the Great and Santa Sophia, the west front of Peterborough Cathedral, Sir Christopher Wren kissing the hand of Charles II in front of St Paul's Cathedral. Stacy Marks represents Astronomy and Navigation by a historical sequence that takes in shepherds and stars, Greek philosophers, Galileo and a telescope, a sailor navigating by the

250. Francis Fowke and Henry Scott,
The Royal Albert Hall, 1865–71.

heavens, and a Tudor-looking ship approaching a modern-looking lighthouse. Modernity is most explicit in Horsley's Engineering section, as it is in the Engineering group of the Albert Memorial. It includes quarrying iron ore, a smelting furnace, a rolling mill, an electric telegraph, a railway engine, and surveying by Royal Engineers – a nice compliment to Fowke and Henry Scott. Armstead historicises the theme with Mechanical Powers, which shows Archimedes, men moving a block of stone and splitting stone with a wedge, and – slightly incongruously – a wine press. With Pickersgill's Pottery and Glass-making the succession of scenes and figures arrives back at Poynter's allegorical section.

Above this pictorial freeze, is a lengthy inscription in moulded terracotta capitals, probably hardly ever read in its totality. Its characteristic blend of optimism, historical commemoration, and high-minded aspiration make it worth quoting in full:

> THIS HALL WAS ERECTED FOR THE ADVANCEMENT OF THE
> ARTS AND SCIENCES AND WORKS OF INDUSTRY OF ALL
> NATIONS IN FULFILMENT OF THE INTENTION OF ALBERT
> PRINCE CONSORT • THE SITE WAS PURCHASED WITH THE
> PROCEEDS OF THE GREAT EXHIBITION OF THE YEAR MDCCCLI
> • THE FIRST STONE OF THE HALL WAS LAID BY HER MAJESTY
> QUEEN VICTORIA ON THE TWENTIETH DAY OF MAY
> MDCCCLXVII AND IT WAS OPENED BY HER MAJESTY THE
> TWENTY-NINTH OF MARCH IN THE YEAR MDCCCLXXI •
> THINE O LORD IS THE GREATNESS AND THE POWER AND THE
> GLORY AND THE MAJESTY FOR ALL THAT IS IN HEAVEN AND
> IN THE EARTH IS THINE • THE WISE AND THEIR WORKS ARE
> IN THE HAND OF GOD • GLORY BE TO GOD ON HIGH AND ON
> EARTH PEACE

Henry Scott estimated that the Royal Albert Hall of Arts and Sciences (250) – to give it its full name – would accommodate an audience of just over 7,000. The lease allowed concerts, choral and organ recitals, distribution of prizes, conversazione, exhibitions of painting and sculpture, and so on. Due to the seats being privately owned, the building has always been difficult to maintain and finance, in spite of assistance by the 1851 Commissioners, who at one time found themselves the owners of eight hundred £100 seats. As a result, the Hall's charter has had to be revised many times to allow it to put on a wider range of attractions and entertainments. One of its main uses, however, has always been for music. From the beginning oratorios were a popular feature. And it is typical of Cole that he should have busied himself equipping the Hall with the largest organ then in England, paying several visits to the workshops of Henry Willis, the builder, during its construction.[59]

While the Hall was in the course of erection, Cole obtained encouragement for a series of annual international exhibitions each devoted to a selected few industries or trades. Between 1869 and 1871, Henry Scott built permanent galleries, subsidised by the 1851 Commission, alongside the arcades of the Royal Horticultural Society's Gardens. Fowke's large conservatory was to be the southern entrance to the Albert Hall, which would itself be brought into use, particularly the upper gallery for the display of pictures. Arrangements were agreed with the Society to allow visitors to the exhibitions access through the Gardens. From the newly opened station of South Kensington, the Metropolitan

District Railway constructed a tunnel under Exhibition Road as far as the Gardens' arcades in order to provide a covered way to the complex of Gardens, Hall, and exhibition galleries, as well as into the South Kensington Museum – though the Department of Science and Art would not allow this entrance to be opened. Later there was a proposal to continue the subway to the Albert Hall, but this came to nothing: with the Gardens and galleries gone, pedestrians are now decanted on to the pavement, half-way up Exhibition Road.

On 1 May 1871, the first exhibition in the completed galleries was opened by the Prince of Wales, who had been elected President of the 1851 Commission in 1869, after the death of Lord Derby. The exhibits were diverse – pottery, textiles, machinery, and educational material – and the show was a success, attracting more than a million visitors and making a profit. The next three, again with a mixture of exhibits, proved financial disasters: fewer than half a million turned up to each, and the situation was aggravated by the refusal of the Royal Horticultural Society to allow free access through their Gardens. In 1874, to Cole's dismay, these annual exhibitions were abandoned. Their failure brought to a crisis the deteriorating relationship between the Royal Horticultural Society and the 1851 Commission, especially as the latter had spent a lot of money renovating the Gardens' arcades at the request of the Society, which had not paid any rent since 1866. The Commission's long standing Secretary, Edgar Bowring, resigned in 1869 on becoming a Member of Parliament. His place was taken by Henry Scott who, during 1873, drew up conditions for the termination of the Gardens' lease. Peculiarly, he was also Secretary to the Royal Horticultural Society, which led to the bizarre situation of him writing letters to himself from one body, and then having to reply to himself from the other. Three years earlier, as he wrote in the spring of 1873, he had foreseen that 'something would happen between the Commissioners and the Society' and offered to resign, stating further that, in his view, the Society never would be able to pay the rent on the Gardens.[60]

After Albert's death, Queen Victoria had assured the Royal Horticultural Society of her 'peculiar and personal patronage and protection' and had asked to be told of any developments that affected its welfare. Accordingly, in 1873, the Society's Council appealed for her support against the Commission,[61] but without any substantial success. Meanwhile, Henry Cole, who was a member of the Council, was also telling the Commissioners' solicitor of the need 'to get rid of the lease & he agreed that was an object worth fighting for'.[62] In spite of all this bad feeling, the Society went ahead with its own plans to create a skating rink in the Gardens. This further upset the Commissioners, who had not been consulted, and they vetoed it. Finally, in 1879, the Society was informed that the Commission intended to repossess the Gardens.[63] The Society fought back, took the Commissioners to court in 1881, and won. An appeal followed, and in March 1882 – almost at the time of Cole's death – the Master of the Rolls, Sir George Jessel, upheld the appeal and judgement was given, with costs, to the Commissioners. The Society was allowed to remain in possession for four months in order to fulfil commitments.

Once the Commissioners had unrestricted use of the Gardens they allowed further exhibitions: these had been limited before, though they had included the National Portrait Exhibitions of 1864, 1865, and 1866. Around the same time, Henry Cole was winkling all the science exhibits from the east side of Exhibition Road, and moving them into the remnants of the 1862 Exhibition building, portions of which were still extant and in use as late as the 1960s. In

1876, the Commissioners offered £100,000 to the government towards the establishment of a separate Science Museum, but the offer was turned down, ostensibly because of the poor state of the economy. The success of the International Fisheries Exhibition in 1883, visited by more than two million people, encouraged the Commissioners to support the 1884 Health, Food and Clothing Exhibition, and the 1885 Inventions Exhibition, both of which attracted four million visitors – though the latter resulted in a small deficit. In 1886, however, came the Colonial and Indian Exhibition, which was seen by five and a half million people and realised a handsome profit of £35,000. Much of this was handed over to a committee formed to consider building an Imperial Institute to mark the Queen's Golden Jubilee. At the same time, the 1851 Commission, in order to bring its own finances into good order, was selling building leases on the east side of Queen's Gate for houses. The impression of an increasingly *ad hoc* approach to the development of South Kensington is confirmed by the nondescript temporary buildings put up on the estate in the 1870s to accommodate the National Training School of Cookery[64] and the Royal School of Art Needlework, both now established elsewhere. In effect, the removal of the Royal Horticultural Society from the South Kensington scene, really marked the end, 'with remarkable short-sightedness',[65] of an ordered development of the estate that had been Prince Albert's vision.

When the decision was eventually taken to place the Imperial Institute (251), designed by Thomas Edward Collcutt (1840–1924), on the estate, the Commission, with no comprehensive plan, constructed Imperial Institute Road east to west from Queen's Gate to Exhibition Road. Prince Consort Road then followed to the north, involving the demolition of Fowke's conservatory and the repositioning of the Memorial to the Exhibition of 1851. Into the former exhibition galleries and part of the Imperial Institute went the India Museum. Though an imposing building, the Institute itself turned out to be a white elephant, as no realistic use was ever found for it. Part was eventually taken

251. Thomas Collcutt, The Imperial Institute, 1887–93, photograph of 1903 (Kensington Central Library).

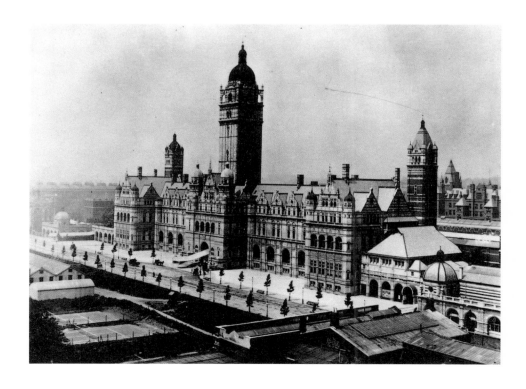

over by London University, while other portions became exhibition galleries, later renamed the Commonwealth Institute. Leases to the east and west of the Albert Hall were offered for sale for commercial development. Up went Albert Hall Mansions (252), by Richard Norman Shaw (1831–1912), between 1879 and 1886 – the first and largest block of flats in London. Another huge block, Albert Court, followed to the east in 1894–1900. To the west, in 1875–6, Henry Cole's son, Harry, designed the National Training School for Music (253), the exterior strikingly decorated with sgraffito; in 1884, overpowering it somewhat, came the adjacent women students' hostel, Alexandra House, by Caspar Purdon Clarke. The Training School became the Royal College of Music in 1883, and subsequently moved into grand, if slightly pompous, new premises, facing the Albert Hall and designed in a red-brick French Renaissance manner (254) by Sir Arthur Blomfield (1829–1899) in 1890–94. Harry Cole's pretty School was eventually leased to the Royal College of Organists, who stayed there until their recent move to St Andrew, Holborn.

252. Richard Norman Shaw, Albert Hall Mansions, 1879–86.

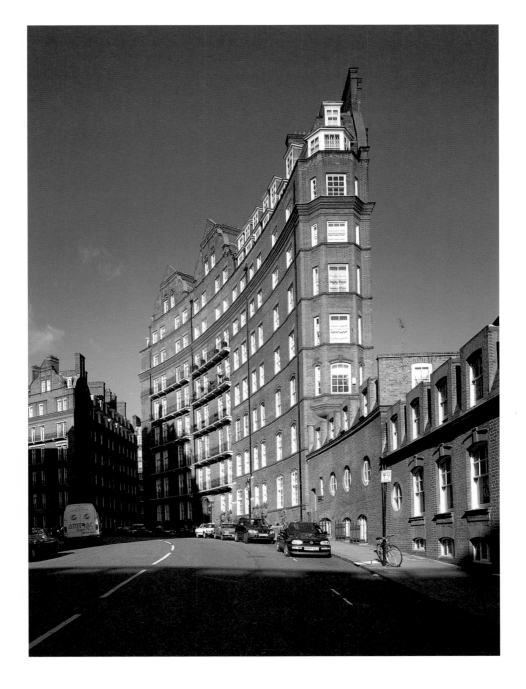

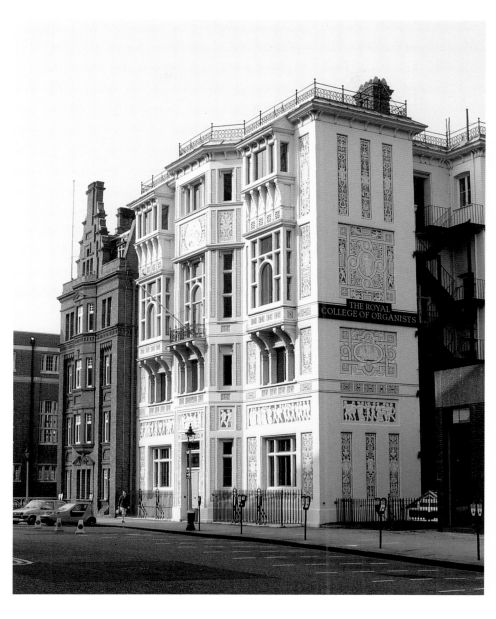

253. Harry Cole, National Training School for Music later the Royal College of Organists, 1875–6.

254. Sir Arthur Blomfield, The Royal College of Music, drawing of the main elevation, 1892 (Royal College of Music).

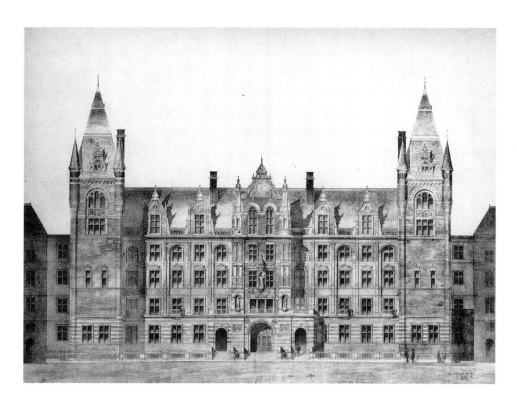

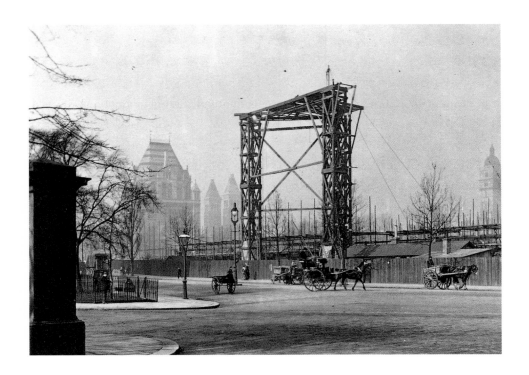

255. Construction work beginning on the Victoria and Albert Museum, photograph of 1899 (Kensington Central Library).

256. Sir Aston Webb, The Victoria and Albert Museum, 1899–1909, photograph of 1913 (Kensington Central Library).

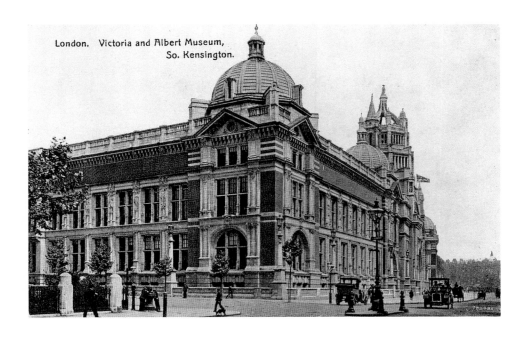

The scientific world had been complaining for years, through many memoranda and petitions to the government, that science was losing out as the South Kensington estate filled up. For its part, the 1851 Commission sold land, south of Imperial Institute Road, to the government for a future science museum and college. Scientists were therefore particularly aggrieved when, in 1891, the Chancellor of the Exchequer, George Goschen (1831–1907), offered part of the land – at the corner of Exhibition Road – as a site for the Tate Gallery.[66] The Gallery eventually went to Millbank, and a post office and meteorological office were later built on this portion of the estate. Even so, the improving economic situation of the 1890s enabled the government to finance the completion of the South Kensington Museum, finished in 1909 and renamed the Victoria and Albert (255, 256), and to build the Royal College of Science, both by Aston Webb (1849–1930). In 1903 the Royal School of Needlework was established in a new building, between the Imperial Institute and Exhibition Road, next to the liver-coloured terracotta of the City and Guilds College, which had been designed by Waterhouse and had opened in 1884. Adjacent, and along Prince Consort Road, adjoining the Royal College of Music, Aston Webb erected his bleakly grand Royal School of Mines in 1909–13. Further west, on the north side of the road, the Ecclesiastical Commissioners bought a plot of land from the estate in 1901 for a new church, Holy Trinity: largely complete by 1907, it is the last major work in London of the great ecclesiastical architect, George Frederick Bodley (1827–1907).

By the end of the nineteenth century the fragmentation of the 1851 estate was almost complete, and the Commissioners turned away from buildings and land. Under the Secretaryship of Lyon Playfair, between 1883 and 1889, the Commission's recurrent annual deficit was turned into surplus, and in 1893 'the estate was declared absolutely free from all charges for the first time since [the] dissolution with the Government in 1858'.[67] Thereafter, the Commissioners increasingly devoted their inheritance from the Great Exhibition to the provision of scholarships.

In 1913 the government made a start on the Science Museum, designed by Richard Allison of the Office of Works. But the First World War intervened, and the first portion of the building did not open until 1928; further building took place in the 1960s, when the last standing remnants of the 1862 Exhibition were demolished, but the museum, now renamed the National Museum of Science and Industry, is still only two-thirds complete. Allison also designed the adjacent Geological Museum in 1914, though it was not built until 1933–5. The estate (257) escaped serious bomb-damage during the Second World War, but havoc was wrought during the 1950s and 1960s, with the expansion and re-housing of Imperial College – formed in 1907 from the union of the Royal College of Science, the Royal School of Mines, and the City and Guilds College. Waterhouse's building for the City and Guilds College was torn down, as too was the Royal School of Needlework. Of the Imperial Institute, only the tower, with its peal of twelve bells, was saved – and then only after prolonged argument and protest. The Eastern and Western Exhibition Galleries disappeared, as did the remains of the arcades of the Royal Horticultural Society's Gardens. The India Museum, rendered homeless, was put into store.

257. (overleaf)
Aerial view of Albertopolis in 1931 (Aerofilms).

Is Albertopolis the right nickname for the area ? Why not Coleville as well ? On a visit to Cole in 1868, the French novelist and historian Prosper Mérimée (1803–1870) claimed he only had to address his letters to 'Mr. S. Kensington' to be sure of reaching him.[68] A century and a half after the Great Exhibition, the Commissioners' estate has almost nothing that was planned or constructed by the time of Prince Albert's death. The Royal Horticultural Society's Gardens, the arcades, Fowke's conservatory, have disappeared without trace: all that is left that the Prince might have seen are a few internal galleries in the Victoria and Albert Museum. It was Cole who, after 1861 and until his own death in 1882, covertly and overtly, had worried, harried, beavered, and bustled in attempts to realise what he considered had been the Prince Consort's intention.

Yet, despite its involved history, bedevilled by financial crises and indecision, the estate that Albert bought has turned out to be remarkably similar to the way he conceived it in his plans of 1852–3. It has three great museums visited by millions, and thousands of students attending its colleges. One half of the South Kensington Museum has grown into the Victoria and Albert Museum, its labyrinthine buildings, the earliest dating from 1857, lurking behind the red brick and Portland stone of Webb's Flemish-Wrenaissance façade. On the site of the 1862 Exhibition, and now incorporating the Geological Museum, is Waterhouse's Natural History Museum, resplendently grey-blue and buff, the first building in England to be entirely encased in terracotta. Adjacent is the other half of the South Kensington Museum, the still only partially completed National Museum of Science and Industry. Imperial College, created – as noted before – from several institutions founded on the site, now occupies a major portion of the estate, its buildings clustered round Collcutt's towering campanile, surviving reproachfully from the Imperial Institute. The Royal College of Music and the Royal College of Organists' building still survive. The National Art Training School, formerly housed in the Victoria and Albert Museum, achieved university status in 1967, and, as the Royal College of Art, is now a neighbour of the Albert Hall in the building by H. T. Cadbury-Brown, Sir Hugh Casson, and Robert Goodden. Finally, there is Sir Henry Cole's great personal achievement, the Royal Albert Hall, familiar to millions as the home of the Promenade Concerts, and now put to a range of uses undreamed of in Cole's day – from the annual Festival of Remembrance to sporting events, circuses, and rock concerts.

Even if some of its present forms are surprising, much of Prince Albert's cultural and educational dream has been realised on the South Kensington estate: not only in stone and brick and terracotta, but through institutions, organisations, and people. From his Memorial in Kensington Gardens, he looks across at an area that has become, and it is to be hoped will remain, world-famous.

258. J. Priestman Atkinson,
'Wanted – A Housemaid Not Afraid of Dirty Work',
Punch, 25 October 1879.

'It is so much less ugly dull' Maintenance, Repairs, and Alterations 1872–1983

Michael Turner

The Albert Memorial was officially handed over to the Commissioners of Works and Public Buildings in September 1872. Since then, the Office of Works and its successors have been responsible for its preservation and maintenance. Nevertheless, the Queen's warrant reserved the right for the Memorial Executive Committee to finish the Memorial, and the Committee continued to be involved on site until the completion of Albert's statue.[1] Much of the work from 1872 to 1983 concerned the routine issues of cleaning and repair common to most structures. While the Office of Works more or less fulfilled its commitment to maintain the Memorial, for much of the twentieth century rejection if not ridicule has characterised the popular perception of the Memorial as a work of art. Certain Works officials were not immune to this view, and to some extent the scope of works in the three major phases of repair which preceded English Heritage's recent restoration project – in 1902–4, 1915 and 1954–5 – reflect this *zeitgeist*. This tendency is exemplified by attitudes towards the gilding – a vital constituent of Scott's shrine which rapidly tarnished in the polluted London atmosphere, and which succeeding generations incrementally eroded.

Completion and early Cleaning and Maintenance

The variety of the materials used on the Memorial created particular problems for the Office of Works even before it was completed. The eight statues of the *Sciences* were originally intended to be executed in marble, but objections from the sculptors of the lower marble groups that their work would be upstaged led Scott in November 1866 to substitute bronze (in actuality they are of brass, but in the contemporary files they are always referred to as bronze). The Executive Committee was concerned that the bronze, which is particularly susceptible to oxidisation, would corrode and disfigure the stonework below. Scott was also keen that the statues should 'preserve as far as possible their original bronze colour and not become mere dark masses' and thus obscure the detail.[2] Enquiries to notable chemists offered no suitable application. The most obvious solution was to gild the bronzes – as had been done on the upper tiers of statuary and other bronze details. In discussion with John Foley and John Clayton, Scott decided that at the lower levels the 'entire surface of gold should be limited to the central figure' but as 'dark masses of metal would clash with the tone of a monument so richly decorated, the effect of the statues should be heightened by being artistically touched in with gold to such an extent as to harmonise with the decorative tone of the entire monument.'[3] Scott accordingly recommended partial gilding, but this suggestion was also rejected by the two artists.

A 'preservative varnish' was therefore devised in 1873, under the supervision of Dr John Percy (1817–1889) of the Government School of Mines, to protect the bronze *Sciences* from corrosion. The Executive Committee, in conjunction with the architect John Taylor, of the Office of Works, participated in these investigations. In initial tests the application seemed successful, but when the eight statues were cleaned a difference in colour was noticed between them owing to a variation in the metals used by the two sculptors, Philip and Armstead, and it was impossible to bring them into uniformity. The gloss finish it produced was also unacceptable, and the varnish rapidly disintegrated. By November 1873 the experiment was deemed a failure, and no further attempt was made to solve the problem by chemical means.[4]

The inability to preserve the bright surfaces of the bronzes exemplified the problem of soiling by the polluted London atmosphere (258). The extensive gilding elsewhere initially enriched Scott's polychromatic design, but it was recognised from the start that the intricate surfaces would rapidly become grimed. A suggestion in 1863 by Henry Cole to avoid this by encasing the Memorial within a glass conservatory had been rejected by Scott. Cole's revival of the idea in 1866 and 1874 came to nothing, but the suggestion was taken up by John Wills, a Brompton gardener, in 1876. Wills and the architect Alfred Bedborough published a design to encase the entire Memorial in a gothic conservatory (259) – with plants representative of the four continents.[5] It was enthusiastically reported by the *Art Journal*, but these suggestions were ignored by the Office of Works.[6] In 1884, however, Wills sounded the alarm about the apparent deterioration of the Memorial and complained to the Queen, repeating his proposal for a conservatory. The Secretary to the Office of Works, A. B. Mitford (1837–1916), countered, pointing out that as the resultant condensation could not be controlled, the problem of corrosion would be exacerbated:[7] the idea of a conservatory was abandoned until its brief resurrection by the Property Services Agency in 1986 (271).

Preserving the appearance of the Memorial was largely addressed by 'dusting' and water cleaning. But as early as March 1870, when elements of the upper structure had been gilded for only six months, the effects of pollution were already showing, as the *Pall Mall Gazette* reported:

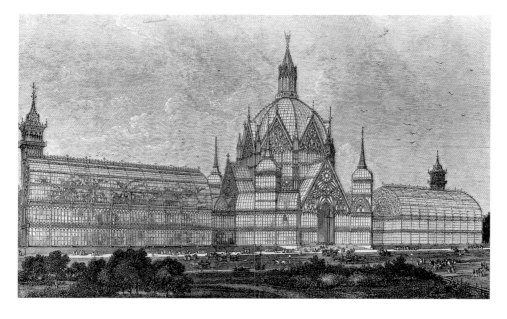

259. Alfred Bedborough and John Wills, Proposal to enclose the Albert Memorial in glass, 1877 (Kensington Central Library).

[T]he cross and some other parts are as black as if they had been up six years. This however is said to be due to the easterly winds which cover the gilt work with a film of soot. The washing of the rain and an occasional sprinkling from a fire engine, will, it is expected, be sufficient to keep the structure bright and clean.[8]

Hosing down with water had been Scott's answer to Cole's criticism that the monument would be disfigured by the atmosphere, and a mains water supply was provided for that purpose. The Committee had also sought the opinion of Armstead and Philip in November 1871 on cleaning their marble frieze, and both men recommended a powerful garden hose between two and four times a year, with a cautious application of potash to remove stubborn stains. Armstead also advised covering the sculptures each winter, although this was dismissed as unnecessary by Philip.[9]

The apparently cavalier attitude of the workmen when cleaning was occasionally the subject of complaint in the press. In September 1872 a correspondent in the *Times* was exercised by the 'dusting' administered to the painters on the Parnassus frieze:

I saw a workman bring a short ladder, roughly made of rough wood, with sharp edges, and dab it against 'Guericault' [sic] whose cheek and nose had to bear the workman's weight, and proceeded to dust the faces of the figures with a brush. He then moved his ladder and assaulted another great man – a policeman looking on and chatting. He then made me tremble by placing the top bar of his ladder almost resting on the top of 'Claude's' nose.[10]

In June 1873 the Executive Committee employed Kelk to clean all the marble statuary prior to carrying out experiments on the bronzes above. This work was the subject of two letters of complaint in the *Times*. One correspondent observed workmen washing the figures of the podium frieze, 'They were being deluged with water, possibly in combination with soap, thus presenting for the time the appearance of being white washed. Worse than this, the men were using, in their customary rough fashion, large bristle paint brushes.'

He continued by citing the opinion of an Italian present that if this continued all the features would disappear within forty or fifty years. Another letter was published the same day:

I observed three men cleaning the marble group of Africa at the north east corner. One of them stood with one foot on the thigh and the other on the back of one of the hands of the great female figure, and on going close, and looking upward, I noticed that his shoes were well studded with hobnails, and that his toes were armed with strong iron plates. [11]

The Executive Committee made enquiries, and were assured that ample sacking to protect the statues was provided, and that it was used by the men, although it was acknowledged that the director of works was only on site twice a day.[12]

In 1873 the Office of Works appointed their own keeper to clean and dust the Memorial and open the gates during the day.[13] Thereafter, the marble work was regularly cleaned by him.[14] The *Hour* reported in March 1874 that during the past year the marble groups had been cleaned 'several times' and the gilding retouched.[15]

It was not until October 1875 that Foley's statue of Albert was installed beneath the canopy, to be gilded and finally unveiled on 9 March 1876. Some commentators in 1876 recognised the necessity for Albert to be gilded to fulfil Scott's design,[16] but pollution had already darkened the higher parts of the Memorial, and cleaning by a hand-held hose could only reach the lower portions. The resultant contrast between new and soiled gold provoked adverse criticism, although the *Times* acknowledged that the new gilding would tone down in time.[17] One of the most hostile commentators was the *Daily News*, in its report on the unveiling:

> *As the sunlight danced on the too glittering figure and rendered futile any attempt to form a clear notion of its proportions, the first thought of every spectator was of the entire want of harmony between the perhaps once gaudy but now tarnished gilding of the Gothic shrine, and the blinding glare of the brand new statue. Never in the history of art has the difficulty of putting new wine into old bottles been so strikingly exemplified.*[18]

Certainly the gilding was bright as revealed by a photograph taken in 1876.[19] The *Morning Post*, more prosaically, considered the statue would require regilding every twenty years.[20] While routine regilding has never been undertaken, the *Post*'s recognition that the Memorial's maintenance requirements would be onerous was nothing if not perceptive.

In 1883 it was stated that the marble statuary had been cleaned regularly for many years under the supervision of Gabbett, the watchman, although staining on the frieze was by then much in evidence. £160 was therefore included in the Works estimates for 1884–5 resulting in a more thorough clean of the statuary groups and the podium frieze in the summer of 1884 using a composition of potassium chloride of lime and whiting.[21] But any desire to maintain the Memorial's original jewel-like appearance was bound to fail without careful cleaning of the entire structure. Regular cleaning was never carried out, largely because of the expense of erecting a full scaffolding, and the higher parts of the Memorial were hardly touched at all. From 1873 to 1914 the only record of cleaning the upper part was in 1892, although in 1914 it was stated that the lower gilt bronze figures and granite columns were washed twice yearly.[22]

Oxide run-off from the bronze *Sciences* inevitably continued to stain the marble below. The Board was exercised by stains, especially on the podium, which always appeared worse during the winter months.[23] However, low level cleaning merely served to highlight the difference between cleaned and uncleaned portions, while dirt from the upper levels simply soiled the cleaned portions in a short space of time. In 1890 the *Daily News* acknowledged that 'certain cleansings of an elementary kind – drenchings with the aid of a garden hose and careful rubbings with sponge and linen – are constantly carried on', but still criticised the accumulation of dirt and the persistent staining.[24]

The Repairs of 1902–1904

This century there have been four major repair projects which have usually been accompanied by a simplification of detail, ostensibly to reduce maintenance costs. The issue of gilding, in particular, has been a significant and recurrent element in the deliberations accompanying substantial overhauls. Although often considered tangential to the main work of repair and conservation, it has had dramatic consequences for the whole appearance of the Memorial.

About a hundred delaminating gold tesserae were observed in December 1883, but nothing was done at the time owing to the cost of erecting a scaffolding and the apparent slow rate of decay.[25] Indeed, the then Secretary of the Board of Works, Mitford, went so far as to say that 'the effect of the deficiencies is rather to give a pleasing texture to the whole, recalling the famous golden roof at Innsbruck.'[26] However, the delaminating mosaics were symptomatic of a serious problem of water ingress within the canopy due to the inadequate maintenance regime, which was becoming more evident by the turn of the century. In the autumn of 1901, Richard Melville Beachcroft (1846–1926), a member of the London County Council, wrote to the *Times* about the Memorial's 'deplorable' condition:

> *Only to-day, when standing on the podium looking at the still beautiful though in many cases disfigured portrait figures, a shower of material fell at my feet from one of the gables which proved to be composed of portions of mosaic. On enquiry I learn that such a fall is of frequent occurrence, and that nothing is done in the way of restoration.*

In view of English Heritage's intervention some ninety years later, Melville's final paragraph was prophetic, 'If the Albert Memorial is not attended to, and that soon, it will develop in appearance, if not in fact, into an ancient monument, when possibly one or other of those active societies ever ready to protect objects of antiquity – or even the London County Council itself – may find it in their power to intervene.'[27]

The Board, ever sensitive to public criticism, acted promptly. A defensive statement was prepared for the press on the 11 October 1901 by the Secretary to the Office of Works, Reginald Baliol Brett, second Viscount Esher (1852–1930), and his briefing notes reveal in particular his cautious approach to the issue of the gilding:

> *1. Since the monument has been erected there have at times always been small showers of powder from the mosaic.*
> *2. The statuary is all in excellent order.*
> *3. It is a matter of taste, but the excessive [deleted] gilding of the monument is thought by many to be in better taste now than when originally erected. To regild would give it a tawdry appearance which may appeal to some people, but is resented by others.*
> *4. The railings are not in good order, and have been subject of much anxious consideration. This treatment is under the consideration of outside experts, whose opinion the F[irst] C[ommissioner] is awaiting.*[28]

George Gilbert Scott's son, John Oldrid Scott (1841–1913), gave his opinion in December 1901 on the failure of some of the tesserae, and localised failure of the lime mortar behind one of the mosaics. He ended his letter by endorsing the

need occasionally to paint the iron structure within the canopy, which had been recommended by his father, but which Oldrid Scott thought had never been done.[29]

Both John Richard Clayton, who had designed the original cartoons, and the Venice and Murano Glass Company (as successor to Salviati and Company) were commissioned to investigate. Clayton reported that the glass had delaminated over about one-third of the gold tesserae in the gables. The lower mosaics to the spandrels and on the soffit of the vaulting had suffered even more because poor drainage at high level had allowed water into the canopy, causing the mortar holding the mosaics to swell and dislodge them.[30] Uppermost was the need to redesign these failing rainwater sumps. Consequently, the Board's surveyor, John Bowman Westcott, rerouted the rainwater pipes and added asphalt to the roof gullies. For some years thereafter the roof gullies were emptied annually.[31]

Clayton suggested two options for the tesserae: either replace all the gold tesserae with new ones permanently protected by glass on the face and sides, thereby preserving Scott's conception, or substitute the original gold with gold-coloured tesserae. The latter was likely to prove cheaper and on these grounds it was initially recommended by Westcott. Subsequently, the Venice and Murano Glass Company estimated £625 for gold enamel mosaic, and £437 10s for gold-coloured enamel, and on viewing samples, Westcott recommended the first.[32] The work was undertaken by the Company, and included adjusting the lettering above the cornice to make room for new canopy drainage. Continued movement, following drying out of the formerly waterlogged mortar during the course of the work, made it necessary to reaffix mosaics already repaired. The result was deemed by both the Office of Works and Clayton 'a complete success'.[33] But the Company estimated its loss on the job at over £1,000, although the claim was refused on the grounds that the firm had had ample opportunity to determine the extent of work required before submitting its estimate.[34]

The issue of gilding on the railings is of considerable interest. Some regilding was evidently undertaken on the Memorial at this time, but its extent is not recorded.[35] However, Esher's attitude to the appearance of the Albert Memorial was equivocal, notwithstanding his former position within Queen Victoria's social circle and his official role in masterminding her funeral and the subsequent coronation of Edward VII, as well as serving on the Queen Victoria Memorial Committee. Esher's disdain for Victoria's more sentimental possessions is evident in his harsh dismissal of the contents of Osborne House in 1901: 'there are *tons* of rubbish'.[36] Esher does not give away his own feelings regarding gilding the Memorial's railings in his statement to the press, but the fact that he first wrote 'excessive' and then considered it more diplomatic to cross it out, strongly suggests that he sided with those who would 'resent' *re*gilding. Consequently, it comes as no surprise that he succeeded in omitting gilding entirely on the railings under the pretext of reducing repair and maintenance costs. However, this substantially impaired the visual impact of the monument and set a precedent for future generations.

The deterioration of the railings, which Esher conceded were not in good order, had been giving concern since 1899. Estimates for £1,200 for repairs and regilding had been included in the 1900–1 estimates. In October 1901 the Office of Works obtained a specification and a high estimate of almost £2,000 for full repairs by Hardman, Powell & Company of Birmingham. Lack of maintenance,

particularly painting, had led to severe corrosion. All the locks required extensive repairs, and many elements were so badly decayed as to require complete replacement – including 554 rosettes. Hardman, Powell's specification included replicating the original three coats of oil paint and one coat of varnish, and selected areas triple gilt 'dotted with colour over the gold', although the firm considered the dotting not necessary.[37]

A letter emanating from Esher went to the First Commissioner, setting out the estimated expenditure based on the Hardman, Powell estimate. 'In addition to this, there will be a constantly recurring expensive outlay. Would you approve of restoring and painting it – but leaving it ungilt – say, for a year – and then if not forced by public criticism – we might abandon gilding altogether. Is this worth "trying on". If so, the cost would be 50 per cent less.'[38]

The First Commissioner agreed. In December 1901, Hardman, Powell submitted a revised estimate of £850 that omitted all burning off and painting; in the event, however, Thomas Elsley of London, who had carried out a condition survey on the railings in 1899, was the successful tenderer at the considerably smaller sum of £156 16s. Plain painting without gilding was estimated at an additional £100. The entire work was completed in the summer of 1904.[39] The total cost of all the work during 1902–4 was estimated at £3,500.[40] Esher's gamble to abandon gilding the railings presumably paid off: there is no suggestion of public criticism in the Works file at the time.

As a postscript to the railings, in 1934 the Marquess of Londonderry (the former First Commissioner of Works in 1928–9 and 1931) suggested removing the railings around the base of the Memorial, which prompted a flurry of memoranda within the Office. But there was little sympathy for this notion, and the matter was ultimately referred to the king, George V who agreed that the Memorial should remain as it is, and the matter was allowed to drop.[41]

These lengthy repairs meant that the Memorial was fully scaffolded from July 1902 until 1904: in February 1904, questions were asked in the Commons about when the scaffolding was going to be taken down. The Works file also contains a cutting from *Punch* which must date from this time: 'Artists are asking angrily who is responsible for the removal of the scaffolding which has for so long concealed the Albert Memorial'.[42]

The Repairs of 1914–1915 and the Removal of the Gilding

At the end of the nineteenth century there had been a recurrent debate between the Metropolitan Police and the Office of Works over responsibility for policing the Memorial.[43] In February 1913, when most maintenance had been transferred to the Works statues staff, a newspaper cutting on file describes David Langston, aged sixty-seven, as the 'little old man who guards the Albert Memorial … busy with his sponge' on the Parnassus frieze. He had been employed cleaning the Memorial for twenty-nine years. 'It is eleven years since the Memorial had its last thorough cleaning, but this year it is to have a half-cleaning. The whiteness of the marbles in the lower half is maintained only by the constant use of a hose-pipe and the old man's sponge.'[44]

At this time, an apparent threat to remove Langston and the other Works attendant brought a remonstration from Scotland Yard, which maintained that without their assistance the police constables on duty at the Memorial would be unable to cope with the constant distractions. These not only included answering questions, but 'preventing damage by curio hunters, excursionists, children &c.' as well as the threat of 'damage to property which is constantly

being committed by agitators for women's suffrage.'[45] In the event, Langston was retained by the Board, but vandalism remained a problem to which the frieze was particularly susceptible on account of its accessibility and the deep undercutting of the figures. The resultant repairs with new pieces of marble created vulnerable straight joints which encouraged water ingress, thus creating further problems.[46]

In 1915, with Queen Victoria and Edward VII dead and memory of the Price Consort rapidly fading, the visual richness of the entire Memorial was severely toned down, again largely by the expedient of removing the gilding. The general reaction against Victorian design was by now well established, and the Memorial was viewed in many circles as the last word in bad taste.[47] Lionel Earle (1866–1948), the last patronage appointment to the Board of Works as permanent Secretary in 1912, not only shared the prevalent distaste for the Memorial, but actively sought to reduce its impact. He successfully directed his personal dislike into departmental policy, which had far-reaching effects on the appearance of the Memorial for over seventy years.

The stimulus to action, as so often with government departments, was public criticism. In July 1913 the Rev. Charles Hyde Brook wrote to the king observing the cleaning being undertaken on London statues and pleading that the upper portion of the Albert Memorial be cleaned too: 'What should be glittering gold is sooty black !'[48] Lord Stamfordham, George V's principal private secretary, forwarded a copy to Earle. The Office of Works was already aware of the poor state of the monument for their 1913 estimates had included a sum of £500 for repairing supposedly dangerous internal ironwork, but this had been struck out.[49] A condition survey conceded that the Memorial was 'beginning to look rather grimy', and required pressing repairs to the lead roof, and renewal or cleaning of the gilding. The metal framework also required painting and gilding, the eight bronze figures needed an overhaul and some new enamelling was necessary. Minor repairs to the roof were undertaken on the north side, following the construction of a partial scaffold. George J. T. Reavell (1866–1943), one of the Works surveyors in charge of royal parks and palaces, estimated the cost of a full repair at £3,000, to be submitted in the draft estimates for 1914–15, pointing out that with the cost of scaffolding alone amounting to £700 'it would seem desirable to make a complete job of it.'[50] Earle forwarded the report to Lord Stamfordham, but suggested that given the current Treasury expenditure on the Navy it was unlikely that funds would be forthcoming.[51]

However, in September 1914, the matter was reopened owing to continued deterioration of the structure. Frank Baines – then a principal architect in the Office of Works – reported that the Memorial required 'immediate overhaul and repair'. Baines listed most of the faults previously identified by Reavell, and followed his estimate of £3,000 for the work, including scaffolding, but thought the money could come from savings on the public buildings vote.[52] Elsewhere, Baines stated that 'All the lower statuary is very stained' and required scouring. The frieze was also 'very badly stained' by dirt and water from the bronze figures, mostly caused by a defective gutter.[53]

On 7 September 1914 Earle agreed to seek Treasury approval, adding a significant rider which reads 'but I hope regilding will be avoided as much as possible. It is so much less ugly dull'. It thus appears that Earle was the originator of the proposal to omit regilding, for the simple reason of aesthetic distaste.[54]

Baines quickly responded to Earle's suggestion and he offered two proposals which Earle put to the Treasury on 15 September: one for £3,000, and the other, for £2,600 if 'omitting regilding'.[55] Earle argued that the cost could probably be met from the underspend on public buildings occasioned by the current dispute in the building trade. The Treasury, not unnaturally, approved the lower figure on 12 October. On 20 October Baines, who had obviously discussed the matter with Earle, went even further by recommending removal of the *existing* gilding:

> *May I press for a decision as to removing the gilt from the statue of the Prince Consort? I am convinced that the improvement wd be great & the final saving on gold leaf considerable. I shd like to slowly reduce the area of gold all over the memorial & I understood you to agree, but you wished to take up the matter with His Majesty I believe.*[56]

Earle wrote to Lord Stamfordham seeking the king's views:

> *The Architect, Mr Baines...has raised the question as to the advantage from an artistic point of view [my italics] of removing the gilt from the Statue of the Prince Consort. I am convinced in my own mind that the improvement would be great if this gilt were eliminated and the statue shown in bronze, and certainly it would effect a great economy ... I personally should like slowly to reduce a good deal of the gilt all over the Memorial, purely from the artistic point of view.*[57]

On 27 October Lord Stamfordham responded:

> *[T]he King thinks it is an excellent idea to eliminate the gilt from the Statue of the Prince Consort and show it in Bronze. Indeed like you His Majesty would be very glad if a good deal of the Gilt all over the Memorial were reduced: so if this could be done with due regard to the original scheme of the sculptor, you would certainly have the King's approval.*[58]

Earle gave instructions to remove the gilt the following day. Nobody, including the King, seemed to worry that a major change to the Memorial's appearance was wholly inconsistent with the desire to respect 'the original scheme'.

In March 1915 exquisite coloured elevations of the Memorial were prepared by Charles Tunstall Small, a draughtsman in the Ancient Monuments Branch of the Office of Works. These show 'Decorations as at present' (260) and 'Decorations as proposed' (261) for submission to the King for final approval.[59] The 'as proposed' drawing – visually a slightly toned down version of the 'as at present' – is annotated to indicate the newly exposed materials of the elements where 'old gilt' was to be removed: Albert, the eight bronze Virtues, lead tiles on the gables and associated bronze cresting, bronze capitals and the stone finials, lions and gargoyles. The only principal component to remain gilded was the orb and cross. The proposals were approved by George V 'in toto' at the end of that month.[60]

Earle visited the Memorial in April and had doubts about stripping the gilding from the bronze leaves of the gables and other metal areas, stemming from his fears over weathering and potential increased maintenance costs, but Baines was able to reassure him that he could see no deterioration to those parts which had always been ungilded.[61] The gold was removed using a caustic poultice of soda and lime bound in sawdust.[62] Where this was difficult or

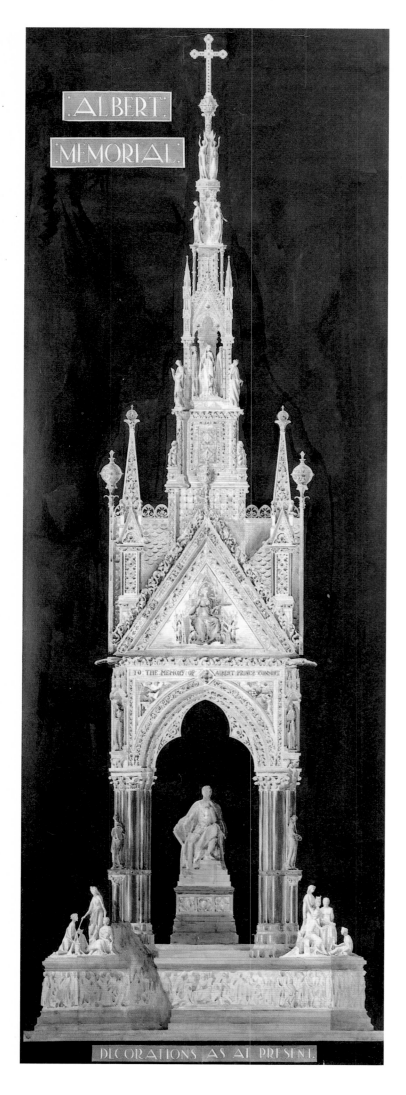

260. Charles Tunstall Small, Elevation of the Memorial showing 'Decorations as at present', March 1915 (National Monuments Record).

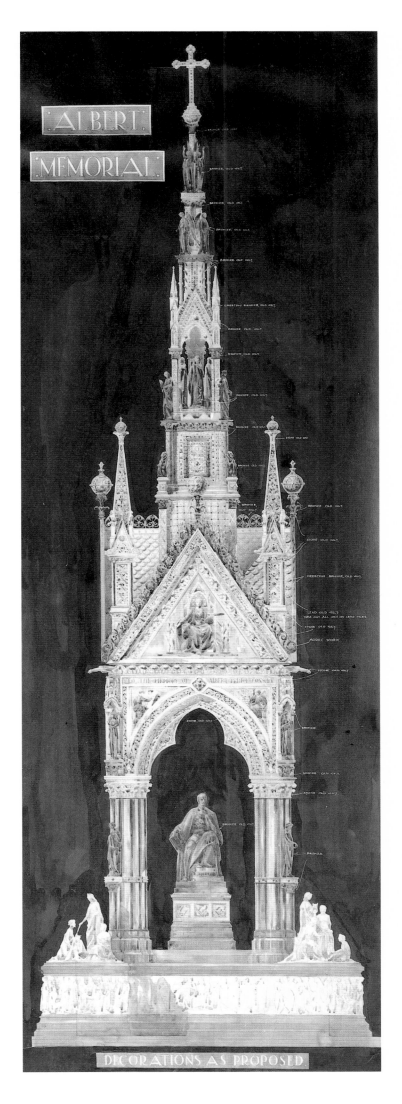

261. Charles Tunstall Small, Elevation of the Memorial showing 'Decorations as proposed', March 1915 (National Monuments Record).

impossible on the stone pinnacles and the leadwork, the gold was painted black – which, contrary to Earle's desire, has in part preserved that gilding from the worst of the ensuing eighty years of atmospheric erosion. On completion of the work Earle wrote to Lord Stamfordham and claimed the Memorial 'has gained a thousand per cent in appearance'.[63] He enclosed with his letter an editorial from the *Architects' and Builders' Journal* which, while not exactly flattering, is representative of informed contemporary taste and did reinforce Earle's view that removal of the gilding was an improvement.

> *The gibe that the best monument in London to look at was the Albert Memorial, because you could not see it for the scaffolding, has now lost its force, the scaffolding having been removed. As one of the best-abused monuments in London, the memorial seems now to have forfeited, or at least to have lessened, its claim to that distinction, for a good deal of the lavish gilding which was its chief cause of offense has been removed, the bronze figures, including Foley's statue of Prince Albert, now showing frankly and honestly the metal of which they are made. Shorn of its tawdriness, the memorial has gained immensely in dignity, although it is true that no mere surface-scraping can reconcile us to the laboured pretentiousness of Sir George Gilbert Scott's design. Scott, however, did a courageous thing in introducing the effigies of ancient and modern architects – fancy portraits of Ictinus, Mnesikles, Chersiphron, and Metagenes, and only too realistic representations of Pugin, Cockerell, and Barry. Of the ancients Mr John T. Emmett wrote: 'they are a set of weak-limbed, semi-idiotic, and half-naked loungers, wrapped in sheets', but he had an over-developed sense of humour, and too much causticity in expressing it.[64]*

As a result of the in-built stresses caused by the use of disparate materials, the Memorial continued to deteriorate, but this was not readily appreciated. Between 1915 and 1928 the gutters were cleaned out and minor repairs undertaken to the canopy on four occasions at a cost of between £121 and £201. In October 1924 Baines, by then Director of Works, sought a report on the present condition of the Memorial, it being almost ten years since the previous major repairs under his supervision. The architect A. W. Heasman stated that relatively minor work on repainting the railings and pointing the steps was proposed in the draft estimates for 1925–6 at £105 and £60 respectively. Heasman was unable to comment on the condition of the Memorial without a scaffold, but added diplomatically (on account of his superior's earlier work) if somewhat over-optimistically: 'I do not anticipate, however, that there will be any serious defects as it was thoroughly overhauled in 1915'.[65] In 1927 an inspection revealed severely blocked gutters, and for four years from 1928 a scaffold was put up on a different quarter of the monument each year to unblock the gutters and remove loose masonry, but no serious repairs were undertaken.[66]

The 1939 Gilding Debate
In 1939 consideration was being given by the Office of Works to regilding Albert. The reasons are not stated, but it represents an enlightened appreciation of the qualities of this memorial to a German-born prince which is both progressive in terms of aesthetic taste, and surprising given the political climate in the summer of 1939. When enquiries were made about the official

reasons for removing the gilding in 1915, the answer was 'as the result of criticism & in order to provide work for the unemployed'.[67] The nature of the criticism is not given, but J. T. L. Kendle, one of the Works staff employed on the statue in 1914, recalled that 'the work was necessary owing to the condition of the surfaces which had become bare'.[68] The implication was that to improve the Memorial's shabby appearance, either these surfaces should be regilded, or entirely stripped. The huge cost of the First World War made savings in expenditure essential, so removing the gilding was preferred to regilding. There was also a theory that the reflection of the gold on the Memorial would be a landmark to Zeppelins. This was dismissed on file, and is surely unlikely, as any reflection would have been incidental in comparison with the distinctive profile of the nearby River Thames.[69] Kendle, now promoted to Superintendent of Works, prepared estimates for regilding in the summer of 1939. These amounted to almost £2,000 for scaffolding, cleaning and regilding, including Albert, and a provisional sum of £500 for repairs, but the proposal foundered with the outbreak of war.[70]

War Damage and the Repairs of 1954–1955
On the night of 1–2 October 1940, during the London Blitz, the Memorial was hit and the top of the north-east stone finial and six feet of the shaft of the cross and orb were lost (262), destroying ninety square feet of paving at the north-east corner and three panels of railings, and causing superficial damage to the podium reliefs as the cross and other debris fell.[71] One of the bronze angels supporting the cross was also destroyed (263): the King was given the head which was eventually taken to the Frogmore Mausoleum where it remains. The Works file explicitly states that the damage was caused by a high explosive bomb, but the Westminster City Council 'Map Record of Incidents 1940–45' does not record any bombs falling near the Memorial on that night, and anti-aircraft fire is generally believed to have been the cause.[72] High explosive bombs falling to the south and east of the Memorial later in October 1940 and February 1944 caused other damage, especially by shrapnel.[73] A detailed elevation of the upper part of the Memorial was produced in November 1940 (264), on which F. L. Rothwell, Assistant Architect, jotted notes on its condition, but at the time only temporary repairs were undertaken to the pavement and railings at a cost of £40.[74]

The post-war reconstruction of monuments and the added interest of retaining 'war wounds' was the subject of occasional discussion in the House of Commons from the mid 1940s until at least 1950.[75] In 1948 Rothwell, by then Senior Architect in the Ministry of Works and Public Buildings, reiterated the Ministry's general policy for war-damaged statues 'to leave all honourable scars of war where no danger exists.'[76] In practice, the general approach seems to have been to repair or replace damaged bronze work, and any stonework which was dangerous or where the design or inscriptions were seriously affected. Minor repairs were not undertaken, particularly if the resultant piecing-in would be unsightly as well as costly.[77] This general policy was followed on the Memorial where Rothwell suggested that superficial war damage could remain as 'honourable scars'.[78] It was thought desirable to replace the metal cross and orb and the lost stone pinnacle in order to preserve the integrity of the monument's profile, although in the event the elements were so simplified and even – in the case of the cross – misaligned, that neither the integrity nor the profile were maintained.

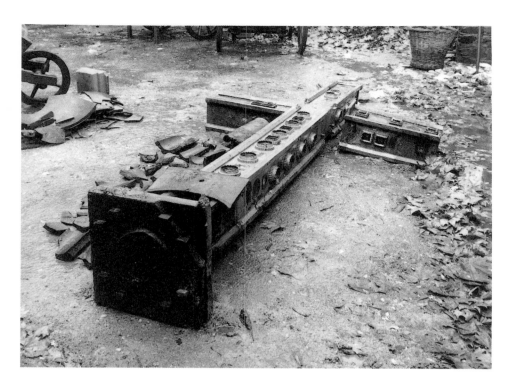

262. The Memorial's summit cross brought down during an air raid, photograph of 1940 (Public Record Office).

263. Parts of the Memorial brought down in an air raid, photograph of 1940 (Public Record Office).

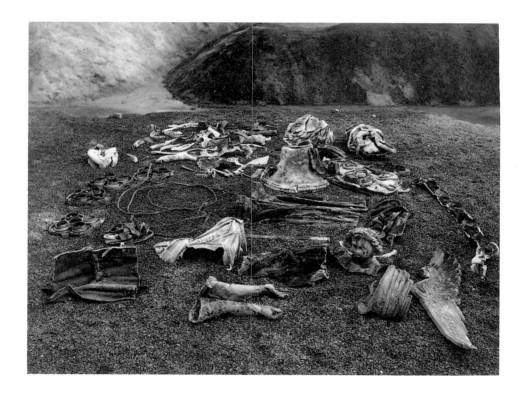

264. Elevation of the upper part of the Memorial, indicating the extent of air raid damage, with notes by F. L. Rothwell, November 1940 (National Monuments Record).

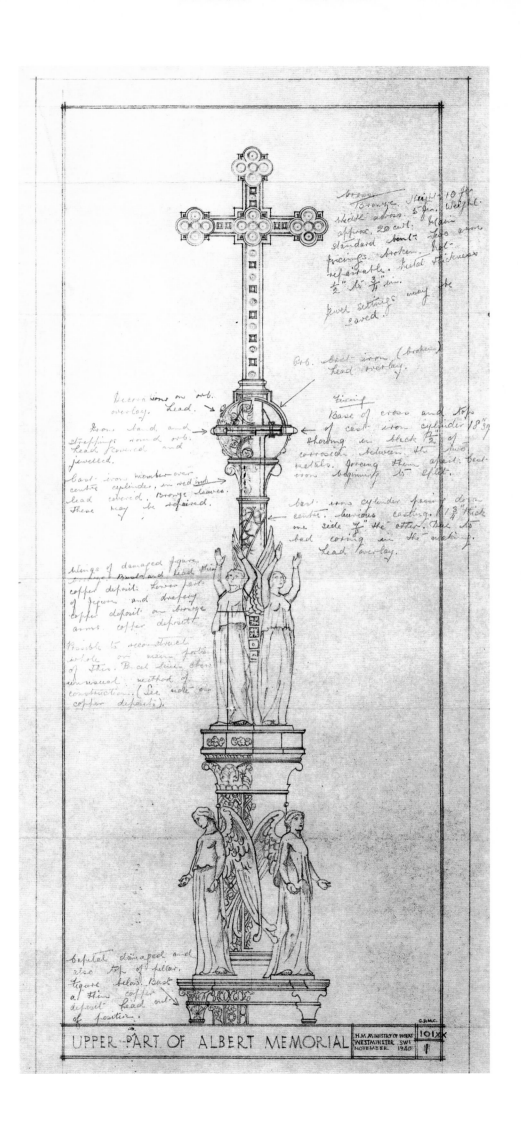

UPPER PART OF ALBERT MEMORIAL

H.M. MINISTRY OF WORKS
WESTMINSTER SW1
NOVEMBER 1940

G.A.MC.

101XX

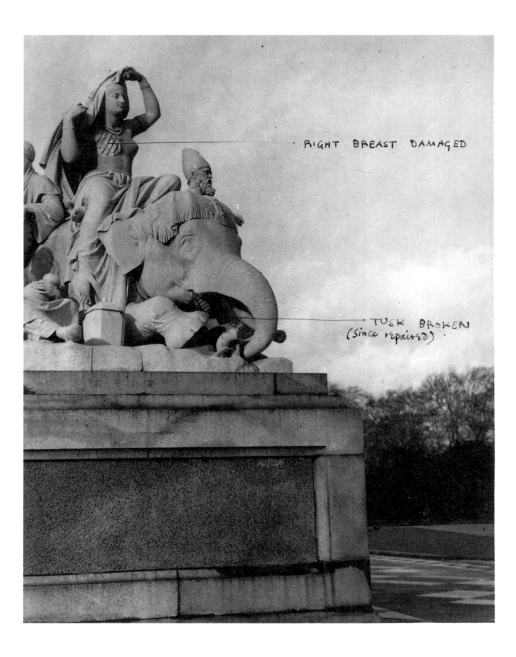

RIGHT BREAST DAMAGED

TUSK BROKEN
(Since repaired).

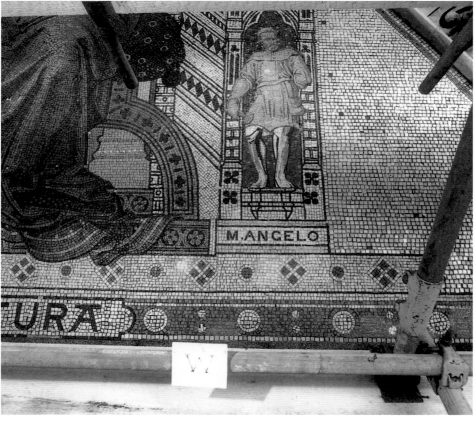

M.ANGELO

URA

In 1949 a critical letter in the *Times* suggesting removing the canopy prompted a preliminary report in August on the condition of the Memorial. Extensive cleaning was not recommended, and this was justified by the romantic argument for the appearance of pleasing antiquity, reminiscent of Mitford's comparison between the Memorial and Innsbruck back in the 1880s. 'As for the upper works, particularly where coloured,' says the report, 'these have acquired a delightfully soft quality and tone which, it is felt, would be a pity, at any rate for a time, to disturb.'[79] However, the Memorial was cleaned and minor repairs undertaken in 1951, then floodlit as part of the Ministry's celebrations for the Festival of Britain. The opportunity was taken to carry out a full survey, but owing to preparations for the coronation there was only time to effect superficial repairs at a cost of some £4,000.[80] It is perhaps indicative of the low regard in which the Memorial was held that more was not done to look after it at this time. It does, after all, commemorate the man who was principally responsible for the Great Exhibition, the centenary of which was the occasion for the Festival of Britain.

The Ministry recognised that the forthcoming work to reinstate the cross would necessitate a complete, and costly, scaffold which would provide an opportunity for a complete overhaul of the monument as part of the war damage restoration. The policy agreed in 1950 was to make good any dangerous elements and to repair any damage visible from the ground.[81] Rothwell estimated the cost in August 1953 at £9,000 including £2,000 for scaffolding, £1,500 for mosaics, and £2,000 for gilding. But the gilding, in particular, contravened the agreed scope of works in 1950; it was therefore omitted in January 1954 and the issue was not raised again.[82]

During the financial year April 1954 to March 1955 the Memorial was extensively repaired. Higgs and Hill were the successful contractors at cost price plus 7.5 per cent – this on account of the impossibility of devising accurate estimates beforehand. The total cost was almost £7,600 with the scaffolding accounting for £2,453. Minor marble repairs were carried out by a Mr Guidici including – on the podium relief – sixteen fingers, four hands, two feet and one head, while much of the lettering was recut and painted. [83] Repairs were also undertaken on the *Continents*, especially *Asia*, which had suffered the most during the war (265). The bronzes were cleaned and repaired, and extensive work was required to repair the intricate lead details. This work was a pragmatic balance between careful replication of lower visible elements such as the marble statuary, and less detailed work for the upper elements. Thus, the missing stone finial was recarved to match the others, but none of the glass jewels was replaced, the stonework being carved to imitate them, then painted to match the originals. But some of this work was of poor quality, especially the restoration of the gable mosaics of *Sculptura* (266) and *Pictura* – on which only £250 was spent – and the plating to secure parts of the internal ironwork.

265. Shrapnel damage to Foley's *Asia*,
annotated photograph of the early 1950s
(Public Record Office).

266. Mosaic repairs of 1955 to the figure of
Michelangelo in Clayton's *Sculptura*.

The principal work, and the most expensive after the scaffolding, was replacing the cross and orb, which cost a total of £1,564 10s. Again, a simplified scheme was adopted. A shorter bronze model without the lead covering and glass inserts was threaded onto a steel rod. On completion in March 1955 the work was immediately the subject of controversy, as the shorter shaft caused the orb to sit hard upon the shoulders of the upper tier of angels (267). The engineers justified this by claiming there was insufficient anchorage for a full-height cross, and this could only be remedied by dismantling more of the upper structure – at considerable extra cost. There was another change as well. Mr Parrot, the clerk of works, on his own initiative had set the cross at a right angle to its original position on the mistaken assumption that this was Scott's intended orientation.[84] This prompted hostile comment, and, as the issue had not been referred to them, the Ministry of Works administrators resorted to bluff. The reduction in height could possibly be justified on the grounds of expediency, they thought, but defending the orientation of the cross was more difficult. The surveyors cited one of Scott's drawings – subsequently published in the lavish 1873 *National Memorial* volume[85] – which shows the Memorial with a side view of Albert, but with the cross facing east-west. In fact, they misread the drawing, which is a west elevation of the Memorial, but with the cross represented in full profile for the sake of visual clarity. One of the Ministry's administrators recognised the dilemma in justifying the altered orientation: 'we can I suppose answer the complaints with the statement that we have restored the original conception of the designer, but it may be difficult to get off with this explanation in view of the other difficulty.'[86] The 'other difficulty', of course, was the deliberate alteration of the proportions of the cross and orb. When the Ministry sought to determine at what point Scott had apparently decided to change the alignment of the cross, the mistake in interpreting the elevation drawing was quickly realised – but cost precluded any remedy for what had already been done.[87]

Notwithstanding the continued practice of low-level cleaning with water, especially the marble groups of the *Continents* and *Industrial Arts* and the Parnassus frieze, in 1961 a complaint about the appearance of the Memorial by Lady Churchill to the Minister, John Hope, led to a Ministerial visit which prompted some rethinking of the way persistent stains were treated.[88] It was recorded that the Memorial was cleaned with water four times a year, although doubling this was suggested. In May 1961 the well-tried technique for cleaning stone monuments by using a fine spray and a scrub with bristle brushes[89] produced 'a slight gain' in appearance. A lime poultice was considered, but rejected, and following consultation with the Building Research Station at Watford, a trial spray on a larger scale than before was instituted. By August it was noted that '660 man hours of washing and cleaning have been carried out and a definite improvement is apparent.'[90]

The major repairs of 1954–5 should have included replacing the missing enamel shield on the south side of the plinth, but this was either never carried out or it was quickly stolen, as it is not shown on 1958 photographs. The loss was not drawn to the attention of the Ministry of Works until 1964. It was subsequently replaced by Starkie-Gardner Ltd, but the quality did not match that of Skidmore's original work.[91]

Minor vandalism continued to exercise the Ministry of Public Buildings and Works well into the 1960s: repair costs solely due to vandalism ranged from £143 to £464 between 1963 and 1968.[92] The dislocation of applied gems at high

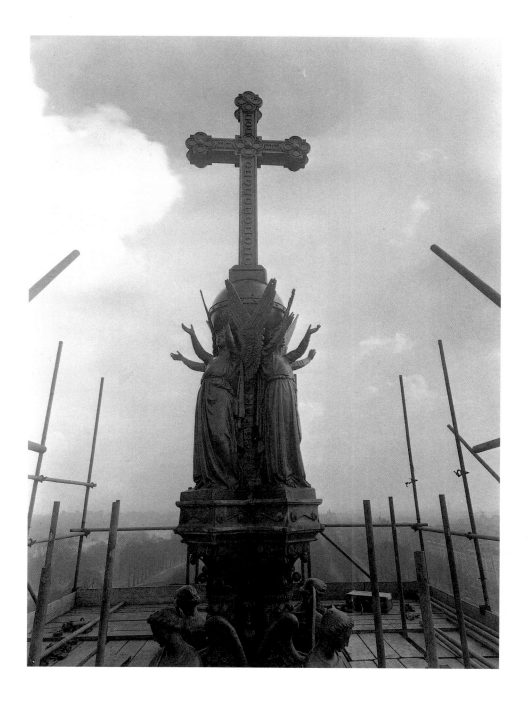

267. The summit cross and the upper angels
undergoing repair in 1955
(National Monuments Record).

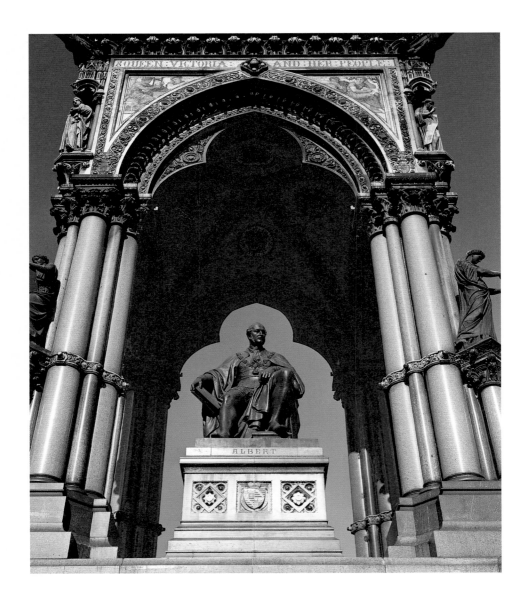

268. The Albert Memorial in a photograph of *c.* 1980.

level was blamed on 'night climbers', who particularly favoured the more secluded north face. These 'students' habitually used the cups as footholds, thus stretching the lead fittings and causing the jewels to fall out. In May 1961, for example, a banner inscribed OXFAM was hung from the cross in the early hours of the morning, and required a steeplejack to remove it.[93] A steeplejack also proved the most cost-effective means of inspecting the Memorial and carrying out minor repairs. In 1968 Sidney Larkins of W. Larkins, who regularly inspected the Memorial, counted six failing cups on one day, although his own activities may have exacerbated the problem. Larkins also identified loose copper leaves, loose studs and lead panels caused by the spalling iron substructure. He recommended a complete examination and refixing of loose elements on the grounds of public safety, which he undertook later that year for a mere £375.[94]

In the 1970s little was done beyond essential repairs. The paving was mended in 1971, as was the Parnassus frieze the following year.[95] In 1973 a binocular survey indicated areas of mosaic requiring attention and some regilding of the tesserae. *Ad hoc* repairs continued until 1983 when, in April, a large section of lead cornice fell from the canopy. Following the findings of a steeplejack inspection in August, a full scaffold was erected in 1984 by the Property Services Agency, thus beginning the process that led to the restoration completed by English Heritage in 1998.

Conclusion

It has to be admitted that Scott's aim to create 'jeweller's architecture'[96] produced a monument which could only effectively be maintained by erecting regularly a full and costly scaffold. This cost was a major disincentive: from 1872 to 1983, including the high level clean of 1892, the Memorial was only fully scaffolded five times. Regular maintenance has largely been confined to superficial and cosmetic washing. Notwithstanding the general antipathy to the Memorial for much of this century, the Office of Works and its successors have been mindful of their responsibilities to maintain the Memorial, given the limitations of the technology of the time. But it was a frequent casualty of budgetary constraints and on occasion the department was only goaded into action by a small but vociferous body of outside opinion which spoke in defence of the Memorial.

But few officials recognised that the gilding was an essential element of Scott's design: as he said himself, it imparts 'the character of *preciousness*'[97] to the whole conception, with its focus on the golden figure of Albert. Earle certainly grasped something of the gilding's aesthetic prominence, but his response was antipathetic. In seeking to make the Memorial 'less ugly' in his terms, by removing the gilding, he created a 'dull' Memorial (268). The result, since 1915, has been to dilute its significance and make its *raison d'être* less comprehensible. Now, with the 1990s repairs (269), and a renewed appreciation of Scott's masterpiece, we can take a more holistic view. In particular, the regilding of Prince Albert, partial regilding elsewhere, and meticulous cleaning, have redressed the tonal imbalance from which the Memorial has suffered for so long.

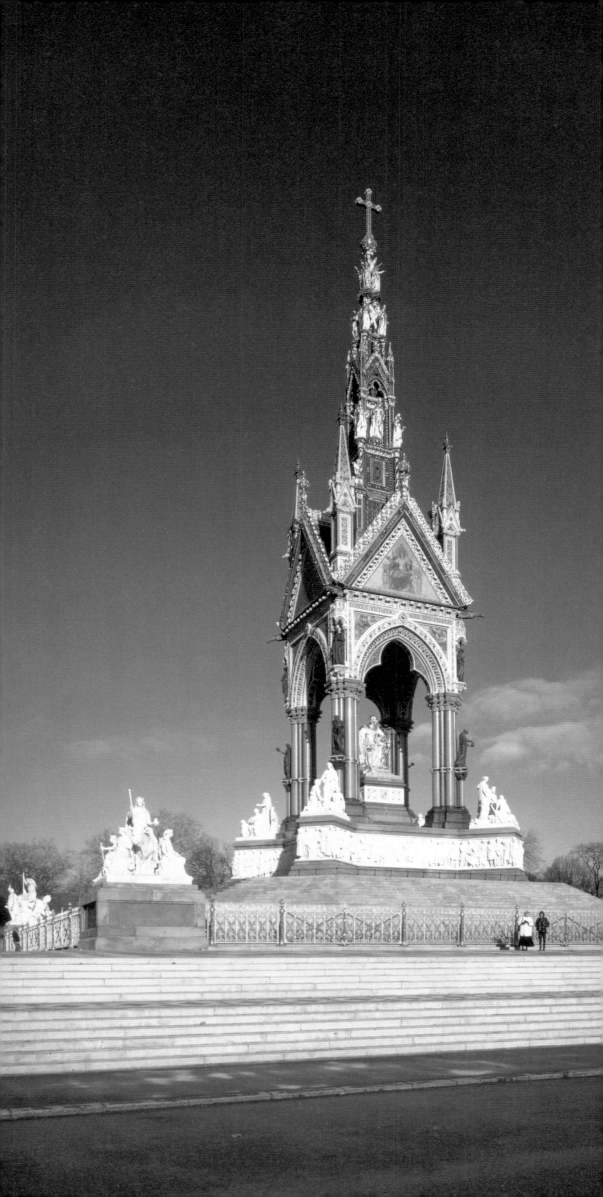

269. The Albert Memorial in 1998
after completion of repair and restoration
by English Heritage.

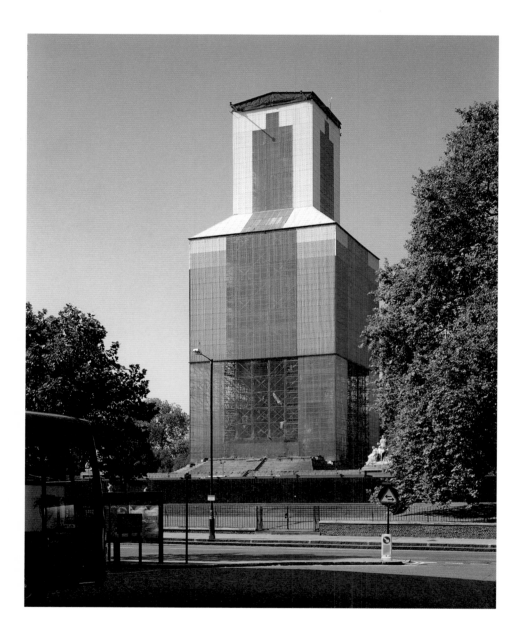

270. The Albert Memorial under the
scaffolding erected for English Heritage's
repair and restoration programme.

Chapter 11

Repair and Conservation
1983–1998

Alasdair Glass

Investigation

The history of the Albert Memorial since its erection is not – as Michael
Turner's chapter shows – a story of complete neglect. However, the difficulty of
inspecting the upper parts of the monument, let alone effecting repairs, was a
discouragement to proper maintenance. More broadly, those responsible for the
Memorial failed to tackle the consequences of inherent design faults. By the
early 1980s, just over a century since its completion, the Memorial had not only
lost much of its original, jewel-like splendour, but was also showing signs of
alarming physical deterioration. The recurrent bouts of washing and cleaning
over the years had been largely cosmetic in their effect, and had been directed,
almost exclusively, to the campanella marble of the sculpture groups and frieze.
Even here there had been little success in removing more persistent staining.
Many of the well-intentioned repairs that had been effected were comparatively
crude; some – particularly the 1954–5 replacement of the orb and cross – were
actually deleterious to the Memorial's appearance. Numerous losses to the
ornamental detail and injuries to the carving were unrepaired. Exacerbating
this attrition of the monument's character were the deliberate and ill-judged
changes to its original aesthetic – especially the removal or over-painting of
almost all the gilding. Most seriously for the survival of the Memorial, and
largely unnoticed, water penetration and the chemical reactions between
disparate metals were causing mounting physical damage to Skidmore's great
flèche.

The full-scale repair and conservation of the Memorial were triggered in
1983 by the fall of a large piece of leadwork from a gable of the main roof, which
would have killed anybody standing below. Although the inspection scaffold
erected in 1984 was too lightweight to reach the top of the flèche, the report
prepared by the late David Dunnett showed that the Memorial had serious
problems which were not confined to the leadwork but affected every aspect of
its construction. He recognised that previous attempts at repair had addressed
the symptoms rather than the causes of decay and in some cases had
aggravated them. Fears at the time that the main cross girder had no safety
factor in extreme conditions were later proved unfounded. As a precaution
against their falling, the finials were removed from the main gables and put into
store and the statues on the spire were tied back with rope.

A report by the Property Services Agency in 1986 considered a wide range
of possibilities for the future of the Memorial. In the light of the then perceived
likelihood of collapse, doing nothing was not an option. The possibilities
considered ranged through complete dismantling, the removal of the spire and

straightforward repair of the Memorial, to full restoration, with the alternative of securing it under a glass pyramid (271). A further report considered possible ways of dealing with the spire, including the idea of replacing its existing structure. Dismantling, the equivalent of a do-nothing option, would have cost several million pounds once the cost of salvaging and providing new homes for the artwork was included. Removal of the spire alone was demonstrably an act of butchery; removal of the canopy as well was not considered – perhaps because it was feared it might have been chosen.

The expense of enclosing the Memorial lay between the cost of repair and that of restoration. The glass pyramid would have looked grotesque from any distance across the park, although the proposal had the virtue of providing access for people to appreciate the quality of the upper parts of the monument. The options study was superficial and in some respects misconceived because of the difficulty of establishing the true condition of the structure, but it served the purpose of bringing ministers to the logical conclusion that the Memorial should be repaired. On 3 December 1987 the Secretary of State for the Environment, Nicholas Ridley, announced in answer to a Parliamentary Question from Patrick Cormack that 'the Government intends that the Memorial should be repaired and restored'.

The brief I proposed as Project Manager for the Property Services Agency was simple – to undertake those repairs to the Memorial which were necessary now or would be within the next sixty years, and to achieve a minimum sixty years life for all work which was done. The strategy agreed with the Department of the Environment was for an initial investigation phase to define the scope of work required and to enable detailed specifications and bills of quantities to be drawn up. This stage would also establish a budget for the project. During the investigation phase, the scaffolding was to be erected which would serve for the whole project and the site compound established. Sufficient dismantling was to be done to identify the problems and trials would be undertaken on possible treatments.

271. Model of a proposal to encase the Memorial in a glass pyramid, 1986 (National Monuments Record).

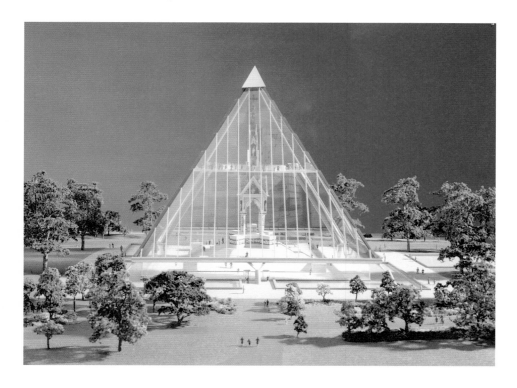

Much attention went into the design of the scaffolding, which had to be erected before the nature of the work had been determined (270). The project team was acutely aware that the scaffolding erected in 1984 had been too lightweight to reach the top of the Memorial. The scaffolding had to provide flexible working levels in a weatherproof envelope, with access for materials, equipment and people by builder's hoist. It had to be completely self supporting, not putting any additional weight onto the Memorial nor any sideways force from wind loading.

There was considerable debate on the vertical profile of the scaffolding, the stepped shape eventually adopted reducing the weight, wind loading and cost of the scaffolding as well as being more elegant and less intrusive, at the expense of greater complexity. Although structurally the break in section could have been lower down, this would have interfered with work at pinnacle level. The terrace and steps surrounding the Memorial were adequate to sustain the dead load of the scaffolding, but it was extended through the steps and tied underneath the supporting arches to resist the effect of wind loading, which could have overturned the whole structure.

The scaffolding was designed to the same standard of wind resistance as a permanent building – the anemometer on the top intended to indicate when the wind was too strong for the hoist to operate safely (40 kts) registered gusts of up to 80 kts. When the full extent of dismantling required later became apparent, the roof of the scaffolding was adapted to make it slide open in two halves, greatly speeding up the process of craning material out and back again. The bronze statues were craned off the columns and spire as the scaffolding rose to give access to their fixings. The cross and orb were removed to allow inspection of the broken top of the iron structure, but left secured to the top of the scaffolding. Two pairs of leaves were removed from Queen's Gate, the entrance to the site, and stored within the compound while protection and temporary gates were fitted. The statue of Albert had already been closely inspected to ensure that it did not need removal for attention before being trapped by the scaffolding rising around it.

The architects' report submitted in September 1991 identified three possible levels of repair: as a minimum, those works necessary to maintain structural integrity; in addition, for a proportionately small increase in cost, those works necessary to maintain or enhance aesthetic integrity and facilitate maintenance; or, at a 50 per cent increase in cost, full restoration. Given the investment already made in the investigation and scaffolding, it was easy to establish that the middle course offered the best value: structurally the Memorial would be saved, its artistic identity would be re-established, and long-term problems of maintenance would be tackled. The work was ready to go out to tender in the Autumn of 1992 when it was halted pending a review of spending by the newly created Department of National Heritage.

The delay was widely deplored, with the *Evening Standard* and the Victorian Society particularly vociferous in the campaign to get work restarted. In an article of 2 June 1993, written in advance of a Victorian Society conference on the Memorial's future, Mira Bel-Hillel of the *Standard* demanded to know 'why we are being deprived of one of London's most important landmarks'. Urging the immediate commencement of basic repairs 'to save our Albert', the article accused ministers of deliberate prevarication. 'The Government is "fully committed" to the restoration', taunted Bel-Hillel, 'Just waiting folks. As soon as "funding becomes available" '. The Victorian Society's conference the

following day, its proceedings subsequently published under the title *Save Albert* (272), was attended by historians, architects, conservationists, local residents and councillors, representatives of English Heritage, and a spokesman for the beleaguered Department of National Heritage. In its resolutions, the conference insisted that the Department 'must recognise that the Albert Memorial is of international importance, historically, culturally and aesthetically', and that its restoration 'must be made a key priority in national conservation policy'. As Chris Brooks, who was chairing, put it, 'We cannot leave London's greatest public monument hidden from its public. We must deliver Albert from limbo'. Nevertheless, the blockage on funding continued. It was only broken by the initiative of English Heritage, whose Chairman, Sir Jocelyn Stevens, announced at the end of 1993 that they were prepared to offer £1 million to begin the programme of repair and conservation.

272. The Victorian Society's publication, *Save Albert*, 1993, with a photograph of a 1987 firework display organised by the Society to draw attention to the Memorial's plight.

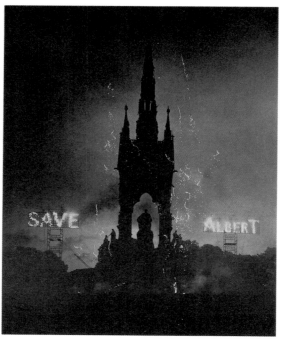

SAVE ALBERT

A Conference on the History, Present State and Future of the Albert Memorial

held at
THE ROYAL GEOGRAPHICAL SOCIETY, LONDON

on
3rd JUNE, 1993

CONFERENCE PAPERS

THE VICTORIAN SOCIETY

Repair and Conservation

It was quickly confirmed that undertaking the project as a series of small contracts spending around £1 million a year, or even less, was not practical. Instead the work was planned in two stages, with the first phase comprising all work required to the spire and canopy roof. This included all the leadwork, ironwork, bronze foliage and the sculpture on the flèche. By June 1994, with English Heritage having promised a total of £2 million and the Department of National Heritage £4 million with the prospect of a further £4 million to come, the project was well and truly launched. Enormous as these sums were, an additional £4 million was forecast as being needed to complete the whole programme: in order to raise this balance The Albert Memorial Trust was established under the patronage of HRH The Prince of Wales, the great-great-great-grandson of Prince Albert.

New project managers were appointed and the previous architect, structural engineers and quantity surveyors re-appointed. Responsibility for the management of the project was given to English Heritage on 1 July. Having been Project Manager for the investigation contract, I was a natural choice to be the Project Director. With continuity of experience and understanding maintained, work was planned to start in October with the aim of completing in June 1999.

The most important decision taken during this period was to undertake the conservation of the ornamental leadwork on-site. This required the construction and fitting out of a workshop for a dozen conservators beside the Memorial. This made it easier to control quality and take decisions quickly on the work to be done, as well as being interesting for visitors to the site. Otherwise, the pieces removed from the Memorial were usually worked on off-site, then returned to site for storage until they were required for re-erection so their condition and environment could readily be monitored.

To ensure that the project was meeting its conservation objectives and that conservation issues were fully discussed, English Heritage set up a Quality Board which met regularly during the busiest period of the work. The Board included members of the consultants' and contractors' teams and specialist English Heritage staff not directly concerned with the management of the project. The specialist sub-contractors were involved in the debate where appropriate. The Quality Board applied the basic principles of current conservation philosophy: that the amount of work done should be the minimum necessary, that as much of the existing fabric should be retained as possible, and that the processes employed should so far as possible be reversible. These principles were applied pragmatically in the light of the rather *ad hoc* construction of the spire and the poor quality of much of the work done to the Memorial since its completion.

The leadwork of the flèche and canopy is of two kinds: the highly ornamental work (273), much of which was pre-fixed to the free-standing primary elements of the ironwork prior to assembly, and simpler 'plumber's work' done *in situ*, often to architectural moulding profiles and on secondary iron formers. The ornamental work was all retained and conserved (274, 275) as described below; the plain work was retained wherever its durability and effectiveness could be guaranteed, after repair and alteration if necessary. In a few areas, like the brackets that secure the *Virtues*, the original lead has been reinstated over new lead which forms the effective weather-tight envelope.

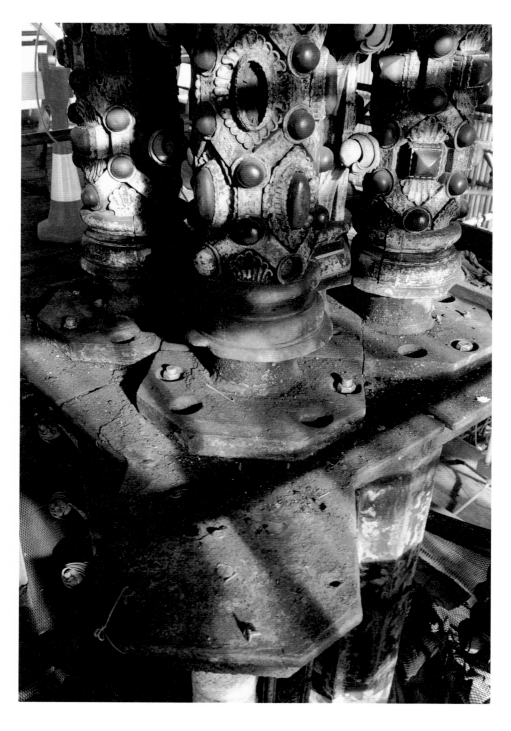

273. Split leadwork around its rusting iron core,
exposed during the dismantling of the flèche in 1995.

274. A column from the flèche being repaired
in the lead workshop.

275. Repaired and regilded finials from the
canopy gables in the workshop.

There are several different sorts of ironwork in the spire and canopy: the wrought iron main crossbeam and the structural members of the roof; the primary cast iron structural members of the canopy and spire; and the secondary cast iron formers which support the architectural leadwork. The primary cast iron members were all retained and repaired where required. The feet of the eight spandrel panels of the gables above the *Virtues* were all rotted, if iron can be described as such. We decided to cast new feet and fix them onto the retained upper part of the spandrels even though the cost was double that of casting wholly new ones. This retained the majority of the original material but presented problems when it came to matching the new feet, from a single pair of patterns, to the original spandrels, which were not cast identically. We were less fastidious about the thinner secondary iron formers which were extensively cracked and decayed. On the whole, unless they could be readily reused, they were remade rather than repaired. Less significance was also attached to the exact position of otherwise identical secondary elements. For example the retained 'top hat' cast iron sections which carry the lead capping and cresting of the main gables were grouped together rather than being reinstated in their exact original positions and interspersed with new replacements.

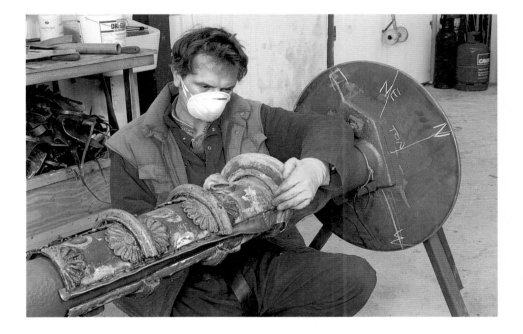

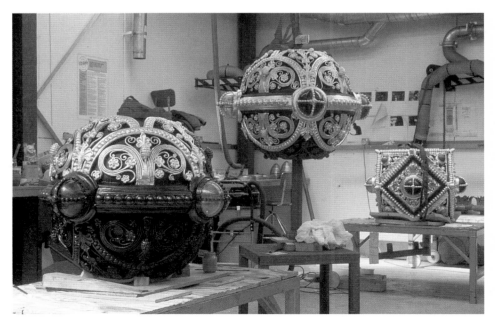

The Memorial was constructed in a continuous if somewhat extended campaign and largely in accordance with Scott's original concept. It would be easy to envisage it simply as a single period building. But it was also the product of more than a hundred years of deliberate and accidental interventions, and indeed of failures to intervene. These have a great deal to tell us about changing circumstances and perceptions of the Memorial during that period, and are as much a part of its history as its original construction or our own programme of repair and conservation.

We were anxious to retain as much as possible of the evidence of the Memorial's history of damage and repair. Thus the existing bronze cross and ball from the summit, placed there in 1955, have been retained even though the originals were lead on iron. They are perfectly respectable pieces of casting, in good condition and indefinitely durable and, as discussed below, could be made indistinguishable in detail from the original. When the original cross and orb were shot off in 1940 one of the upper tier of angels was destroyed as well. Although all four angels were originally different the new angel put back in 1955 copied the one on the opposite side of the tier. Its quality is inferior, but the difference is indistinguishable from the ground and it does not detract from the integrity of Scott's conception, so it has been retained as evidence of the history of the Memorial. In falling, the cross and orb also brought down the upper part of the north-east pinnacle. The replacement was less well carved, was left ungilded and the 'jewels' were made of blobs of coloured mortar. It is quite as durable as the other pinnacles but its gleaming white stone stood out starkly from the ground. It was retained but gilded to match the degree of survival of the original gilding lower down the pinnacle, and the mortar jewels were coloured to provide a visual match with the surviving originals when seen from the ground. The paint may fade but it can be revived.

Restoration

Defining what was 'necessary to maintain structural integrity' was relatively straightforward: deciding what was 'necessary to maintain aesthetic integrity' was inevitably more subjective. The brief was clearly not to undertake a full restoration, however much this may have been wished by some. Full restoration would have contributed little or even run counter to the objective of maintaining structural integrity since the Portland stone has eroded most at the edges of the gilding. In the worst affected areas, producing a surface suitable for regilding would have entailed completely reworking the original carved decoration. Nonetheless, some restoration was essential to re-establish the coherence of Scott's design and thus maintain, in fact enhance, the Memorial's aesthetic integrity. Most simply and obviously, the cross on the top of the spire, which was incorrectly orientated in the 1954–5 repairs, has been replaced correctly facing north-south to match the statue of Prince Albert. The 1950s replacement cross and orb, which were undecorated, have been ornamented in accordance with the original design, which is well documented (276).

276. Repaired and regilded angels with the restored summit cross and column in position.

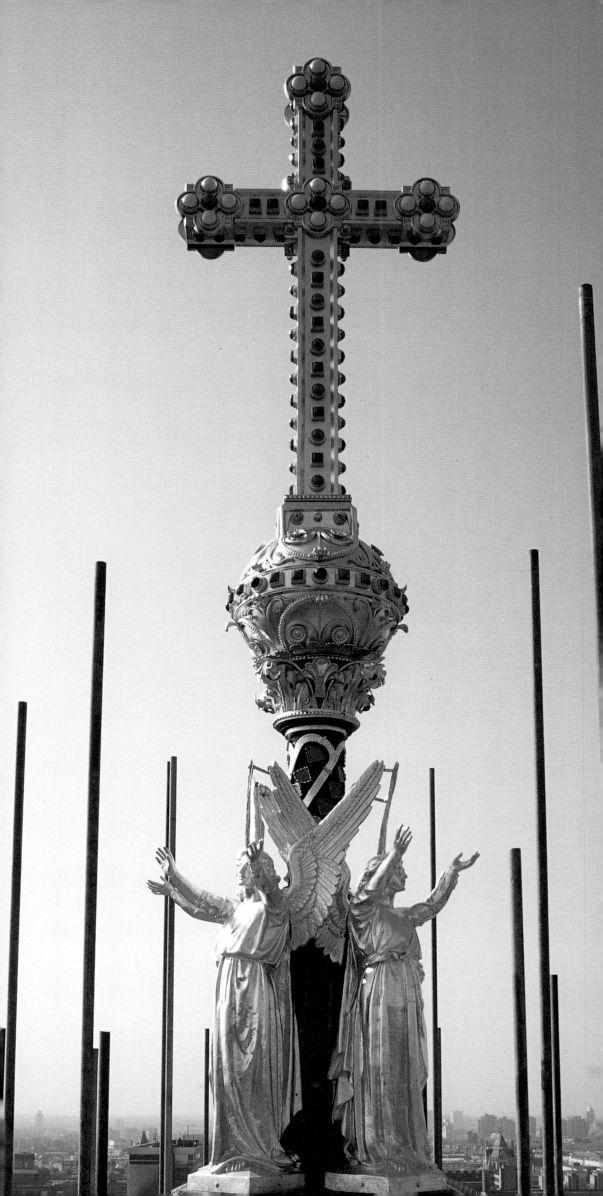

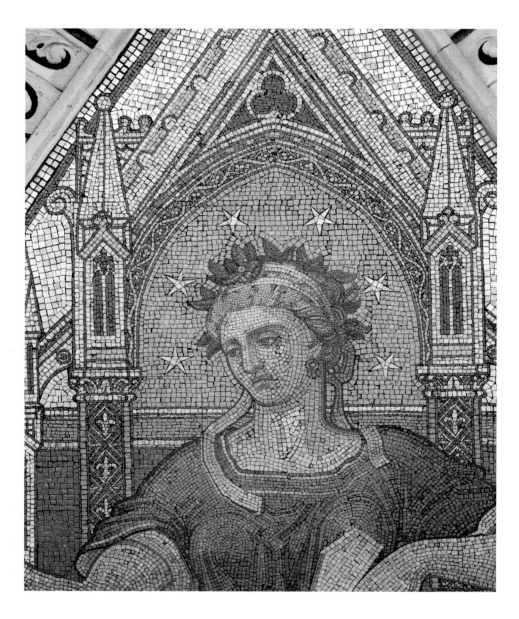

277. John Richard Clayton's *Sculptura* as restored.

The purest piece of restoration is the re-creation of the 5-feet section of column immediately below the orb, omitted when the cross and orb were replaced in 1955. As Michael Turner's researches have shown, this may have been because those responsible were concerned about the strength of the surviving lower part of the column; or it may have been simply to cut costs. Whatever the cause, the effect was to leave the orb resting immediately above the upper tier of angels, forcing their wings outwards and giving the impression not so much that their arms were raised in heavenly aspiration as that they were playing basketball. As the original design of this part of the column was known we had no reservations about recreating it in the original fashion, with a new cast iron core clad in lead and ornamented with coloured glass quadrants (276).

We were anxious to do work on areas that would not be easily accessible once the scaffolding was removed. There was, however, a counter desire to do those items which would be most visible from the ground even though they were more accessible. Another difficulty was ensuring that the balance of the high level work looked right when seen from below. The original designers had appreciated this, elongating the sculptured figures on the spire and exaggerating the shadows and highlights in the mosaics, for example.

In this context, we had little difficulty in endorsing the recommendations of the 1991 report that missing elements of the ornamental bronze leaf-work should only be replaced where necessary to the structural integrity of the element, or where their absence would be clearly visible. Eroded stone was only to be renewed if it was leading to decay of adjacent elements, or would be likely to do so. However, in order to maximise the colour on the Memorial, all missing glass jewels in visible positions were replaced and existing metal substitutes were cleaned and painted to match.

In the case of the mosaics (277), we confirmed the report's recommendation that previous repairs, even if of poor artistic quality, should be retained if otherwise sound since they were indistinguishable from the ground. This was reinforced by the difficulty expected in procuring sufficient replacement material. In the event, as the full extent of old repairs became apparent, any lingering desire to replace them was curtailed by the impossibility of removing them without damage to adjacent areas of original work. This left the mosaicists with the problem of producing high quality replacements for the few wholly lost areas which could border on both original work and poor quality repairs.

As Michael Turner described in the previous chapter, the original gold mosaic ground to the figurative work had to be replaced in the early 1900s. Subsequently some of the replacement mosaic had failed to the point where it was beginning to affect the legibility of the design, particularly of the dedicatory inscription. However there was no sure means of determining whether the decay was progressive or if all the smalti which were likely to fail had already done so. A cheap and effective repair could be made by regilding the affected smalti *in situ*, so this was done to ensure legibility in case of further failure of the gold mosaic.

The major area of debate on the extent of restoration concerned the surface finishes, particularly but not exclusively the treatment of the gilding. Colour was an equally important element in the original design. This had largely survived in the polychrome stonework, the 'jewels' of various materials, and the glass *cloisonné*. It has been revived by cleaning, as with the terrace paving, or recovered, as in the repainting of the railings in their original rich russet. The approach to the surface finishes was conditioned by an appreciation

of Scott's original intentions and how these changed in the course of construction. He clearly delighted in the natural qualities of the materials he used at the accessible levels of the Memorial, but at high level it was the visual impact that counted.

The gilding has been the most contentious area. Gilding had been deliberately removed from the bronze statues of the spire, the ornamental leaf-work and the statue of Prince Albert himself. The figure of Albert had also been treated with lanolin over the years, which had preserved the surface from corrosion at the cost of it being blackened. The rest of the bronze-work had been left to patinate naturally, producing an appearance that was not unattractive, even if different from Scott's original conception, but that also led to staining of areas below, particularly the Parnassus frieze and the *Industrial Arts*.

We readily concluded that the correct finish for the bronze foliage and sculptures of the spire, aesthetically and technically, was to regild them. The poor quality of finish of the surface of the sculptures had clearly not been meant to be left exposed. Conversely, the eight figures of the *Sciences*, which Scott had originally intended to be of marble and which we discovered to be brass rather than bronze as expected, had not been gilded but varnished to avoid detracting from the golden figure of Albert. The varnish failed rapidly and was not replaced as its glossy appearance was widely disliked. Though the *Sciences* had been untreated from an early date, we did not wish to leave them in this state, nor to gild them for the first time, as the high quality of their finish showed that it was not intended to be covered up. Instead they were cleaned and patinated, then treated with a wax coating which, as they are accessible, can be regularly maintained (278, 279).

The ornamental bronze bands around the main columns below the lower tier of *Sciences*, which conceal the joints in the column shafts, were also green before work started. The first thought was to re-gild them fully, but on consideration of the model made for the temporary Visitor Centre where they were so shown I had doubts whether this was the appropriate treatment. More careful and sceptical study of old photographs showed that only the beaded edges of the bands and the jewel bezels had been gilded originally and this is what has been reinstated (280), with the rest patinated to match the *Sciences* sculptures. The capitals of the stub columns which support the lower tier of *Sciences* were formed with bronze leaves which were also originally gilded. In the event we decided not to regild these as the sandstone capitals of the main columns were not being regilded.

More problematical was the extent of regilding required for the stonework and lead-work of the canopy and spire. We were guided in our decisions by Scott's stated intention that what he was trying to achieve was the simulation of chased and gilt silver, and the knowledge that if funds had allowed he would have used marble in place of Portland stone, and bronze in place of lead-clad iron. It was clear from the leadwork that gilding was the last operation to be conducted on the Memorial, after the statues were in place. The ungilded areas of ornamental leadwork had been deliberately blackened for contrast, in simulation of niello, as had some areas of the ornamental stone carving.

278. John Birnie Philip's *Physiology*, conserved and returned to the restored Memorial.

279. Henry Hugh Armstead's *Medicine*, conserved and returned to the restored Memorial.

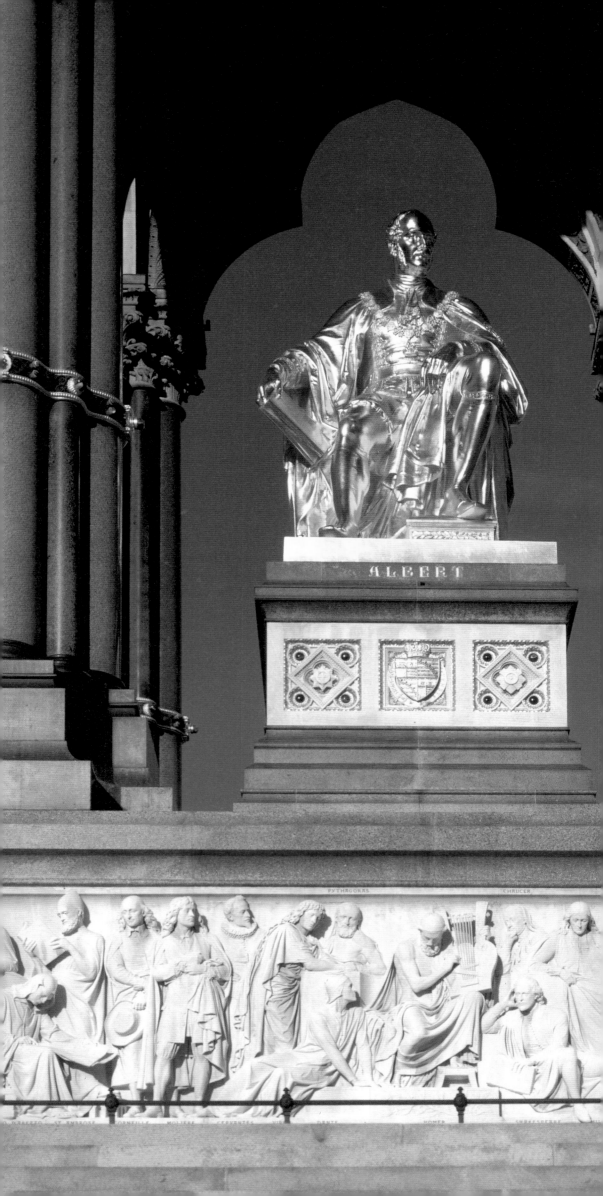

280. John Henry Foley's statue of
Prince Albert, and Henry Hugh Armstead's
Poets and Musicians frieze, as restored.

The finish on the leadwork had remained untouched since completion, except for the removal of the gilding from the beaded bands on the tiles of the main roof. The situation of the stonework was very different. Some of it had been deliberately stripped, particularly the deeply undercut foliage around the main gables and arches, and the capitals of the main columns. Other areas gave evidence of a sequence of events which could not be unravelled, gilding sometimes lying over blackening and blackening at other times over gilding. The extent to which these changes were made during the original construction or in the course of regilding – which has undoubtedly occurred in parts – could not be established. Decisions were therefore taken primarily on architectural rather than strictly historical grounds.

These decisions were conditioned by the differential loss of gilding due to variable exposure, the degree of erosion of the stone surface, and the desire to avoid reintroducing an impervious surface finish to porous stonework. We decided to touch up the surface finish where this would help define the architectural elements, enhance the coherence and legibility of the ornamental work, and reduce visual discrepancies between originally comparable areas. This was achieved on the pinnacles by selective regilding and some touching up with yellow ochre gilding size. The blackening of the foliage work around the main gables and arches was also touched up to improve legibility of the detail.

We thought it essential to give the main arches visual strength and to produce a frame for the mosaic spandrels which was consistent with the top chord formed by the inscription. The inner beak moulding around the spandrels was therefore regilded, as also was the foliage in the outer order of the main arches and in the verticals at the angles, but with the background not being reinforced. Because of fears that the main arches would look two dimensional, a trial was made of partially regilding the inner order. The result was a visual imbalance, particularly with the cusp, and if anything actually reduced the appearance of recession in the arch. The bosses at the junction of the main arches and the mosaic inscription were fully regilded for visual coherence, including the V & A monograms.

Gilding contributes nothing to the durability of lead. The discovery that the surviving gilding on the leadwork could be cleaned by pulse laser, made visible once more, then consolidated, was crucial because it allowed an approach consistent with that to the stonework. The leadwork was in principal regilded only where necessary to clarify architectural elements, or to maintain the balance with the regilded bronze foliage and statues and the gold mosaic. It was therefore largely confined to architectural mouldings, such as on the main gables, where it also helped to camouflage the new stainless steel clips holding the lead in place. Where architectural capitals had newly regilded bronze foliage, the neckings and abacuses were regilded to ensure visual coherence. So also were the outlines of cornices and impost blocks, the pedestals of the bronze lions, and the corbel brackets supporting the Christian *Virtues*.

This somewhat puritan approach to the gilding was relaxed at key points where the minimum of regilding would have the maximum visual effect. The cross and orb had already been regilded as part of their 'restoration', as had the replacement of the missing section of column below the orb. To match them, the finials of the stone pinnacles, similarly seen against the sky, and the lead-clad finials of the main gables, which had been wholly dismantled and rebuilt, were regilded. The fact that these latter finials were also the culmination of the foliage on the roof ridges and gables reinforced the decision. In order visually to

tie down the foliage on the roof ridges, the bead mouldings and rosettes on the lead cladding of the ridge were also regilded. On the spire, the upper roof gables and pinnacles were treated in keeping with the main roof and canopy. The column shafts on the corners of the flèche were given sufficient regilding to ensure they would read as shafts, and to balance the horizontal mouldings. The effect was to outline the spire with gold, which ensured that the regilded statues would be visually integral to the whole.

One difficulty experienced throughout was assessing the eventual overall effect of the gilding and cleaning when seen from below and at a distance. The approach being adopted was endorsed by two visits of English Heritage's London Advisory Committee in February and June of 1997. On the second occasion, a platform was erected at the outer edge of the scaffolding and a considerable amount of boarding temporarily removed so that the whole of the south gable, the south-west pinnacle, the canopy roof, and the base of the flèche behind could be seen together at the same time.

The pedestal of Prince Albert's statue has a band of marble panels to which were fixed five *cloisonné* enamel coats of arms. One was a very poor quality replacement, presumably of the 1950s. Another of the escutcheons had been lost, which confirmed the long-standing intention of providing a replacement of the same technical quality as the original. The shields were set into and flanked by the carved panels, completing the heraldic ensemble. These panels were regilded, as they had been originally, to enhance the legibility of the heraldry and to make the pedestal a sufficiently rich visual support for the regilded statue of Albert (280).

When it came to the campanella marble statuary – the *Continents* and *Industrial Arts* and the Parnassus frieze – we recognised the need for an approach that overtly accepted the idea of restoration. They had suffered relatively little from the effects of weather and could easily be cleaned, as described below. However, being easy to get at, the frieze and *Continents* had been damaged considerably over the years, both deliberately and accidentally. It was clear that repairs had taken place in the past, sometimes more than once, and certainly more than could have resulted from any incidental damage during the carving of the hard and brittle marble.

281. John Bell's *America*, cleaned and with missing details reinstated.

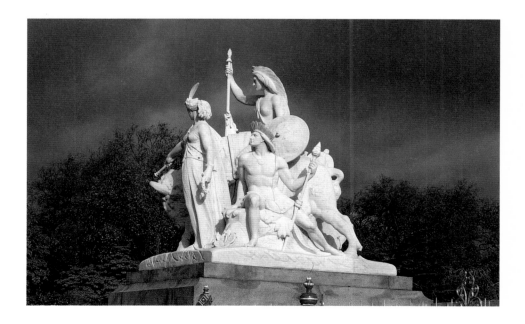

These are open air sculptures to which the public should continue to have access, and the risk of damage has to be accepted. The purpose of the marble sculpture was didactic as well as artistic. Virtually all the figures on the frieze are of named individuals, many of them readily recognisable from known portraits. We thought it would be absurd and a just cause of public complaint if, after spending millions of pounds on the Memorial, the world's artistic worthies were left with missing fingers and damaged features, especially as their original appearance is amply documented. The same considerations led to the replacement of missing symbolic attributes, weapons and other artefacts on the *Continents* groups (281). The right breast of the central figure of the *Asia* group is a modern replacement which was ill-fitting and over-sized. Rather than replace it, it was possible to rework it in situ to a satisfactory form. The somewhat less accessible *Industrial Arts* had fortunately suffered minimal damage. The approach adopted for the marble statuary was followed for the bronze. The missing spear was replaced in St George's hand on the chain of the Order of the Garter on the Prince Consort's statue. The scales carried by the figure of Justice, which at some date had been attached to her wrist, were moved so that she again held them in her hand.

The railings and gates between the *Continents* groups are very much an integral part of the Memorial, though only conceived at a late stage of its construction. Originally they were painted a russet colour, simulating bronze and complementing the Ross of Mull granite panels on the pedestals of the *Continents*. They were also originally gilded, but since 1901 had been simply painted black. It was essential to reinstate the original decorative scheme in order to restore the architectural balance between the upper-middle and lower sections of the Memorial; at the same time missing parts of the railings and gates were replaced (219).

The paving around the Memorial, though difficult to appreciate fully except from aerial photographs, is of considerable elaboration and is a major element within Scott's overall conception (128). It had suffered much over the years and had to be completely taken up and re-laid to restore the original levels

and falls. Much of the paving had been broken or lost, with replacement in different stone or even concrete. The opportunity was taken to replace the substitute materials with the original, except for Swithland slate which is no longer quarried and was impossible to secure in the quantities required. Instead we used the best matching alternative, which came from Killoran, Co. Tipperary (282).

The one visible change we made to Scott's original design for the Memorial was in the arrangement of the shin rail, which runs around the top terrace at the base of the podium. Made of cast bronze, it consisted of two rails at ankle and knee height supported by miniature standards at five foot centres. Because people have stood or sat on the rails, the upper one in particular was severely bent and distorted. It was decided to close up the spacing of the uprights by a third, with additional standards modelled on the originals: this could be done without altering the regularity of their spacing or their relationship to the paving pattern.

Other modifications to the original construction were made for equally practical reasons. The rainwater disposal was completely replaced, with gullies protected by gratings and provided with visible overflows. The main roof gullies were also each provided with two outlets, one leading to the down pipes in an adjacent corner in case of blockage. A syphonic system was used for the down pipes, allowing their size to be minimised, and trace heating was fitted to prevent freezing up in winter. It was possible to dispense with a lightning conductor on the spire by ensuring that all the metalwork was bonded together to give electrical continuity. New lightning conductors were fitted to the main pinnacles, with stainless steel air terminals and PVC covered conductors to prevent staining of the stonework.

An important part of the brief was to facilitate future maintenance. This was met in two ways: firstly by minimising the maintenance needed through the quality of design, materials and techniques; and secondly by making the maintenance that would be required as safe and easy as possible. This anticipated the Construction (Design and Management) Regulations 1993, but enabled us to introduce them into the project far more readily. The single small access hatch to the canopy roof space behind the north-west pinnacle, which was not visible from the ground, was enlarged to make access easier. Similar hatches, reached by a permanent metal grid floor on the level of the bottom flange of the main cross beam, were provided at the other corners, giving access to the rainwater disposal system. A permanent lighting installation was provided within the roof-space and accessible interior of the lower part of the spire. The areas of paving to the north, east and west of the Memorial were re-laid on permanent hard-standings to take cranes or hydraulic hoists capable of giving access for inspection, cleaning and minor repairs to the highest levels of the Memorial. On the south side a crane could stand directly on the South Carriageway but would have to reach over the flight of steps. We also specified a maintenance regime for the first thirty years after completion, with the recommendation that a light inspection scaffolding be erected to ensure that the work done now will last at least the planned sixty years.

282. The restored steps and paved landings of the Memorial.

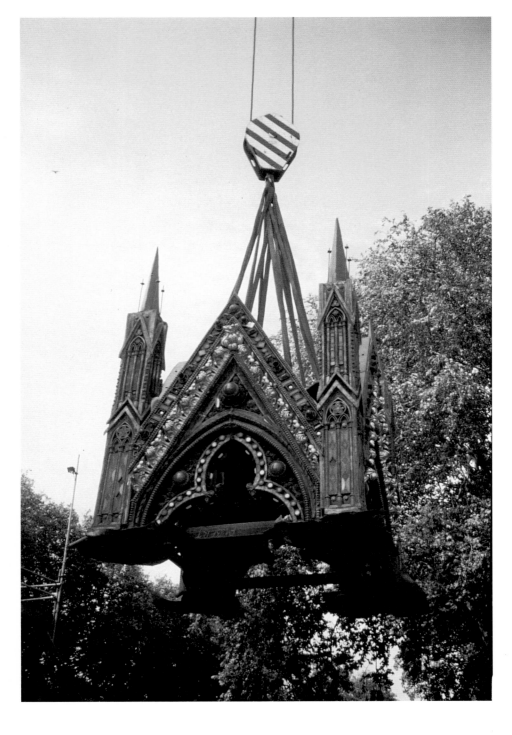

Doing the Work

English Heritage assumed responsibility for the project in July 1994 with the aim of starting work in October. Achieving this initial target was made much easier by the choice of the management form of contract which does not require all the work to be tendered before starting on site. Instead each element of work is tendered as near as possible to when it is needed. Fortunately, 31 October was a Monday and the contractors duly took possession of the site on that day.

The period between then and Christmas was largely taken up with re-establishing the site facilities, offices for the consultants and contractors, a conference room, canteen and showers for the craftsmen, and lavatory facilities for all. At the business end of things, the lower hoist – sold off when the government spending review brought the project to a halt – was replaced, and additional stores were built to contain items removed from the Memorial. The on-site lead workshop included an abrasive cleaning booth to remove the poisonous lead oxide from the back of the lead sheets, an air extract system to protect the craftsmen, and an overhead gantry system to move the heavy leadwork about, often still wrapped round its iron cores.

Work got underway in earnest in the New Year of 1995. Dismantling of the spire and canopy roof then went ahead quickly. Apart from the cracking of the lowest tier of iron columns at the corners of the spire it was relatively free of unpleasant surprises. By the summer all the bronze foliage, leadwork and removable ironwork had been taken down from the Memorial and the narrower top section of the scaffolding was empty.

As we had already realised, a first phase dealing with just the spire and canopy roof did not produce a clean break point, and enough money was available to do more work. As soon as the flèche and the roof were dismantled, we began on the stonework of the canopy, followed by the mosaics. Once the pinnacles and gables had been completed, re-erection of the canopy roof and spire began in January 1997, while work carried on down the main arches and columns. By mid-summer 1997 the canopy roof was back in place. A particular milestone was the reinstatement of the fully restored gable finials (283), which in all their glory gave a first indication of just how stunning the completed job would be. The spire was re-erected in one, virtually continuous operation in August and September. The key to this was the pre-assembly on the ground of the upper roof, located midway up the flèche, which could then be hoisted into position in a single 11.5 tonne lift, right on the limit of the mobile crane. The attempt to lift it on 5 August was abandoned because of high winds, but success was achieved in the early morning calm at 7.00 a.m. the following day (284). The cross and orb were lifted back onto the spire on 18 September, and by the end of November the refixing of the leadwork was practically complete.

Such rapid progress had been made by the autumn of 1997 that we were able to set an earlier completion date of 31 October 1998, eight months ahead of the original programme and just four years after work began. As operations at high level came to an end, major work started at the lower levels of the Memorial. This required leaving the main scaffolding in place and working within it, but allowed people to see the finished work at high level which would not again be readily visible close up for at least thirty years.

283. One of the repaired and regilded gable finials in position.

284. Hoisting the upper roof of the flèche, August 1997.

By the end of the year the statue of the Prince Consort had been cleaned and regilded (280). The removal of years of lanolin wax treatment revealed the incredibly fine detail and modelling of the statue: regilding brought it back to life (285). Cleaning the marble *Continents* also brought out their true quality and the variations in style and character of the work of the different sculptors. Revealing the figure in the marble restored three dimensional qualities which had been lost under the dirt. The cleaning of the pavings around the Memorial (282), prior to lifting them for repair, was a revelation to us all of the importance of their colour and pattern to the totality of the architectural concept.

The management form of contract for the work proved invaluable by involving English Heritage, the consultants, and the main contractor in the difficult task of selecting the specialist sub-contractors. Those tendering for the railings and gates and for the Parnassus frieze were asked to produce trial pieces for elements that had been lost and needed to be replaced. For the railings and gates this confirmed our initial thoughts on the choice of contractor. For the marble frieze trial pieces proved essential, firstly by eliminating some who thought it beneath their dignity to be asked to demonstrate their ability to meet the particular requirements of the job. Tenderers were asked to carve a hand in the style of the frieze from a piece of marble of the same kind, which was provided for them. The choice came down to two sample hands, one a beautiful piece of sculpture in its own right but in no way matching the style of the existing work, and the other less immediately attractive but a perfect match: just what had been asked for.

The final months of the work, as the completion date drew closer, ran true to type for any building project. The *Industrial Arts* and the Parnassus frieze needed more applications of poulticing to remove the copper sulphate staining than had been anticipated. Getting Killoran slate for the paving from Ireland turned into a saga comparable with Scott's difficulties in obtaining Castlewellan granite. In the workshop in Wales, the colour of the first bays of the railings to be repainted looked wrong – an impression wholly dispelled, to everybody's relief, once they were set up back at the Memorial. Reinstating the grass and paths around the Memorial was a major operation in its own right. We took the opportunity to replace the tarmac of the paths with far more attractive golden gravel, and returfed the grass to make possible the formal effect that can be achieved by close mowing. At the same time, the Memorial contractors took on the task of repairing and conserving Queen's Gates for the Royal Parks: rather than dull black, they are now a rich bronze brown, as they were when the Memorial was new.

The 1991 recommendations recognised that the project would attract a high degree of public interest. A small covered display area to be open during site working hours was proposed, explaining the work to the Memorial. From this germ grew the idea of a temporary Visitors' Centre, since not only could the Memorial itself no longer be seen but nothing could be seen of the work being done. Nor was it practical to allow extensive access to the site itself. As most visitors would come at weekends when the site was closed, the Centre needed to be manned, in which case a retail element could recover some of the cost of staffing it. The exhibition brief was expanded to include explanation of who Albert was, why he received such a memorial and why it took the form it did, as well as its subsequent history, the need for the repair programme, and reasons for the cost. A marvellous model showed the Memorial in its full glory and a video presentation showed actual work in progress. The Visitors' Centre (286)

285. The face of Prince Albert regilded.

286. A regilded angel displayed in the Visitors' Centre.

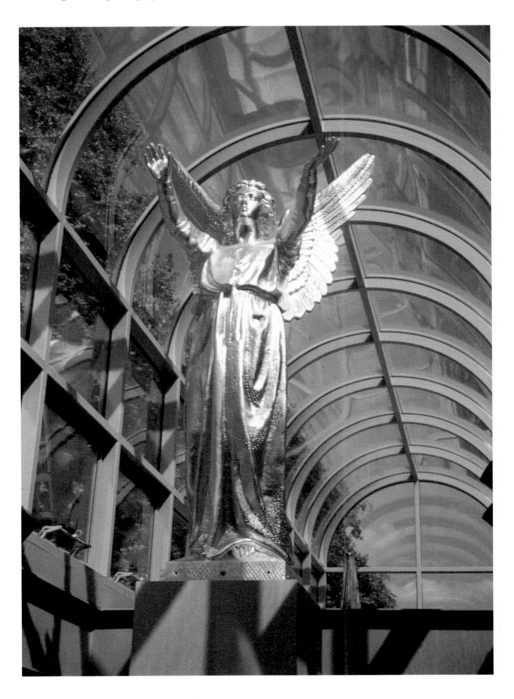

was built from the sketch designs with great speed between New Year and Easter 1995, being used in its part-finished state for the launch of the Albert Memorial Trust on 22 March. It closed to the public at Christmas 1997 having attracted over 224,000 visitors and won an NPI National Heritage Award. The building itself continued to be used for publicity and fund-raising events, and eventually for an exhibition about the proposed commemorative gardens for Diana, Princess of Wales, before it was finally dismantled in August 1998.

Plans to allow the public to go up the scaffolding of the Memorial on Civic Trust Heritage Open Days had to be dropped because of Health and Safety regulations. Nevertheless it was possible for many special interest groups to visit the site and to see the detail of the repair and conservation work in progress. These visits were at their most intensive in April and May 1998, when we were able to give the media, donors, and people who had contributed to the restoration campaign, a final chance to see the work on the upper levels of the Memorial at close quarters. By the end of June, the entire scaffolding had been dismantled.

Cost

Early estimates of the cost were inevitably speculative since so little was known of the nature and extent of work required. While the relative cost of the options was probably fairly accurate after the investigation contract, the absolute cost was still very uncertain. When English Heritage assumed the management of the project in 1994, a budget of £14million, not to be exceeded in any circumstances, was set by extrapolation from earlier estimates. This covered all contractors' and consultants' costs, including archiving, and allowed for VAT and inflation. Previously incurred costs totalling £1.7million for the investigation phase were additional.

The final cost of £11.2million was achieved by a combination of good management and good luck. All work was competitively tendered or negotiated with existing sub-contractors who had won their position by competitive tender. Tenders were let on the basis of quality and ability to deliver on programme, but were nonetheless generally let below budget. The project was fortunate in suffering less than the average rate of construction cost inflation during the post-recession, pre-millennium boom. The eight months reduction in the programme produced substantial savings. The enclosed scaffolding meant that work could continue throughout the winter and no time was lost through bad weather. The area where the work actually done was most different from that anticipated, the mosaics, resulted in savings. The area where an amount of additional work was required, the ironwork, made up a relatively small proportion of the job and was more than compensated for by savings on other aspects of the project.

I was often asked what is the relationship of the cost of the repair and conservation to the original cost of the Memorial, and what it would cost to put up today. There is no simple answer to either question. In his chapter on the building of the Memorial earlier in this book, Robert Thorne gives a total original cost of £143,645. The usefulness of this as a comparator is affected by a number of factors: Kelk contracted to do the work at cost, the relationship between material and labour costs has inverted between then and now, the Government supplied the bronze used in the construction of the Memorial without charge. Even so, as Robert Thorne points out, there were a number of far more expensive building projects in mid-Victorian London. On the other

hand, the Memorial cost nearly three and a half times as much as Scott's contemporary St Mary Abbots, nearby in Kensington Church Street, which at £43,000 was one of the most expensive Gothic Revival parish churches ever built.

All that can be said is that a full restoration of the Memorial, had it been practical, would have cost at least half as much again as the repair and conservation work which has been done. To reproduce it from scratch could cost several times as much as restoration, say £40–£50million. An indicator of the difference between building and conserving the Memorial is that while the marble sculpture – the podium frieze, the *Industrial Arts* and *Continents* – accounted for a third of the original outlay they took up only a thirtieth of the cost of repair and conservation.

The original cost of the Memorial was met by public subscription. It was therefore not unreasonable to expect that some part of the cost of its repair could again be met by a public appeal. A controversial aspect of the fund raising programme was the proposal to get sponsorship from advertising on the scaffolding and hoarding surrounding the Memorial. The resemblance of the scaffolding to a particular brand of vodka bottle was thought inappropriate for exploitation but the length of the site hoarding gave rise to ideas of wit and elegance for linear forms of transport. Proposals got as far as an application for planning permission in July 1997, but this was rejected in September on grounds of scale and height. The threshold of commercial viability was above the ceiling of acceptability.

Considerably more than a footnote to the project was the proposal developed for a permanent interpretation centre at the Memorial. Anyone who sees the brick vaults which support the upper steps and terraces (107), virtually untouched since the day they were built, feels they should be made publicly accessible. The success of the temporary Visitors' Centre confirmed the demand for a permanent provision on site of an explanation of who Albert was, why he deserved such a magnificent memorial, why it took the form it did, why it required repair and conservation and how it was done. Accordingly, we worked on the idea of constructing an exhibition space under the terrace on the south side of the Memorial, giving access to the brick-vaulted undercroft, which could be shown to visitors very much as Scott left it. Entry was to be by ramps which were detached from the terrace around the Memorial and treated as sculptural objects in the landscape.

The proposal was developed to outline design stage by David Chipperfield Architects and secured listed building clearance from Westminster City Council. An investigation trench, dug across the west end of the site, confirmed that there were no archaeological implications for the proposed scheme – there had been speculation about a Roman predecessor to Kensington Gore. Regrettably, the Undercroft Project, as it became known, did not secure the necessary support of the Heritage Lottery Fund. It was by then too late to apply to the Millennium Fund, which might otherwise have been appropriate as the Great Exhibition – so significant a part of the Memorial's commemorative programme – has been claimed as one of the inspirations for the Millennium Dome. Although the chance to provide a permanent centre for interpreting the Memorial at the same time as repairing it was thus lost, the reasons for wishing to create it remain. If the Albert Memorial is understood and appreciated it will continue to be valued and never again be allowed to fall into the state of disregard which led to it being declared a Building at Risk in 1993.

The repaired and restored Prince Consort National Memorial was reopened by Her Majesty the Queen in a twilight ceremony on 21 October 1998 (287), watched by those who had been involved in the project and large numbers of the public. At the climactic moment of the evening Sir Jocelyn Stevens, the Chairman of English Heritage, invited the Queen to unveil the carefully shrouded figure of Prince Albert: as the drapes fell away, Albert was revealed, for the first time in more than eighty years, as Scott had intended him, resplendently golden in his glittering shrine. A *son et lumière* performance, fanfares, fireworks, and the choral climax of Beethoven's Ninth Symphony provided an appropriately exuberant accompaniment, a celebration as spectacular as the Memorial itself.

287. H. M. The Queen, attended by Sir Jocelyn Stevens, reopens the restored Memorial, 21 October 1998.

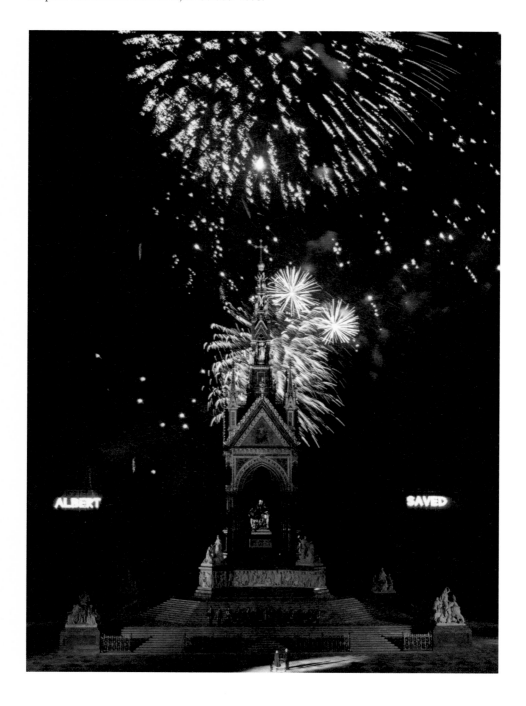

Documentation

This chapter has been written from direct knowledge of the project rather than subsequent research: it is therefore without endnotes. The administrative records of the project need to be distinguished from the conservation archive, the compilation of which is described in chapter twelve.

The whereabouts of the former Property Services Agency files have not been traced. The former Department of the Environment files do not seem to have been transferred to what was then the Department of National Heritage. However, the key documents from these are extant in English Heritage's records because of its involvement in the project from the beginning as the statutory adviser to the Secretary of State for the Environment, later for National Heritage, and latterly for Culture, Media and Sport. These files are in two series because of the transfer of this responsibility from the EH Crown Buildings and Monuments Advisory Group to the City of Westminster and West London Team.

In 1993 English Heritage also became involved in the Memorial as a Building at Risk case, and then, in effect, as a grant case, generating records in the Conservation Group series. Files were set up in the Research and Professional Services Group series in 1994 when EH became involved with the restarting of the project, initially in an advisory capacity. When EH assumed responsibility for the management of the project in 1994 the existing file series was continued. However, when the Major Projects Department was created in 1995 and took over full responsibility for the project, a new series of files was begun, continuing or replacing those of the RPS, though the advisory series that predated the transfer of the project to EH continued in use.

Afterword

I was brought up and later returned to raise a family in a street named after the Prince Consort and practically within sight of his Memorial. To have contributed over more than a decade to its rescue has been the dream of a lifetime. I have been privileged to lead a dedicated and creative team to realise the dream. From Prince Albert's death, the Memorial took fifteen years to achieve full completion with the unveiling of his statue. Redemption has taken a similar period of time, from the point when the Memorial's parlous condition could no longer be ignored to the unveiling again of the central statue restored to its original golden glory. The design and execution of the Albert Memorial was one of the great sagas of Victorian architecture. Its repair and conservation is one of the great triumphs of the conservation movement. The Memorial is not just a monument to Albert but to the age in which he lived, the last age of belief in progress for the betterment of the human condition. Let the rescue of the Albert Memorial be a symbol of hope of better things to come in future.

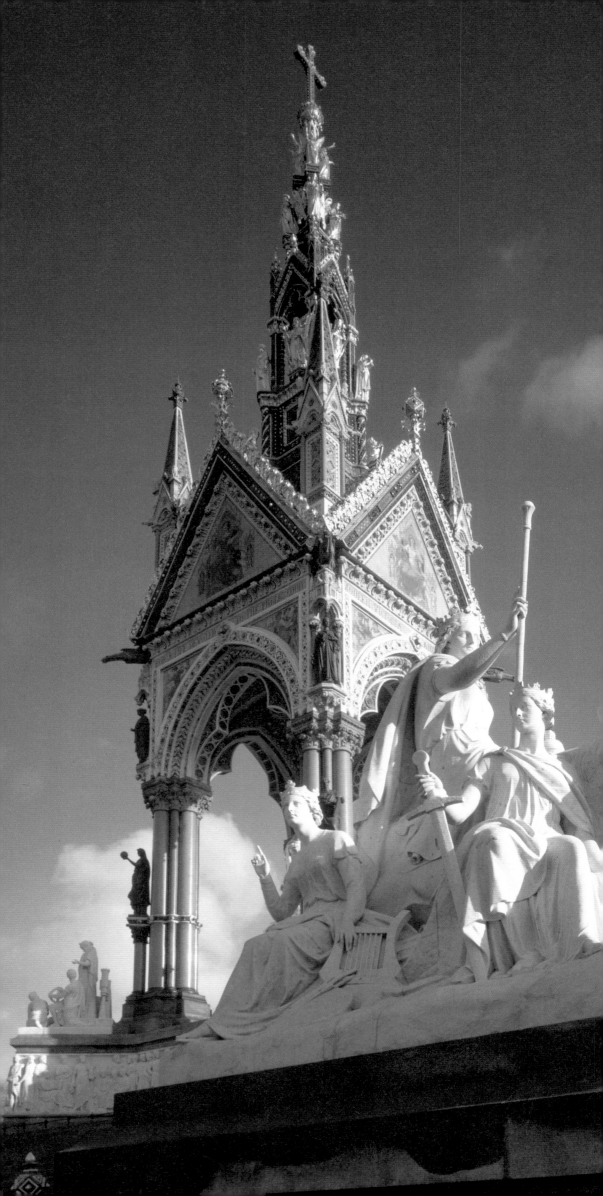

288. The Albert Memorial as restored,
with Patrick MacDowell's *Europe*
in the foreground.

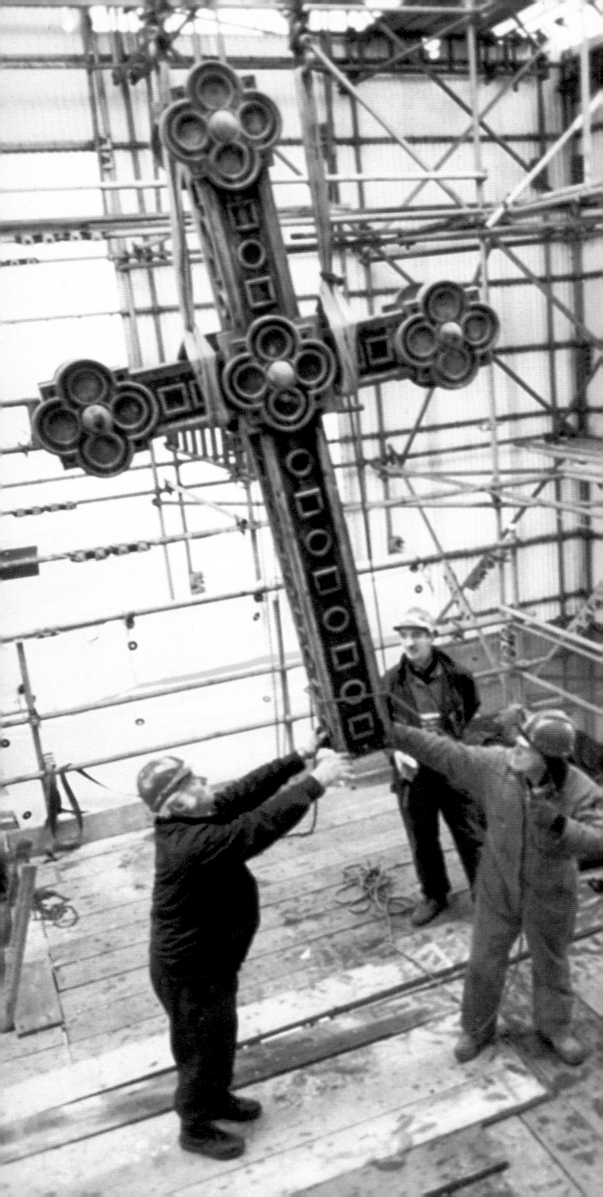

The Conservation Programme

Mike Corfield

When the Memorial was investigated in detail in 1991, specialists in the materials of which it is composed were invited to examine it and carry out trials on sample pieces to determine the best ways of treating the various components. The outcome of this work was a specification for the repairs, and it was this that was used in the tendering processes after the conservation programme started in 1994. The principles that defined the work were those of any conservation project: that there should be minimum intervention, and that as little as possible of the original material should be replaced. An additional parameter was set out in the brief from the Department of the Environment to the consultants, Purcell, Miller Tritton: the Memorial was not to require any further major intervention for sixty years. This meant that in some aspects of the work there was a greater degree of restoration of original finishes than might otherwise have been the case. Principal considerations were the need to re-establish the Memorial's aesthetic identity, to ensure it was structurally sound, and to keep future maintenance to a minimum. These frequently involved additional work in order to tackle the faults created by the original construction methods.

The conservation breaks down naturally into the main material types of the Memorial, and it was in these material-based packages that the contracts for the work were originally tendered, using a straightforward bill of quantities specification defined by the 1988 evaluation. Subsequent developments in cleaning techniques and protective systems were also taken into account, and as work proceeded alternative methods were discussed and, where appropriate, adopted on the advice of the Project Quality Assurance Board and the consultant Quantity Surveyors.

The tendering process was complicated by the sheer scale of the work and the limited numbers of specialist conservators and conservation firms able to undertake it. For some of the major material types it was possible to sub-divide the work. The stonework was let as three separate contracts: the stone pinnacles and gables, the four *Continents*, and the Parnassus frieze. Similarly, the copper alloy components of the Memorial were tendered as three main contracts, one for the *Virtues*, the angels, and the cross and orb, later extended to include the *Sciences* and the bronze bands round the granite columns; one for the foliage decoration; and one for the statue of Prince Albert himself. Smaller contracts were later given for the conservation of the five heraldic enamelled shields on each side of the plinth of the statue, and for the shin rail around the podium. Some work could not sensibly be sub-divided. The leadwork, for example, had to be dealt with by a single contractor. However, in 1994, there was only one British firm specialising in the conservation of decorative leadwork, and in order to establish a competitive tender a second firm was encouraged to

289. Removing the Memorial's summit cross, January 1995.

put together the necessary expertise. As for the mosaics, no firm in the United Kingdom at the time was capable of undertaking work on such a scale, or had the right blend of artistic and conservation skills. As we thought it was important that the country's foremost conservation project should be carried out, as far as possible, by British conservators, we invited a number of Continental specialists in mosaic conservation to seek partnerships with British firms. In the event the contract was awarded to an English consortium.

Documentation

Before any work requiring the dismantling of the Memorial could be started it was necessary to set up a documentation system that would identify the exact location of each component and enable its identification to be maintained throughout the treatment process. The task of designing and implementing this system was included in the leadwork package since these contractors would be responsible for the removal of the copper alloy decoration and the lead cladding from the ironwork. It was vital that at the end of the conservation process the lead cladding was reunited with its correct iron former, and the foliage decoration returned to its original positions, since none of these parts are standardised and each was made to fit its particular situation. In the system adopted, each component was allocated a unique bar coded identity number which was printed on durable polythene labels and attached to it. When the component was removed from the Memorial the number was entered into a database by swiping the bar code with a hand-held scanner attached to a portable computer; additional information was added to the record about the item's exact position on the Memorial, the materials it was composed of, its weight and any associated features. This could all be entered from pre-programmed bar code sheets and the conservator could add additional comments about the item's condition and any other relevant details. At the same time the component was recorded on a video camera before and during removal. At the end of each work period the hand-held computers were downloaded into a main database, and back-ups were made after each day. In this way the security of the record was maintained. The video tapes were digitised and stored as bitmaps, which were sorted in order of ascending height on the Memorial and written onto compact discs. The documentation system allowed for fast, accurate creation of basic records which could be enhanced later as conservation proceeded. The database will form part of the project archive, and to make the information more accessible it is being incorporated, along with all other records, into a spatially organised database first developed to record work on the mosaics.

Dismantling

The most complex part of the conservation was the flèche, and it had to be tackled first. Constructed of cast iron members and wrought iron spacers, bolted together and clad in decorative lead sheeting, it is embellished with gilt copper alloy foliage and supports the gilt copper statues. The lead, which should have provided protection to the iron core, had failed due to thermal expansion and contraction, and this had allowed water to reach the iron; the iron corroded, and in corroding expanded (273). As a consequence the lead was forced further from the iron, allowing in even more water. Continuing over many years, this cycle finally brought down a large piece of lead, thus starting the chain of events that resulted in the whole conservation project.

The Leadwork

Contractors: Eura Conservation Ltd.

The leadwork, which covers all structural elements above the canopy, and additionally is used in the form of tiles on the roofs of the gables, is both a protective medium and an essential part of the decoration of the Memorial. Much of the detailed ornament is cast into it, and it is part gilded and part painted in black to simulate the gold and niello that would have been used on the medieval reliquaries that were Scott's inspiration. The leadwork is richly embellished with glass jewels and cast-in foliage, scrolls, and beaded decoration; the square base of the flèche is covered with a diaper patterned with V and A monograms and the Prince Consort's crests; above this, the lead is decorated with inserts of glass in imitation of cloisonné enamel, and embossed with glass jewels (213–217). The columns are clad in lead with a spiral design, again, studded with glass jewels (208). Although considerable areas of gilding survived, it seemed initially that most had been lost to time and pollution.

Despite damage caused by thermal movement and the corrosion of the iron beneath, the lead was in a remarkably sound condition over all and generally uncorroded, though coated with a black layer of tarry concretion (290). A number of the glass jewels had been damaged or lost, but most remained in their original settings, where some covered the bolts which fixed the lead to the ironwork. Because the lead was attached by countersunk bolts screwed into holes tapped into the iron, and by soldering, it had to be cut to get it off. Moreover, in order to reach the bolts, the glass jewels had to be removed, particularly difficult as they were fixed by decayed and hardened red lead putty within copper alloy mounts, held to the surface lead by decorative lead clasps. Most of the wrought iron bolts could still be undone, though a few were so corroded that they had to be cut. All the time, great care had to be taken to avoid damaging the soft surface of the lead.

We originally planned for the leadwork conservation to be done off site, but as we prepared for tendering it became apparent that the work in this package was so extensive, and the database relating to the leadwork so important to the project as a whole, that we should build a workshop and do the work on site. Obviously, this had to be fitted out and operated to the most stringent safety standards: workers always wore face masks and protective clothing; they were given regular blood tests to check for lead content; extraction systems had to prevent lead dust and fumes from contaminating the surrounding park.

We started to dismantle the flèche early in 1995. The angels and Virtues had already been removed and were stored on site, so the first and most dramatic evidence of work starting was the craning out of the cross and orb from the very summit of the Memorial (289). The copper foliage was removed first, prior to the lead beneath. The columns which comprise the topmost structure of the flèche, and those on the corners of the box sections lower down, were taken off with their lead cladding intact, to be disassembled later. Elsewhere, cladding was removed to get to the bolts securing the iron frame, and stripped off altogether to allow the lower sections of the frame to be dismantled. The tiles covering the canopy roof were held in place by bolts, which were easy to remove. For recording purposes we treated the tiles as uniform castings rather than documenting them individually – a process that would have used up an inordinate length of time. Overall the lead was taken down with very little damage. A few of the jewels were broken because there was no other way of getting them out, so solidly were they cemented by the putty.

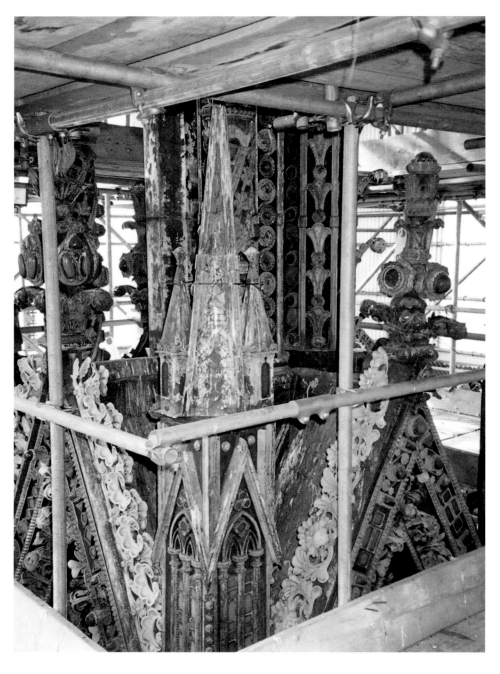

290. Pollution and decay on the upper canopy of the flèche.

291. Conservation and repair in progress in the lead workshop.

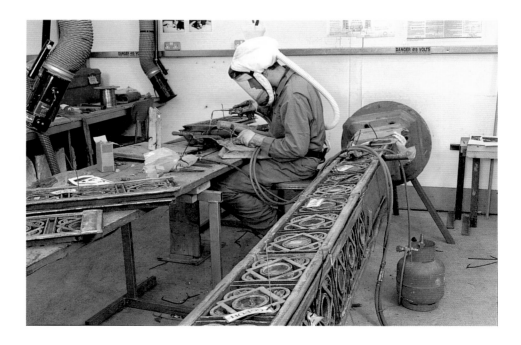

The original plans for treating the leadwork were straightforward. We intended to clean it with brushes or, if needs be, with air-blasted abrasives; to carry out repairs by soldering (291); make any expansion joints that were necessary; add extra flashing to the lead sheets to give greater protection against water penetration; and finally to clean all the existing glass jewels, replacing any that had been lost or broken. The cleaning of the jewels proved problematic. The tender had specified the use of air-blasted abrasives, but the considerable build up of pollution bound to the glass with sooty concretions would have required excessive air pressures which risked damaging the glass. Other methods were tried such as the use of hydrofluoric acid or grit impregnated abrasive rubbers, and the effects assessed under a scanning electron microscope. All methods had an impact on the glass itself, and we feared that any damage to the surfaces of the jewels would cause them to deteriorate rapidly once they were replaced on the Memorial. Newly developed laser cleaning systems seemed to offer the best way of removing the concretions on the glass (292). Lasers work by a process called ablation. The very short bursts of intense light created by the laser are sensitive to colour differences, and the black concretion is shattered as it absorbs the energy of the light hitting it. There is no damage to the substrate material, in this case the glass. Accordingly, a test was carried out using a Q switched Nd YAG 250 millijoule, 25 Hz Laserblast system manufactured in France and supplied by Hodge Clemco Ltd. The tests proved satisfactory in every respect. The glass was again examined in the scanning electron microscope and no sign of damage could be seen. An unexpected outcome of the test was the discovery that the laser also very effectively removed pollution concretions from the lead, and in so doing revealed that far more of the original gilding survived than had at first been apparent. We had assumed that most of the gilding had been removed from the lead when it was stripped from the copper alloy elements in 1915, but the extent of the surviving gold suggests that it had been very rapidly obscured by pollution after the Memorial's erection.

292. Cleaning glass jewels in the workshop using a laser.

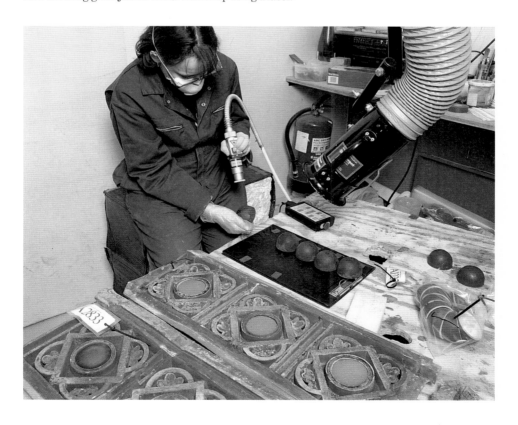

As a result of these tests we urgently reviewed the plans for the leadwork conservation. If so much of the gilding survived, and could be exposed without harming it, then we ought to reveal it. The time and costs were assessed, including the expense of consolidating what were often barely adhering flakes of gilding, and the capital outlay on equipment. Because all the leadwork would have to be cleaned with the laser if it was to be done at all, it was not cost effective to hire the equipment. Eventually we agreed to adopt the laser system and a 50 Hz model was purchased. The glass conservator was trained in its operation and a special booth built where the laser could be used safely.

The technique was outstandingly successful and represented the first use of the system for cleaning decorative lead. So sensitive was the process that even the tiniest flakes of gold, often barely adhering, were revealed without breaking their delicate bond with the lead. It offers considerable scope for future projects where fragile decorative surfaces are covered by dark corrosion or pollution. For the Memorial it enables us to get much closer to the original effect without going in for the wholesale regilding of the leadwork.

The glass jewels were originally made by the Sunderland firm of Hartley Wood, which was still in business and was commissioned to reproduce the missing ones. The jewels are coloured glass flashed onto an opaque white base, and considerable difficulty was encountered in reproducing the finish. Eventually, it was agreed that the red jewels would be made without the white base, as the difference is not detectable from ground level.

The provision of expansion joints required a careful evaluation of each piece, particularly the large diaper panels, to decide where the cuts to create the joints should be made. This was relatively easy with flat panels and simple corner joints, but inventiveness was needed to cope with the corners and sections that were more complex in their assembly. Essentially, overlaps and roll joints have been created by soldering on extensions to the components, and these underlie the adjacent component. The lead pieces have to be able to move as they expand or contract under the influence of temperature, and to accommodate this the holes through which the bolts pass have been enlarged and filled with mastic.

The Ironwork

Contractor: DGT Fabrications

Structural engineering consultant: The Morton Partnership Ltd.

The ironwork conservation was carried out at the DGT works in Foulsham, Norfolk. Prior to this the contractors were responsible for dismantling and lowering all the structural elements, taking those still clad in lead to the leadworkers' shop, and eventually getting everything into store.

Once the lead had been removed, it was possible to see the full extent of the ironwork's deterioration. Despite massive corrosion where the water penetration had been greatest, the iron generally was still sound. The condition of the bolts holding the separate components together varied: some were still good enough simply to be unbolted, while others had completely corroded to iron oxide and provided no structural strength at all. Many had to be drilled out. A few of the components had critical areas corroded to such an extent that there was no metal left; the feet of the spandrels of the upper gable were typically in this state. There were also numerous cracks that had to be found and repaired.

Before repairs could start, the ironwork first had to be cleaned down to the bare metal, so that the full extent of damage could be assessed and any cracking

identified; next, the damaged components could be repaired or replaced; blowholes left by original imperfect casting and former fixing holes filled; a high performance paint system applied; additional strengthening components fabricated; and the treated components returned to site and reassembled.

The original specification called for the use of ultra high pressure water jetting to clean the ironwork remaining on the monument, and grit blasting for the components removed from it. After the specification had been prepared a new system for cleaning became available. Spongejet© makes use of particles of urethane sponge impregnated with various abrasives; these are propelled against the component by pressurised air at between 30 and 75 psi; on impact the corrosion is removed by abrasion and trapped in the sponge. The sponge medium can be collected and recycled. The chief advantage of the system over the original specification is that it only needs a tiny amount of water, thus avoiding possible corrosion between cleaning and coating: many of the components are made from cast iron which, to a certain extent, is able to absorb water. Using Spongejet© for work on site meant that we did not have to supply and dispose of copious quantities of water, so eliminating the risk of contaminating other parts of the Memorial by waste water loaded with iron corrosion. With grit blasting there may also have been a danger from the weight of abrasive material that would have accumulated in the space above the Memorial's canopy, and there would certainly have been difficulties in getting rid of it. Clearly, Spongejet© offered significant benefits, and after some successful test cleaning the system was adopted.

Cracks were detected by using a magnetic particle inspection, in which dyes are used to reveal cracks in magnetised components. These were repaired using Metalock©, a metal stitching process. A series of holes are drilled across the crack and joined by a link bar riveted into a cut slot; studs are then inserted along the line of the crack and again riveted down. The process ensures that full structural integrity is recreated in the component.

The areas of loss, particularly to the spandrels, led to considerable discussion by the Quality Team, trying to decide between making completely new components or taking moulds of the missing area, casting new pieces, and attaching these to the surviving metal. In order to retain as much of the original structure as possible, and because of difficulties in controlling the final size of the new spandrels, we decided to follow the latter course. In theory it seemed easy to make a single mould for the heads and feet of the eight spandrels and to cast identical pieces which could then be cut to size. However, because the original pieces were not identical, possibly because they were not cast from a single pattern or because they had shrunk differently in casting, there were difficulties in bringing the new work together with the old. Eventually a satisfactory match was made for all the spandrels and the new replacements were fixed to the originals by the Metalock© process.

The voids were filled using a non-shrinking epoxy grout. The original bolt holes that fixed the lead to the iron were drilled out to the next largest size, taper tapped, then filled by screwing in a length of cast threaded rod to achieve a metal to metal lock. The old holes had to be filled because the original wrought iron bolts were replaced when the structure was reassembled by stainless steel ones which needed new holes drilled and tapped to their thread size.

After cleaning and structural repairs had been completed the components were given four 50m thick coats of Jotum red lead paint, which was then over-painted with 250m thick Denso Protal wax, a flexible layer which is, to a certain

extent, self-sealing in the event of superficial damage. These coverings will give the iron long term protection against the elements and will eliminate the risk of galvanic corrosion from the other metals in contact with it. The ironwork was then delivered back to the site. The cladding was re-affixed to the columns and the composite components were reassembled, before the Memorial's iron structure was re-erected (293).

The dismantling of the flèche had revealed some deficiencies in the original construction. Because individual elements had not been made to an exact size, as each tier of the Memorial had been built a level working surface was created by lead packing pieces placed on the tops of the iron components. This had worked reasonably satisfactorily, and as the monument was heavily over-engineered, it created no structural instability. A similar, but more carefully engineered system was adopted during re-assembly by again using a crushable lead plug to obtain a level. Once this was correct, the component was lifted and a barrier of cling film laid over the fixed surface; a non-shrinking resin grout was then laid over the cling film and the component replaced. Final tightening of the bolts was done after about thirty minutes when the resin had set.

293. Reassembling the upper box section of the flèche on the Memorial.

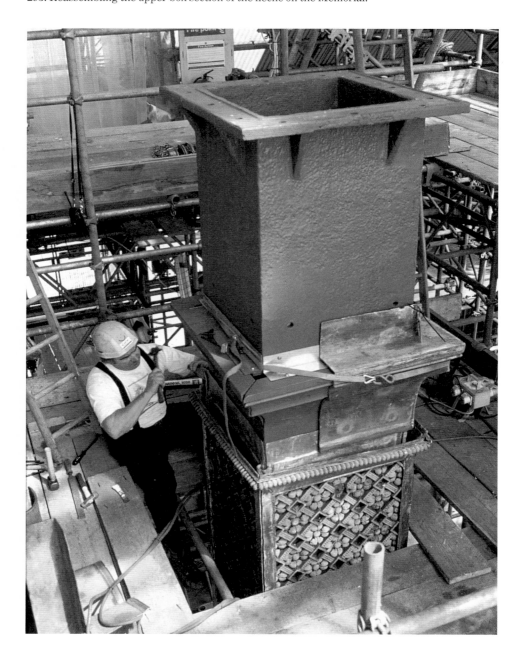

The Copper Alloy Foliage Decoration

Contractor: Dorothea Restorations Ltd.

The copper alloy foliage decorations are composite assemblages of individual acanthus leaves, scrolls and other forms. Lengths of foliage were made up by bolting individual leaves to a copper alloy strip (211), and these were mounted with bolts to the lead along the gable edges and roof ridges (209, 212). Individual leaves were bolted directly to the face of the gable of the upper canopy. Acanthus leaves decorate the pedestals of the four lions and the canopies above the Christian and moral Virtues, and individual leaves bolted to the leadwork frame the diaper panels at the lions' level and embellish the beading below the Virtues.

The copper alloy decoration had originally been protected from corrosion by its gilding. When this was removed in 1915 there was no protection against attack from the polluted atmosphere of London, and the metal corroded to the familiar pale green coloration (294). In itself, this might have been acceptable. However, because the corrosion was not a stable patina but a loosely compacted layer of copper minerals, it was readily washed from the surface of the metal and was absorbed into the stonework adjacent and below, staining it pale green. There are chemical methods for inhibiting copper corrosion, and modern lacquers which can provide a barrier to further attack, but given that conservation had to be effective for sixty years, and that the air of Kensington is still polluted, we could not be wholly confident in these methods. So it was specified that the copper alloy decoration should be regilded after application of a robust paint system.

294. Copper alloy foliage after removal from the Memorial.

The work on the foliage was carried out at the Bristol works of Dorothea Restoration Ltd. Here, the decorative components were broken down into their basic elements, and each was carefully identified to allow for accurate reconstruction. The dismantled elements had all traces of corrosion removed by the JOS abrasive method. This is a low-pressure technique in which the abrasive is carried in a water vortex, and pieces must be carefully dried after cleaning. As they are small, this was much easier to ensure than it would have been with the iron structural components. Cracks and other injuries were then repaired, and the pieces were painted with two coats of primer, two coats of primer/surfacer, and a synthetic enamel undercoat; after which they were ochre sized and gilded with 23½ carat double thickness gold leaf (295). They were then reassembled into their composite forms and returned to the site to be re-affixed to the Memorial by the leadworkers (296).

295. Regilding a cleaned and conserved length of foliage.

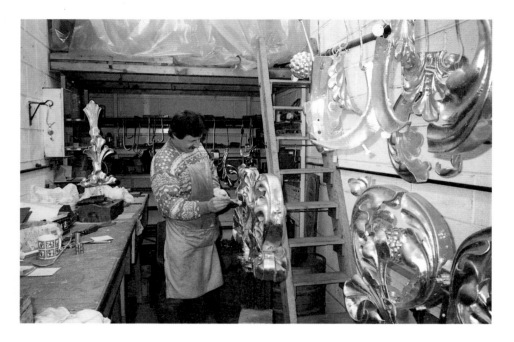

296. Refixing the foliage decoration to one of the gables.

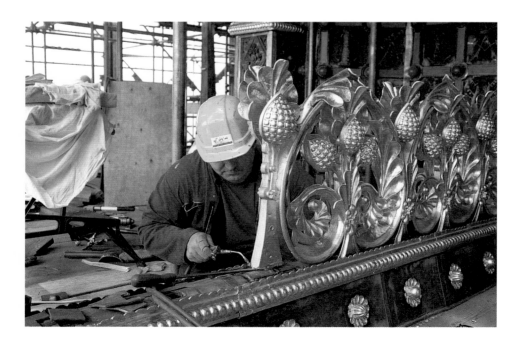

Copper Alloy Statues, Orb and Cross

Contractor: Andy Mitchell, Sculptor

The statues, orb and cross had all corroded like the copper alloy foliage (297). Although the orb and cross at the pinnacle were replacements made in 1954–5, their corrosion was similar. The fixing of the statues on the spire had been inadequate, so, as Alasdair Glass describes in the previous chapter, they were tied back with ropes during the preliminary investigations of 1984, then craned off the Memorial and put into store along with the orbs and dodecahedrons from the apices of the lower gables, which had been removed earlier.

The conservation of the statues and the orb and cross was relatively straightforward and followed the method used for the copper alloy decoration. Each piece was cleaned using the JOS system, and then painted with the same paint system used for the decoration. A coating of orange size was applied over

297. One of the copper alloy lions from the flèche boxed up for dispatch to Andy Mitchell's workshop.

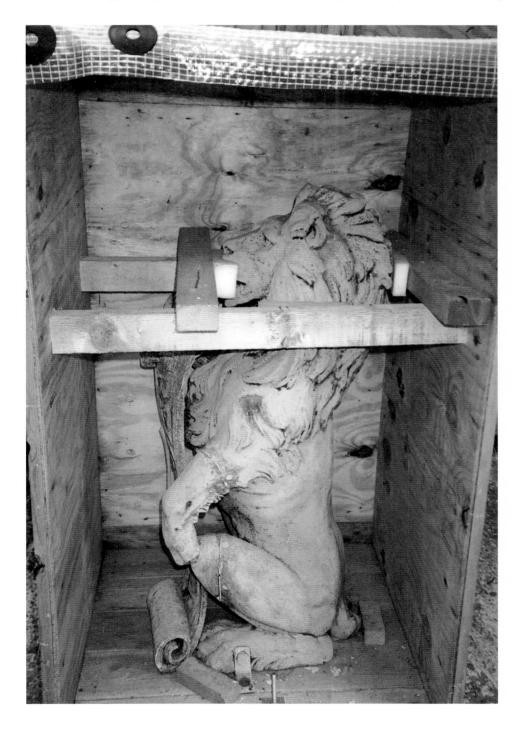

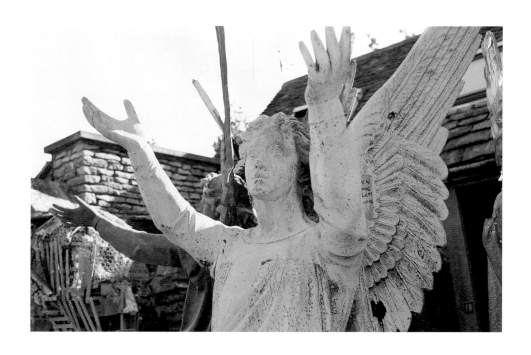

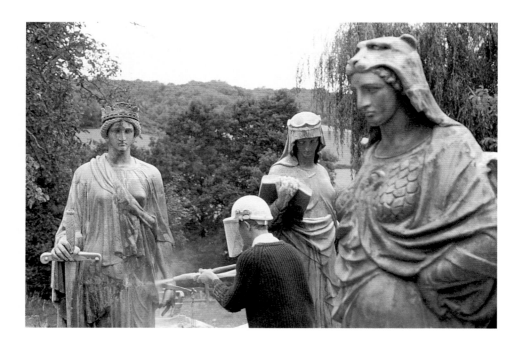

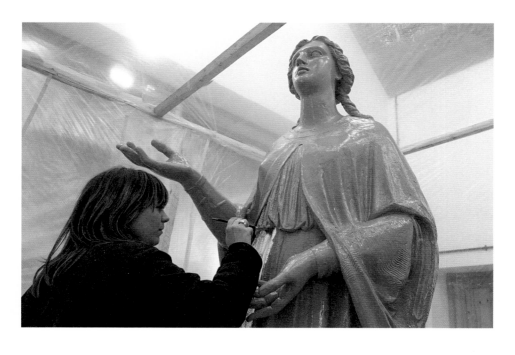

the yellow autoflex topcoat paint and the statues were gilded with a single layer of double thickness gold leaf (298–300). The cross and orb were relatively poor replicas of the originals, but their appearance could be enhanced by replacing the band at the equator of the orb and decorating both items with the correct jewels. A new band was cast and fitted at Andy Mitchell's studio near Wotton-Under-Edge. The column below the orb, omitted in 1954–5, was also cast, with a spiral strap decoration based on the original.

The fixings for the statues had been insubstantial, and an improved design was devised by Andy Mitchell. The statues were given a substantial resin cast base which distributed their load more evenly over the plinths, and new brackets were fitted behind the statues' shoulders to hold them more securely to the monument. The angels' wings were given additional security by adding a linking strap between adjacent wings to reduce the strain on the points where they were fixed to the figures, and wire mesh was fitted over the angels' open backs to prevent birds from nesting there.

The statues of the Sciences were patinated rather than gilded, as Scott had felt this blended better with the materials in the lower part of the Memorial. We encountered some difficulty with the patination, however: the chemicals used should have coloured the bronze metal a pleasing dark brown, but in places there was a distinct reddish hue. Samples were taken and analysed by x-ray diffraction; by this means we discovered that the statues were made of brass rather than bronze. With this knowledge Andy Mitchell was able to change the patination method to give the desired colour (177, 278, 279). We also found that the statues had been modelled on a substantial wrought iron mandrel or framework, and this had been left in place when they were mounted on the Memorial. Further support had been given by filling the bottom couple of feet of the statues with concrete. Andy Mitchell did not think either of these were necessary on such substantial castings, and we agreed that both should be removed.

The bronze bands that cover the join in the granite columns, and link in with the plinths of the lower tier of the Sciences, appear in some early photographs to be partly gilded, and this has been recreated. The ground of the band was patinated to a similar brown to the statues, and the beaded decoration was gilded.

298. One of John Birnie Philip's angels before repair and restoration.

299. James Redfern's *Virtues* being cleaned.

300. Putting yellow size on one of James Redfern's *Virtues* prior to regilding.

The Prince Consort

The statue of the Prince Consort had been stripped of its gilding in 1915 and at the time the project began it had a dark brown patina (268). It was in a stable condition, though with a dirty waxy finish. Infra-red analysis showed this to be a natural wax which was applied when the statue was periodically cleaned; x-ray diffraction identified gypsum and quartz embedded in the wax, which probably came from the eroding stonework. There was some anxiety about a patch of green corrosion which may have been active. X-ray florescence analysis showed the corrosion to be antlerite ($Cu_3SO_4(OH)_4$) with minor amounts of atacamite ($CuCl_2.3Cu(OH)_2$). These are typical corrosion products on copper alloys exposed to polluted atmospheres, but as they are stable there was no need for urgent conservation work on the statue.

We had a lot of discussion about whether the Prince Consort should be regilded. As noted above, the statue was stable, and it was protected from the worst of the elements by the canopy. After lengthy debate it was agreed that, as the primary focus of the Memorial, the Prince Consort would be in danger of being visually overwhelmed by the restored monument, particularly the regilded statues and foliage. It was essential that the Prince be regilded (280). Unlike the higher parts of the Memorial, the statue had received regular maintenance, so the work was straightforward, requiring only that the statue be cleaned to remove all traces of the wax coating and corrosion, then painted and sized before application of a double layer of gold leaf.

The Bronze Shin Rail

The bronze shin rail that runs around the podium is made from square section copper alloy which is fixed to the paving by cast copper alloy brackets. Over the years this rail has become distorted by people standing on it to get a better view of the Parnassus frieze. As there will be access to the Memorial inside the outer railings, we thought it would be prudent to provide more supports. A mould was made from an existing upright and replicas were cast by Andy Mitchell.

The Heraldic Shields

Contractor: Plowden and Smith

The four faces of the Prince Consort's pedestal are embellished with heraldic shields, their design engraved into copper alloy plate and enamelled. The north, east and south faces have a single shield, that to the west has two which bear the arms of Queen Victoria and Prince Albert. The three shields with heraldic quarterings are made from several pieces for each of the armorial elements, the assembled components being held in a framework secured to a backing plate. Two of the shields had been stolen early on in the Memorial's history and replaced by poor quality replicas. The others had survived well, though with some loss of enamel (301). The three original shields had to be restored, preserving their original enamel, then returned to their positions. We did not think that the two replacement shields were of sufficient quality to merit retention, so it was decided to make new ones.

The dismantled elements of the shields were cleaned using an air abrasive unit and fine aluminium oxide powder, and a corrosion inhibitor was applied. The surviving original enamel was consolidated with an acrylic solution which restored its lustre, and the areas of missing enamel were filled using epoxy resin coloured with artists' pigments to match the surviving enamel, finally a protective coat of acrylic lacquer was applied to give further protection. The

Scottish lion of the Royal coat of arms had lost almost all its original enamel so it was agreed that this should be re-enamelled. The bronze that was not enamelled was primed, sized and gilded with double thick 23½ carat gold leaf. The frames of the multi-element shields were cleaned and the shields reassembled using hard solder rather than the lead solder originally used. The frames were screwed to a new backing plate, and sealed with silicone mastic to prevent water getting behind the elements and causing corrosion.

The designs of the two new shields were engraved into 3.2 mm-thick bronze plate and enamelled. The replacement Royal Arms were made from twelve separate pieces, while the arms of Albert were made from a single plate. Some difficulty was encountered with the latter shield due to buckling and distorting during the enamelling, as the plate heated differentially and the enamel did not flow evenly over the larger areas. The completed shields were reset in their gilded mounts on the pedestal (220), the brass rods on the reverse of the backing plates being secured into the stone with epoxy putty. Finally, the edges of the shields were sealed with lime putty to prevent water penetration.

301. One of Francis Skidmore's enamel shields of arms before removal from the pedestal of Prince Albert's statue.

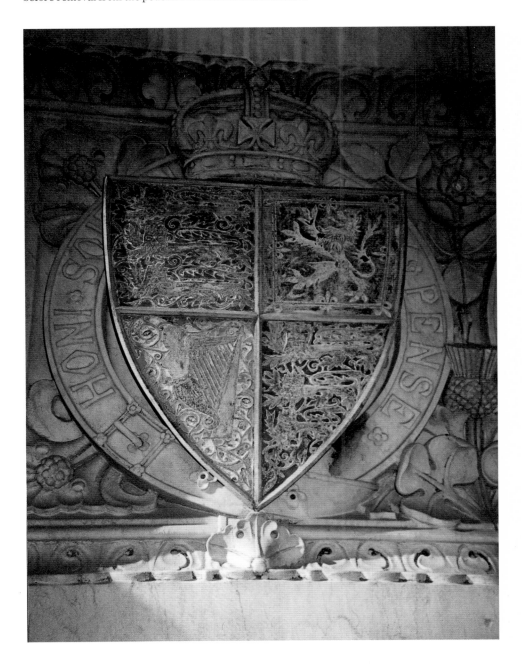

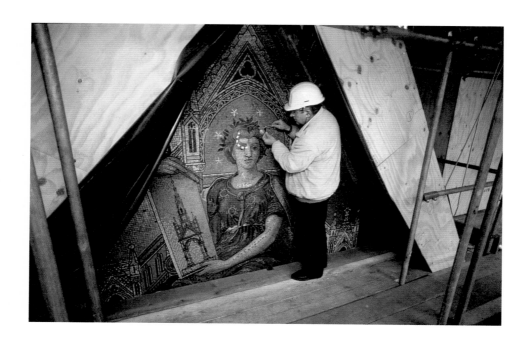

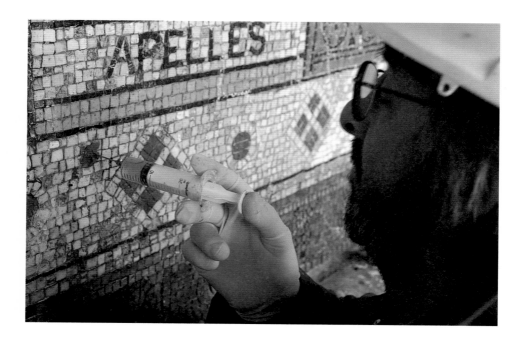

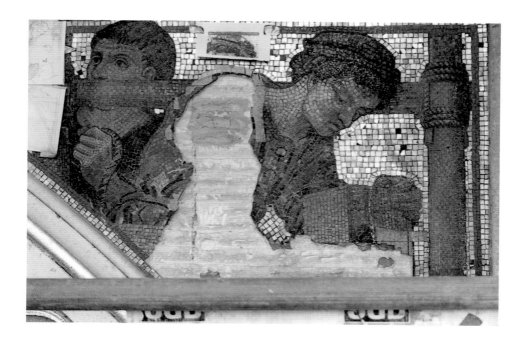

The Mosaics

Contractor: Trevor Caley Associates

Consultant: Cavaliere Giovanni Cucco

The Memorial's mosaics cover the four lower gables, the spandrels of the vault arches, and the canopy vault. As Teresa Sladen's chapter describes, they were designed by John Richard Clayton and made in Venetian glass mosaic at the Salviati workshops. The original work was of very high quality, and a huge range of colours had been used to create very subtle shading and modelling.

The original gold smalti had delaminated rapidly because Salviati had not mastered the manufacturing technique, and used inappropriate firing temperatures. Later, he perfected the process and, in 1904, the Venice and Murano Glass Company was able to supply improved gold smalti which were refired after manufacture to seal them against the effects of frost. Some of the mosaics were reset at this time and were bedded in a cement-based mortar, the original having failed due to water penetration caused by blocked sumps in the roof above. Parts of the original mosaic compositions had been lost, some of the voids had been filled with poor quality restoration – possibly in 1954 – and some had been filled with mortar.

Repair and conservation focused particularly on the bedding of the mosaics and the differential condition of the smalti. On the west gable, the grout between the smalti had been lost and water had penetrated, weakening adhesion. As for condition, the replacement gold smalti had survived well, though a few had lost their gilding, whereas some of the coloured ones – especially reds, pinks, and flesh tones – were deteriorating.

What most concerned us was how the mosaics were attached. We thought that they were bedded in a selinitic mortar, which contains sulphur compounds. When subjected to prolonged dampness such mortars are gradually changed to gypsum with considerable loss of adhesion: standing water in the canopy vault, caused by the failure of the drainpipes, seemed likely to have penetrated the stonework and reacted with the mortar. The problem was so severe that in 1991 the mosaics were covered with muslin to prevent them falling off. Analysis of the mortar seemed to support this assumption, so the specification required the removal of the mosaics, to be repaired off site, before refixing with a cementicious mortar. Preliminary attempts to take down the mosaics showed that – due to patches of Portland cement – considerable damage would result from removing them. Further mortar analysis revealed that though there was sulphate present it was confined to the layers adjacent to the tesserae, suggesting that it resulted from the mortar's calcium carbonate reacting with sulphur-based pollution. As a consequence we decided to conserve the mosaics *in situ*.

302. Giovanni Cucco testing the condition of the gable mosaics.

303. Injecting grout into voids behind the gable mosaics.

304. John Richard Clayton's spandrel mosaic showing a stonemason, with the crude replacements of 1955 removed prior to restoration.

Having made this decision, the first step was to carry out a detailed survey of the mosaics, and particularly to assess the degree of adhesion to the substrate. Giovanni Cucco, the chief mosaicist at the St Mark's Studio in Venice and a specialist in the work of Salviati, had been engaged as adviser to the team. He visited the Memorial and determined the condition of the mosaics by listening to the tone of a tuning fork tapped over the surface (302). By this means it was possible to define those areas which were strongly fixed, those which showed some signs of delamination, those with modest loss of adhesion, and those where the loss was substantial. Having identified the areas in need of attention, we needed to find the best method of reintroducing strength to the bond between the mosaics and the monument. Several lime-based formulations were considered, but we finally opted for a product made by CTS, an Italian firm, which would not only give an excellent bond but could be injected behind the detached mosaic. The grouting material was injected by a large needle through small holes made by removing a few of the smalti (303). This had to be done at numerous points on each of the voids to ensure that the space was completely filled. After the grout had set firm the area was again tapped to check that a good bond had been established with the substrate.

Some areas of poor restoration were removed (304). This had to be done very carefully to avoid damaging adjacent areas, and very fine tools were needed to cut between the closely fitting smalti. Separating the mosaic from the monument was difficult too: as has already been said, adhesion was stronger than was first thought, and we also found that on the spandrels the mosaic's stone substrate had been prepared with deep V-cuts to further improve the bond. Before removing those areas to be replaced, careful tracings were made of the entire composition, and these were used by Trevor Caley to design the new work. There was some concern about finding new stocks of smalti because the Italian factory that produced them had closed. However, the association with Giovanni Cucco was invaluable, and all the colours needed were obtained. Trevor Caley's designs were approved: replacements included giving the stonemason on the spandrel below the *Architectura* gable a beefier forearm more in keeping with the robustness of the original work, while the sculptor on the spandrel below *Sculptura* had his bench remodelled and his forearm repaired. These designs were made up in the same way they had been by Salviati. Here the skills of the mosaicist, and the full range of colours, were vital if the gauche creations of the 1950s restorations were not to be repeated. The crucial test came when the new sections were returned to the Memorial. There was very little room for tolerance, the spaces between the smalti being no more than a millimetre or two. The meticulous tracing of the spandrel compositions, and the care with which the replacement mosaic was made meant that the new pieces fitted with few problems. The results do full justice to Clayton's design and Salviati's creation (232–235).

The deteriorated smalti had to be replaced (305). This was mostly a matter of individual pieces, but some larger areas were affected. The red smalti had decayed particularly badly and substantial parts of *Architectura*'s draperies on the north gable, and those of *Poesis* on the south, were replaced. There was much discussion in the Quality Board about restoring the deteriorated gold smalti. They were scattered across the mosaics as individual pieces, and there were no major areas that had lost their gold. As removing lots of individual smalti risked damaging those adjacent, the eventual solution was to regild the affected ones.

During the course of the work the conservators came to question whether the mosaics had ever been protected by face grouting – that is, sealing the spaces between the smalti with a fine lime mortar composition. The restored mosaics have all been grouted to protect the bedding mortar from compositional changes which might lead to a recurrence of the old problems of sulphation and surface efflorescence.

In all, some 8,000 smalti in about 100 different shades went into creating the new areas of the mosaics; approximately 12,000 smalti in 200 shades were used to replace the ones that had decayed; and 4,500 gold smalti were regilded. 50 kg of injection grout were used to consolidate blown areas and 15 kg for face grouting.

305. Damaged smalti being replaced in the gable mosaics.

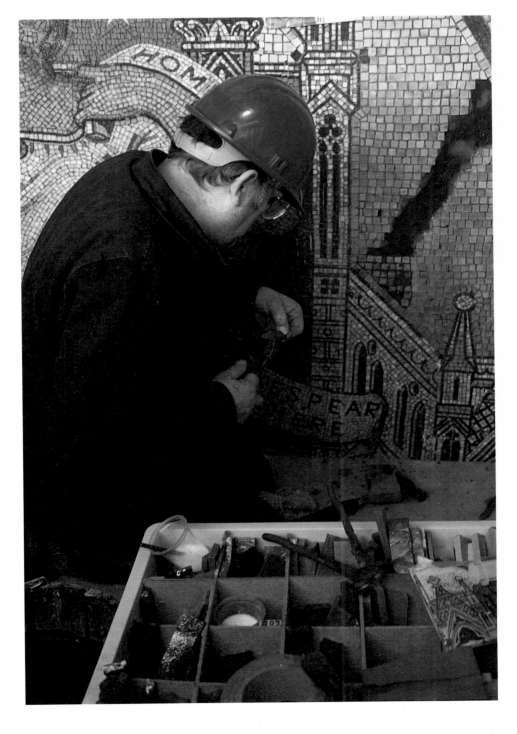

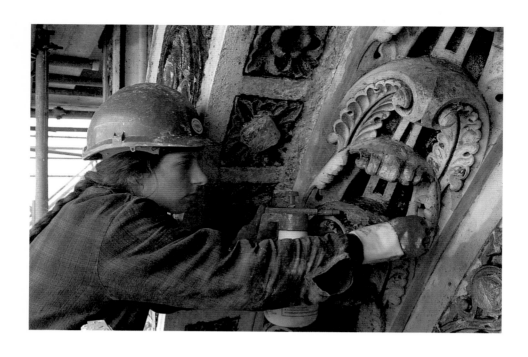

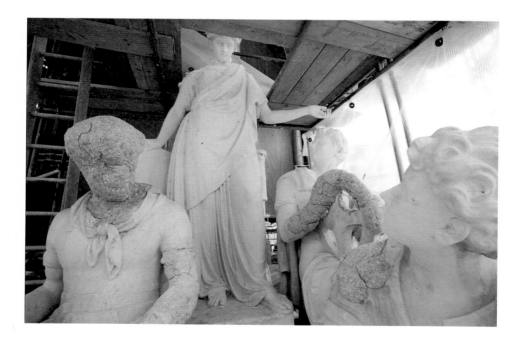

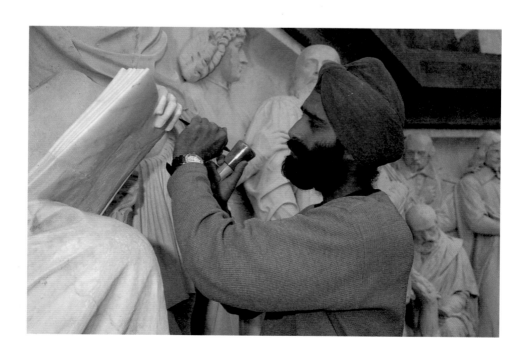

The Portland Stone

Contractor: Nimbus Conservation Ltd.

The stone pinnacles, the small canopies over the upper tier of *Sciences*, and the main canopy are in Portland stone. The pinnacles rise from the corners of the Memorial between the gables; each is square in section, gabled on all four faces, and terminates in a foliated ball finial. The plain outer edges of the pinnacles frame recessed panels filled with geometric carving, originally gilded and further enriched by jewels made from coloured foundry slag. The ochre size on the stonework and the finials survived quite extensively, and some traces of gilding remained. The slag jewels are probably the most hard-wearing of all the Memorial's materials and they are as crisp now as the day they were made, though possibly not as glossy. The north-east pinnacle was damaged in the Second World War and was partially replaced; the jewels on this pinnacle are poor replicas in painted concrete, which, in order to retain something of the Memorial's history of repair, we decided should not be replaced. Each of the pinnacles had been surmounted by a lightning conductor, any strike being conducted to earth by a substantial copper strap fixed to the stonework. Over the years the copper had corroded and the green corrosion products had permeated the adjacent stone.

The gable and cornice are deeply carved with acanthus leaves, as is the second order of the arch; the first order of the arch and the vertical is decorated with slag jewels intertwined with a running tendril, and slag jewels are again used in the third order. The stone of the gable, the arches, and the Darley Dale sandstone capitals of the columns had become very discoloured by pollution, and the canopies over the upper *Sciences* had also been stained by run off from the copper decoration on the gable.

The Portland limestone and Darley Dale sandstone were cleaned by water washing (306), and the stubborn stains removed by poulticing. The latter technique uses a paste of fine clay minerals which is mixed with water; it is applied to the stone and covered with plastic film to delay evaporation; as the poultice dries it draws the contamination from the stone, and after several days it is removed taking with it any absorbed soluble contamination. A refinement of the process, which was extensively used on the Memorial, is to add various salts to the poultice to make the contaminants more soluble; ammonia salts are particularly effective for copper salts, and the hydroxide, carbonate and chloride were used for stubborn stains.

306. Spray washing the masonry of the canopy.

307. John Lawlor's *Engineering* being cleaned by poulticing.

308. Restoring carved detail on the podium frieze.

The Campanella Marble

Contractor: Nimbus Conservation Ltd.

The *Continents*, the *Industrial Arts*, and the Parnassus frieze are all carved from campanella marble. The marble itself has survived well: there has been some weathering which has lessened the crispness of some of the carving, particularly on the more exposed *Continents*, and the stone has a more open structure as softer materials have been eroded from the surface. There was some staining of the *Continents*, and more to the *Industrial Arts*. These and the Parnassus frieze had been particularly badly affected by the run off of copper salts from the higher levels of the Memorial. Mostly, this resulted in green staining, but there was also a black tarry concretion. The grout between the sections that make up the compositions had been lost and this allowed water to enter the plinths beneath them. Some finer details of the groups had fallen victim to vandals or souvenir-hunters – such as the feathers on the head-dress of the Indians, the head of the spear in the *America* group, and odd fingers from the Parnassians.

The conservation of these compositions was broadly similar. Most of the staining was removed by the same poulticing method (307) as was used for the pinnacles; the deeper staining on the Parnassus frieze was particularly persistent, and there was some anxiety over the affect of the ammonia on the copper elements above, but eventually all the staining was removed. The tarry black material was also very stubborn, and in this case a small scale airbrasive unit needed to be used. The joints in the compositions were sealed using standard lime mortars. The replacement of the missing parts required high quality stone carving skills (308). The form of the part often had to be deduced: photographs, where they existed, were a help, but where they did not the carver had to use his artistic judgement. The missing part was first modelled in clay, then, provided the model was approved, it was carved in new campanella marble, finally being fixed to the original stone with dowels.

309. The regilded head of James Redfern's *Charity*.

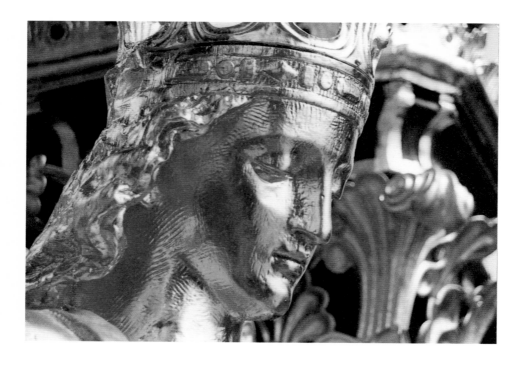

The Railings and Gates

Contractor: Paul Dennis and Son

The railings and gates enclose the Memorial (219). They are fixed to cast iron supports which are bolted to the granite steps between the plinths of the *Continents*. Each set of railings and gate is a frame enclosing six rectangular panels of scrollwork radiating from clasps. The gates are additionally reinforced by diagonal bracing. Originally the railings and gates were coloured russet with gilded finials, but have been painted black since 1901 when, in common with other coloured railings, they were blackened as a mark of respect on the death of Queen Victoria.

The conservation work was carried out at Paul Dennis's works in the Brecon Beacons National Park. First, the paint and corrosion were removed by grit blasting; this was done away from the works because the metal had been primed with red lead, and a higher level of safety precautions was more necessary than could be provided there. The cleaned panels were then returned to the works and dismantled, any small areas of paint and corrosion that had survived the grit blasting being removed by wire brushing. Corrosion was particularly bad in the crevices where the scrolls were held by the clasps, and behind the diagonal bracing, where there was considerable erosion of the metal. The fine ends of the scrolls were also in a very weak state, with deep cracks and some holes right through the metal. New terminals were shaped and welded on where necessary. Each iron component was painted with red lead primer and reassembled. The crevices in the joints were filled with putty and painted over to prevent further water damage.

Regilding

The Memorial has not been 'conserved as found', but each and every change has been carefully debated. Nowhere was this more evident than in the decision to regild. From the outset it had been agreed that, apart from the copper elements, there would be no attempt fully to regild the stone and leadwork. As the reconstruction proceeded it became evident that the newly gilded copper decoration drew the eye too strongly from the main features – rather like a frame dominating a picture. Similarly, we felt that restricting the gilding to the angels, *Virtues* (309) and lions would detract from the visual unity of the flèche, and thus from Scott's conception of a shrine like a medieval reliquary with its spire reaching heavenward. By the judicious application of gilding to the principal vertical edges of the flèche, and by gilding the main horizontals to bring together the groups of statuary at each level, we were able to re-affirm the architectural unity of the Memorial. We had a considerable debate about the gilding of the inner orders of the main arch. A sample area was regilded as a trial, and we sought the assistance of English Heritage's London Advisory Committee in judging the effect: it was agreed that the gilding added nothing to the visual strength of the arch and should not be proceeded with. We also felt that the arch of the upper gable was visually weakened by the impact of the *Virtues* below it and the gilded foliage above: to overcome this, its outer beadwork and the edge of the trilobed arch were gilded. Finally, there was concern that the finials of the pinnacles were lost among the regilded metalwork, so these too were regilded – though subsequently we removed the gilding again as the finials now contrasted too much with the lower parts of the pinnacles.

The Albert Memorial is one of Europe's greatest monuments. There can be few, if any, others that combine so many different materials and craft techniques, or that represent such a wealth of interests and activities in commemorating the life of an individual. Restoring the Memorial to its true grandeur has been one of the later twentieth century's foremost conservation projects. The teams that were brought together to do it have demonstrated the range of expertise to be found among conservators in the United Kingdom. They have used traditional skills and have learned new ones. Innovatory and sophisticated techniques, such as the use of lasers and advanced air-powered cleaning processes, have been employed alongside the craft skills of leadworkers, stone carvers and mosaicists. We have tested modern materials and incorporated them where appropriate, but have generally relied on tried and traditional ones. Most importantly, there has been no attempt to 'improve' George Gilbert Scott's creation. Provided that the Memorial is given the care it deserves there is no reason why the work done during this project should not survive for another hundred years as a fitting tribute to the craftsmen who first built it and the conservators who have applied their skills to its restoration.

EPILOGUE

Epilogue

Chris Brooks

Writing in 1952, Nikolaus Pevsner saw the Albert Memorial, then some eighty years old, as 'the epitome in many ways of High Victorian ideals and High Victorian style, rich, solid, a little pompous, a little vulgar, but full of faith and self-confidence'. He also noted that Scott regarded it 'as his "most prominent work", the outcome of his "highest and most enthusiastic efforts" ', adding that 'as such it will probably one day be recognized'.[1] Sympathetic as this judgement is at such a date, it reveals a wariness not normally associated with the great man's pronouncements. His approval is elicited less by the Memorial itself, its 'rich' and 'solid' qualities, than by the way it seems to exemplify the 'ideals', the 'faith and self-confidence', of a period that, though historically recent, he thinks of almost as a lost age. Qualifying this, perhaps as a corrective to incipient nostalgia, the artistically and morally positive qualities announced by the Memorial are simultaneously found to be just a bit pompous and vulgar. Even so, Pevsner has an uneasy sense that he is missing something; that the historical limitations of his own aesthetic prevent him from acknowledging the justice of Scott's assessment of the work, and from recognising that the Memorial, as well as being a characteristic creation, is also an outstanding one.

The ambivalence of Pevsner's response reflects something of the Memorial itself. When Scott designed it he knew that it would be not only the defining work of his career, but also one that would be in some sense definitive for judgements of the Gothic Revival itself. More dramatically, perhaps, than any other nineteenth-century architectural commission, it was a work that, while still being Scott's, needed to belong to everybody. As the National Memorial it had to fulfil the protean expectations of the public, and satisfy the heartfelt – if largely unformulated – wishes of Victoria. From the very first it was obvious that every stage and aspect of the Memorial's creation – design, construction, decoration, completion – would be subject to the widest scrutiny and criticism: from newspapers as well as professional journals; from architects, artists, and the general run of cultural pundits; from politicians worried about the cost, courtiers nervous about the Queen, and bureaucrats anxious about everything; not least, from ordinary Mr and Mrs John Bull – as Scott, self-professed man of 'the multitude',[2] must have known. While there were several precedents for combining architecture and sculpture in a commemorative work, the examples set by Nelson's Column, the *Wellington Memorial*, and the various London monuments regularly derided by *Punch*,[3] were hardly propitious. Moreover, while the brief for the Memorial's design – discussed in Benedict Read's chapter – was hazy about the relationship between architecture and statuary, it clearly envisaged a sculptural programme of unusual prominence and complexity to surround the focal representation of the Consort. To which was added, of course, Scott's own determination to display to the full gothic's versatility, its decorative richness, its capacity for symbolic and associative meaning.

310. The restored flèche reflected.

The outcome of this medley of complicated, contradictory pressures was paradoxical. Scott's task was to make the Memorial at once extraordinary and representative. Architecturally, the design had to be both superlative and exemplary – Scott at his personal best standing for the achievement of the Revival as a whole. Semantically, it needed to celebrate the qualities that made Albert the unique object of a nation's gratitude and a monarch's grief, but at the same time show him as typifying the shared values and aspirations of a whole culture and society. As a result, the Memorial became – to compress the paradox – exceptionally characteristic. And, given the diversity, expressive vigour, and individuality of High Victorian design, that formulation can be reversed: the Memorial is also characteristically exceptional. One consequence, as Gavin Stamp rightly says in chapter three, is that the Memorial is difficult to place in relation to the history of the Gothic Revival. Unique as a conception, it had no really close architectural antecedents, and no successors. Indeed, the very idea of imitating the Albert Memorial seems unthinkable. Yet its creation could have come at no period in English architecture other than the High Victorian phase of the Revival.

All the elements that made up the Memorial derived from well-established features of contemporary English gothic, but the way Scott used them, and – even more – the way in which they were combined in his design, transformed them. Two of the principal characteristics of High Victorian gothic, the exploitation of polychromatic building materials and the stylistic adoption of the medieval gothic of continental Europe, can be traced back to the late 1840s. Ruskin advocated both in *The Seven Lamps of Architecture* (1849), and at much the same time the ecclesiologists, led by Beresford Hope, stopped demanding adherence to medieval English precedents and began to urge 'development' on the Revival – the creation of a new, eclectic, manoeuvrable gothic directly responsive to the social requirements of the nineteenth century. Butterfield's dramatic use of polychromy, Street's vigorous interpretation of continental styles, the churches of men like John Loughborough Pearson (1817–1897) and William White (1825–1900), led the way. Gothic as 'developed' took on a novel aesthetic toughness that was quickly labelled 'muscularity': brawny structure, simplified geometrical forms, robust functional expression, bold patterns and strong colours. If not in the advance guard, Scott himself could use polychromy and European models to fine effect, as in that cleverly Englished version of Sainte-Chapelle, Exeter College Chapel in Oxford (1857–9). And he could do a line in muscularity too, as witness such forcefully composed churches as Edvin Loach, Herefordshire (1859) and Leafield, Oxfordshire (1860). But the Albert Memorial does something quite different with the constituents of 'development'. For all its polychromy and its Italian gothic inspiration, it eschews muscularity. Instead Scott emphasises intricacy, delicacy, the cumulative effect of intense detail – qualities that demanded the greatest craft skills, both from the people who made the Memorial in the 1860s and those who restored it in the 1990s. Rather than the geometrical abstraction characteristic of High Victorianism's linear patterns and formal massing, the Memorial is crowded with figures and its ornament derives predominantly from organic forms. Its polychromy avoids the strong contrasts favoured by Butterfield and Street: instead the colour and tonal balance – now recovered by cleaning and regilding – achieve a remarkable lightness of effect, a harmonious composition of dusky pink, pearly grey, white and gold, all vividly punctuated with red and blue. Stylistically too, the Memorial differs from other High Victorian products

of the Revival, for its eclecticism moves beyond gothic – as both Benedict Read and Teresa Sladen discuss – to encompass the classicism of Clayton's mosaic figures and the neoclassically inflected realism of the sculpture groups and podium frieze.

The uniqueness of the Memorial as an expression of gothic 'development' extends to all its components. As Peter Howell shows in chapter seven, the design and manufacture of metalwork was a central focus for revived gothic in the Victorian period: but nothing so large and ambitiously lavish as Skidmore's flèche had been conceived before, and it remains unrivalled. High Victorian polychromy inventively explored the use of tile and mosaic for mural decoration: but the Salviati and Clayton mosaics were unparalleled in their scale in modern times, not only in Britain but across Europe, and their use externally had no precedent north of the Alps. While multiple figures and sculptural groups had featured on a number of public monuments, notably Rauch's *Frederick the Great* in Berlin, nothing came close to the legion of figures Scott assembled for the Albert Memorial, nor to the intricacy of their overall arrangement. Rather, as Benedict Read suggests, Scott seems to have drawn inspiration from an eclectic range of analogous conceptions: the tiers of statues on the west fronts of English cathedrals such as Exeter, Wells, Salisbury and Lichfield; the portal sculpture on the cathedrals of northern France; the Parthenon frieze, that most iconic of Victorian cultural favourites; and, of course, the figures that populate the medieval reliquaries he cited as his inspiration for the Memorial as a whole. Similar sources probably underlay the Memorial's iconographic programme, perhaps backed by such pictorial schemes as Delaroche's *Hemicycle* in Paris, and symbolism generally had been a leading concern for English gothicists since Pugin's writings had galvanised the Revival in the 1830s. But, again, as Colin Cunningham's chapter reveals in detail, there is nothing to compare with the scope and complexity of the Memorial's iconography – its synthesis of allegory and realism, its thematic integration, its fusion of the secular and the religious, its internationalism. Here indeed, as Scott said, is 'the real life and soul of the Memorial'.[4]

If a key part of the Albert Memorial's uniqueness lies in the way it outdoes any sources or precedents, then that uniqueness is also what makes the Memorial – to revisit my earlier paradoxes – most characteristic of High Victorian gothic. For the High Victorian phase of the Revival is perhaps the most ardently individualistic of any period in British architectural history. In the 1860s and early 1870s, while the Memorial rose in Hyde Park, gothic architects were producing buildings of exceptional originality: Butterfield's churches of St Alban, Holborn (1859–62) and All Saints, Babbacombe, Devon (1865–74), and the great ranges of Keble College, Oxford (from 1867); Street's St Mary Magdalene's, Paddington (1867–73), and the first of the restlessly inventive churches he designed for the Tatton Sykes estate in Yorkshire; the mighty East End citadels of St Chad and St Columba (both 1868–9) designed by James Brooks (1825–1901); Burges's Cork Cathedral (from 1863), and his Yorkshire churches at Studley Royal and Skelton-on-Usk (both from 1871); Barclay Church, Edinburgh (1862–4) by Frederick Thomas Pilkington (1832–98); Alfred Waterhouse's Manchester Town Hall (from 1868); Pearson's church of St Augustine, Kilburn (from 1870). And many more, not least the tireless Scott's own designs for Glasgow University (from 1867) and for the Midland Grand Hotel at London's St Pancras (from 1868). Unmistakably, these buildings share not only a stylistic manner, but a cognate aesthetic drive, a

vibrant inventiveness and expressiveness, an intensity. Yet they are all distinct, one from the other, each utterly personal to the architect who designed it. So too the Albert Memorial, as uniquely characteristic as it is characteristically unique.

For all that, recognising the Memorial as an articulation of Scott's personal manner brings paradoxes of its own. The Memorial was not Scott's alone, not only in the ways already suggested but also in terms of the creative process that actually produced it. He was answerable to the Executive Committee, where Eastlake and, later, Layard bustled energetically; Kelk kept a jealous hold on the building work; Prince Albert's statue, the focal object of the entire

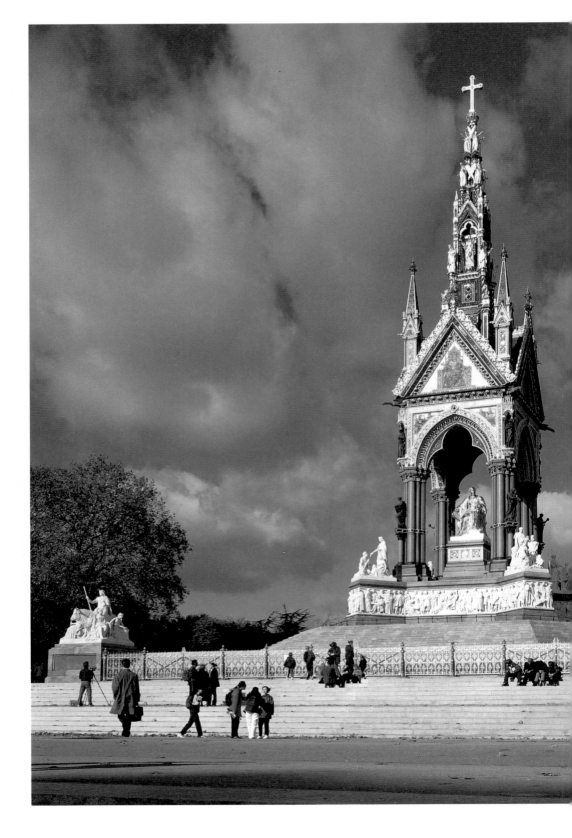

ensemble, was in the wilful hands of Marochetti, commissioned by Victoria herself; the sculptors of the statuary groups, appointed by the Queen on the advice of Eastlake and the Committee, demanded and were accorded considerable autonomy; and to realise the Memorial's central structure Scott depended on a posse of artisans and artists, from the quarrymen of chaotic Castlewellan, to the erratic Skidmore in Coventry, to the indigent Salviati in Venice. To offset all of which, Victoria confirmed via Phipps in May 1863 that Scott was to have 'full control over the works'.[5] It is a mark of Scott's ability, his genius even, that he was able to see 'the works' simultaneously as his own creation and as a great collaborative project bringing together the skills of

311. The Albert Memorial
after repair and restoration, 1998.

architect, builder, designer, craftsman, and sculptor. Scott was to be, in his own phrase, 'a bond of union'[6] between the different arts and artists involved. Perhaps no other gothic revivalist could have fulfilled the role: Butterfield and Street, for example, were notorious for exercising autocratic control over the smallest detail of their buildings. Moreover, the Memorial's very conception made such a role not only practically essential but also emblematically resonant, for the monument celebrates an inspirational alliance of the arts and sciences with the processes of material production, an alliance exemplified by the Great Exhibition in which Albert himself had been the 'bond of union'.

Despite the dictatorial impulses of some leading gothicists, the concept of a creative union between the arts, with the architect as co-ordinator, was central to the ideals of the Revival. Pugin had dreamed of a world made whole again by the agency of the gothic arts; in the concord of architecture, painting, and sculpture he saw in medieval Venice, Ruskin had found a model for all human economy; in his utopian romance, *News from Nowhere* (1891), William Morris was to imagine an England literally rebuilt from the co-operative crafts of its people. Before the Albert Memorial competition, Scott had already realised something of this collaborative aesthetic – and ethic – in his cathedral restorations, particularly Lichfield (from 1855), which he virtually recreated. Of the team Scott assembled to make the central part of the Memorial, Skidmore, Brindley, and Birnie Philip had all worked with him at Lichfield in the 1850s and early 1860s; Armstead did a little later, and the cathedral has much glass by Clayton and Bell. Philip and Brindley had been with Scott earlier at Ely (from 1849). Redfern sculpted the west front figures for Scott's restoration of Salisbury (from 1861), where Skidmore made the screen, Clayton and Bell restored the vault paintings, and the structural ironwork for the spire was devised by Francis Sheilds, whose vital contribution to the Memorial is described by Robert Thorne in chapter four. In various combinations, the same names recur throughout Scott's cathedral work, and indeed in the larger of his church commissions.

It was Scott's model of collaborative cultural production, with himself as the 'bond of union', that made the Albert Memorial possible. A practical response to the promptings of gothic's visionaries, it was also – before the Arts and Crafts Movement – the principal British manifestation of an ideological impetus in the Revival internationally. Particularly, and – given Albert's involvement – most appropriately, in Germany, where Auguste Reichensperger urged that revived gothic be disseminated through the re-establishment of *Bauhütten*, building lodges, attached to cathedrals as in medieval times.[7] The *Bauhütten*, based on the one Reichensperger helped create in the 1840s for the completion of Cologne Cathedral, would be both schools and construction sites, where architects and craftsmen would work and learn together. In the context of German re-unification, Reichensperger saw the strong regional identities of the lodges as vital cultural counters to the centralising ambitions of Prussia. Although this political goal was never realised, the *Bauhütten* ideal was highly influential, particularly in Austro-Hungary. Reichensperger had championed Scott's design for the Hamburg Nicholaikirche in 1845, and after his first visit to England in the following year the two men became close friends. Scott's practice certainly influenced Reichensperger's theories. In return, we can see the *Bauhütten* ideal shaping Scott's enthusiasm for architectural and artistic collaboration, and thus helping to shape the Albert Memorial itself.

The Memorial's embodiment of integrated art, craft, and architecture, both as product and practice, relates it to Reichensperger's building lodges. But its purpose is obviously different from that of the churches and cathedrals that came out of the *Bauhütten*. So too the way in which its artistic synthesis subserves an intricate and highly particular programme of symbolic meaning: the semantics of a great collaborative creation like Cologne derive from the established conventions of Christian iconography; those of the Albert Memorial, for all their religious inflection, are unique to it, devised by Scott and elaborated by the many executants involved. If we follow Gavin Stamp's suggestion, however, and think of the Memorial as a *gesammtkunstwerk* – a total art-work – then there are analogies with certain other gothic or medievalising works of the period. The medieval château of Pierrefonds, thunderously recreated from 1862 by Viollet-le-Duc for Napoleon III, has a co-ordinated interior iconography – only part complete – that promotes the values of feudalism, chivalry, and dynastic inheritance. At Schloss Neuschwanstein (from 1868), perched dizzily in the Bavarian Alps, Ludwig II and the theatre designer Christian Jank devised a myth-spinning ensemble that merged Wagnerian narrative with the cult of absolute monarchy. Perhaps more astonishing than these even is the semantic programme William Burges conjured for the Marquis of Bute at Cardiff Castle (from 1869): incredible room after room, brilliantly coloured and gilded, with carvings and murals representing the seasons, the labours of the months, medieval legends, Greek and Norse myths, the zodiac, and even the organisation of the Cosmos. In their fusion of architecture, art, and iconography these works have clear affinities with the Albert Memorial. Yet with all three – Pierrefonds, Neuschwanstein, Cardiff Castle – there is a crucial difference, for they have the uncanny perfection of realised fantasy, their interiority is essentially private, and their primary address was to an audience of one. In striking contrast, the Memorial is public and participatory, and its audience is everybody.

Which returns us to the issues I raised at the start of this epilogue: the way in which the Memorial is both the conception of one man and the creation – physically and semantically – of many, and the way in which, by commemorating one man it celebrates a whole culture. Essentially dynamic, such issues spring from the very nature of the relationship between the self and society as it was formulated, debated, agonised over by the Victorians – and, of course, still is. Implicitly the Memorial proposes a mode of reconciliation, a means whereby self and society confirm one another: it is Scott's creative vision that grants coherence to the extraordinary social diversity imaged by the Memorial; it is the creative participation of Scott's audience, ourselves as well as his contemporaries, in reading, conceptually constructing, the Memorial that grants validity to the vision. Movingly, we can see the whole semantic transaction as mirroring Prince Albert's struggle to shape a place and identity for himself by working to shape the society of his adopted country. His Memorial is made of such tensions, such conflicts and resolutions. Personal and populist, individualistic and collaborative, idealising and intensely material, worldly and religious, not least medievalist and modern, it builds triumphantly on paradox. Scott was right in his assessment of the Albert Memorial's pivotal importance, for it is at once his climactic achievement and one of the defining statements of High Victorian gothic.

Project Credits

It is not possible to give full credit to all the individuals and organisations who have contributed to the success of the project from its earliest days but the following are proud to represent their colleagues.

Investigation Contract

Department of the Environment
Project Sponsor Jerry Rendell

Project Management
Property Services Agency DOE
 Director and Project Manager Alasdair Glass
 Assistant Project Manager Hedley Pavett

Architects

Purcell Miller and Tritton
 Partner in Charge Corinne Bennett
 Project Architect Duncan Wilson

Structural Engineering

Brian Morton and Partners
 Partner in Charge Brian Morton
 Structural Engineer Rik Fox

Quantity Surveying

Wilson Colbeck and Partners
 Partner in Charge Derek Slatter
 Quantity Surveyor Janet Brown

Main Contractor

James Longley and Co. Ltd
 Site Manager John Eggleton

Scaffolding

Scaffolding Great Britain PLC

Repair and Conservation Contract

English Heritage

Director Oliver Pearcey/Bob Tranter
 Project Director Alasdair Glass
 Head of Conservation Mike Corfield
 Project Assurance Richard Whittaker
 Quality Assurance Paul Velluet
 Public Affairs Debra Isaac
 Appeals Unit Kieran Kettleton
 Appeal Nigel Talbot-Rice

Project Management and Design

Osprey Project Management Ltd
 Director James Reid
 Project Manager Kieran McStravick
 Planning Supervisor Laurie Perry / Kieran McStravick
Peter Inskip and Peter Jenkins Architects
 Partner in Charge Peter Inskip
 Project Architect Duncan Wilson
The Morton Partnership, Structural Engineers
 Partner in Charge Brian Morton
 Structural Engineer Rik Fox

Quantity Surveying

Wilson Colbeck / Dearle and Henderson Consulting
 Partner in Charge Ross Sinclair
 Quantity Surveyor Janet Brown

Management Contractor

John Mowlem Construction PLC
 Site Manager Colin Russell / Brian Bowen
 Technical Assistant John Ganderton
 Surveyor Ray Levy

Architectural Lighting

Lighting Design Partnership
 Director Graham Phoenix
 Engineer Michael Simpson

Ironwork	DGT Fabrications Ltd
Leadwork	Eura Conservation Ltd
Bronze foliage	Dorothea Restorations Ltd
Bronze sculpture	Andy Mitchell
Stonework	Nimbus Conservation Ltd
Mosaics	Trevor Caley Associates
Marble sculpture	Nimbus Conservation Ltd
Steps and terraces	PAYE Stonework & Restoration Ltd
Railings and gates	Paul Dennis & Sons Ltd
Enamel shields	Plowden and Smith
Bronze shinrail	Andy Mitchell
Undercroft brickwork	Stonewest Cox
Electrical installations	MIM Electrical
Rainwater disposal	Fullflow
Landscape reinstatement	Blakedown Ltd
Scaffolding dismantling	Rainham Scaffolding Ltd

Notes

Preface

1. Quoted in Joanna Richardson, *Victoria and Albert* (London, 1977), p. 203.
2. Edwin Hodder, *The Life and Work of the Seventh Earl of Shaftesbury, K.G.*, 3 vols (London, 1887) vol. 3, p. 135.
3. Christopher Hibbert, ed., *Queen Victoria in her Letters and Journal* (London, 1984), p. 346.
4. S. M. Ellis, ed., *A Mid-Victorian Pepys. The Letters and Memoirs of Sir William Hardman, M.A., F.R.G.S.* (London, 1923), p. 69.
5. Quoted Richardson, *Victoria and Albert*, p. 228.
6. Thomas Carlyle, *Chartism* (1839), Chapter 7, 'Not Laissez-Faire'.
7. Thomas Carlyle, *Past and Present* (1843), Book 3, Chapter 4, 'Happy'.
8. Hibbert, *Victoria in her Letters and Journal*, pp. 84–5.
9. Baron Stockmar to Leopold, King of the Belgians, quoted in Theodore Martin, *The Life of His Royal Highness the Prince Consort*, 5 vols (London, 1875–80), vol. 1, p. 18.
10. Kenneth Clark, *The Gothic Revival* (London, 1928; paperback edn., Harmondsworth, 1964), p. 172; Clark revoked the condemnation in a footnote to the 1950 edition.
11. Dudley Harbron, *Amphion or The Nineteenth Century* (London, 1930), p. 110; Harbron used the phrase, borrowed from a late Victorian sneer at the Memorial's expense, as the title for his chapter on Scott.
12. Reginald Turnor, *Nineteenth-Century Architecture in Britain* (London, 1950); Turnor himself thought it 'less depressing than most of Scott's work'.

Chapter One

1. Charles Frederick Vitzhum von Eckstädt, ed., Henry Reeve, *St Petersburg and London*, 2 vols (London, 1887), vol. 2, p. 161.
2. Granville to Canning, 16 December 1861; quoted in Fitzmaurice, *The Life of Lord Granville, 1815–1891*, 2 vols (London, 1905), vol. 1, p. 404.
3. The many products of Albert's commemoration have been admirably surveyed in Elisabeth Darby and Nicola Smith, *The Cult of the Prince Consort* (New Haven and London, 1983).
4. Augusta, dowager Duchess of Leiningen, to Duchess of Kent, 11 August 1821; quoted in Charles Grey, *The Early Years of the Prince Consort* (London, 1867), p. 19.
5. Henry Reeve, ed., *The Greville Memoirs 1837–1860*, 3 vols (London, 1885), vol. 1, p. 266.
6. Lord Grey to Baron Stockmar, quoted in Theodore Martin, *The Life of His Royal Highness the Prince Consort*, 5 vols (London, 1875–80), vol. 2, pp. 555–6.
7. Prince Albert to Baron Stockmar, 24 January 1854, quoted in Martin, *Life*, vol. 2, pp. 559–60.
8. Charles Phipps to Lord Palmerston, 14 December 1861, quoted in Cecil Woodham-Smith, *Queen Victoria, her Life and Times, 1819–1861* (London, 1972), p. 430.
9. Prince Albert to Duke of Wellington, 6 April 1850, quoted in Martin, *Life*, vol. 2, p. 260.
10. In a letter of May 1860 to his eldest daughter Victoria, by then Crown Princess of Prussia, Albert wrote: 'one's feelings remain under the influence of the treadmill of never-ending business. The donkey in Carisbrook [*sic.*] ...is my true counterpart. He ...would much rather munch thistles in the Castle Moat than turn round in the wheel'. Kurt Jagow, ed., *Letters of the Prince Consort, 1831–1861* (London, 1938).
11. Prince Albert to Queen Victoria, 10 December 1839, quoted in Grey, *Early Years*, p. 266.
12. Royal Archives, Windsor, RA Y54/3, George Anson's Memorandum; quoted in Robert Rhode-James, *Albert, Prince Consort, A Biography* (London, 1983), p. 105.

13. The name puns on the German for a palmer or pilgrim.
14. Jagow, *Letters*, p. vii.
15. Whitwell Wilson, *The Greville Diary*, 1927, II, p. 361; pp. 262–3, 8 October and 19 October 1857.
16. Quoted in Martin, *Life*, vol. 1, p. 334, n. 1.
17. See Henry Cole, *Fifty Years of Public Work* (London, 1884), and Elizabeth Bonython's study, *King Cole* (Victoria and Albert Museum, 1982).
18. See Michael Port, ed., *The Houses of Parliament* (London, 1976), and Maurice Bond, ed., *Works of Art in the House of Lords* (London, 1980).
19. Letter from Thomas Uwins, 15 August 1843, quoted in Martin, *Life*, vol. 1, pp. 168–9.
20. Queen Victoria to King Leopold, 25 March 1845; A. C. Benson and Viscount Esher, eds, *The Letters of Queen Victoria. A Selection from Her Majesty's Correspondence between the years 1837 and 1861*, 3 vols (London, 1908), vol. 3, p. 35.
21. For whom see Hermione Hobhouse, *Thomas Cubitt – Master Builder* (London, 1995).
22. Speech to the meeting of the Royal Agricultural Society held at York, 13 July 1848; *The Principal Speeches and Addresses of His Royal Highness the Prince Consort* (London, 1857), enlarged edn (London, 1862), p. 92.
23. Winslow Ames, *Prince Albert and Victorian Taste* (London, 1967), p. 109.
24. See James Stevens Curl, *The Life and Work of Henry Roberts 1803–1876* (Chichester, 1983).
25. Prince Albert to Sir Robert Peel, 21 August 1849, RA, D20/22.
26. See H. T. Wood, *A History of the Royal Society of Arts* (London, 1913).
27. He was not related to Albert's builder Thomas Cubitt, and should not be confused with Thomas's brother, William Cubitt (1791–1863) who, as Lord Mayor of London, called the meeting at the Mansion House on 14 January 1862 which launched the campaign for a Prince Consort National Memorial.
28. Lord John Russell to Queen Victoria, 17 October 1851, quoted in Martin, *Life*, vol. 2, p. 404.
29. Prince Albert to Lord Granville, 3 November 1853, quoted in Martin, *Life*, vol. 2, p. 537.
30. For the whole history see 'The Memorial to the Exhibition of 1851', *Survey of London*, vol. 38, *The Museums Area of South Kensington and Westminster* (London, 1975), pp. 133–6.
31. 'Memorandum by the Prince Consort as to the Disposal of the Surplus from the Great Exhibition of 1851', 10 August 1851, in Martin, *Life*, vol. 2, pp. 569–73.
32. For the detailed history of the development of the whole district, see the *Survey of London*, *The Museums Area*. Hermione Hobhouse's history of the Commission for the Exhibition of 1851 will appear in 2001.
33. See Ulrich Finke, 'The Art-Treasures Exhibition', John H. G. Archer, ed., *Art and Architecture in Victorian Manchester* (Manchester, 1985), pp. 102–26.
34. Ames, *Albert and Victorian Taste*, p. 151.
35. *Times*, 16 December 1861.
36. Laurence Housman, *Happy and Glorious* (London, 1945), pp. 7–8.
37. Hector Bolitho, *Albert the Good* (London, 1932), p. iv.
38. Daphne Bennett, *King without a Crown. Albert, Prince Consort of England 1819–1861* (London, 1977); Robert Rhodes-James, *Albert, Prince Consort. A Biography* (London, 1983); Stanley Weintraub, *Uncrowned King. The Life of Prince Albert* (New York, 1997).
39. See Hermione Hobhouse, *Prince Albert: His life and work* (London, 1983), published in conjunction with the exhibition.

Chapter Two

1. 'Regular Conjugations', *Spectator*, 30 November 1839, p. 1134. I owe this quotation, and several others, to John Plunkett. I am particularly grateful to him for allowing me to draw on the doctoral thesis he is writing on representations of Victoria for Birkbeck College, University of London, and for many discussions we have had about nineteenth-century constructions of the Queen and her Consort.
2. *Art Union*, 15 February 1840, p. 23.
3. Rigdum Funnidos, *The Royal Wedding Jester; or Nuptial Interlude : a collection of the Wedding Facetiae displayed on this joyful event … With numerous comic songs, etc.* (London, 1840), pp. 7–8.
4. Peter Funnell, 'The Iconography of Prince Albert', in Franz Bosbach and Frank Büttner, eds, *Künsterliche Beziehungen zwischen England und Deutschland in der viktorianische Epoche. Art in Britain and Germany in the Age of Queen Victoria and Albert, Prince Albert Studies*, vol. 15 (Munich, 1998), pp. 111–12.
5. Both originals are in the Royal Collection; the National Portrait Gallery has a mezzotint by Charles Edward Wagstaff after Patten, and a lithograph by R. J. Lane after Ross, which Colnaghi & Puckle published in January 1840. They continued to bring out engravings of the Ross, including one by H. J. Ryall published in July 1840.
6. Royal Collection; the NPG has an engraving by F. Bacon, issued by Colnaghi & Puckle on 8 August 1841, and including Albert's signature.
7. There are examples in the NPG and the British Museum; for the latter see F. O'Donoghue and H. M. Hake, *Catalogue of Engraved British Portraits preserved in the Departments of Prints and Drawings in the British Museum*, 6 vols. (British Museum, 1908–25), vol. 1, pp. 27–8. Funnell, 'Iconography of Prince Albert', p. 110n., identifies the original source of the Rogers image as an engraving by Carl Mayer in *Almanach de Gotha pour l'année 1838* (Gotha, 1838).
8. Circulation figures for Victorian journals are notoriously difficult to establish. Most modern commentators work on a conservative estimate of five readers for each copy: on this basis – supported by claims of its own – *Punch* probably had a readership of 200,000 or more by the mid-1840s. The *ILN* sold 41,000 copies in its first year, and 67,000 in 1850 – giving a readership for the latter year approaching 350,000. See Richard D. Altick, *'Punch': the Lively Youth of a British Institution, 1841–1851* (Columbus, 1997), pp. 35–40.
9. For an account of how portraiture realigned perceptions of power relations within the marriage see M. Homans, '"To the Queen's Private Apartments": Royal Family Portraiture and the Construction of Victoria's Sovereign Obedience', *Victorian Studies* (Autumn, 1993), pp. 1–41.
10. For a full analysis of the issues involved see R. Williams, *The Contentious Crown: Public Discussion of the Monarchy in the Reign of Queen Victoria* (Aldershot, 1997).
11. John Plunkett's research demonstrates the pervasiveness and potency of such a concept in the 'Reginamania' that enveloped Victoria's coronation, as too in the political programme advanced in the 1840s by the 'Young England' clique, notably through Disraeli's novels.
12. The Partridge, Winterhalter, and Thorburn are in the Royal Collection; the Lucas, once in the United Services Club, now in the Institute of Directors, London; the Grant in the Collection of Christ's Hospital, Horsham.
13. The only one by a high art sculptor known to me is by Emile Wolff, executed in Rome, dated 1846, and now in the Royal Collection: it shows Albert, preposterously enough, in the armour of an ancient Roman soldier. More appealing is a naïve earthenware figure, life-size, by 'John Millar. Potter to Her Majesty, Edinburgh', which represents the Prince in his field-marshal's uniform. It was sold at Sotheby's in 1972; a photograph is in the NPG Archive.
14. The Baily and the Marochetti are in the Royal Collection, the Francis in the NPG; Marochetti's work was reproduced in Parian ware after Albert's death.
15. The bust, a photograph of which exists in the NPG Archive, is not listed among Weekes's works in Rupert Gunnis, *Dictionary of British Sculptors 1660–1851*, rev. edn (London, 1964), pp. 418–20.
16. Funnell, 'Iconography of Prince Albert', p. 113.
17. The first two issues of *ILN*, 14 and 21 May 1842, came with two fold-out panoramas of London.
18. *ILN*, 14 May 1842, vol. 1, pp. 8–9; 4 June 1842, vol. 1, p. 57; 18 June 1842, vol. 1, p. 89; 13 August 1842, vol. 1, p. 209.
19. *ILN*, 14 May 1842, vol. 1, p. 7.

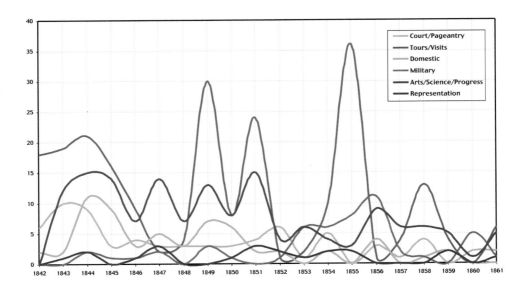

Graph 1. Images of Prince Albert in *The Illustrated London News* (see note 20)

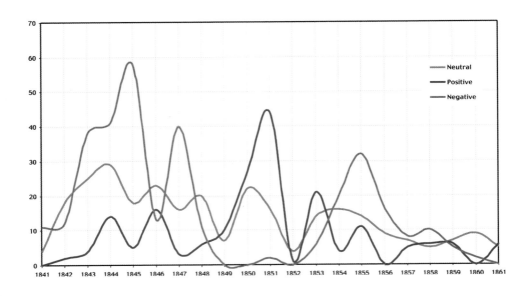

Graph 2. Prince Albert in *Punch* (see note 32)

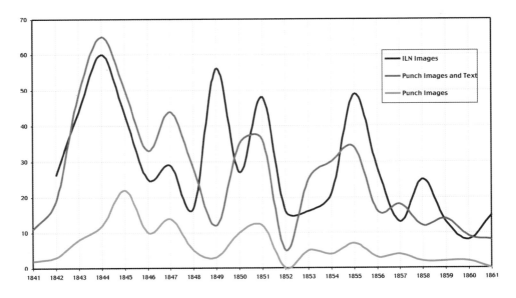

Graph 3. Prince Albert in *Punch* and *The Illustrated London News*

20. The graph makes no attempt to assess the relative prominence of the images: the vertical scale simply allots one unit to each image in which Prince Albert appears, so a double-page spread of a grand event registers the same as a vignette. In the 'Arts/Science/Progress' category I have included a small number of images that are not pictures of him but refer expressly to his activities in these fields; for example, the engravings illustrating the 1845 trip to Coburg that the *ILN* identifies as being 'from his Royal Highness Prince Albert's drawing' (16 August 1845, vol. 7, pp. 104–5; 30 August 1845, vol. 7, pp. 137, 140). Subject categories inevitably overlap, so there is an element of subjectivity in how I have assigned some of the illustrations. In making the choice, however, I have been guided by the character and context of the image itself. For example, the pictures of Victoria and Albert at the theatre (17 June 1843, vol. 2, pp. 421–2; 22 July 1843, vol. 3, p. 56) – attended by lords and ladies, beefeaters, and miscellaneous flunkies – seem to me to belong to glamourised representations of the court; on the other hand, the cut of Kemble reading Shakespeare at Buckingham Palace (25 May 1844, vol. 4, p. 341) seems far more about the royal couple promoting the progress of the arts.

21. See particularly *ILN*, 17 September 1842, vol. 1, pp. 296–7, 300–1, and 24 September 1842, vol. 1, pp. 312–3.

22. See, for example, the illustrations of the train bringing Victoria and Albert back from their 1849 trip to Scotland, *ILN*, 6 October 1849, vol. 15, pp. 233, 236, 237.

23. See, for examples, the various images of 'Her Majesty's Marine Excursion', *ILN*, 21 August 1847, vol. 11, pp. 120–21, 28 August 1847, vol. 11, pp. 133, 136–7, 25 September 1847, vol. 11, p. 200.

24. *ILN*, 17 September 1842, vol. 1, p. 296. As a badge of Scottish national identity, tartan was largely invented by Sir Walter Scott for George IV's State visit to Edinburgh in 1822. Victoria and Albert popularised it, partly through wearing it, partly through using it as a furnishing fabric at Balmoral.

25. *ILN*, 8 April 1843, vol. 2, pp. 242–3; 10 June 1843, vol. 2, p. 403; 17 June 1843, vol. 2, pp. 421–2; 1 July 1843, vol. 3, pp. 7–9; 8 July 1843, pp. 24–5; 5 August 1843, vol. 3, pp. 88–9.

26. *ILN*, 8 July 1843, vol. 3, p. 23.

27. Notably the state visits to France and Belgium, for which see *ILN*, 16 September 1843, 23 September 1843, and 30 September 1843. In Britain, major coverage was given to the royal visit to Cambridge (*ILN*, 28 October 1843, vol. 3, pp. 273, 280–9; 4 November 1843, vol. 3, pp. 295–8) where the degree of D.C.L. was conferred on Albert – an honorary award, but one that nevertheless linked him publicly to an institution of learning.

28. *ILN*, 1 July, 1843, vol. 3, p. 5; 22 July 1843, vol. 3, p. 52, and 29 July 1843, vol. 3, pp. 72–3; 9 December 1843, vol. 3, p. 381; 23 December 1843, vol. 3, p. 408. Albert the scientific farmer was also in evidence at the Smithfield show that year, where one of his pigs was 'highly commended'; the *ILN* obligingly published an engraving of it (16 December 1843, vol. 3, p. 389), the first of several such pictures of the Prince's prize-winning livestock.

29. *ILN*, 6 January 1844, vol. 4, p. 9; the picture is from a drawing by a M. Baugniet, presumably the Belgian engraver Charles Baugniet.

30. *Punch*, 17 July 1841, vol. 1, p. 1. Citations from *Punch* given here include the date of the issue as well as volume and page number, except for the periods 1842–3 and 1849–55 when the publication date was dropped from the main text of each number.

31. Thomas Carlyle, *Past and Present* (London, 1843), book 3, chapter 3, 'Gospel of Dilettantism'. Carlyle's social polemic, in *Chartism* (1839) as well as *Past and Present*, and the terms in which he posed the 'Condition of England Question', seem to me to exercise a pervasive influence on *Punch*'s early radicalism.

32. Although *Punch*'s stance towards Albert is usually clear, there are some items that are ambiguous in character: these have been registered on the graph as neutral. Other neutral items include casual references, the benign jokes and puns *Punch* made about all well-known figures, and a few subsidiary images. The graph weights items according to an approximate but consistent measure of their

relative importance: minor references, jokes, and incidental or marginal images, count one unit on the left axis for each occurrence; whole paragraphs and articles in which Albert is the main subject, or one of the main subjects, and cartoons within the text in which he is one of several figures, each count two units; cartoons within the text in which he is the principal subject, and all full-page cartoons in which he is a major figure, count three units. The graph thus gives a developmental sense of Albert's exposure in *Punch* – what we might think of today as his public profile – and measures his fluctuating popularity. It would be very instructive to plot these results against those for other *Punch* regulars like Palmerston and Russell.

33. *Punch*, 4 December 1841, vol. 1, p. 247.

34. *Punch*, 12 September 1841, vol. 1, p. 100; 11 December 1841, vol. 1, p. 256; vol. 2 (1842), p. 139.

35. *Punch*, vol. 2 (1842), p. 44, and vol. 3 (1842), p. 221; both are probably by Richard Doyle. The first, part of 'Punch's Panorama of the Proceedings upon Laying the First Stone of the New Royal Exchange', is accompanied by a nicely turned verse: 'This is Prince Albert, who really display'd / Such a wondrous genius for spreading the mortar, / You'd have thought he was wedded for life to the trade, / And not, as he is, to the Duke of Kent's daughter.'

36. *Punch*, vol. 3 (1842), pp. 117–18, 135.

37. *Punch*, vol. 3 (1842), pp. 137, 141, 178. A particularly sharp cartoon, 'A Political Parallel' (p. 163), shows working people endlessly pouring money into the leaking tub of the Treasury; one of the leaks is labelled 'Royal Stables'.

38. See, for examples, *Punch*, vol. 3 (1842), pp. 30, 137; vol. 4 (1843), pp. 14, 32, 35, 52, etc. Several of the 1843 items satirise the royal couple's failure to support the English theatre – special pleading on the part of *Punch*, several of whose key contributors wrote for the stage as well.

39. Passing references, *Punch*, vol. 3 (1842), pp. 1, 141.

40. *Punch*, vol. 3 (1842), p. 44.

41. *Punch*, vol. 4 (1843), p. 17.

42. *Punch*, vol. 4 (1843), pp. 246, 256; 22 July 1843, vol. 5, p. 43; 5 August 1843, vol. 5, p. 64; 26 August 1843, vol. 5, p. 87. The broader context for much of this was *Punch*'s increasingly angry campaign to draw attention to the desperate nature of working-class conditions.

43. *ILN*, 21 October 1843, vol. 3, p. 272.

44. *Punch*, 28 October 1843, vol. 5, p. 179; the accompanying text is on p. 178.

45. The core of this was, of course, dynastic, as is constantly apparent in *Punch*'s gibes at the court; many of the passing jokes about Albert turn on his pronunciation and supposedly uncertain grasp of English; and *Punch* even claimed 'an alarming spread of the German School in Art' (28 March 1846, vol. 10, p. 145), including the new frescoes for the Palace of Westminster supervised by Albert's Royal Commission.

46. Carlyle, *Past and Present*, book 3, chapter 1, 'Phenomena'.

47. *Punch*, 4 November 1843, vol. 5, p. 201.

48. *Punch*, 25 November 1843, vol. 5, p. 231.

49. *Punch*, 16 March 1844, vol. 6, p. 120.

50. *Punch*, 5 October 1844, vol. 7, p. 153.

51. *Punch*, 19 October 1844, vol. 7, p. 174.

52. The *battue* had been introduced into England from the Continent in the early years of the century; *Punch*'s attacks should also be seen as part of its campaign against the iniquities of the Game Laws.

53. *Punch*, 1 February 1845, vol. 8, p. 59.

54. *Punch*, 22 February 1845, vol. 8, p. 82.

55. *Punch*, 20 September 1845, vol. 9, p. 131; the 'Parallel' of the title is with a scene on the facing page showing bear-baiting at Elizabeth's court.

56. *Punch*, 21 June 1845, vol. 8, p. 269.

57. *Punch*, 23 August 1845, vol. 9, p. 89; the cartoon parodies Horace Vernet's 1832 painting in Versailles, *The Duc d'Orléans Leaving the Palais Royal*.

58. *Punch*, 20 March 1847, vol. 12, p. 119.

59. *Punch*, 20 March 1847, vol. 12, p. 118.

60. *Punch*, 11 May 1844, vol. 6, p. 200; 10 May 1845, vol. 8, pp. 205 and 211; 31 May 1845, vol. 8, p. 232; the baton and the beadles from this last reappear in 'Les Adieux de Buckingham Palace'.

61. *Punch*, 9 December 1843, vol. 5, p. 256; 20 January 1844, vol. 6, p. 41; 20 April 1844, vol. 6, p. 176; 29 June 1844, vol. 7, p. 10.

62. *Punch*, 3 February 1844, vol. 6, pp. 60–61.
63. *Punch*, 13 July 1844, vol. 7, p. 29. The context was the competition for historical and allegorical statuary for the New Palace of Westminster, organised by the Royal Fine Arts Commission chaired by Albert himself. The significance of the Commission and the Westminster statuary for the sculptural programme of the Albert Memorial is discussed by Benedict Read in chapter five.
64. *Punch*, 29 August 1846, vol. 11, p. 89.
65. The first of the series appeared in *Punch*, 3 January 1846, vol. 10, p. 3.
66. *ILN*, 14 September 1844, vol. 5, pp. 169, 172; 21 September 1844, vol. 5, pp. 184–5; 28 September 1844, vol. 5, pp. 200–1, 204.
67. *ILN*, 12 October 1844, vol. 5, pp. 232–3; *ILN*, 19 October 1844, vol. 5, pp. 244–5, 248–9, 252.
68. The tour forms a substantial part of the *ILN*'s contents for five weeks, from 16 August to 13 September 1845.
69. *ILN*, 6 September 1845, vol. 7, p. 149.
70. *ILN*, 13 September 1845, vol. 7, p. 168.
71. *ILN*, 6 July 1844, vol. 6, p. 5; 14 September 1844, vol. 6, p. 172; 12 October 1844, vol. 6, p. 233.
72. Both pictures are in the Royal Collection. For discussion see Simon Schama: 'The Domestification of Majesty: Royal Family Portraiture 1500–1850', in R. I. Rotberg and T. K. Rabb, eds, *Art and History: Images and their Meaning* (Cambridge, 1988); Homans, '"To the Queen's Private Apartments"'; Funnell, 'Iconography of Prince Albert', particularly pp. 116–9, which usefully summarises current views.
73. NPG Archive, 30139, 30140; Clark and Glover produced lithographs for the comic weekly, the *Fly* (1837–40), including one of the Princess Royal's christening 'presented GRATIS' to readers, 10 February 1841; the royal scenes are complete inventions, but also wholly unsatirical in intent.
74. Reproduced in Hermione Hobhouse, *Prince Albert: His Life and Work* (London, 1983), p. 29; see also Homans, '"To the Queen's Private Apartments"', p. 2 and fig. 6.
75. *Reynolds's Miscellany*, 5 December 1846, p. 73; the *Miscellany* (1846–69), one of the novelist G. M. W. Reynolds's numerous ventures into the literary mass-market, was one of the earliest illustrated periodicals aimed at a lower-class audience.
76. The *Pictorial Times* ran 1843–8; it published numerous cuts of the royal family, including, in 1845, a fold-out engraving of Albert in his Garter robes from Winterhalter's portrait of 1843.
77. From a drawing by J. L. Williams; *ILN*, Christmas Supplement, 23 December 1848; vol. 13, p. 409.
78. *Punch*, vol. 4 (1843), p. 84.
79. *Punch*, 6 September 1845, vol. 9, p. 109.
80. Subtitled 'A Cheap Substitute for a Weekly Newspaper', the *Penny Satirist* ran from 1837 to 1846, then, under an amended title, until 1848; it specialised in attacking public figures.
81. *Punch*, 3 January 1846, vol. 10, p. 7; 25 July 1846, vol. 11, p. 37; 21 November 1846, vol. 11, p. 213.
82. John Leech and Kenny Meadows, for examples, produced cuts for *ILN* as well as *Punch*.
83. For the Irish tour, *ILN*, 11 August 1849, vol. 15, pp. 81–96, 101, 104–5; 18 August 1849, vol. 15, pp. 113–25; for Scotland and the journey back to England, 25 August 1849, vol. 15, pp. 140–41; 6 October 1849, vol. 15, pp. 233–7.
84. *ILN*, 3 February 1849, vol. 14, pp. 72–3; 21 April 1849, vol. 14, pp. 249, 256–7; 5 May 1849, vol. 14, p. 293; 26 May 1849, vol. 14, p. 352; 3 November 1849, vol. 15, pp. 289–300.
85. *ILN*, 3 November 1849, vol. 15, p. 294.
86. Though the *Punch* cartoon on the occasion, vol. 17 (1849), p. 177, shows the royals as a family group, including Victoria.
87. *Punch*, 3 June 1848, vol. 14, p. 228. The speech does seem to have altered public perceptions of Albert; his official biographer claimed that 'it first fairly showed to the country what he was'; Theodore Martin, *The Life of His Royal Highness the Prince Consort*, 5 vols (London, 1875–80), vol. 2, p. 47.
88. 'H.R.H. Field-Marshal Prince Albert Taking the Pons Asinorum', *Punch*, 25 November 1848, vol. 15, p. 225. The cartoon is based on Antoine-Jean Gros' heroic painting of 1796, *Napoleon Crossing the Bridge at Arcola*. The complex relationship between the original picture, the cartoon, and what was happening in France in 1848, typifies the semantic multi-layering of Leech's work at its best.
89. *Punch*, 23 June 1849, vol. 16, p. 255.
90. According to M. H. Spielmann, *The History of "Punch"* (London, 1895), p. 51, '*Punch* had made a dead-set against the Exhibition in Hyde Park' until Paxton's appointment. The press was generally sceptical about the scheme, and Justin McCarthy claimed '*Punch*, in particular, was hardly ever weary of making fun of it', *A History of Our Own Times from the Accession of Queen Victoria to the Berlin Congress*, 4 vols. (1879), vol. 2, p. 114. On the other hand Altick, '*Punch*': the Lively Youth of a British Institution', p. 619, says '*Punch* was on the Prince's side from the start'. I can find little evidence for any hard-line opposition, and the jokes and cartoons about the Hyde Park site are wryly ambivalent. Certainly, there was no kind of campaign against Albert himself, though one sketch offers a rotunda roofed by a vast Albert Hat as a design for the Exhibition building, *Punch*, vol. 19 (1850), p. 22.
91. *Punch*, vol. 18 (1850), p. 145.
92. *ILN*, 6 July 1850, vol. 17, p. 13.
93. In November 1850, in an orientalist skit on contemporary religious bickerings called 'Fragments from the History of Cashmere'. To the Prince, husband of the Empress Kohinur, 'the Lundoonees owed the beautiful turban that they wore for many ages; and it was he who, with the aid of two genii, Packistaun and Foox, raised up in a single night that extraordinary palace of crystal, which brought all the people of the earth to visit Lundoon – and made it the eighth wonder of the world'; *Punch*, vol. 19 (1850), p. 221.
94. Henry Windham Phillips, *The Royal Commissioners for the Great Exhibition 1851*, 1850–1, Victoria and Albert Museum.
95. Franz Xaver Winterhalter, *The First of May: Queen Victoria and Prince Albert presenting Prince Arthur to the Duke of Wellington*, 1851, Royal Collection. The date was the first birthday of Prince Arthur and the eighty-second of his godfather, Wellington: in the picture Albert, a plan of the Crystal Palace in his hand, looks anxiously over his shoulder towards the building in the distance.
96. Henry Selous, *The Great Exhibition in Hyde Park, London; the Opening by H.M. Queen Victoria on 1st May, 1851*, 1851–2, Victoria and Albert Museum.
97. *ILN*, 23 March 1850, vol. 16, p. 188, and 2 November 1850, vol. 17, pp. 348–9; 14 December 1850, vol. 17, p. 452; 3 May 1851, vol. 18, pp. 350–51, and 10 May 1851, vol. 18, pp. 398–9; 25 October 1851, vol. 19, p. 528.
98. *ILN*, 11 October 1851, vol. 19, p. 456.
99. *Punch*, vol. 20 (1851), p. 193.
100. *Punch*, vol. 21 (1851), p. 38.
101. *ILN*, 9 November 1844, vol. 5, p. 292; 16 November 1844, vol. 5, p. 316; 6 September 1845, vol. 7, p. 145; 26 May 1849, vol. 14, p. 352.
102. *ILN*, 19 February 1848, vol. 12, p. 102; 31 January 1849, vol. 14, p. 21; 7 September 1850, vol. 17, p. 200; 23 October 1852, vol. 21, p. 332; 3 September 1853, vol. 23, p. 185.
103. Quoted Martin, *Prince Consort*, vol. 2, p. 538. I am particularly grateful to Grace Moore for discussions about Albert's reputation at the time of the Crimean War.
104. Queen Victoria to Baron Stockmar, 1 February 1854, Martin, *Prince Consort*, vol. 2, p. 564.
105. A Charles Keane cartoon shows a couple of low-life 'citizens' sharing the news that Albert had been caught 'a-sendin' fi-pun-notes to the Hemperer of Rooshy', *Punch*, vol. 26 (1854), p. 48.
106. See particularly 'Shooting at Windsor' and 'King Leopold Reports Progress', *Punch*, vol. 25 (1853), pp. 196, 211. The idea that Victoria was kept in ignorance of the diplomatic manoeuvring is an obvious fiction, which must have been apparent as such at the time. In which case the denunciations of Albert were a way of criticising the policy of the monarchy itself, without risking the opprobrium of a direct attack on the Queen.
107. *Punch*, vol. 26 (1854), p. 3. The poem works on analogies with Dickens' *Bleak House*, which finished serial publication in September 1853. Victoria is Esther in her role as Dame Durden, and John Bull is Jarndyce, her guardian, who has put her in charge of his household – thus reworking

the domestic schema *Punch* had developed for representing the royal couple.

108. *Punch*, vol. 26 (1854), p. 5.
109. *Punch*, vol. 26 (1854), p. 100.
110. *Punch*, vol. 26 (1854), pp. 181, 200, 204.
111. *Punch*, vol. 26 (1854), p. 204.
112. *Punch*, vol. 28 (1855), p. 197; the accompanying poem, 'Prince Albert's Example', as mockingly sardonic as the cartoon, is on p. 199.
113. *Punch*, 3 November 1855, vol. 29, p. 179.
114. *Punch*, 22 December 1855, vol. 29, p. 249.
115. *Punch*, 22 December 1855, vol. 29, p. 253.
116. See particularly *ILN*, 25 June 1853, vol. 22, p. 505; 2 July 1853, vol. 22, pp. 537, 544–5.
117. *ILN*, 21 January 1854, vol. 24, p. 47.
118. *ILN*, 25 February 1854, vol. 24, p. 165; the accompanying text also gives his farewell message to the Guards.
119. *ILN*, 11 March 1854, vol. 24, p. 216.
120. *ILN*, 10 March 1855, vol. 26, p. 236; p. 237 has a picture of wounded guardsmen meeting Victoria and Albert at Buckingham Palace. The Chatham visit was the subject of the impressive large-scale work by Jerry Barrett, *Queen Victoria's First Visit to Her Wounded Soldiers* (1856, NPG): the title stresses the personal relationship between Victoria and the troops, but in the painting the royal party is very firmly composed as a family group.
121. *ILN*, 26 May 1855, vol. 26, p. 497.
122. *ILN*, 26 July 1856, vol. 29, p. 86.
123. *ILN*, 20 May 1854, vol. 24, p. 460.
124. With Napoleon and Eugénie, *ILN*, 21 April 1855, vol. 26, pp. 388–9; with Victor Emmanuel, *ILN*, 8 December 1855, vol. 27, pp. 664–5.
125. See in particular the *ILN* issue for 8 September 1855.
126. Presented to readers with the *ILN* issue for 28 April 1855.
127. *ILN*, 11 July 1857, vol. 31, p. 33.
128. 'H.R.H. F.M. P.A. At It Again !', *Punch*, 12 July 1856, vol. 31, p. 15.
129. See for examples, '"Great and Important Event"', *Punch*, 25 August 1857, vol. 32, p. 165, on the birth of Princess Beatrice; and 'Latest from America', *Punch*, 10 November 1860, vol. 39, p. 185, on the Prince of Wales's return from the States.
130. Royal Collection; after Albert's death Winterhalter produced a copy at Victoria's request, which she presented to the NPG.
131. Funnell, 'Iconography of Prince Albert', p. 119.
132. *ILN*, 21 July 1855, vol. 27, p. 69; the pictures show both individuals and a group assembled outside the hospital; the photographer was Joseph Cundall.
133. For further details of these and other aspects of Victoria and Albert's involvement with photography, see Frances Dimond and Roger Taylor, *Crown and Camera. The Royal Family and Photography 1842–1910* (Harmondsworth, 1987), particularly pp. 11–59.
134. Funnell, 'Iconography of Prince Albert', p. 120.
135. A hand-coloured version of the photograph is in the Royal Collection; the print is in the NPG Archive. The Pound engraving was one of a series of royal portraits, all taken from Mayall photographs; they retailed at 6d., each comprising one large engraving accompanied by a brief bibliographical memoir.
136. *ILN*, 31 May 1856, vol. 28, p. 584.
137. *ILN*, 11 December 1858, vol. 33, p. 543.
138. *ILN*, 4 June 1859, vol. 34, p. 540; the original photograph was taken on 26 May 1857, soon after the birth of Princess Beatrice.
139. *Athenaeum*, 18 August, 1860, p. 230; quoted Funnell, 'Iconography of Prince Albert', p. 120.
140. M. D. Wynter, 'Cartes de Visite', *Photographic News*, 28 February 1862, p. 104.
141. For an excellent survey of the phenomenon and its products see Elisabeth Darby and Nicola Smith, *The Cult of the Prince Consort* (New Haven and London, 1983).
142. The description originates in Layard's correspondence of 1868, when he and Scott inspected Foley's model for the statue, BM Add *MSS* 38995, f. 348; it is quoted as Foley's words in 'Albert Memorial', *Survey of London*, vol. 38, *The Museums Area of South Kensington and Westminster* (London, 1975), p. 162.

Chapter Three

1. George Gilbert Scott, *Personal and Professional Recollections* (London, 1879); ed., Gavin Stamp (Stamford, 1995), pp. 327–8.
2. Scott, *Recollections*, p. 267.
3. Charles Locke Eastlake, *A History of the Gothic Revival* (London, 1872); ed., J. Mordaunt Crook (Leicester, 1970), p. 211.
4. *Building News*, 28 June 1867, p. 435.
5. See 'Albert Memorial', *Survey of London*, vol. 38, *The Museums Area of South Kensington and Westminster* (London 1975), p. 148ff., upon which this chapter relies heavily.
6. Despite which, Victorian sources invariably refer to the Memorial as being in Hyde Park.
7. *The National Memorial to his Royal Highness The Prince Consort* (London, 1873), p.10.
8. *National Memorial*, p. 12.
9. Royal Archives, Windsor, 'Queen Victoria's Journal', 12 February 1863.
10. Roger Fulford, ed., *Dearest Mama. Letters between Queen Victoria and the Crown Princess of Prussia, 1861–1864* (London, 1968), p. 177.
11. 'Albert Memorial', *Museums Area*, p. 151.
12. Scott, *Recollections*, pp. 262–3.
13. Scott, *Recollections*, p. 225.
14. Stephen Bayley, in *The Albert Memorial. The monument in its social and architectural context* (London 1981; paperback edn, London, 1983), comments that there 'is no trace of Edward Barry's drawings, and as he left the greater part of the explanation of his design to them, his proposal is not clear' (p. 38). Each architect accompanied his design with an explanatory text.
15. *Builder*, vol. 21 (1863), p. 233.
16. Illustrated in Bayley, *Albert Memorial*, p. 35.
17. *Builder*, vol. 21 (1863), p. 233.
18. Geoffrey Tyack, *Sir James Pennethorne and the making of Victorian London* (Cambridge, 1992), p. 272.
19. *Builder*, vol. 21 (1863), p. 233.
20. His design is preserved in the Department of Prints and Drawings in the Victoria and Albert Museum.
21. Nikolaus Pevsner, 'An unknown Albert Memorial', *Architectural Review*, vol. 146 (1969), p. 469, where Hittorff's drawings, now in Cologne, are illustrated.
22. Alexander Thomson, 'Art and Architecture', Haldane Lecture II, quoted in *Alexander 'Greek' Thomson* (London 1999), in which his design is illustrated. A tracing of Thomson's damaged original, now in Glasgow School of Art, appears in Ronald McFadzean, *The Life and Work of Alexander Thomson* (London, 1979), p. 140.
23. Alexander Stoddart, 'Thomson, Mossman and Architectural Sculpture' in Gavin Stamp and Sam McKinstry, eds, *'Greek' Thomson* (Edinburgh, 1994), p. 89.
24. Quoted in the *Builder*, vol. 21 (1863), p. 276.
25. Report of the Memorial Committee, reprinted in *National Memorial*, p. 16; quoted in the *Builder*, vol. 21 (1863), p. 312.
26. *Builder*, vol. 21 (1863), p. 313.
27. RA Add I/17A, quoted in 'The Albert Hall' *Survey of London*, vol. 38, *The Museums Area of South Kensington and Westminster* (London 1975), p. 179, illustrated pl. 48; see also Scott, *Recollections*, p. 279.
28. Quoted in the *Builder*, vol. 21 (1863), p. 233.
29. *Builder*, vol. 21 (1863), p. 233.
30. *Builder* vol. 21 (1863), p. 276–7; much of this was reprinted in the 'Architectural Description of the Memorial' by Scott in *National Memorial*, p. 34.
31. 'Albert Memorial', *Museums Area*, p. 152.
32. *Builder*, vol. 21 (1863), p. 361.
33. Scott, *Recollections*, p. 112.
34. *British Architect*, vol. 9, 5 April 1878.
35. *Transactions of the Royal Institute of British Architects* (1878), p. 199.
36. Scott, *Recollections*, p. 87.
37. Scott, *Recollections*, pp. 88 and 373.
38. Scott to Grey, 20 December 1869, RA, Add H2, 2867.
39. See Michael J. Lewis, *The Politics of the German Gothic Revival: August Reichensperger (1808–1895)* (New York, 1993), pp. 99–108.
40. Scott, *Recollections*, p. 176; for the fullest list of Scott's architectural works see David Cole, *The Work of Sir Gilbert Scott* (London, 1980), pp. 205–28.
41. Scott, *Recollections*, p. 210.

42. Scott, *Recollections*, p. 208.
43. *Building News*, 19 April 1878.
44. George Gilbert Scott, *Remarks on Secular and Domestic Architecture, Present and Future* (London, 1857), p. 111.
45. Scott, *Secular and Domestic Architecture*, pp. 263–4.
46. See Scott, *Recollections*, p. 185ff.
47. Basil H. Jackson, ed., *Recollections of Thomas Graham Jackson* (Oxford, 1950), p. 59.
48. Scott, *Recollections*, p. 151.
49. George Gilbert Scott, *Gleanings from Westminster Abbey* (Oxford and London, 1861); 2nd edn, considerably enlarged (Oxford and London, 1863). See also Scott's posthumously published *Lectures on the Rise and Development of Mediaeval Architecture*, 2 vols (London, 1879).
50. Scott, *Recollections*, p. 291.
51. *Illustrated London News*, 30 August 1862, p. 246.
52. Scott, *Recollections*, p. 263.
53. Scott, *Recollections*, pp. 263–4.
54. Scott, *Recollections*, pp. 264–5.
55. *National Memorial*, p. 42.
56. Scott, *Recollections*, p. 265.
57. *National Memorial*, p. 37. Among the Scaliger tombs in Verona, the Cansignorio mausoleum by Bonino da Campione, completed in 1375 with an equestrian figure on top of its pinnacled summit, is perhaps the closest in form to the Albert Memorial.
58. RA Add H2,569–70; quoted in 'Albert Memorial', *Museums Area*, p. 153.
59. Fowke's account of his Italian tour is cited in 'Albert Memorial', *Museums Area*, p. 153.
60. See Elisabeth Darby and Nicola Smith, *The Cult of the Prince Consort* (New Haven and London, 1983), p. 48. Arnolfo, known in the nineteenth century as Arnolfo di Lapo, was the architect of Florence Cathedral and is represented in the centre of the architects' frieze on the Albert Memorial.
61. Francis Turner Palgrave, *Essays on Art* (London,1866); a concluding essay, dated July 1865, expanded on the articles on 'The Albert Cross and English Monumental Sculpture' first published in April and May 1863.
62. See Nicola Smith, 'The Albert Memorial' in Sarah Macready and F. H. Thomson, eds, *Influences in Victorian Art and Architecture* (London, 1985), p. 70.
63. Smith, 'Albert Memorial', p. 65; the design for the Bentinck Memorial was published in the *Builder*, vol. 8 (1850), p. 43.
64. See Barry Bergdoll, *Karl Friedrich Schinkel: An Architecture for Prussia* (New York, 1994), p. 42.
65. John Britton, 'An Address to the Committee and Subscribers of an intended Cenotaph to the Memory of Sir Walter Scott, Bart., at Edinburgh' (December 1833), reprinted in Thomas Bonnar, *Biographical Sketch of George Meikle Kemp* (Edinburgh and London, 1892), pp. 88–9.
66. Scott, *Recollections*, p. 263.
67. Thomas Worthington, 'Memories', MS (1897), vol. 3; quoted in Anthony J. Pass, *Thomas Worthington. Victorian Architecture and Social Purpose* (Manchester, 1988), p. 45.
68. Quoted in the *Builder*, vol. 21 (1863), p. 277.
69. Scott, *Recollections*, p. 266.
70. James Fergusson, *History of the Modern Styles of Architecture*, ed., Robert Kerr, 2 vols (London, 1891), vol. 2, pp. 161–3.
71. Scott, *Recollections*, p. 268.
72. Scott, *Recollections*, appendix 1, p. 477; there is no evidence that Beresford-Hope was in any way involved.
73. Quoted in 'Albert Memorial', *Museums Area*, p. 176.
74. Jackson, *Recollections*, p. 153.
75. [John T. Emmett], 'The State of English Architecture', *Quarterly Review*, April 1872; reprinted in John T. Emmett, *Six Essays* (London, 1891); ed., J. Mordaunt Crook (New York, 1972), p. 16.
76. See Bayley, *Albert Memorial*, p. 46, where Cole's *Memorandum* is discussed and illustrated.
77. Palgrave, *Essays on Art*, p. 289.
78. 'French Reports of the International Exhibition of 1871', *Journal of the Society of Arts*, vol. 20 (1872), pp. 721–2.
79. *Athenaeum*, 15 February 1873, p. 217; quoted in 'Albert Memorial', *Museums Area*, p. 176.
80. Philip Henderson, *The Letters of William Morris* (London, 1950), p. 314. The catalyst for the Society's establishment was Scott's proposed restoration of Tewkesbury Abbey.
81. Scott, *Recollections*, p. 270.
82. Moncure Daniel Conway, 'Decorative Art and Architecture in England', in *Travels in South Kensington* (London, 1882), p. 142. Though Conway thought that the Memorial might have been 'better deserved by some who have no monument but their work', he considered that it 'has at any rate been raised, not to any brilliant devastator of human homes, not to any royal oppressor or scheming diplomatist, but to an ordinary man, who used the position and means intrusted to him for the refinement and moral well-being of the country that adopted him'. The book carries numerous illustrations of the Memorial and has an engraving of Foley's statue of the Prince for its frontispiece.
83. Fergusson, *Modern Styles*, ed., Kerr, vol. 2, p. 161.
84. Kenneth Clark, *The Gothic Revival* (London, 1928), p. 189; the subsequent quotation is taken from the 1950 edition.
85. *Private Eye*, vol. 1, no. 4, 7 July 1962; the photograph was taken by Lucinda Lambton.
86. 'Albert Memorial', *Museums Area*, p. 176.
87. See Andrew Roberts, *Salisbury. Victorian Titan* (London, 1999), p. 795.

Chapter Four

1. *Building News*, 5 July 1872, p. 1.
2. *British Almanac and Companion* (1864), p. 128.
3. See Gavin Stamp, 'The Hungerford Market', *Architectural Association Files*, no. 11 (Spring 1986), p. 61.
4. George Gilbert Scott, *Remarks on Secular and Domestic Architecture, Present and Future* (London, 1857), pp. 107–8.
5. Scott, *Secular and Domestic Architecture*, p. 219.
6. See Dan Cruickshank, 'Gothic Revivalist', *Architects' Journal*, 20 November 1997, pp. 69–70.
7. *The National Memorial to His Royal Highness the Prince Consort* (London, 1873), p. 41.
8. *Engineer*, 26 January 1906, p. 86; *Builder*, vol. 91 (1906), p. 123. Sheilds changed his name to Wentworth-Sheilds by royal licence in 1877.
9. George Gilbert Scott, *Salisbury Cathedral. Reports on the Tower and its Sustaining Piers* (1865).
10. *Retrospective Report on the National Memorial to His Royal Highness The Prince Consort*, Royal Archives, Windsor, Add H4, 21.
11. *Building News*, 18 February 1859, p. 161; see Frederick O'Dwyer, *The Architecture of Deane and Woodward* (1997), pp. 257–67.
12. *Minutes of the Proceedings of the Institution of Civil Engineers*, vol. 87 (1886), pp. 451–5; *Builder*, vol. 32 (1874), p. 381; *Survey of London*, vol. 43 (1994), pp. 345–8. After Kelk's death Bentley Priory became a hotel; during the Second World War it was the headquarters of Fighter Command.
13. *Survey of London*, vol. 38, *The Museums Area of South Kensington and Westminster* (London, 1975), pp. 54, 99–100, 134.
14. 'The Exhibition Building of 1872', *Museums Area*, p. 146.
15. A copy of the *National Memorial to His Royal Highness the Prince Consort* in the RIBA Library carries an inscription saying that it is from the collection of George Burt, Senior Partner of John Mowlem & Co., 'who assisted in the erection of this Memorial'. No other evidence of Burt's involvement in the project appears to have survived.
16. RA, Add H2, 744.
17. RA, Add H2, 763–6. Copies of the contracts between Kelk and Armstead, Skidmore, and Salviati are in RA, Add H2, Vol. 4.
18. RA, Add H2, 3303. As Benedict Read describes in the following chapter, Kelk also badgered Armstead when work on the frieze overran the period set by his contract.
19. *Builder*, vol. 21 (1863), p. 276.
20. *Retrospective Report*, p. 13.
21. *Illustrated London News*, vol. 46 (1865), p. 50.
22. RA, Add H3, 172.
23. RA, Add H2, 1173–4, 1659, 1661.
24. RA, Add H2, 1790–91.
25. 'Albert Memorial', *Museums Area*, p. 158.

26. 'Albert Memorial', *Museums Area*, p. 158; see also Michael Stratton, *The Terracotta Revival* (London, 1993), chapter 3.
27. Robert Thorne, 'Crystal Exemplar', *Architectural Review*, vol. 176 (July 1984), pp. 49–53.
28. *National Memorial*, p. 28; *Builder*, vol. 24 (1866), pp. 341–2.
29. *Retrospective Report*, p. 18. Portable steam cranes were in use elsewhere by the mid-1860s, for instance on the main drainage system being built by Joseph Bazalgette.
30. RA, Add H2, 3424.
31. RA, Add H2, 1448.
32. *National Memorial*, pp. 32–3.
33. RA, Add H2, 2328–30.
34. RA, Add H2, 3892–4.
35. These figures differ slightly from those given in 'Albert Memorial', *Museums Area*, p. 174, but the proportions are similar.
36. It was declared open by the Prince of Wales in 1865; the whole system took a further ten years to finish.
37. Two stations at Victoria in 1860–1, one for the London, Brighton and South Coast Railway, the other for the London, Chatham and Dover; Charing Cross Station in 1864 and Cannon Street Station in 1866, both for the South Eastern Railway; and Broad Street Station in 1865 for the North London Railway.
38. Jack Simmons, *St Pancras Station* (London, 1968), p. 61.
39. 'Royal Albert Hall', *Museums Area*, p. 190.
40. *Builder*, vol. 24 (1866), p. 342.
41. Edwin Clark, *The Britannia and Conway Tubular Bridges* (1850); see R. J. M. Sutherland, 'The Introduction of Structural Wrought Iron', *Transactions of the Newcomen Society*, vol. 36 (1963–4), pp. 67–84.

Chapter Five

Acknowledgements
I am very grateful for the facilities and assistance given to me by the following institutions and their staff: Royal Archives, Windsor, particularly Sheila de Bellaigue, Pamela Clark and Frances Dimond; Department of Western Manuscripts, British Library; Conway Library, Courtauld Institute of Art, University of London; The Library of the Henry Moore Institute, Leeds, especially Denise Raine and Adeline van Roon; the Leeds Library; and Leeds City Art Library. I am very grateful also to Dr Ken Hay, Department of Fine Art, University of Leeds, for departmental assistance towards the cost of getting photographs; to many students and friends; to M. Carl Hedengren for his hospitality and information on Baron Marochetti; lastly in particular to those scholars and friends who generously gave much of their time, sympathy and expertise: Dr Martin Greenwood, Emma Hardy (of the Victoria and Albert Museum), Michael Paraskos (University College, Scarborough) and Dr Philip Ward-Jackson (Conway Library, Courtauld Institute of Art, University of London).

1. Charles Handley-Read, 'The Albert Memorial Reassessed', *Country Life*, vol. 130 (1961), pp. 1514–16, and Benedict Read, *Victorian Sculpture* (New Haven and London, 1982), *passim*.
2. 'Albert Memorial', *The Survey of London*, vol. 38, *The Museums Area of South Kensington and Westminster* (London, 1975), pp. 149, 168–9.
3. See Read, *Victorian Sculpture*, p. 13.
4. *Art Journal* (1864), p. 315.
5. *Art Journal* (1865), p. 87.
6. *Art Journal* (1871), p. 28 on Bell's *America*.
7. *Art Journal* (1871), p. 88 on Calder Marshall's *Agriculture*.
8. *Art Journal* (1871), p. 144 on Lawlor's *Engineering*.
9. *Art Journal* (1871), p. 168 on Foley's *Asia*.
10. *Times*, 17 January 1862.
11. *Times*, 22 February 1862.
12. *Times*, 15 February 1862.
13. Royal Archives, Windsor, 'Queen Victoria's Journal', 5 December 1864 ; the entry was occasioned by Victoria's inspection of the models prepared for the Memorial's statuary groups.
14. RA, Add H2, 107.
15. RA, Add HI, 8–9.
16. RA, Add HI, 10.
17. RA, Add H2, 110.
18. The outstanding account of Eastlake's life and work is D. Robertson, *Sir Charles Eastlake and the Victorian Art World* (Princeton and Guildford, 1978). See also Sir C. L. Eastlake, *Contributions to the Literature of the Fine Arts – Second Series, with a Memoir compiled by Lady Eastlake* (London 1870). Excellent though both are in their different ways, neither features Eastlake's work on the Albert Memorial; this has to be traced in his own papers on the subject, donated by Lady Eastlake to the Royal Archives, and the official papers there.
19. Eastlake, *Contributions*, p. 187.
20. A. H. Layard, 'Eastlake and Gibson', *The Edinburgh Review* (April 1870), pp. 409–10.
21. RA, Add H2, 177.
22. The invitation apparently came from the Queen rather than the Committee; see RA, Add H2, pp. 184–5, and *The National Memorial to His Royal Highness the Prince Consort* (London, 1873), p. 6.
23. *National Memorial*, pp. 7–8.
24. RA, Add H2, 200.
25. RA, Add H2, 118.
26. RA, Add H2, 216.
27. RA, Add H2, 222.
28. *National Memorial*, p. 10; *Art Journal* (1862), p. 190.
29. *National Memorial*, pp. 12–13.
30. 'Albert Memorial', *Museums Area*, p. 150.
31. RA, Add H2, 436.
32. RA, Add H2, 351.
33. RA, Add H2, 436, p. 5.
34. *National Memorial*, pp. 15–16.
35. RA, Add H2, 436, p. 5.
36. RA, Add H2, 436, p. 6; see also the manuscript copy of Scott's text, G. Fisher, G. Stamp, *et al.*, *The Scott Family. Catalogue of the Drawings Collection of the Royal Institute of British Architects* (Farnborough, 1982), RIBA Notebook 23.
37. RA, Add H2, 509.
38. RA, Add H2, 489.
39. RA, Add H2, 501.
40. RA, Add H2, 506.
41. RA, Add H2, 737.
42. RA, Add H2, 743, 763.
43. RA, Add H2, 746.
44. *National Memorial*, pp. 42–3; see also Emma Hardy, 'Farmer and Brindley Craftsman Sculptors 1850–1930', *Victorian Society Annual* (1993), pp. 4–17.
45. RA, Add H2, 1892.
46. *National Memorial*, p. 43.
47. Joan Brocklebank, *Victorian Stone Carvers in Dorset Churches 1856–1880* (Stanbridge, 1979), pp. 19, 41, 66.
48. George Gilbert Scott, *Personal and Professional Recollections* (London, 1879); ed., Gavin Stamp (Stamford, 1995), p. 265.
49. Charles Locke Eastlake, *A History of the Gothic Revival* (London, 1872); ed., J. Mordaunt Crook (Leicester, 1970), pp. 306, <102>; the original designs are in the Armstead Albums, Royal Academy of Arts, London.
50. See Emma Hardy's unpublished typescript, 'James Frank Redfern and George Gilbert Scott's Restoration of the West Front of Salisbury Cathedral' (1996).
51. C. W. Armstead, *Henry Hugh Armstead R.A.* (London, n. d.) [1906], p. 3.
52. Lord E. Gleichen, *London's Open-Air Statuary* (London, 1928), p. 38.
53. Charles Grey to Charles Eastlake, 15 March 1864, RA, Add H2, 785–6.
54. For Victoria and Albert as patrons of sculpture see Read, *Victorian Sculpture*, pp. 130–9.
55. See F. K. Hunt, *The Book of Art, Cartoons, Frescoes, Sculpture and Decorative Art as Applied to the New Houses of Parliament* (London, 1846); T. S. R. Boase, 'The Decoration of the New Palace of Westminster, 1841–1863', *Journal of the Warburg and Courtauld Institutes*, vol. 17 (1954), especially pp. 331, 340; Read, *Victorian Sculpture*, pp. 84, 120–121.
56. Rupert Gunnis, *Dictionary of British Sculptors 1660–1851*, revised edn (London, n. d.) [1964], p. 235.
57. A patron's misunderstanding of the terms of a commission had landed the blameless Foley in court in 1849; see Read, *Victorian Sculpture*, p. 59.
58. See John Physick, *The Wellington Monument* (London, 1970), and Read, *Victorian Sculpture*, pp. 84–5, 93–5.

59. See H. M. Colvin, ed., *The History of the King's Works*, 6 vols, vol. 6, *1782–1851*, by J. Mordaunt Crook and M. H. Port (London, 1973), pp. 492–4.
60. Quoted in R. Shannon, *Gladstone: Peel's Inheritor 1809–1865* (1982); paperback edn (Harmondsworth, 1999), p. 491.
61. RA, Add H2, 787.
62. RA, Add H2, 788–93.
63. RA, Add H2, 794.
64. RA, Add H2, 796–7.
65. RA, Add H12, D.
66. RA, Add H2, 365.
67. RA, Add H2, 739.
68. RA, Add H2, 1086–7.
69. RA, Add H2, 739, 749, 784.
70. RA, Add H2, 787.
71. RA, Add H2, 833, 871, 877, 982, 983.
72. RA, Add H12, D aggregates these negotiations.
73. RA, Add H2, 798.
74. RA, Add H2, 877–8.
75. RA, Add H2, 954.
76. RA, Add H2, 944.
77. RA, Add H2, 1016–7.
78. RA, Add H2, 1087–8.
79. RA, Add H2, 1095.
80. RA, Add H2, 1246–7.
81. Eastlake, *Contributions*, p. 192.
82. RA, Add H2, 1094.
83. BM Add *MSS*, 38992, ff. 164–5.
84. See Austen Henry Layard, *Autobiography and Letters*, 2 vols (London, 1903); G. Waterfield, *Layard of Nineveh* (London 1965); G. Waterfield, 'Henry Layard: Nineteenth–Century Aesthete', *Apollo* (March 1966), pp. 166–73; J. M. Russell, *From Nineveh to New York* (New Haven and London, 1997). Many of Layard's papers are deposited in the Department of Western Manuscripts, British Library.
85. BM Add *MSS* 38992, f. 203.
86. BM Add *MSS* 38992, f. 220.
87. BM Add *MSS* 38992, ff. 286, 305, 275.
88. BM Add *MSS* 38993, ff. 52, 118.
89. BM Add *MSS* 38993, ff. 146–7.
90. BM Add *MSS* 38993, ff. 170–1.
91. RA, Add H2, 1733.
92. BM Add *MSS* 38992, ff. 214, 221.
93. BM Add *MSS* 38992, ff. 244–6.
94. BM Add *MSS* 38992, ff. 246–9.
95. BM Add *MSS* 38992, ff. 267–70.
96. BM Add *MSS* 38993, ff. 52–3.
97. BM Add *MSS* 38994, f. 288.
98. C. E. Halle, *Notes from a Painter's Life* (London, 1909), pp. 7–8.
99. BM Add *MSS* 38992, ff. 236–7.
100. BM Add *MSS* 38993, ff. 9–11.
101. *Gazette des Tribunaux*, 4 September 1847, 18 September 1847.
102. BM Add *MSS* 38993, ff. 9–11.
103. BM Add *MSS* 38993, f. 290. The model was in a small room because Marochetti's large main studio was at this date still occupied by the lions for the *Nelson Memorial* that Landseer was modelling there, with Marochetti assisting in the bronze casting. It thus seems likely that Marochetti himself had been unable to get an adequate sense of the scale of the model of Albert, which was not moved to the principal studio until the end of February 1867.
104. BM Add *MSS* 38993, f. 344.
105. BM Add *MSS* 38993, ff. 356–9.
106. BM Add *MSS* 38993, f. 379.
107. BM Add *MSS* 38993, ff. 388–9.
108. BM Add *MSS* 38993, f. 408.
109. BM Add *MSS* 38994, f. 11.
110. BM Add *MSS* 38994, f. 26.
111. BM Add *MSS* 38994, f. 46.
112. BM Add *MSS* 38994, f. 52.
113. BM Add *MSS* 38994, ff. 61–4.
114. BM Add *MSS* 38994, ff. 69–71.
115. BM Add *MSS* 38994, f. 77.
116. BM Add *MSS* 38994, ff. 161–5.
117. BM Add *MSS* 38994, f. 174.
118. BM Add *MSS* 38994, ff. 251–7.
119. BM Add *MSS* 38994, ff. 267–8.
120. BM Add *MSS* 38994, ff. 287–9.
121. BM Add *MSS* 38994, f. 301.
122. I am grateful to M. Carl Hedengren, Marochetti's descendant, for this information.
123. BM Add *MSS* 38995, f. 1.
124. BM Add *MSS* 38995, f. 5.
125. BM Add *MSS* 38995, ff. 1–5.
126. BM Add *MSS* 38995, f. 5.
127. RA, Add H2, 2431.
128. BM Add *MSS* 38995, ff. 6–7.
129. RA, Add H2, 2430, 2436.
130. BM Add *MSS* 38995, ff. 75–6, 109–10, 153–4, 161, 177–8.
131. BM Add *MSS* 38995, ff. 27–8.
132. For Newton's work as an archaeologist, scholar and curator see I. Jenkins, *Archaeologists and Aesthetes in the Sculpture Galleries of the British Museum 1800–1939* (London 1992); for his friendship with Watts see M. S. Watts, *George Frederic Watts. The Annals of An Artist's Life* (London, 1912), and I. Jenkins, 'G. F. Watts' Teachers: G. F. Watts and the Elgin Marbles', *Apollo* (September 1984), pp. 176–81.
133. RA, Add H2, 2436, 2438, 2451.
134. RA, Add H2, 2462.
135. RA, *Queen Victoria's Journal*, 31 March 1868.
136. BM Add *MSS* 38995, ff. 141–2, 145, 159, 162.
137. BM Add *MSS* 38995, ff. 164–5.
138. BM Add *MSS* 38995, ff. 196–201, 205.
139. BM Add *MSS* 38995, ff. 290–1.
140. BM Add *MSS* 38995, f. 348.
141. RA, Add H2, 1772, 1775, 1808, 1896, 2334.
142. BM Add *MSS* 38994, f. 345.
143. BM Add *MSS* 38995, f. 204.
144. BM Add *MSS* 38994, f. 414.
145. RA, Add H2, 2140.
146. BM Add *MSS* 38996, ff. 80–8.
147. As Chief Secretary to the Treasury, Ayrton had so fallen out with the Chancellor of the Exchequer, Robert Lowe, that the Department's business was virtually at a standstill, and he was too dangerous simply to be moved to the backbenches.
148. See his letter of resignation to Gladstone, BM Add *MSS* 38997, ff. 15–16.
149. BM Add *MSS* 38997, ff. 45–6.
150. RA, Add H2, 2819.
151. BM Add *MSS* 38997, f. 71.
152. BM Add *MSS* 38997, f. 167.
153. See Physick, *Wellington Monument*, p. 74ff.
154. RA, Add H2, 2820.
155. BM Add *MSS* 38997, f. 56.
156. RA, Add H2, 3041.
157. RA, Add H2, 3395.
158. RA, Add H2, 3775.
159. RA, Add H2, 3828.
160. RA, Add H2, 4250.
161. RA, Add H2, 4251.
162. RA, Add H2, 4285.
163. RA, Add H2, 4314.
164. RA, Add H2, 4305.
165. RA, Add H2, 4318.
166. S. A[tkinson], *Arts and Industries in Ireland: 1. John Henry Foley, RA. A Sketch of the Life and Works of the Sculptor of the O'Connell Monument* (Dublin, 1882), p. 34.
167. See *Art Journal* (1870), p. 354.
168. RA, Add H2, 4451.
169. 'Mr Foley … seems to have kept his papers in all sorts of places, [and] may have put the contract in some corner'; RA, Add H2, 4475.
170. For which see Read, *Victorian Sculpture*, pp. 371–9, and John Plunkett, 'Remembering Victoria', *The Victorian*, no. 1 (August 1999), pp. 4–9.
171. RA, Add H2, 4477. For a fuller account of Brock's work on the figure of Albert see J. Sankey, 'Thomas Brock and the Albert Memorial', *The Sculpture Journal*, vol. 3 (1999), pp. 87–92.
172. RA, Add H2, 4488–9.
173. RA, Add H2, 4498.
174. RA, Add H2, 4519.
175. RA, Add H2, 4520.
176. RA, Add H2, 4620.
177. Scott, *Recollections*, pp. 262–6.
178. RA, Add H2, 798.
179. RA, Add H2, 1085.
180. Scott, *Recollections*, p. 266.
181. *Art Journal* (1866), pp. 202–3.
182. Read, *Victorian Sculpture*, p. 117.
183. See Stephen Bayley, *The Albert Memorial. The monument in its social and architectural context* (London, 1981; paperback edn, London, 1983), p. 20.
184. RA, Add H2, 206, and *Illustrated London News*, vol. 19, 7 June 1851, 14 June 1851.
185. S. Lami, *Dictionnaire des Sculpteurs de L'École Français au XIX siècle* (Paris, 1921), vol. 4, p. 159.

186. See F. M. de Lepinay, 'Geoffroy-Dechaume et la restauration de la sculpture de Notre-Dame de Paris', in *De Platre et d'Or*, exhibition catalogue, Musée d'art et d'histoire Louis Senlecq (L'Isle-Adam, 1998–9), p. 160.

187. *Art Journal* (1865), p. 87.

188. *Art Journal* (1868), pp. 239–40.

189. *Art Journal* (1865), p. 88.

190. *Art Journal* (1871), p. 144.

191. *Art Journal* (1871), p. 168.

192. Read, *Victorian Sculpture*, p. 199.

193. *Art Journal* (1865), p. 87.

194. See Hunt, *The Book of Art … as Applied to the new Houses of Parliament*.

195. See particularly the *Third Report of the Commissioners on the Fine Arts* (1844), pp. 11–14, and the *Fourth Report* (1845), p. 7ff., which proposes that the statues in the Royal Robing Room 'might consist of allegorical figures'.

196. RA, Add H2, 798–800.

197. *Art Journal* (1871).

198. *Art Journal* (1872), p. 216.

199. Edmund Gosse, 'The Future of Sculpture in London', *The Magazine of Art*, vol. 4 (1881), p. 282.

200. The movement started in Britain following the death of Sir Robert Peel in 1850; see Read, *Victorian Sculpture*, p. 107. Some recent accounts have claimed the movement began in 1870s France; see M. Agulhon, 'La "statuomanie" et l'histoire', *Histoire vagabond* (Paris, 1988), p. 137ff., and S. Michalski, *Public Monuments: Art in Political Bondage 1870–1997* (London, 1998), pp. 8–9.

201. Scott, *Recollections*, pp. 269–70.

Chapter Six

1. James Dafforne, *The Albert Memorial in Hyde Park: Its History and Description* (London, 1878). Dafforne establishes his credentials on the title page by announcing himself as the author of 'Pictures' by J. M. W. Turner and 'Pictures by Sir Edwin Landseer'.

2. *Handbook to the Prince Consort National Memorial* (London, 1872), 25th impression (London, 1924); it was published 'by authority of the Executive Committee'.

3. Dafforne, *Albert Memorial*, p.44; Dafforne's words here are taken almost verbatim from Foley's description of the statue, quoted in the *Handbook*, p. 88.

4. See Elisabeth Darby and Nicola Smith, *The Cult of the Prince Consort* (New Haven and London, 1983), pp. 67–70, 74–6.

5. RA, Add H2, 798.

6. The words are quoted as Foley's in 'Albert Memorial', *Survey of London*, vol. 38, *The Museums Area of South Kensington and Westminster* (London, 1975), p. 162; they originate in Layard's correspondence, BM Add *MSS* 38995, f. 348.

7. Mark Girouard, 'Victorian Values and the Upper Classes', T. C. Smout, ed., *Victorian Values* (Oxford, 1992), p. 51.

8. His memorial statue in the robes of Chancellor of the University still stands forlornly by a carp pond in a remote corner of the grounds of Madingly Hall.

9. For a full account of the widespread movement to commemorate Prince Albert, see Darby and Smith, *Cult of the Prince Consort*.

10. Dafforne, *Albert Memorial*, p. 31.

11. For a convenient discussion of the complicated issue of church attendance in the period see the 'Introduction' to Chris Brooks and Andrew Saint, eds, *The Victorian church. Architecture and society* (Manchester, 1995), pp.1–29.

12. *Handbook*, p. 22.

13. Mrs [Anna] Jameson, *Sacred and Legendary Art*, 2 vols. (London, 1848); the work had reached a sixth edition by 1870.

14. First Epistle to the Corinthians, xiii, 13.

15. Geoffrey Best, *Mid Victorian Britain* (London, 1979), p. 240, gives a figure of 34.4 gallons of beer consumed per annum for each individual of the population in 1876, 1.3 gallons of spirits per head in 1875, and 0.53 gallons of wine at about the same time.

16. Matthew, x, 16.

17. For a full account of which see Mark Girouard, *The Return to Camelot. Chivalry and the English Gentleman* (New Haven and London, 1981).

18. Kenelm Henry Digby *The Broad Stone of Honour or Rules for the Gentlemen of England*. Second edition subtitled *The True Sense and Practice of Chivalry* (1828–9 and 1844–8).

19. The ideology of chivalry was intrinsic to the whole revival of gothic; see Chris Brooks, *The Gothic Revival* (London, 1999), chapters 6 and 7.

20. The argument took place at the meeting of the British Association of Science in Oxford in June 1860, Darwin's *Origin of the Species* was published in 1859. By 1871, when *The Descent of Man* was published, evolution was generally tolerated as an explanation of the natural world.

21. The Natural History Museum, to the designs of Alfred Waterhouse, was only begun in 1873, and not opened until 1881. However, it was in 1860 that the Trustees of the British Museum had accepted the idea of a new specialist museum, which they decided should be located on the South Kensington Estate purchased by the Commissioners of the 1851 Exhibition.

22. Dafforne, for instance, gives just three lines to the figures of the *Sciences* (*Albert Memorial*, p. 40), where other groups merit one or more pages each.

23. Armstead's *Astronomy* was exhibited in 1868; Algernon Graves, Royal Academy Exhibitors (London, 1905), vol. 1, p. 62.

24. See Benjamin Waterhouse Hawkins' 1854 reconstructions of dinosaurs in the Crystal Palace Park, Sydenham.

25. Dafforne, *Albert Memorial*, p. 54.

26. Quoted in Dafforne, *Albert Memorial*, p. 53.

27. Dafforne, *Albert Memorial*, p. 56; as too the preceding quotations.

28. Named after the French sculptor and potter, Bernard Palissy (1509–89), who appears in his own right in the *Sculptors* frieze of the Memorial.

29. Geoffrey Best, *Mid Victorian Britain*, London 1979, p. 132.

30. The figures are Charles Booth's, quoted in Best, *Mid Victorian Britain*, pp.130–1. In fact child employment in most industries peaked in 1861, but the 1860s saw a huge increase of children in domestic service and retailing, with some increase also in textiles. There was a slight decline of child labour in the pottery industry.

31. Dafforne, *Albert Memorial*, p. 58.

32. Dafforne, *Albert Memorial*, p. 60.

33. Dafforne, *Albert Memorial*, p. 60.

34. Dafforne is quoting here, though he does not say from whom; *Albert Memorial*, p. 67.

35. Albert himself organised the cataloguing of the Raphael Drawings in the Royal Collection, which – revealingly enough – made use of the most progressive technique for reproducing artworks, photography; see Frances Dimond and Roger Taylor, *Crown and Camera. The Royal Family and Photography 1842–1910* (Harmondsworth, 1987), pp. 44–9.

36. The full title is as extraordinary as the painting: *Cimabue's Celebrated Madonna is Carried in Procession through the Streets of Florence; in front of the Madonna, and crowned with laurels, walks Cimabue himself, with his pupil Giotto; behind it Arnolfo di Lapo, Gaddo Gaddi, Andrea Tafi, Niccola Pisano, Buffalmacco, and Simone Memmi; in the corner Dante*. Of this galaxy, Cimabue, Giotto, Arnolfo, Pisano, and Dante are all represented on the Albert Memorial.

37. See Francis Haskell, *Rediscoveries in Art* (London, 1976), pp. 13–17.

38. Dafforne, *Albert Memorial*, p. 68.

39. It may be that the date of the Memorial's design fell unluckily for Wordsworth's memory. There was considerable commemorative enthusiasm in the years immediately following his death in 1850, but then a comparative lull before the late 1870s, when scholars and publishers prompted a strong revival of interest in his work. For the whole subject, see Stephen Gill, *Wordsworth and the Victorians* (Oxford, 1998).

40. As Gavin Stamp describes in chapter three, Palgrave also published an attack upon Scott's design for the Memorial; it is not known what he thought of the selection of poets on the frieze.

41. George Scharf, writing in the *Handbook to the Paintings by Ancient Masters* (Manchester, 1857), which accompanied the Manchester Art Treasures Exhibition with which Albert was associated, said: 'the taste for studying the history of early Italian art is not a recent development in our country alone;

it is a novelty even in Italy itself'. Quoted in Ulrich Finke, 'The Art-Treasures Exhibition', in J. H. G. Archer, ed., *Art and Architecture in Nineteenth Century Manchester* (Manchester, 1985), p. 119.

42. Though Albert was a sufficiently accomplished musician to compose songs and religious pieces, to preside as Director of The Antient Concerts, and to busy himself reorganising the royal band in the 1840s. See Theodore Martin, *The Life of His Royal Highness the Prince Consort*, 5 vols (1875–80), vol. 1, pp. 485–501, 'Memorandum as to the Influence of H. R. H. The Prince Consort upon Musical Taste in England'.

43. Dafforne, *Albert Memorial*, p. 67.

44. Though acquired for the nation before Victoria's reign began, the redisplay of the marbles, with the famous frieze protected behind glass, was actually in progress in the years the Albert Memorial was being constructed, and was completed in 1873.

45. Polykleitos of Argos (*fl.* 450–405 *BCE*) was famous in antiquity for his authorship of the sculptors' workshop manual known as the canon. In nineteenth-century Britain his output was represented by the so-called 'Westmacott athlete' in the British Museum. His most famous works are known only from Roman copies, many of which were not excavated until after the Albert Memorial was built.

46. *Handbook*, p. 74.

47. *Handbook*, p. 73.

48. Dafforne, *Albert Memorial*, p. 61.

49. Dafforne, *Albert Memorial*, p. 61, as also the preceding quotation.

50. The writing and publication of *Modern Painters* were alike protracted: volume 1 appeared in 1843, volume 2 in 1846, volumes 3 and 4 in 1856, volume 5 in 1860. Ruskin's pre-eminence in Victorian art criticism was formally recognised in 1870 when he became first Slade Professor of Fine Art at Oxford.

51. See John Ruskin, *The Stones of Venice*, 3 vols (London, 1851–3), vol. 2, chapter 6, 'The Nature of Gothic'.

52. The motto of The Cambridge Camden Society, later The Ecclesiological Society, which was so influential on Scott's whole development, was *Donec templa refeceris*.

53. '[I]n their highest possible relative degrees, they exist, so far as I know, only in one building in the world, the Campanile of Giotto in Florence'; John Ruskin, *The Seven Lamps of Architecture* (London, 1849), chapter 4, section 43.

54. The Raja Bhai Tower, Mumbai [Bombay] (1868–78), forms the centrepiece of the array of public buildings in the gothic style that Sir Bartle Frere commissioned as an attempt to make Mumbai *Urbs Prima in Indis*.

55. The identities of many more than were known to the nineteenth century have been unearthed by modern scholarship; see particularly John Harvey, *English Mediaeval Architects. A Biographical Dictionary down to 1550*, revised edn (Gloucester, 1984).

56. Dafforne, *Albert Memorial*, p. 70.

57. Royal Archives, Windsor, Add H2, 26; quoted in Stephen Bayley, *The Albert Memorial. The monument in its social and architectural context* (London, 1981; paperback edn, London, 1983), p. 100.

58. *The Illustrated Exhibitor: A Tribute to the World's Jubilee* (London, 1851), p. 74.

59. Anthony Trollope, *Australia*, 2 vols (London, 1873); he visited the country in 1871.

60. Dafforne, *Albert Memorial*, p. 45.

61. Dafforne, *Albert Memorial*, p. 45.

62. Dafforne, *Albert Memorial*, pp. 45–6.

63. *Handbook*, p. 28.

64. *Handbook*, p. 28; Dafforne is careful to point out that the four are not allegorical figures but national portraits, an indication of the growing – and often contentious – Victorian interest in anthropology.

65. Dafforne, *Albert Memorial*, p. 50.

66. Dafforne, *Albert Memorial*, p. 50.

67. *Handbook*, p. 28.

68. Though the Memorial was erected before the beginning of the so-called 'Scramble for Africa', the rapacious carving-up of the continent by the European powers.

69. *Handbook*, p. 29.

70. Dafforne, *Albert Memorial*, p. 51.

71. In the risings caused by the building of the Powder River Road the Sioux went on the warpath in 1862 and 1865, trapping and killing 80 US soldiers at Fort Phil Kerany in 1866. The second treaty of Fort Laramie, 1868, acknowledged Sioux control of South Dakota west of the Mississippi. The final end of Sioux resistance did not come until the battle of Wounded Knee in 1890.

72. RA, Add H2, 917–18.

73. In 1872 Britain was pronounced legally liable to the tune of $15 million.

74. Dafforne, *Albert Memorial*, p. 51.

75. The town of Fray Bentos, in modern Uruguay, is known to the west as a trade name for corned beef: founded in 1859, it acquired its first major meat packing plant in 1861.

Chapter Seven

Acknowledgements

My principal debt of gratitude is to Maureen Bourne, who generously allowed me to make use of her MA dissertation on Skidmore's career, up to and including the Oxford Museum (Department of the History of Art, University of Warwick), and gave me much additional help. Duncan Wilson (of Peter Inskip and Peter Jenkins, Architects), and Andy Mitchell have helped me with information gleaned during the restoration. Others who have assisted include: Marian Campbell of the Victoria and Albert Museum; Joy Court of the Coventry Central Library; Lady de Bellaigue and the staff of the Royal Archives; Dr Edward Diestelkamp; Dr Christopher Hammond; Robert Thorne; Dr Christopher Wilson.

1. Royal Archives, Windsor, Add H4, 5.

2. RA, Add H4, 22.

3. Details of Skidmore's life are taken from Maureen Bourne's dissertation. Obituaries were published in the *Coventry Times*, 18 November 1896; *Coventry Herald*, 20 November 1896; *Coventry Standard*, 20 and 27 November 1896; *Builder*, vol. 71 (1896), p. 430.

4. *Coventry Herald*, 20 November 1896.

5. Ann Eatwell and Anthony North, 'Metalwork', in Paul Atterbury and Clive Wainwright, eds, *Pugin: A Gothic Passion* (New Haven and London, 1994), pp. 172–84.

6. Eatwell and North, 'Metalwork', p. 177.

7. *Coventry Standard*, 27 November 1896.

8. Bourne, p. 10.

9. Eatwell and North, 'Metalwork', pp. 175–6.

10. Bourne, pp. 15–18.

11. Bourne, p. 10.

12. Matthew Digby Wyatt, *Industrial Arts of the Nineteenth Century* (London, 1851), pl. 41; see also *Great Exhibition of the Works of Industry of all Nations: Official Descriptive and Illustrated Catalogue*, 5 vols (London, 1851), vol. 2, p. 694, no. 129. Skidmore acted as local secretary for the Exhibition Committee (*Coventry Standard*, 1 March 1851; Coventry Local Record Office 180/26/2). His exhibits were favourably noticed in the *Ecclesiologist*, New Series vol. 9 (1851), pp. 184–5. A silver-gilt chalice with champlevé enamels, shown at the Exhibition and purchased by the Victoria and Albert Museum in 1852, is illustrated in Simon Jervis, *High Victorian Design* (National Gallery of Canada, 1974), p. 254. References from Bourne, pp. 28–9.

13. *Oxford Architectural Society Reports of Meetings* (1851–3), pp. 73, 77.

14. *OAS Reports* (1853–6), pp. 34–5; see also, *Ecclesiologist*, New Series vol. 12 (1854), p. 124; for Skidmore's revival of enamelling see *Art Journal* (1850), p. 102.

15. *OAS Reports* (1853–6), pp. 37–9; see also, *Ecclesiologist*, New Series vol. 12 (1854), pp. 126–8.

16. W. R. W. Stephens, *Life and Letters of Walter Farquhar Hook*, 2 vols (London, 1878), vol. 1, p. 170.

17. *Coventry Standard*, 7 May 1850.

18. *Coventry Standard*, 13 January 1851.

19. *OAS Reports* (1853–6), p. 107; the restoration of the church was by Scott.

20. *Builder*, vol. 12 (1854), p. 486; *Ecclesiologist*, New Series vol. 12 (1854), pp. 346–52.

21. Paul Thompson, *William Butterfield* (London, 1971), p. 501.

22. *OAS Reports* (1853–6), p. 107.

23. David Cole, *The Work of Sir George Gilbert Scott* (London, 1980), pp. 62, 192n.
24. *Sir Gilbert Scott (1811–1878): Architect of the Gothic Revival* (Victoria and Albert Museum, 1978), no. 32h. Maureen Bourne has discovered that in January 1853 Scott wrote to support Skidmore's application for admission to the Manuscript Room of the British Museum.
25. Cole, *Scott*, p. 83.
26. Colin Cunningham and Prudence Waterhouse, *Alfred Waterhouse* (Oxford, 1992), p. 208.
27. *Ecclesiologist*, New Series vol. 14 (1856), pp. 221, 333–8; Skidmore's paper was specifically praised by Scott in *Remarks on Secular and Domestic Architecture* (London, 1857), p. 110.
28. *Instrumenta Ecclesiastica*, 2nd Series (London, 1856), pls 67–72.
29. Skidmore's enthusiastic letter, dated 10 March 1856, was published in the caption to pl. 72 in *Instrumenta*.
30. *Coventry Standard*, 20 November 1896; *Coventry Times*, 18 November 1896.
31. *Coventry Standard*, 20 November 1896.
32. Information from Maureen Bourne.
33. Much has been published on the Oxford University Museum, but the best account is in Frederick O'Dwyer, *The Architecture of Deane and Woodward* (Cork, 1997), pp. 152–283; all references will be found there.
34. O'Dwyer, *Deane and Woodward*, p. 258.
35. Illustrated, O'Dwyer, *Deane and Woodward*, p. 262.
36. E. T. Cook and A. Wedderburn, eds., *The Complete Works of John Ruskin*, 38 vols (London, 1903–9), vol. 16, p. xlvi.
37. *Remarks on Secular and Domestic Architecture*, p. 109. Maureen Bourne (p. 52) suggests that Skidmore may also have been influenced in his preference for wrought iron by the fact that he would have found it difficult at this time to provide cast iron, whereas wrought iron tubes were readily available from Birmingham.
38. Woodward also asked Skidmore to estimate for providing grates, to Woodward's design, for the Curator's House. The exquisite door furniture of the Museum bears further witness to Skidmore's skill. For praise of his achievement at Oxford, see *Building News*, vol. 5 (1859), p. 338; *Builder*, vol. 17 (1859), p. 401; for criticism, see G. R. Burnell in *The Record of the International 1862 Exhibition* (Glasgow, 1862), p. 200.
39. For example, substantial repairs were carried out in 1876, advice being sought from W. Froude, H. M. Brunel, and Captain Douglas Galton.
40. *Building News*, vol. 6 (1860), p. 273. The University Museum Archives contains two anguished letters from Skidmore dated 17 and 18 March 1859, in which he protests about the painting contract being given to someone whose estimate was lower: he considered it essential that 'the colouring should agree with the arches'.
41. *OAS Reports* (1856–9), p. 55.
42. Letter to Rev. R. St John Tyrwhitt, quoted in Michael W. Brooks, *John Ruskin and Victorian Architecture* (New Brunswick and London, 1989), pp. 127–8.
43. *Coventry Herald*, 20 November 1896. According to the *Coventry Standard*, 27 November 1896, he had intended to show how large workshops could be erected entirely of iron, but could not wait long enough to accomplish this.
44. There is a copy of the company prospectus in the Guildhall Library, London. It contains testimonials by Joseph Phillips and Henry B. Carling, which give useful information about the works and business.
45. Cunningham and Waterhouse, *Alfred Waterhouse*, p. 165.
46. *OAS Reports* (1856–9), pp. 53–4; *Building News*, vol. 5 (1859), p. 295. He had also read a paper 'on metalwork' at the General Architectural Congress in Oxford on 10 June 1858, *OAS Reports* (1856–9), p. 36.
47. Dr Christopher Wilson comments, 'The argument is nonsense'; although it is true that *c.*1200 'the metalwork architecture of shrines did influence full-scale stone architecture: Gothic owes the idea of gablets with crockets and finials to (Mosan) ironwork.' Parker 'was presumably caught on the hop ... I suppose Skidmore felt that he had to come up with something academic-sounding to bamboozle pedantic cavilling about what is artistically a brilliant concept.'
48. A. B. Clifton, *The Cathedral Church of Lichfield* (London, 1900), p. 84; see also p. 64; and see George Gilbert Scott, *Personal and Professional Recollections* (London, 1879); ed., Gavin Stamp (Stamford, 1995), p. 216.
49. *International Exhibition 1862: Official Catalogue of the Industrial Department*, 3rd edn (London, 1862), p. xv and p. 97, no. 6345; see also; J. B. Waring, *Masterpieces of Industrial Art and Sculpture at the International Exhibition* (London, 1863), vol. 2, pl. 112.
50. *Builder*, vol. 20 (1862), pp. 329–30; *International Exhibition 1862: Reports by the Jurors* (London, 1863), pp. 9, 18; Alan Baxter and Associates, Report on the Hereford Screen for the Victoria and Albert Museum (1998); Chris Miele, *Country Life*, 14 January 1999, pp. 36–7.
51. Scott, *Recollections*, p. 216.
52. Christopher Dresser, *The Development of Ornamental Art in the International Exhibition* (London, 1862), p. 152.
53. *Builder*, vol. 20 (1862), p. 330.
54. *Illustrated London News*, 20 August 1862, vol. 41, p. 246. See also Charles Boutell in *The Art Journal Illustrated Catalogue of the International Exhibition* (London, 1862), pp. 202–4, and engravings of details p. 158.
55. Scott, *Recollections*, p. 291.
56. The screen was first taken to the Herbert Art Gallery in Coventry, but is now at the Victoria and Albert Museum, where it is hoped to restore and re-erect it by 2001.
57. *Illustrated Record and Descriptive Catalogue of the Dublin International Exhibition of 1865* (London, 1866), pp. 296, 307. Skidmore showed 'church plate; gas standards; panel of wrought iron screen, &c.'
58. Skidmore is listed as an Honorary Member, *c.*1866–9, after simply as a Member. The Club published sketches by its members (though none by Skidmore) in eight volumes, between 1866 and 1890.
59. See his obituary in *British Architect*, vol. 15 (1881), pp. 58–9. 'Examples of Metal Work designed by B. J. Talbert', *Building News*, vol. 12 (1866), p. 200, includes illustrations of two copper capitals – about whose 'propriety' the journal had doubts – an 'iron tomb canopy with railings &c.', and two alternative patterns for railings. Although the designs are very similar to those in Skidmore's catalogues, none is identical.
60. For the Bisley flagon see the exhibition catalogue, *Victorian Church Art* (Victoria and Albert Museum, 1971), p. 84. The Malvern clock is in the Victoria and Albert.
61. *Sir Gilbert Scott*, no. 24d.
62. *Sessional Papers of the RIBA* (1865), p. 28.
63. *Victorian Church Art*, p. 57; Skidmore also made the ironwork for the organ-front.
64. Scott, *Recollections*, ed., Stamp, p. 487.
65. The cross was 'only a fragment' of a 'vast candelabrum' which originally hung under the tower, removed because its heat damaged the organ; see C. Hyatt, *The Cathedral Church of Chester* (London, 1897), pp. 48–9, and Nikolaus Pevsner and Edward Hubbard, *Buildings of England: Cheshire* (Harmondsworth, 1971), p. 205. For the gates and rails see G. W. O. Addleshaw, *Architectural History*, vol. 14 (1971), pp. 94, 97.
66. Percy Dearmer, *The Cathedral Church of Oxford* (London, 1897), pp. 59, 74; Jennifer Sherwood and Nikolaus Pevsner, *Buildings of England: Oxfordshire* (Harmondsworth, 1974), p. 118.
67. Edward L. Cutts, *An Essay on Church Furniture and Decoration* (London, 1854), pp. 81 and 87, pl. 2.
68. For Brill's Baths, see *Civil Engineer and Architect's Journal*, vol. 29 (1866), pls. 37–8; for St Pancras, see Jack Simmons, *St Pancras Station* (London, 1968), pp. 55, 57.
69. Cole, *Scott*, p. 160.
70. See Cunningham and Waterhouse, *Waterhouse*, n. 26.
71. Pevsner and Hubbard, *Cheshire*, p. 210; see also *Coventry Times*, 18 November 1896, for anecdotes by John Jones.
72. Cunningham and Waterhouse, *Waterhouse*, p. 146.
73. *Coventry Herald*, 20 November 1896.
74. *Coventry Times*, 18 November 1896.
75. W. F. Buckingham, quoted in *Coventry Standard*, 20 November 1896.
76. *Coventry Standard*, 20 November 1896.
77. *Coventry Standard*, 20 November 1896.
78. *Building News*, vol. 6 (1860), p. 147.

79. *Coventry Times*, 18 November 1896.
80. Cunningham and Waterhouse, *Waterhouse*, p. 224.
81. *Art Journal* (1869), p. 225.
82. *Coventry Times*, 18 November 1896. An undated catalogue of the Skidmore firm in the Coventry Central Library (C & W 406 acc.1969), which contains mostly designs for domestic and ecclesiastical metalwork, including an astonishing diversity of gas-light fittings, also includes two pages of furniture.
83. David Meara, *Victorian Memorial Brasses* (London, 1983), p. 76.
84. John Gifford *et al.*, *Buildings of Scotland: Edinburgh* (Harmondsworth, 1984), p. 278.
85. Gifford *et al.*, *Edinburgh*, p. 365.
86. Elizabeth Williamson *et al.*, *Buildings of Scotland: Glasgow* (Harmondsworth, 1990), p. 210.
87. *Coventry Standard*, 20 November 1896.
88. *Coventry Herald*, 20 November 1896.
89. *Transactions of the RIBA* (1876–7), p. 225.
90. John Thomas Micklethwaite, *Modern Parish Churches* (London, 1874), pp. 49–50; Temple Moore, *Architectural Association Journal*, vol. 22 (1907), p. 36. In his *Occasional Notes on Church Furniture and Arrangement* (London, 1908), p. 50, Micklethwaite attacked 'spidery metal' screens.
91. Four sheets of engravings from this catalogue are in the author's possession. Interestingly, Hunter's Road in Birmingham was where John Hardman had lived.
92. *Coventry Standard*, 20 November 1896.
93. *Coventry Herald*, 20 November 1896.
94. *Coventry Times*, 18 November 1896.
95. *Coventry Standard*, 20 November 1896.
96. *Coventry Times*, 18 November 1896.
97. Scott, *Recollections*, p. 216.
98. Scott, *Recollections*, p. 264.
99. An editorial in the *Builder*, vol. 21 (1863), p. 361, appealed for donations of 'pietra dura, crystals, agates, cornelians, malachite, amethysts, porphyry of brilliant colours, and other objects of a similar kind'.
100. RA, Add H3, 132; this otherwise unidentified, four-page *MS* in the Royal Archives must surely be the 'description of the Memorial' to which Skidmore refers in a letter to Doyne Bell of 8 May 1871 (RA, Add H3, 129). Skidmore must have drafted it for the Committee's volume *The National Memorial to his Royal Highness The Prince Consort* (London, 1873). For the leadwork, see also Charles Boutell, *Art Journal* (1867), p. 14.
101. *Builder*, vol. 14 (1856), pp. 409–10, 418–20; *Ecclesiologist*, New Series vol. 14 (1856), pp. 384–97.
102. RA, Add H3, 132–3.
103. RA, Add H2, 741.
104. RA, Add H2, 744–5.
105. RA, Add H2, 751. On 12 March 1864, Henry Cole noted in his diary (National Art Library): 'Grey said Scott kicked at Kelk being ye Contractor !'
106. RA, Add H2, 1448.
107. RA, Add H2, 743; see also *National Memorial*, pp. 24–5.
108. RA, Add H2, 1465.
109. RA, Add H2, 1467.
110. RA, Add H2, 1482.
111. See *Survey of London*, vol. 38, *The Museums Area of South Kensington and Westminster* (London, 1975), p. 157.
112. RA, Add H2, 1534, 1536.
113. RA, Add H2, 1538.
114. RA, Add H2, 1539.
115. RA, Add H2, 1541–2.
116. RA, Add H2, 1543.
117. RA, Add H2, 1544–5.
118. RA, Add H2, 1551–2.
119. RA, Add H2, 1881.
120. RA, Add H2, 1882.
121. RA, Add H2, 1961.
122. RA, Add H2, 1981.
123. *Coventry Herald*, 20 November 1896.
124. I am most grateful to Dr Christopher Hammond, of the School of Materials in the University of Leeds, for assistance on these points.
125. Information kindly contributed by Duncan Wilson and Andy Mitchell.
126. *National Memorial*, p. 32.
127. *Art Journal* (1867), p. 13; Boutell was an expert on medieval brasses and other metalwork. According to the *Coventry Standard*, 20 November 1896, Skidmore's workforce at this period was augmented by 'distressed weavers', paid 8*s.* a week.
128. Skidmore also showed gold and silver plate and 'iron finials on gable and two dormers', *Paris Universal Exhibition 1867: Catalogue of the British Section* (London, 1867), III XXII 3, III XXI 6a, V XL 112, VI LXV 82; *Reports of Artisans selected by … the Society of Arts to visit the Paris Universal Exhibition* (London, 1867), pp. 327–8. Skidmore received an 'Honourable Mention' for his 'decorative ironwork'.
129. Friedrich Pecht, *Kunst und Kunstindustrie auf den Weltaustellung von 1867* (Leipzig, 1867), p. 311.
130. *Paris Universal Exhibition… Catalogue*, I IV 77.
131. RA, Add H2, 2318.
132. RA, Add H2, 2321.
133. RA, Add H2, 2322–4.
134. RA, Add H2, 2325.
135. RA, Add H2, 2327.
136. RA, Add H2, 2328.
137. RA, Add H2, 2330.
138. RA, Add H2, 2326.
139. RA, Add H2, 2332.
140. RA, Add H4, 22–3.
141. *National Memorial*, p. 33.
142. RA, Add H2, 2820.
143. *National Memorial*, p. 33.
144. RA, Add H2, 3307.
145. RA, Add H2, 3302–3.
146. See Cole, *Scott*, p. 128.
147. RA, Add H2, 3307.
148. RA, Add H2, 3302.
149. RA, Add H2, 3305–7.
150. RA, Add H2, 3399.
15.1 RA, Add H2, 3400.
152. RA, Add H2, 3403.
153. RA, Add H2, 3404.
154. RA, Add H2, 3501.
155. RA, Add H2, 3503–5.
156. RA, Add H2, 3510–22.
157. RA, Add H2, 3513.
158. RA, Add H2, 3520.
159. RA, Add H2, 3819.
160. RA, Add H5, *Minute Book of the Proceedings of the Committee*, p. 88 (24 April 1872); RA, Add H2, 3819. Skidmore had already had problems with the gilding of the wrought-iron railing around the Albert Memorial in Manchester (1863–6), which began to deteriorate almost at once; see Elisabeth Darby and Nicola Smith, *The Cult of the Prince Consort* (New Haven and London, 1983), p. 111, n. 44.
161. RA, Add H2, 3819, 3823.
162. RA, Add H2, 3510.
163. RA, Add H2, 3510, 3991–4.
164. RA, Add H5, 103.
165. RA, Add H2, 4222.
166. RA, Add H2, 4224.
167. RA, Add H2, 4225.
168. RA, Add H2, 4230.
169. RA, Add H2, 4237.
170. RA, Add H2, 4238, 4329.
171. Scott, *Recollections*, p. 265.
172. See n. 44 above.
173. *Ecclesiologist*, New Series vol. 13 (1855), p. 147; reprinted in Scott, *Secular and Domestic Architecture*, pp. 283–4.
174. *Art Journal* (1867), p. 14.

Chapter Eight

1. George Gilbert Scott, *Personal and Professional Recollections* (London, 1879); ed., Gavin Stamp (Stamford, 1995), p. 264.
2. See Scott, *Recollections*, p. 224.
3. George Gilbert Scott, *Retrospective Report on the National Memorial to His Royal Highness The Prince Consort* (1869), Royal Archives, Windsor, Add H4. This report, parts of which had already appeared in the *Builder*, vol. 21 (1863), was used as the text for *The National Memorial to His Royal Highness The Prince Consort* (London, 1873).
4. *Builder*, vol. 17 (1859), pp. 203–4.
5. The firm was founded in 1859; see *Ancienne Maison de Dr A. Salviati, Atelier de Mosaiques Monumentales* (Venice, 1893).
6. James Powell of Whitefriars first marketed glass mosaic in 1861; see Powell Archive, National Art Library, ADD 1/52–1977. Although both Minton and Maw & Co. made ceramic tessellated pavements from the 1840s onwards, this material does not

appear to have been used for wall decoration until Colin Minton Campbell began to experiment with it in the 1860s; see Joan Jones, *Minton: The First Two Hundred Years* (Shrewsbury, 1993), pp. 164–74.

7. *Builder*, vol. 20 (1862), pp. 706–7.
8. J. B. Waring, *Masterpieces of Industrial Art and Sculpture at the International Exhibition 1862* (London, 1863).
9. Waring, *Masterpieces*, p. 97.
10. Waring, *Masterpieces*, p. 13.
11. Michele Lessona, *Volere e Potere* (Firenze, 1869); extracted in *Voce di Murano*, 18 March 1869, p. 22.
12. See G. Salviati, 'Mosaic in general, and the late Dr Salviati's Work', *Journal of the Royal Institute of British Architects*, 3rd Series, vol. 1 (1894), pp. 254–60.
13. The mosaics for the spandrels at St Paul's and for the Albert Memorial Chapel were both begun in 1864.
14. The Arts and Crafts Movement saw a revival of interest in the art of mosaic. The completion of the mosaic decoration at St Paul's Cathedral by William Blake Richmond (1842–1921) in the 1890s was probably the most extensive and certainly the most prestigious work of this kind to be carried out in Britain.
15. RA, Add H2, 498.
16. RA, Add H2, 572.
17. See Henry Stacy Marks, *Pen and Pencil Sketches* (London, 1894), pp. 63–4.
18. *Builder*, vol. 21 (1863), p. 837.
19. RA, Add H2, 1855.
20. RA, Add H2, 889.
21. RA, Add H2, 889.
22. RA, Add H2, 1204.
23. RA, Add H2, 1209.
24. Hermione Hobhouse and Julian Litten, *Visit Notes for Windsor Castle and the Royal Mausoleum, Frogmore* (The Victorian Society, September 1997).
25. RA, Add H2, 1410.
26. RA, Add H2, 1413.
27. RA, Add H2, 1450.
28. Francis Skeat, 'Some nineteenth-century stained glass artists and their families', *Family History*, vol. 9 (1976), pp. 28–35.
29. *Builder*, vol. 13 (1855), p. 165.
30. *Illustrated London News*, vol. 27 (1855), p. 476.
31. Powell Archive, National Art Library, ADD 1/45–1977.
32. Clayton illustrated an edition of *Pilgrim's Progress* with drawings in Flaxman's 'Outline Style' in 1856. He also built up a collection of the sculptor's drawings, many illustrating the *Iliad* and *Aeneid*, which were bequeathed to the Royal Academy when he died in 1911; see Skeat, 'Some nineteenth-century stained glass artists', p. 34.
33. RA, Add H4.
34. RA, Add H2, 1495.
35. Layard Papers, BM Add *MSS* 38993, f. 256.
36. RA, Add H2, 1495.
37. RA, Add H2, 1499. The cartoons of the designs on the model in the Victoria and Albert were presumably done by Clayton. It seems likely, however, that there was also a larger model of the gable for which Clayton prepared his first trial designs.
38. BM Add *MSS* 38993, f. 162.
39. BM Add *MSS* 38948, f. 47.
40. See Austen Henry Layard, *Autobiography and Letters*, 2 vols (London, 1903), vol. 2, pp. 21–35.
41. BM Add *MSS* 38948, f. 47.
42. The Arundel Society was founded in 1849 to illustrate the history and monuments of art by issuing publications, and by forming a collection of copies, tracings, and other artistic records of important works, especially if little known.
43. Layard was in Italy in 1853, 1855, 1856, 1858, 1859 and 1860. The Arundel Society printed pamphlets by him on *Quattrocento* and *Cinquecento* frescoes in 1856, 1857, 1858, 1859 and 1860, as well as publishing chromolithographs of the frescoes and 'outlines' based on the tracings he had carried out in the buildings concerned.
44. BM Add *MSS* 38948, f. 81.
45. BM Add *MSS* 39103, f. 241.
46. Probably the decoration of the Throne Room in the Royal Palace at Cairo; see Comitato Mosaicisti Veneziani, *La Rinascita del Mosaico a Venezia*, vol. 9 (1931), p. 9.
47. Hansard, 'Motion for a Select Committee on the Decoration of the Central Hall', 26 July 1869.

48. 'Memorandum of Association of Salviati & Company (Ltd.)', PRO BT31 3405.
49. 'Articles of Association of Salviati & Company (Ltd.)', PRO BT31 3405.
50. RA, Add H2, 1830.
51. RA, Add H2, 1855.
52. BM Add *MSS* 38972, f. 52.
53. RA, Add H2, 1832.
54. RA, Add H2, 1835.
55. RA, Add H2, 1836.
56. RA, Add H2, 1840.
57. RA, Add H2, 1842.
58. RA, Add H2, 1844.
59. RA, Add H2, 1847.
60. RA, Add H2, 1851–3.
61. RA, Add H2, 1850.
62. RA, Add H2, 1855.
63. RA, Add H2, 1864–5.
64. Scott, *Recollections*, p. 222.
65. RA, Add H2, 1858.
66. RA, Add H2, 1861.
67. RA, Add H2, 1867.
68. RA, Add H2, 1915.
69. BM Add *MSS* 38993, ff. 203–5; for the Gaddi illustration see G. Rosini, *Storia della Pittura Italiana*, 7 vols (Pisa, 1848–52), vol. 2, p. 119.
70. BM Add *MSS* 38993, ff. 203–5.
71. BM Add *MSS* 38993, ff, 203–5.
72. BM Add *MSS* 38948, f. 120.
73. Comitato Mosaicisti Veneziani, *La Rinascita del Mosaico a Venezia*, vol. 9 (1931), p. 16.
74. BM Add *MSS* 38948, f. 59.
75. 'Articles of Association of Salviati and Company (Ltd.)', registered 2 January 1868; PRO BT 31 3405.
76. 'Articles of Association of the Venice and Murano Glass and Mosaic Company (Ltd.)', registered 31 August 1868; PRO BT 31 3405.
77. The firm re-registered as The Venice and Murano Glass Company in 1888, and was dissolved in 1915; PRO BT 31 3405.
78. RA, Add H2, 2160.
79. The whole exchange of letters is in RA, Add H2, 2162–4.
80. RA, Add H2, 2169.
81. RA, Add H2, 2295–6.
82. RA, Add H2, 2174.
83. See 'Albert Memorial', *Survey of London*, vol. 38, *The Museums Area of South Kensington and Westminster* (London, 1975), p. 171.
84. *Builder*, vol. 27 (1869), p. 80.
85. BM Add *MSS* 38993, f. 174.
86. Matthew Digby Wyatt, 'On Pictorial Mosaic as an Architectural Embellishment', *Royal Institute of British Architects Papers* (1860–2), p. 135.
87. See Walter Crane's comment in the discussion of a paper read by C. Harrison Townsend, 'The Art of Pictorial Mosaic', *Journal of the Royal Institute of British Architects*, 3rd Series, vol. 8 (1901), p. 239.
88. In 1872 William Burges was appointed to design mosaics for the decoration of St Paul's Cathedral, but his scheme was rejected by the Fine Arts Committee in 1874, and the project abandoned in 1877; see J. Mordaunt Crook, *William Burges and the High Victorian Dream*, (London, 1981), pp. 160–1.
89. *Builder*, vol. 34 (1876), p. 495.

Chapter Nine

The most comprehensive account of the South Kensington area is to be found in *Survey of London*, vol. 38, *The Museums Area of South Kensington and Westminster* (London, 1975). Its development since 1851 is recorded officially in the periodical *Reports of the Royal Commission for the Exhibition of 1851*. The records and archive of the Royal Commission are kept in its offices in the Sherfield Building of Imperial College. The diaries and letters of Sir Henry Cole, and other of his papers are to be found in the National Art Library in the Victoria and Albert Museum; for an account of his life and work see Elizabeth Bonython, *King Cole* (Victoria and Albert Museum, 1982). A comprehensive set of press-cuttings albums, compiled from *c.* 1852 until the 1890s, is kept in the Victoria and Albert Museum's Blythe Building, Blythe Road, Hammersmith: the cuttings relate to the activities of the Royal Commission and the South Kensington Museum; speeches by Prince Albert, Sir Henry Cole and others; parliamentary debates; and the albums include a separate volume kept by Henry Scott on the Royal Albert Hall.

Chapter nine continued

1. Royal Commission, vol. 4 (100), 4 August 1850.
2. Henry Cole, 'Diary', 4 July 1850, National Art Library.
3. Lord John Russell to Queen Victoria, 5 July 1850, Royal Commission, vol. 4 (45).
4. Henry Cole, 'Diary', 4 July 1850.
5. Henry Cole, 'Diary', 16 July 1850.
6. Kurt Jagow, ed., *Letters of the Prince Consort 1831–1861* (London, 1938), p. 175, n. 2.
7. Jagow, *Letters*, pp. 176–7.
8. To relate figures of the mid-nineteenth century to those of today, they should be multiplied by a factor of 50; see Roy Jenkins, *Gladstone*, (London, 1996), p. 149.
9. For Cubitt in Brompton, see Hermione Hobhouse, *Thomas Cubitt – Master Builder* (London, 1971), pp. 445–55.
10. Minutes of the meeting, Royal Commission, vol. 8 (10).
11. Royal Archives, Windsor, F25, 1, 10 August 1851. See also A. P. Burton, '"A flagrant German job": Prince Albert's plans for an industrial university in London', a paper read at *Art in Britain and Germany in the Age of Queen Victoria and Prince Albert*, 13 September 1997, Coburg, Schloss Ehrenburg, Landesbibliothek, to be published in *Prince Albert Studies*, Transactions of the Prinz-Albert Gesellschaft e.V, Coburg (forthcoming).
12. Henry Cole, 'Diary', 14 August 1851.
13. Prince Albert to Baron Stockmar, 18 August 1851, quoted in Theodore Martin, *The Life of His Royal Highness the Prince Consort*, 5 vols (London, 1875–80), vol. 2, p. 391.
14. Henry Cole, 'Diary', 18–23 August 1851.
15. *2nd Report of the Royal Commission for the Exhibition of 1851* (1852), Appendix B.
16. Henry Cole to Charles Grey, 24 October 1851, Colonel Grey to Henry Cole, 25 October 1851, Royal Commission, vol. 9 (5 and 6).
17. *2nd Report of the Royal Commission*, pp. 9–10.
18. Edgar Bowring to W. E. Gladstone, 29 December 1852, Royal Commission, Box 99.
19. See Geoffrey Tyack, '"A gallery worthy of the British people": James Pennethorne's designs for the National Gallery', *Architectural History*, vol. 33 (1990), pp. 120–34.
20. Prince Albert, Memorandum (copy), 20 August 1853, Royal Commission, vol. 19 (117).
21. W. E. Gladstone, 17 October 1853, Royal Commission, Letter 46017.
22. W. E. Gladstone to Lord Granville, 17 October 1853, Royal Commission, vol. 12 (15).
23. Charles Grey to Edgar Bowring, 1 and 3 November 1853, Royal Commission, Add letters 138 and 139.
24. Edgar Bowring to Charles Grey, 17 November 1853, Royal Commission, vol. 12 (33).
25. Charles Grey to Edgar Bowring, Royal Commission, Add letter 164.
26. See John Physick, 'Early Albertopolis: The Contribution of Gottfried Semper', *The Victorian Society Annual* (1994), pp. 28–36.
27. Benjamin Disraeli to Prince Albert, 30 April 1858, Royal Commission, vol. 14 (48).
28. Edgar Bowring to Charles Grey, 18 June 1858, Royal Commission, vol. 14 (65a).
29. The Royal Commission retained the freehold, however, and it was not until the 1980s that the land on which the Victoria and Albert Museum stands was formally conveyed to the government.
30. See John Physick, 'The South Kensington Museum', in Sarah Macready and F. H. Thompson, eds, *Influences in Victorian Art and Architecture* (London, 1985), pp. 73–80.
31. Edmund Walker's water-colour of the opening ceremony (Pl. 243) shows the Prince and the royal children in mourning for the recent death of Queen Victoria's mother, the Duchess of Kent.
32. Charles Phipps to Henry Cole, 9 July 1857, Cole papers, National Art Library, Victoria and Albert Museum.
33. See Betty Bradford, 'The Brick Palace of 1862', *The Architectural Review*, vol. 132 (1962), pp. 8, 15–21; and for the whole saga in detail 'The Exhibition Building of 1862', *Museums Area*, pp. 137–47.
34. Henry Cole, *Miscellanies*, vol. 13, folios 24, 25, National Art Library.
35. Henry Cole, *Miscellanies*, vol. 13, folios 82–5, 158; see also Marcus Binney, 'The Origins of the Albert Hall', *Country Life*, 25 March 1971, pp. 680–3, and for the Hall itself, 'Royal Albert Hall', *Museums Area*, pp. 177–95.
36. Edgar Bowring to Charles Grey, 19 December 1864, Royal Commission, vol. 20 (64).
37. Henry Cole , 'Diary', 20 and 21 November 1864.
38. Henry Cole, 'Diary', 26 January 1865, 'Every one busy with the model of the Hall'; 27 January, 'Model of the Hall. Completed for Osborne'; 29 January, 'Crossed to Osborne, discussed details of the Hall with Phipps. Interview with the Prince of Wales. Seemed interested in the Hall and agreed to work in it'; 30 January, 'Interview with the Queen'.
39. Henry Cole to Charles Grey, 5 August 1864, Royal Commission, vol. 20 (14).
40. Earl of Derby to Lord Granville, 31 July 1864, Royal Commission, vol. 20 (29).
41. Earl of Derby to Charles Grey, 19 December 1864, Royal Commission, vol. 20 (65).
42. Henry Cole, 'Diary', 24 and 25 February 1865.
43. Henry Cole to Charles Grey, 25 February 1865, Royal Commission, vol. 20 (81).
44. Charles Phipps to Queen Victoria, 8 April 1865, Royal Commission, vol. 20 (99).
45. 'I can't help feeling that this was at the bottom of his proposition and that he doesn't care very much for the matter one way or the other', Edgar Bowring to Charles Grey, 19 April 1865, Royal Commission, vol. 20 (108). Lowe was lately the Vice-President of the Committee of Council on Education and shortly to be Chancellor of the Exchequer.
46. Henry Cole, 'Diary', 1 February 1865.
47. Charles Grey to Queen Victoria, 17 May 1865, Royal Commission, vol. 20 (100).
48. The lease is printed in *Sixth Report of the Royal Commission* (1878), Appendix M.
49. Henry Cole, *Fifty Years of Public Work*, 2 vols (London,1884), vol. 1, p. 362n. The axis is well illustrated in a photograph of the foundations of the Albert Hall, and another taken from the School of Science, reproduced in Bonython, *King Cole*, pp. 57–8.
50. Charles Grey to Earl of Derby, 12 January 1866, Royal Commission, vol. 11 (65). On 30 December 1865, Cole's 'Diary' records, 'Grey called. Agreed to proposal to employ Semper or have a competition but only to complete Capt Fowkes design'.
51. Earl of Derby to Prince of Wales, 17 January 1865, Royal Commission, vol. 21 (50).
52. A model of an elaborate early proposal was exhibited by Cole at the 1867 Paris Exhibition: it is illustrated in John Physick and Michael Darby, '*Marble Halls*' (Victoria and Albert Museum, 1973), p. 204. The plaster models were exhibited in the Museum of Construction – part of the South Kensington Museum. When this was dismantled *c.* 1900 they were put in store and forgotten, until recognised by the present writer in 1972; see '*Marble Halls*', p. 12.
53. Henry Cole, 'Diary', 27 June 1866, 'Walked home with Scott. Fergusson had tried to persuade him to make a circus instead of an amphitheatre'.
54. Henry Cole, 'Diary', 28 June 1866, 'Scott having a new design of Hall to accommodate the frieze, agt which I protested'.
55. Henry Cole, 'Diary', 7 April 1868.
56. Henry Cole, 'Diary', 20 May 1867.
57. Henry Cole, 'Diary', 29 June 1867.
58. See Gilbert Redgrave, 'Mosaic Work in Encaustic Tesserae', *The Architect*, 10 July 1869. Despite initial fears that the figures would be too small, 'the result does not carry out this anticipation … while it would be easy to point out individual shortcomings … wiser to say that Scott deserves credit due to a novel and to some extent formidable idea', *The Architect*, 23 October 1870.
59. Henry Cole, 'Diary', 6 February 1869, 'To see Model of Organ at Willis'; 2 June, 'Signed Contract for Organ'; 5 July, 'Costa called to ask me to go with him and see the Organ …'; 14 July, 'With Scott to see the Organ … Met Costa and Bowley there. Went through the works of the 5 organs abt 9000 pipes … Suggested that the works be shown and not hidden'; 11 January 1870, 'With Costa to see progress of Great Organ … examined movement and pipe casting'; 15 March, 'Costa Willis and Bowley called to settle where organ pipes cd be put'; 23 March, 'To Willis' works to hear the first seven stops first tried, tone brilliant. Costa, Bowley, Mr. Gladstone, Sims Reeves &c there'.

60. *Gardeners' Chronicle and Agricultural Gazette*, 29 March 1873, p. 438; Scott's letter of resignation is preserved in an album entitled *Royal Commissioners and Legal* in the Society's Library.
61. Minutes of the Council of the Royal Horticultural Society, 5 April 1873.
62. Henry Cole, 'Diary', 3 March 1874.
63. Letter from Henry Scott, read at a meeting of the Council
64. The Cookery School was one of the institutions encouraged by Cole on the estate after his retirement. It was created after the 1873 exhibition to train teachers to give instruction in local schools in 'cookery suitable to the wants of the middle and lower classes'; see *6th Report of the Royal Commission* (1878), p. 12.
65. Hermione Hobhouse, 'A Quartier Latin of a Dignified and Popular Sort: Prince Albert's own contributions to South Kensington', *The V & A Album*, no. 2 (1983), pp. 366–75.
66. Michael Port, *Imperial London* (London, 1995), p. 101.
67. *8th Report of the Royal Commission* (1911), p. 27.
68. Henry Cole, 'Diary', 29 June 1868.

Chapter Ten

1. For a draft copy of the royal warrant see Royal Archives, Windsor, Add H2, 3979.
2. C. Doyne Bell, Memorandum, 30 June 1873, PRO Work 20/13.
3. PRO Work 20/113.
4. W. J. Ward, Museum of Geology, to C. Doyne Bell, Memorial Committee, 20 September 1873 and 6 November 1873, Sir T. Biddulph, Chairman of the Memorial Committee, to First Commissioner of Works, 24 December 1873; PRO Work 20/13. See also RA, Add H2, 4240–83.
5. *Builder*, vol. 45 (1877), pp. 450, 452; see also Elisabeth Darby and Nicola Smith, *The Cult of the Prince Consort* (New Haven and London, 1983), pp. 50–1.
6. *Art Journal* (1877), p. 158, quoted in John Physick, *Designs for English Sculpture 1680–1860* (London, 1969), pp. 194–5.
7. A. B. Mitford, Memorandum, 23 October 1884, PRO Work 20/13.
8. *Pall Mall Gazette*, 31 March 1870, quoted in Property Services Agency, *The Albert Memorial Report*, revised edn (March 1986), p. 17.
9. H. H. Armstead to D. Bell, 11 November 1871, J. B. Philip to D. Bell, 17 November 1871, RA, Add H2, 3842–3, 3845.
10. *Times*, 24 September 1872; cutting in RA, Add H2, 3988.
11. Both letters appeared in the *Times*, 17 June 1873; cuttings in RA, Add H2, 4110.
12. D. Bell to H. Mason, 17 June 1873, H. Mason to D. Bell, 18 June 1873, RA, Add H2, 4111.
13. Office of Works to Treasury (draft), 8 January and 7 March 1873, PRO Work 20/12.
14. J. Taylor, Memorandum, 22 October 1873, PRO Work 20/13.
15. *The Hour*, 19 March 1874, cutting in RA, Add H2, 4328.
16. PRO Work 20/12, *passim*; *West London News*, 18 March 1876, cutting in RA, Add H2, 4658.
17. *Times*, 13 March 1876, cutting in RA, Add H2, 4657.
18. *Daily News*, 11 March 1876, cutting in RA, Add H2, 4654.
19. NMR, BB67/5368, reproduced in *Survey of London*, vol. 35, *The Museums Area of South Kensington and Westminster* (London, 1975), pl. 41b.
20. *Morning Post*, March 1876, cutting in RA, Add H2, 4658.
21. Colonel M. J. Wheatley, Bailiff of the Royal Parks, Memorandum, 22 June 1883, PRO Work 20/13, *et passim*.
22. F. Baines 'Report on the condition of statues and memorials and other monuments in the charge of H. M. Office of Works', 10 September 1914, PRO Work 20/80.
23. W. Browne to Col. Wheatley, 27 March 1890, PRO Work 20/13.
24. *Daily News*, 21 March 1890, cutting in PRO Work 20/13.
25. Col. Wheatley to Secretary Office of Works, 6 December 1883, PRO Work 20/13.

26. A. B. Mitford, Memorandum, 23 October 1884, PRO Work 20/13; he was doubtless referring to the burnished copper roof of the late fifteenth-century Goldenes Dachl, Innsbruck.
27. *Times*, 9 October 1901, cutting in PRO Work 20/13.
28. Lord Esher, file note, 11 October 1901, PRO Work 20/14.
29. J. O. Scott to First Commissioner of Works, 2 December 1901, PRO Work 20/14.
30. J. R. Clayton, 'Report referring to the mosaics of the Albert Memorial, Hyde Park', n.d. [c. 14 October 1902], PRO Work 20/14.
31. F. Baines, 'Report on the condition of statues and memorials and other monuments in the charge of H. M. Office of Works', 10 September 1914, PRO Work 20/80.
32. Venice and Murano Glass Co., Estimate, 6 February 1903, PRO Work 20/14.
33. J. R. Clayton to J. B. Westcott, 12 June 1903, J. B. Westcott, file note, 13 June 1903, and endorsement by the Secretary, Sir Schomberg McDonnell, 15 June 1903, PRO Work 20/14.
34. A. A. Adams, Venice and Murano Glass Co., to Office of Works, 9 May 1904, PRO Work 20/14.
35. F. Baines, Albert Memorial Proposed Repairs, 4 September 1913, PRO Work 20/13.
36. M. V. Brett, ed., *Journals and Letters of Reginald Viscount Esher*, 2 vols (London, 1934), vol. 1, p. 325.
37. Hardman, Powell & Co. to J. B. Westcott, with Specification and Estimate, 23 October 1901, PRO Work 20/13.
38. L. Earle to A. Akers-Douglas, First Commissioner, 24 October 1901, PRO Work 20/13.
39. PRO Work 20/13, *passim*.
40. G. J. T. Reavell, Memorandum, 22 July 1913, PRO Work 20/13.
41. PRO Work 20/125, *passim*.
42. PRO Work 20/14, *passim*.
43. PRO Work 20/12, *passim*.
44. PRO Work 20/12, undated cutting filed between papers dated 14 and 17 February 1913.
45. Commissioner of Police for the Metropolis to Office of Works, 17 February 1913, PRO Work 20/12.
46. The repairs exacerbated a long-standing problem, as straight joints are a feature of some of the large sculptural groups; A. B. Mitford, Memorandum, 23 October 1884, PRO Work 20/13.
47. The novelist Edith Wharton, for example, considered comparison with the Memorial the most damning criticism she could think of for the tomb of Margaret of Austria in Brou, France, which she likened to 'a kind of superlative Albert Memorial in which regardlessness of cost has frankly predominated over aesthetic considerations'; Edith Wharton, *A Motor Flight through France* (London, 1908; new edn, London, 1995), p. 153.
48. C. H. Brooke, Memorial, 15 July 1913, PRO Work 20/13.
49. F. Baines to L. Earle, 4 September 1914, PRO Work 20/13.
50. G. J. T. Reavell, Memorandum, 22 July 1913, PRO Work 20/13.
51. L. Earle to Lord Stamfordham, 24 July 1913, PRO Work 20/13.
52. F. Baines to L. Earle, 4 September 1914, PRO Work 20/13.
53. F. Baines, Report on the condition of statues, 10 September 1914, PRO Work 20/80.
54. PRO Work 20/13, *passim*.
55. L. Earle to the Treasury, 15 September 1914, PRO Work 20/125.
56. F. Baines to L. Earle, 20 October 1914, PRO Work 20/125.
57. L. Earle to Lord Stamfordham, 20 October 1914, PRO Work 20/125.
58. Lord Stamfordham to L. Earle, 27 October 1914, PRO Work 20/125.
59. F. Baines to L. Earle, 25 March 1915, PRO Work 20/125; C. T. Small, Albert Memorial Drawings, English Heritage.
60. L. Earle to F. Baines, 31 March 1915, PRO Work 20/125.
61. L. Earle to F. Baines, 13 April 1915, F. Baines to L. Earle, 15 April 1915, PRO Work 20/125.
62. This information is contained in a later letter, J. T. L. Kendle to S. G. Wilson, 14 April 1939, PRO Work 20/145.
63. L. Earle to Lord Stamfordham, 9 August 1915, PRO Work 20/125.

64. *Architects' and Builders' Journal*, 4 August 1915,
p. 45. The Emmett quotation is from 'The
Profession of an Architect', *Quarterly Review*,
April 1880, reprinted in J. T. Emmett, *Six Essays*,
2nd edn (London, 1891), pp. 18–19.
65. A. W. Heasman, Architect, Ancient Monuments
Branch, to Sir Frank Baines, Director of Works,
18 October 1924, PRO Work 20/125.
66. W. H. B[urnet], file note, 20 June 1928, PRO Work
20/125.
67. S. G. Wilson to J. T. L. Kendle, 11 April 1939 and file
note, PRO Work 20/125.
68. J. T. L. Kendle to A. W. Heasman, 16 May 1939,
PRO Work 20/125. Kendle also stated that the
caustic compound containing the gold leaf removed
from the Memorial was stored behind the Tate
Gallery: following enquiries it was found that the
cost of extracting the gold again would be too great.
It was subsequently buried and is now built over;
J. T. L. Kendle to S. G. Wilson, 14 April 1939, PRO
Work 20/145.
69. J. T. L. Kendle to A. W. Heasman, 16 May 1939,
PRO Work 20/125.
70. J. T. L. Kendle to A. W. Heasman, 16 May 1939,
PRO Work 20/125.
71. W. G. L. C., file note, 2 October 1940, PRO Work
20/241.
72. Westminster City Archives Centre, Cd 142, Map
Record of Incidents 1940–5. Details of the incident
numbers are recorded in CD 3, Permanent Record
Book.
73. Westminster City Archives, CD3 Permanent
Record Book incident 691 (2), 15 October 1940,
and incident 1718, 23 February 1944. For example,
the figure of *Humility* had an entry hole passing
through the sleeve and exiting between the
shoulder blades; Property Services Agency,
Albert Memorial Report, p. 61.
74. A. Clouting Chief Architect, file note, 12 December
1940, PRO Work 20/241.
75. E. de Normann to AS23, 6 March 1946 *et passim*,
PRO Work 20/257; Parliamentary Q/A 3779, 24 April
1950 (Col. 597), quoted in PRO Work 20/232.
76. F. L. Rothwell to AS23, 30 March 1948, PRO Work
20/238. 'Honourable scars' presumably derives
from the poem by James Montgomery (1771–1854),
'The Battle of Alexandria' (1801): 'Gashed with
honourable scars,/ Low in Glory's lap they lie;/
Though they fell, they fell like stars,/ Streaming
splendour through the sky.'
77. W. A. Proctor to Secretariat, 23 and 29 May 1946,
PRO Work 20/257.
78. M. Williams (for F. L. Rothwell), file note,
31 August 1949, PRO Work 20/241.
79. W. Palmer, 'Preliminary Report on the Present
Condition of the Prince Consort Memorial',
26 August 1949, PRO Work 20.241.
80. *The Sphere*, 30 October 1954, p. 205; file note,
14 March 1950, PRO Work 20/241; G. Brown,
Minister of Works, to Sir P. Spens, 19 July 1951,
PRO Work 20/241, gives the cost breakdown as
£1244 for scaffolding and £2823 for cleaning and
repairs.
81. R. A. Barker, file note, 18 December 1950, and
passim, PRO Work 20/241.
82. F. L. Rothwell, 21 August 1953 and 20 January 1954,
PRO Work 20/241.
83. File note, 4 November 1955, PRO Work 20/241;
this file is the source for all the details of the 1954–5
programme.
84. Mr Parrot's well-meant but mistaken intervention
is explained by the fact that, when clerk of works on
a previous project, he had seen how an architect's
original drawings could be used to revert to the
original design by removing later alterations;
information from John Charlton.
85. *The National Memorial to His Royal Highness the
Prince Consort* (London, 1873), pl. 20.
86. K. P. Leary to A. W. Cunliffe, April 1955, PRO Work
20/241.
87. D. E. Strong, file note, 27 April 1955, PRO Work
20/241.
88. A. B. Saunders, Private Secretary to Minister of
Works, to Mr Ogle-Scan, Ministry of Works,
14 February 1961, *et passim*, PRO Work 20/241.
89. For the practice of water spray cleaning see
Ministry of Works reference 10239, 'Ancient
Monuments, Notes on Repair and Preservation',
revised January 1947, Appendix C.
90. D. Hill, file note, 2 August 1961, *et passim*, PRO
Work 20/241.
91. M. Hardy to Ministry of Works, 12 January 1964,
English Heritage, CB 162 part 1; PRO Work 20/241,
passim.
92. PRO Work 20/241, *passim*.
93. Ministry of Works Report of Accident Damage to
Albert Memorial, 10 May 1961, PRO Work 20/241.
94. S. Larkins to R. E. Woolston, Ministry of Public
Buildings and Works, 19 August 1968, PRO Work
20/241.
95. *Daily Telegraph*, 26 October 1971 and 31 July 1972.
96. George Gilbert Scott, *Personal and Professional
Recollections* (London, 1872), ed., Gavin Stamp
(Stamford, 1995), p. 264.
97. George Gilbert Scott, 'Architectural Description
of the Memorial', *The National Memorial* (1873),
p. 36.

Epilogue

1. Nikolaus Pevsner, *Buildings of England, London
except the Cities of London and Westminster*
(Harmondsworth, 1952), p. 254.
2. George Gilbert Scott, *Personal and Professional
Recollections* (London, 1879); ed., Gavin Stamp
(Stamford, 1995), p. 112.
3. The *Duke of York Column* in Waterloo Place and
Mathew Cotes Wyatt's gargantuan statue of the
Duke of Wellington, set atop Decimus Burton's arch
at Hyde Park Corner, were favourite *Punch* targets.
4. George Gilbert Scott, 'Architectural Description',
in *Handbook to the Prince Consort National
Memorial* (London, 1872), 25th impression
(London, 1924), p. 21.
5. Royal Archives, Windsor, Add H2, 564.
6. RA, Add H2, 799; in the same letter Scott says
that Albert himself 'most earnestly desired' such
creative collaboration. The phrase 'bond of union'
seems to have had special significance for Scott: he
uses it several times in correspondence to describe
different aspects of the Memorial, notably in May
1864 discussing the conceptual links between the
four faces of the podium frieze, RA, Add H2, 821.
7. See Michael J. Lewis, *The Politics of the German
Gothic Revival: August Reichensperger
(1808–1895)* (New York, 1993); for a discussion
of the *Bauhütten* in relation to the international
Revival, see Chris Brooks, *The Gothic Revival*
(London, 1999), p. 261ff.

Index

Aachen Cathedral,
 Shrine of Emperor Charlemagne, **Pl. 206**
 Shrine of Our Lady, 118
Aberdeen, Lord, 314
Acland, Henry 257, 258
Adelaide of Saxe-Meningen, 15
Agrarian Depression, 222, 225
Alabama Affair 249
Albany, Duke of, 42
Albert, Francis Charles Augustus Emmanuel, Prince
Consort
 Agriculture and, 27–8, 59, 222, **Pls. 15, 16**
 'Albert Hat' and, 28–30, 56–65, 82, **Pls. 17, 39, 40, 41, 42, 43, 46**
 'Albertopolis' and, 38, 40, 139, 312–21, 338
 Army and, 28–30, 47–9, 50, 56, 65, 82–4, 85–6, 93, **Pls. 18, 65, 66**
 Arts and, 24, 28, 30, 40–41, 42, 47, 184, 204, 209, 223–41, 289, **Pls. 26, 63, 69**
 Commemoration of, 9, 13, 93–5, 93–112, 117–33, 135, 162–7, 184–5, 198–200, 207–51, 266–7, 323, 421–2, 426, 427; *and see* Albert Memorial
 Court and, 49–50, 53, 56, 207
 Crimean War and, 9, 82–8, 93, **Pls. 64, 65, 66, 67, 68**
 Death of, 8, 38, 41, 88, 287, 289, 305, 321, 330, 338
 Domesticity and, 66–71, 89, 93, 240, **Pls. 49, 50, 51, 52, 53, 54, 55, 71**
 Education and, 30, 62–3, 74, 78–9, 209, 289, **Pls. 54, 62, 63**
 Fashion and, 55, 56
 Field sports and, 17, 55, 59, 66, **Pls. 41, 43**
 Great Exhibition and, 9, 30–38, 74–9, 93, 96, 168, 208, 210, 241, 289, 309, 310–18, **Pls. 19, 21, 24, 59, 60, 61, 62, 166**
 Parents and relations of, 15–17, 56, **Pls. 2, 3, 4, 5, 6**
 Political role and activities of, 8–9, 20–23, 41, 42, 47, 49, 72–3, 82, 86 **Pls. 9, 57**
 Progress and, 30, 50, 52–3, 71, 210, 218–29, **Pl. 36**
 Representations of, 45–96, 207–9
 Cartoons, 46, 54–65, 71–4, 78–84, 88, **Pls. 15, 17, 37, 38, 40, 41, 42, 43, 44, 45, 46, 48, 55, 58, 62, 66**
 Engravings in illustrated press, 46, 49–53, 59, 66, 71, 72–6, 78–9, 85–8, 91, **Pls. 33, 35, 36, 49, 54, 57, 60, 63, 67, 68, 69**
 Music covers, 72, **Pls. 18, 56**
 Paintings, 45–6, 47–9, 65, 66, 88, **Pls. 5, 7, 21, 27, 31, 47, 50, 51, 59, 243**
 Photographs, 88–91, 93, 207, **Pls. 71, 72**
 Prints, 45–7, 71, 91, 207, **Pls. 6, 28, 29, 30, 34, 52, 53, 70**
 Sculptures and statues, 38, 47–9, 124, 184, 187, 207–8, **Pls. 25, 32, 147, 148, 165**; *and see* Albert Memorial, Prince Albert
 Textual items, 45, 54, 55, 74, 85
 Royal finances and, 13, 20–21, 56
 Royal Tours and, 50–52, 66, 71, 72–4, 89, **Pls. 33, 34, 35**
 Social conditions and, 30, 74, 112, 209
Albert Dock, Liverpool, 23
Albert Memorial, City of London, 207, **Pl. 165**
Albert Memorial, Edinburgh, 207, **Pl. 148**
Albert Memorial, Glasgow, 207, **Pl. 149**
Albert Memorial, Liverpool, 207
Albert Memorial, London, 9–10, 91–6, 99–112, 117–33, 135–59, 161–205, 207–51, 253, 266–85, 287–307, 323, 325, 326, 327, 340–61, 364–93, 394–418, 421–7, **Pls. 74, 83, 85, 99, 100, 101, 102, 105, 120, 126, 127, 128, 134, 237, 260, 261, 268, 269, 287, 288, 311, 312**; *and see individual entries below*
 Canopy, 127, 140, 146, 149, 150, 167, 216, 267, 277, 344, 345, 346, 357, 361, 366, 369, 371, 377, 385, 397,403, 411, 415 **Pls. 118, 119, 122, 173, 174, 209, 215, 275, 290, 306**
 Columns, 127, 140, 146, 149, 150, 166, 167, 375, 377, 380, 381, 385, 395, **Pl. 108**
 Conservation and Repair
 Before 1983, 10, 340–61, **Pls. 258, 259, 260, 261, 268**; *and see* War damage
 English Heritage programme, 10, 133, 136, 285, 364–93, 394–418, 422, *and see individual entries for parts of the Memorial*
 War damage and repairs, 10, 353–361, **Pls. 262, 263, 264, 265, 266, 267**
 Construction, 135–59, 267, 388, 426, **Pls. 105, 106, 107, 108, 109, 114, 120, 123, 124, 126**
 Costs and payments, 156, 166, 168, 170, 171–2, 189, 193, 270, 273, 282–3, 299, 388–390

Cross and Orb, 118, 128, 133, 146, 156, 210, 277, 349, 353, 358, 365, 367, 371, 372, 385, 395, 405–407, **Pls. 167, 264, 267, 276, 289**
Design and Design Competition, 99–112, 117–33, 135–6, 161–6, 171–2, 187, 200, 208–9, 266–7, 268, 284–5, 287, 288, 421–7, **Pls. 76, 77, 78, 79, 80, 81, 82, 83**
Enamel shields, 280, 282–3, 358, 408–9, **Pls. 220, 301**
Executive Committee, 109, 166, 171, 180, 184, 194, 210, 268, 270, 273, 276, 279, 280, 283, 287, 288, 289, 293, 302, 305, 309–338, 341, 424, 425
Flèche, 118, 123, 126, 127, 137, 138, 146, 150, 156, 159, 198, 209, 210, 216, 238, 267–83, 365, 369, 381, 385, 395, 396, 397–407, 417, 423, **Pls. 113, 168, 171, 208, 211, 213, 214, 216, 217, 218, 273, 274, 284, 290, 291, 292, 293, 297, 310**; *and see* Cross and Orb, Metalwork, Statues
Foundations and undercroft, 138, 140, 149, 389, **Pls. 105, 106, 107, 114, 116, 128**
Gables, 124, 129, 230, 267, 270, 273, 277, 306, 349, 365, 371, 380, 381, 397, 411, 415, 417, **Pls. 185, 209, 212, 215, 223, 230, 231, 275, 283**
Gates and railings, 156, 267, 277, 280, 282–3, 345, 346, 353, 408, 417 **Pl. 219**
Gilding and regilding, 156, 166, 267, 279, 280, 283, 345, 346–7, 347–53, 357, 380, 381, 397, 399, 400, 403, 407, 408, 412, 415, 417–8, **Pls. 285, 286, 295, 298, 299, 300, 309**
Heraldry, 216, 282, 283, 358, 381, 395, 397, 408, 409, **Pls. 173, 174, 220, 301**
Iconography and meaning, 93–6, 135–6, 162, 172, 177, 182, 198–204, 207–251, 289, 293, 305, 421–2, 423, 426–7
Inscription, 209–10, 305, 375, 380
Jewels, 118, 266, 358, 375, 377, 397, 399, **Pl. 292**
Metalwork, 102, 117–8, 124–5, 133, 136, 137, 138, 146, 150, 156, 159, 209, 253–285, 369–72, 377, 380, 385, 395, 396–407, 417, 418, **Pls. 108, 109, 110, 111, 113, 125, 212, 214, 294, 295, 296**; *and see* Flèche, Gates, Enamel shields
Mosaics, by John Richard Clayton and Salviati & Co.,124, 125, 129, 146, 166, 167, 209, 229, 232, 237, 238, 241, 267, 287–307, 346, 357, 361, 375, 380, 385, 388, 396, 410–413, 418, 423, **Pls. 173, 174, 185, 223, 227, 228, 230, 231, 236, 302, 303, 304, 305**
 Architectura, 238, 305, 412, **Pls. 230, 234**
 Ictinus, 238
 King Solomon, 238
 Poesis, 230, 299, 305, 412, **Pls. 185, 221, 228, 231, 232**
 Homer, 230
 King David, 230, 232, 238
 Pictura, 237, 305, 357, **Pls. 231, 235**
 Apelles, 237
 Raphael, 237
 Sculptura, 234, 305, 357, 412, **Pls. 227, 230, 233, 277**
 Michelangelo, 234, **Pl. 266**
 Phidias, 234
 Spandrels, 230, 234, 257, 297, 305–6, 346, 371, 400, 401, 411, 412, **Pls. 227, 228, 230, 231, 236, 304**
Paving and steps, 149, 353, 361, 382–3, 386, **Pls. 128, 282**
Podium, 127, 150, 156, 229, 293, 353, 357, 383, 408, **Pls. 116, 121**; *and see* Statues and sculpture
Statues and sculpture, 93, 124, 156, 161–205, 218, 221, 267, 276, 277, 280, 343, 348, 365, 366, 377, 382, 389, 405, 407, 408, 416, 421, 423, 424–5
 Albert, 100–104, 108, 124, 162, 164, 165
 John Bell's statue of, 188, **Pl. 149**
 John Henry Foley's statue of, 9, 93, 125, 126, 140, 156, 188–9, 197–8, 207, 208, 221, 209, 283, 293, 344, 349, 352–3, 361, 367, 377, 380, 381, 382, 386, 390, 395, 408, **Pls. 150, 164, 166, 268, 280, 285**
 Carlo Marochetti's statue of, 167, 184–9, 424–5
 Angels, by John Birnie Philip, 156, 198, 210, 273, 276, 277, 279, 353, 371, 372, 375, 395, 397, 405–7, 417, **Pls. 158, 167, 210, 276, 286, 298**
 Continents, 167, 170, 171, 172, 241, 242, 249, 357, 358, 381, 382, 386, 388, 395, 416
 Africa, by Henry Weekes, 172, 177, 198, 241, 246, **Pls. 129, 138, 144, 197, 198**
 America, by John Bell, 172, 180, 196, 200, 241, 249–50, 277, 416, **Pls. 136, 156, 199, 281**
 Asia, by John Henry Foley, 172, 182, 188, 193, 196, 197, 203, 241, 244, 357, 382, **Pls. 135, 150, 157, 162, 195, 196**

Europe, by Patrick MacDowell, 172, 193, 203, 241, 242, 244, 249, **Pls. 137, 153, 193, 194, 288**
Industrial Arts, 167, 170, 172, 177, 218, 221, 222, 226, 229, 240, 358, 377, 381, 382, 386, 388, 416
 Agriculture, by William Calder Marshall, 177, 193, 196, 221, 222–5, **Pls. 140, 152, 178**
 Commerce, by Thomas Thornycroft, 177, 180, 203, 221, 226, **Pls. 139, 161, 181**
 Engineering, by John Lawlor, 159, 177, 193, 196, 203, 221, 226–9, 329, **Pls. 143, 145, 151, 182, 307**
 Manufactures, by Henry Weekes, 177, 180, 221, 222, 225–6, **Pls. 141, 142, 180**
Lions, 146, 216, 276, 279, 403, 417, **Pls. 133, 297**
Podium (Parnassus) frieze, by Henry Hugh Armstead and John Birnie Philip, 113, 125, 150, 156, 166, 167, 182, 184, 194, 198, 201, 229, 230, 231, 232, 234, 237, 240–41, 343, 344, 347, 348, 352, 358, 361, 365, 377, 381, 382, 386, 389, 395, 416, **Pls. 154, 308**
 Architects, by John Birnie Philip, 113, 194, 201, 234, 238–40, 352, **Pls. 155, 192**
 Abbé Suger, 240
 Arnolfo di Lapo (di Cambio), 238, 240
 Barry, Charles, 240, 352
 Brunelleschi, Filippo, 238
 Callicrates, 201, 239
 Chelles, Jehan de, 201, 240
 Chersiphron, 352
 Cockerell, Charles Robert, 239, 352
 Delorme, Philibert, 239
 Giotto, 240
 Ictinus, 201, 239, 352,
 Mansart, François, 239
 Metagenes, 352
 Mnesikles, 352
 Nitocris, Queen of Egypt, 240
 Pugin, Augustus Welby, 113, 194, 240, 352, **Pl. 155**
 Scott, George Gilbert, medallion portrait of, 113, 194, 240, **Pl. 155**
 Steinbach, Erwin von, 240
 Thorpe, John, 239
 William of Sens, 240
 William of Wykeham, 240
 William the Englishman, 240
 Painters, by Henry Hugh Armstead, 234, 237–8, **Pls. 190, 191**
 Angelico, Fra, 237
 Decamps, Gabriel, 238
 Delacroix, Eugène, 238
 Delaroche, Paul, 238
 Gainsborough, Thomas 238
 Giotto, 238
 Hogarth, William, 238
 Ingres, Jean-Auguste-Dominique, 238
 Lorraine, Claude, 237
 Masaccio, 237
 Michelangelo, 237, **Pl. 190**
 Orcagna, 237
 Poussin, Nicolas, 237, **Pl. 159**
 Raphael, 237, **Pl. 190**
 Reynolds, Joshua, 238
 Turner, Joseph Mallord William, 238
 Vinci, Leonardo da, 237, **Pl. 190**
 Wilkie, David, 238
 Poets and Musicians, by Henry Hugh Armstead, 198, 230, 231–4, **Pls. 186, 187, 280**
 Arne, Thomas, 232
 Beethoven, Ludwig van, 234
 Bishop, Henry, 232
 Boyce, William, 232
 Carissimi, Giacomo, 234
 Chaucer, Geoffrey 232
 Dante Alighieri, 198, 234
 Gibbons, Orlando, 232
 Goethe, Johann Wolfgang von, 198
 Handel, George Frederick, 198, 232
 Homer, 198, 232, 234
 Lawes, Henry, 232
 Milton, John 232
 Molière, 230
 Monteverdi, Claudio, 234
 Palestrina, Giovanni da, 234
 Prés, Josquin des, 234
 Purcell, Henry, 232
 Pythagoras, 232

 Shakespeare, William 230, 232
 Tallis, Thomas, 232
 Virgil, 234
 Sculptors, by John Birnie Philip, 201, 234–7, 240, 305, **Pls. 160, 188, 189**
 Bird, Francis, 237
 Bologna, Giovanni di, 237
 Bontemps, 237
 Bryaxis, 201, 234
 Bushnell, John, 237
 Cellini, Benvenuto, 234
 Cibber, Caius Gabriel, 237
 Donatello, 237, **Pl. 189**
 Flaxman, John, 237
 Ghiberti, Lorenzo, 237
 Gibbons, Grinling, 237
 Goujon, Jean, 237
 Leochares, 201, 234
 Michelangelo, 234, 237, **Pl. 189**
 Palissy, Bernard, 237
 Phidias, 182, 201, 234, **Pl. 146**
 Pilon, Germain, 237
 Praxiteles, 234
 Robbia, Luca della, 237
 Roubilliac, Louis-François, 237
 Scopas, 201
 Stone, Nicholas, 237
 Thorvaldsen, Bertel, 234
 Torel, William, 237
 Torrigiano, **Pl. 189**
 Verrocchio, Andrea del, 237
 Vischer, Peter, 237
 William of Ireland, 237
 Sciences, by Henry Hugh Armstead and John Birnie Philip, 197, 218–221, 240, 341–2, 344, 377, 395, 407, 415, **Pls. 175, 176**
 Astronomy, 219, 221, **Pl. 177**
 Chemistry, 219, 221
 Geology, 218, 219
 Geometry, 219, 221
 Medicine, 219, 221, **Pl. 279**
 Philosophy, 219, 221
 Physiology, 219, 221, **Pl. 278**
 Rhetoric, 219, 221
 Virtues, by James Redfern, 198, 210–16, 273, 276, 279, 349, 369, 371, 380, 395, 397, 403, 405–7, 417, **Pls. 168, 218, 299, 300**
 Christian, 146, 210, 216, 380
 Charity, 210, 213, **Pl. 309**
 Faith, 210, 213, **Pl. 171**
 Hope, 210, 213, **Pl. 169**
 Humility, 210, 213
 Moral (or Cardinal), 146, 216
 Fortitude, 216
 Justice, 216, **Pl. 171**
 Prudence, 216, **Pl. 172**
 Temperance, 216, **Pl. 170**
Stonework, 146, 149, 150, 166, 167, 377, 380, 382–3, 386, 395, 415 **Pl. 115, 121, 122, 306**
Visitors' Centre, 386–8, 389, **Pl. 286**
Albert Memorial, Manchester, 124, 209, 284, **Pl. 98**
Albert Memorial Chapel, Windsor, 188, 288, 290, 296, 298
Albert Memorial College, Framlingham, Suffolk, 209
Albert Memorial Museum, Exeter, 207
Albert Memorial Trust, 369, 388
Albertopolis, 40, 42, 229, 309–338, **Pls. 238, 239, 241, 257**
 Academy of Music, proposal for 315
 Albert Court, 332
 Albert Hall, 40, 110, 120, 156, 159, 210, 314, 318–329, **Pl. 248, Pl. 249, Pl. 250**
 Albert Hall Mansions, 323, 332, **Pl. 252**
 Albert University, proposal for, 323
 Alexandra House, 332
 Brompton Park House, 40, 312
 City and Guilds College, 335
 Colleges of Arts and Manufactures, 312
 Cromwell Road, 40, 315, 321
 Eastern and Western Exhibition Galleries, 329–30, 335
 Eden Lodge Estate, 314
 Exhibition Road, 314, 315, 321, 330, 331, 335
 Geological Museum, 335, 338
 Gore House, 313
 Holy Trinity Church, Brompton, 315
 Holy Trinity Church, Prince Consort Road, 335
 Imperial College, 335, 338
 Imperial Institute, 331, 335, 338, **Pl. 251**
 Imperial Institute Road, 331, 335
 India Museum, 331, 335
 International Exhibition of 1862, 41, 117, 139, 150, 167, 260, 287, 321, 323, 330, 335, 338, **Pls. 104,**

245, 246
Kensington Gore, 40
Mechanics' Institutes, proposal for, 312
Memorial to the Exhibition of 1851, 38, 107, 208,
 323, 331, **Pl. 25**
Museum of Industrial Art, proposal for 315
Museum of Manufactures, 316
Museum of Patented Inventions, 315, 321, **Pl. 240**
Museum of Trade, proposal for 315
National Museum of Science, 331, 335, 338
National Training School of Cookery, 331
Natural History Museum, 219, 321, 338, **Pl. 247**
Prince Albert Road, 315
Prince Consort Road, 331, 335
Queen's Gate, 315, 331
Royal College of Art, 338
Royal College of Music, 332, 338, **Pl. 254**
Royal College of Organists, 332, 338, **Pl. 253**
Royal Geographical Society, 314
Royal Horticultural Society Gardens, 40, 208, 318,
 321, 325, 326, 327, 329, 330, 335, 338, **Pls. 242, 243**
Royal School of Art Needlework, 331, 335
Royal School of Mines, 335
South Kensington Museum (Victoria and Albert) 40,
 41, 120, 139, 316, 318, 325, 326, 327, 329, 330, 335,
 338, **Pls. 240, 255, 256**
Albert Square, Manchester, 209
Aldridge, John, 312
Alfred, Prince, 86, 88
Allison, Richard, 335
All Saints', Babbacombe, Devon, 423
All Saints', Bisley, 262
All Saints', Sherbourne, Warwickshire, 114
All Souls', Haley Hill, Halifax, 114, 167, **Pl. 88**
American Civil War, 23, 177, 249
Ames, Winslow, 41, 42
Angelico, Fra, 291
Anson, George, 21, 23
Armitage, Edward, 326, 327
Armstead, Henry Hugh, 166, 167, 172, 187, 188, 194, 197,
 198, 204, **Pl. 134**; *and see*
 Albert Memorial *for* Podium frieze, *Sciences*
Arnold, Matthew, 250
Arnolfo di Cambio, Ciborium in San Paolo fuori le Mura,
 Rome, 120, **Pl. 94**
Arts and Crafts Movement, 10, 125, 167, 307, 426
Art Journal, 161, 203, 205, 277, 342
Art Union, 45, 47
Arundel Society, 293, 294
Association for the Improvement of the Working
 Classes, 74
Athenaeum, 45, 91, 129, 161, 205
Augusta, Duchess of Reuss-Ebersdorf, 15, 17
Ayrton, Acton Smee, 194

Baily, Edward Hodges, 47
Baines, Frank, 348, 349, 352
Balmoral Castle, Aberdeenshire, 21, 229, 232
Barclay Church, Edinburgh, 423
Baring, Thomas, 33, 309
Barlow, William Henry, 137
Baroque Revival, 240
Barry, Sir Charles, 99, 101, 240
Barry, Charles, jnr, 101, 102, 104, 165, **Pls. 76, 77**
Barry, Edward Middleton, 101, 102
Bauhütten, 426–7
Bayre, Antoine-Louis, *Force, Order, War, Peace*, 203
Bazalgette, Sir Joseph, 221
Beachcroft, Richard Melville, 345
Becker, Ernst, 24
Bedborough, Alfred, 242
Bedchamber Affair, 17
Bel-Hillel, Mira, 367
Bell, Alfred, 290, 298
Bell, Doyne, 172, 177, 180, 188, 194, 196, 197, 270, 273,
 283, 289, 296, 297, 302, 426
Bell, John, 167, 168, 170, 171, 177, 180, 188, 196, 200, 279,
 280, 282; *and see* Albert Memorial *America*
Bennett, Daphne, 42
Bentley Priory, Stanmore, Middlesex, 138
Beresford-Hope, Alexander James Beresford, 112, 127,
 167, 422
Besant, Annie, 210
Birmingham Assay Office, 254
Blomfield, Sir Arthur, 332, **Pl. 254**
Blore, Edward, 28
Blomfield, Arthur, 263
Bodichon, Barbara, 250
Bodley, George Frederick, 133, 335
Bolitho, Hector, 42
Bombay University, 238

Boutell, Charles, 277, 285
Boyle, William, 120
Bowring, Edgar, 309, 314, 316, 324, 330
Bradlaugh, Charles, 210
Brandard, J. *Camp Polka*, **Pl. 18**
Brassey, Thomas, 138
Brett, Reginald Baliol (Viscount Esher), 345, 346, 347
Brighton Pavilion, 25, 28
Brighton Railway Company, 311
Brill's Bath, Brighton, 263
Brindley, William, 167, 426, **Pl. 134**
Britannia Bridge, 79, 159
British Association of Science, 218
British Museum, 13, 180, 182, 188, 219, 234, 240, 321
Britton, John, 123
Brock, Thomas, 197
Brompton Park House, 40
Brooke, Charles Hyde, 348
Brooks, James, 423
Brown, Ford Madox, *Work*, 225, **Pl. 179**
Browne, J. D. H. *Caractacus Before Claudius Caesar*,
 204
Brunel, Isambard Kingdom, 52, 106, 310
Buccleuch, Duke of, 33
Buckingham Palace, 28, 65, 66, 89, **Pl. 17**
Builder, the, 102, 104, 110, 124, 159, 257, 260, 261, 287,
 289, 305
Building News, 100, 258
Burges, William, 268, 307, 423, 427
Burton, Charles, *Aeronautic View of the Palace of
 Industry*, **Pl. 20**
Bute, Marquis of, 427
Butterfield, William, 101, 112, 114, 129, 132, 133, 254, 256,
 307, 422, 423, 426

Cadbury-Brown, H. T., 338
Calcutta Cathedral, 262
Caldesi and Montecchi, *The Royal Family... at Osborne*,
 91, **Pl. 71**
Callow, William, *Souvenirs of Rosenau*, **Pl. 1**
Cambridge Camden Society, 112, 113, 254
Cambridge University, 62, 74
Campbell, Colin Minton, 288, 324
Canning, Lord, 13
Canterbury Cathedral, 240
Cardiff Castle, 427,
Carisbrooke Castle, 20
Carless, Emma (Mrs Francis Skidmore), 257, 264
Carlton Club, London, 138
Carpenter, Richard Cromwell, 110, 256, 290
Carlyle, Thomas, 9, 53, 56, 59, 74, 225
Casson, Sir Hugh, 338
Castle Howard, Yorkshire 79
Catherine the Great, 15
Cattistock Church, Dorset, 167
Certoso of Pavia, 102
Chantrey, Sir Francis 170
Charing Cross Station Hotel, London 102
Charles, Prince of Wales, 369
Charlotte, Princess, 15
Chartists, 72
Chatham Dockyard, 135
Chester Cathedral, 262, 263
Chichester Cathedral, 290
Chipperfield, David, 389
Christ Church, Coventry, 254
Churchill, Lady, 358
Clarence, Duke of, 15
Clarendon, Lord, 23, 162
Clark, Kenneth, 10, 130, 132
Clark, W.,
 As Well as Can be Expected, 71, **Pl. 53**
 Welcome! Royal Stranger, 71
Clarke, Caspar Purdon, 332
Clayton and Bell, 114, 289, 299, 302, **Pl. 222**
Clayton, John, 125, 167, 198, 230, 234, 237, 283, 289,
 290–93, 296, 297, 298, 299, 300, 302, 305, 306, 341, 346,
 411, 423; *and see* Albert Memorial Mosaics
Coad, Richard, 273, 277
Cobden, Richard, 33, 309
Coburg, Germany, 15, 16, 17, 59, 66, 71
Coburg family, 15–17, **Pl. 6**
Cockerell, Charles Robert, 162, 201, 239, 316, 338, 352
Collcutt, Thomas Edward, 331, **Pl. 251**
Cole, Harry, 332, **Pl. 253**
Cole, Sir Henry, 24, 30, 32, 33, 40, 110, 126, 128, 139, 140,
 150, 163, 164, 170, 188, 210, 310, 311, 313, 316, 318, 321,
 323, 324–7, 329, 326, 330, 338, 342, 343, **Pl. 244**
Colnaghi and Puckle, 46
Cologne Cathedral, 426, 427
 Shrine of the Three Kings, 118, **Pl. 91**

Colonial and Indian Exhibition 1886, 331
Colvin, Sidney, 128, 205
Commonwealth Institute, 332
Construction (Design and Management) Regulations
1993, 383
Conway, Moncure Daniel, 130
Cork Cathedral, 423
Cormack, Patrick, 366
Cornelius, Peter, 200
Corn Laws, repeal of, 120
Cornwall, Duchy of, 56
Court Circular, 55
Coventry Industrial Exhibition, 263
Crimean War, 9, 82–88, 93, 270
Cross, William, 149
Crystal Palace, *see* Great Exhibition
Cubbington Church, Warwickshire, 256
Cubitt, Sir William, President of Institution of Civil
Engineers, 33, 40, 309
Cubitt, Thomas, 27, 28, 32, 138, 311, **Pl. 14**
Cubitt, William, Lord Mayor of London, 100
Cucco, Cavaliere Giovanni, 411, 412
Cutts, Edward, 262

Dafforne, James, 207, 210, 216, 222, 225, 229, 230, 231,
234, 238, 239, 244, 246, 249, 250
Daily News, 344
Darlington Market, 260, 263
Dean & Co., *The Queen and Prince Albert at Home*, 71
Dean, George, 28
Deane, Sir Thomas, 257, 258
Deane and Woodward, 100, 257
Dechaume, Geoffrey, 201
Delaroche, Paul, *Hemicycle*, 200, 423
Dennis, Paul & Son, 417
Department of the Environment, 366, 391, 395
Department of National Heritage, 367, 368, 369
Department of Science and Art, 316, 330
Department of Works, Woods and Forests, 28, 309, 311
Derby, Lord, 33, 162, 270, 309, 321, 324, 325, 330
Deutsche Allgemeine Zeitung, 277
DGT fabrications, 400
Diana, Princess of Wales, 388
Dickens, Charles, 221, 250
Digby, Kenelm, 216
Dilke, Charles Wentworth, 310, 311
Disraeli, Benjamin, 13, 24, 42, 270, 314, 316
Donaldson, Thomas Leverton, 100–101, 104, 107, 316,
Pl. 78
Donna Anna Maria, Queen of Portugal, 15
Dorothea Restoration Ltd., 404
Drew, George, 310
Dublin Exhibition, 41 (1853), 262 (1865)
Dulwich College, London, 102
Dunnett, David, 365
Durant, Susan, 188
Durham, Joseph, 107, 167, 168; *and see* Albertopolis
Memorial to Exhibition of 1851
Dyce, William, 24, 27, 161
*Neptune Entrusting the Command of the Sea to
Britannia*, 27

École des Beaux-Arts, Paris, 200, 238
Edmeston, James, 112
Earle, Lionel, 348, 349, 352
East India Company, 33, 36
Eastlake, Charles L., 99
Eastlake, Sir Charles Lock, 100, 128, 161, 163, 164, 166,
167, 168, 170, 172, 177, 180, 182, 184, 198, 200, 209, 249,
273, 293, 309, 424, 425, **Pl. 130**
Eastlake, Lady, 296
Eaton Hall, Cheshire, 263
Edvin Loach Church, Hertfordshire, 422
Edward VIII, King of England, 21
Edward, Prince of Wales, (later Edward VII), 28, 54, 71,
74, 78, 86, 88, 110, 321, 324, 325, 330, 346, 348
Elcho, Lord, 194
Eleanor Crosses, 13, 108, 110, 120, 166, 201, 237, **Pl. 84**
Elkington & Co., Birmingham, 171
Ellesmere, Earl of, 33
Elizabeth II, Queen of England, 390
Elsley, Thomas, 347
Ely Cathedral, 117, 167, 262
Emmett, John T., 128, 352
English Heritage, 10, 136, 277, 345, 361, 368, 369, 381,
385, 386, 388, 391, 417; *and see* Albert Memorial
Conservation and Repair
Ernst August, Prince of Hanover, 310
Ernst I, Duke of Saxe-Coburg-Saalfeld, 15, 16, **Pl. 2**
Ernst II, Duke of Saxe-Coburg-Saalfeld, 16, **Pl. 5**

Ettington Park, Warwickshire, 167
Eugénie, Empress of France, 88
Euston Arch, London, 104
Evening Standard, 367
Evreux, Shrine of St Taurin, 118
Exeter Cathedral, 423
Exeter College Chapel, Oxford, 262, 422
Exposition Universelle, Paris 1867, 277

Fairbairn, William, 138, 159, 258
Farmer and Brindley, 167
Farmer, 270
Fernkorn, Anton Dominik, *Memorial to Archduke
Charles*, Vienna, 164
Ferdinand, Prince of Saxe-Coburg-Gotha, 15
Fergusson, James, 106, 130, 326, **Pl. 81**
Festival of Britain, 357
Fishmongers' Hall, London, 112
Flaxman, John, 170, 290
Florence Cathedral, 238
Florschütz, Christoph, 16
Foley, John Henry, *see* Albert Memorial *for* Albert, *Asia
Magna Carta Barons*, 171
Viscount Hardinge, 171
Foreign Office Competition, 100, 101, 114, **Pl. 89**
Fox, Charles, 150
Fox Henderson, 38, 136, 150, 284
Fowke, Francis, 41, 110, 120, 318, 321, 324, 329, 325, 329,
338, **Pl. 245, Pl. 250**
Fowler, Charles, 136
Fowler, John, 326
Francis, John, 47
Franco-Prussian War, 242
Franel, Henri, *Memorial to Duke of Brunswick*, Geneva,
284
Franz-Anton, Duke of Saxe-Coburg Saalfeld, 15, **Pl. 4**
Freake, Charles, 312
Friedrich Wilhem IV, King of Prussia, 310
Frogmore Mausoleum, Windsor, 184, 353
Fuller, Francis, 32, 310

Gabbett, 344
Gaddi, Taddeo, 299
Gamble, James, 326
Gare de l'Est, Paris, 136
Gare du Nord, Paris, 107
Geological Society, 33
George IV, King of England, 17, 21, 27
George V, King of England, 28, 349
Germany, unification of, 242, 426
Ghiberti, Lorenzo, 291
Gibson, John, 167, 168, 170
Giotto, *Ognissanti Madonna*, 299, **Pl. 229**
Gladstone, William, 33, 168, 184, 194, 270, 309, 311, 314,
316, 325
Glasgow University, 100, 107, 423
Gloucester Cathedral, 167
Gloucester, Duchess of, 264
Godwin, Edward William, 100, 112
Goodden, Robert, 338
Goschen, George, 335
Gosse, Edmund, 205
Gothic and Gothic Revival, 99, 100, 101, 107, 110, 113, 114,
126, 128, 129, 130, 133, 136, 137, 167, 194, 201, 209, 210,
216, 230, 238, 240, 253, 257, 266, 284, 306, 307, 344, 389,
421, 422, 423, 426, 427
Grant, Sir Francis, 47
Grant, Ulysses S., 249
Granville, Lord, 13, 24, 33, 309, 312, 316, 321
Great Exhibition, 9, 13, 30, 33, 36, 38, 41, 74, 76, 78, 93,
100, 129, 135, 139, 149, 168, 177, 188, 208, 209, 210, 222,
229, 237, 241, 244, 250, 254, 289, 290, 309, 310, 311, 318,
329, 335, 357, 426, **Pls. 11, 20, 21, 22, 23, 103**
Grimsby Docks, 74
Greenwich Hospital, London, 316
Greville, Charles, 17, 23
Grey, Colonel (later General) Charles, 23, 41, 100, 120,
161, 163, 164, 165, 166, 167, 170, 171, 172, 180, 184, 186,
187, 188, 209, 268, 273, 280, 288, 296, 313, 316, 323, 324,
325, **Pl. 10**
Grey, Lord, 17
Grissell and Peto, 112, 136, 138,
Grosvenor Hotel, London, 138
Grüner, Ludwig, 24, 27, 28, **Pl. 12**
Guidici, 357

Harbron, Dudley, 10
Haghe, Louis,
Martyrs' Memorial, Oxford, **Pl. 86**
Medieval Court at the Great Exhibition, **Pl. 23**
Haghia Sophia, 110

Handley, Henry, 120
Hanover, King of, 56
Hardman, John, 253, 254, 284
Hardman, Powell and Company, Birmingham, 346, 347
Hardman, Sir William, 8
Hardwick, Philip Charles, 101, 104, 109, 165, 166, 207, **Pl. 79**
Harrington, Earl of, 312
Hart and Son, later Hart, Son, Peard & Co., 263, 284
Hartley Wood, 400
Havelock, Henry, 234
Hawkshaw, John, 326
Hayter, Sir George, *Ernst, Duke of Saxe-Coburg and Gotha*, **Pl. 2**
Health, Food and Clothing Exhibition, 331
Heasman, A. W., 352
Herbert Art Gallery, Coventry, 256
Hereford Cathedral Screen, 117, 138 260–62, **Pl. 204**
Heritage Lottery Fund, 389
Herkomer, Hubert, *Hard Times*, 229, **Pl. 183**
Hertford, Lord, 41
Higgs and Hill, 357
Hinderton Hall, Cheshire, 256, 263
Hine, Thomas Chambers, *Bentinck Memorial*, 120, **Pl. 95**
Hiorns, David, 263
Hittorff, Jacob Ignaz, 107
Hodgkin, J. E., 263
Hodgson and Graves, 46
Holy Trinity Church, Coventry, 253, 256
Hook, Walter Farquhar, 253, 254
Hope, John, 358
Horsley, John Callcott, 326, 327, 329
Hour, 343
Housman, Laurence, 41
Hungerford Market, London, 136
Hunt, Charles, *Wonder of Windsor*, **Pl. 6**
Huskisson Memorial Window, Chichester Cathedral, 290
Huxley, Thomas, 218

Ilam Church, Staffordshire, 256
Illustrated London News, 33, 46, 49–53, 54, 55, 56, 59, 66, 71, 72–4, 76, 78, 85–8, 91, 93, 117, 261, 310, **Pls. 33, 35, 36, 49, 52, 54, 57, 60, 61, 63, 64, 65, 67, 68, 69, 73, 104, 106, 249**
Illustrated News of the World, 91
Imperial Glassworks, St. Petersburg, 288
India Office, London, 106
Indian Mutiny (First War of Independence), 234, 244
Institution of Civil Engineers, 33
Instrumenta Ecclesiastica, 256
International Exhibition 1862, 41, 117, 139, 150, 167, 260, 287, 321, 323, 330, 335, 338, **Pls. 104, 245, 246**
International Fisheries Exhibition 1883, 331
Inventions Exhibition 1885, 331

Jackson, Thomas Graham, 117, 128,
Jacobs, William, 149
Jagow, Kurt, 21
Jameson, Anna, 213
Jank, Christian, 427
Jerrold, Douglas, 72
Jessel, Sir George, 330
Jesus College Chapel, Oxford, 167
Jones, Owen, 311
Jordan, Mrs, 15

Keble College, Oxford, 129, 132, 423
Keble College Chapel, Oxford, 307
Keith, John and Son, 254
Kelham Hall, Nottinghamshire, 136
Kelk, John, 41, 92, 138, 139, 140, 149, 150, 156, 159, 166, 194, 268, 279, 280, 282, 299, 302, 312, 321, 343, 388, 424, **Pl. 104**
Kemp, George Meikle, *Sir Walter Scott Memorial*, 101, 110, 123, 200, 284, **Pl. 97**
Kendle, J. T. L., 353
Kent, Duchess of, 15
Kent, Duke of, 15, 17,
Kerr, Robert, 125, 130
King's College, London, 161
Kingsley, Charles, 8, 9,
Kohari family, 15

Lanchenick, J. C., *Brompton Boilers*, **Pl. 240**
Landseer, Sir Edwin, 24, 168, **Pl. 133**
 Windsor Castle in Modern Times, 66–67, **Pl. 50**
Langston, David, 347
Larkins, Sidney, 361
Lawlor, John, *see* Albert Memorial *Engineering*

Layard, Sir Austen Henry, 128, 130, 163, 180–89, 193, 194, 196, 201, 205, 208, 273, 280, 293–6, 297–301, 424, **Pls. 224, 226**
Leafield Church, Oxfordshire, 422
Leaver, James, 262, 284
Leech, John,
 'Brooke Green Volunteer', 65
 'Case of Real Distress', 65, **Pl. 17**
 'Children at Play', 59, **Pl. 44**
 'Cupid Out of Place', 54, **Pl. 37**
 'Grand Military Spectacle', 84, **Pl. 66**
 'Her Majesty, as She Appeared on the First of May', 78, **Pl. 61**
 'H.R.H. Field-Marshal Chancellor Prince Albert taking Pons Asinorum', 74, **Pl. 58**
 'H.R.H. F.M. P.A. At It Again !', 88
 'Just Kilted—A Scene at Blair Atholl', 59, 65, **Pl. 42**
 'Les Adieux de Buckingham Palace', 59–62, **Pl. 45**
 'Mars Attired by Prince Albert', 65
 'Military Reform—A Noble Beginning', 84
 'More Noble Conduct of H.R.H. F.M. P.A.', 84
 'No Place Like Home !', 71, **Pl. 55**
 'Prince Albert "At Home"', 62–3, **Pl. 46**
 'Prince Albert's Studio', 56, **Pl. 40**
 'Prince Albert the British Farmer', 59, 71, 222, **Pl. 15**
 'Queen's "'Sevenpence'"', 55
 'Royal Nursery Rhymes', 56, **Pl. 38**
 'Specimens from Mr. Punch's Industrial Exhibition of 1850', 74
 'Sport ! Or, A Battue Made Easy', 59, 65
 'Throwing the Old Shoe', 82, 85, **Pl. 64**
Leighton, Frederic, 180, 194, 326
 Cimabue's Celebrated Madonna...Carried in Procession, 229, **Pl. 184**
Leopold, King of the Belgians, 15, 17, 21, 25
Lichfield Cathedral, 117, 167, 200, 260, 261, 262, 423, 426, **Pl. 90**
Liddell, John, 321
Lincoln, Abraham, 249
Lloyd, J. A., 309, 310
London Coal Exchange, 74
London County Council, 345
London University, 323, 332
Londonderry, Marquess of, 347
Lott, William, 283
Lough, John Graham, 204
Louis-Philippe, King of France, 59, 66
Lowe, Robert, 321, 324
Lucas brothers, 139, 150
Lucas, John, *H.R.H. Prince Albert*, 47, 65, **Pl. 47**
Ludwig II, King of Bavaria, 427
Luise, Duchess of Saxe-Coburg and Gotha, 15, 16, **Pl. 3**
Luther, Martin, 17, 66
Lyttelton, Lady, 13

MacCormick Reaper, 222
Macdonald, Lawrence, 167, 168
MacDowell, Patrick, *see* Albert Memorial *Europe*
Maclise, Daniel, 24
 Death of Nelson, 25
 Wellington and Blücher after Waterloo, 25, 326
Magee, Bishop William, 263
Malvern Girls' College, 262
Manchester Art Treasures Exhibition 1857, 41, 88, 89, 209, **Pls. 26, 69**
Manchester Assize Courts, 263
Manchester Town Hall, 423
Mansion House, London, 100, 161
Marburg, Shrine of St Elizabeth, 118, **Pl. 206**
Marcus Aurelius, Rome, 164
Marion & Co., 91
Marks, Stacy, 326, 327
Marochetti, Baron Carlo, 47–8, 167, 168, 184; *and see* Albert Memorial *for* Albert
 Angel of Scutari, 168, 184
 Prince Albert, Aberdeen, 184, **Pl. 147**
 Prince Albert, Glasgow, 184, 187, **Pl. 148**
Marshall, William Calder, *see* Albert Memorial *Agriculture*
Martin, Theodore, 41
Martyrs' Memorial, Oxford, 110, 113, **Pl. 86**
Mason, H., 279
Mathews, Charles, 62–3
Mausoleum, Halicarnassus, 104, 182, 184, 188, 201, 234
Mayall, John Edwin, 91, 93, 207, **Pl. 70**
Meadows, Kenny, 65
Mecklenburg marriage, 56
Medievalism, 113, 133, 204, 253, 266, 305, 427
Meeting of Wellington and Blücher after Waterloo (Daniel Maclise), 25

Melbourne, Lord, 17, 21
Mérimée, Prosper, 338
Metropolitan District Railway, 329
Meyern, Louise Leopoldine de,
 Luise, Duchess of Saxe-Coburg and Gotha, **Pl. 3**
 Prince Albert and Prince Ernst, **Pl. 5**
Micklethwaite, John Thomas, 264
Midland Grand Hotel, St. Pancras, London, 100, 129, 137,
156, 263, 423
Millais, John Everett, 180
Mill, John Stuart, 250
Millennium Dome, 389
Millennium Fund, 389
Minton, Hollins and Company, 288, 327
Mitchell, Andy, 277, 407, 408,
Mitford, A. B., 342, 345, 357
Moffatt, William Bonython, 112
Montecchi, Matteo, 302
Moore, Temple, 264
Morning Post, 344
Morris, William, 125, 129, 167, 307, 426
Morton Partnership, 400
Munday, George, 309
Munday, James, 309

Napoleon III, Emperor of France, 88, 242, 427
Nash, John, 28
Nash, Joseph, *India Court of the Great Exhibition*,
Pl. 22
National Gallery, London, 40, 88, 162, 180, 313, 315, 318
Nelson Memorial, Trafalgar Square, 149, 168, 421
Neo-Georgianism, 240
Nesfield, William Andrews, 318
'New Sculpture' Movement, 205
New Street Station, Birmingham, 136, 284
Newton, Charles, 182, 188–189, 196, 197, 201, 280
Nicholaikirche, Hamburg, 113, **Pl. 87**
Noble, Matthew, 124, 167, 168, 203
Normanby, Lord (British ambassador, Paris), 23
Northampton Town Hall, 100
Northcote, Stafford, 33, 309, 311
Norwich Cathedral, 262
Notre-Dame, Paris, 201, 240

O'Dwyer, Frederick, 257
Orcagna, Andrea, Shrine of Madonna in Or San Michele,
Florence, 120, **Pl. 93**
Osborne House, Isle of Wight, 21, 25, 91, 229, 346, **Pl. 13**
Overbeck, Friedrich, 200
Overstone, Lord, 33, 309
Oxford Architectural Society, 256, 260
Oxford Cathedral, 262
Oxford Movement, 112
Oxford University Museum, 100, 138, 257–8, 260, **Pl. 203**

Paddington Station, London, 106, 135
Palace of Westminster, London, 24, 25, 28, 100, 135, 149,
163, 168, 204, 240, 287, **Pl. 132**
Palgrave, Francis Turner, 120, 128, 188, 232
Pall Mall Gazette, 128, 342
Palmerston, Lord, 21, 24, 99, 110, 114, 270, 325
Paris Exhibition 1844, 32
Parker, J. H., 260
Parrot, Mr, 358
Parthenon frieze, 182, 184, 201, 234, 423
Partridge, John, *H.R.H. The Prince Consort*, 47, **Pl. 31**
Patten, George, *Prince Albert*, 45, 46, 47, **Pl. 28**
Paxton, Joseph, 33, 36, 76, 250, 310, 311
Pearson, John Loughborough, 422, 423
Pecht, Friedrich, 277
Peel, Sir Robert, 20, 21, 24, 25, 28, 33, 59, 71, 309, 310
Pennethorne, James, 28, 101, 104, 316, **Pl. 80**
Penny Satirist, 71
Penrose, Francis Cranmer, 288
Percy, John, 342
Pevsner, Nikolaus, 421
Philip, John Birnie, 166, 167, 260, **Pls. 90, 154**; *and see*
Albert Memorial *for* Angels,
 Podium Frieze, *Sciences*
Phillips, Joseph, 284
Phipps, Colonel Charles, 23, 100, 162, 166, 170, 324
Pickersgill, Frederick Richard, 326, 327, 329
Pictorial Times, 71
Pierrefonds, France, 427
Pilkington, Frederick Thomas, 423
Pisano, Niccola, 327
Playfair, Lyon, 24, 28, 40, 309, 310, 311, 335
Plowden and Smith, 408,
Potter, Thomas and Son, 263, 284
Pound, Daniel John, *The Late Prince Consort*, 91, 93,
207, **Pl. 71**

Poynter, Edward, 326, 327, 329
Pradier, James, 200
Pre-Raphaelite Brotherhood, 161, 290
Prichard and Seddon, 167
Prince, Henry, 197
Prior, Thomas Abiel, *Albert Memorial and Hyde Park*,
Pl. 99
Private Eye, 132, **Pl. 101**
Property Services Agency, 342, 361, 365, 366, 391
Public Record Office, London, 104
Pugin, Augustus Welby, 74, 99, 112, 114, 135, 167, 194,
240, 253, 254, 423, 426
Punch, 25, 30, 46, 53–65, 66, 71, 72, 74, 76, 78–9, 82–4, 85,
87, 88, 91, 92, 93, 96, 222, 347, 352, 421, **Pls. 15, 17, 37, 38,
40, 41, 42, 43, 44, 45, 45, 46, 48, 55, 61, 62, 64, 65, 66**, 258
Purcell, Miller Tritton, 395
Pusey, Philip, 257

Quarterly Review, 128
Queen Anne movement, 232

Radi, Lorenzo, 288
Raphael, 24, 89, 194, 229
Rate, Lacklan Mackintosh, 294
Rauch, Christian Daniel, *Frederick the Great*, 164, 170,
200, 423, **Pl. 131**
Rawlinson, Robert, 23
Redfern, James, 167; *and see* Albert Memorial *Virtues*
Redgrave, Richard, 120, 321, 324
Reichensperger, Auguste, 426, 427
Reid, Colonel W. , 33, 40, 310, 311
Religious Census 1851, 210
Rheims Cathedral, 240
Rhodes-James, Robert, 42
Richmond, George, *Sir George Gilbert Scott*, **Pl. 75**
Ridley, Nicholas, 366
Roberts, David, *Opening of the Crystal Palace*, **Pl. 21**
Roberts, Henry, 30, 112, 136, 209
Rochet, Louis, *Monument to Don Pedro the First*, 200
Rosini, *Storia della Pittura Italiana*, 299
Ross, William Charles, 46, 47, **Pl. 24**
Rothwell, F. L., 353, 357
Roundhouse, Camden Town, London, 136
Royal Academy, 24, 65, 74, 79, 100, 161, 162, 180, 221, 318
Royal Albert, The, 86–7, **Pl. 68**
Royal Courts of Justice, Strand, London, 100, 129
Royal Fine Arts Commission, 24, 163, 168, 171, 204
Royal Opera House, 102, 150
Royal Wedding Jester, 45, 47
Rulandt, 24
Ruskin, John, 114, 238, 241, 250, 258, 260, 284, 290, 422,
426
 Tomb of Can Mastino II, **Pl. 92**
Russell, John Scott, 32, 33, 309
Russell, Lord John, 23, 33, 38, 71, 270, 309

St. Alban's, Holborn, London, 423
St. Chad's, Dalston, London, 423
St. Columba's, Dalston, London, 423
St. Finbar's Cathedral, Cork, 307
St. George's Chapel, Windsor, 264
St. George's, Doncaster, 114
St. Giles', Camberwell, London, 113
St. Giles', Exhall, Warwickshire, 254
St. James's Palace, London, 28
St. John the Baptist's, Coventry, 254
St. John the Baptist's, Eastnor, Herefordshire, 256
St. Luke's, Dunham-on-the-Hill, Cheshire, 262
St. Mark's, Venice, 301
St. Mary Abbot's, Kensington, 114, 389
St. Mary's Episcopal Cathedral, Edinburgh, 114
St. Mary's Guildhall, Coventry, 256
St. Mary Magdalene's Church, Paddington, London, 423
St. Mary's, Stafford, 117
St. Michael's, Oxford, 256
St. Paul's Cathedral, London, 204, 287, 288
Sainte-Chapelle, Paris, 422
Saint Laurent, Madame, 15
Salisbury Cathedral, 117, 138, 167, 200, 262, 423, 426
Salisbury, Lord, 133
Salviati, Antonio, and Salviati & Co., 140, 287, 288, 289,
294, 296, 297, 298, 300, 301, 302, 305, 411, 423, 425; *and
see* Albert Memorial, Mosaics
Salvin, Anthony, 290
San Giovanni in Laterano, Rome, 318
San Paolo fuori le Mura, Rome, 120, 318, **Pl. 94**
Santa Maria della Spina, Pisa, 124
Saturday Review, 127, 205
Save Albert Conference 368, **Pl. 272**
Scaliger Monuments, Verona, 118, **Pl. 92**
Schinkel, Karl Friedrich, 16, 104, 120
 Monument to the Liberation, 120, **Pl. 96**

Schloss Ehrenburg, Coburg, 46
Schloss Neuschwanstein, Bavaria, 427
Schloss Rosenau, Coburg, 42, **Pl. 1**
Scotland Yard, 347
Scott, Caroline, 129
Scott, Sir George Gilbert, 9, 92, 99–102, 107–33, 135, 136,
 138, 140, 146, 149, 150, 159, 165, 166, 167, 171, 172, 180,
 182, 186, 187, 188, 194, 197, 198, 201, 203, 204, 205, 208,
 209, 210, 238, 240, 253, 256, 257, 260, 263, 264, 266, 267,
 270, 273, 277, 279, 280, 282, 283, 284, 285, 287, 288, 289,
 290, 293, 296, 297, 298, 306, 323, 325, 358, 397, 341, 342,
 343, 345, 361, 372, 383, 386, 389, 407, 417, 418, 421–7,
 Pls. 75, 86, 87, 88, 89, 90, 204; *and see* Albert Memorial
Scott, Henry, 110, 325, 329, 330, **Pl. 250**
Scott, John Oldrid, 280, 282, 283, 345, 346
Scott, Thomas, 149
Scott, Sir Walter, Monument, 101, 110, 123, 200, 284,
 Pl. 97
Second Reform Act, 250
Seddon, John Pollard, 262
Selous, Henry, 76
Semper, Gottfried, 113, 316, 325, **Pl. 239**
Severn Tunnel, 326
Shaftesbury, Lord, 8, 13
Shaw, Richard Norman, 129, 323, 332, **Pl. 252**
Sheilds, Francis Webb, 137, 138, 146, 159, 426
Shelton, H. C., *The Burial of the Princes in the Tower*,
 204
Shrines, 108, 118, 120, 266–7, **Pls. 91, 93, 206, 207**
Skelton-on-Usk Church, Yorkshire, 423
Skidmore, Francis, 117–8, 253–85, **Pls. 90, 200, 201, 202,
 203, 204, 205**; *and see* Albert Memorial *for* Enamel
 Shields, Flèche, Gates and Railings, Metalwork
Slater, William, 256
Sluter, Claus, *Puits de Moïse*, Dijon, 200
Small, Charles Tunstall, 349, **Pls. 260, 261**
Smirke, Sydney, 101, 318
Smith, Herbert L., *Franz-Anton, Duke of Saxe-Coburg
Saalfeld*, **Pl. 4**
Snell, Saxon, 321
Society of Arts, 30, 32, 309, 321
Society for Improving the Conditions of the Labouring
 Classes, 30
Society for the Protection of Ancient Buildings, 129
Somerset House, 138
South Staffordshire Industrial and Fine Art Exhibition,
 Wolverhampton, 263
Soyer, Louis, 184
Spackman, Sergeant Benjamin, 326, 327
Spectator, 45
Spencer, Earl, 309
Stamfordham, Lord, 348, 349
Stanhope, Lord, 188, 189
Stanley, Lord, 309
Starkie-Gardner Ltd, 358
Statistical Society, 311
Steell, John, 123
Stephens, Frederick George, 161
Stephenson, Robert, 79, 159, 284, 309
Stevens, Alfred, 318
 Wellington Memorial, St. Paul's Cathedral, 71, 168,
 194, 203, 207, 242, 326, 421
Stevens, Sir Jocelyn, 368, 390
Stevenson, John James, 264
Stockmar, Baron von, 9, 17, 20, 21
Stoddart, Alexander, 107
Strachey, Lytton, 41
Strangeways Gaol, Manchester, 263
Street, George Edmund, 101, 114, 129, 132, 133, 263, 422,
 423, 426
Studley Royal Church, Yorkshire, 423
Sussex, Duke of, 30
Sykes, Godfrey, 318

Taj Mahal, 13
Talbert, Bruce J., 262
Tate Gallery, 335
Tatton Sykes Estate, Yorkshire, 423
Taylor, John, 342
Tenniel, John, 'Happy Family in Hyde Park', 78– 79, 96,
 Pl. 62
Theed, William, 162, 166, 188; *and see* Albert Memorial
Africa
Thomas, John, 28
 Boadicea, 171
Thompson, Arthur, 188
Thomson, Alexander 'Greek', 107, **Pl. 82**
Thorburn, Robert, 47, 65
Prince Albert reading the Trent Despatch, **Pl. 9**
Thorne, James, 135
Thornycroft, Hamo, 226, **Pl. 181**

Thornycroft, Thomas, 168; *and see* Albert Memorial
Commerce
Thorwaldsen, Bertel, 170
Times, 41, 110, 161, 310, 311, 343, 344, 345, 357
Tite, William, 101
Topham, E. W., 46
 Prince Albert, **Pl. 29**
 His Royal Highness Prince Consort, **Pl. 30**
Townroe, Reuben, 318, 326, 327
Trent Affair, 23
Trevor Caley Associates, 411, 412
Triqueti, Henri, 188
Trollope, Anthony, 241
Troughton and Bevan, 256
Turnor, Reginald, 10

Ullathorne, Bishop William, 254
Uwins, Thomas, 24–5

Vatican Glassworks, 288
Venice and Murano Glass and Mosaic Company, 302, 346
Victoire, Duchess of Leiningen, 15, 17
Victor Emmanuel II, King of Italy, 88
Victoria Embankment, 138
Victorian Society, The, 42, 132, 367–8, **Pl. 272**
Victoria, Princess Royal, later Crown Princess of
 Prussia, 66, 71, 74, 78, 91, 101 180
Victoria, Queen of England, 8–9, 13, 15, 17–21, 24, 25, 27,
 28, 30, 36, 38, 41, 42, 45, 47, 49, 52, 55, 56, 59, 65, 66–71, 72,
 74, 76, 78, 79, 82, 85–7, 88, 89, 91, 92, 99, 104, 109, 110,
 162–6, 167–8, 170, 171, 172, 177, 180, 184, 186–9, 194, 196,
 207, 208, 209, 229, 268, 283, 293, 302, 305, 309, 324, 325,
 326, 329, 330, 331, 342, 346, 348, 408, 421, 425; **Pls. 6, 8, 15,
 17, 18, 21, 33, 34, 35, 38, 40, 42, 44, 48, 49, 50, 51, 52, 53, 54,
 55, 56, 57, 61, 63, 64, 67, 69, 71**
Victoria Memorial Committee, 346
Victoria Memorial, London, 197
Victoria Station, London, 138
Vignoles, Charles, 138
Villars, Baron de, 312
Viollet-le-Duc, Eugène-Emmanuel, 128, 129, 201, 427

Wagstaff, Charles Edward, *Prince Albert*, **Pl. 28**
Waring, J. B., 287, 288
Waterhouse, Alfred, 256, 260, 263, 321, 335, 338, 423,
 Pl. 247
Watts, George Frederick, 189
Webb, Sir Aston, 28, 335, **Pl. 256**
Weekes, Henry, 49, 168, 197; *and see* Albert Memorial
Manufactures
 Prince Albert, 49, **Pl. 32**
Weintraub, Stanley, 42
Wellington, Duke of, 20
Wellington Memorial, Hyde Park, London, 207
Wellington Memorial, Manchester, 203
Wells Cathedral, 290, 423
Westmacott, Richard, *Abercromby Monument*, 204
Westminster Abbey, 117, 118, 167
Westminster City Council, 389
White, William, 422
Wilberforce, Bishop Samuel, 218
William IV, King of England, 28
Willis, Henry, 329
Wills, John, 342
Windsor Castle, 27, 88, 89
Winfields of Birmingham, 264
Winterhalter, Franz Xaver
 Prince Albert 1842, 47, **Pl. 8**
 Prince Albert 1859, 88
 Prince Albert 1861, **Pl. 27**
 Queen Victoria, **Pl. 7**
 Royal Family, 66–7, **Pl. 51**
 The First of May, 76
Wise, Henry, 312
Wolsey Chapel, Windsor, 288
Woodward, Benjamin, 257, 258
Wooland Church, Dorset, 167
Woolner, Thomas, 188
Woolwich Arsenal, 270, 273
Worcester Cathedral, 117, 167, 262
Worcester College Chapel, Oxford, 307
Woodward, Benjamin, 257
Worthington, Thomas, 124, 284, **Pl. 98**
Wren, Sir Christopher, 287, 327
Wyatville, Sir Jeffry, 27
Wyatt, Matthew Digby, 32, 101, 106, 254, 290, 310, 311,
 Pl. 202

Yeames, Frederick, 326, 327
Young England, 216

Zollverein, 30, 36

Picture Acknowledgements

Figures refer to Plate numbers

The authors and publishers would like to thank the following individuals, collections and photographic archives for permission to reproduce their material. If we have inadvertently infringed copyright we apologise and will rectify it, if advised, in any future edition.

1 Victoria and Albert Museum, London (The Bridgeman Art Library, London). 2–5 The Royal Collection © 2000 Her Majesty Queen Elizabeth II. 6 British Library, London (The Bridgeman Art Library, London). 7–8 The Royal Collection © 2000 Her Majesty Queen Elizabeth II. 9–12 The Royal Archives © 2000 Her Majesty Queen Elizabeth II. 13 English Heritage Photographic Library, London. 14 National Portrait Gallery, London. 15 Chris Brooks. 16 The Royal Collection © 2000 Her Majesty Queen Elizabeth II. 17 Chris Brooks. 18 O'Rorke Collection. 19 Private Collection (The Bridgeman Art Library, London). 20 Guildhall Library, Corporation of London (The Bridgeman Art Library, London). 21 Agnew & Sons, London (The Bridgeman Art Library, London). 22 Guildhall Library, Corporation of London (The Bridgeman Art Library, London). 23 Christopher Wood Gallery, London (The Bridgeman Art Library, London). 24 National Portrait Gallery Archive Engravings Collection, London. 25 Local Studies Collection, Kensington Central Library, London. 26 Local Studies Unit, Manchester Central Library. 27 Rafael Valls Gallery, London (The Bridgeman Art Library, London). 28–30 National Portrait Gallery Archive Engravings Collection, London. 31 The Royal Collection © 2000 Her Majesty Queen Elizabeth II. 32 Private Collection (National Portrait Gallery Archive, London). 33 The Devon and Exeter Institute (Chris Brooks). 34 Museum of British Transport (The Bridgeman Art Library, London). 35 Exeter University (Chris Brooks). 36 The Devon and Exeter Institute (Chris Brooks). 37–8 Chris Brooks. 39 National Army Museum, London. 40–6 Chris Brooks. 47 Crown Estate/ Institute of Directors, London (The Bridgeman Art Library, London). 48 Exeter University (Chris Brooks). 49 The Devon and Exeter Institute (Chris Brooks). 50–1 The Royal Collection © 2000 Her Majesty Queen Elizabeth II. 52 Stapleton Collection (The Bridgeman Art Library, London). 53 National Portrait Gallery Archive Engravings Collection, London. 54 Hulton Getty Picture Collection, London. 55 Chris Brooks. 56 O'Rorke Collection. 57 Exeter University (Chris Brooks). 58 Chris Brooks. 59 The Trustees of the Victoria and Albert Museum, London. 60 Exeter University (Chris Brooks). 61–2 Chris Brooks. 63 Exeter University (Chris Brooks). 64–6 Chris Brooks. 67–9 Exeter University (Chris Brooks). 70 National Portrait Gallery Archive Engravings Collection, London. 71 The Trustees of the Victoria and Albert Museum, London. 72 National Portrait Gallery Archive Engravings Collection, London. 73 Local Studies Collection, Kensington Central Library, London. 74 Hulton Getty Picture Collection, London. 75 The Royal Academy, London. 76–9 British Architectural Library, R.I.B.A., London. 80 Private Collection (Dr. Geoffrey Tyack, Oxford). 81 The Trustees of the Victoria and Albert Museum, London. 82 British Architectural Library, R.I.B.A., London. 83 The Royal Collection © 2000 Her Majesty Queen Elizabeth II. 84 English Heritage Photographic Library, London. 85 Local Studies Collection, Kensington Central Library, London. 86 Gavin Stamp Collection. 87 Hulton Getty Picture Collection, London. 88 J.G. Washington F.R.P.S., Halifax. 89 British Architectural Library, R.I.B.A., London. 90 A.F. Kersting, London. 91 Cologne Cathedral (A.K.G./ Erich Lessing, London). 92 Ashmolean Museum, Oxford (The Bridgeman Art Library, London). 93 Or San Michele, Florence (A.K.G., London). 94 S. Paolo fuori le Mura, Rome (A.K.G., London). 95 Exeter University (Chris Brooks). 96 Private Collection (A.K.G., London). 97–8 A.F. Kersting, London. 99–100 Local Studies Collection, Kensington Central Library, London. 101 Gavin Stamp Collection, by permission of *Private Eye*, London. 102 Local Studies Collection, Kensington Central Library, London. 103 London Metropolitan Archives. 104 Exeter University (Chris Brooks). 105–7 Local Studies Collection, Kensington Central Library, London. 108–9 The Royal Archives © 2000 Her Majesty Queen

Elizabeth II. 110–11 Public Record Office Image Library. 112–14 Local Studies Collection, Kensington Central Library, London. 115 The Royal Archives © 2000 Her Majesty Queen Elizabeth II. 116–17 Local Studies Collection, Kensington Central Library, London. 118–19 Public Record Office Image Library. 120–4 Local Studies Collection, Kensington Central Library, London. 125 Public Record Office Image Library. 126 National Monuments Record, English Heritage, London. 127 The Howarth-Loomes Collection, courtesy of the National Monuments Record London. 128 Local Studies Collection, Kensington Central Library, London. 129 National Monuments Record, English Heritage, London. 130 National Portrait Gallery, London. 131 Courtauld Institute of Art, London. 132 Benedict Read Collection. 133 National Portrait Gallery, London. 134 The Trustees of the Victoria and Albert Museum, London. 135–41 The Royal Archives © 2000 Her Majesty Queen Elizabeth II. 142 National Monuments Record, English Heritage, London. 143–5 The Royal Archives © 2000 Her Majesty Queen Elizabeth II. 146 English Heritage Photographic Library, London. 147 Collections, London/ Colin Inch. 148 Courtauld Institute of Art, London. 149 The Royal Archives © 2000 Her Majesty Queen Elizabeth II. 150 Collections, London/ John Wender. 151 English Heritage, London/ Mark Fiennes. 152 Caroline Dear, Southampton. 153 English Heritage Photographic Library, London. 154 Museum of London. 155 English Heritage Picture Library, London/ Nick White. 156 Caroline Dear, Southampton. 157 English Heritage Picture Library, London/ Nick White. 158 Caroline Dear, Southampton. 159 English Heritage Picture Library, London/ Jeremy Richards. 160 English Heritage Picture Library, London/Nick White. 161 Caroline Dear, Southampton. 162 English Heritage Picture Library, London/ Mark Fiennes. 163 Museo Nazionale, Naples (Scala, Florence). 164 Local Studies Collection, Kensington Central Library, London. 165 Collections, London/ George Wright. 166 English Heritage Picture Library, London. 167 English Heritage Picture Library, London/ Nick White. 168 English Heritage Picture Library, London/ Mark Fiennes. 169 English Heritage Picture Library, London/ Nick White. 170 Chris Brooks. 171 English Heritage Picture Library, London/ Nick White. 172 Caroline Dear, Southampton. 173 Local Studies Collection, Kensington Central Library, London. 174 Caroline Dear, Southampton. 175–6 English Heritage Photographic Library, London/ Jeremy Richards. 177–8 Caroline Dear, Southampton. 179 Manchester City Art Galleries (The Bridgeman Art Library, London). 180 English Heritage, London/ Mark Fiennes. 181–2 Caroline Dear, Southampton. 183 Manchester City Art Galleries (The Bridgeman Art Library, London). 184 The Royal Collection © 2000 Her Majesty Queen Elizabeth II. 185 English Heritage Photographic Library, London/ Nick White. 186 Local Studies Collection, Kensington Central Library, London. 187 Angelo Hornak, London. 188 Local Studies Collection, Kensington Central Library, London. 189–90 English Heritage Photographic Library, London/ Nick White 191–3 Local Studies Collection, Kensington Central Library, London. 194 Caroline Dear, Southampton. 195 Local Studies Collection, Kensington Central Library, London. 196 Caroline Dear, Southampton. 197 Local Studies Collection, Kensington Central Library, London. 198 Caroline Dear, Southampton. 199 Local Studies Collection, Kensington Central Library, London. 200 Central Library, Coventry. 201 St. Alkmund's Church, Duffield, Derbyshire. 202 The Trustees of the Victoria and Albert Museum, London. 203 A.F. Kersting, London. 204 The Trustees of the Victoria and Albert Museum, London. 205 Peter Howell Collection. 206 Aachen Cathedral Treasury (Giraudon/ The Bridgeman Art Library, London). 207 Elisabeth–kirche, Marburg (A.K.G., London). 208–9 The Royal Archives © 2000 Her Majesty Queen Elizabeth II. 210 English Heritage, London/ Richard Waite. 211–12 The Royal Archives © 2000 Her Majesty Queen Elizabeth II. 213 English Heritage Photographic Library, London/ Nick White. 214 The Royal Archives © 2000 Her Majesty Queen Elizabeth II. 215–19 English Heritage Photographic Library, London. 220 Caroline Dear, Southampton. 221 English Heritage Photographic Library, London/ Nick White. 222 David Clayton. 223 The Trustees of the Victoria and Albert Museum, London. 224 National Portrait Gallery, London. 225–6 The Trustees of the Victoria and Albert Museum, London. 227–8 The Royal Archives © 2000 Her Majesty Queen Elizabeth II. 229 Uffizi, Florence

(Scala, Florence). 230–1 Local Studies Collection, Kensington Central Library, London. 232–4 English Heritage, London/ Mark Fiennes 235 English Heritage, London/ Richard Waite. 236 Chris Brooks. 237 The Royal College of Music, London. 238 Trustees of the Commissioners of 1851/ Victoria and Albert Museum, London (John Physick). 239 The Trustees of the Commissioners of 1851/ Victoria and Albert Museum, London. 240 The Trustees of the Victoria and Albert Museum, London. 241 The Trustees of the Commission of 1851/ Victoria and Albert Museum, London. 242–5 The Trustees of the Victoria and Albert Museum, London (John Physick). 246 Private Collection/ The Bridgeman Art Library, London. 247–8 The Trustees of the Victoria and Albert Museum, London. 249 Local Studies Collection, Kensington Central Library, London. 250 A. F. Kersting, London. 251 Local Studies Collection, Kensington Central Library, London. 252 Angelo Hornak, London. 253 John Physick. 254 The Royal College of Music, London. 255–6 Local Studies Collection, Kensington Central Library, London. 257 Aerofilms, Borehamwood. 258 Chris Brooks. 259 Local Studies Collection, Kensington Central Library, London. 260–1 National Monuments Record, London/ English Heritage. 262–3 Public Record Office Image Library. 264 National Monuments Record, London/ English Heritage. 265 Public Record Office Image Library. 266–7 National Monuments Record, London/ English Heritage. 268 A.F. Kersting, London. 269 English Heritage Photographic Library, London/ Nick White. 270 English Heritage Photographic Library, London. 271 National Monuments Record, London/ English Heritage. 272 The Victorian Society, London. 273–6 English Heritage Photographic Library, London. 277 English Heritage Photographic Library, London/ Nick White. 278–9 English Heritage, London/ Mark Fiennes. 280 English Heritage Photographic Library, London/ Nick White. 281 English Heritage Photographic Library, London. 282 English Heritage Photographic Library, London/ Nick White. 283 English Heritage Photographic Library, London. 284 English Heritage Photographic Library, London/ Alasdair Glass. 285 English Heritage Photographic Library, London. 286 English Heritage Photographic Library, London/ Alasdair Glass. 287 English Heritage Photographic Library, London/ Mark Pepper. 288 English Heritage Photographic Library, London/ Nick White. 289–301 English Heritage Photographic Library, London. 302 English Heritage Photographic Library, London/ Nick Turpin. 303–7 English Heritage Photographic Library, London. 308 English Heritage Photographic Library, London/ Jeremy Richards. 309–10 Caroline Dear, Southampton. 311 Angelo Hornak, London.

Picture Research by Julia Brown

KU-295-705

PHL

54060000150903

The Peacock Room

THE
**PAUL HAMLYN
LIBRARY**

DONATED BY
THE PAUL HAMLYN
FOUNDATION
TO THE
BRITISH MUSEUM

opened December 2000

Remember that the most beautiful

things in the world are the most useless;

peacocks and lilies for instance.

— RUSKIN, *The Stones of Venice*

Linda Merrill

The Peacock Room
A Cultural Biography

Freer Gallery of Art
Smithsonian Institution, Washington, D.C.

Yale University Press
New Haven and London

THE
BRITISH
MUSEUM
THE PAUL HAMLYN LIBRARY

747.7 (OVERSIZE)
MER

Copyright © 1998 by Smithsonian Institution
All rights reserved
Published by the Freer Gallery of Art,
Smithsonian Institution, Washington, D.C.,
and Yale University Press, New Haven and London

This publication was made possible by a generous grant
from the Henry Luce Foundation.

Edited by Bruce Elliot Tapper
and Mary Kay Zuravleff
Designed by Carol Beehler
Typeset in Monotype Deepdene by G & S Typesetters, Inc.
Printed and bound in Singapore by C S Graphics, Pte., Ltd.

Library of Congress Cataloging-in-Publication Data
Merrill, Linda, 1959–
The Peacock Room: a cultural biography / Linda Merrill.
 p. cm.
Includes bibliographical references and index.
ISBN 0-300-07611-8 (cloth: alk. paper)
1. Peacock Room. 2. Whistler, James McNeill,
1834–1903— Criticism and interpretation.
I. Freer Gallery of Art. II. Title.
ND237.W6M57 1998
747.7—dc21 98-21534
 CIP

The paper used in this publication meets the minimum
requirements for the American National Standard for
Permanence of Paper for Printed Library Materials,
z39.48-1984.

Jacket: Detail, sideboard in the Peacock Room, by James
McNeill Whistler (1834–1903).
Endpaper: Illustrations by James McNeill Whistler for
*A Catalogue of Blue and White Nankin Porcelain Forming the
Collection of Sir Henry Thompson* (1878). Pencil, pen, ink, and
wash on paper, Freer Gallery of Art, Smithsonian Institution,
Washington, D.C. (clockwise from upper left: 07.177;
07.178; 07.176; 07.179; 93.18; 98.415; 07.175; 07.174).
Frontispiece: A peacock's breast feather, by John Ruskin
(1819–1900). Watercolor on paper, 21.9 × 14.3. The Ruskin
Gallery, Collection of the Guild of Saint George, Sheffield
City Arts Department, England.
At right: Central shutters in the Peacock Room, by Whistler.

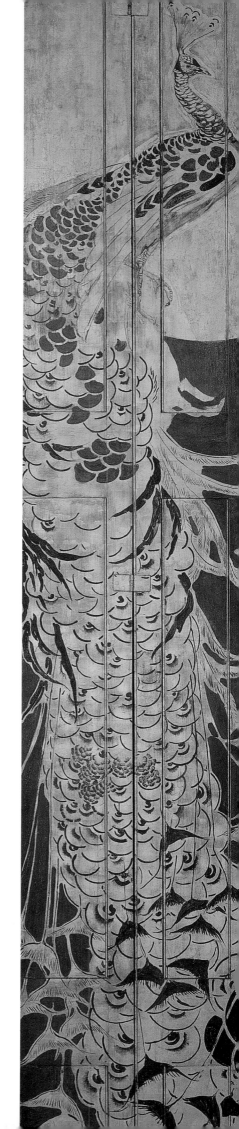

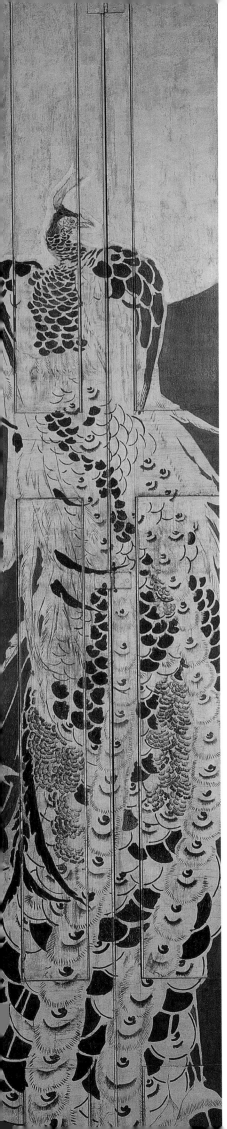

Contents

8 Foreword *Milo Cleveland Beach*

10 Acknowledgments

14 Précis

17 Note to the Reader

19 Introduction *Peacocks with a Past*

43 Chapter 1 *The First Vase*

77 Chapter 2 *The Perfection of Art*

109 Chapter 3 *The Model Patron*

147 Chapter 4 *The Palace of Art*

189 Chapter 5 *The Porcelain Pavilion*

235 Chapter 6 *The Last Alembic*

293 Chapter 7 *The Heirloom of the Artist*

354 Notes

385 Appendix *The Peacock Room Papers*

389 Bibliography

394 Index

Foreword

MILO CLEVELAND BEACH

Director, Freer Gallery of Art and Arthur M. Sackler Gallery

T HE PEACOCK ROOM, permanently on display at the Freer Gallery of Art, is widely regarded as the most important nineteenth-century interior in an American museum. Charles Lang Freer, for whom the museum is named, considered the room a cornerstone of the collection he pledged to the nation, an embodiment of that universal sense of beauty that in his belief united his holdings of Asian and American art. Freer's aesthetic philosophy had arisen from his friendship with James McNeill Whistler, whose prints he had collected as a young man. After meeting Whistler in 1890, Freer became ever more deeply immersed in Whistler's world, and he soon developed a passion for the Asian works of art that inspired Whistler. The painter, however, believed the Asian prints and ceramics then available in Europe were merely the "last gasp of a great tradition," mere shadows of "a far earlier and higher culture." According to Freer, it was Whistler who made him promise to search Asia for evidence of those early periods—a quest that consumed the later years of Freer's life and provided the vast majority of the works which he gave to the United States for the Freer Gallery of Art. Nonetheless, recent visitor surveys indicate that the single most popular work at the Freer Gallery is the Peacock Room.

In this groundbreaking study, Linda Merrill analyzes the Peacock Room's popular and critical reception over the years, in its various manifestations as dining room, porcelain cabinet, succès de scandale, Victorian relic, and museum exhibit. The book offers a fresh perspective on the Peacock Room based on the fruitful collaboration of art history with conservation science. In addition, new discoveries of contemporary photographs, letters, portraits, newspaper accounts, and other primary sources have contributed to this revision of the Peacock Room's history. Although the surviving documents are often inaccurate or incomplete, taken together and considered in light of technical studies they are immensely helpful in reconstructing a truer story of the room's creation. Yet some of the most fascinating art-historical findings relate to its life beyond that brief episode. These include the ill-fated history of a painting that was once

intended for the room but never completed; the room's narrow escapes from destruction at the hands of an unappreciative owner and even of Freer himself, who initially contemplated obtaining only certain panels of the decorations; correspondence concerning Whistler's unrealized "piratical plot" to produce a portfolio of photographs of the room years after his eviction from it; newspaper articles published in London in 1904 lamenting the loss of the Peacock Room to an American millionaire; records of the room's installation in Freer's house in Detroit and of the visitors fortunate enough to see it there; and rare auto-chromes made by Alvin Langdon Coburn in 1909 showing *La Princesse du pays de la porcelaine* surrounded by Freer's own collection of ceramics.

The story of the Peacock Room has much to tell us of Victorian and early twentieth-century taste, and about attitudes toward Asia during that era. Designed as a veritable land of porcelain, the Peacock Room embodies a fantasy view of "the Orient" deeply embedded in European taste. In England, it should be seen as part of a tradition best defined by the Royal Pavilion at Brighton (early in the nineteenth century) but extending to the production of Franz Lehár's operetta *Das Land des Lachelns* (The Land of Smiles) at the Drury Lane Theatre in London in 1931. Yet unlike the architectural extravaganzas of the Regency period, fanciful interpretations of sketches by English travelers in Asia, or Lehár's vision of Peking around 1912, Whistler's concept of Asia came from serious study of works of art by Asian artists. The resemblance of the peacocks that he painted on the window shutters to the birds portrayed in prints by Hiroshige has been noticed, but there are other, perhaps more im-portant influences at work. These include the gold-leaf backgrounds on Japa-nese screens, the extravagant birds adorning Satsuma ware, the glittering sur-faces of "aventurine" lacquer, and the cobalt-blue patterns adorning the Chinese porcelain the Peacock Room was designed to display. All these influences are explored in Linda Merrill's engaging study, and they transform our under-standing of the room.

Whistler's imaginative fusion of these methods and motifs has never re-ceived adequate scholarly attention, yet this aspect of the work is especially in-triguing considering the Peacock Room's present placement in the Freer Gallery of Art, a museum primarily devoted to the exhibition and study of the arts of Asia. It is no surprise that the story of the Peacock Room reveals nine-teenth-century aesthetic attitudes, but that it also defines the transition from fanciful visions of "the Orient" to an understanding based on direct experience of Asian works of art is an important new contribution. The Peacock Room, therefore, provides both a superb visual experience and an extraordinary his-torical context for the collections of the Freer Gallery of Art.

Acknowledgments

\mathcal{P}EACOCK FEATHERS are supposed to bring bad luck, but they have brought me much good fortune over the years this work has been in progress. It was a rare privilege to participate, as curator, in the conservation of the Peacock Room at the Freer Gallery of Art, an ambitious project carried out between 1989 and 1992 that fundamentally altered our perception of Whistler's aesthetic intentions and achievement. As the conservators gradually removed layers of accumulated grime and overpaint, I began to revise the received history of the room, dispelling some of the myths and misconceptions that had settled over the story like mantles of aging varnish. Because I had previously researched another sensational episode in Whistler's biography, his lawsuit for libel against John Ruskin, I expected the errors of fact and emphasis I found embedded in popular accounts. I was wholly unprepared for the revelations of conservation science.

My greatest debt, therefore, is to the conservators who not only restored the Peacock Room to its original state but also taught me how to see it. W. Thomas Chase, then in charge of the Freer Gallery's department of conservation and scientific research, initiated the project in collaboration with Joyce Hill Stoner, an authority on Whistler's working methods. Wendy Samet directed the project with wonderful skill and unflagging enthusiasm. Barbara A. Ventresco, Pia Gesau, and Margaret Contompasis made valuable contributions of time and expertise, and Marina Williams-Delaney, as a student assistant, produced the rendering of the original gilt leather that made its identification possible. Peter Nelsen, an indispensable member of the team, who has probably spent more hours in the Peacock Room than anyone else alive, remains a valued colleague and consultant; I am also indebted to him for producing two stunning illustrations of how the Peacock Room may have looked during its early stages. Paul Jett of the Freer Gallery coordinated the efforts of the conservators, lent his own skills to restoring the metalwork, and answered many technical questions. It was a joy to witness the work and share the excitement of this extraordinarily talented and dedicated team of conservators.

The Getty Grant Program made the conservation project possible, with further funding from the James Smithson Society of the Smithsonian Institution and the Mars Foundation, and a research grant from the Kress Foundation. My own research was substantially supported by a generous grant from the Henry Luce Foundation, which also underwrites this publication. I am grateful not only for that award, which eased every stage of this book's preparation, but also for the commitment to research on American art at the Freer Gallery it represents. Additional costs were defrayed by the Freer and Sackler Galleries' Publication Endowment Fund, initially established with a grant from the Andrew W. Mellon Foundation and other donors.

One of the pleasures of completing a large project is being able to thank officially, at last, the people whose contributions should have been acknowledged long ago. Foremost among them is Jodi Lox Mansbach, who first came to the Freer as an undergraduate intern. In 1992, thanks to the Luce grant, she conducted six months of research on the Peacock Room, ferreting out facts I would not have thought to look for and turning up sources I never knew existed. Her diligent efforts helped to launch this project, and I have benefited from her labors at each successive stage. A number of other volunteers, interns, and assistants helped with various tasks, including Frances Yeh, Susan McCullough, and Grace Liu McLinn. Jessica Banks inherited the project in its final, most work-intensive stages, and managed a mass of production details with remarkable exactitude and good nature.

Nigel Thorp and Margaret MacDonald of the Centre for Whistler Studies, University of Glasgow, have given graciously of their time and knowledge throughout the many stages of this project, and I am grateful to both of them for reading the manuscript and offering thoughtful suggestions on its revision. Patricia de Montfort, also of the Whistler Centre, led me to Elizabeth Pennell's unpublished journals in the Library of Congress, which proved to be a more important source for this study than she may have realized. Beyond the familiar territory of the Whistler field, I have depended on the generosity of several people, some of whom I still have never met, to track down details about lesser-known participants in the Peacock Room story. Terrence Davis generously provided legal documents and other information pertaining to the life of Frederick Leyland; W. F. J. Ritchie and E. Stillman Diehl combed their memories and family archives to turn up traces of Christina Spartali's biography; Gary Edwards contributed his own research on the Spartali family and alerted me to the portrait of Christina by Julia Margaret Cameron that now resides in the Freer Gallery Archives; J. F. Young gave me copies of Thomas Jeckyll's medical records, and Kay Redfield Jamison helped me interpret them and understand the nature of Jeckyll's illness. I was able to visit 49 Prince's Gate through the good graces of Patrick Keith Cameron, Mr. and Mrs. Zuhair Z. Boulos, and Felix Kelly, and to spend time at Speke Hall, near Liverpool, through the kindness and hospitality of its custodian, Craig Ferguson.

I am grateful to the many scholars, curators, and librarians who located

elusive documents, objects, and photographs, replied to countless queries, and navigated a path through collections in their care: Kevin Sharp, Art Institute of Chicago; Shelagh Vainker, Ashmolean Museum, Oxford; John Renton, Bridewell Museum, Norwich; Mary Holahan, Delaware Art Museum, Wilmington; Martin Hopkinson, Hunterian Art Gallery, Glasgow; Katherine Blood, Prints and Photographs Division, Library of Congress; Robin Emmerson, Liverpool Museum; E. K. Parrott, Local History Library and Record Office, Liverpool; Jane Glover, M. H. de Young Memorial Museum, San Francisco; A. J. Tibbles, Merseyside Maritime Museum, Liverpool; Cecilia Chin, National Museum of American Art / National Portrait Gallery Library; Terence Pepper, National Portrait Gallery, London; Felice Fischer and Alison Goodyear, Philadelphia Museum of Art; Anne Woodward, Royal Commission on the Historical Monuments of England; Tim Knox, Royal Institute of British Architects; John Greenacombe, Survey of London; Sue Prichard and Robert Upstone, Tate Gallery; George Brandak, University of British Columbia Library Special Collections, Vancouver; Frances Collard, Eleanor John, Linda Parry, and Chris Titterington, Victoria and Albert Museum; Cynthia Roman, Wadsworth Atheneum, Hartford, Connecticut; and Edward Morris and Joseph Sharples, Walker Art Gallery, Liverpool. I was fortunate in having access to the knowledgeable staff and extensive resources of the Library of Congress in Washington, D.C.—particularly the Rare Book and Manuscript divisions—and in London, to the British Library, the National Art Library, the University of London Library, the University College London Library, and the Courtauld Institute. This project has also profited from the correspondence, conversation, and hospitality of Suzy Castleman, Richard Dorment, Marvin Eisenberg, Betty Elzea and the late Rowland Elzea, Rodney Engen, Alicia Craig Faxon, Mark Girouard, Evelyn Harden, Simon Houfe, Eloy Koldeweij, Margaret S. Moore, Keith Morgan, Leonée Ormond, Jane Ridley, Bill Sargent, Joyce Schiller, Virginia Surtees, Alastair and Jackie Wardlaw, and Michael Whiteway. Mark Samuels Lasner, Cita Stelzer, and two British collectors who wish to remain anonymous kindly permitted me to reproduce works of art from their holdings. I also thank Edward Davis for interpreting the intricacies of the Victorian legal system; Charles Merrill for providing translations from several languages; and Maggie Edson for keeping me in balance and on track.

At the Freer Gallery, I owe a special debt to Sarah Ridley, my colleague in the education department, who helped translate some of my research into a children's story, *The Princess and the Peacocks* (1993), an exercise every scholar should attempt. I am also grateful to Colleen Hennessey, archivist, who has consistently turned up new treasures and located lost ones, and to Kathryn Phillips, Reiko Yoshimura, and Lily Kesckes in the library, and Elisabeth FitzHugh, Martha Smith, and John Winter in the conservation department. Ann Yonemura, with whom I collaborated on the 1995 exhibition *Whistler & Japan*, helped me formulate ideas on the influence of Japanese art on Whistler and his contemporaries. Jan Stuart enlightened me on many matters relating to

Chinese porcelain, and with Louise Cort made an incalculable contribution by collaborating on the campaign to acquire Chinese porcelain for the Peacock Room. Milo Cleveland Beach, director, encouraged me to begin this project years ago, and Thomas W. Lentz, deputy director, gave me time to complete it.

Karen Sagstetter, editor-in-chief, took an interest in this project from the beginning and saw the process through with care and considerate attention. The text was thoughtfully edited by Bruce Elliot Tapper and Mary Kay Zuravleff, and the book skillfully designed by Carol Beehler. John Tsantes went to great lengths to procure photographs of previously unpublished artworks for reproduction in these pages and to produce fresh photographs of the Peacock Room itself. John Nicoll, Yale University Press, ensured that the publication fulfilled our expectations.

Some of the material in this book was presented at the International Whistler Symposium held at the Tate Gallery, London, in December 1994, and at the Whistler Symposium held at the National Portrait Gallery, Washington, D.C., in June 1995; some was published in the *Burlington Magazine* in October 1994 and the *Magazine Antiques* in June 1993. I am grateful to the University Court of the University of Glasgow for permission to quote from Whistler's correspondence, and to the National Trust for permission to quote from the Whitley-Sprot letters at Speke Hall.

Harmony in Blue and Gold: The Peacock Room, the Victorian interior decorated in 1876–77 by James McNeill Whistler (1834–1903), was originally the dining room of 49 Prince's Gate, the London home of Frederick Richards Leyland (1831–1892). A Liverpool ship-owner, Leyland had met Whistler during the 1860s and become the American artist's primary patron, commissioning an important painting called *The Three Girls* (1867–79) and a series of family portraits. In 1875, when Leyland set about remodeling his new mansion in Kensington, Whistler was invited to decorate the entrance hall. Thomas Jeckyll (1827–1881), an architect and designer with a predilection for Japanese style, was assigned the adjoining dining room.

Whistler naturally took an interest in Jeckyll's interior, since one of his own early works, *La Princesse du pays de la porcelaine* (The Princess from the land of porcelain, 1864–65), was to hang above the fireplace in the dining room, surrounded by Chinese blue-and-white porcelain from the Kangxi era (1662–1722). Leyland had purchased his collection from Murray Marks (1840–1918), a London art dealer, who also advised him on the decoration of the house and selected the antique gilt-leather to line the dining-room walls. Jeckyll designed a latticed structure of walnut shelving, embellished with carved designs, with spaces for individual pieces of blue and white. He had nearly completed the project by the end of April 1876, when he expressed uncertainty about what color to paint the shutters and doors. Whistler was brought in to advise, and at Leyland's invitation he began working on the room. Treating the wood-work as he had in the hall, Whistler applied a combination of dutch metal, or imitation-gold leaf, and a transparent greenish glaze. Jeckyll became ill and by the summer was no longer involved.

Whistler, having completed one adjustment to the scheme, undertook other modifications. He asserted that the red flowers on the gilt-leather hangings clashed with the color scheme of *La Princesse* and volunteered to touch up the walls with traces of yellow. Early in August 1876, he announced that the

room was finished, apart from a pattern of semicircles he called waves and pro-posed to paint in blue on the newly green-gold cornices and wainscoting. From Liverpool, Leyland sanctioned that addition and expected the project to end there. But Whistler, alone in London, continued conducting cautious experi-ments that gradually became feats of imagination. By early September, the wave pattern had evolved into a peacock-feather design that Whistler carried onto the Jacobean-style ceiling, radiating from the ornamental pendant lamps. Whistler had gilded Jeckyll's shelving and painted a magnificent array of life-size peacocks on the inside panels of the shutters, where they would shimmer in the gaslight at evening dinner parties.

In mid-October 1876, Leyland unexpectedly returned to London. Per-haps astonished only by the liberties Whistler had taken with his dining room, he neither approved the decorations with sufficient enthusiasm nor consented to the two thousand pounds Whistler asked in return. Eventually, Whistler conceded to half that amount, on the condition that he have access to the room for several more months to make additional refinements. But Leyland further insulted Whistler by writing his check in pounds, when artists were usually paid in guineas; and because a pound equals twenty shillings and a guinea twenty-one, the sum was also fractionally reduced. The quarrel with Leyland liberated Whistler from considering his patron's desires and may have induced him to coat the valuable leather with blue paint.

In November 1876, Whistler produced a full-scale drawing for a mural meant to immortalize the altercation with his patron. During the first days of December, he painted on the south wall, opposite *La Princesse*, the two embattled peacocks that remain the most famous part of the decoration. He used two shades of gold, and silver for highlighting significant details. Scattered at the feet of the angry peacock on the right are the silver shillings Leyland had refused to pay, and silver feathers on his throat allude to the patron's customary ruffled shirts; the silver crest feather of the poor, affronted peacock pointedly recalls the white lock of hair curling above the artist's own brow. Entertaining friends and fellow artists in the Peacock Room, Whistler flagrantly disregarded his patron's privacy. He also issued invitations to the press, which brought flurries of reviews in the London papers during February 1877. In March, Whistler added final touches to the shutters, and by the time the Leylands returned to town for the season, he had completed the decoration and placed the porcelain on the shelves.

Despite the controversy surrounding its creation, the dining room was kept as Whistler left it. After Leyland died in January 1892, the house stood empty until purchased in 1894 by Blanche Watney (ca. 1837–1915), who dis-liked the dining-room decoration and eventually decided to sell it. The Peacock Room was dismantled early in 1904 and moved to the galleries of Obach & Co., a London art dealer. It was purchased on 16 May 1904 by Charles Lang Freer (1854–1919), an American industrialist who had acquired *La Princesse* the previous summer, shortly after Whistler's death in July 1903. The Peacock

Room was shipped to Detroit, Michigan, and re-erected in a new addition to Freer's house on Ferry Avenue. Upon Freer's death in September 1919, the room was moved once again to Washington, D.C., as part of his unprecedented gift to the nation: Freer bequeathed his entire collection of Asian and American art along with funds for a building to house it. The Peacock Room was revealed to the public in May 1923, when the Freer Gallery of Art opened its doors as the first art museum of the Smithsonian Institution.

Note to the Reader

Illustrated works are by James McNeill Whistler, unless otherwise indicated. Whistler oil paintings are identified by the catalogue number (y) in Andrew McLaren Young, Margaret MacDonald, Robin Spencer, and Hamish Miles, *The Paintings of James McNeill Whistler*, 2 vols. (New Haven and London, 1980); drawings and watercolors by the catalogue number (m) in Margaret F. MacDonald, *James McNeill Whistler: Drawings, Pastels and Watercolours, A Catalogue Raisonné* (New Haven and London, 1995); etchings by the title and catalogue number (k) in Edward G. Kennedy, *The Etched Work of Whistler* (1910; reprint, New York, 1978). Dimensions are given in centimeters, with height preceding width.

Abbreviations used in the notes are listed on page 354. Quotations from letters included in the appendix are cited with their corresponding numbers, i.e., letter number four is cited as (app. 4).

Peacocks with a Past

A peculiar charm will always be associated with his Whistlerian dining-room, and it will be long before the world is likely to tire of talking about the peacocks with so fascinating a past!

"Art Notes," *Truth*, 23 June 1904

As EARLY As 1877, writers began apologizing for adding to an already abundant literature on the Peacock Room, whose bibliography now comprises some four hundred entries. The story's popularity does nothing to ensure its authenticity, however, and part of the purpose of this book is to straighten out a narrative sequence that has become, through repeated retelling, distorted and disarrayed. The larger intention is to restore the fuller dimensions of the Peacock Room's history: to clarify the work's ancestry and assess its influence, to retrieve the reputations of some of its participants, and to consider it in correct historical perspective, securely in the context of its time. This new construction of fact also allows an evaluation of the fictions that have grown around the Peacock Room and created part of its popular appeal.

The cultural history of an English interior designed for the display of Chinese porcelain and decorated in the Japanese taste necessarily begins with the late-Victorian enthusiasm for Asian art. James McNeill Whistler played an active part in encouraging and disseminating that taste, which profoundly influenced the shift in direction of his own art during the 1860s from realism to aestheticism. Whistler's enthusiasm for the arts of China and Japan was given visual form in the first of his works to achieve official recognition in France, *La Princesse du pays de la porcelaine*. When it later became a fixture in the Peacock Room, its independent status as a painting was all but forgotten. Chapter 1, "The First Vase," reclaims the original significance of *La Princesse* as an emblem of Whistler's early aestheticism.

Other Whistler paintings less directly relevant to the Peacock Room also enter into its story. One objective of this study is to place the decoration among Whistler's other works, as less an exception—"a monument in isolation," to borrow the artist's own words—than an extension of his own artistic ambitions: as one critic observed in 1904, the Peacock Room was "as perfect an embodiment of the particular idea that Whistler was born to express as any of his pictures."[1] Chapter 2, "The Perfection of Art," retrieves the history of *The*

Detail, peacock in the Freer Gallery Court-yard in 1923 (fig. 7.28).

Three Girls, a work that has been neglected in previous assessments of Whistler's career because it was not completed and does not survive. Yet the painting was inestimably important to Whistler as the visual expression of his mature aestheticist philosophy, the illustration of ideas he later pronounced in the "Ten O'Clock" lecture of 1885.[2] Whistler could never finish it, but the intended appearance of the painting is known through studies and related works and from the descriptions of the artist's contemporaries, who seem to have recognized its potential. As one of them remarked, "the world is distinctly poorer for the non-completion of this magnificent scheme."[3]

Unlike the Peacock Room, *The Three Girls* lacks an appealing, self-perpetuating anecdote: its story, which extends from 1867 to 1879, is one of unrelenting toil and trouble, with a sadly unresolved ending. But that lost painting was the principal object of Whistler's initially amicable relationship with Frederick Leyland, and as the first major commission it tells more about Leyland's patronage than the dining-room decoration more commonly associated with his name, which occupied less than a year of Whistler's time and was never commissioned at all. Throughout the protracted production of *The Three Girls*, Leyland was an ideal patron. His portrait by Whistler, *Arrangement in Black*, another painting more often seen as an adjunct to the Peacock Room legend than a work of art in its own right, is the subject of chapter 3, "The Model Patron."

Surprisingly little notice has been paid to the good relations between Whistler and Leyland, perhaps because the possibility of the artist's romance with his patron's wife has tended to attract inordinate attention. (It is telling that several of the letters Whistler wrote to Leyland have been mistaken, over the years, for letters to his presumed paramour.) The intimacy of that friendship, however, underlies the vehemence of the dispute that later arose around the Peacock Room. Leyland, whose ascension from obscurity to prosperity suggests the flexibility of Victorian social structures, is a fascinating figure in himself, and Whistler's portrait ominously captures the dark side of Leyland's character. Of all the people whose lives Leyland damaged, it emerges, Whistler may have had the least cause for complaint.

Particularly in the late-Victorian period, when the cultural elite aspired to live in the spirit of art, domestic decoration marks the intersection of biography and art history. The Leyland house at 49 Prince's Gate in Kensington, the original setting for the Peacock Room, is the topic of chapter 4, "The Palace of Art." Whistler was not the only artist of the era to apply his talents to interior design, and the Peacock Room might be regarded as the signal instance of the aestheticist demand for artfully life-enhancing environments. The taste for Chinese porcelain embodied by *La Princesse* was spreading in the 1870s from Whistler's artistic circle to the wealthier class of collectors like Leyland, who could afford to create special settings for their treasures. Thomas Jeckyll specialized in such aesthetic interiors, and the Prince's Gate dining room was to have been the crowning example. Jeckyll's design, a reinterpretation of a

traditional Dutch porcelain room, is one of several lost and unfinished works examined in this book.

Chapter 5, "The Porcelain Pavilion," aims to illuminate the origins of Whistler's design in Jeckyll's decoration — to reconstruct the dining room as Whistler found it, and to trace the initial progress of its transformation. The creation of the Peacock Room is typically described as having happened almost instantaneously: once Whistler began tampering with the leather (so the story goes), he painted it blue almost immediately, either to obliterate all traces of a disastrous attempt to touch up the flowers or in "a frenzy of creation."[4] In fact, the course of Whistler's redecoration was neither so straightforward nor compressed. The sequence of his efforts can be pieced together from fragments preserved in letters and journals, accounts of the work-in-progress published in the press, and evidence gleaned from technical studies, which reveal a complicated progression of false starts and revisions. In the beginning, it now appears, Whistler strived to harmonize his own decorations with Jeckyll's. The gilt-leather wall-hangings, long renowned for their putative provenance as the dowry of Catherine of Aragon, turn out to be more important for the part they probably played in the evolution of Whistler's scheme.

It was not until his fateful feud with Leyland over payment for the project that Whistler actually appropriated Jeckyll's decoration. Chapter 6, "The Last Alembic," follows the course of the change from Jeckyll's scheme to Whistler's *Harmony in Blue and Gold*. In painting out the leather, Whistler obliterated all chance of reconciliation with his patron. And in placing a pair of symbolic peacocks on a wall where *The Three Girls* had been intended to hang, he seized the last word in the dispute. This chapter tells of the flash of fame resulting from Whistler's work and of the dismal aftermath: the extended ordeal of the quarrel, the disintegration of the Leyland family, the unraveling of Whistler's livelihood. The long shadow of those events has often been cast over Jeckyll's life, although his own sad decline, which ended with his death in a mental institution in 1881, was not the consequence of the Peacock Room, only one of the story's unhappy endings. The work that encapsulates this darkest phase of Whistler's career is *The Gold Scab*, the incomparable caricature of Frederick Leyland that also parodies the Peacock Room with a startling permutation of its theme of graceful harmony.

Chapter 7, "The Heirloom of the Artist," presents a part of the Peacock Room's biography that has gone largely unrecorded, the period between its completion in 1877 and its establishment in an art museum in 1923. This chapter examines Whistler's memories of the room and the tales he told his friends; Leyland's untimely death, the subsequent sale of *La Princesse*, and its short-lived state of independence; the room's neglect at the hands of Blanche Watney, its public exhibition in London, and its consequential purchase by an American connoisseur. In London in 1904, the English offered a posthumous tribute to Whistler by proposing the room's purchase for the nation, but it was already bound for the United States, where it was to meet with some ambivalence.

Freer privately referred to his largest acquisition as "the blue room," an understated title that implies its quieter condition in Detroit. A friend who sometimes enjoyed after-dinner cigars with Freer in the Peacock Room noted in his memoirs that the interior was "famous for the story that goes with it rather than esteemed as a work of art," perhaps expressing the attitude of his host.[5]

These events illuminate the fluctuations in taste that explain the still-unstable reputation of the Peacock Room. Most accounts report that the work resides now in an American art museum, with that final, irrefutable fact standing like a tombstone at the end of the tale. This book ends with the room's American debut at the Freer Gallery in 1923, hardly a celebratory note. Had the Peacock Room remained in England as proposed in 1904, at the Tate Gallery or the Victoria and Albert Museum, it might have been more widely understood. But in Washington, D.C., isolated and out of context, the Peacock Room was often regarded as an unaccountably Victorian corner of a modern museum of Asian art. Happily, the story of the Peacock Room did not end there. This study in itself, illustrated with photographs of its newly restored brilliance, represents a new perspective on the Peacock Room as both a valued work of art and a token of its time, the product of a remarkable confluence of commercial and aesthetic events that could only have occurred in London (perhaps only in the borough of Kensington) during the final quarter of the nineteenth century.

*I*F THE Peacock Room had not survived, the story of its creation would surely still be told. Whistler, both the author and protagonist of the tale, had determined to make the room a legend in its own time, and to that end contrived a memorable tale with two leading characters and a simple story line. The action peaks when the patron fails to pay the artist properly for his work, and the narrative comes to a swift and just conclusion when Whistler paints a pair of fighting peacocks on the wall. "There Leyland will sit at dinner," or so the artist liked to imagine the scene, "his back to the *Princesse*, and always before him the apotheosis of *l'art et l'argent!*"[6]

It was Whistler's expectation that his story of art and money would be recounted in "some future dull Vasari," an anecdotal compendium of artists' biographies in which Leyland would make an ignominious appearance, "like the man who paid Corregio [*sic*] in pennies" (app. 6). Indeed, it was noted in 1904 that the peacock mural, "in which Whistler vindicated the artist's divine right to the odd shilling of the guinea," afforded "the one Vasarian story to the chronicler of modern art,"[7] and Whistler's own chroniclers, Joseph and Elizabeth Pennell, carried on the tradition of telling the story as a cautionary tale. When the Pennells' *Life of James McNeill Whistler* was published in 1908, Frederick Leyland had been dead some sixteen years and the Peacock Room was no longer standing in the house at Prince's Gate; even so, the Pennells' account concludes

with the image of the patron Whistler had envisioned, seated in the Peacock Room "ungrudgingly" admiring the gilded decoration.[8] Their biography, which appeared in numerous editions and remains the fundamental source for Whistler scholarship, established an enduring impression of the Peacock Room as more significant for its story than as an artwork in itself.

The importance the Pennells attached to preserving Whistler's legend becomes apparent in their biographical method of gathering details to embellish the standard, received accounts. Initiating research just after the artist's death, they assiduously collected "facts and contemporary rumours and opinions" about the Peacock Room from everyone they could identify who had known Whistler and Leyland during the years of their association. To construct "the true story for the *Life*," they compared the assembled versions, sifted the contradictory evidence, and weighed the variants against the story they had heard from Whistler himself one evening around 1900.[9] The tale he had told them emphasized spontaneity as the manifestation of artistic genius: "Well, you know, I just painted as I went on, without design or sketch—it grew as I painted. . . . And the harmony in blue and gold developing, you know, I forgot everything in my joy in it!"[10]

Because Whistler deliberately kept the particulars to himself, the "sequence of events in the dining room remains somewhat obscure," as Denys Sutton observed in 1963.[11] We now know that Whistler's redecoration was not entirely spontaneous, and that the leather was probably painted more in a fit of pique than a moment of unbridled inspiration. The Pennells had not been able to advance the idea that Whistler was actuated by malice, yet the weight of evidence they amassed made it difficult to deny that the artist had taken advantage of Leyland's absence and the comforts of his home. Whistler's contemporaries were nearly unanimous in condemning his bad manners, which probably accounts for the disapproval that creeps into the otherwise laudatory *Life of Whistler*: "It may be that he was over-sensitive, certainly he put himself in the wrong by his conduct to Leyland. But he could no more help his manner of avenging what he thought an insult, than the meek man can refrain from turning the other cheek to the chastiser."[12] Even that qualified rebuke occasioned some anxiety. One night after the biography was published, Whistler turned up in Elizabeth Pennell's dreams, "and I had a little qualm," she noted in her journal, "thinking to myself he will hardly like the way we treated the Leyland affair."[13]

Indeed, in the Pennells' unsatisfying chapter on the Peacock Room, one senses that they knew more about the affair than they were willing to disclose—that Whistler's breach of conduct went beyond painting over costly leather and staging entertainments in an empty house. Remnants of their research appeared in 1921 with the publication of *The Whistler Journal*, a book composed of material the Pennells left out of the *Life* but decided "should not be lost," and generally considered the more trustworthy source.[14] The typescript of Elizabeth Pennell's actual journals, however, which remains with

reams of other papers in the Pennell-Whistler Collection at the Library of Congress, contains stores of information and innuendo omitted from all the published works. Evidently, the Pennells deemed such material inconsequential, indiscreet, or inconsistent with the picture of the artist they set out to portray.

In building their biography, the Pennells worked from the modernist premise that Whistler had lived ahead of his time: if his genius went unacknowledged in his own age (as they believed), it had already been validated, in 1908, by an ever-rising posthumous reputation. Yet in the matter of the Peacock Room, the Pennells' conviction seems to falter. Pronouncing it "the one perfect mural decoration of modern times," they leave the assertion unsupported by the text.[15] They may have believed that the Peacock Room's perfection was self-evident, but their praise sounds more practiced than sincere. If Whistler's easel paintings conformed to their view of modern art as a revolt against contemporary taste, the Peacock Room posed a problem, which has not altogether disappeared: what may have looked elegant and refined in comparison with other works of its era (even other interiors within the house where it resided), appears on its own to be unmistakably Victorian, the outcome of an extraordinary exercise in the "japanesque" style.

After the commotion surrounding its creation had died down, the Peacock Room did not enjoy another spell of celebrity until 1892, when Leyland's death raised the prospect of its sale as part of the house in Prince's Gate. Again the room slipped out of public consciousness, suddenly reappearing in 1904 on exhibition at the London galleries of Obach & Co. and generating an unprecedented spate of publicity. As the London *Star* observed, the Peacock Room had come to be regarded as one of the anecdotes composing Whistler's notoriety: "that it is really a remarkable piece of decoration, that it still exists," came as a surprise and something of a revelation.[16] The phrase Whistler had attached to the peacock mural, "l'art et l'argent," was proving curiously apt, for more like a painting than an interior decoration, the Peacock Room's fame and fortunes had become tied to its place in the art market. Whistler may have wanted to suggest that his creation was intrinsically priceless—that the shillings Leyland had shorn from his payment were of no account, except to symbolize the pettiness of his patron—but one implication of the mural is that art is a viable form of commodity exchange: the emblems of Art and Money may be locked in confrontation, but they are both gilded peacocks, birds of a feather.

That the Pennells should neglect to mention the whereabouts of the Peacock Room in 1908, or even its survival, is all the more surprising, then, in light of its recent sale and exhibition. It was not until the fifth edition of the Whistler biography, published in 1911, that they appended a paragraph noting that the Peacock Room was in the possession of Charles Freer. The addendum concludes, "As he owns the *Princesse*, The Peacock Room is probably once again just as it was when Whistler finished it."[17] From this we may deduce that the Pennells had not seen the room installed in Detroit. For them, it continued

to exist only in memory and imagination. Freer may have owned the actual work, but the Pennells continued to assert their claim to the myth of its creation.

Charles Freer had much in common with Frederick Leyland, even beyond his taste for Whistler's work, but Freer's fundamentally different concept of patronage as perpetual guardianship was to bear lasting consequences for the artist's reputation, to say nothing of his own. If Whistler's parable had been meant to teach Leyland a lesson, Freer was the patron who took it to heart, aspiring "never to do anything to disappoint Mr. Whistler in any way."[18] With the artist's encouragement, Freer assembled the most comprehensive collection of Whistler's works in the world, and he established a monument in the capital city of Whistler's native country. But Freer was apparently bewildered by the Peacock Room, a work that blatantly contradicted its maker's own ideology—which Freer himself had fully assimilated. Whistler's avowedly allegorical mural makes it nearly impossible to consider the Peacock Room from a purely aestheticist point of view: separate from the circumstances of its creation, apart from the personality of its artist, outside the structures of its time. To make it conform to his ideal of Whistler's works as esoteric and refined, Freer willfully divorced the decoration from its former associations. And in promising it to the American nation, he put an end to its unseemly commercial history.

The Peacock Room made one final foray into the commodity sphere before coming to rest in perpetuity at the Freer Gallery of Art. After Freer's death in 1919, when the room had to be transported to Washington, the question of its value was raised for insurance purposes: was it a room—a construction of ceiling, windows, walls, and doors—or was it a single work of art, like the other priceless objects in Freer's collection? The Peacock Room could never escape that ambivalent position, and even today is distinguished in having both an accession number, as a work of art, and a gallery number, as an exhibition space.

F OR MANY YEARS, the Peacock Room was left to justify its own existence in a museum devoted primarily to Asian art. Eventually, its persistent popularity necessitated a publication, and *The Whistler Peacock Room*, an illustrated booklet by Burns A. Stubbs, appeared in 1951. Stubbs had come to the Freer Gallery in 1920 as a "shipper" and in 1944 was made assistant to the director, a position that included curatorial responsibility for the American collection. Stubbs derived the outline of his text from a 1923 typescript by Katharine Rhoades, a former assistant to Charles Freer, whose account was largely drawn from the Pennells' books; Stubbs's contribution was to embellish that well-worn story with details culled from the newspaper clippings Freer had preserved, which

Obach & Co. had forwarded from London at the time of the sale. Blithely borrowed without explanation or attribution, those extracts demonstrate the danger of accepting such ephemera as reliable sources of information: the 1904 accounts make valuable records of contemporary responses to the Peacock Room but are worse than useless for filling out a story that, by then, had taken on the aura of a legend. Nonetheless, Stubbs's account appeared authoritative since it bore the imprint of the Smithsonian Institution, and it was reissued every ten years or so until 1980, when the Freer Gallery published an updated version by Susan Hobbs. In the three prior editions, changes had been made only to the bibliography and illustrations, as though the history of the Peacock Room had been definitively established.[19]

The gallery's durable booklet seems not to have reached an audience in England, however, where the Peacock Room remained part of the popular imagination. In the late 1950s, Nikolaus Pevsner, the editor of *Architectural Review*, invited the architectural historian Peter Ferriday to write about the room. At the time, Ferriday explained, the only reputable references were the Pennells' books and an article on the Leyland house by Theodore Child published in *Harper's New Monthly Magazine* in 1890.[20] Ferriday's article, though colored by a disparaging tone (he seems never to have seen the Peacock Room in person), is a marvel of cumulative detail and enlightening speculation, and for decades was the single best source on the subject.[21]

Ferriday had assumed there would be little to add to the Pennells' account of the Peacock Room, but Rosalind Birnie Philip, Whistler's heir and executor, had died in 1958 and bequeathed all the remaining works and papers in her possession to the University of Glasgow. Until then, the artist's correspondence had been kept mostly out of sight, and all the letters he had written — to which Philip held the copyright — kept strictly out of print. Ferriday must have been among the first to consult them. He recalled that the papers were still unsorted, but with the help of Andrew McLaren Young, curator of the collection, he managed to locate the relevant documents. The passages Ferriday quoted in his article have been reprinted, verbatim, many times; indeed, we can gauge the influence of Ferriday's work by the tenacity of certain of his mistakes, such as assigning authorship to Frances Leyland of the critically important letter from her husband inviting Whistler's advice on the decoration of the dining room.[22]

Among the papers Ferriday perused in Glasgow was a series of letters pertaining to the Peacock Room, which Whistler himself had numbered and preserved as a set with the intention of publication, presumably as another of his brown-paper pamphlets. Perhaps because he was pilloried in the press for *Art & Art Critics*, Whistler's improvident reply to John Ruskin and others after the famous libel trial of 1878, Whistler had abandoned the project. The collected letters are reprinted here as "The Peacock Room Papers," the appendix to this book. The original letters that Whistler wrote to his patron had been bequeathed to Leyland's daughter Florence, whose husband, Valentine C.

FIG. 1 Drawing for the Philadelphia pavilion, 1876, by Thomas Jeckyll (1827–1881). Pencil and blue wash, 55.8 × 42.4. Spencer Museum of Art, University of Kansas; Museum Purchase, Letha Churchill Walker Fund.

Prinsep, published one of them in 1892. It was hoped that more of the correspondence would be disclosed after Whistler's death,[23] but Prinsep kept the letters discreetly in the family, leaving them in 1904 to his son Anthony Leyland Prinsep, from whose estate the Library of Congress purchased them in 1943 to add to the Pennell-Whistler Collection. Shortly afterward, the Library acquired from the Leylands' youngest daughter, Elinor, a group of thirteen letters from Whistler to her mother. Nothing from Frances Leyland to the artist has ever surfaced.

Even without the evidence of the correspondence in Washington, which he apparently knew nothing about, Ferriday could speculate that Frederick Leyland "bulked more largely, and entirely more sympathetically, in Whistler's life than any other English acquaintance." Recognizing that Leyland deserved a biography of his own, Ferriday began to restore dimension to his identity as both a person and a patron; recent studies by M. Susan Duval and Dianne Sachko Macleod have added further details of his life and character.[24] Ferriday also reintroduced Thomas Jeckyll to history. Child had asserted in 1890 that even before the Peacock Room, Jeckyll had "suffered several disappointments, owing to accident having deprived him of the credit of his work," but it was only afterward, Ferriday pointed out, that the architect's "separate identity all but disappeared," leaving him "only Jeckyll of the Peacock Room." (He was literally that for some years, since Jeckyll's Christian name was unaccountably lost from the story. To compound the offense, Stubbs had made the enduring mistake of calling him Henry, which was the name of Jeckyll's brother.)[25]

In an enterprising effort to seek out information on that forgotten Victorian, Ferriday had written to the successors of Barnard, Bishop & Barnards, the Norwich foundry that had employed Jeckyll as its leading designer. His letter was answered by a former Barnards clerk who met Ferriday one night in a Norwich pub and handed over fifteen Jeckyll drawings wrapped in brown paper (fig. 1). These were sketches for the Japanese pavilion designed for the Philadelphia Centennial Exhibition, and they were given to Ferriday because he was the only person who had ever inquired after Jeckyll. They might otherwise have been forgotten or discarded: they had already survived an air raid and remained in fragile condition. Ferriday presented all but two drawings to the Victoria and Albert Museum, and those exquisitely detailed designs, poised between whimsy and precision, formed the foundation for a gradual rehabilitation of Jeckyll's reputation.[26]

Even so, Thomas Jeckyll remained a shadowy figure whose sad ending was made to fit the fable of the Peacock Room: one newspaper headline from 1904 declares the Peacock Room "A Whistler Work Which Drove a Man Mad."[27] In his 1930 biography of Whistler, the first to be published after the Pennells', James Laver recounts the relevant incident in a similar tone:

Unnoticed, a furtive figure creeps into the room. It is Jeckyll, who has heard the rumors and come to see for himself. He looks for the warm

Le Journal de la Beauté

10 Centimes

FIG. 2 *Le Journal de la Beauté*, 1897, by Louis J. Rhead (1857–1926). Color litho-graph, 77.8 × 148.5. The Metropolitan Museum of Art, New York.

brown tone of his beautiful leather; blue shrieks at him from every corner of the room; the gold blinds him; peacocks' eyes follow him; and from the midst of the crowd the "strident peacock laugh" of the man who has committed this outrage. The shock cracks his brain. He staggers home and is found a few hours later muttering to himself and trying to cover the floor of his room with gold. He dies in a madhouse.[28]

Ferriday rejected Laver's dramatization, but it proved irresistible to many later writers.[29] The Jeckyll tragicomedy was not seriously reconsidered until 1984, when David Park Curry's essay "Artist and Architect" was published as part of his catalogue of the Whistler collection at the Freer Gallery. Citing a deranged letter from Jeckyll to Whistler from November 1876, Curry was able to document that the architect "was already unbalanced by the time Whistler was painting the Peacock Room."[30]

Curry's groundbreaking essay proposed precedents for Jeckyll's decoration in the Dutch porcelain rooms designed to display quantities of Chinese imports, reminding us that the Peacock Room was the redecoration of an existing inte-rior scheme. Previously, Jeckyll's contributions had been regarded as impedi-ments to Whistler's creativity and the lamentable cause for any lingering infe-licities. The Pennells had asserted that the original room (which they, of course, had never seen) was "far from beautiful, with its repeated lines, its heavy ceiling, its hanging lamps, and its spaces so broken up that, only on the wall opposite the *Princesse* and on the shutters, could [Whistler] carry out his design in its full splendour and stateliness."[31] Curry was the first to suggest that Jeckyll's inte-rior might have had integrity of its own.

Rigorous art-historical scholarship on the Peacock Room may have been suppressed in part by the bias that privileges "fine art" above "decorative art," a distinction that Whistler (among others) attempted to dismantle. The view that Whistler's work as decorator and designer should be taken as seriously as his other accomplishments is the theme of Deanna Marohn Bendix's *Diabolical Designs* (1995), a book that gives the latest assessment of the Peacock Room. Bendix bestows a host of well-earned superlatives upon the room, identifying Whistler's decoration as "possibly the most famous English room of the period and the most extraordinary single surviving monument of the British aesthetic movement" and arguing for its place "as a precursor of the international art nouveau movement of the 1890s and early 1900s."[32] That Whistler's decoration anticipated art nouveau was proposed by Frederick Sweet in 1968 and has since become a truism,[33] but there remains much to learn about the actual transmission of influence (fig. 2).

In 1904, when word got out that Whistler's decoration was leaving London, one English journalist predicted that "its simplicity, suggestiveness and lack of fussiness and elaboration" would exercise a salutary effect on American interiors by making them "more restful and dignified."[34] But only the most determined devotees made the pilgrimage to Detroit, and by 1923, when the room was finally opened to the public in the new museum in Washington, it would have looked anything but restful and dignified: to emulate its example then would have seemed a lapse in taste. In an intriguing twist of cultural history, the Peacock Room may have lent inspiration to another famous American interior at Graceland, Elvis Presley's Memphis mansion—a room decked out in blue and gold, with panels of stained-glass peacocks.

The Pennells were not the only ones who may have felt let down by the Peacock Room after the buildup of the legend. In a lecture presented at the Freer Gallery in 1934, Elisabeth Luther Cary, art critic for the *New York Times* and author of *The Works of James McNeill Whistler* (1907), confessed to feeling that Whistler had not been "at his best" when he painted it. "The room is, of course, a *tour de force*—and no one else could have done it. But it seems to me to be the one example of poor judgment on Whistler's part, in so far as decorative effect is concerned."[35] That current of dissatisfaction runs through most of the Whistler literature, and forty years later, in a 1977 study of *japonisme*, Frank Whitford boldly described the Peacock Room as "all pompous show, horrifyingly unforgettable—a kind of Far Eastern *kitsch*." In a well-regarded book on Whistler published in 1978, Hilary Taylor expressed much the same opinion, considering the Peacock Room "heavy and over-decorated" and thus the grand, unfortunate exception to the rule of Whistler's art. "When considering Whistler as an interior decorator, discussing those elements of simplicity, deli-

FIG. 3 The Peacock Room, northwest view, ca. 1929. Freer Gallery of Art Archives, Smithsonian Institution, Washington, D.C.

cacy and lightness which seem to preface so much of twentieth-century design, it is as well to bear in mind the Peacock Room, a room which carries with it connotations of the rich, exotic claustrophobia which now seem characteristic of Victorian planning, a room which Whistler at no time rejected"—as Taylor, it would seem, thought he should have. In 1987, John Walker disparaged the Peacock Room as "dismal," particularly when "compared with what it must once have been."[36]

Part of the problem with the Peacock Room, as Walker acknowledged, resided in the circumstances of its display. Dispossessed of its purpose and its porcelain and housed amid Japanese screens and Chinese bronzes, the Peacock Room appeared brazen and embarrassed. Initially, the Freer Gallery had followed its benefactor's practice of placing Asian and American ceramics on the Peacock Room shelves, though never in sufficient quantity to make much of an impression (fig. 3). The first piece of Chinese blue and white was not installed until the late 1950s, and it seems to have been placed there more by chance than calculation. The jar is from the wrong dynasty and of the wrong dimensions for the room, and it looks sadly absurd, sitting by itself on the sideboard (fig. 4). Finally, in the early 1980s, the Freer Gallery accepted a gift for the Peacock Room of several appropriate pieces of Kangxi-era blue-and-white porcelain. Unfortunately, security reasons mandated that they be placed on the uppermost shelves, where they were out of reach but also almost out of sight (fig. 5). Unsympathetic furnishings did little to enhance the Peacock Room's appearance. For some years, a plush Victorian ottoman sat in the center of the space, a souvenir of the overstuffed interiors that Whistler's art rebelled against.

FIG. 4 The Peacock Room, southwest view, ca. 1950. Freer Gallery of Art Archives, Smithsonian Institution, Washington, D.C.

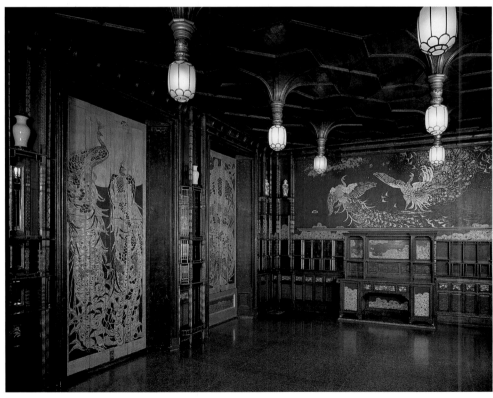

FIG. 5 The Peacock Room, southeast view, ca. 1984. Freer Gallery of Art Archives, Smithsonian Institution, Washington, D.C.

A more serious obstacle to appreciation was the physical condition of the work itself. Beginning with its life in London, at a time when air pollution posed a serious threat to art, the Peacock Room had acquired a patina of grime sealed to the woodwork with coats of furniture polish. As early as 1892, the

dirtiness of the decorations was a matter of remark. The room undoubtedly suffered from neglect in the next decade, when it stood for a time in an untenanted house and then in the possession of someone who was planning its destruction and could not have bothered much about its state of preservation. But the worst was yet to come. The Peacock Room's first dismantling took place in 1904, in preparation for the Obach exhibition, and while it must have entailed some damage to the decorations, none was apparent to the critics who saw the room on display. Their descriptions, however, consistently list brown among its colors: since that had not been prominent in the original arrangement, we may deduce that Whistler's copper-greens were already going dark beneath dirt and discolored varnish.

By the time the Peacock Room had weathered its second move and reconstruction in Detroit, it was showing unmistakable signs of strain. The cracks in the ceiling that had been visible there became woefully obvious in Washington: the room had suffered most seriously in the passage to and installation in the museum intended for its preservation. At the Freer Gallery in 1926, an attempt was made to repair the peacock mural, which was badly buckled and cracked, and afterward the damaged ceiling; but by 1942 it had become unhappily apparent that the structure was unstable and liable to self-destruct if further measures were not taken at once.[37] John A. Finlayson, an art restorer for the Museum of Fine Arts in Boston, was brought to Washington to begin the project; progress was postponed by the Second World War, but Finlayson and his brother Richard commenced a comprehensive rehabilitation in 1947.[38] Working on weekends, they dismantled the Peacock Room, incidentally revealing the

FIG. 6 The Peacock Room, north view after removal of shelving during restoration, 28 December 1947. Freer Gallery of Art Archives, Smithsonian Institution, Washington, D.C.

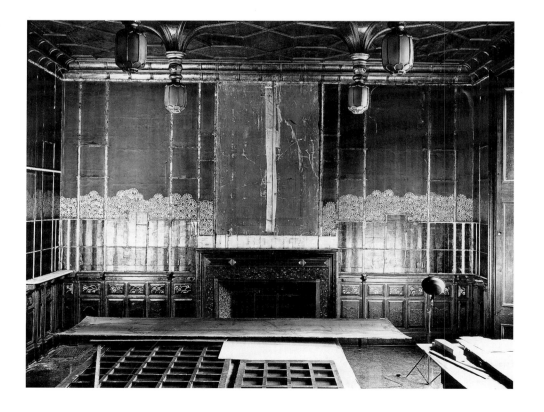

Introduction

original leather wall-hangings, still visible behind the shelving (fig. 6). Their lasting contribution was a new framework to support the decorations. This was constructed of three-quarter-inch plywood coated with plastic and cradled to keep it from warping (fig. 7). After the leather had been cleaned and treated with wax, it was affixed with a wax adhesive to the new wooden shell.

The restorers also made cosmetic "repairs" to the room using gold and silver leaf "as needed" and retouching the surfaces "with oil colors." (Their methods are known from cryptic notes on a set of working photographs preserved in the Freer Gallery Archives, the project's only documentation.) In addition to correcting paint losses caused by structural repairs, the Finlaysons took it upon themselves to repaint parts of the decoration they considered damaged or unfinished. Many diaphanous peacock feathers on the shutters were clumsily reworked, disguising what we would recognize as Whistler's deft and economical brushwork. The nimbus that originally emanated from the artist's signature at the top of the central shutters, a meaningful detail that features in all of Whistler's sketches, completely disappeared when the deliberately distressed gilt surface was covered with a fresh coat of flat, gold paint.

The Finlaysons should not be held too much to blame for such transgressions, since they carried out the restoration in accord with the attitudes of their time: they lavished attention on the parts of the Peacock Room that might be considered paintings—the shutters and the mural, named by Stubbs "the most important features"—and virtually ignored the rest, the "subsidiary decoration."[39] Because cleaning was limited to certain surfaces, the damaged areas on the ceiling, the canvas behind the shelving, the wainscoting, and the doors

FIG. 7 The Peacock Room, northwest view during restoration with new wooden framework, ca. 1948. Freer Gallery of Art Archives, Smithsonian Institution, Washington, D.C.

FIG. 8 The Peacock Room, detail of the ceiling, cleaning test, 1989. Department of Conservation and Scientific Research, Freer Gallery of Art, Smithsonian Institution, Washington, D.C.

FIG. 9 The Peacock Room, detail of the dado, partially cleaned, 1991. Department of Conservation and Scientific Research, Freer Gallery of Art, Smithsonian Institution, Washington, D.C.

were only retouched, often with a "wadded rag" instead of a brush and with paint that matched passages deeply embedded with grime. The restorers thus contributed a turbid greenish-brown to Whistler's color scheme, and by the time they finished, the original color harmony of the Peacock Room had fallen out of tune.[40] The room's physical structure had been stabilized, however, and the introduction of air-conditioning in 1957 ensured the constant level of temperature and humidity necessary for its future preservation.

By the 1970s, Freer Gallery conservators had begun to suspect that the Finlayson restoration had produced some of the Peacock Room's disturbing aesthetic discrepancies. The extent of the muddle was not fully understood until 1989, when cleaning tests revealed how far the original decoration had been obscured (fig. 8). While the entire Freer Gallery remained closed for renovation, a team of conservators from the University of Delaware / Winterthur Art Conservation Program conducted a comprehensive conservation treatment, approaching the Peacock Room as Whistler chose to see it, as one enormous painting. Under the direction of Wendy Samet, with the assistance of Joyce Hill Stoner, using solvents specially devised by Richard Wolbers, they gradually removed the dense accumulation of dirt, repaint, and yellowed varnish that covered every surface of the room.[41]

The results were astonishing. When, for example, the conservators cleaned the wainscoting—a part of the room the Finlaysons had regarded as part of the furniture, or frame, and left alone—its dark, mottled surface became a shimmering greenish gold, transforming the character of the walls (fig. 9). Likewise, revitalizing the lusterless ceiling revealed a network of peacock feathers spun across a golden ground, validating the Victorian comparisons with Japanese lacquer that had been set aside as misleading or irrelevant. Evidence of the domi-

nant inspiration for Whistler's decoration came back into view with unexpected conjunctions of coppery golds, blues, and greens that vividly recall the iridescence of peacock feathers.

By uncovering aspects of design hidden for seventy years or more, the conservation inspired a new appreciation of the Peacock Room, one that extended beyond its status as the subject of a story. The Freer Gallery recognized the significance of the aesthetic transformation and reformed the style of its display. A plain blue rug was installed, in accord with Whistler's intent, and the terrazzo replaced with floorboards to give a sense of the domestic setting. The gallery acquired a pair of Jeckyll's sunflower andirons in 1983 and a matching cast-iron fire-basket in 1995. The lighting was subtly modified to better illuminate *La Princesse du pays de la porcelaine*, which had suffered too long in the dark. Most important, a campaign was begun to acquire Chinese porcelain of the sort that Leyland collected, in the range of shapes and sizes dictated by Jeckyll's shelving. That collection, which still has room to grow, confirms the importance of blue and white to the decoration's aesthetic coherence.

Perhaps now the Peacock Room can take its place in the scheme of Whistler's production. The architect E. W. Godwin once declared that Whistler's reputation could rest upon the Peacock Room alone. "Had the 'Mother,' the 'Carlyle,' the 'Sarasate' never been painted," he wrote in 1886, referring to three of Whistler's famous portraits now in Paris, Glasgow, and Pittsburgh, "had the gems of water-colour drawings and the treasures of etchings been all destroyed; had we forgotten the varied delicacy of those exhibition rooms in Piccadilly and Bond Street this man has created for our joy, we should still know him to be a master so long as wall or ceiling or shutter remained of the marvellous peacock decoration."[42]

Wall and ceiling and shutter do survive: the art, to quote Whistler, *"alone remains* the fact." All the rest "is merely the anecdote" (app. 6).

pages 36–41

Harmony in Blue and Gold: The Peacock Room, 1876–77. Oil paint and metal leaf on leather, canvas, and wood, 425.8 × 1010.8 × 608.3. Freer Gallery of Art, Smithsonian Institution, Washington, D.C. (04.61). These photographs, taken after the latest conservation, show the northeast view; the central shutters on the east side; *La Princesse du pays de la porcelaine* (1864–65) on the north wall; and the southwest view.

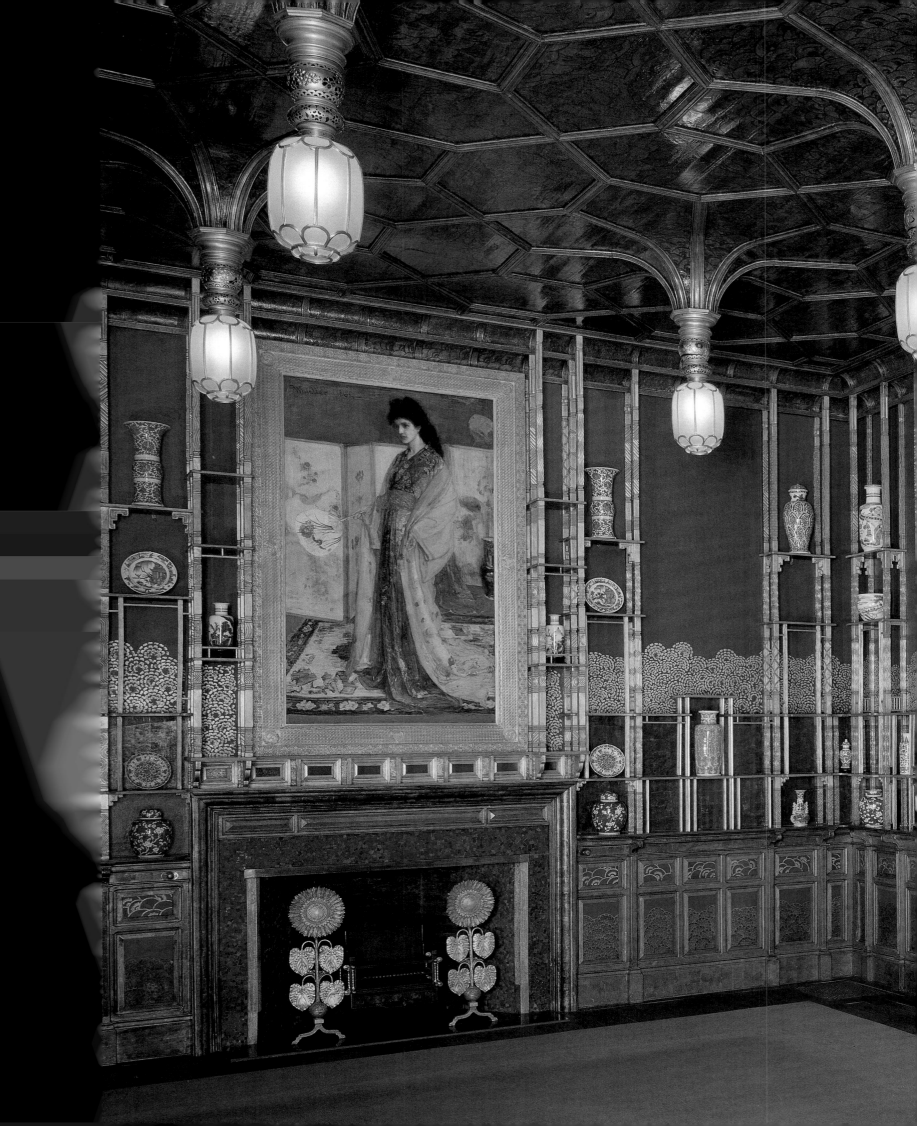

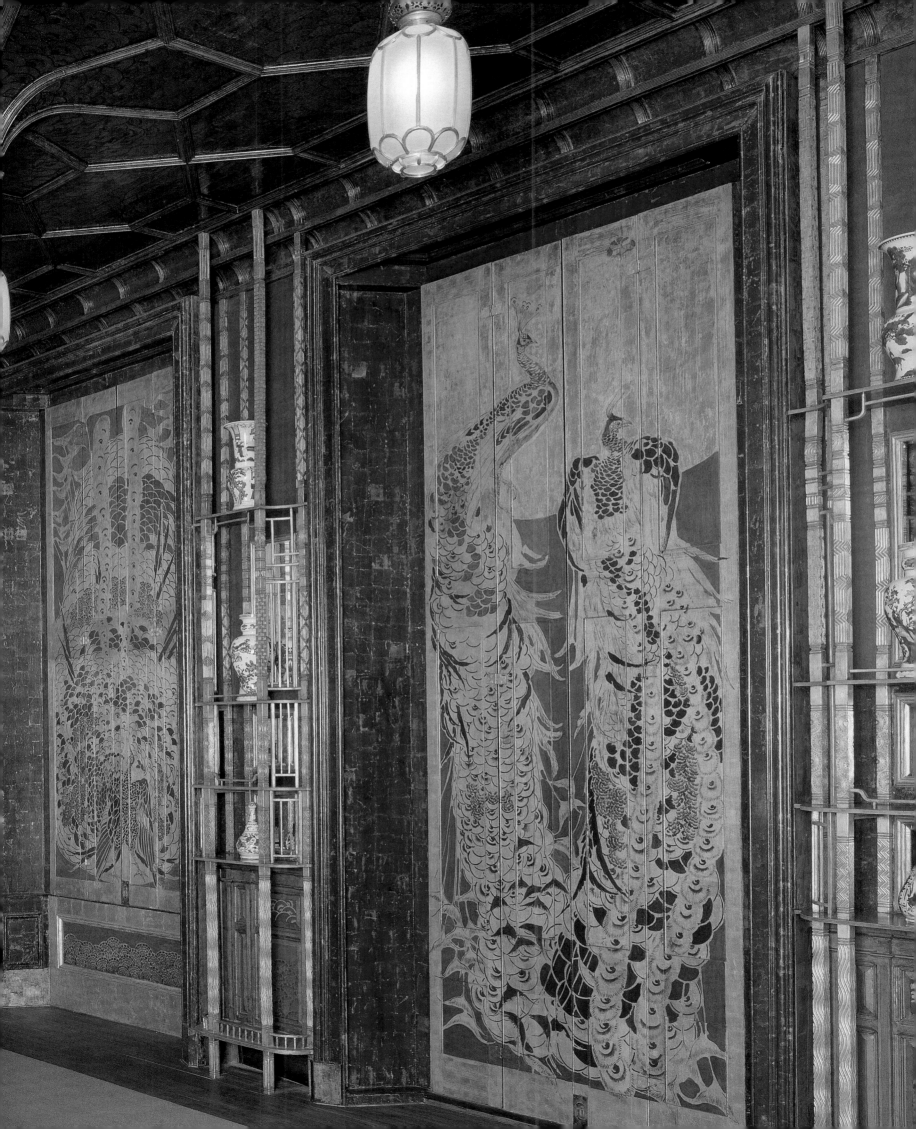

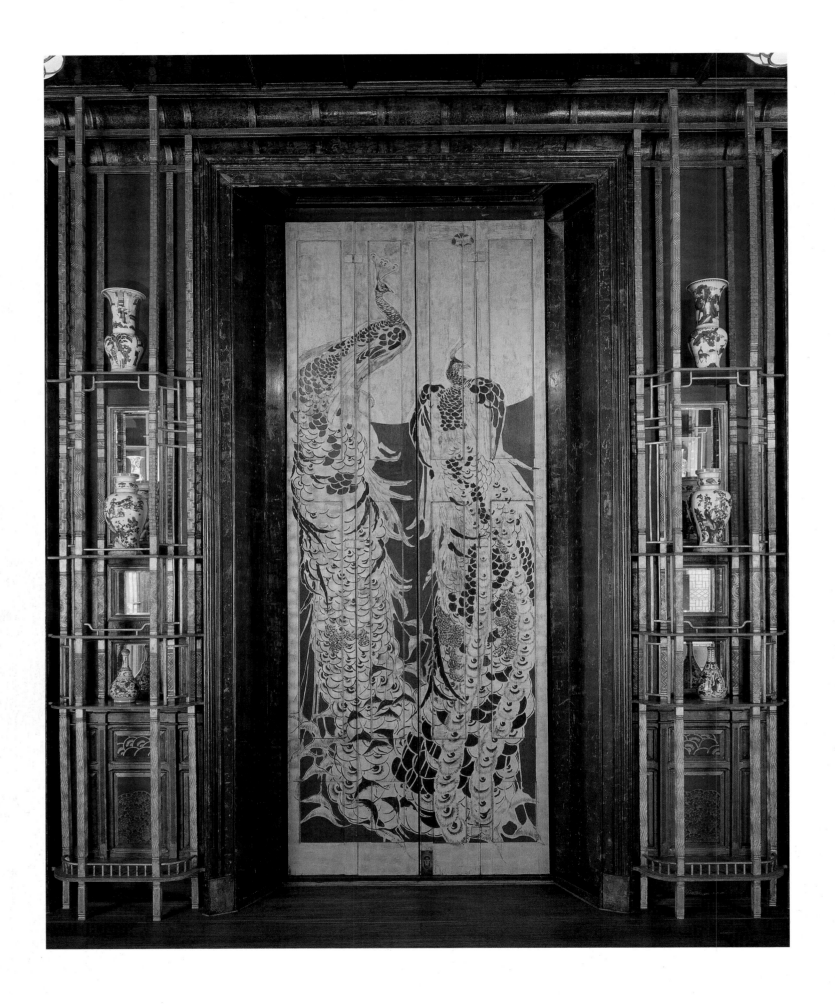

Introduction

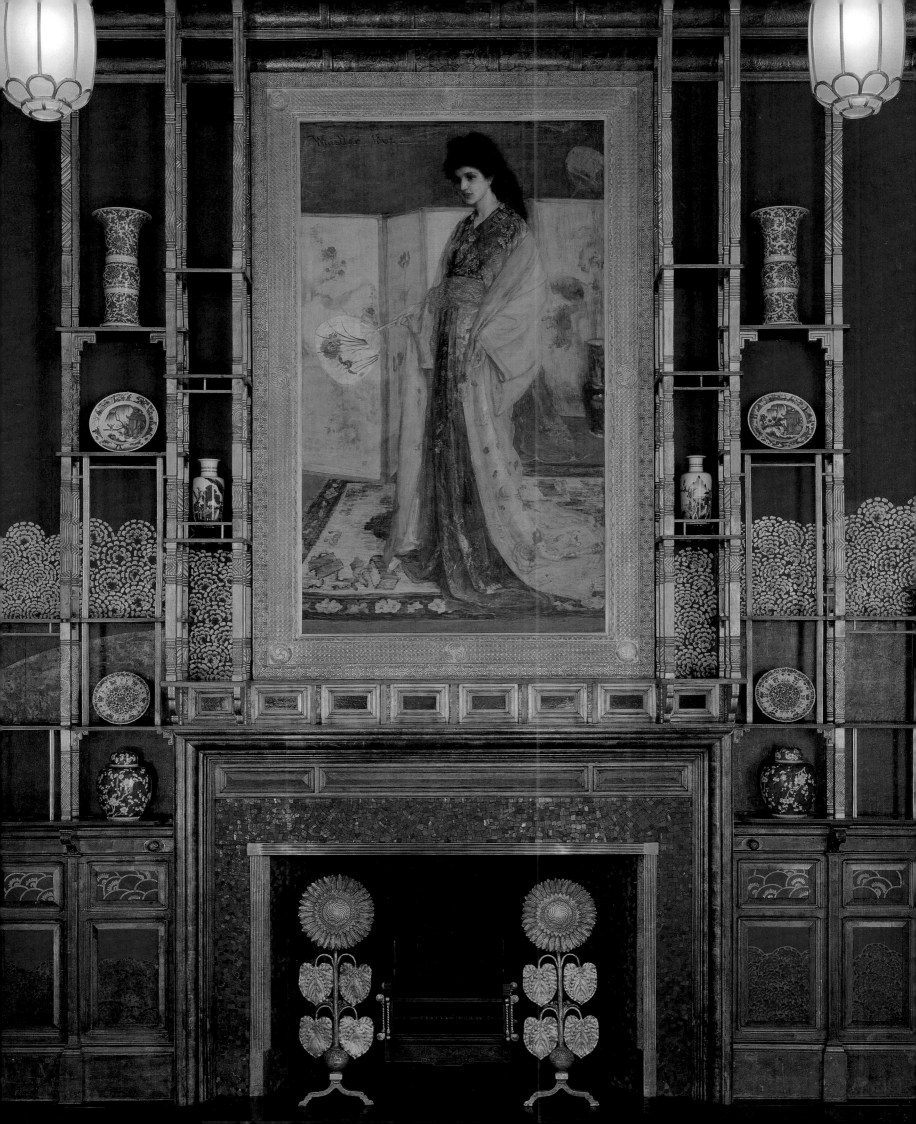

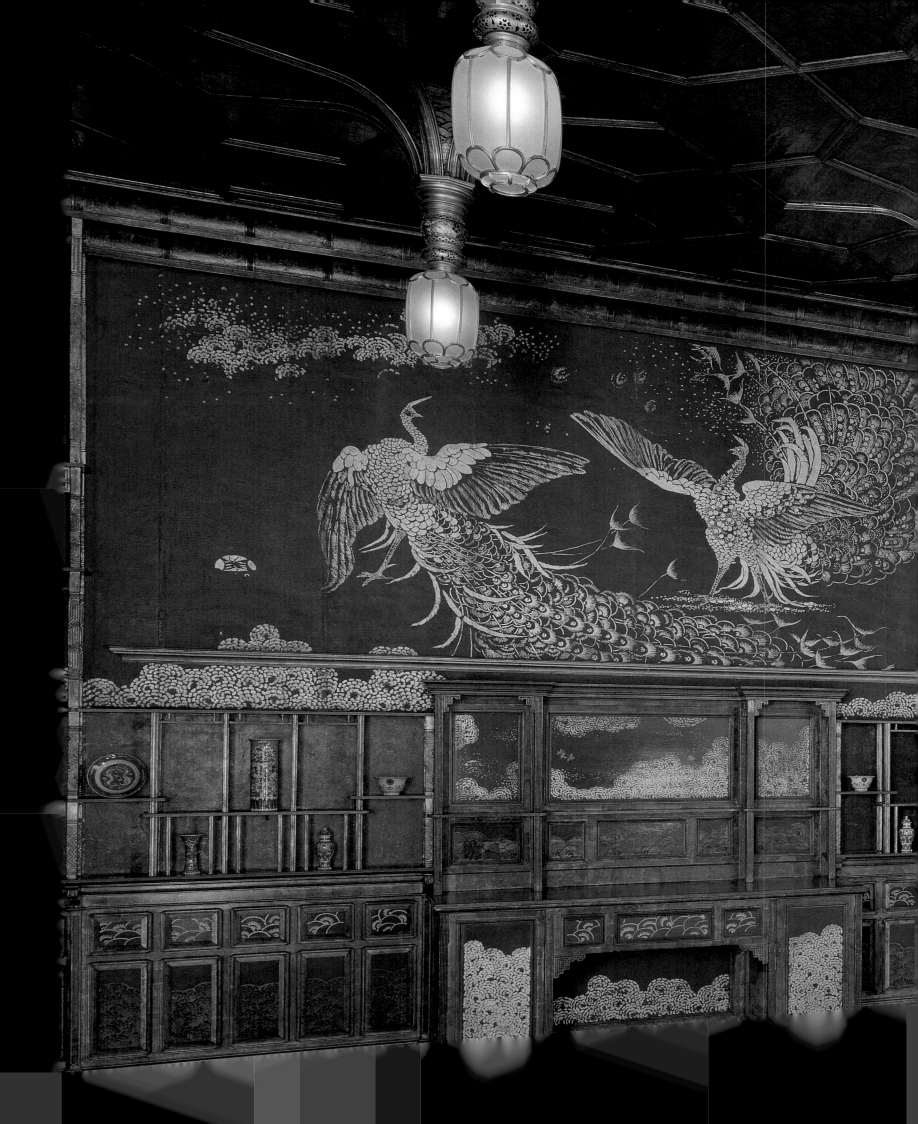

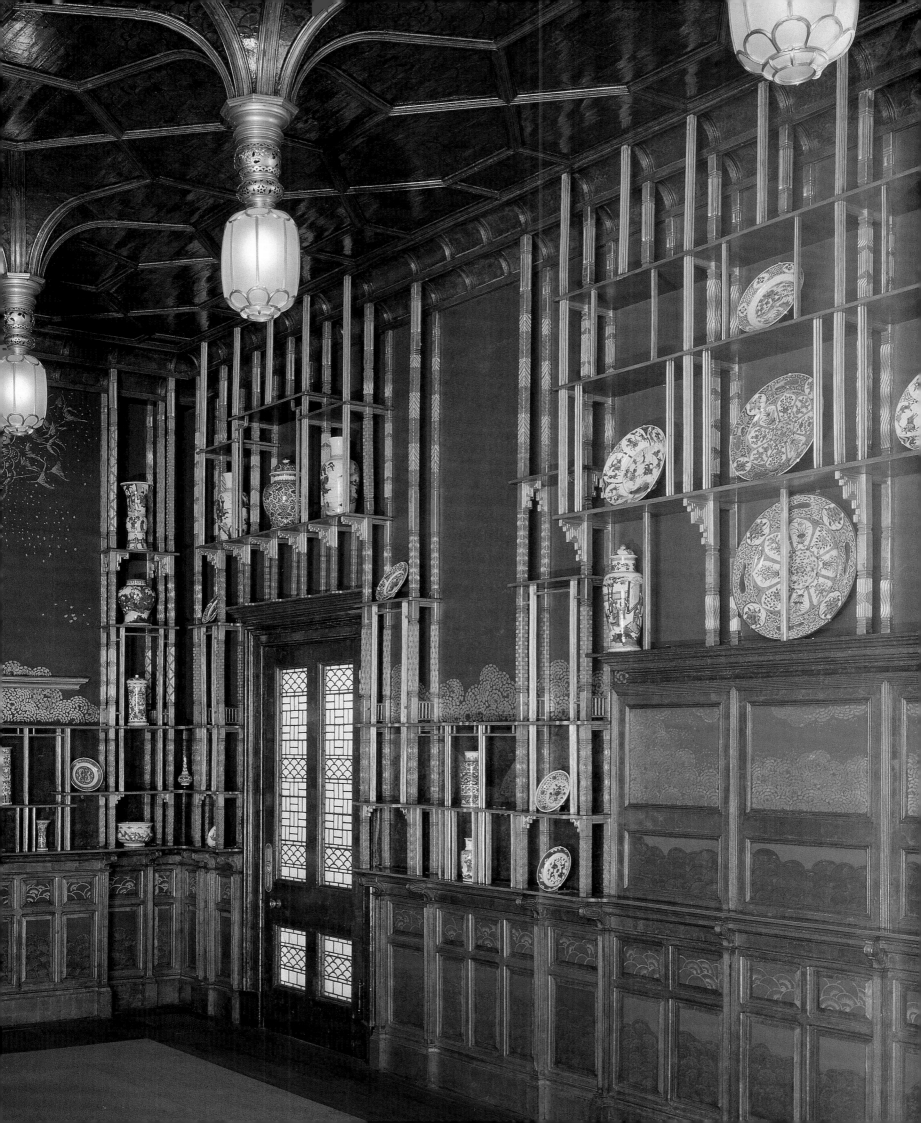

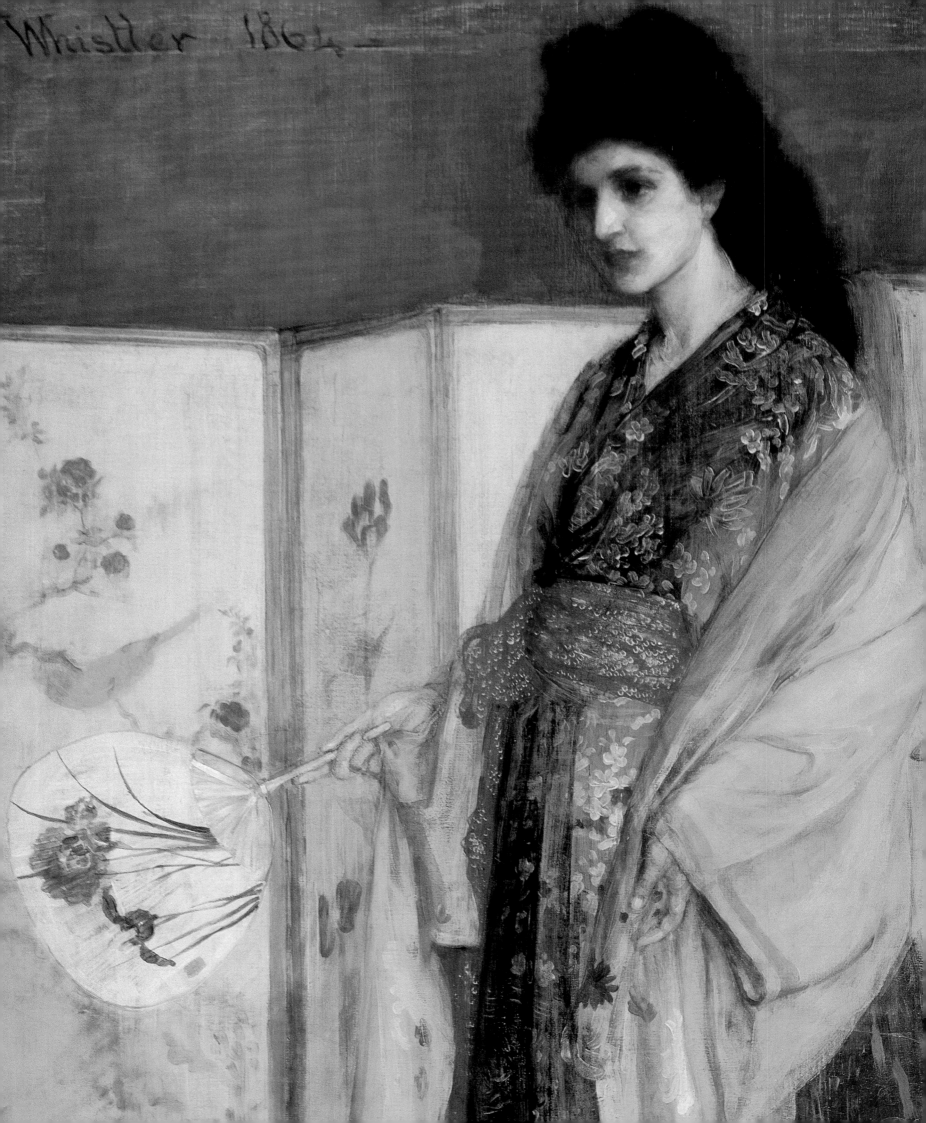

1 The First Vase

THE PRIMAL WORK OF ART is not a picture but a pot, according to the story of creation Whistler tells in his "Ten O'Clock" lecture. In the beginning was a gourd, which the first painter decorated with "quaint patterns." Eventually, other artists joined him and thought of fashioning clay into gourd-like shapes; but it was only when they learned, together, to transcend the influence of nature that the first vase was made. Whistler's construction of events has art emerging from collective creativity: working alone, the artist had failed to complete the imaginative leap from gourd to vase, or from an object modeled on nature to one possessing the beauty of art. The parable pointedly recalls a critical chapter in Whistler's own career, when a community of aesthetes assisted his release from realism. The culminating work of that period—the "first vase" of Whistler's legend—is *La Princesse du pays de la porcelaine* (fig. 1.1), the painting destined for the Peacock Room.

First exhibited in Paris in 1865, *La Princesse* has often been regarded as the descendant of *The White Girl* (fig. 1.2), a painting Whistler exhibited at the Salon des Refusés in 1863.[1] Notices regarding *La Princesse* mention "La Fille blanche" so consistently that the earlier work seems to have remained alive in French memory throughout the intervening years. As Whistler's friend the artist Henri Fantin-Latour observed, *La Princesse* did not create the same sensation. Yet Whistler had invested all his hopes in *La Princesse*, and one critic reflected at the end of the century that when Whistler signed the painting in 1865, "he wrote his name, one would have thought, on the roll of fame."[2]

The model for *The White Girl* was Joanna Elizabeth Hiffernan, whom Whistler had met in 1861 while living at 70 Newman Street in a tiny apartment opposite the Hiffernans' house. George du Maurier, who briefly shared Whistler's flat, referred to her father as a "passionate & impulsive Irishman" who Whistler feared might disgrace his daughters after the death of their mother.[3] Patrick Hiffernan was described to the Pennells, however, as "a sort of Captain Costigan," the happy-go-lucky Irishman in Thackeray's *Pendennis* who was more protective of his daughter's good name than his own, and Hiffernan

And presently there came to this man another—and, in time, others—of like nature, chosen by the Gods—and so they worked together; and soon they fashioned, from the moistened earth, forms resembling the gourd. And with the power of creation, the heirloom of the artist, presently they went beyond the slovenly suggestion of Nature, and the first vase was born, in beautiful proportion.

"Mr. Whistler's 'Ten O'Clock'"

Detail, *La Princesse du pays de la porcelaine* (fig. 1.1).

FIG. 1.1 *La Princesse du pays de la porcelaine* (Y50), 1864–65. Frame designed by the artist. Oil on canvas, 199.9 × 116.1. Freer Gallery of Art, Smithsonian Institution, Washington, D.C. (03.91).

seems to have been willing to accept Whistler as a son-in-law.[4] The common-law marriage was in effect by the autumn, when Whistler and Jo Hiffernan left Newman Street for Wapping, an unsavory part of London on the river Thames near Rotherhithe. Whether Hiffernan began as Whistler's lover or his model is uncertain, but she was both by the end of 1861, when she accompanied him to Paris.

According to Gustave Courbet, Jo Hiffernan possessed "a feeling and talent for art." The watercolorist George Price Boyce was favorably impressed with landscapes she painted on beach stones, and her sketches are said to have been accomplished enough to occasionally be mistaken for Whistler's. Eventually, the Pennells relate, she came to know "more about painting than many painters."[5] Whistler, then, may have taken Hiffernan to France partly to expose her to the artistic milieu in which he maintained personal and professional ties and still felt most at home. He also wanted to show her off to his friends. Though not beautiful by conventional Victorian standards, Hiffernan had a spectacular mane of coppery red hair, which Whistler unleashed when they went to meet Courbet, drawing her tresses around her shoulders to create the image Courbet later committed to canvas as *La Belle Irlandaise* (1865–66). The sculptor Charles Drouet recalled that Courbet had been "immensely struck with her, which pleased Whistler greatly," and though the Pennells construed the purpose of that display as forcing Courbet "to see beauty in the beautiful," their interpretation depends on a philosophy that Whistler had not yet adopted.[6] Drouet's anecdote suggests, instead, that Whistler still courted Courbet's good opinion and was simply proud of being envied for his model.

Whistler would later fervently deny that Courbet had exerted any influence on his art ("there is none, and you will not find it in my canvases"), but with the exception of Luke Ionides, who upheld the myth of Whistler's originality, his contemporaries were convinced that no other artist affected him as much.[7] When Whistler first set foot in France at the age of twenty-one, Courbet's works were on display in a solo exhibition staged in response to his exclusion from the Paris Salon. Caught up in the novelty of bohemian life, Whistler may not have seen Courbet's exhibition or read the discussions of his theories in *L'Artiste*. But the inclusion of Courbet's *Young Ladies of the Banks of the Seine (Summer)* at the 1857 Salon revived the topic in the press, and by then Whistler would have been well versed in the tenets of realism. He quickly mastered the realist manner, and when Courbet saw Whistler's uncompromising portrait of an old woman who sold violets at the gates of the Luxembourg Gardens, *La Mère Gérard* (ca. 1858), he reportedly exclaimed, "What can I say? That's it!"[8]

The French critic Théodore Duret explained to the Pennells that Courbet's influence on Whistler extended beyond his art to his attitude toward the public. *The White Girl*, which Whistler painted in Paris in a rented studio on the boulevard Pigalle, was not only meant to impress Courbet (as the model herself had done), but to shock the bourgeoisie.[9] The costume and backdrop are

The First Vase

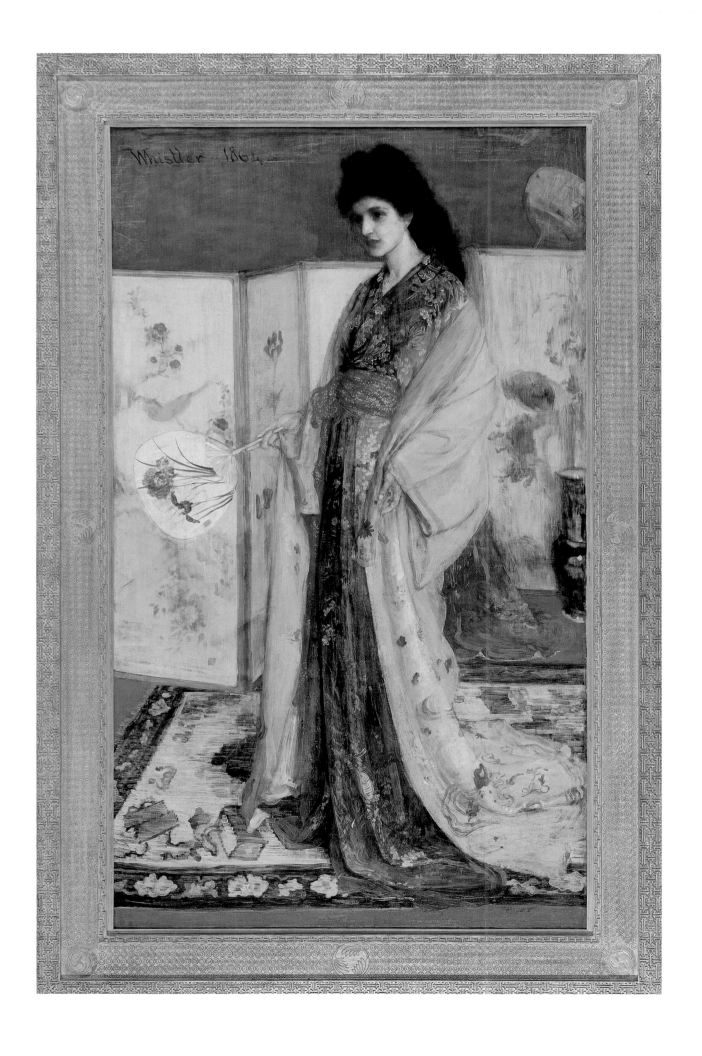

The First Vase

45

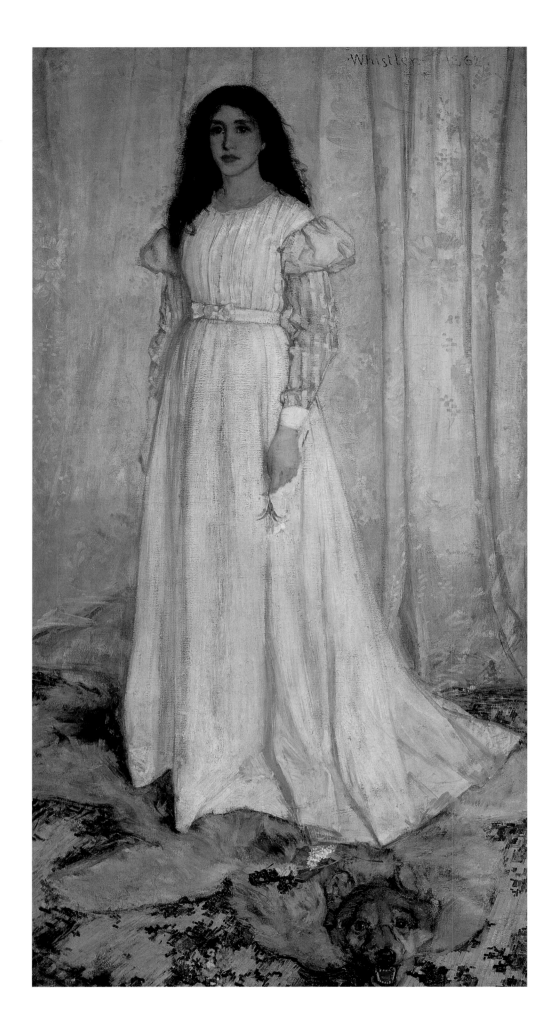

FIG. 1.2 *Symphony in White, No. 1: The White Girl* (Y38), 1862. Oil on canvas, 213.0 × 107.9. National Gallery of Art, Washington, D.C.; Harris Whittemore Collection.

The First Vase

startlingly white, as if in response to the English critic who had disparaged *La Mère Gérard* the previous spring, expressing the hope that Whistler might "leave off using mud and clay on his palette, and paint cleanly, like a gentleman." But in April 1862, when *The White Girl* went to the Royal Academy for consideration, Jo Hiffernan wrote to George Lucas, a friend of theirs in Paris, that the picture was not understood even by the artists in England and that Whistler believed "the old duffers" at the Academy would refuse it.[10] As indeed they did, perhaps sensing that *The White Girl* subverted the Victorian art establishment, which demanded narrative pictures captioned with articulate titles.

Whistler was acquainted with rejection. Just as he had shown *At the Piano* (1859) at François Bonvin's studio in Paris after it failed to find a place in the Salon, so he sent *The White Girl* to a private gallery in London whose "avowed purpose" was to display "the works of young artists who may not have access to the ordinary galleries." In the catalogue of the Berners Gallery, Whistler's painting was labeled "Rejected at the Academy," and taking note of that rejection in its review, the *Athenaeum* opined that Whistler himself would someday recognize the reasonableness of the exclusion: his work was "a striking but incomplete picture," and although the figure's face was well-enough drawn, "it is not that of Mr. Wilkie Collins's 'Woman in White.'" In reply, Whistler wrote his first letter to the press, denying the connection between his painting and a popular novel he had never read, and stating that *The White Girl* "simply represents a girl dressed in white standing in front of a white curtain."[11]

That assertion has often been dismissed as disingenuous. *The White Girl*, with its melancholy figure and rich symbolic overtones, appears to invite interpretation: literary subjects and narrative glosses are regularly draped across the painting even now. Alternatively, Whistler's letter to the *Athenaeum* has been read as a proclamation of aestheticist belief, placing *The White Girl* at the forefront of the works advancing the cause of Art for Art's Sake—a construction Whistler himself later reinforced by naming the picture the first of his "symphonies" in white.[12] At the time he wrote his letter, Whistler probably meant no more than he said: his definition of *The White Girl* situated the picture among his portraits of urban working-class women, which included such etchings as *La Rétameuse* (1858), of a Parisian tinker, and *La Mère Gérard* (fig. 1.3), of the flowerseller. Like them, *The White Girl* depicts a woman at work, in this case as a professional model, posing for a picture. The studio setting accounts for the anachronistic costume and the rather too meaningful props—a lily and a bearskin rug—and also for the wilted appearance of the artist's model, who has dropped her pose along with her flowers. Her vacant expression, sometimes attributed to the ordeal of lost virginity, may simply express her weariness at the end of a working day.

Whistler could have witnessed such a scene in any number of London studios. By recreating it in Paris, he deliberately adopted a French perspective for commenting on the tired conventions he observed in Victorian art. *The White*

FIG. 1.3 *La Mère Gérard* (K11), 1858. Etching, fourth state, 12.7 × 8.9. Freer Gallery of Art, Smithsonian Institution, Washington, D.C. (98.223).

Girl self-consciously employs the iconography of the fallen woman found in such Victorian pictures as John Rodham Spencer-Stanhope's *Thoughts of the Past* (1858–59), yet it firmly resists the predictable reading.[13] The artist's own straightforward explanation of the theme as "a girl dressed in white standing in front of a white curtain" summarily defeats what Charles Rosen and Henri Zerner have named "the three enemies of Realist painting": the sentimental, the picturesque, and the anecdotal. *The White Girl* belongs among other "model pictures," as Frances Borzello classifies works such as Edouard Manet's *Déjeuner sur l'Herbe* (1863). Such paintings subvert the conventional way of depicting the model, often by having her return the viewer's gaze, and the artists use these works as visual manifestos, "to state something important about their beliefs."[14] By shattering the illusion of art, Whistler also compelled confrontation with a sitter who, like *la rétameuse* or Mère Gerard, would never be admitted into polite society.

It is hardly surprising that a public accustomed to looking through pictures to find the fiction within would fail to recognize a model depicted only as model. But if Whistler anticipated the failure of his French realist picture in London, he seems to have been certain of its acceptance in Paris. "I have set my heart upon this succeeding," Whistler wrote to Lucas, "as it would be a crusher for the Royal Academy here, if what they refused were received at the Salon in Paris and thought well of." He delivered *The White Girl* to the Salon himself, and on Varnishing Day he wandered through the rooms of the enormous Palais de l'Industrie looking for his picture. Whistler felt first anxious, then ill, as he searched the galleries a second time, in the hope that he had missed it in the crowd of exhibits.[15]

The rest is history: three-fifths of the works submitted to the Salon that year had been rejected, and of those, some seven hundred, including Whistler's "Dame blanche" and Manet's *Déjeuner sur l'Herbe*, were sent to the Salon des Refusés. On its opening day, Henri Fantin-Latour wrote to Whistler that all their Paris friends—notably Courbet—had seen and admired *The White Girl*: "Now you are famous!"[16] Famous, but not content, for Whistler had not abandoned the ambition to see one of his paintings hanging on the walls of the Paris Salon.

I̲N REACTING against the Royal Academy with *The White Girl*, Whistler appeared to align himself with the English avant-garde, formerly represented by the Pre-Raphaelite Brotherhood. Although that fraternity, founded in 1848 by seven young men in the spirit of artistic revolution, had long since disbanded, a second phase of Pre-Raphaelitism was surging in 1862. Dante Gabriel Rossetti, the painter and poet who had been a leading figure in the original Brotherhood, led the revival. He and his brother William Michael Rossetti, an art critic, had already known Whistler by reputation when they met him in 1862

The First Vase

FIG. 1.4 *Bocca Baciata*, 1859, by Dante Gabriel Rossetti (1828–1882). Oil on panel, 32.2 × 27.1. Frame designed by the artist. Museum of Fine Arts, Boston; gift of James Lawrence (1980.261).

through the poet Algernon Charles Swinburne, a mutual friend. Swinburne said afterward that he knew "Whistler would be exactly the man Gabriel would like," William Rossetti recalled, "to which Gabriel replied that he could not say that was precisely the fact, although he was pleased to know him."[17]

Gabriel Rossetti was at that time resolutely remaking his art ("learning to paint at last") in the conviction that masterpieces were distinguished not by their subjects, but by their "colour and execution." Since 1859 he had been producing half-length portraits of women "chiefly as studies of rapid flesh painting." The first of those, *Bocca Baciata* (fig. 1.4), was an avowedly sensual painting that "introduced a level of ambiguity into English picturemaking," as Dianne Sachko Macleod has noted. "This picture's artful strategies demand a more complex interplay between spectator and image than was required by Victorian narrative painting"—precisely the interplay posed by Whistler's *White Girl*, which was creating a sensation in London the summer Whistler met Rossetti. How telling, then, that *Bocca Baciata* was the work Whistler proposed to take to Paris in 1862, for exhibition on Rossetti's behalf.[18]

FIG. 1.5 Algernon Swinburne, Gabriel Rossetti, Fanny Cornforth, and William Rossetti in the garden of 16 Cheyne Walk (Tudor House), 1863. *Carte de visite* by W. & D. Downey, London. National Portrait Gallery, London.

Whistler and Jo Hiffernan were temporarily residing on the Queen's Road in Chelsea. Because Gabriel and William Rossetti were planning to move to a riverside mansion in Cheyne Walk, they were often in the neighborhood, and Whistler would accompany them on "jaunts." The three became attached through bonds of "strong affection." As Whistler later recollected those "olden days": "You had both been my best friends," he wrote to William in 1882, "may I never lose such staunch and noble friendship as your own."[19] In October 1862, the brothers Rossetti settled at Tudor House, which was also home for a time to Algernon Swinburne. Fanny Cornforth (née Sarah Cox), the model for *Bocca Baciata*, was often there as well, and she eventually displaced the other tenants (fig. 1.5). When Whistler moved to a house nearby, the artists began seeing each other nearly every day, according to William Rossetti, "Mr. Whistler being eminently endowed with good-fellowship."[20]

It was shortly before *The White Girl* went on view at the Salon des Refusés in March 1863 that Whistler and Jo Hiffernan took occupancy of 7 Lindsey Row. Whistler was altogether "cleaned out" from his move, he wrote to the artist Frederick Sandys from "Old Chelsea" that spring, but his picture was "a real success in Paris, and already I have had a letter to know if it may be possessed for gold." Nothing came of that prospect, but despite his straitened circumstances, Whistler took in his French friend Alphonse Legros when Legros fled Paris to escape his father's creditors.[21] They all shared the house that summer, establishing Lindsey Row as an English outpost of bohemian life. But then at the end of the year, the imminent arrival of Whistler's mother was announced, necessitating the eviction of Legros and the removal of Hiffernan to lodgings in Fulham.

Anna McNeill Whistler may not have known the particulars of her son's domestic arrangements before she came to London in 1863, but she strongly believed that her arrival was providential. She had departed her birthplace, Wilmington, North Carolina, one dark November evening "in the teeth of a heavy gale." According to her fellow traveler William Laurie Hill, Mrs. Whistler was prepared to brave any danger to fulfill what she saw as her duty to join "Jemie" and his half-sister, Deborah Haden, in England. And as the boat slipped through the Union blockade in the dead of night, Anna remained serene, for "our Heavenly Father is with us on the sea," she said, "as well as on the land."[22] Once safely in London with her son, she wrote a long letter to an American friend, the Reverend James H. Gamble, providing a detailed picture of life at 7 Lindsey Row. Everyone "most truly interested" in her son, she reported, had remarked "the improvement in his home and health" since she had settled in to stay. (Du Maurier, on the other hand, had heard that Whistler was "utterly miserable," although "living in respectability.")[23]

Hill would later reflect that "it was in this sweet quiet home, presided over by a mother whom he deeply loved and cherished, that Whistler did some of the best work of his life, and her loving presence had much to do with nerving him for a struggle that lasted until he had passed his fortieth year." Indeed,

The First Vase

as Charles Lang Freer later noticed, a remarkable number of Whistler's works are dated 1864, suggesting that his thirtieth year held for him some special meaning.[24] Whistler (fig. 1.6) and his mother had adopted a routine that could account for some of his productivity: he would paint in the studio all day long while Anna sat downstairs by the fireside, and after dinner at half past six, he would read aloud the American news from *The Times* until eleven o'clock, when Anna retired and Whistler resumed his work. Occasionally they were joined after supper by one or more of the "artist-friends" with whom Whistler had become "only too popular," according to his mother: "It is so much better for him *generally* to spend his evenings tete à tete with me, tho I do not interfere with hospitality in a rational way."[25]

Whistler is so often cast in isolation that it comes as something of a surprise to find him in 1864 happily enmeshed in a web of friendship and aesthetic influence. But as Richard Dorment points out, it was only after the Ruskin trial of 1878 that Whistler dissociated himself from the English school of painting, including those artists he befriended in the early 1860s.[26] His society in Chelsea, which Anna Whistler insightfully described as "visionary and unreal," included the Rossettis, Swinburne, Boyce, and Sandys, and although the association was never formalized like the Pre-Raphaelite Brotherhood, it came into existence in a similar spirit of reform. Rather than reading the works of Ruskin, the members would gather of an evening at 7 Lindsey Row to admire the porcelain in Whistler's "very rare collection of Japanese and Chinese" and marvel at the "curious subjects" portrayed upon them: Whistler considered those paintings on porcelain "the finest speciments [*sic*] of Art," his mother reported to Mr. Gamble. "You will not wonder that Jemies inspirations should be (under such influences) of the same cast."[27]

Swinburne probably provided the philosophical underpinnings for those artistic conversaziones. His 1862 review of Baudelaire's *Les Fleurs du mal* (1857) had contained the first statement in English of the French aestheticist creed, which Swinburne expressed more cogently the following year in an essay on William Blake: "Art for art's sake first of all, and afterwards we may suppose all the rest shall be added to her (or if not she need hardly be overmuch concerned)."[28]

In keeping with the cause of elevating art above the commonplace, membership in the Chelsea circle was exclusive. Du Maurier wrote to Thomas Armstrong, an artist who had studied with him and Whistler in Paris but was living in Manchester, that Whistler and the "Rossetti lot" had become as thick as thieves: "Their noble contempt for everybody but themselves envelops me I know. Je ne dis pas qu'ils ont tort [I'm not saying they're wrong], but I think they are best left to themselves like all Societies for mutual admiration of which one is not a member."[29] Seventeen years later, in the *Punch* cartoon that has come to emblematize the Aesthetic movement (fig. 1.7), du Maurier parodied their attitude: a woman in a trailing dress poses like Whistler's *Princesse* before a folding screen, bowing her dark head toward a "quite consummate" teapot.

FIG. 1.6 James McNeill Whistler, ca. 1865. Photograph inscribed *To my friend Rosetti / J Whistler*. Library of Congress, Washington, D.C., Prints and Photographs Division, Pennell Whistler Collection.

THE SIX-MARK TEA-POT.
Æsthetic Bridegroom. "It is quite consummate, is it not!"
Intense Bride. "It is, indeed! Oh, Algernon, let us live up to it!"

FIG. 1.7 "The Six-Mark Tea-Pot," a cartoon in *Punch*, 30 October 1880, by George du Maurier (1834–1896).

FIG. 1.8 *Purple and Rose: The Lange Lijzen of the Six Marks* (Y47), 1864. Oil on canvas, 91.5 × 61.5. Philadelphia Museum of Art; John G. Johnson Collection. Frame, shown at right, designed by the artist.

The First Vase

Casting an ironic eye on the ideals once professed by a society too exclusive to admit him, du Maurier renders the most ordinary of household items an object of extravagant adoration, thereby deflating the cherished source of Whistler's inspiration. "Oh Algernon," the lady murmurs to her Aesthetic Bridegroom, who bears Swinburne's name but resembles Oscar Wilde, "let us live up to it!"[30]

Du Maurier's cartoon, "The Six-Mark Tea-Pot," alludes to the first of Whistler's so-called inspirations, which announced his ambition to reform his painting in the image of porcelain, or to live up to his own blue china. *The Lange Lijzen of the Six Marks* (fig. 1.8), probably the "unfinished Chinese" picture Rossetti mentioned in a letter of December 1863, was the work farthest advanced when Anna Whistler came to London, and it was virtually complete by February 1864, when she wrote a detailed description in her letter to Mr. Gamble. The porcelains depicted in the picture were all "facsimiles," she explained, of the ones arrayed around her in the drawing room at Lindsey Row; the canvas itself remained in the artist's studio where, she was given to understand, Whistler worked "from life," using professional models.[31] In this case, the model was Jo Hiffernan, whose intimacy with the artist was being sedulously concealed from his mother. Her features are indistinct but recognizable in *The Lange Lijzen,* for which she sat in a tableau made up of Whistler's prized possessions, with a paintbrush in one hand and a blue figured vase in the other.

The Dutch title of the painting hints at the provenance of Whistler's collection and also the source of his expertise, for the phrase *lange lijzen* is Dutch for the "lanky people," or "dawdlers," painted on Chinese porcelain of the Kangxi era (1662–1722) (fig. 1.9). Whistler may have picked up the phrase in conversation with porcelain dealers in Holland, where Chinese imports had long been plentiful and cheap; this would account for the misspelling of the term and its consequent corruption to "long Elizas," a reasonable translation of *Lange Leizen,* as the words appeared in the 1864 Royal Academy catalogue.[32] Virtually every critic of that exhibition began the discussion of Whistler's work with a go at the title, which evidently remained in the recondite language of connoisseurship. "The name given to it," the *Observer* remarked, "has puzzled a good many people; but it is explained as having a technical reference to the painting of blue china—the picture itself is less capable of explanation."[33] The title's obscurity was no doubt deliberate, a ploy to confound the Victorian tendency to read paintings like books.

Whistler had spent several weeks in Amsterdam during the summer of 1863, intending, du Maurier understood, "to do an etching of the big Rembrandt of Rembrandts," the *Night Watch.*[34] It appears that he also began, or substantially augmented, his collection of Chinese porcelain, for in September he wrote to John O'Leary, an Irish revolutionary he knew from Paris days, that he

FIG. 1.9 Illustration for Plate XIV (M624) for *A Catalogue of Blue and White Nankin Porcelain Forming the Collection of Sir Henry Thompson* (1878). Pencil, pen, ink, and wash on paper, 22.5 × 17.5. Freer Gallery of Art, Smithsonian Institution, Washington, D.C. (07.175).

had just returned from "another runaway journey into Holland," where he had "ruined" himself in old china. Du Maurier, who saw the porcelain the following month, reported to Armstrong that Whistler had purchased the lot for sixty pounds.[35] Whistler's visit to Holland may also have reinforced his interest in Dutch genre painting evident in realist works such as *At the Piano* and *The Music Room* (1861); *The Lange Lijzen* bears Dutch overtones that extend beyond its title. Perhaps Whistler's enthusiasm for porcelain drew him to seventeenth-century still lifes featuring pieces of Chinese blue and white; the writings of Théophile Thoré may have led him to the works of Vermeer, which could well have inspired *The Lange Lijzen*.[36]

Whistler told Luke Ionides about a porcelain seller in Rotterdam, the widow Van der Pflaum, whom he had coaxed with a barrel of beer to part with some of her wares.[37] The setting of *The Lange Lijzen* may recall that very shop, or another in which he purchased blue and white. Even though the painting lacks overt signs of a commercial establishment, Anna Whistler observed that the objects were arranged "as if for purchasers." The interpretation must have been imposed by Whistler himself, who told Fantin-Latour he had portrayed "une Marchande de porcelaine."[38] The shop displays a range of merchandise consistent with the inventory of a typical Dutch importer. The furnishings are mostly Chinese, including the model's lacquered yoke-back chair, which has sometimes been mistaken for an English studio chair. The folding screen in the corner could be made of Dutch leather, and what Anna Whistler identifies as a "Scinde" rug may be a copy of a Turkoman carpet from Central Asia. Except for the large covered jar in the foreground, which may be delft, all the porcelain in the picture appears Chinese, though made for the Western market. The presence of a Japanese lacquer tray and circular fan might be explained by the fact that shops specializing in Chinese porcelain often carried Japanese goods, too, as the Dutch had enjoyed limited trade with Japan since the seventeenth century.[39]

If the setting is true to life, the scene itself represents a blatant fiction. Whistler described the figure to Fantin-Latour as "une Chinoise en train de peindre un pot"—a Chinese woman painting a pot—a definition that calls attention to the chief fallacies of the picture. First, the red-haired woman is no *Chinoise*: as William Rossetti points out, "there is not even an attempt at the Chinese cast of countenance." Moreover, she cannot possibly be painting a pot that has obviously been finished and fired. Anna Whistler implies an understanding of the fanciful conceit by suggesting that the model only appears "intent upon painting a beautiful jar which she rests on her lap."[40] *The Lange Lijzen* better supports an allegorical reading, in which the vase represents the creative product and the brush is the artist's attribute, as in Whistler's self-portrait of 1872, *Arrangement in Grey*.[41]

Many biases conspire against this interpretation, for to place *The Lange Lijzen* in the tradition of paintings of artists' studios is to take this china painter in fancy dress seriously as an artist and to grant porcelain, one of the decora-

The First Vase

tive arts, a status reserved in the West for easel paintings. Yet there can be little doubt of Whistler's veneration for the painter of "the finest speciments of art," as his mother referred to Chinese blue and white. In the "Ten O'Clock" lecture of 1885, Whistler again envisions the studio of a Chinese porcelain painter, though cast as a man—the favorite of the goddess, Art, who finds him "caressing his blue porcelain, and painting his coy maidens, and marking his plates with her six marks of choice."[42]

The figure's Chinese robe is brilliantly embroidered with the butterflies that later take Japanese form and alight on Whistler's paintings as signatures. This work is signed with a column of slanting letters, presumably in imitation of Chinese calligraphy—a meaningful departure for Whistler, whose works of that period are typically signed in the emphatic manner of Courbet. His signature appears with the painting's date on two oblong strips usually taken for Japanese cartouches but more likely intended, as at least one critic saw at the time, to be "coloured-paper labels" like the red one on the green book lying on the table.[43] While he deliberately obscured his own name, Whistler identified with the porcelain artist by copying onto the frame of the picture the six Chinese characters or "marks" that would have appeared on her jar (thought to be the artist's signature, they actually indicate the era of the porcelain's production). The frame of the picture is also where Whistler chose to paint his butterfly cipher in later works.

This is the first of Whistler's decorated frames, which according to his mother were always priced separately, if clearly conceived as an integral part of the composition. In making them extensions of the paintings, Whistler undermined the illusion of the frame as a window on a fictive world, asserting the self-sufficiency of the painting as an object. The idea probably came from

FIG. 1.10 *Wapping* (Y35), 1860/64. Oil on canvas, 72.0 × 101.8. National Gallery of Art, Washington, D.C.; John Hay Whitney Collection.

FIG. 1.11 *Variations in Flesh Colour and Green: The Balcony* (Y56), ca. 1864–70. Oil on panel, 61.4 × 48.8. Freer Gallery of Art, Smithsonian Institution, Washington, D.C. (92.23).

Rossetti, who in 1864 was reframing several early works in the style that he and Ford Madox Brown had recently devised. According to the framemaker trading on Wardour Street who fabricated Whistler's early frames, Rossetti was the actual designer.[44]

If in many ways Whistler followed Rossetti's example, he never adopted his friend's antipathy to public exhibition—that "strange contempt for fame" that du Maurier considered "rather grand." Whistler could not afford the luxury of popular indifference, and in 1864 he sent *The Lange Lijzen* to the Royal Academy, together with *Wapping* (fig. 1.10), a painting previously intended for Paris. Whistler started *Wapping* in 1860, while still dedicated to depicting the realities of modern life. To ensure its authenticity, he worked "among a beastly set of cads and every possible annoyance and misery," according to du Maurier, circumstances dramatically different from the aesthetic ambiance of Lindsey Row, where he completed the composition in 1864.[45] *Wapping* is full of incident "all so true to the peculiar tone of London," as Anna Whistler described the scene, thereby making it an odd Academy companion to *The Lange Lijzen*, which embodied a "singular but clever conceit" drawn from the world of art. As the *Art Journal* observed, "The lady might herself have sat as a model to a painter of the celestial empire; or she looks as if she had just stepped out from a china bowl, so stiff is she in bearing, and so redolent of colour is her attire."[46] In the estimation of William Rossetti, it was "the most entirely *artistic* work" in the exhibition; if *Wapping* was "a trophy of realism," *The Lange Lijzen* was "a triumph of colour."[47]

Color, indeed, was the primary attraction of Whistler's work, the eye-catching quality that made it stand out from the hundreds of other paintings on display at the Royal Academy. Its brilliance might have been calculated to ensure success, for the critics' praise of its color composition, "which seems instinctive in the Chinese," was nearly unanimous.[48] Such assessments also shifted the focus, as Whistler probably intended, from the painting's subject—the realist's concern—to the purely formal elements that brought about its beauty.

Whistler produced *The Lange Lijzen*, a picture about painting, while intent upon establishing himself in the Victorian art world as a painter, when he had been known primarily as a printmaker. He had stopped etching the previous year, possibly because of competition with his brother-in-law, Francis Seymour Haden, a physician and amateur artist whose reputation as an etcher was on the rise. The Royal Academy exhibition of 1864 was the first to which Whistler submitted not a single print. His preoccupation with professional identity may also explain the incongruous presence in *The Lange Lijzen* of an artist in a business establishment, since Whistler, too, was busy producing

The First Vase

The First Vase

FIG. 1.12 *Caprice in Purple and Gold: The Golden Screen* (Y60), 1864. Oil on panel, 50.2 × 68.7. Freer Gallery of Art, Smithsonian Institution, Washington, D.C. (04.75).

wares for the market. He had several works in progress that year besides *The Lange Lijzen*, some recently commissioned and others under revision. It appeared to his mother that the practice of painting had become irresistible, that his genius was soaring "upon the wings of ambition." He seems to have possessed absolute confidence that like so many others in Victorian London (Alphonse Legros, in particular), he stood to reap a "harvest of guineas," even though his pockets remained, for the moment, conspicuously empty. Anna's role was to regulate "the every day realities" of her son's existence, "for with all the bright hopes he is ever buoyed up by, as yet his income is very precarious."[49]

Whistler's attention was frequently diverted that winter. On at least two occasions there were ice floes on the Thames, and he could not resist painting the spectacle from the open window, oblivious of the cold or his mother's discomfort. He made two oil sketches widely considered "most effective," but the necessity of earning a living (and maintaining his mistress and mother in separate houses) compelled him to abandon those views of the frozen river and resume work on the "oriental paintings" his mother understood were being carried out on commission. One was *The Balcony* (fig. 1.11), whose patron was G. J. Cavafy, a member of the London Greek community who proved "a providence" to Whistler, du Maurier remarked, in purchasing his paintings of the Thames.[50] Anna Whistler described *The Balcony* in 1864 as a "group in oriental costume" looking out "upon a river, with a town in the distance"—a curiously vague indication of a setting visible from her drawing-room window (which had no balcony). This suggests that the original background may not have been identifiable as the factories of Battersea across the Thames from Chelsea. Perhaps in its earliest manifestation the picture was based entirely on Whistler's

The First Vase

imagination, nourished by Japanese art, for the scene is consciously constructed to accord with Japanese principles of design: the floor falls abruptly away from the figures, whose forms are cropped at the margin of the asymmetrical composition, and an ornamental spray of azalea floats across the foreground. To Victorian eyes, *The Balcony* appeared a straightforward pastiche of Japanese prints. "The picture might have been painted in Japan," the *Art Journal* observed in 1870, upon its initial exhibition. "It affects to be Japanese in colour, composition, and handling."[51]

Katharine Lochnan and Toshio Watanabe have argued that some of Whistler's etchings from around 1860 betray an approach to pictorial space that could only have arisen from exposure to ukiyo-e woodblock prints,[52] yet evidence of his contact with Japanese art during his student days in Paris is chiefly circumstantial. He seems not to have felt its full effect until he began acquiring examples of his own. Whistler's acquisitive impulse may have quickened with his move to Lindsey Row in 1863 and the need for household decoration. With *The White Girl* on view at the Salon des Refusés, Whistler made frequent trips to Paris, perhaps purchasing the Japanese garments and accessories pictured in *The Balcony* from a new boutique on the rue de Rivoli, whose proprietor, Mme. Desoye, he called "la Japonaise." By the time his mother arrived at the end of the year, Whistler's "artistic abode" was amply adorned with Japanese fans, prints, and folding screens.

The Golden Screen (fig. 1.12), another of Whistler's "inspirations" from 1864, visually quotes Hiroshige's landscape series *Sixty-odd Famous Places of Japan*, prints that must have formed the heart of the artist's burgeoning collection. Japanese prints were still so uncommon in London that many of Whistler's contemporaries did not even know what they were: when *The Golden Screen* was exhibited in 1865, one critic referred to the print in the model's hand as "a picture, drawing, fan, or whatever it may be," and another could see nothing beyond "a heap of Chinese patterns of the most Chinese brilliancy."[53] Though less overtly than in *The Balcony*, *The Golden Screen* shows signs that Whistler's study of Asian art was beginning to control his artistic vision. The model (Jo Hiffernan again) assumes an improbable position for a Victorian lady, seated on the floor like a Japanese courtesan portrayed by Utamaro (fig. 1.13). The painting's spatial construction is also bewildering by European standards: Victorian critics were quick to note that even allowing for an oblique point of view, the lacquer chest beside the figure is out of perspective, and the folding screen appears suspended in midair. Indeed, the Japanese method of depicting space in two dimensions is illustrated by the screen-painting itself, a metaphor of Whistler's own work, with its shimmering surface of pattern and color.

William Rossetti later recalled that Whistler first exposed him and his brother to Japanese art and inspired them to procure examples of their own. In his *Reminiscences*, William tells of Gabriel's delight in Japanese designs—"their enormous energy, their instinct for whatever savours of life and movement, their exquisite superiority to symmetry in decorative form, their magic of touch and

FIG. 1.13 *Utanosuke of Matsubaya*, Edo period (late 18th–early 19th century), by Kitagawa Utamaro (1753–1806). Woodblock print, ink and color on paper, 36.5 × 25.3. Freer Gallery of Art, Smithsonian Institution, Washington, D.C.; gift of Eugene and Agnes E. Meyer (74.99).

FIG. 1.14 Illustration for Plate III (M601) for *A Catalogue of Blue and White Nankin Porcelain Forming the Collection of Sir Henry Thompson* (1878). Pencil, pen, ink, and wash on paper, 20.3 × 13.4. Freer Gallery of Art, Smithsonian Institution, Washington, D.C. (07.178).

impeccability of execution"—but asserts that he was the more avid collector. As a critic widely respected by his contemporaries, William Rossetti made a vital contribution to the propagation of aestheticism in England through his thoughtful assessments of new directions in art.[54] An early indication of his liberal views comes in a review of the 1862 International Exhibition in London, where Sir Rutherford Alcock had gathered a variety of Japanese objects for display. Arguing that an aptitude for art in any form required "a strong perception of character and beauty in the abstract properties of form and colour," Rossetti concluded that "about the very best fine art practised at the present day in any corner of the globe, is the decorative art of the Japanese."[55]

Gabriel Rossetti's interest in Japanese art was exceeded by "his passion for blue china," William recalled, which proved "stronger and more prolonged."[56] Unlike the ukiyo-e prints that made a dramatic appearance on the European scene, Chinese porcelain had long been available in Europe; neither Whistler nor Rossetti was the first in England to collect it, but their intense appreciation helped create the popular craze du Maurier would christen "chinamania." It is tempting to imagine their passion for porcelain igniting on the first recorded occasion of their acquaintance, a party at Swinburne's in July 1862, when George Price Boyce presented his host with two "old blue and white wedgwood [*sic*] dishes and a very fine Chinese plate or dish." A frequent visitor to the homes of both Whistler and Rossetti and a devoted collector himself, Boyce may also have stimulated the artists' legendary competition for blue and white when, in February 1864, he declared Whistler's to be "the most interesting collection of old blue china porcelain" he had ever seen.[57]

Once when Whistler bragged about his own pots, Rossetti is reported to have said, "My dear Jimmy, if I take to it, I will beat your collection in a week"—as he did, purchasing for two hundred pounds an entire collection of blue and white from the Marquis d'Azeglio, the retiring Sardinian ambassador.[58] Shortly afterward Rossetti wrote his friend James Anderson Rose that he hoped they could go to Holland in search of Chinese porcelain—"but do not hint a word to Whistler," he added. "Since I lately bought all in a bunch this gorgeous collection, I pant and gasp for more." By April, Rossetti's enthusiasm was irrepressible. "My Pots now baffle description altogether," he wrote to Ford Madox Brown, "while the imagination which could remotely conceive them would deserve a tercentenary celebration. COME AND SEE THEM."[59]

As William Rossetti observed, "The zeal of a collector was upon him; and that zeal is not always 'according to knowledge,' nor yet according to morals. But it seems that in collecting, as in love and war, everything is fair."[60] There are many stories. Val Prinsep recounted how Gabriel Rossetti had gone out late one evening to buy a pot Whistler had mentioned and asked if he had wanted; although Rossetti was not interested, he hadn't wanted Whistler to own it either, and he roused an entire street trying to persuade the dealer to open his shop in the middle of the night. The entrepreneur Charles Augustus Howell, best known as a raconteur, eventually entered the competition and became the

The First Vase

FIG. 1.15 *The Blue Bower*, 1865, by Dante Gabriel Rossetti (1828–1882). Oil on canvas, 82.5 × 69.2. The Barber Institute of Fine Arts, University of Birmingham, England.

third in that "triumvirate of Chinese worshippers." There is a tale about Rossetti absconding with a piece of imperial porcelain Howell had found in the unlikely quarter of Hammersmith; Howell promptly stole it back, replacing it with a cracked piece of delft, so that when Rossetti went to show off the purloined pot he would be humiliated before his friends.[61]

Rossetti's particular penchant was for the covered jars decorated with a pattern of blossoming prunus branches on a field of cracking ice that signified the end of winter (fig. 1.14). Misinterpreting the motif, Rossetti called these "hawthorn pots," a designation that proved as enduring as "long Elizas," the phrase attributed to Whistler. The name may have originated with a painting called *The Blue Bower* (fig. 1.15), Rossetti's own homage to Chinese porcelain, done on commission to the dealer Ernest Gambart in 1865. Rossetti had been "casting around for what kind of foliage to paint" when Howell suggested haw-thorn; in the end, the artist used cornflowers and passion flowers in the pic-ture, but the background for the figure (modeled by Fanny Cornforth) was composed of blue-and-white discs apparently inspired by the rounded lids of "hawthorn" jars. The brilliant clarity of the cobalt blue, the quality most

FIG. 1.16 Fanny Cornforth before the mirror, 1863, photographed by W. & D. Downey, London. Delaware Art Museum, Wilmington; Samuel and Mary R. Bancroft Memorial, 1935.

prized by collectors of Kangxi-era porcelain, lends the painting all its purpose: Rossetti defined it simply as "an oil-picture all blue," and F. G. Stephens, emphasizing its aesthetic appeal, wrote that "the music of the dulcimer passes out of the spectator's cognizance when the chromatic harmony takes its place in appealing to the eye." [62]

In removing reference to period or place, Rossetti casts the face of a beautiful woman as the countenance of poetic introspection. [63] Whistler completed his own introspective image in the spring of 1865, possibly borrowing a device from a photograph of Fanny Cornforth that shows the model in profile beside a looking glass—a pose capturing two aspects of the subject in a single composition (fig. 1.16). The image of a woman with a mirror makes an apposite conceit for a portrait of an artist's model, whose destiny it is to see her face repeatedly reflected in paintings, and *The Little White Girl* (fig. 1.17) is Whistler's truest portrait of Jo Hiffernan. He began it in 1864, at a time when women's dresses were so voluminous that the simple white frock she wears would have appeared willfully outmoded. It may have resembled her customary costume, for du Maurier once noted with disapproval that Hiffernan appeared "got up like a duchess, without crinoline." [64] More significantly, she stands at the hearth of the home she had shared with Whistler until his mother took her place as the lady of the house. Her pose appears calculated to display the gold ring on the third finger of her left hand, and her white dress assists the transformation of the image of an artist's mistress into the picture of innocence.

The composure of Whistler's painting belies the domestic drama that lay behind it. *The Little White Girl* was probably conceived in response to Whistler's brother-in-law Seymour Haden's recent determination that Jo Hiffernan's former occupancy of 7 Lindsey Row had defiled the house, and his consequent refusal to allow his wife to step across its threshold. "It all much upset the quiet peaceful life of our studio," Whistler wrote Fantin-Latour, adding that the prohibition was hard on him as well as his sister Deborah, since they were so "devoted to each other." It also pained and inconvenienced Whistler's mother, who volunteered to Mr. Gamble that she had to take a cab to Sloane Street on Sunday afternoons, just to see her grandchildren. [65]

As a portrait of Jo Hiffernan, who had long lived out of wedlock with Whistler, *The Little White Girl* technically belongs to that extensive class of Victorian paintings of fallen women, usually in settings charged with symbols to round out their moral meaning. The best-known example is William Holman Hunt's *Awakening Conscience* (fig. 1.18), depicting a kept woman at the moment of her salvation. Like *The Little White Girl*, the work possessed a deeply personal significance for its author: Hunt planned to marry the model, Annie Miller, once she was educated to his standard, and the book on the table, a history of writing, probably alludes to that elevating program. Otherwise, every incident in the painting carries the same implication, from the cat and bird beneath the table, to the soiled and cast-off glove upon the floor, to the woman's clenched, bejewelled hand, with rings on every finger but the one that counts.

FIG. 1.17 *Symphony in White, No. 2: The Little White Girl* (Y52), 1864–65. Oil on canvas, 76.5 × 51.1. Tate Gallery, London.

The First Vase

The First Vase

FIG. 1.18 *The Awakening Conscience*, 1853–54, by William Holman Hunt (1827–1910). Oil on canvas, 76.2 × 55.9. Tate Gallery, London.

The parlor itself, famously condemned by John Ruskin for the "fatal newness" of its furniture, is a meretricious setting for the story of redemption that dawns in the garden reflected in the mirror. The picture's frame, adorned with marigolds for sorrow, bells for warning, a star for spiritual revelation, and a moralizing motto, reinforces the message. As if all that were not enough, verses from Ecclesiasticus and Isaiah were printed below the title in the Royal Academy catalogue.

Whistler's *Little White Girl*, in contrast, shows a room sparsely furnished with simple embodiments of beauty. The title does nothing to elucidate a meaning (the critic for the *Evening Star* observed that the figure was "not little, not white, and not a girl—but a tall, drab, spotty-faced woman"), though it does allude to another work of Whistler's art, *The White Girl* of 1862.[66] Whistler ignores the Victorian requirement that paintings furnish moral instruction and pointedly fails to present nature in the usual way, as a source of redemption: as if to seal the aesthetic interior from the outside world, the mirror reflects not a garden, as in *The Awakening Conscience*, but a framed painting that resembles Whistler's own depictions of the Thames. To present his ideal of art, twice removed from life, Whistler constructed a complex of artificial images—a painting of a painting reflected in a mirror. As artists, he and Rossetti both preferred "a kind of curtained existence, in which they could ignore the claims of the schools and the world in general," Royal Cortissoz observed in 1903, "and make pictures as far removed from the joys and troubles of mere humanity as so many pieces of Oriental porcelain."[67]

Indeed, aestheticism demands distance from contemporary life: the aesthete not only refuses to comment on the conflicts of his time but keeps himself

FIG. 1.19 "Intellectual Epicures," a cartoon in *Punch*, 5 February 1876, by George du Maurier (1834–1896).

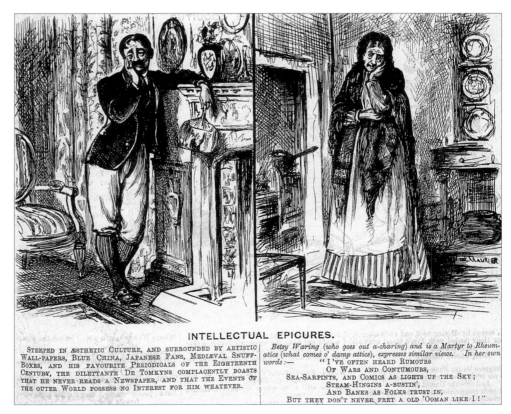

INTELLECTUAL EPICURES.

STEEPED IN ÆSTHETIC CULTURE, AND SURROUNDED BY ARTISTIC WALL-PAPERS, BLUE CHINA, JAPANESE FANS, MEDIÆVAL SNUFF-BOXES, AND HIS FAVOURITE PERIODICALS OF THE EIGHTEENTH CENTURY, THE DILETTANTE DE TOMKYNS COMPLACENTLY BOASTS THAT HE NEVER READS A NEWSPAPER, AND THAT THE EVENTS OF THE OUTER WORLD POSSESS NO INTEREST FOR HIM WHATEVER.

Betsy Waring (who goes out a-charing) and is a Martyr to Rheumatics (what comes o' damp attics), expresses similar views. In her own words:—
" I'VE OFTEN HEARD RUMOURS
OF WARS AND CONTUMOURS,
SEA-SARPINTS, AND COMICS AS LIGHTS UP THE SKY;
STEAM-HINGINS A-BUSTIN',
AND BANKS AS FOLKS TRUST IN,
BUT THEY DON'T NEVER FRET A OLD 'OOMAN LIKE I!"

aloof to preserve a rarefied ideal of beauty. In the cartoon titled "Intellectual Epicures" (fig. 1.19), the props and the pose of du Maurier's aesthete make silent, but salient, reference to Whistler's. *The Test* by Thomas Armstrong (fig. 1.20), exhibited with Whistler's *Little White Girl* at the Royal Academy in 1865, reverses the pose of Whistler's model: a dark-haired woman dressed in blue rests her right arm on a mantelpiece adorned with emblems of aestheticism, Chinese and Japanese porcelains and a pair of peacock feathers in a vase. These are not the focus of attention, but the background for the task at hand—the education of a child—and the proud young mother appears a model of Victorian womanhood. Whistler's white girl, on the other hand, is evidently a lady of leisure engaged in the nonproductive consumption of time, as ornamental as the inanimate objects around her.

In the great Victorian debate over the place of art in modern life, Whistler sided emphatically with Swinburne, who declared in his seminal essay on Blake that the business of art "is not to do good on other grounds, but to be good on her own: all is well with her while she sticks fast to that."[68] In 1864 the poet was Whistler's closest *confrère*, and *The Little White Girl* is a more complete expression of the artist's debt to Swinburne's writings than any other painting of the period. Whistler acknowledged the association by inviting his friend to compose verses to serve as the picture's "Academy-Catalogue motto," just as Hunt had quoted passages from the Bible to gloss *The Awakening Conscience*: in both cases, the printed word served partly to deflect attention from the more private dimension of the work, objectifying an image of the heart. Whistler must also have recognized that a public identification of his name with Swinburne's could only assist the rise of his own reputation, for the previous month *Atalanta in Calydon* had been published to tremendous critical acclaim, with the *Sunday Times* declaring Swinburne "permanently enrolled among our great English poets."[69]

It was as a favor to his friend, therefore, that Swinburne improvised a poem one Sunday morning and delivered it to Lindsey Row in time to meet the deadline for the Royal Academy catalogue. He offered to try again if Whistler didn't find it "serviceable," but Gabriel Rossetti had read the poem, Swinburne said, and thought it "full long for its purpose."[70] Rossetti, in fact, seems to have been closely involved in this signal collaboration between the painter and the poet. It was probably at his suggestion that Swinburne's verses were printed on gold paper and affixed to the picture frame (fig. 1.21), a practice Rossetti had recently initiated with sonnets composed to accompany *The Girlhood of Mary Virgin* (1848–49).[71] Moreover, it may have been Swinburne's greater familiarity with Rossetti's works in progress that gave rise to the poem's conceit, evidently based on a reading of *The Little White Girl* as an image of a woman's face "languidly contemplative of its own phantom":

> I watch my face and wonder at my bright hair
> Nought else exalts nor grieves

FIG. 1.20 *The Test*, 1865, by Thomas Armstrong (1832–1911). Oil on canvas, 79.0 × 59.5. Wadsworth Atheneum, Hartford, Connecticut; Ella Gallup Sumner and Mary Catlin Sumner Collection Fund.

FIG. 1.21 *The Little White Girl* (fig. 1.17) in its original frame (not extant). Photograph signed with the butterfly and inscribed, *To Swinburne / from J. McNeill Whistler.* Collection of Mark Samuels Lasner.

FIG. 1.22 *Woman Combing Her Hair*, 1864, by Dante Gabriel Rossetti (1828–1882). Watercolor on paper, 36.19 × 33.02. Private collection, Great Britain.

The rose at heart, that heaves
With love of her own leaves, and lips that pair.

Rossetti's contemporary "toilette" pictures, like Whistler's painting, typically depict a woman in white, often with a piece of blue china (fig. 1.22); but in Rossetti's works, the woman invariably sits before a mirror (pictured or implied) dressing her abundant hair, better illustrating Swinburne's lines than Whistler's *Little White Girl*, who appears indifferent to her own reflection. Perhaps Whistler recognized the imperfect parallel, for he later changed the frame and in future works emphasized what he would define in the "Ten O'Clock" as "the *painter's* poetry": "the amazing invention that shall have put form and colour into such perfect harmony, that exquisiteness is the result."[72]

THE TALL covered jar on the mantel in *The Little White Girl* is positioned to show a female figure with head slightly inclined, standing before a folding screen (fig. 1.23)—the image of a *lange lijs* that lent its composition to *La Princesse du pays de la porcelaine* (see fig. 1.1). Although its title clearly states the source of inspiration, scholars have generally disregarded the connection between Chinese porcelain and *La Princesse*, preferring to relate Whistler's composition to Japanese prints. Yet the artist's French contemporaries nearly all recognized *La Princesse* as a "pastiche chinoise," and when it was exhibited at the 1865 Salon, the painting was even called "la Chinoise," for short.[73] Théophile Thoré regarded the painting as a "chinoiserie of artless grandeur," and Paul de Saint-Victor defined it as "la potichomanie," or chinamania. Ernest Chesneau, lamenting its lack of originality, described *La Princesse* as "le décalque mis au carreau et grandi d'une figure de potiche"—nothing but the image, enlarged and squared for transfer, of a figure on a porcelain vase.[74]

China is the country more commonly associated with porcelain, but Whistler's and Rossetti's collections both comprised examples from both China and Japan. Together those countries compose an imagined *pays de la porcelaine*, whose domain is described by the blue-and-white Chinese rug in *La Princesse*: as Théophile Gautier observed, the princess poses on a pavement of porcelain.[75] Her robes fan out on the floor exactly like those of her prototype in China, even though her costume is clearly Japanese. (This may account for Whistler's occasional references to the painting as "la Japonaise," since he often spoke of pictures by the clothes the models wore—"the white girl," for example, or "la Chinoise.") The frame Whistler designed repeats the fret and spiral motifs from the frame of *The Lange Lijzen*, but the decorative roundels with Chinese characters have been replaced by Japanese family crests, incorporating the comma-shaped or *tomoe* motif and the palm leaf or paulownia flower.[76]

A preparatory oil sketch for *La Princesse du pays de la porcelaine* (fig. 1.24)

shows the silver kimono, salmon robe, and scarlet sash that appear on various figures in *The Balcony*, which could imply that the compositions were conceived around the same time, possibly as early as February 1864. The oil sketch is also related in technique to other paintings then in progress: as Denys Sutton observed, its "liquid tonalities" distinctly resemble the "white paint dragged across the surface" in *Chelsea in Ice*, one of the paintings Whistler's mother described in her February letter.[77] Rendered with the broad, fluid strokes that resurface in the suite of oil sketches known as the Six Projects, the sketch for *La Princesse* exemplifies the analytical approach Whistler later explained to a reporter for the *World*—a process in which he "unravelled the harmonies of outline and colour in the 'Lange Lizen,' who pose on the tall jars of China and Japan."[78]

The palette of the oil sketch is strikingly different from that of *The Lange Lijzen* and the other costume pictures of the 1860s, which depend upon the darker tonalities of old Dutch pictures. The resulting painting, which Whistler eventually titled *Rose and Silver*, impressed William Rossetti as "a triumph of power in *light* colour." Its color harmonies may have been suggested by the Chinese enamelware that was popular with French collectors and went by the name of *famille rose* (fig. 1.25). Louis Auvray observed in 1865 that in copying a figure from a Chinese vase, Whistler had also captured the delicate red and salmon tones of a Chinese porcelain painter.[79]

With *La Princesse*, the earliest picture for which an oil sketch survives, Whistler appears to have tried out a new working method, perhaps on the recommendation of Gabriel Rossetti. Henry Treffry Dunn, Rossetti's studio assistant, described that artist's practice of planning a picture's subject and composition before selecting a model for the final version.[80] Whistler's oil sketch for *La Princesse* appears to prefigure the final painting by almost a year, and the figure's auburn hair suggests that the original model was Jo Hiffernan, while a woman of very different aspect stood for the painting itself.[81] The explanation for this change in model could be practical, since there is reason to suspect that Hiffernan had a baby around this time, and though the costumes and poses of *The Golden Screen* and *The Little White Girl* might have disguised a pregnancy, the silken robes and sloping posture of *La Princesse* could not. Or perhaps, for this painting in particular, Whistler required a model whose beauty was beyond dispute, and at least one English critic had deemed Jo Hiffernan's likeness in *The Lange Lijzen* "hideous"—"a worse specimen of humanity than could be found on the oldest piece of china in existence."[82]

The ideal model did not appear until the spring of 1864, and Whistler found her through his association with the Greek community in London. Aleco (Alexander) Ionides and his elder brother Luke had been among Whistler's first friends in Paris; their father, Alexander Constantine Ionides, was a prosperous London merchant and financier, the consul general for Greece, and one of Whistler's first patrons. It was on the strength of his commissions for a portrait of Luke and the picture of the river that became *Brown and Silver: Old Battersea*

FIG. 1.23 Detail, *The Little White Girl* (fig. 1.17).

FIG. 1.24 *Oil Sketch for "La Princesse du pays de la porcelaine"* (Y49), ca. 1864. Oil on paper mounted on panel, 62.8 × 34.0. Worcester Art Museum, Massachusetts; bequest of Theodore T. and Mary G. Ellis Collection (1940.56).

The First Vase

Bridge (ca. 1860) that Whistler had taken the studio on Newman Street, and the prospect of further patronage from the Greek community had been a strong inducement for him to stay in London.[83] Whistler became a frequent visitor to the Ionides' gracious home at Tulse Hill, in southwest London, where amateur theatricals and Sunday-night suppers kept him and others of the "Paris gang" happily fed and entertained.

The spring of 1864 was the Ionides' last in that part of London, and their house held a new attraction: the two beautiful daughters of Michael Spartali, a cotton merchant and distant relation. Spartali was to succeed Ionides in 1866 as Greek consul general, even though he had never set foot in Greece. Born in Smyrna (now Izmir, in western Turkey), Spartali was nine months old when his family left the Levant, fleeing "with their lives" to Trieste; he received his early education in Switzerland before coming to London at the age of twelve. He and his wife, Euphrosyne Valsami, settled north of London in Tottenham and had four children: Marie, Christina, Demetrius, and Eustratius. Early in 1864, the family had moved to a "handsome showy house" called The Shrubbery on the north side of Clapham Common. From there they called frequently on their friends at Tulse Hill and were soon holding suppers and receptions of their own, which Whistler attended, Marie Spartali recalled, "whenever he was asked."[84]

Little is known about Michael Spartali's second daughter, Christina (fig. 1.26), beyond her image in Whistler's painting. She was baptized in the Greek Orthodox Church on 23 June 1846 and educated, with her sister, to a standard unusual in Victorian society. "Masters and professors were engaged to educate the young girls to the greatest perfection," wrote Ellen Clayton in 1876: "Not only ancient Greek and Latin, but several modern languages were acquired by them, with music, drawing, and other accomplishments."[85] Their own home provided a lively political education: Charles Hallé recalled finding assorted revolutionaries at The Shrubbery, such as the Italian patriots Giuseppe Mazzini and Giuseppe Garibaldi and the Russian writer and political agitator Aleksandr Ivanovich Herzen. William Rossetti (who had known Christina, though not as well as Marie) provided a clue to her character in a diary entry from 1867, when he first dined with the Ionides family and found them "all very intelligent, and the women especially well-informed and interested in intellectual subjects—as is also the case with the Spartalis."[86] Christina is also said to have been an accomplished pianist, probably to accompany Marie, who sang; but it was her face that made her famous. When the Spartalis attended balls at court in Paris, crowds would gather round their carriage to catch sight of the celebrated beauties inside.[87] W. Graham Robertson, whose mother had been the Spartalis' neighbor, wrote of their "lofty beauty, gracious and noble; the beauty worshipped in Greece of old," and Hallé declared that Euphrosyne Spartali and her daughters "surpassed in beauty any three women" he had ever known.[88]

Upon her marriage around 1868 to the Belgian count Edouard Cahen d'Anvers, Christina Spartali vanished from the London scene. Her parents

FIG. 1.25 Chinese *"famille rose"* vase, Qing dynasty, Qianlong period (1736–95). Porcelain with enamels over the glaze, 17.2 × 09.5. Freer Gallery of Art, Smithsonian Institution, Washington, D.C. (54.127).

FIG. 1.26 Christina Spartali, ca. 1865. *Carte de visite* by Hanna & Kent, London. National Historical Museum, Athens, Greece, Photograph Archives.

had opposed the betrothal, as they would Marie's in 1871 to the American journalist William J. Stillman (though that objection was "much less well-grounded in its offence," according to William Rossetti), and it was only in 1871, when Christina became seriously ill, that she and her father were reconciled. By then she had a child, Rodolfo, and was living in Naples; family tradition holds that her husband was ennobled by the Pope for building a bridge in Rome, making Christina the marchesa di Torre Alfina.[89] Besides that picturesque property in Umbria near Acquapendente, the marchese possessed a Roman residence, the Palazzo Torlonia, on the Corso. The writer Paul Bourget, who visited there in 1874, found himself suddenly "au faîte de la société"—at the pinnacle of society—and it was from that experience that he acquired the conviction that only luxury and fortune "permit us to realize our dreams of beauty."[90] Yet Christina Spartali's later life seems to have been singularly unhappy. When she sought a divorce in 1880, Gabriel Rossetti wrote to Aglaia Coronio (née Ionides) that it "was high time" she did, and William Rossetti supplied a melancholy ending to the story with the observation that Christina had died "after much suffering from a strange cataleptical malady."[91] That event, which may not in fact have been related to any physical condition, occurred around 1884, when she was not yet forty.[92]

It had not been long after the family settled into The Shrubbery that Michael Spartali set about finding an art instructor for his elder daughter, Marie. He applied for advice to Luke Ionides, who appealed to Gabriel Rossetti, who recommended Ford Madox Brown; when Rossetti learned that Marie Spartali was to become his friend's pupil, he wrote, "I hear now too (which I did not know before) that she is one and the same with a marvellous beauty of whom I have heard much talk. So just box her up, and dont let fellows see her, as I mean to have first shy at her in the way of sitting." Rossetti apparently expected Marie to call at Cheyne Walk "to see the crib and appurtenances," or the house and its adjuncts, notably the menagerie in the garden. But according to the enduring account provided by Thomas Armstrong, the surpassing beauty of the Spartali sisters "was revealed to this artistic circle" all at once, one Sunday afternoon that summer at Tulse Hill.[93]

Armstrong's story has been named among the myths that multiplied in the memoirs of certain male Victorians, yet he makes such an effort to recall the precise details of the episode that one wants to accept his account implicitly.[94] It was Armstrong's recollection that he and a coterie of other artists including Whistler, Gabriel Rossetti, Legros, du Maurier, Matthew White Ridley, and possibly E. J. Poynter, crowded into a four-wheel cab in Chelsea and set out for Tulse Hill specifically to see the "stunners": "We were all à genoux before them," Armstrong remembered, "and of course every one of us burned with a desire to try to paint them." In October, back again in Manchester, Armstrong learned from du Maurier that Whistler alone was fulfilling their collective wish, having already begun "a large picture with the smallest Miss Spartali in it as a Chinese."[95]

The anecdote does recall other legends of artists' "discoveries," such as Rossetti sighting Jane Burden at an Oxford theater or Walter Deverell finding Elizabeth Siddal in a milliner's shop, and shows how easily Whistler can be fitted into the Pre-Raphaelite paradigm. His *Princesse du pays de la porcelaine*, consistent with its inspiration in the languorous figures on Chinese vases, exhibits the enervated, somewhat melancholy air associated with pictures from Pre-Raphaelitism's second stage. But while *La Princesse* has traditionally been regarded as resembling in style and subject certain paintings by Rossetti, that artist had yet to produce anything comparable in 1864: his half-length portraits of recent years were of neither the scale nor the complexity of Whistler's monumental work. The association is sometimes attributed to Rossetti's portraits of Christina's elder sister, which establish an authentically sororal relationship between the artists' paintings; but five years were to pass before Rossetti painted Marie Spartali, and in the pictures for which she posed, she appears more closely related to other Rossetti models than to Christina as portrayed in *La Princesse*. The more likely cause for the connection, as Elisabeth Luther Cary remarked in 1907, is that the dark beauty of Whistler's model—"the deep brooding eyes, the dusky hair, the ripe lips and long neck"—calls to mind the many portraits of Jane Morris that Rossetti painted throughout the 1870s.[96]

There is one early portrait of Jane that may have influenced *La Princesse*, but it was painted by William Morris. Although the history of *La Belle Iseult* (fig. 1.27)—or *Guenevere*, as it has long been known—remains partly obscure, it is possible that the painting was in Rossetti's studio during the mid-1860s, open to Whistler's inspection.[97] Despite a marked difference in size, the works bear a striking resemblance to each other: Iseult looks like a medieval cousin of Whistler's Kangxi princess, with the same curved back and bowed head, in a setting similarly evocative of a distant time and place. The critical difference is that Whistler's *princesse* is not the heroine of any European legend, having been drawn from "the curious subjects" portrayed on Chinese porcelain, which Whistler and his friends undoubtedly regarded as illustrations of unfamiliar tales. William Rossetti wrote an article for the *Reader* in 1863, "Japanese Woodcuts: An Illustrated Story-book Brought from Japan," that seems to give a glimpse into Whistler's drawing room, where in addition to Chinese porcelain, the Chelsea aesthetes sometimes studied "a Japanese book of paintings," probably prints, that Anna Whistler reported was "unique in their estimation."[98]

Rossetti's essay was as its author supposed "nearly the earliest article that appeared in England upon Japanese figure-designs."[99] It focuses on a single volume of uncolored prints described in such detail it can be identified as *The Picturebook of Heroes* (1837) by Hokusai, a manual designed to teach artists how to draw figures in action, composed of scenes from various East Asian legends randomly arranged. Rossetti assumed that the illustrations told a story, "some popular heroic legend of ancient time: the deeds of some Japanese Theseus or

FIG. 1.27 *La Belle Iseult (Queen Guenevere)*, 1858, by William Morris (1834–1896). Oil on canvas, 71.0 × 50.0. Tate Gallery, London.

FIG. 1.28 Christina Spartali, ca. 1868, by
Julia Margaret Cameron (1815–1879).
Freer Gallery of Art Archives, Smithsonian
Institution, Washington, D.C.

Roland." But failing to weave a plausible narrative from the pictures, he took
a purely aesthetic approach. In commenting on the first design, for instance,
which depicts a warrior on a hillside, Rossetti wrote that "the mere sharpness
of the lines traced by the engraver's hand is a pleasure to look at in this, as
in all the designs: steady, precise, no falling-short and no superabundance—
struck right, as it would seem, on the instant."[100] Indecipherable subject mat-
ter compelled him to regard the woodcuts as an artist would (and Whistler
must have done), delighting in novel elements of style. In much the same way,
Whistler's *Princesse* might be considered a Chinese Guinevere or Iseult, but in
the absence of an authoritative literary source, an appreciation of the painting
must finally depend upon a meaning that lies within the frame.

 An index of Whistler's success might be the critical commentary the work
engendered, primarily a debate over the sources of artistic inspiration, while
the discussion of Morris's painting centers on whether the figure derives from
one Arthurian legend or another. It is revealing, then, that *La Princesse* has been
regarded as an Asian version of *The White Girl*, the picture misconstrued
as an illustration of a novel by Wilkie Collins. By placing his princess in a dis-
tant land of porcelain, Whistler obviated the possibility that the painting
would be associated with any work of popular fiction. Pairing those works also
reveals a thematic connection that transcends the similarity of composition. If
The White Girl is an essentially realist painting with an implicit comment on
Victorian values, *La Princesse du pays de la porcelaine*, which also portrays a model
striking a pose, is quintessentially aesthetic, meant to be received in silence.

 Marie Spartali Stillman informed the Pennells that her father had been
typical of the London Greeks (apart from the Ionides) who chose only the most
expensive portraitists, as the high prices seemed to validate their abilities.
Whistler in 1864 would not have fallen into that category, and there is no evi-
dence to suggest that Michael Spartali ever commissioned him to paint a por-
trait of Christina. Indeed, in 1866 Rossetti was still waiting for Spartali to "be
tempted into the picture market."[101] Moreover, *La Princesse du pays de la porcelaine*
was never meant to be a portrait in the technical sense, although contemporary
photographs confirm that it is a good likeness of Christina Spartali. Whistler
apparently elongated her figure in the manner of the *lange lijzen*, but he captured
the distinctively downcast demeanor that also appears in a portrait by Julia
Margaret Cameron (fig. 1.28), the Spartalis' neighbor on the Isle of Wight,
where they had a summer home. In 1892, Whistler was to capitalize on the
enduring romance of the Pre-Raphaelite stunners by exhibiting *La Princesse*
with the Society of Portrait Painters and attaching the parenthetical title,
Portrait de Miss S. . . . But from the beginning, *La Princesse du pays de la porcelaine*
was meant as an exhibition picture and intended for the Paris Salon. Mindful
of the French taste for chinoiserie, Whistler must have calculated the chances
of its success in 1865 where *The White Girl*, an essay in modern life, had failed
in 1863.[102]

 Recollecting the painting's production more than forty years earlier (and

The First Vase

mistaking the date of its inception), Marie Stillman told Elizabeth Pennell how her sister had posed for Whistler twice a week throughout the winter. She herself had gone along to chaperon.[103] "When they came the first time, he knew exactly what he wanted—the costume was ready, he gave her the pose, as it is now, at once, and arranged the screen background as it remained." This seems to confirm that Whistler had worked out the scheme in advance, employing a different model. Christina Spartali would stand at one end of the partially darkened room, beside the canvas, while Whistler stood at the other, periodically dashing forward to apply a single stroke of paint. "Mrs. Whistler would come and put her head in at the studio door and say, 'Jimmie, don't you think it is time for the young ladies to have some lunch?' But he would go on and on. When, at last, he was willing to let them stop to eat, the luncheon was brought into the studio, and they sat on low stools, and it was a sort of picnic."[104] The fact that Whistler's mother figures in this story at all distinguishes these modeling sessions from Jo Hiffernan's, which took place in the studio Anna was forbidden to enter, and shows how strictly propriety was maintained at 7 Lindsey Row.[105]

Whistler would work in silent concentration until darkness fell. The sisters often left at the end of the day thinking the painting almost complete, only to return the next morning and find that Whistler had rubbed it all down—a fate that would befall many other Whistler portraits. At some point in the process Christina fell ill with peritonitis, "and the doctor thought standing so much had helped to bring it on." According to Marie Stillman, it was her sister who insisted on maintaining the pose, being "so interested" herself in the painting, but the Pennells placed the blame squarely on Whistler. They said he was "pitiless with his models," never allowing the poor girl to rest, even when he was painting her head and she might easily have been seated.[106] Thus was their story shaped to fit the prevailing Pre-Raphaelite mythology, in which an artist's thoughtlessness to his model is construed as a sign of his industry and dedication, as when John Everett Millais allowed Lizzie Siddal to remain too long in a cold tub of water while enacting the role of the dead Ophelia.

Helen (Nellie) Ionides Whistler, who married Whistler's younger brother William in 1877, informed the Pennells that her cousin Chariclea, the youngest of Alexander Constantine Ionides' five children, had posed for La Princesse while Christina Spartali was ill.[107] Whistler is said to have gone to Christina's bedside during her convalescence to produce "a very beautiful study of her head in pencil," which he reportedly promised, but never delivered, to Marie.[108] (No such studies survive; while the story may be true, it carries the fragrance of Pre-Raphaelite legend.) There were a few more sittings after Christina's recovery, and throughout the early months of 1865 Whistler spent every waking hour working on "la Japonaise." He only just managed to finish La Princesse in time for submission to the Paris Salon, where the painting was not only accepted but hung on the line, a particular triumph for Whistler as it marked his first official recognition in France.[109]

FIG. 1.29 *Portrait of Whistler*, 1865, by Henri Fantin-Latour (1836–1904). Oil on canvas, 46.8 × 36.6. Freer Gallery of Art, Smithsonian Institution, Washington, D.C. (06.276).

He himself had posed that spring for a painting by Fantin-Latour, *Hommage à la Vérité: Le Toast*, which pictured a female nude holding a mirror and a distinguished assembly of contemporary artists. Whistler insisted on wearing what he called his Japanese costume—a truly remarkable thing, he told Fantin-Latour, that should guarantee him pride of place in the composition.[110] *Le Toast*, with its incongruities of allegory and portraiture, did not prove a critical success, and Fantin-Latour soon destroyed it. He did retain the portrait head of Whistler (fig. 1.29), which is sufficient to show that his robe was in fact Chinese, as Whistler is also reported to have called it at the time.[111] When, therefore, *La Princesse* went on view in Paris, Whistler appeared in the costume of a Chinese artist, impersonating the painter of the *lange lijzen*.

AFTER THE Salon, the history of *La Princesse* becomes anecdotal and obscure. Marie Stillman told Elizabeth Pennell that she and her sister had tried to persuade their father to buy it, but that he had neither liked nor understood it. She also told how Whistler, so desperate for funds he was willing to sell *La Princesse* for a hundred pounds, gave it to Rossetti to show one of his patrons. The prospective buyer reportedly objected to Whistler's signature, writ large across one corner of the composition, which stirred up a storm in the studio since Whistler did not take well to criticism. He is said to have refused to alter his signature in any way, although signs of abrasion beneath the letters suggest a different story.[112] There is a tradition tracing the origin of Whistler's butterfly monogram to that episode, which seems to have originated with the Pennells' speculation that Rossetti's patron's objection "made Whistler realise the discordant effect of a large signature on a picture."[113] Rossetti is supposed to have proposed that Whistler draw "a sort of Eastern cartouche" to enclose his initials and substitute for a signature, in the way that Rossetti had long signed his own works. Whistler did indeed fashion from his initials a Japanese-like monogram, but that famous butterfly cipher would not make its debut until many years later, after Rossetti's influence had been superseded by that of Albert Moore.[114]

Late in January 1866, *La Princesse* ("a personage who is anything but oriental in her features or form") was named the "most important" of several additions recently made to the *Twelfth Annual Exhibition of Pictures by Artists of the French and Flemish Schools* held at Gambart's gallery at 120 Pall Mall. Because it entered the assemblage late, Whistler's painting attracted little attention from the press, and its initial London showing was never officially recorded. The *Athenaeum* review, probably written by F. G. Stephens, is worth reprinting here, therefore, as it gives the earliest official English response to Whistler's French success:

The First Vase

Standing upright, holding a screen in one hand, while the other escapes from the sleeve of a mantle and is extended, and having her head bent slightly forward, the subject is in the attitude of speech. In its disproportionate shortness the left arm is absurdly wrong; in other respects the figure is fairly drawn, much more successfully so than any former figure by Mr. Whistler. In solidity and effectiveness the treatment of the picture is nearly perfect; in colour it is even more worthy of admiration. The lady wears a long, loose robe of fawn-colour, embroidered with grey foliage and crimson flowers; she has a broad scarf of powerful vermilion tint round her waist, the ends of which are pendent almost to the earth; this is interwoven with gold. Her body-robe is of pale ashy grey, or rather of the colour of tarnished silver, opaque, embroidered with lighter grey, or green, blue and crimson; she stands on a rug of bluish white, marked with a deep blue pattern, and is backed by a stone-white coloured screen painted in colours.[115]

Unlike the French reviews, this distinctively Victorian critique indulges in description, entirely disregarding the subject's association with Chinese porcelain.

After the close of Gambart's exhibition, *La Princesse* was probably sent to Rossetti's studio to join the other works Whistler left there for safekeeping when he departed in February on a mysterious mission to South America. That summer, while Whistler was abroad, a representative of Gambart's wrote to the artist's solicitor, James Anderson Rose, requesting the address of "a Lady who called here some time ago respecting Mr. Whistler's affaires"—presumably Jo Hiffernan, who was desperately trying to raise money in Whistler's absence.[116] She may have arranged for the sale of *La Princesse*, although tradition holds that Rossetti finally succeeded in selling the painting, and perhaps he did negotiate the deal. The Pennells never identify the purchaser, whose name has not previously been disclosed, but Marie Stillman told them it was Frederick Huth, whose son Louis, a prominent collector of Chinese porcelain, was soon to become one of Whistler's patrons.[117] Frederick Huth died a few years later, or so the story goes, providentially permitting *La Princesse du pays de la porcelaine* to pass into the keeping of Frederick Leyland.

2 The Perfection of Art

Set apart by them to complete their works, he produces that wondrous thing called the masterpiece, which surpasses in perfection all that they have contrived in what is called Nature; and the Gods stand by and marvel, and perceive how far away more beautiful is the Venus of Melos than was their own Eve.

"Mr. Whistler's 'Ten O'Clock'"

*I*N THE latter half of the 1860s, Whistler temporarily withdrew from the marketplace and dedicated himself to producing something beyond "what merely 'would sell.'"[1] His principal project was a work he called *The Three Girls*, the first and most important commission from Frederick Leyland, the patron for whom Whistler was to paint the Peacock Room. From the beginning, Whistler envisioned *The Three Girls* as his masterpiece, the ultimate expression of his highest ideals of art. Already in 1868, when the painting was scarcely begun, Swinburne perceived in it the promise "of a more majestic and excellent beauty of form than his earlier studies, and of the old delicacy and melody of ineffable color." Overburdened with such expectations, *The Three Girls* "was never destined to be completed," as T. R. Way remarked. Its fatal problem, Whistler's mother perceived, was that the artist had "tried too hard to make it the perfection of Art."[2]

Frederick Leyland, a Liverpool shipowner and art collector, would have known Gabriel Rossetti's art long before he met the painter in person, as there had been several opportunities to see it on display at the Liverpool Academy. Although Rossetti had been skeptical at first about showing works in that provincial city, he suspended his snobbery in 1858 to send a watercolor called *A Christmas Carol*; owners of two other works by Rossetti lent their paintings that year, and further examples of his art went on view at the Liverpool Academy exhibitions of 1861 and 1862. Finally in 1864, Rossetti sent an oil painting, *Fazio's Mistress* (1863), the work that marked a shift in his style from the medieval to the Venetian—or, as William Holman Hunt despaired, from Stoicism to Epicureanism.[3] He fully expected it to be rejected by the Liverpool committee and submitted it only at the "special wish" of an old friend, John Miller.[4] A tobacco merchant and shipowner, Miller was also an avid art collector and Liverpool's leading champion of Pre-Raphaelitism. As Dianne Sachko Macleod points out, Miller "set such a high standard of patronage in the early years of the Pre-Raphaelite movement that the artists spent the rest of their lives searching for his equal."[5]

Detail, *The White Symphony: Three Girls* (fig. 2.7).

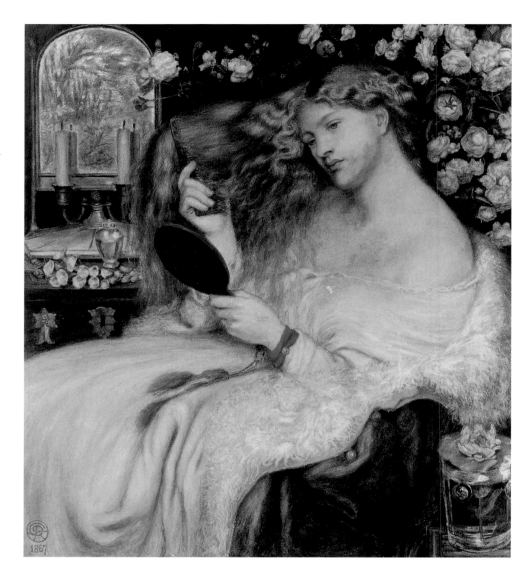

FIG. 2.1 *Lady Lilith*, 1867, attributed to Dante Gabriel Rossetti (1828–1882), partly by Henry Treffry Dunn (1838– 1899). Watercolor on paper, 51.3 × 44.0. The Metropolitan Museum of Art, New York; Rogers Fund, 1908 (08.162.1). This is a watercolor replica of the oil painting *Lady Lilith* (fig. 2.2), which Rossetti subsequently revised.

Miller may have influenced Leyland's appreciation of *Fazio's Mistress*, which exemplifies the type of painting that came to characterize Leyland's collection. It was Miller, in any event, who informed Rossetti, toward the end of 1865, of Leyland's desire to purchase one of his works. Rossetti responded with a letter to Leyland offering a painting in progress, *Sibylla Palmifera*, which Miller may have seen on the easel; somehow or other the proposal miscarried (the completion of the painting was commissioned by a competing collector, George Rae), and Leyland always regretted having lost it. But by the following spring he had repeated his "wish to have a good picture," and Rossetti granted Leyland first option on another of the works descending from *Fazio's Mistress*, the painting that became *Lady Lilith*.[6]

Rossetti's price was 450 guineas (or £472 10s, a pound being equal to twenty shillings, and a guinea to twenty-one), and the sum was to be divided into three payments—one in advance, one when the picture was well along, one upon completion. Leyland was willing to accept these terms but declined to commit himself until he had seen the painting in progress; he met Rossetti at

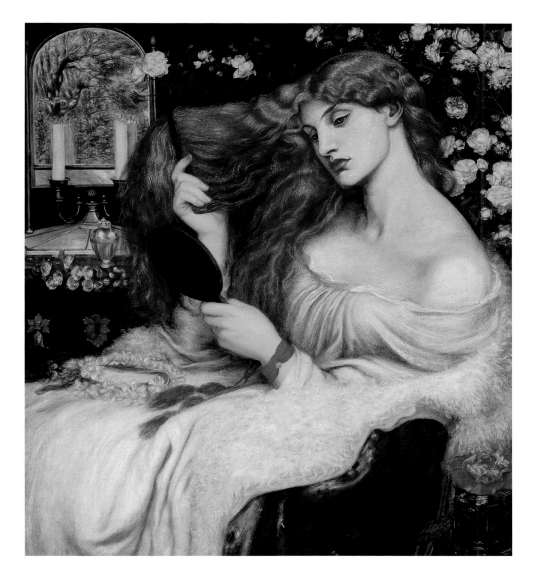

FIG. 2.2 *Lady Lilith*, 1864–72, by Dante Gabriel Rossetti (1828–1882). Oil on canvas, 97.8 × 85.1. Delaware Art Museum, Wilmington; gift of the Estate of Samuel and Mary R. Bancroft, 1935.

the artist's studio in April 1866, and he had paid the first installment by the end of the month. Leyland promptly made a second payment in July and advanced the remainder of the money in August, even though the work remained far from complete. Rossetti assured him that the painting would arrive in Liverpool by the end of September and promised it would be "better than any picture of its class."[7] *Lady Lilith*, however, was not finished in September, or indeed that year, but remained with the artist, subject to considerable alteration, until 1869.

 Much like Rossetti's other "toilette" pictures (see fig. 1.22), the one meant for Leyland was conceived simply as "a lady combing her hair," with a landscape in the background—"its colour chiefly white and silver," as Rossetti described it to his patron, "with a great mass of golden hair."[8] The difficulties arose when the painting assumed a sensational subject. In August 1866, Rossetti referred to his work-in-progress as "the picture of Lady Lilith," who was, according to Hebrew legend, Adam's first wife. Dispossessed by Eve, Lilith assumed the shape of a serpent to creep into Eden, present temptation in the form of forbidden fruit, and bring about the Fall of Man.[9]

Reading Shelley's translation of Goethe's *Faust*, Rossetti had fixed upon the Walpurgisnacht scene, in which Mephistopheles warns Faust to beware of the golden-haired woman glimpsed through the crowd, who turns out to be Lilith.[10] The episode strikingly recalls Rossetti's first encounter with Fanny Cornforth at a London amusement park in 1857. Rossetti had literally bumped into her (or so she recalled), accidentally dislodging her golden hair that was, by all accounts, spectacular. The incident led to Cornforth's posing for *Found* (1854–81), typecast as a fallen woman with her tresses all disheveled. She was, in fact, a professional prostitute, who then became Rossetti's lover. Reportedly distraught when he married Lizzie Siddal, Cornforth assumed a constant place in Rossetti's affections and a corresponding prominence in his paintings after Siddal's death, possibly suicide, in 1862.[11]

In the deeply personal portrait of Fanny Cornforth as *Lady Lilith* (fig. 2.1), Rossetti's lingering guilt over the death of his wife becomes apparent. The laudanum that killed Lizzie Siddal figures in the form of poppies and the lost paradise of their wedded bliss in the verdant garden reflected in the mirror; as the golden-haired temptress, Cornforth is cast as the irresistible agent of Rossetti's despair. Some years later, Rossetti would dismantle that painful association, persuading Frederick Leyland to let him substitute the cool visage of another model for the voluptuous features of Fanny Cornforth (fig. 2.2).

W HILE LEYLAND and Rossetti were establishing the terms of what would prove to be an enduring and mutually profitable relationship, Whistler was away in South America. He had departed abruptly in February 1866, not to return until the end of the year. His reasons for going have never been satisfactorily explained, and the secrecy that surrounds his adventure would seem to support Ronald Anderson's theory that the trip resulted from Whistler's friendship with John O'Leary, the Irish separatist charged with high treason only months before the artist took flight.[12] Traditionally, the South American episode has been interpreted as a reaction to complications besetting Whistler's personal life, but it seems unlikely that even his mother's disapproval of his relationship with Jo Hiffernan could impel a sudden journey to another hemisphere. Nor is it plausible that Whistler left London because of difficulties with Hiffernan herself. While they drifted apart after 1867 (a separation always presumed to have been effected at his request), there is no evidence that they were nearing a breach in 1866. In fact, Whistler granted Hiffernan power of attorney before he left, and named her his sole beneficiary (though if the O'Leary theory holds, he may have thought it prudent to distance himself temporarily from all Irish connections). Furthermore, upon his return to London in November 1866, Whistler went to live at 14 Walham Grove, the lodgings Hiffernan had taken in 1863, when Anna Whistler was installed at 7 Lindsey Row.[13]

FIG. 2.3 *Sketch of "Symphony in White, No. 3"* (M323). From a letter to Henri Fantin-Latour, 16 August 1865. Library of Congress, Washington, D.C., Manuscript Division, Pennell Whistler Collection.

The "real object" of the escapade—or so William Rossetti was reliably informed by Frederick Sandys—was a business speculation Whistler entered into with "a certain Capt. Doty": he was to deliver to Valparaíso, Chile, the torpedoes meant to destroy the Spanish fleet that had recently recommenced hostilities in South America. Because of bad weather and other unlucky circumstances, the expedition was delayed; and "before the torpedoes were available for blowing up the Spaniards, these latter had blown up Valparaiso."[14] Whistler and his co-conspirators witnessed the attack from the safety of the hills above the harbor, and children taunted them as cowards when they rode back into the devastated city. Whistler's secret mission had ended in humiliating failure and, we may assume, without the anticipated pecuniary reward.

Even with this explanation (which features in the portion of William Rossetti's diaries discreetly left unpublished), the episode seems unaccountable, for only the previous spring Whistler had achieved indisputable success on both sides of the English Channel, with three paintings at the Royal Academy and *La Princesse* at the Paris Salon. Perhaps the years of unrelenting industry that had brought about those triumphs left him exhausted and uninspired. Toward the end of November 1865, his mother had written of her "intense" anxiety over his finishing a painting for a prospective patron (Louis Huth); her own apprehension probably mirrored that of her son.[15] The work in question, which Anna Whistler referred to as "the Sofa," was begun shortly after the successful Academy exhibition of *The Little White Girl*, and Whistler's own working title for his new painting, "The Two Little White Girls," suggests that it was meant as a variation on the theme. He sent Fantin-Latour a sketch of his work in progress (fig. 2.3), writing that the image of Jo Hiffernan, who was to wear the same linen dress and repose on a sofa with a second woman in white, was "the purest" thing he had ever painted. He was finding tremendous satisfaction in his work, he said. "I realize perfectly everything I am doing. Be-

sides, things become simpler from day to day, and I now pay most attention to
the composition."[16]

His new composition, as even the roughest sketch suggests, was inspired
by a painting Whistler would have seen that spring at the Royal Academy, *The
Marble Seat* (fig. 2.4), by a younger artist, Albert Moore. Neither narrative nor
historical, *The Marble Seat* depicts three women swathed in classical draperies
and resting on a bench in a woodland clearing; they prefigure the white girls in
Whistler's painting, awkwardly disposed on a white sofa. Moore's earlier
works, chiefly Biblical subjects in the Pre-Raphaelite manner, seem not to have
attracted Whistler's attention. *The Marble Seat*, however, was a milestone that
established the conceit for all Moore's future paintings, in which the subject
becomes "merely a mechanism for getting beautiful people into beautiful situa-
tions," as Sidney Colvin observed, "whereas in modern art the aspect, of the
people and their situations, whether beautiful or otherwise, has been generally
merely an instrument for expounding the subject."[17]

If in the first half of the decade Whistler had located aestheticism in
material objects such as Chinese porcelains and the paintings they inspired,
in 1865 he reconceived that philosophy under the combined influence of
Swinburne and Moore. The new terms were both more ideological and abstract:
works of art became to him not ends in themselves, but Platonic reflections of
an ideal beauty just beyond his grasp. The Elgin Marbles, sculpture from the
Parthenon frieze that inspired *The Marble Seat*, had recently been rearranged
to brilliant effect in the British Museum, setting off a wave of classicism among
Victorian painters. But Moore's works differ from those of his contemporaries,
as Allen Staley has observed, by "the absence of classical subjects, of nostalgia
for a Greek or Roman Golden Age, and of any concern for archeological exac-
titude." Like Whistler's interest in Japan, Moore's interest in Greece was
purely aesthetic: Moore was dedicated "to the visible, decorative, form-and-

colour department of his art," as Colvin put it, "and scarcely at all to its intel-lectual, narrative, thought-and-fancy department."[18] His position would never be popularly understood or officially recognized in Britain, and when Moore died in 1893 at the age of fifty-two, Whistler wrote as though his friend had been an exotic flower transplanted from foreign soil, "The greatest artist that, in the century, England might have cared for and called her own—how sad for him to live there—how mad to die in that land of important ignorance and Beadledom."[19]

One of the works abandoned in the studio when Whistler left for Valparaíso was a monumental painting intended for the Salon, a group portrait meant to commemorate his new artistic fraternity. "There is yourself and Moore," Whistler wrote to Fantin-Latour, "the White Girl seated on the sofa, and la Japonaise walking about. In short, an apotheosis of everything capable of scandalising the Academicians." Although it has recently been described as a "Realist masterpiece,"[20] the painting seems to have been meant as a reply to Fantin-Latour's *Hommage à la Vérité* (1865), constituting an ambitious dedication to Beauty as represented by the costumed models and the Chinese porcelain arrayed behind them. By the beginning of 1866, however, Whistler had pro-duced only a small oil sketch lacking the figures of Fantin-Latour and Moore (fig. 2.5), and he must have felt tremendous pressure to complete this work and his other unfinished project, "The Two Little White Girls," for exhibition the following season. Setting out for South America in February to avoid an April deadline might seem an extreme measure, but it may have appeared at the time the only feasible solution. If nothing else, the trip promised to bring an end to the "whirl of excitement of ambition and hopes and disappointments and bitterness" that Whistler later confessed had long engulfed him. This would account for his family's explanation that Whistler had gone to Valparaíso for his health, even though the city was known for its insalubrious climate.[21]

Whistler's farcical adventure may in fact have rescued him from the brink of crisis, for upon returning to London he completed "The Two Little White Girls" for the 1867 Academy (fig. 2.6). The hiatus in its production was marked with a conspicuous correction of the original date, 1865, to the year of its com-pletion. The picture was also given a musical title, *Symphony in White, No. 3*, with the words inscribed along the lower margin of the canvas, along with the amended date and Whistler's signature. ("Could not Mr. Whistler put a little more writing in the corners of his pictures," mused the critic for the *Evening Star*—"his address, say, and the name of his colourman?")[22] With the famous exception of P. G. Hamerton, who observed that the painting was "not pre-cisely a symphony in white," the critics fully comprehended the analogy of painting with another art. Even the writer for the *Illustrated London News*, a paper not known for its grasp of intellectual subtleties, recognized Whistler's title as a proposition "to attain abstract art, as exclusively addressed to the eye as a symphony independent of words is addressed to the ear."[23]

Perhaps the most perceptive review was by F. G. Stephens, who obvi-

FIG. 2.5 *Whistler in His Studio* (Y63), 1865. Oil on panel, 62.9 × 46.4. The Art Institute of Chicago; Friends of American Art Collection (1912.141).

ously understood Whistler's ambition to produce pictures "for the sake of ineffable Art itself, not as mere illustrations of 'subjects,'" and especially admired his colors "for their beauty, wealth and melodious combining." The criticism Stephens ultimately leveled at the painting could not be dismissed, therefore, as the fulmination of a philistine. "Mr. Whistler has a good deal of feeling for beauty in line, and, if he will, can draw," Stephens continued: "therefore we hold him deeply to blame that these figures are badly drawn. . . . Such neglect as that which left the seated woman's arms in the state before us, is an impertinence of which the artist ought to be as much ashamed as we hope he would be if found in a drawing room with a dirty face."[24]

Stephens's admonition resonates through a confessional letter Whistler wrote to Fantin-Latour several months later, lamenting his failure to have mas-

tered the difficult discipline of drawing while still a student.[25] He had taken the opportunity in the spring of 1867 to assess his art in light of two concurrent exhibitions representing French tradition and its antithesis: a memorial of works by Ingres and a massive retrospective of paintings by Courbet. Six of Whistler's own works were on display in Paris then, at the Salon and the Exposition Universelle, ranging in date from *At the Piano* of 1859 to *Crepuscule in Flesh Colour and Green*, which resulted from his Valparaíso voyage. Set in that context, his art appeared "a chaos of intoxication, of trickery, of regrets — incomplete things," produced by a degenerate student. "Ah my dear Fantin," Whistler wrote, "what a frightful education I've given myself — or rather what a terrible lack of education I feel I have had! — With the fine gifts I naturally possess what a fine painter I should be by now! If, vain and satisfied with those gifts only, I hadn't shunned everything else!" Although his admiration for the "aggressively French" art of Ingres was lukewarm, Whistler fervently wished he had been that artist's student, for under his tutelage he might have resisted the "disgusting" influence of Courbet, which caused him to follow what seemed at the time the easier path. "All he had to do was open his eyes and paint what he found in front of him!" wrote Whistler, distancing himself through syntax from that other, younger self.

FIG. 2.6 *Symphony in White, No. 3* (Y61), 1865–67. Oil on canvas, 51.1 × 76.8. Barber Institute of Fine Arts, University of Birmingham, England.

FIG. 2.7 *The White Symphony: Three Girls*
(y87), ca. 1867. Oil on millboard, mounted
on panel, 46.4 × 61.6. Freer Gallery of Art,
Smithsonian Institution, Washington, D.C.
(02.138).

Having seen the error of his ways, Whistler could only start over from the
very beginning. "This explains the enormous amount of work that I am now mak-
ing myself do," he informed Fantin-Latour. "Well old chap I've been undergoing
this education for more than a year now—for a *long time*, and I'm sure I will
make up the time I've wasted but what a punishment!" The principal exercise in
that grueling project of self-improvement meant to atone for the sins of the past
was *The Three Girls*, a picture in which "beautiful nature" was to be confined to a
potted plant. All but a fragment of the final canvas would eventually be de-
stroyed, but several related works survive to suggest the painting's subject, which
Swinburne interpreted as a "garden balcony" but others regarded consistently as a
hothouse (fig. 2.7). Three young women are disposed around a flowering tree, one
crouching to attend it, another bending forward to observe it, the third standing
off to one side, monumental and aloof, a parasol encircling her head like a halo.
The object of their attention is a natural form abstracted from its setting, with no
particular purpose apart from being beautiful. In a later reinterpretation of the
central figure, Whistler makes the plant a lily, an emblem of aestheticism.[26]

FIG. 2.8 *Pomegranates*, 1866, by Albert Joseph Moore (1841–1893). Oil on canvas, 25.4 × 35.56. Guildhall Art Gallery, Corporation of London.

The friezelike arrangement of figures in Grecian draperies alludes, like *Symphony in White, No. 3*, to the Elgin Marbles, while certain accessories refer to the wave of inspiration flowing from Japan. To create an ideal aesthetic domain, Whistler harmonized two distinct artistic traditions, as if to tell in a single painting "the story of the beautiful" he mentions in closing the "Ten O'Clock" lecture: "hewn in the marbles of the Parthenon—and broidered, with the birds, upon the fan of Hokusai."[27] The composition could probably not have been conceived independently of Moore's *Pomegranates* (fig. 2.8), a painting shown at the Royal Academy while Whistler was abroad in 1866. It would have been in progress the previous year, when Whistler had written Fantin-Latour that "the young Moore" was the only artist in England worthy of joining their cause, which he now defined as "a continuation of the true traditions of painting in the nineteenth century." Moore's *Pomegranates* echoes a venerable example of French academic tradition, Poussin's *Et in Arcadia Ego* (fig. 2.9), a painting that was itself drawn from an inherited vocabulary of classical art.[28] *Pomegranates* might almost be read as a parody of the Poussin, breaching decorum, with the enigma of the tomb trivialized to idle curiosity. (What are those girls looking for anyway, more fruit?)

The Three Girls was to make even more explicit reference to *Et in Arcadia Ego*, for unlike Moore's *Pomegranates*, Whistler's work features a standing figure that closely corresponds to the spirit of death in Poussin's painting. The composition of *The Three Girls*, therefore, would have been familiar to the intended audience, lending weight to its message. As serious in its way as the inscription spelled out by the Arcadian shepherds, Whistler's hothouse imagery decrees that if art is to flourish it must be sheltered from the natural world, an environment inhospitable to aesthetic beauty. Whistler later articulates that

FIG. 2.9 *Et in Arcadia Ego*, ca. 1640, by Nicolas Poussin (1594–1665). Oil on canvas, 86.36 × 121.92. Musée du Louvre, Paris.

The Perfection of Art

startling conviction in the "Ten O'Clock" lecture: "Nature is usually wrong: that is to say, the condition of things that shall bring about the perfection of harmony worthy a picture is rare, and not common at all."[29]

Having embarked upon a course of self-education that was to prove anything but remunerative, Whistler was sorely in need of a patron. It is possible that he and Frederick Leyland met before the Valparaíso interlude, but they probably became acquainted during the spring of 1867, when *Symphony in White, No. 3* was on display at the Royal Academy. The commission for *The Three Girls* may even have been awarded in response, for it was intended as yet a further elaboration of the theme, culminating the series as *Symphony in White, No. 4*.[30]

Shortly after his return from South America and temporary retreat to Walham Grove, Whistler resettled in a larger house along Lindsey Row and resumed his friendship with his neighbor Gabriel Rossetti. Leyland, by then, was a frequent visitor to Tudor House, and Rossetti, consistent with his custom of sharing patrons, undoubtedly introduced him to Whistler. That summer, for example, Rossetti brought Leyland and Ford Madox Brown together, a meeting that resulted in a substantial commission for a replica of Brown's *Chaucer Reading the "Legend of Custance" to Edward III* (1851). Leyland was showing himself to be an especially sympathetic patron, commissioning two further works from Rossetti in spite of the fact that *Lady Lilith* was already overdue. One commission was for *The Loving Cup* (no longer extant), the other for a companion-piece to *A Christmas Carol*, a painting of a richly dressed woman singing and playing the lute, which Leyland had purchased in February as the first of many works in his collection to manifest a musical theme.[31]

The work commissioned as a pendant to *A Christmas Carol* was to be related, it appears, only in the opulence of the subject's dress, "a flowing white and gold drapery," as Rossetti described it to Leyland, "which I think comes remarkably well and suits the head perfectly." The head was Mrs. Leyland's (fig. 2.10), but Rossetti gave the game away only in closing his letter "with kind remembrances to the original."[32] Like Whistler's *Princesse*, Rossetti's projected painting would be more a costume picture than a portrait, with studio props to enhance the theme of purposeless beauty: the conceit called for an extravagant scarf studded with peacock feathers and a blue-and-white pot in the artist's favorite "hawthorn" pattern. Rossetti initially referred to it only as "Mrs. Leyland's picture," but he eventually settled on the title *Monna Rosa* in reference to lines by an Italian poet that fit the composition "happily," he thought: "With a golden mantle, necklace, and rings, / It pleases her to have with these nothing else but a rose in her hair." In the final painting, Frances Leyland plucks a rose from the Chinese jar, which poses improbably as a flowerpot, the peacock feathers streaming down behind her (fig. 2.11).[33]

FIG. 2.10 Study for *Monna Rosa* (*Portrait of Frances Leyland*) (fig. 2.11), 1867, by Dante Gabriel Rossetti (1828–1882). Red chalk on paper, 29.85 × 26.67. Collection of Cita Stelzer.

· It may be significant that the day Rossetti began *Monna Rosa*, Whistler dined at Tudor House, together with John Miller and "other friends"— perhaps including Frederick Leyland, whom Rossetti was introducing that spring as the "picture buyer for whom I am doing the Lilith and a nice chap." [34] Whistler's own vision of ideal beauty, *The Three Girls*, was apparently under way by August, when Anna Whistler noted that her son was "steadily at work in his Studio for he has received orders for two pictures at 300 guineas each." [35] Already, Whistler felt "weighed down with the most impossible work," he confided in a letter to Fantin-Latour. "It's the pain of giving birth! you knew that—I've several pictures in my head and they only come out with some difficulty—for I must tell you that I am now experiencing demands and difficulties way beyond the time when I was able to throw everything down on the canvas pell mell—in the knowledge that instinct and fine colour would always bring me through in the end!" He enclosed a "rough pen drawing" of the

composition then occupying his attention, and that sketch, now lost, probably conveyed Whistler's ideas for *The Three Girls*.[36] It may have resembled an ink sketch in Glasgow (fig. 2.12), rapidly drawn on a sheet of lined paper torn from an exercise book. Albert Moore also began projects this way (fig. 2.13), with "a mere thumb-nail note, often in pen-and-ink on some odd scrap of paper," constantly repeated until the design was firmly established.[37]

Indeed, the new demands on Whistler's strength and patience were imposed by Albert Moore and the academic regime he imparted, a painstaking process of preparatory work. Whistler told Fantin-Latour he spent "the whole day drawing from models!!"—his emphatic punctuation expressing frustration at being reduced to student exercises when he was accustomed to professional performance.[38] But Moore had likewise entered a "period of probation," according to his student and biographer Alfred Lys Baldry. Although he had studied briefly at the Royal Academy, Moore had acquired little formal training: one contemporary observed that "no great painter was ever more nearly self-taught."[39] He had an instinct for drawing figures and "disposing groups of them in dignified and delightful relations with one another," but his sense of color (Whistler's particular strength) was considered wanting. More perfect color than Moore's could be found, wrote Sidney Colvin, "on a thousand fans, screens, and printed hangings of Japan," to say nothing of paintings by European old masters.[40] In possession of complementary talents, then, Whistler and Moore exchanged expertise and worked together through the decade with the common goal of perfecting artistic expression.

Early in October 1867, Whistler wrote to Frederick Leyland that *The Three Girls* was "getting on," though not yet ready to be seen. "I will be again greatly obliged if you could let me have some more money on account," he added. "You see I ask without hesitation, as you were kind enough to say I might—and I would like to have a hundred." This letter, the earliest to document Whistler's relationship with Leyland, appears not to be his first request for an advance. Rossetti may have encouraged Whistler to be bold, as he himself had approached their patron for money the previous month without adverse effect. In any event, Leyland set the pattern for future transactions by promptly posting a check to Whistler for £105, calculating the sum as he customarily did for Rossetti, in guineas rather than pounds.[41]

If Whistler was unwilling to show Leyland the painting of *The Three Girls* itself, he consoled his patron with the promise of a "final oil sketch."[42] That picture, or a subsequent version of it, has survived (see fig. 2.7): Thomas Way acquired it at the time of Whistler's bankruptcy and later sold it to Charles Freer, who recognized its importance in the evolution of Whistler's style.[43] *The White Symphony* is painted on millboard, a support with "a slightly granulated surface," as a Victorian artists' manual explains, "this being better calculated to receive, and give effect to, the bold and broad style in which sketches and studies for pictures are usually painted." Whistler appears to have used a palette knife for the blossoms and his fingers for the faces of the three girls,

FIG. 2.12 Study of *The Three Girls* (M361), 1869/72. Pen and ink on paper, 18.3 × 21.7. Hunterian Art Gallery, University of Glasgow.

leaving them deliberately devoid of expression. Moore prepared comparable color studies, Baldry explains, to "fix the proper relation between colour area and degree of brilliancy necessary for maintaining due balance and support throughout the canvas."[44]

Though composed like its predecessors in the key of white, this so-called symphony pulsates with color. As Swinburne would describe it, "The main strings touched are certain varying chords of blue and white, not without interludes of the bright and tender tones of floral purple or red." The colors appear woven through the canvas—"in other words," Whistler explained the method to Fantin-Latour, "the same colour reappearing continually here and there like the same thread in an embroidery—and so on with the others— more or less according to their importance—the whole forming in this way an harmonious *pattern*—Look how the Japanese understand this!—They never search for contrast, but on the contrary for repetition."[45] This highly contrived use of color, which Whistler was later to describe as the "science of colour and '*picture pattern*,'" also characterizes the works of Albert Moore, who carried the practice to an extreme. "He colours not to imitate life," Sidney Colvin complained, "but to produce an agreeable pattern."[46]

By November, Whistler felt the need for a change of scene. He wrote to George Lucas about finding a place in Paris ("nothing but a bare studio with a little room to sleep in") where he might work in solitude. "I have a great deal of very hard work to do, and must be more quiet than I can be here. Also care but little to meet the old cafe set just now, as I have no time for talk." Nothing came of the idea, and the next month he assured Lucas that he was "hard at

The Perfection of Art

work" on the large picture he hoped would be ready for the Academy that spring, "with perhaps one for the Exposition" in Paris.[47] He also wrote to Leyland asking for the balance due on *The Three Girls*, which was "steadily progressing," he said—"and depend upon me for its completion as soon as possible." Leyland may have felt a sense of déjà vu, since Rossetti had extracted further payment for *Lady Lilith* the previous year in the same way, making that very promise, as yet unfulfilled. Nevertheless, he obligingly posted a check for fifty guineas, expressed as £52 10s.[48]

In his letter to Leyland, Whistler confided that he was engaged in "a struggle with the enemy" and was gathering ammunition "to do great decisive battle with strong forces." This must allude to Seymour Haden's motion, at the end of 1867, to expel Whistler from the Burlington Fine Arts Club, creating another serious distraction from work.[49] The previous spring James Reeves Traer, a partner in Haden's medical practice whom Whistler described as his own "much loved companion," had died in Paris in the company of "a lady not his wife." Haden had furtively arranged an ignominious burial, "like a pauper in a common grave," neglecting to notify Traer's family or inform his friends. Whistler, unable to abide the insult, "struck him and then and there punished him," as he subsequently explained to his mother: "No son of yours could or *would* bear longer with the blackguard insolence of such a bully as Seymour Haden."[50] Out of deference to Traer's family, these circumstances were not publicly revealed; in the apparent absence of a reasonable defense for assaulting Haden, the Burlington asked for Whistler's resignation. Haden's solicitors subsequently prepared a case against Whistler for slander, an action the artist felt certain was meant to interfere with his work, as indeed it did. "Poor Jemie," Anna said, "could not during the persecutions of Mr. Haden finish any picture!"[51]

When, therefore, the Royal Academy exhibition opened on the first Monday in May 1868, *The Three Girls* was absent yet again. Whistler's disappointment may have been relieved by the sympathy and generosity shown by his patron, who wrote a "kind note" enclosing one hundred guineas "in addition to the price agreed to for the Garden picture." Evidently, this was entirely Leyland's initiative.[52] He may have seen the work in progress that summer, around the time William Rossetti noted in his diary that Whistler was "doing on a largeish [*sic*] scale for Leyland the subject of women with flowers." That he should describe Whistler's "garden picture" in those terms is significant, since he later defended his brother against the charge that he considered women and flowers "the only objects worth painting": if Gabriel depicted the subject to the point of monotony, it was only because his patrons wanted nothing else.[53]

Indeed, Leyland played his part in perpetuating the pattern: both *Lady Lilith* and *Monna Rosa*, to name but two, are variants on the women-and-flowers theme. Rossetti used the subject "for compositions conceived as harmonious arrangements of colors," as Sarah Phelps Smith has noted, adding a literary dimension only as the works evolved (along with symbolic accessories, a telling

FIG. 2.13 Sketch for *A Venus* (fig. 2.20), by Albert Joseph Moore (1841–1893). From a letter to F. R. Leyland, 12 December 1868. Library of Congress, Washington, D.C., Manuscript Division, Pennell Whistler Collection.

title, and a poem to serve as an illuminating caption). Whistler was working in much the same way in this period, although his picture for Leyland was meant to resonate with music rather than poetry: it was to bear the title of a symphony and a frame inscribed with quotations from Schubert's *Moments musicaux*.[54]

Swinburne, while acknowledging the distance between "their provinces of work, their tones of thought and emotion," recognized that Whistler and Rossetti shared "one supreme quality of spirit and of work, coloured and moulded in each by his individual and inborn force of nature; the love of beauty for the very beauty's sake, the faith and trust in it as in a god indeed." He proposed the connection in a pamphlet written with William Rossetti, *Notes on the Royal Academy Exhibition, 1868*, in which Swinburne's own discussion extended to include certain works that had not been "submitted to the loose and slippery judgment of an academy." Whistler's failure to complete his paintings for exhibition was thus construed as a conscious decision—as though, like Gabriel Rossetti, he had deliberately withheld his works from public view.[55]

Swinburne's emphasis on the artists' common aesthetic intentions now appears vaguely ironic, since Whistler's close-knit association with the Chelsea aesthetes had begun to unravel when he adopted Albert Moore as a mentor. ("Like the dread Jehovah of the Israelites," Prinsep wrote of Rossetti, "he was a jealous God, and, from the moment he was not all in all to us, a gradually widening rift established itself.")[56] Moreover, Rossetti had begun his retreat into the world of his pictures, which increasingly reflected his obsessive frame of mind. It is revealing that he insisted that Swinburne mention *La Pia de' Tolomei* (1868–81), the first in a series of such portraits of Jane Morris, whose beauty would eventually overwhelm the artist's imagination. The fortunes of *La Pia*, as it proved, were not so very different from those of *The Three Girls*. Rossetti was certain it would be "his best single figure picture," and Leyland commissioned it, in all good faith, for the enormous sum of eight hundred pounds, yet would not receive his painting for another thirteen years.[57]

*T*HE WHITE SYMPHONY (see fig. 2.7), Whistler's oil sketch for *The Three Girls*, was one of the "slighter works lately painted" that Swinburne extolled in his 1868 review: "The soft brilliant floor-work and wall-work of a garden balcony serve . . . to set forth the flowers and figures of flower-like women." There were two other oil studies under discussion in which the "keynote," as Swinburne described the prevailing idea, inclining toward a musical metaphor, was "an effect of sea."[58] From the descriptions that followed, those studies may be identified as early versions of the paintings we now know as *Variations in Blue and Green* (fig. 2.14) and *Symphony in White and Red* (fig. 2.15). These would have been among the works William Rossetti saw in Whistler's studio, along with

The Perfection of Art

FIG. 2.14 *Variations in Blue and Green* (Y84), ca. 1868. Oil on millboard mounted on panel, 46.9 × 61.8. Freer Gallery of Art, Smithsonian Institution, Washington, D.C. (03.178).

FIG. 2.15 *Symphony in White and Red* (Y85), ca. 1868. Oil on millboard mounted on panel, 46.8 × 61.9. Freer Gallery of Art, Smithsonian Institution, Washington, D.C. (03.177).

the incomplete version of *The Three Girls*, and described in his diary as "coloured sketches of four or five other subjects of the like class, very promising in point of conception of colour-arrangement." [59]

Traditionally, those five unfinished "symphonies," which Whistler called simply "sketches of figures & Sea," have been grouped with *The White Symphony: Three Girls* to compose the set of paintings known as the Six Projects. [60] The misconception that Whistler himself regarded the six as a series arose only after the artist's death, when Freer acquired the group of five he knew from the

walls of Whistler's dining room and lent them, together with *The White Symphony* (purchased the previous year), to the Whistler Memorial Exhibition in Boston in 1904. There, the assembled group was called the "Six Schemes," a collective title apparently of Freer's own invention. The Pennells sustained the association in the first edition of their biography, referring to the paintings as "Six Schemes or Projects," and extrapolating from the facts of one commission to advance the possibility that the set, as a whole, was intended for Frederick Leyland.[61] Gradually their speculation calcified into accepted fact, even though the evidence confirms that Leyland commissioned only one of the works, or at most two. The Pennells further presumed the Projects to constitute Whistler's earliest decorative scheme, basing their supposition on the observation that all six pictures were approximately the same size and appeared to relate to Whistler's finished works "as the sketches of Rubens and Tiepolo to their great decorations." That the so-called Six Projects were intended from the start as an architectural scheme, and thus an important precursor to the Peacock Room, has also come to be accepted, although no one has satisfactorily identified a possible patron or interior.[62]

Richard Dorment has proposed that Whistler's Projects were inspired by a series of seven paintings relating to the story of St. George and the Dragon produced by Edward Burne-Jones between 1865 and 1867 for the house of Myles Birket Foster.[63] But in theme and sensibility, Whistler's suite of sketches more closely parallels Burne-Jones's unrealized scheme of illustration for *The Earthly Paradise* (1868–70) by William Morris. That poem follows a band of fourteenth-century Norsemen who set out in search of paradise but alight in "a nameless city in a distant sea," where a belief in classical gods survives; consequently, the cycle of stories Morris recounts alternates between Greek myths and Norse legends. The same eclecticism pervades Burne-Jones's Cupid and Psyche illustrations, which combine elements of Greek and medieval (or Pre-Raphaelite) style. As hybrids of two distinct but equally venerable traditions, they embody the theme of Morris's poem—that the only paradise on earth is the paradise of art. Whistler's Projects, combining elements of classical and Japanese style, emerge from an identical impulse to elevate beauty above the arbitrary divisions of history and geography.

The controlling image of Whistler's series is the single standing nude that the artist himself identified as Venus (fig. 2.16). Indeed, the series was known as the "Venus Set" before Freer retitled them, obscuring their family name; the program of the paintings becomes plainly apparent once *The Three Girls* is removed from the set.[64] The classicizing subject of the goddess surrounded by attendants on the mythical shores of her native sea was a common theme in aestheticist art. Swinburne had treated it in a poem of 1866, "Laus Veneris" (Praise of Venus), inspired by the German legend of Tannhäuser, the noble knight seduced from his righteous existence by the goddess of love. Swinburne's composition was, he said, a rehandling of an old story in a new way, and Whistler's Projects are reinterpretations of an ageless artistic theme.[65]

Another precedent may be found in the work of Fantin-Latour, whose *Scène du Tannhäuser* (1864), based on Wagner's opera, also depicts the realm of Venus. Whistler greatly admired Fantin-Latour's paintings of this type, called *féeries* (fantasies), imaginative interpretations of musical themes that differed dramatically from the artist's other works. "Instead of the sober colors and dry, impersonal facture of the portraits the *féeries* are painted in a bright, Delacroix-like palette," writes Michael Fried, in words that might as well be used to describe Whistler's Projects. "Fantin-Latour's personal touch is everywhere evident; and a mixture of techniques—slurring wet into wet, glazing, scumbling, scraping—dissolves contours and gives the picture surface a heavily worked, in places wax-crayonish texture."[66] It is revealing that Whistler borrowed the first of those works, *Parade de la féerie* (Display of enchantment), after its exhibition at the Salon des Refusés and kept it with him for another twenty years. He may have looked to Fantin-Latour's work for inspiration while designing dreamlike compositions of his own, similarly aspiring to the condition of music. "He is a sort of Wagner in painting," one critic wrote of Whistler, "a Wagner who is always composing beautiful themes, exquisite conceptions of harmony, and leaving them unfinished."[67]

FIG. 2.16 *Venus* (Y82), ca. 1868. Oil on millboard mounted on panel, 61.8 × 45.6. Freer Gallery of Art, Smithsonian Institution, Washington, D.C. (03.175).

Aᴺᴰ ɴᴏᴡ I am up to my neck in work!" Whistler wrote Fantin-Latour at the end of September 1868, apologizing for the lapse in correspondence, "which means that I write a little and then the models come and the daylight, and the sun sets far too soon and then someone comes in and stays to dinner—and if I go out for a moment boom! night time! and I'm worn out, dropping with sleep and incapable of doing anything!"[68] The next month his mother was enlisted to turn visitors away from Lindsey Row. Whistler was working conscientiously, she reported to Mr. Gamble, leaving the studio only at night for air and exercise; yet he was "so interested in his Studies he never complains of confinement or fatigue," she added, and would look forward to leisure only "when his very large paintings are advanced further." Nevertheless, home held distractions, and Whistler eventually availed himself of an offer to share a studio "more favorable for light," Anna Whistler explained. "It was rather a sudden move."[69]

The agent of Whistler's escape was Frederick Jameson, identified by E. W. Godwin in the *Building News* as "one of our youngest practising architects," showing great promise of "future success."[70] Whistler may have known him from Paris days, and Jameson had purchased one of his paintings, *Crepuscule in Opal: Trouville* (1865), for twenty-five pounds. In 1866, when E. J. Poynter (another member of the Paris set) had married, Jameson took his rooms at 62 Great Russell Street, and shared them with Arthur Murch until that artist was compelled to leave London for his health at the end of 1868, providentially

making room for Whistler.[71] Like Edward Burne-Jones, the tenant before Poynter, Whistler would have taken as his studio the front room on the first floor, which overlooked the forecourt of the British Museum and afforded "a better painting light than usual," according to Georgiana Burne-Jones. Otherwise, the house had little to commend it: the sitting room looked out upon the back wall of a house that was "blotched in a leprous way," and the third room, presumably a bedroom, was extremely small.[72]

Yet for Whistler, relocating to Bloomsbury was full of possibility. The move established distance from his mother, who had resolved not to complain about being left so much alone, but whose very silence must have seemed to Whistler a reproach. It also meant proximity to the Elgin Marbles, housed across the street, and to Albert Moore, who lived nearby in Fitzroy Square. Symbolically, Whistler's temporary relocation made a break with the past, in particular with Rossetti, whose methods in comparison with Moore's must now have seemed to Whistler as instinctive and undisciplined as those of his own degenerate youth. Rossetti, for his part, did not think much of Whistler's new companion. "As for Moore there can be no doubt that he possesses certain gifts of drawing and design (in its artistic relation) in an admirable degree," he wrote to a patron in April 1868, damning with faint praise. By way of qualification Rossetti added, "I have not seen anything of his done lately." Evidently, Whistler had done nothing to alter Rossetti's earlier assessment of Moore as "a dull dog."[73]

Though the interlude was fated to end in frustration, Jameson remembered the seven months he lived with Whistler as a period of perfect harmony. "We lived in great intimacy, and the studio was always open to me, whatever he was doing. We had all our meals together, . . . and I never heard a complaint of anything in our simple household arrangements from him. Any little failure was treated as a joke."[74] Unfailingly companionable and good-natured, Whistler was especially courteous to the professional models he hired to pose for his pictures, including Augusta Maria Jones, known as Gussie, whose sister Milly had appeared with Jo Hiffernan in *Symphony in White, No. 3*.[75] The models were paid a shilling an hour (more, in those days, than the typical wage of a seamstress) and well fed for their labor, as Anna Whistler noted in a letter that December, telling why she was observing certain household economies. There was also rent to pay and materials to buy, and despite Whistler's "self sacrifice," his sojourn on Great Russell Street proved extremely expensive. "In short," as he himself summed up the situation, "a continued outgoing and nothing coming in."[76]

The works that Whistler had in progress, Jameson recalled, were "some Japanese pictures," presumably the Projects, and particularly *The Three Girls*.[77] Thomas Armstrong, who had moved to London from Manchester, visited Whistler at Great Russell Street and witnessed him making careful drawings of figures "so that he might not be worried about his drawing while he was intent on getting the best quality and colour in the surface of his paint."[78] Although most of the working drawings would be destroyed, Thomas Way

FIG. 2.17 *Nude Study for "The Three Girls"* (M359), ca. 1869. Black and white crayon on brown paper, 27.5 × 27.5. Freer Gallery of Art, Smithsonian Institution, Washington, D.C. (02.189).

recovered one from Whistler's wastepaper basket (fig. 2.17). An elaborate study for the central figure in *The Three Girls*, it exactly matches Baldry's description of those made by Moore in black-and-white chalk on a sheet of brown paper approximately thirty centimeters high, drawn at an early point in a project primarily to establish the model's pose. Whistler's drawing has masses of pin-holes along the sides, which suggests his frequent reference to it as he struggled with the painting over many years.[79]

Such studies, when perfected, were enlarged to full-size cartoons, which Armstrong also mentions having seen in Whistler's studio. In these, the features and proportions of the figures are altered to compensate for the inevitable deficiencies of human models — the purpose being to improve on nature: William Whistler, who had settled in London in 1865, remembered his brother posing a model beside a skeleton, "with a bust of the Venus de Milo at hand," presumably as a necessary corrective. The figures' faces were thus transfigured, like those of Albert Moore's, into "the low-browed, broad tempered, sweetly gentle and tenderly grave faces that the nameless sculptor knew and loved and handed down to us through the Aphrodite found at Milo."[80] The completed design would then be transferred to the canvas by laying the cartoon on top, pricking the lines with tiny holes, and dusting the surface with powdered charcoal. Whistler transposed the composition of *The Three Girls* to "an

FIG. 2.18 *Standing Nude* (M357), 1869. Pounced cartoon; black crayon with touches of white chalk on brown paper, 119.4 × 61.4. Freer Gallery of Art, Smithsonian Institution, Washington, D.C. (04.66).

ordinary white primed canvas" in just this way, outlining the adumbrations of the figures in red.[81]

No cartoon for *The Three Girls* survives, but another example from the same period, pricked for transfer, gives proof of Whistler's practice (fig. 2.18). This highly finished nude with idealized features appears anomalous in Whistler's oeuvre, and so much closer in style to the works of Albert Moore "as to suggest," writes Margaret MacDonald, "a certain level of collaboration between them."[82] The figure was intended to be "clad in thin transparent drapery," Whistler said in 1869, and the composition completed with "a lot of flowers and very light bright colors."[83] A corresponding oil sketch (fig. 2.19) indicates the color scheme and placement of the flowers—a spray of pink azalea around the figure and purple iris in a vase. Had the painting come to fruition, it would have recalled *La Princesse du pays de la porcelaine*: this figure also holds a Japanese fan and stands before a flight of others pinned upon a wall. It may likewise have been conceived as an homage to a treasured source of artistic inspiration, the Greek terracotta statuettes from the fourth century B.C., called Tanagras.[84] Whistler's standing figure with a fan, a chiton draped across one arm, resembles one Tanagra figurine in particular, from the collection of Aleco Ionides, a photograph of which Whistler preserved in an album.[85]

If eventually the cartoon would have evolved into a painting resembling the oil sketch now titled *Tanagra*, in its unfinished state it more closely resembles a contemporary painting by Albert Moore, *A Venus* (fig. 2.20). Moore's work appears to take its pose from a then-famous nude by Ingres, *La Source* (1856): as Alison Smith has noted, the indefinite article in its title was probably employed to transfer the viewer's attention from "the mythological Venus to the decorative alignments of the figure."[86] Moore's painting was commissioned by Frederick Leyland, apparently on Whistler's recommendation (he had adopted Rossetti's generous habit), but Leyland had not yet seen the work when it went to the Royal Academy in 1869. There was controversy among members of the hanging committee over its acceptance, settled only when Frederic Leighton threatened to withdraw his own exhibits if *A Venus* were rejected; but upon its exhibition, Whistler assured Leyland that he possessed "the most beautiful work in the Academy—no that would be saying nothing—I mean one of the most marvelously perfect things that has been produced." He could not be too enthusiastic about it, he said: the painting was faultless, "one of the finest things in England."[87]

Whistler's own standing nude, to which the title *Venus* was later attached to mark its similarity to Moore's painting, offers a further sign of stylistic reciprocation and mutual regard. A primitive form of the butterfly monogram appears in a square at the lower right of the composition, Whistler's first use of that cipher. Albert Moore had signed his own works with a stylized Greek anthemion since 1866, but in *A Venus* he places the device (with the date) in a Japanese-style cartouche. When the next year Whistler's butterfly emblem made its public debut with *The Balcony* (see fig. 1.11), a critic for *The*

FIG. 2.19 *Tanagra* (Y92), ca. 1867–70. Oil on canvas, 31.1 × 17.5. Maier Museum of Art, Randolph-Macon Woman's College, Lynchburg, Virginia, Fine Arts Fund, 1953.

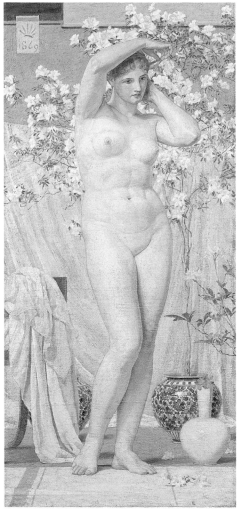

FIG. 2.20 *A Venus*, 1869, by Albert Joseph Moore (1841–1893). Oil on canvas, 63.0 × 30.0. York City Art Gallery, England.

FIG. 2.21 *Symphony in Blue and Pink* (Y86), ca. 1868. Oil on millboard mounted on panel, 46.7 × 61.9. Freer Gallery of Art, Smithsonian Institution, Washington, D.C. (03.179).

Times remarked "the queer little labels with bloody hands upon them which Mr. A. Moore and Mr. Whistler and *their* followers love to stick into the corners of their pictures like a postage stamp."[88] Whistler intended to use the device on *The Three Girls* as well: its placement is indicated by the pinkish block on the left side of the oil sketch (see fig. 2.7) and confirmed by the butterfly emblem that figures in a pen-and-ink drawing of the composition (see fig. 2.12).

If the similarities between Whistler's and Moore's works in this period seem obvious, Whistler himself appears not to have suffered the anxiety of influence before September 1870, when he saw "two beautiful sketches" by Moore for a further pair of paintings that Leyland had commissioned. "It struck me dimly," Whistler wrote to Moore in response, in a tortured syntax communicating his discomfort with the subject, "perhaps—and with great hesitation —that one of my sketches of girls on the sea shore, was in motive not unlike your yellow one—of course I dont mean in scheme of color but in general sentiment of movement and in the place of the sea—sky and shore &c—" Whistler was thinking of one of the Projects, the painting later titled *Symphony in Blue and Pink* (fig. 2.21), in which the second figure from the left approximates the windblown figure in *Seagulls* (fig. 2.22), the painting that resulted from one of Moore's sketches.[89]

Whistler proposed that the architect William Eden Nesfield, a close friend of Moore's, be asked to arbitrate the matter. After serious deliberation, Nesfield determined that any superficial similarity between the works could better be ascribed to aesthetic affinity than reciprocal influence: "There can be no danger from the vulgar fact of there being shore, sea, & sky & a young woman walking on the foreground."[90] Moore appears to have accepted Nesfield's

judgment and proceeded to prepare *Seagulls* for the 1871 Academy, but Whistler left *Symphony in Blue and Pink* unfinished. Perhaps his fears were not entirely allayed. Once uncertainty took hold, it proved difficult to dislodge, forming yet another impediment to completing the long-awaited painting for Leyland, *The Three Girls*.

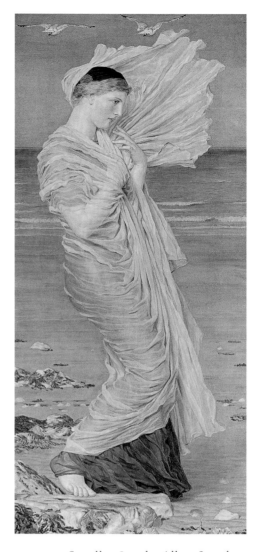

FIG. 2.22 *Seagulls*, 1871, by Albert Joseph Moore (1841–1893). Oil on canvas, 155.0 × 69.0. Williamson Art Gallery and Museum, Birkenhead, England.

Whﻴﻟﻪ WORKING in Bloomsbury, Whistler was acutely self-critical, "painfully aware of his defects," especially in drawing. He confided his doubts to Jameson, who wrote Joseph Pennell in 1906 that he hoped to speak with him in person, "because in some ways I believe that very few men now living have heard [Whistler] talk in the way he talked to me. To my judgement he was the most absolutely truthful man about himself that I ever met."[91] Armstrong, too, had been struck by Whistler's keen self-knowledge, which had led to some despair. He recollected one evening in particular, when he watched Whistler remove wet paint from a canvas with a palette knife and wipe the surface clean, thereby eradicating an entire day's work on *The Three Girls*. When Armstrong remonstrated that Whistler might at least have waited till morning, the artist answered, "No. If I had left it till to-morrow I might have persuaded myself that it was good enough to leave permanently." Even Frederick Leyland had been delighted with the picture, when once he saw it in the studio and it appeared to be nearly complete. Indeed, Whistler confessed, everyone was "highly pleased with it—except myself. Instead of going on with it as it was, I wiped it clean out, scraped it off the canvas and put it aside."[92]

Whistler's perfectionism grew out of a conviction he shared with Albert Moore, that a finished work of art should bear the aspect of "a happily contrived and expressive sketch."[93] This opposed the Pre-Raphaelite practice of making innumerable changes to a composition, sometimes over several years, to render it ever closer to reality. The philosophy also affronted the Victorian work ethic. The aspect of effortlessness was to become a controversial hallmark of Whistler's style, with serious consequences in his libel suit against Ruskin in 1878, but Swinburne had recognized it as a virtue of Whistler's work as early as 1868. Of the paintings then in progress, he wrote: "They all have the immediate beauty, they all give the direct delight of natural things; they seem to have grown as a flower grows, not in any forcing-house of ingenious and laborious cunning. This indeed is in my eyes a special quality of Mr. Whistler's genius; a freshness and fulness of the loveliest life of things, with a high clear power upon them which seems to educe a picture as the sun does a blossom or a fruit."[94]

The "forcing-house" image undoubtedly arose from the conceit of *The Three Girls*, a painting as contrived, as Swinburne would have been aware, as any hothouse flower. The spontaneity was all in the seeming, and Swinburne

FIG. 2.23 *Study for "Tillie: A Model"* (M369), 1870/73. Chalk on brown paper, 30.1 × 20.1. Hunterian Art Gallery, University of Glasgow; Birnie Philip Gift.

subtly acknowledged that the illusion had been achieved only through expenditure of effort. Whistler's ambition was to sustain the "freshness" of the sketch through the finishing stages, for evidence of industry in art appeared to him "a blemish, not a quality; a proof, not of achievement, but of absolutely insufficient work, for work alone will efface the footsteps of work." To Whistler's thinking, "The masterpiece should appear as the flower to the painter—perfect in its bud as in its bloom."[95]

The whole purpose of Whistler's retreat to Bloomsbury had been to complete *The Three Girls* for the 1869 Royal Academy exhibition. As the first to be held in new premises at Burlington House, it promised to draw exceptional crowds.[96] And "as he could not Exhibit last May," Anna Whistler wrote to a friend in December 1868, "so his reputation seems hanging on the work of the next three months!" And yet, as she ruefully defined his incapacitating pursuit of perfection, Whistler never seemed to "satisfy his own difficult standard of Art."[97]

When Whistler realized that he could not possibly get *The Three Girls* to the Academy committee on time, "he was awfully down," Jameson recalled, "and there was a morning of despair."[98] On the afternoon of March the tenth, desperate with disappointed hopes, Whistler surprised his mother with a visit, appealing for her assistance. "Leyland must be written to," he said (Anna Whistler recalled his plea verbatim), "but I cannot do it. You can dear Mother for me, & I am sure you will try to relieve my mind that far." And so, on his behalf, she wrote a letter to Whistler's patron. "Yesterday the conviction was forced upon him that he should only ruin his work by persevering now in vain attempts to finish your picture, & that he must set it aside til he should be in better tone, mortifying tho it be to him that it is not to be exhibited this season." She conveyed her son's promise to repay the sum advanced (four hundred pounds, which Whistler proposed to borrow from his half-brother George in America) and sent his assurances that the commissioned work would be finished upon his return to Chelsea, before he began anything new: "Only beg him to believe I have not failed to do so before now from lack of endeavour to gratify his wish and my own." Anna volunteered the opinion that Whistler's failure was a consequence of working on Sundays, yet she sympathized with his sorry plight. "If mortal energy & industry could have accomplished it, his might, he has worked so hard night and day to attain his ambition, his first motive to please you who have been so indulgently patient."[99]

Leyland's reply, which does not survive, seems to have reaffirmed his patience as a patron, for it was composed in what Whistler described as a "kind and sympathizing tone." Yet Whistler responded only after learning from Rossetti that Leyland had fallen seriously ill. "How gladly I should run down to talk with you instead of sending this miserable scrawl—which cannot express the affection I feel," he wrote, belatedly. "If I am only able to show part of it feebly in the picture one of these days I shall be less pained than I am at present because of its long delay."[100] He himself had never been better: after a

The Perfection of Art

few Turkish baths to relieve his neuralgia, he was fully "himself again," according to his mother, and by the beginning of May all anxiety over *The Three Girls* was a thing of the past. He even attended the opening of the Academy exhibition, an occasion that might have been expected to encourage fresh despair. "You'd have fancied he was rejoicing over his own success," Anna Whistler remarked, all amazed, "with so much zeal did he enjoy the days holiday."[101]

The success belonged to Albert Moore, whose *Venus* seems to have inspired Whistler to return to the studio "intent upon perfecting his *drawings*," Anna explained: "painting pictures will be his delight soon as he masters the *foundation*." It was probably in this period that Whistler produced scores of sketches in chalk on brown paper—studies of the individual figures, both nude and draped, that were to compose *The Three Girls*. Several survive of the left-hand figure, for which the model Tillie Gilchrist was hired to pose (fig. 2.23). According to Way, Whistler's studio was papered with such sketches, just as Albert Moore's "was full of such work," or so he had been told, "pinned to the walls."[102]

By June 1869, Whistler was back in Chelsea, with little to show for his months away and deeper than ever in debt. To Thomas Winans, a family friend who Whistler hoped would lend five hundred pounds, he said that his situation was discouraging, but not hopeless. "The result of the education I have been giving myself, these two years and more, will show themselves in the time gained in my future work," he wrote, promising productivity. As for *The Three Girls*, he intended soon to start it "all over again from the very beginning!—But with a certainty that will carry me through in one third the time!"[103] This optimism may have been meant to assure Winans that his investment would be safe, yet Whistler sounded a surprisingly positive note even to George Lucas, who held no such stake in his future. "Tant pis," Whistler wrote, expressing only the slightest regret at having failed to complete his work for the Royal Academy that spring, "for I should much have liked to have been among the set in this new place—enfin—next year."[104]

Whistler did submit something in 1870, but not *The Three Girls*, which remained suspended in a state of aspiration. The work he sent to the Academy instead was *The Balcony* (see fig. 1.11), which, as we have seen, had been in progress even longer than *The Three Girls*. When he began it in 1864, Whistler was vacillating between a new fascination with Asian art and an ingrained inclination to depict the modern scene; he brought those incompatible concerns together in *The Balcony* by depicting, beyond the Japanese tableau, the actual view from his window—the smokestacks and factories of Battersea, fading into the fog. Whistler had signed and photographed the painting in 1865, presumably before delivering it to the patron, G. J. Cavafy, but he was to borrow the picture many times to make revisions and each time "added to its worth," he said, "until at last I had more than quadrupled its value."[105] William Rossetti saw *The Balcony* at Lindsey Row in 1867, the year Whistler wrote Fantin-Latour of his intention to enlarge it for the Paris Salon.[106] But that proved

FIG. 2.24 *Sketch for "The Balcony"* (Y57), ca. 1869–70. Oil on panel, 61.0 × 48.2. Hunterian Art Gallery, University of Glasgow; Birnie Philip Bequest.

another unrealizable ambition, and by 1870 Whistler's career had reached a point of crisis. Because William Whistler's medical career was also foundering, the household had never a penny to spare, Anna Whistler confided to her sister. "They occupy their time & talent now for future advantage, they work so hard, with their minds intent upon rising in the scale of medical science & Artistic attainment, we must wait patiently for the harvest."[107]

It was probably during this period that Whistler began a second version of *The Balcony* with essentially the same composition as the first, but with an aesthetic tenor and color scheme more in keeping with his recent works (fig. 2.24). In the new rendition, the cityscape loses specificity but gains a pastel tonality consistent with the foreground tableau; the central standing figure who in the first version had worn the costume of *La Princesse* appears here dressed in the fashion of *The Three Girls*. This revision of *The Balcony*, also meant

to be enlarged, was ultimately left unfinished. Yet the exercise seems to have inspired Whistler to augment the "worth" of the original, adding more blossoms, a new signature, and several little butterflies that flutter through the scene. In preparation for its Academy debut, therefore, Whistler had artfully integrated the Japanese and London realms of *The Balcony*, signaling a partial reconciliation with realism. Impoverished and defeated by recent failure, Whistler amended his motives, returning his attention to the world around him and discovering the beauty intrinsic to modern life.

The imitator is a poor kind of creature. . . . It is for the artist to do something beyond this: in portrait painting to put on canvas something more than the face the model wears for that one day; to paint the man, in short, as well as his features.

"The Red Rag," *The Gentle Art of Making Enemies*

\mathcal{A}T THE HEIGHT of their dispute over the Peacock Room, Whistler predicted that Frederick Leyland would be remembered only as the owner of the work whose price he had refused to pay. For the most part, that prophesy held true: because Leyland never publicly defended himself against the charges leveled by the artist, he has gone down in history much as Whistler intended, as a philistine whose taste for art was tainted by a love of money. But Whistler had painted an enduring image of his patron, *Arrangement in Black* (fig. 3.1), which can be taken as a token of his earlier esteem, if also as a portent of the trouble yet to come. In Whistler's portrait, Frederick Leyland appears as the artist first knew him: "not only a prosperous man in Liverpool," in the words of Whistler's mother, "but a very cultivated gentleman of taste." [1]

Frederick Leyland deliberately obscured the details of his background, consigning his past to the shadows from which he emerges in Whistler's portrait. One of the more illuminating versions of his life story is found in a quasi-biographical "portrait" of 1884, "sketched from memory, and filled in from fancy" by a fellow Liverpudlian, B. G. Orchard. Until the final sentence, when Orchard discloses the identity of his subject, Leyland appears as "Victor Fumigus," or Smoking Victory, a name that adumbrates the darkness that tarnished his success. [2]

"A boy of obscure birth," as Orchard puts it, Frederick Richards Leyland was born in Liverpool on 30 September 1831. He attested on his marriage certificate that his father was John Leyland, a bookkeeper, but as that was Leyland's own profession at the time, he may simply have noted the first occupation that sprang to mind, inventing respectability. Apparently, the Leyland family name was touched with infamy: Orchard relates the rumor that at some time in his youth, Frederick Leyland had been "offensively taunted at a dinner table respecting matters the opprobrium of which did not justly attach to him, and that he then vowed that a day should come when those who had wounded his haughty spirit should humbly seek his favour." [3] Beyond the mantle of silence

Detail, *Arrangement in Black* (fig. 3.1).

FIG. 3.1 *Arrangement in Black: Portrait of F. R. Leyland* (Y97), 1870–73. Oil on canvas, 192.8 × 91.9. Freer Gallery of Art, Smithsonian Institution, Washington, D.C. (05.100).

The Model Patron

that settles over Leyland's early years, the only clue to the origin of that "opprobrium" comes in a letter that Whistler wrote in 1880, soon after he had severed his relations with Leyland, which implies that his former patron's father had been "transported," presumably to a penal colony in Australia.[4] Considering the circumstances, and the source, this allusion to Leyland's criminal connections cannot be given too much weight, but neither should we dismiss the possibility that, during the period of their closest association, Leyland had confided family secrets.

The authoritative *Modern English Biography* (1921) states that Leyland's father died in 1839. Although this fact cannot be verified, it was presumably around that time that Leyland's mother (fig. 3.2)—whether by his father's death, desertion, or deportation—effectively became the "widow in needy circumstances" a contemporary report describes, with three small boys, one an infant, to raise alone.[5] A dozen years later, Ann Jane Leyland appears in the 1851 census report as a "maiden," age thirty-eight, living at 27 Seymour Street in Liverpool (her address since 1848), with two lodgers, a servant, and three children: Frederick, then nineteen; John Elphick, eighteen; and Thomas Alexander, twelve. There is no further record of the youngest boy's existence, but John became an accountant and eventually a manager of the English Assurance Company.[6] By 1861, Ann Leyland had gained respectability, possibly through the efforts of her sons, and in that year's census is named a widow, with the profession of "lady." None of her children was still at home, but she had two servants and was lodging a married couple there.

The enduring legend that Leyland's mother supported her family by selling pies in the Liverpool streets was recounted to Elizabeth Pennell in 1906 by Marie Spartali Stillman, who probably heard it from Gabriel Rossetti in the 1870s. Her account holds that "Bibby, the rich shipping man," was one of Mrs. Leyland's regular customers and that his avuncular interest in her son was vaguely attributable to Bibby's taste for Leyland's mother's pies: "Once he asked her what she was going to do with her son and, as her plans for him were vague, took the boy to sweep out his office and run his errands."[7]

In fact, Ann Leyland was neither so abject in social standing nor so passive a participant in the fate of her most promising child. A Liverpool contemporary, H. E. Stripe, tells of an eating-house on Chapel Street where the merchants in his firm, John Bibby & Sons, dined upstairs on the first floor, while "ordinary clerks" such as himself remained below. "Whenever I took my dinner there Mrs. Leyland always received the cash. She was a very pleasant and circumspect lady and had a word to say to most of her customers." It was his impression that she had spoken to Bibby about her eldest son's prospects even before bringing him to work one morning. Stripe had taken them into "the private office" to wait for Mr. Bibby, and fifty years later he could still recall remarking "what a shame it was for a mother to bring a little son such as Fred into a troublesome concern such as Bibbys"—little suspecting the boy's precocious talents or imagining his future success.[8]

At fourteen, Frederick Leyland was by all accounts exceptionally bright. Stripe regretted that the boy could not have stayed in school a few years longer, but Leyland had already exhausted the possibilities his Liverpool education had to offer. He had attended a boys' school run by the Mechanics' Institute on Mount Street (later the Liverpool Institute), founded in 1837 to offer a solid, secular education "on the lowest possible terms."[9] Leyland reportedly developed extraordinary mathematical skills there and a remarkable command of modern languages; "few lads of his years could be called his equals in general attainments."[10] The teenager may have entered Bibby's employ with motives of his own, for Orchard reports that even then, Leyland's ambition was "to become the superior of some commercial aristocrats whose behaviour to him and his had been less gentlemanly than that of his proffered patron."[11]

Leyland himself admitted to Rossetti that his professional life began with a stint as Bibby's office boy, though he may have told his children a different story. In a brief biography published after his death, Leyland's son-in-law Val Prinsep maintained that Leyland had joined the firm as an apprentice, "not as office boy, as has been asserted."[12] His initial tasks probably were chores like sweeping floors, running errands, and stamping letters; but it did not take Bibby long to recognize that the boy he had placed on the lowest rung of the ladder was made "not to run errands, but to organise and direct great enterprises." Leyland was accordingly apprenticed to learn the shipping trade through practical experience.[13] Small for his age when he came to the company, Fred began shooting up in stature. Stripe remembered how, a few years later, one of the partners stood the boy against a wall to measure his height and exclaimed in amazement, "Why Fred will you never be done growing?" Leyland's mind was expanding, Stripe supposed, at much the same rate.[14]

Founded in 1807, Messrs. Bibby, Sons, & Co. originally consisted of a small fleet of vessels that transported mail and passengers between Dublin and Liverpool. The company extended its operation in 1813, upon the abolition of the East India Company's monopoly of trade with India, and by 1839 twelve Bibby ships were engaged in packet service to Egypt.[15] When John Bibby died in 1840, his sons John and James Jenkinson Bibby took over, renaming the firm John Bibby & Sons. John's interest lay in the family's copper works at Birkenhead, so James assumed responsibility for the expanding shipping business. The young Leyland arrived in 1844, just before the repeal of the British Corn Laws lifted restrictions on importing wheat from Egypt and Russia; duties on Mediterranean produce were subsequently repealed as well. At first, importers insisted on using sailing ships, believing that steam would injure the flavor of their products. For a time, James Bibby also maintained that steamers in the Mediterranean "would never pay." But finally in 1851 a single steamship was built for trial, and it proved so successful that Bibby resolved to replace the entire fleet. During the 1850s, the steamships collectively called the Bibby Line were launched into the Mediterranean trade, ahead of most of their competitors.[16]

Retrospectively, Leyland was credited with bringing about that critically important shift from sailing ships to steamers. He is also said to have designed (or at least envisioned) the line of steamships known as "Bibby's boats," or sometimes "Bibby coffins." The deep and narrow design of these vessels rendered them unstable in storms, but it also allowed them to transport huge cargoes at low cost in coal. Other shipping companies scoffed, but the boats were immensely profitable. Leyland lived to see the design adopted by "all the great lines," Prinsep said, "and his ideas taken, often without acknowledgment." Company histories maintain, more credibly, that the designer and engineer of those ships was a different protégé, Edward J. Harland;[17] however, it is plausible that Leyland played a part in persuading Bibby to try steamers in the Mediterranean. Stripe doesn't say, but his account reveals that even at nineteen, Frederick Leyland was offering advice and "working his way gradually into the good graces of Mr. James."[18]

In earlier days, Leyland had confided to Stripe his intention "to make a fortune and then retire for he did not intend to spend all his life in business," and with that ambition in mind, Leyland began telling tales about his colleagues. His first target was Robert Lawn, manager since 1835, who had taught Leyland bookkeeping; Lawn resigned in 1851, "disgusted at the conduct of Fred R. Leyland who was just then pushing himself into note and endeavoured to supplant him." Such was the manner, said Stripe, in which Leyland showed his gratitude, and such would be his behavior all his life "to any one who stood in his way." Stripe may have been biased, but his account accords with other tales of Leyland's business practices. Leyland himself would have regarded the loss of such coworkers as Lawn or Richard Martyn, another loyal employee whom Leyland "soon eclipsed," as a kind of natural selection, part of the predetermined scheme of his ascendancy.[19]

Over the years, Leyland occupied virtually every position in the firm, rising from office boy to bookkeeper by 1855, to clerk by 1857, to merchant by 1859. As the author of his obituary reflected, Leyland "allowed no ordinary difficulty to check his progress, but was always self-reliant and thoroughly indifferent to the opinions of others; indeed, his independence was a very prominent characteristic."[20] Accounts of Leyland's life consistently emphasize his dedication to work, in contrast to other clerks in the company whom Stripe characterized as "a very boozing lot," given to playing cards at Liverpool public houses. Leyland learned all he could about the Mediterranean region and persuaded Bibby to let him travel to the ports where they did business. Recognizing that a further knowledge of languages would make him indispensable, he went to night school (probably at the Liverpool Institute, which offered evening classes for working men) to master Spanish and Portuguese; he also knew French and is said to have spoken perfect Italian.[21]

Eventually, the Bibby brothers turned over the Mediterranean enterprise to Leyland, for Orchard observes that "even then, his imperious nature, conscious of superiority and impatient of interference, had asserted itself so strongly

FIG. 3.2 *Leyland's Mother* (K103), 1873. Drypoint, 22.6 × 15.0. Freer Gallery of Art, Smithsonian Institution, Washington, D.C. (98.402).

that they thought a good deal before daring to modify any arrangement he had suggested." Under Leyland's direction, "rivers of opulence" flowed into the firm, and his income increased accordingly: soon after taking his place "in the private office," he shrewdly requested a share in one steamer, to be paid from its profits, and as the Bibby Line gradually superseded its competitors, he acquired shares in every steamer in the fleet.[22]

The turning point in Leyland's career came in 1861, when he handled a dispute between John Bibby & Sons and the Birkenhead Corporation, which wanted to purchase land occupied by the family's copper works. The Bibbys "left themselves in the hands of Mr. Leyland," who presented their case so skillfully to the arbitrator that the resulting judgment was "greatly in favour of the firm."[23] Sir Hugh Cairns, a brilliant politician, praised Leyland's performance and declared that if he had chosen to be a lawyer, Leyland would surely have risen to become lord chancellor—the position that Cairns himself assumed shortly afterward.[24] Leyland's abilities in the Birkenhead action also won him the gratitude and confidence of his employers, who admitted him into partnership when his apprenticeship expired and altered the name of the firm to John Bibby Sons & Co. And so, the story goes, "the son of the chop house keeper entered the firm," taking his place among the wealthiest citizens of Liverpool.[25] Exactly when the partnership was founded is difficult to determine from the welter of conflicting accounts, but it may have been in 1864, when the Bibby family history recounts that "adjustments" were made to the original partnership, resulting in the separate management of the copper works (relocated to St. Helens) and the shipping firm, whose offices were on Water Street. One year later, James Bibby decided to retire to Shropshire. He rarely ventured back to Liverpool, and Leyland ran the company almost single-handedly in his absence. With the opening of the Suez Canal in 1869, Leyland perceived the need to seek trade beyond Suez or with the United States, but Bibby possessed neither the vision nor the ambition to bring that expansion about, and Leyland began negotiations to buy out his partners.[26]

Under the articles of agreement, the partnership was due to dissolve by "effluxion of time" at the end of 1872.[27] That November, Leyland wrote to both Whistler and Rossetti that he had been "worried and anxious" over recent disputes with his partners but had succeeded in dictating his own terms. "I have at last carried my point and got quietly rid of them, and they leave me in full possession on the 1st January when I shall hoist my own flag and carry on the business in my own name."[28] Rossetti replied, "No doubt it was a hard push, but I should have expected precisely this result, unless indeed you had transported them for life into the bargain."[29] Leyland is said to have fought to keep the Bibby name, as would have been the usual business practice, and having won the battle determined to use his own. But the letters he wrote to his friends in London imply that converting the Bibby Line to the Leyland Line had always been part of his ambition. Leyland told Whistler that at the end of December the brass plate would be removed from the office door and "the name of Bibby

and all belonging to them consigned to the limbo of forgotten things."[30] According to Liverpool lore, on the morning the transfer took place, Leyland installed a new plate inscribed "F. Leyland" in large letters and dispatched the old one, with his compliments, to Mr. Bibby. With his acquisition of the firm (for which he paid his partners "some enormous cheque," according to C. A. Howell), Frederick Leyland came into possession of twenty-one steamers and a tug, finally becoming, in Prinsep's words, "supreme autocrat and ruler."[31]

I n Art as in business," Val Prinsep declared, "Leyland's education had to be formed. Art is a matter of education, and however firm a conviction may be, it is not arrived at in a moment."[32] Just when and how that education began, Prinsep does not disclose, but it is possible that Leyland's introduction to art had come with his introduction to business, from one or both of his employers. Stripe gives an account of a business call to John Bibby's Allerton estate in the days when he and Leyland were both clerks. Stripe had looked around Bibby's drawing room and, pointing out a painting above the mantel that depicted the inside of a stable, observed that "Mr. John" did not display much taste in pictures. "Leyland broke out in a very snarling way condemning them all excepting a small painting placed on [one] side of the chimney stack stuck out of sight which he said was worth more than all the others together. It was by an Italian artist."[33]

Stripe's story tells more about Leyland's arrogance than Bibby's aesthetic taste, which may not have been so very different from his clerk's. In 1867, Bibby bought a Rossetti drawing and arranged to meet the artist. Rossetti thought he had potential as a patron, having heard that Bibby had offered "huge commissions" to such artists as John Rogers Herbert, a portraitist and painter of historical subjects—"so let us hope," Rossetti wrote to Ford Madox Brown, "he may cut up well eventually."[34] As he must have done: by 1884, when F. G. Stephens detailed the holdings of Bibby's estate, the collection closely corresponded to Leyland's holdings at that time, even including a Rossetti watercolor related to *Lady Lilith* and a replica of *The Loving Cup*.[35]

Through Bibby, Leyland may have met the prominent Liverpool collector John Miller, and considering that Miller introduced Leyland to Rossetti, it is likely that Leyland "made his acquaintance with modern art and artists" through Miller as well.[36] It may also have been from Miller that Leyland adopted the very idea of patronage, for in addition to fostering the exhibition and sale of Pre-Raphaelite works in Liverpool, Miller sustained the careers of such local artists as William Lindsay Windus and William Davis. By 1858, when Leyland was beginning to accumulate his fortune, he might have seen at Miller's house such signal Pre-Raphaelite works as Millais's *Autumn Leaves* (1855–56) and Windus's *Burd Helen* (1856); the latter, the most famous Liverpool painting of the century, was among the works that eventually came into Leyland's possession.

Miller may also have initiated Frederick Leyland into certain collecting practices, since both men initially purchased pictures with the expectation of selling them for profit. Leyland's earliest acquisitions, mostly Romantic landscapes by Turner and David Cox, were expensive pictures of "undoubted beauty," as Prinsep described them, and popular with collectors. Profitably disposing of them in May 1872 yielded £15,500 that Leyland probably used to buy out his business partners; a second sale in 1874 raised money for new ships. But beyond speculation, Leyland may have used the sales to divest himself of the "objects of his early admiration" once his attention shifted to paintings from the second phase of Pre-Raphaelitism, "the extreme school of the emotional and decorative," works more in tune with Leyland's taste in music, which tended toward Wagner.[37]

For all his love of art, Frederick Leyland may have taken greater pleasure from his piano. Prinsep was given to understand that Leyland had purchased a grand piano with his first savings, but Stripe relates that he was given the instrument by a relative, which casts a doubt on the legendary deprivation of Leyland's youth. At his London house in Prince's Gate, Leyland was to keep one piano in his study and another (along with a harpsichord) in the drawing room. He is said to have practiced every morning before breakfast and to have eventually become highly proficient. Stripe heard him play the "Hallelujah Chorus" from memory and observed that "his long fingers enabled him to reach notes beyond the octave and give a good effect to a tenor." Even so, Leyland failed to acquire the skill to play his favorite pieces; in later life, he persuaded more accomplished musicians (possibly including his friend the Italian pianist and composer Luigi Albanesi) to sit beside him and perform the works of Beethoven according to his own interpretation.[38] Mastering the piano may have been the only personal goal that Leyland failed to achieve through sheer strength of will, and there is some poignancy in his unflagging dedication to the task, which Whistler could never comprehend. He told the Pennells that Leyland was always "portentously solemn and serious" about his music, describing how he would come home from the office and head straight for his piano without stopping to speak to a soul. One day, when Leyland had been practicing scales for what seemed like hours, a workman who happened to be there remarked (to Whistler's unending delight) that the master of the house "must be a light-hearted gentleman."[39]

The intensity of Leyland's focus on music may be related to his development of "an inner isolated life."[40] Leyland vehemently disliked "the society of the philistines," he wrote to Whistler on one occasion, restating his "old opinion that the safest place for man is to be content with his own company."[41] One contemporary imagined that Leyland believed his social isolation was due to the jealousy of his peers, but the animosity between him and Liverpool society seems to have run much deeper. According to Orchard, "His was one of those intense natures which, long after Fortune has been conquered, long after taunts and hasty sneers have been forgotten by their utterers, allow the string of early troubles to rankle in their hearts."[42]

The Model Patron

The "one real friendship" of Leyland's life is said to have been with Gabriel Rossetti: Prinsep conceded that Leyland may have admired other men, but he never heard him speak with equal enthusiasm about anyone else—except perhaps Thomas Alva Edison, whom Leyland met only once.[43] Evidently, the friendship meant more to Leyland than to Rossetti, whose life was comparatively crowded with close relations. Hall Caine, a Liverpool native who served for a time as Rossetti's assistant, could not imagine that the two had anything in common, but surmised that Leyland might have brought to Tudor House "an atmosphere of great adventures in a big world." Caine also recognized that as a patron, Leyland was to be encouraged. Indeed, Rossetti served as "painter-in-ordinary to the limited few," and lived on an income primarily from Leyland for nearly twenty years.[44] Among other benefits, the constancy of those commissions freed Rossetti from the need to subject his work to public exhibition and critical scrutiny.

For his part, Leyland derived satisfaction from feeling (as William Rossetti observed of his brother's patrons in general) that "all these fine performances would collapse without a purchaser to sustain them." It was mostly because of Rossetti that Leyland was able to assemble the celebrated collection that brought him recognition as a patron of the arts. Rossetti was a "Godsend" to "that very successful shipowner," or so Whistler would contend in 1892, rebutting Prinsep's opinion of the converse. "Without him," Whistler argued in favor of his old friend, "this wealthy person would never have been urged from his busy obscurity."[45]

FREDERICK LEYLAND married in March 1855, "purely from love," Orchard surmised, "and without reference to fortune or social rank." The bride was Frances Dawson, the twenty-year-old daughter of a master mariner (or the "captain of a small vessel," as Stripe describes him) and a resident of Toxteth Park, a working-class district of Liverpool.[46] Her parents, Thomas and Jane Dawson, were both from Northumberland, where Frances was born in 1836. A younger sister Jane was born around 1842 and the youngest, Elizabeth, in 1850.[47]

If Frances Dawson did nothing to enhance Frederick Leyland's wealth or social standing, she was reputedly charming and beautiful, and she was as lively and sociable as her husband was serious and aloof. Within a year of their wedding at St. Barnabas' Church, the Leylands had a son, Frederick Dawson, always known as Freddie. They were living then with Leyland's mother on Seymour Street, but by the time their second child, Fanny, was born in October 1857, they had moved to Huyton, not far from Liverpool. Florence was born two years later, at 104 Huskisson Street in Liverpool, and Elinor, the baby they called Babs, arrived in mid-October 1861.[48] By then the family had settled at

36 Falkner Square, not far from Frederick Leyland's mother, who had been reestablished on Falkner Street. Still under development, that middle-class neighborhood was composed of comfortable but undistinguished two-story houses. "In a region so recently peopled," a Liverpool historian observed of Falkner Square, "there can be nothing of interest derived from antiquity."[49]

In 1866, Leyland took "a fancy" to Speke Hall (fig. 3.3), an impractical, half-timbered manor house eleven kilometers outside Liverpool, advertised as "one of the most ancient and picturesque timbered mansions in England."[50] Originally surrounded on three sides by a moat and shielded from the city by an estuary of the River Mersey, the house possessed all the romance lacking from Falkner Square. In 1856, John Miller had shown it off to Ford Madox Brown as one of Liverpool's leading aesthetic attractions. Brown recorded the viewing in his diary:

> It rained pitiously [sic] & we did not see half the place inside or out, but enough to give us the idea of what a glorious old place it is. The interior of the quadrangle which is completely filled up with two fine ewe [sic] trees is one of the most beautiful places in the world I believe, the whole is built of cement & timber in a sort of small diapre [sic] pattern. Altogether it is quite true that the first batch of Elizabethan Architects were eminently artists.[51]

It would be a remarkable house for a man of new wealth to occupy, and in 1867, when the family was obliged to leave Falkner Square and Speke Hall was still available, Leyland overruled his wife's objections.[52] "Your address is quite an excitement," Rossetti wrote upon hearing the news, "a glory and a dream."[53]

Still one of the finest examples of timber-frame buildings in England, Speke Hall was built in stages between 1490 and 1612 by the Norris family. During the eighteenth century it passed by marriage to the Beauclerks and fell into neglect, recovering only in 1795 when a Liverpool merchant, Richard Watt II, bought the house and began its rehabilitation. Richard Watt V, inheriting the property in 1855, proceeded with the restorations, but he and his wife both died young, leaving work on the house unfinished and their only daughter an orphan. It was on behalf of that child, Adelaide, that the trustees of the Watt estate — the Liverpool solicitor George Whitley and Adelaide's great-uncle and guardian James Sprot, who was raising her in Scotland — had undertaken to lease Speke Hall in 1866. They advertised the house in the Liverpool papers as "an interesting specimen of Old English domestic architecture, rarely to be met with at the present day."[54]

Whitley and Sprot deemed several potential tenants unsuitable before Frederick Leyland applied in September 1867 and convinced his prospective landlords that the extent of his wealth matched the importance of the property. Rumor had it that Leyland possessed a magnificent antique silver service, which Whitley thought "would accord with the house" (fig. 3.4); that he had

FIG. 3.3 Speke Hall, Liverpool, 1867, photographed by M. W. H. Wilson. Liverpool Record Office and Local Studies Division.

recently purchased a pair of carriage horses at two hundred pounds a piece ("this however is rather dubious"); and that his partnership earned him an annual salary of twenty-five thousand pounds. Indeed, Leyland could easily afford the annual rent of Speke Hall—at £350, less than he had paid Rossetti the previous year for a single work of art.[55]

The Leylands appear to have relished their early years at Speke, a period marked by hospitality and displays of social conscience. Frederick Leyland contributed money to the Garston parish church, and in 1868 he offered to stage "a good blow-out" for the tenants after the Lancashire County Council elections (the trustees discouraged the idea, as it might have looked like coercion). Frances Leyland presented boots and frocks to the local schoolchildren on Christmas Eve 1869, then organized a sumptuous New Year's fête for them at Speke, where the "scholars" wore new clothes, ate plum pudding, and danced to the music of the Garston Druid's band. The Leylands were also popular with their neighbors, and in April 1870 invited so many guests to dinner that some of the horses had to be stabled at the village pub.[56] Altogether, it appears, while Frederick Leyland resided at Speke Hall, "the place was the talk of the neighbourhood."[57]

During his first year's tenancy, Leyland demonstrated his competence to serve as lord of the manor, and within weeks of taking up residence began an extensive renovation of Speke Hall. Accordingly, in 1867, the trustees extended his lease for seven more years in the hope he might "continue his improvements." He did this entirely at his own expense throughout his tenure at Speke Hall, having taken on the Watt tradition of historic restoration.[58] Among the rooms already restored was the Great Hall, or "banqueting hall," presumably the "Gallery 30 feet high" that Whistler mentioned in a letter.[59] Even without paintings on the oak-paneled walls, the space would have been imposing, yet the Leylands meant to use it as their dining room. During their first winter

FIG. 3.4 The Leyland plate, ca. 1870. Speke Hall, Liverpool.

at Speke, however, they discovered that the wind howled "dismally" through the room, and a warmer, smaller space in the west wing was prepared for everyday dining.[60] Leyland also converted a disused kitchen into a billiard room, a scullery into a library, and a storeroom (once a chapel) into a sort of family room, later used as a gun room, where shooting parties gathered during partridge-hunting season.[61]

In all his renovations, Leyland remained respectful of the architecture of Speke Hall, attempting to maintain its original charm. The decorative details of the new fireplace in the library, for instance, were borrowed from that of the Great Hall (though given a new inscription: "A Frende Loveth Atte All Tymes"). The lintels above the doors opening onto the refurbished west corridor were made to match some sixteenth-century examples in another part of the house, and the ponderous sandstone chimneypieces added to several renovated rooms were copied from a seventeenth-century mantel in a nearby manor house, the Old Hutte.[62] Leyland was correspondingly intolerant of the modernizations made by previous occupants. In February 1868 he took action against the blue drawing room, so extravagantly decorated that the family likened it to "a French plum box." The Louis xv–style furniture was banished to storage and the walls draped with fluted gray satin; a new fireplace was installed, with japanesque tiles and a brass-and-iron grate adorned with sunflowers.[63]

The only clearly contemporary decoration that Leyland imposed upon Speke Hall was wallpaper purchased from Messrs. Morris, Marshall, Faulkner & Co., the decorating firm of which Rossetti was a founding member. Leyland used all three of the patterns available in the 1860s: *Fruit* (or *Pomegranate*) on the library walls, *Daisy* behind the shelves and in a different color scheme in the

gun room, and *Trellis*, the most elaborate of the three, in the west corridor above a dark paneled dado.[64] Those early Morris designs appear so in keeping with the Elizabethan spirit of Speke Hall that Leyland's decision to use them might seem obvious, were it not for the fact that the patterns had not yet achieved popularity.[65] Indeed, Leyland's choice was so far in advance of popular taste that it seems likely Rossetti had a hand in the decoration of the house, even if his advice was dispensed from the distance of London.

Rossetti had been invited to Speke Hall soon after the family settled there, probably to help select the furnishings. He was to have been accompanied by two fellow members of the firm, Ford Madox Brown and Peter Paul Marshall (also the son-in-law of John Miller), but the excursion never came about—because of Brown and Marshall, Rossetti explained, who had each become indisposed or disinclined.[66] Georgiana Burne-Jones, noting that Leyland was "keeping Christmas at an ideal place" that year, hoped he would succeed in persuading his friends to help him enjoy it. Leyland, as she must have been aware, had urged Rossetti to spend New Year's at Speke, but the artist again discovered an excuse involving other people, so as not to offend his patron.[67] The trip was again postponed a few weeks later, when Rossetti complained of being "sunk deep in many miry ways of work & business." The next month found him haunted by "the demon Worry." "But I live in hope," he wrote to Leyland, "of soon coming yet."[68]

It was not until the summer of 1868 that the long-awaited visit took place, and by then Rossetti was unfit for work. His primary affliction seems to have been depression, with attendant delusions and insomnia exacerbated by a liberal intake of alcohol. C. A. Howell, who accompanied Rossetti to Liverpool, later defined his condition as "total and absolute indifference to *every thing*," a hopeless state that lasted seventeen days; Howell had been able to do nothing for him beyond limiting his brandy and keeping him "quite out of Leyland's way."[69] Some months later Rossetti ascribed that illness to anxiety over what he believed was failing eyesight and obliquely apologized to Leyland for his "seedy state" while at Speke. "You will not I am sure misunderstand me or think I underrate your friendship, when I say that I do not feel able to come to Speke again just now, as I am too nervous and worried to hold my own in any circle of friends, and to shut myself up like a bogie would increase my dumps."[70] As it happened, Rossetti never did return to visit Leyland in Liverpool, perhaps partly because of unsettling memories of the time he had spent there in 1868. But a letter written to Jane Morris the next summer reveals a further reason for dreading another spell at Speke: Leyland himself was "a good friendly fellow," Rossetti wrote, but the rest of the family was sure to make the visit "a sad bore."[71]

WHISTLER, IN CONTRAST to Rossetti, had cast his net for an invitation to Speke Hall from the moment he learned of Leyland's lease. "What a jolly country house yours must be," he wrote his new patron in the autumn of 1867. "One of these days I hope to see it."[72] Yet it was not until September 1869 that Whistler and his mother were asked to visit. Frederick Leyland had been confined to Liverpool by illness for several months and may have craved company from London; he may also have hoped that a journey out of town would improve Whistler's state of mind, facilitating the completion of *The Three Girls*. While the Whistlers were at Speke that autumn, some of the Leyland children came down with scarlet fever; Anna Whistler nursed them through, earning the family's undying devotion.[73] The more important consequence of the visit was that Whistler set aside *The Three Girls*, presumably with Leyland's blessing. When he returned to Speke Hall the next year, it was expressly to paint "a life-size full length portrait of Mr. Leyland his host."[74]

Whistler may have gone to Liverpool in 1869 intending to propose a portrait in substitution (or consolation) for the belated *Three Girls*. Some months earlier, when he was so distraught over failing to finish the work for Leyland that he resorted to his mother's intercession, Whistler had taken a desperate tour of the London art world with his obliging friend Frederick Jameson, who recalled their wandering "in and out of galleries and museums, until, at last, before Velasquez, in the National Gallery, Whistler took heart again."[75] At that time, there were only two works attributed to Velázquez in the National Gallery: *Philip IV Hunting Wild Boar* ("*La Tela Real*"), a panoramic view of the king's encounter with a charging boar, and a bust-length portrait of Philip IV (fig. 3.5), which had entered the collection in 1865. It was probably the latter, the "little head of Philip," that restored Whistler's spirits.[76] In the stern expression of the Spanish monarch, Whistler may have found a semblance of the Liverpool patron who was, at that moment, so much on his mind; for in the portrait he eventually painted, the turn of Leyland's head matches King Philip's, and his cold, dark eyes hold the same unflinching gaze (fig. 3.6).

Velázquez assumed new importance for Whistler at the end of the 1860s. His work had interested Whistler since at least 1857, when as many as twenty-two paintings attributed to Velázquez went on view at the Art Treasures Exhibition in Manchester. "Before that time I think we had all learnt to admire his *Infanta Margaret* in the Louvre," Thomas Armstrong recalled, "but Velazquez was not much talked about in those days." It was Whistler's experience in Manchester that inspired "the appreciation of the Spanish painter, whom he afterwards, so to speak, took into partnership."[77] Whistler and Fantin-Latour subsequently revisited the Velázquez paintings in the Louvre, and in 1862 Whistler set out for the Prado, intending to learn by heart everything he saw by Velázquez. As it happened, he got no further than the Pyrenees, but he vowed to complete the trip the next year with Fantin-Latour on what he called their holy pilgrimage. That plan also failed to reach fruition. Whistler never

FIG. 3.5 *Philip IV*, ca. 1656, by Diego Rodríguez de Silva y Velázquez (1599–1660). Oil on canvas, 64.1 × 53.7. The National Gallery, London.

The Model Patron

made it to Madrid, but he did obtain photographs of Velázquez paintings (as promised to Fantin-Latour), which he kept all his life and employed as inspiration throughout his career.[78]

Whistler confessed to Frederick Leyland that he was not "learned in the mass" of Velázquez's works, though he had formed "an ideal" of his art based on the handful of paintings that he did know well. Whistler's knowledge was put to the test in 1871, when Leyland asked his advice on a portrait of an unnamed soldier known as *The Corregidor of Madrid*, optimistically attributed to Velázquez. "The fact is my dear Baron," Whistler replied, "I do not recommend you to buy the picture as a fine Velasquez—now that I have seen it well—It certainly is a fine and most impressive picture—and I do not doubt that it is of that period—the scheme being one that at first sight and in the evening as was the case yesterday with me, would make one suppose he stood before a Velasquez sure enough—" Reexamining the painting by the light of day, Whistler found it to fall short of his criteria for authenticity: the drawing was weak, the color tones unconvincing, the execution heavy and awkward. Suspecting it to be either the work of a pupil or a contemporary copy (he was certain it was "an old thing"), Whistler deemed the painting unworthy of the name Velázquez: "For *me* it is *manqué*—for others it might still remain the fine picture it certainly *ought to be*."[79]

Leyland seems to have been willing to accept Whistler's verdict, but because of a confusion in the correspondence, he received the portrait in Liverpool, and in the end he decided to keep it. Perhaps the portrait looked authentic in the dim light of the Great Hall, for Whistler revised his own opinion upon seeing it there in 1871.[80] By 1882, the portrait was not only accepted as genuine but deemed "one of the most important works of Velasquez out of Spain," and two years later it was confidently exhibited at the Royal Academy.[81] But after that its fortunes fell. In 1892, because of questionable authenticity, the painting sold from Leyland's estate for £130 (less than half what it cost Leyland twenty years earlier), thereby validating Whistler's first instincts. The painting has long since disappeared.

Another presumed Velázquez greatly admired by the Victorians but later dropped from the canon is an equestrian portrait of the Conde-duque de Olivares. Owned in the nineteenth century by the Earl of Elgin, it is now in the Metropolitan Museum of Art, reattributed to Juan Bautista del Mazo, Velázquez's son-in-law. Whistler probably saw the *Olivares* in 1876 at the Royal Academy's *Exhibition of Works by the Old Masters*, when he may have made the sketch entitled *Souvenir of Velázquez*; it was at a dinner party that season that Whistler proffered his opinion that "art had reached a climax with [the] Japanese and Velasquez."[82] Many years later, in the quasi mythology of the "Ten O'Clock" lecture, Velázquez figures as a lover of the goddess Art, whose other favorite, we recall, was the Chinese porcelain-painter. Finding the Spanish artist in "the Gallery at Madrid," the goddess "promises that in after-years, others shall pass that way, and understand"—a pointed prophesy of Whistler's

FIG. 3.6 Detail, *Arrangement in Black: Portrait of F. R. Leyland* (fig. 3.1).

own unqualified devotion. Whistler documents this line of descent in his unfinished self-portrait in the studio (see fig. 2.5), in which he appears in a room full of porcelain, striking a pose that recalls the Spanish master in his most celebrated work, *Las Meninas*. The goddess, we infer, eventually made her way to Chelsea, to bestow upon Whistler "the power of creation, the heirloom of the artist."[83]

Because the currents of Whistler's subconscious often rise to the surface in the "Ten O'Clock" lecture, his effort to equate Velázquez's Spanish princesses "clad in inaesthetic hoops" with the sculptures of the Parthenon may betray an attempt at self-justification.[84] In taking up portraiture in the Velázquez manner, Whistler was compelled (or in any case permitted) to abandon the studio pictures that brought him so much grief in the latter 1860s—notably *The Three Girls*, in which he had aspired to the perfection embodied by the Elgin Marbles. After struggling so long with complex arrangements of female figures in color, Whistler must have happily undertaken the painting of a solitary man in black. He appears to have persuaded not only his patron but also himself that individual portraits were less a diversion than a solution to the problems besetting more complicated compositions.

Whistler had scarcely produced a painting since 1866, yet he set out for Speke Hall in August 1870 fully expecting to complete his portrait of Frederick Leyland within a matter of months. Four weeks after reaching Liverpool, he informed his mother that he was "getting on capitally," despite the fact that Leyland was not available for sittings during the working day. Anna considered this a blessing: Leyland's own unrelenting industry meant that Whistler could not "confine himself to his Easel as he does too closely in his own Studio here."[85]

During the idle hours of the day, Whistler became better acquainted with the Leyland family, which seems to have delighted in his company. Speke Hall was "full of kindness," he wrote his mother, though it looks forbidding in the single etching Whistler made that year (fig. 3.7), in which the south front of the house appears at a distance, sheltered by the bare branches of elm trees.[86] Rather than making an accurate portrait of the place (the image was not reversed), Whistler apparently intended to convey the mood of the manor house in winter. Frederick Leyland's absence is implied by the female figure isolated in the foreground—possibly Frances Leyland, whose pose and costume Whistler was to alter through ten variant states of the etching over nearly a decade, as if measuring a change in attitude toward the house.[87]

If Frederick Leyland was rarely at home, he did at least remain in Liverpool during the months Whistler resided at Speke. Rossetti had been expecting him to turn up in London as usual, "but I begin now to believe," he wrote Leyland that October, "that the society of the great Jemmy makes you sluggish as regards pleasures far afield." Rossetti himself had been working on pastel portraits of Leyland (fig. 3.8). He was pleased with the latest version, though he imagined it to be "far from able to compete with the last labours to which

FIG. 3.7 *Speke Hall* (K96), 1870. Etching and drypoint, second state, 22.5 × 15.0. Freer Gallery of Art, Smithsonian Institution, Washington, D.C. (98.332).

The Model Patron

FIG. 3.8 *Frederick Leyland*, 1870, by Dante Gabriel Rossetti (1828–1882). Crayon on paper, 48.26 × 40.64. Frame designed by the artist. Private collection, Great Britain.

Jemmy has doubtless been addicting himself to the like result."[88] Given his specialization in female faces, Rossetti would have been an unlikely choice to paint a full-length portrait of his patron. Still, he may have been annoyed to learn that Whistler had won that prize commission, since Whistler himself had never painted anything of the kind: his only previous commissioned portrait was the bust-length picture of Luke Ionides painted in 1859, and the only comparable full-length compositions were *The White Girl* and *La Princesse du pays de la porcelaine*, neither of which was technically a portrait at all.

As might have been expected, Whistler failed to finish Leyland's portrait during his 1870 visit, but commencing a new project seems to have pushed him through the impasse of his perfectionism. The next summer he began the inestimably famous portrait of his mother, *Arrangement in Grey and Black*. More important, he finished it. "If you could hear Mrs Hoopes describe the struggle Jemie has gone thru in his persevering work to *finish* pictures," Anna Whistler wrote her sister, "you would understand the transition from 'hope deferred which maketh the heart sick' to the cheering present and future work." The portrait of Mrs. Whistler had been accomplished with relative ease — perhaps,

FIG. 3.9 *Nocturne in Blue and Silver* (Y113), ca. 1871. Oil on canvas, 44.1 × 61.0. Fogg Art Museum, Harvard University Art Museums, Cambridge, Massachusetts; bequest of Grenville L. Winthrop (1943.176).

as the sitter herself surmised, because the artist had "no nervous fears" in painting it: "it was to please himself and not to be paid for in other coin."[89] Frederick Leyland's portrait was another matter, for Whistler was living in debt to his patron and must have been full of nervous fears.

If Leyland's liberal patronage occasioned some anxiety, it also enabled Whistler's creativity to flourish. Inspired by an unusually clear August evening in 1871, Whistler produced the first of his moonlight pictures of the Thames. The river had long provided subjects for his art, but in these poetic urban land-scapes, Japanese conventions control the presentation of a scene. Abbreviating the forms of barges or smokestacks to single, eloquent brush strokes, and limit-ing the palette to the narrow range of color that emerges at dawn or twilight, Whistler achieves a graceful synthesis of Japanese design and Western subject matter. That year, perhaps as a Christmas present, Whistler gave one of his early moonlight paintings (fig. 3.9) to Frances Leyland, whose husband, in return, gave Whistler the musical term that defines the genre. "I say I can't thank you too much for the name 'Nocturne' as a title for my moonlights," Whistler wrote to Leyland. "You have no idea what an irritation it proves to the Critics and consequent pleasure to me—besides it is really so charming and does so poetically say all I want to say and *no more* than I wish!"[90]

By October 1871, when the first of Whistler's Nocturnes (still titled *Harmony in Blue-green—Moonlight*) went on view at the Dudley Gallery, Whistler was back at Speke Hall, ready to resume his portraiture. Perhaps to prove that he could in fact complete a project, Whistler sent to London for his mother's portrait, which was ceremoniously unveiled in the Great Hall. Leyland's daughters exclaimed that the portrait was the picture of peace, and a

perfect likeness of the sitter: "Isn't it the very way Mrs. Whistler sits with her hands folded on her handkerchief! oh it is exactly like her!" The painting was hung between the presumed Velázquez and the still unfinished portrait of Frederick Leyland, and Whistler proudly reported to his mother "that the two portraits bore the comparison with the painting of the famous Spanish Artist to his satisfaction." To his pupil Walter Greaves he wrote, "They are in the improving company of a grand Velasquez you know, and it is saying a great deal when I am able to feel not ashamed of their bearing under such trying conditions."[91] Leyland must have been impressed by the assembly as well, since Whistler was soon engaged in painting a portrait of the patron's wife that was to be "as life like," Anna Whistler said, "as all think mine." Whistler also began a portrait of one of the Leylands' daughters, suggesting that he had been granted a commission to portray the entire family—just as Velázquez, the Pennells pointed out, had painted the wife and children of Philip IV.[92] But in the end, Whistler only finished to his complete satisfaction the portrait he had first begun, that of the paterfamilias himself.

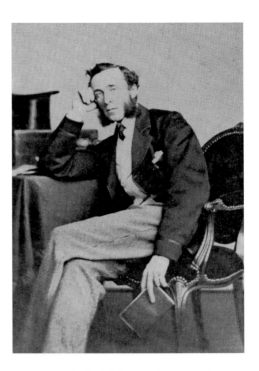

FIG. 3.10 Frederick Leyland, ca. 1866. *Carte de visite* by J. R. Parsons, formerly in the possession of Gabriel Rossetti.

FREDERICK LEYLAND'S contemporaries consistently describe him as tall, stylish, "almost showy."[93] A *carte de visite* that Leyland gave Rossetti early in their acquaintance shows him in side whiskers and formal clothes—tails and a top hat—with remarkably long, thin legs and fingers (fig. 3.10). An oil sketch embodying an early conception of Whistler's portrait portrays a more mature man, fully bearded and sturdily authoritative (fig. 3.11). Leyland wears a fashionably short frock coat that breaks up the long lines of his figure, which forms a black silhouette against a vacant gray wall.[94] In what appears to be a subsequent study for the portrait (fig. 3.12), Whistler accentuates the elegance of Leyland's slender form: the lower viewpoint makes the most of his imposing stature, and the evening clothes set off, rather than disguise, his attenuated profile.[95]

The pose chosen for the second study, only slightly modified in the final work, is reminiscent of the attitude taken by Philip IV in a full-length Velázquez portrait of which Whistler owned a photograph (fig. 3.13).[96] Philip IV had made black the official color of the Spanish court, and the fashion had spread to England and the Netherlands. The works of Hals, Van Dyck, and Rembrandt that appear to have influenced Whistler's style of portraiture are populated by men in black. In the Victorian age, a parallel period of commerce and prosperity, black came again to dominate male fashion. It had been introduced early in the century by the "Dandiacal Sect," in Thomas Carlyle's phrase, whose exemplar was Beau Brummell, famous for the extraordinary pains he took with his dress, which was simple and elegant and very often black. Although the word "dandy" now connotes excess, it originally signified impeccable appearance and attention to the cut and quality of one's clothes, attributes for which Frederick Leyland was renowned.[97]

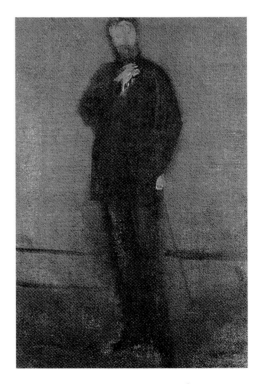

FIG. 3.11 *Study in Grey: Portrait of F. R. Leyland* (Y95), probably 1870. Oil on canvas, 30.5 × 21.0. Private collection.

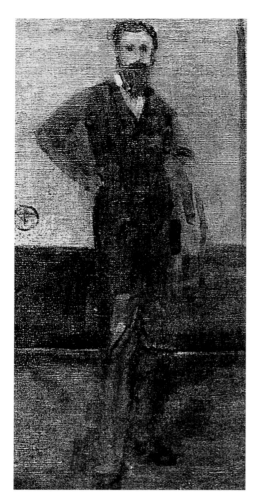

FIG. 3.12 *Portrait Sketch of F. R. Leyland* (Y96), ca. 1870. Oil on canvas, 36.8 × 22.9. Present whereabouts unknown.

"Endowed with a by no means ungraceful person, and a striking countenance, he has not disdained to do what has in him lain to heighten the charms with which nature has blessed him," a contemporary journalist wrote of Leyland. "No tailor would, we are sure, dare to take liberties with him; a discerning haberdasher, whom he honoured with a visit, would, we feel, hasten to place the choicest and most brilliant treasures at his disposal."[98] Hall Caine defined Leyland as "an unaccountable dandy of the type of the earliest days of Disraeli," and could not make sense of the disparity between his sartorial refinement and his humble origins. But dandyism, as John Harvey explains in *Men in Black*, manifested a self-respect that was independent of social status. For Leyland, the style afforded a means of displaying the taste, and the wealth, he had acquired through his own efforts. It was rumored in Liverpool that he wore a new pair of kid gloves every day.[99]

Whistler's portrait of his patron as "a gentleman in evening dress, relieved only by the white of the shirt and the grey of an overcoat hung over the arm," appears to have fixed Leyland's image for the rest of his life: by 1898, when "an elegant-looking man in a peculiar kind of evening dress" makes an appearance in Theodore Watts-Dunton's roman à clef *Aylwin*, there would have been little doubt as to whom the character (called Symonds) was meant to represent.[100] The principal peculiarity of Leyland's costume was the ruffled shirtfront, another mark of the dandy. In time, Leyland's white cambric ruffle became his attribute. Whistler was to include this detail even in casual sketches of his patron asleep in a chair (fig. 3.14), and the observation that Leyland was the last man in Liverpool—perhaps all of England—to habitually wear a frill is noted among his professional achievements in *Modern English Biography*.[101] Indeed, evening shirts with ruffles were already on their way out of style when Whistler began Leyland's portrait in 1870; by the time he exhibited it in 1874, they were unusual enough for Rossetti to predict that the picture might "set the fashion in frills."[102] In Whistler's image, the frills form a luminous wedge that seems to light up like a torch "those long features, that dark hair, that luxuriant beard, those keen piercing eyes, that stern brow, and that massive forehead," as Orchard describes Leyland's aspect, matching his appearance in the portrait point by point.[103]

According to Frances Leyland, her husband was good about posing even though he had little time to spare, and he submitted to still more sessions with Whistler in London during the early months of 1872.[104] For Whistler, the key to character lay in the subject's stance: what he most admired in portraits by Velázquez was the way the subjects seemed to "live within their frames, and *stand upon their legs*, that all nobility and sweetness, and tenderness, and magnificence should be theirs by right." And it was in the drawing of the legs, Leyland himself recollected, that Whistler had been nearly reduced to tears, regretting once again that he had not mastered "the construction of the human form during his student days."[105] Such remorse suggests that Whistler had still to overcome the insecurities that had caused him to undertake an intensive self-

 The Model Patron

education in the 1860s. It is revealing that for this important portrait he fell back on the methods practiced by Albert Moore, hiring a well-known model named Fosco to pose in the nude so he could paint the figure in flesh-colored distemper before adding clothing and going over the composition with oil. But every effort, as before, ended in dissatisfaction, with Whistler rubbing down the work and starting over. According to Walter Greaves, who observed the work in progress, Whistler "got into an awful mess over it."[106]

Greaves tells a story, possibly apocryphal, of Whistler's mother insisting one day on seeing the portrait, even though it remained in the underpainting stage. When the canvas was turned away from the wall, she was horrified to find an image of Frederick Leyland in the nude. "Oh dear! oh dear!" she is said to have exclaimed. "I thought the picture was finished a long while ago; when will my son finish it?"[107] If this incident took place at all, it may have been around mid-March 1872, "in the pressure of the Season," when Anna Whistler had been given to understand that her son was in the process of "*perfecting*" the portrait. By May, it was hanging in their drawing room: Anna took some visitors there to show them the view of the river, and when one of the ladies sat down to rest, she was startled to find herself facing a "life like stranger."[108] Yet according to the Pennells, who seem to have heard it from Greaves, Leyland's portrait was not completed until the winter of 1873. Whistler's friend Alan S. Cole saw it that February and noted in his diary that it was "in hand." Perhaps it was around this time that Whistler tried copying the portrait in an etching, the print a reversal of the drawing on the plate (fig. 3.15).[109]

At some point during the protracted course of the portrait's execution, the background dissolved dramatically into shadow. Both early oil sketches show Leyland's figure posed against a lighter background. In the latter version, the wall is enlivened by the dado and vertical marker that figure in other portraits of the period, such as *Harmony in Grey and Green: Miss Cicely Alexander* (1872–74), in which the setting's austerity is softened with butterflies and blossoms, and *Arrangement in Grey and Black, No. 2: Portrait of Thomas Carlyle* (1872–73), where the butterfly monogram from the Leyland sketch appears to have alighted. From its conception as an arrangement in gray and black, therefore, Leyland's portrait evolved into the first of Whistler's arrangements in black.[110] The gathering gloom in which the figure stands gives a psychological dimension to the portrait that is lacking from the sketches, as though Whistler only gradually discovered the darker aspect of Leyland's personality.

That side of Leyland's character emerged most publicly toward the end of 1872, when Leyland was arranging to take over the Bibby firm. The scandalous story of how he went to the kindly employers who had saved him from life in the gutter and demanded that they sell him the business or deal with him as a competitor was already becoming a legend; it was largely as a result of Leyland's purported behavior to the Bibbys that he was, in the words of a contemporary, "hated thoroughly by a very large circle of acquaintances."[111] In November 1872, Howell heard from a Liverpool resident that Leyland's enemies in that

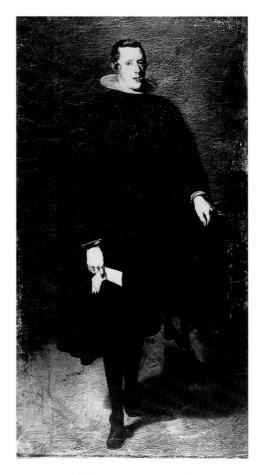

FIG. 3.13 *Philip IV*, ca. 1626–28, by Diego Rodríguez de Silva y Velázquez (1599–1660). Photograph from Whistler's collection, Glasgow University Library, Special Collections.

FIG. 3.14 *Portrait Study of Frederick R. Leyland* (M425), 1871/73. Chalk on brown paper, 28.6 × 18.6. The Metropolitan Museum of Art, New York; gift of Harold K. Hochschild, 1940 (40.91.5).

FIG. 3.15 *F. R. Leyland* (K102), ca. 1873–75. Etching and drypoint, second state, 29.4 × 17.6. Freer Gallery of Art, Smithsonian Institution, Washington, D.C. (07.150).

FIG. 3.16 *Don Adrián Pulido Pareja*, ca. 1647, ascribed to Juan Bautista del Mazo (ca. 1612/16–1667). Oil on canvas, 204.0 × 114.5. The National Gallery, London.

city were "so numerous and loud that he seems to hurry through the streets, and stands there almost hated." When news of his callous action went abroad, placards reading "Skunks and robbers kick over the ladder up which they climb" were posted on Leyland's office door.[112] And the more he was despised, it seems, the more despicable Leyland became.

It was in 1873 that Leyland had a falling-out with Rossetti over the commission for *La Ghirlandata*, an altercation so serious that it nearly ended their association. Howell, who claimed to know Leyland well enough to "quote his answer on any subject a fortnight before it comes," had warned Rossetti about his patron's disagreeable temper, "a downright royal black Leyland sulk." He confided, "I begin to suspect that he is not quite right in his head. No one would dream of it, but I am sure I am right, and the thing is a species of madness like any other."[113] Also around this time, Leyland had "a devil of a row" with his son, who desperately wanted to leave school. Freddie wrote to Whistler from Harrow that he had not communicated with his parents for three weeks. "Awkward," he admitted, "but damn it all. I cant help it, as the governor has such a devil of a temper and wont listen to reason."[114] The change in Whistler's portrait from gray to black during this period may follow a darkening of the sitter's mood, for Leyland was becoming "a picture of despair," in Howell's words, "silent, and scowling at the day."[115]

The radical simplification of the background that transformed Leyland's portrait into an "arrangement in black" may also have been inspired by the exhibition at the Royal Academy, in January 1873, of a portrait then accepted as a genuine Velázquez (fig. 3.16).[116] The Spanish admiral Don Adrián Pulido Pareja stands, like Frederick Leyland, with his right foot forward, looking out of the picture with a stern, cold stare. But the salient similarity between the portraits resides in their indeterminate settings, in which the walls behind the figures, if they exist at all, rise seamlessly from the floor. Several artists of Whistler's time were impressed by the vacant backgrounds in Velázquez's full-length portraits: Manet, for instance, wrote Fantin-Latour from Madrid in 1865 about the portrait of Pablo de Valladolid, "The background disappears, air surrounds the man, dressed all in black and alive."[117] Those words apply as well to Whistler's *Arrangement in Black*. Isolated in atmosphere, Leyland's dark figure seems to step out of a void, "wondered at by all," as Orchard observes, "but dear to none, dwelling apart like a star."[118]

Frances Leyland confided to Elizabeth Pennell that she had "pretended to be indignant" when Whistler refused to paint her dressed in black, as he was portraying Mrs. Louis Huth at the time.[119] His drypoint of Mrs. Leyland wearing a dark velvet dress may have been made as a concession to her wish (fig. 3.17). The portrait of Helen Ogilvy Huth became the second *Arrangement*

The Model Patron

in Black as it underwent a schematic simplification that parallels the first: two studies show the subject standing before a decorative curtain similar to the one that figures in the portrait of Whistler's mother, replaced in the final version by what the Pennells term the "atmospheric envelope." [120] Whistler's portrait of Mrs. Leyland (fig. 3.18), in contrast, evolved into one of the lightest in color and most elaborate in design of all his works, making a perfect complement to the somber, nearly monochrome portrait of her husband, *Arrangement in Black: Portrait of F. R. Leyland.*

The pair of Leyland portraits conforms to the Victorian formula of "black men and bright women," accentuating the division between the sexes. [121] And the costumes correspond to the subjects' separate realms of influence: Frederick stands with cloak in hand, ready to step out into the world, while Frances poses in a dress too extravagantly ornamental for almost any occupation besides standing still. Whistler is said to have insisted on designing that dress himself, and numerous chalk and pastel drawings document its development. [122] Most of these sketches look more like fashion plates than portrait studies, with the figures holding up the dresses as featureless as mannequins (fig. 3.19). The white chiffon costume that finally emerged is apparently a tea gown, an informal garment a lady would wear only at home, during the late hours of the afternoon before dressing for dinner. The concept was new in the early 1870s, when Frances Leyland's loose, uncorseted dress would have looked daring, perhaps even improper; but by the middle of the next decade, tea gowns were widely fashionable in aesthetic circles and could be identified by the defining features of Whistler's design: soft colors, sensual fabrics, puffed sleeves, a "Medici" collar, and a Watteau-inspired *sac-bac* that falls from gathers at the shoulders and ends in a long, flowing train. [123]

The "flesh colour" setting for the portrait appears specifically designed to harmonize with Frances Leyland's auburn hair, but it was, in fact, the drawing room at 2 Lindsey Row. [124] Although the portrait was conceived at Speke Hall, it traveled back to London with Whistler; when the Leylands settled in town for the 1871 season, Mrs. Leyland came to pose in Chelsea nearly every day. Anna Whistler was invariably there to receive her, and Lucy, the cook, helped with the sitter's toilette. When Whistler's mother was unwell, Mrs. Leyland arrived bearing lavish gifts, the fruits of the Leyland Line. [125] When she herself was indisposed, a professional model named Mary (Maud) Franklin donned the dress and stood in Mrs. Leyland's place. Maud Franklin would have been only fifteen when those sessions began in 1872, and her precocity is the theme of a portrait probably begun around that time, *Arrangement in White and Black* (fig. 3.20), which is more closely related in pose and sensibility to the portrait of Frederick Leyland than to the portrait of his wife. [126]

Of the many sketches Whistler made of Mrs. Leyland's dress, only one— a rough sketch hidden on the back of a preparatory drawing for the portrait of Mrs. Huth—captures the final pose, in which the subject stands with her back to the artist, her face to one side and her hands clasped behind her. [127] The

FIG. 3.17 *The Velvet Dress (Mrs. Leyland)* (K105), 1873. Drypoint, fifth state, 23.2 × 15.8, signed with the butterfly and inscribed by the artist, *Mrs. Leyland.* Freer Gallery of Art, Smithsonian Institution, Washington, D.C. (04.6).

FIG. 3.18 *Symphony in Flesh Colour and Pink:*
Portrait of Mrs. Frederick R. Leyland (Y106),
1871–77. Oil on canvas, 195.9 × 102.2.
The Frick Collection, New York.

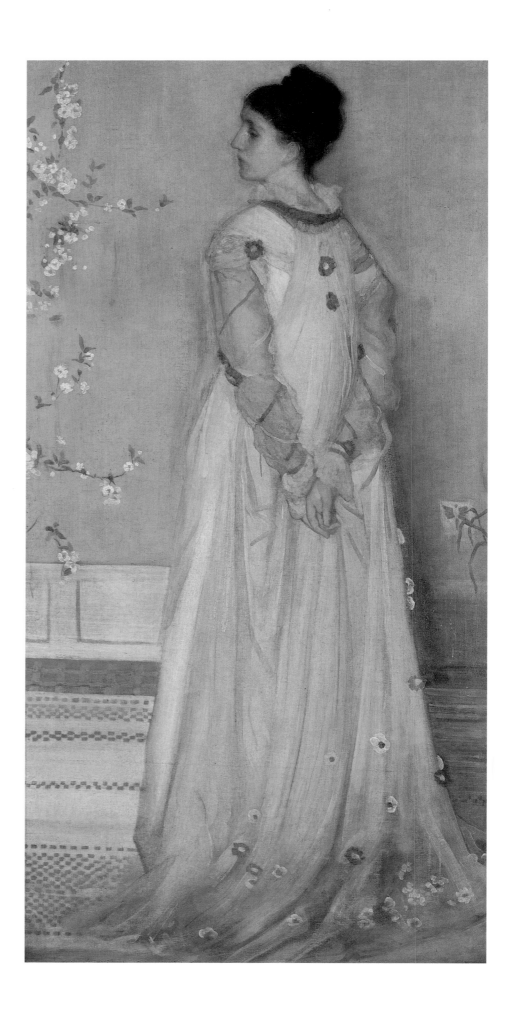

The Model Patron

attitude makes a marked contrast to the frontal pose and assertive stance of Frederick Leyland in the pendant portrait, but Whistler may also have selected the three-quarter rear view to show the costume's most interesting feature to best advantage. This aesthetic decision may have been inspired, as Lochnan suggests, by Japanese prints showing courtesans in this attitude, the better to display the backs of their beautiful kimonos. But according to Frances Leyland, the pose was characteristic, not contrived, one she assumed "unconsciously when she stood talking."[128] Her ungloved hands, which are said to have caused Whistler endless trouble, have been regarded as signs of the artist's intimacy with his subject; if so, Whistler enjoyed the same close relationship with Helen Huth and several other of the women he portrayed throughout the 1870s.[129]

FIG. 3.19 *Study for Frances Leyland's Dress* (M430), ca. 1871. Chalk and pastel on brown paper, 26.6 × 17.5. Freer Gallery of Art, Smithsonian Institution, Washington, D.C. (05.157).

Yet there can be no doubt that Whistler's friendship with Frances Leyland deepened during the painting of her portrait. Mrs. Leyland was a lady of leisure with time to spare. She never grew tired of posing, she told Elizabeth Pennell, as Whistler shared his troubles and looked to her for sympathy. Indeed, Whistler apparently confided all manner of things, even certain improprieties of his past: on more than one occasion Mrs. Leyland met his illegitimate child Charles James Whistler Hanson, whom Whistler referred to as "an accident." Charlie was born in 1870 to Louisa Hanson, a parlormaid, and adopted at six months by Jo Hiffernan.[130] Romantic friendships between Victorian artists and sympathetic married women were neither unusual nor improper, and to assume without further evidence that Whistler and Frances Leyland had a sexual affair is to betray a distinctly modern perspective.[131] They were often together in London when Frederick Leyland was out of town or otherwise engaged, but that was a necessity of the times; as Frances Leyland herself explained, "One had to have a man when one went out in London."[132] Not even Anna Whistler detected impropriety in her son's activities, reporting to her sister in 1872 that Whistler (and his brother) had escorted Mrs. Leyland (and her sister) to the opera, and later that Whistler had taken Mrs. Leyland (with her sister and two daughters) to see the actress Isabel Bateman perform at the Lyceum Theatre. Indeed, she said, her son was becoming "like a brother in the family circle."[133]

For a time it appeared that Whistler might actually join the Leyland family. His relationship with Lizzie Dawson, Frances Leyland's youngest sister, seems to have flowered in 1871, when both were visiting Speke Hall. The romance would account for Whistler's decision to remain in Liverpool for Christmas, despite his mother's illness. He stayed even after the holidays ended unhappily with the death from diphtheria of another guest, Ada Jee, casting "a sad gloom over the house," as Leyland reported to Rossetti. But in mid-February, after two more members of the household took ill, Leyland and a number of "dependents," perhaps including Whistler, were seen at the Speke station, leaving early for the London season.[134] A few days later, back in London, Whistler announced that he had offered his hand to Lizzie Dawson, and because the news was revealed in Frederick Leyland's presence, at Rossetti's table, there is no reason to doubt its authenticity. William Rossetti noted afterward in

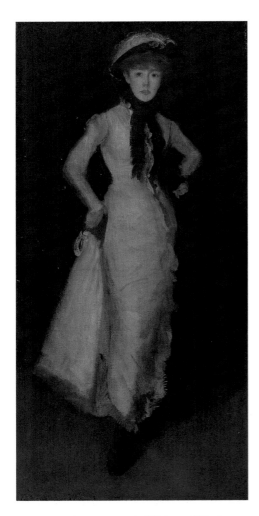

FIG. 3.20 *Arrangement in White and Black* (Y185), ca. 1873–76. Oil on canvas, 191.4 × 90.9. Freer Gallery of Art, Smithsonian Institution, Washington, D.C. (04.78).

FIG. 3.21 *Elizabeth Dawson, Full Face* (M441), ca. 1872. Chalk and pastel on brown paper, 28.3 × 16.6. Hunterian Art Gallery, University of Glasgow; Birnie Philip Gift.

his diary that although Miss Dawson was young (she was twenty-one and Whistler thirty-eight), Whistler's suit was "believed to be prosperous."[135]

Only two drawings have been identified as portraits of Lizzie Dawson (fig. 3.21), but there are probably others among the scores of figure sketches Whistler produced during the Leyland years.[136] She may have been pictured in a portrait of a young girl at a window, now lost, that Whistler reputedly produced on the entreaties of "the ladies of the house" for a Garston Church bazaar; she may also be the subject of an incomplete (but extant) portrait of a lady he left unaccountably anonymous.[137] Lizzie undoubtedly figures among the group pictured in the billiard room at Speke Hall in a work of forgotten origin traditionally known as "The Leyland Aunts" (fig. 3.22); as Leyland had only brothers, the aunts must be Dawsons. Whistler is there, leaning back in undisguised boredom beside Frances Leyland, with the auburn hair, who wears a red velvet dress and a prominent white ruffle; to his left is a young woman who resembles the sitter in a contemporary drypoint by Whistler, *The Silk Dress* (1873), which is thought to be a portrait of Lizzie Dawson.[138]

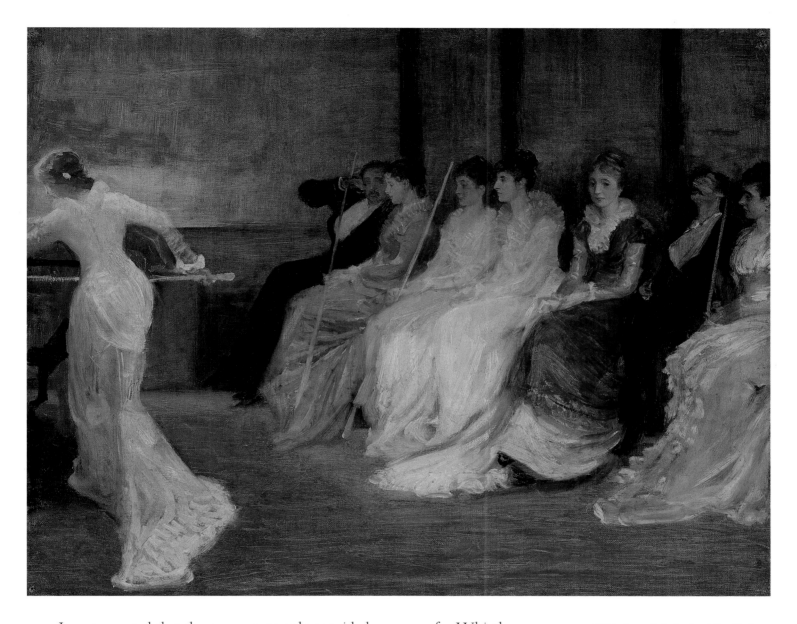

FIG. 3.22 *Whistler and the Leyland Family in the Billiard Room, Speke Hall*, ca. 1873, artist unknown. Oil on canvas, 42.8 × 63.5. Walker Art Gallery, Liverpool.

It was rumored that the engagement only provided an excuse for Whistler to spend more time with Lizzie's sister,[139] but this may not in fact have been the case. The relationship was apparently broken off more than once, for reasons that remain obscure, each time at Lizzie's instigation.[140] It finally concluded late in 1873, with "kind and considerate" letters written to both Whistler and his mother. Whistler imparted the news to Frances Leyland in a "doleful letter" so heavy with desolation as to leave little doubt of his broken heart. "You will understand readily how my visit to Speke will now be put off for a while," he wrote.[141] His misery was compounded that autumn by a spell of bronchitis and rheumatic fever that kept him confined to bed for five weeks, and the Leylands' son Freddie wrote in mid-October how sorry he was to learn that Whistler remained unwell, "and also in the Blues which is dreadful." Freddie refers to a scandal that seems to have involved his aunt Lizzie and some unnamed gentleman, which he had heard about from the "intended bride" herself: "It's lucky I wasn't in the house or I would have given that fellow the most damnable

thrashing he ever had in his life."[142] Whatever the circumstances, the situation must have strained Whistler's standing with the Leylands, and Frances would have found her allegiances divided. In retrospect, she told Elizabeth Pennell that her sister, although pretty, had not been the wife for Whistler, "and it was a good thing the engagement was broken."[143]

I~N~ F~EBRUARY~ 1872, when Whistler was bringing the unfinished portraits of the Leylands and the portrait of his mother back to London from Speke Hall, all three paintings narrowly escaped destruction when fire broke out in the luggage car, discovered just as flames were starting to consume the packing cases. Anna Whistler interpreted the miracle of their salvation as a sign that her own portrait (her son's "favorite work") would be respectably hung that spring at the Royal Academy—as it was, despite rumors of controversy surrounding its selection and placement.[144] Whistler had also hoped to exhibit the Leylands' portraits that year, but the conflagration seems not to have augured as well for them.

Immediately upon his return, Whistler initiated a new discipline for work. He rose at seven every morning to row for an hour on the river before breakfasting on hominy and milk, his only meal until evening. "While he works almost without respite he seems to realize no desire for food," Anna Whistler observed, "but only to work whilst it is called today!" He maintained that punishing schedule throughout the month of March, for the paintings were due at the Academy the first week of April. Anna had learned from experience, however, not to "anticipate rewards to Jemie's diligence," and indeed, the "beautiful life size of Mrs. L." remained far from finished when the Academy deadline arrived. Whistler had to content himself that year with the success of his mother's portrait, which marked his reappearance "before the London Artistic world after his withdrawal for perfecting his Studies."[145]

The exhibition of Whistler's "Mother" in 1872 also marked the artist's final appearance at the Royal Academy. A legend arose, which Whistler helped to foster, that he declined to follow that painting's success with other works because he was disgusted with the way the committee had received it. Yet throughout the summer following that exhibition, Whistler worked determinedly to complete *Symphony in Flesh Colour and Pink*, intending to show it with his portrait of Frederick Leyland at the 1873 Academy. He told Alan Cole in March 1873 that he was trying to finish Mrs. Huth's portrait and other "Academy pictures" and thought they would be ready in time, since they were "going on splendidly"; but something interfered, postponing progress on the pictures. "So it is," Anna remarked, "patience must be tried."[146]

The patience that was tried may have been the sitter's. Frances Leyland recounted to Elizabeth Pennell a familiar refrain: how she would leave the studio at the end of a day thinking only a few more hours were needed to complete

the portrait, only to find the canvas scrubbed down the next morning, "with the work to be done over again."[147] In a letter Whistler wrote at New Year's, probably of 1874, he acknowledged Mrs. Leyland's continuing indulgence and regretting how he seemed "doomed to disappoint" in his effort to show gratitude.

> The thought of your portrait is upon me! Well do I remember the persevering kindness with which you so patiently bore the fatigue of those many tiring days!—How can I ever thank you!—And I am now so unhappy to know that the work itself is not worthy of the weariness it caused you—It should have been so beautiful! Do you know that I sometimes dare to hope that still it may be saved—The strange little something, that stands between a master-piece in its perfection, and failure, might at any moment yield—and a mornings work bring with it the bright life that is now smouldering with in—So lovely is the conception too! Ah well! Believe me though my dear Mrs. Leyland it is not only selfish glorification or ambition that still frets me in my disappointment—It would have been my pride to in some measure through my work thank the kind hostess who has I fear been often vexed by the waywardness & tiresome eccentricities of a never ending guest![148]

Evidently, Whistler never did discover the "strange little something" that might have brought about the portrait's perfection, for it remained unfinished in the spring of 1874, even when it finally went on public view.

That January, Whistler had signed a twelve-month lease of the Flemish Gallery, a ground-floor room at the back of a house at 48 Pall Mall. He intended to exhibit not only the Leyland portraits but also several other important paintings he finally had ready to reveal—notably the portraits of Helen Huth, Thomas Carlyle, and Cicely Alexander.[149] Several of his Nocturnes had previously been shown at the Dudley Gallery, but never in the wider context of his work, which included the "Sketches for Large Paintings" (the oil sketch for *The Three Girls* and two of the Projects) that had engaged his attention throughout the 1860s. Whistler, then, meant to present the range of work produced since his return from Valparaíso, the outcome of his artistic re-education.

The private view took place on the sixth of June 1874, a full month after the opening of the Royal Academy exhibition but near enough the start of the season to ensure a fashionable attendance and undivided attention from the press. Whistler seems to have followed the advice given to Rossetti by Howell, when Rossetti fleetingly considered holding a solo exhibition: Stage the show "when every one is in town but when *nothing else* is going."[150] Hearing of Whistler's plans, Rossetti assumed that Whistler had convinced Leyland his portrait would be unhappily hung at the Royal Academy, "whereupon L., rather than see himself hoisted, paid bang out for an independent show of them." Whistler may have harbored that hope, but there is no evidence that Leyland

FIG. 3.23 *Freddie Leyland Seated* (M508), ca. 1873. Chalk or charcoal on brown paper, 30.5 × 23.5. Private collection, Great Britain.

paid outright for the exhibition, and afterward Anna Whistler observed that while the venture made her son famous, it did not bring remuneration "in proportion to the expenses attendant upon it." Rossetti may have been accurate, however, in assessing the artist's ambition for the display—that it would "send Whistler sky-high," and so impress Leyland that he would stop buying pictures from anyone else.[151]

As the first two paintings on the walls and in the catalogue, the portraits of Frederick and Frances Leyland dominated *Mr. Whistler's Exhibition*. The critic for the *Globe*, who thought the show established Whistler's "rank among the first portrait painters of the day," considered those two works sufficient in themselves "to render the exhibition more than remarkable." Leyland's portrait—identified in the catalogue only as *Portrait, "Arrangement in Black,"* although the name of the sitter was an open secret—received special commendation from Henry Blackburn, who wrote that it "more nearly approaches the style of Velazquez than that of any living painter." J. Comyns Carr, writing for the *Pall Mall Gazette*, also decided, on the basis of the portraits, that "Mr. Whistler may claim kinship with Velasquez. The great Spanish painter exhibits always this kind of noble fidelity to simple truth joined with a quick understanding of his subject."[152] Gabriel Rossetti, whom Whistler escorted to the exhibition after it closed to the public, preferred the portraits of Anna Whistler, Carlyle, and Cicely Alexander. "The others were not equal to these," he reported to a friend, "but the head of Leyland is very like him, and the figure of Mrs. L a graceful design, though I cannot see that it is at all a likeness."[153]

For all their triumph in Pall Mall, the portraits of Frederick and Frances Leyland remained unfinished in Whistler's eyes, and at the close of the exhibition they went back to his studio instead of to Speke Hall. Leyland's patience must have been growing thin, yet he allowed Whistler to continue working in accord with his own "artistic scruples" (app. 20)—setting a dangerous precedent, as it proved, for future projects.

FREDERICK LEYLAND not only provided the financial foundation for Whistler's existence during the 1870s but also lent him the comforts of family life. The artist's genuine affection for his patron's children resonates through letters he wrote to Mrs. Leyland in Liverpool. "I find myself really longing for news from the Hall! Flo—and Freddie—and the Babs and Fannie!—Give my love to them all—they have written me charming letters and I am very fond of them!"[154] Over the years, Whistler affectionately recorded moments from their childhoods in dozens of works of art, though he failed to produce the portraits in oil their father had commissioned. It has been suggested that some large, highly finished pastel portraits of Freddie, Florence, and Elinor may have been produced in lieu of the commissioned oils; but as they remained in Frances

Leyland's possession after the dissolution of her marriage in 1879, and were hers to bequeath, they must have been given to her by the artist. As Whistler later maintained, "The late Mr. Leyland never *bought* any drawings of mine." [155] Those pastels depict the children without flattery, and in ordinary clothes, just as a mother might particularly love them. Freddie looks a little indolent (fig. 3.23), Florence rather plain, Elinor plump and sulky. Fanny's portrait is unaccountably missing from the set. [156]

Whistler's drypoint portraits, on the other hand, are on the whole more aesthetically satisfying, and were probably made with the children's father in mind. Freddie seems not to have posed for these pictures, but the Leyland girls appear in what must have been characteristic attitudes. Fanny sits in a ladylike position recalling the pose of Whistler's mother, to whom she was particularly attached (fig. 3.24). Florence, with a hoop, looks livelier and ready to play (fig. 3.25), and Elinor assumes an assertive stance (fig. 3.26), reminiscent of Velázquez's *Pablo de Valladolid*. Frederick Leyland may have commissioned these works in January 1873, around the time he purchased twenty-three of Whistler's early etchings. [157] But the children look younger than they would have been that year, when Fanny was fifteen, Florence thirteen, and Elinor eleven, so perhaps the plates had been prepared as early as 1871, when Whistler sent to London from Speke for etching needles and copper plates. [158]

Whistler also made dozens of drawings of Leyland family members during the early 1870s, some of which may represent preliminary notions for the painted portraits of the Leylands' daughters apparently commissioned around 1871. (The scope of that commission narrowed to the three girls when Freddie, having endured three sessions, refused to sit again.) Drawings such as *Standing Figure with a Fan* (fig. 3.27) may relate to plans for Whistler's portrait of Fanny

FIG. 3.24 *Fanny Leyland* (K108), 1871/73. Drypoint, second state, 19.6 × 13.2. Freer Gallery of Art, Smithsonian Institution, Washington, D.C. (98.338).

FIG. 3.25 *Florence Leyland* (K110), 1871/73. Etching, eighth or ninth state, 21.3 × 13.7. Freer Gallery of Art, Smithsonian Institution, Washington, D.C. (98.342).

FIG. 3.26 *Elinor Leyland* (K109), 1871/73. Drypoint, third state, 21.4 × 14.0. Freer Gallery of Art, Smithsonian Institution, Washington, D.C. (98.339).

FIG. 3.27 *Standing Figure with a Fan* (M532), ca. 1870–73. Chalk on brown paper, 20.6 × 13.0. Freer Gallery of Art, Smithsonian Institution, Washington, D.C. (05.142).

FIG. 3.28 *Study in Grey and Pink* (M470), ca. 1872–74. Chalk and pastel on brown paper, 21.7 × 13.9. Freer Gallery of Art, Smithsonian Institution, Washington, D.C. (05.151).

Leyland who, as the eldest, was presumably first in line.[159] We know from Whistler's mother that he began a full-length portrait of one of the girls in the autumn of 1871, and Whistler himself reported to Walter Greaves that he had "two large canvases underway" (one being the portrait of Frances Leyland) that October. The "plan" for his new pictures was "very pleasing," he said, suggesting that the family portraits were conceived as an ensemble: this would account for the extensive series of brown-paper drawings from this period

in which costumes, poses, and props become nearly interchangeable.[160] Whistler's ideas for the first work may have taken shape in *Study in Grey and Pink* (fig. 3.28), a pastel scheme for a portrait of Fanny that might have hung comfortably between those of her parents. The background resembles one originally conceived for the portrait of her father (see fig. 3.12), its severity mitigated with color tones and ornaments borrowed from that of her mother.

If Whistler did begin a portrait of Fanny in 1871, it appears to have been set aside for several years while the sitter outgrew her childhood and Whistler embarked on an ambitious commission to paint the six daughters of another patron, W. C. Alexander. He may not have taken up Fanny's portrait again until September 1874, when Anna Whistler reported that her son was at Speke Hall painting the "two youthful daughters of the Leylands." This turned into an extended working visit that lasted until March, and Whistler wrote to James Anderson Rose that his brush had been in his fingers every day "until candle light."[161] The earlier scheme may have been passed down to Florence, since Whistler now planned to paint Fanny dressed for riding (as he meant also to portray Alexander's eldest daughter, May). Perhaps Fanny's was the portrait seen and described by T. R. Way as "a young lady in a riding habit and silk hat standing against a dark brown panelled wall, on warm-coloured matting."[162] That work was subsequently lost, destroyed, or overpainted: nothing of it remains.

The second portrait, of Florence (fig. 3.29), is the only one of the three that survives, although it underwent so many transformations between inception and completion that it cannot be assumed to represent the artist's initial intentions. It may have originated in the scheme set out in *Study in Grey and Pink* (which it somewhat resembles in costume and pose), darkening gradually over the years in the manner of Frederick Leyland's portrait. Perhaps it was the work exhibited in 1877 as *Harmony in Amber and Black*, which William Rossetti described as a "blonde lady in white muslin with black bows, and some yellow flowers in the corner," an account that matches the pastel study in several particulars. But the background details must already have been obscured by shadows, considering Oscar Wilde's remark that the lady of Whistler's portrait appeared "caught in a black London fog."[163]

Florence Leyland remembered posing for Whistler when she was seventeen or eighteen, the age she appears in the portrait.[164] Yet it seems unlikely that the sittings continued much beyond her seventeenth birthday in September 1876, when Whistler was fully engaged in an altogether more engrossing enterprise: the decoration of what was to become the Peacock Room. Moreover, Florence's portrait and those of her sisters seem to have all been in progress by the spring of 1875, when Whistler made plans to resume his work at Speke Hall. His mother, just recovering from the life-threatening illness that had brought Whistler home from Liverpool in March, dreaded the prospect of his departure and implored Frances Leyland to instruct Elinor, her youngest, to take pity on the artist and cooperate: "I know she is weary of him & of posing, but I am sure

FIG. 3.29 *Portrait of Miss Florence Leyland* (Y107), ca. 1875–79. Oil on canvas, 191.8 × 91.8. Portland Museum of Art, Maine; gift of Mr. and Mrs. Benjamin Strouse, 1968 (1968.1).

FIG. 3.30 *Baby Leyland* (M517), ca. 1872.
Black and white chalk on brown paper,
28.0 × 18.0. Freer Gallery of Art,
Smithsonian Institution, Washington,
D.C. (05.147).

she & Flo & Fannie will be as anxious as we all are to have their likenesses perfected."[165]

Whistler especially doted on Elinor, or Babs, whom he described as "exasperatively lovely" and portrayed in a variety of poses in a preponderance of the brown-paper drawings (fig. 3.30).[166] In all likelihood, her portrait was Whistler's favorite. Its intended composition and color scheme are known from an extant pastel study, *The Blue Girl* (fig. 3.31), in which Elinor strikes nearly the same Velázquez pose she assumed for her drypoint portrait. According to T. R. Way, Whistler had been inspired by Gainsborough's "Blue Boy" (ca. 1770), one of the most popular pictures in England.[167] But Whistler had no qualms about his portrait's originality. He referred to his plan to paint Elinor Leyland in blue velvet and cashmere as his own "invention" and warned Walter Greaves against wandering, even inadvertently, into his "symphony in blue": "You know how jolly it is and of course I shall paint it directly I have time."[168] He was probably painting Elinor's portrait on what proved to be his last visit to Speke, around Christmas 1875. In the end, Whistler's arrangement in blue was abandoned and then destroyed, the same fate suffered by another treasured project for Frederick Leyland, *The Three Girls.*

To Leyland, the portraits of his family were principally a means to an end—the completion of the first and most important commission, now woefully overdue. Whistler had taken up *The Three Girls* again in November 1872, three years after setting it aside for the portraits, writing Leyland: "You will I hope be pleased to hear that among other things I am well at work at your large picture of the three Girls and that it is going on with ease and pleasure to myself." Leyland had ascribed the happy change to Whistler's recent practice in portraiture, which he believed had been therapeutic, and he hopefully predicted that his own ordeal of posing had been suffered for a worthy cause—that his "martyrdom" had not been all in vain.[169]

By the next spring, when Whistler invited Alan Cole to view *The Three Girls,* he was referring to his work in progress as "Symphony in White and Red—full palette!" The new title implies that his aspirations had risen impossibly high: he later told Otto Bacher that his "most ambitious desire was to paint a grand concerto-like picture with the title 'Full Palette'. . . . If I can find the right kind of thing I will produce a harmony in color corresponding to Beethoven's harmonies in sound."[170] It must have been in that mood of creative optimism that Whistler prepared the most elaborate frame he ever designed, which, unlike the painting, has survived. It was produced by Foord & Dickinson, the framemakers Whistler had used since the 1860s, who applied the gilding in the old manner, directly on the wood so the grain showed through. Whistler adorned the flat of the frame with small blue flowers, possibly meant as "hawthorn" petals in allusion to Chinese blue and white, arranged with

studied informality; he signed it with a butterfly that might almost be mistaken for a blossom were it not enclosed in a circle, in the signature style of that period. The most distinctive feature of the frame, however, is the tiny musical passage inscribed on one side—a treble clef, a key signature, and the opening notes of the third part of Schubert's *Moments musicaux*. It has been suggested that the passage was chosen to allude to the three girls in the painting, and that someone, possibly Leyland, had whiled away the hours in Whistler's studio by playing the piece on the piano.[171]

That charming vision of Leyland at the piano has no foundation in fact, but Whistler was occasionally entertained in the studio by a pianist named Horace Jee (designated "X" in the *Whistler Journal*), whom he had met through the Leylands. (It was Horace's sister Ada who died at Speke Hall.) Although Jee is listed in Liverpool directories as a cotton broker and a salt merchant, Whistler remembered him as a "professional hanger-on, drifting from one house to another," and incidentally an aesthete, "before the silly name was invented." He was also a genius of a musician, which explains Leyland's otherwise unaccountable attachment to that "prince of parasites": as Whistler explained to the Pennells, "He was supposed not to know his notes, and for that to be all the more wonderful." In 1873, Horace Jee had drifted down to London and occasionally helped to relieve "the monotony of work" in Whistler's studio with music, using the artist's Chinese chair as a piano stool.[172] This minor character in the story may have been responsible for the Schubert on the frame of *The Three Girls*, which was later to surround, with startling incongruity, Whistler's horrific caricature of Frederick Leyland, *The Gold Scab* (see fig. 6.33).

After Whistler recovered from rheumatic fever in 1873, he made some progress on the "big picture," or so he informed Frances Leyland in a letter written at New Year's, and *The Three Girls* continued "growing" throughout the spring of 1874.[173] But it was not until the end of the summer of 1875 that the painting was mentioned again. Whistler had helped his mother move to the seaside at Hastings for her health, then spent a "delightful little holiday at Speke." Upon his reluctant return to London, he wrote to Mrs. Leyland with undisguised affection, "Of course I am up to my elbows in paint and only venture to think very little at a time of Speke Hall—or at once the brush would be dropped for the dreamy cigarette—and you can fancy the ready ease with which I yield to pleasant temptation!"[174] That autumn, he was encouraged in his work by the discovery of a new model (her identity is unknown), who was posing for him "altogether," or in the nude: Whistler described her to Frederick Leyland as "simply adorable," and to Frances as "a beautiful creature to replace the 'perfect woman,'" possibly referring to Tillie Gilchrist. Within a few weeks, Whistler would say that the picture grew more beautiful every day; yet he set it aside again at the end of September 1875, when he returned to Speke to "go at the portraits."[175]

Symphony in Red and White, as Whistler finally titled *The Three Girls*, was still in the artist's studio in March 1876 and was seen by a reporter for the *New*

FIG. 3.31 *The Blue Girl* (M521), ca. 1874–75. Pastel on paper, 25.2 × 14.5. Freer Gallery of Art, Smithsonian Institution, Washington, D.C. (05.126).

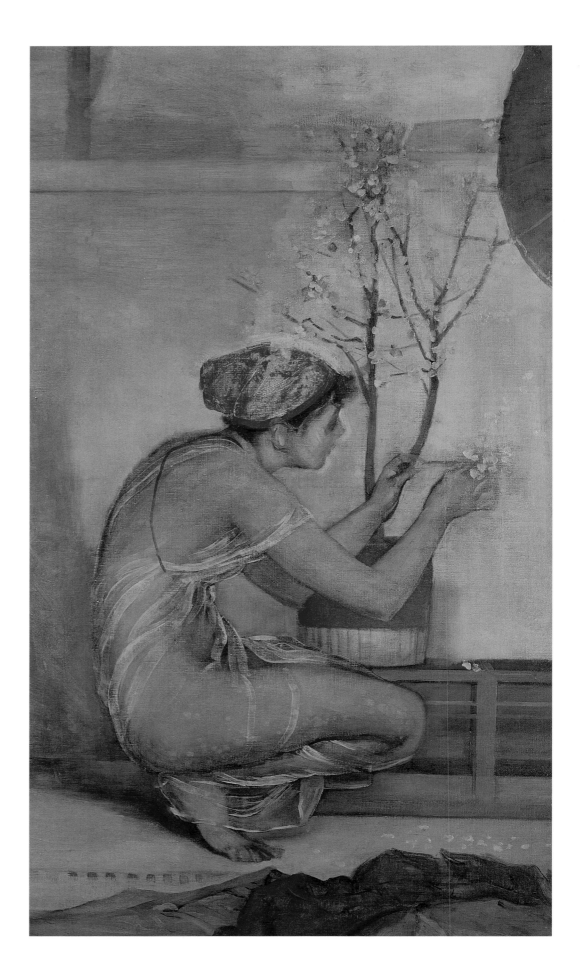

FIG. 3.32 *Girl with Cherry Blossom* (Y90), ca. 1876. Oil on canvas, 139.3 × 73.7. Private collection; on extended loan to the Courtauld Institute of Art, University of London.

The Model Patron

York Herald. The fragment that survives as *Girl with Cherry Blossom* (fig. 3.32) affords a glimpse of the painting then in progress, which the American writer considered to display all Whistler's "splendid qualities—the marvellous beauty of his coloring and the masterly perfection of his drawing":

> In the soft, glowing atmosphere of a hothouse three girls in flowing white draperies are superbly posed—varied types of youth and beauty and grace. A charming figure in the centre, with scarf thrown to the floor, crouching down on tiptoe, lifts with dainty hand a scarlet flower. Her companion, eagerly observant, bends over her in a pose of incomparable naive grace. On the other side the third figure stands in serene majesty, calmly contemplative. The beauty of this picture in color, design and composition is simply transcendent.[176]

To anyone's eyes but Whistler's, the painting must have seemed complete—as it should have been, after nearly eight years in progress. Moreover, the ultimate deadline was in sight, for Leyland was preparing to occupy his new house in London, where a prominent place had been reserved for *The Three Girls* in the dining room, on the wall opposite *La Princesse du pays de la porcelaine*.[177]

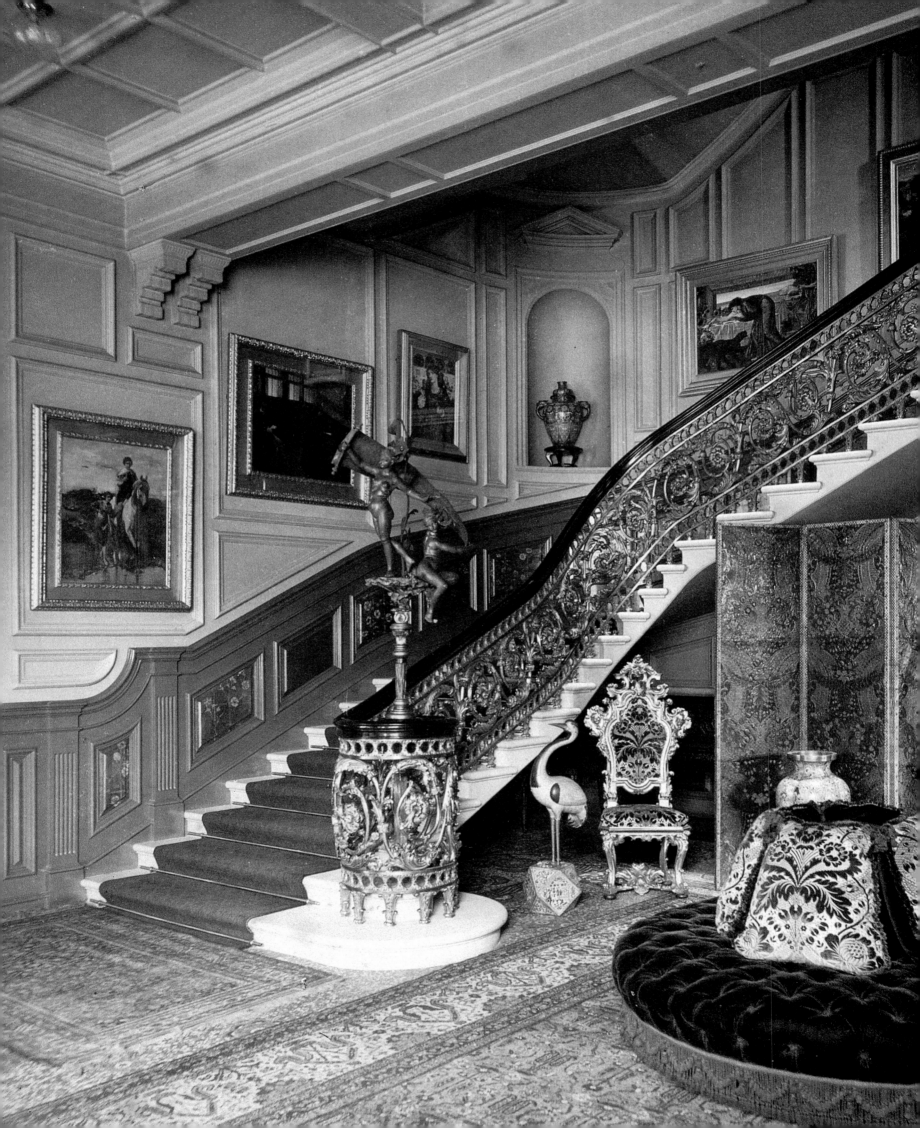

4 *The Palace of Art*

*And time, with more state, brought more
capacity for luxury, and it became well
that men should dwell in large houses, and
rest upon couches, and eat at tables; where-
upon the artist, with his artificers, built
palaces, and filled them with furniture,
beautiful in proportion and lovely to
look upon.*

"Mr. Whistler's 'Ten O'Clock'"

Frederick Leyland's new London home, as
Theodore Child allowed in an article written with the owner's assistance and
consent, was not an architectural masterpiece, "simply one of the commodious,
rectilinear London residences of the pre-aesthetic period." Its ordinariness was
a matter of remark, for like a Florentine palazzo, the sober exterior gave no hint
of the luxury within: mosaic floors and Persian carpets, Beauvais tapestries and
Spanish leather, marquetry tables, Chippendale chairs, Milanese cabinets,
and Florentine cassoni; old master paintings by Bellini, Giorgione, Botticelli,
and Rembrandt; and contemporary works by Whistler, Rossetti, Burne-
Jones, and Albert Moore. Leyland's ambition, as Child construed it, was to
realize at 49 Prince's Gate "his dream of living the life of an old Venetian mer-
chant in modern London."[1]

To the Victorian mind, Leyland's Kensington palazzo would have seemed
a veritable "Palace of Art," embodying Tennyson's famous evocation of the
chambers of a poetic soul. Written in 1832 in response to Richard Trench's
admonition, "Tennyson, we cannot live in art," the poem tells of a "sinful soul"
who loves nothing but beauty. For a time, the spirit dwells contentedly apart
from humanity, reveling in a "lordly pleasure-house" adorned with art of every
kind, until its life in art becomes a living death: "shut up as in a crumbling
tomb," the aesthetic soul begins to conjure moldering corpses in the darker cor-
ners of the palace and falls into despair. The poet promises salvation in a set-
ting close to nature, "a cottage in the vale," converting his graceful lyric into a
cautionary tale; yet Tennyson betrays an aestheticist predilection with his last-
minute plea for the preservation of the palace—if only as a place to visit, not
to live.

Tennyson's resonant verses in which images of opulent interiors turn into
chambers of horror express a Victorian distrust of the senses, an abiding worry
that over-indulging a taste for beauty leads inexorably to decadence and de-
spair. So deeply embedded in popular consciousness did "The Palace of Art"
become that *Punch*, the most widely read periodical of the age, published two

Detail, entrance hall at 49 Prince's Gate
(fig. 4.29).

FIG. 4.1 The drawing room at Whistler's house at 2 Lindsey Row, London, 1867–78. Library of Congress, Washington, D.C., Prints and Photographs Division, Pennell Whistler Collection.

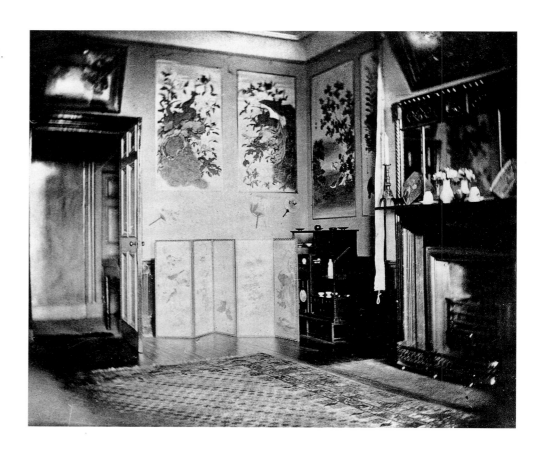

parodies of the poem in the 1870s, reminding the new aesthetes that living in art held dire consequences, both for the soul and for society. The first "New Version" appeared in 1877: it concerns a "man of taste" who inhabits a "lordly picture-place" unmistakably modeled on the glamorous new Grosvenor Gallery, recently founded by Sir Coutts Lindsay. Besotted with art, the aristocratic aesthete devolves into the same morbid state of mind as Tennyson's gifted spirit and ultimately begs for the salubrious effects of the natural world—"green leaves and flesh and blood. . . Fresh air and light of day." The second pastiche, published two years later, equates a tendency toward Art for Art's Sake with the demise of mental faculties. As the owner of "a high aesthetic house" contemplates an "ancient plate of willow-pattern blue," his brain begins to shrink and his wits to dwindle until, at last, "the sight began to pall." Thoroughly sick of blue china, he cries out for Satsuma, "or blue-green Cloisonné."[2]

The artist who most conscientiously upheld the notion that aestheticism is a symptom of social pathology was William Morris, the preeminent designer of the Victorian age. Morris began his career fashioning beautiful furnishings for Red House at Bexleyheath, the home he referred to as a palace of art. But like the soul in Tennyson's allegory, Morris repudiated the exclusivity of the palace to advance the socialization of art: "I do not want art for a few, any more than education for a few, or freedom for a few," he proclaimed in 1877, advocating "simplicity of life, begetting simplicity of taste . . . simplicity everywhere, in the palace as well as in the cottage."[3] But a painful paradox lay at the heart of Morris's enterprise, for his high standards of workmanship made his

products prohibitively expensive for all but the privileged few. Joseph and Elizabeth Pennell seized upon that contradiction in "Whistler as a Decorator, with an Incidental Comparison of the Influence of Whistler and that of William Morris," an article published in 1912 to promote the comparative "genius" of Whistler. "Morris preached art for the people and would run up a bill for five thousand dollars in decorating a room," while Whistler, who advocated an "aristocracy of art," could nonetheless "arrange a room" for a few dollars that was "beautiful in its simplicity and appropriateness." Moreover, the distinguishing characteristics of Whistler's style—distempered walls, painted woodwork, straw matting, muslin curtains—derived from "the houses of the people rather than the palaces of the few."[4]

Whistler's own early essays in interior design were conducted at home, and as even the Pennells concede, "he did not at once achieve simplicity in decoration any more than he at once succeeded in painting with the liquid colour of the nocturnes."[5] It appears that he lived much as he worked, his houses like his paintings perpetually in progress. Whistler's rooms are said to have always had the look of just having been moved into, with packing cases lying about spaces "scarcely furnished or decorated." At his second Chelsea house at 2 Lindsey Row, for example, where Whistler settled at the start of 1867, the drawing room was not painted until the day of his first formal dinner party, which took place around 1870.[6] And with his interiors, as with his paintings, people sometimes had trouble distinguishing originality from eccentricity—knowing whether certain "peculiarities" were the outcome of accident or design. The writer Anne Thackeray Ritchie, for example, recalled finding "little heaps" of fabric on the floor that she took to be "cloths flung impatiently aside" until Whistler admonished her to step carefully, as the scarves were decorating the floor.[7]

But from the start, 2 Lindsey Row was remarkable for its "many delightful Japanesisms," as William Rossetti noted on his first visit to the house, presumably alluding to the "*flight* of fans" pinned to the drawing-room walls. This eccentric practice invariably attracted the attention of Whistler's contemporaries and was later so widely copied that it became a decorating cliché.[8] The only surviving photograph of the drawing room at 2 Lindsey Row (fig. 4.1) shows the circular fans arrayed on a wall behind a small, five-panel Japanese screen, a scene that recalls *La Princesse du pays de la porcelaine*, painted at Whistler's previous "artistic abode," 7 Lindsey Row; perhaps for that reason, the photograph has long been mistaken for a room in that other house. At 2 Lindsey Row, the studio was distinct from the living rooms, and the Asian objets d'art that figured prominently in the early "Japanese" pictures became an integral part of the decor. The blue-and-white porcelain was displayed in a niche in the dining room (fig. 4.2), where the walls were inexpensively distempered "in various shades of peacock-blue."[9] Indeed, Whistler's signal contribution to the history of collecting, according to Gerald Reitlinger, was to make Chinese porcelain an essential element of the fashionable interior. By

the mid-1870s, decorating manuals such as *A Plea for Art in the House* by W. J. Loftie were recommending that readers "avoid the European and cleave to the Oriental" when purchasing china for their homes.[10]

Whistler further advanced the association of blue and white with high aesthetic taste by introducing Chinese porcelain into the Pall Mall galleries, where he held his solo exhibition in 1874. Aiming to create an "artist's-studio appearance," an environment calculated to foster appreciation for his pictures, Whistler applied the decorating principles developed in his private home to the public exhibition of his art. The walls above the skirting board were tinted a soft shade of red, and the wainscoting painted "creamy white"; the floors were covered with yellow matting, and the couches upholstered in a "rich light maroon"; blue-and-white vases were disposed on ledges and steps around the room and filled with yellow flowers.[11] Only the previous year, the *Sixth Exhibition of the Society of French Artists* had featured "pottery and porcelain of a novel character" in its galleries, reportedly enhancing the attractions of the paintings displayed.[12] Yet the press took special notice of Whistler's exquisite installation, calling it "a triumph of art." Marie Spartali Stillman maintained that Whistler's exhibition in Pall Mall "was the first time in London anyone had ventured to show that a picture exhibition could be beautifully arranged."[13]

Whistler's 1874 exhibition was also his earliest public demonstration of the design concept famously expounded by the Pennells, "that the painter must also make of the wall upon which his work hung, the room containing it, the whole house, a Harmony, a Symphony, an Arrangement, as perfect as the picture or print which became a part of it."[14] It was a timely display, for as the American clergyman Moncure Conway observed in a series of articles on English decorative art and architecture published later that year, many of London's leading artists were starting to apply their talents to interior design. The "artistic houses" of the 1870s were collaborative efforts that emerged from a unified vision of artist and architect. Contemporary commentators perceived this form of aesthetic cooperation as a return to the traditions of the Renaissance, when masters such as Giotto and Michelangelo were willing to adorn interiors with their art. As the tastemaker Mary Eliza Haweis reasoned in 1881, Why should it be beneath an artist's dignity to paint on wood or plaster if not "on thick rags—i.e. canvas?"[15]

One exemplary aesthetic enterprise was the decoration of the Kensington residence of George Howard (later Earl of Carlisle), representing the combined efforts of William Morris, Edward Burne-Jones, and Philip Webb. The morning room at 1 Palace Green, decorated between 1872 and 1881, featured a series of paintings in the frieze illustrating the story of Cupid and Psyche. These had been adapted by Burne-Jones from drawings made for the unrealized edition of Morris's *Earthly Paradise*, and the poem itself became the room's conceit, with verses inscribed in gold on a "peacock-green" wainscoting below a gold and silver Morris design. Altogether, it was said, the interior shimmered

FIG. 4.2 The dining room at Whistler's house at 2 Lindsey Row, London, 1867–78. Library of Congress, Washington, D.C., Prints and Photographs Division, Pennell Whistler Collection.

"like a page of an illuminated missal."[16] Whistler "had no sympathy with this sort of thing," according to the Pennells. Unlike William Morris, he "never tried to live out of his time."[17]

Whistler's first interior-design commission, and the only such project preceding the one at Prince's Gate, was comparatively minimalist. The patron was William Cleverly Alexander, a London banker who had demonstrated his progressive taste in 1872 by purchasing Whistler's first Nocturne and commissioning portraits of his daughters. The critic Roger Fry was to characterize Alexander as "the most unpretentious of men. He seemed incapable of regarding his wealth or the quite remarkable taste which guided its expenditure as any claim to distinction. In contradistinction to so many collectors who use their possessions to make status, he seemed almost to apologize for his good taste and his good fortune."[18] Indeed, Alexander lived a quiet life in keeping with his Quaker beliefs. When Whistler's mother spent a weekend with the family in August 1872 at Harringay House, their home north of London, she was greatly impressed when "all of the little ones" (there were seven children) assembled with the servants for morning worship, Alexander himself presiding. "Their home life," she wrote the Reverend Gamble, "is quite according to your ideas & mine."[19]

In the autumn of 1873, the Alexanders moved to Aubrey House on Campden Hill, the last country house in Kensington. Perhaps in admiration of the simple, understated interiors at 2 Lindsey Row, Alexander asked Whistler's advice on redecorating one of the three interconnected rooms that made up the

FIG. 4.3 Plans for installing porcelain in the dining room at Aubrey House (M487), 1873–74. Pen and ink on paper, 22.8 × 17.8. The British Museum, London, Department of Prints and Drawings; presented by the Misses R. F. and J. I. Alexander (1958.2.8.20).

FIG. 4.4 *Design for Wall Decoration for Aubrey House* (M491), 1873–74. Charcoal and gouache on brown paper, 18.3 × 12.9. Hunterian Art Gallery, University of Glasgow.

south front of the Georgian house. Flanked by a dining room and drawing room added in the 1750s, the Long Room was the center of the original residence, and it was there that Alexander planned to display his small but prized collection of Chinese porcelain.[20] Whistler recommended ways to show the pieces to best advantage, by placing vases on pedestals between the bays of the windows and grouping dishes on the sideboard in the dining room (fig. 4.3). He also suggested color schemes for some of the rooms, sketching out various combinations of blues and golds (fig. 4.4).

In fact, we know more about those rejected color schemes than about the one that Alexander ultimately accepted, which the Pennells describe only as "a harmony in white."[21] There are no extant drawings or photographs, which could not in any event have captured its subtlety, but the novelist Violet Hunt, a family friend of the Alexanders, recalled that "the mouldings round the doors and so on were carried out carefully in many gradations of white." The design was not an unqualified success. Jean Alexander, one of the youngest children,

later revealed that "Whistler disliked it as much as we did."[22] It also proved impractical: within three or four years the walls were so dirty that Alexander covered them with tapestries and Italian paintings. By 1913 the paneling itself had been removed to better accommodate his collection of old master paintings.[23]

The only means of gathering a visual impression of Whistler's white decoration is through the portrait he painted of May Alexander, his patron's eldest daughter (fig. 4.5). The background is "misted with vaguely defined mauves that shimmer as one moves before the work," David Park Curry observes: "Whistler's walls, with color applied upon color, may have had a similar shimmering appearance."[24] Whistler had written to Mrs. Alexander in 1875 about his idea to picture May in "the new drawing room with its white and black wainscot": he proposed working on it there, as "it would be so delightful to be able to hang the picture up every now and then and see how it would look in its own proper place!"[25] May's younger sister Cicely, whose portrait had been painted a few years earlier at Whistler's house in Lindsey Row, recalled that while he worked, Whistler often turned to regard the looking glass above the mantelpiece, "I suppose to see the reflection of his painting."[26] That practice may have inspired the daring aesthetic conceit devised for the portrait of May: on the walls of the drawing room at Aubrey House, the portrait in its frame would create the illusion of a mirror capturing the image of a young girl standing against the opposite wall. To fully appreciate the effect, the painting would have to be seen in the very setting in which it had been made, as an inextricable element of an aesthetic interior.

FIG. 4.5 *Miss May Alexander* (Y127), 1875. Oil on canvas, 192.4 × 101.6. Tate Gallery, London.

*B*Y THE TIME Frederick Leyland purchased the house at 49 Prince's Gate,[27] he had spent a decade and a fortune amassing works of art to embellish it. Speke Hall may have satisfied his longing to possess an ancestral home, but Leyland's growing collection provided one incentive for acquiring a house in London. The Leylands had always stayed at the opulent Alexandra Hotel on trips to the city, but as Frederick's visits became more frequent, both for business and the pleasure of artistic company, he required a place to feel at home. Moreover, a London house for a Liverpool family to occupy during the three or four months of the social season made an unparalleled show of success. It was "the luxury only of the older families," as one of Leyland's contemporaries noted, "or of those of great wealth."[28]

The Leylands' first London house was 23 Queen's Gate, in the fashionable borough of Kensington. Leyland was apparently arranging to occupy it by February 1868, when Rossetti inquired whether an enormous painting Leyland had recently acquired was intended for London or Speke Hall. Leighton's *Syracusan Bride Leading Wild Beasts in Procession to the Temple of Diana* (1865–66) was so large that the artist himself had feared it might not sell, which suggests

that the painting was purchased with a particular setting in mind, and Speke was not accommodating of pictures that size.[29] By the time Leyland made what he thought was the final payment on Whistler's *Three Girls*, he would have envisioned it hanging at Queen's Gate, perhaps on the walls of the music room, as Richard Dorment has surmised.[30]

Leyland's years at Queen's Gate were his most acquisitive: between 1868 and 1874 he not only accumulated most of his art collection but, as Susan Duval has noted, he also developed the notion "of a complete artistic environment."[31] He was assisted in that enterprise by several painters, notably Edward Burne-Jones, who was commissioned to create a pair of watercolor panels on the theme of spring and autumn, with accompanying verses by William Morris. When the first of those works was delivered to Queen's Gate in 1868, the artist proposed four more: "a summer nearly naked, a winter heavily draped, and a Day and Night—by degrees." Leyland was under no obligation to buy them, though Burne-Jones suggested "they would make a nice set of decorative pictures for one room." Leyland, of course, agreed to purchase them all, and when Burne-Jones wrote the next year describing their unifying scheme "of colour & expression & everything," he expressed the hope that Leyland would "eat & drink with friends, in their company for fifty years to come," never imagining that the dining-room ensemble was to be superseded by Whistler's altogether more ambitious scheme of decoration, the Peacock Room.[32]

C. A. Howell was among the first to recognize that Leyland's purchases were typically governed by the demands of interior decoration. Leyland was not a true collector, Howell told Rossetti, for he "only buys a thing when he wants it for a certain place."[33] In 1871, acknowledging that the lack of such places might curtail Leyland's patronage, Rossetti suggested that his patron give himself "the delight in life of building a fine gallery for big pictures." Leyland might convert the back of the smoking room for the purpose, the artist advised, if indeed he intended to remain at Queen's Gate: "If not, then you could change your quarters with a view to such facilities. I know I'd do it if I were you, for what is life worth if one doesn't get the most of such indulgences as one most enjoys?" But Leyland only continued indulging his love of modern art, and by March 1873 it appeared that Rossetti's fears had been realized, for the house was completely filled with pictures and Leyland was not biting at anything new. "As long as he keeps to Queen's Gate," Howell confirmed, "he will not buy much more."[34]

The next year, however, Leyland acquired a new residence less than a kilometer away—"Lord Somers' house," Rossetti was informed, "which he is going to do up swell."[35] Charles Somers-Cocks, the third Earl Somers, had purchased the leasehold on 49 Prince's Gate in 1870, the year the neighboring Royal Albert Hall opened to the public. His sister-in-law Sarah Prinsep was hostess of Little Holland House, where G. F. Watts kept a studio; Sarah's son was Val Prinsep, the artist who later married Leyland's daughter Florence. Prince's Gate, therefore, came with a distinguished pedigree that was at once

social and artistic. Just as important, the house possessed fourteen bedrooms, six reception rooms, five dressing and bath rooms, several offices, and stables for eight horses—accommodation neither excessive nor diminutive, it was said, "for the occupation of a Family of Distinction, desirous of associating its name with the World of Fashion."[36]

Prince's Gate was part of a residential development by Sir Charles James Freake that began in the late 1850s with Italianate stucco houses designed by H. L. Elmes.[37] Number 49, which stood at the end of a terrace, was one of the first to be completed around 1869, and by the time Leyland took his lease in July 1874, all but two of the houses in the row were occupied. The exterior was nondescript, which may have been part of its appeal: Leyland avoided the appearance of ostentation, according to Thomas Sutherland, president of the Peninsular & Oriental steamship line and one of the few who seem to have genuinely liked and respected Leyland. A lavish new house would have looked inappropriate, Sutherland said, "for a man like himself who had made his own money."[38]

In contrast to his decoration of Speke Hall, carried out in the spirit of renovation, Leyland remodeled 49 Prince's Gate "from the front door to the attic," his approach to modern buildings.[39] A few years earlier, Leyland had persuaded Bibby to take new offices in James Street, which he "fitted up in a superior style to his own taste," according to H. E. Stripe. The ground floor of the building was lowered, the rooms reconfigured, the original entrance

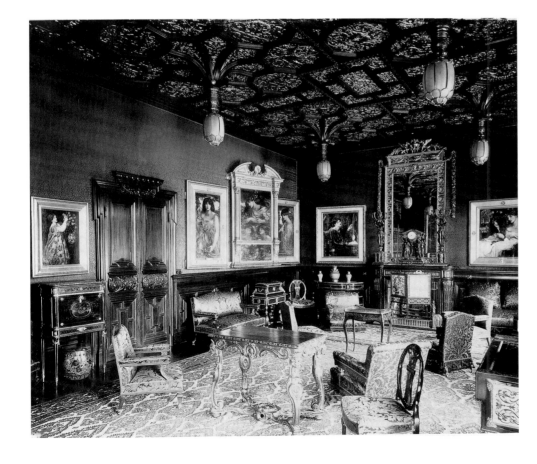

FIG. 4.6 The drawing room at 49 Prince's Gate, London, 1892, photographed by H. Bedford Lemere (1864–1944). National Monuments Record; Royal Commission on the Historical Monuments of England, London.

FIG. 4.7 The Italian Room at 49 Prince's Gate, London, ca. 1890, photographed by Henry Dixon & Son, London. Private collection, Great Britain.

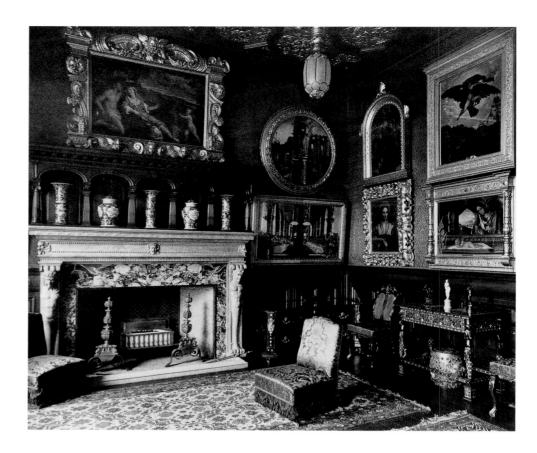

replaced with a more commanding one at the upper end of the street, and costly mahogany furnishings purchased in Paris—"the great expense incurred he felt to be of no moment whatever."[40] Similarly, Leyland set out to make his London home "the most artistic dwelling in the Metropolis," as one Liverpool historian remarked, "and whether he achieved that ambition or not, it is certain that at one time his residence No. 49 Prince's Gate was the most talked-of dwelling in the Capitol."[41] Before beginning that comprehensive conversion, Leyland consulted the art dealer Murray Marks, who trafficked in virtually everything an aesthete might require for furnishing a palace of art—not only pictures and porcelain but also tapestries, textiles, gilt leather, antique furniture, and Italian bronzes. Marks's devoted biographer, G. C. Williamson, was to argue for his place at the heart of Leyland's decorative enterprise.[42]

Apart from the Peacock Room, the most celebrated interiors at Prince's Gate were the three interconnecting drawing rooms on the first floor. The front "salon" (fig. 4.6), overlooking the Royal Horticultural Gardens across Exhibition Road, was designed for the display of single-figure compositions by Rossetti. The "scheme of decoration" was to be confined to half-length portraits arrayed on the walls "like music notes," as Leyland explained the concept, "a head in each."[43] The middle drawing room was more loosely arranged, with a varied assemblage of modern works, including the six decorative panels by Burne-Jones. The third salon, facing Prince's Gardens, had a different theme. "Without is London, within is Italy," Theodore Child observed, "for both the furniture and the pictures which adorn the walls are Italian."[44]

The Palace of Art

Leyland's extensive collection of early Italian paintings had originally hung in the billiard room downstairs, which the family used as a dining room while that decoration was in progress.[45] But in 1879, Leyland made the signal acquisition of four Botticelli paintings that Vasari himself had seen in the house of the Pucci in Florence.[46] Leyland accorded them "places of honor in the intimacy of his aesthetic life," reconfiguring the drawing rooms to accommodate them on either side of a chimneypiece that was itself "a handsome remnant of an Italian Renaissance house." The noted architect Richard Norman Shaw was commissioned to design an overmantel (fig. 4.7) and also to expand the middle drawing room into "a gallery sort of place," with a glass-roofed alcove extending over the vestibule to make more room for pictures. To subdivide the triple space without blocking the view from one room to another, the architect devised an elaborate pair of walnut and burnished-brass screens that became among the best-known features of the house.[47]

The most striking of Shaw's contributions to 49 Prince's Gate is the ceiling of the triple drawing room (fig. 4.8), a "roof oozing gold lanterns," as W. Graham Robertson described it.[48] Shaw's drawing-room ceiling, "panelled in natural walnut with caissons of gilt arabesque design," elaborates on the more celebrated ceiling in the dining room (later the Peacock Room) designed by Thomas Jeckyll, whose renovations to the ground-floor rooms at Prince's Gate were in progress by 1875. Shaw did not begin work there until four years later, which makes Jeckyll the first if not the more famous architect to convert Leyland's "ugly London house into an Italian palace."[49]

The widespread misconception that Shaw decorated Leyland's house "with the assistance of a brother architect Jeckyll" originated in 1904, in the

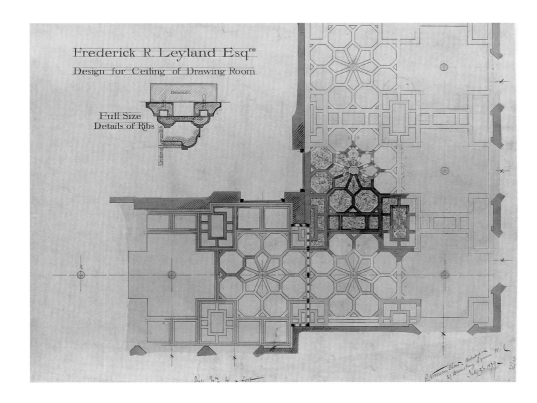

FIG. 4.8 *Design for Ceiling of Drawing Room*, 1879, by Richard Norman Shaw (1831–1912). Ink and wash on paper, 51.0 × 66.0. The Royal Academy of Arts, London, on loan from the Royal Institute of British Architects.

Obach & Co. exhibition catalogue. The Pennells further tangled the chronology with the tale that Shaw was already working at Prince's Gate when Murray Marks suggested that Jeckyll (whom he knew) be commissioned to redesign the dining room; Williamson made matters worse by describing Jeckyll as "a much younger man" than Shaw, thereby creating the enduring impression that he had been that architect's apprentice.[50] In fact, Jeckyll was four years older and an experienced professional with a rising reputation in London for highly original designs in the Japanese style. In light of the consequences, Marks may have preferred to emphasize his association with Shaw, for the decoration of Prince's Gate proved to be Jeckyll's last, and most unfortunate, commission.

THOMAS JECKELL, as his name was originally spelled, was born in 1827 in Wymondham, Norwich, the son of a Nonconformist minister (fig. 4.9).[51] Like most Victorian architects, Jeckyll seems to have obtained his professional training through apprenticeship in the office of a local architect. By 1850 he was listed in a Norwich directory as an architect and surveyor. His first important project, in 1852, was the restoration of a fifteenth-century house in Norfolk, Elsing Hall. He recorded his theories on its original appearance in an article published by the Norfolk and Norwich Archaeological Society, of which he was an active member.[52] The society's president, Sir John P. Boileau, may have been responsible for some of the commissions Jeckyll secured from Norfolk gentry during the latter half of the 1850s; Jeckyll designed a monument to Boileau's son for Ketteringham Church in 1856, and his succeeding Norfolk projects were mostly ecclesiastical.[53] He oversaw the restoration of several parish churches until the early sixties, when he began designing them himself in Old English style. By all accounts, these buildings are unexceptional. "His church at Hautbois (1864) is of no interest," Pevsner writes, "his Methodist church at Holt (1862) and his church at Thorpe outside Norwich (1866) are terrible." As Peter Ferriday put it, "Gothic was not his style."[54]

Jeckyll had moved to London in 1858, the year he became a fellow of the Royal Institute of British Architects, and rented rooms at 10 Buckingham Street while maintaining his architectural practice in Norwich. In the spring of 1860, George du Maurier, an "early friend" of Jeckyll's, came to London and sublet Whistler's back-room studio at 70 Newman Street, allowing Whistler himself to move temporarily to Rotherhithe.[55] Du Maurier reveled in his friendship with Whistler ("already one of the great celebrities here") but was miserable in his "blasted apartment" ("the very personification of discomfort and disorder"), and he made optimistic plans to take a house with Jeckyll and two other friends from Paris, Aleco Ionides and Bill Henley.[56] Although the scheme was never realized, it suggests that Jeckyll was, by then, an honorary member of the Paris set.[57] Du Maurier later regretted certain evenings spent

FIG. 4.9 Thomas Jeckyll, standing, and his father, George Jeckell, 1860s. Norfolk Studies Library, Norwich, England.

with Whistler and Jeckyll, "in which a great deal too much wine and smoke have been taken in," as he wrote his fiancée, "and too much wild talk let out, for happiness."[58]

Jeckyll enjoyed comparative prosperity in London, and by March 1861 he was living in a first-floor flat in Pall Mall that struck du Maurier as the height of luxury, with windows opening onto a balcony and an "immense drawing room regardless of expense."[59] The envious edge of that remark implies a cooling of the friendship, which du Maurier's correspondence reveals was never especially cordial. Regrettably, much of what we know about Jeckyll during these years comes from du Maurier's letters, which betray the writer's own immaturity and social unease, while spelling out an unattractive image of Jeckyll as a clinging, lying, snobbish bore. "Tom J. is rather a little tuft-hunter," du Maurier wrote his sister in 1861, "and will probably cut me for marrying a linen draper's daughter, unless I make a great name like Leech, in which case il me léchera les pieds" (he'll kiss my feet).[60] These same letters reveal Jeckyll's

extraordinary generosity: he offered to pay the expenses of a trip down the Rhine, for example (which never came about, and "would have been a great bore," du Maurier decided), and repeatedly lent his friend large sums of money that created an artificially constricting bond between them. "As soon as I can pay him," du Maurier confided to his mother, "I shall see much less of him."[61]

By 1862, Jeckyll had become an embarrassment. "Getting very unpopular," du Maurier complained of him to Thomas Armstrong, "for he tells such colossal lies & talks so beastly big about his friends Wales & St. Alban's." To his mother, du Maurier wrote, "I do wish he would not be such a little snob and idiot for all the fellows to laugh at him and make fun of him to his very face."[62] Indeed, Jeckyll was regarded as peculiar, even in an age tolerant of eccentricity. His Norwich contemporaries remembered him as "a pale little man with a bald head and dark beard," who customarily wore knee breeches and buckle shoes.[63]

Professionally, however, Jeckyll was steadily advancing. He had begun in 1859 what proved a long and fruitful association with Barnard, Bishop & Barnards, a Norwich brass and iron foundry. Known primarily for practical products such as mesh-wire netting, Barnards was starting to earn a reputation for ornamental metalwork when Jeckyll received his first major commission, the design of a set of monumental gates for a park. The cast- and wrought-iron panels of Jeckyll's "Norwich Gates" (fig. 4.10), as they came to be called, composed of interlacing patterns of hawthorn branches, oak leaves, morning glories, and wild flowers, are among the most elaborate examples of naturalistic wrought-iron ever made. Seventy artisans were involved in their manufacture, laboring for months in what Ruskin would have praised as in the nature of the Gothic: forging the foliage "with the aid and study of natural types, which lay before them for study throughout the work," they obtained for the gates "much individuality of character."[64]

When unveiled at the International Exhibition of 1862, the Norwich Gates "excited the wonder and admiration alike of the public and the whole critical press." Even du Maurier admitted that the Norwich Gates were "one of the finest things in the International," and Whistler, never easily impressed by the accomplishments of his peers, praised them as the manifestation of their designer's "exquisite sense of beauty and great knowledge." Someone is supposed to have remarked that they were fit for a prince, and the Gentlemen of Norfolk and Norwich accordingly opened a public subscription to buy them for the Prince of Wales as a wedding present. They were installed in 1863 at the new royal residence at Sandringham Park.[65]

Crowned with the aura of royal patronage, the Norwich Gates made a promising start to Jeckyll's career as a metalwork designer, earning him the sobriquet "Jeckyll of the Gates" and, according to du Maurier, "lots of money." Far from snubbing his friend when he married the draper's daughter, Jeckyll appeared at du Maurier's wedding "joyously bedecked," and the only outward indications of his newfound prosperity were a move to Holborn in 1862 and

FIG. 4.10 Norwich Gates, 1859–62, designed by Thomas Jeckyll (1827–1881), manufactured by Barnard, Bishop & Barnards, Norwich. From *The Art-Journal Catalogue of the International Exhibition*, 1862.

The Palace of Art

a change in the spelling of his name.[66] Ferriday suspected the reason for the latter was snobbery, speculating that Jeckyll sought to associate himself with the landed family named Jekyll (of which the landscape architect Gertrude was a member), but that would imply a still different spelling of the name.[67] Perhaps Jeckyll followed the example of Frederick Sandys, another Norwich artist, who added the "y" to his own surname to recover an earlier spelling. Sandys got his start illustrating handbooks on Norfolk antiquities, so Jeckyll might have known him in Norwich, from the beginning of his career.[68] If not, they surely would have met in the mid-1860s, when Jeckyll was hovering around the edges of the Rossetti circle.

It was under the influence of the Chelsea aesthetes that Jeckyll succumbed to the "Japanese mania," assimilating the vocabulary of East Asian design. His "conversion from the Gothic" has traditionally been linked to the 1867 Exposition Universelle in Paris, where Jeckyll's second set of ornamental gates occupied a place of honor; but those compositions already featured some of the Japanese-inspired motifs that came to distinguish Jeckyll's style, notably the ornamental badges or medallions in the lower registers containing stylized flowers in bas relief.[69] Christopher Dresser pointed out the prevalence of "circular ornamentation" in Japanese design in a lecture of 1863, around the time the motifs began cropping up in English art. Rossetti and Whistler used ornamental discs on picture frames, and William Eden Nesfield began incorporating what he called "pies" into architectural designs, most spectacularly at the lodge at Kinmel Park, where sunflower medallions fill the frieze.[70] Lines of influence are difficult to establish among these artists, who traveled in the same circles and freely shared enthusiasms and ideas, but as early as 1897, Gleeson White named Jeckyll "the first to design original work with Japanese principles assimilated—not imitated." The architectural historian H. S. Goodhart-Rendel observed that Jeckyll may not have been the equal, as an architect, of either Nesfield or E. W. Godwin, but "his pattern designing was epoch-making, and the subject of much imitation by others."[71]

Jeckyll's earliest project in the orientalizing style may have been a suite of furniture designed around 1866 for the industrialist Edward Green, including a Jacobean sideboard carved with the Chinese scrolls and other Asian motifs that Jeckyll employed in varying density and combination throughout his career.[72] He refined his Anglo-Asian grammar of art in the domestic metalwork designed for Barnards, particularly the fire grates fronting the firm's revolutionary slow-combustion stoves (fig. 4.11). As the hearth of the English home, the "grate and its arrangements" became "matters of serious importance in every room," as Moncure Conway noted in 1874, and Barnards' ingenious stoves, designed to produce more heat with less coal, made exemplary products of the Aesthetic movement: "They have not sacrificed principle to beauty, but made comfort and elegance go hand in hand."[73] The first of Jeckyll's grates (or "Norwich stoves") was registered with the Patent Office in 1873; Barnards continued to produce them, and architects (including Shaw) to recommend them, throughout the

(REGISTERED)
SLOW COMBUSTION STOVE,
With Register Door and Frame, Fire Bricks, and Cramps.

No. 682.
This Engraving shews the Stoves as hitherto and still supplied by B. B. & B. An Engraving shewing the appearance of the Stove when fitted with Fire Basket and Bars as advocated by " Another Country Parson " will be found at page 204.

FIG. 4.11 Slow Combustion Stove No. 682. From *Complete Catalogue of General Manufactures*, Barnard, Bishop & Barnards, 1878. Bridewell Museum, Norwich.

FIG. 4.12 Jeckyll's signature insects on Slow Combustion Stove No. 682, ca. 1874, designed by Thomas Jeckyll (1827–1881), manufactured by Barnard, Bishop & Barnards, Norwich. Cast iron, 91.3 × 60.0. Freer Gallery of Art, Smithsonian Institution, Washington, D.C. (FSC-M-16).

century.[74] They were manufactured in a variety of shapes and sizes, both in polished brass and economical cast iron, which tastemakers advised could be painted gold.[75] Ranging in price from one to twenty pounds, the grates were available to virtually every British household, and it was through those objects of daily necessity that Jeckyll introduced Japanese design into Victorian domestic life. He was among the first, a contemporary journalist pointed out, to capture the spirit of Japanese style and turn it "to a practical account."[76]

The surfaces of Jeckyll's grates were typically adorned with circular medallions of stylized sunflowers or chrysanthemums, asymmetrically superimposed on a background of fretwork or reeding. Often, at least one disc held a pair of Jeckyll's signature moths (fig. 4.12), an emblem reminiscent of Whistler's butterfly cipher. Marion H. Spielmann, editor of the *Magazine of Art*, was informed that Jeckyll had been "the true inventor of the charming little device which Whistler used to such purpose later on," which seems plausible in light of Jeckyll's imaginative use of stylized insects in the Japanese manner.[77] If he devised only one form of Whistler's constantly evolving monogram, it may have been the short-lived emblem employed around 1873, a curiously long-bodied butterfly, rather like a dragonfly, enclosed in a circle like a Jeckyll medallion.

Whistler later asserted that Jeckyll had been among his "intimate comrades and we were greatly attached," and he also claimed, "I doubt if Tom counted among his admirers any more sincere and devoted than myself." Jeckyll, for his part, was "quite abject" in his admiration for Whistler, according to Thomas Armstrong, which suggests that during the 1860s he transferred his affections from du Maurier to one more tolerant of extravagant devotion.[78] In 1867, Jeckyll demonstrated his allegiance during the Haden affair, collaborating with William Rossetti on a "campaign" to save their friend from expulsion from the Burlington Fine Arts Club.[79] Whistler, in turn, may have been responsible for Jeckyll's introduction to the Arts Club (Whistler was a founding member, and Jeckyll belonged from 1867 through 1871), and the Decemviri, an informal dining society founded in the late 1860s with a membership limited to ten, no two members practicing the same profession. In 1868, when Jeckyll fell behind with dues to the Arundel Club, Whistler paid them for him.[80]

Jeckyll had moved that spring from Gloucester Road to 5 St. George's Terrace, a respectable Kensington row house not far from Frederick Leyland's residence at 23 Queen's Gate. Despite his debt to the Arundel, Jeckyll's fortunes were apparently improving, and they rose still further around 1870, when he abandoned ecclesiastical projects to design an extravagant five-story house for the mayor of Cambridge, Henry Rance. Familiarly known as Rance's Folly, the house at 62 St. Andrew's Street, Cambridge, was among the earliest

examples of the Aesthetic-movement style called Queen Anne.[81] Photographs reveal a remarkable "mathematical ceiling" in the dining room (fig. 4.13), patterned with "eccentric circles studded with the roundels familiar from the grates."[82] The wallpaper in the frieze bears a similar design superimposed on a Japanese "wave pattern," the motif Jeckyll was to employ at 49 Prince's Gate.

The Rance project may have led to Jeckyll's most important commission before Frederick Leyland's, designs for the house of his old friend Aleco Ionides. The Ionides family had left their suburban home at Tulse Hill in 1864, after the Bank of London's failure adversely affected them; they purchased 1 Holland Park with proceeds from the sale of Euterpe Ionides' diamonds.[83] Designed by Francis Radford, the house was built on land formerly attached to Holland House, the earliest of Kensington's great houses, developed for residential use in the 1860s; Leighton and Prinsep had been among the first to purchase land from the estate, effectively founding an artists' colony in Melbury Road. Unlike those custom-built studio houses, 1 Holland Park was "a builder's house of a not uncommon Bayswater type," Walter Crane recollected, but over the years, as the Ionides fortune was repaired, alterations and additions rendered it ever more remarkable.[84] Like their previous residence at Tulse Hill, the Ionides' house became a favorite resort of artists, particularly Burne-Jones, Philip Webb, and William Morris. All of them became involved in the redecoration of the house from 1877 through the 1880s.[85] But as at Prince's Gate, Thomas Jeckyll was the first designer engaged in the transformation.

In 1870, Aleco Ionides assumed ownership from his father and commissioned Jeckyll to design a new wing, which was to include a morning room, a billiard room, a master bedroom, and a servants' hall (fig. 4.14). Jeckyll gave the

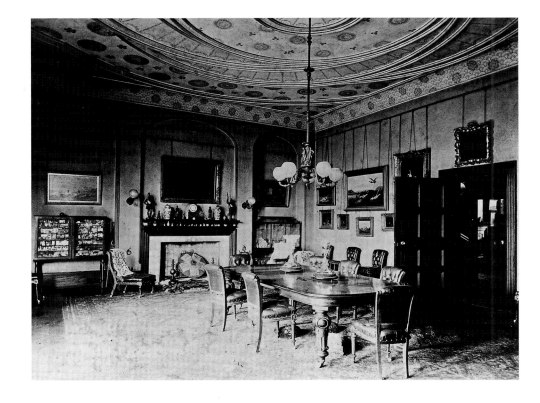

FIG. 4.13 The dining room at 62 St. Andrew's Street, Cambridge, ca. 1870. National Monuments Record; Royal Commission on the Historical Monuments of England, Swindon.

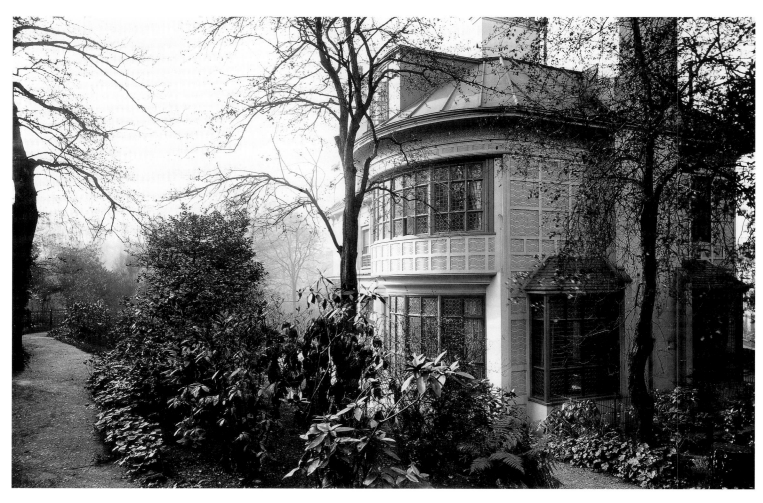

FIG. 4.14 Addition to 1 Holland Park,
London, 1893, photographed by H. Bedford
Lemere (1864–1944). National Monuments
Record; Royal Commission on the Historical
Monuments of England, London.

two-story structure a novel Chinese-style roof, with a band of waves under the eaves recalling the wallpaper frieze in the Rance dining room. The addition's concrete exterior was incised with undulating grooves that also figure on Jeckyll's fire grates; these may have been suggested by patterns on Chinese bronzes known from Owen Jones's *Examples of Chinese Ornament*, published in 1867, if not from the objects themselves.[86] The motif was to be continued on the furniture Jeckyll designed for the master bedroom in 1875 (fig. 4.15), when Aleco Ionides married Isabella Sechiari and his parents retired to Hastings.[87]

One purpose of the new wing was to make the most of the view of Holland House, and Jeckyll designed a broad bay of windows with "Old English" leaded glass that spanned the width of the addition. Eventually, he planned the surrounding garden as well.[88] For the upstairs sitting room, or morning room (fig. 4.16), he chose pale yellow walls with sunbursts on the ceiling to create a sense of sunlight, however dim the day. He had the seating in the bay upholstered in green fabric (or leather) cheerfully adorned with sunflowers, and the corners fitted with bracketed shelves for a few choice pieces of porcelain. The bright simplicity of Jeckyll's design becomes especially striking when compared with a view of the same room some years later, after Morris & Co. converted it into a study (fig. 4.17). The firm retained the most arresting feature of Jeckyll's interior, however—the green marble fireplace with blue-and-

white dishes echoing the medallions in the ornamental brass grate (fig. 4.18).[89] In the étagère above the mantelpiece, panels of Japanese lacquer form the background for red-and-white "Nankin" vases. There was a second striking fireplace in the billiard room, with red-luster tiles framing a grate of the same design, surmounted by a high oak structure inset with lacquer panels (fig. 4.19). Jeckyll's "quasi-Japanese treatment" of the chimneypieces set the style for the heavier, more elaborate structures Barnards later produced to encase their grates, with shelves for displaying pottery and bric-a-brac.[90]

While the morning room was made to mirror the light and color of the natural world, the billiard room, situated directly below, afforded a purely aesthetic experience. Jeckyll designed every element, even the so-called English Renaissance billiard table carved with decorations "distinctly in the manner of the foliage and fretwork of Japan." The design may consciously recall the playfully extravagant chinoiserie rooms of the seventeenth and eighteenth centuries, which were often lined with Asian lacquerware. At the Dutch pleasure-palace of Honselaarsdijk near The Hague, for instance, Chinese lacquer screens had been dismembered to provide panels for the walls of a "Chinese" closet which, like the billiard room in Holland Park, featured porcelain massed on the chimneypiece.[91] Adapting this tradition to the Victorian taste for things Japanese, Jeckyll set red-lacquer panels into the ceiling and in two narrow bands along the walls between the cornice and the wainscoting: the designer Lewis F. Day observed that "hundreds of Japanese trays must have been slaughtered to supply them."[92] Jeckyll divided the expanse of wall between the lacquer panels with reeded oak moldings, arranging Japanese paintings and "fine old Japanese prints" to repeat the pattern formed by the transoms and mullions of the windows overlooking Holland Park (fig. 4.20). This produced the pleasing illusion of windows onto an artificial world of birds and flowers, a

FIG. 4.15 Dressing table, 1875, designed by Thomas Jeckyll (1827–1881). Padauk wood with ebony moldings and brass mounts, 101.6 × 66.0 × 144.8. The Victoria and Albert Museum, London (w.13-1972).

FIG. 4.16 The morning room at 1 Holland
Park, London, ca. 1870, by Thomas Jeckyll
(1827–1881). Pencil and watercolor,
24.6 × 32.1. The Victoria and Albert
oMuseum, London (E.1797-1979).

FIG. 4.17 The study at 1 Holland Park,
London, 1902, photographed by H. Bedford
Lemere (1864–1944). National Monuments
Record; Royal Commission on the Historical
Monuments of England, London.

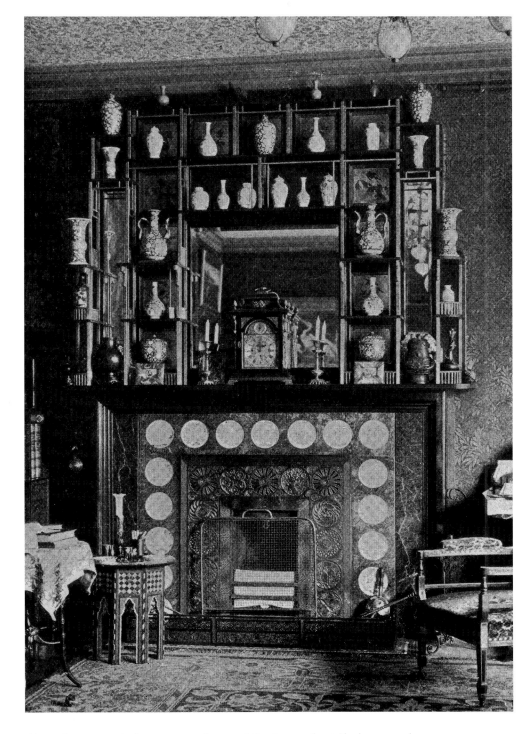

FIG. 4.18 The fireplace in the morning room at 1 Holland Park, London, ca. 1870–73, designed by Thomas Jeckyll (1827–1881). From *International Studio*, December 1897.

diverting conceit for a room devoted "only to the idle hours when one wants to be amused."[93]

Below the billiard room was the servants' hall. No photographs of it have come to light, but Day provides a tantalizing description of a room in which blue-and-white porcelain stood on shelves from floor to ceiling: "One leaves it with an impression of fresh and delicately beautiful colour, blue and white and pale yellow, and a wonder what the servants think of it!" The color scheme was later popularized by Whistler, who would employ it in his own dining room. But the shelving Jeckyll designed for porcelain in this "very museum of old blue

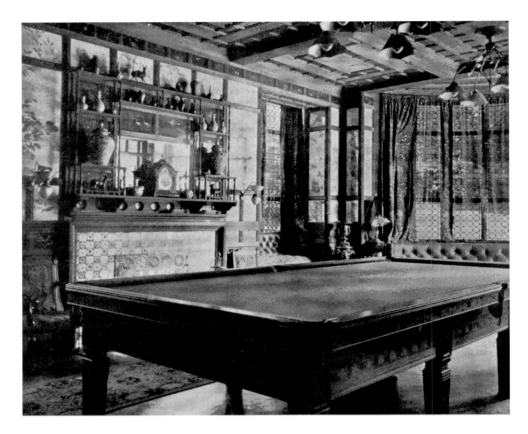

FIG. 4.19 The billiard room at 1 Holland Park, London, designed by Thomas Jeckyll (1827–1881), ca. 1870–73. From *International Studio*, December 1897.

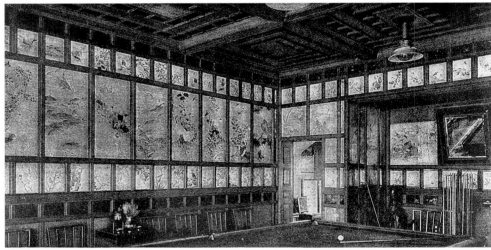

FIG. 4.20 The billiard room at 1 Holland Park, London. From *Art Journal*, 1892.

china" clearly anticipates the Peacock Room, "built, as one may say, upon the wreck of Mr. Jeckyll's work" in Holland Park.[94]

Frederick Leyland's first piece of blue-and-white porcelain may have been a pot he bought as a gift for Rossetti in the spring of 1870. Although he eventually amassed an enormous quantity of his own, Leyland seems never to have acquired his friend's passion for blue china, and the fame of his collection was to reside in the room designed for its display. Howell, who among other things

dealt in blue china, explained to Rossetti that Leyland was "never taken with the beauty of a certain pot or any thing, he only sees that such and such a corner requires a pot and then he orders one." [95] Indeed, like many collectors of the period, Leyland seems to have regarded Chinese porcelain primarily as a tasteful appointment for the artful interior. Photographs of Prince's Gate interiors show arrangements of Chinese porcelain in spaces otherwise devoted to Flemish tapestries or Italian paintings. The noted collector A. T. Hollingsworth, writing in 1891, emphasized the importance of blue and white "first as an undeniably exquisite decoration for the interior of our houses, and secondly, as a thing of rare beauty in itself, and apart from all consideration of its adaptability to its surroundings." [96]

The late nineteenth-century "decorator's taste" for blue china was actively encouraged by Murray Marks, who is said to have "selected," or supplied, most of the pieces in Leyland's collection. Recognizing "what a feast of colour a great collection of Blue and White porcelain could produce," Marks would also have realized how much profit could be made from selling it in quantity. He did not originate the craze himself, but "few were more intimately concerned in the development in England of the *culte* of Blue and White Nankin porcelain." [97]

Emanuel (Murray) Marks (fig. 4.21) was the fourth child of Emanuel Marks van Galen, who had dropped his Dutch surname after emigrating to England as a young man. Setting up shop at 395 Oxford Street as an importer of furniture, china, and "curiosities," the elder Marks leased part of his premises to Frederick Hogg & Co., a firm specializing in Chinese goods. His son Murray became captivated by their wares, particularly the porcelain, and "by dint of steady reading at the British Museum" learned all he could about it. Eventually he went against his father's wishes and behind his back to withdraw some stock from the family warehouse and establish his own business on Sloane Street. Enjoying moderate success, Murray moved his firm to High Holborn around 1868 and continued to trade as a "curiosity dealer" like his father. When the elder Marks retired in November 1875, the younger took over the Oxford Street premises, commissioning his friend Richard Norman Shaw (himself a collector of "pots") to remodel the facade in Queen Anne style. [98]

What may have been the seminal event of Murray Marks's career took place late in 1865 or in 1866, when he made the acquaintance of Rossetti. "I don't think I was ever so impressed by anybody in my life," Marks recalled. [99] Then engaged in fierce competition with Whistler, Rossetti had asked for assistance in acquiring "some of the finest examples" of Chinese porcelain, and on Marks's next trip to Holland, where he retained family ties, he purchased a quantity of china for a small sum and offered it to Rossetti for fifty pounds. (What Rossetti couldn't afford was purchased by another enthusiastic collector, Louis Huth.) That transaction, according to Marks himself, began the English "rage" for Chinese blue and white. Indeed, the sale marks a shift in the pattern of acquisition in England, as "the fever spread from Whistler and Rossetti to the ordinary collector." [100]

FIG. 4.21 Murray Marks, 1860s. The Victoria and Albert Museum, London; National Art Library (Reserve Collection Q.4).

Eventually, the fever became the epidemic that George du Maurier dubbed "chinamania." A series of *Punch* cartoons on the theme presents the popular enthusiasm for blue and white as a mental pathology displacing natural human affection: "Acute Chinamania," from 1874, pictures a woman despairing over the breakage of a porcelain dish, a loss not even her "complete set" of children can make up for.[101] Du Maurier also recognized the commercial implications of the craze, suggesting in "Aptly Quoted from the Advertisement Column" (fig. 4.22) that London dealers created the demand for blue-and-white china by casting it as a necessity. Lady Charlotte Schreiber, who preferred early English porcelain herself, found The Hague in 1876 full of London dealers "flitting about" in quest of the porcelain. "The rage for everything 'blue and white' is truly ridiculous," Lady Charlotte noted in her journal. "The dealers own it to be so, but are not to be blamed for profiting by the madness of the hour."[102]

The phenomenal rise in the value of Chinese blue and white is commonly illustrated with the Huth jar, reputed to be the finest example of a "hawthorn" pot in London. Louis Huth had purchased the jar for twenty-five pounds in the early 1860s from a friend who had bought it in an antiques shop for twelve shillings. During the fever of chinamania, Huth refused fabulous sums to part with his pot, and after his death in 1905 it sold at Christie's for nearly six thousand pounds—slightly more than the Peacock Room itself had sold for, one year earlier.[103] It was that very pot which had made Rossetti determined to find "another like it in the world," as he wrote to Murray Marks in 1866, leading to his purchase in 1867 of a pair of "sumptuous hawthorn-pots with covers" for the unprecedented sum of one hundred and twenty pounds.[104]

FIG. 4.22 "Aptly Quoted from the Advertisement Column," a cartoon in *Punch*, 15 December 1877, by George du Maurier (1834–1896).

APTLY QUOTED FROM THE ADVERTISEMENT COLUMN.
Thrifty Wife. "OH, ALGERNON! *MORE* USELESS CHINA! *MORE* MONEY THROWN AWAY WHEN WE HAVE SO LITTLE TO SPARE! *Amiable Chinamaniac.* "POOH! POOH! MY LOVE! 'MONEY NOT SO MUCH AN OBJECT AS A *COMFORTABLE HOME*,' YOU KNOW!"

The Palace of Art

William Rossetti attributed the escalation in the price of porcelain to his brother's "zeal and persistence" in collecting, but it was Marks who engineered the inflation.[105] In 1872, when Rossetti was recovering from a spell of mental illness and was desperately in need of funds, he sold back to Marks his pair of hawthorn pots for seventy or eighty pounds; eventually he realized that he had been "unlucky" in that transaction, for as Howell pointed out, blue china was "six times as dear" in 1872 as it had been in the 1860s, during their "collecting days."[106] Moreover, the value of Rossetti's china had been considerably enhanced by its prestigious provenance. Marks must have realized a substantial profit in reselling the treasured jars to Sir William Armstrong, who placed them in the drawing room of his Northumberland country house designed by Richard Norman Shaw.[107] Marks managed to trade on his artistic associations to set himself above the common trade. Arthur Lasenby Liberty, for example, had opened a small import shop in Regent Street in May 1875 that proved so successful it was expanded within the year. Faced with such competition, Marks appealed to "the plutocracy of the Art market," an exclusive clientele consisting of collectors such as Frederick Leyland, who could afford any price but insisted on quality and demanded expertise.[108] The ordinary purchaser simply had to take his chances, and "a few years hence," as W. J. Loftie consoled his readers, "the labours of investigators may have determined the comparative rarity and value of the pieces in your collection." Indeed, scholarship on Asian ceramics was still in its infancy, and even the most fundamental issue of connoisseurship—the country of origin—sometimes remained open to question. As late as 1875, the so-called hawthorn pattern had not yet been "authoritatively classed amongst Chinese or Japanese productions," according to G. A. Audsley, who tended to believe that it was Japanese.[109]

It was not until 1876 that Augustus Wollaston Franks, the keeper of antiquities at the British Museum, made the first attempt "to distinguish the respective productions of China and Japan." Franks lent his extensive holdings for exhibition at the Bethnal Green Museum in London. Although the collection comprised a wide variety of Asian porcelain, it did not necessarily contain the most beautiful examples, as Franks himself conceded in the catalogue.[110] That distinction might have gone to the collection of Sir Henry Thompson, reportedly begun on Rossetti's advice and assembled by Murray Marks. Consisting entirely of Chinese blue and white, Thompson's collection was among the first to attract public attention; Marks used it to confirm his status "as *the man who* . . . knew more about such porcelain than anyone else in London and as the recognized authority on the subject."[111] Within months of the exhibition at Bethnal Green and shortly after Shaw had transformed the facade of 395 Oxford Street, Marks conceived a catalogue of Thompson's holdings that was to become, in itself, an objet d'art.

$I_{\text{T WAS}}$ Whistler absolutely who invented Blue and White," Murray Marks assured the Pennells.[112] By the time Marks met Whistler — probably through Rossetti, around 1867 — the artist's collecting was already tapering off through lack of funds, and by the end of the decade he was selling at least as much as he was buying. Marks obliged Whistler by disposing of his porcelain "on the various occasions on which he was in difficulties," as G. C. Williamson phrased it. Whistler's pots, like Rossetti's, were resold to more prosperous collectors — possibly including Sir Henry Thompson himself.[113]

Like Marks, Thompson was the son of a shopkeeper, but he escaped the family business in Croydon at the age of twenty-eight, determined to study medicine. "Late as it was he worked hard," du Maurier wrote his mother in 1864; "here he is at 44 at the very top of his profession, and in manner, information etc. one of the most delightful men in London."[114] By 1876 Thompson had become one of the leading physicians of Europe, with a roster of patients including Leopold I of Belgium, Napoléon III of France, and Nicholas II of Russia. He was a pioneer in cremation, a student of astronomy, an expert on diet, and the only member of the medical profession admitted to London society, where he became renowned for dinner parties given nearly every week for "all the most notable and interesting people in London." An art form in themselves, these "Octaves" began at eight o'clock and consisted of eight dishes. Thompson regarded his eight male guests as notes forming the C-major scale, and he thought of himself as the staff that brought them together.[115]

When du Maurier met him, Thompson had been thinking of giving up medicine for art ("he has great talent and delights in the society of artists"), but he found he could practice both and was soon exhibiting paintings at the Royal Academy.[116] The subject of his work in 1872, a Japanese gray-crackle jar, suggested "a taste for some form of ceramic art" that developed into a passion for Chinese blue and white.[117] Thompson himself was to contribute seven of the illustrations to Murray Marks's catalogue of his collection, prompting one to wonder why he didn't execute them all. Although his drawings show a certain "hardness and want of Oriental character," as Williamson observes, they are "full of striking reality" and valuable documents for collectors.[118] But Marks commissioned Whistler to produce the illustrations, reputedly on the strength of some rough sketches Whistler had submitted to Marks in the early 1870s for porcelain patterns of his own (fig. 4.23).[119] Some of these dishes have recognizably Chinese patterns along the rims, but otherwise the designs are distinctively Whistlerian: one contains a quotation from *The Three Girls*, another embodies the artist's peculiar vision of Battersea Bridge, two depict sailing ships resembling those Whistler painted in blue on the white walls of a passageway at 2 Lindsey Row. Whistler's designs were to have been produced as porcelain by the Fine Art Company that Marks spoke of establishing in 1867, in partnership with Gabriel Rossetti, Edward Burne-Jones, Luke and Aleco

FIG. 4.23 *Designs for Plates* (M591), ca. 1872. Pencil on paper, 9.7 × 23.2. The British Museum, London, Department of Prints and Drawings; presented by the Misses R. F. and J. I. Alexander (1958.2.8.16).

Ionides' brother Constantine, and others. It was to be a decorating business along the lines of Morris & Co., but an altogether "more pushing & enterprising scheme," so William Rossetti understood. Marks consulted Howell, who was appointed secretary; but when Howell realized the proposed company "would do away with a proportion of his profits," Williamson relates, "and would prevent the secret negotiations and underground consultations, in which he delighted," the venture went no further, and Whistler's ideas for blue and white were never realized.[120]

A more important precursor to the catalogue commission was probably the pen-and-ink drawing Whistler had made for Murray Marks early in their acquaintance, to show the dealer what he desired for his own collection (fig. 4.24).[121] Marks would always treasure that "vivid little drawing" of seven pieces of Chinese porcelain, which revealed "what feeling the artist had for the exquisite beauty of the designs" and displayed Whistler's remarkable skill in suggesting the "original colour and glaze" of the porcelain, even in black and white.[122] Whistler's nineteen illustrations for the Thompson catalogue capture the same aura of exquisiteness, described in a Parisian review as "une tendresse presque féerique"—an almost magical delicacy that gave new charm to the objects portrayed.[123] Like all Whistler's best work, the drawings appear effortless, but a set of preliminary studies shows how he labored to achieve his light touch. In some he created atmosphere with watercolor washes (fig. 4.25), though he must have decided his interpretation overwhelmed the inherent beauty of the objects, for the final versions depict the porcelains floating on an empty page or standing on the barest suggestion of a shelf (fig. 4.26).

Whistler also appears to have emulated the brushwork of the Chinese porcelain painters, getting "inside the skin of the original artists," as Margaret MacDonald puts it, to reprise the role he had assumed a decade earlier in painting *La Princesse du pays de la porcelaine*.[124] Indeed, it must be more than coin-

FIG. 4.24 *Sketches of Blue-and-White Porcelain* (M592), ca. 1867. Pen, ink, and wash on paper, 17.9 × 10.9. Present whereabouts unknown.

cidental that Whistler made these drawings during the very months he was decorating the dining room at Prince's Gate, which involved a similar collection of Chinese porcelain. Whistler had begun the catalogue project by early October 1876, when Thompson informed the artist J. Alden Weir that Whistler was "working from some old china which he had lent him." He was ready for a second installment by the end of December. "Bring a lot more pots and take away the old ones," Whistler instructed Murray Marks, advising him

The Palace of Art

that the drawings were turning out to be "much more valuable" than expected.[125] This may have meant only that the designs were requiring more time than predicted, but it may also have implied that the assignment taken on as a potboiler was assuming aesthetic importance.[126]

For some reason probably having do with the Peacock Room, the Thompson catalogue did not appear until the spring of 1878, when it was published by Ellis & White. The illustrations were reproduced by the autotype process, and the deluxe large-paper edition was encased in tooled-leather covers with the "hawthorn" pattern embossed in white on a golden ground.[127] The catalogue was consciously fashioned as a collector's item: a notice on the flyleaf that only 220 copies had been printed, of which 100 were reserved for private circulation, was sufficient in itself "to make the hunter's mouth water."[128] Moreover, the text was "merely descriptive," according to the *Athenaeum*, "and of no general interest," a deficiency Williamson excused with the explanation that Marks's introduction was meant only "to present the subject to the reader who was already interested in it."[129] The "Blue china book,"

FIG. 4.25 *Study for an Illustration of a Dish and Square Canister* (M630), 1876–77. Pen, ink, and wash on paper laid down on card, 23.0 × 20.0. Munson-Williams-Proctor Institute, Utica, New York (69.174).

FIG. 4.26 Illustration for Plate XVIII (M631), *A Catalogue of Blue and White Nankin Porcelain Forming the Collection of Sir Henry Thompson* (1878). Pen, ink, and wash on paper, 22.3 × 17.9. Freer Gallery of Art, Smithsonian Institution, Washington, D.C. (98.415).

FIG. 4.27 Trade card designed for Murray
Marks, ca. 1875, possibly by Henry Treffry
Dunn (1838–1899).

as Marks recalled, was brought out entirely at his own expense: "Sir Henry had
nothing to do with the catalogue beyond purchasing a certain number of copies
from me."[130] The Pennells relate that the venture was not a financial success—
Marks sustained a loss of two or three hundred pounds—but a profit was
undoubtedly realized in other ways.[131] James Orrock, for instance, such an
avid collector of porcelain that he was called "Admiral of the Blue" (though
he himself preferred "Emperor of China"), credited Thompson's collection
with giving him his "first revelation of the manifold splendour of Blue China."
Inestimably impressed, he sought out Murray Marks and with the dealer's
wares laid the foundation of his own extraordinary collection.[132]

To celebrate the publication of the catalogue, Marks exhibited the
original illustrations and the actual collection of 339 pieces of porcelain, all in
frames designed by Richard Norman Shaw. We can gather the effect of the dis-
play from Marks's sumptuous trade card, bearing a still life of peacock feathers
in a "hawthorn" pot surrounded by a gilded frame (fig. 4.27). A "special private
view" was held late on the night of 30 April 1878 and attended by artists,
actors, and others "known or supposed to be interested in the Sir Henry
Thompson collection."[133] The invitation card (fig. 4.28) was drawn by Rossetti's

assistant, Henry Treffry Dunn, who may also be responsible for the business card, implausibly reported to be the collaborative effort of Rossetti, Morris, and Whistler.[134] Identifying the artist solves one longstanding mystery, but the invitation remains something of an enigma: in the vignette at the top, only Whistler (on the right) can be confidently identified.[135] The disposition of the figures across the picture plane, as if on stage, suggests that the scene portrays actors playing aesthetes, as many had in recent years. *A Tale of Old China*, for instance, a one-act play performed at St. George's Hall in the spring of 1875, involved a prosperous German art dealer who recognizes the rising value of "oriental china" in London: "Every dish, cup or vase will be worth ten times its weight in gold, if I can only bide my time."[136] Marks must have known that satire of his profession (and possibly of himself), and Dunn may have alluded to it in the invitation card, employing a theatrical conceit sure to appeal to the many guests from "the Dramatic profession"—including George Grossmith, who some years later impersonated Whistler in the role of Bunthorne in Gilbert and Sullivan's aesthetic operetta *Patience*.[137]

The "very *recherché* supper" had a menu selected to set off the blue-and-white china on which the meal was served.[138] Marks recalled that Rossetti had turned a dish full of food upside down to examine the potter's marks on the base, but the same anecdote is told of a dinner party held years earlier at Whistler's house on Lindsey Row.[139] Perhaps that familiar story was only recounted by one of the guests at the private view (which it seems doubtful Rossetti would even have attended), leaving Marks with a vivid but misplaced recollection of the good old days, when the artists themselves had set the stage for chinamania.

FIG. 4.28 *Invitation to a Private View of the Collection of Sir Henry Thompson*, 1878, attributed to Henry Treffry Dunn (1838–1899). Pen and ink on paper, 18.5 × 24.0. The Victoria and Albert Museum, London; National Art Library (Reserve Collection Q.4).

THE CENTERPIECE of Leyland's house in Prince's Gate was a grand marble staircase with a magnificent ormolu balustrade (fig. 4.29). It had a priceless provenance: the London home of the Percy family, one of the last "of the old fashioned London mansions of the nobility." Over a chorus of public protest, Northumberland House had been demolished in the summer of 1874 to make way for a thoroughfare leading from Charing Cross to the Victoria Embankment. That September the mansion "underwent its final phase of degradation" when every brick and board came under the hammer of the auctioneer, and of the £6,500 realized from the sale, £360 came from the staircase alone.[140] It had been designed by Thomas Cundy in 1818 as part of a reconstruction of the mansion's Strand front carried out by the third Duke of Northumberland. (The first duke was Sir Hugh Smithson, who took the Percy name when he married into the family in 1766; his illegitimate son James became the benefactor of the Smithsonian Institution.)[141] In 1851, on the occasion of the Great Exhibition, the public was admitted to Northumberland House; thousands ascended the marble stairs to the ballroom and picture gallery on the first floor (fig. 4.30). In 1874, another "multitude of people with tickets of admission from the Metropolitan Board of Works" thronged the house to see the famous staircase in situ one last time.[142]

That national treasure was to form the spine of the house at Prince's Gate, rising five stories from a grand entrance hall that Leyland entrusted Whistler to decorate. As Hermann Muthesius observed, the prominence of the hall in nineteenth-century English dwellings was ornamental rather than useful: "There

FIG. 4.29 Entrance hall at 49 Prince's Gate, London, ca. 1890, photographed by Henry Dixon & Son. Private collection, Great Britain. Paintings, from left to right, are *Burd Helen*, by Windus; *Le Maitre du chapelle*, by Legros; *The Loving Cup*, by Rossetti; *The Wine of Circe*, by Burne-Jones; and *Valkyrie*, by Sandys. *La Pia de' Tollomei*, by Rossetti, hangs below the staircase. The open door on the left leads to the dining room.

is little occasion to use its great capacity, for it lies immediately inside the front-door and is therefore in the wrong position in the ground-plan to be used as a banqueting-hall or a ball-room. All that remains, therefore, is to look upon it as an imposing area, the sole purpose of which is to create an aesthetic impression."[143] Though subsequently overshadowed by his redecoration of Leyland's dining room, Whistler's initial commission for Prince's Gate was, therefore, an honorable project of great importance, for the hall was to set the tone for the entire house.

Some years earlier, in 1873, Whistler had decorated his own more modest stair hall at 2 Lindsey Row, "giving the walls a lemon tint above a dado of gold."[144] Cicely Alexander had seen the work in progress while posing for her portrait and later recalled "numberless little books of gold leaf lying about, and any that weren't exactly of the old gold shade he wanted, he gave to me."[145] Whistler eventually discovered the desired tone for the dado (or lower panels of the wainscoting) in dutch metal, an alloy of copper and zinc that makes an inexpensive substitute for genuine gold leaf; upon that "old gold" surface, he painted pink and white chrysanthemum petals that were sometimes mistaken for butterflies.[146] Whistler sketched the design on a sheet of Leyland's monogrammed stationery, perhaps for his patron's benefit, giving a suggestion of the flower petals strewn across the walls behind the stair.[147]

At Prince's Gate, Whistler adapted the essential elements of the Lindsey Row decoration to enhance the gilt-bronze balustrade. The decoration in Leyland's hall, however, was to be confined to the dado, so as not to compete with the paintings by Windus, Legros, Rossetti, Burne-Jones, and Sandys lining the upper walls. Whistler's own portrait of Leyland hung at the top of the stairs; at the foot, crowning a pillar, was a gilded carving of two female figures, one holding an oriflamme, which Marks is said to have acquired from a Venetian palace.[148] In a rough sketch left with W. C. Alexander, Whistler drew the sculpture as an artful flourish rising high above the newel post (fig. 4.31). He seems to have had an abiding affection for the "little group": he tried to acquire it from the sale of Leyland's estate in 1892, but it must not have sold for the "sum within reason" his finances could afford.[149]

The color scheme Whistler devised to harmonize with the ormolu balustrade was described by Theodore Child as "shades of willow." The upper wall panels, where Leyland's paintings were to hang in gilded frames, were painted a pale shade of green, consistent with Moncure Conway's recommendation that same year of "the many beautiful shades of olive or sage-gray" that the artist W. J. Hennessy had used in his house, where "each frame on the walls has a perfect relief, each picture a full glow."[150] A more famous example of greenish walls and woodwork was close by Prince's Gate in the South Kensington Museum (later the Victoria and Albert), a refreshment room decorated by Morris, Marshall, Faulkner & Co. (fig. 4.32). Commissioned in 1865 but not completed until the early 1870s, the decoration of the Green Dining Room had been closely attended by the London artistic community, and its

FIG. 4.30 The Percy Staircase, Northumberland House, Strand, London. From the *Builder*, 20 December 1873.

FIG. 4.31 *Sketch of the Staircase at 49 Prince's Gate* (M578), ca. 1876. Pencil on paper, 12.2 × 19.7. The British Museum, London, Department of Prints and Drawings; presented by the Misses R. F. and J. I. Alexander (1958.2.8.18).

influence cannot be overestimated. In particular, the "pleasant sage colour" of the paneling helped set a fashion for green in domestic design, despite some popular objections to the color as "a murky mortuary compound" associated with "corruption and the charnel house."[151]

Whistler may also have taken special notice of the dado panels in the Morris room, which were gilded and painted with floral decoration. At Prince's Gate, the dark green moldings of the wainscot set off similar "picture panels" of flowers on a golden ground (fig. 4.33). Whistler's morning glories, "delicate sprigs of pale rose and white flowers in the Japanese taste," were highly stylized and asymmetrically arranged in keeping with the principle he observed in Japanese art, "that any realism was out of place in decoration."[152] The background was "dutch metal in large masses," in Leyland's words,[153] the same material Whistler had employed at Lindsey Row. Having learned from experience how to achieve an "old gold" effect, he exploited the property of imitation gold that is usually considered its chief disadvantage, allowing the metal leaf to oxidize. When Alan Cole saw the decoration in progress at

FIG. 4.32 Refreshment Room (Green Dining Room) designed by Philip Webb (1831–1915) and William Morris (1834–1896), ca. 1865–70. The Victoria and Albert Museum, London.

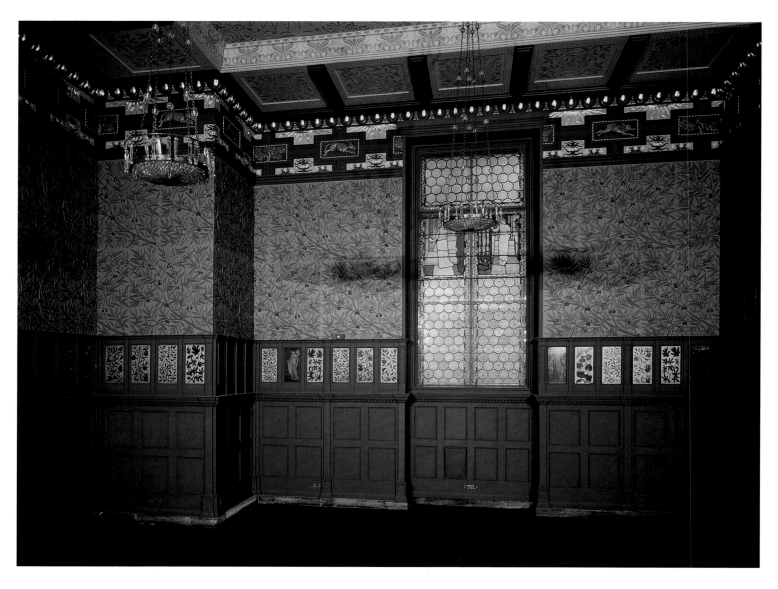

The Palace of Art

FIG. 4.33 *Panel from the Stair Hall of 49 Prince's Gate* (Y175), 1876. Oil paint and metal leaf on wood, 51.1 × 36.8. Freer Gallery of Art, Smithsonian Institution, Washington, D.C. (04.472).

Prince's Gate in March 1876, the darkening dado panels impressed him as being "very delicate cocoa-color and gold."[154]

Once the dutch metal had tarnished the desired degree, Whistler sealed its surface with the same transparent-green glaze he had used as a fixative, then gently abraded the surface so the gold tones shimmered through the cooler green. The grid pattern formed by the slightly overlapping squares of metal leaf suggests a trellis, but the design as a whole must have been calculated to set off the graceful arabesques of the balustrade, as Curry pointed out. "As one mounted, heavy moldings repeated the rhythmic element of the stair treads, while glints reflecting off the bronze balustrade were echoed by similar glints from the metallic foil on the dado panels." Child likened the effect to the Japanese lacquerware called "aventurine" for its resemblance to Venetian aventurine glass, which contains particles of copper.[155] Considered "the most beautiful of all Lacquers used for grounds," aventurine is commonly found on the inside of lacquer trays and boxes, brightening dark interiors (fig. 4.34).[156]

Whistler had long been intrigued by Japanese lacquer and would surely have seen Sir Rutherford Alcock's collection at the 1862 International Exhibition. There was an even more extensive display, sent by the Japanese themselves, at the Paris Exposition Universelle of 1867, and although the assemblage was afterward dispersed, many pieces were subsequently "re-collected"

FIG. 4.34 Interior of *suzuribako* (inkstone case), Edo period or Meiji era (19th century). Lacquer on wood, 4.9 × 22.9 × 25.1. Freer Gallery of Art, Smithsonian Institution, Washington, D.C.; Museum Purchase (44.25).

by James Lord Bowes of Liverpool.[157] Bowes was the president of the Liverpool Art Club, founded in 1872, and he lent more than half the objects in the club's first exhibition held that December. It was "confined to oriental Art," the *Art Journal* observed, "showing how widely the taste was diffused in that locality," and recommended by *The Times* as an exhibition "all who are interested in such matters should strive to see."[158] Whistler surely would have seen it: he was at Speke Hall that Christmas and again briefly in the new year, when the show was extended by popular demand. In any event, the attendant publicity would have alerted him to the wealth of Japanese art in Liverpool.

In 1875, the Liverpool Art Club's exhibition was devoted exclusively to Bowes's collection of Japanese lacquer. G. A. Audsley wrote the catalogue, describing the technique (as he understood it) in detail. With "aventurine" lacquer, he explained, squares of precious metals "are inlaid, as it were, into the lacquer surface: this is done by fixing them with the first coat of lac, and then filling up to their thickness with many successive layers, and ultimately grinding the whole to an even surface."[159] At Prince's Gate, Whistler seems to have followed those instructions to the letter, achieving a gleaming ground that glimmered with coppery flecks of gold.

Another model for the dado panels, as Curry has proposed, may be found in Japanese screens such as the one Whistler pictured in *The Golden Screen* (see fig. 1.12), with designs painted on a gold-leaf background.[160] By the 1870s, Japanese screens had become highly fashionable and widely available in London, as suggested by an 1872 article in the *Art Journal* detailing the English awakening to "the extraordinary merit of the decorative work in Japan" and singling out a shop in Oxford Street that specialized in mounting Japanese prints, embroideries, and painted silks on folding screens.[161] Whistler himself possessed just such a screen, composed of two Japanese paintings on silk. Toward the end of 1872, he had converted it into an artwork of his own, covering one side with brown paper on which he painted a highly abstract Nocturne of the moonlit Thames (fig. 4.35). He embellished its gilded border with the same style of petals that he painted, around the same time, on the frame for *The Three Girls*, and according to Walter Greaves the screen, too, was meant for Leyland. There is no evidence of a commission, however, and in the end Whistler kept it for himself.[162]

Greaves also reports that Whistler painted the screen with "verdigris blue," the same greenish glaze he applied to the dado at Prince's Gate. Verdigris, a copper pigment, had been used since Roman times and was still available from Winsor & Newton, among other art suppliers, but it was not considered "safe," and Greaves warned Whistler that the color would not last.[163] Leyland also had doubts, and in mid-August he advised Whistler not to proceed until they knew whether the decoration was "lasting enough for the work put on it."[164] As it proved, the "verdigris blue"—possibly a solution of verdigris and turpentine, in which the greenish color of the copper resinate was protected by the resinous medium—was stable, but by the time that fact was ascertained, Whistler had moved on to decorating the dining room.

The interruption of the project at Leyland's request may explain why some surviving dado panels lack painted designs. It has always been assumed that Whistler's commission extended only to the panels lining the stairs, which are visible in photographs of the hall (see fig. 4.29). But Whistler's single sketch for the project (fig. 4.36) shows the decoration continuing all around the room. The folding screen and other furnishings that block the view of the dado may have been installed specifically to disguise an incomplete decoration.[165] Whistler's sketch reveals another puzzling element: a painting of a woman with a parasol, hanging on the wall beside the fireplace. The composition corresponds to a design for a mosaic of "a Japanese art worker" commissioned in March 1872 for the South Court of the South Kensington Museum (fig. 4.37).[166] Whistler never completed the project, even though it became "much more important" as he worked on it.[167] Perhaps he considered putting it to another use: its appearance in the Prince's Gate sketch suggests that it may have been offered to Leyland as part of the decoration, or to fulfill the earlier commission for figure paintings. Whistler's various conceptions for the "Japanese art worker" reprise the Asian-inspired themes of the mid-1860s. *Woman in a Japanese Dress Painting a Fan* (fig. 4.38), for example, an imaginative reconstruc-

FIG. 4.35 *Blue and Silver: Screen, with Old Battersea Bridge* (Y139), ca. 1872. Oil on brown paper laid down on silk, 195.0 × 182.0. Hunterian Art Gallery, University of Glasgow.

FIG. 4.36 *Sketch of the Stair Hall at 49 Prince's Gate* (M577), ca. 1876. Pencil on paper, 11.3 × 17.7. Hunterian Art Gallery, University of Glasgow.

FIG. 4.37 *A Lady with a Parasol* (M459), ca. 1872–73. Pastel on paper, 25.4 × 14.6. Present whereabouts unknown.

tion of an Asian artist's studio, recalls the conceit of *The Lange Lijzen of the Six Marks* (see fig. 1.8). In composition, however, the picture is almost a reversal of *La Princesse du pays de la porcelaine*. Perhaps this is because in 1872, while Whistler was planning the Japanese mosaic, *La Princesse* returned temporarily to his keeping.

FREDERICK LEYLAND may have seen *La Princesse* for the first time in Rossetti's studio in 1865 or 1866, following the painting's debut at the Paris Salon. Yet he did not acquire the painting until after its first official display in London, at the International Exhibition of 1872. Whistler had intended to show it alongside *The White Girl*, but failing to complete repairs to that work in time, he sent *The Little White Girl* in its place.[168] The pair of paintings was displayed in a room otherwise occupied only by "fine art furniture," an advantage granted by Alan Cole, the director of the exhibition, who also permitted Whistler the privilege of providing his own statement "as to the theory of his manner" for the reception program. There Whistler posited the first association between *La Princesse* and *The White Girl*, attempting to make the early, realist painting conform to his current aestheticist practice. He defined both works as the "complete results of harmonies obtained by employing the infinite tones & variations of a limited number of colours."[169] To underscore the abstract qualities of *La Princesse* at a time when all his works were assuming musical titles, Whistler gave it a new English name, *Variations in Flesh Colour, Grey and Blue—"The Princess."* Tom Taylor of *The Times* inadvertently carried the point by describing Whistler's "Chinese lady with a fan" as "a clever and curious study in colour, but as nothing else."[170]

The Palace of Art

FIG. 4.38 *Woman in a Japanese Dress Painting a Fan* (M460), ca. 1872. Chalk and pastel on paper, 27.9 × 17.8. The Cleveland Museum of Art, Ohio; gift of Mrs. Henry A. Everett for the Dorothy Burnham Everett Memorial Collection (1933.222).

Of the five to six hundred British paintings shown at that exhibition, all but about a hundred had been contributed by the artists themselves, and most were offered for sale. *La Princesse* is listed in the catalogue without further attribution, from which we may infer that it belonged to Whistler, though how it returned to his possession after its sale in 1866 to Frederick Huth remains a mystery. Because no price is published, we can assume that it was not for sale.[171] Negotiations for its purchase may already have been under way, for it appears that at the close of the exhibition, *La Princesse* went directly to

Leyland's residence at 23 Queen's Gate. Whistler reported to his patron in early November that *La Princesse* was "hanging in the 'Velasquez Room' by the fire place opposite the door so that you can see her from the hall as you go in— She looks charming." Evidently, it displaced the paintings that normally hung there, for the housekeeper inquired of Leyland where the Spanish portraits were now to go.[172]

La Princesse was to be publicly exhibited only once more during Leyland's lifetime, at the *Second Annual Exhibition of Modern Pictures* in Brighton, in September 1875. Appropriately for the picture's subject matter, the exhibition took place in the Royal Pavilion Gallery, one of the outlying buildings on the grounds of England's most extravagant specimen of chinoiserie. (The pavilion itself, emptied of its Asian treasures twenty-five years before, was used in the mid-1870s for balls and prayer meetings.)[173] On this occasion, the title was cast as *Arrangement in Flesh Colour and Grey—La Princesse des Pays de la Porcelaine*, the plural *des pays* granting the princess dominion over more than one porcelain country. Whistler proudly informed his patron that it was given "the place of honor" in the exhibition and identified in the catalogue as "loaned by F. R. Leyland, en parenthèse."[174]

Leyland doubtless acceded to that loan only because he was between houses at the time. He had expected to settle at Prince's Gate in the autumn of 1875 but there must have been some delay with the renovations, for he still had not moved into the new house in the spring of 1876.[175] Owing, perhaps, to Leyland's unsettled state, *La Princesse* went from Brighton to Whistler's studio, rather than Prince's Gate, and the *New York Herald* reported in March that "the much talked of 'Chinese Princess'" was among the "completed and famous works" retained by the artist—works that might be sent to Philadelphia for the first American world's fair in 1876.[176] Whistler's mother was especially eager that her son "be loyal enough to cross the Atlantic to contribute some of his genius to the Centennial Exhibition," and the artist himself must have recognized the opportunity it presented.[177] But for the first time, if not the last, Leyland let Whistler down. Within weeks of the New Yorker's report, another American journalist visited Whistler's studio, and when he broached the subject of the Centennial was told that the owners of Whistler's paintings were collectively "reluctant to commit them to the dangers of the sea." The artist had particularly entreated "one English gentleman" to lend the portrait "of a Chinese girl of rank"—which can only be *La Princesse*—but his patron had replied, "No, sir: I will not risk losing my prize, but I will dine and smoke with you, and laugh at your Yankee cheek!"[178]

Anna Whistler expressed regret that "Jemie's works are not this year seen in our native land," and Whistler himself, in retrospect, may have considered it a further cause of discord with Leyland that *La Princesse* remained unseen in 1876, waiting until Prince's Gate was ready to receive it.[179] At the time, however, he could hardly have argued with Leyland's decision. Apart from the

Nocturne given to Frances Leyland (see fig. 3.9), *La Princesse* was the only one of his paintings securely in his patron's possession. As Leyland would later have cause to point out, during the past decade he had paid a thousand guineas for pictures, not one of which had been delivered—"nor indeed," he wrote the artist, "during the whole of our acquaintance have you finished for me a single thing for which you have been paid." To which Whistler could only reply, "Is not the Peacock Room finished?"[180]

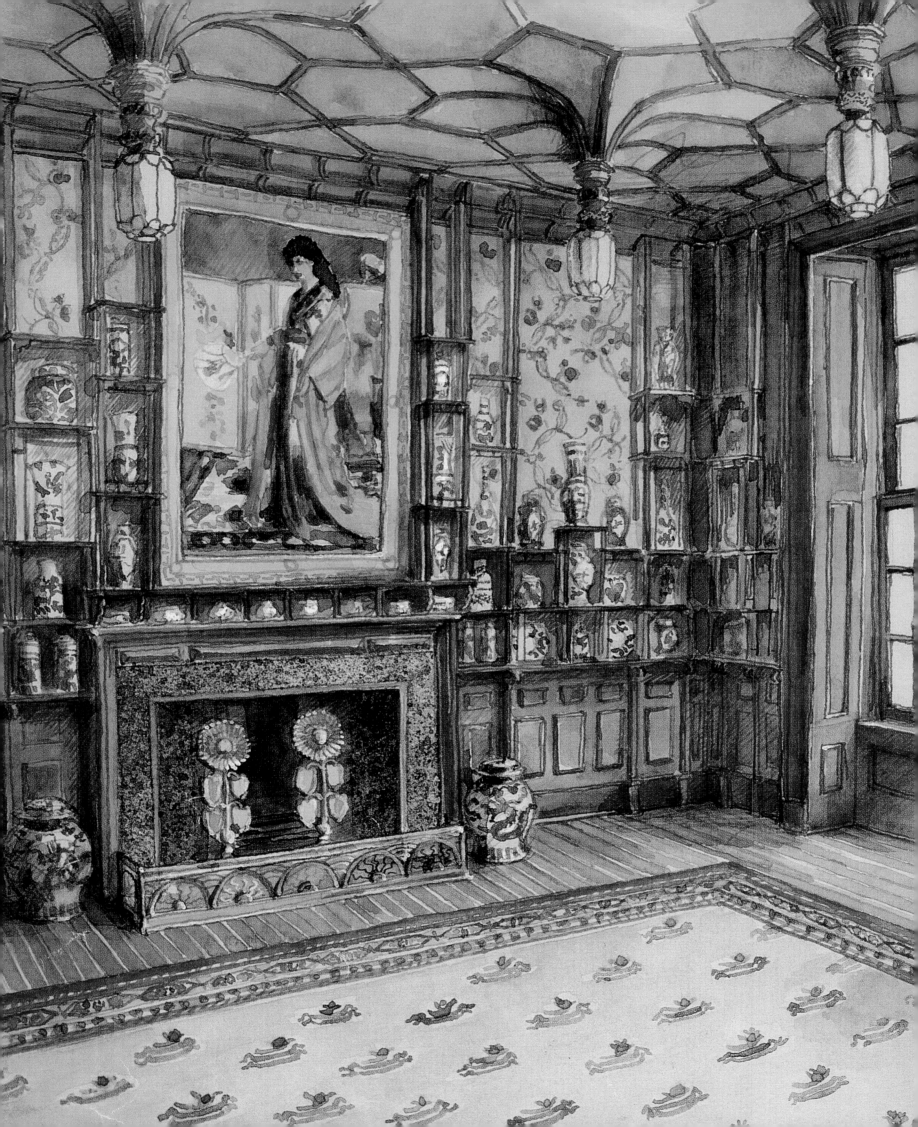

5 *The Porcelain Pavilion*

*And the people lived in marvels of art —
and ate and drank out of masterpieces —
for there was nothing else to eat and to
drink out of, and no bad building to live
in; no article of daily life, of luxury, or of
necessity, that had not been handed down
from the design of the master, and made by
his workmen.*

"Mr. Whistler's 'Ten O'Clock'"

THE STORY RARELY TOLD about the Peacock Room is of the decoration that lies beneath the iridescent feathers and coat of prussian blue, the original design for the Leyland dining room. That scheme by Thomas Jeckyll is traditionally dismissed as the canvas on which Whistler wrought his art, if not as "a complete failure and Jeckell's worst work."[1] Although its appearance can only be conjectured (fig. 5.1), Jeckyll's decoration assuredly possessed integrity of its own and might have entered the annals of Victorian art even without Whistler's interference. The notion that Whistler redecorated the room all at once, in a frenzy of artistic inspiration, has created an impression that he always held it in low regard; but early in the enterprise, Whistler confessed—uncharacteristically, and in print—that "the graceful proportions and lovely lines" of Jeckyll's work had served as inspiration.[2] To justify his own, more controversial creation, Whistler eventually had to downplay and even denigrate that earlier design; but until the failure of Leyland's appreciation compelled more drastic action, he had remained considerate of his surroundings, tuning his modifications to suit Jeckyll's scheme.

Charged with designing a setting for Leyland's abundant collection of Chinese porcelain, Jeckyll reinterpreted a traditional architectural form. As Murray Marks's biographer understood it, the idea "was that the Blue and White china should be well displayed on a background wholly suitable to it, and that it should be arranged in open shelves of carved and gilt wood, which would make a series of upright lines on the walls of the room, subdivided at intervals in Japanese fashion, in order to exhibit the plates, pots, beakers and vases." Although this was not a novel concept, the historical sources of Jeckyll's conceit were to be forgotten in the wake of Whistler's spectacular reconception of the theme.[3]

Porcelain cabinets, or rooms designed to display particular collections of china, originated in the seventeenth century, when quantities of Asian porcelain were imported into Europe. The first documented example, at the Oranienburg Palace near Berlin, was created in 1662 for Louise Henriette of

Detail, dining room at 49 Prince's Gate (fig. 5.1).

FIG. 5.1 The dining room at 49 Prince's Gate, London, as it may have appeared in 1876 with Thomas Jeckyll's decorations. Illustration by Tennessee Dixon for *The Princess and the Peacocks; or, the Story of the Room* (New York, 1993), by Linda Merrill and Sarah Ridley.

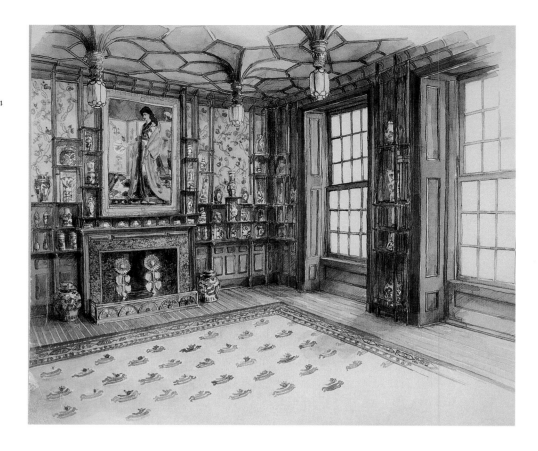

Orange (Holland); when that palace was reconstructed between 1688 and 1695, Frederick III honored his mother's memory with a new and more extravagant porcelain chamber, a pavilion-like room facing a park.[4] Schloss Charlottenburg, which Frederick built for his wife, Sophia, around 1710, featured "a much more full-blooded porcelain room," as Oliver Impey describes it—the first to display Chinese vases and bottles, in addition to plates and dishes, arranged on little brackets covering the walls above the wainscot. Daniel Marot, a French Huguenot architect employed by the House of Orange, developed the architectural style that became traditional, combining the high Parisian manner with the Dutch taste for massed porcelain.[5]

Queen Mary II, wife of William of Orange, made porcelain rooms fashionable in England when she displayed her enormous collection of Chinese porcelain, in the Marot style, at Hampton Court and Kensington Palace. Consequently, Daniel Defoe observed, "the custom or humour . . . of furnishing houses with china-ware" rapidly increased, and soon porcelain was seen piled on cabinets and chimneypieces "to the tops of the ceilings."[6] The vogue spread through Europe and persisted into the second quarter of the eighteenth century. As a child of ten, Whistler himself saw a porcelain room in Russia, at Catherine the Great's suburban palace Tsarskoe Selo: his mother described in her diary "one suite in the Chinese style," in which all elements of the room were "framed together by the finest Chinese porcelain."[7]

The engravings that disseminated Marot's style reveal the richly framed paintings, ornate shelving structures, built-in furnishings, and opulent light

fixtures that Thomas Jeckyll was to incorporate into his design for Leyland's dining room.[8] But the importance of the porcelain cabinet as a precedent extends beyond its structural components, for the form exemplified Marot's dedication to aesthetic unity. As Peter Thornton observes, "it is unlikely that anyone previously can have paid quite so much attention, in such detail, to every aspect of interior furnishing and decoration."[9] This concept of the total work of art, or *Gesamtkunstwerk*, which Whistler is commonly credited with creating in the Peacock Room, was already informing Jeckyll's interior designs, notably those for the Ionides house in Holland Park. At Prince's Gate, in much the same way, Jeckyll was to design all the elements of the room, from the andirons to the light fixtures, to create an integrated aesthetic scheme.

If the ancestral roots of Jeckyll's decoration reside in eighteenth-century *Porzellanzimmer*, there was a contemporary relation in London, Murray Marks told the Pennells, in the home of Cyril Flower, later Lord Battersea. A barrister and rentier, Flower was among the earliest and most enthusiastic of the chinamaniacs.[10] In 1874, his future mother-in-law, Lady de Rothschild, spied him in Holland "buying everything he could lay his hands on": "Mr. Flower is bitten with the Oriental blue and white china mania," she noted in a letter home, "and is as difficult to tear away from any shop containing those treasures as an American lady from Worth."[11] Flower displayed his collection "with special taste" at his flat in Victoria, "in a suite of rooms designed for the installation of his blue-and-white"—presumably the interior that Marks had in mind. Ferriday plausibly supposed it had been designed by Jeckyll, who is said to have carried out several commissions for Flower during the early 1870s.[12] They may have met through Frederick Sandys, who also enjoyed Flower's patronage, or even through Whistler, who wrote Flower a letter in 1875 that implies a mutual friendship with Jeckyll.[13]

The salient characteristic of Flower's porcelain room, which Ferriday posits as proof of Jeckyll's involvement, was that its walls were hung with "Spanish" leather.[14] This may not have been genuinely Spanish, for the term has long been used indiscriminately to signify "gilt leather." That term, too, is misleading, since the leather was not technically gilt: sized with glue and covered with silver leaf, the surface was burnished and coated with amber varnish to simulate the effect of gold. The production of gilt leather, originally Islamic, centered in Spain until the seventeenth century, when the trade was taken up in other parts of Europe, particularly Holland, where the industry was revolutionized with the invention of a new method of embossing.[15] Painted patterns gradually replaced embossing as baroque designs gave way to the lighter motifs of eighteenth-century silks and chintzes, a stylistic shift attributed, in part, to the influence of Marot.[16]

The tradition of covering the walls of porcelain rooms with gilt leather originated at Oranienburg. In the eighteenth century, when "Chinese rooms" became fashionable in England, gilt leather was the wall covering of choice: its "colour effects" were deemed "most suitable as a background for objects from

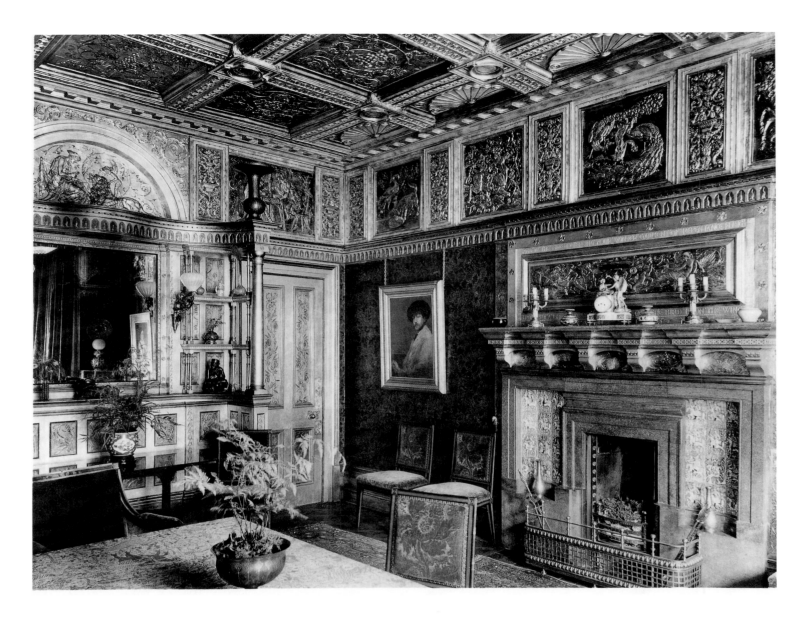

FIG. 5.2 The dining room at 1 Holland Park, London, ca. 1892, photographed by H. Bedford Lemere (1864–1944). The Victoria and Albert Museum, London (E.1-1995). The room was decorated by Walter Crane (1845–1915). Whistler's *Arrangement in Grey: Portrait of the Painter* (Y122) hangs near the door.

the Far East."[17] Its use declined with the development of wallpaper and other more economical means of adorning interiors, but as Cyril Flower's leather-lined rooms suggest, the taste was revived in late-Victorian London, coincident with a renewed interest in Chinese decorative arts. The artists George H. Boughton and Lawrence Alma-Tadema both had gilt leather in their houses, and at 1 Holland Park the dining-room walls were lined with "old Cordovan leather embossed with a pattern in lacquered gold, bronze-green, and a little dark red" (fig. 5.2).[18] Jeckyll's rendering of his design for the morning room (see fig. 4.16) shows squares of patterned, amber-colored wall-covering, suggesting that gilt leather, rather than wallpaper, may have been used there as well.

Genuine gilt leather was difficult to obtain, and Mary Eliza Haweis, in *The Art of Decoration* (1881), deplored that rolls of Spanish leather were probably moldering, long forgotten, in the lofts of certain stately homes.[19] A substitute appeared on the market after 1872, when the Japanese began exporting "leather paper." Manufactured to resemble the Dutch gilt leather brought to

The Porcelain Pavilion

Japan during the seventeenth and eighteenth centuries, it was more expensive than ordinary wallpaper but considerably cheaper than leather, and it quickly caught on.[20] By 1876, Japanese "leather-like embossed paper" was available from Liberty's shop on Regent Street and approved by even as particular a tastemaker as E. W. Godwin.[21]

This affordable imitation only heightened the appeal of the genuine article. Antique gilt leather was among the luxury goods carried by Murray Marks, whose leading customer, Frederick Leyland, used it lavishly at 49 Prince's Gate. A six-panel screen of "old Venetian stamped and gilt leather" occupied a prominent place in the entrance hall (see fig. 4.29),[22] and the walls of the lower ground-floor study (evidently designed by Thomas Jeckyll) were lined with "old-gold Spanish leather with a soft floral design interspersed between bold red-brown Arabesques" (fig. 5.3). This was undoubtedly the oldest, most valuable leather in the house, but the leather destined for renown was in the dining room. Inspired by Cyril Flower's example, Marks had recommended gilt leather as the appropriate background for Leyland's Chinese porcelain and acquired it on his client's behalf at a cost of one thousand pounds.[23]

Those leather hangings were to be the source of many misconceptions; as early as 1908, Marks pointedly reminded the Pennells that it was "Norwich leather," not Spanish, he had secured for Frederick Leyland, and that the designs were painted, not embossed, upon the surface.[24] Those specifications point to wall hangings of a relatively recent date, certainly no earlier than the mid-eighteenth century. The reference to Norwich may indicate the leather's

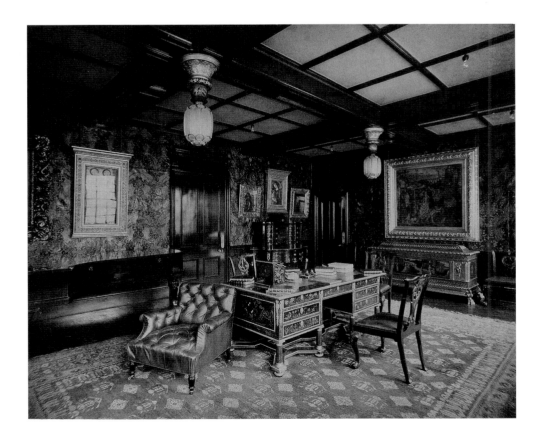

FIG. 5.3 Leyland's study at 49 Prince's Gate, London, ca. 1890, photographed by Henry Dixon & Son, London. Private collection, Great Britain.

FIG. 5.4 The original leather in the Peacock Room, visible behind the shelving, 1948. Freer Gallery of Art Archives, Smithsonian Institution, Washington, D.C.

provenance rather than the site of its manufacture, for the hangings were reportedly purchased from a "Tudor house" in Norfolk.[25] Ferriday further speculated that the house in question stood in Old Catton, and that the leather sold from its walls had been salvaged from a ship wrecked with the Spanish Armada.[26]

Ferriday's story is a variation on the tale propagated by G. C. Williamson in 1919, after everyone who might have contested its validity had died. In his tribute to Murray Marks, Williamson relates that the wall hangings had come to England as part of the dowry of Catherine of Aragon, first wife of Henry VIII: they had been presented to the owner of the Norfolk estate by Elizabeth I, "or a sovereign of about her period." Basing his history on certain "facts" that had only lately come to light, Williamson tells how the city of Cordova presented Catherine with sufficient leather to cover the walls of twelve rooms; how she gave some of it to her chamberlain for a dining room at Sutton Place; how other pieces made their way to Anne of Cleves and then to Preston Manor. The distinguishing characteristic of that historic Spanish leather was its pattern of open pomegranates, the emblem of Catherine of Aragon: as incontrovertible evidence linking it to Prince's Gate, Williamson asserts that the pomegranate "appeared extensively in the leather at Mr. Leyland's house."[27]

In fact, there are no pomegranates in the pattern, but spiraling ribbons of roses and other summer flowers painted (not embossed) upon a lustrous surface. Outlines of the original design show through the veil of blue paint, and vestiges of the original color scheme remain untouched beneath the shelving that Whistler never bothered to dismantle (fig. 5.4). The pattern looks neither Tudor nor Spanish: the flowers appear distinctively Dutch, arranged in the "sprawling" patterns that Godwin recognized as rococo.[28] It matches a remnant of Dutch gilt leather thought to date from the third quarter of the eighteenth century, if not later (fig. 5.5).[29] The leather Whistler encountered in Leyland's dining room was old, therefore, but by Victorian standards scarcely even antique; and valuable, but far from priceless. Whatever his other transgressions, Whistler should not be held to blame for casually annihilating a national treasure redolent of British history.

The fiction surrounding Leyland's ill-fated leather adds a romantic mystique to the story of the Peacock Room and fortifies the myth that Jeckyll's design was musty and out-of-date, oppressively gloomy and desperately in need of Whistler's deft attention. So tenacious is this impression that the leather is often assumed to have been brown, even though "Spanish" leather is "gilt" by definition. Traces of the original wall coverings came briefly into view during the 1940s, when the Peacock Room was taken apart for repairs, and it was determined that the "surface was embossed with a cross-hatch and twisted-ribbon design and covered with German gilding—that is, silver leaf coated with amber shellac and thus made to resemble gold leaf." This important revelation was published by the Freer Gallery in 1951; however, against all evidence, the author persisted in asserting that "Catherine's device, the open

The Porcelain Pavilion

pomegranate," was to be found among the "richly colored flowers." And when the Peacock Room booklet was reissued in 1980, the mythical pomegranates were emphatically reinstated, and the unfounded image of Thomas Jeckyll's "sedate" interior fully restored.[30]

The room Jeckyll designed was constructed by Joseph William Duffield, a Kensington builder with offices not far from Prince's Gate. When the Peacock Room was offered for sale in 1904, Duffield wrote the dealers, Obach & Co., to protest the impression presented in the press—that the room had been designed by Whistler. "In fact we have the original architects drawings from which Whistler borrowed his work. We have thought it would be to your interest to place you in possession of these facts, otherwise you may be called to account." The drawings themselves were never recovered, but Charles Freer preserved Duffield's letter, the only surviving document of Jeckyll's involvement.[31]

Ironically, it was the substructure Jeckyll devised to support the shelving and wall hangings that would allow the Peacock Room to be dismantled and reassembled several times. Obach & Co. discovered in 1904 that the room's construction was "wonderfully favorable" to the purpose of taking it apart: "In some parts it almost looked as if the decorations had been put up with a view to be taken down again."[32] The reason was that Jeckyll's chamber had been built into an existing room: "The whole of this decoration forms an inner wooden shell standing out about an inch and a half from the brick and plaster wall." That framework (or "matchboarding") was covered with sheets of canvas, to which the leather was affixed from the lower edge of the cornice coves, which eased the transition from ceiling to walls, to the upper edge of "a second dado," in effect, some two meters from the floor.[33] From that point to the meter-high walnut wainscoting, the canvas was exposed, though it was meant to be concealed by a dense display of porcelain filling the double row of shallow shelves that stood before it. Indeed, to a greater extent than anyone has recognized, Jeckyll's design was dictated by limitations imposed by the leather, apparently in short supply. A remnant bearing a slightly different pattern, with carnations rather than roses, was installed above the fireplace, where it would ordinarily be hidden by *La Princesse du pays de la porcelaine* (fig. 5.6).[34] The upright spindles of the shelving were positioned to cover the seams in the leather hangings — except on the south wall, where another large painting, *The Three Girls*, was envisioned to serve that purpose.

The ceiling, like the walls, constituted an independent structure set inside the original room. Obach & Co. removed it easily "by cutting through the ceiling-rafters, thus taking it down in a few large pieces."[35] It, too, was made of wood, with canvas covering the pendants from which gas lamps were hung; fabric tapes disguised the joins of the wooden planks, forming the uniform surface on which moldings in geometric patterns were imposed. Jeckyll's elaborate ceiling endured a barrage of criticism. W. Graham Robertson, for instance, was disappointed to learn that upon its removal to Washington, the Peacock Room

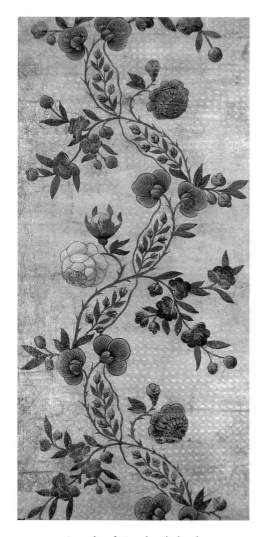

FIG. 5.5 Sample of Dutch gilt leather (*Holländisches "Guldenleder"*), ca. 1770. Silver leaf and paint on leather, 83.83 × 38.1. Deutsches Tapetenmuseum, Kassel, Germany.

FIG. 5.6 The leather originally behind *La Princesse du pays de la porcelaine* in the Peacock Room at 49 Prince's Gate, London, 1892. Freer Gallery of Art Archives, Smithsonian Institution, Washington, D.C., Charles Lang Freer Papers.

had not been liberated from that "incubus."[36] Godwin had been the original critic, naming the ceiling among the "objectionable features" of Jeckyll's architecture; he described it as "divided by flat small ribs into the 8-pointed star patterns so very common in Elizabethan and Jacobean work; the ribs are arranged so as to produce the two rows of four stars each, and in the centre of every star the ribs descend pendantwise, with anything but an easy curvature, to terminate in gas lanterns."[37]

The Tudor aspect was also remarked upon in 1877, by a critic for the *Observer* who was reminded of King's College Chapel at Cambridge. More recently, Elizabeth Aslin compared the patterns of the wooden ribs to those on the ceiling of the Great Watching Chamber in Hampton Court Palace, "with light fittings replacing the original pendant finials."[38] But Jeckyll's primary source appears to have been the "elegant geometrical" ceiling in the Oak Parlour at Heath Old Hall, the sixteenth-century Yorkshire house he had restored for Edward Green in 1866.[39] A nineteenth-century drawing of Jeckyll's restored parlor (fig. 5.7) reveals its relevance to the dining room at Prince's Gate: the ceiling features wooden ribs molded into stars within circles and semi-circles; shelves of porcelain are ranged along one wall; and the furnishings—a Jacobean-style table and chairs with carved Chinese motifs, recognizably Jeckyll designs—contribute to the air of playful eclecticism that Godwin disdained at Prince's Gate. The dining room, he complained, was not "*altogether* of any fashionable modern style, Jacobean, Queen Anne, or Japanese. To speak most tenderly, it was at the best a trifle mixed."[40]

FIG. 5.7 The Oak Parlour, Heath Old Hall, Wakefield, England. Illustration by W. H. Milnes (1865–1957) for *The Old Hall at Heath*, by Lady [Mary] Green, 1889. The Victoria and Albert Museum, London; National Art Library (258.E).

The Porcelain Pavilion

The gas lamps descending from the ceiling of the Leyland dining room, memorably described by Tom Taylor, art critic for *The Times*, as "stalactitic droppers," were also designed by Jeckyll, and probably manufactured by B. Verity & Sons, the Covent Garden lamp and candelabra makers who later claimed to have taken orders from Jeckyll "as Mr. Leyland's representative."[41] Eight lamps with white-glass shades to disperse the glare of gaslight were disposed in two parallel rows, lending the room an even illumination; the brass fittings were pierced with fanciful designs of butterflies, dragonflies, and flowers. In keeping with the theme of the room, the lamps may have been intended to suggest Chinese paper lanterns, though they appear in other rooms of the house as well. (Leyland must have admired them if no one else did.) It has been assumed that the ceiling, like the canvas on the walls, was toned to match the walnut of the wainscoting, but this presupposes the dark color scheme that was never part of Jeckyll's conception. Considering the bright and whimsical conceits of his other interiors, we might better imagine that the structure was meant to be lightened in some way—perhaps by gilding the geometric ribs to bring out pattern of "stars" illuminating the room at night.

During the day, the room would be lit from three large windows facing east—the optimal aspect, according to Hermann Muthesius, since "the only sunlight that is welcome in the dining-room is that of the morning sun at breakfast."[42] Godwin disapproved of the architectural inconsistency of those windows (french casements and large panes in the center, "Queen Anne" sashes and small panes on either side) and also found fault with the interior shutters, which were "not at all like Queen Anne, but are of the vernacular Kensington type."[43] Jeckyll himself had not committed these solecisms—he apparently kept the shutters and windows just as he found them—and it is important to remember that Jeckyll's design (like Whistler's afterward) was the modification of an existing scheme. (This, incidentally, may explain the turquoise-blue mosaic around the fireplace, which there is no evidence that Jeckyll altered, or that Whistler added.)[44] The french doors permitted access to the "characteristic landscape of aristocratic London" that Theodore Child admired, "Prince's Gate gardens, with its symmetrical lawns of intense green, the severe elliptical curves of yellow gravel-walks, the sturdy silhouettes of trees."[45] Just as Whistler's *Princesse du pays de la porcelaine* may have inspired the chinoiserie style of the room, so the wall of windows overlooking the park appears to have suggested the conceit of a garden pavilion.

THE TRIANON de Porcelaine at Versailles was the earliest of the European garden pavilions. The architect, Louis Le Vau, had been inspired by the so-called Porcelain Pagoda of Nanking (Nanjing), a nine-story structure covered with porcelain tiles that became famous with the publication of Johan Nieuhof's *Embassy from the East-India Company of the United Provinces to the Grand*

Tartar Cham Emperor of China in 1665. Conceived about ten years later, the Trianon's three pavilions were designed in the high baroque style of Louis XIV, but with balustrades decked in Chinese vases, rooftops dressed in blue-and-white faience tiles, and interiors filled with Chinese furniture and other chinoiserie. In 1715, Maximilian II Emanuel, Elector of Bavaria, was inspired by the Trianon, in turn, to build the Pagodenburg, the first of several garden buildings at Nymphenburg designed in the Chinese taste. The vogue for those exquisite pavilions, pleasure palaces designed exclusively for the consumption of leisure time, was well established by the mid-eighteenth century, when William Chambers (who had visited the Porcelain Pagoda in China) designed the famous exemplar: the Great Pagoda in the Royal Botanic Gardens at Kew.

Gradually the fashion migrated from the grounds of country houses to the sites of urban entertainment—in London, to public gardens such as Ranelagh and Vauxhall and pleasure parks such as Cremorne, where chinoiserie pavilions were employed as bandstands and dancing platforms.[46] And at the Exposition Universelle in Paris, 1867, a two-tiered, pitched-roof, open-structured "pagoda" was displayed in the Chinese Exhibition of the English Quarter, which Thomas Jeckyll surely would have seen.[47] The monumental pavilion Jeckyll subsequently designed for Barnard, Bishop & Barnards (fig. 5.8), ostensibly intended "for erection on a lawn, or in the ornamental grounds of a mansion," was dependent on such Chinese precedents, and perhaps on account of its predecessors came to be called a "pagoda." Nikolaus Pevsner, reflecting the prejudices of his period, described it as "one of the most gorgeous Victorian cast-iron monstrosities of England, . . . not looking in the least like a pagoda, nor indeed like anything else."[48] In its own time, Jeckyll's pavilion was confidently acclaimed a triumph of art. "Every part is admirable in execution," the *Art Journal* declared, "while, as a whole, it is perfect."[49]

FIG. 5.8 The Philadelphia pavilion at the 1878 Exposition Universelle, Paris, designed by Thomas Jeckyll (1827–1881), manufactured by Barnard, Bishop & Barnards, Norwich. From *British Architect*, November 1878.

The Porcelain Pavilion

FIG. 5.9 The willow pattern, ca. 1800. Transfer print from engraved copper plate, 25.8 diameter. The Spode Museum Trust Collection, Stoke-on-Trent, England.

Designed in 1876 for display at the United States Centennial International Exhibition in Philadelphia, the pavilion was Jeckyll's greatest work for Barnards, a tour de force in cast and wrought iron. Twenty-eight square columns supported an upper tier reached by a spiral staircase, with twenty more columns supporting the roof. Despite imposing proportions and ponderous weight, the structure appealed to contemporaries as a lighthearted, nearly indescribable confection.[50] Because relatively few Britons saw the pavilion in Philadelphia, it did not achieve full recognition in England until 1878, after it won a gold medal at the Paris Exposition. And by then, as Lewis Day remarked, the designer was "beyond reach of praise or blame for the work which he so evidently loved."[51] In retrospect, that fantastic creation appears the emanation of an ebullient mind already losing hold on reality.

Jeckyll might have found inspiration in any number of chinoiserie pavilions standing in Victorian parks and on the grounds of country houses, or from the Chinese export furniture enjoying renewed popularity in Britain and available from London dealers such as Murray Marks. He would have known Whistler's famed "pagoda cabinet," which the artist had acquired in Paris, at the 1867 exposition.[52] And during the course of his apprenticeship, he undoubtedly came across the "Chinese Residence" illustrated in Richard Brown's influential *Domestic Architecture* (1841), reflecting an architectural style known primarily through depictions in Chinese export wallpaper, lacquerware, and porcelain.[53]

Indeed, Jeckyll may have found the profile for the Philadelphia pavilion on an ordinary dinner plate (fig. 5.9).

The ubiquitous willow pattern, developed by Josiah Spode around 1795 from various designs on Chinese porcelain, is as European an invention as the romantic legend that grew up around it. The image of three figures crossing a bridge, a pair of birds in flight, and a pavilion or tea house in a garden, became popularly associated with China.[54] In the mid-nineteenth century, Albert Smith attributed that country's hold on the English imagination to the "celebrated blue landscape in enamel . . ., so very faithful in its attendance throughout our entire lives," and the late-Victorian enthusiasm for Chinese blue and white may also owe something to that sense of nostalgia.[55] The public approached Jeckyll's two-tiered pavilion with recognition and delight, as it offered an experience previously reserved for the aesthetic imagination—the sensation of stepping into a well-loved work of art.

Both in Philadelphia and Paris, Jeckyll's pavilion became the setting for a display of Barnards' domestic metalwork (fig. 5.10), including the celebrated

FIG. 5.10 The Philadelphia pavilion, 1876, designed by Thomas Jeckyll (1827–1881), manufactured by Barnard, Bishop & Barnards, Norwich, photographed by the Centennial Photographic Co. Bridewell Museum, Norwich, England.

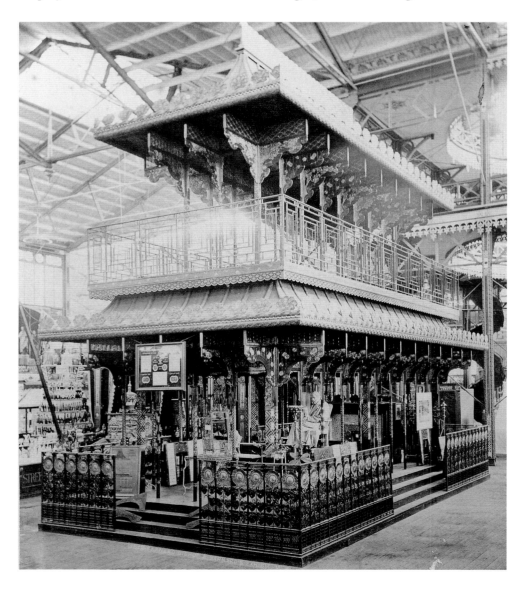

The Porcelain Pavilion

FIG. 5.11 Drawing for the Philadelphia pavilion, 26 January 1876, by Thomas Jeckyll (1827–1881). Pencil and wash on paper, 47.0 × 46.0 and 51.5 × 35.0. The Victoria and Albert Museum, London; gift of Peter Ferriday (E.5445–E.5446-1958).

fire grates and attendant fittings for the hearth—those practical, beautiful, affordable objects that had come to exemplify aesthetic taste.[56] The pavilion itself assimilated an exotic artistic style into the familiar landscape of England. Jeckyll decorated the spandrels of the lower story with stylized birds and butterflies and "quaint and geometrical patterns" in Japanese style, constituting a veritable grammar of his art. But he adorned the fan-shaped affairs cresting the structure with the roses, honeysuckle, and hydrangea of an English country garden and drew as well from the local landscape: larks, swallows, jays, and pheasants disported among apple blossoms and flowering whitethorn, fir trees, and fields of daisies and narcissus (fig. 5.11).

Of the profusion of naturalistic motifs adorning Jeckyll's pavilion, the most striking was the sunflower (fig. 5.12). Partly in consequence of the pavilion's popularity, the sunflower became, with the lily and the peacock feather, a leading emblem of the Aesthetic movement. Jeckyll had discovered by 1876 what Oscar Wilde pointed out in 1882, that the sunflower's "gaudy leonine beauty" appeared made for the purpose of decorative art.[57] Without compromising its natural form, the flower could be stylized in the manner of a Japanese family crest. In the railing for the pavilion's veranda, Jeckyll played on other peculiarities of the overgrown flower that stands on a sturdy stem and turns its massive head toward the light, planting seventy-two cast-iron specimens in formation around the structure's base (fig. 5.13). The blossoms were originally gilded, though that detail may not have lasted long, exposed to the elements. The Centennial catalogue proclaimed the sunflower border "unrivalled of its kind," and the critic G. A. Sala could only compare it to the golden maize said to have encircled the fabled palace of El Dorado.[58]

Jeckyll's extravagant garden ornament, embowered with blossoms and billowing with birds, had been conceived as a thing of beauty; it only acquired a practical purpose after 1880, when it was purchased by the Norwich

FIG. 5.12 Drawing for the Philadelphia pavilion, 24 January 1876, by Thomas Jeckyll (1827–1881). Pencil and wash on paper, 42.0 × 45.0. The Victoria and Albert Museum, London; gift of Peter Ferriday (E.5447-1958).

FIG. 5.13 Sunflower railing from the Philadelphia pavilion, 1876, designed by Thomas Jeckyll (1827–1881), manufactured by Barnard, Bishop & Barnards, Norwich. From *Gems of the Centennial Exhibition* by George Titus Ferris, New York, 1877.

Corporation and used as a bandstand in Chapel Field Gardens.[59] Barnards, however, was to capitalize on the pavilion's popularity with a range of new products, from benches to fire grates, based on Jeckyll's decoration (fig. 5.14).[60] The only by-products apparently conceived by Jeckyll himself were andirons, or firedogs, he adapted from the sunflower railing (fig. 5.15). They were registered with the British Patent Office on 11 April 1876, shortly before the opening ceremonies in Philadelphia, and were among the objects on display; the original examples were made to match the sunflowers in the railing, with iron stems and brass blossoms.[61] Although the andirons were commercially available by 1878, their size would have made them unsuitable for the hearths of ordinary homes.[62]

It was in the dining room of 49 Prince's Gate that Jeckyll's andirons made their domestic debut. Legend has it that Whistler gilded (or replaced) the originals, presumed to have looked heavy and discordant after his splendid redecoration; but, in fact, the pair of sunflowers Jeckyll placed beneath *La Princesse* was golden to begin with, made entirely of polished brass. The aesthetic achievement attributed to Whistler, therefore, of making the andirons function as "two strong golden discs that carried the eye over the cavernous inky space of the fireplace" to provide "visual support" for the gold-bordered picture that hangs above the mantel, should properly go to Jeckyll.[63] The aesthetic fitting of fireplaces was his specialty, after all, and the design for Prince's Gate might be regarded as an elaboration of the overmantels developed for Holland Park, "the first impulse toward that same masterly freak of decoration," as Lewis Day phrased it, "indulged in at Mr. Leyland's expense."[64]

The Porcelain Pavilion

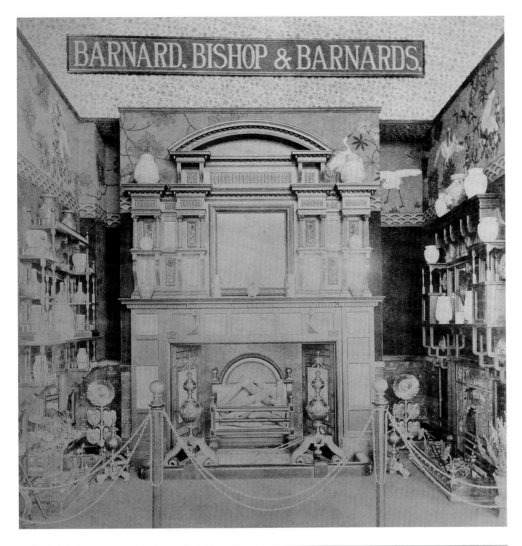

FIG. 5.14 Barnard, Bishop & Barnards London showroom, ca. 1880, photographed by the London Stereoscopic Co. Bridewell Museum, Norwich, England. Jeckyll's sunflower andirons are shown here, as is a wallpaper frieze derived from an embroidered panel he designed for the Philadelphia pavilion.

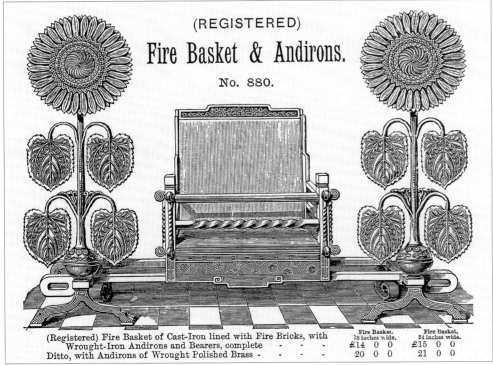

FIG. 5.15 Fire Basket and Andirons No. 880. From *Complete Catalogue of General Manufactures*, Barnard, Bishop & Barnards, 1884. Bridewell Museum, Norwich, England.

THE LEYLANDS' dining room and the Philadelphia pavilion were designed almost concurrently, and even apart from the sunflower andirons there are telling similarities between them. The geometric railing of the pavilion balcony, "a kind of Japanese open fret-pattern formed wholly of straight lines," reappears in miniature in the Peacock Room as delicate wooden railings bordering some of the shelves, as if to keep the pots from falling off.[65] The forest of slender, square, richly embellished columns supporting the pavilion's upper tier, imparting an illusory weightlessness to the heavy iron structure, is also echoed in the dining room, in the density of fragile spindles and ornamental brackets holding up narrow shelves heavily laden with porcelain. Indeed, the very shape of the room, with lamps pendant from the ceiling, presents an impression of the crested pavilion turned inside out.

The open shelves Jeckyll designed to hold Leyland's porcelain, "worthy of notice for the distinction and originality of their construction and the exquisiteness of their decorative carving,"[66] were built like latticework over the walls, with a few spaces left vacant—notably on the south wall opposite the fireplace, where Whistler's "garden picture," *The Three Girls*, was meant to complete the pavilion theme. Although the design has often been attributed to the influence of Japanese architecture, it actually displays little of that style: as Toshio Watanabe has observed, it was Whistler's redecoration that rendered the room "an original Japoniste interior."[67] Jeckyll's structure, with its shelves and brackets and balusters, owes more to European precedents, those chinoiserie rooms designed for particular collections: as Charles Freer was later to remark, "The shelving was built to hold Mr. Leyland's collection of porcelain, and can never be useful for any other purpose."[68]

The construction is meaningless without the porcelain in place. Haldane Macfall, seeing the shelves empty in the 1920s and apparently ignorant of their original function, dismissed as an "abomination" those "slender spindles or narrow square upright shafts of wood": to his mind, they produced the irrelevant impression of Japanese cages for grasshoppers or fireflies.[69] But when considered in connection with Leyland's collection, Jeckyll's "cages" make perfect sense. Each space was designed to accommodate one of the standard shapes and sizes of Qing-dynasty blue and white, predominantly from the Kangxi era (1662–1722). Tall, slender vases were to fill the vertical spaces in the upper regions of the room; large shallow dishes fit the square niches on the west wall opposite the windows; smaller "saucers" could be ranged in rows above the doors. The largest number of openings, circling the room at eye level, were made to hold pieces roughly square in proportion—brush pots, censers, and the popular "hawthorn" jars—and the shelves in columns between the windows were backed with mirrored glass to display particularly prized examples. Yet the porcelain takes its place as part of an integrated scheme: as one journalist observed in 1890, crediting Whistler with the achievement, "the collection of china, softened by being half in shadow, becomes subordinate and does not obtrude itself as a series of blue and white spots."[70]

FIG. 5.16 The leather in the Peacock Room, photographed in raking light, ca. 1947. Freer Gallery of Art Archives, Smithsonian Institution, Washington, D.C.

The sources for the carved patterns on the spindles that frame the porcelain are difficult to establish. Of the dozen or so designs, a few appear (greatly magnified) in the Philadelphia pavilion, and some can be found in Jeckyll's earlier furniture and metalwork designs. Jeckyll may have seen examples in the Chinese and Persian patterns illustrated in Owen Jones's *Grammar of Ornament*, first published in 1856,[71] but similar motifs turn up in a range of decorative arts, from Japanese textiles to Spode china. Beyond the Chinese porcelain itself, an immediately available vocabulary could be found in the patterns impressed in low relief on the gilt-leather hangings, in imitation of embossing (fig. 5.16). The most prevalent imprint, a cross-hatching pattern (fig. 5.17), figures in several of the spindles, but not, significantly, on the piers of the pavilion.[72]

The architectural fittings of the dining room were completed by the spring of 1876, and its decoration was sufficiently advanced for at least some blue-and-white pots to be installed for effect (fig. 5.18). Murray Marks, one of the few people who would been admitted at that stage, reportedly declared that Leyland's dining room had "never looked so well as it did when first of all the Blue porcelain was put up upon Jeckyll's shelves, and the dull, quiet, rich effect of the leather formed the sumptuous background."[73] Those who did not see the dining room at that moment in its development could scarcely imagine what it looked like before Whistler's radical revisions: Luke Ionides, for instance, criticized Jeckyll's decorations as "rather too rococo in character to suit the sober colours of the Spanish leather," a reversal of the facts that suggests he never saw the room in its early state.[74]

FIG. 5.17 Wood spindle in the Peacock Room.

FIG. 5.18 Southeast corner of the dining room at 49 Prince's Gate, London, as it may have appeared in April 1876. Rendering by Peter R. Nelsen, 1997.

Jeckyll was apparently still engaged at Prince's Gate at the end of April, when Leyland wrote to Whistler from Liverpool that the designer was wondering "what colour to do the doors and windows in dining room. He speaks of two yellows and white." The treatment proposed for the woodwork (presumably including the ceiling and dado, as well as the shutters and doors) would have dispelled the gloom that tends to be ascribed to Jeckyll's design, producing a bright interior rather like the morning room at Holland Park. But Leyland had another idea. "Would it not be better," he wrote Whistler, "to do it like dado in the hall—i.e. using dutch metal in large masses. It ought to go well with the leather. I wrote to him suggesting this but I wish you would give him your ideas."[75] This letter contradicts the widely held belief that Jeckyll had completed his work in the room when Whistler entered the picture. It also confirms that Whistler's intervention began at his patron's invitation, not on his own initiative.

The Porcelain Pavilion

A possibly significant silence surrounds the months that followed. According to Child, whose informant was Murray Marks, "it was by a mere accident that Mr. Whistler came to decorate" Leyland's dining room,[76] an "accident" that must account for the abrupt disappearance from the scene of the original designer. Decorum may have prevented Marks (or Child) from mentioning the real reason Whistler was brought into the project, for Jeckyll's medical records reveal that his erratic behavior began around this time.[77] His sudden incapacitation for work would have brought about a crisis at Prince's Gate, which Leyland initially thought to resolve by hiring Morris & Co. to "decorate and furnish" the room left inconveniently incomplete; this information, published by the Pennells without attribution, came from Alan Cole, usually a reliable source, who recalled of the members of Morris's firm, "when Whistler stepped in and began his work, they simply were left out altogether—they vanished."[78] Whistler himself later informed Jeckyll's brother that the room had been "given up" to him to decorate, which suggests that Leyland ultimately decided to allow Whistler to carry Jeckyll's project to completion—starting with the gilding and lacquering of the woodwork—once the artist had finished his work in the adjacent hall. Curiously, no one has stopped to wonder why Jeckyll remained absent throughout this process "and really never saw the room," as Whistler would explain, "until the whole color scheme was nearly complete."[79]

WHISTLER'S LIFE during the halcyon days of 1876, before his time and attention were consumed by the Leyland dining room, had been marked by society and high spirits, as the diary of Alan Cole reveals. Late in February, Whistler and Cole's sister Isabella Fowke took the leads in a play performed in the theater of the Royal Albert Hall for an audience of South Kensington families and "distinguished musical people," including the Swedish soprano Jenny Lind-Goldschmidt.[80] Whistler himself adapted the script of Augustus Dubourg's *Twenty Minutes under the Umbrella* to display his "peculiar gifts to the best advantage," or so the *Daily News* surmised:

> He at times, perhaps, indulges somewhat too freely in subtleties and refinements, which would make his success in public and before a mixed audience doubtful, but the same fault is found with his paintings and etchings which, nevertheless, are held in high esteem by the cognoscenti. In his acting, as in his painting, he aims at harmonising the details of his work in such a way that the whole first strikes the spectator, who is then led insensibly to study how that effect is produced.

Cole recorded that the artist was elated with his performance.[81]

The next month found Whistler "in great excitement over Sir Coutts Lindsay's Gallery for pictures"—the Grosvenor Gallery, which was to open on Bond Street the following spring, promising a venue where the "subtleties and refinements" of Whistler's art might at last be fully appreciated. Whistler proposed to Alan Cole that "it might be opened with only one picture worthy of being shown that season."[82] One wonders which picture he had in mind. It was around this time that Whistler wrote to his mother in Hastings how, after "years of tribulation and heart-breaking discouragement," he sensed the dawning of rewards:

> and if health be continued to me I believe I shall have established for myself a proud reputation in which you will rejoice with me—not because of the worldly glory alone, but because of the joy you will see in me as I produce lovely works, one after the other without any more of the old agony of doubt and uncertainty. This condition I am now just beginning to enjoy—and I have never done such painting as I am now executing.

Anna heard from others also that her son had "attained to the perfection in his art he has been aiming at for many years," perhaps alluding to *The Three Girls*, which had long embodied Whistler's struggle for perfection.[83] "Mr. Whistler is now working on a 'Symphony in White and Red,' consisting of three fair maidens clothed in thin white drapery," reported the London correspondent for an American newspaper in April, "but I am telling secrets of the studio, and I promised to keep this description till the picture was finished."[84]

That Whistler was in fact feeling "free and happy" in his labor was confirmed in May, when Cole observed his friend "madly enthusiastic" about a newfound power of painting life-sized portraits "in two sittings or so." One of these rapidly executed works portrayed Henry Irving in the character of Philip II of Spain; another was a portrait of Sir Henry Cole on which Whistler made "a strong commencement" in just two hours.[85] Whistler was also learning to capture "the difficult tones of moonlight," William Rossetti observed in the *Academy* that season, describing some recently completed works including *Nocturne: Blue and Silver—Bognor* (fig. 5.19). Probably begun in 1875, that Nocturne "differs from all the others and is perhaps the most brilliant of the lot," Whistler wrote to Cyril Flower, urging him to take Jeckyll with him to his studio. "Go and see if ever you saw the sea painted like that! And the mystery of the whole thing—nothing apparently when you look at the canvas, but stand off—and I say the wet sands and the water falling on the beach in the blue glimmering of the moon—and the sheen of the whole thing—*enfin*—then I have exhausted the subject."[86] Yet neither Flower nor any of Whistler's other prospective patrons—not even Murray Marks, who was specially invited to become its proud possessor—seem to have considered the painting worth its price of three hundred guineas.[87]

Indeed, Whistler's artistic accomplishments did nothing to alleviate his financial distress in 1876, partly the product of widespread economic recession.

FIG. 5.19 *Nocturne: Blue and Silver — Bognor* (Y100), ca. 1875. Oil on canvas, 50.3 × 86.2. Freer Gallery of Art, Smithsonian Institution, Washington, D.C. (06.103).

Alfred Chapman, a Liverpool patron who saw *Nocturne: Blue and Silver — Bognor* on display that summer at the Deschamps Gallery, wrote to Whistler that he would like to have it, but "times are too bad at present to allow me to think of going in wholesale for things of beauty tho' they be a joy forever." No one could hold the work in greater esteem, he said, offering sixty guineas; and Whistler, grateful for appreciation and desperate for funds, acceded to that price.[88] It may have been from necessity, therefore, as much as any prospect of pleasure, that Whistler determined to go to Venice at the end of the season, expressly to execute a set of twenty etchings. If his reputation as a painter remained uncertain, he had achieved "undisputed ascendancy as an etcher," his mother informed an American friend: his prints had quadrupled in value, and "it is gratifying to collectors to know he will resume this branch of art."[89] Whistler's intentions were announced in the July *Academy* and publicized with printed prospectuses titled "Venice — by Whistler," through which he hoped to gain sufficient subscriptions to finance the project.[90]

That season of 1876 was the first the Leylands spent in residence at 49 Prince's Gate, and it was to be their last spell of intimacy with Whistler. He continued working intermittently on his portraits of Elinor and Florence and made casual plans for other portraits of the Leyland children, never imagining that the boundless support of his patron was about to end. A bantering letter written that spring suggests the tone of Whistler's friendship with Frederick Leyland. Addressed "My very dear Leyland," it is so full of private jokes as to be almost indecipherable to any other reader; it appears Leyland had promised Whistler a present, which the artist assumed was to express appreciation for the "beautiful work done" in the stair hall at Prince's Gate. But the "very questionable Japanese o — Marks o — Boulevard du Temple — bric à brac stand" delivered one day to 2 Lindsey Row made it manifestly clear that Leyland's gesture was ironic. "You were grand when you helped me buy the lacquer cabinet," Whistler wrote in response, referring to a more respectable

piece of Japanese furniture—"but this," he added, "is unkind." In exchange for that "wicked sarcasm," Whistler dispatched *La Princesse* to Prince's Gate.[91]

Because the painting was meant to hang opposite *The Three Girls*, it is not surprising that Whistler took a proprietary interest in the dining room's decoration. Originally, he could not have expected to gain much beyond the satisfaction of seeing his paintings hung in style, since the room, though unfinished, bore the unmistakable stamp of another artist. Ethel Tweedie recollected that Whistler "jumped at the idea" of taking up the decoration because he was "poor and out at elbows, as usual," and he undoubtedly needed money: Whistler may have meant to use his earnings, as Katharine Lochnan suggests, to finance his trip to Venice.[92] No formal "business contract" was ever executed.[93] There may have been a verbal agreement that Whistler would receive five hundred pounds for the project, which both patron and painter considered, at that point, "a very slight affair and the work of comparatively a few days" (app. 1).

But as Frances Leyland was later to recall, Whistler's conscientiousness kept him at Prince's Gate all summer. To speed things along, Frederick Leyland invited the artist to live with his family for a while, so he could be at work by seven in the morning, "and I know how reluctantly he would break off," his mother wrote, "to dress for an 8 o'clock dinner."[94] Throughout this ordeal, Anna Whistler was informed in early July, the artist remained healthy and in good spirits, though naturally tired at the end of days spent "on ladders, upon the walls of the Leyland dining room busily decorating there." Later that month, she heard about the beautiful effect "produced by the Whistler genius," but mindful, perhaps, of the pressing need to stimulate her son's income, Anna betrayed some disapproval with her prescient observation, "a gentleman's private residence is not an exhibition."[95]

Accounts of the Peacock Room invariably begin with Whistler attempting to modify the colors of the wall hangings to bring the "Spanish" leather into harmony with *La Princesse*. His efforts actually commenced, however, with the more mundane task of completing parts of the room that Jeckyll had left undone—the ceiling, the shutters and doors, the canvas cornice and upper dado, and the walnut wainscoting—virtually everything, that is, *except* the leather. Whistler's later claim to have executed every inch of the decoration on his own may not have encompassed this preliminary stage, for which he enlisted the aid of Walter Greaves, who with the help of his brother Henry "laid on the gold."[96] "At moments they worked so frantically that it seemed to be raining gold," recounted Mortimer Menpes, who heard the story from Whistler. "Their hair became gilded; gold settled on their faces and on their lungs; they choked, and sneezed, and could hardly breathe."[97] The gold was actually copper—dutch metal, like that used in the stair hall, which Leyland had suggested would harmonize with the leather.

The difficulty seems to have been not the gilding itself, but treating the dutch-metal surfaces to suit the antique tone of the gilt leather. As in the hall,

this was achieved by allowing the metal leaf to tarnish slightly, then isolating it with a transparent, copper-green glaze that was thick enough to arrest further changes from atmospheric corrosion, creating the color Whistler called "green gold." Contemporary accounts consistently describe the woodwork as golden, which suggests that it initially appeared more gilt than green, probably resembling the golden surface of the main door leading to the stair hall (fig. 5.20). Cross sections of paint samples from the wainscot give evidence of three separate gilding campaigns in some places: evidently, Whistler failed to achieve the desired result with his first attempt.[98]

The artist's earliest efforts in the dining room, therefore, were made to complement the leather, which Whistler respected, if not admired. But the installation of *La Princesse* seems to have presented an unforeseen dilemma: Whistler complained (so the story goes) "that the red flowers scattered over the gold ground of the Spanish leather hurt the harmony of his picture."[99] Over Marks's objection that the leather set off "the chief beauty of the room," which he naturally considered to be the porcelain, Whistler was "allowed to have his way."[100] Thus began the tedious process of retouching hundreds of red flowers with yellow, thereby narrowing the color scheme to shades of gold, green, and blue. *La Princesse* was not to be the only beneficiary of Whistler's modification: Thomas Armstrong recollected that the result was "a happy one, having in view the purpose to which the leather was to be put, namely, to be a becoming background to the valuable blue china."[101] The *Academy* was to observe in September that by introducing the "fair primrose tint into the flowers," Whistler's object had been "to bring the different golds into relation," to harmonize the leather with the newly gilded surfaces of the dado and the ceiling.[102] Significantly, *La Princesse* is not even mentioned in that review, so Whistler's ambition cannot have been only to rescue his painting from disgraceful surroundings.

If it was "rather good-natured" of Leyland to allow Whistler to paint as he pleased upon the expensive leather hangings, as Gardner Teall reflected in 1903, the patron had no reason, at that stage, to doubt the artist's judgment.[103] A popular anecdote (originating in 1904) tells how Leyland further obliged Whistler by permitting him to trim the border off a precious oriental carpet, purchased that summer especially for the dining room, when Whistler objected that the red in the pattern "killed the rose in the painting." Possibly apocryphal, the story accords in spirit with T. R. Way's impression that Leyland "did not mind anything Whistler did," though Alan Cole recollected that Whistler's retouching understandably "began to get on Leyland's nerves."[104] At some point Whistler may have tried gilding the objectionable red blossoms, perhaps in hopes they would quietly disappear into the golden ground; but the result he pronounced "horrible," according to Marks, perhaps inducing him to experiment with blue.[105] That color too, proved "quite injurious on the tone of that leather," as Whistler informed his patron one Wednesday in August, "and so I have carefully erased all trace of it—retouching the small yellow flowers

FIG. 5.20 Detail, exterior face of the north door of the Peacock Room.

FIG. 5.21 Detail, leading on the south door of the Peacock Room.

wherever required—leaving the whole work perfect and complete." The walls, he announced, were finished: "the men" (presumably the brothers Greaves) were to varnish them the next day, and then the porcelain could be returned to the shelves. All that remained was one minor detail, which could be completed on Friday, Whistler hastened to add, "without at all interfering with the pots or the leather."[106]

The new detail was a "wave pattern," which Whistler proposed to paint in blue on the "green gold" of the cornice and the dado. The pattern already figured in the leaded glass of Jeckyll's serving-room door (fig. 5.21), and Leyland may have sanctioned the idea in the belief that it would unify the decoration; for in revising Jeckyll's design, Whistler was also dismantling its aesthetic coherence. Jeckyll's wave pattern, used in the cresting of the Philadelphia pavilion and the cornice of the Rance dining room, also happened to be the pattern that Whistler knew best. Indeed, his whole experience in pattern-making resided in his picture frames (fig. 5.22), which Walter Greaves was often employed to decorate with the wave or "mackerel-back" pattern.[107] The two coves of the cornice required a double scheme of decoration, and Whistler developed an abstract design of blue flecks for the upper tier, reserving the blue waves for the cove bordering the leather. But as he worked, that simple pattern evolved into a new motif that was, Godwin observed, "really neither more nor less than the scale or feather pattern drawn on gold in blue lines, with a blue touch in the middle of it"—a pattern mimicking the markings of a peacock's plumage.[108]

I AM NEARLY blind with sleep and blue peacocks feathers," Whistler wrote Frances Leyland that August, after she returned to Speke Hall at the end of the season. "Princes Gate is so lonely and so dismal without you that as I work and labor through the dreary silence I cannot well overcome the sense of being left by you all—and I miss you and miss you dreadfully." He reported that he was working at the house nearly every day, sometimes from six in the morning till nine at night, and was consequently "quite broken down with fatigue." He admitted weariness only to Mrs. Leyland and his mother, whom he could count on for sympathy and support. "Things are very tired and exhausted," he wrote, displacing his complaint, for the decoration itself was said to be "something quite wonderful and I am extremely proud of it."[109]

Whistler's work at Prince's Gate entailed an unprecedented level of physical labor—"such a great undertaking," as Anna Whistler imagined, "painting walls & ceiling as he would do a picture in oils. . . . No wonder he looks thin, tho he is so elastic in spirit and thankful for strength according to his need." Whistler's health had always been precarious. Childhood bouts of rheumatic fever had irreparably weakened his heart, and several times in the 1870s he was

FIG. 5.22 *Symphony in Grey and Green: The Ocean* (Y72), 1866. Oil on canvas, 80.7 × 101.9. Frame designed and decorated by the artist, ca. 1872. The Frick Collection, New York.

seriously ill; he remained so delicate that when he went to Hastings to visit his mother, he took a cab the short distance uphill to her house.[110] Fifteen-hour days spent on ladders and scaffolds would have taxed his energy to the limit: this was clearly a labor of love, and he "wouldn't do it again for any one alive," he confessed to Frances Leyland, adding with a hint of foreboding that he sometimes wondered "whether you will all appreciate it."[111]

A few days later, Frederick Leyland put the artist's fears to rest, approving "the ornament on the cove" he had seen on a recent trip to London and prophesying that the room would be "a great success." Assuming the project to be nearly complete, Leyland enclosed a check for fifty pounds, and in the words that would contribute to their legendary misunderstanding, advised Whistler to let him know, when he had finished, how much more would be required.[112] Whistler construed this as an offer to name his own price. He replied that the sum would be large, "but even then barely pay for the work—It is very difficult to know."[113]

Leyland did not expect to meet Whistler again before the artist's departure for Venice: they had missed each other in town because Whistler had been in Hastings, bidding his mother goodbye. Lionel Robinson, waiting all summer for his friend to finish work at Prince's Gate so they could go together to Italy, was growing impatient, and Whistler feared he would soon "run off" without him. But eager as he was to leave the desolation of London, Whistler was "still labouring and painting" there two weeks later, as he wrote to inform Frances Leyland. "The dining room has proved a Herculean task and I am bound to

FIG. 5.23 *Designs for the Dining Room* (M579a and M579d), ca. August 1876. Pen and ink on paper, 24.5 × 19.8. The British Museum, London, Department of Prints and Drawings; presented by the Misses R. F. and J. I. Alexander (1958.2.8.19).

finish it, though nearly ill with work—for were I to drop it, doubtless I should never take it up again!" Reiterating the extent of his long, hard days, Whistler supposed there would be ten more before he could leave town.[114] He did not disclose the reason for the delay, and perhaps, as Harper Pennington surmised, "the room 'got away' from him after he had begun to paint in it."[115] Indeed, he seems to have been growing bolder with his revisions—or, as Leyland only later realized, developing into an "elaborate scheme of decoration" what had been meant as a relatively modest undertaking (app. 21).

One sketch Whistler made to describe his plan to W. C. Alexander shows the floral pattern of the gilt leather sandwiched between his own designs, tellingly disproportionate to the original decoration (fig. 5.23).[116] The two-foot band of green-gold canvas forming the upper dado presented a special challenge, since it was shadowed by the shelves and would be largely obscured by the porcelain meant to stand before it. The architect William Burges, also a collector of Asian art, had confronted a similar problem some years earlier

The Porcelain Pavilion

FIG. 5.24 The Peacock Cabinet, 1873, designed by William Burges (1827–1881). From *The House of William Burges, A. R. A.*, edited by Richard Popplewell, 1886.

when designing a cabinet for Chinese porcelain and other precious artifacts (fig. 5.24): his solution was an ornamental peacock fanning its feathers behind the objects on the shelves to make a polychrome background visible through the gilded spindles. If only through Godwin, an intimate friend of Burges's, Whistler would have known about this "Peacock Cabinet," and his own scheme for the canvas background, a combination of three peacock motifs he later defined as "the Eye, the Breast-feathers, and the Throat," was to create a similar effect.[117] Cross sections from that register of the wall reveal that Whistler took special pains to distress the surface so the gold would glimmer through the darkness behind the gleaming china.[118]

Alan Cole recollected that the peacock theme developed "practically" from Leyland's collection of blue and white; it is tempting to speculate, more specifically, that the birds on the rims of Leyland's most spectacular dishes, chargers destined for the wide west wall (fig. 5.25), may have played a part in the inspiration.[119] Whistler's transformation of waves (or fish scales) into

FIG. 5.25 Chinese dish with peacock decoration, Kangxi era (1662–1722). Glazed porcelain with cobalt pigment, 55.8 diameter. Freer Gallery of Art, Smithsonian Institution, Washington, D.C.; gift from the Collection of Ann M. Lanier of the Montjoy Family of Vienna, Austria (1991.63).

peacock feathers effected an associative link between his decoration and the porcelain on the shelves, for as Murray Marks's trade card elegantly attests (see fig. 4.27), peacock feathers were, during the late-Victorian period, the requisite accessories to Chinese porcelain. The coupling of those aesthetic ornaments may have originated in Chelsea during the 1860s, when Whistler and Rossetti were competing for pots and Rossetti was collecting "beasts" for his fabled menagerie. In 1864 the Norwich collector W. H. Clabburn presented Rossetti with a peacock that remained in the garden of Tudor House until 1871, when a deer trampled out the feathers of its train and obliterated the source of its aesthetic appeal. One imagines Rossetti gathering the fallen feathers and arranging them like flowers in his treasured blue pots.[120]

A second drawing Whistler made for Alexander describes the peacock feathers painted on the outer face of the shutters (fig. 5.26), where they would be visible during the daytime, when the panels were folded open to permit a view of the garden. The artist probably considered this embellishment to fall within the bounds of his commission to treat the woodwork in the room; he never thought to ask for authorization. Neither did he ask permission, apparently, to continue the "ornament" from the "cove," which Leyland had approved, onto the ceiling—his most ambitious design so far. Whistler's sketch reveals that the pattern on the ceiling was originally to consist of the two designs

FIG. 5.26 *Designs for the Dining Room* (M579b and M579c), ca. 1876. Pen and ink on paper, 24.5 × 19.8. The British Museum, London, Department of Prints and Drawings; presented by the Misses R. F. and J. I. Alexander (1958.2.8.19).

developed for the cornice, the "Eye" and "Throat" feather patterns. The latter motif was eventually abandoned for a more elaborate decoration, which created a luxurious effect: "Radiating from pendent lamps we find the larger design suggested by the eye feather of the bird, and consisting of a series of segments of circles, so treated as to give the impression of the low relief of overlapping feathers. Intervening between the circular spaces in which this ornament is disposed is the second pattern suggested by the softer plumage of the peacock's breast."[121] By painting feathers in concentric circles around the pendant lamps, Whistler illusionistically flattened the "fussy ceiling," as Godwin observed. The delicate patterns cast across the gilded surface also lightened the structure and lent it a "rare quality of iridescence."[122]

"Imagine him on ladders and scaffolding using his palette and studio brushes!" wrote Anna Whistler to James H. Gamble early in September.[123] Spinning this web of peacock feathers across a broad expanse of ceiling required tremendous physical stamina and apparently inspired some technical innovations. Charlie Hanson, Whistler's six-year-old son who was taken to Prince's Gate by Jo Hiffernan, remembered seeing his father lying on a scaffold to paint the ceiling—a position that may have given rise to the legend that Whistler accomplished the decoration while resting in a hammock.[124] Another improbable story relates that Whistler wielded his paintbrush from the end of a fishing pole, which can only have been the attenuated bamboo rod that Whistler was affecting, in that period, as a walking stick.[125]

At the end of August, Whistler wrote to Alan Cole urging him to return to London from his Scottish holiday, if only to see the Leylands' dining room. He expected to "complete the thing" that week and then be off to Venice, even

FIG. 5.27 *Designs on the Shutters* (M580), 1876. Pen and ink on paper, 11.2 × 17.7. S. P. Avery Collection, Miriam and Ira D. Wallach Division of Art, Prints and Photographs, The New York Public Library; Astor, Lenox and Tilden Foundations.

though there remained "some lovely peacocks to do on the shutters."[126] That array of magnificently plumaged birds was intended to culminate the decorative scheme, uniting the various feather motifs. As in his other decorations in the room, Whistler worked with prussian blue upon a gilded ground—"the flat tint and gold which belongs to the conventional treatment of the decorator," as Tom Taylor observed, rather than the "natural colours" of the peacock.[127] These paintings were to be reworked many times over the next few months as Whistler refined their complex figure-ground relationships, but the essential compositions, which appear in a sketch Whistler sent to Samuel Avery in New York (fig. 5.27), were settled from the start. On the outer pairs of shutters were two peacocks "with their tails spread fanwise," as Theodore Child described them, "advancing in perspective toward the spectator." On the center panels was a pair of peacocks "perched peacefully halfway up," in the words of one reporter, "their gorgeous tails descending like drapery in [a] graceful sweep to the floor."[128] Whistler was to argue that these decorations alone were worth more than the others combined, and to symbolize his pride in them he signed the central composition as though it were a painting, with his butterfly emblem shining from the golden moon (figs. 5.28–30).

These were not "the common fowls of the farmyard," as one contemporary critic observed, but "creatures compounded of pheasant and phoenix—such things as peacocks may come to be in the course of natural and sexual selection."[129] The extravagantly inefficient train of a peacock flouted the rules of natural selection, and at one time, Charles Darwin confessed, the very sight of a peacock feather could make him sick. Darwin solved the peacock problem with the theory of sexual selection, which held that the flamboyant plumage had developed over evolutionary time to give the males an advantage in mating. Nevertheless, as Darwin observed in *The Descent of Man* (1871), the beautiful feathers of peacocks and certain pheasants made the birds appear "more like a work of art than of nature," which may account for their appeal to Whistler.[130]

The Porcelain Pavilion

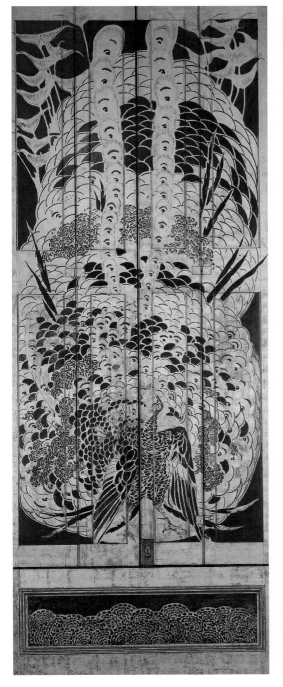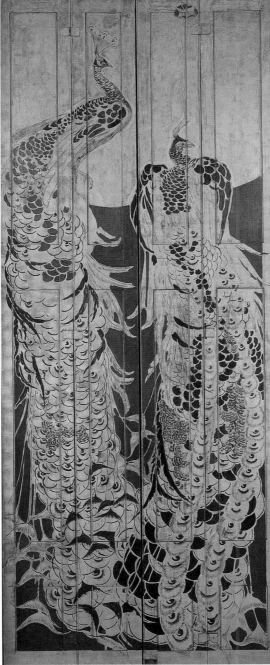

Charlie Hanson recalled that his father had often gone to the zoo in those days "to study the peacock in various positions" and produce "studies in colour of that beautiful bird," yet one of Whistler's aesthetic precepts was that art improved on nature. If he went "straight to nature" for preliminary studies, William Rossetti acknowledged that in executing the designs Whistler had allowed himself "considerable scope for decorative fantasy, or arbitrary artistic adaption."[131]

Indeed, the peacocks on the shutters were largely inspired by art. Although few of Whistler's contemporaries recognized the specific sources, even Tom Taylor perceived that the decoration at Prince's Gate was in spirit

FIGS. 5.28–30. The shutters in the Peacock Room.

The Porcelain Pavilion

219

FIG. 5.31 Folding embroidered screen, ca. 1876, possibly designed by Thomas Jeckyll (1827–1881), executed by students of the Royal School of Art Needlework, London. From *Masterpieces of the Centennial International Exhibition,* vol. 2, *Industrial Art,* by Walter Smith, Philadelphia, 1877.

FIG. 5.32 *Peacock in a Plum Tree,* early 1840s, by Andō Hiroshige (1797–1858). Woodblock print, 71.12 × 50.8. Tokyo National Museum, Japan.

"Japanesque."[132] The folding format of the shutters may have reminded Whistler of Japanese folding screens, and possibly also led him to exchange dutch metal for real gold. He applied the metal leaf to the inner faces of the shutters in a "blocky manner" that F. W. Moody, an instructor at the South Kensington School of Design, found objectionable; but it was done deliberately, to produce a pattern of squares like that of a Japanese screen, resulting from the overlapping edges of incredibly fine leaves of gold.[133]

The Porcelain Pavilion

As for the peacocks themselves, models would not have been hard to find: G. A. Audsley observed that "representations of the peacock are great favourites with the Japanese artists, and are successively given in nearly all branches of their decorative arts."[134] But like the Nocturnes, which reveal a profound understanding of Hiroshige prints but produce an original effect, Whistler's peacock decorations demonstrate an assimilation of Japanese style—in particular, a way of depicting "the action of birds," in William Rossetti's words, "their quaint turns of head or lithe deviations of neck; the decorative and at the same time naturalistic treatment of plumage." Whistler, we know, owned fifteen Japanese pictures of "birds of many varieties and of the richest plumage."[135] Two appear in the photograph of his drawing room at 2 Lindsey Row, and in the middle painting we can just make out the flowing feathers of a peacock's train (see fig. 4.1).

A more relevant model may have been a contemporary English folding screen, an early and fanciful pastiche of Japanese style exhibited at the Philadelphia Centennial (fig. 5.31). In one panel a magnificent peacock perches in a pomegranate tree, its feathers trailing to the ground, posed like the dominant bird on Whistler's center shutters. Embroidered by students at the Royal School of Art Needlework, the screen's designer is unknown, though supposed to be "one of the artists employed by that institution." Walter Crane has been suggested, but there is reason to doubt the attribution, and the more likely candidate may be Thomas Jeckyll, who designed at least one other embroidery pattern for the school based on Japanese bird-and-flower paintings.[136] The borders of the panels bear Jeckyll's characteristic wave pattern, and the wooden frame (which has not survived) strikingly recalls his furniture and woodwork designs, down to the delicately reeded uprights and the ornamental brackets on the base.

If Whistler had Japanese peacocks in mind, they may have been the ones depicted in the ōban-size prints of Hiroshige, which have a long, narrow format like the shutters themselves. Although its posture is reversed, the regal bird in *Peacock in a Plum Tree* (fig. 5.32) has the same cascading tail and elevated leg of the upper peacock in the central composition, and the one pictured in *Peacock and Peonies* (fig. 5.33), with its back turned and its head to one side, shares something of the second peacock's attitude. It may be significant that Hiroshige's birds appear in separate prints. In Japanese art, peafowl are conventionally portrayed in pairs, but it is rare to find two cocks together without a hen. Whistler's peacocks, then, occupy a remarkable state of peaceful coexistence, and Charlie Hanson, watching his father paint the long golden feathers of those splendid specimens, found himself wondering why they were not fighting.[137]

FIG. 5.33 *Peacock and Peonies*, early 1840s, by Andō Hiroshige (1797–1858). Woodblock print, 72.2 × 24.6. Museum of Art, Rhode Island School of Design, Providence; gift of Mrs. John D. Rockefeller, Jr. (34.633).

WHISTLER'S PEACOCKS were nocturnal: because of their setting, they came out only in the evening, when the shutters were closed and they would glimmer in the gaslight. In contending that this was an inappropriate position for such expensive decorations, Frederick Leyland was to miss the point, for these peacocks were designed to afford an enchanting surprise. The *Academy* gave the secret away on 2 September 1876, describing how the various motifs in the dining room were collected on the shutters into life-sized "images of the living peacock." Though conceived to support "the effect of the china," Whistler's decoration had lately assumed "a coherent and independent scheme of its own," the critic announced. "Mr. Whistler has trodden upon new ground, and has essayed a very interesting experiment in a branch of art where tradition is too apt to exercise extravagant authority."[138]

With the painting of the shutters, Whistler had made the room his own, and it is not surprising that the *Academy*'s reporter overlooked Jeckyll's part in the project. Whistler rushed to assure Leyland that he had written a letter to the journal so that "Tommy may have his full share of the praise as is right."[139] But he was too caught up in the originality of his own work to worry about issues of authorship. Proudly dispatching the review to Hastings, Whistler told his mother he had done "a *noble* work, . . . and one we may be proud of. So very beautiful! and so *entirely* new, and original, as you can well fancy it would be, for at least *that* quality is recognized in your son."[140] In his letter to Leyland, Whistler added, "There is no room in London like mon cher, and Mrs. Eustace Smith is wiped out utterly!"[141]

Mary Smith, known as Eustacia, had settled with her husband at 52 Prince's Gate around the time the Leylands took occupancy of number 49.[142] The Smiths' residence was to be a showplace for contemporary paintings; their collection was smaller than Leyland's but similar, with works by Burne-Jones, Legros, and Moore. (One painting by Frederic Leighton, *Venus Disrobing*, for which Eustacia claimed to have modeled for the feet, had even belonged to Leyland until he disposed of it at auction in 1872.)[143] George Aitchison had been commissioned to decorate the house in collaboration with Leighton and Thomas Armstrong, and Whistler's claim to wiping out Mrs. Smith suggests that he was consciously engaged in an undeclared competition. He probably alluded to Eustacia Smith's boudoir, with its frieze of white cockatoos by Walter Crane (fig. 5.34).[144]

Birds were considered especially well suited to the decoration of a frieze: R. W. Edis observed in *The Decoration and Furniture of Town Houses* (1881) that as subjects, birds could be "treated naturally, in combination with simple foliage and artistic arrangement of pots and flowers, so as to form an exceedingly beautiful decoration for the upper part of the walls of a dining- or drawing-room, or lady's boudoir."[145] For his own house, Edis had commissioned a frieze from Henry Stacy Marks, the acknowledged master of ornitho-

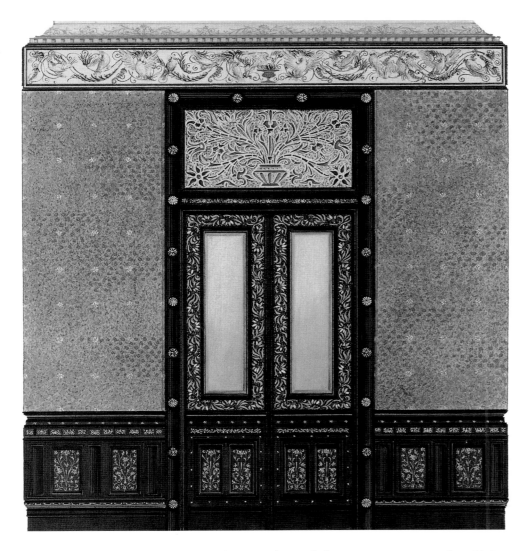

FIG. 5.35 Wallpaper designs by E. W. Godwin (1833–1886), produced by Jeffrey & Co., London. From *Building News*, 8 May 1874.

logical painting, which featured peacocks and flamingos, among other living things; and E. J. Poynter had used peacocks as the motif for the plaster frieze of the East Dining Room (or Grill Room) of the South Kensington Museum. One of Whistler's departures from tradition, therefore, was to paint his peacocks in full length, across one wall of the room, to dominate the decoration.

Clearly, Whistler's innovation was not in the motif. As J. Comyns Carr pointed out in 1877, "Peacocks have been painted before, and blue and gold is no new combination of color." Enumerating contemporary examples only confirms Carr's argument "that in Mr. Whistler's hands these familiar materials take an entirely new form and become a thing of original and independent invention."[146] The peacocks in E. W. Godwin's decorations for Dromore Castle, for instance, are often cited as precursors of Whistler's, though the design bears little relevance to the Peacock Room. Based on Japanese crests, Godwin's "medallions with birds' heads of quaint device" came to public attention in the early 1870s through drawings published in the *Architect* and the *Building News;* they gained currency in 1873, reappearing in a wallpaper design meant to be used in the conventional way, for a dado or a frieze (fig. 5.35).[147]

The Porcelain Pavilion

Whistler himself is said to have devised a peacock decoration that antecedes the Peacock Room. According to W. C. Alexander, the artist had initially proposed "a Peacock Room arrangement" for the drawing room at Aubrey House.[148] This became a fixture in histories of the room, although the statement was discounted as a rumor in 1904 by C. J. Holmes, who maintained that the peacock design "came to Whistler gradually, as a result of the experiments he had made in harmonizing his picture with Jeckyll's decoration."[149] Alan Cole, who was on the scene, also questioned Alexander's account, for he remembered an *"evolution* of blue and gold" in the Peacock Room, the development of a design that had not been preconceived.[150] Perhaps Alexander, recollecting a suggestion made more than thirty years earlier, remembered only that Whistler had advanced a plan for a blue-and-gold decoration ("a Peacock Room arrangement") that was rather rich for his own taste.

Another celebrated peacock decoration contemporary with Whistler's color schemes for Aubrey House may have added to the confusion: a peacock frieze by Albert Moore, for the house of A. Frederick Lehmann at 15 Berkeley Square (fig. 5.36). (A notice, wrong on many counts, was published in *Notes and Queries* in 1907, warning that this not be mistaken for "Whistler's peacock room in Queen's Gate, which was also done for Mr. Lehmann.")[151] Lehmann's drawing-room walls were reddish brown, and the ceiling, embellished with boughs of leaves and flowers, featured cross-beams "finely feathered with gold." In between was Moore's "matchless frieze" of peacocks on a gilded ground.[152] Unlike Whistler's birds, Moore's were "ad libitum," ranging freely round the room with their trains behind them "in repose."[153] Nothing of that frieze survives except the cartoons of the stately peacocks in various attitudes, as composed as the classicizing figures in Moore's paintings (fig. 5.37). Some of the outlines have been pricked or incised for transfer to canvas. This suggests that

FIG. 5.36 *Design for the Front Drawing Room at 15 Berkeley Square*, 1872–73, by George Aitchison (1825–1910). Watercolor and gold on paper, 52.07 × 72.39. The British Architectural Library, London, Royal Institute of British Architects.

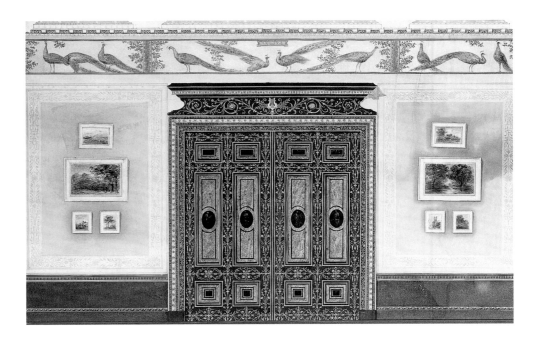

The Porcelain Pavilion

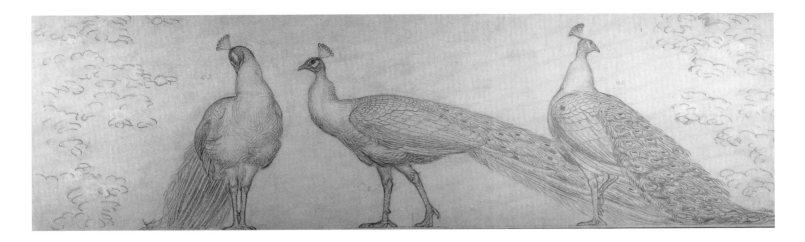

FIG. 5.37 *Cartoon for the Peacock Frieze at 15 Berkeley Square*, 1872–73, by Albert Joseph Moore (1841–1893). Charcoal and white chalk on brown paper, 46.0 × 154.9. The Victoria and Albert Museum, London (D.262-1905).

Moore approached this decorative project as if it were an easel painting, possibly providing an example for his devoted friend Whistler.

As in the period when he had worked with Moore and proved unable to pronounce a picture finished, Whistler appears to have been incapable of bringing his dining-room decoration to a close. Even after the *Academy* article appeared and he informed his mother he had achieved "what I have longed to do, the completion of this *famous* dining room," Whistler admitted he had yet another week of work, perhaps two, before he could leave the house "and say *I am content.*"[154] He wrote triumphantly to Leyland around the same time, "Je suis content de moi!" Yet a few lines later he confessed that he was not quite finished, and he implored his patron to stay away a little longer, as he did not want the room to be seen until every last touch was in place. That request is often read as a command, heightening a sense of Whistler's imperious behavior; but the artist's motives, at this juncture, were most probably innocent. He proposed spending a day or two at Speke Hall once the room was completed, "a sort of farewell visit before I get off for Venice," then accompanying Leyland back to London so they could "enjoy the success of this great work together — I seeing it also with rested eyes." It seems not to have occurred to him that Leyland might disapprove, for Whistler boasted freely of the changes he had made. "I assure you," he wrote, employing a metaphor calculated to appeal to his patron, "you can have no more idea of the ensemble in its perfection gathered from what you last saw on the walls than you could have of a complete Opera judging from a third finger exercise!"[155]

Whistler had reason to anticipate praise, since he had heard nothing but that from the few allowed into "the 'Peacock Palace' in Prince's Gate." Among those visitors were the Marquis of Westminster, the Prince of Teck (husband of Queen Victoria's daughter Mary), and the Princess Louise. "I know you will be pleased that this testimony of its worth should be offered after so much labor, therefore I tell you," Whistler wrote his mother.

The mere visits of Princes and Dukes, we well know, is no *voucher* for the quality of a work of art, for they are simply curious people, generally *better*

mannered than others about them, but able to look with the same satisfaction upon a *bad* thing, as a good one. Still they are charming people, and show *real* delight in this *beautiful* room, keep up the buzz of publicity most pleasantly in London Society, and this is well, and I hope good may result.[156]

The publicity Whistler felt certain would enhance his standing in society was equally sure to offend his retiring patron, and the artist must have sensed that in welcoming visitors he risked losing Leyland's good will.

Initially, according to G. W. Smalley, Whistler permitted only family and close friends occasional glimpses of the room.[157] His sister Deborah Haden stopped by the house one day uninvited, writing Anna Whistler afterward that the room "was beautiful beyond her language to describe." After the *Academy* article was published, Whistler became more liberal with invitations. Through his mother, he asked Deborah to come back with her daughter, Annie, any day she pleased, and he sent word to James Anderson Rose that he should visit right away, as the dining room was "nearly completed and magnificent."[158] It was probably also around this time that he wrote to Millais, whose work Whistler had long admired, that he hoped he would come to see the decoration; and perhaps also to Poynter, who was to speak highly of the room to Alan Cole.[159]

On 11 September, the date Whistler had thought he would be in Venice, he entertained Alan Cole with a "brilliant description of his successful decorations at Leyland's," and that weekend, when Freddie Leyland had looked forward to seeing him at Speke Hall, Whistler was still working in London.[160] On 20 September, Cole finally paid a visit to the "Peacock Room" (as he called it for the first time), describing the peacock-feather devices in his diary as "extremely new and original." The next day Whistler sent a telegram to Liverpool informing Leyland that the room was "superb" and would soon be finished, asking for one hundred pounds and begging forgiveness for the "abrupt" communication. Leyland, characteristically, responded with an immediate check, and Whistler wrote in gratitude, "The room I believe will delight you as it does apparently every body who sees it." He still expected to turn up at Speke, "possibly next week."[161]

It is not known exactly what Whistler was doing during the month or so that followed, for an unaccountable hiatus appears in his own correspondence and in the accounts of his contemporaries. His plans for Venice evaporated when Lionel Robinson did depart without him, leaving Whistler alone to refine the decoration in ways that may have been imperceptible to anyone else.[162] The extent of his efforts can be gleaned from paint samples, in some cases revealing as many as thirteen layers of ground, oil paint, pigmented glazes, and metal leaf, which suggest a lengthy progression of false starts and revisions. It was that process Whistler described to the Pennells in 1900: "I had got to such a point in the work, putting in every touch with a freedom that was won-

derful, so much so, that when I got round to the corner where I had started, I painted a bit of it over again that the difference should not be seen. I just painted it as I went on, without design or sketch."[163] Taken together, technical analysis and contemporary sources confirm that Whistler did not conceive the peacock decoration all at once: he could not have let Leyland know ahead of time what he planned to do with the dining room because when he began it, he had not known himself.

G ORGEOUS" was the word Whistler used to describe his decoration in the early autumn days of 1876. He informed Alan Cole he had done "something gorgeous" and told his mother that Princess Louise had been taken with the "'gorgeous loveliness' of the work."[164] He declared to Frances Leyland that the dining room was "thoroughly new and most gorgeous though refined"— appending an important qualification, since he knew the Leylands were not given to extravagant display. He must have chosen his words with special care when writing to Frederick Leyland that the decoration had become "really alive with beauty—brilliant and gorgeous while at the same time delicate and refined to the last degree."[165]

Those words, intended to prepare his patron for the glittering transformation the dining room had undergone, proved insufficient to soften Leyland's shock when he finally returned to London. Leyland had stayed away too long— not because of any word from Whistler, but because the pressure of business kept him confined to Liverpool: the Leyland Line had recently been launched into the Atlantic trade.[166] Apparently, Leyland came back to town around the middle of October 1876 without notifying anyone of his intention, and Whistler, who had long looked forward to the day when he and his patron would admire the work together, must have been stunned by his unexpected reappearance. As the Pennells point out, the redecoration could not have taken Leyland completely by surprise: the artist's letters both to him and to his wife, to say nothing of the detailed report in the *Academy*, would have made him aware of the scale of Whistler's work. But he may have been annoyed to find Whistler still there, having been told more than a month earlier, when he had last sent a check, that the room was to be completed any day, and Alan Cole ascribed Leyland's irritation to Whistler's excruciating pace, "the work seeming to drag on indefinitely."[167]

Leyland also appears to have taken the side of Thomas Jeckyll. When he arrived, Whistler was gilding the spindle shelving. Whistler's primary purpose may have been to harmonize the walnut structure with the gilt-leather hangings, but he also hoped to bring out the carving on those "lovely columns," as he was later to explain: "Before in their original state of dull brown walnut it could only be made out on close inspection and across the room was quite

invisible." When Leyland objected that Jeckyll "might be annoyed at his work being gilded without his previous consent," Whistler had contended that "Tom would be pleased," remembering how he had sought advice on colors for the Philadelphia pavilion.[168]

Leyland's objection at that point may have expressed a more general concern with Whistler's lack of consideration, for the artist had now blatantly overstepped the terms of the commission. It may also have discomfited Leyland to find the dining room growing more "gorgeous" by the minute. His friend Thomas Sutherland recalled that he "didn't like the idea of so much gold and gilding in the decorations," considering it vainglorious for the home of a self-made man.[169] The room itself, with feathers on the ceiling, peacocks on the shutters, and trains of flowers clinging to the leather-covered walls, might well have appeared to Leyland in a state of aesthetic confusion, the inevitable consequence of Whistler's effort to graft his own ambitious scheme onto another artist's design.

Sutherland said that Leyland told the artist "his dining-room was ruined and Whistler's time wasted,"[170] but Leyland may not in fact have stated his disapproval so explicitly. One of the letters Whistler later wrote his patron makes a telling reference to "the mortification of work done that was neither rejoiced in nor even wished for" (app. 8), as though it was the absence of joy that hurt his feelings most. Whistler would have been profoundly disappointed when his patron failed to extol the design; for unlike the dukes and princes who could look with the same satisfaction upon a bad thing as a good one, Frederick Leyland was a man whose taste Whistler genuinely respected, despite his later claims to the contrary. The legendary quarrel that came to revolve around money arose, therefore, from a perceived failure of appreciation: had Leyland "rejoiced" in the work, as Whistler had anticipated, remuneration might never have become an issue. "Alas!" wrote T. R. Way, "that a little want of tact, possibly on both sides, should have brought about such a lamentable result."[171]

If he was not to be rewarded with praise, Whistler expected some other compensation, and "the crisis came," the Pennells relate, "when Whistler, thinking himself justified by months of work, asked two thousand guineas for the decoration of the room, as a reasonable price." Their wording suggests doubt that the price was indeed reasonable, and Ferriday advanced the theory that Whistler never expected to receive it: "he was cunning enough to have named this unlikely sum merely to wrongfoot Leyland. Rich man refuses to pay impoverished artist proper fee for work done."[172] But that "unlikely sum" had evidently been calculated with care. Whistler was to argue that the peacocks on the shutters were in themselves worth twelve hundred pounds (app. 1): if we regard the three pairs of shutters as three separate paintings, each at a cost of four hundred pounds, then Whistler's price seems reasonable.

At first, according to Theodore Watts-Dunton, who told the story to William Heinemann, Leyland only laughed at Whistler's demand "and took no

further notice of it." But then on the following Sunday morning, he talked the matter over with Gabriel Rossetti. Once Whistler's closest colleague and companion, Rossetti had come to consider him "an uneducated brainless fellow," Watts-Dunton reports, his paintings "flat and wanting in knowledge of technique."[173] There was never outright dissension, and William Rossetti was to maintain that his brother and Whistler had "ceased to be in the way of meeting" only because of Gabriel's reclusive habits. Rossetti himself revealed his true feelings in an 1879 letter to Jane Morris, writing of his former friend's "incredible career of swindling quackery for some time past."[174] Leyland seems to have felt the full force of Rossetti's antipathy when he told him the story of the Peacock Room: Rossetti reportedly declared it outrageous for Whistler to demand so exorbitant a price for the mere modification of an interior design—which he, of course, had never seen. And when Leyland said he was willing to pay Whistler one thousand pounds, Rossetti contended that even that "was far too much, and rather pooh-poohed the idea of the whole thing or that Leyland should give him anything at all."[175] Rossetti, incidentally, had recently sold a painting of his own for precisely two thousand guineas.[176]

The matter remained unresolved when Leyland returned to Liverpool. Alan Cole called on Whistler at the end of the week to find him preoccupied, or "vague," and the room still unfinished.[177] Yet the day after Cole's visit Whistler sent a telegram to Leyland stating (or implying) that he had completed his work and required payment in return. Leyland's measured reply, dated 21 October, seems to have set the quarrel in motion, for his letter became the first in the series Whistler was to number and preserve as a record of the dispute. In it, Leyland regrets he is unable to consent to the sum Whistler mentioned when they met, and apologizes for the "unpleasant correspondence" that had passed between them. Nevertheless, he argues, "I do not think you should have involved me in such a large expenditure without previously telling me of it" (app. 1).

Hoping to settle the amount Whistler was entitled to charge, Leyland proposed that for the parts of the project he had authorized—"the decorations to the ceiling and the flowers on the old leather, as well as the other work about the house"—Whistler be paid for the time expended, at his "average rate of earnings as an artist." Leyland may not have intended this as an insult but Whistler, already deeply wounded by his patron's unfeeling response to the decoration, could only have recoiled from the suggestion that he be compensated like a common laborer who worked for an hourly wage. The part of the letter that was not to be borne, however, was Leyland's offhand dismissal of Whistler's greatest gift: the peacocks on the shutters might be worth their price as pictures, the patron acknowledged, but as decorations they were much too costly, "and you certainly were not justified in placing them there without any order from me. I certainly do not require them and I can only suggest that you take them away and let new shutters be put up in their place" (app. 1). That those paintings might simply be removed, nullifying the aesthetic unity Whistler had

worked so hard to achieve, must have struck the artist as outrageous. Pointedly declining to address Leyland's concerns, he telegrammed to Liverpool that he was "shocked to find nothing" in Leyland's letter and demanded two hundred pounds (app. 2). For the first time in their long association, Leyland flatly refused. "I am not disposed to pay any more money until we arrive at a final arrangement in respect of the decorations at Princes Gate" (app. 3).

Meanwhile, according to Alan Cole, the dining room was still "developing" in the days after Leyland's fateful visit (fig. 5.38). On 26 October, Whistler was putting peacock plumage on the lower panels of the wainscot—the same design as on the ceiling, but easier to see: "If there is one quality more admirable than another in the treatment of blue on gold," Godwin was to observe, "it is where using two blues, resolving as it were one of them into the gold, he has attained what he sought—an iridescent effect without the use of the real colours of the natural plumage."[178] That same afternoon, Leyland returned to London to find the Marquis of Westminster with Whistler at Prince's Gate. It seems that Leyland said something in front of that distinguished guest that deeply embarrassed the artist and precipitated Leyland's descent, in Whistler's eyes, from princely patron to "British Business Man" (app. 4).

The incident was followed by tense negotiation as they tried to settle the business at hand, Leyland offering Whistler one thousand pounds (app. 7), which Whistler initially refused to accept.[179] But eventually they agreed "to bare [sic] alike the disaster of the decoration," as Whistler phrased it. "I pay my thousand guineas as my share in the dining room, and you pay yours" (app. 4). Simply to have accepted the sum Leyland was prepared to pay would have been conceding to his low estimate of the decoration's worth. Whistler's unconventional offer to pay himself half the cost of the project was a means of keeping the price intact; for as he later explained to J. Comyns Carr, Leyland was "only a millionaire, and that a thing should be costly is the only proof that he has of its value."[180]

The thousand pounds Whistler received for decorating the Peacock Room amounted to "a trifle over 10 shillings per foot," the *Hornet* calculated in 1877. Years later, Whistler was still complaining that he had never been "properly paid" for his work at Prince's Gate.[181] But a thousand pounds, roughly equivalent to two hundred thousand dollars in modern currency, was no small sum at a time when a flat in Mayfair could be leased for one hundred and fifty pounds a year and a Savile Row suit purchased for eleven; the annual salary of an upper middle-class professional, able to keep three servants, would have been about five hundred.[182] Leyland himself regarded his payment as "liberal and handsome," Watts-Dunton said, "one which nobody else in England would have made" in the absence of a commission.[183] In any event, he might surely be forgiven for refusing to pay Whistler more for yet another unfinished work.

The second part of the compromise, whereby Whistler would be permitted to continue decorating the room, effectively discharging his share of the price, can only be explained by the state of the decoration at the time of the

The Porcelain Pavilion

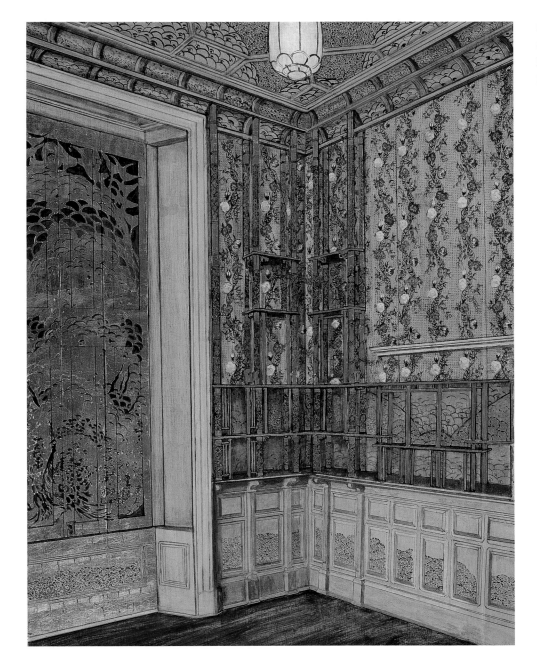

FIG. 5.38 Southeast corner of the dining room at 49 Prince's Gate, London, as it may have appeared in October 1876. Rendering by Peter R. Nelsen, 1997.

quarrel: as Leyland was later to remind the artist, "the work had progressed so far that I had no choice but to complete it" (app. 19). In light of past experience, Leyland might have imagined the artist in residence for another decade or so, and that concern probably underlies the terms of their agreement: Whistler could proceed without interference or interruption from Leyland, but only until the family returned to London at the start of the season. Sir Henry Cole, hearing the story later in great detail from Whistler, gathered that the Peacock Room had been "thrust upon" Leyland, that he "had suffered it to be done." But as Mortimer Menpes was to tell the tale, "Leyland was once more turned out, and the Master completed his operations."[184]

Having settled for what he considered an inadequate fee, Whistler expected to have it paid promptly. When, three days later, he had yet to

receive a check, he wrote a contentious letter to Leyland, opening with the admonition, "Put not your trust in Princes." Whistler felt betrayed: it was as if, the Pennells remark, "the years of friendship counted for nothing."[185] The decoration he began as a labor of love was henceforth to be a matter of commerce; for it was from Leyland he had learned "that from a business point of view, money is all important and that Saturday should not have passed and Monday's post bring no cheque to Your promising pupil in business wisdom" (app. 4). Thus the conflict was cast as a dispute between parties in a business transaction, one of whom had failed to comply with the conventions of trade. By focusing on money, or its absence, Whistler reduced a nine-year friendship to a base equation and covered up the real cause of the conflict, a perceived breakdown in Leyland's sympathy and affection.

As it happened, Leyland had not failed Whistler: his check for six hundred pounds—the thousand agreed upon, less £250 lent and £150 advanced—was already in the mail (app. 5). Moreover, he seems not to have realized the depths of Whistler's anger, for he was astonished that the artist had written him "in such a tone" (app. 7). But when the check finally arrived in London, on the last day of October, it was in Whistler's opinion not only too late, but too little: Leyland had compounded the insult of a paltry payment by expressing it in pounds, the currency of trade, when professionals were customarily paid in guineas. And because a pound was worth twenty shillings and a guinea twenty-one, the already offensive sum was even smaller than expected—"another fifty pounds off," Whistler wearily observed. "Well I suppose that will do—upon the principal [sic] that anything will do" (app. 6).

According to the Pennells, having his guineas reduced to pounds was the "unpardonable sin," something Whistler considered "unbecoming in a transaction between gentlemen." Leyland's form of payment clearly rankled: in 1892, when the dealer D. C. Thomson committed the same offense, Whistler declared he was reminded of Leyland—"You have cut the shillings off my guineas!!!"[186] This attitude has been regarded as one of Whistler's peculiarities, but it was not uncommon among Victorian artists. G. F. Watts explained to Madeline Wyndham that "like Doctors we always work for the guineas," and Rossetti was known to be inflexible in this regard: once when Alexander Constantine Ionides sent Rossetti a check for one hundred pounds, the artist replied, "Many thanks, but please send me five pounds more, as my price is in guineas."[187] More to the point, Leyland had paid guineas in the past. Even if the agreed sum had been stated in pounds, as Leyland maintained (app. 7), Whistler would have expected guineas; and just as when he expected words of praise, he would have been deeply offended not to get them. Whistler did not dispute Leyland's "right to change the guinea of tradition to the current sovereign," he replied, but merely noticed it, "as new—Forgive the tone, if you find it flippant" (app. 8).

Perhaps Whistler adopted this unlikely attitude of resignation to assure Leyland that their disagreement was resolved, as a ploy to keep him safely out

The Porcelain Pavilion

of town, for he was already plotting his revenge. "He could no more help his manner of avenging what he thought an insult than the meek man can refrain from turning the other cheek to the chastiser," the Pennells reflect.[188] His letters to Leyland were becoming increasingly self-conscious—multiple drafts preserved in Glasgow attest to the trouble he took in composing them—and he would later ask Leyland's permission to publish the correspondence (app. 19), a plan probably conceived as Whistler worked out the design for the mural opposite the fireplace. Significantly, that was the space reserved for his masterpiece, *The Three Girls*, which Whistler must finally have determined never to surrender to the philistine of Prince's Gate. The peacock tableau he envisaged in its place would illustrate his own interpretation of events, as expressed in the letters he regularly dispatched to Liverpool. On 31 October 1876, Whistler offered the first, cryptic clue to his intentions. "Bon Dieu! What does it matter!—The work just created, *alone remains* the fact—and that it happened in the house of this one or that one is merely the anecdote—so that in some future dull Vassari [sic] you also may go down to posterity, like the man who paid Corregio [sic] in pennies!" (app. 6). The pair of fighting peacocks would immortalize their quarrel, from the artist's point of view, for the chroniclers of posterity—those biographers and historians who were to play Vasari to Whistler's Correggio.

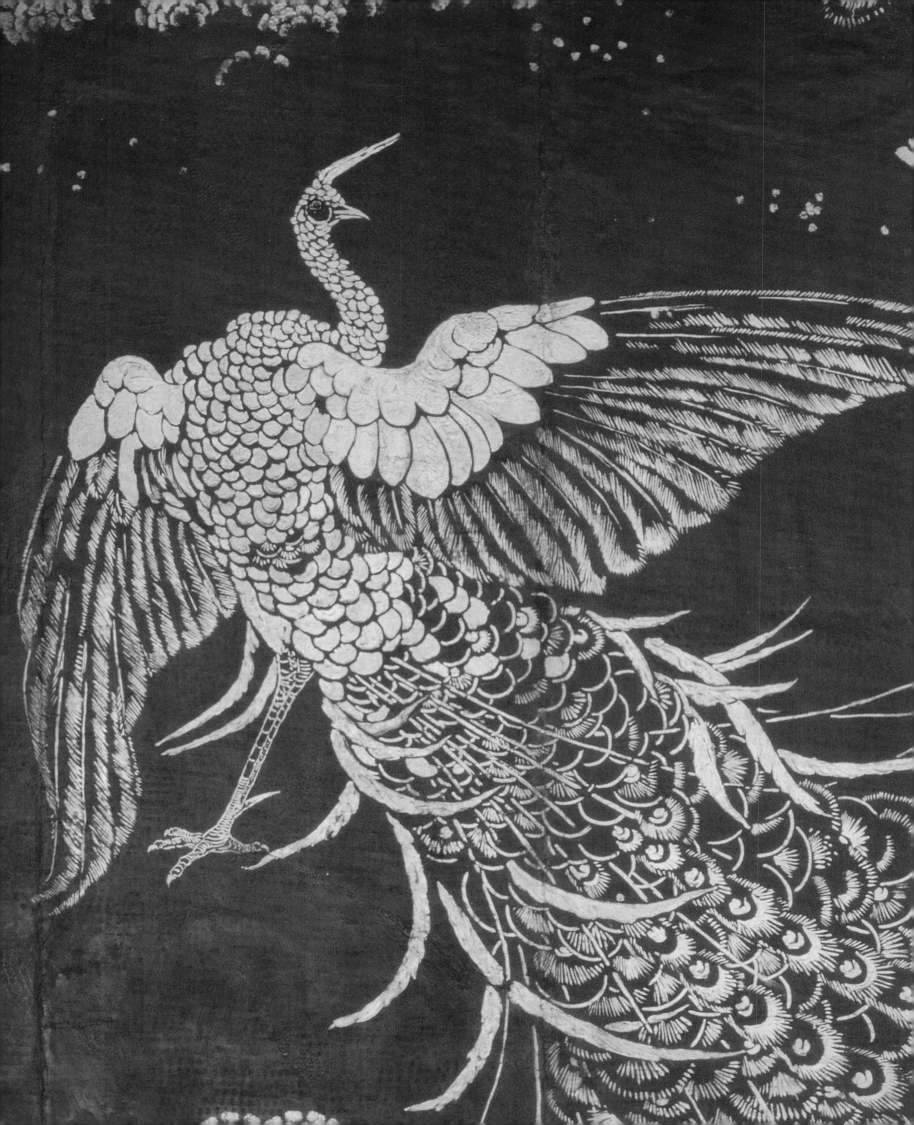

6 The Last Alembic

I<small>N THE WEEKS FOLLOWING</small> Whistler's devastating disappointment with Frederick Leyland, the artist worked through the dwindling daylight hours of the changing season to transform the dining room into a three-dimensional painting with the color scheme of a Nocturne. The quarrel had unleashed Whistler's full creative powers, and the "grandeur of enthusiasm" said to have seized him in the Peacock Room may have come from feeling suddenly free from any obligation to please his patron.[1] As he later implied in the "Ten O'Clock" lecture, artistic inspiration was a form of alchemy that transmuted the ordinary into art; but in this case, Whistler's magic grew darker as the gilded decoration modulated into blue, until at last the room became one in which "nature, sunlight, or any mortal compromise could never enter," the poet Arthur Symons observed, "a wizard's chapel of art."[2]

The metamorphosis began with Whistler's audacious decision to paint the walls peacock blue. Until his altercation with Leyland, Whistler had worked to harmonize his decorations with the design and color tones of the antique leather; afterward, he appears to have concluded that if his efforts in the dining room had failed, it was because the leather was incorrigible. In painting it out, Whistler also effaced evidence of his own painstaking attempts to correct the aesthetic dissonance of the original scheme, holding to his habit of scraping down canvas after canvas to allow for a clean start. It was while he was retouching the flowers on the walls, or so the story goes, that Whistler discovered that the texture of the leather was "agreeable to work on."[3] And so, with "great pails of Antwerp blue" and the help of Walter Greaves, Whistler set to work "to smother the Spanish leather."[4]

Described in a contemporary account as "a greenish peacock blue," the color Whistler deployed on the walls was prussian (or antwerp) blue, a pigment popular with Victorian artists and considered unparalleled "in its wonderful depth, richness and transparency."[5] Alice Carr observed that once the walls were painted that "deep, glorious blue," they made a restful contrast to other parts of the room that were gilded or enveloped in peacock feathers.

In all that is dainty and lovable he finds hints for his own combinations, and thus is Nature ever his resource and always at his service, and to him is naught refused.

Through his brain, as through the last alembic, is distilled the refined essence of that thought which began with the Gods, and which they left him to carry out.

"Mr. Whistler's 'Ten O'Clock'"

Detail, south wall of the Peacock Room (fig. 6.3).

FIG. 6.1 *Ceiling Designs and a Wall Elevation of the Peacock Room* (M989), ca. 1884. Pen and ink on paper, 17.8 × 22.9. Isabella Stewart Gardner Museum, Boston, Massachusetts; gift of Harper Pennington, 1904.

Godwin, who applauded Whistler's act of transformation, detected scarcely a trace of the original leather panels, but Thomas Armstrong noticed the imprinted pattern showing through the paint, creating what he considered a disagreeable effect: Whistler might easily have removed the wall hangings and replaced them with canvas.[6] The artist Harper Pennington also objected to Whistler's painting over the leather, which he thought too fine and valuable to be so wantonly destroyed. Whistler had remonstrated that "the artist's mission was to destroy what was bad as well as to produce what was good," but Pennington sensed that he knew his action had been indefensible: "It was as though one asked a painter to touch up the frame of a poor picture, dear to one for any reason except merit, and the painter had produced a masterpiece over the features of some friend."[7]

Among the first to witness the transfigured features of the dining room was Algernon Mitford (later Lord Redesdale), one of Whistler's closest friends and a new neighbor on Lindsey Row. Mitford had been away all summer, and when he went with Alan Cole to Prince's Gate on 29 October 1876, he was alarmed to find the artist perched on a ladder, "looking like a little evil imp." Mitford inquired whether Leyland had been consulted before the "Spanish" leather was painted: Whistler laughed and justified himself by saying he was making the most beautiful room there ever was.[8] A day or two later, when Leyland's check "shorn of its shillings" arrived in the mail, Whistler's efforts were newly energized. J. Comyns Carr recalled the artist's "delighted anticipation" of his patron's shock at the disappearance of the leather: "He already scented the joy of the battle that impended, and this added a peculiar zest to

his labours in the accomplishment of a purely artistic task." By mid-November, Cole reported, Whistler was "quite mad with excitement."[9]

Painting the leather necessitated refinements to the existing decoration, as Whistler later explained to Pennington, demonstrating with sketches "how the idea of his Peacock Room had grown into reality" (fig. 6.1).[10] On the newly blue wall bordering the shelves, Whistler added gold undulations related to the breast-feather motif. On the gilded wainscot below, he painted the upper panels prussian blue, embellishing them with a gold eye-feather motif that was slightly abraded to create a flickering effect; this decoration picked up Jeckyll's wave pattern in the leaded-glass door, which Whistler now gilded to match. On the lower panels of the wainscot, which already featured an iridescent peacock-feather design, Whistler filled in the upper field with blue to visually tie it to the blue leather above. He left only the greenish gold moldings unadorned, to function as frames for the painted decorations. "Into the paint he crammed gold, and afterward more blue," Menpes recounted the process, "and so on, until in the end the room was one glorious shimmer of gold and blue intermingled, a very beautiful whole—in fact, a masterpiece."[11]

The gold breast-feather design shimmering on the solid blue wall was designed to recall the gilded decoration on Japanese lacquerware. This latest embellishment complemented the "aventurine" decoration already present on the ceiling and upper dado, and it may have inspired a daring new aesthetic conceit. Without the Dutch gilt leather and the view of the park, Jeckyll's inspiration of a garden pavilion was meaningless; Whistler's room, with the shutters closed to display the peacocks and seal the space from the outside world, was to resemble a Japanese lacquer box (fig. 6.2). It may have been to enhance this effect that Whistler fleetingly considered cutting the pendants off

FIG. 6.2 Toilet case, Momoyama or Edo period (early 17th century). Lacquer on wood with decoration in *maki-e* (sprinkled design), 19.6 × 30.4 × 26.5. Freer Gallery of Art, Smithsonian Institution, Washington, D.C. (07.106).

FIG. 6.3 Detail, south wall of the
Peacock Room.

the ceiling, which would have restored the room to its rectangular shape. And it was undoubtedly to impart a third dimension to the design that he ordered a plain blue carpet to replace the original oriental rug. "Ah! what a carpet!" one critic exclaimed over Whistler's addition, extolling its tertiary shade as "too expressive to be green, too lovely to be blue."[12] The artist himself simply called it "the blue floor," a field of solid color to complete the scheme.[13]

For Victorian connoisseurs, much of the appeal of Japanese lacquerware lay in the variety of pattern and technique that could be found on a single object. In the catalogue of the Liverpool Art Club's inaugural exhibition, G. A. Audsley described an elaborate lacquer cabinet shown at the 1867 Paris exposition in which there were "no less than nine distinct species of Lacquer, and twenty-four different modes of artistic treatment displayed on the principal features." That luxurious piece had been produced expressly to demonstrate a range of lacquer-working methods, "but the artistic treatment of any one description may vary considerably" in virtually any example one might find.[14] Similarly, in the Peacock Room, Whistler devised countless variations on his original theme, finding freedom in the limitations he imposed. "There are but the two patterns," G. W. Smalley observed in the *New York Daily Tribune,* "yet so ingeniously are they varied that at first sight you would say the patterns were a dozen or more. They are diversified in size, and the actual touch of the brush is never in two places quite the same, but from his fidelity in his pattern the painter never departs." It was through this artful alternation of blue on gold, and gold on blue, that Whistler avoided "monotony on the one hand and excess on the other."[15] As Roger Fry observed, he adopted the taste "of a Japanese worker in lacquer."[16]

The mural Whistler created for the south wall (fig. 6.3) was to bear an especially striking resemblance to Japanese lacquer.[17] Its peacocks were not simply painted in gold, like other decorations in the room, but made to stand out on the surface in low relief, like the ornament on the lids of the most highly

The Last Alembic

prized lacquer boxes (fig. 6.4). The production of raised ornamentation on Japanese lacquer involved a "complicated and tedious manipulation" of materials, Audsley explained, although the precise method employed in the gilding remained a mystery: "It is on the surface of the lac, but whether it is laid on in leaf, or powder dusted on a wet coat of varnish, we are unable to decide."[18] Whistler, then, had to invent a method of simulating the effect of "raised lacquer." He painted the peacocks on the blue wall with an ocher-colored substance composed of lead white and calcium carbonate mixed with white clay, thick enough to hold impasto and lend texture to the composition. He may have allowed that underpainting to dry before coating it with size and applying three shades of gold leaf, whose arrangement was modified as he developed the design.[19] Evidence of Whistler's painstaking attempts to capture the appearance of the raised designs on Japanese lacquer defeats the charge that in the Peacock Room, as in his paintings, Whistler failed to demonstrate "a serious concern" for his Japanese sources.[20] But as J. Comyns Carr observed, Whistler's greatest skill was in allusion, rather than imitation. "The painter . . . would seem to be very little indebted to the art of his own or any other time, for, although it is possible to trace in his style of decoration an influence derived from the study of Oriental design, this is so entirely absorbed in the artist's own individuality as to be scarcely more than a reminiscence of general principles."[21] Perhaps for this reason, it is as difficult to identify prototypes for the peacocks painted on the wall as for the gilded birds gracing the shutters.

In Whistler's own collection of Japanese paintings, birds were represented "with a boldness which no European art can rival," Moncure Conway observed, and those may have suggested the notably "tortuous necks" of the peacocks he painted in the mural.[22] The Japanese woodcut of peafowl from *The Keramic Art of Japan* of 1875 (fig. 6.5), Audsley's best-known work, has become

FIG. 6.4 Inkstone case, Edo period (19th century). Lacquer on wood with *maki-e* (sprinkled design) decoration in gold and silver powders, 4.5 × 20.9 × 23.0. Freer Gallery of Art, Smithsonian Institution, Washington, D.C. (44.25).

FIG. 6.5 Japanese woodcut reduced by photolithography "from the pages of one of the common school books of the country." Plate L from volume 1 of George Ashdown Audsley and James Lord Bowes, *The Keramic Art of Japan*, 2 vols., 1875.

FIG. 6.6 Satsuma faience vase and stand. Plate XII from volume 2 of George Ashdown Audsley and James Lord Bowes, *The Keramic Art of Japan*, 2 vols., 1875.

an obligatory illustration to discussions of sources for the Peacock Room, even though its comparison to Whistler's composition is tenuous. A more convincing source for at least one of Whistler's peacocks appears in another plate from the same book, showing a large, polychrome faience vase with dragon handles (fig. 6.6).[23] If he eschewed the brilliant coloring of the model, Whistler adopted the "freedom and artistic grace" of the design, the quality for which Satsuma ware was particularly admired; the transposition of that image of a bird from a Japanese vase to a wall painting recalls Whistler's translation of a female figure from a piece of Chinese porcelain to *La Princesse du pays de la porcelaine*, the painting that was to hang on the opposite wall. Whistler might have seen the

The Last Alembic

FIG. 6.7 *Fukasa.* Plate VII from volume 1 of George Ashdown Audsley, *The Ornamental Arts of Japan,* 2 vols., 1882.

actual vase in Liverpool, since it was part of the Bowes collection, but the reproduction alone could have given him the pose for the apparently affronted peacock. Whistler's second peacock might be expected to hide on the opposite (unillustrated) side of the Satsuma vase, or to appear on the other vase that made the pair, but peahens appear in both places.[24]

That second, more flamboyant peacock corresponds in many ways to a Japanese example in yet another medium, a bird embroidered on deep blue satin "dusted in places with gold powder" (fig. 6.7), which strikes a similar attitude: wings spread and train raised like a fan. This image was not to be published until 1882, some years after the Peacock Room was painted, but Whistler may

have known the actual work, which belonged to his patron W. C. Alexander. Perhaps it was also from this panel that Whistler adopted the conceit of glass beads for the peacocks' eyes. These were popularly believed to be real jewels, "a diamond in one case, and in the other an emerald," and Tom Taylor's impression that the eye of the antagonized peacock was a ruby proved difficult to dislodge. From certain angles, that clear glass bead does seem to emit a diabolical glint of red.[25]

I F WHISTLER's earlier efforts in the Peacock Room had been largely extemporaneous, the peacock mural was in contrast laboriously deliberate. He may have worked out the composition in rough sketches as he prepared the wall with an even coat of prussian blue (fig. 6.8); but sometime during the month of November, Whistler produced a full-scale, twelve-foot cartoon on brown paper (fig. 6.9), reverting to the academic method he had learned from Albert Moore and employed years earlier to transfer the design of *The Three Girls* to canvas. Margaret MacDonald has detailed the revisions Whistler made to this remarkable drawing, the largest in his oeuvre, which was in tatters by the time he had finished with it.[26]

The cartoon was all of the Peacock Room that Whistler could keep—as he did, hidden away, until the end of his life. Rosalind Philip, Whistler's sister-in-law and heir, discovered the cartoon rolled up in his studio several

FIG. 6.8 *Sketch of Peacocks on the Wall of the Peacock Room* (M582d), 1876. Pen and ink on paper, 31.9 × 20.3. Hunterian Art Gallery, University of Glasgow; Birnie Philip Bequest.

The Last Alembic

FIG. 6.9 *Cartoon for the Peacock Mural* (M584), 1876. Chalk and wash on brown paper, pricked for transfer, 181.0 × 389.2. Hunterian Art Gallery, University of Glasgow.

months after his death and reported to Charles Freer in Detroit that the draw-ing was "wonderful in execution." Freer, who had yet to acquire the Peacock Room, was so desperate to see the birds in their conceptual state that he thought of taking the next steamer across the Atlantic: "The winter sea has no terrors with the peacocks ahead." He had been studying *La Princesse du pays de la porcelaine*, a recent acquisition, and it was teaching him "new wonders"; he fan-cied the cartoon would afford similar revelations.[27] Indeed, with the "strongly Oriental touch" that Denys Sutton recognized as "rather reminiscent of a Hokusai drawing," the cartoon is in many ways more fluent and expressive, more compelling and satisfying, than the stiff, frozen tableau of the mural itself. There, Whistler "completed the process of stylizing every detail into a consis-tent, elegant decoration," and "in the process," MacDonald observes, "some of the vigour of the original design was lost."[28] The cartoon had served its pur-pose by the end of November, when the process of gilding the design was well under way: "Golden Peacocks promise to be superb," Alan Cole noted in his diary. By the close of the following week, Whistler had emblazened the blue wall with the resplendent pair of birds that remains the most famous part of his celebrated decoration. "Peacocks superb," Cole concluded on the fourth of December 1876.[29]

As the Pennells point out, the mural called "The Rich Peacock and the Poor Peacock" was Whistler's sole foray into allegory.[30] E. W. Godwin, who would have been aware of its hidden significance, provided an illuminating account of the subject in the *Architect*:

The scene is wonderfully dramatic, so dramatic in fact as to make one fancy that a story might well be wrapped up in it. There is a haughty tremulous rage in one bird, the very feathers seeming to shake, a seeming secured

partly by a shower of gold dots, and partly by force of drawing in the raised and recurved tail, and in the erectile feathers of the throat. In the other bird, the one of the emerald eye, whose back is towards us and whose tail, depressed, sweeps over the top of the sideboard, one sees an outward calm, but a suppressed strength in the partly raised wing, the firmly planted foot, and the nervous tension of every feather of him, which would make us tremble for the life of the raging cock if once roused to retaliate. There is, indeed, more of Aristophanes, more of the Greek satirist, here than of Japanese drawings on fans, or trays, or crapes. The birds are, in fact, human peacocks after all, not those of the ornithologist nor the peacocks of the Zoo., and as such give an interest to the work outside the drawing, the composition, and the colour.[31]

For most of Whistler's contemporaries, the identities of those "human peacocks" remained obscure: as A. J. Eddy put it, "the likeness was not immediately perceptible."[32] Indeed, Theodore Child noted in 1890 that the meaning of the cryptic panel was "so discreetly concealed that it would remain forever lost in the spirited charm of the whole, had not anecdotic memories treasured up the souvenir of the artist's wrath and of its ingenious manifestation." Considering Whistler's reputation for belligerence, it is not surprising that the protesting peacock was often taken to represent the artist, while the more complacent one, who apparently has nothing to say in the matter, was interpreted as a portrait of the patron.[33]

The message of the mural would have been transparent only to those with an eye for allegory or a close acquaintance with the protagonists. Whistler executed the composition primarily in gold, but he rendered the details personalizing the peacocks in silver; those touches may have tarnished quickly in the gaslit room, since they were subsequently repainted with immutable platinum.[34] The shillings Whistler found lacking from his payment turn up around the feet of the "rich" peacock on the right. Other silver coins are cast among its feathers, implying that the bird is made of money and highlighting the pettiness of its crime: "Thus," wrote Menpes, "was the story of the economy of the odd shillings recorded for all time."[35] To give the bird an unmistakable identity, Whistler bestowed a flourish of silver feathers on its throat, alluding to the ruffled shirts Leyland continued to wear long after they had gone out of fashion.

The second peacock, apparently poor and put-upon, assumes the attitude of resignation that Whistler affected in his letters to Frederick Leyland. Its posture conveys disdain for the fury of the wealthy bird—whose feathers, we infer, have been ruffled over nothing. The single distinguishing detail of this elegantly offended bird is its silver crest feather—a reference to the artist himself, who was excessively proud of the lock of white hair that rose artfully above his forehead (fig. 6.10). That famous attribute first appeared around 1870 and was often mistaken for a feather. Whistler liked to explain it as the mark

of the Devil, who seized his chosen ones by a lock of their hair.[36] This apparent affectation must have been natural since his sister possessed the same shock of white hair, but Whistler predictably enhanced his own, frizzing it so the lock stood out from his curls like a plume.[37] This and other of Whistler's personal vanities were to become legendary, cementing his identification with the haughty peacock of Prince's Gate. Sidney Colvin recalled, for instance, that Whistler was "sometimes unendurable from the peacock pitch of his laugh."[38]

As proverbial personifications of pride, peacocks made apt subjects for Whistler's allegory, for the dispute with Leyland had been as much about pride as money. In the birds' confrontational stance (which Godwin held to represent defiance, not a fight), Whistler captured the moment when he struck his compromise with Leyland on the price of the project—an agreement that permitted each to maintain dignity but granted neither satisfaction. As the focal point of the room, the mural becomes the crux of its story, even though the mural's chronology has long been veiled in contradiction. The most common version of the mural's completion recounts that the silver details are merely Whistler's "finishing touches"—an "editorial change" made to a composition that otherwise predates the falling out with Leyland—so that Whistler's rancor concludes with an artful stroke of wit.[39] But the entire mural was produced after the quarrel, and the silver details were always part of the conception: the shillings and tufts appear even in the cartoon, as details washed in white. Moreover, technical evidence confirms that the silver-colored elements were silver from the start, with the exception of the crest feather of the "poor" peacock, originally executed in gold.[40]

Silver is not mentioned in contemporary accounts, but that color may have been regarded as one of the "golds of various tones" that Whistler employed in the mural.[41] Nor do any of the 1877 accounts explain the significance of the drama enacted on the south wall. Whistler is said to have deciphered it for his friends, "as if in confidence," and J. Comyns Carr (who circumvented the matter in his own critique) told Whistler he was more interested in the beauty of the work than in its success as a satire. "But not so Jimmy," according to Alice Carr, who accompanied her husband to Prince's Gate and witnessed the artist's rehearsal of "the delicate steps in the progress of his quarrel": "To this collector of scalps the thought that he had achieved a memorial to his quarrel which would preside over all the millionaire's fêtes was sheer, unadulterated joy."[42] Perhaps it was part of Whistler's punitive purpose that strangers should know the mural's significance before Leyland himself perceived it. In Gardner Teall's rendition of events, "Mr. Leyland failed to discover its unpleasant allegory until its cryptic sarcasm shone forth one day in startling effrontery."[43]

Whistler thought of offering Leyland a hint some months after the mural was completed, in a letter drafted but apparently never sent. In this, the artist advises his erstwhile patron to consult "the Cartoon opposite you at dinner, known to all London as 'L'Art et L'Argent' or The Story of the Room." The clue lies in the word *argent*—meaning both money and silver—the site of the

FIG. 6.10 James McNeill Whistler, 1879, photographed by the London Stereoscopic Company. National Portrait Gallery, Smithsonian Institution, Washington, D.C.; gift of Jem Hom.

mural's symbolic significance. In naming the composition "Art and Money," Whistler attempted to allegorize the mural, casting himself as an emblem of art and condemning Leyland to the role of the more vainglorious bird.[44] But an abstract interpretation that transcends the circumstances surrounding the creation of the room never quite fit the image on the wall, which endures as caricature rather than allegory. If Whistler would later have cause to complain about the cupidity of English patrons in general, his objection in 1876 was focused on one offender in particular.

O N THE EIGHTH of December 1876, the *Morning Post* published an article about Whistler's decorations at 49 Prince's Gate (the residence, it reported, of Mr. Naylor Leyland), with the stated purpose of drawing attention to the work and "a few of the points of its character."[45] Rumor had it that Frederick Leyland was "much perturbed" by that article, and according to Alan Cole it also threw Whistler into "a state." Several things could account for their distress, beginning with the misprinting of Leyland's name. Moreover, because the article described the room in some detail, Leyland, in Liverpool, would have learned from his morning paper how extensive were the changes Whistler had wrought in his London dining room: there was, for example, the unequivocal statement, "the walls are blue." This report might well have cast Whistler into anxiety, and with its publication, Cole informed the Pennells, "the trouble came to a crisis."[46]

Leyland may have come back to London because of it, making the unexpected visit at a moment "when the room was half finished and in a state of wild disorder" that Whistler described to Mortimer Menpes. Whistler forbade Leyland to enter the room, Menpes relates, presumably in accordance with their oral agreement that the artist could work unsupervised until the spring;

> but Leyland stole in surreptitiously one day while the artists were at work. He paused on the threshold aghast. His rage knew no bounds, and he demanded of Whistler what he had done with his Spanish leather, which had cost him so many hundreds of pounds. Whistler turned his face, half covered with gold and blue paint, and surveyed Leyland critically. "Your Spanish leather," he said, "is beneath my peacocks; and an excellent ground, too, it formed to paint them on."

Improbable as it sounds, Menpes's story corroborates Louise Jopling's recollection that Whistler and Leyland argued over the plight of the leather "before the room was quite finished."[47] According to Cole, Leyland offered to pay Whistler the disputed sum if he would leave his house, but the artist answered that "he would make a gift of the whole thing first." It was T. R. Way's belief that Leyland did not actually mind the sacrifice of his wall hangings, feeling

certain he would gain "something beautiful in return." And unless he felt honor-bound by the unwritten terms of his agreement with Whistler, there is no better explanation for Leyland's failure to throw the artist out.[48]

As for Whistler, he had seized an opportunity to salvage something for himself. His unerring faith in the importance of publicity was to be rewarded a short time later, when the London correspondent for the *Leeds Mercury* named him "the latest recruit" to an elite group of artists that included E. J. Poynter and Frederic Leighton, painters who had lately lent their talents to the decoration of houses. Predicting that the dining room at Prince's Gate would become "one of the sights of the next London season," the reporter concluded that in the "peacock room" (and this was the moniker's first appearance in print), Whistler had "achieved the double success of beauty and originality."[49]

That complimentary account was reprinted in the *Architect* on 13 January, attracting the attention of the London art world to Whistler's foray into domestic design. From the brief notice that followed in the *Court Journal and Fashionable Gazette*, we may deduce that the room was also thought to be of interest to a broader, if still exclusive, audience.[50] And when a more extended review appeared in the *Observer*, a weekly paper known for tracking the rumors current in London society, it was for the purpose of informing "the greater circle of what is going on." Congratulating Frederick Leyland on his association with artists who did not object to being called "eccentric," the journalist reported that Whistler, "having executed his fancies in a minor manner in the hall and the staircase, has now for nearly a year past had the dining room handed over to him with a *carte blanche* as to the decoration thereof." Whistler himself was probably the source of this exaggeration; he may also have offered up the blatant falsehood of the concluding sentence, evidently calculated to infuriate his patron: "Mr. Leyland, we believe, allows his collection to be viewed by the public during his absence from town—a boon which has only to be known to be greatly appreciated."[51]

The *Observer*'s reporter had not only been admitted to the Peacock Room but escorted to the billiard room, where the Italian paintings hung, and to the drawing rooms upstairs, which held Leyland's unparalleled collection of works by Rossetti and Burne-Jones. In drawing notice to works of art currently on display, the article reads like an exhibition review, implicitly inviting the public's attendance. Naturally, people came to call—"sundry art critics and many artists and amateurs," as Godwin would characterize the crowd, "interested in the progress of modern decorative painting." Exhibiting a flagrant disregard for the privacy of his patron, Whistler welcomed them one and all. Considering the means of advertisement, he should not have been surprised (though he is said to have been dismayed) when visitors took the opportunity to view the Rossetti paintings and admire the Percy staircase.[52]

Before long, Cole recalled, carriages were crowding Prince's Gate. Sir Henry Cole, who came with Lawrence and Laura Alma-Tadema, was highly impressed with the originality of Whistler's scheme, describing it in his diary

as "illustrations of Peacocks & their tails." In the pains he was taking with his decoration, as in the "minuteness" of his etchings, Whistler was proving to be as scrupulous as William Mulready, Sir Henry remarked, and Alan Cole noted in his own diary that Whistler was "much disgusted" at being compared to a popular genre painter known for the prettiness and triviality of his subjects.[53] Arthur Liberty called at the Peacock Room on two or three occasions, later recollecting how Whistler had adopted the "pleasant pose" of suggesting that he assisted with advice, "but no man, I suppose, was ever more independent of advice or less patient with it."[54] The artist George H. Boughton, a fellow American expatriate, retained from his visit a vivid memory of Whistler working on the ceiling; as far as he could tell, the artist "let no hand touch it but his own."[55] Louise Jopling, however, recorded her reminiscence of calling one morning at Prince's Gate for a lesson in decoration, when Whistler permitted her to paint one corner of the room, and Marie Spartali Stillman encountered two of Whistler's "pupils" there, hard at work—undoubtedly Henry and Walter Greaves.[56]

As the sister of the model for *La Princesse*, Mrs. Stillman possessed a particular reason for wanting to see the Peacock Room, yet she was initially reluctant to call, knowing the Leylands were out of town. When she did, she was amazed that Whistler served tea and otherwise behaved "as if the house belonged to him."[57] That he was making unjustifiable use of the house was the reason given by Alan Cole for Leyland's having lost his temper—"for, after all, it did not belong to Whistler if the decoration did."[58] The tales of the artist's lavish entertainments, while adding a sociable dimension to a story of art appreciation, are surely much exaggerated. Ethel Tweedie, for example, tells of Whistler asking friends to stay for luncheon, impromptu parties that became almost daily events: hearing of this, Leyland is said to have instructed his butler never to serve Whistler or his friends again. But apart from a caretaker, the Leylands' servants were all at Speke Hall. The "devoted satellite" that J. Comyns Carr witnessed preparing picnics in the vacant house must have been Walter Greaves.[59]

One of the more enchanting anecdotes about the Peacock Room comes from Lady Ritchie. Still Anne Thackeray when the incident took place, she was living near the Leylands at Hyde Park Gate. One day when she was out walking in the neighborhood, her companion mentioned that Whistler was working at 49 Prince's Gate; they entered the house and found the dining room "full of lovely lights and tints, and romantic, dazzling effects." Whistler, dressed in a painter's smock, lay down his brush and maulstick to greet them, and they talked about "old Paris days." When he recalled that Miss Thackeray had once preferred talking to dancing, she remonstrated, "No indeed I liked dancing best," and was instantly whirled in Whistler's arms "half-way down the room."[60]

A print by Utamaro (fig. 6.11), depicting the artist painting a *hō-ō* bird, a fantastic hybrid of pheasant and peacock, while several ladies watch from the

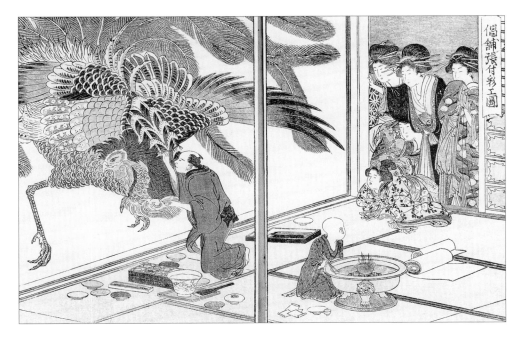

FIG. 6.11 *Utamaro Painting a Hō-ō Bird in One of the Green Houses*, by Kitagawa Utamaro (1753–1806). From Kitagawa Utamaro, *Annals of the Green Houses* (1804). The British Museum, London, Department of Japanese Antiquities.

doorway, has been proposed, improbably, as a source for Whistler's Peacock Room.[61] The image might better be regarded as an apt illustration of an artist performing for an audience, as Whistler often did, even though the hard work of painting was actually accomplished in private. It may be true, as one reporter speculated, that Whistler often worked at night because during the day "so many people were anxious to get a glimpse of the mysterious room, Whistler's time was engaged in explanations."[62] Another reason might have been that he wished to keep the workman's aspect of his operation secret: Anne Thackeray, finding Whistler in his painter's smock with artists' implements in hand, had caught him by surprise.

A now-famous account of Whistler "working" in the Peacock Room, written long after the event by the London correspondent of an American paper, tells of finding the artist at Prince's Gate "dressed wholly in black velvet, with knickerbocker pantaloons stopping just below the knee, black silk stockings, and low pointed shoes, with silk ties more than six inches wide and diamond buckles"—the costume, it would seem, of a man impersonating an aesthete. Whistler was reportedly lying flat on his back with "fishing-rod" in hand and binoculars at his side, "diligently putting some finishing touches on the ceiling. . . . Occasionally he would pick up his double glasses, like some astronomer peering at the moon, and, having gained a nearer and better view of the effect, he would again begin to agitate the paint-brush at the other end of the long pole." Whistler could not possibly have maintained the control he required to paint delicate lashes of peacock feathers on the ceiling from the distance of the floor, using a brush tied to a fishing rod. But he may have acted out this feat to impress his more credulous visitors, unschooled in artistic methods. By lying on a mattress, he is said to have explained, he could "overcome the difficulty and annihilate space"—or make the most arduous aspect of his enterprise look easy.[63]

FIG. 6.12 Whistler's broadside, "*Harmony in Blue and Gold. The Peacock Room*," February 1877. Inscriptions by William Michael Rossetti. Library of Congress, Washington, D.C., Rare Book and Special Collections Division, Lessing J. Rosenwald Collection.

"HARMONY IN BLUE AND GOLD. THE PEACOCK ROOM."

The Peacock is taken as a means of carrying out this arrangement.

A pattern, invented from the Eye of the Peacock, is seen in the ceiling spreading from the lamps. Between them is a pattern devised from the breast-feathers.

These two patterns are repeated throughout the room.

In the cove, the Eye will be seen running along beneath the small breast-work or throat-feathers.

On the lowest shelf the Eye is again seen, and on the shelf above—these patterns are combined : the Eye, the Breast-feathers, and the Throat.

Beginning again from the blue floor, on the dado is the breast-work, BLUE ON GOLD, *while above, on the Blue wall, the pattern is reversed,* GOLD ON BLUE.

Above the breast-work on the dado the Eye is again found, also reversed, that is GOLD ON BLUE, *as hitherto* BLUE ON GOLD.

The arrangement is completed by the Blue Peacocks on the Gold shutters, and finally the Gold Peacocks on the Blue wall.

The illusion of effortlessness, as we have seen, was fundamental to Whistler's concept of beauty. If he failed with *The Three Girls*, Whistler succeeded with the Peacock Room in "leaving his work alive," as the *Examiner* remarked: "There is a vitality in every line, a freshness in every touch, of all this elaborate and yet never laboured ornament. Whatever may have been the

The Last Alembic

amount of care and thought bestowed in the process, and we know there must have been much, he has not allowed the final effect to be harmed by the presence of either." Only through solitary, laborious effort could Whistler efface the "footsteps" of his work to achieve the effect he sought, as "careless as the beauty of flowers, and . . . as harmless and unobtrusive as the splendour of richly-coloured birds."[64]

THE EARLIEST press reports of the Peacock Room may have piqued public interest in Whistler's project, but they could not have done much to enhance his reputation as an artist. The *Observer's* account, for instance, held that if at first sight "this profusion of gold transports one into the realm of Aladdin," in time the room began to feel oppressive. The *Court Journal* was patently absurd, describing a sort of chamber of horrors, "painted so as to resemble gigantic peacocks, whose wings, of azure and gold, extend over the ceiling and the shutters and walls."[65]

To ensure that other commentators would not commit such errors, Whistler designed a leaflet (fig. 6.12) pointing out the ingenious alternation of blue and gold and the inventive arrangements of peacock tail, breast, and throat feathers, formally titling the scheme *Harmony in Blue and Gold: The Peacock Room*, as if it were a painting. A precursor of the modern press release, the broadside provided art critics with Whistler's version of the facts, and it was to be frequently and extensively quoted in the press. The Pennells were unconvinced that Whistler himself composed the text, but as Peter Ferriday remarked, "they must have given it a very cursory reading."[66] No one else could have written it, for the phrases have the cadence of words so often spoken they had become almost an incantation.

A single folded sheet, the leaflet was printed by Thomas Way, who was soon to teach Whistler the art of lithography. Godwin, who knew Way from the Hogarth Club, is said to have introduced him to Whistler expressly for this purpose. The leaflet is now exceedingly rare—not even the Pennells ever saw more than one example—and it is doubtful that many copies were printed.[67] According to Marie Stillman, Whistler also produced cards of admission to a private view. These cards filled a bowl placed prominently at Liberty & Co. and were handed out to customers; it was her understanding that some were sent to Leyland in Liverpool. If so, they may have brought him back to London in alarm: in Menpes's tale, Whistler advises Leyland to stay away from the viewing. "These people are coming not to see you or your house: they are coming to see the work of the Master, and you, being a sensitive man, may naturally feel a little out in the cold."[68] Although this unlikely exchange was probably fabricated by Whistler, it represents the insolence that has often been considered a primary reason for his falling out with his patron. It now

appears that Whistler's notorious behavior was more a consequence than a cause of the conflict: Whistler was trying to secure his own fame at the expense of Leyland's dignity. In that he seems to have succeeded. When the first "newspaper puffs" were published, Leyland later said, he felt deeply humiliated at seeing his name "so prominently connected with that of a man who had degenerated into nothing but an artistic Barnum" (app. 19).

Whistler received a few selected representatives of the press at Prince's Gate on 9 February 1877, including J. Comyns Carr and Tom Taylor, whose reviews were published the following week in the *Pall Mall Gazette* and *The Times*. Both critics were favorably disposed toward Whistler at the time (they were soon to enter the ranks of his enemies), and if Carr was the more intellectually astute, Taylor of *The Times* was, as Godwin acknowledged, "always burning with the best intentions."[69] Carr had closely followed Whistler's progress at Prince's Gate and was well aware of the artist's darker motives, yet he focused his article on the "light and fairy-like character" of the design, which bore "the stamp of a spontaneous and untutored growth": "We feel no more disposed to reproach the artist for the brilliancy of his colouring or the fantastic freedom of his design than we should be to lecture the peacock itself upon its plumage, or to object to the pride of its movement." Taylor's notice was comparatively, and predictably, pedestrian. "The whole interior is so fanciful and fantastic, and at the same time so ingenious and original in motive as to be completely Japanesque."[70] Taylor's review struck E. W. Godwin as intolerable. "It does not much matter when the mistakes are made concerning publicly exhibited works that everyone can see, but wall paintings in private houses that comparatively few can have the opportunity of seeing should be thought over twice, if they are worth thinking of at all."[71]

Intending to set the record straight, Godwin visited 49 Prince's Gate the day after Taylor's notice appeared in *The Times* to prepare an article of his own for the *Architect*, making notes and drawings of salient details on a copy of Whistler's broadside (fig. 6.13). He may have brought along his new wife, the artist Beatrix Philip, who confessed years later, after Whistler had become her second husband, that she had loved him "even from the Peacock room days."[72] Godwin's only complaint with Whistler's decoration concerned *La Princesse*, which he thought looked "somewhat sad, not to say dirty, by the side of all the gold and blue, and is an interruption to the scheme that I, for one, do not much care for." Other critics may have sensed the same incongruity, for the painting is rarely mentioned in the spate of reviews. Tom Taylor's well-meaning effort to relate it to the "Japanese taste" of the whole only met with Godwin's scorn: "It is quite true that a Japanese dress appears in the picture over the fireplace, but the picture is not a Japanesque picture." Godwin himself would have preferred "more wall space and more peacocks."[73] If that opinion disappointed Whistler, he may have reasoned that once the porcelain was in place, the thematic and aesthetic importance of the painting to the peacock scheme would become immediately apparent.

FIG. 6.13 Details from the Peacock Room sketched on a copy of Whistler's broadside, February 1877, by E. W. Godwin (1833–1886). Glasgow University Library, Special Collections.

The weekly papers, published on 17 February, carried more reviews of the Peacock Room. William Rossetti, who had noted in his journal after the private view that the decoration was "a highly artistic, beautiful, & effective work, not glaring, but perhaps rather excessive in gorgeousness," observed in the *Academy* with characteristic equanimity that Whistler had "produced a salient triumph of artistic novelty—too uniformly gorgeous, it may readily be conceived, for some tastes, but singularly captivating and complete."[74] The *Queen*, a self-described "Lady's Newspaper," disapproved of the "sketchy representations of the peacocks," opining that Whistler had "sacrificed the true object of his art to the sensuous attractions of colour."[75] But the other reviews were mostly admiring: *London* described the decoration as "a mystical blue and golden rose of gaiety" (which prompted a parody of its purple prose in another newspaper), and the *Examiner* expressed regret that Théophile Gautier had not lived to see the room: "probably few would have more keenly appreciated the strange Oriental beauty of the 'harmony in blue-and-gold.'"[76] The next day, not surprisingly, Alan Cole found Whistler "elated with the praises of the Press of Peacock Room."[77]

Still more accounts were to follow, several flagrantly plagiarizing parts of those already published, each helping to make Whistler's Peacock Room the talk of the town. By 24 February, when the *Examiner* published a second notice, the features of the decoration were held to be too familiar to require reiteration. Nevertheless, Whistler invited "a privileged few" to Prince's Gate the following afternoon, *Vanity Fair* reported, presumably to sustain public interest until the very moment of Leyland's return.[78] As a result, word of the design entered even those papers whose readership was not recognized for aesthetic

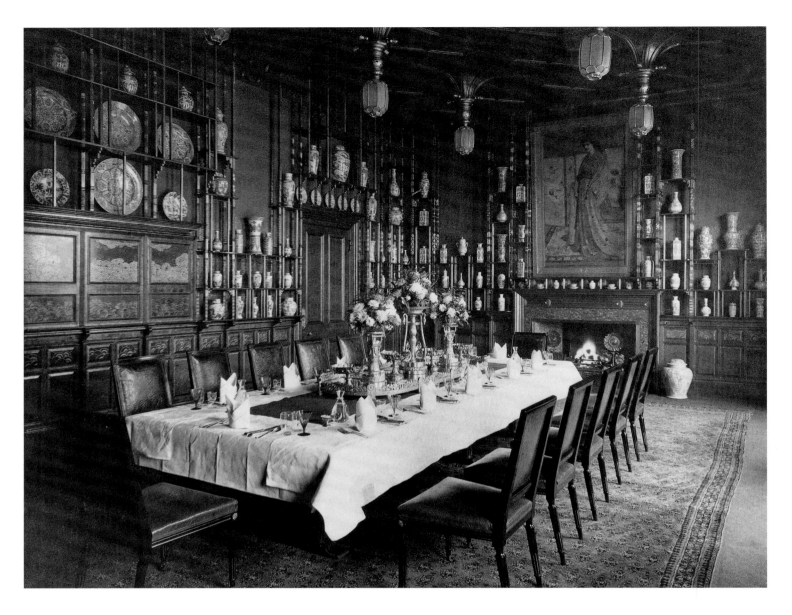

inclination. There was a description in *Figaro*, for instance, of Whistler's "curious decorative freak," and a surprisingly serious account in the journal *Fun*. The Peacock Room also generated bits and pieces of hopeless humor in the pages of *Punch*, including the vignette "A Bird's Eye View of the Future," which told of a country house where each room bore the name of different bird (the Common Barn-Door Fowl Room, for example), and an inane notice warning "all in quest of elaborate house decoration" to send for a certain artist "if you want to pay dearly for your whistle."[79]

Occasionally, a critic paused to consider how the Peacock Room could ever fulfill its ostensible purpose. *London* could not fathom a family saying grace in that room, "nor is it the place for a quiet little dinner of four." The *Examiner* suspected that "commonplace dining would be out of place here, where opium should be the most substantial food." *Vanity Fair*, supposing that "locusts and wild honey might be allowed," raised the related question, What was a person to wear? "I know only of one ladies' costume which would not interfere

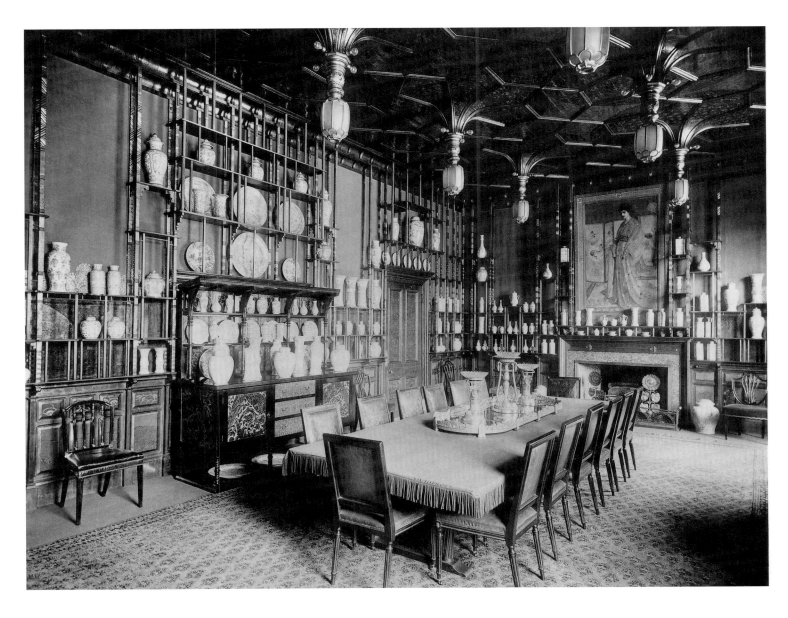

FIG. 6.15 The Peacock Room at 49 Prince's Gate, 1892, photographed by H. Bedford Lemere (1864–1944). National Monuments Record; Royal Commission on the Historical Monuments of England, London.

with the gold and blue around and above, and that dress (including a hat) is composed entirely of peacock feathers."[80] Facetious though they may have been, these concerns about food and costume apparently arose from an implicit understanding of the Peacock Room as an exquisitely unified aesthetic interior. It was even reported in a New York paper that the furnishings were to be tuned to the walls, "the chairs gold, lined with blue leather; the dining-table to be laid with a blue cloth underneath, and the linen itself to be fringed with azure. Whether the service will be all gold, or partly blue and white china, is an open question."[81] An 1890 photograph showing the table set for dinner suggests that the scheme was carried out according to Whistler's plan (fig. 6.14): according to Lady Archibald Campbell, the tablecloth was indeed blue, "whereon stand old Nankin dishes, filled with golden fruit."[82]

The dining-room furniture may have been chosen or even designed by Thomas Jeckyll to suit the originally commissioned decorative scheme: the chairs are adorned with sunflowers. It is also possible that the table and chairs

FIG. 6.16 Sideboard in the Peacock Room.

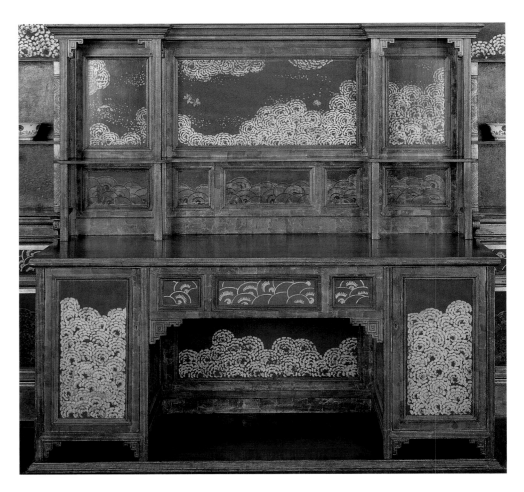

were brought from the Leylands' former home in Queen's Gate, along with an ebonized sideboard designed by Philip Webb for the Morris firm in the early 1860s.[83] That piece appears in an 1892 photograph of the Peacock Room (fig. 6.15), standing against the west wall directly below the structure designed to hold large dishes. It fits the space so precisely that Jeckyll must have intended to accommodate it, presumably on Leyland's instruction; if the Morris sideboard sounded an incongruous note, it fulfilled a practical purpose. One of the earliest press accounts of the Peacock Room notes the presence of a sideboard against the west wall between the doors, which can only be this piece; Whistler must have subsequently recognized its incompatibility and removed it altogether, filling the wall panels behind it with additional decorations in blue and gold.[84]

More in keeping with the room, another, simpler sideboard (fig. 6.16) was meant to stand against the south wall below the peacock mural. It seems to have been late in arriving at Prince's Gate, and throughout most of February the space remained vacant.[85] Made of walnut like the shelving, the sideboard not only conforms to Charles Eastlake's definition of the ordinary English type, its "wide and deep shelf fitted with one or two drawers and resting at each end on a cellaret cupboard," but also meets his standards for the ideal: "If this piece of furniture were constructed in a plain and straightforward manner, and were additionally provided with a few narrow shelves at the rear for displaying

The Last Alembic

the old china vases and rare porcelain, of which almost every house contains a few examples, what a picturesque appearance it might present at the end of a room!"[86] In 1904, C. J. Holmes tentatively ascribed the design of the sideboard to Whistler, and the Pennells later dignified that presumption into an attribution.[87]

There can be little doubt, however, that Jeckyll designed the sideboard as one of the fixtures of the original room.[88] Its brackets and spindles are consistent with the style of the shelving, and its form closely resembles that of the dressing table Jeckyll made for Aleco Ionides in 1875 (see fig. 4.15). Whistler, for his part, undertook to embellish the sideboard. The iridescent eye-feather pattern he employed as decoration, a variation on the breast-feather design on the dado, matches the pattern on the west wall where the Morris sideboard had stood, and the method of gilding corresponds to that of the mural above. By signing it with butterflies, Whistler to all appearances claimed Jeckyll's sideboard, along with the rest of the room, as his own creation.

THE LEGEND of Thomas Jeckyll's descent into madness as the "tragic consequence" of Whistler's redecoration originated with Theodore Child's 1890 account. "Alas! When he saw the Spanish leather disappear and the peacock harmony in blue and gold become the talk of the town, he went home and began to paint the floor of his bedroom gold, and in a few weeks he died mad in a private lunatic asylum."[89] Child's informant, Murray Marks, furnished the Pennells with the same details, down to the curious circumstance, regularly recounted, of the lunatic gilding his bedroom floor. The Pennells omit to mention Jeckyll's untimely demise in their retelling, sparing Whistler one degree of blame.[90] In fact, Jeckyll died not a few weeks but a few years later, in 1881, and that critical error in Marks's account, which telescopes events for dramatic effect, should cast doubt on his entire story. The source of his information is not known, since Marks was reportedly "absent abroad" when the alleged events took place.[91] It is possible he heard the tale from Leyland, who may have imputed Jeckyll's misfortune to Whistler's actions as a means of heightening the severity of his crime. Whistler, however, can be held accountable only for creating an atmosphere in which the slightest innuendo could flourish into fiction.

According to Thomas Armstrong, Jeckyll "had many amiable qualities, but there had been perceptible for a long while a warp of eccentricity which at times suggested mental derangement."[92] However ill-advised it would be to venture a retrospective diagnosis of that "derangement" on the basis of Jeckyll's exiguous biography, medical records suggest he may have suffered from the severest form of manic-depressive illness, or "recurrent mania," as it was called at the time. The condition is "characterized by attacks of insanity," as the Victorian physician John Millar explained in 1877, "coming on without any apparent cause, followed by depression and recovery."[93] With this disorder,

Jeckyll would have been perfectly well most of the time, able to function normally in his personal and professional life; occasionally, he would have lapsed into spells of the elevated mood, energy, and activity associated with the manic state, alternating with the darker phases of lethargy and despair.

As Kay Redfield Jamison points out in *Touched with Fire* (1993), an illuminating study of manic-depressive illness and the creative temperament, "the arts have long given latitude to extremes in behavior and mood." Indeed, apart from Armstrong, Jeckyll's contemporaries seem to have regarded his "warp of eccentricity" as consistent with his bohemian ways.[94] His illness might account, however, for the bizarre behavior that so discomfited George du Maurier in the 1860s, and his alleged mendacity and snobbery may have been the presentations of delusions and grandiosity. The disorder could underlie Jeckyll's frequent and otherwise inexplicable financial reversals, which may have arisen either from uneven periods of production or uninhibited spending sprees. It might even explain why he seems to drop in and out of his profession and the memoirs of his peers, becoming "one of those people whose names crop up in places and ways that suggest that they were interesting," as Ferriday observed, "and when one looks further there is nothing else to be discovered."[95]

Recognizing the affliction that disordered Jeckyll's life does nothing to diminish his artistic achievement, but it may help to explain it. The psychological changes in cognition and perception that take place during mildly manic periods, such as an increased aptitude for recognizing resemblances between widely disparate objects and ideas, and for combining them in extravagant or even incongruous ways, also characterize artistic creativity.[96] Thomas Jeckyll possessed an unusual talent for synthesizing various sources of inspiration into highly original works of art. That associative quality is manifest even in his earliest designs, but it becomes especially remarkable in the Philadelphia pavilion and the Leyland dining room, two highly demanding projects he assumed around the same time and produced in concert. Both are fantastic, exuberantly eclectic confections made up of architectural and decorative motifs drawn from all phases of Jeckyll's professional experience. In retrospect, we might regard them as the culmination of his career, the artistic summit from which he was fated to fall.

On admitting Jeckyll to a Norwich mental hospital, his brother, Henry Jeckell, testified that although "Tom" had lived "a fast life," his peculiarities were manifest mainly in his style of dress until around 1873, when he determined to reform his dissolute ways and concentrate on his profession. Jeckyll may have turned instinctively to creative work to escape the pain of his disordered life and to structure the chaos of his thoughts,[97] and his transition from architect to designer may have been a means of coping with an increasingly inconstant emotional state by providing greater scope for his flights of fancy. But his brother recalled that two years after resolving to save himself through work, Jeckyll "thought he was a lost man," a melancholy phase that lasted six long months. He emerged from that despair deeply religious, and by the sum-

The Last Alembic

mer of 1876 was refusing to go to bed, "saying people did not require sleep," the classic clinical feature of acute mania. He also became "strange in his manner throwing his boots at people &c.," and that dramatic shift in his behavior would account for Jeckyll's sudden disappearance from Prince's Gate. As Whistler later wrote to Jeckyll's brother, "Tom was absent and really never saw the room until the whole color scheme was nearly complete."[98]

The draft of that letter is the only surviving evidence that Thomas Jeckyll did in fact see the Peacock Room before his mental collapse. It is not possible from this distance to reconstruct the circumstances of the visit, but the letter suggests that Jeckyll had been sane enough to approve the gilding of the "lovely columns," the activity then in progress; this suggests that he appeared in the Peacock Room around mid-October and not, as some legends relate, at the February private view. Perhaps Whistler was deluded in thinking that Jeckyll was "finally" pleased with the work he had done, although Jeckyll may have purposefully presented that impression. He reportedly remained "abject" in his admiration for the artist, and his affection and esteem for Whistler may have exacerbated Jeckyll's ultimate disappointment. Armstrong speculated that "in completely upsetting Jeckyll's scheme as he did," Whistler may have precipitated — but not caused — the "crisis in his mental state."[99]

Jeckyll resurfaced in mid-November 1876, writing Whistler that he wished to bring the Duchess of Wellington to see the room, and that he wanted to have the house to himself on that occasion. By then, he was unequivocally insane. "I am drawing with precision and vast rapidity," Jeckyll wrote, confiding that "the Lord God Jehovah does not let me touch a pen . . . or pencil without gripping my hand so tight so that it shakes and aches."[100] From this document it appears that Jeckyll was exhibiting the full range of symptoms associated with manic psychosis — paranoid, religious, and grandiose delusions, and visual and auditory hallucinations. His family's only recourse was to commit him to Heigham Hall, a private asylum on the Old Palace Road in Norwich.[101] As evidence of his brother's insanity, Henry Jeckell testified that Tom had "proposed to line his house with gold," but nothing was said about an incident at Prince's Gate.[102]

Henry Jeckell may have thought the peacocks later lauded in the press had been part of his brother's design, for which Whistler was unjustly accepting credit. He appears to have written a letter (now lost) in response to the December article in the *Morning Post* that concluded with the words, "The whole of the work has been done by Mr. Whistler himself."[103] Whistler procrastinated over a reply clarifying "all misapprehension" until February 1877, possibly prompted to action by William Rossetti's article in the *Academy*, the only review that credited Thomas Jeckyll with "the constructive arrangement of wall and ceiling." Whistler intended to enclose a copy in his letter to Henry Jeckell with the suggestion that it be republished in a Norwich paper.[104] He also promised to "publicly testify" to Thomas Jeckyll's contribution in letters to the *Builder* and the *Architect*. He had done so once before, in September 1876,

sending a notice to the *Academy* "to make clear one fact, important in this matter": "The design of the elegant and beautiful framework in Mr. Leyland's dining-room is by Mr. Jeckyll, the distinguished architect, to whose exquisite sense of beauty and great knowledge we owe the well-remembered 'Norwich Gates,' and whose delicate subtlety of feeling we see in perfection in the fairy-like railings of Holland Park."[105]

Drafts of Whistler's second, promised letter to the press survive in Glasgow, but a final version was never sent to the papers — or, in any event, was never published.[106] Whistler may have decided that to remind the public of Jeckyll's contribution would only complicate the story that he was, by then, intent on telling, by dividing the credit and confusing the source of inspiration. His pledge to Henry Jeckell may never have been sent, either: "Your brother Tom was always one of my intimate comrades and we were greatly attached," he wrote in a draft, "and in the sorrow that has come upon him no one has been more grieved than myself."[107] That statement is the only corrective to the callous quip relayed much later by Mortimer Menpes, now a standard element of the story: "When Whistler heard of the pathetic ending of the Spanish-leather gentleman, he smiled, and said, 'To be sure, that is the effect I have upon people.'"[108]

Thomas Jeckyll remained at Heigham Hall until May 1877, when he returned to his family home in Park Lane, Norwich. That winter his father fell into "a very excited almost maniacal state" and died in March 1878. (His father's fate provides a firmer foundation for the diagnosis of Jeckyll's condition, since manic-depressive illness is hereditary.) Only a few days before their father's death, Henry had committed his brother to Bethel Hospital as "a person of unsound mind": Thomas Jeckyll was described as "a melancholy looking man" with bruises on his sides and arms, "in a state of acute mania."[109] He lived out the rest of his life there, under the care of Sir Frederic Bateman, a prominent Norwich physician, but little could be done to alleviate his suffering.[110] Notes from the hospital casebooks indicate that Jeckyll remained always in an unsettled condition, "sometimes being very noisy at others quiet." Once at Bateman's suggestion Jeckyll was given drawing materials. "I fear the experiment will not succeed," the doctor noted, "as he has been amusing himself by disfiguring the walls."[111]

By the autumn of 1880, Jeckyll appeared to be "sinking." There was a change for the worse on 29 August 1881, and he died the next morning.[112] Neither of the brief obituaries published a few weeks later in London papers mentioned the Leyland commission — perhaps, as David Park Curry surmises, from a decorous "unwillingness to stir up the controversy one more time." The notice in the *Building News*, possibly written by Lewis Day, recalled the distinctive "Japanese-like character" of Jeckyll's metalwork designs, notably the Philadelphia pavilion, recently re-erected in a Norwich park. "For some time the deceased had suffered from a mental derangement," that account of Jeckyll's life concludes, "and he died at Norwich on the 30th of last month, at the comparatively early age of 54 years."[113]

Nᴇxᴛ ᴛᴏ Thomas Jeckyll, Lewis Day declared in 1887, "the most influential convert to Japanese forms" was E. W. Godwin, "an artist of yet higher powers."[114] Among those who wrote about the Peacock Room, Godwin alone paid attention to the architectural features that Whistler inherited from the designer. His essay, published in the *Architect* on 24 February 1877, was the most considered and instructive of the critical reviews. Godwin's avowed purpose was "to contribute a fragment, however little, towards the right understanding of such work as Mr. Whistler in his markedly original manner now and again sets before us." That ambition entailed distinguishing Whistler's contributions from Jeckyll's, which were in Godwin's view deplorable. As an architect tilling the same aesthetic field, he should not be expected to render an unbiased opinion on the work of a competitor, and it was Godwin's only regret that Whistler had not associated himself with "some architect who could and would have worked with and *for* him."[115]

That vision of a more perfect collaboration, in which "we might have had a complete exhibition of the artist's power as a composer of *opera* in colour decoration," was to be realized in 1878, in the Anglo-Japanese interior that Godwin and Whistler orchestrated together for the Paris Exposition Universelle. *Harmony in Yellow and Gold*, sometimes called the Primrose Room, was displayed in the stand of the London furniture-maker William Watt of Grafton Street (fig. 6.17), "whose sign stares you in the face at the top," G. W. Smalley observed, "in a way which would drive Mr. Whistler mad if he saw it, for in his fancies below, there is certainly no suggestion of the shop."[116] Indeed, the arrangement may originally have been conceived as a decorative scheme for an actual residence, the White House on Tite Street, which Godwin was designing for Whistler during 1877 and 1878. The room, as its name implies, was decorated in a subtle arrangement of yellow tones, with "primrose" walls, "pale sulphur" tiles, an ocher-colored velvet rug, and "golden" mahogany furniture upholstered in a fabric of "pale citron."[117]

The polished-brass grate in the fireplace was one of Jeckyll's designs, lending credence to the supposition that the Primrose Room was meant for the White House: Whistler had ordered "Jeckyll stoves" for those interiors as well, instructing his architect to select "plain simple yellow" Doulton tiles to surround them—"I cannot [abide] any of the other abominations," he said.[118] Indeed, something of the Jeckyll spirit lingers on in this ensemble. Its color scheme revives the combination of yellows that Jeckyll proposed to Leyland for the dining room at Prince's Gate, and its primrose-yellow walls recall the servants' hall of the Ionides house. In addition, the design of the centerpiece—the so-called cabinet mantelpiece, "with canted corners for porcelain, a deeply-moulded mantel-shelf and superposed cabinet above for ceramics or bric-à-brac"—reinterprets the form that Jeckyll had developed at Holland Park.[119]

But the more immediate inspiration for the Primrose Room was the Peacock Room itself. *Harmony in Yellow and Gold* may be considered a variation on that

FIG. 6.17 *Harmony in Yellow and Gold*, the William Watt stand at the 1878 Exposition Universelle, Paris. Designed by E. W. Godwin (1833–1886), with decorations by Whistler.

FIG. 6.18 Detail, *Harmony in Yellow and Gold* (fig. 6.19).

theme, an example of how Whistler's *Harmony in Blue and Gold* might have turned out if Godwin had been the architect, with Whistler "sole director from the first." The Paris decoration exhibited motifs almost identical to those at Prince's Gate, translated into a "caprice in yellow," as Smalley observed. "The peacock reappears, the eyes and the breast feathers of him; but whereas in Prince's Gate it was always blue on gold, or gold on blue, here the feather is all gold, boldly and softly laid on a golden-tinted wall."[120] The primary decorative device, "a kind of scale ornament," calls to mind Godwin's insistence in his article for the *Architect* that the "alternation of semicircles" in Jeckyll's leaded glass could "be equally well described as the scale pattern or the feather pattern, but which also might just as well have been evolved from a wave or flower." In this case, Whistler's designs may derive from the common Japanese themes of peonies or chrysanthemums, although his contemporaries interpreted them as clouds, "with butterflies ingeniously introduced."[121]

As on the sideboard in the Peacock Room, a dainty flight of butterflies appears on the mantelpiece in calculated juxtaposition to the highly stylized form that served as Whistler's signature (fig. 6.18). From those butterflies, "coupled with the colour of the whole," *Harmony in Yellow and Gold* acquired its secondary title, the Butterfly Suite; only the centerpiece survives, and that in the altered form of a china cabinet (fig. 6.19).[122] That butterflies served not only as decorative motifs but also as keys to the color harmony is often overlooked. The yellow scheme demonstrated the artist's conviction, later expounded in the "Ten O'Clock" lecture, that nature was the artist's resource: "In the citron wing of the pale butterfly, with its dainty spots of orange, he sees before him the stately halls of fair gold, with their slender saffron pillars, and is taught how the delicate drawing high upon the walls shall be traced in tender tones of orpiment, and repeated by the base in notes of graver hue."[123]

It may have been while he was working on the Peacock Room that Whistler discovered how a bird or a butterfly might offer "hints" for effective color combinations. Late in the scheme of that room's decoration, he melded blue and gold to create the iridescent green that distinguishes a peacock's plumage. The introduction of that new, more vivid shade of green was presumably a last-minute revision; no commentators writing in 1877 mention the color green in their reviews. In fact, it may have been partly because of those accounts, which consistently describe the repetition of blue and gold, "the only variety

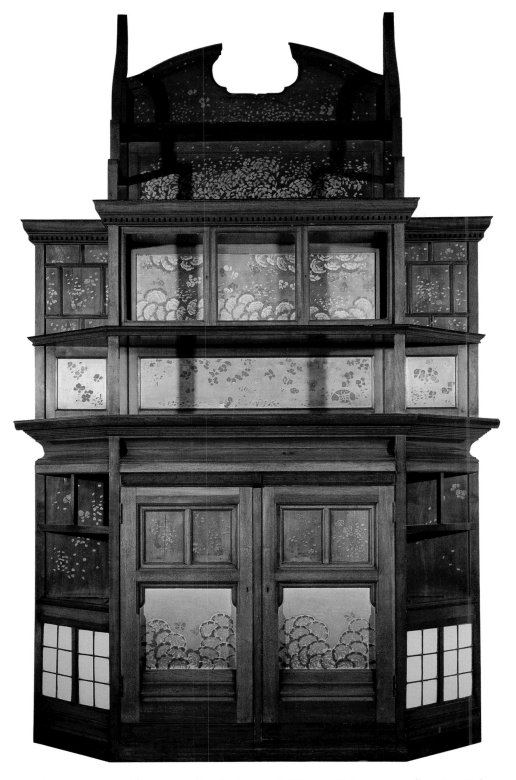

FIG. 6.19 *Harmony in Yellow and Gold: The Butterfly Cabinet* (Y195), 1877–78, designed by E. W. Godwin (1833–1866), with decorations by Whistler. Mahogany, with oil paint and gold leaf, 303.0 × 190.0. Hunterian Art Gallery, University of Glasgow.

of colour permitted being in the dark-toned blue and the grayer flat tint," that Whistler reconsidered the Peacock Room's color scheme and worked to save it from monotony.[124] By adding green to certain passages, he produced what A. J. Eddy regarded in 1903 as "a color-effect rich beyond description." As Oscar Wilde described it in 1882, "Everything is of the colours in peacocks' feathers, and each part so coloured with regard to the whole that the room, when lighted up, seems like a great peacock tail spread out."[125]

To the gilded wainscot, Whistler evidently applied yet another coat of the copper-green glaze he had used as both fixative and sealant for the dutch-metal leaf, toning down the gold another degree of green.[126] He also went over the canvas register of the dado and the circular "eye-feather" sections of the ceiling with a green glaze, in which a higher concentration of pigment was suspended in the varnish, producing a more vibrant (though still transparent) shade of green. All the newly treated surfaces were gently distressed, as before, so that glints of gold would flicker through the green. In effect, Whistler was carrying to completion the methods of Japanese lacquering he understood from Audsley's imperfect explanation: "When a sufficient time has passed to secure the perfect drying of the whole, the surface is ground down and polished. The final coloured coatings are then laid on and the surface highly finished; the latter being a work requiring great patience and skill."[127] To thus "finish" the surfaces in the Peacock Room (all but the blue leather), Whistler applied a clear coat of varnish, which he knew would saturate the colors, enhance the iridescence, and produce a sheen like polished lacquer. Early photographs show the gilded spindles reflected in the shiny ceiling (see fig. 6.15).

Finally, to complete the newly modulated color composition, Whistler redecorated the shutter surrounds and the inside panels of the doors, which by all accounts—including Godwin's meticulously detailed one—had previously been gold. On the panels framing the shutters, Whistler scraped down the surfaces to the wood, leaving random traces of metal leaf, then repainted them with transparent green glaze (fig. 6.20). He may have applied the paint with the tissues that separated the leaves of gold and dutch metal: by the time he finished decorating, there would have been hundreds littering the floor. This created a pattern that echoed the overlapping gold-leaf squares on the shutters themselves—producing the effect of gilding, without the gold.[128] He employed a simpler method on the doors, glazing the dutch-metal surfaces with a more concentrated solution of copper-green. Whistler was to practice that technique again a few years later at Tofte Manor, the Bedfordshire home of his patron Lewis Jarvis, where the drawing-room decoration was "a lovely gold and green; squares merging into each other."[129] Some of those surfaces have recently been recovered, confirming that Whistler repeated the interlayering of verdigris and dutch-metal leaf, but with confidence gained from experience in the Peacock Room.

Beyond its appearance in a peacock's feather, the emerald green Whistler added to the decoration of the Peacock Room would have been chosen to complement the Chinese porcelain. At an earlier stage, when the panels were still resplendent with gold, they would have resembled those of *Harmony in Yellow and Gold*—the background for pieces of Japanese Kaga ware, selected for the "yellowishness of the red" of its enameled decoration.[130] Warm gold tones would not have been so well suited to the cooler cobalt of Leyland's porcelain; the problem may not have been immediately apparent, however, since the pots were apart from the Peacock Room for the duration of the decoration. None of

The Last Alembic

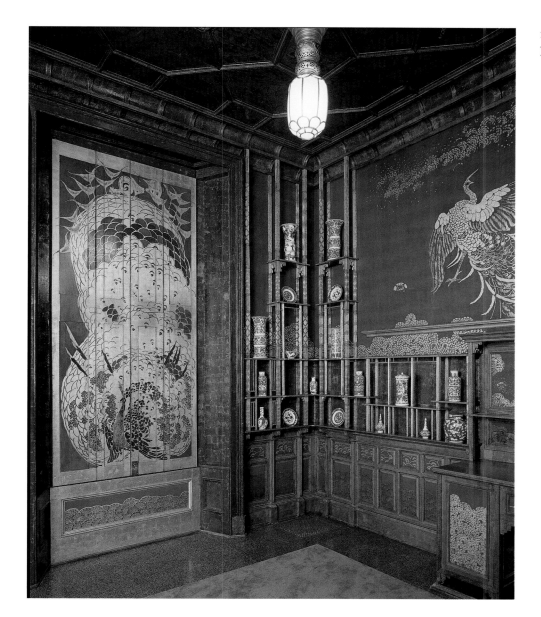

FIG. 6.20 Detail, southeast corner of the Peacock Room.

the London critics saw the porcelain in place, though all had been informed that the "compartments" of the shelving structure "were destined to hold the blue and white porcelain of Cathay." *London* wondered whether the china could, in fact, be shown "to advantage in so much glitter."[131]

Whistler has often been accused of disregarding the aesthetic requirements of the Chinese blue and white in his preoccupation with his painting or his vengeance. Murray Marks and Frederick Leyland are said to have shared the opinion that he ultimately rendered the room unsuitable "for showing off the porcelain as had been the original idea." Thomas Armstrong, who was admittedly predisposed to admire whatever Whistler did at that time, confessed to disliking the effect of the blue-and-white porcelain in the Peacock Room: "the colour did not serve as a happy background for people or furniture, and it was fatal to the precious blue china for the reception of which the alteration had been undertaken by Tom Jeckyll; the cobalt blue of the pots suffered terribly from juxtaposition with Whistler's paint, made of Prussian or Antwerp blue."[132]

The Last Alembic

But that unexpected combination of blues, which created a distinctive, minor chord of color, was not only intentional, but tested for effect: it appears in the still-life fragments which are all that remain of a contemporary arrangement in blue, Whistler's unfinished portrait of Elinor Leyland, *The Blue Girl*, in which the background for the Chinese porcelain is painted prussian blue (fig. 6.21).

The Last Alembic

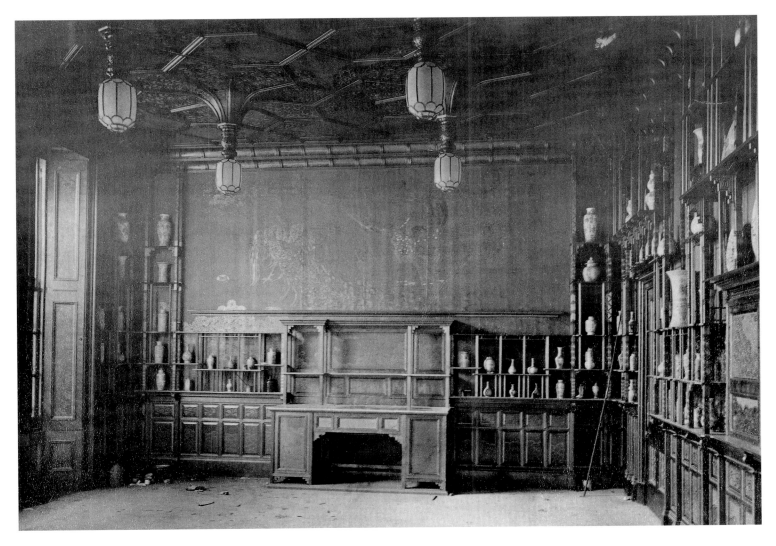

The earliest extant photograph of the Peacock Room (fig. 6.22) further verifies that Whistler regarded the blue-and-white porcelain as an integral part of his *Harmony in Blue and Gold*. The picture, which Whistler sent to Samuel Avery in New York, appears to commemorate the project's completion; the artist may even have taken it himself, since the bamboo rod propped in the corner indicates his presence. The room remains in disarray, with the carpet still missing from the floor, but the porcelain has been thoughtfully restored to the shelves. With *La Princesse du pays de la porcelaine* as its centerpiece, and the gilded spindles framing each pot as though it were a picture, the Peacock Room completes the equation of easel paintings with porcelain paintings that Whistler had proposed, years earlier, in *The Lange Lijzen of the Six Marks*.

FIG. 6.22 The Peacock Room at 49 Prince's Gate, London, 1877, possibly photographed by Whistler. S. P. Avery Collection, Miriam and Ira D. Wallach Division of Art, Prints and Photographs, The New York Public Library; Astor, Lenox and Tilden Foundations.

WHISTLER REVELED in every review of the Peacock Room and may even have carried clippings with him in his pockets, as Leyland was given to understand (app. 17a). He preserved them in a scrapbook dedicated to the purpose. Although he later affected disdain for the press, his scrapbook serves as an

archival record of his work at Prince's Gate. He must have taken special satisfaction in G. W. Smalley's article in the *New York Daily Tribune*, which drew attention to "the difference between upholsterers' tricks and the sincerity of an artist of genius. Nobody, not the most untrained eye, could mistake the touch here for that of a mere craftsman"—a laborer, in other words, who might appropriately be paid in pounds, instead of guineas.[133] Perhaps to reward this insight, Whistler invited Smalley to visit the Peacock Room a second time, closer to its completion. "I saw the room again last night," Smalley noted in an article composed in early March, "and I don't find that its splendor palls. Now that almost the last touch has been given to it, and the dark blue carpet is down, and some of the furniture is in, and the niches enshrine the blue china they were meant for, the whole effect is singularly quiet, and the eye finds all the repose it can ask for."[134]

We can only imagine what Leyland must have thought, as he sat at Speke Hall reading in the London papers about his own magnanimity in allowing Whistler to have his way. Godwin's article in the *Architect*, for instance, concluded with congratulations to Leyland "on his possession of this wholly admirable and unique work of art—art that would have been impossible but for the long peace and prosperity which have blessed this country," as though the patron were a Roman emperor. When those same "Notes on Mr. Whistler's 'Peacock Room'" were reprinted on 3 March in a Liverpool paper, Godwin's review was pointedly retitled "Mr. Leyland's Peacock Room," perhaps as an indication that the owner was about to repossess his London home.[135]

Leyland's forbearance had already been eroding at the end of February 1877, when he finally requested that Whistler "refuse any further applications to view the room": the housemaid had complained that the number of people calling to see it hindered her efforts to prepare for the family's return (app. 9). Whistler drafted a reply apologizing for the "riotous peacocks" that were bringing all of London to traipse through Leyland's house. He threatened to remove the shutters, as Leyland once suggested, and then he crossed out the threat, uncertain how to respond to his patron's unforgivable lapse of appreciation (app. 10). He enclosed an article he had been reading when Leyland's "gracious little note" arrived, probably the laudatory piece in the *Examiner*: "We can well conceive of a scheme of beauty that might have been more serious than this, but scarcely of any that could possess a higher dignity and distinction. To have gained an effect bright and glad and yet not trivial, that should fit with luxurious surroundings and still be in itself simple and severe, was surely no easy achievement."[136] Regardless of the sentiment expressed, another newspaper "puff" dispatched to Liverpool could only have aggravated Leyland's irritation.

For Whistler, the crowning accolade came not from the press, but from the pulpit. On 18 February 1877, in the fashionable venue of St. James' Hall, the Reverend Hugh Reginald Haweis delivered a sermon titled "Money and Morals," which according to Smalley contained "much good counsel How Not to Spend your Money; followed by suggestions for the right spending of

it."[137] The Peacock Room was cited as an example of the latter practice— indulging in a luxury that might, upon reflection, afford "something akin to a religious awe":

> I began to understand the mystery and wealth of thought and beauty which lay hidden, nay, which lay like an open secret in a Peacock's plume. I said I never knew this before, but this man knew it, he has sat down before this great irridescent [*sic*] work of God—he has watched it, and questioned it, and to him it has yielded up its secret, and he has here told it out for the joy of the whole world.

There was an entire sermon in the room, he declared, "the text of which was a peacock's feather, . . . and it will do good to every one who goes there and has ears to hear, or rather eyes to see."[138]

Those words would have gladdened the heart of Whistler's mother, and we can only hope that he sent her in Hastings a copy of the printed sermon, with relevant passages marked in the margins, like the one he prepared for Frederick Leyland but apparently never posted.[139] To the Reverend Haweis himself, Whistler wrote,

> I cannot tell you how deeply I feel the wonderful sympathy you have shown for my work. Nothing has given me such surprised delight as your marvelously beautiful description of my decoration—That it should have so much moved you, is to me a proof greater than hitherto has been accorded of its worth—and I may frankly say that no writing has given me such a flush of pleasure as the poem of praise I have just read in your sermon.

He implored the preacher to come with his wife, Mary Eliza Haweis, the author of manuals of taste, to see the Peacock Room a second time. "It is now about complete," he wrote, adding that the Leylands were expected in London almost any day.[140]

It must have been around this time, the final days of February, that Frances Leyland returned to 49 Prince's Gate unannounced and "let herself in by her own key," as T. R. Way recounted the rumor to the Pennells. She heard Whistler in the dining room, talking to some visitors, and just as she was passing by, something was said about her husband. "Whistler shrugged his shoulders and spread out his hands and said, 'What can you expect from a parvenu?'"[141] There is little reason to doubt the authenticity of the insult, which accords with Whistler's attitude toward his estranged patron, and Mrs. Leyland herself told the Pennells she had objected to something Whistler said in the Peacock Room about her husband. Yet she claimed not to remember ever having quarreled with the artist, and Whistler contended, soon after the event, that she had "never uttered a discourteous word" (app. 20).

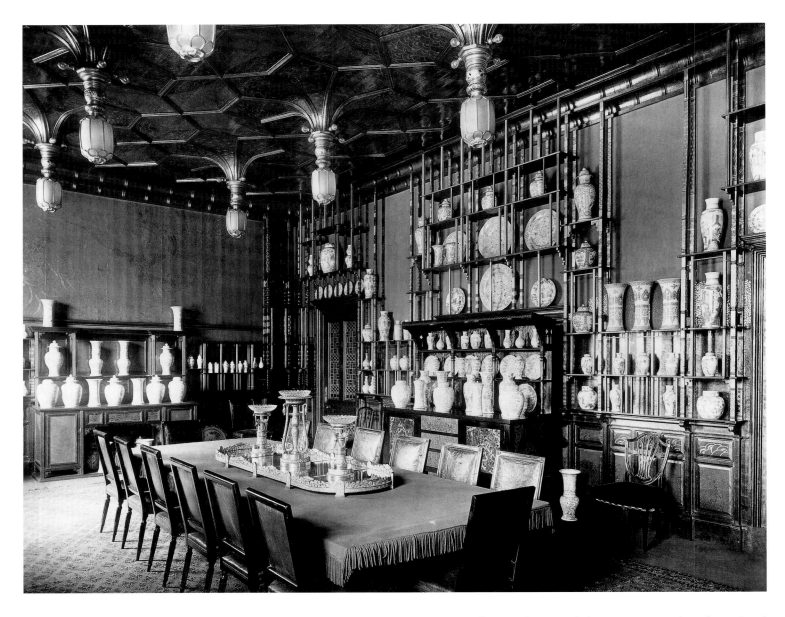

FIG. 6.23 The Peacock Room at 49 Prince's Gate, London, 1892, photographed by H. Bedford Lemere (1864–1944). National Monuments Record; Royal Commission on the Historical Monuments of England, London.

These accounts contradict the conclusion of the story as Frederick Leyland heard it—that the artist's "insolence was so intolerable" that Mrs. Leyland ordered him out of the house (app. 19). Frances Leyland presumably had good reasons for giving her husband that version of events, which also became grist for the London gossip mill; but it cannot be true, as Way maintained, that the servants subsequently denied Whistler admission to the house "and that was the end," since the artist was back on Monday, 5 March, showing the Peacock Room to a friend of his sister's.[142] That evening, however, Alan Cole was at Prince's Gate until two in the morning "consoling" Whistler as he finished painting the peacocks on the shutters. The fact that Whistler stayed so late and felt in need of consolation suggests that he knew those to be his final hours in the Peacock Room.[143]

FREDERICK LEYLAND'S reaction upon returning to London can only be conjectured. We know that Murray Marks was "bitterly disappointed" with the scheme as Whistler left it—that although he "gradually came to be of the opinion that the decoration of the room was a masterpiece of a very wonderful character," he regretted the disappearance of the leather and the complete transformation of Jeckyll's design. As Dianne Macleod has observed, the room was to have been Marks's own "crowning achievement." In the absence of any other account, this has been accepted as Leyland's attitude as well. Leyland, with Marks, is said to have removed much of the china from the shelves in the opinion that the decoration would have to stand alone.[144] If so, Leyland subsequently overcame this objection, for when Vernon Lee saw the room in 1883, the "gold etageres" were filled with blue and white, and the 1890s photographs show the shelves replete with porcelain (fig. 6.23). It has become a commonplace to credit Leyland with leaving the dining room alone, "toning down not a flying feather, not a piece of gold in that triumphant caricature," in the words of the Pennells, who inaugurated the tradition.[145] But as Val Prinsep pointed out, "the world heard only one story, and . . . Leyland, as the one who really reaped the benefit, could afford to laugh and was content to hold his tongue."[146]

AS THOUGH there were some prospect of reconciliation, Freddie Leyland wrote a friendly note to Whistler early in April expressing the hope that he would soon "be on better terms" with the family at 49 Prince's Gate.[147] Perhaps the seriousness of the breach was not at first apparent: that spring of 1877, Frederick Leyland was so often out of town that Rossetti didn't know from one week to the next whether his patron was "a Londoner or Liverpoolian."[148] Frances Leyland herself may not have been in residence until somewhat later in the season than usual. At the end of June, she attended an "At Home" at William Rossetti's, where she appears to have encountered Whistler for the first time since the rumored incident in the Peacock Room. "At the first moment he seemed to be coldly received by Mrs. Leyland and her daughter," the host recorded in his journal, "but very soon I saw him in the liveliest chat with the former, and I should hope their serious difference (of which there has been much talk lately) may be made up: perhaps Leyland will be less malleable."[149]

Indeed, it was Leyland's understanding that his wife had summarily dismissed Whistler from the house. He assumed the artist would stay away from Prince's Gate out of "an ordinary sense of dignity" (app. 19), and was probably unaware that Frances Leyland continued socializing with Whistler. Margie Cole, Alan Cole's wife, told the Pennells that Mrs. Leyland frequently invited Whistler to dine at Prince's Gate in her husband's absence, and heedless of

appearances, "he was always willing to go."[150] It may have been to prove she took no part in the dispute that Frances Leyland lent *Nocturne in Blue and Silver* (see fig. 3.9), her gift from the artist, to the Grosvenor Gallery exhibition that opened in May and displaced the Peacock Room as the center of society's attention. Lady Blanche Lindsay, who had founded the gallery with her husband Sir Coutts, played the violin at a concert in July, for which Mrs. Leyland lent "her house," as Whistler phrased it to his friends, urging them to attend if only to see the Peacock Room: "I remind you of it that you may not leave in the whirl of fine music without looking at my birds!"[151]

But it was naive of both Whistler and Frances Leyland to imagine they could continue exactly as before. Their friendship may have remained platonic, but Whistler's public animosity toward Frederick Leyland cast quite a new construction on the relationship. Naturally, people talked. On 6 July, Leyland "accidentally learnt" that the previous week Whistler had escorted his wife and daughter to view the recently completed residence of Baron Albert Grant near Kensington Palace. Whistler maintained that he had called at Prince's Gate that afternoon to show the Peacock Room "to two French gentlemen who should carry the impression of it with them to Paris," and that the outing with Frances and Florence, taken in the family carriage, was an impromptu event (app. 12). But the letter Leyland wrote to Whistler—in a tone that this time took the artist by surprise—implies that he had heard about the incident from someone other than his wife, which made it seem less innocent than it may in fact have been. "After what has passed, and in the relative position which it is publicly known that you and I occupy towards each other, I cannot trust myself to speak of the meanness of your thus taking advantage of the weakness of a woman to place her in such a false position before the world." Consequently, the servants were instructed not to admit Whistler to the house again, and Frances and the children were told to have nothing further to do with him (app. 11).

Whatever her "weakness" for the artist may have meant for Frances Leyland's reputation, it clearly compromised her husband's, and when Frederick Leyland learned that his own name had fallen on the tongues of gossips, there was "trouble at home," according to Alan Cole.[152] Whistler learned about it from Freddie, who implied that Whistler had become "a means of outrage and pain" to his mother and sisters. This compelled the draft of a letter (apparently never sent) imploring the elder Leyland to keep the quarrel between themselves, and "leave the ladies out."[153] To Whistler's distress, Freddie took his father's side, and declared his sisters to be "all of the same opinion" (app. 15). The Leyland girls are said to have exalted their father and considered their mother "rather vain and foolish, and did not like her receiving the attentions of Whistler the way she did." Indeed, they were young and vulnerable to "the gossip of the day," which according to Elizabeth Pennell was inclined to concur that Whistler was in love with their mother. There was even a rumor, which Gabriel Rossetti relayed to Frances Leyland (he may also have been her husband's informant), that she and Whistler were planning to elope. Mrs. Leyland

FIG. 6.24 *Fighting Peacocks* (M583), 1876. Pencil on paper, 22.2 × 17.6. Glasgow University Library, Special Collections.

later told the Pennells how, hearing Rossetti's rumor, she declared the whole idea absurd.[154]

An incident that may have given rise to such a story took place one Friday afternoon a week or so after the Kensington outing, when Whistler was seen walking with Mrs. Leyland at Lord's Cricket Ground. He later claimed to have encountered Frances and her daughters accidentally, and "could not do otherwise than recognize old friends" (app. 17); but since cricket was not among Whistler's known enthusiasms, Leyland suspected the meeting had been arranged in advance. "If after this intimation I find you in her society again," he wrote on 17 July, "I will publicly horsewhip you" (app. 14).

Whistler took some time with his reply, crafting a response that would represent his interests to posterity. He illustrated an early draft of his letter with a sketch of the fighting peacocks on Leyland's dining-room wall, one of them wielding a whip (fig. 6.24). The letter he finally posted to Prince's Gate, keeping copies for himself, restored the Peacock Room to the foreground of the dispute. "It is positively sickening to think that I should have labored to build up that exquisite Peacock Room for such a man to live in!" Declaring his belief that Leyland was known only as the owner of the room whose price he had refused to pay, Whistler concluded, "Your last incarnation with a horsewhip I leave you to work out" (app. 17).[155] Predictably, Whistler seized the opportunity to "work out" his own image of Leyland incarnate as a horsewhip (fig. 6.25), drawing on one of the sheets of Arts Club stationery he also used for his drafts. In this first and wittiest of the caricatures, Leyland is depicted as a slender rod with a ruffled profile, standing in a pool of fallen coins. Whistler obviously delighted in fashioning the acronym "FRILL" from Leyland's initials, supplying the implication that ruffled shirts signified an absence of refinement and good taste. "Whom the gods intend to be ridiculous," he quipped, "they furnish with a frill!" (app. 17).

Leyland returned Whistler's letter. "It is an ingenious puff of the work you have done at my house and it will be useful for you to keep with the news-

FIG. 6.25 *"F. R. L." . . . frill! (Caricature of F. R. Leyland)* (M719), 1877. Pen and ink on paper, 17.5 × 11.2. Ashmolean Museum, Oxford.

paper cuttings you are in the habit of carrying about with you. An advertisement of this kind is of such importance in the absence of (or in the incapacity to produce) any serious work that I feel it would be an unkindness to deprive you of the advantage of it" (app. 17a). As Ferriday remarked, "that is something more trenchant than anything in *The Gentle Art*."[156]

*I*T MAY NOT have been coincidental that Leyland's unprecedented aspersion of Whistler's ability to produce "serious work" closely followed the publication in the *Architect* of John Ruskin's critique of Whistler's works at the Grosvenor Gallery, originally published in the July number of *Fors Clavigera*: "I have seen, and heard, much of Cockney impudence before now: but never expected to hear a coxcomb ask two hundred guineas for flinging a pot of paint in the public's face."[157] With an audacity that stunned the English art establishment, Whistler brought suit, demanding one thousand pounds in damages for the alleged libel. This was precisely the sum Whistler was to claim that Leyland failed to pay him for the Peacock Room—a sum he had come to regret having surrendered so easily. But as Leyland was obliged to remind him, "you chose to accept £1000 for it rather than contest the matter and I am not disposed to reopen the question" (app. 21).

For more than a year, Whistler had pinned his hopes on the Grosvenor Gallery. Artists exhibited there by invitation, rather than by competition, so their pictures might "be fairly and honestly seen and judged," as Sir Coutts Lindsay defined his ideal.[158] Three years had passed since Whistler displayed his works en masse in London. He could not afford another solo exhibition, and because he had given up the intention of ever showing at the Royal Academy, the Grosvenor must have appeared a paradise: Linley Sambourne's *Punch* cartoon (fig. 6.26) employs a composition and conceit that recalls Whistler's mural in the Peacock Room.[159] It was principally because of that preoccupation that Whistler had nothing new to submit to the Grosvenor in 1877. He hurriedly touched up a few portraits, including the one of Henry Irving he had painted with such élan the previous year, and selected several Nocturnes, notably the abstract painting inspired by the fireworks at Cremorne, which was to be the focus of Ruskin's disdain. Whistler's portrait of Thomas Carlyle, *Arrangement in Grey and Black, No. 2*, was placed prominently in the vestibule, and seven other paintings made a substantial display along one wall of the west gallery, where the frieze had been decorated to resemble a midnight sky. Walter Crane attributed that decorative scheme to Whistler, but it is difficult to imagine when the artist would have found time to carry out such a project, or why, if he had, he would have kept the contribution quiet.[160]

When the doors of the Grosvenor Gallery opened in May, Whistler was the first to arrive.[161] Because of the Peacock Room, he was known by sight to members of the press and was something of a celebrity among the artistic popu-

lation. Oscar Wilde, then an Oxford undergraduate, sought him out to ask whether he knew the mosaics at San Vitale in Ravenna, "another and older peacock ceiling in the world."[162] But just as Whistler's anticipation of Leyland's delight in the Peacock Room had ended in emotional devastation, so his hopes for popular and critical acclaim at the Grosvenor were to be sadly defeated. Marie Stillman recollected that Sir Coutts "expected great things of Whistler," but that the pictures shown at the inaugural exhibition "were to him frankly a disappointment, as they were to many others." Sensing this, she believed, Whistler was shattered.[163] And in times of disappointment, we have seen, he became acutely sensitive to criticism.

The news of Whistler's intended lawsuit appeared in the *Athenaeum* on 21 July 1877, when it might have been brought to Leyland's attention by Edward Burne-Jones. Ruskin had favorably compared that artist's works to Whistler's in the same review, and Burne-Jones instantly volunteered to champion the critic's cause. Considering the timing of these events, it is likely that Burne-Jones (if not Rossetti) discussed the matter with Leyland, who now possessed a strong incentive for standing on Ruskin's side. As the chief witness for the defense, Burne-Jones was enlisted to assist Ruskin's counsel in preparing for trial, and to this end he wrote to Leyland requesting facts about Whistler's portrait commissions—whether the works had been paid for and "whether they are still detained."[164] Indeed, much of the garbled information that turns up in the defendant's brief may have come from Burne-Jones, perhaps including the unfounded assertion that Whistler had spent two years on the decoration

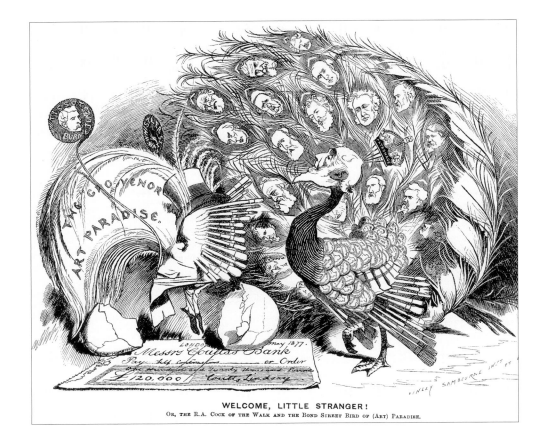

WELCOME, LITTLE STRANGER!
OR, THE R.A. COCK OF THE WALK AND THE BOND STREET BIRD OF (ART) PARADISE.

FIG. 6.26 "Welcome, Little Stranger!" a cartoon in *Punch*, 12 May 1877, by Edward Linley Sambourne (1844–1910).

at Prince's Gate, painting the walls "with what he called Devil Peacocks being things with Devils heads and peacocks bodies"—an eerie premonition of Whistler's caricature of Leyland, *The Gold Scab*.[165]

More damaging was the statement Burne-Jones prepared for the lawyers. "The point and matter seems to me to be this, that scarcely any body regards Whistler as a serious person," it began, then developed the theme that Whistler's practice was primarily "the art of brag." Never once, declared Burne-Jones, had Whistler "committed himself to the peril of completing anything."[166] It is hard not to read those words as reflecting Leyland's own view of Whistler's "swaggering self-assertion," as expressed in the letters that Whistler was proposing to publish; the correspondence illuminates the destructive side of friendship, revealing how Leyland's former intimacy with Whistler lent the most effective weapons for attack. "There is one consideration, indeed, which should have led you to form a more modest estimate of yourself," Leyland wrote, invoking the very doubts and insecurities that had long prevented the completion of *The Three Girls*, "and that is your total failure to produce any serious work for so many years" (app. 19).

Walter Crane recollected that shortly before *Whistler v. Ruskin* went to trial late in November 1878, Leyland held a party at Prince's Gate for Prinsep, Boughton, Poynter, Armstrong, and Burne-Jones—a "company of artists" in which Whistler's absence would have been conspicuous. When the dinner conversation turned to Whistler's works, Burne-Jones, oddly impervious to the splendor of the setting, adamantly refused to recognize their merits. Crane later reasoned that "under the circumstances he could hardly afford to allow any credit to Whistler," but his dismissive remarks may also have been meant to impress his host and patron, for Burne-Jones was trying to take the place in Leyland's constellation that Whistler had formerly occupied.[167] When at last the case went to trial, it was Leyland's impression of Whistler as "an artistic Barnum"—bolstered by the testimony of Burne-Jones—that informed the proceedings. The verdict was given to the plaintiff, with the contemptuous award of a farthing in damages, a notional victory not unlike the one Whistler had

FIG. 6.27 "Verdict for plaintiff," from *The Gentle Art of Making Enemies*, 1892.

Verdict for plaintiff. Damages one farthing.

The Last Alembic

attained in the Peacock Room. Afterward, faced with paying his own costs in the matter, Whistler found himself with little more than that farthing to his name. In the sketch he made to illustrate his version of events in *The Gentle Art of Making Enemies* (fig. 6.27), the coin is encompassed by the long barbed tail of his butterfly, the stinger that had come to symbolize Whistler's spite.

I CANNOT TELL YOU more of Jemie's work than the Articles in London Papers report of his paintings exhibited this Season in the Grosvenor Gallery," Whistler's mother had written Mr. Gamble in the summer of 1877. "The portrait of Carlyle is highly praised. He is painting others in his Studio & never spares time to write me. I hear of his being in excellent health. But I judge that altho his famous work in the Peacock Room was a great achievement (even in his own eyes) vexation of spirit has been experienced by him in the inadequate compensation for so many months concentration of his ability." She confided this fact, she said, only to say that in spite of his fame, her son remained without fortune.[168]

Although his debts had been accumulating for years, Whistler attributed his ruin entirely to the Peacock Room. "The work of which you have doubtless heard (Mr. Leyland's dining room) which has absorbed me for the past year, and which is now fully completed, has been anything but remunerative," he wrote to his patron William Graham, "indeed it has left me very ill off." To his friend Liberty, now his creditor, Whistler said that his financial "annoyance" was due to "that confounded Peacock Room, where I had no 'business contract'!" And to Elizabeth Greaves (the mother of his "pupils"), to whom he also owed money, Whistler confessed that his luck had been bad ever since the Peacock Room, and that he was, for the time, simply "ruined by it."[169]

It was while his own unpaid bills were accumulating that Whistler received a letter from B. Verity & Sons regarding "alterations &c" carried out at Prince's Gate, presumably some modification of the Peacock Room lamps.[170] Frederick Leyland had refused to settle the account since he had not ordered the work: "to use his own words," Verity wrote, "we must sue *you* for this amount." Leyland's suggestion that Whistler pay the bill—no small matter at £279—stemmed from his "keen sense of the ridiculous," Whistler replied. That Leyland was innately comic might be ascertained from his frills and buckles, "evidently outward and visible signs of an inward and irresistible spirit of joke."[171] Whistler was endlessly, somewhat hysterically, amused by his latest assault, recounting "the story of the Leyland and the Gas bill" to everyone who would listen and expecting all to be as entertained as he. "He promised me a whipping and sends me his gas bill!" Whistler wrote to Theodore Watts-Dunton, urging him to halt his efforts to settle the dispute— "Mon cher these things are not done every day! Leyland and his gas bill are the joy of London and shall you rashly interfere!"[172]

Whistler's mirth, however, was soon to turn malicious. The week Verity's letter landed at Lindsey Row, Whistler attended a performance of John Hollingshead's play, *The Grasshopper*, at the Gaiety Theatre. It was "not very good," Alan Cole noted in his diary, "though a tremendous puff for Whistler."[173] At one point in the play a portrait of the artist by Carlo Pellegrini, produced in the "Whistlasquez" style and distinctively framed in tinted gold, made a cameo appearance on stage: it was practically a parody of *Arrangement in Black* (see fig. 3.1), the first of Whistler's portraits painted in the style of Velázquez.[174] If Frederick Leyland had originally called to the artist's mind the regal visage of Philip IV, he now reminded Whistler of Mephistopheles. Within days, Whistler was at work on a parody of his own, a copy of his portrait of Leyland in the guise of a character in another Gaiety production, a burlesque of Goethe called *Little Doctor Faust*.[175] Like so many works Whistler painted in this period, that portrait has not survived, although tales of it were told for many years; it was still rumored to exist in 1903, when Whistler's obituary in *The Times* described a life-sized painting of Frederick Leyland as a devil with horns and hoofs.[176]

As it happened, the original *Arrangement in Black* was still in Whistler's studio, together with *Symphony in Flesh Colour and Pink* (see fig. 3.18), his pendant portrait of Frances Leyland. Both had been "publicly approved of" in 1874, Whistler reminded Leyland, and he had kept them only because of certain "artistic scruples" (app. 20). Those scruples were "uncommonly well founded," Leyland replied. Nevertheless, he was prepared to receive the portraits as they were (app. 21). That remark "impugning their artistic value" caused Whistler to keep them even longer, until their value could be "guaranteed by brother artists," as he put it in a letter to Watts-Dunton: "It is far from my wish to rob Leyland of any real right, whatever may be my opinion of his conduct." The portraits were seen by T. R. Way some months later, "before they were sent home," presumably in the early summer months of 1879.[177]

The portrait of Leyland's daughter Florence (see fig. 3.29), which had also been paid for in full, was a different matter. It remained incomplete, Whistler explained, "simply because the young lady has not sufficiently sat for it—and as she is not likely to sit for it again, I must do what I can to make it as worthy of me and of herself as possible."[178] The unfinished portrait may have been shown at the Grosvenor Gallery in 1877, disguised as *Harmony in Amber and Black*. During the seventeen months between the exhibition and the Ruskin trial, Whistler repeatedly dodged the issue of that portrait's identity, stating in answers to interrogatories, and again in court, that *Harmony in Amber and Black* had been painted over since the exhibition: one reporter noted that Whistler had done so "with a view to alter it and change its character as a picture. It is in a transition state." A photograph of the portrait in that transitional state reveals a marked resemblance to Whistler's mistress Maud Franklin, who must have stood in for the absent sitter.[179] Although Whistler eventually restored Florence's features to the figure, the resulting work was never satisfactory.

The Last Alembic

Joseph Pennell considered it uncharacteristic, and Charles Freer questioned its authenticity.[180] Part of the problem may have been its poor condition: according to one contemporary report, all three Leyland portraits were kept in a garret and damaged by the rain.[181]

It was also rumored that the Leyland portraits had been "sequestered from observation and . . . ignored by the parties for whom they were painted."[182] Indeed, by the time the works were finally delivered to Prince's Gate, another portrait of Frances Leyland had been completed (fig. 6.28), to Whistler's enduring irritation. Frederick Leyland commissioned the work from Phil Morris soon after the completion of the Peacock Room, perhaps in the belief that he would never receive Whistler's portrait of his wife. Morris was an associate of the Royal Academy, who for a time had been Whistler's "chosen companion"; however, Mrs. Leyland unwittingly delivered the death blow to the artists' friendship by requesting "the Whistler pattern frame" for her portrait. To Morris's request for the framemaker's address, Whistler replied, "If you've got the portrait then for God's sake have the frame."[183] Morris could not understand his friend's animus, since he claimed to have received Whistler's permission to accept the commission. But what did he expect? Whistler wrote: "Was Whistler to beseech you to desist? for him, the crime once entertained — was already perpetrated."[184] The damage was doubtless compounded in 1878, when the portrait by Morris was shown at the Royal Academy, reminding Whistler that he had never achieved his ambition to exhibit his own portrait of Mrs. Leyland there.[185]

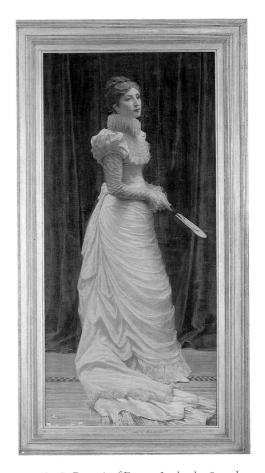

FIG. 6.28 *Portrait of Frances Leyland*, 1879, by Philip Richard Morris (1838–1902). Oil on canvas, 201.29 × 88.9. Private collection, Great Britain.

*T*HOMAS SUTHERLAND, a mutual friend of Whistler and Leyland, long remembered the day in May 1879 when Whistler appeared unexpectedly at his office in the City, looking more eccentric than ever, "his long overcoat down to his heels, his hair well oiled, his hat much on one side, his white lock in evidence, his long cane in his hand." They had talked about trifles until Whistler rose to leave, withdrawing a legal document from his pocket with the offhand explanation that it was a bankruptcy petition. Sutherland had lent Whistler money at some point, and Whistler insisted that he record as large a debt as possible to increase his influence at the meeting of creditors, which was to take place on 4 June. In the event, there were sixteen other creditors present, including Whistler's butcher and greengrocer, and Frederick Leyland. None of the others appeared to understand the meaning of the proceedings, and when Leyland made some comment to that effect, Whistler reportedly "sprang to his feet and began a wonderful speech about plutocrats with their millions and it was all they could do to pull him down by his coat tails into his chair again."[186] This was probably Whistler's and Leyland's last encounter, as Ferriday surmised: "The acquaintance had been of fifteen years. In the circumstances of its termination only one of them emerged with any credit, either personal or financial."[187]

According to Thomas Way, Whistler owed Leyland fourteen hundred pounds, but the bankruptcy papers themselves record a debt of £350, for "money paid." [188] The chief creditor, in fact, was the recently deceased Thomas Winans, who had lent and advanced Whistler twelve hundred pounds; after Winans came James Anderson Rose, Whistler's solicitor, who was owed nearly £478, and then C. A. Howell, who reported having lent Whistler £450 during 1878, although he claimed *Arrangement in Grey and Black: Portrait of the Painter's Mother* for £250. It was rumored at the time, and the implications have persisted, that Leyland bought up various debts to accentuate his standing in the proceedings; but this was clearly not the case. However Whistler may have chosen to interpret his declining fortunes, the accounts filed with the court suggest that he was ruined by expenses attending the construction of the White House, which compounded a long accumulation of petty debts: nearly half his creditors claimed sums of less than ten pounds. Nor did Leyland seek to destroy his dignity. Whistler was spared the stigma of being named a bankrupt (which he would have remained until his debts were paid or discharged by the court) when his creditors resolved "that the affairs of Whistler shall be Liquidated by Arrangement and not in Bankruptcy." Leyland had voted with the majority. [189]

Yet Whistler did have to endure the humiliation of a Committee of Inspection charged with overseeing the sale of his estate and the settlement of his affairs. Two of its members, Howell and Way, were friendly overseers, who did what they could to ease the painful process. Leyland was the third member of the committee, and Whistler depicted him in that role (fig. 6.29), wearing his signature buckles and frills and looking anxious and agitated, in marked contrast to his apparent composure in *Arrangement in Black*. It galled the artist that Leyland was in a position to scrutinize the details of his financial situation, "calculating the assets of the painter whom he was supposed to have patronised." [190] According to Rossetti, one of Whistler's final "feats" was to inventory the copper plates for his etchings as "copper at 3/6 a lb." (three shillings and sixpence), which might have enabled him to buy back the plates at nominal cost: "This however Leyland (who has much helped in flooring him) spotted and prevented." [191] Perhaps in consequence of that action, Whistler produced an even more spiteful caricature showing Leyland determining to "keep an eye on the assets of the White House" (fig. 6.30). In this drawing the loathed creditor appears to have lost his neck. With his head sunk onto his shoulders, he looks more evil than ever, a Mephistopheles in evening clothes. Whistler himself, whose thoughts seem to have been the more malevolent, figures in the drawing as the viperous butterfly poised for attack.

Soon after the bankruptcy petition went into effect, Whistler produced a pair of paintings intended for display at the White House, where his creditors would expect to find assets for liquidation. These were "satirical" works, meant to embarrass Leyland in a way that would overwhelm any lingering discomfort associated with the Peacock Room. Both were "odd things," Alan Cole remem-

FIG. 6.29 *"F.R.L." frill — of Liverpool* (M718), ca. 1879. Pen and ink on paper, 17.6 × 11.0. Ashmolean Museum, Oxford.

FIG. 6.30 *Caricature of F. R. Leyland* (M720), 1879. Pen and ink on paper, 17.6 × 11.0. Hunterian Art Gallery, University of Glasgow; Birnie Philip Bequest.

bered, painted over unfinished works, yet Whistler valued them enough to be anxious about what became of them after he had departed for Venice.[192] *The Loves of the Lobsters*— or, as Cole has it, *Ye Loves of Ye Lobsters*—was seen at the White House on 13 May 1879 by the writer Augustus Hare, who had been invited to view Whistler's pictures. He was disappointed that only the one was in evidence, and it looked as though the artist "had upset the inkstand and left Providence to work out its own results." Amid the inky chaos were two bright red lobsters "curvetting," calling to mind Lewis Carroll's "Lobster Quadrille."[193] The second satire, seen by Alan Cole less than two weeks later, was "an arrangement in rats," depicting the ark on Mount Ararat. Way described it to the Pennells as "a little sort of Noah's Ark on a hill, with people going in and all about and sitting on the roof."[194]

It is impossible now to decipher the hermeneutics of these pictures, but the lobsters and other creatures must have been caricatures of people whose identities were recognizable to Leyland and probably also some of his peers, since Whistler meant them to be sold with his other effects and to create "a great sensation in the auction room." Way thought that the lobsters, "with frills everywhere about them," were intended as portraits of Frederick and Frances Leyland, and that the animals "all in frills" on Noah's ark were "more or less portraits of the Leylands and their friends"; but it seems implausible that Whistler would have painted Mrs. Leyland or her children in that way, for he always surrounded them, he said, with "exalted feelings of respect" (app. 20).[195] Those pernicious portraits, therefore, must relate to the more private and painful phase of Whistler's retaliation.

The aroma of scandal that has long wafted over the story of the Peacock Room is commonly traced to the supposed love affair between Whistler and Frances Leyland. Indeed, it has recently been asserted that "Leyland summarily divorced his wife . . . after suspecting her of being intimate with Whistler," although the Leylands were never divorced, and any real evidence of adultery would have given Frederick Leyland incontestable grounds.[196] The Pennells' *Whistler Journal* carried the innuendo from which the legends were to grow, and their references to a possible liaison were so baldly unsubstantiated that Lippincott, the publisher, advised against committing them to print. Elizabeth Pennell had tried without success to coax Frances Leyland, at seventy, into saying she might have married Whistler, had she been a widow at that time; but Mrs. Leyland would only say it was a shame that Whistler "could not have married her—it would have been much better for him."[197] Ultimately, Mrs. Pennell could gather little more than a vague impression that Mrs. Leyland's relationship with Whistler "had something to do with the break after the Peacock Room"—as indeed it did, though not in the way originally conjured by her romantic imagination.[198]

The biographer's intuition that something shocking lurked below the surface was aroused in 1906, when she interviewed Nellie Whistler, the artist's sister-in-law, who had married into the family in April 1877—a critical period in the course of the Leyland quarrel. "There was no question that Whistler had behaved badly to Leyland," she told Elizabeth Pennell, "though she would not say just how."[199] Nellie Whistler may have confided in her cousin Luke Ionides, who made the elliptical observation some years later that the "disagreement" between Whistler and Leyland "arose from a dispute about a lady, in whom both were interested, but for the public it was merely about financial matters"—a statement that has been taken as evidence of Mrs. Leyland's marital infidelity.[200] Oddly, Leyland himself was not suspected as the source of the rumored sexual misconduct, even though his "immorality and doings with women" were widely acknowledged during his lifetime, and according to his contemporary H. E. Stripe, "he did not appear to care who knew it." Rossetti was aware that Leyland sometimes consorted with "a lady" not his wife, and Whistler must be assumed to have known about the affair as well.[201] Indeed, Leyland's amorous adventures may have provided an oblique subject for *The Loves of the Lobsters*. "I wonder you did not paint the lobsters making love before they were boiled," a visitor remarked upon seeing the picture in Whistler's studio, perhaps discerning its secret significance, if Augustus Hare did not.[202]

It was in breaking the gentlemanly code of silence that Whistler committed an unpardonable sin, an act so dishonorable that scarcely anyone would speak of it to the Pennells. The secret was finally disclosed by Margie Cole, after several failed efforts to persuade her husband to speak on the subject: she frankly admitted that Whistler had set about discovering the details of Leyland's liaisons with the express intention of informing Frances Leyland about her husband's mistresses—a strategy devised to destroy the marriage.

Whistler, it seems, could not bear the thought of Mrs. Leyland siding with her husband, and this further revenge was a means of making her his ally, as she evidently became. It is difficult not to see her, the person with most to lose, as a pawn in this distasteful game, and the whole affair, as the Coles observed, was "most discreditable." Evidently the Pennells concurred, since the episode is left out of the *Life of Whistler*, though it remains unclear whose reputation they endeavored to protect. Alan Cole (who proved willing to talk once his wife had opened the door) told them that when Whistler threatened to publish the facts of Leyland's extramarital affair, Leyland had only laughed, knowing that such a revelation of a man's private life would be viewed by his peers with derision and contempt. His daughter Elinor is said to have preserved the artist's letters on the subject so that if Whistler ever revealed anything against her father, she could publish them to tarnish his own reputation.[203] These have never come to light, and if Whistler kept the corresponding letters from Leyland, they were undoubtedly destroyed by the censoring hand of Rosalind Philip.

Rosa Laura Caldecott, the object of Leyland's affections at that time, lived apart from her husband at Denham Lodge, a substantial house on Hammersmith Road, from 1875 until 1883, the year she gave birth to Frederick Richards Leyland Caldecott.[204] Val Prinsep knew her as the "unhappy lady" who had attempted to deceive Leyland and his family. She had tried to obtain maintenance for her child until she died in 1890. After Leyland's death in 1892, Prinsep told Lord Russell, who interceded on behalf of the orphaned child, that his father-in-law had not acknowledged the boy as his—"indeed the whole history of his conception & birth is so miraculous that it cannot be wondered at that a man of the world should have the gravest doubts."[205] Mrs. Caldecott was also known to Whistler. While in Venice in 1880, he was informed that she and Leyland had visited the studio together a week after the sale of the White House, when they had seen "the lobsters and Ararat 'various.'" The former satire is said to have interested them most, causing them to look at each other "quizzically—though not unhappily quite—perhaps to the lighthearted this is fame." In a letter to Nellie, Whistler refers to the "lobsters and Caldecott pictures" as things Leyland would surely want destroyed, lending further credence to the theory that the works contained references, however obscure, to Leyland's private affairs.[206]

If Whistler cannot be held entirely to blame for destroying the Leylands' domestic life, his actions may well have precipitated its demise. Frances Leyland left her husband in the summer of 1879, after threatening to do so several times. Mrs. Cole, who may have exaggerated the numbers for the sake of the story, recalled that Leyland's lovers and illegitimate children had started to call at Prince's Gate demanding money, which Leyland almost invariably supplied. (Perhaps the notion that he was populating the metropolis with befrilled babies lies behind Whistler's theme of Noah's ark.) Finally, it seems, Frances Leyland's humiliation became intolerable. William Rossetti, having learned the regrettable news from the Leylands' former governess Louisa Parke, noted in

FIG. 6.31 *Frederick Richards Leyland,* 1879, by Dante Gabriel Rossetti (1828–1882). Pastel on paper, 64.2 × 46.3. Private collection.

his journal on 23 June 1879 that "Mrs. Leyland is now definitely parted from her husband (the fault being his, it seems)."[207] They may have kept the separation quiet until after Fanny Leyland's wedding in early July to James Stevenson-Hamilton, "a man twice her own age with 3 kids ready made," according to Gabriel Rossetti, who produced a portrait of the bride's father wearing a white ruffled shirt as a wedding present (fig. 6.31). But by the end of August, word was out.[208]

The Leylands' agreement stipulated that Frances be granted "a settled separate income" of two thousand pounds a year, with an additional thirty-five hundred pounds provided for a house and "equipage," so Rossetti was surprised to learn from Leyland in August that she had taken cheap lodgings in Liverpool and "keeps no carriage and makes no show of any kind."[209] She was to pay the price of independence in being excluded entirely from the family's affairs: by leaving her husband, Frances Leyland also lost her children, who in these circumstances were considered the property of their father. Freddie, the eldest, was by then employed in the Leyland firm, and the next year he married Sybil Lake Beadle, the daughter of "a connexion" of Val Prinsep's. Florence, however, was just on the verge of coming out in society, and Elinor was not yet sixteen.[210] The irrevocable loss occurred in March 1880, when Fanny died in Italy after giving birth to a premature child.[211] Leyland and his other daughters happened to be there when she died, but Frances Leyland, Whistler was astonished to hear, had not even been permitted to attend the funeral.[212] Leyland himself was completely brokenhearted. "Poor fellow!" Rossetti reflected. "His affections are really most strong where they take root."[213]

As for Whistler, by the end of August 1879 he was "bust up altogether," Rossetti was informed, "though his late bankruptcy has somehow left him still stemming the tide." He was finally planning the trip to Venice postponed so many times, initially because of the Peacock Room and then by other traumas, "and his goods, such as they are, will be sold up by auction," Rossetti wrote to Jane Morris. "Watts [-Dunton] is of opinion that Yankeeland will soon get him again for good."[214]

The fate of *The Three Girls,* the painting that had delimited Leyland's patronage, was still to be determined. Back in July 1877, in an effort to settle their business affairs, Whistler had distinguished it as "an imaginative picture which can only be finished under certain conditions" (app. 20), to which Leyland responded that he had paid for the painting nine years earlier, "and however imaginative the work may be, it is high time now that it should be delivered if it is ever to be finished." Whistler having made it impossible for the painting to hang, as planned, in the dining room at Prince's Gate, Leyland intimated that he meant to sell it upon receipt (app. 21). Whistler apparently decided not to give him that particular satisfaction: he revealed his plan to retain

The Last Alembic

the picture in February 1878, writing Watts-Dunton that he meant to repay Leyland the four-hundred-guinea advance, though he scarcely knew how.[215]

That spring, just before the opening of the second Grosvenor Gallery exhibition in 1878, Whistler held a "show day" in his studio, and *The Three Girls* was among the three works on display. Way remembered that even though Whistler "had been at work upon this subject for years," it remained unfinished, with the figures still nearly in the nude. In July, Whistler moved the painting with him to the White House, where the art dealer Walter Dowdeswell saw it on the easel, and an American reporter who saw it some months later defined it as a work in progress "for the exhibitions."[216] Finally, in the grim month of May 1879, *The Three Girls* became part of Whistler's bankrupt estate, listed not among his assets but as one of two unfinished works removed to his brother William's house on Wimpole Street. In their incomplete state, those pictures were declared to possess an indeterminate, or inconsequential, monetary value. By failing to finish *The Three Girls*, therefore, Whistler succeeded in keeping it out of Leyland's hands; but that act of passive vengeance only precipitated its inevitable ending, since the ideal of perfection Whistler set for the painting was by definition unattainable.

The Three Girls was soon to disappear in mysterious circumstances created, in all probability, by C. A. Howell. A gifted raconteur and prodigious liar, Howell was also possessed of keen business instincts and tremendous personal charm, and was at one time or another the intimate friend of nearly all the leading figures in this story. Those relationships inevitably foundered over his alleged dishonesty or double-dealing, although his intrigues were occasionally well-intentioned. He clearly helped Whistler through this period of acute financial crisis—encouraging him to print his etchings, taking on his debts, managing his affairs, and according to one contemporary, keeping his son Charlie from starvation. Howell's account books from the latter 1870s note sums lent to Whistler, to Maud Franklin, and to "Mrs. Abbott" (the name used by Jo Hiffernan), and reveal that between the time of the quarrel with Leyland and the flight to Venice, Whistler lived "from hand to mouth, in a generally impecunious condition."[217] By August 1879, Howell and Whistler were devising a plot for *The Three Girls*: Howell asked the artist to "state 'distinctly and in writing'" exactly what he would give in exchange for the painting if Howell secured it on his behalf from the bankrupt estate.[218]

Whistler, then, may not have been informed of all the facts, but he should not have been surprised when *The Three Girls* went missing from the sale. Howell tended to attract "portable property," W. Graham Robertson remarked, as a magnet attracts steel.[219] From Venice, Whistler voiced suspicion of Howell's involvement, though he dearly wished the "little purloining business" might rather be traced to Leyland: "We would have him hanged or transported like his father!"[220] Howell, in fact, managed to remain in the good graces of both Whistler and Leyland during this period, and might easily have played them against each other. Perhaps he stole *The Three Girls* for one, planning to

FIG. 6.32 *Pink and Grey: Three Figures* (y89),
ca. 1879. Oil on canvas, 139.7 × 185.4.
Tate Gallery, London.

keep it "for future transaction" with the other, as Whistler suspected. The
fragment called *Girl with Cherry Blossom* (see fig. 3.32), which turned up at
Dowdeswell's gallery in 1879, was probably cut from the purloined canvas.

The situation was further complicated by the existence of an impostor, "a
rough copy, or commencement of a copy," of *The Three Girls* (fig. 6.32). Whistler
claimed to have made it during one of his final days in the White House, just
before the original was seized by his creditors, but signs of changes to *Pink and
Grey: Three Figures* (as that "rough copy" came to be called) indicate that it was
neither literally copied nor dashed off in a day.[221] We know from T. R. Way
that Whistler began several versions of *The Three Girls*, so *Pink and Grey* may be
one of those earlier canvases hastily completed in 1879. It was a good enough
imitation to fool Frederick Jameson, who had witnessed the real work in
progress on Great Russell Street, but not Thomas Armstrong: he considered
the copy to lack the quality of the original, painted at what Armstrong con-
sidered the high point of Whistler's career.[222] It is in some ways unfortunate
that the copy did survive, for though it gives a valuable indication, to scale, of
the intended composition of *The Three Girls*, it conveys little of the perfect beauty
Whistler had in mind. That ideal, as both Way and Armstrong acknowledged,

was better represented by the oil sketch called *The White Symphony: Three Girls* (see fig. 2.7), which somehow escaped the indignity of the sale and came into Way's safekeeping.

Because it was painted after his declaration of bankruptcy, Whistler maintained that *Pink and Grey* belonged indisputably to him. But at the final meeting of his creditors, Leyland fought to keep the copy for himself, and the canvas, over the strenuous objection of Thomas Way, was ultimately rewarded to him.[223] The picture would at least be better off with Leyland, Way concluded, "than in the hands of a rascally dealer who might have bought it had it been put up for sale."[224] Yet Leyland himself is plausibly supposed to have "afterwards sold it for a trifle to a dealer to spite Jimmy." A subsequent owner of *Pink and Grey* told Charles Freer that when the picture was exhibited on Bond Street some years later, "Jimmy still thinking it was Leyland's & that it was for sale disowned it."[225] Whistler did declare in print that he wanted to secure the canvas in order to preserve his rightful place in the eyes of posterity. In this case, Whistler said, "To destroy is to remain."[226]

I*N EARLY SEPTEMBER* 1879, even as he arranged his route of exile and prepared to sell his house and personal possessions, Whistler appeared to Alan Cole "in great spirits"—if still "full of venom against Leyland whom he regards as 'the Author' of his disagreeables." It was in that mood of energetic malice that Whistler produced a problematic painting of "a demoniacal Leyland playing piano," as Cole described it, "Ye gold scab—with an irruption [sic] of *Frilthy* Lucre—forcible piece of weird decoration—hideous—displaying bitter animus" (fig. 6.33).[227] Whistler's rancor toward Leyland had spilled onto a canvas, leaving an imprint of his former patron as a person beneath contempt, a grotesque hybrid of man and beast horrifically deformed by greed.

In *The Gold Scab*, Leyland is portrayed as a mangy peacock perching on the gabled roof of Whistler's White House, planting his scaly fingers on the keyboard of an implausible piano. The horrified expression on his face suggests that he has only just become aware of the repulsive transformation taking place. The starched frill of his shirtfront has become a malicious motif, crowning his head like a cock's comb and embellishing the single note of his musical score with its punning, acronymic title (FRiLthy). The tails of his elegant coat have been transfigured into the trampled train of a peacock, and the scattered coins that lent wit to the peacock mural are gathered here in money bags emblematic of Leyland's crime. The turquoise tones and peacock-feather patterns that rise above the creature's buckled claws like puffs of poisonous gas render *The Gold Scab* a feverish hallucination of the Peacock Room. Whistler himself appears as a butterfly sporting a whiplash stinger, the barb aimed directly at the back of Leyland's neck.

FIG. 6.33 *The Gold Scab: Eruption in Frilthy Lucre* (Y208), 1879. Oil on canvas, 186.7 × 139.7. Frame designed by the artist, ca. 1872–73. Fine Arts Museums of San Francisco; gift of Mrs. Alma de Bretteville Spreckels through the Patrons of Art and Music (1997.11).

The Gold Scab was conceived as a prank. It was to take the place of *The Three Girls*, which Whistler knew Leyland would particularly look for when he came to inspect the studio in his capacity as creditor. The irony of the substitution could not have been ignored: instead of *The Three Girls*, which was to have been the most beautiful painting of them all, and the product of perfect harmony between the patron's desire and the painter's ambition, Leyland would find this repellent reminder of an emotional wound that would not heal. To make sure it was recognized as the masterstroke of their vendetta, Whistler designed *The Gold Scab* to occupy the frame embellished with hawthorn petals and musical notes to encompass that ill-fated commission.

But except by Leyland and perhaps a few other intimates, the picture's significance was not understood. A contemporary newspaper account describes "a demon sitting on the ridge of a Gothic house playing the piano, on which is spread out a morceau entitled 'The Gold Scab: An Eruption. By Filthy (or Frithy) Lucre [*sic*].' To the uninitiated in art the sarcasm seems a great deal better than the painting, but, if the work be Mr. Whistler's, it is puzzling to understand how he should have chosen such a subject."[228] Indeed, as Arthur Symons observed, *The Gold Scab* was Whistler's "one expression of a personal feeling so violent that it overcame his scruples as an artist."[229] So intent was he on shocking Leyland that Whistler failed to recognize how, in the process, he was satirizing himself: with its musical theme and carefully controlled color tones, *The Gold Scab* stands as a caricature of his serious works, as Kirk Savage has argued, those "harmonies" and "arrangements" calculated to be free from feeling.[230]

As a work of art remaining in the White House, *The Gold Scab* became part of the inventory of Whistler's estate, subject to liquidation along with other assets. Leyland is said to have sued to keep it out of the sale.[231] That action may have excluded it from the auction of Whistler's furniture and effects held at the White House in mid-September but did not prevent its appearance with Whistler's other artworks at Sotheby's in February 1880. Discreetly described in the catalogue as "A Satirical Painting of a Gentleman styled *The Creditor*," it failed to attract much attention at the sale, according to E. F. Benson, "unfortunately for the success of the dainty revenge."[232] Dowdeswell, a printseller then trading at 36 Chancery Lane, purchased *The Gold Scab* for the paltry sum of twelve guineas, and it was Rossetti's impression that Howell was somehow involved in that transaction.[233] From Dowdeswell's, the painting was sold to Captain Henry S. Hubbell, who reportedly proposed presenting it to Leyland's London club; it reappeared on the market in 1882, when E. W. Godwin announced its sale in the *British Architect*. He made no mention of Frederick Leyland, but described the picture as a portrait of the devil "in the form of a peacock-man."[234] A former framemaker of Whistler's is said to have bought *The Gold Scab*, perhaps for the sake of the frame, then sold it in the early 1890s for ten pounds or so to the artist G. P. Jacomb-Hood. To Whistler's immense satisfaction, Jacomb-Hood refused to part with the painting even when offered eight hundred pounds in 1892, the year of Frederick Leyland's death.[235]

The Last Alembic

The value of Whistler's works was escalating by then, as a result of the sale of his mother's portrait to the Musée du Luxembourg in Paris and the portrait of Carlyle to the City of Glasgow, and Whistler declared that with those two paintings in public museums and *The Gold Scab* safe with Jacomb-Hood, his fame was secure.[236] His assertion that the three were equally important was a pretense: Whistler never expected *The Gold Scab* to survive the sale of his estate. At the time it was made, his only ambition for the painting was for it to inflict immediate pain on Frederick Leyland. He did not bother applying a ground to the canvas that might have prevented, or at least postponed, the disfigurements of age; consequently, paint has seeped through the permeable surface of the fabric, leaving the blue tones dull and mottled and the white house and piano keys unpleasantly tinged with brownish underpaint.[237]

Had *The Gold Scab* disappeared along with *The Three Girls*, as Whistler predicted, the story of the Peacock Room would have ended with the gilded allegory on the wall above the sideboard, and the artist might have gone down in the annals of art in much the way that he intended — as the offended party in the dispute, who took an appropriate revenge in art. But with *The Gold Scab*, Whistler carried the metamorphosis too far. Its survival lends an ironic twist to his means of retribution, for it now appears less a caricature of Leyland than an expression of Whistler's paranoid perception. Indeed, in its awfulness, the painting compels pity for the patron and undermines the artist's hopes for his own posthumous reputation. That is why Charles Freer, twice offered *The Gold Scab*, could not bring himself to buy it — even though, as the Pennells point out, it would have completed the Peacock Room story. "The only interest I could ever feel in the picture," Freer wrote the London dealer William S. Marchant in 1904, "would be to wish it, for the sake of the artist's reputation, quietly destroyed." He could not help feeling that "everything from Mr. Whistler's brush should appeal in every way to the finest sentiments of the human mind," and the exquisiteness of thought and execution he associated with the master's work was markedly absent from *The Gold Scab*.[238] The painting continues to unsettle admirers of Whistler's work, for it compels confrontation with the most disagreeable aspects of the artist's personality — characteristics that might otherwise be ignored in the interests of aesthetic appreciation.

Painting *The Gold Scab* might have been expected to purge Whistler's mind of malice, yet he had no desire to let go of the hideous picture once it was completed. Certain of its imminent destruction, Whistler had it photographed shortly before departing for Venice. According to Otto Bacher, that reproduction became the only decoration in his rooms at the Casa Jankovitz, apart from a picture of himself "with a most disagreeable sneer on his face" (see fig. 6.10), which was how he said he wanted to be regarded by his enemies. Bacher, presumably encouraged by Whistler, understood *The Gold Scab* to be the "central figure subject in the Peacock Room."[239] Jacomb-Hood also sustained the impression that the work was intended to hang there, above the mantelpiece, and years later, when *The Gold Scab* reached its final resting place in San Francisco,

a reporter described it as "Whistler's famous rejected panel for the peacock room." The dealer in possession of the painting planned to prepare a special gallery for its exhibition, decorated to resemble the Peacock Room itself.[240] The persistence of that misunderstanding testifies to the difficulty of reconciling the horrible *Gold Scab* with the beautiful interior it so pointedly recalls. Even Whistler, nourishing his animosity toward Leyland with the image of *The Gold Scab*, found himself in "a pleasant frame of mind" in Venice when he thought of the true artistic achievement that had inspired his revenge. One cold winter's day, he attended a "grand high mass in St. Marc's and very swell it all was," he wrote to Nellie Whistler, "but do you know I couldn't help feeling that the Peacock Room is more beautiful in its effect!"[241]

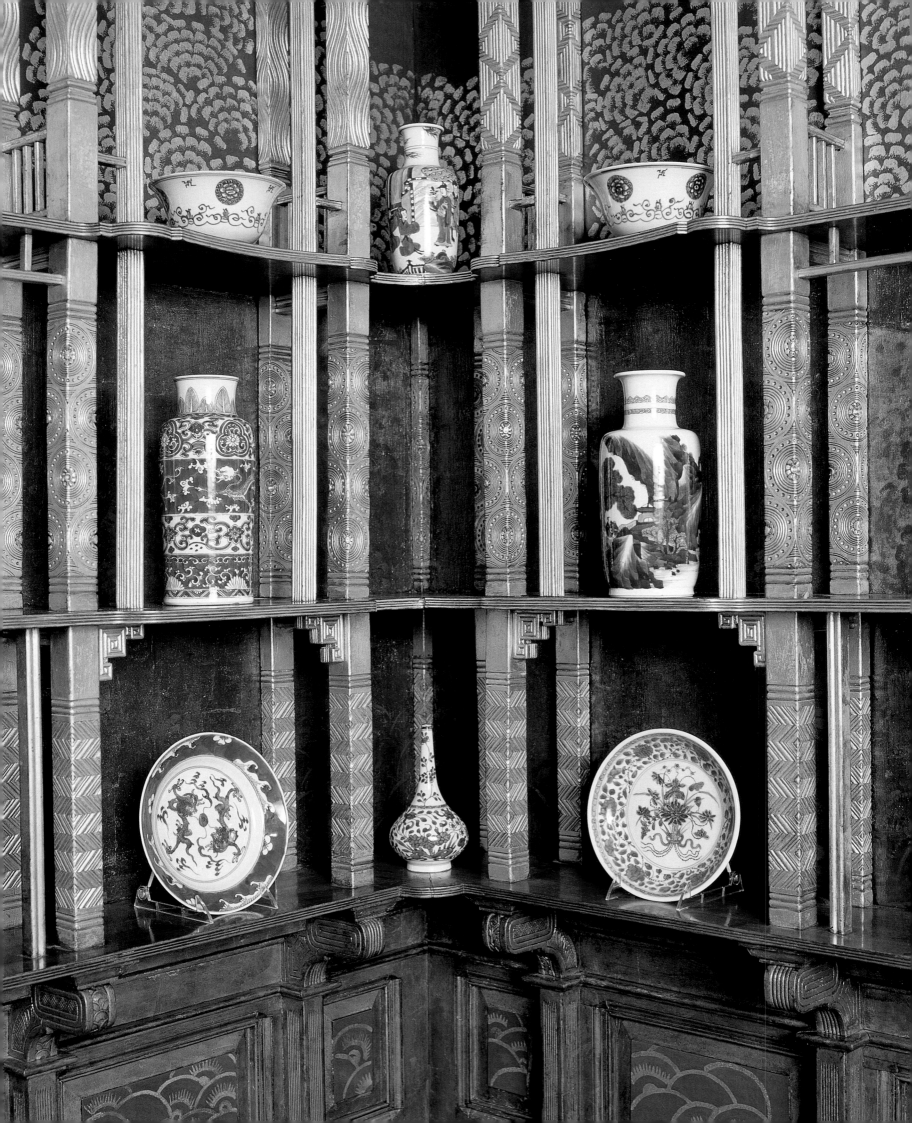

7 The Heirloom of the Artist

THE MOST REMARKABLE thing about the Peacock Room, as the *Daily Telegraph* observed in 1904, may simply be that "the men have vanished, but the work remains."[1] When a painting goes out of fashion, it can be sold or removed to the attic, but when the aesthetic appeal of a room wears off, it is usually redecorated. Consequently, few Victorian interiors have survived intact to provide relevant schemes for comparison. A notable exception is the Arab Hall (fig. 7.1), designed in 1877 by George Aitchison (with ornament by William De Morgan, Walter Crane, J. Edgar Boehm, and Randolph Caldecott) as a showcase for Frederic Leighton's Syrian and Iznik pottery and tiles; it was the only room of Leighton House (now a museum) to retain its original decoration through the postwar reaction against Victorian taste.[2] Nothing remains, on the other hand, of the Japanese Parlor in William H. Vanderbilt's "palace" on Fifth Avenue (fig. 7.2), the crowning achievement of the New York decorating firm Herter Brothers. From photographs and detailed descriptions published in 1883, soon after the house was completed, we know this was an American interpretation of an Anglo-Japanese interior, with shelving fashioned as "an Oriental *étagère*," not unlike Jeckyll's for the Peacock Room, and a stained-glass window by John La Farge appropriately adorned with a peacock, "fantastic and gorgeous rather than possible, . . . a bird of eastern fairyland."[3] How the Peacock Room itself managed to withstand the threat of destruction—even when the instincts of taste rebelled against it, and often in the absence of a single living champion—remains something of a wonder.

Frederick Leyland, the first owner of the Peacock Room, died on 4 January 1892, at the age of sixty. Murray Marks believed that "the antagonism between Whistler and Leyland, and the disappointment that Leyland had when he came home and found what had happened, had a great deal to do with his premature decease"—a neat but implausible conclusion to the story of the Peacock Room.[4] No one else ventured to suggest that reverberations from that quarrel contributed to Leyland's sudden death on a London underground train, but the authors of his obituary notices recounted the circumstances in morbid detail,

So in all time does this superb one cast about for the man worthy her love — and Art seeks the Artist alone.

Where he is, there she appears, and remains with him — loving and fruitful — turning never aside in moments of hope deferred — of insult — and of ribald misunderstanding; and when he dies she sadly takes her flight, though loitering yet in the land, from fond association, but refusing to be consoled.

"Mr. Whistler's 'Ten O'Clock'"

Detail, northwest corner of the Peacock Room.

FIG. 7.1 *Design for the Arab Hall, Leighton House*, 1880, by George Aitchison (1825–1910). Watercolor and gold heightened with white on paper, 63.5 × 43.81. The British Architectural Library, London, Royal Institute of British Architects.

addressing the public's fascination with the abrupt and unceremonious ending of a life that seemed otherwise blessed with good fortune.

By the time he died, Leyland was in possession of twenty-six steamers trading in American and Mediterranean ports, which in size and efficiency were unsurpassed by any vessels afloat.[5] The service to the United States inaugurated in 1876 had expanded after 1888, with new ships transporting cattle from Boston to Liverpool. Together with other importers of American livestock, Leyland's company came under attack from Samuel Plimsoll, who alleged that the animals were routinely mistreated and arrived on British shores in lamentable condition; when Leyland's lawyers deftly proved that Plimsoll's charges were exaggerated, the inquiry was dropped, the firm exonerated, and Leyland lauded as hero of the cause. Thereafter, his opinion was held in such esteem that parliamentary committees routinely solicited his advice on shipping matters.[6] Although Leyland retired at the end of the 1880s, leaving his son Freddie in command, he would periodically "swoop down from London" to ensure that his company continued to run at "concert pitch."[7]

Leyland's only other professional interests resided in the new technologies of the late nineteenth century. In 1889 he was named president of the National Telephone Company, the occupation given in his obituary in *The Times*, and he assumed a leading position in the Edison & Swan United Electric Light Company. Because those concerns were centered in London, Leyland spent most of the last years of his life at 49 Prince's Gate. After the house had been fully remodeled and appointed, Leyland's patronage of modern art dropped off. He explained to Rossetti in 1880 that he had already spent so much on art he didn't care to purchase any more, and would "fill up the new room"—Richard Norman Shaw's drawing-room extension—"with pictures from the office."[8] Indeed, between his holdings in London and in Liverpool, Leyland already possessed "a considerable proportion of the masterpieces of the most intellectual and cultivated branch of the modern English school," F. G. Stephens observed in 1882, taking special note of the paintings by Rossetti, eight of which were lent to the Royal Academy the following year for that artist's memorial exhibition.[9]

Yet Leyland continued commissioning pictures from Edward Burne-Jones, who was at work on a long-promised painting of sirens ("that will not be very big and will need to be very pretty") when the patron died.[10] As Rossetti's art had dominated 49 Prince's Gate, so Burne-Jones's set the tone for Leyland's new residence in Liverpool, Woolton Hall. The Leylands had been required to surrender Speke Hall in 1877, when Adelaide Watt came of age and determined to occupy her ancestral home. They moved out in June, closing their Elizabethan idyll around the time their family began to break apart. Woolton Hall, an imposing house in the same vicinity, had been built for the Molyneaux family in 1704 and enlarged around 1775 by Robert Adam; in the earlier part of the nineteenth century it was occupied by William Winstanley, a Whistler family connection.[11] The Watt trustees had purchased the property as an invest-

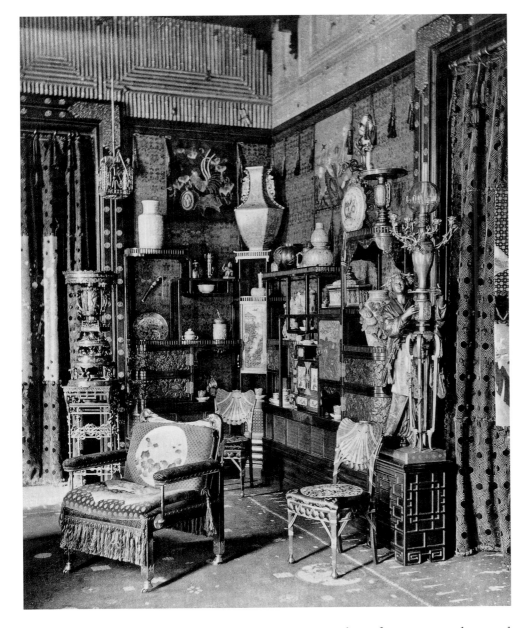

FIG. 7.2 William H. Vanderbilt's Japanese Parlor, from *Mr. Vanderbilt's House and Collection* by Edward Strahan [Earl Shinn], New York, 1883–84.

ment in 1871, and in selling it to Leyland six years later for nineteen thousand pounds, the estate sustained a substantial loss.[12]

A few years after acquiring Woolton Hall, Leyland bought yet another residence, The Convent, or Villette, near Broadstairs in Kent. This was a modern house of neo-Gothic style, which Shaw had been engaged to remodel and expand. Just after Leyland's death, Shaw wrote to Murray Marks about how Leyland had been looking forward to living in that house; he added that Marks was "to have hung the tapestry and done all sorts of things."[13] Leyland's house in Broadstairs, then, like the one at Prince's Gate, might have become a lucrative collaboration; perhaps its untimely loss resurrected Marks's resentment against Whistler for commandeering the Leyland dining room in London, inducing his irrational blame of the artist for their patron's death. Villette was also the residence of Annie Ellen Wooster, who seems to have supplanted Rosa Caldecott in Leyland's affections.[14] Miss Wooster's children were

Fred Richards Wooster, born in Dover in 1884, and Francis George Leyland Wooster, born in Ramsgate in 1890.[15] The boys were brought up to regard Frederick Leyland as their guardian, but they are identified in his will as Leyland's "reputed" sons and were handsomely provided for.[16]

On the last morning of Leyland's life, Val Prinsep relates, before leaving Prince's Gate "never to return alive," he appeared in perfect health, bounding up the stairs to the drawing room to gaze once more on a "beloved bronze," a statuette attributed to Donatello that had just been purchased from Murray Marks.[17] Sometime during the day, Leyland arranged for the transport of three new chimneypieces to Villette, then went to his office in the City to transact business. At five o'clock, he and the managing director of the National Telephone Company, Lieutenant-Colonel Robert R. Jackson, walked briskly to the Cannon Street station of the London underground and boarded a first-class carriage. Minutes later, Leyland fell silent, put his hand to his throat, and gasped for breath. Jackson unbuttoned Leyland's overcoat, which seemed to bring relief, and decided to take him home; but when Leyland became unnaturally pale and still, Jackson called for help. The railway guard who lifted him from the train at Blackfriars station observed that Leyland "was on the point of death" and a doctor was called to the scene, but "it was unhappily clear" by the time he arrived "that Mr. Leyland had expired," having died in the arms of the station inspector for the District Railway.[18]

Freddie Leyland was summoned from Liverpool. Presumably he told his sister Elinor; Florence was abroad and received the news in Naples.[19] Because their father had died so unexpectedly and was known to possess a large fortune and more enemies than friends, there may have been suspicion of foul play. But at the inquest held on 7 January 1892, it emerged that Leyland had been diagnosed with a weak heart six years earlier, and the physician who attended at Blackfriars deduced from the case history that his death had been due to syncope from heart disease; the jury put any rumors to rest, returning a verdict of death from natural causes.[20] The following day, Leyland was laid to rest at Brompton Cemetery. His coffin, made of polished oak with brass mountings and cloaked with flowers sent from Leyland's staff in Liverpool, was borne in an open hearse and followed by the private carriages of the principal mourners: the three surviving Leyland children and Francis Herbert Leyland Stevenson-Hamilton, the eleven-year-old son of Leyland's deceased daughter, Fanny. Others invited to the funeral included John Bibby Jr., the son of Leyland's former business partner, the composer Luigi Albanesi, Lionel Robinson, Burne-Jones, and Murray Marks.[21] Leyland's widow was not present, nor was any member of the family at Broadstairs.

Two weeks later, *Piccadilly* reported that the reading of Frederick Leyland's will was "awaited with interest." Indeed, it was said that if Leyland had only lived a little longer, he might have been the richest man in the world.[22] As it was, the value of his estate was sworn at £916,153, or some $180 million in modern terms. Of that fortune, Frances Leyland inherited nothing, as previous

provisions had been made for her future, and the three Leyland children received equal legacies. The two daughters had already accepted part of their inheritance in the form of marriage settlements—Elinor in 1889, when she married the stockbroker Francis Elmer Speed, and Florence in 1884, when she married her father's friend Val Prinsep.[23] Freddie's share (or forty thousand pounds of it) was set aside through a "spendthrift clause," preserving the legacy for his wife and children in the unhappy event of bankruptcy.

Leyland's will also provided for Annie Wooster, who was to inherit all the art, furnishings, household effects, horses, and carriages attached to the house where she lived at the time of his death. Because Villette was still under renovation, this bequest may have been smaller than intended, but Miss Wooster was also to receive the income from twenty thousand pounds (with a guaranteed interest of four percent) until her marriage or her death, whichever came first. The same sum was held in trust for each of her two children. To raise capital for those additional bequests, the trustees (Florence Prinsep and Elinor Speed) were instructed to sell from the estate whatever was required, as soon as practicable after Leyland's death. Six months later, the house at 49 Prince's Gate, with all its art and furnishings, was advertised for sale, reviving stories about Whistler and the Peacock Room that might otherwise have receded quietly into the haze of history.

WHISTLER MAY never have seen the Peacock Room again after leaving London late in 1879, but he exercised his memory by recounting the myth of its creation for his friends, illustrating the story with sketches of salient details. The practice had begun in Venice, where Otto Bacher was treated to both verbal and visual descriptions of the Peacock Room.[24] Upon returning to London and resettling on Tite Street, across from the White House, Whistler sketched for his neighbor Frank Miles one of the shutter compositions and the infamous peacock panel, adding a new touch of malice to the patron peacock (fig. 7.3). Perhaps the fullest visual account was given to the artist Harper Pennington eight years after the event. One evening at the Beefsteak Club, Whistler dashed off four sheets of sketches detailing the designs on the walls, ceiling, and shutters of the Peacock Room, including one view of a window with the peacock folded out of sight. Pennington cherished the drawings and eventually presented them to Isabella Stewart Gardner for preservation in her Boston "palace." The Pennells made the mistake of publishing them as "sketches for the Peacock Room," thereby propagating the "foolish legend" that Whistler had employed them as preliminary studies, when in fact they represented a "really wonderful feat of accurate recollection."[25] Whistler's memory of the Peacock Room had started to recede by the end of 1898, when in pencil sketches made for Albert Ludovici at Frascati's restaurant he rearranged some architectural

features and struggled with the configuration of the peacock on the right-hand shutters (fig. 7.4). Even so, the drawings capture the exuberance of the original.[26]

The public never entirely forgot the Peacock Room, even after the commotion attending its creation died down. Lionel Robinson recalled how people continued to come from far away to see it, and he commended Leyland's liberality "in permitting those to whom it would be a source of interest or instruction to have access to this remarkable production of Mr. Whistler's art."[27] Helen Lenoir, who asked to see the Peacock Room in the 1880s, told Whistler she thought Leyland could hardly refuse to grant admission, and it appears he rarely did. The writer Vernon Lee paid a call in 1883 and wrote to her mother that she had "never seen anything so beautiful and fairylike." The artist William Rothenstein visited one day with Arthur Studd, when Leyland himself was not at home; they were admitted "by a major-domo, with powdered hair, yellow livery with heavy knots across the shoulders and noble silk-clad

FIG. 7.3 *Sketch of a Shutter and Fighting Peacocks* (M1603), 1880s or 1890s. Crayon on paper, 22.7 × 17.8. Library of Congress, Washington, D.C., Prints and Photographs Division, Pennell Whistler Collection.

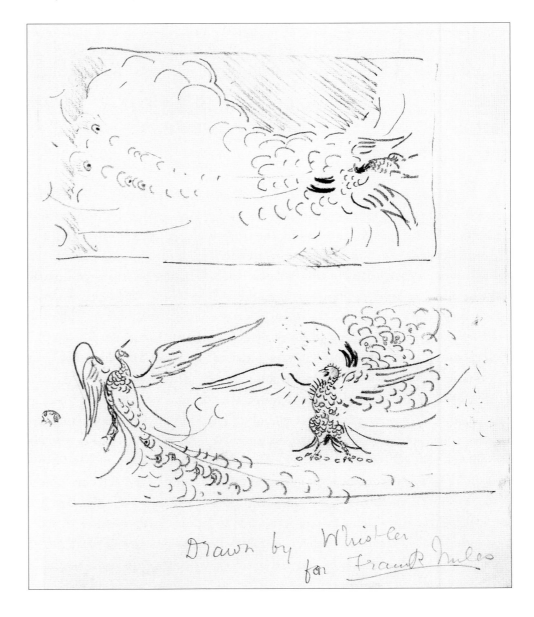

The Heirloom of the Artist

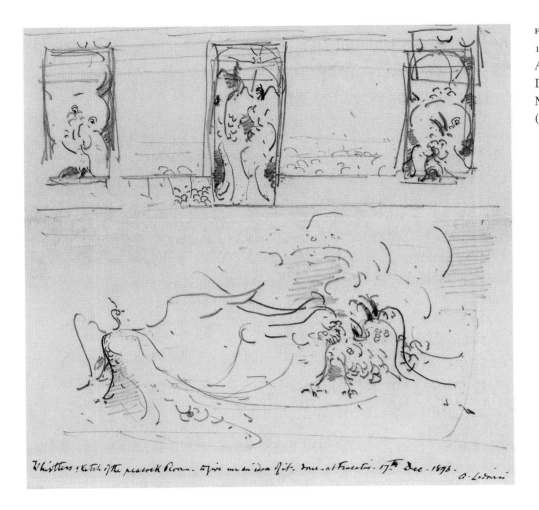

FIG. 7.4 *Sketches of the Peacock Room* (M1581), 1898. Pencil on paper, 18.7 × 17.8. The Art Institute of Chicago, The Charles Deering Collection; gift of Mrs. Chauncey McCormick and Mrs. Richard E. Danielson (1927.5883).

calves," Rothenstein recalled, "so impressive a figure, that Studd, in presenting a letter of introduction at the door, instinctively took off his hat."[28] Even pilgrims sent by Whistler were graciously accommodated. Lois B. Cassatt, who posed for her portrait, *Arrangement in Black, No. 8*, in April 1883, told Elizabeth Pennell that Whistler had passed the time by recounting the story of the Peacock Room, which he afterward arranged for her to see. Frederick Leyland received her and her husband "very cordially," Cassatt recalled, "and gave us his side of the controversy," which unfortunately went unrecorded.[29]

More often, it seems, Whistler slipped his friends through the doors of Prince's Gate with the help of an obliging go-between: Flossie Boughton (later Mrs. Robb), a relation of the American artist George H. Boughton and a friend of Leyland's daughters. "My very charming Flossie," begins the letter that seems to have initiated the practice, "I want you to do something for me — and you can I am sure — for you are not only lovely and delightful but with wit enough in your little head to succeed in whatever you undertake." Miss Boughton, who was sure to be invited to an upcoming dance at Prince's Gate, was asked to procure "tickets" for two gentlemen who wanted to see the Peacock Room, because "les amis de nos amis sont nos amis," Whistler explained. Several such letters were written in the 1880s, one requesting an invitation for the sculptor Waldo Story to "the very next Peacock room ball."[30] Apparently these were regular

events. William Rossetti attended one on Valentine's Day 1882, and Walter Crane recollected a fancy-dress party held at Prince's Gate for artists and their families: the costumes created a spectacle in the handsome house, with "so decorative a background as the peacock room, which was used for the supper."[31]

One of the more intriguing episodes in the history of the Peacock Room took place in July 1885, when John Singer Sargent sent some friends from Paris to visit Henry James. They were Prince Edmond de Polignac; Samuel Pozzi, the society doctor and book collector; and Count Robert de Montesquiou-Fezensac, the celebrated dandy described by Sargent as "unique extra-human," whom Whistler was to portray in 1891 as another "arrangement" in black.[32] The Frenchmen were "yearning to see London aestheticism," and James obligingly showed them paintings by Rossetti and Burne-Jones; but in that "esthetic salad," as Montesquiou described the experience, Whistler was to be "the principal leaf."[33] Dining together at the Reform Club, he and Montesquiou formed an instant bond of mutual adulation, and Montesquiou expressed a longing to see the Peacock Room. He may have read about it in Théodore Duret's recently published *Critique d'avant-garde*, a collection of essays that included one on Whistler, extolling the elegance and originality of "La Chambre du Paon."[34] On Whistler's instruction, James enlisted the assistance of Flossie Boughton, writing that his French visitors hungered "to behold the mystic apartment." James invited her to join them at Whistler's house for Sunday lunch. James himself could not be there, which made it awkward to issue that invitation, "but on the whole," he reflected, "nothing that relates to Whistler is queerer than anything else." In the event, Whistler served fried eggs, which Montesquiou remembered as attractive "arrangements" in white and yellow, and although there is nothing more to document the episode, we may suppose they eventually reached their destination—for Miss Boughton, Whistler said, never let him down.[35]

Another European aesthete who visited the Peacock Room during the 1880s was the Belgian critic Octave Maus, whose article on Whistler's work published in the September 1885 *L'Art Moderne* (of which he was editor) named the decoration one of the curiosities of London. Apart from a speculation that *La Princesse du pays de la porcelaine* depicts the mistress of the house, Maus's critique is sensitively written and surprisingly well informed. It also contains the first reference in print to the legends that were beginning to gather around the Peacock Room. Maus supposed that only the artist's more malicious acquaintances perceived an allegory in the mural of the fighting peacocks and recognized Whistler's likeness in the bird that "examines his adversary, his head thrown back with a mocking air, ready to peck at him." He himself regarded the mural as simple decoration and considered such narrative interpretation slanderous—the words of those who wished to impute more misdeeds to Whistler than he had actually committed.[36]

The effort to fashion an understanding of the Peacock Room separate from the artist's troublesome personality was already under way in London.

E. W. Godwin had written a letter that summer to the *Court and Society Review* attempting to return attention to Whistler's qualities as a craftsman, as evident in "the highest decoration the modern world has seen." The Peacock Room, Godwin declared, "is a poem and a series of pictures, though never, for an inch of space, failing in its unity or entangling a link of the chain of beauty the great artist forged for the house in Prince's Gate."[37] Unity was also the theme of Janey Sevilla (Lady Archibald) Campbell's treatment of the room in *Rainbow-Music; or the Philosophy of Harmony in Colour-Grouping*, published in 1886:

> Whether trailed on the battle-ground or swirling in the air, each shattered feather has its scientific value in the general scheme, as in a fugue. It is, in other words, contrapuntal painting, for under infinite changes, the air, or theme, pervades the whole composition. In the grand result we see enforced under the crown of Unity the laws of permutation, combination, variation. The artist himself describes it as a harmony in Blue and Gold.

Lady Archibald was a friend of Godwin's, and she alludes to him as the "authority" who had dismissed a judgment of the Peacock Room as japanesque, "the only term then in vogue for anything new." Assuming the stance of a cultural historian, she also acknowledges that the episode remained vivid in the minds of her contemporaries. Those who had not seen the Peacock Room in person might still know the scheme through hearsay, she supposed, or "remember the journalistic controversy which raged at the time of its creation—how the nationality of the wondrous peacocks was disputed—how their glories were preached from the pulpit."[38]

But the story of the Peacock Room was already growing muddled through misunderstanding and murky recollection. An 1883 letter to the editor of *Society* endeavored to correct a previously published misconception that the balustrade from Northumberland House survived at "Palace Gate" by correctly identifying the house as one on Prince's Gate, the same that held the celebrated Peacock Room. The author might have been the first to reveal the meaning of the fighting peacocks in the British press, though he mistook "the melancholy bird with drooping tail" for the patron.[39] Inaccuracies were proliferating by 1884, when the *Plumbing and Decorating Chronicle* printed a paragraph more fictitious than factual, taking almost the tone of a fairy tale:

> The "Peacock" drawing-room of Thos. Layland, Esq. shipowner, of Liverpool, at Queen's Gate, London, is hand-painted, representing the noble bird with wings expanded, painted by an Associate of the Royal Academy, at a cost of 7000l., and fortunate in claiming Mr. Layland's daughter as his bride, and is one of the finest specimens of high art in decoration in the kingdom. The mansion is of modern construction.[40]

Evidently, the hapless correspondent was under the impression that Val Prinsep,

A.R.A.—who had lately made the news by marrying Florence Leyland—was the author of the Peacock Room.

It was that egregious misattribution, rather than the other errors of name, address, and price, which provoked a response from Whistler that was to become among the best-known of his letters to the press. His avowed intent was to correct the record, "that justice may be done, the innocent spared, and history cleanly written," yet Whistler addressed his letter to Edmund Yates, or "Atlas," of the *World*, rather than to the obscure, "insidious" journal that had published the mistake. Thus Whistler reprinted a text in a society journal that would otherwise never have been widely noticed (he himself received the article from a clipping service), taking the opportunity to circulate a legend of his own about the Peacock Room—that his work at Prince's Gate had been carried out in secret, and in solitude. "He is not guilty, this honest Associate!" Whistler wrote:

> It was *I*, Atlas, who did this thing—*I alone did it*'—I 'hand-painted' this room in the 'mansion of modern construction.' Woe is me! *I* secreted, in the provincial shipowner's home, the 'noble birds with wings expanded'—*I* perpetrated, in harmless obscurity, 'the finest specimen of high-art decoration'—and the Academy is without stain in the art of its member.

A few years later, Whistler immortalized this egotistical missive by reprinting it in *The Gentle Art of Making Enemies* under the title "Noblesse oblige." This time, rewriting history "cleanly," he expunged all mention of Leyland's name and corrected his own unfortunate misquotation of a line from *Coriolanus*: "Alone I did it" was the fatal vaunt of Shakespeare's uncompromising Roman general, who claimed to have "flutter'd" his enemies single-handedly, "like an eagle in a dovecote."[41]

Among the many enemies Whistler claimed to have scalped in his campaign against uninformed art criticism was the American journalist Theodore Child, who had pointed out, in the American press, some of the paradoxes in Whistler's "Ten O'Clock" lecture. Because he had previously penned an article of praise, Child became in Whistler's mind a Judas, a friend whose betrayal could be bought: "Was it dollars, Theodore, that did it? or were they shekels of the '*Haute Juiverie*'?" The ensuing correspondence was carried out in the pages of the London press throughout the month of January 1887, and it ended with the artist's declaration that he had lifted Child's scalp so adroitly that the critic lingered on in Paris, "a ghastly spectacle," unaware that the trophy had been catalogued and hung with Whistler's gruesome collection.[42]

After that, Whistler might not have expected to hear again from Theodore Child. But in 1889, with remarkable professionalism, the critic proposed

writing an essay on American art at the Paris Exposition Universelle that would include a substantial discussion of Whistler's career: despite everything that had passed between them, Child considered Whistler "the most eminent of all the American artists resident in Europe."[43] Whistler forwarded approval of the plan ("but I should like this time to be taken from an altogether different point of view") and sent ideas for obtaining pictures for reproduction. "What would be a great thing would of course be a reproduction of portions of the Peacock room, which I hear you have been to see. How this could be managed I dont quite see, for as you know, if Leyland had any notion of it, the place would be sealed up forever. Still to the brave all is possible." And he had a plan. After procuring a "burglarious photographer," Child was to bribe the servants to gain admission to the Peacock Room ("I should suppose that the family, or what is left of them are generally out of town in the winter"). He promised to furnish "excellent anecdotes" and material "scientific and other" to accompany the pictures, and pledged to accept full responsibility for the episode. Indeed, he looked forward to Leyland's astonishment at the seamless execution of the crime.[44]

What Whistler didn't know was that Theodore Child already possessed "the run of the shipbroker's house," for he was also drafting an article about 49 Prince's Gate, "A Pre-Raphaelite Mansion."[45] Upon learning of his friendly association with Leyland, Whistler wrote to Child, "I ought not to have forgotten that as Philosopher you might well have frequented this befrilled Philistine — This Criminal of Commerce — even as did Victor Hugo the condamnés à mort — au point de vue de l'Art!" Unable to resist one final sally, he added, "As you sit at the table, you can see your host on the wall! and it is not everyone who may have the joy of dining on roast Peacock any day he likes!!"[46]

Child's article on the Leyland house, replete with facts and anecdotes gleaned not from Whistler, but from Murray Marks, appeared in the December 1890 issue of *Harper's New Monthly Magazine*. It included a single illustration of the Peacock Room, legitimately obtained, the first image of the decoration ever published (see fig. 6.14). Child deciphered Whistler's cryptic comment about roast peacock, analyzing in unprecedented detail the reputed meaning of the mural. Perhaps that "souvenir of the artist's wrath" recalled the way the artist's wrath had once rained down on him, for Child noted that the irate peacock stood amid some "shekels." For anyone else, those silver coins were simply shillings.[47] Just over a year later, having heard that Frederick Leyland had died and that his collection was about to be dismantled, Child wrote to Murray Marks that, as luck would have it, his *Harper's* article had just been published in London, in a volume titled *Art and Criticism*. "Let the rich buy it," Child proposed, "before they go to the sale."[48] But that would not be necessary. In the months leading up to the auction of Leyland's estate, Child's essay was repeatedly reprinted in the British periodical press, usually without attribution; through that means, it became the foundation text for future studies of the Leyland collection, which invariably focus on the Peacock Room.

Paragraphs from *Harper's* were also used in the lavish brochure published by the estate agents to advertise "The Noble Leasehold Mansion" at 49 Prince's Gate, to be sold by auction in June 1892. Soon after the firm Osborn & Mercer was given the commission "to dispose of that charming residence," the agents wrote to Whistler, then resident in Paris, acknowledging the "care attention and advice" he had contributed to the house and requesting that he let them know if anyone in his acquaintance required "such a model of tasteful refinement," whereupon they would dispatch "descriptive particulars and the necessary card to view."[49] It was presumably with such a card in hand that T. R. Way visited the Peacock Room sometime between Leyland's death and the sale of the estate. He found the interior unchanged, with *La Princesse* still presiding over the blue china, and the peacocks fighting "as they had done since the painter put the last touch upon them."[50] The house may have been more than usually full of pictures and porcelain that spring, for Murray Marks had been engaged to bring additional furnishings and artworks to London from Woolton Hall in preparation for the sale of the estate. Apart from some family portraits, few of Leyland's possessions were to remain in Liverpool; Freddie Leyland told Marks that he himself was "not desirous of possessing any of the articles."[51]

While 49 Prince's Gate remained fully furnished, H. Bedford Lemere, architectural photographer to the Queen, was commissioned to document the interiors. Leyland's children may have wanted to preserve their memories of Prince's Gate, but the more immediate purpose was to provide alluring illustrations for the sales brochure. Lemere took pictures in natural light whenever possible, using small apertures and long exposures to produce images of almost preternatural clarity. In his remarkable records of the Peacock Room (see figs. 6.15 and 6.23), made with sunlight streaming through unshuttered windows, it is even possible to discern the patterns painted on individual pieces of porcelain.[52]

Whistler himself had cherished the notion of having photographs made of the Peacock Room ever since the Child fiasco. Late in May, shortly before it was scheduled to be sold as part of 49 Prince's Gate, he proposed to D. C. Thomson, director of the Goupil Gallery in London, the production of an album, "Mr. Whistler's Peacock Room." Whistler envisioned more than a dozen pictures, showing various details of the decorations: the four peacock compositions (three pairs of shutters and the mural), the sideboard, a view of each wall, several of the ceiling, and *La Princesse du pays de la porcelaine*. Presuming that the rights of reproduction remained with him, Whistler hoped the venture might finally bring remuneration for his work in Leyland's house. "It is absurd that all this hurrah should go on about the Peacock Room and I be out of it." Thomson made a commendable effort to execute Whistler's wishes and managed to secure several photographs of the room.[53] Although the "Peacock Album" itself never materialized, a set of the photographs survives at the Freer Gallery, sent to Charles Freer by Thomson's successor at the Goupil Gallery in

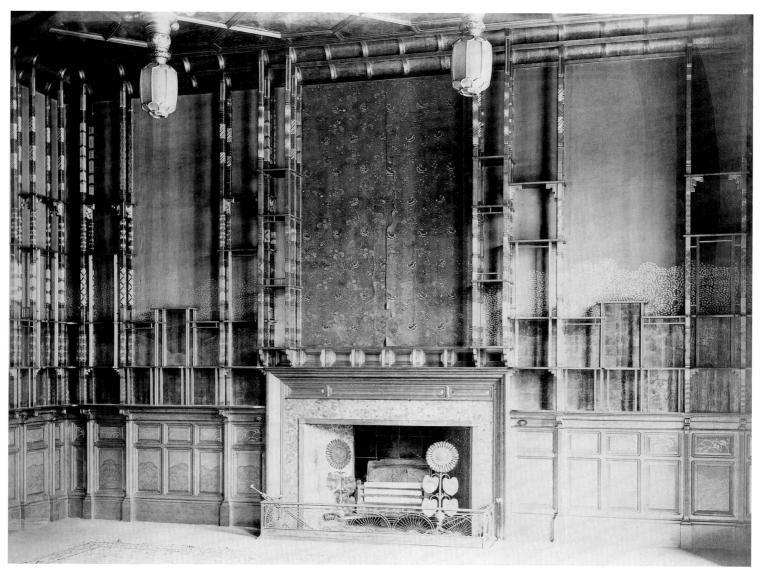

1902.[54] One shows a detail of the ceiling, with the crown of electric lightbulbs that Leyland had appended to Jeckyll's gas fixtures. Another makes an interesting historical document but gives a poor reflection of the room's intended appearance (fig. 7.5): Leyland's rug and fireplace furnishings are still in place, but the painting and porcelain are missing, having already been removed to Christie, Manson & Woods for auction.

The late Frederick Leyland's "valuable and extensive collection of old Nankin porcelain" was the first of his collections to go under the hammer, at one o'clock on Thursday afternoon, 26 May 1892. Once those 134 lots were disposed of, the auctioneers moved on to Chinese cloisonné, including the pair of birds (fig. 7.6), variously described as storks and ostriches, that once had stood in the entrance hall at Prince's Gate.[55] The Leyland furniture, to be auctioned the following day, was displayed with the paintings, which were to be sold on Saturday. The only one of those Whistler cared anything about — or so he wrote to Thomson in February, while gathering pictures for an exhibition of his own — was the "portrait of Miss Spartali in Japanese dress. It hangs in the

FIG. 7.5 The north wall of the Peacock Room at 49 Prince's Gate, London, 1892. Freer Gallery of Art Archives, Smithsonian Institution, Washington, D.C., Charles Lang Freer Papers.

Peacock Room and is not likely to be taken down. If it ever comes to the hammer, *then* we will talk about it."[56]

Whistler learned about the sale from an article by Val Prinsep published in the *Art Journal* in May. As the son-in-law of the deceased, Prinsep stood to profit from the publicity: the opening paragraph of his encomium declared the Leyland collection to display "taste and knowledge, and, above all, artistic conviction." A second essay, written by Whistler's old friend Lionel Robinson, focused on the old-master pictures but referred in passing to the Peacock Room, which was illustrated with two wood-engravings by E. J. Mitchell.[57] But nowhere was *La Princesse* mentioned, and Whistler feared the worse. Indeed, the painting had been entered for sale: Leyland's executors were indifferent to the demands of aesthetic unity that might have kept the painting with the room, even though, one critic remarked in 1904, "it was little short of barbarism to allow them to be separated."[58] Beatrix Whistler—Godwin's widow, whom Whistler had married in 1888—wrote to the dealers E. G. Kennedy in New York and Alexander Reid in Glasgow on her husband's behalf, encouraging them to bid for "the beautiful portrait of a lady in Japanese dress," which Whistler is said to have considered "the most brilliantly coloured of them all."[59] The artist wrote his own letter to Thomson. "What are you going to do about this sale? I certainly think that you ought to try and get the 'Princesse des pays de la Porcelaine'—It is a *beauty!* and ought to be easy to place—In any case, even if you do not buy—you surely ought to see that the picture is properly competed for."[60]

Having thus set three dealers into competition, Whistler was astonished and annoyed to learn that the winning bid for *La Princesse* was only 420 guineas. Two works by Burne-Jones, *Merlin and Vivien* and *The Mirror of Venus*, had sold to the dealer William Agnew for more than thirty-five hundred pounds apiece, the highest prices of the auction; it was noted at the time that while Rossetti appeared to have had his day, "that of Burne-Jones is barely come."[61] Indeed, the sorry price paid for *La Princesse* was in line with those of several paintings by Rossetti—slightly more than *La Pia de' Tolomei*, slightly less than *Lady Lilith* (see fig. 2.2), and about the same as *Monna Rosa* (see fig. 2.11), the portrait of Frances Leyland that John Bibby Jr. bought for £462. Whistler's painting fared much better than *A Venus* by Albert Moore (see fig. 2.20), which sold for £215, probably less than Leyland had paid for it in 1869.[62] Still, the sale was a disappointment. "I can see from the tone of your letter," Whistler wrote to Thomson, who had given him the news, "that you feel you have disgraced yourself in my eyes!" He predicted (probably truly, as it happened) that Thomson would never forgive himself for letting "that splendid picture go for so ridiculous a sum," when he might at least have acquired it as an investment. "Now do kindly tell who *did* have the wit and pluck to buy it?"[63]

The only other bidder had been Alexander Reid, who according to his client William Burrell "did more than any other man has ever done to introduce fine pictures to Scotland and to create a love of art."[64] The son of a Glasgow

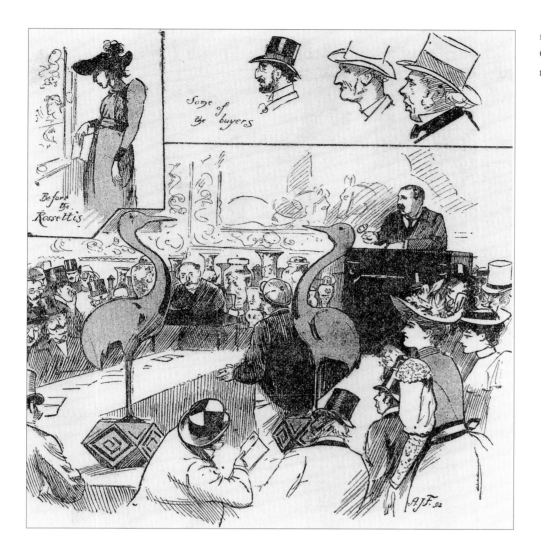

FIG. 7.6 "London Vignettes: Sale at Christie's," from an unidentified London newspaper, late May or early June 1892.

gilder, Reid had joined the Paris firm of Boussod, Valadon & Cie. during the 1880s and in 1889 founded La Société des Beaux-Arts in Glasgow, where he exhibited works by such artists as Degas, Monet, and Pissarro. *La Princesse*, then, had "fallen into good hands," as Beatrix Whistler wrote to Reid at the end of May 1892. The artist himself recommended that the dealer ask no less than two thousand guineas for the picture, and that it be cleaned and revarnished before further exhibition: "It would be quite a different thing if it got rid of the Leyland grime."[65] Liberated at last from the notoriety of its setting, *La Princesse* was bound for a brief life of independence.

*B*Y THE EARLY 1890s the Peacock Room episode was "all but forgotten," according to Elizabeth Pennell,[66] and Aubrey Beardsley, born only in 1872, may have known little about it before visiting 49 Prince's Gate one summer day in 1891. He and his sister had been led through the grand, art-laden rooms by one of the notoriously pretentious servants (fig. 7.7), and the next day Beardsley wrote his friend G. F. Scotson-Clark, with irrepressible enthusiasm, that the

FIG. 7.7 "Going thro' the rooms," by Aubrey Vincent Beardsley (1872–1898). From a letter to G. F. Scotson-Clark, [July 1891]. Library of Congress, Washington, D.C., Manuscript Division, Pennell Whistler Collection.

Leyland collection was "GLORIOUS." Listing the paintings he recalled, Beardsley marked the most significant with exclamation points. Of those, he said, the best were by Burne-Jones. Nothing on his list was by Whistler, and there was no mention of the Peacock Room, the single most famous work of art in the Leyland residence.[67] Scotson-Clark himself queried Beardsley's omission; he vaguely recollected a picture of a Japanese woman painting a vase, probably confusing *La Princesse* with *The Lange Lijzen of the Six Marks* (see fig. 1.8). Beardsley replied a few days later, noting the large Whistler painting in the Peacock Room, which he supposed was the one that his friend had in mind. "The figure is very beautiful and gorgeously painted, the colour being principally old gold." Lest there be some mistake (and "old gold" is not the color commonly associated with the painting), Beardsley filled the page with a watercolor rendering of *La Princesse* (fig. 7.8), framed in gold and signed (inaccurately) with a butterfly, hanging on a wall bedecked with a fanciful flock of peacocks.[68]

Coming across that illustrated letter in 1929, Elizabeth Pennell imagined that Whistler would have accepted the sketch of *La Princesse* "in her Beardsley incarnation" as a tribute. Her late husband had often asked himself how Beardsley had fallen under the spell of Whistler's "Japanese and Peacock Period," and the letter documented his encounter with a formative influence on his art. Indeed, of all who saw the Peacock Room in person, Beardsley is thought to have come away the most deeply affected. As C. Lewis Hind remarked in 1925, it was "an event in his life."[69] Yet it is difficult to reconcile the profound

The Heirloom of the Artist

FIG. 7.8 *La Princesse* in the Peacock Room, by Aubrey Vincent Beardsley (1872–1898). From a letter to G. F. Scotson-Clark, [July 1891]. Pen and ink and watercolor, 19.05 × 20.32. Library of Congress, Washington, D.C., Manuscript Division, Pennell Whistler Collection.

impression the Peacock Room is supposed to have made on Beardsley's imagination with that first letter to Scotson-Clark, which fails to mention the room at all, or with the second, which recollects it only in connection with *La Princesse*, and in response to the interest of his correspondent. Even then, apart from a few flourishes of peacock feathers, Beardsley's illustration gives little notion of Whistler's decorative motifs. The peacocks painted on the walls suggest a reminiscence more dependent on the room's title than its actual appearance; based on this evidence alone, we would have to conclude that Beardsley had barely noticed the Peacock Room.[70]

Moreover, no recognizable signs of influence on Beardsley's art were to be in evidence for some time. This so unsettled Haldane Macfall that he shifted the probable date of Beardsley's letter to Scotson-Clark to the early months of 1893 (impossibly, since Leyland's collection was by then disbanded), to make his visit to the Peacock Room a more immediate inspiration for the drawings exhibiting its motifs: "Why should this undisguised mimicry of Whistler have been delayed for two years?"[71] The initial impact of the decorations on Beardsley's style is traditionally (if tentatively) traced to the artist's first pro-

FIG. 7.9 *J'ai baisé ta bouche Iokanaan* (Salome with the head of John the Baptist), 1893, by Aubrey Vincent Beardsley (1872–1898). From *The Studio*, April 1893.

fessional venture, drawings begun in 1893 for *Le Morte d'Arthur*. A profusion of peacocks fill those pages, and traces of a breast-feather pattern can be found in several illustrations—forming the scales of the questing beast, for example, in the first volume's frontispiece.[72] Yet Beardsley's peacocks are as likely to have been inspired by the book designs of Walter Crane, such as "The Peacock's Complaint" from *Baby's Own Aesop* (1887), as by Whistler's decorations at Prince's Gate.

Indeed, by 1893 peacocks could hardly be considered Whistler's particular province, although the Peacock Room may have played a part in popularizing the birds and their feathers as emblems of art and beauty. Leyland's Kensington address also helped to link the fabled interior with the Aesthetic movement, as defined in the pages of *Punch*: in George du Maurier's "Aesthetic Love in a Cottage," for example, an impoverished bride declares to Mrs. Cimabue Brown that she and her husband will have to reside in "dear old Kensington," where peacock feathers could be purchased for only a penny apiece.[73] Oscar Wilde, the avatar of aestheticism who declared his regard for the Peacock Room in 1882 "as the finest thing in colour and art decoration that the world has ever known since Correggio painted that wonderful room in Italy where the little children are dancing on the walls," embedded peacock feathers in the ceiling of his drawing room on Tite Street, reportedly the conception of Whistler himself.[74] And at Liberty & Co., the commercial matrix of the Aesthetic movement, the most famous and enduring art fabric ever issued was Arthur Silver's "Peacock Feather," designed around 1887.

Even when other aesthetic accessories went out of fashion around the fin de siècle, the peacock remained a favorite icon of art nouveau, which Beardsley's drawings helped to define and disseminate. It might be argued that the bold arrangements and inversions of figure-ground relationships in Beardsley's peacock chapter headings to *Le Morte d'Arthur* dimly mirror the influence of Whistler's peacocks at Prince's Gate, but by that time Beardsley had discovered Japanese prints for himself and could have borrowed elements from their method unmediated by Whistler's examples. He claimed to have struck a distinctive "new style" in the summer of 1892, "suggestive of Japan, but not really Japonesque."[75]

The Whistlerian element in Beardsley's art becomes pronounced in the drawings published in the inaugural issue of the *Studio* to accompany Joseph Pennell's groundbreaking article, "A New Illustrator: Aubrey Beardsley," which essentially established Beardsley's British reputation. In *J'ai baisé ta bouche Iokanaan* (fig. 7.9), for example, the vertical format is subdivided by a sweeping, sinuous line that strikingly recalls the composition of the central shutters in the Peacock Room, where a pair of birds is sharply silhouetted against the moon. In this context, the design in the upper left corner appears to echo the golden breast-feather pattern that Whistler painted on the peacock-blue walls. But the fact remains that nearly two years had passed since Beardsley set foot in the house at Prince's Gate. Because his memory of the Pea-

The Heirloom of the Artist

cock Room had never been accurate, the 1893 designs probably owe less to the actual interior than to the reproductions of it that had recently appeared in the press, in connection with the sale of the Leyland estate. These included photographs of the south wall and the shutters in the *Pall Mall Budget*, a paper for which Beardsley shortly afterward produced a series of weekly sketches; and wood engravings published in the *Art Journal* to accompany Prinsep's article on the "glorious" Leyland collection (fig. 7.10).[76] The latter may have been more useful for his purposes, effecting the translation from interior decoration to graphic design, and from blue and gold to black and white.

In Beardsley's notorious illustrations of 1894 for Oscar Wilde's *Salomé*, the impact of the Peacock Room, particularly the shutters, becomes incontestable. With these, as Malcolm Easton has observed, "not only would a similarly arrogant subjection of nature to decorative ends, and marshalling of empty space to sharpen the silhouette, become important factors in Aubrey's art, the actual Whistlerian shorthand is taken over by the younger artist in design after design."[77] As if to acknowledge the debt, Beardsley featured nefarious-looking butterflies in many of his illustrations, some lashing long tails like scorpions, which probably owe their inspiration to the spritely signatures abounding in *The Gentle Art of Making Enemies*, reprinted in 1892.[78] Butterflies and peacocks figure in Wilde's text, but the references to Whistler and particularly the Peacock Room are so pronounced in the *Salomé* drawings that they might better be regarded as artistic allusions than tokens of influence. *The Peacock Skirt* (fig. 7.11), for example, even more than Beardsley's earlier *J'ai baisé ta bouche Iokanaan*, recalls the pair of peacocks on Whistler's center shutters. The clouds of stippled feathers surrounding Beardsley's peacock and the long, arched covert-feathers rising elegantly from its tail are clear quotations from the Peacock Room, if declaimed in the accent of art nouveau. But the sinuous tendrils swinging from Salome's headdress, described by Brian Reade as "trailing and arabesque lines of ragged feathers," appear to derive from a different, if related, source: Whistler's own parody of the decorations at Prince's Gate, *The Gold Scab* (see fig. 6.33).[79]

There is nothing to prove that Beardsley ever saw *The Gold Scab* in person, but it had resurfaced in London around 1892, when G. P. Jacomb-Hood spotted it in a Chelsea shop window; the fact that he was subsequently offered eight hundred pounds for it ("the new money of the millionaire of the Burlington," Whistler said, presumably alluding to Val Prinsep's recent inheritance) suggests that his acquisition was brought to public attention through some means of display.[80] We can only surmise that Beardsley would have seen *The Gold Scab* if the opportunity arose, since he was seeking out works by Whistler at that time; as an accomplished caricaturist possessing a keen visual wit, he would have been especially susceptible to the decadent charms of Whistler's "Satirical Portrait of a Gentleman." Two rough sketches of *The Gold Scab* in the Pennell Collection (fig. 7.12), circumstantially attributed to Whistler and formerly in the possession of Frank Miles, the friend and onetime housemate of Oscar

FIG. 7.10 Central shutters in the Peacock Room, 1892. Illustration by E. J. Mitchell for the *Art Journal*, May 1892.

FIG. 7.11 *The Peacock Skirt*, 1894, by Aubrey Vincent Beardsley (1872–1898). Pen and ink on paper, 23.0 × 16.8. Fogg Art Museum, Harvard University Art Museums, Cambridge, Massachusetts; bequest of Grenville L. Winthrop (1943.649).

Wilde, may have been drawn by Beardsley.[81] Their inaccuracies suggest they were made from memory, by someone impressed with certain details of Whistler's design—notably the butterfly's whiplash tail and curvilinear sweep of the peacock's bedraggled feathers, the very elements that turn up in *The Peacock Skirt*. But even if he knew the painting only by repute, Beardsley might have found in *The Gold Scab* an instance of evil "as a mode through which he could realize his conception of the beautiful," in the words of Oscar Wilde,[82] aptly suiting his conception for the *Salomé* drawings. For while Beardsley's watercolor sketch conveys a benign and whimsical first impression of the Peacock Room, his illustrations for *Salomé* are cast in the darker mood of Whistler's cruelest caricature, itself a willful perversion of an emblem of beauty. *The Gold Scab*, then, may have provided Beardsley's inspiration for setting the story of Wilde's satanic drama in what Macfall describes as "the Japan of Whistler's Peacock Room."[83]

That Beardsley could parody Whistler's art as wittily as the artist himself becomes apparent in the title page to *The Dancing Faun* (1894), where Whistler appears as a horned, satyrlike creature wearing patent-leather bows on his dainty hoofs, posing in a spare setting reminiscent of his own most famous portraits. In 1891, having seen Whistler's portrait of Cicely Alexander, Beardsley described it as "a truly glorious, indescribable, mysterious and evasive picture," and its image (unlike the Peacock Room) was so indelibly imprinted on his mind that a week later he could render an impression of it, he boasted, that "almost amounts to an exact reproduction in black and white of Whistler's *Study in Grey and Green*."[84] It is telling, therefore, that when Whistler's *Gold Scab* was exhibited as *Arrangement in Green and Gold* in 1900, when the subject of Whistler's satire had already been forgotten, one of the "serious new critics" expressed regret that Whistler had "allowed himself" to be influenced by Aubrey Beardsley. By then, the disturbing, diabolical overtones of *The Gold Scab* had become indelibly identified with Beardsley's style.[85]

IVESTED OF its art and furnishings, the Pre-Raphaelite mansion at 49 Prince's Gate, slated to be sold at auction on 17 June 1892, contained a single—and singular—attraction. The Peacock Room was the focus of most press announcements of the sale, including an illustrated article in the *Pall Mall Budget* published the day before the auction, recounting the legend largely as told by Theodore Child.[86] But despite the publicity, or perhaps because of it, "The Mansion" was withdrawn when bidding closed at twenty thousand pounds. Putting a brave face on that unlucky turn of events, Val Prinsep reflected in the *Art Journal* that the house could now enjoy a rest, "and possibly its future possessor may be wise enough to leave it in its present state."[87]

Prinsep's remarks appeared in "A Collector's Correspondence," an article reprinting several affable letters from Gabriel Rossetti to Frederick Leyland.

FIG. 7.12 *Sketch of "The Gold Scab"* (M1602), possibly ca. 1892, attributed to Whistler. Pen and ink on paper, 17.8 × 22.7. Library of Congress, Washington, D.C., Prints and Photographs Division, Pennell Whistler Collection.

Prinsep pointedly declined to discuss "the too-celebrated quarrel between Leyland and Whistler in the matter of the Peacock room" but illustrated their former intimacy with the text of a single letter from Whistler, the now-famous missive thanking Leyland for the title *Nocturne*. That public acknowledgment of Leyland's hitherto uncredited contribution to Whistler's aesthetic achievement appears to have revived a resentment that might otherwise have been laid to rest with the patron. This, coupled with the insulting insinuation that Leyland had only laughed at the artist's effrontery in the Peacock Room affair, prompted Whistler to draft one of his truculent letters to the press. Protesting "the indecency of the publication of [Leyland's] diary," Whistler struggled to say (in characteristically epigrammatic style) that intimacy was "the rational prelude to rupture." Although he never completed the letter, he kept his draft, as if to prove the Pennells' point that "until the colour fades from the panel, the world cannot forget the quarrel. Whistler himself never forgot it, and his resentment against Leyland never lessened." His own letter (evidently never sent) concluded, "Once a friend—always an enemy!"[88]

 After the inconclusive offering of 49 Prince's Gate for sale, the Peacock Room disappeared abruptly from public view. Some supposed it had been

removed from the house, en bloc, in 1892.[89] Five years later, Vernon Lee, writing in the *Fortnightly Review*, recounted her memory of a "blue field of night, strewn with peacocks' eyes and chrysanthemum petals, where the great birds plume and swirl, with their gold-sequined tails and breasts, and their pupils of diamonds," and regretted that so few had taken the trouble to see what, "at this moment, for aught I know, may have ceased to be visible, nay, to exist any longer!"[90] A privileged few viewed the Peacock Room while the house stood empty. Alfred Atmore Pope, for example, an art collector from Cleveland, Ohio, was rewarded for purchasing a Whistler painting in 1894 with a visit arranged by D. C. Thomson only days before the property was conveyed, at last, to a new owner.[91]

Thomson wrote to Whistler one year later about an alarming rumor he had heard, that the person newly in possession of the house at 49 Prince's Gate might want to destroy the Peacock Room. "I wish he would," was Whistler's reply. "It would be so perfectly English in its assertion of legal right! Or do you think he wants to sell it—Equally English—But in this case we might get it for America—Find out about it and let me know."[92] John Singer Sargent, who was living in London at the time, must have heard another version of the story, for his only uncertainty was whether the room would be removed from the house entire or in part. "It ought to be kept together," he wrote to Isabella Stewart Gardner in Boston, "but the shutters alone would be a treasure. How can you let the Peacock room belong to anybody else!"[93] The idea that the Peacock Room might be bodily extracted from its setting had been raised in 1892 by Lionel Robinson, who suggested that the decoration be preserved "in order to show to future generations the taste, the genius, and the boldness of our own," but he thought it unrealistic to hope it might ever be acquired by a museum.[94] Perhaps inspired by that suggestion, Whistler had made a point of letting both E. G. Kennedy and Alexander Reid know that the Peacock Room "could with care be moved." That seemed the only hopeful possibility in 1894, when, as the architect Stanford White phrased it, Prince's Gate fell into the hands of the philistines.[95]

At the time she bought the house, Blanche Watney had never heard of Whistler or the Peacock Room.[96] Born Blanche Marie Georgiana Burrell of Highfield Park, Tunbridge Wells, she had married James Watney, a member of Parliament for East Surrey, and had two sons, Vernon and Claude. After James Watney's death in 1886, Vernon took control of the family business, the brewers Watney & Co., and Blanche became the proud possessor of a luxurious yacht on which members of her circle enjoyed extravagant cruises to destinations as far afield as St. Petersburg; when the ship was not at sea, the crew was pressed into service at home.[97] There was a scandal in her past, which may have been forgotten or forgiven by the time she bought the Leyland house: it emerged in 1867, in the course of a legal action brought against an irresponsible tenant, that Mrs. Watney was not then the widow she had led her tenant to believe, but was living separately from her husband in unmentionable circum-

stances. "If I had known the lady's situation," averred the defeated defendant, "I should not have taken her house." [98]

The redoubtable Blanche Watney was not the utter philistine Stanford White supposed, for she owned *Helios and Rhodos* and *Flaming June* by Frederic Leighton and is said to have posed for his *Clytemnestra* of 1874. [99] Since 1875 she had lived at Thorney House on Palace Gate (next door to the artist John Everett Millais), but her landlord, the Duke of Bedford, sold the freehold of the property in 1894, which suggests that she took a new house in Kensington more from necessity than desire. [100] It is difficult to imagine what Mrs. Watney saw in 49 Prince's Gate, since she immediately set about extensive remodeling. (She remained at Thorney House until the work was completed in 1896.) Sir Ernest George designed an imposing neoclassical terrace for the east side of the house, accessible through the french doors in the Peacock Room. The front portico was enclosed to make a cloak room and marble vestibule opening onto the refurbished entrance hall: the historic Percy staircase was retained, though relegated to the background, and the room received a new marble floor, a massive canopy fireplace, and an elaborately sculptured fountain. [101] Whistler's delicate lacquered dado did not accord with the marmoreal grandeur of the scheme, and the panels were removed (but kept and later sold to Charles Freer). What had been the morning room, or tapestry room, was converted into a dining room, with the adjoining study made into a serving room (its gilt-leather hangings were evidently transferred to the walls of the new dining room). Mrs. Watney seems not to have objected to the triple drawing room on the first floor, possibly the reason she chose the house, for that space was kept largely as she found it. But as Thomson had heard, she was thinking of disposing of the Peacock Room. According to Stanford White, she considered it "a menace to her own personality." [102]

W. Graham Robertson, who did not much admire the Peacock Room himself, claims credit for having saved it from certain ruin. He had met Mrs. Watney at a party; when conversation turned to her new house on Prince's Gate, she remarked that she intended to have the "hideous" former dining room "entirely redecorated." Robertson inquired what she meant to do with the existing decoration, and she said she supposed it could be "scraped off or repainted or something," whereupon he patiently explained how the room was constructed, with sheets of leather that could be removed along with the shutters and other "pictures" in the decoration. He added that "the room was world-famous & that the decorations would command a large price." The latter fact succeeded in diverting her destructive designs. [103]

Stanford White, visiting Paris in 1895, had learned from Whistler himself that the Peacock Room might soon become available for purchase. Prevailed upon to assess the possibility of reconstructing it in the home of some American millionaire, White called at Prince's Gate that September. He and Sargent found the house "being gutted and torn down preparatory to furbishing up in the latest modern style." White reported to Whistler: "It was

as much as our lives were worth to get into the Peacock Room and when we did get in there, it was all carefully covered up with pasted tissue paper." Only a dozen square feet of one wall were revealed for their regard, but that glimpse was enough to convince White that "before it was covered by your own splendid work, it seems to me that the room must have been one of the most damnably ugly and hideous rooms ever concocted." Blanche Watney ("Her Royal Highness") was away, probably cruising on her yacht, so White could not ascertain whether the Peacock Room was actually for sale, but he promised to "pitch in" and help place it in America whenever it might be. He did point out that unless the room were installed in a new house specially constructed to contain it, it might be difficult to find a space of the right size, "especially in height, as our houses here are built with lower ceilings."[104]

Sargent, meanwhile, reported his findings to Mrs. Gardner, who made the unlikely proposition that the Peacock Room be purchased for the Boston Public Library. Some years earlier, Whistler had been commissioned to execute a mural for Bates' Hall in the new building, but his fee had yet to be raised.[105] He told the Pennells of his plan to paint "a great peacock ten feet high," and tradition holds that he drew it on a tablecloth that later, lamentably, went into the wash; regrettably, "nothing came of the first great opportunity given him for mural decoration since the Peacock Room."[106] That the room itself might take the place of the commissioned mural was difficult for Sargent to assimilate: he was in favor of the purchase in principle but wary of Mrs. Gardner's suggestion that only parts of the decoration be transplanted to Boston. "Wouldn't you much prefer," he inquired of Whistler, "that it should be kept together in a space of the same size or thereabouts rather than that bits of it would be scattered about in a large hall?"[107]

These discussions concluded when Sargent learned, after White's departure from London, that Mrs. Watney had decided not to sell the Peacock Room after all—"but it is time," he wrote, "for her to have changed her mind." Indeed, Blanche Watney was known for exercising that prerogative.[108] The Peacock Room, therefore, remained some years longer in her possession, and visitors were "occasionally, but not often, admitted" to see it, A. J. Eddy noted in 1903.[109] Charles Freer had been among the fortunate few, calling at Prince's Gate on 14 May 1902. "She showed me the room," he later recollected in a letter to Rosalind Philip, "and when I objected to the storage of bric-a-brac, dime novels, etc., which I found heaped upon the prettily painted shelves, she asked me what to substitute, and I naturally replied, 'Porcelain of the finest Chinese periods'—a life work, as you well know, for even an ardent expert." When he later learned that she had determined to sell the detested decoration, he conjectured the reason might be that she had heeded his advice but found the practice of collecting too exhausting to continue. Or perhaps, he proposed, "the peacocks, having tired of a life of dullness, are now calling for freedom, and in this or some other way are disturbing the life of Mrs. Watney."[110]

FREER'S ABIDING ambivalence about the Peacock Room was probably born of that first experience, when he had contended not only with the uninformed taste and imperious manner of Mrs. Watney, but also with the jarring presence of cheap novels on gilded shelves meant for Chinese porcelain, and with the looming absence of *La Princesse du pays de la porcelaine*. Without the painting, Whistler's unrelieved arrangement of blue, green, and gold can cause aesthetic claustrophobia: quite apart from its thematic function, *La Princesse* provides an essential interruption to the scheme, dispelling visual monotony. In Blanche Watney's house, a mirror took its place above the mantel, and a photograph made just after the room had been cleared of furniture and bric-a-brac captures the wearisome effect of that looking glass reflecting the pendant lamps on into infinity (fig. 7.13). Without the painting and the porcelain, Eddy observed, the room was "but a melancholy reminder of former beauty." [111]

La Princesse du pays de la porcelaine, after the disgrace of the Leyland sale, had gone on to make the "great hurrah" that Whistler had prophesied in 1892. Yet because it was admired specifically for those qualities absent from his more recent work, Whistler found the latter-day praise for *La Princesse* even more tedious than the customary abuse. "Such nonsense about joyousness and period," he wrote to Alexander Reid about the Glasgow critics who were flaunting their "dilettante connoisseurship" in the press. Placing his own "first vase" well within the scheme of his aestheticist practice, Whistler explained that "the picture takes its place simply with all the others and differs in no way from the portrait of Carlyle, excepting inasmuch as Carlyle himself dear old Scotsman differs from a young lady in a Japanese dressing gown." [112]

Because *La Princesse* had been confined to 49 Prince's Gate for so many years—and as Whistler's mother had recognized, "a gentleman's private residence is not an exhibition"—the artist was eager for the painting to be shown in London, where it was "scarcely known," he told Alexander Reid. [113] In fact, the painting had been exhibited in London twice before, in 1866 and 1872, and after the publicity engendered by the Peacock Room, *La Princesse* could hardly be called unknown; still, it looked different out on its own, seen at eye level and in the light of day. At Whistler's urging, Reid lent the work to the second exhibition of the Society of Portrait Painters, where "it would be seen by *every body*," the manager assured him, and undoubtedly become "the talk of the town." [114] Titled *Harmony in Flesh-Colour and Grey, La Princesse des Pays de la Porcelaine (Portrait of Miss S—)*, it was given a place of honor. (Whistler was a member of the committee.) Then in 1893, *La Princesse* made its first transatlantic trip, to the World's Columbian Exposition in Chicago, and afterward continued on to Philadelphia, where it might have been seen at the American world's fair in 1876, had Frederick Leyland permitted it to travel. The painting's appearance in Chicago was, therefore, inestimably important to Whistler, demonstrating his achievement to the country of his birth and creating a new market for his paintings. "There is where all the thousands will come to you

for those pictures of mine," he wrote to Reid, "and I do want them to be got out of England!"[115]

Indeed, Whistler had lobbied from the first for the export of *La Princesse* to the United States, initially recommending as potential buyers Potter and Berthe Honoré Palmer, who inhabited an art-filled castle on the shores of Lake Michigan.[116] His English patrons, capitalizing on the recent appreciation in the value of his works by selling "literally for thousands what they had gotten for odd pounds," had finally, irreparably, let him down. "This shows how much they cared for the pictures themselves," Whistler reflected ruefully, "and what was their appreciation of the painter."[117] But *La Princesse*, for sale at fifteen thousand dollars, was not to find a home in the United States in 1893. Harrison Morris, who brought the painting to Philadelphia from Chicago, tried to persuade the Pennsylvania Academy to acquire it, but the institution that had turned down Whistler's "Mother" when it was offered for fifteen hundred dollars steadfastly refused to consider this comparatively "extravagant" canvas at ten times the price.[118]

La Princesse, then, went back to Britain, and was eventually sold to William Burrell, the Scots collector with the Midas touch, whose shipping firm operated out of Glasgow. Burrell already owned *Arrangement in Black and Brown: The Fur Jacket*, a painting shown with *La Princesse* in Chicago, and he proved extraordinarily generous in lending his Whistler works for exhibition: in the decade he owned *La Princesse*, it was shown five times, at exhibitions in Glasgow, Edinburgh, London, and Venice. The show that attracted the most attention was the First Exhibition of International Art at Knightsbridge, organized in 1898 by the International Society of Sculptors, Painters, and Gravers, of which Whistler was the recently elected president. With the partial exception of a writer for the *Art Journal* who noted that the picture once occupied "the renowned Percode Room in Queen's Gate," the appearance there of *La Princesse* seems to have effaced the critics' memory of its former setting.[119] As if to announce at once its new, independent status and its relationship to other paintings in his oeuvre, Whistler retitled it on this occasion *Rose and Silver*, and it retained that name for many years, as the one first known to Freer, its future owner.[120] F. G. Stephens, picking up the hint implicit in the title, recognized at last how Whistler's *Princesse* "confessedly reproduces the sparkling and gay tints and jewellery of light in innumerable jars and beakers of fine old florid porcelain well known to collectors."[121]

In 1902, William Burrell sent nearly forty modern pictures to Christie's for sale, either because they conflicted with the neo-Gothic interiors of his new house or because he needed funds for a new fleet of ships.[122] Yet he held onto *La Princesse* until the following year, and then, just after Whistler's death, as if to fulfill the artist's early wish, he sold the painting to an American. Charles Lang Freer (fig. 7.14) had bought a Whistler pastel from Burrell the previous year, and had seen *La Princesse* hanging at the owner's house on George Square.[123] He would also have seen the painting ten years earlier, at the

FIG. 7.13 Northwest corner of the Peacock Room at 49 Prince's Gate, London, 1904, photographed for the Obach & Co. exhibition catalogue, *The Peacock Room* (1904). Freer Gallery of Art Archives, Smithsonian Institution, Washington, D.C., Charles Lang Freer Papers.

Chicago World's Fair, though he had not mentioned it specifically in writing afterward to Whistler and citing other works as those that seemed to him "supremely fine."[124] The omission is surprising, considering the importance the painting would assume in his collection. If Freer had not already owned *La Princesse*, it is unlikely he would ever have considered purchasing the Peacock Room.

Freer had met Whistler in 1890 and two years later bought *The Balcony* (see fig. 1.11), venturing for the first time past Whistler's prints and other works on paper into the more expensive realm of oil paintings. His fortune had risen with the railways, and in 1899 he engineered the monopoly of the American railroad car-building industry, a feat that allowed his retirement from active business and the dedication of his attention primarily to art. That was also the year Whistler proposed to Freer that he assemble "a fine collection of

FIG. 7.14 Charles Lang Freer at the Villa Castello, Capri, ca. 1901. Freer Gallery of Art Archives, Smithsonian Institution, Washington, D.C., Charles Lang Freer Papers.

Whistlers!! perhaps *The* collection"—as Freer was to do, with the artist's assistance and advice. As he confided to his friend Charles Moore, "Mr. Whistler let me have so many of his paintings with the understanding that at my death they would go to some public institution—preferably in Washington." [125]

Though usually identified as Whistler's patron, Charles Freer actually acquired relatively few pictures directly from the artist. He commissioned only one—*The Little Blue Girl* (fig. 7.15), whose primary title was *Harmony in Blue and Gold*, like the Peacock Room—but that work was to define his relationship with Whistler as surely as *The Three Girls* had set the contours of Frederick Leyland's patronage. Freer first saw the painting in progress in 1894, visiting the artist's Paris studio on his way around the world, and upon returning to Detroit a year later he expected to find *The Little Blue Girl* waiting there. But in the interim, Beatrix Whistler had fallen ill with cancer, and Whistler had begun to associate Freer's painting with her sad decline. After she died in 1896, the artist continued reworking the composition—not scraping it down and starting over, as he had done with *The Three Girls*, but disfiguring the face with mantles of paint.

Unaware of the form that Whistler's grief was taking, Freer grew impatient for his picture and sent a cable to London in March 1897 asking for it outright. Within days, a letter arrived from Whistler that must have rended Freer's heart: "I write to you many letters on your canvas!—and one of these days, you will, by degrees, read them all, as you sit before your picture—And, in them, you will find, I hope, dimly conveyed, my warm feeling of affectionate appreciation for the friendship that has shown itself to me, in my forlorn destruction." The words recall the affectionate regards Whistler had once sent Frederick Leyland in reference to *The Three Girls*, another painting laden with disappointed hopes. [126] In reply, Freer made the pledge that sealed the friendship: whenever Whistler felt ready to transfer *The Little Blue Girl* to his keeping, Freer would care for it exactly as the artist would wish, and when he himself was gone, the picture would "rest with its own beautiful kind, so, 'that in after years, others shall pass that way, and understand.'" [127]

Freer's quotation from the "Ten O'Clock" lecture (which he is said to have known by heart) is revealing: in the unlikely universe that Whistler described, in which the goddess seeks the artist through the ages to help her compose a "story of love and beauty," Freer had identified the part he was qualified to play. As he later explained, "In the days of the early Renaissance in Italy, and still earlier, when the great art of Japan and China was at its best, encouragement and appreciation were supreme: and, of course, under friendly encouragement, the Goddess was more frequent in her visits to the home of the artists." [128] Though not an artist himself, Freer could participate in the exalting enterprise of Art through his power of appreciation, manifest in his power of acquisition. But unlike the prototypical aesthete-investor Frederick Leyland, who intended his collection to be dismantled on his death, Freer meant for his to be preserved in perpetuity.

The Heirloom of the Artist

FIG. 7.15 *Harmony in Blue and Gold: The Little Blue Girl* (Y421), 1894–1903. Oil on canvas, 74.7 × 50.5. Frame designed by the artist and signed with the butterfly. Freer Gallery of Art, Smithsonian Institution, Washington, D.C. (03.89).

The Little Blue Girl came into Freer's keeping only after Whistler's death on 16 July 1903. Freer had been in London that summer and called on the artist nearly every afternoon, but on the day that Whistler died, he was detained by an appointment with T. R. Way and arrived at the artist's house five minutes later than usual, five minutes too late. The terrible realization that he had let Whistler down in the final moments of his life must have been more than Freer could bear; he may actually have convinced himself of the truth of the story he later told his friends, that the artist had died in his arms.[129] Though not given an official part in the settlement of Whistler's affairs, Freer assisted Rosalind Philip, the executor of the estate, and assumed a self-appointed role as guardian of Whistler's posthumous reputation. Resisting the urge to inveigh against the unflattering stories proliferating in the press, Freer trusted the Master's art to speak for itself and ultimately prevail. But Whistler's mortality must also have

set Freer to thinking about his own. When he bought *La Princesse du pays de la porcelaine* a month after the artist's death for £3,750—nearly ten times its price in 1892—Freer divulged to William Burrell his plan to present the painting "to the American National Museum."[130]

At the memorial exhibition of Whistler's works that opened in Boston early in 1904, *La Princesse* was given pride of place (fig. 7.16), usurping the position originally reserved for a portrait of the artist's wife. Freer's painting hung on its own, crowned with a laurel wreath and elevated on a stage at the south end of Copley Hall, between a pair of arches opening onto a gallery of lithographs: as Lee Glazer has noted, the display "took on the appearance of a devotional altarpiece, the *Princesse* the central panel of an aestheticist trip-tych."[131] One contemporary Boston critic remarked "what a fine thing it would be if that famous Peacock Room . . . could only be transplanted to the exhibi-tion," but such a proposition seemed impossibly remote, as it was naturally assumed that the Leyland house would have to come along as well. "It seems that nothing is a fixture here below," that same critic would observe scarcely six months later, when Freer bought the Peacock Room. "Apparently, we need merely to possess our souls with patience to acquire many of the coveted art objects of the old world."[132]

I N THE FIRST of many books about Whistler to appear soon after his death, *The Art of James McNeill Whistler: An Appreciation*, by T. R. Way and G. R. Dennis, the authors express the hope that if the house at 49 Prince's Gate should ever come onto the market again, the Victoria and Albert Museum might purchase the Peacock Room as "a great addition to the nation's trea-sures."[133] Perhaps the idea was brought to the attention of Blanche Watney, for it was early in 1904 that she suddenly decided the time had come to sell the Peacock Room. She set the price at ten thousand guineas and engaged as agents Messrs. Brown and Phillips of the Leicester Galleries in Leicester Square. Ernest Brown had known Whistler (he was the one who persuaded the Fine Art Society in 1879 to commission the Venetian etchings that restored the artist's solvency), and he and his partners recognized immediately that the Peacock Room was lucrative property, "coveted by American collectors." But Brown's small firm, founded only in 1903, could not afford to purchase, dis-mantle, and export the room itself, so he enlisted the cooperation of Obach & Co., a larger establishment on New Bond Street.[134]

Gustav Mayer, the managing partner of Obach, had dealt with Freer before and knew that he owned *La Princesse du pays de la porcelaine*. Following the logic that the painting and the room should be together, he cabled the collector in Detroit on 26 January 1904 to offer him the Peacock Room for eleven thousand pounds. "The whole decorations and pictures can be taken down and put up again," Mayer explained. But early the next morning, Mayer learned from

The Heirloom of the Artist

FIG. 7.16 Installation photograph of the Whistler Memorial Exhibition, Copley Hall, Boston, showing *La Princesse du pays de la porcelaine*, 1904. Freer Gallery of Art Archives, Smithsonian Institution, Washington, D.C., Charles Lang Freer Papers.

Ernest Brown that Mrs. Watney had since spoken to her son, who also held an interest in the house, and consequently decided not to part with the Peacock Room. The dealer's disappointment deepened that evening, when he received a cablegram from Freer stating that although he could not use the entire "Leyland room," he would gladly purchase the shutters and peacock mural for five thousand pounds—the approximate equivalent, today, of a million dollars. Mayer hardly knew what to do. "I did not want to give it up altogether, and to appear very anxious to buy might have spoilt any future chance. So I decided to wait a short time. Within a week the very thing I had hoped for happened. Mrs. Watney again changed her mind and informed me through her agent that she would be pleased to reopen the negotiations." But she flatly refused to entertain Freer's proposition: the room would be sold entire or not at all.[135]

Negotiations for the complete decoration had therefore recommenced when Mrs. Watney capriciously broke them off again, citing "circumstances which she was not at liberty to disclose." Her decision was final, she said, and Mayer gave up hope—until a few days later, when she unexpectedly resumed the discussion. "You will no doubt be surprised at not having heard from me before this, giving details of the Peacock Room," he wrote wearily to Freer on 6 February, "but the present owner, a lady of extraordinary changeableness, has changed her mind three times in ten days, completely reversing her decision in each case." Finally, on 17 February, Mayer was able to offer the Peacock Room to Freer at a reduced price of eighty-five hundred guineas, including the expenses attending its disassembly and packing for shipment to Detroit.[136]

Meanwhile, Freer had been pondering his own precipitate decision to purchase only parts the Peacock Room. Justifying himself to Rosalind Philip,

he explained that when he saw the room in 1902, "the architectural features of the spindling wooden shelves and the elongated pendants of the ceiling seemed hopeless in form, and valuable only because of the work done upon them by the Master." To his mind, the installation of those objectionable elements any-where else "would never be particularly interesting," yet because he feared that the room was "hated and doomed," he felt constrained to save "the most valu-able parts," if he could, to reunite with *La Princesse*. Of course, in suggesting he might extract the peacocks, Freer himself posed the most present danger to the Peacock Room.[137] Rosalind Philip replied with a message from her sister Ethel Whibley: Freer would be blessed if he "preserved the beautiful treasure intact." As a more immediate incentive, he might install the room "in the won-derful new Museum" he proposed building in Washington. Freer himself later confessed he had never thought of placing the Peacock Room in the museum, which betrays a misapprehension of the room's integrity as a work of art.[138]

Mayer had gently endeavored to correct that misperception. "I cannot help thinking that it would be a pity if the room which is not only the great-est but also the only remaining example of Mr. Whistler's mural decoration, were to be lost forever, in its original form," he wrote to Freer. "And as you have the 'Princesse du Pays de la Porcelaine' you are better able than anyone now living to restore the room to its former splendor." Mayer also urged Freer to consider his ambition for the collection as a whole: "Mural decoration is, I believe, the only side of Mr. Whistler's art which is not fully represented in your splendid collection; if now you were to add this masterpiece to it, the pre-eminence of your collection would be beyond all possibility of dispute."[139] Rosalind Philip, for her part, weighed in with an offer to lend Freer the use of her Northern Pacific Railroad bonds (an investment Freer had made on her behalf the previous year, in exchange for several Whistlers), if he would only buy the entire decoration.[140] Gradually these arguments began to take hold. The interest Whistler's sisters-in-law had shown in keeping the room together made a powerful impression, and its preservation began to appear "a pleasant duty," Freer said, one he felt "strongly inclined" to undertake.[141]

He was unusually distracted by other matters just then, since his business partner, Colonel Frank J. Hecker, had recently been appointed to the commis-sion overseeing construction of the Panama Canal. Even so, Freer's procrastina-tion over the Peacock Room was out of character: like Mrs. Watney, he could not make up his mind whether to keep a room he did not like or give it up to someone who might. He stalled for time, requesting further details from Mayer "in order to get a thoroughly clear understanding of the proposition." He pos-sessed only the vaguest notion of the room's construction: he was uncertain, for example, whether there was leather on the walls. "As I had no thought in this direction at the time I visited the Leyland house, I carry in mind only the artis-tic impression. The decorations seem to me to be very beautiful, but in trying to determine the physical condition of affairs, I am all at sea."[142]

The critical question, of course, was whether the components could in

FIG. 7.17 The library at 49 Prince's Gate, London, ca. 1905. National Monuments Record; Royal Commission on the Historical Monuments of England, London.

fact be removed from Prince's Gate and resurrected elsewhere without injury. As it happened, the Peacock Room was already undergoing deconstruction. Although Mayer had neglected to mention it to Freer, one condition of the sale was that the decorations be immediately dismantled and removed, since Mrs. Watney wanted the space redecorated for the summer.[143] She planned to make a proper library, fitted along the lower walls with wooden shelving vaguely reminiscent of the Peacock Room (fig. 7.17). Indeed, when the house was resold in 1919, the catalogue attributed the "shelves and cages around the room" to "Jekyll," when the only trace of Thomas Jeckyll's work that remained at Prince's Gate was the splendid pair of sunflower andirons that Mrs. Watney had evidently kept as a souvenir. They stood in the library fireplace until the house was sold, and they subsequently disappeared.[144]

The prospect of dismantling the Peacock Room seemed daunting until the "unsuspected fact" of its construction was discovered — that the decorated surfaces stood conveniently separate from the ceiling and walls of the original interior — and in the end the structure proved surprisingly simple to take apart. In a detailed letter addressing Freer's concerns and enclosing a set of recent photographs to refresh his faded memory, Mayer asserted that it was "no longer a matter of belief merely but an absolute certainty that the decorations can be

The Heirloom of the Artist

re-erected in another room and in such a way that it will be impossible to see any trace of the moving."[145] Yet not even that assurance was sufficient for Freer to make up his mind. In London, Rosalind Philip heard from the dealer William Marchant (who heard it from G. P. Jacomb-Hood) that the Peacock Room had in fact been sold. "Is the wonderful room to be yours after all?" she wrote hopefully to Freer in March. In the event he had not made up his mind, she extended a final, sentimental appeal that was certain to exercise an influence. Whistler had spoken of the Peacock Room shortly before he died, she recalled, "in that peculiar way he sometimes had, as if he were thinking aloud," and she was only glad he had not known what its fate would be— "so you can understand why we are anxious that you should become its possessor."[146]

Nevertheless, in April, Freer remained uncommitted, still uncertain of the outcome of "negotiating" for the Peacock Room. As he wrote to his fellow collector Richard A. Canfield, "It is a matter that requires a great deal of consideration, as well as a goodly sum of money."[147] The artist D. W. Tryon, who visited Detroit briefly that spring, argued in favor of the purchase, reasoning that the Peacock Room was not only one of Whistler's "distinguished things," but also relatively inexpensive.[148] Indeed, if Freer could offer £5,000 without a moment's hesitation, it seems unlikely that coming up with another £3,500 would have posed an insuperable problem. To Mayer, Freer excused his delay with the explanation, "when it was necessary to think of caring for all of the decorations and their permanent preservation, many obstacles had to be overcome," but those obstacles seem to have been more psychological than practical. Before he could make a final decision, Freer felt compelled to assess the situation in person, and even though nearly three months had passed since Mayer first made his offer, he obligingly agreed to hold the Peacock Room until Freer arrived in London.[149]

On 4 May 1904, Freer set sail on the *Oceanic*, landing in Liverpool one week later. He made a pilgrimage to Speke Hall, perhaps in search of a sign from the past that might fortify his nerve or change his mind. It was natural for Freer to take an interest in Frederick Leyland, whom he had never met. Nor had he ever seen Whistler's portrait of the patron, *Arrangement in Black* (see fig. 3.1), then in the possession of Florence Prinsep. The following year, when the painting went on view at the English memorial exhibition of Whistler's art, Freer (in Detroit) wrote to Canfield (in London) that he had "long imagined what it must be like" and that his friend's description had made his "blood tingle." Twenty minutes after posting his letter, Freer learned that Canfield had secured the Leyland portrait and would sell it to him for three thousand pounds; he wired his assent instantly, deciding on that work of art sight unseen.[150] In the Pennells' estimation, Whistler's *Arrangement in Black*, rather than the Peacock Room, granted Frederick Leyland immortality. "Other contemporary collectors are forgotten," they observed, "but Leyland is remembered and he owes it to Whistler."[151]

The same fate was to befall Frances Leyland, whose principal claim to posthumous fame was her association with the artist. Her obituary notice in *The Times* opens with the statement that her death "recalls to mind one of Whistler's famous patrons," and proceeds to tell the story of the Peacock Room.[152] Freer had also paid a call on Mrs. Leyland in the summer of 1904. She was living then in London, and Freer was enchanted with the visit, which had been arranged by William Marchant. The content of their "interesting interview" can only be conjectured, but it appears that Freer was especially taken with Mrs. Leyland's Whistlers. He noted in his appointment diary that *Nocturne in Blue and Silver* (see fig. 3.9), "very light blue and in perfect order," pictured the same view of Battersea that appeared in *The Balcony*, and *Symphony in Flesh Colour and Pink* (see fig. 3.18) appealed to him as "a splendid representation of the wonderful natural grace of Mrs. Leyland."[153] In 1910, when Frances Leyland's death raised the possibility that the pictures might come onto the market, Freer's interest focused on the Nocturne alone, for he recollected that the portrait had been badly stained "owing to disaster of some kind." The portrait passed temporarily into the possession of Florence Prinsep, but Freer was later approached more than once "to make offers for the treasure." He always declined, citing "special personal considerations" he never explained, and eventually it was purchased by Henry Clay Frick of New York.[154] The Pennells were indignant that the person who owned the portrait of Frederick Leyland should refuse to purchase the pendant portrait of his wife, and they presented this apparent lapse of judgment as indicative of Freer's unaccountable taste.[155] Perhaps it was. Or perhaps Freer had heard from Whistler the whole sad story of the Leylands, and having already acquired the portrait of Frederick, determined not to bring about a posthumous reunion.

W HEN FREER arrived in London from Liverpool in 1904, it was the height of the English spring. With Rosalind Philip and Ethel Whibley, he went immediately to see the Peacock Room (though it must have been in pieces) at Messrs. Obach's Galleries, 168 New Bond Street, and they spent a weekend talking the matter over, as he had wished, "before reaching a conclusion." Then on Monday, 16 May 1904, Freer bought the Peacock Room (fig. 7.18). The price was aptly named in guineas (more than eight times the amount that Whistler had made), translated in the bill of sale to £8,400 (or $42,000), the current equivalent of nearly $1.7 million. Although Mayer had come down on his price by only one hundred pounds, Freer managed to get a rather undistinguished Whistler self-portrait thrown into the bargain.[156]

Taking advantage of his time in Britain and a sojourn in Paris, Freer secured "a few other treasures by the master," as he wrote to Colonel Hecker in Detroit.[157] From Obach & Co., Freer bought the decorated dado panels from the hall of Prince's Gate, ten drawings, five prints, a watercolor, a pastel, three

FIG. 7.18 Bill of sale from Obach & Co.,
London, 16 May 1904. Freer Gallery of
Art Archives, Smithsonian Institution,
Washington, D.C., Charles Lang Freer
Papers.

chairs reputedly (but doubtfully) designed for the Peacock Room, and three
lithographs by Beatrix Whistler. He also acquired works from the London
dealers Marchant and Colnaghi, from Reid and Burrell in Glasgow, and from
J. J. Cowan in Edinburgh; from Théodore Duret in Paris, Freer purchased the
portrait of Maud Franklin, *Arrangement in White and Black* (see fig. 3.20), which
he was to hang as a pendant to Whistler's portrait of Leyland. Once Freer was
back in Detroit, Rosalind Philip wrote that his collection must nearly be com‑
plete: by her count (which she knew to be inadequate), Freer had purchased
"fourteen pictures and a Peacock Room in one year."[158]

The Heirloom of the Artist

AT THE END of May, two weeks after Freer's purchase, Ernest Brown sent Elizabeth Pennell a paragraph he hoped might be inserted in the newspapers, revealing "the mysterious Whistler news that I would not tell you"— that his little firm had sold the Peacock Room "for a large sum" to Messrs. Obach & Co., who were shortly to exhibit it at their Bond Street gallery, giving the public a chance to see the fabled interior "exactly as the Master designed it."[159] Gustav Mayer undoubtedly conceived the idea of an exhibition while Freer was still deliberating; although the ostensible purpose of finding a buyer had been achieved, the show would doubtless bring Obach & Co. valuable publicity, and Freer probably had no choice but to accede. Yet when the *Pall Mall Gazette* announced the exhibition on 2 June 1904, not a word was said about the room's recent sale, a fact kept quiet at Freer's "own urgent request."[160]

The news that the Peacock Room had been successfully removed from 49 Prince's Gate raised the false hope that it might be acquired for England. In an influential obituary of the artist in the *Athenaeum*, Roger Fry had pointed out that the nation did not yet possess a single work by Whistler: "It is to be hoped that, now that he is dead, even our officials may give to his works a tardy recognition."[161] Several papers accordingly suggested that the Peacock Room be purchased, either through public subscription or by the recently established National Art Collections Fund, to be placed in "its own special corner in the Victoria and Albert Museum" or built into the new Tate Gallery—"one does not mind where, so that it is ours finally for the education and pleasure of the rising generation and every succeeding one."[162] According to the *Daily News*, a hint that the room might come onto the market had been given to the authorities months earlier, and the National Art Collections Society was roundly criticized for its apathy and neglect.[163] By the time that hint was in the air, however, it may already have been too late: only if the requisite sum had been raised during Freer's indecision might the Peacock Room have remained in England.

The public outcry occasioned by its sale to a dealer rather than an English institution was part of a larger issue being played out in Parliament and the pages of the press, for the Peacock Room reappeared on the scene at the very moment that public attention was fixed on indicting the Chantrey trustees. Sir Francis Chantrey's 1877 bequest was to be used to purchase art "of the highest merit" for the nation (works executed in Great Britain, but by artists of any nationality); the bequest was administered by the president and council of the Royal Academy. The *Daily News* alleged that the trustees were using the money "as a sort of prize fund for the advertisement of the Burlington House Exhibition," buying indifferent paintings at inflated prices from academicians while more meritorious works—often available for less—were neglected. In reporting this scandal, the most frequently cited instance was Whistler's *Arrangement*

in Grey and Black: Portrait of the Painter's Mother, sold to the Musée du Luxembourg in 1892 for £160: in 1904, its value was estimated at no less than £10,000.[164]

Indeed, the Chantrey failures were cast into relief by the recent escalation in the prices of Victorian art, brought about by an inevitable shift in taste. The *Burlington Magazine* could account for the apparent mismanagement of public funds only by speculating that the custom of buying works from the Academy exhibition had originated during the 1870s, when "the merits of the great outsiders were not generally recognized."[165] England's belated acknowledgment of "the great outsiders," including Whistler, held serious consequences for its public collections, for the nation could scarcely compete with the new American millionaires. It was practically a foregone conclusion that the Peacock Room would leave the country: its centerpiece, *La Princesse du pays de la porcelaine*, had already been sold to an American "for an immense sum" (commonly exaggerated to five thousand pounds), "and since it is most unlikely that he would part with it, one is inclined to hope that the Peacock Room, the gorgeous casket for the jewel he already has in his possession, may be acquired by the same gentleman." Some days later such conjecture was confirmed with the "dismal announcement" that within twenty-four hours of the public's admittance to the Peacock Room, the famous decoration had "passed into the possession of an American."[166]

Obach & Co. had managed to conceal the truth for an entire month and never would disclose the fact that the room had actually been sold several weeks before it went on view. Obach resolutely declined to disclose the name of the new owner or the price that had been paid, even though the "ubiquitous reporters" tried every conceivable trick, Mayer told Freer, to obtain the information.[167] A few days after the purchase was announced, the *Morning Post* noted that although Charles Lang Freer of Detroit had been mentioned in connection with it, the rumor might have arisen only from the fact that he owned *La Princesse*. At the time, Freer's name was virtually unknown in Britain, and there were other, more glamorous possibilities. The *Illustrated London News* speculated that the purchaser was Isabella Stewart Gardner: "It may easily be supposed that the lady who thought nothing of carrying a chapel over from Italy to Boston will think less of importing this mere husk of a London drawing-room." In fact, Mrs. Gardner learned only later that month, from Sargent, that the Peacock Room had indeed been sold, "probably to Mr. Freer, an American who has bought so many other Whistlers." If not for Mrs. Watney's "changeableness," it might have been in Boston.[168]

Freer himself had remained in Britain only long enough to see the Peacock Room re-erected on New Bond Street, slipping away the day before the press viewing in hopes of avoiding suspicion. But while he was crossing the Atlantic, a "reliable" source informed the London correspondent of the *New York Herald* that Freer was indeed the purchaser of the Peacock Room.[169] He was warned, and upon arriving in New York eluded the waiting reporters by sending word that he was ill and wouldn't disembark until morning; after the crowd dis-

persed for supper, he descended the gangplank unobserved and quietly caught a cab for the Waldorf-Astoria Hotel.[170] When Freer finally reached Detroit, he would only say that "his intimacy with the Whistler family precluded his talking on the subject," and several weeks later was still refusing either to confirm or deny the report of his purchase. "I am in no mood to talk about the matter," he told one journalist, who reasonably construed his silence as validation of the rumor.[171]

In August, bored with stale speculation and hungry for something new, the New York *World* reported that J. P. Morgan, the "Wall Street King," was the new owner of the Peacock Room.[172] Freer requested copies of the newspaper from a trustworthy acquaintance in New York and used the report to deflect attention from himself: "A New York paper stated last week that it was owned by J. Pierpont Morgan," he told one Detroit reporter, "and that is all I know about it"—a response politely ascribed to "Mr. Freer's modesty." By his own account, Freer's statement had been, more truthfully, "that is all I have to say about the room."[173]

Freer customarily avoided publicity—he regarded reporters as "newspaper fiends," even "engineers of Satan"—but his dislike of "newspaper notoriety" was never more pronounced than in the months surrounding his acquisition of the Peacock Room.[174] He confided in a few close friends, but publicly sustained his "little mystery" as long as possible.[175] Well acquainted with the Peacock Room's celebrity, he should have expected his own attendant fame, or notoriety. "It was inevitable," Aline Saarinen observed. "The Peacock Room had been good copy from the beginning." Freer informed both Gustav Mayer and Rosalind Philip that he did plan to disclose the facts, but in a dignified manner and only "when the proper time arrives."[176] After his extraordinary reluctance to buy the Peacock Room, Freer's unwillingness to claim ownership might be interpreted as a sign of continuing uncertainty, even embarrassment, about his decision; but it may be that his secrecy was meant to forestall unseemly speculation about what the Peacock Room had cost, which Freer feared might be the only way the public would interpret its value. He was "keeping mum," he told D. W. Tryon, "because the newspapers are trying to find out lots of things in connection with the matter, which do not at all concern the public." Indeed, Freer did not own up to his possession until 1905, when the "expedient" occasion arose of his presenting not only the Peacock Room but also the rest of his collections to the American nation. And by then, the trail was cold.[177]

T HE REEMERGENCE of the Peacock Room on the London art scene after years of seclusion at Prince's Gate was fortuitously timed, for as many contemporaries noted, 1904 was "the Whistler year." The death of the artist the previous summer had brought about the predictable reassessment of his reputation and

reappraisal of his works, and all of London was caught up in "a mild Whistler revival." Obach & Co. staged an important exhibition of etchings during the winter, Dunthorne's Gallery showed lithographs in the spring, and other of Whistler's works could be seen in half a dozen exhibitions around town.[178] The public, then, was primed for the Peacock Room, which could finally be considered against the backdrop of Whistler's career and in the fuller context of Victorian art and design. Having assumed the status of a Victorian icon, it was promptly historicized—placed by the *Standard* "in the Early or Early-Middle period of Whistler's art," when the painter had been capable of such "ingenious, not merely dexterous, elaboration."[179]

Reading through the voluminous press cuttings preserved by Charles Freer, one senses that the Peacock Room was never more instinctively understood than in 1904, when the positive influence of the Aesthetic movement, especially on domestic decoration, had begun to be acknowledged. As Hermann Muthesius summarized the English assimilation of aestheticism in *The English House* (published that year), "the attention of the public had been guided back to the appreciation of the interior as a work of art."[180] The very fact that the Peacock Room was being shown in a Bond Street gallery suggests that its status as fine art was no longer questioned, and Obach & Co. was widely commended for the consideration it showed in preparing the decoration for display. The reconstructive feat itself appeared a marvel: "it could have been no easy task to translate a room in its entirety from one house to another," and it seemed somehow magical that one entered the Peacock Room through its actual door.[181] If the lights were considered a little bright and the floor and the furnishings not quite in keeping, such petty complaints did little to impede the public's appreciation. The only limitation of the gallery setting was the absence of real windows behind the shutters, which meant that the room could not be seen by natural light; but as many hastened to point out, the Peacock Room was a dining room, intended to be enjoyed at night, with the peacocks displayed on the shutters in all their gilded glory.[182]

But the lack of *La Princesse du pays de la porcelaine*, which Obach & Co. had hoped to borrow for the exhibition, was widely, deeply, and sincerely felt. As in Mrs. Watney's house, a mirror took its place. The *Studio* remarked that "some who saw the room at Mr. Leyland's have hazarded the opinion that by the removal of the painting it is left more completely decorative in itself,"[183] but the greater part objected that the picture's displacement by a mirror deprived the interior "of its character and charm," partly by introducing "glitter" into a setting that was otherwise remarkable for its "exquisite reticence and repose."[184] The *Daily Telegraph* offered the creative suggestion that a sixteenth-century Persian carpet might make a better substitute, since it would serve, like the painting, to save the scheme from uniformity—a recommendation implying a sympathetic understanding of the room's original aesthetic.[185]

Another indication that the Peacock Room was appreciated in 1904 as it would not be again for decades to come is that Obach & Co. took the trouble

The Heirloom of the Artist

of assembling Chinese porcelain to complement Whistler's decoration. A. T. Hollingsworth lent his collection, which included pieces purchased from Sir Henry Thompson's collection, and blue and white from other sources was "pressed into the service," as well. Even so, some critics complained that not every shelf was filled as the artist had intended, and one made the point that "the gilt racks and painted leather partook far more of the nature of a background, when Mr. Leyland's blue and white porcelain crowded the niches."[186] The Peacock Room, then, was widely regarded as a porcelain cabinet, dependent on the pots for aesthetic effect. In the same way, the "Japanese Room" in Henry G. Marquand's house in New York City, "a room for the reception and display of a considerable collection of Chinese porcelains and other art objects from the extreme Orient," was understood to be a completely different thing when the pedestals and shelves stood vacant, as it "was never intended to be complete without the porcelains in their proper places." When that interior was published in 1905, after the collection was dispersed at auction, photographs of the denuded space were thoughtfully juxtaposed with others taken "while the room was still in use as a museum of works of Oriental art."[187]

The London critics in 1904, distantly echoing their predecessors in 1877, proclaimed the Peacock Room to be the artistic event of the season. Obach & Co., known for "the dissemination of serious and varied Art," was about to discover that it had provided "a sensation to the fashionable world."[188] The exhibition opened to the public on 10 June 1904 and carried an admission charge of half a crown, causing one reporter to reflect that "the spirit of the Master would be mightily refreshed by finding that the toll-money is taken in half-crowns, and not, as elsewhere, in mere shillings."[189] The Pennells were informed that the fee was to discourage "too great a crowd." Nevertheless, the room was thronged with people day after day, and in the end the exhibition proved so popular it was extended through the third week of July. "The large attendance shows the real interest in the Master's work," Charles Freer observed, "in the one particular place in the universe where it was originally most decried."[190]

One reason for its popularity was that even before the publicity surrounding the Obach exhibition, nearly everyone in London had heard of the Peacock Room. According to the *Star*, the Peacock Room was so famous as an anecdote that the actual fact of its existence occasioned some surprise. "Human nature being what it is," much of the public's fascination resided in "the still-remembered squabble between commissioner and commissioned, besides the tragic ending of the decorative artist first employed." Indeed, the story was so often retailed in the papers that by the end of June it was presumed that all of London could recite it.[191] Some writers relied on Theodore Child's durable account, others on the observations more recently published in Way and Dennis's *Art of James McNeill Whistler*, which went into a second printing in 1904. But several journalists quoted extensively from a brand new source, the "racy description" of the room in the memoirs of Mortimer Menpes. Were it not for the book's timely appearance, Menpes's account might have gone largely

unnoticed, but publicity for the Peacock Room was also publicity for *Whistler as I Knew Him*—or, as Harper Pennington dismissed it, "The Exaggerated Whistler."[192]

In contrast to Menpes's sensational account was the measured introduction to Obach's elegantly printed, richly illustrated catalogue. The author, C. J. Holmes, was coeditor of the *Burlington Magazine* and Slade Professor of Fine Art at Oxford University; he later became director of the National Gallery in London.[193] His dispassionate retelling of the Peacock Room story is informed with skepticism, conceding that "few definite facts" were to be found amid the accumulated rumors. But the most striking aspect of his essay is its reverence for Whistler's patron. The opening words are, "Frederick Richard [*sic*] Leyland was in several ways a remarkable man," and the conclusion reminds the reader not to forget Whistler, "when justice is done to Mr. Leyland's more strenuous generation." In light of Holmes's account, the *Star* had reason to wonder whether "the whole credit of the work should not rest with Mr. Leyland."[194]

Despite its bias, Holmes's essay was widely quoted in the press and set the tone for other commentary praising the "enlightened" patrons of Whistler's time, now a dying breed. An artist himself, Holmes looked back with longing on the days when such an extravagance as the Peacock Room had been possible, when convictions about art had been strong enough to test. "Even the squabbles and enmities of the past, trying and troublesome though they must have been, were at least an evidence of genuine, if not always well directed enthusiasm," he wrote, casting the famous controversy in quite a new perspective.[195]

Holmes's nostalgia typifies those early years of the Edwardian era, when imperialist certainties were beginning to subside but virulent anti-Victorianism had not yet come into play. The structures of taste were poised for change in 1904, the year Virginia Woolf moved from Kensington to Bloomsbury, and already the Peacock Room's most admired qualities were those distinguishing it from other decorations of its time. One critic remarked that the "trained sensibilities" of professional designers might be affronted by the peacock plumage freely extending over the shutters, "regardless of the limitations of panels, and utterly oblivious of such constructional features as hinges and lock plates"—a sign of liberation that "must have been a delight to Whistler, if he ever gave it a thought."[196] Thus the artist was cast as a proto-Edwardian, if not yet a proto-modernist, who waged war against the stifling conventions still prevalent in certain drawing rooms. The Peacock Room, declared the *Studio*, "is a witness to a very determined effort on the part of one man to escape from all the traditions that have controlled decoration in this country."[197]

Inevitably, some critics found the decoration to fall short of Whistler's other artistic achievements. Several ventured to suggest that the artist himself "would never have claimed for the Peacock Room a very high place among his original works," and others accounted for its weaknesses with the explanation that the decoration was experimental, the tour de force "of a genius playing the amateur in an art of which he is not a master." One common complaint con-

cerned the "execrable" gilding, another the unpleasant surface of the overpainted leather.[198] The younger generation, in particular, was disappointed in the room, and imagined that the fabled blue had dulled with age, since it lacked the expected quality of "enchantment."[199] To some extent, they were right: the Peacock Room had endured another decade of urban life since Lionel Robinson noted in 1892 that "fifteen years of London atmosphere have done their worst." But the problem, as some surmised, may only have been that no reality could support the reputation the Peacock Room had earned, "bordering on the miraculous."[200]

If it could not live up to the expectations of Edwardian youth, neither could the Peacock Room match the fondest memories of aging Victorians. On seeing the room again after nearly thirty years, they missed the "dazzling sheen and resplendence" that lived on in recollection. What had not been brought from Prince's Gate to New Bond Street, the writer for *Truth* lamented, was "the essential atmosphere of the old room, its interesting associations, the subtle, intangible spirit that animated what now seems but a mere empty shell."[201] In removing the Peacock Room from the site of its creation, the vital connection between the work of art and the human lives that once informed it had been appreciably diminished, and that link was to attenuate with each ensuing move.

*P*ARTLY BECAUSE of Freer's reticence and partly because the Peacock Room was not so famous in the United States, the American press did not initially pay much attention to the work's imminent arrival on its shores. The *New York Herald*, which had scooped the story of its sale, recognized that the significance of the news had not been sufficiently appreciated and in July 1904 published a full-page illustrated article on the Peacock Room (fig. 7.19), offering a hybrid history drawn from varied sources and introducing a few original details: it said, for example, that the peacock representing Whistler's patron was "smothered in golden eagles." The New York *Sun* also registered that curious act of latent patriotism, stating that the peacock mural contained "a symbolic representation of the Almighty Dollar."[202]

That the Peacock Room should be misinterpreted in America is perhaps not surprising; it has always been difficult to describe in words, and the few pictures then available provided an incomplete impression. In the United States, as in Britain, photographs from Obach's catalogue were widely reproduced, but without giving any sense of how the views fit together into three-dimensional space. Moreover, the American public and writers for the periodical press, unlike their British contemporaries, had not enjoyed the opportunity of examining the work for themselves. A suggestion was made that the Peacock Room be exhibited in the United States ("the American who is rich enough to

FIG. 7.19 *"Whistler's Peacock Room," New York Herald*, 17 July 1904.

buy it ought to be generous enough to share his enjoyment of it"), but the only such proposal Charles Freer took to heart came from Boston, where Whistler's memorial exhibition had been held to great acclaim the previous spring. "Personally, it would give me great pleasure to have the Copley Society exhibit the room," he wrote to its president, Holker Abbott, who had seen the Peacock Room in London, "and I am sure that the people of Boston would enjoy seeing it. But my personal object in making its purchase was to keep the room intact and to preserve it for the longest time possible, and if damage of any material kind should result from its exhibition in your city, both you and I would never quite forgive ourselves for assuming the risk."[203] Freer's fears were justified—the painted leather was already beginning to buckle and crack—but the lack of an American exhibition widened the chasm of ignorance. Even the director of the Detroit Museum of Art, who might have been expected to know better, believed that Whistler's decorations "consisted of a frieze, with possibly a panel or two painted on leather and on canvas by the artist himself."[204]

In September 1904, a peculiarly American "aggregation of misstatement of fact and colour," as Freer called it, was published in the *Chicago Sunday Tribune*. The article added one or two elements to the traditional story—that, for instance, the mad architect had threatened to murder both Whistler and Leyland as he gilded his floor—but the text was overwhelmed, even undermined, by the accompanying illustrations (fig. 7.20). Conceding the impossibility of providing "a proper conception of the general effect," the paper pledged "to reproduce the colors faithfully and as accurately as modern presses can print them." The result was "a unique travesty upon the real thing," evidently arising from the misconception that because peacock plumage, which set the scheme, displays "practically every hue of the rainbow," Whistler's color choices had been unlimited.[205] Freer sent copies of the paper to several friends, with ironic regrets that Whistler had not lived to see that "estimate of his sense of color." He took special pleasure in the mysterious second figure apparent in the painting of *La Princesse*, and in the unaccountable introduction of red to the furnishings: "The pork-packers of the Western metropolis have evidently been dining with the Leylands," Freer wrote to Rosalind Philip, "and have left their finger marks on the chairs." To F. W. Gookin of Chicago, who had drawn his attention to the article, Freer observed that there was only one thing to do: "I should at once abandon all other plans and send the room intact to Chicago, for no where else will it ever be as thoroughly appreciated."[206]

Even as Chicago reveled in that vibrant reinterpretation of his latest and largest acquisition, Freer himself was trying to gain appreciation for it by making "quiet comparisons of the large decorations of the room"—the only parts then present in Detroit—"with the most successful things of a similar nature of fifteenth and sixteenth century work in the Orient." To Richard Canfield, he wrote that while he had previously acknowledged the importance of the Peacock Room, he had not been able to place it "on as high a pedestal as it deserved" before seeing it in the context of his Asian art collections. "It will

WHISTLER'S PEACOCK ROOM
for America

Famous walls which record the eccentric artist's erratic genius to decorate a Detroit home

WINDOW SHUTTER WORKED OUT IN GOLD LEAF

THE CELEBRATED PEACOCK PANEL

JAMES ABBOTT McNEILL WHISTLER

DESIGN ON WINDOW SHUTTER

IN THIS ROOM IS SHOWN THE PICTURE THAT LED TO THE CREATION OF THE PEACOCK ROOM

please you to know," he wrote, "that Whistler's things, in bigness of feeling, strength of line, use of space and general aesthetic accomplishment, hold their own with the very best." Freer also situated the decorations in the scheme of his Whistler holdings, proposing that because the Peacock Room lacked the "finish" of the artist's other works, "it should be classified along with the six paintings in my collection, usually spoken of as the 'Venus Set,'" now known as the Six Projects: "When the room shall have been erected and the six 'Venus Sketches' can be seen and studied together, a new and very important interpretation can be enjoyed by the real students of art."[207]

But Freer's declaration of the Peacock Room's aesthetic affinity with other parts of the collection rings hollow. The qualities he found it to share with works of Asian art are too broad to be convincing, and the comparison to the Projects on the basis of its unfinished state is groundless: the artist himself maintained that the Peacock Room was a finished work of art. Freer appears to have undertaken that inconclusive exercise in direct response to the popularity of the Peacock Room made distressingly apparent in the Chicago *Tribune*—to demonstrate that he stood with "the real students of art" and not among the masses. Only by this highly refined, comparative method of art appreciation could Freer begin to reconcile with the esoteric tone of his collection a room that had created a sensation in London, inspired a travesty in Chicago, and become altogether "a sort of common topic for the tea-table," as Whistler might have said. For the Peacock Room was the only work of art that Freer ever purchased more from obligation than desire, as a "pleasant duty," rather than a pleasure; and it may have been the only one that ever failed to take "strong hold" of his affections.[208]

Even more pressing than the need to place the Peacock Room in the scheme of his collections was the practical necessity of placing it in Detroit. The local newspaper in the Indiana town where Freer got his start in business had illustrated the remarkable rise in his fortune by telling how, in Logansport, he had inhabited "a hall bed-room adorned with two chromos and a hat-rack," while in Detroit, Freer resided in a "palace which has as its conspicuous feature an entire room decorated by James McNeil [sic] Whistler."[209] In truth, Freer's rather modest, shingle-style house at 33 Ferry Avenue was nothing like Frederick Leyland's palace of art at 49 Prince's Gate. Its interiors were more subtly suffused with Whistler's influence: the dining room was painted primrose yellow, and the reception-room walls were decorated in Whistlerian fashion, with dutch-metal leaf and pigmented glazes creating the effect of "an opalescent, shimmering dream of color and pattern, comparable to a peacock's breast or the wings of a butterfly."[210] The Peacock Room—even if Freer had liked it well enough to live in—would never have fit into that house, and immediately upon returning from London, Freer had begun considering how to accommodate the decorations "until such time as they shall go to their permanent home."[211]

Since late in 1902, the year his Whistler collection made its most dramatic growth, Freer had worked with his architect Wilson Eyre on planning a small

Whistler's Peacock Room

World's Greatest Masterpiece Of Decorative Art

Bought By An American

OF all examples of contemporary decorative art the most elaborate and magnificent, perhaps, is the famous Peacock room by the late James McNeil Whistler.

So comprehensive is this decoration that not only the ceiling and the walls are covered by it, but the smallest panel in the remotest corner as well. Rich, gorgeous, though delicate and harmonious, coloring is everywhere.

The Peacock room was painted by Whistler for his friend, the late Frederick Leyland of Princes' Gate, England, and critics and lovers of art journeyed from many parts of the world to see it.

When Mr. Leyland died connoisseurs in England pleaded that the room be purchased by the British government and placed in a public gallery "for the education and pleasure of rising generations." To permit the room to fall into the hands of an individual, they argued, would be cause for patriotic grief.

Purchased by an American.

While this matter was being discussed Charles L. Freer, a multi-millionaire of Detroit, slipped in and purchased the decoration, paying about $60,000 for it. So much to the anger and disappointment of the English critics, it not only has fallen into the hands of an individual, but will be shipped out of the country to America as well.

Mr. Freer is perhaps better known in Europe than in this country as the owner of one of the finest libraries of rare editions in the world. For many years, while he was associated with the late Senator James McMillan of Michigan, with whom he accumulated a great portion of his wealth, Mr. Freer spent all the time he could spare in traveling abroad picking up books. His rambles as a bibliophile brought him into companionship with dealers in paintings, with critics, and with the artists themselves. In this way he came to meet Whistler, whom he considered one of the foremost masters. Mr. Freer began by buying his pictures whenever opportunity presented itself. Then he commissioned him to paint on order until his collection of works by Whistler is said to be unsurpassed.

Knowing the artist intimately—a rare privilege, for Whistler was reserved almost to eccentricity—what could be more natural than that he should long to get possession of all his works? Especially was Mr. Freer desirous of obtaining the remarkable Peacock room, his intention being to move it across the Atlantic to embellish his mansion in Detroit.

Whistler Objects to Picture's Setting.

The origin and development of the Peacock room quite behind Whistler's peculiar temperament. Probably no great modern work of art has so unique a history.

The late Frederick Leyland was an Englishman possessing a palatial house filled with the best examples of Burne-Jones, Rossetti, Ford Madoxy Brown, and other modern masters. Leyland was also an admirer of Whistler. He purchased the celebrated "La Princess du Pays de la Porcelaine," by him, and placed it over the mantelpiece of his dining room. This room was beautifully ceiled and paneled in wood by the well known architect Jeckyll, who had carte blanche as to cost and arranged the color scheme to harmonize with Mr. Leyland's fine collection of Nankin porcelain and with Whistler's painting. One day at luncheon, as Mr. Leyland's guest, Whistler remarked that the design of the room and his picture did not go well together, they lacked harmony, he said.

Decorates Room to Match Painting.

Although quite satisfied with the room up to that, Mr. Leyland was much impressed by Whistler's criticism. In fact, it grew upon him, until he really became distressed. Finally he commissioned the artist to decorate the room to fit the picture.

Whistler entered upon his task with his entire soul. For days at a time he remained in that one room pondering its needs.

Once satisfied with the layout as it presented itself to his mind's eye, Whistler fell to work passionately. He took little rest during a period of six months. On his knees or squatting, Turkish fashion, he painted the panels of the wainscoting; on a ladder or scaffolding, or sometimes in a hammock, he painted peacocks all over the walls and the ceiling. To reach remote corners he sometimes used a brush fastened to the end of a fishing rod. When the work was done Mr. Leyland marveled at the odd design, the perfect splendor of the coloring, the sumptuous effect, and he named it the Peacock room.

Whistler Takes Characteristic Revenge.

He was delighted, but it appears that there was some deplorable misunderstanding between the merchant prince and the artist as to the amount of compensation, the latter was to receive. Probably, taking into consideration Whistler's peppery nature, the fault was not Leyland's. But Whistler felt aggrieved and took a characteristic revenge.

One shutter was still unfinished, and on it he painted two peacocks one with ruffled plumage, grasping in one claw a pile of gold, to represent Leyland, and the other, calmly indifferent to the other's severity, to typify himself. Mr. Leyland said nothing and let the designs remain. But the trouble over the room was not only serious but

TWO OF THE SHUTTERS FROM THE PEACOCK ROOM AND THE ROOM COMPLETE, AS DESIGNED BY WHISTLER

comic. Jeckyll had taken an immense deal of pride in that apartment. He was a man of extremely sensitive nature, and when he saw all the results of his work gradually obliterated by Whistler's brush he fell into a morbid condition which before long developed into violent insanity. He was found one day painting the floor of his house with gold and threatening to murder Leyland and Whistler. He was removed to an asylum, where he soon afterward died.

Most Striking Interior Decoration.

Critics from London and Paris were invited to view the wonderful creation. They looked around and overhead in astonishment. They adjudged it to be the most striking piece of interior decoration of the age.

To give the reader a proper conception of the general effect is impossible. The best that can be done is to detach a small bit or two from the panel scheme and try to reproduce the colors faithfully and as accurately as modern presses can print them.

Two of the shutter designs presented herewith give a good idea of the technique, the great detail of the drawings and the extraordinary brilliancy and harmony of hues and tints. As the feathers of the peacock, especially those of the species to be found on the grounds of Warwick castle, present practically every hue of the rainbow, Whistler was not limited in his use of color.

And if an artist ever understood color it was he. Yet his Peacock room studies he fairly reveled in it. Yet he determinedly guarded himself against the temptation to overpaint. Where a mediocre artist handling the same design would have produced something sensational in its flaring splashes, Whistler's object was to obtain harmonious effect, making the room superbly rich, yet quiet and restful.

addition to his house. Having already turned the horses out of the stables to make room for works of art, he was running out of space again, and much as he hated the idea of an art gallery in a private residence, he could see no way around it. In July 1904, Freer wrote to Eyre that he wanted to discuss the "changes" they had been considering: without disclosing why the problem was suddenly more complex, Freer simply said his "views" had been enlarged.[212] In August, Eyre spent two days in Detroit, and in September he forwarded a rendering of his plans, which included a skylit gallery above the stables and a stone-faced addition to each end, with the Peacock Room occupying the new west wing.[213] Two months later, Freer still regarded the scheme as "preliminary and experimental." He betrayed his continuing unease by writing to Gustav Mayer that he imagined the architect would eventually devise something "inviting enough" to persuade him to proceed. Indeed, negotiations between Freer and Eyre's representative in New York, L. G. Warrington, were to continue all year long. Finally, in the spring of 1905, Freer went overseas in hopes of finding the work complete when he returned; but there were the inevitable delays, and Warrington, who proved maddeningly uninterested in the project, was summoned to Detroit and abruptly dismissed.[214] Construction dragged on for another year, and the new building was not completed until the spring of 1906 (fig. 7.21).

Meanwhile, the Peacock Room arrived in Detroit in twenty-seven packing cases that weighed, all together, more than eight metric tons. Freer found everything in good order and fine condition; the only missing elements were the stones "selected by Mr. Whistler for the peacocks' eyes," which he knew possessed no intrinsic value but wanted anyway, "because of their association." (Obach's sent them separately.)[215] In accordance with Freer's instructions, the cartons had been shipped in two installments. The first, which left London late in July 1904, included the shutters and the peacock mural, "framed simply and shipped in one lot as 'paintings'": as works of art by an American, they were admitted into the United States free of the customs duty normally assessed at sixty percent.[216] Freer expected the second shipment, comprising the rest of the room and retained in London until September, to be subject to the tax customarily imposed on imported furniture. The government, however, "showed unexpected consideration," he confided to Rosalind Philip, by assessing no duty on any decorations enhanced by Whistler's touch. Ironically, the tax collector recognized what even Freer found difficult to comprehend: that as a work of art, the Peacock Room was more than an assemblage of its parts. Freer, then, paid duty only on those elements that Whistler had left alone—Jeckyll's glass lamps and brass fittings and the fireplace tiles—and the sum could not have been a burden, since Obach & Co. had been instructed to assess the items "as near as possible to what . . . such second-hand articles actually are worth."[217]

The Peacock Room was installed in the new addition to 33 Ferry Avenue during March 1906. The only part of the room original to Detroit was a painted concrete floor that Freer considered "perfect," an improvement over the

FIG. 7.21 Freer's house at 33 Ferry Avenue (later 71 East Ferry Avenue), Detroit, ca. 1910. Freer Gallery of Art Archives, Smithsonian Institution, Washington, D.C., Charles Lang Freer Papers.

"ugly" oak parquet at Prince's Gate.[218] Under his watchful supervision, the reconstruction was performed by a local contracting firm, the Vinton Company, which charged just over a thousand dollars for "making repairs around Mr. Freer's house, erecting Peacock Room, cold-water painting in storage loft and painting walls of living rooms, gallery and hall."[219] The invoice suggests that even though the company had no special expertise, the Peacock Room project presented no difficulties. Leila Mechlin, the art editor for the Washington *Star*, traveled to Detroit to see the room in 1906, and afterward reported that it had been "perfectly reset" in a specially constructed building: "The work of replacing this remarkable creation has been carried on with the utmost success, and neither in transportation nor in resetting has it suffered the least violence."[220]

I T IS MOST comforting to be rid of the workmen in my house," Freer wrote to Rosalind Philip in June 1906. He added, however, that if the number of people wanting to see the Peacock Room continued to multiply, he would have to enlist an army of policemen to guard his property.[221] He appears to have felt more threatened by philistines than vandals. There was one named Mrs. Chadbourne, who was in "a sort of frenzy to see the Peacock Room," and a newlywed couple from New York who arrived in a huge motor car: the bride,

innocent of the Peacock Room, inquired whether the wallpaper was a Morris design. With all its popular appeal, the Peacock Room might soon become a circus, Freer imagined. He could even charge admission: "I think it will stand capitalization for a pretty good sum."[222] Instead, Freer presented the Peacock Room as a gift to the nation.

With the announcement in 1906 of Freer's magnanimous and unprecedented offer, there was another spate of publicity. As word spread of the room's installation in Detroit, more and more people became "frantic to see it," Freer wrote to Rosalind Philip in September, "but as you will readily appreciate I am not making special efforts to accommodate the many."[223] To inquiries, Freer replied that the room was open to "art students or others interested in Mr. Whistler's art," though one critic was informed that Freer "permitted no one to enter unless they carried with them a genuine appreciation of the genius of its creator."[224] Among the worthies were the art collectors Henry O. and Louisine Havemeyer, who journeyed to Detroit expressly to see the Peacock Room. Freer took the opportunity to show them "the cream" of his Asian collections as well, and afterward wrote to Ernest Fenollosa, the scholar who advised him on Japanese art, that the Havemeyers had been "completely overwhelmed by the things they saw."[225]

Freer made special efforts to accommodate such intelligent and sympathetic visitors. When, for example, he learned that the Japanese writer Nomura Michi wished to stop in Detroit on her journey around the world, he postponed his own trip to Egypt to meet her. The Peacock Room, she remarked in her account of the trip, was "a magnificent sight," its ceiling assembled like a wavy arch.[226] Freer invited the Michigan branch of the National Archaeological Society to hold its annual meeting there in 1906, and despite telling Rosalind Philip that he would "never have much patience with the masses," he welcomed hundreds of Dayton school teachers and "as many visitors from Ohio . . . as may care to come" one autumn Saturday in 1908.[227] Guests were often admitted to the Peacock Room even in Freer's absence, as his secretary reported in letters dispatched to Yokohama or Peking.[228]

La Princesse du pays de la porcelaine had finally been reunited with the Peacock Room, and Elisabeth Luther Cary, who had seen the painting in Chicago, was under the impression that it had somehow gained a new "sobriety and quietness" of color. "In memory the 'Princesse' had blazed with poppy red and gold and silver. It had seemed daring and immensely vivacious in handling; but in its place among the golden peacocks, under artificial light, it became the keynote of a tender and subdued harmony."[229] The Peacock Room itself seems to have appeared more muted in Detroit, as if to blend in with its quieter surroundings. Madge Bailey, a Seattle journalist who saw it in 1913, later recollected "its restful influence from the noise and dust of the city streets without," comparing the effect to the "refreshing calm" of the Blue Grotto in Capri.[230]

For a time, Freer insisted on calling it the Blue Room, perhaps hoping the understated title would tone down its more sensational associations. As if to

The Heirloom of the Artist

repudiate its Victorian social life, he furnished the room with an incongruous seventeenth-century table, used to display ancient Chinese bronzes or the priceless Bible manuscripts stored in a vault behind the leaded-glass door; the sideboard might hold a Tang dynasty stone head or Buddhist statues from Japan.[231] So that these works could be seen by natural light, the shutters were left open during the day. Mary Chase Perry Stratton, founder of the Pewabic Pottery in Detroit, remembered that they were closed only long enough for visitors to glimpse the gilded peacocks on the panels.[232]

Wilson Eyre was commissioned to design decorative iron grilles for the windows "as protection against burglary," a concern occasioned by the installation of Freer's "valuable lot of pottery."[233] One of the ironies of the Peacock Room's fate is that although it entered the most extensive private collection of Asian art in the United States, that collection did not contain a single specimen of the Chinese blue and white that the room had been created to display. Freer, who had advised Blanche Watney to collect porcelain for the Peacock Room, was not inclined to do so himself, for his interest in ceramics was confined exclusively to pottery. Fenollosa explained that Freer's "banishment of porcelain" arose from a dislike of its surface quality, "hard and obvious, like brand-new water colors gleaming from white bristol boards." He much preferred "the softer and rougher grounds of pottery" that more closely resembled "the old, coarse tinted papers, on which both old and modern masters loved to try their suggestive sketches."[234] In this instance, then, Freer permitted his own aesthetic preferences to supersede Whistler's. According to his friend and confidante Agnes Meyer, Freer concurred with the unnamed critics who believed "that the whole room must have looked appalling when the gilded wooden framework was filled with a bewildering array of Chinese blue and white vases of different dimensions."[235]

The "choice specimens of Eastern pottery" that Freer chose to take their place—pieces reputed to have come from Egypt, Persia, Mesopotamia, China, Korea, and Japan—could not possibly have made a less "bewildering array."[236] Yet it was not until they had been placed on the shelves that Freer made peace with the Peacock Room. In the spring of 1908, he commissioned photographs of the room (fig. 7.22), and he sent a set to Rosalind Philip. Hoping she would like the arrangement, he also apologized for the unaccountable cluster in one corner: he understood, of course, that "one piece only should appear in each space."[237] Evidently, Freer expected no objection to his using the Peacock Room to display pieces of pottery it was never meant to hold—works that plainly took precedence, in his estimation, over the decorations themselves. Having once experimented with a Chinese rug, Freer returned it to the dealer with the explanation that its "large design of contrasting colors" interfered with "the appearance of the objects on the shelves." No mention was made of its effect on Whistler's harmony in blue and gold.[238]

The Peacock Room had already been divorced from its domestic setting, its cultural context, and its raison d'être; Freer removed the work still further

FIG. 7.22 The Peacock Room at Freer's house, Detroit, 1908, photographed by George R. Swain. Freer Gallery of Art Archives, Smithsonian Institution, Washington, D.C., Charles Lang Freer Papers. The large Islamic vase on the right (Freer Gallery, 03.206) is from the Nasrid period (late 14th–early 15th century); the vessel on the table (Freer Gallery, 07.33) is a Chinese ceremonial bronze from the Early Eastern Zhou period (8th century B.C.).

from the circumstances of its creation by imposing an entirely different frame of reference. Each pot placed on the shelves had undergone the same decontextualization, but Freer felt that the Peacock Room particularly needed to be refined of its former associations. Trammeled in anecdote, the room was thought to suffer from the colorful reminiscences of Whistler's contemporaries: "How terrible such things are," Freer lamented, "in view of the real work which tells its own story to all who can see."[239] Freer himself was wholly insensible to social and cultural history. His passion for Asian art never translated into an interest in Asian history, politics, or literature, for he had adopted Whistler's belief, avowed in the "Ten O'Clock" lecture, that "the master stands in no relation to the moment at which he occurs."[240] His fascination was with the "kinship inherent in all works of art." As he explained to Charles Moore, "All works of art go together, whatever their period."[241] In assembling his collection, then, and in filling the Peacock Room with pots it was never meant to contain, Freer put Whistler's precepts uniquely into practice.

The Heirloom of the Artist

The notion that the artists represented in Freer's collection had more in common with each other than with others of their time was given pictorial form in 1909, in a series of autochromes produced by the American pictorialist photographer Alvin Langdon Coburn. Coburn went to Detroit at the suggestion of Charles H. Caffin, an art critic who hoped to present a lecture on Whistler illustrated with color slides made by the new Lumière process: the scheme could only be realized with Freer's cooperation, since his unparalleled collection (including the Peacock Room) would necessarily form the basis of the talk.[242] Freer was notoriously unwilling to allow photography of his collection, considering it a solemn duty to protect his art from "fiendishly unjust reproductions,"[243] and it is doubtful he would have permitted this experiment if Ernest Fenollosa had not endorsed the potential of the autochrome process shortly before his death the previous year. Freer confided to Fenollosa's widow that his only regret was that "the good Professor" could not have delivered the lecture himself.[244]

Coburn was "a young man of taste," Caffin assured Freer, "trained to appreciate the qualities that distinguish Whistler's various expressions." And in the week he spent at 33 Ferry Avenue, Coburn felt almost as though he had met Whistler in person; as he recalled, "I became steeped in his atmosphere during that precious time."[245] After much trial and error, he produced autochrome plates of all Freer's important Whistlers, including *La Princesse*, photographed in place in the Peacock Room (fig. 7.23), making Coburn's autochrome the first authentic color image of Whistler's decoration. Other parts of the room were evidently not considered worth the effort, but eleven autochromes were made of odd assemblages of Asian pottery, lacquers, and bronzes that Freer composed to illustrate the Whistlerian theory of universal aesthetics — that artistic beauty transcends "the slovenly suggestion of nature" and passes through the ages as "the heirloom of the artist." As one contemporary critic explained, "It was Mr. Freer's idea that the art world revolved upon a common centre of great elemental inspiration. Thus one could discover the relation of one art to another and read Whistler with the same language that interpreted the Oriental."[246]

Caffin's lecture, a befuddled if well-intentioned expression of Freer's beliefs, was presented at the Detroit Museum of Art in April 1909, and it may have been, as Caffin supposed, the first art-history lecture ever to be illustrated with color slides.[247] Freer disseminated his theories more successfully himself the next year at the University of Michigan's *Exhibition of Oriental and American Art*, organized to inaugurate the new art building, Alumni Memorial Hall, in Ann Arbor. Despite the esoteric topic and the small town where it was staged, the exhibition attracted more than twelve hundred visitors a day for the three weeks it was on view. Freer's selections, displayed in the second-floor galleries, were intended to reveal "the vital relation between the older Oriental art and the American art of today."[248] The exhibition poster and the cover of the catalogue, designed by a member of the university's architecture department, cap-

FIG. 7.23 *La Princesse du pays de la porcelaine* in the Peacock Room in Freer's house, Detroit, 1909, photographed by Alvin Langdon Coburn (1882–1966). The Royal Photographic Society Collection, Bath, England.

FIG. 7.24 Poster for the Exhibition of Oriental and American Art, University of Michigan, 1910, by William Caldwell Titcomb (1882–1963). Stenciled gold ink on black paper, 51.75 × 29.21. University of Michigan Museum of Art; gift of the Ann Arbor Art Association, in memory of Ruby S. Churchill (1972/2.28).

tured the aesthetic spirit of the show with a stylish adaptation of the central shutters in the Peacock Room (fig. 7.24).

In juxtaposing works from modern America and ancient Asia to illustrate how aesthetic quality could transcend time and place, the University of Michigan exhibition was a small-scale rehearsal for the new museum Freer envisaged in Washington, D.C. As he later wrote to Rosalind Philip, "the Far Eastern objects in the collection have increased abundantly since Mr. Whistler passed on," and he had added many "treasures then unknown" to his collection that he wished the artist could have lived to see. Nevertheless, five exhibition rooms were to be consecrated to Whistler, "and only specimens of his own production will ever be shown therein excepting the Peacock room, in which, on the original shelves, beautiful pieces of Oriental or other harmonizing pottery will stand." (By 1918, when that letter was written, Freer had acquired a number of ceramics from the Pewabic Pottery, apparently for display on those shelves.) The Peacock Room itself was to stand between the Whistler rooms and the Chinese galleries "as the apogee of the holy of holies," in the words of Agnes Meyer, "the ultimate offering on the altar of friendship." [249]

The terms Freer imposed on his gift to the nation, which the Smithsonian Institution was eventually persuaded to accept, allowed him to make refinements and additions to the collections but prohibited alterations after his death, thereby granting him a measure of control even from beyond the grave. He devised this restrictive scheme in a futile effort to sustain what even Whistler had recognized as temporary, "the ephemeral influence of the Master's memory—the afterglow, in which are warmed, for a while, the worker and disciple." [250] As the artist's foremost follower, Freer conceived his collection as a work of art in itself, in which every object contributes to the harmony of the whole. Indeed, the Freer Gallery might have been the ultimate monument to aestheticism, more perfect even than the Peacock Room, and just as closely bound to the time of its creation.

But shortly before his death, Freer acknowledged that "the story of the beautiful" was not in fact complete, as Whistler had confidently proclaimed, "hewn in the marbles of the Parthenon—and broidered, with the birds, upon the fan of Hokusai." Freer saw that story expanding with every archaeological find in Asia, so he appended a codicil to his will allowing "occasional" acquisitions of Asian and Near Eastern art and appointing a few disciples of his own to safeguard the integrity of the collection. He could not have anticipated the consequent growth of the Asian holdings, which caused the Whistler collection to diminish dramatically in proportion. To make way for other things, many of the Whistlers (along with other works of American art) were to be gradually retired to storage, with the result that the Peacock Room would come to look more than ever out of place.

The Heirloom of the Artist

Charles Freer's death in New York on 25 September 1919 effected the transfer of his art to the American nation. In Detroit, the collections were prepared for removal to the new building that stood intact but still unfinished on the National Mall in Washington (fig. 7.25). Its architect was Charles Adams Platt, who specialized in adapting Italian Renaissance style to American buildings. Joseph Pennell thought the Freer building looked like "the unfinished basement of a Florentine palace—a woeful failure as an American art museum, for there is nothing American about it"—but on the whole, Platt's design was regarded as eminently suitable for a gallery of its kind, recalling "other Lorenzos and Florentine patrons who had the touch of Maecenas."[251]

A space with three large windows had been reserved for the Peacock Room in the southeast corner of the gallery. Because it was considered part of the building, it was the first work of art to leave Freer's house; the rest of the collection remained in Detroit until 1921. Platt was eager to install the decorations in Washington, to complete a building project that already had extended more than seven years, and within days of Freer's death a blueprint was prepared, showing the plan of the Peacock Room and its electrical specifications.[252] The decorating firm of Stratemeyer & Teetzel was engaged to dismantle and pack it for shipping, and work proceeded so rapidly that Platt had cause to wonder, in mid-November 1919, whether "sufficient care" was being taken with the job. By the end of the month, the room was ready to travel and insured for one hundred thousand dollars—more than twice what Freer had paid for it fifteen years before.[253] Forty-seven crates containing the decorations and *La Princesse* were loaded onto an American Railway Express train late on the night of 3 December and seven days later were safely inside the Freer building,

FIG. 7.25 Sketch of the Freer Gallery, 1920, by Charles Adams Platt (1861–1933). United States Commission of Fine Arts, Washington, D.C.

"apparently in good condition."[254] Adding to its other peculiarities, one journalist remarked, the Peacock Room now possessed "the uncommon distinction, for a room, of having made two long journeys."[255] And at the relatively youthful age of forty-two, it was about to be reconstructed for the third time.

Although Platt directed that the installation should begin without delay, the foreman of the Detroit crew was disabled for several weeks. He sent a sketch to scale, but the contractor reasonably feared having "strangers work on the room who have not seen it," and the process was postponed until the beginning of the new year. Promising "to get to work and stick to it until it was finished," the Detroit foreman and a second carpenter dedicated the month of January 1920 to restoring the decorations to a new wooden framework.[256] The original substructure must have been left in Detroit, either because it had deteriorated beyond repair or (more likely) because it was thought more economical to replace it than to move it to Washington. A later renovation revealed the "flimsily constructed wooden shell" made in 1920 from second-grade pine planks "grooved along the lateral edges and keyed together by loose-fitting splines." It was wondered, at the time, why the original architect had not provided "a more solid foundation, less subject to movement caused by atmospheric changes" for such a valuable work. Thomas Jeckyll probably had. The inferior substructure erected in Washington proved so inadequate that as early as 1926 most of the ceiling had to be removed, and during the late 1940s the entire framework, not yet twenty years old, had to be replaced.[257]

Relying mainly on memory and a series of photographs prepared at Ferry Avenue and labeled as elevations, the team worked in Washington as rapidly (and probably as carelessly) as it had in Detroit. But apart from reversing the placement of the north and south pairs of shutters, an error that was neither recognized nor rectified until the 1990s, the Peacock Room was accurately reassembled. By the second week of February 1920, everything had been installed except the lamps, which had to be rewired. Platt determined that the decorators hired to carry out other projects in the Freer building were qualified to "make a finish of the work," which according to John Bundy, Platt's Washington representative, consisted "merely of touching up those spots where the paint has been broken off or rubbed, of which there is not a great deal, but it will be more or less tedious."[258] A team of painters from the New York firm Cooper, Sampietro & Gentiluomo commenced "cleaning walls, etc." on 18 February, but as a decorative project rather than a restoration, the only records kept were accounts of workmen's hours and cryptic entries in Bundy's diary noting the number of men working at any one time on the walls, ceiling, or doors of the Peacock Room. On 4 March, after seventy-eight hours and at a cost to the contractor of $125, the cleaning and retouching was completed. In Bundy's opinion, the Peacock Room had "turned out very well, suffered very little in the moving."[259] The shortcomings of the painters' efforts must have been apparent to others, however, since an art restorer was brought from Boston in 1923 to "finish up" in the Peacock Room, yet again.[260]

The Heirloom of the Artist

Contemporary photographs reveal that the substandard framework had already proved susceptible to the fluctuations of Washington weather, which was wreaking havoc with the decorations: one critic noted that the Peacock Room had assuredly reached its final resting place, since the cracks apparent in the leather indicated that it would never survive another move.[261] The shoddy workmanship in the Peacock Room was entirely out of keeping with the high standards observed elsewhere in the Freer Gallery, which suggests that the architect had not given the project his customarily scrupulous attention: the Peacock Room, after all, was the only interior of the building he had not designed himself. Charles Platt objected to the notion, common at the time, that Whistler's room was "the most unique feature of the Gallery." "My personal opinion is that the room is ugly but it will live forever on account of the peacocks which Mr. Whistler has painted on the walls of the room and on the shutters of the windows, and the picture which occupies the place over the mantel."[262] Like Freer, if for reasons of his own, Platt regarded the room as little but the frame for certain pictures, an attitude that would prevail for decades to come.

Elizabeth Pennell visited the Freer Gallery in July 1920 with Freer's old friend from Detroit, Charles Moore, now chairman of Washington's Fine Arts Commission. She had not seen the Peacock Room since the Obach exhibition in 1904 (the Pennells had not been welcome in Detroit), and because the lights were not yet installed, it was impossible for her to see it at the Freer "in its full beauty. One window had to be left with shutters open for the designs on the others to be visible." She was, however, permitted a glimpse of La Princesse, which was protected by a curtain drawn aside for visitors. A few days later, when lunching with some friends, Mrs. Pennell mentioned having seen the Peacock Room, and someone in the company inquired, "Who was it painted the Peacock Room? Leighton?" After that, she noted in her journal, "I spoke no more of Whistler."[263] At another luncheon, given at the Library of Congress in 1921, Mrs. Pennell sat beside Grace Dunham Guest, a member of the Freer curatorial staff, who commented that Mr. Freer had kept dark-toned pottery on the Peacock Room shelves in Detroit, but she wondered "how it would look with blue-and-white." That innocent remark made Elizabeth Pennell worry about the management of Whistler's legacy, as did Miss Guest's ominous observation that La Princesse could hold its own, "however it might be with the rest of the Peacock Room."[264]

Charles Freer himself had never set foot in the gallery, but his imprint was everywhere, as suggested by an autochrome made in January 1923 for the National Geographic, the first color reproduction of the Peacock Room ever published (fig. 7.26).[265] The photograph reveals that the Italian table had been brought from Detroit to occupy its accustomed place (it was removed before the museum opened to the public) and, more significantly, that some of Freer's ceramics had been installed on the shelves. By the end of 1923, twenty-five pieces of Chinese, Japanese, and Near Eastern pottery were scattered about the

FIG. 7.26 The first published color photograph of the Peacock Room, by Charles Martin for *National Geographic,* May 1923.

Peacock Room. Some thought evidently went into their selection, for most pieces were glazed in tones described as turquoise, apple green, or lapis lazuli. Several were "of the type of West Asian pottery known as Rakka," distinguished by its iridescent surfaces, which must have formed an interesting effect when juxtaposed with Whistler's peacock feathers.[266] But there were "one or two extraordinary jarring notes," one critic observed, "that will naturally lead to those differences acrimonious and otherwise which this 'only mural' of Whistler has ever aroused." On the north wall near *La Princesse,* for example, was a Japanese water jar with a red-orange glaze and "splashes of blue-grey and yellow-grey overflow," a piece that could not have harmonized with anything in the room.[267]

The aura of Freer's ambivalence appears to have accompanied the Peacock Room to Washington, where its popularity continued to perplex those with more mandarin sensibilities. Almost as soon as the room was standing, people started clamoring to see it. At first the Smithsonian administration obliged, but the absentee curator of the collections, John Ellerton Lodge (who maintained his post at the Boston Museum of Fine Arts even while directing preparations at the Freer), strenuously objected to the Smithsonian's practice, maintaining that "the Museum should be kept inviolate until, so to speak, it reaches the age of consent."[268] The Regents accordingly passed a resolution closing the Freer Gallery to visitors, and when its "inviolate" state occasioned some complaints, a Smithsonian official said that "nothing was hung" at the Freer Gallery anyway—"nothing was in order yet except the Peacock Room and, if you hadn't seen that, you hadn't missed much."[269]

And yet, predictably, when the museum finally opened to the public, the Peacock Room attracted disproportionate attention. It was also cast into an

The Heirloom of the Artist

FIG. 7.27 The Peacock Room, ca. 1923. Freer Gallery of Art Archives, Smithsonian Institution, Washington, D.C.

unflattering glare of publicity. "Most of us have seen too many interiors of chop-suey houses—we call them 'joints'—to be greatly impressed by 'the peacock room,'" sneered Guy Pène du Bois, who detected an atmosphere "of gim-cracks and tinsel" in the decorations, especially when compared with the "real Chinese art" in adjacent galleries. Richard De Wolf observed that the Peacock Room might serve a purpose in demonstrating Whistler's versatility, but that it was, "after the rest of the collection, the least bit disappointing." Struck by the "luxury of the *bon vivant*," he could not discern a trace of "the exquisite taste of the artist of 'nocturnes' and 'arrangements.'"[270]

Vicissitudes of taste account for some of the change in attitude since 1904, but the Peacock Room's unsympathetic installation at the Freer Gallery must also be held to blame (fig. 7.27). "So much has been said and written of the Peacock Room that it may fall short of expectation when first seen in its present quarters," the *Christian Science Monitor* observed, "and the reason for this should be made clear, for the sake not solely of the visitor's enjoyment but still more of Whistler's reputation." The "Gallery Book" written by Freer's former assistant Katharine Rhoades, issued in typewritten form at the end of 1923, provided a straightforward recitation of the story (taken largely from the Pennells' *Life*), but neglected to mention that the Peacock Room was shown in Washington "under very different conditions from those for which Whistler created his harmony." The museum administration must not comprehend the damage being done to the room's aesthetic integrity, the writer supposed, or it could never allow it to be shown in such an unsympathetic state.[271]

To begin with, the two dozen pieces of pottery on the more than two hundred shelves were far too few to justify the complicated architecture of the room, and the emphatic gold lines of the mostly empty structure disrupted

FIG. 7.28 Peacock in the Freer Gallery courtyard, 1923, photographed by Arnold Genthe (1869–1942). Freer Gallery of Art Archives, Smithsonian Institution, Washington, D.C.

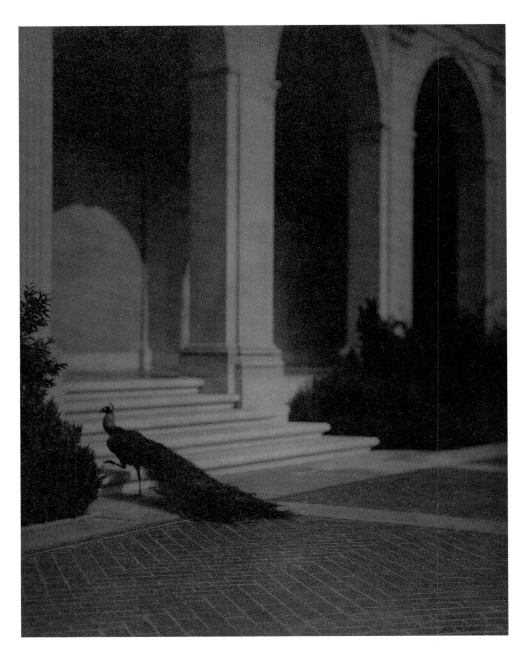

the aesthetic of Whistler's own "arrangement." (Pène du Bois observed that the "silly little shelves," which might once have held "a tremendous quantity of Victorian rubbish," now appeared to serve no purpose whatsoever).[272] Moreover, Whistler's decoration had been intended as a background for the furnished dining room of a wealthy Victorian merchant, but that opulent environment was not even suggested at the Freer Gallery: there was no blue carpet (or even floorboards), but cold, dark terrazzo; no dining table and chairs, but a pair of hard wooden benches; no bright sunflower andirons, but a nondescript, anachronistic fire screen.[273] Finally, and most harmfully, the shutters were always thrown open to admit the light of day—bright Washington sunshine that clashed with the electric glare of the pendant lamps. It had long been recognized that because the Peacock Room was a dining room, meant to be seen by artificial light, "any opinion formed upon its effect by daylight is necessarily

The Heirloom of the Artist

unjust." But in Washington, daylight had the further deleterious effect of casting the room's infirmities into cruel relief and making painfully obvious the blemishes from the recent "retouching," since the decorators had failed to match the original shade of blue. Elizabeth Stokes complained that visitors could not even close the panels to view the peacocks without a gallery attendant standing nervously on guard, seriously impeding aesthetic response. "Give us a bit of romance!" she implored. "Shut the shutters, dull the lamps, let a little dust collect in the corners. It was a mystical room, its peacock greens and blues, and browns were never intended for arc lights and magnifying glasses."[274] In the antiseptic chambers of the museum, the room had lost its power to enchant.

As if in compensation, live peacocks were imported from the zoo and given the run of the Freer Gallery courtyard. They remained there until November and returned in the spring, a practice that continued throughout the 1920s. It is not known to whom is owed this inspiration, but the Freer peacocks became the pride of the museum and the adored pets of the staff: during their first summer in residence, four chicks were hatched, and Grace Guest wrote to John Lodge (who was surprisingly amenable to this frivolity) that if she didn't have so much to do, she would spend all her days watching them. Sadly, in September, the entire brood of peachicks died, but the original flock flourished, lending color and animation to an otherwise austere environment.[275] When Arnold Genthe arrived to photograph the new museum, he "made no effort to take views of the Court," Katharine Rhoades reported, "excepting as it happened to make a pleasing background for our poultry" (fig. 7.28).[276]

Ironically, in this case, it was not nature, but art, whose song seemed out of tune. One critic observed, that inaugural year, that the peacocks at the Freer Gallery displayed "their gorgeous hues of green and blue and gold almost as if to mock the lower key of gold and the rather dirty bluish green which is the general tone of the Leyland dining room."[277] In 1923, there would have been no way of knowing how far the room's beauties had tarnished over time, or even of imagining its original splendor, which was not to be retrieved for another seventy years. The Peacock Room, it now appears, had come to be regarded like an old family heirloom, dutifully preserved in the faint expectation that somewhere in the future, the ill-favored thing might be dusted off, polished up, and restored of its legendary charm.

Full references to shortened citations
and manuscript sources are provided in
the Bibliography. Place of publication is
London, unless otherwise noted.

Abbreviations

AAA	Archives of American Art, Smithsonian Institution, Washington, D.C.
AMW	Anna McNeill Whistler
ASC	Alan Summerley Cole
BM	British Museum, London
CLF	Charles Lang Freer
DGR	Dante Gabriel Rossetti
ERP	Elizabeth Robins Pennell
FGA	Freer Gallery of Art, Smithsonian Institution, Washington, D.C.
FRL	Frederick Richards Leyland
GDM	George du Maurier
Gentle Art	*The Gentle Art of Making Enemies*, by J. M. Whistler (1892)
GUL	Glasgow University Library, Scotland
JHG	James H. Gamble
JMW	James McNeill Whistler
LC	Library of Congress, Washington, D.C.
Life of Whistler	*The Life of James McNeill Whistler*, by J. and E. R. Pennell (1908), 2 vols.
MMM	Merseyside Maritime Museum
PUL	Princeton University Libraries
PWC	Pennell Whistler Collection, Library of Congress, Washington, D.C.
RIBA	Royal Institute of British Architects, London
UBC	University of British Columbia Library, Vancouver
UCL	University College London Library
V&A	Victoria and Albert Museum, London
Whistler Journal	*The Whistler Journal*, by J. and E. R. Pennell (1921)
WMR	William Michael Rossetti

Introduction

1. "Mr. Whistler's 'Ten O'Clock,'" *Gentle Art*, 155; "The Peacock Room," *Athenaeum* no. 3999 (18 June 1904): 793.

2. See *Life of Whistler*, 2:34: "Mr. W. C. Alexander has told us that, when he listened to the *Ten O'clock* at Prince's Hall, there was nothing in it fresh to him; he had heard it all for years from Whistler. The only new thing was Whistler's decision to say in public what he had long said in private."

3. Way, *Memories of Whistler*, 28.

4. Tom Prideaux, *The World of Whistler, 1834–1903* (New York, 1970), 118.

5. Charles Moore, "Memoirs," 284, Charles Moore Papers, LC Manuscript Division. These words were later stricken from the manuscript.

6. Quoted in *Life of Whistler*, 1:209.

7. "The Peacock Room," *Athenaeum* no. 3999 (18 June 1904): 793.

8. *Life of Whistler*, 1:209.

9. *Whistler Journal*, 100 and 111.

10. *Life of Whistler*, 1:204.

11. Sutton, *Nocturne*, 83.

12. *Life of Whistler*, 1:209.

13. ERP journal, 11 Nov. 1909, PWC 352.

14. *Whistler Journal*, 100.

15. *Life of Whistler*, 1:207. Burns A. Stubbs tellingly attributes the quotation to Whistler in *James A. McNeill Whistler: A Biographical Outline Illustrated from the Collections of the Freer Gallery of Art*, Freer Gallery of Art Occasional Papers, no. 1 (Washington, D.C., 1950): 17.

16. "Art and Artists," *Star*, 14 June 1904, 1.

17. Pennell and Pennell, *Life of Whistler* (1911 edition), 151.

18. CLF to Richard A. Canfield, 25 Feb. 1903, FGA LB10.

19. Stubbs, *Whistler Peacock Room*. The first edition of 1951 went into a second printing in 1962; the second edition (erroneously published as the third) appeared in 1965, the third in 1972. The revision by Susan Hobbs was published as the fourth edition in 1980.

20. Child, "Pre-Raphaelite Mansion."

21. Ferriday to the director of the Freer Gallery, 20 Sept. 1989, FGA curatorial files; Ferriday, "Peacock Room."

22. Ferriday, "Peacock Room," 407 and 412; Ferriday to the director of the Freer Gallery, 20 Sept. 1989, FGA curatorial files.

23. Prinsep, "Collector's Correspondence"; "Art and Artists," unidentified newspaper, [London], 24 Sept. 1903, GUL PC21/5.

24. Ferriday, "Peacock Room," 409; Duval, "Reconstruction of Leyland's Collection" (1982) and "F. R. Leyland" (1986); Macleod, *Art and the Victorian Middle Class* (1996), especially 284–89 and 442–43.

25. Child, "Pre-Raphaelite Mansion," 84; Ferriday, "Peacock Room," 414; Stubbs, *Whistler Peacock Room*, 2.

26. Ferriday to the director of the Freer Gallery, 20 Sept. 1989, FGA curatorial files. Ferriday gave the drawing reproduced as fig. 1 to Charles Handley-Read; it was sold from that estate in 1977. Ferriday kept one drawing for himself; the others are in the Victoria and Albert Museum (see figs. 5.11 and 5.12). Jeckyll's furniture and designs were featured in an exhibition at the Fine Art Society in London with a catalogue by Robin Spencer, *The Aesthetic Movement and the Cult of Japan* (1972). Some projects in Jeckyll's early career were recovered by Mark Girouard in *Sweetness and Light* (1977), 118–19, and *Victorian Country House* (1979), 366–70.

27. *Star*, 10 June 1904, 2.

28. James Laver, *Whistler* (New York, 1930), 160–61.

29. Ferriday quotes from this passage, calling it a "remarkable flight of fancy" ("Peacock Room," 407). Stubbs had added an embellishment lifted from a newspaper clipping—that Jeckyll was discovered "babbling incoherently of fruit and flowers and peacocks" (*Whistler Peacock Room*, 9, from *Modern Society* 24 [18 June 1904]: 17–18, in FGA PC2). Variations on that detail

were to appear in Saarinen, *Proud Possessors*, 130–31, and Weintraub, *Whistler*, 177–78.

30. Curry, *Whistler at the Freer*, 54.

31. *Life of Whistler*, 1:207.

32. Bendix, *Diabolical Designs*, 128 and 141. Bendix's account of the Peacock Room appears in chapter 4, "Passage to the Splendor of the Peacock," 121–42. Although we cover similar ground, Bendix and I take different approaches to the Peacock Room and often draw different conclusions. Bendix was one of the few scholars to see the Peacock Room while it was still under conservation and among the first to note the significance of the cleaning; her explanations of technical matters, however—the assertion, for instance, that "the walls of the room have undergone chemical changes that have created darkening and fading of fugitive effects" (138)—are sometimes unreliable.

33. Frederick A. Sweet, *James McNeill Whistler: Paintings, Pastels, Watercolors, Drawings, Etchings, Lithographs*, exhib. cat., Art Institute of Chicago (Chicago, 1968), 33.

34. "The Peacock Room," *London Notes*, 18 June 1904, FGA Whistler PC2/8.

35. [Elisabeth Luther Cary], "A Comment on Whistler's Contribution to Art," in "Whistler Memorial Program: The Freer Gallery of Art," *American Magazine of Art*, Anniversary Supplement: Proceedings of the Twenty-Fifth Annual Convention of the American Federation of Arts, 27 (Sept. 1934): 15.

36. Frank Whitford, *Japanese Prints and Western Painters* (New York, 1977), 147; Hilary Taylor, *Whistler*, 87 and 88; John Walker, *James McNeill Whistler*, Library of American Art (New York, 1987), 75.

37. Stubbs, *Whistler Peacock Room*, 14.

38. The dates and progress of the work are recorded in the Freer Gallery diaries, FGA Building Records: the restoration began on 10 October 1947 and continued nearly every weekend, Friday through Monday (with intermittent restoration work on other American paintings in the collection), until 4 October 1948, when the Peacock Room "reopened to the public at 4:05 p.m." It closed again on 6 July 1949 "for ceiling repairs," and *La Princesse* was also "retired"; the Finlaysons cleaned and relined the painting in September 1950, completing it on 2 October 1950, and "thus finishing their work on the Peacock Room."

39. Stubbs, *Whistler Peacock Room*, 6.

40. It was reported that as a result of its restoration, the Peacock Room appeared "almost precisely as it was completed by

Whistler": "Whistler Memento," *Hobbies: The Magazine for Collectors* (Chicago) 55 (Dec. 1950): 45.

41. See Samet, Stoner, and Wolbers, "Approaching the Cleaning of Whistler's Peacock Room." For more popular accounts of the project and its results, see Baker, "Polishing the Peacock Room," and Merrill, "Whistler's Peacock Room Revisited." A complete technical record of the project is on deposit in the Department of Conservation and Scientific Research, FGA.

42. E. W. Godwin, letter to the editor, "Whistler and the Philistines: What is a 'Master'?" *Court and Society Review* 3 (22 July 1886): 657.

Chapter 1

1. See, for example, Julius Meier-Graefe, *Modern Art: Being a Contribution to a New System of Aesthetics*, trans. Florence Simmonds and George W. Chrystal, 2 vols. (1908), 2:201 and 213; Sandberg, "'Japonisme' and Whistler," 504; and Fried, *Manet's Modernism*, 229.

2. Fantin-Latour to Alphonse Legros, [June] 1865, GUL Barbier Papers 171; R. A. M. Stevenson, "The International Society of Sculptors, Painters, and Gravers," *Pall Mall Gazette*, 16 May 1898, 2. For contemporary French reviews, see Goebel, *Arrangement in Black and White*, 2:721–27.

3. GDM to Thomas Armstrong, [1862], *Du Maurier Letters*, 118.

4. *Life of Whistler*, 1:94; *Whistler Journal*, 161.

5. Courbet to JMW, 14 Feb. 1877, *Letters of Gustave Courbet*, ed. and trans. Petra ten-Doessehate Chu (Chicago, 1992), no. 77-9; Boyce, *Diaries*, 15 Jan. 1863, 37; Luke Ionides, *Memories*, 12; *Life of Whistler*, 1:94.

6. ERP journal, 10 May 1907 (Drouet), PWC 352; *Life of Whistler*, 1:95.

7. JMW to Fantin-Latour, [Sept.?] 1867, in Spencer, *Whistler Retrospective*, 82; ERP journal, 20 Mar. 1904 (Ionides), PWC 352. Among those who stressed the importance of Courbet's influence were Théodore Duret (10 Feb. 1904, PWC 352) and Thomas Armstrong (12 Sept. 1906, PWC 353).

8. Courbet, quoted by Armstrong, trans. Spencer, *Whistler Retrospective*, 57. Whistler arrived in Paris in November 1855; Courbet's exhibition, which had opened on 28 June, closed at the end of December.

9. ERP journal, 10 Feb. 1904 (Duret), PWC 352.

10. "Royal Academy Exhibition [Second Notice]," *Daily Telegraph*, 6 May 1861, 5; Hiffernan to Lucas, 9 Apr. 1862, in Mahey, "Letters of Whistler to Lucas," no. 1.

11. JMW to Lucas, 26 June [1862], in Thorp, *Whistler on Art*, no. 5; "Fine-Art Gossip," *Athenaeum*, no. 1809 (28 June 1862): 859. Whistler's letter, or "explanation," dated 1 July 1862, was published in the *Athenaeum*, no. 1810 (5 July 1862): 23. The unsigned review in the *Athenaeum* is commonly attributed to F. G. Stephens, but the next year W. M. Rossetti conveyed a message to Stephens from Whistler "to the effect that he wishes you could look up, at a forthcoming meeting of the Artists' and Amateurs' Society, Willis's Rooms, his White Woman . . . of course the object is that you should write something about it." This suggests that Stephens had not already written about the painting (24 Mar. [1863], W. M. Rossetti, *Selected Letters*, no. 85).

12. Recent examples include Dorment and MacDonald, *Whistler*, cat. no. 14, and Anderson and Koval, *Whistler*, 107. Whistler noted the present title in GUL PC1/3; it was exhibited as *Symphony in White, No. 1* only after his death, at the Whistler Memorial Exhibition in London, 1905.

13. For a comparison of these paintings, see Anderson and Koval, *Whistler*, 108–9.

14. Charles Rosen and Henri Zerner, *Romanticism and Realism: The Mythology of Nineteenth Century Art* (Boston, 1984), 164; Borzello, *Artist's Model*, 165. For an interpretation of the painting as "a seminal work in the emergence of English symbolism," see Christopher Newall, "Themes of Love and Death in Aesthetic Painting of the 1860's," in *The Age of Rossetti, Burne-Jones and Watts*, ed. Andrew Wilton and Robert Upstone, exhib. cat., Tate Gallery (1997), 39.

15. JMW to Lucas, 16 Mar. [1863], PWC 2; Harper Pennington, "James Abbot [sic] McNeill Whistler," PWC 297.

16. Fink, *American Art at Paris Salons*, 80–81; Fantin-Latour to JMW, [15 May 1863], GUL F12 ("Te voila célèbre!").

17. WMR to Joseph Pennell, 19 Nov. 1906, memorandum, PWC 298; WMR to William Bell Scott, 19 June [1867], W. M. Rossetti, *Selected Letters*, no. 125.

18. DGR to William Bell Scott, [Nov. 1859], *Letters of Rossetti*, no. 319; Macleod, *Art and the Victorian Middle Class*, 269; DGR to G. P. Boyce, 2 Oct. 1862, UCL Ogden.

19. *Life of Whistler*, 1:98–99; JMW to WMR, [1 July 1882], UBC Angeli-Dennis 24/19.

20. WMR to Joseph Pennell, 19 Nov. 1906, memorandum, PWC 298; W. M. Rossetti,

Reminiscences, 2:316. D. G. Rossetti wanted Whistler to come no closer, however: when the house next door to his became vacant in 1864, Rossetti urged Boyce to take it, since "Whistler is after some other place & *entre nous* I had rather have you for a neighbour than that dearest but most excitable of good fellows" (DGR to G. P. Boyce, 27 Dec. 1864, UCL Ogden).

21. JMW to Sandys, [ca. May 1863], fragment, GUL PC21/77; ERP journal, 10 May 1907 (Oulevey), PWC 352.

22. William Laurie Hill, "James McNeill Whistler as I Knew Him," PWC 334.

23. AMW to JHG, 10–11 Feb. 1864, in Thorp, *Whistler on Art*, no. 9; GDM to Thomas Armstrong, [Feb. 1864], *Du Maurier Letters*, 227.

24. William Laurie Hill, "James McNeill Whistler as I Knew Him," PWC 334; CLF to August F. Jaccaci, 4 Apr. 1904, FGA LB8.

25. AMW to JHG, 10–11 Feb. 1864, in Thorp, *Whistler on Art*, no. 9.

26. Dorment and MacDonald, *Whistler*, 23.

27. AMW to JHG, 10–11 Feb. 1864, in Thorp, *Whistler on Art*, no. 9.

28. Swinburne, *William Blake*, 91. Swinburne began the essay in 1863.

29. GDM to Armstrong, 11 Oct. 1863, *Du Maurier Letters*, 216.

30. For Oscar Wilde's famous remark of 1876, "Oh, would that I could live up to my blue china!" see Walter Hamilton, *The Aesthetic Movement in England* (1882), 90. Richard Kelly interprets the cartoon as a parody of Whistler's *Lange Lijzen* (*George du Maurier* [Boston, 1983], 34).

31. DGR to James Leathart, 9 Dec. 1863, UBC Leathart 1/8; AMW to JHG, 10–11 Feb. 1864, in Thorp, *Whistler on Art*, no. 9.

32. The Dutch *lijs* (plural, *lijzen*) means "dawdler." A. T. Hollingsworth offered the theory that the French corrupted the Dutch term for "long young ladies" to *Longues Elises*, or "Long Elizas" (*Nankin China*, 34).

33. "Royal Academy (Third Notice)," *Observer*, 15 May 1864, 6.

34. GDM to Thomas Armstrong, [June 1863], *Du Maurier Letters*, 206.

35. JMW to O'Leary, in Anderson, "An Irish Rebel and Ireland," 255 (letter reproduced as fig. 3); GDM to Armstrong, 11 Oct. 1863, *Du Maurier Letters*, 216.

36. Sutton, *Nocturne*, 50.

37. Luke Ionides, *Memories*, 11.

38. AMW to JHG, 10–11 Feb. 1864, and JMW to Fantin-Latour, ca. 4 Jan./3 Feb. [1864],

in Thorp, *Whistler on Art*, nos. 9 and 8.

39. A chair similar to the one pictured here is illustrated in Curtis Evarts, "Classical Chinese Furniture in the Piccus Collection," *Journal of the Classical Chinese Furniture Society* 2 (Autumn 1992): fig. 19. Jan Stuart kindly provided these identifications.

40. W. M. Rossetti, "The Royal Academy Exhibition," *Fraser's Magazine* 70 (July 1864): 68; AMW to JHG, 10–11 Feb. 1864, in Thorp, *Whistler on Art*, no. 9.

41. Broun, "Thoughts That Began with the Gods," 39. The model's gesture with the brush may have been suggested by paintings on Chinese porcelain depicting figures with hands modestly covered by their sleeves: see for example the brush pot in Phoenix Art Museum, *Chinese Ceramics in the Wong Collection*, exhib. cat. (Phoenix, 1982), no. 68.

42. "Mr. Whistler's 'Ten O'Clock,'" *Gentle Art*, 156–57. For another interpretation, see Fried, *Manet's Modernism*, 225.

43. Francis Turner Palgrave, "The Royal Academy of 1864," in *Essays on Art* (1866), 63. See also "The Exhibition of the Royal Academy (Second Notice)," *Evening Star*, 8 May 1865, 3: "There are a few persons who think Mr. Whistler is a great painter; that he thinks so himself is evidenced by the manner in which he inscribes his name in very large letters on all his work."

44. ERP journal, 7 Feb. 1909 (Meyer), PWC 352. Gustav Mayer ("Meyer") of Obach & Co. heard this from the framemaker himself.

45. GDM to his mother, [Apr. 1864] and [Oct. 1860], *Du Maurier Letters*, 235 and 16.

46. AMW to JHG, 10–11 Feb. 1864, in Thorp, *Whistler on Art*, no. 9; "The Royal Academy," *Art Journal*, 1 June 1864, 165–66. On the evolution of *Wapping*, see Robin Spencer, "Whistler's Subject Matter: 'Wapping' 1860–1864," *Gazette des Beaux-Arts* (Paris) 100 (Oct. 1982): 131–42.

47. W. M. Rossetti, "The Royal Academy Exhibition," *Fraser's Magazine* 70 (July 1864): 58, and "Art-Exhibitions in London," *Fine Arts Quarterly Review* 3 (Oct. 1864): 29.

48. "Fine Arts. Exhibition of the Royal Academy (Third Notice)," *Illustrated London News*, 21 May 1864, 494. See Henry Morley, "Pictures at the Royal Academy," *Fortnightly Review* 11 (1 June 1872): 695: "If we gave only one minute's attention to each work in the Academy Exhibition," one critic figured, "it would take twenty-five hours to see them all."

49. AMW to JHG, 10–11 Feb. 1864, and JMW to Fantin-Latour, ca. 4 Jan./3 Feb. 1864, in

Thorp, *Whistler on Art*, nos. 9 and 8.

50. GDM to Thomas Armstrong, [Feb. 1864], *Du Maurier Letters*, 227. Cavafy had previously purchased *The Last of Old Westminster* (1862) and *Battersea Reach* (ca. 1863).

51. "The Royal Academy. One Hundred and Second Exhibition," *Art Journal*, 1 June 1870, 168.

52. Lochnan, *Etchings of Whistler*, 94–95 and 132; Watanabe, *High Victorian Japonisme*, 232.

53. [F. G. Stephens], "Fine Arts: Royal Academy," *Athenaeum*, no. 1958 (6 May 1865): 628; "Notes on Art by Artismator," *Sunday Times*, 28 May 1865, 2.

54. W. M. Rossetti, *Reminiscences*, 1:276–77.

55. W. M. Rossetti, "The Fine Art of the International Exhibition," *Fraser's Magazine* 66 (Aug. 1862): 188, 189.

56. W. M. Rossetti, *Reminiscences*, 1:283.

57. Boyce, *Diaries*, 28 July 1862 and 5 Feb. 1864, 35 and 39.

58. Prinsep, "Private Art Collections," 132.

59. DGR to J. A. Rose, 24 Feb. 1864, PWC 22; DGR to F. M. Brown, [Apr. 1864], *Letters of Rossetti*, no. 523.

60. W. M. Rossetti, *Reminiscences*, 1:283.

61. Prinsep, "Private Art Collections," 132; H. T. Dunn, *Recollections of Rossetti*, 43–50.

62. DGR to Kate Howell, 18 June [1865], in Cline, *Owl and the Rossettis*, no. 8; DGR to F. M. Brown, 18 Apr. 1865, *Letters of Rossetti*, no. 604; [F. G. Stephens], "Fine Arts: Mr. Rossetti's Pictures," *Athenaeum*, no. 1982 (21 Oct. 1865): 546.

63. On this use of Pre-Raphaelite symbolism, see John Dixon Hunt, *The Pre-Raphaelite Imagination, 1848–1900* (1968), 177–210.

64. GDM to Thomas Armstrong, [Feb. 1862], *Du Maurier Letters*, 105. A cartoon probably by du Maurier, "Punch's Advice to Ladies" (*Punch*, 21 Feb. 1863, 73), portrays a woman wearing a crinoline and posed with one hand on the mantel like Whistler's *Little White Girl*, proposing the useful function of a fireguard for the impractical fashion Whistler's model pointedly fails to follow.

65. JMW to Fantin-Latour, ca. 4 Jan./3 Feb. 1864, and AMW to JHG, 10–11 Feb. 1864, in Thorp, *Whistler on Art*, nos. 8 and 9. Du Maurier may have recalled the episode in his novel *Trilby* (1894), in which an Irish model comes between the artist Little Billee and his much beloved but highly respectable sister. L. Kashnor suggests this connection in *Whistler and His Circle: Letters and Documents* (1927), vii.

66. "The Exhibition of the Royal Academy [Second Notice]," *Evening Star*, 8 May 1865, 3. W. M. Rossetti, who called the earlier and larger painting "The Big White Girl," seems to have been the only contemporary critic to grasp the allusion ("The Royal Academy Exhibition," *Fraser's Magazine* 71 [June 1865]: 747).

67. Cortissoz, "Whistler," 832.

68. Swinburne, *William Blake*, 90.

69. Quoted in Humphrey Hare, *Swinburne: A Biographical Approach* (1949), 108.

70. Swinburne to JMW, 2 Apr. 1865, GUL s265.

71. Rossetti reframed *The Girlhood of Mary Virgin* in 1864 (W. M. Rossetti, *Family Letters*, 1:148); the painting was lent to the artist for this purpose in December (see DGR to F. M. Brown, [7 Dec. 1864], *Letters of Rossetti*, no. 571).

72. "Mr. Whistler's 'Ten O'Clock,'" *Gentle Art*, 147.

73. Jules Claretie, "Deux Heures au Salon," *L'Artiste* (Paris), 15 May 1865, in Goebel, *Arrangement in Black and White*, 2:721; C. de Saul, "Salon de 1865," *Le Temps* (Paris), 6 June 1865, 2. Readings of the painting in terms of *japonisme* are too numerous to cite, but among the first to establish a connection with ukiyo-e artists was Marie Norris, "Whistler and the Ukiyo-ye," *Lotus* (Boston), Dec. 1903, 25–26. Two influential discussions in these terms are Sandberg, "'Japonisme' and Whistler," and a letter written in response by Basil Gray, "'Japonisme' and Whistler," *Burlington Magazine* 107 (June 1965): 324. Recent assessments include Watanabe, *High Victorian Japonisme*, 239, and Lambourne, *Aesthetic Movement*, 54. Curry, on the other hand, identifies the painting's roots in French chinoiserie (*Whistler at the Freer*, cat. no. 5), and Broun observes that "both title and image imply that this is a *lange leizen* come to life" ("Thoughts That Began with the Gods," 39).

74. Willem Bürger [Théophile Thoré], "Salon de 1865," *L'Indépendance Belge* (Brussels), 14 June 1865, 2; de Saint-Victor, "Salon de 1865 (Quatrième article)," *La Presse* (Paris), 28 May 1865, 3; Chesneau, "Beaux-Arts: Salon de 1865: III: Les Excentriques," *Le Constitutionnel* (Paris), 16 May 1865, 2. Spencer states that critics considered the painting "merely an enlarged tracing of a Japanese print, without the breath of real life," evidently mistranslating Chesneau's *potiche* as "print" ("Whistler and Japan: Work in Progress," in Society for the Study of Japonisme, *Japonisme in Art: An International Symposium* [Tokyo, 1980], 63). In fact, no

French critics name Japanese prints as a source for Whistler's painting, although Théophile Gautier writes, "Ce n'est qu'une figure de paravent, découpée et collée sur une toile" (It is nothing but a figure on a screen, cut out and pasted on a canvas) ("Salon de 1865. VI. Peinture," *La Moniteur universel* [Paris], 24 June 1865, 2).

75. Théophile Gautier fils, "Salon de 1865 (1er article)," *Le Monde illustré* (Paris) 9 (6 May 1865): 283 ("Le tout posant sur un dallage de porcelaine").

76. Horowitz, "Whistler's Frames," 126; Ikegami Chuji, "British Design à la japonaise of Picture Frame: D. G. Rossetti and J. M. Whistler," in *East and West in Asian Art History: Opposition and Exchange* (Kobe University, Japan, 1991), 97.

77. Sutton, *Nocturne*, 42.

78. "Celebrities at Home. No. XCII: Mr. James Whistler at Cheyne-Walk," *World*, 22 May 1878, 5.

79. W. M. Rossetti, *Rossetti Papers*, 105; Auvray, *Le Salon de 1865* (Paris, 1865), in Goebel, *Arrangement in Black and White*, 2:726.

80. H. T. Dunn, *Recollections of Rossetti*, 67.

81. This contradicts the view first stated in 1951 and repeated ever since, that the model for the sketch "is Oriental in type" (Stubbs, *Whistler Peacock Room*, 19).

82. "Art: Royal Academy Exhibition [Fourth Notice]," *Reader* 3 (4 June 1864): 724. On Hiffernan's possible pregnancy, see *Whistler Journal*, 124.

83. Luke Ionides, *Memories*, 9.

84. WMR diary, 18 Jan. 1885, UBC Angeli-Dennis 15/4; ERP journal, 13 Nov. 1906 (Stillman), PWC 353. According to Vasos Tsimpidaros, Michael Spartali was not from Smyrna but from the village of Sparta near Prousa (present-day Bursa) in Turkey (*Greeks in England* [Athens, 1974], trans. W. F. J. Ritchie).

85. Ellen C. Clayton, *English Female Artists*, 2 vols. (1876), 135–36. W. F. J. Ritchie kindly provided the date of Christina's baptism.

86. Hallé, *Notes from a Painter's Life*, 73; W. M. Rossetti, *Rossetti Papers*, 229.

87. "Mrs. William J. Stillman," obituary notice dated 13 March 1927, *New York Times*, Bancroft Archives, Delaware Art Museum, Wilmington.

88. Robertson, *Life Was Worth Living*, 12–13; Hallé, *Notes from a Painter's Life*, 72.

89. WMR diary, 25 Oct. and 14 Dec. 1871, UBC Angeli-Dennis 15/2; Marie Spartali to WMR, 22 Dec. [1869], UBC Angeli-Dennis

24/12. Christina's two sons were Hugo and Rodolfo (E. Stillman Diehl to author, 24 Jan. 1996, and W. F. J. Ritchie to author, 1997).

90. Michel Mansuy, *Un Moderne: Paul Bourget* (Besançon, France, 1961), 206 ("J'ai commencé à comprendre ce qu'étaient le luxe et la fortune, et j'ai acquis la conviction qu'eux seuls conviendraient, en nous permettant de réaliser nos rêves de beauté"). Bourget was a friend of the marchese's younger brother, the composer Albert Cahen.

91. DGR to Aglaia Coronio, 24 Sept. [1880], *Letters of Rossetti*, no. 2335, in reply to Coronio to DGR, [1880], UBC Angeli-Dennis 2/17. Julia Ionides identifies Spartali as "the Countess" mentioned in this letter in "The Greek Connection," 167.

92. W. M. Rossetti, *Reminiscences*, 2:492. Shortly after Christina's death her father's firm collapsed, and the Spartalis were obliged to leave The Shrubbery (WMR diary, 18 Jan. 1885, UBC Angeli-Dennis 15/4).

93. Luke Ionides to DGR, 21 Apr. [1864], *Letters of Rossetti*, no. 525; DGR to F. M. Brown, 29 Apr. 1864, *Letters of Rossetti*, no. 528; Armstrong, "Reminiscences," 195. Although Armstrong gives no date for the excursion, Leonée Ormond reliably places it during his visit from Manchester, between February and April 1864 (*Du Maurier*, 155). Robertson recounts the story in *Life Was Worth Living*, 12–13.

94. Jan Marsh and Pamela Gerrish Nunn, *Women Artists and the Pre-Raphaelite Movement* (1989), 98. This story is often confused with another, which took place at a garden party held at the Shrubbery: upon seeing Marie Spartali, so it goes, Swinburne exclaimed she was so beautiful he wanted to cry (Armstrong, "Reminiscences," 196).

95. GDM to Thomas Armstrong, [Oct. 1864], *Du Maurier Letters*, 244. The only other known painting for which Christina posed was *Christina* (unlocated) by Marie Spartali: it was painted at The Shrubbery and exhibited at the Dudley Gallery in 1869, when it was "noticed particularly for 'the fascination of its inward gleaming eyes'" (Frances Hays, *Women of the Day: A Biographical Dictionary of Notable Contemporaries* [1885], 182). The author of that critique appears to have been W. M. Rossetti: see Marie Spartali to WMR, 2 Nov. [1869], UBC Angeli-Dennis 24/12.

96. Cary, *Works of Whistler*, 60.

97. The painting remains in the original frame, which is of the type Rossetti and F. M. Brown designed ca. 1863–64, with a narrow outer molding of gilded reeds, a quartered square in each corner, roundels with wheel patterns along the sides, and a wide grained flat: see Alastair Grieve, "The Applied Art of Rossetti—I. His Picture-Frames," *Burlington Magazine* 115 (Jan. 1973): 20. This suggests that the painting may have been in Rossetti's hands during that period, if only for reframing. On the history of the painting, see Jan Marsh, "William Morris's Painting and Drawing," *Burlington Magazine* 128 (Aug. 1986): 571–77. For a comparison of *La Belle Iseult* and *La Princesse*, see John Milner, *Symbolists and Decadents* (1971), 22–23.

98. AMW to JHG, 10–11 Feb. 1864, in Thorp, *Whistler on Art*, no. 9.

99. W. M. Rossetti, *Reminiscences*, 1:276; Hiroyuki Tanita, "W. M. Rossetti's 'Hoxai' (Hokusai)," *Journal of Pre-Raphaelite Studies* 6 (Nov. 1985): 89–90.

100. W. M. Rossetti, "Japanese Woodcuts," 501–2. When he wrote the article, Rossetti knew Hokusai only by the pseudonym "Gwakyorogi" (Gakyō Rōjin).

101. ERP journal, 13 Nov. 1906, PWC 353; DGR to F. M. Brown, 23 Feb. 1866, *Letters of Rossetti*, no. 673.

102. Phylis Floyd illuminates the connection between the rococo revival and the attendant appreciation of porcelain in Jane Voorhees Zimmerli Art Museum, *Seeking the Floating World: The Japanese Spirit in Turn-of-the-Century French Art*, exhib. cat. (Rutgers, N.J., 1989), 17. Fink speculates that the "oriental decor" of Whistler's *Princesse* "provided a more acceptable exotic appearance for the figure as compared with the ambiguous costume and setting of *The White Girl*" (*American Art at Paris Salons*, 82).

103. *Life of Whistler*, 1:122–24. The date Stillman assigned to the sittings, 1863–64, has traditionally been accepted as the date of the painting, but du Maurier's letter to Armstrong reveals that Christina began posing only in the autumn of 1864.

104. ERP journal, 13 Nov. 1906, PWC 353.

105. On Anna's exclusion from the studio, see AMW to JHG, 7 June 1864, GUL W518.

106. *Life of Whistler*, 1:124.

107. ERP journal, 2 Mar. 1911, PWC 353. Helen Whistler thought *Arrangement in Flesh Colour and Grey: The Chinese Screen* (Y51) might be a study of Chariclea made at that time. It is identified as "a study of Miss Spartali" in *Whistler Journal*, 126, but the figure bears little resemblance to her, and the association may arise only from the screen in the background of the composition. Joseph Pennell doubted the painting's authenticity, as did Denys Sutton ("A Whistler Exhibition," *Burlington Magazine* 102 [Oct. 1960]: 460)—as do I.

108. ERP journal, 13 Nov. 1906, PWC 353.

109. JMW to Fantin-Latour, [Mar. 1865], PWC 1; Duret, "Artistes Anglais," 365.

110. JMW to Fantin-Latour, [Mar. 1865], PWC 1. For a discussion of Fantin-Latour's painting, see Fried, *Manet's Modernism*, 203–12.

111. *Life of Whistler*, 1:131. Félix Deriège refers to it as a "robe de mandarin" ("Salon de 1865: Peinture," *Le Siècle* [Paris], 30 June 1865, 1). Léonce Bénédite calls it "la fameuse robe chinoise" ("Artistes Contemporains: Whistler," *Gazette des Beaux-Arts* [Paris] 34 [1905]: 148).

112. ERP journal, 13 Nov. 1906.

113. *Life of Whistler*, 1:124–25.

114. Williamson, *Murray Marks*, 49–50; Curry, *Whistler at the Freer*, cat. no. 5.

115. [F. G. Stephens], "Fine-Art Gossip," *Athenaeum*, no. 1996 (27 Jan. 1866): 140. This extract, unattributed and untitled, is preserved in Glasgow (GUL PC1/21). Virginia Surtees notes that *La Princesse* was exhibited at Gambart's gallery in January 1866 (Ford Madox Brown, *Diary*, 212 n. 5).

116. F. J. Pegeram to J. A. Rose, on behalf of Ernest Gambart, 21 July 1866, PWC 2.

117. ERP journal, 13 Nov. 1906, PWC 353. Stillman's statement has not been confirmed; she could have been mistaken, although there is no reason to doubt her story. On the Huth family, see Macleod, *Art and the Victorian Middle Class*, 432.

Chapter 2

1. JMW to Thomas Winans, [ca. June 1869], in Thorp, *Whistler on Art*, no. 10, where the letter is dated [spring 1867].

2. Swinburne, *Notes on the Royal Academy*, 44; Way and Dennis, *Art of Whistler*, 30; AMW to FRL, 11 Mar. [1869], PWC 34A.

3. Mary Bennett, "A Check List of Pre-Raphaelite Pictures Exhibited at Liverpool, 1846–67, and Some of Their Northern Collectors," *Burlington Magazine* 105 (Nov. 1963): 492; William Holman Hunt, *Pre-Raphaelitism and the Pre-Raphaelite Brotherhood*, 2 vols. (New York, 1906), 2:143.

4. DGR to F. M. Brown, [3 Sept. 1864], *Letters of Rossetti*, no. 552.

5. Macleod, *Art and the Victorian Middle Class*, 152.

6. Prinsep, "Collector's Correspondence," 249 and 252; DGR to FRL, 9 Apr. 1866, *Rossetti-Leyland Letters*, no. 1.

7. DGR to FRL, 1 and 3 Aug. 1866, *Rossetti-Leyland Letters*, nos. 3 and 4.

8. Ibid., 9 Apr. 1866, no. 1.

9. Ibid., 3 Aug. 1866, no. 4. On Lilith, see John Masefield, *Thanks before Going: Notes on Some of the Original Poems of Dante Gabriel Rossetti* (New York, 1947), 59.

10. Virginia M. Allen, "'One Strangling Golden Hair': Dante Gabriel Rossetti's *Lady Lilith*," *Art Bulletin* 66 (June 1984): 290–91. Rossetti attached the relevant quatrain from *Faust* to the watercolor replica of *Lady Lilith* (see fig. 2.1): "Beware of her hair for she excels / All women in the magic of her locks, / And when she twines them round a young man's neck / She will not ever set him free again."

11. Marsh, *Pre-Raphaelite Sisterhood*, 142.

12. Anderson, "An Irish Rebel and Ireland," 254–58. As evidence to support the theory, there survives a newspaper clipping in a press-cutting book, "Seizure of a Dublin News Paper by the Police," reporting the seizure of *Irish People*, the apprehension of its editor (O'Leary), "and, it is said, several Americans" (GUL PC14/25).

13. See Boyce, *Diaries*, 17 Nov. 1866, 45. A letter from Rossetti to C. A. Howell dated September 1866 by Charles Fairfax Murray but probably written in November or December) gives Whistler's address as 14 Walham Grove, Walham Green (Cline, *Owl and the Rossettis*, no. 25).

14. WMR diary, 2 Nov. [1866], UBC Angeli-Dennis 15/1.

15. AMW to JMW, 25 Nov. [1865], GUL W520.

16. W. M. Rossetti, *Rossetti Papers*, 228; JMW to Fantin-Latour, [16 Aug. 1865], PWC 1 (trans. GUL Barbier Papers 181).

17. Colvin, "English Painters," 5.

18. Staley, "Condition of Music," 87; Colvin, "English Painters," 4.

19. Quoted in Baldry, *Albert Moore*, 25.

20. JMW to Fantin-Latour, [16 Aug. 1865], PWC 1, trans. GUL Barbier Papers 181; Dorment and MacDonald, *Whistler*, 115.

21. JMW to AMW, [spring 1867], GUL W523; AMW to JHG, [Aug. 1867], GUL W529.

22. "The Exhibition of the Royal Academy: East Room," *Evening Star*, 4 May 1867, 7.

23. Philip Gilbert Hamerton, "Pictures of the Year. IX," *Saturday Review*, 1 June 1867, reprinted as "Critic's Analysis" in *Gentle Art*, 44; "Fine Arts: Exhibition of the Royal Academy," *Illustrated London News*, 25 May 1867, 519.

24. [F. G. Stephens], "Fine Arts: Royal Academy," *Athenaeum*, no. 2067 (18 May 1867): 667.

25. JMW to Fantin-Latour, [Sept.?] 1867, in Spencer, *Whistler Retrospective*, 82–84. John Siewert gives an insightful analysis of this letter and its underlying significance in "Whistler's Decorative Darkness," *The Grosvenor Gallery: A Palace of Art in Victorian England*, ed. Susan P. Casteras and Colleen Denney (New Haven and London, 1996), 101–3.

26. *The Lily* (M364), 1870/72.

27. "Mr. Whistler's 'Ten O'Clock,'" *Gentle Art*, 159.

28. Spencer, *Aesthetic Movement*, 34; JMW to Fantin-Latour, [16 Aug. 1865], PWC 1, trans. GUL Barbier Papers 181; John Sandberg, "Whistler Studies," *Art Bulletin* 50 (Mar. 1968): 60.

29. "Mr. Whistler's 'Ten O'Clock,'" *Gentle Art*, 143.

30. Way designates the painting Whistler's fourth "Symphony in White" in Way and Dennis, *Art of Whistler*, 30, and Way, *Memories of Whistler*, 26. A notation at the foot of a letter from Leyland to Whistler (5 Oct. [1867], PWC 6B) indicates a payment of £50 on 10 May 1864, but there is no other evidence to support an acquaintance before 1867.

31. W. M. Rossetti, *Rossetti Papers*, 224; DGR to FRL, 18 June 1867, *Rossetti-Leyland Letters*, no. 6. The original *Chaucer* is in the Art Gallery of New South Wales, Sydney; the replica is in the Tate Gallery, London. A *Christmas Carol* is now in a private collection (Surtees, *Paintings of Rossetti*, cat. no. 195).

32. DGR to FRL, 18 June 1867, *Rossetti-Leyland Letters*, no. 6.

33. Ibid., 31 May and 18 June 1867, nos. 5 and 6 (verse trans. Fennell, 99 n. 4). There is a watercolor copy of *Monna Rosa* in a private collection, cited in Maria Teresa Benedetti, *Dante Gabriel Rossetti* (Florence, 1984), cat. no. 284.

34. W. M. Rossetti, *Rossetti Papers*, 233; DGR to George Price Boyce, [29 Apr. 1867], UCL Ogden.

35. AMW to JHG, [27 Aug. 1867], GUL W529. Both pictures may have been for Leyland, although the second would not be mentioned again until 1869 and appears never to have been begun.

36. JMW to Fantin-Latour, [Sept.?] 1867, in Spencer, *Whistler Retrospective*, 82.

37. Baldry, *Albert Moore*, 73. On Whistler's sketch, see MacDonald, *Whistler*, cat. no. 361.

38. JMW to Fantin-Latour, [Sept.?] 1867, in Spencer, *Whistler Retrospective*, 84.

39. Baldry, *Albert Moore*, 42; Harold Frederic, "A Painter of Beautiful Dreams," *Scribner's Magazine* (New York) 10 (Dec. 1891): 718.

40. Colvin, "English Painters," 5–6.

41. JMW to FRL, 5 Oct. [1867], PWC 6B; DGR to FRL, 9 Sept. 1867, *Rossetti-Leyland Letters*, no. 8; JMW to FRL, [ca. 8 Oct. 1867], PWC 6B.

42. JMW to FRL, 5 Oct. [1867], PWC 6B.

43. Freer considered his acquisition of *The White Symphony* to be in many ways "the most important one artistically that could be made of Mr. W.'s work" (CLF to Frank J. Hecker, 17 July 1902, FGA Hecker). Whistler himself is said to have called the oil sketch *The White Symphony: Three Girls* (CLF to Rosalind Philip, 30 Nov. 1903, FGA Philip), but it was twice exhibited during his lifetime as *Symphony in White and Red*: at *Mr. Whistler's Exhibition* of 1874 (no. 13) and the *Royal Society of British Artists Winter Exhibition* of 1887–88 (no. 352). The oil sketch was first exhibited as *The White Symphony* (by Freer) at the Whistler Memorial Exhibition in Boston, 1904. The title *Symphony in White and Red* was assigned to another work in Freer's collection (fig. 2.15).

44. J. S. Templeton, *The Guide to Oil Painting* (1846), quoted in Carlyle, "Critical Analysis of Artists' Handbooks," 259; Baldry, *Albert Moore*, 73.

45. Swinburne, *Notes on the Royal Academy*, 44; JMW to Fantin-Latour, 30 Sept. 1868, in Thorp, *Whistler on Art*, no. 11.

46. JMW to Fantin-Latour, [18 Jan. 1873], in Thorp, *Whistler on Art*, no. 15; Colvin, "English Painters," 6.

47. JMW to George Lucas, [5 Nov. 1867], in Mahey, "Letters of Whistler to Lucas," no. 8; JMW to Lucas, [12 Dec. 1867], typescript, PWC 2.

48. JMW to FRL, [Dec. 1867], PWC 6B.

49. Ibid. Cf. W. M. Rossetti, *Rossetti Papers*, 245: "A dinner at Whistler's (his Brother [William], [the collector Henry Virtue] Tebbs, and [Thomas] Jeckyll, with myself), and grand discussion as to the campaign of to-morrow, when the motion for his expulsion from the Burlington is to come off" (12 Dec. 1867).

50. ERP journal, 8 Oct. 1903 (Helen Whistler), PWC 352; JMW to AMW, [spring 1867], GUL W523. Annie Haden Thynne, Haden's daughter (and Whistler's niece), told the Pennells that Traer "unfortunately drank himself to death Whistler was young at the time & was over enthusiastic as in the end Traer proved himself quite

unworthy of his loyalty" (ERP journal, 28 July 1907, PWC 300). For a fuller account of the story, see Lochnan, *Etchings of Whistler*, 145–46.

51. Wrentmore & Sons to JMW, 10 Feb. 1868, PWC 2, and JMW to J. A. Rose, [ca. 11 Feb. 1868], PWC 2; AMW to Margaret Hill, 14 Dec. 1868, PWC 2. The Rossettis, who may have known the whole story, withdrew their memberships in solidarity. See W. M. Rossetti, *Rossetti Papers*, 245, and "Rossetti and Whistler" in Rosalie Glynn Grylls [Lady Mander], *Portrait of Rossetti* (1964), 228–29.

52. JMW to FRL, 26 May [1868], PWC 6B.

53. W. M. Rossetti, *Rossetti Papers*, 28 July 1868, 320, and *Family Letters*, 1:203. Whistler wrote to J. A. Rose that Leyland was in town and "might be coming in to look at his picture" on [24 July 1868], PWC 2.

54. Sarah Phelps Smith, "Dante Gabriel Rossetti's 'Lady Lilith' and the 'Language of Flowers,'" *Arts Magazine* 53 (Feb. 1979): 142; Horowitz, "Whistler's Frames," 129.

55. Swinburne, *Notes on the Royal Academy*, 50 and 44.

56. Prinsep, "Private Art Collections," 132.

57. DGR to Swinburne, [1868], *Letters of Rossetti*, no. 774; Surtees, *Paintings of Rossetti*, cat. no. 207.

58. Swinburne, *Notes on the Royal Academy*, 44.

59. W. M. Rossetti, *Rossetti Papers*, 320. On 28 June 1867, Rossetti noted in his diary, "W. has several works in hand a Venus &c &c" (UBC Rossetti-Angeli 15/1).

60. JMW to Stephen Richards, 12 June 1892, PWC 2.

61. *Life of Whistler*, 1:148–49. The paintings were also listed under the title "The Six Schemes" in Bernhard Sickert, *Whistler* (1908), 154–55. Ernest Fenollosa, following Freer's example, referred to them as "the eight [*sic*] supreme 'Arrangements'" ("Collection of Freer," 62). This may account for the Pennells' uncertain reference in the revised edition of the *Life of Whistler* (1911) as "Six or Eight Schemes or Projects" (p. 105).

62. *Life of Whistler*, 1:149. Spencer names the Projects the "direct forerunner" of the Peacock Room (*Aesthetic Movement*, 34–35). It has even been suggested that they were meant for the Peacock Room, "although their installation would have displaced the shelving" (Hobbs, *Whistler Peacock Room*, 15).

63. Dorment and MacDonald, *Whistler*, 93.

64. CLF to Rosalind Philip, 30 Nov. 1903, FGA Philip; CLF to R. A. Canfield, 7 Sept.

1904, FGA LB14. Curry relates the "rococo" palette and the program of the paintings to Watteau's *Departure for Cythera* (*Whistler at the Freer*, 45 and 109).

65. "Notes on Poems and Reviews," 1866, in *Swinburne Replies*, ed. Clyde Kenneth Hyder (Syracuse, 1966), 26.

66. Fried, *Manet's Modernism*, 214. Fantin-Latour's *Tannhäuser on the Venusberg*, or *Scène du Tannhäuser* (now in the Los Angeles County Museum of Art), was then in the Ionides collection.

67. *Baltimore Bulletin*, 27 Nov. 1875, GUL PC2/2. Whistler returned the painting, exhibited in 1863 as *La Féerie* (Fairyland; now in the Musées des Beaux-Arts, Montreal) to Fantin-Latour through Edwin Edwards, describing it as "a sort of triumphal march (left with me years ago). . . . I believe [Fantin-Latour] gave it to me but in any case he has often asked for it since and will be charmed to have it again though I shall be sorry to part with it" ([ca. 1883], PWC 1).

68. JMW to Fantin-Latour, 30 Sept./31 Oct. 1868, in Thorp, *Whistler on Art*, no. 11.

69. AMW to JHG, 30 Oct. 1868, GUL 531; AMW to Margaret Hill, 14 Dec. 1868, PWC 34.

70. E. W. Godwin, "Three Modern Architects," *Building News* 13 (30 Nov. 1866): 799–800.

71. ERP journal, 18 Oct. 1906 (Jameson), PWC 353. Thomas Armstrong had recommended that the Pennells interview Jameson, among others, "about Paris days" (ERP journal, 15 Aug. 1906, PWC 353). Whistler wrote to Howell from Great Russell Street on Thursday, 7 January [1869], "You know I am down here now having taken Murch's studio while he is away" (GUL LB11). The Pennells presumed that this interlude took place during the winter of 1867–68, when Whistler's mother was away (*Life of Whistler*, 1:47), but Jameson had been "tolerably sure" that Whistler shared his studio "after October 1868, but whether it began that winter or not I can't determine. My impression is that it was in the year 1869" (Jameson to ERP, 23 Oct. 1906, PWC 289).

72. Burne-Jones, *Memorials*, 1:228.

73. DGR to James Leathart, 22 Apr. 1868, in Green, *Albert Moore*, 39; DGR to F. M. Brown, [1864], *Letters of Rossetti*, no. 515.

74. *Life of Whistler*, 1:148.

75. It has been assumed that Whistler's model at this time was Milly Jones (see Young et al., *Paintings of Whistler*, lxi), but a letter Whistler wrote from Great Russell Street to Gussie Jones postponing a model-

ing session bears a note identifying the correspondent as Whistler's model, who had also posed for Sandys's *Proud Maisie* (typescript, PWC 3; see also *Whistler Journal*, 161). According to Betty Elzea, that model was the third Jones sister, Mary Emma, known as Sandys' "Little Girl." Milly (Emelie Eyre) Jones had also been D. G. Rossetti's model before she became an actress: W. M. Rossetti notes in his diary (26 Feb. 1867), "Gabriel, by an introduction to Miss Herbert, has succeeded in getting Milly Jones a theatrical engagement" (UBC Angeli-Dennis 15/1). Milly married an actor, Frederick Henry Robson, whose father was the famous Frederick Robson.

76. AMW to Margaret Hill, 14 Dec. 1868, PWC 34; JMW to Thomas Winans, [ca. June 1869], in Thorp, *Whistler on Art*, no. 10. On the modeling profession, see Borzello, *Artist's Model*.

77. *Life of Whistler*, 1:148.

78. Armstrong, "Reminiscences," 198. Armstrong reminds the reader "that Albert Moore's influence with Whistler was very marked at this period." He himself was working closely with Moore at the time: see Armstrong's painting of a group of women in a crepuscular landscape, *The Hayfield* (1869), Ionides Collection, V&A.

79. William Marchant to CLF, 29 July 1902, FGA Marchant; Baldry, *Albert Moore*, 73 (see also Way, *Memories of Whistler*, 27–28). This may have been the drawing exhibited in 1874 as no. 13, *Crouching Figure for Large Picture*, in *Mr. Whistler's Exhibition*, London, 1874. See also MacDonald, *Whistler*, cat. no. 359.

80. Way, *Memories of Whistler*, 27; Harold Frederic, "A Painter of Beautiful Dreams," *Scribner's Magazine* (New York) 10 (Dec. 1891): 722.

81. Way, *Memories of Whistler*, 71.

82. MacDonald, *Whistler*, cat. no. 357.

83. JMW to Thomas Winans, [ca. June 1869], in Thorp, *Whistler on Art*, no. 10.

84. The title of the oil sketch, *Tanagra*, may be misleading, as it was assigned by Young in 1960 to accord with an apparently related sketch whose title, *Tanagra*, also turns out to be apocryphal; Whistler himself exhibited that sketch in 1888 as *Rose et argent* (or *Rose and Silver*), the name he also gave to *La Princesse*. See Young et al., *Paintings of Whistler*, cat. no. 92; and MacDonald, *Whistler*, cat. no. 356, *Rose and Silver*.

85. Album of photographs of Tanagra figurines in the Ionides Collection, p. 2, Hunterian Art Gallery, Glasgow. Whistler probably acquired the album in 1894

(MacDonald, *Whistler*, cat. no. 1419). Exactly when he first encountered the Tanagra figurines themselves remains an open question, but he appears to have been among the first to appreciate them. Spencer points out that Tanagras were available in Paris by the mid-1860s, although rare in England before 1870 ("Whistler and His Circle," 25). According to Marcus Huish, Aleco Ionides was "on the spot" when they were excavated and so secured his collection "almost at first hand" ("Tanagra Terracottas," *Studio* 14 [15 July 1898]: 101). Lewis Day notes that Ionides' figurines "were among the first found at Tanagra, before ever forgeries were thought of" ("Kensington Interior," 140).

86. Alison Smith, *Victorian Nude*, 117. Susan Hobbs originally posited a connection between *La Source* and Whistler's *Standing Nude* in 1978 (FGA object record 04.66). Whistler's nude comes even closer to an 1868 oil study for Moore's painting, in which the model grasps a drapery omitted from the final version: see *Study for 'A Venus'* in Green, *Albert Moore*, cat. no. 25.

87. Moore to FRL, 12 and 22 Dec. 1868 and 8 Apr. 1869, PWC 6A; Alison Smith, *Victorian Nude*, 113; JMW to FRL, [spring 1869], PWC 6B.

88. [Tom Taylor], "The Royal Academy Exhibition (First Article)," *The Times*, 30 Apr. 1870, 12. In 1863, Christopher Dresser had pointed out that the anthemion, long identified with ancient Greece, was also "the chief ornament of Japanese art" ("The Prevailing Ornament of China and Japan," *Building News* 9 [22 May 1863]: 388).

89. JMW to Moore [early Sept. 1870], in Thorp, *Whistler on Art*, no. 12. Moore had sent the sketches for Leyland's inspection at the end of August. Evidently Leyland saw "the pale yellow subject" that spring; the new figure Moore had "hit upon" was meant to make "a very suitable companion" (Moore to FRL, 29 Aug. 1870, PWC 6A). The second work was *Shells* (ca. 1870), exhibited at the Royal Academy in 1874, now in the Walker Art Gallery, Liverpool. Whistler's *Symphony in Blue and Pink* was evidently not in the studio when Swinburne saw two of the Projects in 1868, but it was exhibited with them in 1874.

90. Nesfield to JMW, 19 Sept. 1870, GUL N20.

91. F. Jameson to Joseph Pennell, 18 Sept. 1906, PWC 289.

92. Armstrong, "Reminiscences," 197; JMW to Thomas Winans, [ca. June 1869], in Thorp, *Whistler on Art*, no. 10. Way recounted what he called "a legend" about

the painting (though he attested to its truth to the Pennells)—that once, when Whistler thought he had finished the picture, "Albert Moore came to see it, and criticised some tone or colour, and that next day Whistler was found with the picture scraped out ready to begin again!" (*Memories of Whistler*, 28).

93. Baldry, *Albert Moore*, 77.

94. Swinburne, *Notes on the Royal Academy*, 45.

95. "Propositions No. 2," *Gentle Art*, 115 and 116.

96. See AMW to FRL, 11 Mar. [1869], PWC 34A, and JMW to George Lucas, [3 May 1869], typescript, PWC 2.

97. AMW to Margaret Hill, 14 Dec. 1868, PWC 34.

98. ERP journal, 18 Oct. 1906, PWC 353.

99. AMW to FRL, 11 Mar. [1869], PWC 34. The episode is recounted novelistically by Elizabeth Mumford in *Whistler's Mother: The Life of Anna McNeill Whistler* (Boston, 1939), 265–69. Mumford misunderstood the painting in question to be Whistler's portrait of Leyland, a mistake perpetuated by Weintraub in *Whistler*, 154.

100. JMW to FRL, [spring 1869], PWC 6B.

101. AMW to JHG, 6 May 1869, GUL 536.

102. Ibid.; Way, *Memories of Whistler*, 27–28. The drawings of Gilchrist would later be developed into the etching *Tillie: A Model* (K117). See MacDonald, *Whistler*, cat. nos. 368–70.

103. JMW to Thomas Winans, [ca. June 1869], in Thorp, *Whistler on Art*, no. 10.

104. JMW to Lucas, [ca. 3 May 1869], typescript, PWC 2.

105. JMW to John Cavafy, son of G. J. Cavafy, [May 1879], GUL C50. There is a photograph of the painting in its 1865 state in the Baltimore Museum of Art: George A. Lucas Collection (L.1933.53.9050).

106. W. M. Rossetti, *Rossetti Papers*, 31 Mar. 1867, 228–29; JMW to Fantin-Latour, [Sept?] 1867, in Spencer, *Whistler Retrospective*, 83.

107. AMW to Kate Palmer, 29 Oct. 1870, PWC 34.

Chapter 3

1. AMW to JHG, 7–10 Sept. 1870, GUL W539.

2. B. G. Orchard confessed that his portraits were not "absolutely accurate. In the main they are close resemblances, perhaps as close as most artistic portraits are. Nevertheless, there is, partly of necessity and

partly of my free will, a strong imaginative element in each": *A Liverpool Exchange Portrait Gallery. First Series: Being Twenty Literary Portraits of Business Men; Sketched from Memory, and Filled in from Fancy* (Liverpool, 1884), 6.

3. Orchard, "Victor Fumigus," 95.

4. JMW to Helen Whistler, [Mar./Apr. 1880], from Venice, GUL W683.

5. Boase, *Modern English Biography*, 6:51; "Interviews with Great Men (Imaginary): Frederick R. Leyland, Esq.," *Liberal Review* (Liverpool), 9 July 1881, 9.

6. H. E. Stripe relates in his memoirs that John Leyland married into "a talented musical and highly respectable family of Liverpool" and founded the city's Y.M.C.A., but after settling in London in 1862, he "became very proud and haughty and used his wife and her relations most scurvily and I am sure without any reason whatever for such treatment. I fear his former religious feelings had left him" (MMM Stripe MS, 83).

7. *Whistler Journal*, 99. Remarking the "Yankee exaggeration" of the story, Ferriday supposed it to have come from Whistler ("Peacock Room," 408).

8. MMM Stripe MS, 68.

9. Picton, *Memorials of Liverpool*, 2:259.

10. "Sudden Death of Mr. F. R. Leyland," *Liverpool Daily Post*, 7 Jan. 1892, 7.

11. Orchard, "Victor Fumigus," 93.

12. Caine, *Recollections of Rossetti*, 91; Prinsep, "Private Art Collections," 129.

13. Orchard, "Victor Fumigus," 93.

14. MMM Stripe MS, 69.

15. Chandler, *Liverpool Shipping*, 85.

16. Lindsay, *History of Merchant Shipping*, 4:418; MMM Stripe MS, 66.

17. Prinsep, "Private Art Collections," 129–30; Bibby Line, *Bibby Line, 1807 to 1957* (1957), 18–19; Nigel Watson, *The Bibby Line, 1807–1990: A Story of Wars, Booms, and Slumps* (1990).

18. MMM Stripe MS, 70–71.

19. Ibid., 63–64.

20. "Death of Mr. F. R. Leyland," *Liverpool Courier*, 6 Jan. 1892, 5.

21. MMM Stripe MS, 46 and 72–73; "Sudden Death of Mr. F. R. Leyland," *Liverpool Daily Post*, 7 Jan. 1892, 7.

22. Orchard, "Victor Fumigus," 94–95; MMM Stripe MS, 72.

23. "Death of Mr. F. R. Leyland," *Liverpool Courier*, 6 Jan. 1892, 5.

24. MMM Stripe MS, 75.

25. Orchard, "Victor Fumigus," 95.

26. Haws, *Merchant Fleets*, 2:109; MMM Stripe MS, 76–77 and 90.

27. "Sudden Death of Mr. F. R. Leyland," *Liverpool Daily Post*, 7 Jan. 1892, 7.

28. FRL to JMW, 8 Nov. 1872, GUL 101; FRL to DGR, 11 Nov. 1872, *Rossetti-Leyland Letters*, no. 45.

29. DGR to FRL, 2 Dec. 1872, *Rossetti-Leyland Letters*, no. 46.

30. FRL to JMW, 8 Nov. 1872, GUL L101.

31. Howell to DGR, 4 Mar. 1873, in Cline, *Owl and the Rossettis*, no. 207; Prinsep, "Private Art Collections," 129. Although Bibby withdrew from the concern, he retained his shares in the steamers; it later emerged that Leyland had found a "cunning way" to keep his accounts so that Bibby "was cheated of his rights, while Mr. Leyland obtained a greater amount of his share of profits than he was entitled to" (MMM Stripe MS, 84 and 90).

32. Prinsep, "Private Art Collections," 130.

33. MMM Stripe MS, 70–71.

34. DGR to F. M. Brown, 28 June 1867, *Letters of Rossetti*, no. 721.

35. [F. G. Stephens], "The Private Collections of England. No. LXXVIII Allerton and Croxteth Drive, Liverpool," *Athenaeum*, no. 2970 (27 Sept. 1884): 408.

36. Ferriday, "Peacock Room," 408.

37. Prinsep, "Private Art Collections," 130; Duval, "F. R. Leyland," 110; Haws, *Merchant Fleets*, 2:118. On these sales, see "Picture-Sales," *Art Journal* 11 (May 1872): 143, and 13 (Sept. 1874): 286.

38. MMM Stripe MS, 70; Prinsep, "Private Art Collections," 129.

39. *Whistler Journal*, 99–100.

40. Orchard, "Victor Fumigus," 96.

41. FRL to JMW, 19 Aug. 1875, GUL L102.

42. "Interviews with Great Men (Imaginary): Frederick R. Leyland, Esq.," *Liberal Review* (Liverpool), 9 July 1881, 9–10; Orchard, "Victor Fumigus," 95.

43. Prinsep, "Private Art Collections," 134.

44. Caine, *Recollections of Rossetti*, 91; Robinson, "Leyland Collection," 138.

45. W. M. Rossetti, *Family Letters*, 1:250; JMW to [the *Art Journal*, June 1892], draft/fragment, GUL X78.

46. Orchard, "Victor Fumigus," 95; MMM Stripe MS, 80.

47. 1851 Census Report, 48 Bedford St., Toxteth Park, Liverpool. Frances Dawson Leyland's birth date has previously been published as 1834, but she was born in North Shields, Northumberland, on 21 November 1836. In 1840, the Dawsons had a daughter named Elizabeth, who seems to have died in infancy; ten years later, they named their youngest child Elizabeth Clark, but always called her Lizzie.

48. Birth certificates for Frederick Dawson Leyland, 19 Jan. 1856; Fanny Leyland, 29 Oct. 1857; Florence Leyland, 2 Sept. 1859; and Elinor Leyland, 16 Oct. 1861 (Family Records Centre, London).

49. Picton, *Memorials of Liverpool*, 2:260 and 226.

50. Leaflet, 25 May 1866, Speke Hall. The property extended over 150 acres, and the lease included rights to shooting and fishing and a seat in the Garston church.

51. F. M. Brown, *Diary*, 27 Sept. 1856, 190. The two venerable yew trees, Adam and Eve, reputed to be older than the hall itself, still dominate the courtyard. Speke Hall is now administered by the National Trust.

52. The circumstances surrounding Leyland's decision to lease the house are given in George Whitley to James Sprot, 11 Sept. and 30 Oct. 1867, Speke Hall. The correspondence between the Watt trustees was first brought to light in Tibbles, "Speke Hall."

53. DGR to FRL, [Oct./Nov. 1867], *Rossetti-Leyland Letters*, no. 14. Fennell dates this letter [Feb./Mar. 1868], but since Leyland took possession of Speke on 16 October 1867, the letter was probably written around then. F. M. Brown also wrote to congratulate Leyland on his "lucky acquisition" (Brown to FRL, 23 Nov. 1867, PWC 6A).

54. Cousens, *Speke Hall*, 5 and 42; leaflet, 25 May 1866, Speke Hall. The advertisement was published in August 1866 in the *Liverpool Mercury* (Tibbles, "Speke Hall," 37 n. 3).

55. Tibbles, "Speke Hall," 34; Whitley to Sprot, 11 Sept. 1867 and 30 Oct. 1867, Speke Hall. By comparison, Whistler leased 2 Lindsey Row on 25 December 1866 for £80 per annum.

56. Whitley to Sprot, 11 Nov. 1868, 24 Dec. 1869, 9 Jan. [1870], 5 Feb. 1868, and 9 Apr. 1870, Speke Hall.

57. "Interviews with Great Men (Imaginary): Frederick R. Leyland, Esq.," *Liberal Review* (Liverpool), 9 July 1881, 10.

58. Whitley to Sprot, 18 May 1868, Speke Hall. Before Tibbles detailed these changes in "Speke Hall" (1994), Leyland's contributions had gone largely unacknowledged. His tenancy is not mentioned in "Speke Hall, Lancashire," *Country Life* 13 (14 Mar. 1903): 336–42; or in "The Property of the Trustees of the Late Miss Adelaide Watt," *Country Life* 51 (7 and 14 Jan. 1922): 16–22 and 48–55.

59. AMW to Kate Palmer, 3–4 Nov. 1871, in Thorp, *Whistler on Art*, no. 13; JMW to FRL, [ca. 8 Oct. 1867], PWC 6B.

60. Whitley to Sprot, 30 Oct. 1867 and 30 Oct. 1868, Speke Hall.

61. Tibbles, "Speke Hall," 35; Cousens, *Speke Hall*, 9. Entering into the spirit of country-house life, Whistler once joined a hunting party at Speke Hall: he told Thomas Armstrong he had taken a shot at something, seen fur fly, and assumed he had hit a hare until he spotted the keeper removing pellets from his dog (ERP journal, 12 Sept. 1906, PWC 353, and *Life of Whistler*, 1:187).

62. Tibbles, "Speke Hall," 35.

63. Whitley to Sprot, 5 Feb. 1868, Speke Hall; Cousens, *Speke Hall*, 13–14 and 42. The drawing-room ceiling was also "new painted," according to Whitley; Whistler considered it "very swell" (JMW to unidentified correspondent, n.d., PWC 3).

64. Cousens, *Speke Hall*, 9–10; Tibbles, "Speke Hall," 35.

65. Katharine A. Lochnan, "Wallpaper," in Art Gallery of Ontario, *The Earthly Paradise: Arts and Crafts by William Morris and His Circle from Canadian Collections*, ed. Katharine A. Lochnan, Douglas E. Schoenherr, and Carole Silver, exhib. cat. (Toronto, 1993), 125. The initial sale of the Morris papers was so limited that the firm did not release new patterns until 1871.

66. DGR to FRL, [Sept./Oct. 1867], *Rossetti-Leyland Letters*, no. 14.

67. G. Burne-Jones to FRL, 27 Dec. 1867, PWC 6A; DGR to FRL, 28 Dec. 1867, *Rossetti-Leyland Letters*, no. 9.

68. DGR to FRL, 17 Jan. and 17 Feb. 1868, *Rossetti-Leyland Letters*, nos. 10 and 12.

69. Howell to WMR, 8 and 10 July 1872, in Angeli, *Pre-Raphaelite Twilight*, 61–62.

70. DGR to FRL, [12 Aug. 1868], *Rossetti-Leyland Letters*, no. 18.

71. DGR to Jane Morris, 30 July 1869, *Rossetti and Jane Morris*, no. 7.

72. JMW to FRL, [ca. 8 Oct. 1867], PWC 6B.

73. ERP journal, 15 Oct. 1906 (Margie Cole), PWC 353.

74. AMW to Margaret Hill, 10 Sept. [1870], PWC 34.

75. *Life of Whistler*, 1:155.

76. Walter Greaves, quoted in *Whistler Journal*, 120.

77. Armstrong, "Reminiscences," 189.

78. JMW to Fantin-Latour, [Oct./Nov. 1862], from Guéthary, Basses-Pyrénées, PWC 1. On the photographs, see Nigel Thorp, "Studies in Black and White: Whistler's Photographs in Glasgow University Library," in Fine, *James McNeill Whistler*, 89.

79. JMW to FRL, 23 Aug. [1871], PWC 6B. MacDonald dates this letter 1869 (*Whistler*, cat. no. 424), and Lochnan dates it 1870 (*Etchings of Whistler*, 158 n. 2), but it was in 1871 that 23 August fell on a Wednesday, the day mentioned in the letter. *The Corregidor of Madrid* is described as "the full-length portrait of a man, holding in one hand his hat and glove, the other being slightly raised," in Robinson, "Private Art Collections," 136.

80. JMW to Walter Greaves, [Oct. 1871], typescript, PWC 9.

81. Stephens, "Private Collections of England," 534.

82. MacDonald, *Whistler*, cat. no. 653; ASC diary, 6 Jan. 1876, quoted in *Life of Whistler*, 1:189.

83. "Mr. Whistler's 'Ten O'Clock,'" *Gentle Art*, 157 and 140.

84. Ibid., 137.

85. AMW to Margaret Hill, 10 Sept. [1870], PWC 34.

86. Ibid. Whistler wrote his publisher from Speke Hall, probably in the autumn of 1870, offering to produce for the planned edition of etchings "an entirely new one and consequently infinitely better" to replace *Chelsea Bridge and Church* (K95), which he thought unacceptable (JMW to F. S. Ellis, typescript, PWC 9). Perhaps *Speke Hall* was an effort in that direction. *Speke Hall, No. 2* (K143), probably begun in 1875 but apparently left unfinished, depicts a happier scene of people at play on the north lawn.

87. Lochnan, *Etchings of Whistler*, 160. The etching was not finished until 1878–79, when Whistler may have completed it using sketches or photographs (see Dorment and MacDonald, *Whistler*, cat. no. 74).

88. DGR to FRL, 25 Oct. 1870, *Rossetti-Leyland Letters*, no. 27. Another pastel *Head of Frederick Leyland* by Rossetti in the Delaware Art Museum (previously dated 1879) is probably a rejected version Rossetti gave to Fanny Cornforth, from whom it was purchased by Samuel Bancroft (Rowland Elzea, *The Pre-Raphaelite Collections of the Delaware Art Museum* [Wilmington, 1984], 130). See also Surtees, *Paintings of Rossetti*, cat. no. 346.

89. AMW to Kate Palmer, 3–4 Nov. 1871, in Thorp, *Whistler on Art*, no. 13. On *Arrange-ment in Grey and Black: Portrait of the Painter's Mother*, see Young et al., *Paintings of Whistler*, cat. no. 101, and Margaret F. MacDonald, "Whistler: The Painting of the 'Mother,'" *Gazette des Beaux-Arts* (Paris) 85 (Feb. 1975): 73–88.

90. JMW to FRL, [Nov. 1872], in Thorp, *Whistler on Art*, no. 14.

91. AMW to Kate Palmer, 3–4 Nov. 1871, in Thorp, *Whistler on Art*, no. 13; JMW to Walter Greaves, [Oct. 1871], from Speke Hall, typescript, PWC 9.

92. AMW to JHG, 29 Nov. 1871, GUL W541; *Whistler Journal*, 98–99.

93. See for example Caine, *My Story*, 157.

94. In 1869, the *Tailor and Cutter* called the short frock coat "the most fashionable garment made" (quoted in C. Willett Cunnington and Phillis Cunnington, *Handbook of English Costume in the Nineteenth Century* [1970], 229).

95. This sketch is now lost. It was offered to Freer in 1909, but he did not think it "sufficiently interesting" to add to his collection (CLF to F. C. Yardley, 27 Mar. 1909, FGA LB27).

96. Curry, *Whistler at the Freer*, cat. no. 15. Among Whistler's photographs in Glasgow are reproductions of three different full-length portraits of Philip IV.

97. Harvey, *Men in Black*, 80–81 and 156–57.

98. "Interviews with Great Men (Imaginary): Frederick R. Leyland, Esq.," *Liberal Review* (Liverpool), 9 July 1881, 10.

99. Caine, *Recollections of Rossetti*, 91; Harvey, *Men in Black*, 29–32. The gloves are mentioned in "Interviews with Great Men (Imaginary): Frederick R. Leyland, Esq.," *Liberal Review* (Liverpool), 9 July 1881, 10.

100. "Mr. Whistler's Exhibition," *Echo*, 8 June 1874, in Goebel, *Arrangement in Black and White*, 2:800; Theodore Watts-Dunton, *Aylwin* (1898; reprint, 1934), 230. Thomas Hake identifies Symonds as Leyland in *Notes and Queries* 9 (7 June 1902): 450–52, reprinted as an appendix to the 1914 edition of the novel.

101. Boase, *Modern English Biography*, 6:51.

102. DGR to F. M. Brown, 31 May 1874, *Letters of Rossetti*, no. 1490. After 1850, frills on evening shirts were gradually replaced by tucks and pleats; after 1870, shirt fronts became plain. See Buck, *Victorian Costume*, 195.

103. Orchard, "Victor Fumigus," 97–98.

104. *Life of Whistler*, 1:176. On Leyland's London sittings, see AMW to JHG, 10–13 Apr. [1872], GUL W543.

105. "Mr. Whistler's 'Ten O'Clock,'" *Gentle Art*, 158. Prinsep recorded Leyland's remark in "Personal Recollections," 579.

106. Greaves, "Notes on Old Chelsea," 19; *Life of Whistler*, 1:176.

107. Greaves, "Notes on Old Chelsea," 20.

108. AMW to JHG, 13 March 1872, GUL W542; AMW to Kate Palmer, 21 May/5 June 1872, in "Whistler's Mother," *Art Digest* (New York) 7 (Jan. 1933): 6; AMW to JHG, 5/22 Nov. 1872, GUL W546.

109. *Life of Whistler*, 1:176–77; ASC diary, 16 Feb. 1873, PWC 281. Lochnan suggests that the print was a *première pensée* for the portrait and dates it ca. 1870 (*Etchings of Whistler*, 158), but it corresponds more closely to the final portrait than to the original conception. The work is dated ca. 1875 by Margaret MacDonald (Arts Council of Great Britain, *Whistler: The Graphic Work*, exhib. cat. [1976], no. 80).

110. Munhall counts some forty paintings by Whistler with "black" titles, including several titled *Arrangement in Black*, the last called "No. 10" (see "The Black Portraits" in *Whistler and Montesquiou*, 154–64).

111. Thomas White, "Albert Moore and the 'D.N.B.,'" 152. On the Leyland legend, see for example Jones, *Pioneer Shipowners*, 117.

112. Howell to DGR, 15 Nov. 1872, in Cline, *Owl and the Rossettis*, no. 163.

113. Howell to DGR, 11 and 13 Oct. 1873, in Cline, *Owl and the Rossettis*, nos. 309 and 311. For an account of Leyland and Rossetti's disagreement and its consequences, see *Rossetti-Leyland Letters*, xx–xxiii.

114. Freddie Leyland to JMW, 15 Oct. 1873, GUL L137.

115. C. A. Howell to DGR, 20 June 1873, in Cline, *Owl and the Rossettis*, no. 252. Macleod discusses the portrait as a manifestation of Leyland's business struggles in *Art and the Victorian Middle Class*, 288.

116. Royal Academy of Arts, *Exhibition of the Works of the Old Masters, associated with Works of Deceased Masters of the British School*, exhib. cat. (1873), no. 149: *Portrait of Don Adrián Pulido Pareja, Knight of Santiago, Admiral of the Fleet of New Spain*, lent by the Earl of Radnor. The painting was purchased for the National Gallery in 1890 and catalogued as by Velázquez until 1929 (National Gallery, London, *The Spanish School*, by Allan Braham, rev. Neil MacLaren, 2d ed. [1970], cat. no. 1315).

117. Madlyn Millner Kahr, *Velázquez: The Art of Painting* (New York, 1976), 51. Whistler had a photograph of the painting, bearing the printed caption, "J. Laurent Fotog. de S. M. Madrid": see Nigel Thorp, "Studies in Black and White," in Fine, *James*

McNeill Whistler, 89 and 99 n. 33.

118. Orchard, "Victor Fumigus," 98.

119. Whistler Journal, 102.

120. Life of Whistler, 1:177. On Arrangement in Black, No. 2: Portrait of Mrs. Louis Huth (1872/74), see Young et al., Paintings of Whistler, cat. no. 125; on the studies, see MacDonald, Whistler, cat. nos. 454 and 455.

121. Harvey, Men in Black, 196.

122. Whistler Journal, 101. On these studies, see MacDonald, Whistler, cat. nos. 429–33, 436–38, and 454v. On the evolution of the dress design, see Nakanishi, "Symphony Reexamined," 156–67.

123. On tea gowns, see Sandra Barwick, A Century of Style (1984), 67–70; and Buck, Victorian Costume, 66 (figure 11 shows a printed muslin tea gown from 1890–92). On eighteenth-century influence, see Curry, Whistler at the Freer, 46 and cat. nos. 229–34.

124. Whistler Journal, 301. The geometrical patterns of the floor matting have been flattened to make a decorative pattern in the background, an effect suggesting the continuing influence of Albert Moore (Staley, "Condition of Music," 85).

125. AMW to Mrs. Mann, 7 May [1872], GUL W544; AMW to JHG, 5/22 Nov. 1872 and 10–13 Apr. [1872], GUL W546 and W543.

126. Whistler Journal, 101–2. The portrait is traditionally dated ca. 1876 (Young et al., Paintings of Whistler, cat no. 185), but the butterfly signature (now barely discernible) is characteristic of 1872–73, and the white dress and fur tippet resemble the costume portrayed in the 1873 etching Maud Standing (K114). On Franklin, see Margaret F. MacDonald, "Maud Franklin," in Fine, James McNeill Whistler, 13–26.

127. Study for "Symphony in Flesh Colour and Pink: Portrait of Mrs. Frances Leyland" was first published in Nakanishi, "Symphony Reexamined." See also MacDonald, Whistler, cat. no. 454v.

128. Lochnan, Etchings of Whistler, 163; Whistler Journal, 102.

129. Life of Whistler, 1:178; Nakanishi, "Symphony Reexamined," 167.

130. Whistler Journal, 101 and 104; ERP journal, 27 Sept. 1906 (Helen Whistler), PWC 353. Charles Whistler-Hanson, as he styled himself in 1924, said that he was Whistler's godson ("Is It a Whistler? Expert Opinion," Morning Post, 29 Apr. 1925, 8). Whistler made a drypoint portrait of Charlie, ca. 1876, The Boy (K135).

131. See Mark Girouard, The Return to Camelot: Chivalry and the English Gentleman

(New Haven and London, 1981), 200. An egregious example of the unfounded assumption about Whistler and Frances Leyland appears in G. H. Fleming, James Abbott McNeill Whistler: A Life (New York, 1991), 160: "Even for someone who worked as deliberately as he did, Whistler devoted an excessive amount of time to this painting [of Frances] on his numerous visits to Liverpool. As for Mrs. Leyland, she often travelled alone to London on 'shopping trips,' which always included a rendezvous with her portraitist in her hotel room [!]. All of this combined with the phraseology of his letters leads to an inescapable conclusion: Frances Leyland was Whistler's mistress, and Frederick Leyland was a cuckold."

132. Whistler Journal, 101. An unaccompanied Victorian woman might be mistaken for a prostitute.

133. AMW to Kate Palmer, 21 May/5 June 1872, in "Whistler's Mother," Art Digest (New York) 7 (Jan. 1933): 6.

134. FRL to DGR, 26 Dec. 1871, Rossetti-Leyland Letters, no. 32; Whitley to Sprot, 15 Feb. 1872, Speke Hall. The death of Ada Louisa Jee (often misspelled "Gee"), is also reported in Whitley to Sprot, 30 Dec. 1871, Speke Hall.

135. The Diary of W. M. Rossetti, 1870–1872, ed. Odette Bornand (Oxford, 1977), 165–66, 21 Feb. 1872.

136. See MacDonald, Whistler, cat. nos. 440–42.

137. Whistler's reputed picture "of a young girl in the light of a window" painted for the church bazaar had been purchased by a Mr. Seager, who passed it along to Richard Roberts of Liverpool, from whose estate it was sold in 1905 at Christie's. The story was recounted at the sale, but it was reported that "the vision of the master's work enshrined among slippers and tea-cosies moved them not. . . . It was some time before a votary plucked up courage to bid five guineas, and Mr. Parsons had the last word at 25 gs" ("Whistler and a Church Bazaar," Daily Telegraph, 15 May 1905, 12). The unnamed portrait, painted ca. 1872, is Portrait Sketch of a Lady (Y184), Freer Gallery of Art (05.328).

138. See Edward Morris, Victorian and Edwardian Paintings in the Walker Art Gallery and at Sudley House (1996), 50–51. Morris dates the painting "about 1875," but the close-fitting dress worn by the woman playing billiards, a "cuirasse" bodice that comes down over the hips with the fullness of the dress redistributed into a train, was fashionable around 1873 (Christina Walkley and Vanda Foster, Crinolines and Crimping Irons:

Victorian Clothes [1978], 24). This date also accords with the presence of Lizzie Dawson and her other sister, Jane, together perhaps with Fanny Leyland, at 16, and Florence, 14, though there may be other friends or relatives in the group. MacDonald conjectures that Lizzie posed for The Silk Dress (K107): see Whistler, cat. no. 440.

139. ERP journal, 27 Sept. 1906 (Helen Whistler), PWC 353.

140. See JMW to Frances Leyland, [probably Sept. 1872], PWC 2: "Freddie tells me that the Baby Dawson . . . has been known to speak of me with indifference! Say to her with my affection that I hope it is not again 'broken off.'"

141. JMW to Frances Leyland, [probably autumn 1873], PWC 2.

142. Freddie Leyland to JMW, 15 Oct. 1873, GUL L173. On Whistler's illness, see AMW to Mary Emma Eastwick, 8 Sept. 1873, PWC 34, and Boyce, Diaries, 11 Nov. 1873, 58.

143. Whistler Journal, 101.

144. AMW to JHG, 10–13 Apr. [1872], GUL W543. Legend has it that the painting was originally rejected by the selection committee and consigned to the cellars until William Boxall threatened to resign if it were not hung: see Merrill, Pot of Paint, 31–33 and 327 n. 8.

145. AMW to JHG, 13 Mar. 1872, GUL W542.

146. JMW to ASC, [ca. Mar. 1873], typescript, PWC 8; AMW to Kate Palmer, 21 May/5 June 1872, in "Whistler's Mother," Art Digest (New York) 7 (Jan. 1933): 30.

147. Life of Whistler, 1:177.

148. JMW to Frances Leyland, [New Year's 1874?], typescript, PWC 13.

149. Memorandum of Agreement between E. Clifton Griffiths and JMW, 19 Jan. 1874, PWC 20. For a full account of the show see Robin Spencer, "Whistler's First One-Man Exhibition Reconstructed," in The Documented Image: Visions in Art History, ed. Gabriel P. Weisberg, Laurinda S. Dixon, and Antje Bultmann Lemke (Syracuse, 1981), 27–49.

150. Howell to DGR, 13 Nov. 1872, in Cline, Owl and the Rossettis, no. 161.

151. DGR to F. M. Brown, 31 May 1874, Letters of Rossetti, no. 1490; AMW to Mary Emma Eastwick, 8 Sept. 1874, PWC 34.

152. "Exhibition of Mr. Whistler's Paintings and Drawings," Globe, 20 June 1874, 2; Blackburn, "'A Symphony' in Pall Mall," Pictorial World, 13 June 1874, in Spencer, Whistler Retrospective, 109; [J. C. Carr], "Exhibition of Mr. Whistler's Paintings

and Drawings," *Pall Mall Gazette*, 13 June 1874, 11.

153. DGR to F. M. Brown, [Aug.? 1874], *Letters of Rossetti*, no. 1515.

154. JMW to Frances Leyland, [New Year's 1874?], typescript, PWC 13.

155. MacDonald, *Whistler*, cat. nos. 508–110; JMW to D. C. Thomson, [29 May 1892], PWC 2. Frances Leyland also told Elizabeth Pennell that Whistler had written from Paris "protesting against the sale of certain sketches of herself and the children, which he said were hers and not Leyland's. He had given them to her, Leyland had not bought them" (*Whistler Journal*, 104).

156. It is possible that Fanny's was "the brown paper drawing of Whistlers" that Leyland asked Howell to return (and perhaps never recovered), and which he wanted to have "framed to match the others" (FRL to C. A. Howell, 22 Oct. 1880, GUL L135).

157. Lochnan, *Etchings of Whistler*, 161. Impressions of these prints in Samuel Avery's collection (now in the New York Public Library) are dated 1873 in Whistler's hand (Howard Mansfield, *A Descriptive Catalogue of the Etchings and Dry-Points of James Abbott McNeill Whistler* [Chicago, 1909], cat. nos. 107–9).

158. JMW to Walter Greaves, [Oct. 1871], PWC 9.

159. Curry, *Whistler at the Freer*, cat. no. 236 (see also MacDonald, *Whistler*, cat. no. 532). On Freddie's refusal to pose, see *Whistler Journal*, 101.

160. AMW to JHG, 29 Nov. 1871, GUL W541; JMW to Walter Greaves, [Oct. 1871], typescript, PWC 9.

161. AMW to Mary Emma Eastwick, 8 Sept. 1874, PWC 34; JMW to J. A. Rose, 4 Mar. 1875, PWC 2.

162. Way and Dennis, *Art of Whistler*, 46.

163. W. M. Rossetti, "The Grosvenor Gallery. (Second Notice)," *Academy* 11 (26 May 1877): 467; Wilde, "Grosvenor Gallery," 124. On the portrait of Florence, see also Merrill, *Pot of Paint*, 40–42.

164. *Whistler Journal*, 105.

165. AMW to Frances Leyland, 12 May [1875], PWC 34A.

166. JMW to Frances Leyland, [probably Sept. 1872], typescript, PWC 13. For drawings of Elinor, see MacDonald, *Whistler*, cat. nos. 510–18.

167. Way, *Memories of Whistler*, 30. Richard Dorment attributes Whistler's venture into portraiture in the 1870s to the National Portrait Exhibitions held at South Kensington,

1866–68, which included portraits by Gainsborough and others working in the grand English manner (Dorment and MacDonald, *Whistler*, 25 and 140).

168. JMW to Walter Greaves, [ca. 1875], typescript, PWC 9.

169. JMW to FRL, [ca. 2 Nov. 1872], PWC 6B; FRL to JMW, 8 Nov. 1872, GUL L101.

170. JMW to ASC, [ca. Mar. 1873], typescript, PWC 8; Bacher, *With Whistler in Venice*, 58–59.

171. Horowitz, "Whistler's Frames," 130.

172. On Horace Jee ("X"), see *Whistler Journal*, 97 A letter from Jee to Charles Deschamps written on Whistler's behalf is dated 3 September 1873; one from Whistler written circa January 1874 mentions letters "written for me by my friend Mr. Jee who was staying with me at the time" (PWC 1). In an undated letter to Frances Leyland, Whistler says that Miss Caird, who was posing for her portrait, "must have found that day in the Studio rather a dull one for Horace who might have relieved the monotony of work with his piano did not turn up until the next day!" (PWC 2). Anna Whistler refers to rough handling of the "Japanese Camp stool" in a letter to Whistler, 11 July 1876, GUL W552.

173. JMW to Frances Leyland, [New Year's 1874?], typescript, PWC 13, and [spring 1874?], PWC 2.

174. JMW to Frances Leyland, [probably late Aug. 1875], PWC 2.

175. JMW to FRL, 4 Sept. [1875], PWC 6B; JMW to Frances Leyland, [probably late Aug. 1875] and [mid-Sept. 1875], PWC 2.

176. "American Artists in London: What They Have Done for Philadelphia," *New York Herald* (dateline London, 20 Mar.), 10 Apr. 1876, 5.

177. Way and Dennis, *Art of Whistler*, 100.

Chapter 4

1. Child, "Pre-Raphaelite Mansion," 81–82.

2. "The Palace of Art: New Version, Part II," *Punch*, 14 July 1877, 9 (see also Part I, *Punch*, 7 July 1877, 305); "The Palace of Art," *Punch*, 15 Feb. 1879, 70. As further evidence of the poem's hold on the Victorian imagination, see H. H. Stratham's rendering of its architecture in *Builder* 72 (2 Jan. 1897): 10.

3. Morris to Edward Burne-Jones, [Nov. 1865], *The Letters of William Morris*, ed. Philip Henderson (1950), 22; William Morris, "The Lesser Arts," in *Strangeness and Beauty: An Anthology of Aesthetic Criticism,*

1840–1910, ed. Eric Warner and Graham Hough, 2 vols. (Cambridge, 1983), 1:86–87.

4. *Whistler Journal*, 301. Originally published in *Century Illustrated Monthly Magazine* (New York) 83 (Feb. 1912): 500–13.

5. *Whistler Journal*, 300.

6. ERP journal, 1 Nov. 1906 (Sutherland), PWC 353; *Whistler Journal*, 123–24.

7. Alan Cole sent Mrs. Ritchie's notes to Elizabeth Pennell on 27 Dec. 1906 (PWC 281).

8. W. M. Rossetti, *Rossetti Papers*, 5 Feb. 1867, 222. Lady Wolseley originated the felicitous metaphor "flight of fans" in a letter to Joseph Pennell, 1 July 1907 (recollecting a visit to Whistler's house around 1877), PWC 304. E. W. Godwin advocated "a fitting disposition of Japanese fans" as an alternative to his preferred decoration for dining-room walls, "a few Japanese-painted crape hangings" ("My Chambers, and What I Did to Them. Chapter II. A.D. 1872," *Architect*, 8 July 1876, 19).

9. "Celebrities at Home: No. XCII: Mr. James Whistler at Cheyne-Walk," *World*, 22 May 1878, 5. The Pennells reproduced three photographs of Whistler's house in the *Whistler Journal* (following p. 152), including the two reproduced in these pages, captioned "Whistler's First House in Lindsey Row." The third shows the fireplace in the dining room and contains incontrovertible proof that it dates from the later period: the print on the wall is a reproduction of *Waking* by Millais, of 1865–67 (Alastair Grieve, "Whistler and the PreRaphaelites," *Art Quarterly* 34 [1971]: 219, 223 n. 7). Presumably, all three picture the same house. They may have come not from "Mr. Chambers," as stated in the captions, but from Juliet M. Morse, who occupied 2 Lindsey Row after Whistler, and who offered to lend Mrs. Pennell photographs "of Lindsey Row taken in his time of occupation" (26 Feb. 1905, PWC 294).

10. Reitlinger, *Economics of Taste*, 202–3; Loftie, *Plea for Art*, 81.

11. "Mr. Whistler's Exhibition," *Builder* 32 (25 July 1874): 622.

12. "Fine Arts. Society of French Artists," *Standard*, 21 Apr. 1873, 2. Curry makes this point in "Total Control," in Fine, *James McNeill Whistler*, 75.

13. *Manchester Examiner and Times*, 8 June 1874, PWC 199; ERP journal, 13 Nov. 1906 (Stillman), PWC 353.

14. *Whistler Journal*, 299.

15. Conway, "Decorative Art in England,"

783; M. E. Haweis, *Art of Decoration*, 372.

16. "The Cupid and Psyche Frieze by Sir Edward Burne-Jones, at No. 1 Palace Green," *Studio* 15 (Oct. 1898): 3–13.

17. *Whistler Journal*, 300.

18. [Roger Fry], "A Monthly Chronicle," *Burlington Magazine* 219 (May 1916): 82.

19. AMW to JHG, 5–22 Nov. 1872, GUL w546. She thanks Mrs. Alexander for the invitation in a letter partly written by Whistler, 26 Aug. [1872], BM 1958.2.8.34.

20. Gordon Nares, "Aubrey House, Kensington: The Home of the Misses Alexander," *Country Life* 121 (9 May 1957): 924–25. Freer saw and admired Alexander's collection of Chinese porcelain: see CLF to Edward S. Morse, 23 Aug. 1902, FGA LB9.

21. *Life of Whistler*, 1:202–3. One of Whistler's drawings is reproduced in *Whistler Journal*, following p. 302, as "Sketch for Sideboard." Bendix discusses Whistler furniture designs for Alexander in *Diabolical Designs*, 111–13; I have found no evidence that Whistler designed furniture. On the Aubrey House color schemes, see MacDonald, *Whistler*, cat. nos. 490–92.

22. ERP journal, 11 Apr. 1907 (Hunt), PWC 352; Spencer, "Whistler and His Circle," 53 n. 2.

23. Florence M. Gladstone, *Aubrey House Kensington, 1698–1920* (1922), 54.

24. Curry, "Total Control," in Fine, *James McNeill Whistler*, 80 n. 24. The portrait was left incomplete when the sitter came down with scarlet fever: her parents blamed Whistler, and Alexander abandoned the idea of having portraits made of the other children. See ERP journal, 24 Nov. 1906 (Alexander), PWC 353, and Reginald Colby, "Whistler and 'Miss Cissie,'" *Quarterly Review* 298 (July 1960): 319.

25. JMW to Mrs. Alexander, [Feb./Mar. 1875], BM 1958.2.8.35 (and typescript copy, PWC 7). MacDonald transcribes a fragment of this letter somewhat differently and dates it "probably 1873" in *Whistler*, cat. no. 498. Alexander told E. L. Cary that the portrait had been painted in his newly redecorated drawing room, where the painting was intended to hang (Cary, *Works of Whistler*, cat. no. 190).

26. Cicely (Alexander) Spring-Rice to Joseph Pennell, 9 Sept. [1907], PWC 299.

27. "Prince's Gate" is spelled to accord with most Victorian and modern sources, but according to the Survey of London, the spelling is properly "Princes Gate."

28. Forwood, *Recollections of a Busy Life*, 60.

29. DGR to FRL, 17 Feb. 1868, Rossetti-*Leyland Letters*, no. 12; Leighton to Austen Henry Layard, [1865/66], regarding "a very large picture which from its size may very likely not sell & will in that case leave my year almost barren of pecuniary results" (quoted in Stephen Jones et al., *Frederic, Lord Leighton*, exhib. cat., Royal Academy of Arts [1996], no. 35). Leyland would resell the painting (now in a private collection) at Christie's on 13 June 1874 and "make a haul," according to Rossetti (2,550 guineas) shortly before moving to 49 Prince's Gate, which may not have held an appropriate space: see DGR to C. A. Howell, [19 June 1874], in Cline, *Owl and the Rossettis*, no. 357, and *Art Journal* 13 (Sept. 1874): 286.

30. Dorment and MacDonald, *Whistler*, 94.

31. Duval, "Leyland," 110.

32. Burne-Jones to FRL, 19 Sept. 1868 and [1869], PWC 6A. According to Georgiana Burne-Jones, Leyland met Edward Burne-Jones at the 1865 Old Water Colour Society exhibition (*Memorials*, 1:295). The Morris verses are mentioned in Stephens, "Private Collections of England," 440. That Burne-Jones's works hung in the Queen's Gate dining room may account for the Pennells' belief (deleted from later editions of the *Life*) that his paintings were meant to hang with *The Three Girls* in the dining room at Prince's Gate (*Life of Whistler*, 1:204; Dorment and MacDonald, *Whistler*, 164).

33. Howell to DGR, 4 Mar. 1873, in Cline, *Owl and the Rossettis*, no. 207.

34. DGR to FRL, 27 Dec. 1871, Rossetti-*Leyland Letters*, no. 33; Howell to DGR, 4 Mar. 1873, in Cline, *Owl and the Rossettis*, no. 207.

35. Howell to DGR, 1 Mar. 1874, in Cline, *Owl and the Rossettis*, no. 344.

36. Osborn & Mercer, *The Mansion*, 2.

37. Gere, *Nineteenth-Century Decoration*, 329.

38. *Whistler Journal*, 107. Such a mansion was under construction in the immediate vicinity for Baron Albert Grant, a millionaire entrepreneur and art collector who obtained his aristocratic title in Italy. In 1872, Grant purchased the freehold of property opposite Kensington Palace and the next year began building a palatial residence designed by James Knowles in flamboyant French-château style, rumored to cost £300,000 and said to be the largest private residence in town. The opulent interiors were completed in 1876, but the building stood unoccupied for several years "in all its hideous magnificence," a dwelling too extravagant for domestic life; it was demolished in 1882. See Annabel Walker and Peter Jackson, *Kensington and Chelsea: A Social and Architectural History* (1987), 39–40, and Priscilla Metcalf, *James Knowles: Victorian Editor and Architect* (Oxford, 1980), 249–50.

39. Prinsep, "Collector's Correspondence," 252.

40. MMM Stripe MS, 78.

41. *Historical Collection of William Heaton Wakefield (1861–1936)*, vol. 9, MS 118, Liverpool Local History Library.

42. Williamson, *Murray Marks*, 84–85.

43. FRL to DGR, 26 July 1876, Rossetti-*Leyland Letters*, no. 103; Howell to DGR, 7 July 1873, in Cline, *Owl and the Rossettis*, no. 261. Dianne Macleod offers a psychoanalytic reading of Leyland's decorative preference in "The 'Identity' of Pre-Raphaelite Patrons," in *Re-Framing the Pre-Raphaelites: Historical and Theoretical Essays*, ed. Ellen Harding (Aldershot, England, 1996), 23–25.

44. Child, "Pre-Raphaelite Mansion," 86.

45. The Italian paintings are described in "Art at Home—Mr. Layland's [*sic*] at Princes-Gate," *Observer*, 28 Jan. 1877, 5.

46. The Botticelli paintings illustrate Boccaccio's tale of Nastagio degli Onesti. In 1868, they had been sold to Alexander Barker of London. Three are now in the Cambó Collection, Barcelona; the fourth, *The Marriage Feast*, purchased from the Donaldson Collection in 1894 by Vernon Watney (son of the subsequent owner of 49 Prince's Gate), remained at Cornbury Park, Oxfordshire, until 1967, when it was acquired by a descendant of the Pucci family and returned to its original home in Florence. See Roberto Salvini, *All the Paintings of Botticelli*, trans. John Grillenzoni (New York, 1965), cat. nos. 141–44.

47. Child, "Pre-Raphaelite Mansion," 84–87; Saint, *Norman Shaw*, 188. The screens were made in 1879 by the firm Charles Mellier & Company and later illustrated in the *Architect* 36 (17 Dec. 1886): plate 43. They are described in Williamson, *Murray Marks*, 88. Shaw was also to redecorate the morning room on the ground floor in 1885 (Saint, *Norman Shaw*, 152–53).

48. Robertson to Kerrison Preston, 5 Dec. 1936, *Letters from Graham Robertson*, 363.

49. Child, "Pre-Raphaelite Mansion," 86; Williamson, *Murray Marks*, 85. Leyland's letters reveal that work being done on the house by October 1875 was not completed until April 1876 (see *Rossetti-Leyland Letters*, nos. 97 and 100). Curry noted that the house was renovated "first at Jeckyll's hands, later under the guidance of Richard Norman Shaw" (*Whistler at the Freer*, 58), overturning the belief that Shaw preceded Jeckyll. Ferriday, for instance, assumed that the Jacobean ceiling in the Peacock Room was

"dictated by the rest of the house—it matched the Shaw interior" ("Peacock Room," 411); Duval said the dining-room ceiling was designed by Shaw, though Jeckyll designed the pendant lamps ("Leyland," 113); Bendix argued that the gaslight fixtures, already present, "significantly affected" Jeckyll's ideas for the dining room (Diabolical Designs, 121).

50. Obach, Peacock Room, [3]; Life of Whistler, 1:203, and Whistler Journal, 109; Williamson, Murray Marks, 85.

51. His parents were George and Maria Ann (Balduck) Jeckell; Thomas was baptized 20 June 1827 (Jeckyll card file, Bridewell Museum, Norwich).

52. Thomas Jeckell, "Brief Remarks on Elsing Hall," in vol. 6, Norfolk Archaeology; or Miscellaneous Tracts Relating to the Antiquities of the County of Norfolk (Norwich, 1864): 189–92. See also Michael Hall, "Elsing Hall, Norfolk," Country Life 86 (12 Mar. 1992): 44–47.

53. Owen Chadwick, Victorian Miniature (1960), 151. One antiquarian lecture sponsored by the society would have been "rather a dry affair" were it not for the contribution of Jeckyll, who "illustrated the various styles of the church windows, etc., on a blackboard from the National School" (A Norfolk Diary: Passages from the Diary of the Rev. Benjamin John Armstrong, M.A. [Cantab.], Vicar of East Dereham, 1850–88, ed. Herbert B. J. Armstrong [1949], 47).

54. Pevsner, North-East Norfolk, 67; Ferriday, "Peacock Room," 410. See also Girouard, Victorian Country House, 367. Jeckyll's first church design was the Methodist Church, Holt, in 1862 (Berger, "Thomas Jeckyll," 15).

55. Ormond, Du Maurier, 31; Armstrong, "Reminiscences," 206.

56. GDM to Moscheles, in Felix Moscheles, In Bohemia with Du Maurier: The First of a Series of Reminiscences, 3d ed. (1897), 124; GDM to his mother, [Oct. 1860], Du Maurier Letters, 15 and 19.

57. Ormond, Du Maurier, 96; Armstrong, "Reminiscences of du Maurier," in Lamont, Thomas Armstrong, 152.

58. GDM to Emma Wightwick, [Sept. 1861], Du Maurier Letters, 69.

59. Ibid., GDM to Isabel du Maurier, [Mar. 1861], 33.

60. Ibid., [July 1861], 56.

61. Ibid., GDM to his mother, Oct. 1860 and [Sept. 1861], 15, 19, and 66.

62. Ibid., GDM to Armstrong, [May 1862], and to his mother, [19 May 1863], 139 and 135.

63. Herbert Crosse, "A Nineteenth Century Norwich Architect," letter to the editor dated 29 Aug. 1937, Eastern Daily Press (Norwich), 1 Sept. 1937, Bridewell Museum, Norwich.

64. "The 'Norwich' Gates," British Architect 22 (19 Dec. 1884): 298.

65. Ibid.; GDM to Thomas Armstrong, [May 1862], Du Maurier Letters, 139; Whistler, "Notes and News," 275.

66. Francillon, Mid-Victorian Memories, 165; GDM to Thomas Armstrong, [May 1862], and to his mother, 12 Jan. [1863], Du Maurier Letters, 139 and 191.

67. Peter Ferriday to the director of the Freer Gallery, 16 Jan. 1982.

68. Anthony Crane, "The Pater," in Betty O'Looney, Frederick Sandys, 1829–1904, exhib. cat., Brighton Museum and Art Gallery (Brighton, 1974), 13; Esther Wood, "A Consideration of the Art of Frederick Sandys," Artist, winter special number, 1896, 10.

69. W. M. Rossetti, Reminiscences, 1:276. On Jeckyll's "conversion," see Day, "Victorian Progress," 195, and Aslin, Aesthetic Movement, 93; Watanabe suggests that Jeckyll encountered Japanese art in 1862 (High Victorian Japonisme, 196). Jeckyll's 1867 gates are included in The Illustrated Catalogue of the Universal Exhibition, published with the Art Journal (1868), 104.

70. Christopher Dresser, "The Prevailing Ornament of China and Japan," Building News 9 (22 May 1863): 388. On Nesfield's "pies," see Girouard, Victorian Country House, 321–22.

71. Gleeson White, "Epoch-making House," 111; RIBA Goodhart-Rendel. Lewis Day noted that Jeckyll was "one of the first" to manifest the effect of the Japanese works exhibited in 1862 ("Victorian Progress," 195); and the Morning Leader, though styling him "Henry Jekyll," said he was "among the first in this country to perceive the aesthetic value of Japanese art" ("Art Notes: The Story of the 'Peacock Room,'" 30 June 1904, 4).

72. On the Green commission, see Girouard, Victorian Country House, 366–69, and Jeremy Cooper, Victorian and Edwardian Decor, 118 and 138.

73. Conway, "Decorative Art in England," 43; J. M. Smith, Ornamental Interiors, 205.

74. Berger, "Thomas Jeckyll," iv; RIBA Goodhart-Rendel.

75. J. M. Smith, Ornamental Interiors, 205–6.

76. "Our Office Table," Building News 41 (16 Sep. 1881): 378.

77. [Marion H. Spielmann], "James A. McNeill Whistler: 1834–1903. The Man and the Artist," Magazine of Art 28 (Nov. 1903): 15. Jeckyll also used the emblem to emboss his drawings: see for example, Ground Plan for 1 Holland Park (V&A E.1796–1979).

78. JMW to Henry Jeckell, [late Feb. 1877], GUL J28; Armstrong, "Reminiscences," 206.

79. W. M. Rossetti, Rossetti Papers, 12 Dec. 1867, 245. Jeckyll had also reasoned with Whistler before the members, when Whistler rashly demanded an apology (ERP journal, 18 Oct. 1906 [Frederick Jameson], PWC 353). And he copied out letters relevant to Haden's offense, presumably to present as evidence in support of Whistler's cause. See AMW to Deborah Haden, 14 Dec. [1867], GUL W535, and Henry R. Edenborough to JMW, 20 Dec. 1867, GUL E28, both in Jeckyll's hand; Nigel Thorp kindly drew these to my attention.

80. Jeckyll to J. A. Rose, 19 June 1868, PWC 6B (see also the letters of 3 and 14 March 1868). Jeckyll was also a member of the Decemviri, in which he represented architecture, Whistler painting, and Swinburne poetry: see Francillon, Mid-Victorian Memories, 165, and Francillon, "Literary: James McNeill Whistler," Graphic 78 (7 Nov. 1908): 576.

81. "Art Notes: The Story of the 'Peacock Room,'" Morning Leader, 30 June 1904, 4. Goodhart-Rendel described the house as "a distinguished building of red brick with a great deal of Jeckyll Japanese in the internal details of the ceilings, lead glazing, screens, etc." (RIBA Goodhart-Rendel). The house was demolished in 1957.

82. Ferriday, "Peacock Room," 411.

83. Alexander C. Ionides, Jr., Ion: A Grandfather's Tale, 2 vols. (Dublin, 1927), 2:14.

84. Crane, Artist's Reminiscences, 218; Gleeson White, "Epoch-making House," 104.

85. Armstrong, "Reminiscences," 195. Vestiges of the interiors survive, including the so-called Holland Park carpet and the famous Forest tapestry: see Linda Parry, ed., William Morris, exhib. cat., Victoria and Albert Museum (1996), nos. M108 and M120.

86. Owen Jones, Examples of Chinese Ornament: Selected from Objects in the South Kensington Museum and Other Collections (1867), reprinted as The Grammar of Chinese Ornament (New York, 1987), plate 98, "Inlaid Bronze Dish." Berger points out that Jeckyll reinterprets the East Anglian practice of pargeting, or incising cement-plasterwork ("Thomas Jeckyll," 51), and Saint credits Nesfield and Shaw with resurrecting the tradition (Norman Shaw, 49).

87. The cupboard (W.14–1972) from this

suite is also in the Victoria and Albert Museum; an ebonized bookcase and étagère is in the Cecil Higgins Museum and Art Gallery, Bedford, England. The wardrobe is reproduced in Julia (Ionides) Atkins, "The Ionides Family: Patrons of the Avant Garde," *Antique Collector* 58 (June 1987): 93.

88. Ground Plan for 1 Holland Park (V&A E.1796-1979), showing alterations to the garden after construction of the addition, in pencil and watercolor, embossed with a seal of two opposing moths, inscribed by Jeckyll, "1 Holland Park," with notes, dated 7 April 1875.

89. There is a fireplace-surround like this, described as cast-iron with silvered bronze patina and thirteen medallic decorations with Japanese-inspired motifs, in the Wolfsonian, Miami, Florida (86.17.2); see Burke et al., *In Pursuit of Beauty*, 286 (ill. 8.22). According to Berger, this grate was registered 13 November 1874 ("Thomas Jeckyll," v).

90. Gleeson White, "Epoch-making House," 110.

91. Thornton, *Seventeenth-Century Interior Decoration*, 249.

92. Day, "Kensington Interior," 144.

93. Ibid.; Gleeson White, "Epoch-making House," 110. Horowitz proposes that Jeckyll's reeded moldings were prototypes for the reeded frames Whistler later used for watercolors and pastels ("Whistler's Frames," 127).

94. Day, "Kensington Interior," 143-44. The Ionides house was damaged during World War II, sold in 1952 to the London County Council, and demolished in 1953. See London County Council and the London Survey Committee, *Survey of London*, ed. F. H. W. Sheppard, vol. 37, *Northern Kensington* (1973), 124n.

95. Howell to DGR, 4 Mar. 1873, in Cline, *Owl and the Rossettis*, no. 207. On the 1870 pot given to Rossetti, see DGR to Howell, 7 Jan. 1873, no. 186, and Williamson, *Murray Marks*, 63.

96. Hollingsworth, *Nankin China*, 25. Byron Webber posits as "the basis for the passion for Blue China" the observation that it complements English paintings: "with carpets from the old looms of Persia to complete the scheme of colour, nothing else is required to make the picture 'fortunate'" (*James Orrock*, 2:187).

97. Reitlinger, *Economics of Taste*, 203; Williamson, *Murray Marks*, 85, 36, and 31.

98. Williamson, *Murray Marks*, 4-13; Saint, *Norman Shaw*, 48-49. Marks's obituary

recalls "the beautiful elevation in Oxford-street and the exquisite blue ware it enshrined" ("Mr. Murray Marks," *The Times*, 8 May 1918, 9).

99. Quoted in Byron Webber, *James Orrock*, 2:191. Webber places the meeting in 1862 or 1863; Williamson says Marks and Rossetti met in 1861, but that Marks "really made the painter's acquaintance" in 1864 (*Murray Marks*, 52). Other evidence suggests the meeting came later. William Rossetti apparently met "Marks the China-dealer, at dinner at Chelsea," on 25 October 1866, while Whistler was in Valparaíso (WMR diary, UBC Angeli-Dennis 15/1).

100. Byron Webber, *James Orrock*, 2:191-92; Williamson, *Murray Marks*, 33-34; *Life of Whistler*, 1:117.

101. "Acute Chinamania," by George du Maurier, *Punch's Almanack for 1875*, 17 Dec. 1874, n.p.

102. *Lady Charlotte Schreiber's Journals: Confidences of a Collector of Ceramics and Antiques throughout Britain, France, Holland, Belgium, Spain, Portugal, Turkey, Austria, and Germany from the Year 1869 to 1885*, ed. Montague J. Guest with annotations by Egan Mew, 2 vols. (1911), 1:431-32 and 435, 24 and 29 May 1876.

103. Louis Huth to Orrock, in Byron Webber, *James Orrock*, 2:193; Reitlinger, *Economics of Taste*, 206. The pot sold in 1974 for 1,700 guineas and in 1997 for around £24,000: see Anthony Derham, "Blue-and-White at a Price," *Apollo* 128 (Dec. 1988): 406-7); and at Christie's, London, *Export Art of China and Japan: The China Trade Sale*, sale cat. (7 Apr. 1997), no. 18.

104. DGR to Marks, 3 Aug. 1866, *Letters of Rossetti*, no. 685; W. M. Rossetti, *Rossetti Papers*, 21 May 1867, 233.

105. W. M. Rossetti, *Family Letters*, 263, and *Reminiscences*, 1:283.

106. WMR to Marks, 2 July [1872], V&A Marks; DGR to Howell, [18 Dec. 1872], in Cline, *Owl and the Rossettis*, no. 178; Howell to WMR, 26 Sept. 1872, in Angeli, *Pre-Raphaelite Twilight*, 65. Marks paid £650 for Rossetti's entire collection of porcelain.

107. "Cragside and the Royal Preparations," *Newcastle Daily Journal*, 19 Aug. 1884, 2; Girouard, *Victorian Country House*, 452 n. 14. Other pieces from Rossetti's collection were sold to George Salting, the Australian collector who bequeathed his holdings to the Victoria and Albert Museum (Williamson, *Murray Marks*, 34n).

108. Byron Webber, *James Orrock*, 2:187.

109. Loftie, *Plea for Art*, 8; Audsley and Bowes, *Keramic Art of Japan*, 12-13.

110. Augustus Wollaston Franks, *Catalogue of a Collection of Oriental Porcelain and Pottery Lent for Exhibition by A. W. Franks*, exhib. cat., 2d ed., Bethnal Green Museum, London (1878), ix. The first edition was published in 1876.

111. Grego, "Old Blue-and-White," 10; Williamson, *Murray Marks*, 36-37.

112. ERP journal, 9 Dec. 1906, PWC 353.

113. Williamson, *Murray Marks*, 47-48; Reitlinger, *Economics of Taste*, 209. Several pieces from Thompson's collection ended up in the Fitzwilliam Museum, Cambridge. At least one piece from Whistler's collection, a covered jar, is in the Salting collection at the Victoria and Albert Museum (c.836&A-1910); and a dish said to have been Whistler's is now in the Philadelphia Museum of Art (1977.97.1).

114. GDM to his mother, [Sept. 1864], *Du Maurier Letters*, 242.

115. J. Alden Weir to his parents, 9 Oct. 1876, in D. W. Young, *Life and Letters of Weir*, 108; Cope, *Versatile Victorian*, 93 and 96.

116. GDM to his mother, [Sept. 1864], *Du Maurier Letters*, 242 and 300n.

117. Cope, *Versatile Victorian*, 82. Thompson's 1885 Royal Academy exhibit was *Old Blue—Still Life*.

118. Williamson, *Murray Marks*, 44; unidentified clipping, [Paris, May 1878], GUL PC1/104 ("Sir Henry Thompson manie le burin avec beaucoup d'habileté, et ses dessins sont pleins d'une réalité frappante, qui est d'une haute valeur pour l'amateur de porcelaines").

119. ERP journal, 24 Nov. 1906 (W. C. Alexander), PWC 353. See also MacDonald, *Whistler*, cat. no. 591.

120. *Life of Whistler*, 1:153-54; WMR diary, 22 Oct. 1867, UBC Angeli-Dennis 15/1; Williamson, *Murray Marks*, 99.

121. Byron Webber, *James Orrock*, 2:192. The Pennells conflate this sketch with Alexander's drawing of dishes (fig. 4.23), misidentifying it in *Life of Whistler* (vol. 1: facing p. 216) as "Sketches for Blue and White," even though the drawings portray authentically Chinese designs. Williamson also gets it wrong, captioning the drawing, "Whistler's Drawing of Chinese Porcelain Prepared for Submission to Sir Henry Thompson, as a Suggestion for the Illustrations in His Catalogue" (*Murray Marks*, opposite p. 44).

122. Quoted in Byron Webber, *James Orrock*,

2:192. This was doubtless the drawing to which Marks alluded in a letter to Joseph Pennell, 25 Nov. 1906, PWC 293: "You may probably care to see a pen and ink sketch of Whistler's which he made at the time he began to collect Nankin china." It remained in Marks's possession until his death, was sold at Christie's in July 1918, and then disappeared. See MacDonald, *Whistler*, cat. no. 592.

123. Unidentified clipping, [Paris, May 1878], GUL PC1/104.

124. Dorment and MacDonald, *Whistler*, cat. no. 83. See also Margaret F. MacDonald, "Whistler's Designs for a Catalogue of Blue and White Nankin Porcelain," *Connoisseur* 198 (Aug. 1978): 290–95, and *Whistler*, cat. nos. 593–651.

125. Weir to his parents, 9 Oct. 1876, in D. W. Young, *Life and Letters of Weir*, 108; JMW to Marks, 29 Dec. [1876], in Williamson, *Murray Marks*, facsimile opposite p. 48.

126. When Whistler saw the drawings again in 1893, he declared that "if he had them now he would not sell them for less than one hundred dollars each" and signed them with a second butterfly, simply "for the pleasure of having seen them again" (J. H. Jordan to CLF, 1 May 1893, FGA Williams). Those double-sided drawings are now in the Glasgow Art Gallery and Museum.

127. Williamson, *Murray Marks*, 43. The cover of the deluxe edition is reproduced in *Whistler Journal*, opposite p. 71. See also Dorment and MacDonald, *Whistler*, cat. no. 83.

128. Byron Webber, *James Orrock*, 2:194.

129. "Fine-Art Gossip," *Athenaeum*, no. 2645 (6 July 1878): 25; Williamson, *Murray Marks*, 45.

130. Marks to Joseph Pennell, 25 Nov. 1906 and 11 Feb. 1907, PWC 293.

131. ERP journal, 9 Dec. 1906, PWC 353, and *Life of Whistler*, 1:217.

132. Byron Webber, *James Orrock*, 2:190 and 189. Another commercial consequence was the sale of the Thompson collection itself in 1880, when a pot purchased for £250 in 1876 went for 700 guineas; Marks himself acquired many of the "choicest" pieces for resale. See Williamson, *Murray Marks*, 47, and Cope, *Versatile Victorian*, 83–84.

133. Williamson, *Murray Marks*, 38 and 45–46; Byron Webber, *James Orrock*, 2:195.

134. ERP journal, 9 Dec. 1906 (Marks), PWC 353; Williamson, *Murray Marks*, 14–15.

135. Williamson, *Murray Marks*, 39–42. Others in the gathering have been unconvincingly identified as Howell (eating oysters), Rossetti (standing, with a pipe) and Leyland (playing the piano).

136. F. C. Burnand, *A Tale of Old China* (1874), BM Manuscript Collections. On the play, see O'Hara, "Willow Pattern," 430.

137. Williamson, *Murray Marks*, 38–39. Other guests from the dramatic profession were Herbert Beerbohm Tree, John Laurence Toole, David James, Squire Bancroft, Fred Terry, and Charles Wyndham.

138. Williamson, *Murray Marks*, 38. See also Byron Webber, *James Orrock*, 2:195.

139. Williamson, *Murray Marks*, 46–47. The Pennells heard the story from Inez (Mrs. Clifford) Addams (ERP journal, 6 Dec. 1907, PWC 352).

140. "Northumberland House," *Builder* 31 (20 Dec. 1873): 998; Edward Walford, "Northumberland House and its Associations," in *Westminster and the Western Suburbs*, vol. 3 of *Old and New London: A Narrative of Its History, Its People, and Its Places*, ed. George Walter Thornbury (1875), 141. Walford noted that the lots included "the grand marble staircase," but it is unlikely that Leyland replaced the original stairs at Prince's Gate. A letter to the editor of *Society*, 3 Feb. 1883, corrects a previously published statement that "the grand staircase of Northumberland House is in a mansion at Palace Gate": "the *grand staircase* is not there, or, for the matter of that, anywhere, but the ormolu balustrade is at Mr. Leyland's house in *Prince's Gate*, a distinction with a difference" (GUL PC7/15). See also "Northumberland House," *The Times*, 9 Sept. 1874, 8, and 12 Sept. 1874, 10.

141. "Northumberland House," *Builder* 31 (20 Dec. 1873): 998: "The name of Smithson has obtained fame and an adjectival form in the United States, where the munificence of an Englishman (who claimed some kind of connexion with the noble family of Northumberland) has given that country the opportunity of raising a noble institution for the advancement and popularisation of science."

142. Ibid.; "Northumberland House," *Illustrated London News*, 25 July 1874, 89.

143. Muthesius, *English House*, 90.

144. Conway, "Decorative Art in England," 36. Conway's remarks about Whistler's house were reprinted in the *Baltimore Bulletin*, 21 November 1874; a copy inscribed by Anna Whistler, "For the Artist at Speke Hall," is in a file dated 1877 in PWC 199.

145. *Life of Whistler*, 1:174. See also AMW

to JHG, 30 Sept./2 Oct. 1874, GUL W547: "I wonder if I ever wrote you of all Jemie did to this house No. 2 summer before last? You would be delighted at its brightness in tinted walls & staircases."

146. *Life of Whistler*, 1:224; Conway, "Decorative Art in England," 36.

147. See MacDonald, *Whistler*, cat. no. 659r, where the sketch is dated 1877/78 on the assumption that Whistler painted the dado decoration just before vacating 2 Lindsey Row; the Leyland monogrammed stationery suggests an earlier date. The sketch itself bears the misleading inscription, "Leyland's House, Princes Gate."

148. Way, *Memories of Whistler*, 34–35; Williamson, *Murray Marks*, 87. Child attributed the sculpture to Jacopo Sansovino and supposed that it had once adorned the prow of a Venetian galley ("Pre-Raphaelite Mansion," 82).

149. Beatrix Whistler to Alexander Reid, 1 May 1892 and [30 May 1892], FGA Beatrix Whistler.

150. Child, "Pre-Raphaelite Mansion," 82; Conway, "Decorative Art in England," 40–41. Conway also notes that the dining-room walls in George H. Boughton's Kensington house were "sage-green, thus setting off finely the beautiful pictures and the many pieces of old china" (p. 788).

151. "Fine Arts," *Athenaeum*, no. 2099 (18 Jan. 1868): 98; "Decoration of Refreshment Rooms, South Kensington," *Building News* 19 (5 Aug. 1870): 105.

152. Child, "Pre-Raphaelite Mansion," 82; Conway to Joseph Pennell, 3 Dec. 1906, PWC 281. Conway expounds Whistler's principle in "Decorative Art in England," 35. The seventeen panels in the Freer collection (04.458–74) were purchased from Obach & Co. in 1904 for £300: they are discussed by Curry in *Whistler at the Freer*, cat. no. 72. Four additional panels are in the furniture department of the Victoria and Albert Museum (W.35, 36, 37, 38–1922), presented by the Arts Club in 1922.

153. FRL to JMW, 26 Apr. 1876, GUL L103.

154. ASC diary, 24 Mar. [1876], PWC 281.

155. Curry, *Whistler at the Freer*, cat. no. 72; Child, "Pre-Raphaelite Mansion," 82.

156. Audsley, *Japanese Lacquer*, 8–9. The Japanese term for "aventurine" is *nashiji*, or pear-skin ground, in reference to the gritty appearance of the lacquered surface, embedded with bits of metal.

157. Ibid., 5. On the 190 pieces of Japanese lacquer shown in 1862, see Sir Rutherford Alcock, *The Capital of the Tycoon: A Narrative*

of a *Three Years' Residence in Japan*, 2 vols. (1863), 282, and "The Japanese Court in the International Exhibition," *Illustrated London News*, 20 Sept. 1862, 318.

158. T. C. Archer, "Oriental Art in Liverpool," *Art Journal* 13 (Jan. 1874): 14; "The Liverpool Art Club," *The Times*, 26 Dec. 1872, 3.

159. Audsley, *Japanese Lacquer*, 5. The text is reprinted from the 1872 Liverpool Art Club exhibition catalogue, Audsley, *Oriental Exhibition*, 80.

160. Curry, *Whistler at the Freer*, cat. no. 72.

161. "Japanese Decoration in England," *Art Journal* 11 (Jan. 1872): 29.

162. *Whistler Journal*, 122. The two Japanese paintings making up the screen were intended to be mounted as scrolls. The inscription, in Chinese characters, contains a Japanese date equivalent to the year 1867; the artist may have been Osawa Nampo (ca. 1845–?). See J. P. Palmer to Andrew McLaren Young, 9 July 1973, and Isao Nakayama to Martin Hopkinson, 2 Sept. 1982, Hunterian Art Gallery object files, Glasgow.

163. Christian Brinton, *Walter Greaves (Pupil of Whistler)*, exhib. cat., Cottier & Co. (New York, 1912), 16; Carlyle, "Critical Analysis of Artists' Handbooks," 2:227.

164. FRL to JMW, 17 Aug. 1876, GUL L105.

165. The dado panels in the Victoria and Albert Museum are larger than those in the Freer and may have come from the hall itself or from the space beneath the stairs; panel w.38–1922 has no decoration. Two of the Freer panels (04.465 and 04.467) were also apparently left unfinished, without morning glories, and one (04.470) lacks a verdigris coating on the left and lower edges. On Whistler's drawing, see MacDonald, *Whistler*, cat. no. 577.

166. Henry Cole to JMW, 20 Mar. 1872, GUL S163. The commission of designs from Whistler must have been an afterthought, since the scheme of eminent artists' portraits by Poynter, Leighton, Watts, and Prinsep, among others, was already virtually complete.

167. JMW to Henry Cole, [ca. 27 Apr. 1873], typescript, PWC 1. On the progress of the project, see ASC diary, 26 Jan. and 9 Feb. 1873, PWC 281; JMW to ASC, [ca. Mar. 1873], PWC 8; JMW to Henry Cole, [ca. 27 Apr. 1873], typescript, PWC 1; JMW to ASC, [21 May 1873], typescript, PWC 8. Several related drawings survive: see MacDonald, *Whistler*, cat. nos. 458–59 and 1227.

168. JMW to ASC, [Apr. 1872], PWC 1, and [25 Apr. 1872], typescript, PWC 8. The sub-

stitution was made after the catalogue went to the printers.

169. ASC to ERP, 24 and 27 Feb. 1907, PWC 281. *La Princesse* was called *Japanese Woman* in the program: this puzzled Cole, who remembered the painting as "the Princesse de la Porcelaine de Chine (or some such title)."

170. [Tom Taylor], "The International Exhibition. British Oil Paintings," *The Times*, 14 May 1872, 6.

171. Frank Rede Rowke, ed., *Official Catalogue, Fine Arts Department (Under Revision)*, ed. Frank Rede Fowke, exhib. cat., London International Exhibition (1872), no. 260. A prefatory note states, "Where not otherwise stated, the Artist is also the Contributor," and says that a work without a price should be considered "Not for Sale." *La Princesse* was in Whistler's studio by March 1872, when Anna Whistler mentions "a very large & beautiful painting" that had just been "sent away," presumably to the International Exhibition (AMW to JHG, 13 Mar. 1872, GUL W542).

172. JMW to FRL, [ca. 2 Nov. 1872], PWC 6B; F. M. Brown to FRL, 10 Dec. 1872, PWC 6A. *The Corregidor de Madrid*, attributed to Velázquez, and *Portrait of the Duke of Albuquerque, in Armor* by Alonso Sánchez Coello (1531–1588), "a Spanish master comparatively little known," seem to have gone back to Liverpool: see [Stephens], "Private Collections of England," 438 and 534–35.

173. Conway, "Decorative Art in England," 627–28.

174. JMW to FRL, 4 Sept. [1875], PWC 6B.

175. FRL to DGR, 8 Oct. 1875 and 5 Apr. 1876, *Rossetti-Leyland Letters*, nos. 97 and 100.

176. "American Artists in London: What They Have Done for Philadelphia," *New York Herald* (dateline London, 20 Mar.), 10 Apr. 1876, 5.

177. AMW to JHG, 9/18 Sept. 1875, GUL W548.

178. E. D. Wallace, "The Fine Arts Abroad," *Forney's Weekly Press* (Philadelphia), 1 Apr. 1876, GUL PC1/91.

179. AMW to Mary Emma Eastwick, 19 July 1876, PWC 34.

180. See app. 19 and 20.

Chapter 5

1. Ferriday, "Peacock Room," 412.

2. Whistler, "Notes and News," 275.

3. Williamson, *Murray Marks*, 88–89. On

the long-forgotten, "complicated architectural heritage" of the room, see Curry, *Whistler at the Freer*, 58.

4. L. Reidemeister, "Die Porzellankabinette der Brandenburgisch-Preuszischen Schlösser" (The Porcelain Chambers of the Brandenburg-Prussian Castles), in *Jahrbuch der Preuszischen Kunstsammlungen* (Yearbook of the Prussian Art Collections) 54 (1933), 262–64 (trans. Heinz Gerstle, 1992).

5. Oliver Impey, *Porcelain for Palaces* (1990), 60–61; Jacobson, *Chinoiserie*, 39–41; Meredith Chilton, "Rooms of Porcelain," in *The International Fine Art and Antique Dealers Show* (New York, 1992), 14.

6. Daniel Defoe, *A Tour through the Whole Island of Great Britain*, ed. P. N. Furbank and W. R. Owens (New Haven, 1991), 65. Originally published 1724–26.

7. "Extracts from Mrs. Whistler's Journal," 29 May 1844, copied by Emma Palmer, PWC 296. Evelyn Harden, who is preparing an edition of Anna Whistler's Russian diary, suggests that Anna conflated two different rooms. The walls of the Chinese Salon were covered with Chinese coromandel lacquer panels and "very precious Chinese enamels," and the ceiling held chandeliers made from Chinese vases; the Mirror Room was smaller, with mirrored walls and doors divided by majolica frames (letter to author, 26 May 1996).

8. Curry, *Whistler at the Freer*, 59–60.

9. Thornton, *Seventeenth-Century Interior Decoration*, 78; Thornton, *Authentic Decor: The Domestic Interior, 1860–1920* (New York, 1984), 49.

10. *Whistler Journal*, 109. On Flower, see Macleod, *Art and the Victorian Middle Class*, 214–15. Flower owned Whistler's *Golden Screen* (fig. 1.12), which pictures a Chinese vase Freer singled out as "a marvellous bit of blue and white" (CLF diary 1902, FGA).

11. Lady de Rothschild to Annie Yorke, in Cohen, *Lady de Rothschild*, 165–66.

12. Grego, "Old Blue-and-White," 10; Ferriday, "Peacock Room," 410; RIBA Goodhart-Rendel.

13. JMW to Cyril Flower, [1875], from Speke Hall, in Cohen, *Lady De Rothschild*, 198. Sandys wrote of Flower to J. A. Rose, "He will do anything for me . . . [his cousin] Wickham Flower hates me . . . but Cyril is my friend" ([1 Aug. 1876], PWC 23).

14. *Whistler Journal*, 109.

15. Ladislav Cselenyi, *Cuir Doré Hangings in the Royal Ontario Museum*, History, Technology and Art Monograph 2 (Toronto, 1973), 17.

16. William Rieder, "Antiques: European

Leather Screens," *Architectural Digest* 50 (Nov. 1993): 188–91.

17. Hans Huth, "English Chinoiserie Gilt Leather," *Burlington Magazine* 71 (July 1937): 31.

18. Mary Eliza Haweis, *Beautiful Houses; Being a Description of Certain Well-Known Artistic Houses*, 2d ed. (1882), 48 and 25; Day, "Kensington Interior," 142.

19. M. E. Haweis, *Art of Decoration*, 223.

20. Scholten, *Goud Leer*, 102. Leather paper was especially recommended for libraries, dining rooms, and smoking rooms: see Edis, *Decoration of Town Houses*, 207.

21. E. W. Godwin, "Afternoon Strolls . . . A Japanese Warehouse," *Architect* 16 (23 Dec. 1876): 363.

22. Christie, Manson & Woods, *Catalogue of the Valuable and Extensive Collection of Old Nankin Porcelain . . . of F. R. Leyland*, cat. no. 301.

23. Child, "Pre-Raphaelite Mansion," 82–84; *Whistler Journal*, 109.

24. *Whistler Journal*, 109. The misconception may have originated in 1877: "It appears that soon after taking possession of his house, Mr. Leyland decorated his dining room with some splendid old stamped leather; but, in an evil moment for the leather, Whistler, the harmonious, found it necessary to his peace of mind to cover the old Cordova fabric with a coat of blue" ("The Social Week," by Talon Rouge, *Vanity Fair*, 3 Mar. 1877, 138). Armstrong introduced a note of doubt in 1912, recollecting that the dining-room walls "were to be covered with old Spanish or Dutch leather" ("Reminiscences," 206).

25. Williamson, *Murray Marks*, 89. Leather workshops specializing in chinoiserie hangings and folding screens had been established in England during the eighteenth century (Eloy Koldeweij, *Ledertapeten*, exhib. cat., Galerie Glass [Essen, Germany, 1991], 7), but there is no evidence of a gilt-leather industry in Norwich (John Renton, Assistant Keeper of Social History at the Castle Museum, to author, 26 July 1996). Apart from Marks, the only contemporary who cites Norwich leather in connection with the Prince's Gate dining room is M. E. Haweis, who expressed dismay that Whistler had worked his decoration "upon a fine collection of old Norwich leather, which, however 'ugly' in some eyes, was undoubtedly too precious to be thus destroyed" (*Art of Decoration*, 224).

26. Ferriday, "Peacock Room," 411.

27. Williamson, *Murray Marks*, 89–91.

28. Godwin, "Peacock Room," 118.

29. Eloy Koldeweij, an authority on gilt leather, places the Kassel leather in the nineteenth or early twentieth century (letter to author, 15 Apr. 1992). It may be a copy of the design at Prince's Gate.

30. Stubbs, *Whistler Peacock Room*, 2; Hobbs, *Whistler Peacock Room*, 11 and 13. A description of the original gilt leather had been previously reported in "Whistler Memento," *Hobbies: The Magazine for Collectors* (Chicago) 55 (Dec. 1950): 43 and 45.

31. J. W. Duffield to Obach & Co., 3 June 1904, FGA Obach. The Duffield family firm was established in 1818. In 1876, the offices were in Jay Mews, Kensington Gore, and by 1904, Duffield was in business with his son in Kensington High Street.

32. Gustav Mayer, Obach & Co., to CLF, 23 Mar. 1904, FGA Obach.

33. Godwin, "Peacock Room," 118.

34. Judging from the photograph, the panel looks identical to the eighteenth-century leather in the governor's room of the Pietershof in Hoorn, the Netherlands (Eloy Koldeweij to author, 15 Apr. 1992), reproduced in Scholten, *Goud Leer*, 57. The present whereabouts of the leather panel is unknown; Morris Philipson's mystery novel, *Somebody Else's Life* (New York, 1987), revolves around its disappearance.

35. Gustav Mayer to CLF, 23 Mar. 1904, FGA Obach.

36. Robertson to Kerrison Preston, 5 Dec. 1936, *Letters from Graham Robertson*, 363.

37. Godwin, "Peacock Room," 118.

38. "Art at Home—Mr. Layland's [sic] at Princes-Gate," *Observer*, 28 Jan. 1877, 5; Aslin, *Aesthetic Movement*, 94.

39. Lady [Mary] Green, *The Old Hall at Heath, 1568–1888* (Wakefield, 1889), 72–73: the ceiling is described as "circles and lozenges with subdivisions and pendant bosses," and the Oak Parlour itself as one of the rooms Jeckyll had given "an air of lightness and comfort, hardly to be expected some years ago" (p. 21).

40. Godwin, "Peacock Room," 118.

41. [Taylor], "Peacock Room," 4; B. Verity & Sons to JMW, 3 Jan. 1878, GUL v51.

42. Muthesius, *English House*, 86.

43. Godwin, "Peacock Room," 118.

44. Stubbs stated that Jeckyll built the fireplace (*Whistler Peacock Room*, 2); Teall said Whistler replaced the original tiles with this mosaic ("Whistler and the Art Crafts," 190).

45. Child, "Pre-Raphaelite Mansion," 86.

46. Jacobson gives a detailed history of English pavilions in *Chinoiserie*, especially chapter 6, "Chinoiserie in the Landscape," 152–75.

47. Berger, "Thomas Jeckyll," 35.

48. Sala, *Paris Herself Again*, 2:42; Pevsner, *North-East Norfolk*, 268.

49. "Contributions to the International Exhibition at Philadelphia," *Art Journal* 15 (June 1876): 185.

50. Ibid. The pavilion weighed more than 36 metric tons and measured approximately ten meters long, ten meters high, and five-and-a-half meters wide: a detailed description is given in Philadelphia International Exhibition, *Official Catalogue*, 79–80.

51. Day, "Notes on English Decorative Art," 171. Sala wrote in 1878, "the combined redundancy, gracefulness, and delicacy of its details in which the influence of the prevailing Japanese style is decidedly apparent—attest alike the elegant fancy and the artistic taste of Mr. Jeckyll, its designer" (*Paris Herself Again*, 2:42).

52. A photograph of the cabinet, now at Leighton House in London, is reproduced in *Whistler Journal*, opposite page 62. Mr. and Mrs. Sydney Morse told the Pennells that Whistler bought the Chinese cabinet "originally in the Paris Exhibition of 1878" (ERP journal, 9 Oct. 1904, PWC 352), but they probably meant 1867. See W. M. Rossetti, *Rossetti Papers*, 222 (5 Feb. 1867): "Saw for the first time his pagoda cabinet." It was later styled the "Owl Cabinet" because of misadventures sustained at the hands of C. A. Howell, who managed to sell the cabinet twice (ostensibly on Whistler's behalf). See Williamson, *Murray Marks*, 128–32, and Anderson and Koval, *Whistler*, 248–49. Whistler gives his own version of events in *Correspondence: Paddon Papers: The Owl and the Cabinet* (1882).

53. Richard Brown, *Domestic Architecture* (1841), plate XLIII; Jacobson, *Chinoiserie*, 200.

54. O'Hara, "Willow Pattern," 423.

55. Smith quoted in Basil Gray, "The Development of Taste in Chinese Art in the West, 1872 to 1972," *Transactions of the Oriental Ceramic Society* 39 (1974): 20. D. G. Rossetti's attachment to "blue willow" preceded his passion for blue-and-white Chinese porcelain, and the pattern was dear to other members of the Pre-Raphaelite circle as well: Elizabeth Siddal closed a letter to Georgiana Burne-Jones "with a willow-pattern dish full of love to you and Ned" ([1860–61], in Burne-Jones, *Memorials*, 1:221).

56. Sala, *Paris Herself Again*, 2:44–45.

57. Wilde, "The English Renaissance of Art," in *Essays and Lectures* (1908; reprint, New York, 1978), 154.

58. Philadelphia International Exhibition, *Official Catalogue*, 80; Sala, *Paris Herself Again*, 2:42–44. See also Walter Smith, *Industrial Art*, vol. 2 of *The Masterpieces of the Centennial International Exhibition* (Philadelphia, 1876), 407.

59. "Barnards Have Led the Way Since 1826," *Eastern Evening News* (Norwich), 18 Nov. 1976, 13. The pavilion was damaged during the Second World War, dismantled in 1944, and sold for scrap; part of the railing survives as gates to tennis courts in Heigham Park (Gere and Whiteway, *Nineteenth-Century Design*, 161).

60. Philadelphia International Exhibition, *Official Catalogue*, 80. Jeckyll's reputed embroidery design, made to disguise some unfinished portions of the pavilion when it was displayed in Philadelphia, is reproduced in "Art Needlework. II.," *Magazine of Art* 3 (1880): 178. (Linda Parry kindly provided this reference.)

61. Berger, "Thomas Jeckyll," v; Philadelphia International Exhibition, *Official Catalogue*, 79. In Paris, the andirons were installed in the dining room of the Prince of Wales's pavilion (The Paris Universal Exhibition VII," *Magazine of Art* 1 [1878]: 188). For examples of surviving brass and iron sunflower andirons, see Barbican Art Gallery, *Japan and Britain*, cat. no. 113 (illustrated in Japanese edition only). A matching Barnards fire basket is at the Freer Gallery, in the Peacock Room (FSC-M74).

62. Fischer Fine Art, *Aspects of Victorian and Edwardian Decorative Arts*, sale cat. (1982), no. 49. This attributes their rarity to the "complexity of their manufacture, which necessitated the making of all the petals by hand from wrought iron." In fact, the parts of the flowers appear to have been individually cast and welded together. But they are rare: besides the pair at the Freer (acquired 1983), there is a pair in the Toledo Museum of Art (acquired 1995).

63. Curry, *Whistler at the Freer*, 68. The original "brass dogs" were sold as part of the house in 1919 (Messrs. Trollope, 49, *Prince's Gate*, 10).

64. Day, "Kensington Interior," 144.

65. Day, "Notes on English Decorative Art," 170. The pattern might also be considered Chinese.

66. Child, "Pre-Raphaelite Mansion," 84.

67. Sato and Watanabe, *Japan and Britain*, 117, and Watanabe, *High Victorian Japonisme*, 196. On Japanese precedents,

see for example Ferriday, "Peacock Room," 411, and Hobbs, *Whistler Peacock Room*, 9.

68. CLF to Gustav Mayer, 27 Jan. 1904, FGA LB 13.

69. Macfall, *Aubrey Beardsley*, 45.

70. "Art in America: Our Decorations Compared with Those of Europe," *Mail and Express* (New York), 8 Feb. 1890, GUL PC11/20.

71. Curry, *Whistler at the Freer*, 65.

72. That such background patterning appealed to contemporary designers is borne out by *The Sunflower* by Bruce Talbert, a wallpaper designed for Jeffrey & Co., later adapted for an embossed leather-paper version (V&A E.37–1945 and E.8–1945).

73. Williamson, *Murray Marks*, 95.

74. Luke Ionides, *Memories*, 15.

75. FRL to JMW, 26 Apr. 1876, GUL L103.

76. Child, "Pre-Raphaelite Mansion," 82.

77. "Notes from Male Casebooks 1878–93, Thomas Jeckell," Bethel Hospital Archives, Norfolk and Norwich Record Office.

78. *Life of Whistler*, 1:203; ERP journal, 8 Oct. 1906 (ASC), PWC 353.

79. JMW to Henry Jeckell, [late Feb. 1877], draft, GUL J28.

80. E. D. Wallace, "The Fine Arts Abroad," *Forney's Weekly Press* (Philadelphia), 1 Apr. 1876, GUL PC1/91.

81. "Royal Albert Hall Theatre," *Daily News*, 28 Feb. 1876, 6; ASC diary, 28 Feb. 1876, PWC 281.

82. ASC diary, 19 Mar. 1876, PWC 281.

83. JMW to AMW, [ca. 1876], typescript, PWC 19; AMW to Emma Eastwick, 19/28 July 1876, PWC 34.

84. E. D. Wallace, "The Fine Arts Abroad," *Forney's Weekly Press* (Philadelphia), 1 Apr. 1876, GUL PC1/91.

85. JMW to AMW, [ca. 1876], typescript, PWC 19; ASC diary, 1 and 19 May 1876, PWC 281.

86. [W. M. Rossetti], "Notes and News," *Academy* 9 (19 Feb. 1876): 180; JMW to Flower, [ca. 1875], in Cohen, *Lady de Rothschild*, 198.

87. JMW to Murray Marks, [ca. 1875], V&A Marks.

88. Alfred Chapman to JMW, 5 and 17 July 1876, GUL C77 and C78.

89. AMW to JHG, 8–9 Sept. 1876, GUL W553, and Katherine E. Abbott, ed., "The Lady of the Portrait: Letters of Whistler's Mother," *Atlantic Monthly* 136 (Sept. 1925): 328.

90. [W. M. Rossetti], "Notes and News," *Academy* 10 (29 July 1876): 120. Whistler

mentions the prospectuses being "sent all over the place" in a letter to Alan Cole, [late Aug. 1876], LC Rosenwald.

91. JMW to FRL, [spring 1876], copy, GUL L104. The "lacquer cabinet" is probably the "Japanese China Cabinet" listed in Sotheby, Wilkinson & Hodge, *Catalogue of the Decorative Porcelain, Cabinets, Paintings, and Other Works of Art of J. A. McN. Whistler* as no. 76. Howell bought it for ten guineas.

92. Tweedie, *Thirteen Years*, 169; Lochnan, *Etchings of Whistler*, 181.

93. JMW to Arthur Liberty, [1876], GUL L145.

94. *Whistler Journal*, 105; AMW to JHG, 8–9 Sept. 1876, GUL W553.

95. AMW to JMW, 11 July 1876, GUL 552; AMW to Emma Eastwick, 19/28 July 1876, PWC 34.

96. *Life of Whistler*, 1:204–5, and *Whistler Journal*, 117.

97. Menpes, *Whistler as I Knew Him*, 130. It was later reported that an eyewitness had "deposed" to seeing Whistler emerge from Prince's Gate after a morning's work, "his hair and face covered with the gold which he had been laying on, and looking more like Danaë than an arch impressionist" ("Art Notes: Peacocks with a Past," *Truth*, 23 June 1904, 1612).

98. On the technique, see Samet, Stoner, and Wolbers, "Approaching the Cleaning of Whistler's Peacock Room," 7 and 10; on the use of copper resinate (or verdigris), see Winter and FitzHugh, "Technical Notes," 152.

99. Child, "Pre-Raphaelite Mansion," 82. The idea that the leather was "too dark in tone" arose only in 1904, when the fact that it was gilded had come to be forgotten: see, for example, Obach, *Peacock Room*, [3].

100. Williamson, *Murray Marks*, 91–92.

101. Armstrong, "Reminiscences," 206–7.

102. "Notes and News," *Academy* 10 (2 Sept. 1876): 249.

103. Teall, "Whistler and the Art Crafts," 188.

104. Obach, *Peacock Room*, [4]; *Whistler Journal*, 106; ERP journal, 8 Oct. 1906 (ASC), PWC 353.

105. *Whistler Journal*, 109.

106. JMW to FRL, [ca. 9 Aug. 1876], PWC 6B.

107. Greaves quoted in *Catalogue of Oil Paintings, a Water Colour and Etchings by Walter Greaves (Pupil of Whistler)*, exhib. cat., Goupil Gallery (1911), 4.

108. Godwin, "Peacock Room," 118.

109. JMW to Frances Leyland, [ca. 12 and 17 Aug. 1876], PWC 2.

110. AMW to JHG, 8–9 Sept. 1876, GUL w553; ERP journal, 21 Nov. 1906 (Emily Chapman), PWC 353. On Whistler's health, see Paul G. Marks, "Old Affirmations, New Conclusions," in The Whistler Papers, ed. Liana DeGirolami Cheney and Paul G. Marks (Lowell, Mass., 1986), 70.

111. JMW to Frances Leyland, [ca. 12 Aug. 1876], PWC 2.

112. FRL to JMW, 17 Aug. 1876, GUL L105.

113. JMW to Frances Leyland, [ca. 17 Aug. 1876], PWC 2. See also app. 20–21.

114. JMW to Frances Leyland, [ca. 12 Aug. 1876] and [late Aug. 1876], PWC 2.

115. Pennington, "Whistler," 162.

116. Alexander told the Pennells that Whistler "frequently talked out schemes of decoration" with him, "which is why he has all these little pen-and-ink sketches" (ERP journal, 24 Nov. 1906, PWC 353).

117. Whistler, Harmony in Blue and Gold. There is no evidence to prove that Whistler saw the Peacock Cabinet, but Burges is known to have seen the Peacock Room: see J. Mordaunt Crook, William Burges and the High Victorian Dream (1981), 413 n. 59.

118. Samet, Stoner, and Wolbers, "Approaching the Cleaning of Whistler's Peacock Room," 9.

119. ASC to ERP, 29 Aug. 1907, PWC 281.

120. DGR to WMR, 23 Apr. 1864, and to his mother, 24 Aug. 1866, Letters of Rossetti, nos. 526 and 686; W. M. Rossetti, Family Letters, 1:254. On Rossetti's peacock, "a troublesome creature, which gave great annoyance to the neighbours by its continual shrill trumpetings," see Dunn, Recollections of Rossetti, 41.

121. [J. C. Carr], "Mr. Whistler's Decorative Paintings," 11.

122. Godwin, "Peacock Room," 118; "Decorative Art," Morning Post, 8 Dec. 1876, 2.

123. AMW to JHG, 8 Sept. 1876, w553.

124. Charles Hanson, autobiographical notes, GUL H342.

125. See for example Obach, Peacock Room, [3].

126. JMW to ASC, [late Aug. 1876], LC Rosenwald.

127. [Tom Taylor], "Peacock Room," 4.

128. Child, "Pre-Raphaelite Mansion," 83; "Art in Decoration," Standard (attrib.), 22 Feb. 1877, GUL PC 1/42.

129. "In and Out of London: Mr. Whistler's Peacocks," London, 17 Feb. 1877, 63.

130. Helena Cronin, The Ant and the Peacock: Altruism and Sexual Selection from Darwin to Today (Cambridge, England, 1991), 113 and 169.

131. Charles Hanson, autobiographical notes, GUL H342; [W. M. Rossetti], "Notes on Art and Archaeology," 147.

132. [Taylor], "Peacock Room," 4.

133. ASC diary, 27 Oct. 1876, PWC 281.

134. G. A. Audsley, The Ornamental Arts of Japan, 2 vols. (1882), 1: plate VII.

135. W. M. Rossetti, "Japanese Woodcuts," in Fine Art, Chiefly Contemporary, 364; Conway to Joseph Pennell, 3 Dec. 1906, PWC 281. Conway mentions "fifteen large panels of Japanese pictures, each about five feet by two" in "Decorative Art in England," 36.

136. Walter Smith, Examples of Household Taste (New York, 1880), 255. On the screen's attribution, see Catherine Lynn, "Surface Ornament: Wallpapers, Carpets, Textiles, and Embroidery," in Burke et al., In Pursuit of Beauty, 108 n. 111; the screen as it appears today (collection of Paul Reeves) is reproduced in color. On Jeckyll's embroidery design, see "Art Needlework—II," Magazine of Art 3 (1880): 178. See also figure 5.74.

137. Charles Hanson, autobiographical notes, GUL H342.

138. "Notes and News," Academy 10 (2 Sept. 1876): 249.

139. JMW to FRL, [ca. 2 Sept. 1876], PWC 6B.

140. JMW to AMW, [early Sept. 1876], copy, FGA Whistler. Anna Whistler made a copy of the letter for her sister Emma Palmer, who presented it to Freer on 23 September 1905. Freer replied, "The extract from Mr. Whistler's own letter, concerning the painting of the Peacock Room, is of deep interest to me. It shall be carefully preserved, and shall remain always with the room as an item of most interesting historical and personal interest" (26 Sept. 1905, FGA LB18).

141. JMW to FRL, [ca. 2 Sept. 1876], PWC 6B.

142. Eustacia Smith was notorious for her liaison with Sir Charles Dilke. Their affair began in 1868 and was openly rekindled after Dilke's wife died in the winter of 1874–75, which may explain an ironic reference Leyland made to his neighbor in a letter to Whistler that summer, as "la respectable Smith" (19 Aug. 1875, GUL 102).

143. Timothy Wilcox, "The Aesthete Expunged: The Career and Collection of T. Eustace Smith, MP," Journal of the History of Collections 5 (1993): 43–57; Macleod, Art and the Victorian Middle Class, 293. On the Smith collection, see [F. G. Stephens], "The Private Collections of England. No. III—Gosforth House.—Tynemouth," Athenaeum, no. 2395 (20 Sept. 1873): 372–73.

144. On the frieze, see Crane, Artist's Reminiscences, 166.

145. Edis, Decoration of Town Houses, 84–85.

146. [J. C. Carr], "Mr. Whistler's Decorative Paintings," 11. For a recent rundown of peacocks in Victorian art, see Lambourne, Aesthetic Movement, 56–57. Lambourne suggests that because Godwin's Peacock pattern was originally printed in blue, it may have "echoed in Whistler's memory."

147. "Wall Decorations," Building News 21 (8 May 1874): 492; Lambourne, Aesthetic Movement, 58.

148. ERP journal, 24 Nov. 1906 (Alexander), PWC 353. See also Life of Whistler, 1:202.

149. Obach, Peacock Room, [3].

150. ASC to ERP, 29 Aug. 1907, PWC 281.

151. John Hebb, "Albert Moore and the 'D.N.B.,'" Notes and Queries 8 (20 July 1907): 47.

152. The room is described in Conway, "Decorative Art in England," 781.

153. "Architecture at the Royal Academy," Builder 32 (16 May 1874): 409.

154. JMW to AMW, [early Sept. 1876], copy, FGA Whistler.

155. JMW to FRL, [ca. 2 Sept. 1876], PWC 6B.

156. JMW to AMW, [early Sept. 1876], copy, FGA Whistler.

157. Smalley, "Progress in Household Art," 2.

158. AMW to JHG, 8–9 Sept. 1876, w553; JMW to AMW, [early Sept. 1876], copy, FGA Whistler; Virginia Vaughan to J. A. Rose, [5 Sept. 1876], PWC 6B.

159. JMW to Millais, [1876], PWC 2; ASC diary, 26 Oct. 1876, PWC 281.

160. ASC diary, 11 Sept. 1876, PWC 281; Freddie Leyland to JMW, [ca. 14 Sept. 1876], GUL L139.

161. ASC diary, 20 Sept. 1876, PWC 281; JMW to FRL, 21 Sept. 1876 and [ca. 22 Sept. 1876], PWC 6B.

162. Life of Whistler, 1:205.

163. Whistler Journal, 98, recording a conversation with Whistler on 16 July 1900.

164. JMW to ASC, [late Aug. 1876], LC Rosenwald; JMW to AMW, [early Sept. 1876], copy, FGA Whistler.

165. JMW to Frances Leyland, [ca. 17 Aug. 1876], PWC 2; JMW to FRL, [ca. 2 Sept. 1876], PWC 6B.

166. Freddie Leyland had written Whistler that "the governor" was planning to send ships to America (10 Jan. 1876, GUL L138).

167. *Whistler Journal*, 111 and 108.

168. JMW to Henry Jeckell, [late Feb. 1877], GUL J28. The reference to the pavilion's color is obscure, but the zinc coating used on its roof to inhibit corrosion may have been applied as a paint, with the zinc in pigmented form. Whistler may also have meant that he advised on the tone of the gold leaf used in the gilding.

169. *Whistler Journal*, 107.

170. Ibid.

171. Way, *Memories of Whistler*, 35.

172. *Life of Whistler*, 1:208; Ferriday, "Peacock Room," 413.

173. Heinemann journal, 26 Apr. 1903, PWC 288.

174. WMR to Joseph Pennell, 19 Nov. 1906, memorandum, PWC 298; DGR to Jane Morris, [26 Aug. 1879], *Rossetti and Jane Morris*, no. 76.

175. *Whistler Journal*, 110.

176. Macleod, *Art and the Victorian Middle Class*, 309.

177. ASC diary, 20 Oct. 1876, PWC 281.

178. ASC diary, 26 Oct. 1876, PWC 281; Godwin, "Peacock Room," 118.

179. According to Watts-Dunton, in *Whistler Journal*, 111.

180. Alice Carr, *Reminiscences*, 108.

181. Untitled, *Hornet*, [ca. May 1877], GUL PC25/15; JMW to D. C. Thomson, [ca. 25 May 1892], PWC 17.

182. Dakers, *Clouds* 26; Geoffrey Best, *Mid-Victorian Britain 1851–1875* (New York, 1979), 110. The current valuation is calculated as £1 equaling $200, as in Macleod, *Art and the Victorian Middle Class*, 225 n. 10.

183. *Whistler Journal*, 110–11.

184. Henry Cole diary, 3 Apr. 1877, National Art Library, V&A; Menpes, *Whistler as I Knew Him*, 131.

185. *Life of Whistler*, 1:209.

186. *Whistler Journal*, 111; JMW to D. C. Thomson, [after Sept. 1892], PWC 18.

187. Watts quoted in Dakers, *Clouds*, 34; Luke Ionides, *Memories*, 51.

188. *Life of Whistler*, 1:209.

Chapter 6

1. Godwin, "Peacock Room," 118.

2. Symons, "Whistler," 130.

3. Armstrong, "Reminiscences," 207.

4. Menpes, *Whistler as I Knew Him*, 130.

5. "Decorative Art," *Morning Post*, 8 Dec. 1876, 2. The description of prussian blue comes from an 1869 artist's handbook quoted in Carlyle, "Critical Analysis of Artists' Handbooks," 2:198.

6. Alice Carr, *Reminiscences*, 107; Godwin, "Peacock Room," 118; Armstrong, "Reminiscences," 207.

7. Pennington, "Whistler," 162–63, and Pennington to Joseph Pennell, 2 Mar. 1907, PWC 297.

8. ASC diary, 29 Oct. 1876, PWC 281; ERP journal, 20 Aug. 1907 (Mitford), PWC 352; *Life of Whistler*, 1:206.

9. J. C. Carr, *Coasting Bohemia*, 95; ASC diary, 10 Nov. 1876, PWC 281.

10. Pennington to William Heinemann, 13 Nov. [1908], typescript copy, PWC 285.

11. Menpes, *Whistler as I Knew Him*, 130. On Whistler's technique, see Samet, Stoner, and Wolbers, "Approaching the Cleaning of Whistler's Peacock Room," 10.

12. ASC diary, 15 Dec. 1876, PWC 281; "In and Out of London: Mr. Whistler's Peacocks," *London*, 17 Feb. 1877, 63.

13. Whistler, *Harmony in Blue and Gold*.

14. Audsley, *Oriental Exhibition*, 78–79.

15. Smalley, "Progress in Household Art," 2; "Wall Painting by Mr. Whistler," *Architect* 17 (13 Jan. 1877): 26.

16. [Roger Fry], "Mr. Whistler," *Athenaeum*, no. 3952 (25 July 1903): 133.

17. As noted in "Decorative Art," *Morning Post*, 8 Dec. 1876, 2.

18. Audsley, *Oriental Exhibition*, 81.

19. Winter and FitzHugh, "Technical Notes," 149–50.

20. Stephen Jones, "England and Japan: Notes on Christopher Dresser's Japanese Visit, 1876–1877," in *Influences in Victorian Art and Architecture*, ed. Sarah Macready and F. G. Thompson (1985), 150.

21. [J. C. Carr], "Mr. Whistler's Decorative Paintings," 11.

22. Conway, "Decorative Art in England," 36.

23. The woodcut was first published in connection with the Peacock Room in Spencer, *Aesthetic Movement*, 70. A closer comparison can be made to Walter Crane's frieze for the Ionides dining room at 1 Holland Park: see the panel above the fireplace in figure 5.2. The vase as a model was first proposed by Martin Hopkinson: see Denys Sutton, ed., *James McNeill Whistler*, exhib. cat., Yomiuri

Shimbun and the Japan Association of Museums (Isetan Museum of Art, Tokyo, and others, 1987), no. 48.

24. Audsley, *Oriental Exhibition*, 57. Both vases are illustrated, cat. nos. 294 and 295; also in Bowes Museum, *Catalogue of the Magnificent and Unique Collection of Japanese Art Objects, acquired by the late Mr. Bowes*, sale cat. (Liverpool, Messrs. Branch & Leete, 6 May 1901), no. 1712.

25. "Mr. J. A. M. Whistler's Decorative Work: The Peacock Room," *Queen* 61 (17 Feb. 1877): 124; [Taylor], "Peacock Room," 4.

26. MacDonald, *Whistler*, cat. no. 584. See also Dorment and MacDonald, *Whistler*, cat. no. 82. The angry peacock's tail feathers originally curved over its head, and the head and wings of the docile peacock changed position.

27. Rosalind Philip to CLF, 12 Nov. 1903, and CLF to Philip, 30 Nov. 1903, FGA Philip.

28. Sutton, *Nocturne*, 84; MacDonald, *Whistler*, cat. no. 584.

29. ASC diary, 29 Nov. and 4 Dec. 1876, PWC 281.

30. The title was given to the mural by Mitford: see *Life of Whistler*, 1:208, and *Whistler Journal*, 108.

31. Godwin, "Peacock Room," 119.

32. Eddy, *Recollections and Impressions*, 130.

33. Child, "Pre-Raphaelite Mansion," 83. Examples of confusion include "Whistler's 'Peacock Room,'" *Builders' Reporter and Engineering Times*, 8 June 1904, 311; and "The Peacock Room: A Whistlerian Revenge," *Daily News*, 10 June 1904, 4.

34. Winter and FitzHugh, "Technical Notes," 152–53.

35. Menpes, *Whistler as I Knew Him*, 131.

36. Eric Denker, *In Pursuit of the Butterfly: Portraits of James McNeill Whistler*, exhib. cat., National Portrait Gallery (Washington, D.C., 1995), 60–61; *Life of Whistler*, 1:80–81.

37. AMW to Kate Palmer, 21 May/5 June 1872, in "Whistler's Mother," *Art Digest* (New York) 7 (Jan. 1933): 6.

38. Sidney Colvin to ERP, 5 Sept. 1906, PWC 281.

39. Graves, "Whistler," 342; Curry, *Whistler at the Freer*, 58.

40. Curry, *Whistler at the Freer*, 56; MacDonald, *Whistler*, cat. no. 584; Winter and FitzHugh, "Technical Notes," 151.

41. "Decorative Art," *Morning Post*, 8 Dec. 1876, 2.

42. "Whistler's 'Peacock Room,'" *Builders' Reporter and Engineering Times*, 8 June 1904, 311; Alice Carr, *Reminiscences*, 108–9.

43. Teall, "Whistler and the Art Crafts," 191.

44. JMW to FRL, [after 27 July 1877], draft, GUL L133. This letter is commonly said to have been written to Frances (for example, in Young et al., *Paintings of Whistler*, cat. no. 178; Anderson and Koval, *Whistler*, 108; Dorment and MacDonald, *Whistler*, cat. no. 82).

45. "Decorative Art," *Morning Post*, 8 Dec. 1876, 2. On Naylor Leyland, "a rich man of many possessions," see "Statesmen— No. DCXXXIX: Captain Herbert Scarisbrick Naylor Leyland, M.P.," *Vanity Fair*, 9 Aug. 1894, 109.

46. ASC diary, 9 Dec. 1876, PWC 281; ERP journal, 27 Nov. 1906 (Cole), PWC 353.

47. Menpes, *Whistler as I Knew Him*, 130–31; Jopling, *Twenty Years*, 216.

48. ERP journal, 8 Oct. 1906 (ASC), and 25 Sept. 1906 (Way), PWC 353.

49. Untitled, *Leeds Mercury*, [Jan. 1877], GUL PC25/9.

50. "Wall Painting by Mr. Whistler," *Architect* 17 (13 Jan. 1877): 26; "Fine Arts, Science, &c.," *Court Journal and Fashionable Gazette*, 27 Jan. 1877, 103.

51. "Art at Home—Mr. Layland's [sic] at Princes-Gate," *Observer*, 28 Jan. 1877, 5.

52. Godwin, "Peacock Room," 118; ERP journal, 13 Nov. 1906 (Marie Stillman), PWC 353.

53. *Whistler Journal*, 109; Henry Cole diary quoted in Ferriday, "Peacock Room," 412; ASC diary, 17 Dec. 1876, PWC 281.

54. Liberty to Joseph Pennell, 9 Feb. 1907, PWC 291; Liberty quoted in Alison Adburgham, *Liberty's: A Biography of a Shop* (1975), 28.

55. George H. Boughton, "A Few of the Various Whistlers I Have Known," *Studio* 30 (Dec. 1903): 215.

56. Jopling, *Twenty Years*, 216; *Life of Whistler*, 1:206, and *Whistler Journal*, 106.

57. ERP journal, 13 Nov. 1906 (Stillman), PWC 353.

58. Ibid., 27 Nov. 1906 (Cole); *Whistler Journal*, 108–9.

59. Tweedie, *Thirteen Years*, 169; J. C. Carr, *Coasting Bohemia*, 95.

60. ERP journal, 8 Feb. 1912 (Miss Cole), PWC 353; ASC to ERP, 27 Dec. 1906, PWC 281; *Life of Whistler*, 1:206–7.

61. Initially proposed in Helen Smith, *Deco-rative Painting in the Domestic Interior*, 222–23; see also Dorment and MacDonald, *Whistler*, cat. no. 82, and Robert Hughes, *American Visions: The Epic History of Art in America* (New York, 1997), 242.

62. "Whistler's 'Peacock Room,'" *Builders' Reporter and Engineering Times*, 8 June 1904, 311.

63. "Artistic," *Family Herald* (attrib.), n.d., GUL LB12.

64. "Art: Ornamental Painting," *Examiner*, 24 Feb. 1877, 245.

65. "Art at Home—Mr. Layland's [sic] at Princes-Gate," *Observer*, 28 Jan. 1877, 5; "Fine Arts, Science, &c.," *Court Journal and Fashionable Gazette*, 27 Jan. 1877, 103.

66. *Life of Whistler*, 1:208; Ferriday, "Peacock Room," 413.

67. *Whistler Journal*, 106; *Life of Whistler*, 1:208. The copy the Pennells saw, which belonged to Deborah Haden, eventually entered the Pennell Whistler Collection at the Library of Congress. That library has a second copy in the Rosenwald Collection (fig. 6.12). There are also six copies in Glasgow (GUL Whistler 246 and PC25/1).

68. ERP journal, 13 Nov. 1906 (Stillman), PWC 353; Menpes, *Whistler as I Knew Him*, 132.

69. ASC diary, 9 Feb. 1877; Godwin, "Peacock Room," 118.

70. [J. C. Carr], "Mr. Whistler's Decorative Paintings," 11; [Taylor], "Peacock Room," 4.

71. Godwin, "Peacock Room," 118.

72. Beatrix Whistler to JMW, 20 Nov. 1895, GUL W639.

73. Godwin, "Peacock Room," 119.

74. WMR diary, 9 Feb. 1877, UBC Angeli-Dennis 15/2; [W. M. Rossetti], "Notes on Art and Archaeology," 147.

75. "Mr. J. A. M. Whistler's Decorative Work: The Peacock Room," *Queen* 61 (17 Feb. 1877): 124.

76. "In and Out of London: Mr. Whistler's Peacocks," *London*, 17 Feb. 1877, 63–64; "Variorum Notes," *Examiner*, 17 Feb. 1877, 216. The spoof on the *London* review is "The Peacock Room of Prince's Gate. (Blanche and Marion, Conversing)," GUL PC25/6.

77. ASC diary, 18 Feb. 1877, PWC 281.

78. "Art: Ornamental Painting," *Examiner*, 24 Feb. 1877, 245; "The Social Week," by Talon Rouge, *Vanity Fair*, 3 Mar. 1877, 138.

79. "Art and Science Gossip," *Figaro*, 24 Feb. 1877, 10; "Here, There, and Every-where," *Fun*, 21 Feb. 1877, 67; "A Bird's-eye View of the Future (With Mr. Punch's Compliments to Mr. Whistler upon the Peacock Room at Princes Gate)," *Punch*, 3 Mar. 1877, 85, and *Punch*, 3 Mar. 1877, 90.

80. "In and Out of London: Mr. Whistler's Peacocks," *London*, 17 Feb. 1877, 63; "Variorum Notes," *Examiner*, 17 Feb. 1877, 216; "The Social Week," by Talon Rouge, *Vanity Fair*, 3 Mar. 1877, 138. Mrs. Walter Crane possessed a peacock-feather cape she wore that Christmas to a fancy dress party: see [Hugolin Haweis], *Four to Fourteen* (1939), 45–46.

81. Smalley, "Progress in Household Art," 2. The report was repeated in "Personal," *Harper's Bazar* (New York), 31 Mar. 1877, 195.

82. Campbell, *Rainbow-Music*, 13.

83. Duval, "Leyland," 113. A "rare ebonised Morris & Company sideboard, designed for 49 Princes Gate and used in the Peacock Room," was sold at Sotheby's, Belgravia (*Arts and Crafts Furniture, Textiles, Enamels, Metalwork and Stained Glass*, sale cat. [6 Dec. 1978], no. 173).

84. "Art at Home—Mr. Layland's [sic] at Princes-Gate," *Observer*, 28 Jan. 1877, 5.

85. The vacant space is mentioned in "Mr. J. A. M. Whistler's Decorative Work: The Peacock Room," *Queen* 61 (17 Feb. 1877): 124; "Art in Decoration," *Standard* (attrib.), 22 Feb. 1877, GUL PC 1/42; and "Personal," *Harper's Bazar* (New York), 31 Mar. 1877, 195.

86. Eastlake, *Hints on Household Taste*, 74.

87. Obach, *Peacock Room*, [3]; *Life of Whistler*, 1:203. Stubbs went so far as to suppose that Whistler designed the sideboard after painting the mural, to meet the need for "some kind of an ornament or fixture to fill up the space beneath the panel" (*Whistler Peacock Room*, 7 and 9).

88. Curry, *Whistler at the Freer*, 61.

89. Child, "Pre-Raphaelite Mansion," 84.

90. ERP journal, 9 Dec. 1906 (Marks), PWC 353; *Whistler Journal*, 110; *Life of Whistler*, 1:207.

91. Williamson, *Murray Marks*, 92.

92. Armstrong, "Reminiscences," 207–8.

93. Millar, *Hints on Insanity*, 30.

94. Jamison, *Touched with Fire*, 4.

95. Ferriday, "Peacock Room," 410.

96. Jamison, *Touched with Fire*, 105.

97. Ibid., 123.

98. JMW to Henry Jeckell, [after 17 Feb. 1877], draft, GUL J28.

99. Armstrong, "Reminiscences," 206–7. Lewis Day, writing about the Ionides house,

slipped in the statement that Jeckyll "naturally resented being painted-out in that superior way" ("Kensington Interior," 144), and Luke Ionides conjectured that Jeckyll felt "unfair advantage" had been taken of his friendship (*Memories*, 15). Whistler's high-handed attitude toward Jeckyll's design and its supposed "tragic consequence" was almost certainly the cause of his longstanding feud with Frederick Sandys, who reportedly "remonstrated with Whistler about his action in connection with the Peacock room" (O. Kyllman to ERP, 20 Sept. 1906, PWC 290). On that quarrel, see also *Whistler Journal*, 22, and Williamson, *Murray Marks*, 108–9.

100. Jeckyll to JMW, 11 Nov. 1876, GUL J27.

101. On the symptoms of manic psychosis, see Jamison, *Touched with Fire*, 13. Heigham Hall was a "provincial licensed house" that offered "privacy to those who do not wish it to be generally known that they have a relative insane" (Millar, *Hints on Insanity*, 84–85). The institution's records were destroyed in 1933.

102. "Order for the Reception of a Private Patient: Thomas Jeckell," 23 Feb. 1878, Bethel Hospital Archives, Norfolk and Norwich Record Office.

103. "Decorative Art," *Morning Post*, 8 Dec. 1876, 2.

104. JMW to Henry Jeckell, [after 17 Feb. 1877], GUL J28. [W. M. Rossetti], "Notes on Art and Archaeology," 147. Rossetti had noted in his diary, "The *construction* of the room is not W's, but Jeckyll's" (9 Feb. 1877, UBC Angeli-Dennis 15/2).

105. Whistler, "Notes and News," 275. Freddie Leyland, reading this in Liverpool, had written to Whistler, "Your epistle could not be surpassed—Ye Gods what language. How Jekyll [*sic*] must have blushed" ([14 Sept. 1876], GUL L139).

106. JMW to *Builder* and *Architect*, drafts of a letter to the editor, GUL B207 (some sentences are written in another hand).

107. JMW to Henry Jeckell, [after 17 Feb. 1877], GUL J28.

108. Menpes, *Whistler as I Knew Him*, 132.

109. "Notes from Male Casebooks 1878–93, Thomas Jeckell," Bethel Hospital Archives, Norfolk and Norwich Record Office. The admitting physician reported, "Thinks he is God Almighty & that he is in hell, that all around are devils, & that he can strike any one dead."

110. See Millar, *Hints on Insanity*, 31–32: "Sedatives have but little beneficial effect in this class of cases, and the only remedy which I have found to be of decided use is

large doses of quinine given during the convalescent period." Sir Frederic Bateman won an international prize for his work on aphasia and was the author of *On Aphasia, or Loss of Speech, and the Localisation of the Faculty of Articulate Language* (1870; 2d ed., 1890), and *The Idiot; His Place in Creation, and His Claims on Society*, (2d ed., 1897).

111. "Visiting Physician's Report Book," notes by Sir Frederic Bateman, 18 Nov. 1878, Bethel Hospital Records, Norfolk and Norwich Record Office.

112. "Notes from Male Casebooks 1878–93, Thomas Jeckell," Bethel Hospital Archives, Norfolk and Norwich Record Office. This document gives the cause of death as "Softening of Brain." The death certificate gives "Brain disease."

113. Curry, *Whistler at the Freer*, 54; "Our Office Table," *Building News* 41 (16 Sept. 1881): 378. The second obituary was "Notes on Current Events," *British Architect* 16 (23 Sept. 1881): 471–72.

114. Day, "Victorian Progress," 195.

115. Godwin, "Peacock Room," 118.

116. Smalley, "Household Decoration," 2.

117. "The Paris Universal Exhibition V," *Magazine of Art* 1 (Sept. 1878): 116.

118. JMW to Godwin, [22 Mar. 1878], GUL G105. The best-selling "abomination" for a Barnards stove was a tile with a floral motif designed by William De Morgan, the "BBB": see Jon Catleugh, *William De Morgan Tiles* (New York, 1983), 67.

119. "Exhibits for the Paris Exhibition," *Building News* 34 (22 Mar. 1878): 287.

120. Smalley, "Household Decoration," 2.

121. Godwin, "Peacock Room," 118; "The Paris Universal Exhibition—v," *Magazine of Art* 1 (Sept. 1878): 116. There are some pencil sketches on a box for lithographic paper in the Hunterian Art Gallery that probably relate to designs in *Harmony in Yellow and Gold* (see MacDonald, *Whistler*, cat. no. 702).

122. "Anglo-Japanese Furniture, Paris Exhibition," *Building News* 34 (14 June 1878): 596. Pickford Waller, who discovered the suite in a secondhand furniture shop toward the end of the 1880s, filled in the fireplace with the dado panels: see Waller to Joseph Pennell, 6 Feb. 1909, and Waller to ERP, 9 Feb. 1909, PWC 302.

123. "Mr. Whistler's 'Ten O'Clock,'" *Gentle Art*, 145.

124. [Taylor], "Peacock Room," 4.

125. Eddy, *Recollections and Impressions*, 129; Wilde, "House Beautiful," 916.

126. In contrast to the early 1877 accounts, which invariably describe the wainscot as gold, an 1890 account describes the woodwork as "greenish bronze" ("Art in America: Our Decorations Compared with Those of Europe," *Mail and Express* [New York], 8 Feb. 1890, GUL PC11/20).

127. Audsley, *Japanese Lacquer*, 8–9.

128. The suggestion that Whistler may have used gold-leaf tissues to apply the paint was made by conservator Peter Nelsen.

129. Simon Houfe, "Whistler in the Country: His Unrecorded Friendship with Lewis Jarvis," *Apollo* 98 (Oct. 1973): 284.

130. Smalley, "Household Decoration," 2.

131. "In and Out of London: Mr. Whistler's Peacocks," *London*, 17 Feb. 1877, 63.

132. Williamson, *Murray Marks*, 94; Armstrong, "Reminiscences," 207.

133. Smalley, "Progress in Household Art," 2.

134. Smalley, "Books and Art in London," 6. The dateline is 9 March 1877.

135. Godwin, "Peacock Room," 119.

136. "Art: Ornamental Painting," *Examiner*, 24 Feb. 1877, 244–45. If Leyland's letter was written on 23 February (Friday), then Whistler might also have been reading, on Saturday, 24 February 1877, the review in the *Builder*, which had nothing new to say ("'The Peacock Room,'" 182), or in *Figaro*, which called the room "a curious decorative freak," and is unlikely to have been forwarded to Liverpool ("Art and Science Gossip," 10).

137. Smalley, "Books and Art in London," 6.

138. Haweis, *Money and Morals*, 8.

139. The pamphlet in Glasgow (GUL Whistler 188) is in an unstamped envelope addressed in Whistler's hand to Leyland at Speke Hall.

140. JMW to Rev. Haweis, [26 Feb. 1877], Brandeis University Libraries Special Collections Department, Waltham, Mass.

141. ERP journal, 25 Sept. 1906 (Way), PWC 353.

142. *Whistler Journal*, 102–3 and 105–6; JMW to Mrs. Lyulph Stanley, [4 Mar. 1877], GUL S173.

143. ASC diary, 5 Mar. 1877, PWC 281.

144. Williamson, *Murray Marks*, 94–95; Macleod, *Art and the Victorian Middle Class*, 313.

145. *Vernon Lee's Letters*, 126; *Life of Whistler*, 1:209.

146. Prinsep, "Collector's Correspondence," 252.

147. Freddie Leyland to JMW, 3 Apr. 1877, GUL L140.

148. DGR to FRL, 19 Mar. [1877], *Rossetti-Leyland Letters*, no. 105.

149. WMR diary, 28 June 1877, UBC Angeli-Dennis 15/2. Abbreviated words in this passage have been spelled out.

150. ERP journal, 7 Dec. 1906, PWC 353 (see also *Whistler Journal*, 103).

151. JMW to Steven Tucker, 30 June 1877, GUL T209; JMW to Mrs. Singleton, [ca. 30 June 1877], FGA Whistler.

152. ERP journal, 27 Nov. 1906, PWC 353.

153. JMW to FRL, [ca. 13 July 1877], draft, GUL L119 (also L120).

154. ERP journal, 7 Nov. 1906 (ASC), PWC 353; *Whistler Journal*, 100–1.

155. Drafts and copies of the letter (app. 17) include GUL L122 (draft), L123 (draft on Arts Club stationery), L124 (copy on Arts Club stationery), and L126 (copy).

156. Ferriday, "Peacock Room," 413.

157. "Mr. Ruskin on the Grosvenor Gallery," *Architect* 18 (14 July 1877): 18.

158. *Art Journal*, quoted in Barrie Bullen, "The Palace of Art: Sir Coutts Lindsay and the Grosvenor Gallery," *Apollo* 102 (Nov. 1975): 354.

159. Perhaps this image gave rise to Watts-Dunton's recollection that Whistler had painted a portrait of Leyland in the tail of one of his peacocks (*Whistler Journal*, 110–11).

160. Crane, *Artist's Reminiscences*, 175. The decoration was modeled on the studio of the Lindsays' house at Cromwell Place: see "Fine Arts: The Grosvenor Gallery," *World*, 2 May 1877, 10, and Jopling, *Twenty Years*, 114.

161. Virginia Surtees, *Coutts Lindsay, 1824–1913* (1993), 146.

162. Wilde, "Grosvenor Gallery," 125n.

163. ERP journal, 13 Nov. 1906, PWC 353.

164. Burne-Jones to FRL, [ca. Nov. 1878], PWC 6A.

165. Defendant's brief, *Whistler v. Ruskin*, PWC 27; see also Merrill, *Pot of Paint*, 108. The Pennells wrote that in the brief, "The decoration of *The Peacock Room* is wilfully confused with *The Gold Scab*" (*Whistler Journal*, 326): but the brief was composed in 1877–78, and *The Gold Scab* painted in 1879.

166. Burne-Jones, "Statement to Defense Counsel," in Merrill, *Pot of Paint*, 295–96.

167. Crane, *Artist's Reminiscences*, 199–200.

168. AMW to JHG, 8/12 June 1877, GUL W558.

169. JMW to William Graham, [ca. 23 July 1877], GUL G150; JMW to Arthur Liberty, [ca. 1877–78], GUL L145; JMW to Mrs. Greaves, [ca. 1877–78], typescript copy, PWC 9.

170. B. Verity & Sons to JMW, 3 Jan. 1878, GUL V51. See also WMR diary, 9 Feb. 1877: "W. has introduced some slight modificns., & proposes others, especy. as regards the lighting" (UBC Angeli-Dennis 15/2).

171. JMW to B. Verity & Sons, 4 Jan. 1878, copy, and [ca. 3 Jan. 1878], draft, GUL V54 and V53. On the back of another draft (V52), Whistler drew a horsewhip, inscribed "FRL. frill" (M661).

172. JMW to FRL, [ca. June 1879], draft or copy, GUL L134; JMW to Watts-Dunton, [Feb. 1878], draft, GUL W70 (the final letter is published in *Nine Letters to Th. Watts-Dunton from J. McNeill Whistler* [1922], 15).

173. ASC diary, 7 Jan. 1878, PWC 281. See also JMW to [ASC], [7 Jan. 1878], typescript copy, PWC 32: "we will go to a French place I know and on to the Grasshopper—nous deux—I have a lovely letter to show you—apropos of F.R.L.!" *The Grasshopper: A Drama in Three Acts*, by John Hollingshead, opened at the Gaiety Theatre in December 1877. On the play, see Merrill, *Pot of Paint*, 103–6.

174. The Pellegrini portrait of Whistler (present whereabouts unknown) is reproduced in A. E. Gallatin, *The Portraits and Caricatures of James McNeill Whistler: an Iconography* (1913), cat. no. 154.

175. ASC diary, 20 Jan. 1878, PWC 281.

176. "Death of Mr. Whistler," *The Times*, 18 July 1903, 12. This report also appears in Cortissoz, "Whistler," 832; "Whistler and Gainsborough," *Daily News*, 13 June 1904, 6; and Tweedie, *Thirteen Years*, 170. There are several extant sketches of demons that may be related to the portrait (M665–68); these appear with sketches of Nellie Farren, who performed in both *The Grasshopper* and *Little Doctor Faust*. The sketches on Whistler's draft letter to B. Verity & Sons (GUL V52) are closely related to the demons depicted in M665v and 668r.

177. JMW to Watts-Dunton, 2 Feb. [1878], in Thorp, *Whistler on Art*, no. 17; Way, *Memories of Whistler*, 29. Alan Cole had seen Whistler's "excellent portraits of Mr. and Mrs. Leyland" on 29 July 1877 (ASC diary, PWC 281).

178. JMW to Watts-Dunton, 2 Feb. [1878], in Thorp, *Whistler on Art*, no. 17. See also app. 20.

179. Quoted in Young et al., *Paintings of Whistler*, cat. no. 181. The photograph appears to date from about 1881 and is inscribed by Whistler, "Arrangement in grey & Black, No. 2," the title usually attached to the portrait of Thomas Carlyle: it is reproduced in Pennell and Pennell, *Life of Whistler* (1911), opposite p. 264, as a destroyed portrait of Maud Franklin.

180. William H. Goodyear to Joseph Pennell, 8 Jan. 1906, PWC 279; CLF to Albert Roullier, 17 Mar. 1910, FGA LB29. "If genuine," Freer wrote, "it certainly is . . . one of the sort that Mr. Whistler himself would surely have destroyed had it been in his possession during the latter years of his life."

181. ERP journal, 28 Nov. 1920 (Mrs. Hinde), PWC 351.

182. William H. Goodyear, "A Portrait by Whistler," *Museum News* (Brooklyn Institute of Arts and Sciences) 2 (Dec. 1906): 38.

183. JMW to Phil Morris, 15 Oct. 1877, copy, PWC 4; George A. Holmes to Joseph Pennell, 8 Nov. 1906, PWC 285; Holmes's recollections, 13 Nov. 1906, PWC 284.

184. Phil Morris to JMW, 26 Sept. [1877], and JMW to Phil Morris, 15 Oct. 1877, copy, PWC 4.

185. The work may have been shown again at the Grosvenor Gallery in 1885 as *Portrait Study in Silver Tones*, said to capture the spirit of Whistler's art, "the nearest thing in harmony and sentiment to his melodic method": "An inner frame of silver, surrounded by pale gold, leads the eye agreeably to the figure of a lady in silvery grey satin; and this new or revived system for which the art-world may fairly thank Mr. Whistler of suiting frame and picture, is practised with complete success by Mr. Morris" ("The Grosvenor Gallery: First Notice," [May 1885], GUL PC Chronological Series). In 1906, Elizabeth Pennell saw both portraits hanging in the sitter's drawing room (*Whistler Journal*, 103).

186. ERP journal, 1 Nov. 1906 (Sutherland), PWC 353.

187. Ferriday, "Peacock Room," 414.

188. ERP journal, 25 Sept. 1906, PWC 353. Leyland eventually received "a magnificent dividend warrant of one penny halfpenny in the £ on his debt," or less than one percent (FRL to C. A. Howell, 22 Oct. 1880, GUL L135).

189. A copy of Whistler's bankruptcy papers made by H. H. Hammond (b. 1869) was sent to the Freer Gallery on 1 August 1953 (FGA Central Files). Hammond, formerly "attached" to the London Bankruptcy Court, sent this partly to disclose "how false was the charge against Leyland." Another copy of the papers is in Glasgow (GUL LB8).

190. JMW to FRL, [ca. June 1879], draft or copy, GUL L134.

191. DGR to Jane Morris, [26 Aug.] 1879, *Rossetti and Jane Morris*, no. 76.

192. ASC diary, 25 May 1879, PWC 281. The caricatures were sold for a pittance to Thomas Way, who rolled them up and kept them from resurfacing in public. At some point toward the end of Whistler's life, they appear to have been discreetly destroyed (ERP journal, 25 Sept. 1906, PWC 353). The Pennells report (erroneously) that Freer owned them: see *Life of Whistler*, 1:259, and *Whistler Journal*, 113.

193. Hare, *Peculiar People*, 235, 13 May [1879].

194. ASC diary, 25 May 1879, PWC 281; ERP journal, 25 Sept. 1906, PWC 353. The second satire is *Mount Ararat* (Y210).

195. Way, *Memories of Whistler*, 34; ERP journal, 25 Sept. 1906 (Way), PWC 353 (cf. *Life of Whistler*, 1:256).

196. Macleod, *Art and the Victorian Middle Class*, 295. The divorce report first appeared in Duval, "Leyland," 114.

197. J. Bertram Lippincott to ERP, 6 Jan. 1921, PWC 292; *Whistler Journal*, 101 and 105.

198. ERP journal, 26 Oct. 1906 (Frances Leyland), PWC 353.

199. ERP journal, 27 Sept. 1906 (Helen Whistler), PWC 353.

200. Luke Ionides, *Memories*, 15; Macleod, *Art and the Victorian Middle Class*, 330 n. 90. On Luke Ionides' close friendship with "Nell," see his letter to ERP, 12 Jan. 1917, PWC 289.

201. MMM Stripe MS, 82; DGR to FRL, 18 May 1877, *Rossetti-Leyland Letters*, no. 110.

202. Hare, *Peculiar People*, 235.

203. ERP journal, 7 Dec. 1906, PWC 353.

204. Letter from Terrence Davis to author, 15 Apr. 1996. Frederick Caldecott was Mr. Davis's grandfather.

205. Val Prinsep to Lord Russell, [after Jan. 1892], PWC 6c. Prinsep enclosed "a charitable contribution of Five pounds to help him out of his difficulties." Lord Russell was Charles, First Baron Russell of Killowen (1832–1900), the attorney general, later appointed lord chief justice of England.

206. JMW to Helen Whistler, [Mar./Apr. 1880], GUL W683; Matthew Elden to JMW, [ca. 1880], GUL E37.

207. ERP journal, 4 Mar. 1909 (Margie Cole), PWC 352; WMR diary, 23 June 1879, UBC Angeli-Dennis 15/3.

208. DGR to Jane Morris, [20 July 1879], and [26 Aug. 1879], *Rossetti and Jane Morris*,

nos. 65 and 76. Divorce was not an option: before 1923 a woman could sue for divorce only if her husband's adultery was aggravated by cruelty or ended in desertion.

209. WMR diary, 23 June 1879, UBC Angeli-Dennis 15/3; DGR to his mother, [17 Aug. 1879], *Letters of Rossetti*, no. 2087.

210. WMR diary, 8 Mar. 1880, UBC Angeli-Dennis 15/3; ERP journal, 4 Mar. 1909 (Mrs. ASC), PWC 352.

211. WMR diary, 8 Mar. 1880, UBC Angeli-Dennis 15/3. Francis Herbert Leyland Stevenson-Hamilton was born 29 February 1880; Fanny died 2 March 1880.

212. JMW to Helen Whistler, [Mar./Apr. 1880], from Venice, GUL W683. It was probably a picture of Fanny's gravestone that Elizabeth Pennell saw in Frances Leyland's flat, years later, amid a group of family photographs (*Whistler Journal*, 103).

213. DGR to Jane Morris, [10 Mar. 1880], *Rossetti and Jane Morris*, no. 108. See also FRL to DGR, 3 Mar. 1880, *Rossetti-Leyland Letters*, no. 116.

214. DGR to Jane Morris, [26 Aug. 1879], *Rossetti and Jane Morris*, no. 76.

215. JMW to Watts-Dunton, 2 Feb. [1878], in Thorp, *Whistler on Art*, no. 17.

216. Way, *Memories of Whistler*, 25–27; Dowdeswell, "Reminiscences of James Abbott McNeill Whistler," 2/26, LC Rosenwald; "James M'Neil Whistler," unidentified New York newspaper (dateline London, 18 Mar. 1879), GUL PC Chronological Series.

217. ERP journal, 12 Jan. and 8 Feb. 1907 (Miss Chambers and Mrs. Jenner), PWC 352, and *Whistler Journal*, 69.

218. C. A. Howell to JMW, 25 Aug. 1879, GUL H283.

219. Robertson, *Life Was Worth Living*, 187.

220. JMW to Helen Whistler, [Mar./Apr. 1880], GUL W683.

221. Ibid; Young et al., *Paintings of Whistler*, cat. no. 89.

222. Way and Dennis, *Art of Whistler*, 31–32, and Way, *Memories of Whistler*, 27; *Life of Whistler*, 1:148; Armstrong, "Reminiscences," 198.

223. JMW to Helen Whistler, [Mar./Apr. 1880], GUL W683, and Matthew Elden to JMW, 12 Apr. [1880], GUL E36.

224. Thomas Way to William Whistler, 15 Apr. 1880, GUL W78.

225. Alfred Chapman to CLF, 20 Feb. 1904, FGA Chapman. Chapman said Whistler had written to him afterward, regretting that he

had disowned the picture, but no such letter survives to corroborate the story.

226. JMW to *Pall Mall Gazette*, 1 Aug. [1891], in Thorp, *Whistler on Art*, no. 45. See also JMW to E. G. Kennedy, 5 Aug. 1895, Kennedy Papers 1:69, New York Public Library.

227. ASC diary, 7 and 8 Sept. 1879, PWC 281.

228. "A Whistlerian Derangement," 19 Sept. 1879, unidentified newspaper clipping in Whistler autograph letters to Walter and C. M. Dowdeswell 2/50a, LC Rosenwald.

229. Symons, "Whistler," 126.

230. Savage, "Forcible Piece of Weird Decoration," 48.

231. Graves, "Whistler," 343.

232. E. F. Benson, *As We Were: A Victorian Peep-Show* (1930; reprint, 1985), 262.

233. *Life of Whistler*, 1:259; DGR to Jane Morris, [10 Mar. 1880], *Rossetti and Jane Morris*, no. 108.

234. *Whistler Journal*, 113; [Godwin], "Notes on Current Events," *British Architect* 14 (6 Jan. 1882): 2.

235. E. J. Horniman to Joseph Pennell, 8 Sept. 1906, PWC 285; Jacomb-Hood, *With Brush and Pencil*, 47; JMW to Jacomb-Hood, [May 1892], PWC 2.

236. Jacomb-Hood, *With Brush and Pencil*, 47. Jacomb-Hood held onto *The Gold Scab* until after Whistler's death, then sold it to Theron C. Crawford, a friend of the Leyland family. In 1912, having failed to interest Freer in it, Crawford gave *The Gold Scab* to A. L. Gump of San Francisco in exchange for some Chinese porcelain. See Carol Green Wilson, *Gump's Treasure Trade: A Story of San Francisco* (New York, 1965), 154–55; and CLF to Rosalind Philip, 29 June 1910, GUL F515.

237. Record of Examination and Condition (1977.11), Painting Conservation Department, The Fine Arts Museums of San Francisco.

238. *Whistler Journal*, 113; CLF to W. S. Marchant, 2 Feb. 1904, FGA LB13; CLF to Rosalind Philip, 7 and 31 Mar. 1904. Freer was offered the painting again in 1910, when the price had risen from £800 to £2,000 (CLF to Theron C. Crawford, 28 Mar. 1910, FGA LB30).

239. Bacher, *With Whistler in Venice*, 17.

240. Jacomb-Hood, *With Brush and Pencil*, 47; "Refused Whistler in Local Gallery," *San Francisco Examiner*, 4 Aug. 1911, 5, object file, De Young Museum, San Francisco.

241. JMW to Helen Whistler, [ca. Jan. 1880], GUL W681.

Chapter 7

1. "Whistler's 'Peacock Room,'" *Daily Telegraph*, 13 June 1904, 7.

2. Julia Findlater, "100 years of Leighton House," *Apollo* 143 (Feb. 1996): 4–9.

3. "The Vanderbilt Palaces," *New York Times*, 25 Aug. 1881, 3; Edward Strahan [Earl Shinn], *Mr. Vanderbilt's House and Collection* (Boston, 1883–84), 3:62 and 64. The mansion was demolished in 1947.

4. Williamson, *Murray Marks*, 96.

5. Lindsay, *History of Merchant Shipping*, 4:421–22.

6. Chandler, *Liverpool Shipping*, 126; Jones, *Pioneer Shipowners*, 122–24. See also Leyland's letter to *The Times* on the Cattle Diseases Bill, 23 May 1878, 4.

7. "Death of Mr. F. R. Leyland, *Liverpool Courier*, 6 Jan. 1892, 5; Jones, *Pioneer Shipowners*, 121–22. Freddie Leyland was named head of the firm upon his father's death. It became a limited company and then amalgamated with the Furness Line; around 1900 the Atlantic trade was acquired by the International Navigation Company, New York, a complex of shipping concerns controlled by J. P. Morgan, which sold off its interests in the Leyland Line in 1932. After that, "ship after ship went to the scrapyards, and thus a famous Liverpool Line came to an end" (Chandler, *Liverpool Shipping*, 127).

8. FRL to DGR, 10 June 1880, *Rossetti-Leyland Letters*, no. 119. Rossetti had predicted this: "Another dead 'un is Leyland, who I feel sure won't buy again at all" (DGR to Jane Morris, 5 Mar. 1878, *Rossetti and Jane Morris*, no. 27). Leyland himself wrote to Albert Moore that year that he was "not buying pictures at present" (draft on *verso* of Moore to FRL, 29 Jan. 1878, PWC 6A).

9. [Stephens], "Private Collections of England," 438.

10. Edward Burne-Jones to FRL, in Burne-Jones, *Memorials*, 2:222.

11. "James A. Whistler, The Artist," by J. D. S., leaflet, Liverpool, June 1874, PWC 27. Winstanley was the brother-in-law of the artist's Aunt Eliza. See Robin Spencer, "Whistler's Early Relations with Britain and the Significance of Industry and Commerce for His Art. Part I," *Burlington Magazine* 136 (Apr. 1994): 216–17.

12. Tibbles, "Speke Hall," 37.

13. Saint, *Norman Shaw*, 153; Shaw to Marks, 16 Jan. 1892, V&A Marks.

14. Duval, "F. R. Leyland," 115. The liaison may have begun as early as 1879: there is a place in the vicinity of Villette called Mount Ararat, which could account for the subject of one of Whistler's satirical paintings.

15. Fred was born 21 September 1884 at Godwin Lodge, Charlton, Dover; the names of his parents are given on his birth certificate as "Fred Richards Wooster" and "Annie Ellen Wooster, formerly Wooster." Francis was born 13 January 1890 at Stone Road, Broadstairs, Thanet, Ramsgate; no father's name is given on the birth certificate.

16. Margie Cole reflected that if Leyland had lived longer, there might have been more children and less money for his legitimate offspring (ERP journal, 4 Mar. 1909, PWC 352). Ferriday was informed by the nephew of Freddie Leyland's grandson that the family never mentioned Frederick Leyland "because of his domestic goings-on. He was obviously regarded as a cad" (letter to the director of the Freer Gallery, 20 Sept. 1989).

17. Prinsep, "Collector's Correspondence," 252.

18. This account is drawn primarily from obituaries: "Sudden Death of Mr. F. R. Leyland," *Liverpool Daily Post*, 7 Jan. 1892, 7, and "Death of Mr. F. R. Leyland," *Liverpool Courier*, 6 Jan. 1892, 5. The chimneypieces are mentioned in Richard Norman Shaw to Murray Marks, 16 Jan. 1892, V&A Marks.

19. Henry Woods to Florence Prinsep, 22 Jan. 1892, PWC 6C.

20. "Inquest on the Late Mr. F. Leyland," *Liverpool Courier*, 8 Jan. 1892, 7.

21. "Funeral of Mr. F. R. Leyland, *Liverpool Daily Post*, 9 Jan. 1892, 3; "The Late Mr. F. R. Leyland," *Liverpool Courier*, 9 Jan. 1892, 5. Leyland's grave is marked by an impressive bronze monument designed by Burne-Jones. Frances Leyland is buried there as well.

22. "Art Notes," *Piccadilly*, 21 Jan. 1892, 14; Obach, *Peacock Room*, [2].

23. Boase, *Modern English Biography*, 52. Leyland's will is dated 3 April 1889; probate was granted 4 February 1892. After Florence became an heiress, *John Bull* remarked that Prinsep had become "about the richest, as he is about the most popular, member of the Academy" ("Arts and Letters," 23 Jan. 1892, 55). In fact, Prinsep added substantially to his Holland Park house that year. In 1896, when it was rumored that he might be elected president, Whistler quipped that Prinsep, having married Florence Leyland, was qualified to entertain the Academicians, "even if he can't paint for them" (Heinemann journal, 24 Aug. 1896, PWC 288).

24. Bacher, *With Whistler in Venice*, 32.

25. Harper Pennington to William Heine-mann, 13 Nov. [1908], typescript copy, PWC 285. See also Pennington to Joseph Pennell, 14 Sept. 1906, PWC 297; and MacDonald, *Whistler*, cat. nos. 990–99. The Pennells corrected their mistake in *Whistler Journal*, but it reappears in Rollin van N. Hadley, ed., *Drawings: Isabella Stewart Gardner Museum* (Boston, 1968), 39, and Bendix, *Diabolical Designs*, 135. Another of the drawings is reproduced here as fig. 6.1.

26. See MacDonald, *Whistler*, cat. no. 1581.

27. Robinson, "Private Art Collections," 134.

28. Helen Lenoir to JMW, 25 Feb. 1886, GUL D134; Vernon Lee to her mother, [11 July 1883], in *Vernon Lee's Letters*, 126; William Rothenstein, *Men and Memories: Recollections of William Rothenstein, 1872–1900* (New York, 1935), 97.

29. Lois B. Cassatt to ERP, 10 June [1919], PWC 280.

30. JMW to Flossie Boughton, [probably Apr. or May 1881] and [1881–83], GUL B135 and B134. See also Whistler's letters of [1882/1885] and [June 1887], GUL B137 and B141.

31. WMR diary, 14 Feb. 1882, UBC Angeli-Dennis 15/3; Crane, *Artist's Reminiscences*, 200.

32. The episode is recounted in Edel, *Henry James*, 149–53, and in the revised edition, *Henry James: A Life* (New York, 1985), 315–17. All three visitors, Edel points out, later lent their characters to Proust. On *Arrangement in Black and Gold: Comte Robert de Montesquiou-Fezensac* (Y398), see Munhall, *Whistler and Montesquiou*.

33. Montesquiou, *Les Pas effacés*, 2:243, trans. Munhall, *Whistler and Montesquiou*, 60.

34. Henry James to Montesquiou, [July 1885], *La Chauve-souris et le Papillon: Correspondance Montesquiou-Whistler*, ed. Joy Newton (Glasgow, 1990), no. 1; Théodore Duret, "James Whistler," in *Critique d'avant garde* (Paris, 1885), 252–53.

35. James to Flossie Boughton, 3 July 1885, in Edel, *Henry James*, 152; Montesquiou, *Les Pas effacés*, 2:244; JMW to Flossie Boughton, [1885/1889], GUL B144.

36. [Octave Maus], "James M. Neill Whistler," *L'Art Moderne* (Brussels) 5 (Sept. 1885): 294–96.

37. E. W. Godwin, letter to the editor, "Whistler and the Philistines: What Is a 'Master'?" *Court and Society Review* 3 (22 July 1886): 657.

38. Campbell, *Rainbow-Music*, 14–15, 12.

39. *Society*, 3 Feb. 1883, GUL PC7/15.

40. The letter is quoted in Whistler's letter

to "Atlas," 25 Dec. [1884], published in "What the World Says," *World*, 31 Dec. 1884, 15. The editor of the journal, conveying his apologies to Whistler, explained that the correspondent was "as a rule, well-informed" (James Hewson to JMW, 2 Jan. 1885, GUL P628).

41. "Noblesse Oblige," *Gentle Art*, 174–75.

42. Theodore Child, "Mr. Whistler's Ten O'Clock: A Transatlantic Criticism," *Sun* (New York), 5 Dec. 1886, 7; JMW to Child, reprinted in "Mr. Whistler and His Critic's Convictions," *Truth*, 13 Jan. 1887, 55, and "The Cocks of Chelsea Crow," *The Gentle Art of Making Enemies*, ed. Sheridan Ford (Paris, 1890), 149–50.

43. Theodore Child, "American Artists at the Paris Exhibition," *Harper's New Monthly Magazine* (New York) 79 (Sept. 1889): 490.

44. JMW to Child, [1889], Baltimore Museum of Art: George A. Lucas Collection.

45. Child acknowledged "the ample and generous courtesy of Mr. Leyland" in "Pre-Raphaelite Mansion," 82n.

46. JMW to Child, [1889], Baltimore Museum of Art: George A. Lucas Collection.

47. Child, "Pre-Raphaelite Mansion," 83.

48. Child to Marks, 15 Jan. 1892, V&A Marks.

49. Osborn & Mercer to JMW, 4 Mar. 1892, copy, PWC 335.

50. Way, *Memories of Whistler*, 34.

51. Freddie Leyland to Marks, 16 Apr. 1892, V&A Marks.

52. On Lemere, see Nicholas Cooper, *Opulent Eye*, 2.

53. JMW to D. C. Thomson, [ca. 25 May 1892], PWC 16. On the commission of the project, see JMW to Thomson, [ca. 29 May 1892] and [ca. 7 June 1892], PWC 2; and JMW to Thomson, [ca. 20 July 1892], PWC 16.

54. See CLF to Marchant, 22 Aug. 1902, FGA LB9. The set also includes a view of the west wall, a detail of the west wall, and photographs of each of the three pairs of shutters (FGA).

55. "A Sale at Christies," [May/June 1892], GUL PC22/11. The journalist who dropped by to sketch the "vignette" noted that while no one there appeared especially well-to-do, "the lines of carriages waiting outside, the throng of flunkeys in the vestibule, and the high bidding prove the contrary." A copy of the sale catalogue, Christie, Manson & Woods, *Catalogue of the Valuable and Extensive Collection of Old Nankin Porcelain . . . of F. R. Leyland*, annotated and sent to Whistler by T. R. Way, is in the Glasgow University Library.

56. JMW to D. C. Thomson, 14 Feb. 1892, typescript, PWC 16.

57. Prinsep, "Private Art Collections," 129; Robinson, "Private Art Collections," 134.

58. "The Peacock Room," *To-day*, 8 June 1904, 156.

59. Beatrix Whistler to E. G. Kennedy, 1 May 1892, NYPL 1/12, and Beatrix Whistler to Reid, [1 May] 1892, FGA Beatrix Whistler.

60. JMW to Thomson, [ca. 19 May 1892], PWC 2.

61. "The Leyland Picture Sale," *St. James's Gazette*, 30 May 1892, 14.

62. A. C. R. Carter, "The Art Sales of 1892," *Art Journal* 55 (Sept. 1892): 285. Two copies of the sale catalogue, Christie, Manson & Woods, *Catalogue of the Very Valuable Collection of Ancient and Modern Pictures of Frederick Richards Leyland*, annotated with prices paid, are in the Delaware Art Museum, Wilmington, Bancroft Papers.

63. JMW to Thomson, [29 May 1892], PWC 2.

64. Quoted in Marks, *Burrell*, 68.

65. Beatrix Whistler to Reid, [ca. 30 May 1892], FGA Beatrix Whistler.

66. ERP to Mr. Kennerley, 3 Apr. 1929, PWC 24.

67. Beardsley to G. F. Scotson-Clark, [July 1891], PUL Gallatin Beardsley. The letter is incompletely published in Beardsley, *Letters*, 19.

68. Beardsley to G. F. Scotson-Clark, [July 1891], PWC 24. The letter is incompletely published and dated "Sunday midnight" in Beardsley, *Letters*, 20–21.

69. ERP to Mr. Kennerley, 3 Apr. 1929, PWC 24; C. Lewis Hind, *The Uncollected Work of Aubrey Beardsley* (1925), vii. See also Reade, *Aubrey Beardsley*, 16; Simon Wilson, *Beardsley* (Oxford, 1976), 12; and Stanley Weintraub, *Beardsley: A Biography* (New York, 1967), 26.

70. Gail S. Weinberg attributes the omission to Beardsley's "first flood of enthusiasm" in "Aubrey Beardsley: The Last Pre-Raphaelite," *Pre-Raphaelite Art in Its European Context*, ed. Susan P. Casteras and Alicia Craig Faxon (Madison, N.J., 1995), 212.

71. Macfall, *Aubrey Beardsley*, 95–96.

72. Reade, *Beardsley*, cat. no. 56.

73. "Aesthetic Love in a Cottage," *Punch*, 19 Feb. 1881, 78.

74. Wilde, "House Beautiful," 916. On the Tite Street decoration, see Richard Ellmann, *Oscar Wilde* (1988), 257–58; H. Montgomery Hyde, *Oscar Wilde* (New York, 1975), 95–97; and Gere, *Nineteenth-Century Decoration*, 328.

75. Beardsley to G. F. Scotson-Clark, [ca. 15 Feb. 1893], PUL Gallatin Beardsley.

76. "Mr. Whistler's Peacock Room," *Pall Mall Budget* 60 (16 June 1892): 864–65.

77. Malcolm Easton, *Aubrey and the Dying Lady: A Beardsley Riddle* (Boston, 1972), 9.

78. Beardsley had caricatured Whistler's signature in "The New Coinage: Four Designs Which Were Not Sent in for Competition," *Pall Mall Budget*, 9 Feb. 1893, 154.

79. Reade, *Beardsley*, cat. no. 277. Jodi Lox established a connection between *The Gold Scab* and *The Peacock Skirt* in "Bringing Forth the Peacock in Whistler's Peacock Room and Beardsley's Salome," unpublished senior essay, Yale University, 1990.

80. Harper Pennington to Joseph Pennell, 2 Mar. 1907, PWC 297; JMW to G. P. Jacomb-Hood, [May 1892], PWC 2. Jacomb-Hood lent *The Gold Scab* for exhibition in Glasgow in early 1893, which suggests he would have been willing to show it in London: see Alexander Reid to JMW, 20 Dec. 1892, GUL R47; JMW to Reid, 5 Jan. 1893, GUL LB4/63; and Reid to JMW, 17 Jan. 1893, GUL R50.

81. See MacDonald, *Whistler*, cat. no. 1602. I am not persuaded that Whistler drew that clumsy butterfly.

82. Oscar Wilde, *The Picture of Dorian Gray* (1891; reprint, Oxford, 1981), 147.

83. Macfall, *Aubrey Beardsley*, 98.

84. Beardsley to G. F. Scotson-Clark, 9 Aug. 1891, in Beardsley, *Letters*, 25.

85. Pennell and Pennell, *Life of Whistler* (1911), 187; ERP to Mr. Kennerley, 3 Apr. 1929, PWC 24. On the exhibition, see "Minor Exhibitions," *The Times*, 26 Mar. 1900, 3; and Frank Rinder, "Some London Exhibitions," *Art Journal*, May 1900, 158.

86. "Mr. Whistler's Peacock Room," *Pall Mall Budget* 60 (16 June 1892): 864–65.

87. Ferriday, "Peacock Room," 414; Prinsep, "Collector's Correspondence," 252.

88. JMW [to the *Art Journal*, June 1892], draft/fragment, GUL x78; *Life of Whistler*, 1:209.

89. For example, Williamson, *Murray Marks*, 96, and Jopling, *Twenty Years*, 216.

90. Lee, "Imagination in Modern Art," 514.

91. JMW to Thomson, [21 Sept. 1894], typescript copy, PWC 18; JMW to Pope, [23 Sept. 1894], Hill-Stead Museum, Farmington, Conn.

92. JMW to Thomson, [6 Aug. 1895], typescript copy, PWC 18.

93. Sargent to Gardner, 29 Aug. [1895], typescript copy, AAA Isabella Stewart Gardner Papers.

94. Robinson, "Private Art Collections," 134.

95. Beatrix Whistler to Reid, [1 May] 1892, FGA Beatrix Whistler; Beatrix Whistler to E. G. Kennedy, 1 May 1892, NYPL 1/12; Stanford White to JMW, 20 Sept. 1895, GUL M58.

96. W. Graham Robertson to D. M. Gregg, 28 Aug. 1932, FGA.

97. See Shirley Nicholson, A Victorian Household (1988), 107–11; Letters of Anne Thackeray Ritchie, ed. Hester Ritchie (1924), 257.

98. Francis Lyne, Tribunals of Commerce. A Letter to the Merchants, Bankers, and Traders of London . . . with an outline of the Trial of Watney v. Lyne (1867), 34. The report of Watney v. Lyne appears in The Times, 28 Jan. 1867, 9, and 29 Jan. 1867, 11.

99. Information on Mrs. Watney from Laetitia Gifford, her great-granddaughter in conversation with author, 8 May 1993. Helios and Rhodos was bequeathed to the Tate Gallery ("Gift of a Leighton Picture to the Nation," The Times, 9 Mar. 1915, 11), but destroyed in the Thames Flood, 1928.

100. Information from John Greenacombe, General Editor, Survey of London, Royal Commission on the Historical Monuments of England, in conversation with author, 5 August 1996, and letter to author, 8 April 1997.

101. Messrs. Trollope, 49 Prince's Gate, 9–11.

102. Stanford White to JMW, 20 Sept. 1895, GUL M58.

103. W. Graham Robertson to D. M. Gregg, 28 Aug. 1932, FGA. Gregg presented this letter to the Freer Gallery on 25 July 1934, and Robertson regretted that his "highly scurrilous and ribald letter" had ended up there: "I only remember very vaguely but am quite clear that it is vulgar and offensive. It is also true, which makes it worse" (letter to Kerrison Preston, 25 Nov. 1936, Letters from Graham Robertson, 362).

104. Stanford White to JMW, 20 Sept. 1895, GUL M58.

105. Sargent to Gardner, 2 Nov. [1895], typescript, AAA Isabella Stewart Gardner Papers.

106. Walter Muir Whitehall, Boston Public Library: A Centennial History (Cambridge, Mass., 1956), 149; Life of Whistler, 2:132.

107. Sargent to JMW, 1 Nov. [1895], GUL S34.

108. Ibid.

109. Eddy, Recollections and Impressions, 130.

110. CLF to Rosalind Philip, 28 Jan. 1904, copy, FGA Philip.

111. Eddy, Recollections and Impressions, 130.

112. JMW to Alexander Reid, [15 and 26 June 1892], FGA Whistler.

113. AMW to Mary Emma Eastwick, 19 July 1876, PWC 34; JMW to Reid, [15 June 1892], FGA Whistler.

114. F. G. Prange to Reid, 15 June 1892, FGA Reid.

115. JMW to Reid, [26 June 1892], FGA Whistler.

116. Beatrix Whistler to Reid, [30 May 1892], FGA Beatrix Whistler.

117. JMW to CLF, [29 July 1899], in Merrill, With Kindest Regards, no. 37; JMW to Helen Whistler, [May 1892], GUL W710.

118. Harrison S. Morris, Confessions in Art (New York, 1930), 45.

119. Julia Cartwright, "International Art at Knightsbridge," Art Journal 61 (Aug. 1898): 250.

120. See CLF to Edward R. Warren, 19 Feb. 1904, FGA LB13: "Under all the circumstances, it would be wiser to follow Mr. Whistler's original catalogue, or, at least, the earliest known to me, in which the title appeared as follows: 'Rose and Silver—La Princess du Pays de la Porcelaine.'"

121. [F. G. Stephens], "Minor Exhibitions," Athenaeum, no. 3687 (25 June 1898): 829.

122. Marks, Burrell, 93.

123. CLF diary, 27 May 1902, FGA. In June 1902, Freer purchased San Giovanni Apostolo et Evangelistae (M783).

124. CLF to JMW, 9 Jan. 1894, in Merrill, With Kindest Regards, no. 14.

125. Ibid., JMW to CLF, [29 July 1899], no. 37; Moore, "Memoirs," 281, Charles Moore Papers, LC Manuscript Division.

126. JMW to CLF, [ca. 24 Mar. 1897], in Merrill, With Kindest Regards, no. 29. Cf. JMW to FRL, [Apr./May 1869], PWC 6B.

127. CLF to JMW, [6 Apr. 1897], in Merrill, With Kindest Regards, no. 32.

128. CLF to Augustus Koopman, 12 Dec. 1901, FGA LB8.

129. See for example CLF to Whitney Warren, 13 Mar. 1908, FGA LB27; Bailey, "Fine Arts Notes"; and Coburn: An Autobiography, 61–62.

130. CLF to William Burrell, 20 Aug. 1903, FGA LB11.

131. "Whistler Exhibit Finest in Years," Boston Herald, 24 Feb. 1904, 5; Lee Glazer, "'A Modern Instance': Thomas Dewing and Aesthetic Vision at the Turn of the Century," Ph.D. diss. (University of Pennsylvania, 1996), 141.

132. "The Chatterer," Boston Herald, 15 June 1904, 6.

133. Way and Dennis, Art of Whistler, 101.

134. Oliver Brown, Exhibition: The Memoirs of Oliver Brown (1968), 2–6 and 16.

135. Telegram quoted in CLF to Mayer, 27 Jan. 1904, FGA LB13; Mayer to CLF, 17 Feb. 1904, FGA Obach.

136. Mayer to CLF, 6 and 17 Feb. 1904, FGA Obach.

137. CLF to Rosalind Philip, 28 Jan. 1904, copy, FGA Philip; CLF to Mayer, 27 Jan. 1904, FGA LB13.

138. Rosalind Philip to CLF, 11 Feb. 1904, copy, and CLF to Philip, 7 Mar. 1904, FGA Philip.

139. Mayer to CLF, 17 Feb. 1904, FGA Obach.

140. Rosalind Philip to CLF, 11 Feb. 1904, copy, FGA Philip. On the bonds, see CLF to Philip, 17 Aug. 1903.

141. CLF to Rosalind Philip, 7 Mar. 1904, FGA Philip.

142. CLF to Mayer, 5 Mar. 1904, FGA LB13.

143. Mayer to CLF, 23 Mar. 1904, FGA Obach.

144. Messrs. Trollope, 49 Prince's Gate, 10.

145. Mayer to CLF, 23 Mar. 1904, FGA Obach.

146. Rosalind Philip to CLF, 9 Mar. 1904, typescript, FGA Philip.

147. CLF to Canfield, 8 Apr. 1904, FGA LB13.

148. H. C. White, Life of Tryon, 80.

149. CLF to Mayer, 19 Apr. 1904, FGA LB13; CLF to Rosalind Philip, 20 Apr. 1904, GUL F479.

150. CLF to Canfield, 28 Apr. and 1 May 1905, FGA LB17. Freer wrote that Canfield was "the most generous of men" in allowing him to buy the portrait, but someone realized a tidy profit, since William Marchant, who sold the painting to Canfield, had bought it for £1,500 (ERP journal, 22 Dec. 1908, PWC 352).

151. Whistler Journal, 99.

152. "Obituary: Mrs. Frances Leyland," The Times, 13 Jan. 1910, 11.

153. CLF diary 1904, FGA; CLF to Roland Knoedler, 8 Nov. 1917, FGA Knoedler. See also CLF to Rosalind Philip, 28 May 1904, GUL 480.

154. CLF to Marchant, 18 Jan. 1910, FGA LB29; CLF to Roland Knoedler, 8 Nov. 1917, FGA Knoedler.

155. *Whistler Journal*, 113.

156. On *Self-Portrait*, see Young et al, *Paintings of Whistler*, cat. no. 124.

157. CLF to Frank J. Hecker, 5 June 1904, FGA Hecker.

158. Rosalind Philip to CLF, 3 Aug. 1904, typescript copy, FGA Philip.

159. Ernest Brown to ERP, 31 May 1904, PWC 279.

160. "Whistler's Peacock Room," *Pall Mall Gazette*, 2 June 1904, 10; CLF to Frank J. Hecker, 5 June 1904, FGA Hecker.

161. [Roger Fry], "Mr. Whistler," *Athenaeum*, no. 3952 (25 July 1903): 134.

162. "Whistler's 'Peacock Room,'" *Daily Telegraph*, 13 June 1904, 7; M. D. Dunn, "Art Notes," 706.

163. "The Peacock Room: Sale to an American," *Daily News*, 13 June 1904, 4; "London Letter . . . Whistler's Peacock Room," *Yorkshire Daily Observer* (York), 11 June 1904, 4.

164. "The Chantrey Bequest," *Daily News*, 10 June 1904, 6.

165. "The Chantrey Trustees and the Nation," *Burlington Magazine* 5 (May 1904): 117.

166. "The Peacock Room," *To-day*, 8 June 1904, 156; "Whistler's Peacock-Room," *Evening Times* (Glasgow), 13 June 1904, 8. The art drain to the United States was the subject of Henry James's last published novel, *The Outcry* (1911).

167. Mayer to CLF, 13 July 1904, FGA Obach.

168. "Art and Artists," *Morning Post*, 16 June 1904, 2; "Art Notes," *Illustrated London News*, 18 June 1904, 932; Sargent to Gardner, 28 June [1904], AAA Isabella Stewart Gardner Papers.

169. "'Peacock Room' Goes to Detroit," *New York Herald*, 14 June 1904, 10.

170. Curwood, "Charles L. Freer," 78–79.

171. "Mr. Freer is Mum," *World* (New York), 20 June 1904, 10; "The Story of Whistler's Famous 'Peacock Room,'" *Detroit Journal*, 23 July 1904, FGA Whistler PC2/17.

172. "Whistler's Work Coming Here," *World* (New York), 17 Aug. 1904, FGA Whistler PC2/17.

173. CLF to Ushikubo, 19 Aug. 1904, FGA LB1; "'Peacock Room' Now in Detroit," *Evening News* (Detroit), 3 Sept. 1904, FGA Whistler PC2/14; CLF to Rosalind Philip, [Aug. 1904], draft, FGA Philip.

174. CLF to Rosalind Philip, 21 July 1904, GUL F489; Curwood, "Charles L. Freer," 78.

175. CLF to Holker Abbott, 15 Aug. 1904, FGA LB14. For other confidences, see CLF to William K. Bixby, 11 July 1904, and to Emma W. Palmer, 16 July 1904, FGA LB14; and CLF to Anna Caulfield, 17 Nov. 1904, FGA LB15.

176. Saarinen, *Proud Possessors*, 129; CLF to Mayer, 23 June 1904, FGA LB14, and to Rosalind Philip, 21 July 1904, GUL F489.

177. CLF to Tryon, 20 July 1904, FGA LB14; CLF to Gustav Mayer, 11 July 1904, FGA LB14.

178. "A Volume of Whistler," *Collectors' Circular* 3 (25 June 1904): 153.

179. "Whistler's 'Peacock Room,'" *Standard*, 10 June 1904, 4.

180. Muthesius, *English House*, 162.

181. M. D. Dunn, "Art Notes"; untitled, *Modern Society*, 18 June 1904, 18.

182. "Whistler's Peacock Room," *Daily Chronicle*, 11 June 1904, 8; "Whistler's 'Peacock Room,'" *Morning Post*, 10 June 1904, 9; "Art and Artists," *Star*, 14 June 1904, 1.

183. "The Peacock Room. A Whistlerian Revenge," *Daily News*, 10 June 1904, 4; "Studio-Talk," *Studio* 32 (Aug. 1904): 241–42.

184. "Art Notes: Peacocks with a Past," *Truth*, 23 June 1904, 1612; "Whistler's Decorative Masterpiece," *Collectors' Circular* 3 (25 June 1904): 150.

185. "Whistler's 'Peacock Room,'" *Daily Telegraph*, 13 June 1904, 7.

186. "Whistler's Peacock Room," *Guardian* (attrib.), 29 June 1904, FGA Whistler PC2/11; "Art Notes: The Story of the 'Peacock Room,'" *Morning Leader*, 30 June 1904, 4. A "Pale Blue Hawthorn Plate" formerly in Thompson's collection is reproduced in Hollingsworth, *Nankin China*, opposite page 33, and other pieces are illustrated in Grego, "Old Blue-and-White."

187. Russell Sturgis, "The Famous Japanese Room in the Marquand House," *Architectural Record* (New York) 18 (Sept. 1905): 193.

188. "Whistler's 'Peacock Room,'" *Standard*, 10 June 1904, 4.

189. "Art Notes," *Illustrated London News*, 18 June 1904, 932.

190. ERP journal, 9 June 1904, PWC 352; Gustav Mayer to CLF, 13 July 1904, FGA Obach; CLF to Mayer, 11 July 1904, FGA LB14.

191. "Art and Artists," *Star*, 14 June 1904, 1; "The Peacock Room," *Bazaar*, 18 June 1904, FGA Whistler PC2/8; "Whistler's Decorative Masterpiece," *Collectors' Circular* 3 (25 June 1904): 148.

192. Pennington, "Whistler," 156: "The author . . . has collected the trivial gossip of 'once upon a time,' a lot of more than dubious stories which he must have heard long ago, apparently at second hand, and printed them on better paper than they deserve."

193. *Self & Partners (Mostly Self): Being the Reminiscences of C. J. Holmes* (1936). Holmes got his start as a bookkeeper for the Ballantyne Press in 1892, when the office was still strewn with proofs of Whistler's *Gentle Art* "and full of memories," Holmes recalled, "of his visits and conversation" (139).

194. Obach, *Peacock Room*, [2 and 5]; "Art and Artists," *Star*, 14 June 1904, 1.

195. Obach, *Peacock Room*, [4].

196. "Other Folks' Houses . . . The Peacock Room," by Hestia, *Gentlewoman* 29 (23 July 1904): 158.

197. "Studio-Talk," *Studio* 32 (Aug. 1904): 241.

198. "Art Exhibitions," *The Times*, 13 June 1904, 9; "The Peacock Room," *Athenaeum*, no. 3999 (18 July 1904): 793; "The Peacock Room," *London Notes*, 18 June 1904, FGA Whistler PC2/8.

199. "The Development of Interior Decoration," *Court Journal*, 25 June 1904, 1076; "World of Art and Music," *Family Herald* 93 (July 1904): 365.

200. Robinson, "Private Art Collections," 134; "London Notes . . . Another Art-Gem for America," *Manchester Evening Chronicle*, 14 June 1904, 2.

201. "Whistler's Peacock Room," *Guardian* (attrib.), 29 June 1904, FGA Whistler PC2/11; "Art Notes: Peacocks with a Past," *Truth*, 23 June 1904, 1612.

202. "Whistler's Peacock Room for America," *New York Herald*, 17 July 1904, 8; "Whistler's Peacock Room," *Sun* (New York), 26 June 1904, 2.

203. Untitled, *Town Topics* (New York), 15 Dec. 1904, 7; CLF to Holker Abbott, 15 Aug. 1904, FGA LB14, and 13 Sept. 1904, FGA LB15.

204. "Whistler's Peacock Room," *Journal* (Detroit), 15 June 1904, FGA Whistler PC2/6.

205. CLF to Mr. Morse and to Richard A. Canfield, 7 Sept. 1904, FGA LB14; "Whistler's Peacock Room," *Chicago Sunday Tribune*, 4 Sept. 1904, n.p.

206. CLF to F. W. Gookin, 7 Sept. 1904, FGA LB14; CLF to Rosalind Philip, 8 Sept. 1904, FGA Philip.

207. CLF to Canfield, 7 Sept. 1904, FGA LB14.

208. "Mr. Whistler's 'Ten O'Clock,'" *Gentle Art*, 135; CLF to Alfred Chapman, 7 Sept. 1901, FGA LB8 ("In adding to my little group of [Whistler's] things, I wish to obtain only such examples as will take strong hold of my affections").

209. "Chas. Freer Buys 'Peacock Room,'" *Logansport Journal*, 10 Sept. 1904, FGA Whistler PC2/19.

210. H. C. White, *Life of Tryon*, 81.

211. CLF to Rosalind Philip, 8 Sept. 1904, GUL F491.

212. CLF to Wilson Eyre, 4 Dec. 1902, FGA LB10, and 18 July 1904, FGA LB14.

213. CLF to Wilson Eyre, 6 Sept. 1904, FGA LB14. For a detailed account of the project, see Brunk, "House that Freer Built," 25–29.

214. CLF to Mayer, 2 Nov. 1904, FGA LB15; CLF to Eyre, 20 Sept. 1905, FGA LB18.

215. CLF to Rosalind Philip, [Oct. 1904], draft, FGA Philip; CLF to Gustav Mayer, 11 Apr. 1906, FGA LB19; CLF to Obach & Co., 2 July 1906, FGA LB20.

216. CLF to Gustav Mayer, 23 June and 11 July 1904, FGA LB14.

217. CLF to Rosalind Philip, [Oct. 1904], draft, FGA Philip; CLF to Obach & Co., 19 Aug. 1904, FGA LB14.

218. CLF to Charles Platt, 1 Dec. 1917, FGA Platt.

219. Vinton Company, 11 May 1906, FGA General Vouchers.

220. Mechlin, "Freer Collection," 358. Freer had written to Gustav Mayer asking for the superintendent's plans on 2 November 1904 (FGA LB14).

221. CLF to Rosalind Philip, 20 June 1906, copy, FGA Philip.

222. Ibid., 16 Jan. 1905; CLF to Charles J. Morse, 31 July 1906, FGA LB20.

223. CLF to Rosalind Philip, 24 Sept. 1906, FGA Philip.

224. CLF to Mrs. Frances C. Tobey, 13 Oct. 1906, FGA LB21; Bailey, "Fine Arts Notes."

225. CLF to Rosalind Philip, 24 Sept. 1906, copy, FGA Philip; CLF to Fenollosa, 27 Sept. 1906, FGA LB21.

226. Nomura Michi, *Sekai isshu nikki: Diary of a Journey around the World* (Tokyo, 1908), 66–70 (transl. Miyako Funakoshi). This includes a photograph of the north wall of the Peacock Room with Freer's ceramics in place, the earliest publication of that image.

227. See CLF to Fenollosa, 1 Nov. 1906, FGA LB21; CLF to Rosalind Philip, 24 Sept. 1906, copy, FGA Philip; CLF to Annie Campbell, 9 Oct. 1908, FGA LB25.

228. See for example J. M. Kennedy to CLF, 23 May 1907, FGA LB22, and 19 Aug. 1909, FGA LB28.

229. "Whistler's Art and Personality in 'The Peacock Room,'" *Literary Digest* (New York), 18 Oct. 1919, 70, quoting from E. L. Cary in the *New York Times*.

230. Bailey, "Fine Arts Notes."

231. *List of a Selection of Art Objects Owned by the National Gallery of Art (Freer Collection)*, exhib. cat. (Detroit, 14 Nov. 1912), 7. On the vault, see CLF to Wilson Eyre, 13 Sept. 1904, FGA LB14. The walnut table, "furnished for use in Peacock Room," was purchased from Wm. Wright Company, Detroit (2 July 1906, FGA General Vouchers); it remains at the Freer Gallery.

232. Mary Chase Perry Stratton, "Memoirs," 78, typescript kindly provided by Thomas Brunk.

233. CLF to Eyre, 6 Aug. 1906, FGA LB20.

234. Fenollosa, "Collection of Mr. Freer," 62. See also CLF to J. W. Gregg, 28 Jan. 1910, FGA LB29; and Dana H. Carroll, "The Freer Collection for the Nation," *Scribner's Magazine* (New York) 60 (Sept. 1916): 386.

235. Meyer, *Charles Lang Freer*, 8.

236. Mechlin, "Freer Collection of Art," 359.

237. CLF to Rosalind Philip, 18 Sept. 1908, FGA LB25. On the photography commission, see Stephen Warring's daily ledger, 11 and 16 Apr. and 23 May 1908, FGA; and G. R. Swain to J. M. Kennedy, 11 June 1908, FGA Art Vouchers.

238. CLF to Ushikubo, New York, 14 Sept. 1908, FGA LB25.

239. CLF to Rosalind Philip, 9 July 1912, GUL F521, in reference to the forthcoming publication of T. R. Way's *Memories of Whistler*.

240. "Mr. Whistler's 'Ten O'Clock,'" *Gentle Art*, 154–55. On Freer's attitude toward Asia, see Warren I. Cohen, *East Asian Art and American Culture: A Study in International Relations* (New York, 1992), 63.

241. Charles Moore, "Memoirs," 280, Charles Moore Papers, LC Manuscript Division.

242. Caffin to CLF, 25 Jan. [1909], FGA Caffin.

243. CLF to Caffin, 27 Jan. 1909, FGA LB26.

244. CLF to Caffin, 27 Jan. 1908, FGA LB 26; CLF to Mary Fenollosa, 18 Feb. 1909, FGA LB26.

245. Caffin to CLF, 25 Jan. [1909], FGA Caffin; *Coburn: An Autobiography*, 62–63.

246. Stokes, "Art Gems," 9.

247. Caffin to CLF, 25 Jan. [1909], FGA Caffin. A typescript of Caffin's lecture, "The Art of James McNeill Whistler," delivered 23 April 1909, is in the Freer Gallery of Art Library.

248. Wilfred B. Shaw, "The Relation of Modern American Art to that of China and Japan: Demonstrated at the Recent Exhibition at Ann Arbor," *Craftsman* (New York) 18 (Aug. 1910): 522.

249. CLF to Rosalind Philip, 22 July 1918, GUL F528; Meyer, *Charles Lang Freer*, 11.

250. "Mr. Whistler's 'Ten O'Clock,'" *Gentle Art*, 157n.

251. Joseph Pennell, "Greatest Collection of Whistlers," *New York Times Magazine*, 6 May 1923; Brainerd Bliss Thresher, "Charles Lang Freer and His Art Collection," *Asia* 19 (Dec. 1919): 1203.

252. Blueprints by Ora H. Harnden, Detroit, 29 Sept. 1919, FGA Building Records.

253. Platt to Stratemeyer & Teetzel Co., 15 Nov. 1919, and Platt to Frederic Culver, Indemnity Mutual Marine Assurance Co. of New York, 2 Jan. 1920, FGA Building Records.

254. [Frank J. Hecker] to Platt, 3 Dec. 1919; Platt to John Bundy, 5 Dec. 1919; Bundy to Platt, 9 Dec. 1919, FGA Building Records.

255. "Notes and Comments," *Christian Science Monitor* (Boston), 24 Oct. 1919, 18.

256. August F. Nusbaun to John Bundy, 11 Dec. 1919; Stratemeyer & Teetzel Co. to George A. Fuller Co., 30 Dec. 1919; Bundy to Platt, 7 Jan. 1920, FGA Building Records.

257. Stubbs, *Whistler Peacock Room*, 2, 4, and 14.

258. Stratemeyer & Teetzel Co. to John Bundy, 3 Feb. 1920; Bundy to Stratemeyer & Teetzel Co., 6 and 12 Feb. 1920, FGA Building Records.

259. Bundy to Platt, 6 Mar. 1920, and Bundy to Stephen Warring, 9 Mar. 1920, FGA Building Records.

260. See Freer Gallery diary, 18 Mar. 1923, FGA: "Mr. H. E. Thompson came Friday to finish up in the Peacock Room."

261. De Wolf, "Freer Gallery," 52.

262. Platt to H. P. Caemmerer, Commission of Fine Arts, 24 Aug. 1920, copy kindly provided by Keith Morgan.

263. ERP journal, 19 and 21 July 1920, PWC 351.

264. Ibid., 27 May 1921.

265. Freer Gallery diary, 28 Jan. 1923, FGA.

266. [Katharine N. Rhoades], "The Peacock Room, 1876–1877," [June 1923], manuscript draft, FGA Registrar's Records.

267. Watts, "Opening of the Freer," 275.

268. John Lodge to Katharine Rhoades (in Detroit), 11 Sept. 1920, FGA Registrar's Records.

269. ERP journal, 18 July 1922, PWC 351. The resolution was passed on 9 December 1920.

270. Du Bois, 350–51; De Wolf, "Freer Gallery," 52. See also Royal Cortissoz, *American Artists* (New York, 1923), 357–58.

271. "The Freer Gallery's First Catalogue," *Christian Science Monitor* (Boston), 17 Mar. 1924, 11. Even in 1951, when Rhoades's gallery book was revised for publication, the disparity between the Peacock Room's original appearance and its current method of exhibition went unacknowledged: the room was "once again on display substantially as it was in Leyland's London home" (Stubbs, *Whistler Peacock Room*, 14).

272. Du Bois, "Art by the Way," 51.

273. Stokes, "Art Gems," 9.

274. Robinson, "Private Art Collections," 134; Stokes, "Art Gems," 9.

275. Grace Guest to John Lodge, 3 July 1923; Katharine Rhoades to Lodge, 12 and 20 Sept. 1923, FGA Registrar's Records. F. G. Wright of Romford, Essex, had written to Obach & Co. on 2 July 1904 offering a peacock with a pedigree, "a splendid specimen" (FGA Obach).

276. Rhoades to Lodge, 23 May 1923, FGA Registrar's Records.

277. Watts, "Opening of the Freer," 275.

The Peacock Room Papers

Whistler gathered and numbered the following letters with the intention of publishing them, but he never carried out the project. They appear here in the order he indicated, with the original syntax, spelling, capitalization, and textual alterations.

1 *Leyland to Whistler*
21 October 1876

Liverpool, 21 Oct 1876
Dear Whistler,

I have just received your telegram; but I think it will be more satisfactory now that the work is finished if we settle the amount you are entitled to charge.

I can only repeat what I told you the other day that I cannot consent to the amount you spoke of — £2000 — and I do not think you should have involved me in such a large expenditure without previously telling me of it. The peacocks you have put on the back of the shutters may possibly be worth (as pictures) the £1200 you charge for them but that position is clearly a most inappropriate one for such an expensive piece of decoration; and you certainly were not justified in placing them there without any order from me. I certainly do not require them and I can only suggest that you take them away and let new shutters be put up in their place.

As to the decorations to the ceiling and the flowers on the old leather, as well as the other work about the house, it seems to me the only way of arriving at a fair charge is to take the time occupied at your average rate of earnings as an artist.

I am sorry there should be such an unpleasant correspondence between us; but I do think you are to blame for not letting me know before developing into an elaborate scheme of decoration what was intended to be a very slight affair and the work of comparatively a few days.
 Yours truly
 Fred R. Leyland

Original letter, GUL L106

2 *Whistler to Leyland*
[22 October 1876]

Received your letter — Shocked to find nothing in it — Will answer text by and bye. ~~Expect from you meanwhile~~ From you ~~should~~ meanwhile should have relied upon cheque. Cannot affect final arrangement — Require today two hundred — Will not you send?

Draft or copy of a telegram, GUL L107

3 *Leyland to Whistler*
23 October 1876

Liverpool
23 Oct 1876
Dear Whistler,
 I have received your telegram, but I am not disposed to pay any more money until we arrive at a final arrangement in respect of the decorations at Princes Gate.
 Yours truly
 Fred R. Leyland

Original letter, GUL L108

4 *Whistler to Leyland*
[ca. 30 October 1876]

"Put not your trust in Princes" . . . is not to the point, since you solemnly withdrew from that untenable position on friday last in favor of the Marquis of Westminster, — to my utter ruin and discomfiture!

But my dear Leyland I did still trust in the "British Business Man," to which safer role you carefully returned on that occasion — Was I wrong?

We agreed to bare alike the disaster of the decoration — I pay my thousand guineas as my share in the dining room, and you pay yours — bon! — but then mon cher you *dont* pay yours! —

I learned my lesson of friday and know that from a business point of view, money is all important and that Saturday should not have passed and Monday's post bring no cheque to
 Your promising pupil in business wisdom
 J. McN. Whistler

Draft or copy of a letter, GUL L109

5 *Leyland to Whistler*
30 October 1876

Liverpool
30 Oct. 1876
Dear Whistler,
 I enclose cheque for £600 which with the £250 lent you and the £150 advanced, completes the £1000 agreed to be paid you for decorations at Princes Gate.
 Yours truly
 Fred R. Leyland

Original letter, GUL L110

6 *Whistler to Leyland*
31 October [1876]

Dear Leyland — I have enfin received your cheque — for six hundred pounds — ~~I perceive~~ shorn of my shillings I perceive! — another fifty pounds off — Well I suppose that will do — upon the principal that anything will do —

Bon Dieu! What does it matter! —

The work just created, *alone remains* the fact — and that it happened in the house of

this one or that one is merely the anec-
dote—so that in some future dull Vassari
you also may go down to posterity, like the
man who paid Corregio in pennies!—
 Ever yours
 J. McN. Whistler
 [butterfly signature]
2 Lindsey Houses, Chelsea
Tuesday 31 Oct

Copy of a letter, GUL L111

7 *Leyland to Whistler*
 1 November 1876

Speke Hall
Liverpool
1 Nov 1876
Dear Whistler,
 I have received your two letters and am
more surprised than I can tell you that you
should think fit to write to me in such a
tone. The work is not yet finished and it is
really intolerable that you should feel
aggrieved that the balance of the complete
payment was only sent to you on Monday
instead of Saturday—the very day of my
return.
 As to the amount I distinctly recollect
my offer (which you accepted) was to pay a
thousand pounds and I am certainly not
inclined to pay more.
 Yours truly
 Fred R. Leyland

Original letter, GUL L114

8 *Whistler to Leyland*
 [3 November 1876]

Dear Leyland— I was unable yesterday to
acknowledge your note—
 You put it wrongly— It was I who made
the offer to meet you as you liked—and you
who accepted— I volunteered to share the
expense as well as the mortification of work
done that was neither rejoiced in nor even
wished for— After this, your right to
change the guinea of tradition to the current
sovereign I don't dispute— I merely notice
it as new—
 Forgive the tone, if you find it flippant.
 Ever yours
 J. McN. Whistler
2 Lindsey Houses
Friday Oct.

Copy of a letter, GUL L112

9 *Leyland to Whistler*
 [probably 23 February 1877]

Friday
Dear Whistler,
 The housemaid tells me that the number
of persons calling to see the dining room
interferes with her greatly in getting the
house ready—
 There is so little time now left before we
turn up, that I must ask you to refuse any
further applications to view the room.
 Yours truly
 F. R. Leyland

Original letter, GUL L115

10 *Whistler to Leyland*
 [late February 1877]

 Dear Leyland— I enclose an article I
was just reading when your gracious little
note was handed to me—
 I apologize for my riotous peacocks— it
is unseemly of them to have brought all
London traipsing into your house— they
really will have to be removed as you said
they ought to be.

Draft of a letter, GUL L116

11 *Leyland to Whistler*
 6 July 1877

49 Princes Gate
6 July 1877
Sir,
 I have accidentally learnt that on Monday
last you called at my house and afterward
accompanied Mrs. Leyland and my daughter
Florence in my carriage to look over Baron
Grant's house.
 After what has passed and in the relative
position which it is publicly known that
you and I occupy towards each other, I can-
not trust myself to speak of the meanness of
your thus taking advantage of the weakness
of a woman to place her in such a false posi-
tion before the world and I write now to
tell you that I have strictly forbidden my
servants to admit you again, and that I have
also told my wife and children that I do not
wish them to have any further intercourse
with you—
 Yours truly
 Fred R. Leyland
J. M. Whistler Esq.

Original letter, GUL L117

12 *Whistler to Leyland*
 [7 July 1877]

My dear Leyland—
 I have received your letter and refrain
from making any comment upon it—
 The last time I saw you was at my own
table,—since when I have received no
official intimation from you that you[r] house
was closed to me—
 I called openly last Sunday, in full after-
noon expecting to meet you. My call on the
Monday was of a nature that has not been
often obtruded upon you by me since your
return— I wished to show my work to two
French gentlemen who should carry the
impression of it with them to Paris.
 You hint at want of respect and regard to
the ladies of your family—if I did not feel
both very deeply I should have replied to
your letter in a very different way—
 Yours faithfully
 J A McN. Whistler
Yesterday afternoon upon receiving your let-
ter I immediately drove round to you but
you were out.—

Copy of a letter, GUL L118

13 *Whistler to Frances Leyland*
 [8–17 July 1877]

 Dear Mrs. Leyland— I enclose a copy of
Mr. Leylands letter to me—and the answer
that upon reflection the next day I was
enabled to send him—
 May I beg that, if you see no objection,
these may be openly shown to your daugh-
ters the family.
 I trust to your long knowledge of me to
believe the regret I feel at causing any of you
a moments discomfort, while I believe feel it
due to the friendship I value that I should
not be misunderstood in this matter even to
a word that might not be seen—
 I pray do not give yourself the pain to
answer this, and believe me
 my dear Mrs. Leyland always sincerely
your
 J—

Draft or copy of a letter, GUL L144

14 Leyland to Whistler
17 July 1877

Woolton Hall
Liverpool
17 July 1877
Sir,

I am told that on Friday last you were seen walking about with my wife at Lord's Cricket Ground.

After my previous letter to you on this subject it is clear that I cannot expect from you the ordinary conduct of a Gentleman and I therefore now tell you that if after this intimation I find you in her society again I will publicly horsewhip you.

 Yours truly
 Fred R. Leyland
J. M. Whistler Esq.

Original letter, GUL L121

15 Freddie Leyland to Whistler
17 July 1877

Liverpool
July 17th 1877
My dear Sir

My father has this moment told me the contents of his letter to you. I sincerely hope that after my conversation with you last Friday, you will not again approach my mother in any way. You must perceive that any quarrel of this nature that my father may have is mine also & I trust you will not force matters further, as I must tell [you] frankly I consider myself bound to follow his lead in this affair.

 Yrs truly
 Fred D. Leyland
J. McN. Whistler
I may also tell you that my sisters are all of the same opinion, & that the present state of affairs is very uncomfortable to them.

Original letter, GUL L141

16 Whistler to Freddie Leyland
[ca. 17 July 1877]

My dear Freddie— I must simply refuse to ~~quarrel with~~ have any quarrel what ever with you ~~and utterly repudiate your fathers method of fighting his battles double handed — Ever yours~~

I am afraid, do you know *really* I am afraid that your father must fight his battle single handed

 Ever yours—

Draft or copy of a letter, GUL L142

17 Whistler to Leyland
[ca. 21 July 1877]

I have had no time to write—and am really fatigued with the whole thing—

Your letters, with the "Sir" of the Invoice, and the "Yours Truly" that you cannot escape, pall upon me—and altogether you seem to me, as Carlyle says, "to be rapidly developing a capacity for becoming a bore."—

It is positively sickening to think that I should have labored to build up that exquisite Peacock Room for such a man to live in!

You speak of your "public position before the World" and apparently forget that the World only knows you as the possessor of that work they have all admired, and whose price you refused to pay!

A great deal remains to be said or perhaps written upon that subject whenever one has time or occasion— Meanwhile all that I do or say about it is quite open—

With reference to your family, as a Gentleman, little as you may know about it—I could not do otherwise than recognize old friends when I met the ladies who have always treated me with uniform kindness and courtesy—

Your last incarnation with a horsewhip I leave you to work out— Whom the Gods intend to make ridiculous, they furnish with a frill!

 [butterfly signature]
 Copy sent to Liverpool—

Original letter, GUL L125

17a Leyland to Whistler
22 July 1877

49 Princes Gate
22 July 1877
Sir,

I return your letter— It is an ingenious puff of the work you have done at my house and it will be useful for you to keep with the newspaper cuttings you are in the habit of carrying about with you. An advertisement of this kind is of such importance in the absence of (or in the incapacity to produce) any serious work that I feel it would be an unkindness to deprive you of the advantage of it.

 Yours truly
 Fred R. Leyland
J. M. Whistler Esq.

Original letter written on the back of Whistler's (app. 17)

18 Whistler to Leyland
23 July 1877

Dear Leyland A thousand thanks. It is really too kind and nice of you to give me your permission to publish the correspondence.

Copy of a telegram, GUL L127

19 Leyland to Whistler
24 July 1877

Woolton Hall
Liverpool
24 July 1877
Sir,

I have received your telegram stating that you intend to publish our recent correspondence. In this case there are one or two statements in your letters that require correction.—

1st.— "That I refused to pay for your work at my house"—

The fact is I paid you £1000 for this work; and I am quite content to leave it to the judgement of those who know the real value of your work whether you have been underpaid or not. You chose to begin an elaborate scheme of decoration without any reference to me until the work had progressed so far that I had no choice but to complete it; and it is really too absurd that you should expect me to pay the exaggerated sum your vanity dictated as its value.

2nd That prior to my first letter you received no official notification that you were not to visit my house.

Five months ago your insolence was so intolerable that my wife ordered you out of the house and to any one with an ordinary sense of dignity I should have thought this was notification sufficient.

The fact is your vanity has completely blinded you to all the usages of civilized life; and your swaggering self-assertion has made you an unbearable nuisance to every one who comes in contact with you. There is one consideration, indeed, which should have led you to form a more modest estimate of yourself, and that is your total failure to produce any serious work for so many years. At various times during the last eight or nine years you have received from me sums amounting to one thousand guineas for pictures, not one of which have ever been delivered; nor indeed during the whole of our acquaintance have you finished for me a single thing for which you have been paid.

It is scarcely necessary for me to notice your assertion that I am only known as the possessor of your peacock room. I hope it is not true; but if true it is doubly painful for, at the time so many newspaper puffs of your work appeared, I felt deeply enough the humiliation of having my name so prominently connected with that of a man who had degenerated into nothing but an artistic Barnum.

Yours truly
Fred R. Leyland
J. M. Whistler Esq.

Original letter, GUL L128

20 *Whistler to Leyland*
25 July [1877]

This is the last ~~letter~~ note I shall address to you upon the subject that has inspired our recent correspondence—

I will only take up the two principal points of your letter—

1st Mrs. Leyland never ordered me out of her house—never uttered a discourteous word to me in her life—but what am I to think of the man who shirks the real question at issue and invariably screens himself behind those exalted feelings of respect with which I at least surround his family!—

2nd You say that during the whole of our acquaintance I "have never finished for you a single thing for which I have been paid"—

Is not the Peacock Room finished?—

I have in my possession two portraits which though publicly approved of, my own artistic scruples alone have prevented me from forwarding to you, who are their owner—

They shall be sent at once.

A third portrait ~~for which you have paid me is~~ needs further sittings—it is for you to determine whether it shall be completed or whether you shall receive it as it is.—

A fourth painting for which you have paid me is an imaginative picture which can only be finished under certain ~~circumstances~~ conditions—

In regard to this work I will do one of two things. I will either finish it for you—or I will paint it and sell it, and repay you the four hundred guineas which you paid me for it—

One last word as regards the value of the Peacock Room—

I have a letter from you dated the 17th of August/76 in which after praising the work done you practically told me to name my own price—

I did name my price—and you refused to pay it.

You now offer to submit the matter to arbitration.

I accept—

Name your arbitrator—I will name mine—and a referee shall be agreed upon between us—

J A McN Whistler
London
July 25
F. R. Leyland Esq.

Draft or copy of a letter, GUL L130

21 *Leyland to Whistler*
27 July 1877

Woolton Hall
Liverpool
Sir,

I quite appreciate your "artistic scruples" to deliver the two portraits which you consider finished and I must say these scruples are uncommonly well founded. I am however willing to receive them as they are, as also the third portrait in its unfinished state.

As respects the fourth painting it is difficult to understand what are the conditions you find necessary for its completion.

You have been paid for it nine years ago and however imaginative the work may be, it is high time now that it should be delivered if it is ever to be finished.

Your proposal that I should wait for its completion and then let you sell it is quite unnecessary. I can do that myself.

As to the work at my dining room, you chose to accept £1000 for it rather than contest the matter and I am not disposed to re-open the question. At the time I would have been quite willing to refer the amount to arbitration. I don't know what are the expressions in my letter of August 1876 which you construe into an offer to have you to name your own price, but I am sure that nothing I ever said or wrote to you can fairly bear that construction.

At the time named I did not even know that you contemplated the elaborate scheme of decoration you ultimately adopted.

As to your being ordered out of my house, I can only say I was told so at the time by my wife and children; and, notwithstanding your denial, I fully believe it is true.

Yours truly
Fred R. Leyland
J. M. Whistler Esq.

Original letter, GUL L132

Bibliography

This bibliography includes references frequently cited in the notes or specifically relevant to the Peacock Room. For additional Whistler references, see Robert H. Getscher and Paul G. Marks, *James McNeill Whistler and John Singer Sargent: Two Annotated Bibliographies* (New York, 1986). Place of publication is London unless otherwise noted.

Manuscript Collections

Baltimore Museum of Art, Maryland. The George A. Lucas Collection.

British Museum, London. Department of Prints and Drawings. Alexander Volume (1958.2.8).

Freer Gallery of Art Archives, Smithsonian Institution, Washington, D.C. Charles Lang Freer Papers and Freer Gallery Building Records.

Glasgow University Library, Special Collections. James McNeill Whistler Papers, comprising the Rosalind Birnie Philip Papers and the Joseph W. Revillon Papers.

Library of Congress, Washington, D.C. Manuscript Division, Pennell Whistler Collection, comprising the papers of Joseph Pennell, Elizabeth Robins Pennell, and James McNeill Whistler. Rare Book and Special Collections Division, Lessing J. Rosenwald Collection.

Merseyside Maritime Museum Archives, Liverpool. "Sketch of the Commercial Life of H. E. Stripe," unpublished manuscript of autobiographical notes (DX/1744), ca. 1893.

New York Public Library. Manuscripts and Archives Section, Edward Guthrie Kennedy Papers, 1887–95.

Princeton University Libraries, New Jersey. Department of Rare Books and Special Collections. Gallatin Beardsley Collection.

Royal Institute of British Architects, London, British Architectural Library Manuscripts Collection. H. S. Goodhart-Rendel Papers 43/5, Notes on Thomas Jeckyll (Jeckell), 1940.

Speke Hall, Liverpool. The National Trust. Letters from George Whitley to James Sprot, trustees of the Watt Estate, 1867–74.

University of British Columbia Library, Vancouver. Special Collections and University Archives Division, Helen (Rossetti) Angeli-Imogene Dennis Collection, and James Leathart Papers.

University College London Library. Ogden Manuscripts (82), Letters of Dante Gabriel Rossetti to George Price Boyce.

Victoria and Albert Museum, London, National Art Library. Reserve Collection Q4–5, Correspondence and photographs of Murray Marks, bound in two-volume edition of G. C. Williamson, *Murray Marks and His Friends: A Tribute of Regard* (1919).

Secondary Sources

Anderson, Ronald. "Whistler: An Irish Rebel and Ireland." *Apollo* 123 (April 1986): 254–58.

Anderson, Ronald, and Anne Koval. *Whistler: Beyond the Myth.* 1994.

Angeli, Helen Rossetti. *Pre-Raphaelite Twilight: The Story of Charles Augustus Howell.* 1954.

Armstrong, Thomas. "Reminiscences of Whistler." In *Thomas Armstrong, C.B., a Memoir, 1832–1911*, edited by L. M. Lamont, 171–214. 1912.

Aslin, Elizabeth. *The Aesthetic Movement: Prelude to Art Nouveau.* New York, 1969.

Audsley, George Ashdown. *Catalogue Raisonné of the Oriental Exhibition of the Liverpool Art Club.* Exhib. cat., Liverpool, 1872.

————. *Descriptive Catalogue of Art Works in Japanese Lacquer Forming the Third Division of the Japanese Collection in the Possession of James L. Bowes, Esq., Liverpool.* Exhib. cat., Liverpool Art Club, Liverpool, 1875.

Audsley, George Ashdown, and James Lord Bowes. *Keramic Art of Japan.* 2 vols. 1875.

Bacher, Otto H. *With Whistler in Venice.* New York, 1908.

Bailey, Madge. "Fine Arts Notes." *Post-Intelligencer* (Seattle), 26 October 1919, part 6, 4.

Baker, Kenneth. "Polishing the Peacock Room." *Architectural Digest* (Los Angeles) 50 (March 1993): 26–32.

Baldry, Alfred Lys. *Albert Moore: His Life and Works.* 1894.

Beardsley, Aubrey. *The Letters of Aubrey Beardsley.* Edited by Henry Maas, J. L. Duncan, and W. G. Good. Rutherford, N.J., 1970.

Bendix, Deanna Marohn. *Diabolical Designs: Paintings, Interiors, and Exhibitions of James McNeill Whistler.* Washington, D.C., 1995.

Berger, Charlotte. "Thomas Jeckyll (1827–1881)—an Avant-Garde but Forgotten Talent." B.A. Honors thesis, Leeds University, 1994.

Boase, Frederic. *Modern English Biography.* 1892–1921. Reprint, 1965.

Borzello, Frances. *The Artist's Model.* 1982.

Boyce, George Price. *The Diaries of George Price Boyce.* Edited by Virginia Surtees. Norwich, 1980.

Broun, Elizabeth. "Thoughts That Began with the Gods: The Content of Whistler's Art." *Arts Magazine* (New York) 62 (October 1987): 36–43.

Brown, Ford Madox. *The Diary of Ford Madox Brown*. Edited by Virginia Surtees. 1981.

Brunk, Thomas W. "'The House that Freer Built.'" *Dichotomy: A Semi-Annual Review of Art and Architecture* (University of Detroit School of Architecture) 3 (spring 1981): 1–53.

Buck, Anne. *Victorian Costume and Costume Accessories*. 2d ed., rev. Carlton, Bedford, 1984.

Burke, Doreen Bolger, et al. *In Pursuit of Beauty. Americans and the Aesthetic Movement*. Exhib. cat., Metropolitan Museum of Art, New York, 1986.

Burne-Jones, Georgiana. *Memorials of Edward Burne-Jones*. 2 vols. 1904. Reprint, 1993.

Caine, Hall. *My Story*. New York, 1909.

———. *Recollections of Rossetti*. 1928. Reprint, New York, 1990.

Campbell, Lady Archibald [Janey Sevilla]. *Rainbow-Music; or, the Philosophy of Harmony in Colour-Grouping*. 1886.

Carlyle, Leslie Anne. "A Critical Analysis of Artists' Handbooks, Manuals and Treatises on Oil Painting Published in Britain between 1800–1900: With Reference to Selected Eighteenth-Century Sources." 2 vols. Ph.D. diss., Courtauld Institute of Art, University of London, 1991.

Carr, Alice Vansittart. *Mrs. J. Comyns Carr's Reminiscences*. Edited by Eve Adam. 1926.

Carr, Joseph Comyns. *Coasting Bohemia*. 1914.

[———]. "Mr. Whistler's Decorative Paintings." *Pall Mall Gazette*, 15 February 1877, 11.

Cary, Elisabeth Luther. *The Works of James McNeill Whistler*. 1907. Reprint, New York, 1913.

Chandler, George. *Liverpool Shipping: A Short History*. 1960.

Child, Theodore. "A Pre-Raphaelite Mansion." *Harper's New Monthly Magazine* (New York) 82 (December 1890): 81–99. (Reprinted in *Art and Criticism: Monographs and Studies*, 305–43. New York, 1892.)

Christie, Manson & Woods, London. *Catalogue of the Valuable and Extensive Collection of Old Nankin Porcelain, Old Chinese Enamelled Porcelain and Cloisonné Enamels, Decorative Objects, Furniture, and Tapestry, the Property of F. R. Leyland, Esq., Deceased, Late of 49, Prince's Gate, S.W., and Woolton Hall, near Liverpool*. Sale cat., 26–27 May 1892.

———. *Catalogue of the Very Valuable Collection of Ancient and Modern Pictures of Frederick Richards Leyland, Esq., Late of 49, Prince's Gate, and Woolton Hall, Liverpool, Deceased*. Sale cat., 28 May 1892.

Cline, C. L., ed. *The Owl and the Rossettis: Letters of Charles A. Howell and Dante Gabriel, Christina, and William Michael Rossetti*. University Park, Pa., 1978.

Coburn, Alvin Langdon. *Alvin Langdon Coburn: Photographer: An Autobiography*. Edited by Helmut Gernsheim and Alison Gernsheim. New York, 1996.

Cohen, Lucy. *Lady De Rothschild and Her Daughters, 1821–1931*. 1935.

Colvin, Sidney. "English Painters of the Present Day." *Portfolio: An Artistic Periodical* (1870): 5.

Conway, Moncure Daniel. "Decorative Art and Architecture in England." Parts 1–3. *Harper's New Monthly Magazine* (New York) 49 (October–November 1874): 617–32, 777–89; 50 (December 1874): 35–49.

Cooper, Jeremy. *Victorian and Edwardian Decor: From the Gothic Revival to Art Nouveau*. New York, 1987.

Cooper, Nicholas. *The Opulent Eye: Late Victorian and Edwardian Taste in Interior Design*. Photographs by H. Bedford Lemere. New York, 1977.

Cope, Zachary. *The Versatile Victorian: Being the Life of Sir Henry Thompson, Bt., 1820–1904*. 1951.

Cortissoz, Royal. "Whistler." *Atlantic Monthly* (Boston) 92 (December 1903): 826–38.

Cousens, Belinda. *Speke Hall: Merseyside*. 1994.

Crane, Walter. *An Artist's Reminiscences*. New York, 1907.

Curry, David Park. *James McNeill Whistler at the Freer Gallery of Art*. New York, 1984.

———. "Total Control: Whistler at an Exhibition." In *James McNeill Whistler: A Reexamination*, edited by Ruth E. Fine, Studies in the History of Art, vol. 19. Washington, D.C., 1987.

Curwood, J. Olivier. "Charles L. Freer: An American Art Collector." *International Studio* 87 (June 1905): 76–79.

Dakers, Caroline. *Clouds: The Biography of a Country House*. New Haven. 1993.

Day, Lewis F. "A Kensington Interior." *Art Journal* 56 (May 1893): 139–44.

———. "Notes on English Decorative Art in Paris." *British Architect* 10 (1 November 1878): 170–71.

———. "Victorian Progress in Applied Design." *Art Journal* 50 (June 1887): 185–202.

Dorment, Richard, and Margaret F. MacDonald. *James McNeill Whistler*. Exhib. cat., Tate Gallery, London, 1994. Reprint, New York, 1995.

De Wolf, Richard C. "The Freer Gallery of Art." *Minaret* (Washington, D.C.), September/October 1923, 50–52.

du Bois, Guy Pène. "Art by the Way." *International Studio* (New York) 74 (July 1923): 50–51.

du Maurier, George. *The Young George du Maurier: A Selection of His Letters, 1860–67*. Edited by Daphne du Maurier. 1951.

Dunn, Henry Treffry. *Recollections of Dante Gabriel Rossetti and His Circle (Cheyne Walk Life)*. 1904.

Dunn, M. Dudley. "Art Notes: Whistler's Famous Peacock Room." *Madame* 35 (June 1904): 706–7.

Duret, Théodore. "Artistes Anglais: James Whistler." *Gazette des Beaux-Arts* (Paris) 23 (April 1881): 365–67. (Reprinted as "James Whistler," in *Critique d'avant-garde*, 247–60. Paris, 1885.)

Duval, M. Susan. "F. R. Leyland: A Maecenas from Liverpool." *Apollo* 124 (August 1986): 110–15.

———. "A Reconstruction of F. R. Leyland's Collection: An Aspect of Northern British Patronage." Master's thesis, Courtauld Institute of Art, University of London, 1982.

Eastlake, Charles. *Hints on Household Taste*. 4th ed. 1878. Reprint, New York, 1969.

Edel, Leon. *Henry James: 1882–1895 The Middle Years*. Philadelphia, 1962.

Eddy, Arthur Jerome. *Recollections and Impressions of James A. McNeill Whistler*. 1903.

Edis, Robert W. *Decoration and Furniture of Town Houses*. 1881.

Fenollosa, Ernest F. "The Collection of Mr. Charles L. Freer." *Pacific Era* (Detroit) 1 (November 1907): 57–66.

Ferriday, Peter. "Peacock Room." *Architectural Review* 125 (June 1959): 407–14.

Fine, Ruth E., ed. *James McNeill Whistler: A Reexamination*. Studies in the History of Art, vol. 19. Washington, D.C., 1987.

"Fine Arts, Science, &c." *The Court Journal and Fashionable Gazette,* 27 January 1877, 103.

Fink, Lois Marie. *American Art at the Nineteenth-Century Paris Salons.* Cambridge, 1990.

Forwood, Sir William B. *Recollections of a Busy Life: Being the Reminiscences of a Liverpool Merchant, 1840–1910.* Liverpool, 1911.

Francillon, R. E. *Mid-Victorian Memories.* 1914.

Fried, Michael. *Manet's Modernism, or, The Face of Painting in the 1860s.* Chicago, 1996.

Gere, Charlotte. *Nineteenth-Century Decoration: The Art of the Interior.* New York, 1989.

Gere, Charlotte, and Michael Whiteway. *Nineteenth-Century Design from Pugin to Mackintosh.* New York, 1994.

Girouard, Mark. *Sweetness and Light: The "Queen Anne" Movement 1860–1900.* Oxford, 1977.

———. *The Victorian Country House.* Rev. ed. 1979.

Godwin, E. W. "Notes on Mr. Whistler's 'Peacock Room.'" *Architect* 17 (24 February 1877): 118–119. (Reprinted as "Mr. F. R. Leyland's 'Peacock Room,'" in *The Daily Courier* [Liverpool], 3 March 1877, 6; also reprinted as "Mr. Whistler's 'Peacock Room,'" in *American Architect and Building News* [Boston] 2 [24 March 1877]: 95.)

Goebel, Catherine Carter. *Arrangement in Black and White: The Making of a Whistler Legend.* 2 vols. Ann Arbor, 1988.

Graves, Algernon. "James Abbott McNeill Whistler." *Printseller and Print Collector* 1 (August 1903): 340–45.

Greaves, Walter. "Notes on Old Chelsea." In *Catalogue of Oil Paintings, Drawings and Etchings of Chelsea . . . by Walter and H. Greaves (Pupils of Whistler).* Exhib. cat., Goupil Gallery, 1922.

Green, Richard. *Albert Moore and His Contemporaries.* Exhib. cat., Laing Art Gallery, Newcastle upon Tyne, 1972.

Grego, Joseph. "Old Blue-and-White Nankeen China." *Magazine of Art* 10 (January 1887): 9–13.

Hallé, C. E. *Notes from a Painter's Life, including the Founding of Two Galleries.* 1909.

Hare, Augustus. *Peculiar People: The Story of My Life.* Edited by Anita Miller and James Papp. Chicago, 1995.

Harvey, John. *Men in Black.* Chicago, 1995.

Haweis, Mary Eliza. *The Art of Decoration.* 1881. Reprint, New York, 1977.

Haweis, H. R. *Money and Morals: A Sermon Preached at St. James' Hall, London, February 18, 1877.* 1877. (Reprinted as "Money and Morals: A Tract for the Times," in *Arrows in the Air* [1878], 143–77.)

Haws, Duncan. *Merchant Fleets in Profile.* 2 vols. Cambridge, 1979.

Hobbs, Susan. *The Whistler Peacock Room.* 4th ed. Washington, D.C., 1980.

Hollingsworth, A. T. *Old Blue and White Nankin China.* Vol. 26 of *Sette of Odd Volumes.* 1891.

Horowitz, Ira M. "Whistler's Frames." *Art Journal* (New York) 39 (winter 1979/80): 124–31.

Ionides, Julia. "The Greek Connection— The Ionides Family and Their Connections with Pre-Raphaelite and Victorian Art Circles." In *Pre-Raphaelite Art in Its European Context,* edited by Susan P. Casteras and Alicia Craig Faxon, 160–74. Madison, N.J., 1995.

Ionides, Luke. *Memories.* Paris, 1925. (Originally published as "Memories." *Transatlantic Review* [Paris] 1 [January 1924]: 37–52).

Jacobson, Dawn. *Chinoiserie.* 1993.

Jacomb-Hood, G. P. *With Brush and Pencil.* 1925.

Jamison, Kay Redfield. *Touched with Fire: Manic-Depressive Illness and the Artistic Temperament.* New York, 1993.

Jones, Clement. *Pioneer Shipowners.* Liverpool, 1934.

Jopling, Louise. *Twenty Years of My Life, 1867 to 1889.* 1925.

Konody, P. G. "Whistler's Pfauenzimmer." *Kunst und Kunsthandwerk* (Vienna) 7 (1904): 385–91.

Lambourne, Lionel. *The Aesthetic Movement.* 1996.

Lamont, L. M., ed. *Thomas Armstrong, C.B., a Memoir, 1832–1911.* 1912.

Lee, Vernon [Violet Paget]. "Imagination in Modern Art: Random Notes on Whistler, Sargent, and Besnard." *Fortnightly Review* 62 (1 October 1897): 513–21.

———. *Vernon Lee's Letters.* 1937.

Lindsay, William Shaw. *History of Merchant Shipping and Ancient Commerce.* 4 vols. 1874–76.

Lochnan, Katharine A. *The Etchings of James McNeill Whistler.* 1984.

Loftie, W. J. *A Plea for Art in the House.* Art at Home Series, vol 1. 1876.

MacColl, D. S. "Whistlers Pfauenzimmer." *Kunst und Künstler* (Berlin) 3 (December 1904): 112–14.

MacDonald, Margaret F. *James McNeill Whistler: Drawings, Pastels, and Watercolours, a Catalogue Raisonné.* 1995.

Macfall, Haldane. *Aubrey Beardsley: The Clown, the Harlequin, the Pierrot of His Age.* New York, 1927.

Macleod, Dianne Sachko. *Art and the Victorian Middle Class: Money and the Making of Cultural Identity.* New York, 1996.

Mahey, John A. "The Letters of James McNeill Whistler to George A. Lucas." *Art Bulletin* (New York) 49 (September 1967): 247–57.

Marks, Richard. *Burrell: A Portrait of a Collector.* Glasgow, 1988.

Marsh, Jan. *The Pre-Raphaelite Sisterhood.* New York, 1985.

Mechlin, Leila. "The Freer Collection of Art." *Century Magazine* (New York) 73 (January 1907): 357–68.

Menpes, Mortimer. *Whistler as I Knew Him.* 1904.

Merrill, Linda. *A Pot of Paint: Aesthetics on Trial in "Whistler v. Ruskin."* Washington, D.C., 1992.

———. "Whistler and the 'Lange Lijzen.'" *Burlington Magazine* 136 (October 1994): 683–90.

———. "Whistler's Peacock Room Revisited." *Magazine Antiques* (New York) 143 (June 1993): 894–901.

———, ed. *With Kindest Regards: The Correspondence of Charles Lang Freer and James McNeill Whistler, 1890–1903.* Washington, D.C., 1995.

Messrs. Trollope, London. *49, Prince's Gate, S.W.7: Illustrated Particulars and Conditions of Sale of This Spacious and Artistic Town Mansion.* Sale cat., 14 October 1919.

Meyer, Agnes E. *Charles Lang Freer and His Gallery.* Washington, D.C., 1970.

Millar, John. *Hints on Insanity and Signing Certificates.* 2d ed. 1877.

Montesquiou, Robert de. *Les Pas effacés.* Vol. 2 of *Mémoires.* Paris, 1923.

Munhall, Edgar. *Whistler and Montesquiou: The Butterfly and the Bat.* New York and Paris, 1995.

Muthesius, Hermann. *The English House.* 1904. Reprint, New York, 1987.

Nakanishi, Branka. "A Symphony Reexamined: An Unpublished Study for Whistler's Portrait of Mrs. Frances Leyland." *Art Institute of Chicago Museum Studies* 18 (fall 1992): 156–67.

Obach & Co., London. *The Peacock Room,* [by C. J. Holmes]. Exhib. cat. June 1904.

O'Hara, Patricia. "'The Willow Pattern that We Knew': The Victorian Literature of Blue Willow." *Victorian Studies* (Bloomington, Ind.) 36 (summer 1993): 421–42.

Orchard, B. G. "Victor Fumigus." In *A Liverpool Exchange Portrait Gallery. Second Series: Being Lively Biographical Sketches of Some Gentlemen Known on the Flags; Sketched from Memory, and Filled in from Fancy,* 93–98. Liverpool, 1884.

Ormond, Leonée. *George du Maurier.* Pittsburgh, 1969.

Osborn & Mercer, London. *The Mansion; formerly the residence of the late F. R. Leyland, Esq.* Sale cat., 17 June 1892.

Pennell, Elizabeth Robins, and Joseph Pennell. *The Life of James McNeill Whistler.* 2 vols. 1908.

———. *The Life of James McNeill Whistler.* 5th ed., rev. 1911.

———. *The Whistler Journal.* Philadelphia, 1921.

Pennington, Harper. "James A. McNeill Whistler." *International Quarterly* 10 (October 1904): 156–64.

Pevsner, Nikolaus. *North-East Norfolk and Norwich.* Harmondsworth, England, 1962.

Philadelphia International Exhibition Executive Commission. *Official Catalogue of the British Section, Park I.* Exhib. cat. 1876.

Picton, J. A. *Memorials of Liverpool: Historical and Topographical.* 2 vols. 2d ed., rev. 1875.

Prinsep, Valentine C. "A Collector's Correspondence." *Art Journal* 55 (August 1892): 249–52.

———. "James A. McNeill Whistler: 1834–1903. I. Personal Recollections." *Magazine of Art* 27 (October 1903): 577–80.

———. "The Private Art Collections of London: The Late Mr. Frederick Leyland's in Prince's Gate. First Paper: Rossetti and His Friend." *Art Journal* 55 (May 1892): 129–34.

Reade, Brian. *Aubrey Beardsley.* 1967. Reprint, Suffolk, 1987.

Reitlinger, Gerald. *The Economics of Taste: The Rise and Fall of the Objets d'Art Market Since 1750.* New York, 1963.

Robertson, W. Graham. *Letters from Graham Robertson.* Edited by Kerrison Preston. 1953.

———. *Life Was Worth Living: The Reminiscences of W. Graham Robertson.* New York, 1931. (Reprinted as *Time Was: The Reminiscences of W. Graham Robertson* [1981].)

Robinson, Lionel. "The Private Art Collections of London: The Late Mr. Frederick Leyland's in Prince's Gate. Second Paper: The Leyland Collection." *Art Journal* 55 (May 1892): 134–38.

Rossetti, Dante Gabriel. *Letters of Dante Gabriel Rossetti.* Edited by Oswald Doughty and John Robert Wahl. 4 vols. Oxford, 1965–67.

Rossetti, Dante Gabriel, and Frederick R. Leyland. *The Rossetti-Leyland Letters: The Correspondence of an Artist and His Patron.* Edited by Francis L. Fennell. Athens, Ohio, 1978.

Rossetti, Dante Gabriel, and Jane Morris. *Dante Gabriel Rossetti and Jane Morris: Their Correspondence.* Edited by John Bryson in association with Janet Camp Troxell. Oxford, 1976.

Rossetti, William Michael. *Dante Gabriel Rossetti: His Family Letters, with a Memoir.* 2 vols. 1895. Reprint, New York, 1970.

———. *Fine Art, Chiefly Contemporary: Notices Re-Printed, with Revisions.* 1867.

———. "Japanese Woodcuts: An Illustrated Story-book Brought from Japan." *The Reader* 2 (31 October and 7 November 1863): 501–3 and 536–38. (Reprinted as "Japanese Woodcuts," in *Fine Art, Chiefly Contemporary* [1867], 363–87.)

———. *Selected Letters of William Michael Rossetti.* Edited by Roger W. Peattie. University Park, Pa., 1990.

———. *Some Reminiscences of William Michael Rossetti.* 2 vols. New York, 1906.

———, ed. *Rossetti Papers, 1862 to 1870.* 1903. Reprint, New York, 1970.

[Rossetti, William Michael]. "Notes on Art and Archaeology." *Academy* 11 (17 February 1877): 147.

Saarinen, Aline B. "Tea and Champagne: Charles Lang Freer." In *The Proud Possessors: The Lives, Times, and Tastes of Some Adventurous American Art Collectors,* 118–43. New York, 1958.

Saint, Andrew. *Richard Norman Shaw.* New Haven, 1976.

Sala, George Augustus. *Paris Herself Again in 1878–9.* 2 vols. 1880.

Samet, Wendy, Joyce Hill Stoner, and Richard Wolbers. "Approaching the Cleaning of Whistler's Peacock Room: Retrieving Surface Interrelationships in 'Harmony in Blue and Gold.'" In *IIC [International Institute for Conservation] Preprints of the Contributions to the Brussels Congress, 3–7 September 1990,* edited by John S. Mills and Perry Smith, 6–12. 1990.

Sandberg, John. "'Japonisme' and Whistler." *Burlington Magazine* 106 (November 1964): 500–7.

Sato, Tomoko, and Toshio Watanabe. *Japan and Britain: An Aesthetic Dialogue, 1850–1930.* Exhib. cat., Barbican Art Gallery, 1991.

Savage, Kirk. "'A forcible piece of weird decoration': Whistler and *The Gold Scab*." *Smithsonian Studies in American Art* (New York) 4 (spring 1990): 41–53.

Scholten, Frits, ed. *Goud Leer: Kinkarakawa: De geschiedenis van het Nederlands goudleer en zijn invloed in Japan* (Gilt leather: Kinkarakawa [gilt leather]: The history of Dutch gilt leather and its influence in Japan). Zwolle, Netherlands, 1989.

Smalley, George W. "Books and Art in London: Notable Literary Events." *New York Daily Tribune,* 29 March 1877, 6.

———. "London Topics: Household Decoration. . . . Whistler's 'Harmony in Yellow and Gold.'" *New York Daily Tribune,* 6 July 1878, 2. (Reprinted as "A Harmony in Yellow and Gold," in *American Architect and Building News* [Boston] 4 [27 July 1878]: 36.)

———. "London Topics: Progress in Household Art." *New York Daily Tribune,* 5 March 1877, 2.

Smith, Alison. *The Victorian Nude.* Manchester, 1996.

Smith, Helen. *Decorative Painting in the Domestic Interior in England and Wales, c. 1850–1890.* 1984.

Smith, John Moyr. *Ornamental Interiors, Ancient and Modern.* 1887.

Spencer, Robin. *The Aesthetic Movement.* 1972.

———. "James McNeill Whistler and His Circle: A Study of His Work from the Mid-1860's to the Mid-1870's." M.A. thesis, Courtauld Institute of Art, University of London, 1968.

———, ed. *Whistler: A Retrospective.* New York, 1989.

Staley, Allen. "The Condition of Music." In *The Academy: Five Centuries of Grandeur and Misery, from the Carracci to Mao Tse-tung,*

edited by Thomas B. Hess and John Ashbery, 80–87. *Art News Annual* 33. New York, 1967.

[Stephens, Frederic George]. "The Private Collections of England," parts 71 and 72, "Galleries in and near Liverpool." *Athenaeum*, no. 2866 (30 September 1882): 438–40; no. 2869 (21 October 1882): 534–35.

Stokes, Elizabeth K. Phelps. "Art Gems in Rich Setting at Capital." *New York Evening Post*, 7 May 1923, 9.

[Stubbs, Burns A.] *The Whistler Peacock Room.* Washington, D.C., 1951.

Surtees, Virginia. *The Paintings and Drawings of Dante Gabriel Rossetti (1828–1882): A Catalogue Raisonné.* Oxford, 1971.

Sutton, Denys. *Nocturne: The Art of James McNeill Whistler.* 1963.

Swinburne, Algernon Charles. *Notes on the Royal Academy Exhibition, 1868, Part II.* 1868. Reprint, New York, 1976. (Reprinted as "Notes on Some Pictures of 1868," in *Essays and Studies* [1875], 358–80.)

———. *William Blake: A Critical Essay.* 1868. Reprint, New York, 1967.

Symons, Arthur. "Whistler." Parts 1–3. *Weekly Critical Review: Devoted to Literature, Music and the Fine Arts* (Paris) 2 (30 July, 6, 13 August 1903): 36–37, 49–50, 81. (Reprinted as "Whistler," in *Studies in Seven Arts* [New York, 1906], 121–47.)

Taylor, Hilary. *James McNeill Whistler.* 1978.

[Taylor, Tom]. "A Peacock Room." *The Times*, 15 February 1877, 4.

Teall, Gardner C. "Mr. Whistler and the Art Crafts." *House Beautiful* (New York) 13 (February 1903): 188–91.

Thornton, Peter. *Seventeenth-Century Interior Decoration in England, France and Holland.* New Haven, 1978.

Thorp, Nigel, ed. *Whistler on Art: Selected Letters and Writings 1849–1903 of James McNeill Whistler.* Washington, D.C., 1995.

Tibbles, A. J. "Speke Hall and Frederick Leyland: Antiquarian Refinements." *Apollo* 139 (May 1994): 34–37.

Tweedie, Mrs. Alec [Ethel Brilliana]. *Thirteen Years of a Busy Woman's Life.* 1912.

Watanabe, Toshio. *High Victorian Japonisme.* Swiss Asian Studies, vol. 10. New York, 1991.

Watts, Harvey M. "Opening of the Freer Gallery of Art." *Art and Architecture* (Washington, D.C.) 15 (June 1923): 271–77.

Way, T. R. *Memories of James McNeill Whistler, the Artist.* 1912.

Way, T. R., and G. R. Dennis. *The Art of James McNeill Whistler: An Appreciation.* 1903.

Webber, Byron. *James Orrock, R.I.: Painter, Connoisseur, Collector.* 2 vols. 1903.

Weber, Susan. "Whistler as Collector, Interior Colorist and Decorator." MHPA thesis, Parsons School of Design/Cooper-Hewitt Museum, New York, 1987.

Weintraub, Stanley. *Whistler: A Biography.* 1974. Reprint, New York, 1988.

Whistler, James McNeill. *The Gentle Art of Making Enemies.* 1892. Reprint, New York, 1967.

———. "Mr. Whistler's 'Ten O'Clock.'" In *The Gentle Art of Making Enemies*, 131–59. 1892. Reprint, New York, 1967.

———. "Notes and News." Letter to the editor. *Academy* 10 (9 September 1876): 275.

[———]. *Harmony in Blue and Gold. The Peacock Room.* 1877.

White, Gleeson. "An Epoch-making House." *International Studio* (New York) 3 (December 1897): 102–12.

White, Henry C. *The Life and Art of Dwight William Tryon.* Boston, 1930.

White, Thomas. "Albert Moore and the 'D.N.B.'" *Notes and Queries* 8 (24 August 1907): 152.

Wilde, Oscar. "The Grosvenor Gallery." *Dublin University Magazine* 90 (July 1877): 118–26.

———. "The House Beautiful." In *Complete Works of Oscar Wilde*, 913–25. Glasgow, 1994.

Williamson, George C. *Murray Marks and His Friends: A Tribute of Regard.* 1919.

Winter, John, and Elisabeth West FitzHugh. "Some Technical Notes on Whistler's 'Peacock Room.'" *Studies in Conservation* 30 (1985): 149–54.

Young, Andrew McLaren, Margaret MacDonald, Robin Spencer, and Hamish Miles. *The Paintings of James McNeill Whistler.* 2 vols. 1980.

Young, Dorothy Weir. *The Life and Letters of J. Alden Weir.* Edited by Lawrence W. Chisolm. New Haven, 1960.

Index

Abbott, Holker (1858–?), 336
Academy, 208, 209, 211, 222, 225–27, 253, 259–60
Adam, Robert (1728–1792), Woolton Hall, 294
aestheticism, 51, 60, 64–65, 86
 and domestic decoration, 20, 310, 332
 opposition to, 148–49
 and Whistler, 19–20, 47, 82, 86
Aesthetic movement, 51, 53, 161, 201, 332
Agnew, William (1825–1910), 306
Aitchison, George (1825–1910)
 Design for Mrs. Eustace Smith's Boudoir, 222, fig. 5.34
 Design for the Arab Hall, Leighton House, 293, fig. 7.1
 Design for the Front Drawing Room at 15 Berkeley Square, 224, fig. 5.36
Albanesi, Luigi (1821–1897), 116, 296
Alcock, Sir Rutherford (1809–1897), 60, 181
Alexander, Cicely (1864–1932), 153, 179
 on "Ten O'Clock" lecture, 354 n2
 Whistler's portrait of, 129, 312
Alexander, Jean (d. 1972), 152–53
Alexander, May (Agnes Mary) (1862–?), 141
 Whistler's portrait of, 141, 153, fig. 4.5
Alexander, William Cleverly (1840–1916), 141, 151, 153, 179, 214, 216, 224
 Japanese *fukasa*, 241–42, fig. 6.7
 porcelain collection, 152
 and portrait commission, 141
 See also Aubrey House
Alma-Tadema, Lawrence (1836–1912), and Laura, 192, 247
Anderson, Ronald, 80
Andō Hiroshige (1797–1858), 221
 Peacock and Peonies, 221, fig. 5.33
 Peacock in a Plum Tree, 221, fig. 5.32
 Sixty-odd Famous Places of Japan, 59
Arab Hall (Aitchison), 293, fig. 7.1
Architect, 223, 243, 247, 252, 259, 262, 268, 288
 Ruskin's critique in, 274

Architectural Review, 26
Armstrong, Thomas (1832–1911), 51
 correspondence of, 51, 54, 160
 and Jeckyll, 162, 257–59
 and Leyland, 276
 on Peacock Room, 211, 236, 265, 371 n24
 Smith commission, 222
 on the Spartalis, 70
 on Whistler and Velázquez, 122
 Whistler's correspondence with, 362 n61
 on Whistler's working method, 103, 286, 355 n7
 and Whistler's works, 98–99
 works:
 The Hayfield, 360 n75
 The Test, 65, fig. 1.20
Armstrong, Sir William (1810–1900), 171
Art & Art Critics (Whistler), 26
Art and Criticism (Child), 303
Art for Art's Sake. *See* aestheticism
Art Journal, 56, 59, 182, 198, 311–12, 318
art nouveau, 29
Arts Club, 162
Art Treasures Exhibition, Manchester (1857), 122
Arundel Club, 162
Aslin, Elizabeth, 196
Athenaeum, 47, 175, 275, 329
Aubrey House, 151–53
 Whistler's designs for, 152–53, 224, fig. 4.4
 Whistler's plans for installing porcelain in, 152, fig. 4.3
Audsley, G. A. (1838–1925), 171, 221, 239
 The Keramic Art of Japan, 239–40, figs. 6.5, 6.6
 Liverpool Art Club catalogue, 182, 238
Auvray, Louis (1810–1890), 67
Avery, Samuel Putnam (1822–1904), 218, 267, 365 n157

B. Verity & Sons, 197, 277–78, 377 n176
Bacher, Otto (1856–1909), 142, 290, 297

Bailey, Madge, 342
Baldry, Alfred Lys (1858–1939), 90, 92, 99
Bancroft, Samuel (1840–1915), 363 n88
Bancroft, Squire (1841–1926), 369 n137
Barker, Alexander, 366 n46
Barnard, Bishop & Barnards, 27, 160–61, 165, 198, 200–2
 London showroom, fig. 5.14
 See also Jeckyll, Thomas
Bateman, Isabel (1854–?), 133
Bateman, Sir Frederic, 260
Baudelaire, Charles (1821–1867), *Les Fleurs du mal*, 51
Beadle, Sybil Lake (later Leyland), 284
Beardsley, Aubrey (1872–1898), 307–12
 butterflies of, 311
 and *The Gold Scab*, 21, 311–12, fig. 7.12
 illustrated letter to Scotson-Clark, 307–9, figs. 7.7, 7.8
 visit to 49 Prince's Gate, 307–9
 and Whistler, 310–11
 works:
 The Dancing Faun, 312
 J'ai baisé ta bouche Iokanaan, 310–11, fig. 7.9
 Le Morte d'Arthur, 310
 The Peacock Skirt, 311–12, fig. 7.11
Bendix, Deanna Marohn, 29
Benson, E. F. (1867–1940), 288
Berkeley Square, No. 15, 224–25, figs. 5.36, 5.37
Berners Gallery, 47
Bethnal Green Museum, 171
Bibby, James Jenkinson (1813–1897), 112–15, 155
Bibby, John (1775–1840, founder of the firm), 112
Bibby, John (1810–1883, son of the founder), 112–15
Bibby, John Jr. (1839–1898, grandson of the founder), 296, 306
Bibby Line, 112–14
Birkenhead Corporation, 114
Blackburn, Henry (1830–1897), 138

Blake, William (1757–1827), essay by, 51, 65

blue-and-white porcelain. *See* porcelain, Chinese blue-and-white

Boehm, J. Edgar (1834–1890), 293

Boileau, Sir John P., 158

Bonvin, François (1817–1887), 47

Borzello, Frances, 48

Boston Public Library
 purchase of Peacock Room for, 316
 Whistler's commission for, 316

Botticelli, Sandro (1445–1510), 157, 366 n46

Boughton, Flossie (Mrs. Robb), 299–300

Boughton, George H. (1833–1905), 192, 248, 276, 299, 369 n150

Bourget, Paul (1852–1935), 70, 358 n90

Boussod, Valadon & Cie., 307

Bowes, James Lord (1834–1899), 182, 241

Boxall, William (1800–1879), 364 n144

Boyce, George Price (1826–1897), 44, 51, 60

British Museum, 82, 98, 171

Brompton Cemetery, 296

Brown, Ernest, art dealer, 322–23, 329

Brown, Ford Madox (1821–1893), 70
 Chaucer Reading the "Legend of Custance" to Edward III, 88
 correspondence of, 60, 115
 and Leyland, 88, 362 n53
 picture frames by, 56, 358 n97
 and Speke Hall, 118, 121

Brown, Richard (fl. 1804–45), *Domestic Architecture*, 199

Brown and Phillips, Messrs., 322

Brummell, Beau [George Bryan] (1778–1840), 127

Builder, 259, 376 n136

Building News, 97, 223, 260

Bundy, John, 348

Burden, Jane. See Morris, Jane Burden

Bürger, Willem [Théophile Thoré], 66

Burges, William (1827–1881), "Peacock Cabinet," 214–15, fig. 5.24

Burlington Fine Arts Club, 93, 162

Burlington Magazine, 330, 334

Burne-Jones, Edward (1833–1898), 96, 98, 163
 Beardsley on, 308
 decorations for Myles Birket Foster, 96
 and Leyland, 154, 275–76, 294, 296, 379 n21
 and Marks, 172
 works:
 Earthly Paradise, illustrations for, 96, 150
 Merlin and Vivien, 306
 The Mirror of Venus, 306
 works at 49 Prince's Gate, 156, 308
 works at 23 Queen's Gate, 154
 works at Woolton Hall, 294

Burne-Jones, Georgiana (1840–1920), 98, 121, 366 n32, 371 n55

Burrell, William (1861–1958), 306, 318, 322, 328

Butterfly Cabinet. *See* Whistler, works, *Harmony in Yellow and Gold*

Caffin, Charles H. (1854–1918), 345

Cahen, Albert (1846–1903), 358 n90

Cahen, Edouard, 69

Caine, Hall (1853–1931), 117, 128

Cairns, Sir Hugh (1819–1885), 114

Caldecott, Frederick Richards Leyland (1883–?), 283

Caldecott, Randolph (1846–1886), 293

Caldecott, Rosa Laura (1843?–1890), 283, 295

Cameron, Julia Margaret (1815–1879), 72
 Christina Spartali, 72, fig. 1.28

Campbell, Lady Archibald (Janey Sevilla) (d. 1923), 255
 Rainbow-Music, 301

Canfield, Richard A. (1855–1914), 326, 336

Carlyle, Thomas (1795–1881), 127
 Whistler's portrait of, 35, 129, 137, 138, 274, 277, 290, 317

Carr, Alice (Mrs. J. Comyns) (1850–?), 235, 245

Carr, J. Comyns (1849–1916), 138, 230, 236,
 and Peacock Room, 223, 239, 245, 248, 252

Carroll, Lewis (1832–1898), "Lobster Quadrille," 281

Cary, Elisabeth Luther (1867–1936), 29, 71, 342

Casa Jankovitz, Venice, 290

Cassatt, Lois B., Whistler's portrait of, 299

A Catalogue of Blue and White Nankin Porcelain (Marks), 171–77
 Whistler's illustrations for, 53, 61, 173–75, figs. 1.9, 1.14, 4.25, 4.26

Catherine of Aragon (1485–1536), dowry of, 21, 194

Cavafy, G. J., 58, 105

Centennial International Exhibition (1876), Philadelphia, 221
 Jeckyll's Japanese pavilion at, 27, 199–202, 204, 258, 260, figs. 1, 5.10
 La Princesse and, 186–87

Centennial Photographic Co., photograph by, fig. 5.10

Chambers, William (1723–1796), 198

Chapman, Alfred (1839–1917), 209

Chantrey, Sir Francis (1781–1841), bequest of, 329

Chesneau, Ernest (1833–1890), 66

Chicago Sunday Tribune, on Peacock Room, 336, 338, fig. 7.20

Chicago World's Fair (1893), 317–19

Child, Theodore (1846–1892), 302
 Art and Criticism, 303
 on Peacock Room, 26–27, 207, 218, 244, 257, 302–4, 312, 333
 on 49 Prince's Gate, 147, 156, 179, 181, 197

Christian Science Monitor, 351

Christie, Manson & Woods, 305, 318

Clabburn, W. H., 216

Clayton, Ellen (1834–1900), 69

Coburn, Alvin Langdon (1882–1966), 345
 autochrome photographs by, 345, fig. 7.23

Coello, Alonso Sanchez (1531–1588), 370 n172

Cole, Alan S. (1846–1934)
 diary of, 207, 278
 and International Exhibition of 1872, 184
 on Leyland marriage, 272, 283
 and Peacock Room, 211, 215, 217, 224, 226–27, 229–30, 236–37, 243, 246–48, 253, 270
 Whistler's correspondence with, 136, 208, 217
 on Whistler's work, 129, 280–81

Cole, Margie (Mrs. Alan S.), 271, 282–83

Cole, Sir Henry (1808–1882), 208, 231, 247–48

Collins, Wilkie (1824–1889), *The Woman in White*, 47, 72

Colnaghi, art dealers, 328

Colvin, Sidney (1845–1927), 82, 90, 92, 245

The Convent (Villette), 295–97

Conway, Moncure (1832–1907), 150, 161, 179, 239

Cooper, Sampietro & Gentiluomo, 348

Copley Hall, Boston, 322, fig. 7.16

Copley Society, 336

Cornforth, Fanny (1835?–1905), 50, 61–62, 80, 363 n88, figs. 1.5, 1.16

Cortissoz, Royal (1869–1948), 64

Courbet, Gustave (1819–1877), 44, 48, 85
 works:
 La Belle Irlandaise, 44
 Young Ladies of the Banks of the Seine (Summer), 44

Court and Society Review, 301

Court Journal and Fashionable Gazette, 247, 251

Cowan, J. J. (1846–1936), 328

Cox, David (1783–1859), 116

Crane, Walter (1845–1915), 163, 274, 276, 300
 embroidered screen attributed to, 221
 and 1 Holland Park, 192, 374 n 23, fig. 5.2
 ornament for Arab Hall, 293
 works:
 Baby's Own Aesop, 310
 Design for Mrs. Smith's Boudoir, 222, fig. 5.34

Crawford, Theron C., 378 n236

Cundy, Thomas (1756–1825), 178

Curry, David Park, 28, 153, 181–82, 260

Daily News, 207, 329

Daily Telegraph, 293, 332

d'Anvers, Edouard Cahen, 69

Darwin, Charles (1809–1882), *The Descent of Man*, 218

Davis, William (1812–1873), 115
Dawson, Elizabeth (Lizzie) (1850–?), 117, 362 n47
 Whistler's engagement to, 133–36
 Whistler's portraits of, 134, 364 n137, fig. 3.21
Dawson, Jane (1842–?), 117, 364 n138
Day, Lewis F. (1845–1910), 165, 167, 199, 202, 260–61, 361 n85
 on Jeckyll, 202, 375 n99
Decemviri, 162, 367 n80
Defoe, Daniel (1660–1731), 190
Delaware, University of/Winterthur Art Conservation Program, 34
De Morgan, William (1839–1917), 293, 376 n118
Dennis, G. R., *The Art of James McNeill Whistler*, 322, 333
Deschamps Gallery, 209
Desoye boutique, 59
Detroit, Michigan, Peacock Room in, 340–45
 photographs of, 343, 345, figs. 7.22, 7.23
Detroit Museum of Art, 336, 345
Deverell, Walter (1827–1854), 71
De Wolf, Richard, 351
Dilke, Sir Charles (1843–1911), 373 n142
Dixon, Henry, & Son, photographs by, figs. 4.7, 4.29, 5.3, 6.14
Dixon, Tennessee, illustration by, fig. 5.1
Dodgson, Charles Lutwidge [Lewis Carroll] (1832–1898), 281
Dorment, Richard, 51, 96, 154, 365 n167
Dowdeswell, Walter, 285–86, 288
Downey, W. & D., photographs by, figs. 1.5, 1.6
Dresser, Christopher (1834–1904), 161, 361 n88
Drouet, Charles (1836–1908), 44
du Bois, Guy Pène (1884–1958), 351–52
Dubourg, Augustus W. (1830?–1910), *Twenty Minutes under the Umbrella*, 207
Dudley Gallery, 126, 137, 358 n95
Duffield, Joseph William, builder, 195
du Maurier, George (1834–1896), 43
 and "chinamania," 60, 170
 on the Hiffernans, 43, 62
 and Jeckyll, 158–60, 258
 Punch cartoons by:
 "Aesthetic Love in a Cottage," 310
 "Aptly Quoted from the Advertisement Column," 170, fig. 4.22
 "Intellectual Epicures," 65, fig. 1.19
 "The Six-Mark Tea-Pot," 51, 53, fig. 1.7
 and Thompson, 172
 and *Trilby* (1896), 357 n65
 on Whistler, 50, 56, 58
Dunn, Henry Treffry (1838–1899), 67
 Invitation to a Private View of the Collection of Sir Henry Thompson (attrib.), 176–77, fig. 4.28
 Lady Lilith (with Rossetti), 80, 115, fig. 2.1

trade card for Murray Marks (attrib.), 176–77, fig. 4.27
Dunthorne's Gallery, 332
Duret, Théodore (1838–1927), 44, 328, 355 n7
 Critique d'avant-garde, 300
Dutch gilt leather, 54, 191–95
 in Peacock Room, 21, 194–95, 206, 210–11, 235–36, 246–47, figs. 5.4, 5.5, 5.6
dutch metal, 179–81, 210–11, 220, 264
Duval, M. Susan, 27, 154

Eastlake, Charles (1836–1906), 256–57
Easton, Malcolm, 311
Eddy, A. J. (1859–1920), 244, 263, 316
Edis, R. W. (1839–1927), *The Decoration and Furniture of Town Houses*, 222
Edison, Thomas Alva (1847–1931), 117
Elgin Marbles, 82, 87, 98, 124
Ellis & White, publishers, 175
Elmes, H. L. (1814–1847), architect of Prince's Gate, 155
Elsing Hall (Jeckyll), 158
Evening Star, 64, 83
Examiner, 250, 253, 268
Exhibition of International Art (1898), 318
Exhibition of Oriental and American Art. *See* Michigan, University of
Exposition Universelle, Paris
 1867 exposition, 85, 198
 1878 exposition
 Jeckyll's gates at, 161
 Jeckyll's pavilion at, 198–202, 204, fig. 5.8
 William Watt stand at, 261–62, fig. 6.17
 1889 exposition, 303
 Japanese lacquer display at, 181–82, 238
Eyre, Wilson (1858–1944), 338, 340, 343

"famille rose," 67, fig. 1.25
Fantin-Latour, Henri (1836–1904), 43, 48
 féeries by, 97
 Manet's correspondence with, 130
 and Velázquez, 122–23
 Whistler's correspondence with, 54, 62, 81, 84–87, 90, 92, 97, 105
 works:
 Hommage à la Vérité: Le Toast, 74, 83
 Parade de la féerie, 97
 Portrait of Whistler, 74, fig. 1.29
 Scène du Tannhäuser, 97
Farren, Nellie (1846–1898), 377 n176
Faust (Goethe), 80, 278
Fenollosa, Ernest (1853–1908), 342–43
Ferriday, Peter, 26
 on Jeckyll, 158, 161, 191, 258
 on Peacock Room, 26–28, 194, 228, 251, 274
 on Whistler and Leyland, 274, 279
Ferry Avenue. *See under* Freer, Charles Lang
Figaro, 254, 376 n136

Fine Art Society, 322
Finlayson, John and Richard, art restorers, 32–34
First Exhibition of International Art (1898), 318
Flemish Gallery, Pall Mall, 137–38, 150
Flower, Cyril (later Lord Battersea) (1843–1907), 191–93, 208
Foord & Dickinson, framemakers, 142
Fors Clavigera, 274
Fortnightly Review, 314
Fosco (model), 129
Foster, Myles Birket (1825–1899), 96
Fowke, Isabella Cole, 207
Franklin, Maud (Mary) (1857–1941), 131, 278, 285
 Whistler's portraits of, 131, 328, fig. 3.20
Franks, Augustus Wollaston (1826–1897), 171
Freake, Sir Charles James, 155
Frederick III (1656–1713), 190
Freer, Charles Lang (1854–1919), 287, 366 n20, 370 n10
 death of, 347
 gift to the nation by, 342, 346
 house at 33 Ferry Avenue, Detroit, 338, 340–41, fig. 7.21
 and *La Princesse*, 35, 243, 318–19
 patronage, concept of, 25
 and Peacock Room, 24–25, 195, 204, 243, 304, 316, 333, 336–46, 373 n140
 photograph of, 318, fig. 7.14
 and Projects, 95–96, 338
 purchase (and refusal) of Whistler's works, 90, 290, 315, 363 n95, 368 n152
 and Blanche Watney, 316, 343
 and Whistler, 51, 319–21
 on Whistler's works, 51, 279
Freer Gallery of Art
 Freer's plan for, 346
 Peacock Room in, 22, 25, 30, 32, 34–35, 347–53
 vintage photographs of, 30, 33, 349, 351, figs. 3, 4, 5, 6, 7, 7.26, 7.27
 peacocks at, 353, fig. 7.28
 publications, 25–26, 194–95
 sketch by Platt, 347, fig. 7.25
Frick, Henry Clay (1849–1919), 327
Fried, Michael, 97
Fry, Roger (1866–1932), 151, 238, 329
Fun, 254

Gainsborough, Thomas (1727–1788), "Blue Boy," 142
Gambart, Ernest (1814–1902), 61
 gallery of, 74–75, 358 n115
Gamble, Rev. James H., letters to, 50–51, 53
Gardner, Isabella Stewart (1840–1924), 297, 314, 316, 330
Garibaldi, Giuseppe (1807–1882), 69

Gautier, Théophile (1811–1872), 253, 357 n74
Gautier *fils*, Théophile (fl. 1860s), 66
Genthe, Arnold (1869–1942), 353
 photograph by, 353, fig. 7.28
The Gentle Art of Making Enemies (Whistler), 274, 277, 302, 311, 382 n193, fig. 6.27
George, Sir Ernest (1839–1922), 315
Gilbert and Sullivan, 177
Gilchrist, Tillie, sketch of, 105, 143, fig. 2.23
Glasgow, University of, 26
Glazer, Lee, 322
Globe, 138
Godwin, Beatrice. *See* Whistler, Beatrix
Godwin, E. W. (1833–1886), 97, 193, 197
 decorations for Dromore Castle, 223, fig. 5.35
 Harmony in Yellow and Gold: The Butterfly Cabinet (with Whistler), 261–62, 264, figs. 6.17, 6.19
 and Japanese fans, 365 n8
 on Jeckyll, 161, 261
 and Peacock Room, 194, 212, 215, 217, 230, 236, 243–45, 247, 251–52, 261, 264, 268, 301
 sketches of Peacock Room by, 252, fig. 6.13
 wallpaper designs of, 223, fig. 5.35
 on Whistler's works, 35, 288
 White House, 261–62
Goethe, Johann Wolfgang von (1749–1832), *Faust*, 278
Goodhart-Rendel, H. S. (1887–?), 161, 367 n81
Gookin, F. W. (1853–1936), 336
Goupil Gallery, 304
Graham, William (1816–1885), 277
Grant, Baron Albert (1830–1899), 272, 366 n38
The Grasshopper (Hollingshead), 278, 377 n176
Great Exhibition (1851), 178
Greaves, Elizabeth, 277
Greaves, Henry (1844–1904), 210, 212, 248
Greaves, Walter (1846–1936), 127, 129, 140, 142, 182
 assistance in Peacock Room, 210, 212, 235, 248
Green, Edward (1831–1923), 161, 196
Green Dining Room (Morris, Marshall, Faulkner & Co.), 179–80, fig. 4.32
Grossmith, George (1847–1912), 177
Grosvenor Gallery, 148
 1877 exhibition, 208, 272, 274–75, 278
 1878 exhibition, 285
 1885 exhibition, 377 n185
Guest, Grace Dunham, 349, 353
Gump, A. L. (1869–1947), 378 n236

Haden, Annie (later Thynne) (1848–1937), 226

Haden, Deborah Whistler (1825–1908), 50, 62, 226, 375 n67
Haden, Francis Seymour (1818–1910), 56, 62
Hallé, Charles (1846–1914), 69
Hamerton, P. G. (1834–1894), 83
Hammond, H. H., 377 n189
Handley-Read, Charles (1918–1971), 355 n26
Hanna & Kent, photograph by, fig. 1.26
Hanson, Charles (Charlie) James Whistler (1870–1935), 133, 285
 and Peacock Room, 217, 219, 221
 Whistler's drypoint portrait of, 364 n130
Hanson, Louisa, 133
Hare, Augustus (1834–1903), 281–82
Harland, Edward J., engineer, 113
"Harmony in Blue and Gold. The Peacock Room" (Whistler, leaflet), 251–52, 375 n67, fig. 6.12
Harper's New Monthly Magazine, 26, 303–4
Harvey, John, 128
Havemeyer, Henry O. (1846–1907), and Louisine (1855–1929), 342
Haweis, Rev. Hugh Reginald (1835–1901), 268
 "Money and Morals," 268–69
Haweis, Mary Eliza (1852–1898), 150, 269, 371 n25
 The Art of Decoration, 192
Heath Old Hall (Jeckyll), 196, fig. 5.7
Hecker, Colonel Frank J. (1846–1927), 324, 327
Heinemann, William (1863–1920), 228
Henley, Bill (Lionel Charles) (1843?–1893), 158
Hennessy, W. J. (1839–1917), 179
Herbert, John Rogers (1810–1890), 115
Herter Brothers, Japanese Parlor, 293, fig. 7.2
Herzen, Aleksandr Ivanovich (1812–1870), 69
Hiffernan, Jo (Joanna Elizabeth), (1840?–?), 43–44
 correspondence of, 47
 as model, 53, 59, 62, 67, 73, 81, 98
 relationship with Whistler, 50, 75, 80, 133, 285
 and Whistler's son, 133, 217
Hiffernan, Patrick, 43–44
Hill, William Laurie, 50
Hind, C. Lewis (1862–1927), 308
Hiroshige. *See* Andō Hiroshige
Hobbs, Susan, 26, 361 n86
Hogarth Club, 251
Hokusai Katsushika (1760–1849), 87, 243, 346
 The Picturebook of Heroes (1837), 71–72
Holland Park, No. 1, 162–68, 191, 202, 261
 billiard room of, 165, 167, figs. 4.19, 4.20
 dining room of, 192, 374 n23, fig. 5.2
 Jeckyll's addition to, 163–64, fig. 4.14
 Jeckyll's furniture for, 164, 257, fig. 4.15

morning room (study) of, 164–65, 192, figs. 4.16, 4.18
 Morris & Co. decoration of, 164–65, fig. 4.17
Hollingsworth, A. T., 169, 333
Hollingshead, John (1827–1904), *The Grasshopper*, 278
Holmes, C. J. (1868–1936), 224, 257, 334
Hornet, 230
Howard, George (1843–1911), house at 1 Palace Green, 150
Howell, Charles Augustus (1840–1890), 285
 art dealings of, 60–61, 173, 280, 288
 and Leyland, 115, 129–30, 154, 168–69
 and Rossetti, 121, 137, 154, 168–69
 sale of "Owl Cabinet," 371 n52
 and *The Three Girls*, 285–86
Hubbell, Captain Henry S., 288
Huish, Marcus (1845–1921), 361 n85
Hunt, William Holman (1827–1910), 77
 The Awakening Conscience, 62, 64–65, fig. 1.18
Hunt, Violet (1866–1942), 152
Huth, Frederick (d. 1872?), 75, 185
Huth, Helen Rose Ogilvy (Mrs. Louis Huth) (1837–1924), 133
 Whistler's portrait of, 130–31, 136–37
Huth, Louis (1821–1905), 75, 81, 169
 porcelain ("Huth") jar of, 170

Illustrated London News, 83, 330
Impey, Oliver, 190
Ingres, Jean-Auguste-Dominique (1780–1867), 85
 La Source, 100, 361 n86
International Exhibitions, London
 1862 exhibition, 60, 160, 181
 1872 exhibition, 184
International Society of Sculptors, Painters, and Gravers, 318
Ionides, Aleco (Alexander) (1840–1898), 67, 100, 158, 163, 257
 See also Holland Park, No. 1
Ionides, Alexander Constantine (1810–1890), 67, 73, 232
Ionides, Chariclea (1844–1923), 73
Ionides, Constantine (1833–1900), 173
Ionides, Euterpe (1816–1892), 163
Ionides, Helen. *See* Whistler, Helen
Ionides, Isabella Sechiari (1853–1913), 164
Ionides, Luke (1837–1924), 44, 54, 67, 70, 282
 on Jeckyll, 205, 376 n99
 Whistler's portrait of, 125
Irving, Henry (1838–1905), Whistler's portrait of, 208, 274

Jackson, Lieutenant-Colonel Robert R., 296
Jacomb-Hood, G. P. (1857–1929), 288–89, 311, 326
James, David (1839–1893), 369 n137
James, Henry (1843–1916), 300
 The Outcry (1911), 382 n166

Jameson, Frederick (fl. 1859–89), 97–98, 103, 122, 286
Jamison, Kay Redfield, *Touched with Fire* (1993), 258
Japanese Parlor (Herter Brothers), 293, fig. 7.2
Japanese prints, 59, 60, 221, 239–40, figs. 5.32, 5.33, 6.5
 inspiration for Peacock Room, 221
 Whistler's collecting of, 59, 71, 221
Jarvis, Lewis (1845–1900), 264
Jeckell, George (d. 1878), 260, fig. 4.9
Jeckell, Henry, 27, 258–60
Jeckyll [Jeckell], Thomas (1827–1881), 20–21, 27–28, 158–68
 death of, 21, 260
 ecclesiastical architecture of, 158
 Elsing Hall, restoration of, 158
 and Flower, 208
 furniture by
 dressing table, 165, 257, fig. 4.15
 folding screen (attrib.), 221, fig. 5.31
 in Peacock Room, 255–57
 Heath Old Hall, restoration of, 196, fig. 5.7
 illness of, 27–28, 207, 257–59
 and 1 Holland Park, 367 n77
 addition to, 163–64, fig. 4.14
 billiard room, 165, figs. 4.19, 4.20
 furniture for, 165, 257, fig. 4.15
 morning room, 164–65, 206, figs. 4.16, 4.18
 and Ketteringham Church, 158
 and Prince's Gate dining room, 20, 27–28, 189, 205, 237, 259, 271, figs. 5.1, 5.18
 construction of, 195, 204–5, 261, 348
 departure from, 207
 furniture for, 255–57
 precedents for, 189–94, 196
 spindle shelving for, 194–95, 204–5, fig. 5.17
 and 62 St. Andrew's Street, Cambridge, 163, fig. 4.13
 Norwich Gates (1859–62), 160, 260, fig. 4.10
 Philadelphia pavilion (1876), 258, 260
 at Centennial International Exhibition, 198–202, 204, fig. 5.10
 drawings for, 27, 201, figs. 1, 5.11, 5.12
 embroidered panel for, 221, fig. 5.14
 at Exposition Universelle (1878), 199, fig. 5.8
 models for, 199–200, fig. 5.9
 sunflower railing of, 201–2, 204, fig. 5.13
 photograph of, fig. 4.9
 signature of, 162, fig. 4.12
 slow combustion stoves, 161–62, figs. 4.11, 4.12
 in Primrose Room, 261
 sunflower andirons, 35, 202, 325, figs. 5.14, 5.15

wallpaper frieze, fig. 5.14
 See also Barnard, Bishop & Barnards; Peacock Room
Jee, Ada Louise (d. 1871), 133, 143
Jee, Horace, 143
Jekyll, Gertrude (1843–1932), 161
John Bibby & Sons, 111–14
John Bibby Sons & Co, 114
Jones, Gussie (Augusta Maria), 98
Jones, Mary Emma, 360 n75
Jones, Millie (Emelie Eyre, later Robson), 98
Jones, Owen (1809–1874)
 Examples of Chinese Ornament (1867), 164
 The Grammar of Ornament (1856), 205
Jopling, Louise (1843–1933), 246, 248

Kaga ware, 264
Kennedy, E. G. (1849–1932), 306, 314
The Keramic Art of Japan (Audsley), 239–40, figs. 6.5, 6.6
Kitagawa Utamaro (1753–1806)
 Utamaro Painting a Hō-ō Bird in One of the Green Houses, 248–49, fig. 6.11
 Utanosuke of Matsubaya, 59, fig. 1.13
Knowles, James (1831–1908), 366 n38

lacquerware, Japanese, 181, 237, 239, figs. 4.34, 6.2, 6.4
 influence on Whistler of, 34, 181–82, 238–39, 264
La Farge, John (1835–1910), Japanese Parlor, 293
L'Artiste, 44
L'Art Moderne, 300
Laver, James, 27–28
Lawn, Robert, 113
Lee, Vernon [Violet Paget] (1856–1935), 271, 298, 314
Leeds Mercury, 247
Legros, Alphonse (1837–1911), 50, 58, 70
 Le Maître de chapelle, fig. 4.29
Lehmann, A. Frederick (1826–1891), 224
 See also Berkeley Square, No. 15
Leicester Galleries, 322
Leighton, Frederic (1830–1896), 100, 247
 Clytemnestra, 315
 Flaming June, 315
 Helios and Rhodos, 315
 A Syracusan Bride Leading Wild Beasts in Procession to the Temple of Diana, 153–54
 Venus Disrobing, 222
Leighton House, Arab Hall, 293, fig. 7.1
Lemere, H. Bedford (1864–1944), 304
 photographs by, figs. 4.6, 4.14, 4.17, 5.2, 6.15, 6.23
Lenoir, Helen (later D'Oyly Carte) (1852–1913), 298
Le Vau, Louis (1612–1670), 197
Leyland, Ann Jane (1805?–1877), 111, 117–18
 Whistler's drypoint portrait of, fig. 3.2

Leyland, Elinor (later Speed) (1861–1952), 27, 117, 283, 284, 296–97
 marriage of, 297
 Whistler's drypoint portrait of, 139, 142, fig. 3.26
 Whistler's pastel portrait of, 138–39, fig. 3.30
 Whistler's unfinished portrait of, 127, 138–39, 141–42, 209, 266, fig. 6.21
 pastel study for, 142, fig. 3.31
Leyland, Fanny (later Stevenson-Hamilton) (1857–1880), 117, 284, 296
 death of, 284
 Whistler's drypoint portrait of, 139, fig. 3.24
 Whistler's pastel portrait of, 138–39
 Whistler's unfinished portrait of, 127, 138–41
Leyland, Florence (later Prinsep) (1859–1921), 26, 117, 272, 284, 296–97, 302, 326–27
 marriage of, 296–97
 Whistler's drypoint portrait of, 139, fig. 3.25
 Whistler's pastel portrait of, 138–39
 Whistler's portrait of, 127, 139, 141–42, 209, 278–79, fig. 3.29
Leyland, Frances Dawson (1836–1910), 117, 128, 130, 296–97
 death of, 327
 and Freer, 327
 life of, 117, 119
 marriage of, 117, 139, 283–84, 296
 and Peacock Room, 210, 212–13, 269–70
 portraits of
 by anonymous, 134, fig. 3.22
 by Phil Morris, 279, fig. 3.22
 by Rossetti, 88, figs. 2.10, 2.11
 and Whistler, 20, 27, 124, 126, 133, 135–37, 269–73, 282–84
 Whistler's drypoint portrait of, 130, fig. 3.17
 Whistler's portrait of, 127, 130–31, 136–38, 140, 278, 279, 327, fig. 3.18
Leyland, Freddie (Frederick Dawson) (1856–?), 117, 135–36
 and death of F. R. Leyland, 296–97, 304
 in Leyland business, 284, 294
 marriage of, 284
 Whistler's friendship with, 130, 271–72, 376 n105
 Whistler's pastel portrait of, 138–39, fig. 3.23
Leyland, Frederick Richards (1831–1892), 20–21, 77–78, 109–21, 293–97
 art collection of, 77, 116, 153–54, 222, 305–6
 death of, 296–97
 estate of, 305–6, fig. 7.6
 life of, 27, 109–19
 musical interests of, 116
 patronage
 of Burne-Jones, 154, 247

of Liverpool artists, 77
of Moore, 100, 361 n89
of Rossetti, 77, 88, 117, 119, 130, 154, 168, 247
of Whistler, 88, 103–4, 138, 139
personal appearance of, 127–28
photograph of, 127, fig. 3.10
porcelain collection of, 35, 168–69, 264–65
purchase of *La Princesse*, 75, 145, 184–86
reputation of, 129–30
Rossetti's portraits of, 124, 284, 363 n88, figs. 3.8, 6.31
Whistler's caricatures of, 273, 280, figs. 6.25, 6.29, 6.30
as Whistler's creditor, 279–80
Whistler's portrait of, 20, 109, 122–26, 127–31, 136–38, 278, 280, 326, figs. 3.1, 3.6
 etching after, 129, fig. 3.15
 oil sketches for, 127, 141, figs. 3.11, 3.12
Whistler's sketches of, 128, fig. 3.14
See also Prince's Gate, No. 49; Queen's Gate, No. 23; Speke Hall; Woolton Hall. *See also under* Peacock Room; Whistler, works, *The Gold Scab*
Leyland, John (d. 1839?), 109–10
Leyland, John Elphick (1832?–?), 111
Leyland, Thomas Alexander (1839?–?), 111
Leyland family
 portrait of, 134, fig. 3.22
 at Speke Hall, 118–21, 133, 294
 Whistler and, 124, 133–36, 138–42
Leyland Line, 114, 131, 227, 294
Liberty, Arthur Lasenby (1843–1917), 171, 248, 277
Liberty & Co., 193, 251, 310
The Life of James McNeill Whistler (Pennell and Pennell), 22–26, 28, 96, 283, 351
Lind-Goldschmidt, Jenny (1820–1887), 207
Lindsay, Lady Blanche (1844–1912), 272
Lindsay, Sir Coutts (1824–1913), 148, 208, 272, 274–75
Lindsey Row, No. 2, 56, 59, 62, 73, 80, 97, 105
 photographs of, 149, 221, figs. 4.1, 4.2
Lindsey Row, No. 7, 50–51, 149
Little Doctor Faust (Gaiety Theatre), 278, 377 n176
Liverpool Academy, 77
Liverpool Art Club, 182, 238
Liverpool Institute, 112, 113
Lochnan, Katharine, 59, 133, 210
Lodge, John Ellerton (1876–1942), 350, 353
Loftie, W. J. (1839–1911), 171
 A Plea for Art in the House, 150
London, 253–54, 265
London Stereoscopic Company, photographs by, figs. 5.14, 6.10
Louise, Princess (1848–1939), 225, 227
Louise Henriette of Orange, 189–90

Louvre, 122
Lucas, George A. (1824–1909), 47–48, 92, 105
Ludovici, Albert (1852–1932), 297

MacDonald, Margaret, 100, 173, 242–43, 363 n109
Macfall, Haldane (1860–1928), 204, 309, 312
Macleod, Dianne Sachko, 27, 49, 77, 271, 366 n43
Manet, Edouard (1832–1883), 130
 Déjeuner sur l'Herbe, 48
Marchant, William S., art dealer, 290, 326, 328, 381 n150
Marks, Henry Stacy (1829–1898), 222
Marks, Murray (Emanuel) (1840–1918), 158, 169–77, 199, 304
 and Leyland, 179, 193, 296
 and Peacock Room, 193–94, 205–6, 211, 257, 265, 271, 293, 303
 photograph of, fig. 4.21
 and Rossetti, 169
 and Thompson, 171
 trade card of, 176–77, 216, fig. 4.27
 and Whistler, 172–77, 208
 See also A Catalogue of Blue and White Nankin Porcelain
Marot, Daniel (1661–1752), 190–91
Marquand, Henry G. (1819–1902), 333
Marquis d'Azeglio, 60
Marquis of Westminster, 225, 230
Marshall, Peter Paul (1830–1900), 121
Martin, Charles, photograph by, fig. 7.26
Martyn, Richard, 113
Mary II (1662–1694), 190
Maus, Octave (1856–1919), 300
Maximilian II Emanuel (1662–1726), 198
Mayer, Gustav, art dealer, 322–27, 329–31, 340
 See also Obach & Co.
Mazo, Juan Bautista del (1612/16–1667)
 Conde Duque de Olivares, Equestrian, 123
 Don Adrián Pulido Pareja, 130, fig. 3.16
Mazzini, Giuseppe (1805–1872), 69
Mechlin, Leila (1874–1949), 341
Menpes, Mortimer (1860–1938), 210, 231, 237, 244, 246, 251, 260
 Whistler as I Knew Him, 333–34
Mephistopheles, 278, 280
Meyer, Agnes (1887–1970), 343, 346
Michi, Nomura, 342
Michigan, University of, Exhibition of Oriental and American Art, 345–46, fig. 7.24
Miles, Frank (1852–1891), 297, 311–12
Millais, John Everett (1829–1896), 73, 226, 315
 Autumn Leaves, 115
 Waking, 365 n9
Millar, John, 257–58
Miller, Annie (1835–1925), 62
Miller, John (1798–1876), 77–78, 89, 115–16, 118, 121

Milnes, W. H. (1865–1957), illustration by, fig. 5.7
Mitchell, E. J., illustration by, fig. 7.10
Mitford, Algernon (later Lord Redesdale) (1837–1916), 236
Montesquiou-Fezensac, Comte Robert de (1855–1921), Whistler's portrait of, 300, 379 n32
Moody, F. W. (1824–1886), 220
Moore, Albert Joseph (1841–1893), 82–83, 99, 129, 242
 and F. R. Leyland, 100, 361 n9
 and Rossetti, 98
 signature of, 100, 102
 and Whistler, 74, 82–83, 94, 98, 100, 102, 361 n92
 working methods of, 90, 92
 works:
 Cartoon for the Peacock Frieze at 15 Berkeley Square, 224–25, fig. 5.37
 The Marble Seat, 82–83, fig. 2.4
 Pomegranates, 87, fig. 2.8
 Seagulls, 102–3, fig. 2.22
 Shells, 361 n89
 A Venus, 100, 105, 306, fig. 2.20; sketch for, 90, fig. 2.13; study for, 361 n86
Moore, Charles (1855–1942), 320, 344, 349
Morgan, J. Pierpont (1837–1913), 331, 379 n7
Morning Post, 246, 259, 330
Morris, Harrison S. (1856–1948), 318
Morris, Jane Burden (1839–1914), 71, 94, 121, 229, 284
Morris, Phil (Philip Richard) (1838–1902), 279
 Portrait of Frances Leyland, 279, fig. 6.28
 Portrait Study in Silver Tones, 377 n185
Morris & Co., 173, 207
 at 1 Holland Park, 164, fig. 4.17
Morris, Marshall, Faulkner & Co.
 Refreshment Room (Green Dining Room), South Kensington Museum, 179–80, fig. 4.32
 sideboard by, 256, 375 n83
 and Speke Hall, 120–21
 wallpaper designs of, 120–21
Morris, William (1834–1896), 148–51, 154, 163
 and 1 Holland Park, 163
 works:
 La Belle Iseult (Queen Guenevere), 71–72, fig. 1.27
 The Earthly Paradise, 96, 150
 Refreshment Room, South Kensington Museum, 179–80, fig. 4.32
 See also Morris & Co.; Morris, Marshall, Faulkner & Co.
Morse, Juliet M. (Mrs. Sydney), 365 n9, 371 n52
Morse, Sydney, 371 n52
Mr. Whistler's Exhibition (1874), 137–38, 150, 360 n79

Mr. Whistler's "Ten O'Clock" (Whistler). *See*
 "Ten O'Clock" lecture
Mulready, William (1786–1863), 248
Murch, Arthur (fl. 1850–51), 97
Musée du Luxembourg, 290, 330
Muthesius, Hermann (1861–1927), 178–79,
 197
 The English House, 332

National Archaeological Society, 342
National Art Collections Fund, 329
National Art Collections Society, 329
National Gallery, London, 122, 334
National Geographic, 349
National Portrait Exhibitions, 365 n167
Nelsen, Peter, renderings by, figs. 5.18,
 5.38
Nesfield, William Eden (1835–1888),
 102–3, 161
New York Daily Tribune, 238, 268
New York Herald, 143–44, 186, 330
 on Peacock Room, 335, fig. 7.19
Nieuhof, Johan (1618–1672), 197
Nocturnes, 126, 221, 235, 313. *See also under*
 Whistler, works
Norfolk and Norwich Archaeological
 Society, 158
Northumberland House, 178
 Percy staircase, 178, 315, fig. 4.30

Obach & Co., art dealers
 exhibition of Peacock Room, 32, 158,
 329–30, 332–33
 The Peacock Room (sale cat.), 317, 325,
 334–35, fig. 7.13
 sale of Peacock Room, 24, 26, 170, 195,
 322–23, 327, 340, fig. 7.18
 sale of staircase panels, 369 n152
Observer, 53, 196, 247, 251
O'Leary, John (1830–1907), 53, 80
Oranienburg Palace, 189–91
Orchard, B. G., 109, 112, 113, 116, 117,
 128, 130
 "Victor Fumigus," 109
Orrock, James (1829–1913), 176
Osborn & Mercer, real-estate agents, 304
"Owl Cabinet," 371 n52

Paget, Violet. *See* Lee, Vernon
Pagodenburg, 198
"The Palace of Art," 147–48 (Tennyson),
 148 (*Punch*)
Palace Green, No. 1, 150
Pall Mall Budget, 311–12
Pall Mall Gazette, 138, 252, 329
Palmer, Emma (1835?–?), 373 n140
Palmer, Potter (1826–1902), and Berthe
 Honoré Palmer (d. 1918), 318
Parke, Louisa, 283
Parsons, J. R., photograph by, fig. 3.10
Patience (Gilbert and Sullivan), 177
Peacock Room, plates 1–4, fig. 6.20
 Beardsley's illustration of, 308, fig. 7.8

ceiling of, 195–97
 sketches of, 216–17, 237, 379 n25,
 figs. 5.26, 6.1
conservation of (1989–92), 34–35,
 figs. 8, 9
construction of, 195, 204–5, 261, 348
cornice of, 212, 214, fig. 5.23
creation of, 210–57, 262–65, 270
in Detroit, 340–45, figs. 7.22, 7.23
doors of, 211, 212, 264, figs. 5.20, 5.21
at the Freer Gallery, 25, 30–35, 347–53,
 figs. 3, 4, 5, 6, 7, 7.26, 7.27
furnishing of, 255–57, figs. 6.14, 6.15,
 6.23, 7.5
Godwin's sketches of, 252, fig. 6.13
historiography of, 19–35, 300–2, 322,
 329–35
leaflet describing, 251–52, 375 n67, fig.
 6.12
leather in, 194–95, 205, 210–12, figs.
 5.4, 5.5, 5.6, 5.16
Leyland's opinion of, 265, 271
National Geographic reproduction of
 (1923), 349, fig. 7.26
newspaper illustrations of (1904),
 335–36, figs. 7.19, 7.20
peacock mural in, 238–46, fig. 6.3
 cartoon for, 242–43, fig. 6.9
 sketches of, 242, 273, 297–98, figs.
 6.8, 6.24, 7.3, 7.4
 sources for, 239–42, figs. 6.4, 6.5, 6.6,
 6.7
porcelain in, 20, 30, 35, 168, 189, 204,
 211, 214, 215–16, 264–67, 271,
 305
 Freer and, 316, 343
 substitution of pottery, 343–44,
 349–50, 351–52
at 49 Prince's Gate, 255–56, 267, 271,
 303–5, 317, 335, figs. 5.6, 6.22,
 6.14, 6.15, 6.23, 7.5, 7.13
publicity of, 222, 226, 246–54, 267–68
 with Freer's gift, 342
 at 1904 sale, 329–33, 335–36
 after Whistler's departure, 298,
 302–03
renderings of
 with Jeckyll's decorations (April
 1876), 189, 205, figs. 5.1, 5.18
 in October 1876, 230, fig. 5.38
restoration of (1947–50), 30–34, 348,
 figs. 6, 7
sale of
 to Freer (1904), 319, 322–31, 327, fig.
 7.18
 with 49 Prince's Gate (1892), 24,
 304–06
 to Watney (1894), 314–16
shutters of, 218, 222, 229, 270, figs.
 5.28, 5.29, 5.30
 illustration of, fig. 7.10
 sketches of, 218, 297–98, figs. 5.27,
 7.3, 7.4
 sources of, 219–21, figs. 5.32, 5.33

sideboard in, 256–57, fig. 6.16
spindle shelving of, 204–5, 227–28, 264,
 fig. 5.17
sunflower andirons, 202, figs. 5.14, 5.15
visitors to, 225–26, 230, 236, 247–49,
 251, 298–300
 See also Cole, Alan S.; Godwin, E. W.
wall decoration, sketches of, 214, 237,
 379 n25, figs. 5.23, 6.1
 See also Jeckyll, Thomas
peacocks
 in Beardsley's work, 311, fig. 7.11
 on Chinese porcelain, 215, fig. 5.25
 in the Freer Gallery courtyard, 353, fig.
 7.28
 in Japanese art, 219–21, figs. 5.32, 5.33
 at the London zoo, 219
 in Victorian art, 223–24
 and wallpaper, 223, fig. 5.35
Pellegrini, Carlo (1839–1889), 278
Pennell, Elizabeth Robins (1855–1936), 22,
 233, 307, 308, 326
 The Life of James McNeill Whistler (1908),
 22–26, 28, 351
 visit to Freer Gallery, 349
 "Whistler as a Decorator" (1912),
 149–51
 The Whistler Journal (1921), 23–24, 26,
 143, 282
Pennell, Joseph (1857–1926), 22, 233, 326
 on Beardsley, 310
 on the Freer Gallery, 347
 The Life of James McNeill Whistler (1908),
 22–26, 28, 351
 "Whistler as a Decorator," 149–51
 The Whistler Journal (1921), 23–24, 26,
 282
Pennell Whistler Collection, 24, 27, 311,
 375 n67
Pennington, Harper (1855–1920), 214,
 236–37, 297, 334
Pennsylvania Academy, 318
Percy staircase, 178, 315, fig. 4.30
Pevsner, Nikolaus (1902–1983), 26, 158,
 198
Pewabic Pottery, 343, 346
Philadelphia Centennial Exposition. *See*
 Centennial International Exhibition
Philip, Beatrice. *See* Whistler, Beatrix
Philip, Rosalind Birnie (1873–1958)
 and Freer, 242–43, 316, 321, 323–24,
 326–28, 331, 336, 340–42, 346
 as Whistler's heir and executor, 26, 283
Philip IV (1605–1665), 122, 127, 278
 Velázquez portraits of, 122, 127, figs.
 3.5, 3.13
Philipson, Morris, 371 n34
Piccadilly, 296
Platt, Charles Adams (1861–1933), 347–39
Plimsoll, Samuel (1824–1898), 294
Plumbing and Decorating Chronicle, 301–2
Polignac, Prince Edmond de, 300
Pope, Alfred Atmore (d. 1913), 314

porcelain, Chinese blue-and-white
 dish with peacock decoration, 215, fig.
 5.25
 of Kangxi era, 30, 53, 62, 204
 Rossetti and, 60–62, 66, 168–72, 216
 Victorian collecting of, 168–77
 Whistler's designs for, 172–73, 368
 n121, fig. 4.23
 Whistler's interest in, 19, 20, 53–55, 60,
 66, 159–50, 169, 172–74
 Whistler's sketches of, 173, fig. 4.24
 See also A Catalogue of Blue and White
 Nankin Porcelain
 See also under Alexander, William
 Cleverly; Aubrey House; Leyland,
 Frederick Richards; Peacock Room;
 peacocks; Thompson, Sir Henry;
 Whistler, works, La Princesse du pays
 de la porcelaine
Porcelain Pagoda of Nanking, 197
Poussin, Nicolas (1594–1665), Et in Arcadia
 Ego, 87, fig. 2.9
Poynter, E. J. (1836–1919), 70, 97–98, 223,
 226, 247, 276
Pozzi, Samuel (1846–1918), 300
Pre-Raphaelite Brotherhood, 48, 71, 103
Presley, Elvis (1935–1977), decoration at
 Graceland, 29
Primrose Room, 261–62, fig. 6.17
Prince's Gate, No. 49, 147–48, 153, 154–58
 Beardsley's visit to, 307–9, fig. 7.7
 drawing rooms (and Italian room),
 156–57, 247, figs. 4.6, 4.7, 4.8
 sale of
 in 1892, 297, 304–06
 in 1894, 314–16
 stair hall of, 178–83
 paintings in, 179
 Percy staircase for, 178, 247, fig. 4.30
 photograph of, 178, 183, 193, fig. 4.29
 Whistler's decorations for, 178–83,
 369 n152, figs. 4.31, 4.33, 4.36
 study of, 116, 193, fig. 5.3
 Blanche Watney and, 21, 314–16,
 322–25, fig. 7.17
Prince's Gate, No. 52, 222, fig. 5.34
Prinsep, Anthony Leyland (1888–1942), 27
Prinsep, Florence. See Leyland, Florence
Prinsep, Sarah, 154
Prinsep, Val (Valentine Cameron)
 (1838–1904), 60, 94, 311
 on Leyland, 112–13, 115–17, 271, 283
 and Leyland estate, 26–27, 306, 312
 in Leyland family, 154, 276, 284, 297,
 301
 on Leyland's death, 296
Projects (so-called Six Projects), 67, 95–97,
 98, 137, 338
Punch
 "Aptly Quoted from the Advertisement
 Column," 170, fig. 4.22
 "A Bird's Eye View of the Future," 254
 chinamania series, 170

"Intellectual Epicures," 65, fig. 1.19
"The Palace of Art: New Version," 148
"Punch's Advice to Ladies," 357 n64
"The Six-Mark Tea-Pot," 51, 53, fig. 1.7
"Welcome, Little Stranger!" 274, fig.
 6.26

Queen, 253
Queen's Gate, No. 23, 153–54

Radford, Francis, 163
Rae, George (1817–1902), 78
Rainbow-Music (Campbell), 301
Rance, Henry, 162, 164
Reade, Brian, 311
Reader, 71
Red House (Morris), 148
Reid, Alexander (1854–1928), 306–7, 314,
 317–18, 328
Reitlinger, Gerald (1900–?), 149
Rembrandt (1606–1669), 127
 The Night Watch, 53
Rhead, Louis J. (1857–1926), Le Journal de la
 Beauté, 29, fig. 2
Rhoades, Katharine (1885–1965), 25, 351,
 353
Ridley, Matthew White (1837–1888), 70
Ritchie, Lady. See Thackeray, Anne
Robertson, W. Graham (1867–1948), 69,
 157, 195–96, 285, 315
Robinson, Lionel, 213, 226, 296, 298, 306,
 314, 335
Robson, Frederick Henry, 360 n75
Rose, James Anderson (1819–1890), 60, 75,
 141, 226, 280
Rosen, Charles, 48
Rossetti, Dante Gabriel (1828–1882),
 48–49
 and Chinese porcelain, 60–62, 66,
 169–72, 216
 decorating firm of, 120–21
 frames by, 56, 161, 358 n97
 and Japanese art, 59–60
 and Leyland, 77–80, 111, 115, 153,
 271–72, 275, 280, 294
 commissions from, 77–80, 88, 93, 119,
 282
 friendship, 117
 letters to, 312
 portraits of, 124, 284, 363 n88, figs.
 3.8, 6.31
 and Speke Hall, 121
 and The Little White Girl, 65
 and Marks, 172, 177
 on Moore, 98
 patrons of, 115, 229
 on Peacock Room, 229
 photograph of, fig. 1.5
 and 49 Prince's Gate, 156
 and La Princesse, 74–75
 and Traer, 360 n51
 at Tudor House, 50, 117
 and Whistler, 48–51, 64, 70, 71, 74–75,
 95

on Whistler's exhibition of 1874,
 137–38
on Whistler's works, 288
working method of, 67
works:
 The Blue Bower, 61–62, fig. 1.15
 Bocca Baciata, 49–50, fig. 1.4
 A Christmas Carol, 77, 88
 Fazio's Mistress, 77–78
 Found, 80
 Frederick Leyland (1870), 124, fig. 3.8
 Frederick Richards Leyland (1879), 284,
 fig. 6.31
 La Ghirlandata, 130
 The Girlhood of Mary Virgin, 65
 Head of Frederick Leyland (1870), 363
 n88
 Lady Lilith, 78–80, 88, 93, 115, 306,
 fig. 2.2
 Lady Lilith (attrib., with Dunn), 80,
 115, fig. 2.1
 The Loving Cup, 88, 115, fig. 4.29
 Monna Rosa (Portrait of Frances Leyland),
 88, 306, fig. 2.11; study for, 88, fig.
 2.10
 La Pia de' Tolomei, 94, 306, fig. 4.29
 Sibylla Palmifera, 78
 The Wine of Circe, fig. 4.29
 Woman Combing Her Hair, 79, fig. 1.22
Rossetti, William Michael (1829–1919), 48
 and aestheticism, 60
 on Dante Gabriel Rossetti, 93, 173
 and Jeckyll, 162, 259
 on the Leylands, 117, 283–84
 and Peacock Room, 219, 253, 300
 on the Spartalis, 69–70
 and Traer, 360 n51
 and Whistler, 48–49, 59, 81, 133–34,
 229
 on Whistler's works, 54, 56, 67, 94–95,
 105, 141, 149, 208
 works:
 "Japanese Woodcuts," 71–72
 Notes on the Royal Academy Exhibition,
 1868, 94
Rothenstein, William (1872–1945), 298–99
Rothschild, Lady Louisa de (1821–1910),
 191
Royal Academy, London, 48, 56, 64, 65,
 81, 82, 88, 274
 and Chantrey bequest, 329–30
 1868 exhibition, 93
 1869 exhibition, 100, 104–5
 1870 exhibition, 105, 107
 1872 exhibition, 136
 1874 exhibition, 361 n89
 1878 exhibition, 279
 Exhibition of Works by the Old Masters
 (1876), 123
 Rossetti memorial exhibition, 294
 Thompson exhibiting at, 172
Royal Botanic Gardens, Kew, 198
Royal Pavilion Gallery, 186

Royal School of Art Needlework, folding
 screen by, 221, fig. 5.31
*Royal Society of British Artists Winter
 Exhibition* (1887–88), 359 n43
Ruskin, John (1819–1900), 64, 160
 and critique of Whistler's work, 274
 and *Whistler v. Ruskin*, 26, 51
Russell, Lord Charles (1832–1900), 283

Saarinen, Aline (1914–1972), 331
Saint-Victor, Paul de (1827–1881), 66
Sala, G. A. (1828–1895), 201
Salomé (Wilde), 311–12
Salon, Paris, 44, 47–48, 66, 72, 73–74, 85,
 105, 184
Salon des Refusés, Paris, 43, 48, 50, 59, 97
Salting, George (1836–1909), 368 n107
Sambourne, Edward Linley (1844–1910),
 "Welcome, Little Stranger!" 274,
 fig. 6.26
Samet, Wendy, 34
Sandys, Frederick (1829–1904), 50–51, 81,
 376 n99
 and Jeckyll, 161, 191
 works:
 Proud Maisie, 360 n75
 Valkyrie, fig. 4.29
Sargent, John Singer (1856–1925), 300,
 314–15, 330
Satsuma vase, 240–41, fig. 6.6
Savage, Kirk, 288
Schloss Charlottenburg, 190
Schreiber, Lady Charlotte (1812–1895),
 170
Schubert, Franz Peter (1797–1828), *Moments
 musicaux*, 94, 143
Scotson-Clark, G. F. (1872–1927), 307–9
Sechiari, Isabella (later Ionides)
 (1853–1913), 164
Shaw, Richard Norman (1831–1912), 171
 Design for Ceiling of Drawing Room, 157, fig.
 4.8
 frames designed by, 176
 and Marks, 169, 295
 and 49 Prince's Gate, 157–58, 294
 and Villette, 295
Siddal, Elizabeth (Lizzie) Eleanor
 (1829–1862), 71, 73, 80, 371 n55
Silver, Arthur (1853–1896), "Peacock
 Feather," 310
"The Six-Mark Teapot" (du Maurier), 51,
 53, fig. 1.7
Six Projects. *See* Projects
Sixth Exhibition of the Society of French Artists,
 150
Smalley, G. W. (1833–1916), 226, 238,
 261–62, 268
Smith, Albert, 200
Smith, Alison, 100
Smith, Eustacia (Martha Mary Dalrymple)
 (d. 1919), 222
 art collection of, 222
 52 Prince's Gate, boudoir of, 222, fig.
 5.34

Smith, Sarah Phelps, 93
Smithson, Sir Hugh (1711/12–1786), 178
Smithson, James (1765–1829), 178
Smithsonian Institution, 26, 178, 346, 350
Société des Beaux-Arts, Glasgow, 307
Society, 301, 369 n140
Society of French Artists, 150
Society of Portrait Painters, 72, 317
Somers-Cocks, Charles, Lord (1819–1883),
 154
Sotheby's, London, 288
South Kensington Museum (later Victoria
 and Albert Museum), 27, 329
 Grill Room (East Dining Room), 223
 Refreshment Room (Green Dining
 Room), 179–80, fig. 4.32
 Whistler's commission for, 183
Spanish leather. *See* Dutch gilt leather
Spartali, Christina (later le comtesse
 d'Anvers) (1845?–1884), 69–70
 portrait of, 358 n95
 photographs of, figs. 1.26, 1.28
 and *La Princesse*, 70, 72–73
Spartali, Euphrosyne Valsami, 69
Spartali, Marie (later Stillman)
 (1844–1927), 69–75, 111, 150, 248,
 251, 275
 Christina, 358 n95
Spartali, Michael (1819–1914), 69, 70, 72
Speed, Elinor. *See* Leyland, Elinor
Speed, Francis Elmer, 297
Speke Hall
 Freer at, 326
 history of, 118
 Leyland's decoration of, 120–21
 Leyland's lease of, 118–19, 294
 Leyland's restoration of, 118–20
 Leyland's silver service for, 118, fig. 3.4
 photograph of (1867), fig. 3.3
 Rossetti at, 121
 Whistler at, 122, 124–26, 131, 133,
 141, 142, 143, 182
 Whistler's etchings of, 124, fig. 3.7
Spencer-Stanhope, John Rodham
 (1829–1908), *Thoughts of the Past*, 48
Spielmann, Marion H. (1858–1948), 162
Spode, Josiah (1754–1827), 200, 205
 willow pattern, 200, fig. 5.9
Sprot, James, 118
Standard, 332
Star, 24, 333–34
Stephens, F. G. (1828–1907), 62, 74–75,
 83–84, 115, 294, 318
Stevenson-Hamilton, Francis Herbert
 Leyland (1880–1949), 296
Stevenson-Hamilton, James (1838–1926),
 284
Stillman, Marie. *See* Spartali, Marie
Stillman, William J. (1828–1901), 70
Stokes, Elizabeth, 353
Stoner, Joyce Hill, 34
Story, Waldo (1854–1915), 299
Stratemeyer & Teetzel Co., decorators, 347

Stratton, Mary Chase Perry (1867–1961),
 343
Stripe, H. E. (1813–?), 111–13, 115, 155,
 282
Stubbs, Burns A. (d. 1964), 25–27, 33
Studd, Arthur (1863–1919), 298–99
Studio, 310, 332, 334
Sun (New York), 335
Sutherland, Thomas, 155, 228, 279
Sutton, Denys, 23, 67, 243
Swain, George R., photographer, fig. 7.22
Sweet, Frederick (1903–?), 29
Swinburne, Algernon Charles (1837–1909),
 49–51
 collaboration with Whistler, 65–66
 photograph inscribed to, 65, fig. 1.21
 photograph of, fig. 1.5
 and Rossetti and Whistler, 49–51, 60
 on Whistler's work, 77, 82, 86, 92, 94,
 103–4
 works:
 Atalanta in Calydon, 65
 "Laus Veneris," 96
 Notes on the Royal Academy Exhibition,
 1868, 94
Symons, Arthur William (1865–1945), 235,
 288

Talbert, Bruce James (1838–1881), *The
 Sunflower*, 372 n72
Tanagra figurines, 100
Tannhäuser legend, 96
Tate Gallery, 329
Taylor, Hilary, 29–30
Taylor, Tom (1817–1880), 184, 197,
 218–20, 242, 252
Teall, Gardner (1878–?), 211, 245
Tebbs, Henry Virtue (d.1899), 359 n49
Teck, Prince (Duke) of, 225
"Ten O'Clock" lecture (Whistler), 20, 43,
 55, 66, 87, 88, 123–24, 235, 262,
 302, 320, 344, 354 n2
Tennyson, Alfred, Lord (1809–1892), "The
 Palace of Art," 147–48
Terry, Fred (1864–1932), 369 n137
Thackeray, Anne (later Lady Ritchie)
 (1837–1919), 149, 248–49
Thompson, Sir Henry (1820–1894)
 exhibition invitation, 176–77, fig. 4.28
 porcelain collection of, 172, 174, 333
 See also A Catalogue of Blue and White
 Nankin Porcelain
Thomson, D. C. (1855–1930), 232, 304–6,
 314–15
Thoré, Théophile [Willem Bürger]
 (1807–1869), 66
Thornton, Peter, 191
Thynne, Annie. *See* Haden, Annie
Tibbles, Tony, 362 n58
The Times, 65, 182, 184, 197, 252, 278,
 294, 327
Titcomb, William Caldwell (1882–1963),
 poster by, fig. 7.24
Tofte Manor, 264

Toole, John Laurence (1830–1906), 369 n137

Traer, James Reeves (d. 1867), 93, 359 n50, 360 n51

Tree, Herbert Beerbohm (1853–1917), 369 n137

Trench, Richard (1807–1886), 147

Trianon de Porcelaine, Versailles, 197

Trilby (du Maurier), 357 n65

Truth, 335

Tryon, D. W. (1849–1925), 326, 331

Tsarskoe Selo, 190

Turner, Joseph Mallord William (1775–1851), 116

Tweedie, Ethel (d. 1940), 210, 248

Twenty Minutes under the Umbrella (Dubourg), 207

University of Delaware. *See* Delaware, University of

University of Michigan. *See* Michigan, University of

Utamaro. *See* Kitagawa Utamaro

Valparaíso, Chile, Whistler in, 80–81, 83

Valsami, Euphrosyne (later Spartali), 69

Vanderbilt, William H. (1821–1885), Japanese Parlor, 293, fig. 7.2

van Galen, Emanuel Marks, 169

Vanity Fair, 253–55

Vasari, Giorgio (1511–1574), 157

Velázquez, Diego Rodríguez de Silva y (1599–1660)
 influence on Whistler of, 122–24, 127, 130, 138, 142, 278
 works:
 The Corregidor of Madrid (attrib.), 123
 Las Meninas, 124
 Pablo de Vallodolid, 139
 Philip IV (full length), photograph from Whistler's collection, 127, fig. 3.13
 Philip IV (head of), 122, fig. 3.5
 Philip IV Hunting Wild Boar ("*La Teal Real*"), 122
 See also Mazo, Juan Bautista del

"Verdict for plaintiff," 277, fig. 6.27

Verity & Sons, 197, 277–78, 377 n176

Victoria and Albert Museum, 322. *See also* South Kensington Museum

Villette (The Convent), 295–97

Vinton Company, 341

Wagner, Richard (1813–1883), 97, 116
 Tannhäuser, 97

Walker, John (1906–1995), 30

Waller, Pickford (1849–1930), 376 n122

Warrington, L. G., 340

Watanabe, Toshio, 59, 204

Watney, Blanche (1837?–1915), 21, 314–17, 343

Watney, Vernon (1860–1928), 314, 366 n46

Watt, Adelaide (1857–1921), 118, 294

Watt, Richard II (d. 1796), 118

Watt, Richard V (1835?–1865), 118

Watt, William, exposition stand, 261–62, fig. 6.17

Watts, G. F. (1817–1904), 154, 232

Watts-Dunton, Theodore (1832–1914), 228–30, 278, 284–85, 377 n159
 Aylwin, 128, 277

Way, Thomas (1837–1915), 90, 251

Way, T. R., Jr. (1861–1913)
 The Art of James McNeill Whistler, 322, 333
 and Freer, 321
 on Leyland/Whistler relationship, 211, 228, 269–70
 and Whistler liquidation, 280
 and Whistler's works, 77, 98–99, 304
 on Whistler's work, 281, 286–87, 141–42, 278

Webb, Philip (1831–1915), 150, 163, 256
 Refreshment Room, South Kensington Museum, 179–80, fig. 4.32

Weir, J. Alden (1852–1919), 174

Whibley, Ethel (1861–1920), 324, 327

Whistler, Anna McNeill (1804–1881), 50
 on W. C. Alexander, 151
 correspondence with Leyland, 104
 correspondence with J. M. Whistler, 225–26
 on creation of Peacock Room, 210, 212, 217
 descriptions of Whistler's works and working methods, 53–54, 56, 58, 67, 71, 77, 81, 89, 104, 106, 124, 125–26, 136, 141, 209, 277
 illness of, 141
 and Leyland's portrait, 129
 residing with Whistler, 50–51, 59, 62, 73, 80, 97, 98, 131
 at Speke Hall, 122
 Whistler's portrait of, 35, 125–27, 131, 136, 138, 280, 290, 318, 329–30

Whistler, Beatrix (christened Beatrice, 1855–1896), 252, 306–7, 328

Whistler, Helen (Nellie) Ionides (1849–1917), 73, 282–83, 291

Whistler, James McNeill (1834–1903)
 art education of, 85–86, 105, 137
 and Chinese porcelain, 19, 20, 51, 53–54, 60, 66, 149–50, 169, 172–74
 commissions, 88–89, 183, 316, 320
 death of, 321, 331
 frames by, 55–56, 65, 142–43, 161, 182, 212, 279, 288, 368 n93, figs. 1.1, 1.8, 1.21, 5.22, 6.33, 7.15
 and Freer, 319–21
 health of, 212–13
 influence of Velázquez on, 122–24, 127, 138, 142, 278
 and Japanese art, 19, 34, 149, 180–82, 238–42, 264
 and Jeckyll, 158–60, 162
 and Frances Leyland, 20, 124, 126, 133, 135–37, 269–73, 282–84

and Frederick Leyland, 20, 88, 103–4, 116, 122, 138–39, 209–10
 patrons of, 58, 264, 277
 personal appearance of, 244–45
 photographs of, 51, 244, 290, figs. 1.6, 6.10
 portraits of
 by anonymous, 134, fig. 3.22
 by Fantin-Latour, 74, fig. 1.29
 on invitation, 176–77, fig. 4.28
 realist style of, 44, 54
 residences of
 Lindsey Row, No. 2, 131, 149, 151, 172, 179–80, 221, figs. 4.1, 4.2
 Lindsey Row, No. 7, 50–51
 Queen's Road, Chelsea, 50
 Rotherhithe, 44, 158
 White House, Tite Street, 261–62, 280–81, 283, 285–88
 self-portraits by, 327, fig. 2.5
 signature of, 55, 74, 83, 262
 butterfly monogram, 55, 74, 100, 102, 107, 162, 277, 280, 287
 in Valparaíso, Chile, 80–81, 83

Whistler, James McNeill (1834–1903), works
 drawings and watercolors:
 Baby Leyland (M517), 142, fig. 3.30
 The Blue Girl (M521), 142, fig. 3.31
 Caricature of F. R. Leyland (M720), 280, fig. 6.30
 Cartoon for the Peacock Mural (M584), 242–43, fig. 6.9
 A Catalogue of Blue and White Nankin Porcelain, illustrations for (M592–651), 53, 61, 173, 173–75, figs. 1.9, 1.14, 4.25, 4.26
 Ceiling Designs and a Wall Elevation of the Peacock Room (M989), 237, fig. 6.1
 Design for Wall Decoration for Aubrey House (M491), 152–53, fig. 4.4
 Designs for Plates (M591), 172–73, 368 n121, fig. 4.23
 Designs for the Dining Room (M579a–d), 214, 216–17, figs. 5.23, 5.26
 Designs on the Shutters (M580), 218, fig. 5.27
 Elizabeth Dawson, Full Face (M441), 134, fig. 3.21
 "*F. R. L.*" . . . *frill!* (*Caricature of F. R. Leyland*) (M719), 273, fig. 6.25
 "*F. R. L.*" *frill—of Liverpool* (M718), 280, fig. 6.29
 Fighting Peacocks (M583), 273, fig. 6.24
 Freddie Leyland Seated (M508), 138–39, fig. 3.23
 A Lady with a Parasol (M459), 183, fig. 4.37
 The Lily (M364), 86, 359 n26
 Nude Study for "The Three Girls" (M359), 99, fig. 2.17
 Plans for installing porcelain in the dining room at Aubrey House (M487), 152, fig. 4.3

Portrait Study of Frederick R. Leyland (M425), 128, fig. 3.14

Sketches of Blue-and-White Porcelain (M592), 173, fig. 4.24

Sketches of "The Gold Scab" (attrib.; M1602), 311–12, fig. 7.12

Sketches of the Peacock Room (M1581), 298, fig. 7.4

Sketch of a Shutter and Fighting Peacocks (M1603), 297, fig. 7.3

Sketch of Peacocks on the Wall of the Peacock Room (M582d), 242, fig. 6.8

Sketch of "Symphony in White, No. 3" (M323), 81, fig. 2.3

Sketch of the Stair Hall at 49 Prince's Gate (M577), 183, fig. 4.36

Sketch of the Staircase at 49 Prince's Gate (M578), 179, fig. 4.31

Souvenir of Velázquez (M653), 123

Standing Figure with a Fan (M532), 139, fig. 3.27

Standing Nude (M357), 100, 361 n86, fig. 2.18

Study for Frances Leyland's Dress (M430), 131, fig. 3.19

Study for "Tillie: A Model" (M369), 105, fig. 2.23

Study in Grey and Pink (M470), 141, fig. 3.28

Study of The Three Girls (M361), 90, 102, fig. 2.12

Venus (M357). See *Standing Nude*

Woman in a Japanese Dress Painting a Fan (M460), 183–84, fig. 4.38

etchings:
The Boy (K135), 364 n130
Chelsea Bridge and Church (K95), 363 n86
Elinor Leyland (K109), 139, fig. 3.26
F. R. Leyland (K102), 129, fig. 3.15
Fanny Leyland (K108), 139, fig. 3.24
Florence Leyland (K110), 139, fig. 3.25
Leyland's Mother (K103), fig. 3.2
Maud Standing (K114), 364 n126
La Mère Gérard (K11), 47, fig. 1.3
La Rétameuse (K14), 47
The Silk Dress (K107), 134
Speke Hall (K96), 124, fig. 3.7
Speke Hall, No. 2 (K143), 363 n86
Tillie: A Model (K117), 361 n102
The Velvet Dress (Mrs. Leyland) (K105), 130–31, fig. 3.17

oil paintings:
Arrangement in Black: Portrait of F. R. Leyland (Y97), 20, 109, 122–26, 127–31, 136–38, 179, 278, 280, 326, figs. 3.1, 3.6
 etching after, 129, fig. 3.15
 oil sketches for, 127, 141, figs. 3.11, 3.12
 title of, 363 n110
Arrangement in Black, No. 2: Portrait of Mrs.

Louis Huth (Y125), 130–31, 133, 136–37
Arrangement in Black, No. 8: Portrait of Lois B. Cassatt (Y250), 299
Arrangement in Black and Brown: The Fur Jacket (Y181), 318
Arrangement in Black and Gold: Comte Robert de Montesquiou-Fezensac (Y398), 300, 379 n32
Arrangement in Flesh Colour and Grey. See *La Princesse du pays de la porcelaine*
Arrangement in Flesh Colour and Grey: The Chinese Screen (Y51), 358 n107
Arrangement in Grey: Portrait of the Painter (Y122), 54, 374 n23, fig. 5.2
Arrangement in Grey and Black: Portrait of the Painter's Mother (Y101), 35, 125–27, 136, 138, 280, 290, 318, 329–30
Arrangement in Grey and Black, No. 2: Portrait of Thomas Carlyle (Y137), 35, 129, 131, 137–38, 274, 277, 290, 317
Arrangement in White and Black (Y185), 131, 328, fig. 3.20
At the Piano (Y24), 47, 54, 85
The Balcony. See *Variations in Flesh Colour and Green: The Balcony*
Battersea Reach (Y45), 357 n50
Blue and Silver: Screen, with Old Battersea Bridge (Y139), 182, fig. 4.35
The Blue Girl: Portrait of Elinor Leyland (Y111), 142
 fragments from, 266, fig. 6.21
 study for, 142, fig. 3.31
Brown and Silver: Old Battersea Bridge (Y33), 67, 69
Butterfly Cabinet. See *Harmony in Yellow and Gold*
Caprice in Purple and Gold: The Golden Screen (Y60), 59, 67, 182, 370 n10, fig. 1.12
Chelsea in Ice (Y53), 67
Crepuscule in Flesh Colour and Green (Y73), 85
Crepuscule in Opal: Trouville (Y67), 97
Girl with Cherry Blossom (Y90), 145, 286, fig. 3.32
The Gold Scab: Eruption in Frilthy Lucre (Y208), 21, 143, 276, 287–91, 311, fig. 6.33
 sketch of, fig. 7.12
The Golden Screen. See *Caprice in Purple and Gold*
Harmony in Amber and Black. See *Portrait of Miss Florence Leyland*
Harmony in Blue and Gold: The Little Blue Girl (Y421), 320–21, fig. 7.15
Harmony in Blue and Gold: The Peacock Room. See *Peacock Room*
Harmony in Blue-Green—Moonlight. See *Nocturne in Blue and Silver*
Harmony in Green and Rose: The Music Room (Y34), 54

Harmony in Grey and Green: Miss Cicely Alexander (Y129), 129, 137–38, 312
Harmony in Yellow and Gold: The Butterfly Cabinet (Y195), 262, 264, figs. 6.18, 6.19
 as Primrose Room, 261–62, fig. 6.17
The Lange Lijzen. See *Purple and Rose: The Lange Lijzen of the Six Marks*
The Last of Old Westminster (Y39), 357 n50
The Little Blue Girl. See *Harmony in Blue and Gold: The Little Blue Girl*
The Little White Girl. See *Symphony in White, No. 2: The Little White Girl*
The Loves of the Lobsters (Y209), 281–82
La Mère Gérard (Y26), 44
Miss May Alexander (Y127), 153, fig. 4.5
The Music Room. See *Harmony in Green and Rose: The Music Room*
Nocturne: Blue and Silver—Bognor (Y100), 208–9, 221, fig. 5.19
Nocturne in Blue and Silver (Y113), 126, 187, 272, 327, fig. 3.9
Oil Sketch for "La Princesse du pays de la porcelain" (Y49), 66–67, fig. 1.24
Panel from the Stair Hall at 49 Prince's Gate (Y175), 180, fig. 4.33
Pink and Grey: Three Figures (Y89), 286–87, fig. 6.32
 See also *The Three Girls*
Portrait of Miss Florence Leyland (Y107), 141, 278–79, fig. 3.29
Portrait Sketch of a Lady (Y184), 364 n137
Portrait Sketch of F. R. Leyland (Y96), 127, 141, fig. 3.12
Primrose Room. See under Whistler, works, *Harmony in Yellow and Gold*
La Princesse du pays de la porcelaine (Y50), 43, 149, 300, 336, fig. 1.1
 and *The Balcony*, 106
 Beardsley's sketch of, 308–9
 and Burrell, 318
 and Centennial International Exhibition, 186–87
 and Chinese porcelain, 19–20, 66, 71, 173–74, 197, 240–41
 date of, 71
 in Detroit, 340–45, fig. 7.23
 exhibition of, 43, 184–87, 317–18
 and Freer, 318–22, 330
 at Freer Gallery, 35, 347, 349, 355 n38
 and Huth, 185
 and Japanese art, 66, 183–84
 and Leyland, 186, 210
 models for, 70–71, 73
 oil sketch for, 66–67, fig. 1.24
 Punch parody of, 51–52, fig. 1.7
 in Peacock Room, 195, 211, 252, 267, 304, 332, 342
 and Pre-Raphaelites, 71–72
 and Reid, 306–7, 317
 and sale of Leyland's estate, 304–6
 and *Standing Nude*, 100

at the Whistler Memorial Exhibition, 322, fig. 7.16
Projects (so-called Six Projects), 67, 95–97, 98, 137, 338
See also Symphony in Blue and Pink; Symphony in White and Red; Variations in Blue and Green; Venus
Purple and Rose: The Lange Lijzen of the Six Marks (y47), 53–56, 58, 66, 184, 267, 308, fig. 1.8
Rose and Silver. See La Princesse du pays de la porcelaine
Rose et argent. See Tanagra
Six Projects. See Projects
Sketch for "The Balcony" (y57), fig. 2.24
Study in Grey: Portrait of F. R. Leyland (y95), 127, fig. 3.11
Symphony in Blue and Pink (y86), 102–3, 361 n89, fig. 2.21
Symphony in Flesh Colour and Pink: Portrait of Mrs. Frederick R. Leyland (y106), 130–31, 136–38, 140, 278, 279, 327, fig. 3.18
study for dress, 131, fig. 3.19
Symphony in Grey and Green: The Ocean (y72), fig. 5.22
Symphony in White, No. 1: The White Girl (y38), 43–44, 47–48, 50, 59, 64, 72, fig. 1.2
exhibition of, 184
model for, 43–44
and La Princesse, 184
Symphony in White, No. 2: The Little White Girl (y52), 62, 64–67, 81, 184, 357 n64, figs. 1.17, 1.23
original frame of, 65, fig. 1.21
Symphony in White, No. 3 (y61), 81–84, 87–88, 98, fig. 2.6
sketch of, fig. 2.3
Symphony in White, No. 4. See The Three Girls
Symphony in White and Red (y85), 94, 359 n43, fig. 2.15
"Symphony in White and Red." See The White Symphony: Three Girls
Tanagra (y92), 100, fig. 2.19
The Three Girls (y88), 19–20, 77, 92–94, 98, 102–6, 122, 124, 142, 195, 208
commission for, 88–89

contemporary viewings of, 142–45
fate of, 284–87
frame for, 142–43, 182, 288, fig. 6.33
and The Gold Scab, 288
Japanese inspiration of, 87
for Peacock Room, 145, 204, 210, 233
signature for, 102
sketches for, 90, 92, 105, 137
Whistler's ideas for, 86–87, 90
and Whistler's porcelain designs, 172
See also Girl with Cherry Blossom; Nude Study for "The Three Girls"; Pink and Grey: Three Figures; study of The Three Girls; The White Symphony: Three Girls
Variations in Blue and Green (y84), 94, fig. 2.14
Variations in Flesh Colour and Green: The Balcony (y56), 58–59, 67, 100, 102, 105–7, 319, fig. 1.11
sketch for, fig. 2.24
Variations in Flesh Colour, Grey, and Blue. See La Princesse du pays de la porcelaine
Venus (y82), 96, fig. 2.16
See also Standing Nude
Wapping (y35), 56, fig. 1.10
Whistler in His Studio (y63), 327, fig. 2.5
"Whistler's Mother." See under Whistler, works, Arrangement in Grey and Black
The White Girl. See Symphony in White, No. 1
The White Symphony: Three Girls (y87), 86, 94–96, 102, 287, 359 n43, fig. 2.71
Freer and, 90, 359 n43

publications:
Art & Art Critics, 26
The Gentle Art of Making Enemies, 274, 302, 382 n193
"Verdict for plaintiff," 277, fig. 6.27
"Harmony in Blue and Gold. The Peacock Room" (leaflet), 251–52, 375 n67, fig. 6.12

Whistler, William McNeill (1836–1900), 73, 99, 106, 285
Whistler and the Leyland Family in the Billiard Room, Speke Hall (anon.), 134, fig. 3.22

Whistler Journal (Pennell and Pennell), 282
Whistler Memorial Exhibition (1904), 96, 322, 336, fig. 7.16
Whistler v. Ruskin, 103, 274–77
"Verdict for plaintiff," 277, fig. 6.27
"Whistler's Mother." See under Whistler, works, Arrangement in Grey and Black
See also Whistler, Anna McNeill
White, Gleeson (1851–1898), 161
White, Stanford (1853–1906), 314–16
White House, 261–62
Whitford, Frank, 29
Whitley, George, 118
Wilde, Oscar (1854–1900), 53, 141, 201, 263, 275, 310–12
Salomé, 311–12
William of Orange (1650–1702), 190
Williamson, G. C. (1858–1942), 172–73, 175, 194
willow pattern, 148, 200, fig. 5.9
Wilson, M. W. H., photographer, fig. 3.3
Winans, Thomas (1820–1878), 105, 280
Windus, William Lindsay (1822–1907), 115
Burd Helen, 115, fig. 4.29
Winsor & Newton, 182
Winstanley, William (1772–1852), 294
Winterthur Art Conservation Program, 34
Wolbers, Richard, 34
Wolseley, Lady, 365 n8
Woolf, Virginia (1882–1941), 334
Woolton Hall, 294–95, 304
Wooster, Annie Ellen, 295–97
Wooster, Francis George Leyland (1890–?), 296–97
Wooster, Fred Richards (1884–?), 296–97
World, 67, 302, 331
World's Columbian Exposition (1893), Chicago, 317–19
Wyndham, Charles (1937–1941), 369 n137
Wyndham, Madeline (1835–1920), 232

Yates, Edmund ("Atlas") (1831–1894), 302
Young, Andrew McLaren, 26

Zerner, Henri, 48

Photographic credits

The author and publisher wish to thank the museums, libraries, archives, and private collectors who permitted the reproduction of works of art in their possession and supplied the necessary photographs. All photographic material (and permission to publish it) was obtained directly from the source indicated in the caption, except for the following: figs. 1.15, 2.6, and 2.8, Bridgeman Art Library, London/New York; figs. 1.17, 1.18, 1.27, 4.5, and 6.32, Art Resource, New York; fig. 2.4, from A. L. Baldry, *Albert Moore: His Life and Works* (1894); fig. 3.10, from Jeremy Maas, *The Victorian Art World in Photographs* (New York, 1984); fig. 3.11, from Sotheby's, New York; fig. 3.12, from E. R. and J. Pennell, *The Whistler Journal* (Philadelphia, 1921); figs. 4.24 and 4.27, from George C. Williamson, *Murray Marks and His Friends: A Tribute of Regard* (1919); fig. 4.37, from the Witt Library, Courtauld Institute of Art, University of London; fig. 6.17, from Elizabeth Aslin, *E. W. Godwin: Furniture and Interior Decoration* (1986); fig. 6.31, from Sotheby's, London; fig. 7.6, from Whistler Press Cuttings, vol. 22, Glasgow University Library, Special Collections; figs. 7.19 and 7.20, from Charles Lang Freer Papers, Freer Gallery of Art, Smithsonian Institution, Washington, D.C. Every effort has been made to obtain permission for illustrations taken from published sources under copyright.

The following are reproduced by special permission: fig. 1.4, courtesy Museum of Fine Arts, Boston; fig. 3.4, The National Trust, England; figs. 3.5 and 3.16, courtesy of the Trustees, National Gallery, London; fig. 3.22, courtesy, Board of Trustees of the National Museums and Galleries on Merseyside; fig. 4.9, courtesy of the Norfolk County Council Library and Information Service, Norfolk Studies Library, Norwich, England; figs. 4.15, 4.16, 4.21, 4.28, 4.32, 5.2, 5.7, 5.11, 5.12, 5.37, V&A Picture Library, The Victoria and Albert Museum, London; fig. 5.1, courtesy of Hyperion Books for Children, New York; fig. 6.7 and 7.9, The British Library, London. All rights to works illustrated in figs. 1.2 and 1.10 are reserved © 1998 Board of Trustees, National Gallery of Art, Washington, D.C.; fig. 2.9, © Photo RMN; figs. 3.9 and 7.11, courtesy of the Fogg Art Museum, Harvard University Art Museums; figs. 3.18 and 5.22, © The Frick Collection, New York; figs. 4.3, 4.23, 4.31, 5.23, 5.26, and 6.11, © The British Museum; figs. 4.6, 4.14, 6.15, and 6.23, © RCHME Crown Copyright; fig. 4.13, © Mrs. Gregory; fig. 4.17, © Mrs. J. Atkins; fig. 4.38, © 1977 The Cleveland Museum of Art; fig. 5.9, © Robert Copeland; fig. 7.17, © B. T. Batsford, Ltd.; fig. 7.26, © National Geographic Society, Washington, D.C.

Fig. 2 is from the Leonard A. Lauder Collection of American Posters, Gift of Leonard A. Lauder, 1984 (1984.1202.145), © 1998 The Metropolitan Museum of Art.

Photographers known to the author but not cited in the captions are Geremy Butler Photography, figs. 5.34 and 5.36; Robb Harrell, figs. 4.34 and 6.4; Daniel McGrath, fig. 4.32; Glen Segal, fig. 2.20; John Tsantes and Jeffrey Crespi, fig. 6.20; John Tsantes and Robb Harrell, plates 1–4, figs. 5.17, 5.20, 5.21, 5.28, 5.29, 5.30, 6.3, and 6.16.

The renderings of the Leyland dining room illustrated in figs. 5.18 and 5.38 are by Peter R. Nelsen, ©1997 Freer Gallery of Art.